PORTRAITS BY INGRES
IMAGE OF AN EPOCH

"What man has better painted the nineteenth century? The gallery of portraits by Ingres, begun in 1804 and completed in 1861, is that not the most faithful image of an epoch?"

Léon Lagrange, 1867

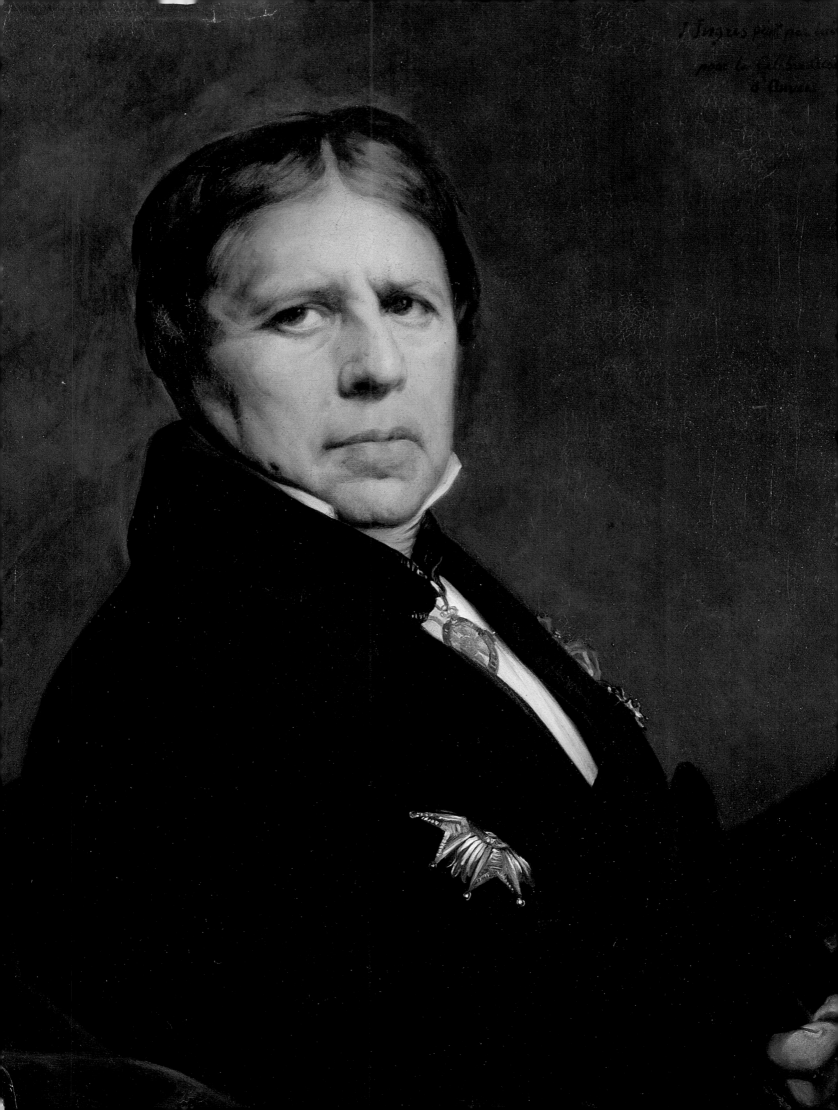

PORTRAITS BY INGRES
IMAGE OF AN EPOCH

Edited by
GARY TINTEROW AND PHILIP CONISBEE

drawings entries by HANS NAEF

with contributions by
PHILIP CONISBEE
REBECCA A. RABINOW
CHRISTOPHER RIOPELLE
ROBERT ROSENBLUM
ANDREW CARRINGTON SHELTON
GARY TINTEROW
GEORGES VIGNE

The Metropolitan Museum of Art, New York

Distributed by Harry N. Abrams, Inc., New York

This catalogue is published in conjunction with the exhibition "Portraits by Ingres: Image of an Epoch," held at The National Gallery, London, January 27–April 25, 1999, the National Gallery of Art, Washington, D.C., May 23–August 22, 1999, and The Metropolitan Museum of Art, New York, October 5, 1999–January 2, 2000.

The exhibition is made possible in New York by the generous support of
The Florence Gould Foundation.

The exhibition is supported in London by the Corporate Members of
The National Gallery, London.

The exhibition was organized by The Metropolitan Museum of Art, New York, the National Gallery of Art, Washington, D.C., and The National Gallery, London.

This publication is made possible by the Doris Duke Fund for Publications.

Published by The Metropolitan Museum of Art, New York

John P. O'Neill, Editor in Chief
Margaret Donovan and Ellyn Childs Allison, Editors
Bruce Campbell, Designer
Gwen Roginsky and Hsiao-ning Tu, Production
Robert Weisberg, Computer Specialist

The entries by Hans Naef were excerpted from his *Die Bildniszeichnungen von J.-A.-D. Ingres* (5 vols., Bern, 1977–80) and translated from the German by Russell Stockman. Translations from the French are by Mark Polizzotti, Mary Laing, and Gary Tinterow. The bibliography was compiled and edited by Jean Wagner and Jayne Kuchna.

Typeset in Fournier and Diotima
Printed by Julio Soto Impresor, S.A., Madrid
Bound by Encuadernación Ramos, S.A., Madrid
Color separations by Professional Graphics, Rockford, Illinois
Printing and binding coordinated by Ediciones El Viso, S.A., Madrid

The original text of the quotation on page 2 is: "Quel homme a mieux peint le dix-neuvième siècle? La galerie des portraits d'Ingres, commencée en 1804, terminée en 1861, n'est-elle pas l'image la plus fidèle d'une époque?" (Léon Lagrange, *Le Correspondant*, May 25, 1867, p. 75).

Jacket/cover illustration: *Madame Moitessier Seated*, 1856 (cat. no. 134)
Frontispiece: *Self-Portrait*, 1864–65 (cat. no. 149)

Library of Congress Cataloging-in-Publication Data
Ingres, Jean-Auguste-Dominique, 1780–1867.
Portraits by Ingres: image of an epoch / edited by Gary Tinterow and Philip Conisbee;
drawing entries by Hans Naef; with contributions by Philip Conisbee . . . [et al.]
p. cm.
Catalog of an exhibition held at the National Gallery, London, Jan. 27–Apr. 25, 1999,
the National Gallery of Art, Washington, D.C., May 23–Aug. 22, 1999,
and the Metropolitan Museum of Art, New York, Oct. 5, 1999–Jan. 2, 2000.
Includes bibliographical references and index.
ISBN 0-87099-890-0 (hc). — ISBN 0-8109-6536-4 (Abrams). — ISBN 0-87099-891-9 (pbk. : alk. paper)
1. Ingres, Jean-Auguste-Dominique, 1780–1867—Exhibitions. I. Tinterow, Gary.
II. Conisbee, Philip. III. Naef, Hans, 1920–. IV. National Gallery (Great Britain)
V. National Gallery of Art (U.S.) VI. Metropolitan Museum of Art (New York, N.Y.) VII. Title.
ND1329.I53A4 1999
759.4—dc21 98-48508
 CIP

Second Printing

CONTENTS

CURATORS OF THE EXHIBITION

PHILIP CONISBEE
Senior Curator of European Paintings, National Gallery of Art, Washington, D.C.

CHRISTOPHER RIOPELLE
Curator of Nineteenth-Century Art, The National Gallery, London

GARY TINTEROW
Engelhard Curator of European Paintings,
The Metropolitan Museum of Art, New York
assisted by
REBECCA A. RABINOW
Research Associate,
The Metropolitan Museum of Art, New York

LENDERS TO THE EXHIBITION

The numbers in the following list refer to works in the catalogue.

Public Institutions

BELGIUM
Antwerp, Koninklijk Museum voor Schone Kunsten 149
Liège, Musée d'Art Moderne et Contemporain 2

ENGLAND
Cambridge, The Syndics of the Fitzwilliam Museum 67, 137
London, The British Museum 50, 71, 130
London, The Trustees of The National Gallery 33, 134
London, The Board of Trustees of the Victoria & Albert Museum 60
Oxford, The Visitors of the Ashmolean Museum 18, 75, 95

FRANCE
Aix-en-Provence, Musée Granet 25
Besançon, Musée des Beaux-Arts et d'Archéologie 28
Carpentras, Musées de Carpentras 131
Lyons, Musée des Beaux-Arts 155, 158
Montauban, Musée Ingres 4, 5, 6, 129, 144
Nantes, Musée des Beaux-Arts 35
Orléans, Musée des Beaux-Arts 21, 24
Paris, Conservatoire National Supérieur de Musique 120
Paris, École Nationale Supérieure des Beaux-Arts 96
Paris, Musée de l'Armée 10
Paris, Musée de la Vie Romantique 105
Paris, Musée des Arts Décoratifs 81
Paris, Musée du Louvre 9, 12, 17, 20, 22, 23, 30, 72, 82, 90, 92, 93, 94, 97, 99, 102, 103, 110, 111, 118, 138
Rouen, Musée des Beaux-Arts 8
Toulouse, Musée des Augustins 7
Versailles, Musée National du Château 122

GERMANY
Bayreuth, Richard Wagner Stiftung 116

ITALY
Florence, Galleria degli Uffizi 148

NETHERLANDS
Amsterdam, Rijksmuseum 59
The Hague, Gemeentemuseum 73
Rotterdam, Museum Boijmans Van Beuningen 151

RUSSIA
Saint Petersburg, State Hermitage Museum 86

SWITZERLAND
Bern, Kunstmuseum 154, 165
Geneva, Société des Arts 128
Vevey, Musée Jenisch 76
Zurich, Foundation E. G. Bührle 31, 36

UNITED STATES OF AMERICA
Boston, Museum of Fine Arts 55
Buffalo, Albright-Knox Art Gallery 162
Cambridge, Fogg Art Museum 47, 126, 127, 135, 159
Chicago, The Art Institute of Chicago 42, 44, 98, 117, 164
Cincinnati, Cincinnati Art Museum 119
Cincinnati, The Taft Museum 87
Detroit, The Detroit Institute of Arts 161
Kansas City, The Nelson-Atkins Museum of Art 29
Los Angeles, The J. Paul Getty Museum 64, 142, 143
Los Angeles, Los Angeles County Museum of Art 68
New London, Lyman Allyn Art Museum 141
New York, The Frick Collection 125
New York, The Metropolitan Museum of Art 27, 41, 49, 53, 54, 58, 63, 77, 78, 79, 83, 85, 88, 89, 101, 123, 124, 145, 147, 153, 156
New York, The Pierpont Morgan Library 13, 52
Philadelphia, Philadelphia Museum of Art 32, 45
Rochester, Memorial Art Gallery, University of Rochester 1, 80
Sacramento, Crocker Art Museum 16
Saint Louis, The Saint Louis Art Museum 57
Virginia, Virginia Museum of Fine Arts 46, 69
Washington, D.C., National Gallery of Art 14, 26, 40, 48, 62, 91, 104, 133, 140, 157, 163

Other Collections

André Bromberg 43, 74, 106
Konrad Klapheck, Düsseldorf 146
Jan and Marie-Anne Krugier-Poniatowski 100
Prat Collection, Paris 107, 108
Paul Prouté S.A. 136
Yves Saint Laurent and Pierre Bergé 84, 115
Dian and Andrea Woodner, New York 112

Anonymous lenders 3, 11, 15, 19, 34, 37, 38, 39, 51, 56, 61, 65, 66, 70, 109, 113, 114, 121, 132, 139, 150, 152, 160

DIRECTORS' FOREWORD

Cursed portraits! They always keep me from undertaking important things." Constantly frustrated by slow progress on his portraits, the paintings he called his "big enemies," Jean-Auguste-Dominique Ingres (1780–1867) pretended to prefer to paint grand public decorations and huge altarpieces. But there was rarely a moment in his career when he did not have a portrait on his easel and another in the works. The demand for these portraits was unending, a reflection of the immense value placed on them. By the end of Ingres's career, they were rightly considered to be his immortal work, his legacy. One critic neatly tied them to the artist's genre of choice, epic history painting: "Ingres's portraits, worthy to be displayed next to those of the greatest masters, should be considered true history paintings: they are at once individuals and types." Charles Baudelaire considered them to be "true portraits, that is . . . the ideal reconstruction of the individuals." As perfected reconstructions, Ingres's portraits are indeed an ideal reflection of his period, the true image of an epoch as it wished to be remembered.

Spanning six decades—the last years of the Revolution, the Napoleonic Empire, the Bourbon Restoration, the July Monarchy, the Second Republic, and the Second Empire—Ingres's gallery of portraits constitutes a Who's Who of the ruling elite in France, the aristocracy of birth, beauty, politics, wealth, and intellect. With 42 paintings, 101 independent drawings, and 22 studies, this exhibition—the first in Great Britain or the United States to be devoted to Ingres's portraits—is the most extensive of its kind in 132 years. Not since the memorial exhibition organized at the École des Beaux-Arts, Paris, in 1867 have so many of the artist's portraits, painted and drawn, been brought together. For its remarkable size and scope, we are indebted to a host of generous private collectors, museum directors, and curators across Europe and America. Rarely have so many possessors so willingly parted with their greatest masterpieces in order to enjoy the delights of such a grand reunion. On the behalf of the fortunate visitors to the exhibition, we express our thanks.

We congratulate the curators—Philip Conisbee, Christopher Riopelle, and Gary Tinterow—for their success in assembling the exhibition. For their informative texts, we thank the many contributors to this catalogue, which has been produced with the support of the Doris Duke Fund for Publications. The exhibition is supported in Washington by Airbus Industrie. In New York the exhibition is supported by The Florence Gould Foundation. Finally, it is our pleasure to recognize the Federal Council on the Arts and Humanities for granting U.S. Government Indemnity and the Department of Culture, Media, and Sport for granting British Government Indemnity.

Neil MacGregor
Philippe de Montebello
Earl A. Powell III

ix

ACKNOWLEDGMENTS

First and foremost we thank the directors of our three museums—Neil MacGregor, Philippe de Montebello, and Earl A. Powell III—for their enthusiastic support of the exhibition. We are extremely grateful for their assistance, encouragement, and many important contributions to the project.

No exhibition of Ingres's work could succeed without the cooperation of the great repositories of his art in France, and we are profoundly grateful to our colleagues there for their generous and enthusiastic contributions to the success of our endeavor. In Paris, at the Réunion des Musées Nationaux, we thank the director, Françoise Cachin, and Irène Bizot. At the Musée du Louvre, Paris, we thank the director, Pierre Rosenberg; in the Département des Peintures, Jean-Pierre Cuzin, Sylvain Laveissière, Olivier Meslay, and Anne Roquebert; in the Département des Arts Graphiques, Françoise Viatte, Arlette Sérullaz, and Jean-François Méjanès. At the Musée Ingres in Montauban, Georges Vigne welcomed our project with open arms; in addition to handsome loans, he contributed an important essay to this catalogue and served at all times as a key source of information on Ingres's work and life.

Throughout Europe and America, curators and collectors consented to lend their most cherished masterpieces or to share valuable information on the location of works by Ingres. In addition to the people and institutions named in the list of lenders, we extend our thanks to the following for their contributions to the project: Christina Acidini, Clifford Ackley, Pierre Arrizoli-Clementel, Jean Aubert, Joseph Baillio, Valerie Bajou, Sylvan Barnet, Isabelle Battez, Pierre Bergé, Maria van Berge-Gerbaud, Danny Berger, André Bromberg, Dorine Cardyn-Oomen, Victor I. Carlson, Marjorie Cohn, Malcolm Cormack, Denis Coutagne, James Cuno, Alain Daguerre de Hureaux, Francine Dawans, Benjamin Doller, Douglas Druick, Jay M. Fisher, Claude Gaier, Jean-Louis Gaillemin, Kate Ganz, Phyllis Hattis, John and Paul Herring, Ay-Whang Hsia, Paul Huvenne, Guido Jansen, David Johnson, Paul Z. Josefowitz, Isabelle Klinka, Frédéric Lacaille, Susan Lambert, Marie-Hélène Lavallée, Katharine C. Lee, R. M. Light & Co., Patricia Mainardi, Giovanna Melandri, Eric Moinet, Edgar Munhall, Jane Munro, Jacques Perot, Claude Pétry, Mikhail Piotrovsky, Pauline Prevost-Marcilhacy, Antonio Paolucci, Joseph J. Rishel, Baronne Elie de Rothschild, Samuel Sachs II, Guy Stair Sainty, Maria-Christina Sayn-Wittgenstein, David Scrase, Mario Serio, Denita Sewell, Kenneth Soehner, Miriam Stewart, Margret Stuffmann, Patty Tang, Alain Tarica, Bernard Terlay, E. V. Thaw, Margit and Rolf Weinberg, Jon Whiteley, Guy Wildenstein, Marc F. Wilson, and Mrs. Charles Wrightsman.

We are indebted to Dr. Hans Naef, the doyen of Ingres scholars, for graciously allowing us to reproduce his texts on the artist's portrait drawings, since these essays remain the essential source for all studies of Ingres's portraiture. Mrs. Marianne Feilchenfeldt made an enormous contribution to the catalogue by reviewing with Dr. Naef the translations of his texts. These were prepared, with wit and grace, by Russell Stockman. We also thank Walter and Maria Feilchenfeldt for their many kindnesses. Many other "Ingristes" welcomed the project and shared with us their extensive knowledge. Robert Rosenblum contributed the insightful introduction. Pierre Rosenberg and Louis-Antoine Prat very kindly opened their Ingres archives to us and made a number of pertinent suggestions. Eric Bertin devoted countless hours to the task of correcting various portions of the catalogue manuscript and provided a number of little-known exhibition and bibliographic references. Daniel Ternois furnished an index to his forthcoming edition of Ingres's letters to Charles Marcotte and answered a number of specific queries. Sylvie Aubenas gave access to the vast iconographic resources of the Bibliothèque Nationale de France. Paula Warrick and Andrew Shelton graciously shared their research materials with the organizers, and the latter kindly reviewed several texts. Jeff Van Gool, Librarian at the Koninklijke Academie voor Schone Kunsten, Antwerp, generously transcribed previously unpublished letters written by Ingres. Robert McDonald Parker produced, as usual—and as if by magic—all sorts of unpublished and obscure documents and acted as the project's ambassador in Paris. We thank everyone most heartily.

At the National Gallery, London, we thank Michael Wilson, who steered the project through every stage of its development, tirelessly assisted by Mary Hersov, Joanna Kent, and Anne Starkey. Rosalie Cass arranged numerous complicated loans with the help of Sarah Frances and Chloe Dodwell. We also thank conservators Martin Wyld and David Bomford and curators David Jaffé and Nicholas Penny. Humphrey Wine kept a careful

eye on the project during the period when the National Gallery was without a curator of nineteenth-century paintings. Elspeth Hector helped ease all research in the library. Kathy Adler and Mari Griffith offered thoughtful insights throughout. John England and Isabella Kocum restored the beautiful frame for *Madame Moitessier Seated*. John Leighton, former curator at the National Gallery and present director of the Van Gogh Museum, Amsterdam, launched the exhibition in London.

Christopher Riopelle wishes to thank Christopher Brown, formerly of London and now director of the Ashmolean Museum, Oxford, for his advice and encouragement from both cities. He also wishes to thank Colin B. Bailey, Philippe Bordes, Ann Dumas, John Goodman, Katherine Crawford Luber, Joseph J. Rishel, Carl Brandon Strehlke, and Caroline Riopelle for long, lively, and helpful discussions of Ingres problems.

At the National Gallery of Art, we thank D. Dodge Thompson, Naomi Remes, and Jonathan Walz, Exhibitions; Mark Leithauser, Gordon Anson, William R. Bowser, Donna J. Kwerderis, and Barbara Keyes, Design and Installation; Sally Freitag and Hunter Hollins, Office of the Registrar; Andrew C. Robison and Margaret Morgan Grasselli, Old Master Drawings; David Bull and Sarah Fisher, Painting Conservation; Judith Walsh, Paper Conservation; Stephanie Belt, Loans Department; Neal Turtell and his Library staff; Frances P. Smyth, Editor's Office; Ira Bartfield and Sara Sanders-Buell, Imaging and Visual Services; Ann Leven, Office of the Treasurer; Nancy R. Breuer, Office of the Secretary–General Counsel; and Sandy Masur, Corporate Relations.

Philip Conisbee would like to offer special thanks to his present and former curatorial colleagues Lisa Bottomly and Florence E. Coman for their bibliography and research; to Margaret Morgan Grasselli, Kimberly Jones, and Nancy Yeide for their catalogue entries; to Kate Haw and Ana Maria Zavala for their administrative zeal; to Professor Lorenz Eitner for making available his draft catalogue entries on the National Gallery's portraits by Ingres; to Eileen Ribeiro for her advice on costume; to Chiara Stefani for her research in Rome; and to Faya Causey for her usual support of many kinds.

This handsome catalogue was produced at The Metropolitan Museum of Art. We thank John P. O'Neill for devoting his considerable resources to the project and Ann Lucke for shepherding the complicated manuscript from draft through proofed text. Margaret Donovan and Ellyn Allison edited the manuscript with exemplary insight, tact, and skill. We are especially grateful to them for their many indulgences and numerous improvements. Cynthia Clark and Kathleen Howard provided expert editorial assistance with captions and catalogue entries. Jayne Kuchna and Jean Wagner shaped the unwieldy lists of references and bibliography into a thing of beauty. Robert Weisberg supervised the typesetting with meticulous care and patience. Hsiao-ning Tu skillfully expedited the production schedule and supervised the scanning of images, many of which were ordered by Linda Hirschmann. Bruce Campbell provided the elegant design, and Gwen Roginsky supervised the color reproduction, printing, and binding.

At the Metropolitan Museum, we wish to thank for their generous collaboration the curators who provided loans from their departments—Everett Fahy, George Goldner, Colta Ives, and Laurence Kanter. We also thank Charlotte Hale, Dorothy Mahon, Marjorie Shelley, and Hubert von Sonnenberg for their insights and help regarding conservation. Nina Maruca skillfully made transportation arrangements. Daniel Kershaw and Sophia Geronimus designed the installation and graphics for the exhibition. Diana Kaplan and Carol Lekarew provided assistance in the Photograph and Slide Library. We thank Emily Rafferty and the Development Office for their efforts to secure funding. As always, Linda Sylling administered the budget with skill and charm. Mahrukh Tarapor provided much-needed advice and assistance.

Gary Tinterow wishes to extend his deepest thanks to Rebecca A. Rabinow for administering the exhibition with grace and accuracy and for contributing the excellent chronology to the catalogue. Both exhibition and catalogue have benefited from her intelligent and attentive eye. He also thanks Olaiya Land and Gabriella de la Rosa for their careful and exhaustive research and Kathryn Calley Galitz for her remarkable synthesis of huge amounts of material into cogent notes. In addition, she updated information for all of Dr. Naef's catalogue entries. In the Department of European Paintings, Susan A. Stein, Dorothy Kellett, Samantha Sizemore, Julie Steiner, Eleanor Hyun, Andy Caputo, Gary Kopp, Theresa King-Dickinson, and John McKanna all contributed in important ways. Sylvain Bellenger, Guy Boyer, Jean-Loup Champion, and Tony Smith are warmly thanked for their research assistance and friendship and James F. Joseph for his patient support and companionship.

Philip Conisbee
Christopher Riopelle
Gary Tinterow

NOTE TO THE READER

All works illustrated in this book are by J.-A.-D. Ingres unless otherwise stated.

The first six chapters following the introduction offer a chronological overview of Ingres's portraiture. At the end of each chapter are the corresponding catalogue entries arranged in two chronological sections, the paintings preceding the independent drawings. The last two chapters discuss, respectively, the critical reception of Ingres's work during his lifetime and his collaborations with his students and other artists.

The dates given for works in this exhibition were assigned by the authors of the catalogue entries. In most cases, they also compiled the provenances, exhibition histories, and reference lists for the catalogued works. Additional information provided by Eric Bertin is indicated by his initials in brackets: [EB].

Information about mediums, dimensions, and inscriptions was supplied by the owners of the works. The paper on which drawings were made is white unless otherwise noted. Dimensions are given with height preceding width. Measurements are given in centimeters and to the nearest eighth of an inch.

Unless otherwise indicated, catalogued works will be exhibited at all three venues: London, Washington, and New York.

The letter "W" refers to Georges Wildenstein's *Ingres*, a catalogue raisonné of the artist's paintings published in 1954. Similarly, the letter "N" refers to Hans Naef's *Die Bildungszeichnungen von J.-A.-D. Ingres*, a catalogue raisonné of Ingres's portrait drawings published in 1977–80. Works by Ingres mentioned but not illustrated in this catalogue are identified by their Wildenstein or Naef number; if the work is in a public collection, that information is given as well.

Bibliographical references are cited in abbreviated form in the catalogue entries and in the chapter notes. The corresponding full citations will be found in the bibliography that begins on page 557.

Catalogue entries are signed with the author's initials, which are listed in the following key:

P.C. Philip Conisbee
M.M.G. Margaret Morgan Grasselli
K.J. Kimberly Jones
H.N. Hans Naef
C.R. Christopher Riopelle
A.C.S. Andrew Carrington Shelton
G.T. Gary Tinterow
N.Y. Nancy Yeide

Portraits by Ingres

Image of an Epoch

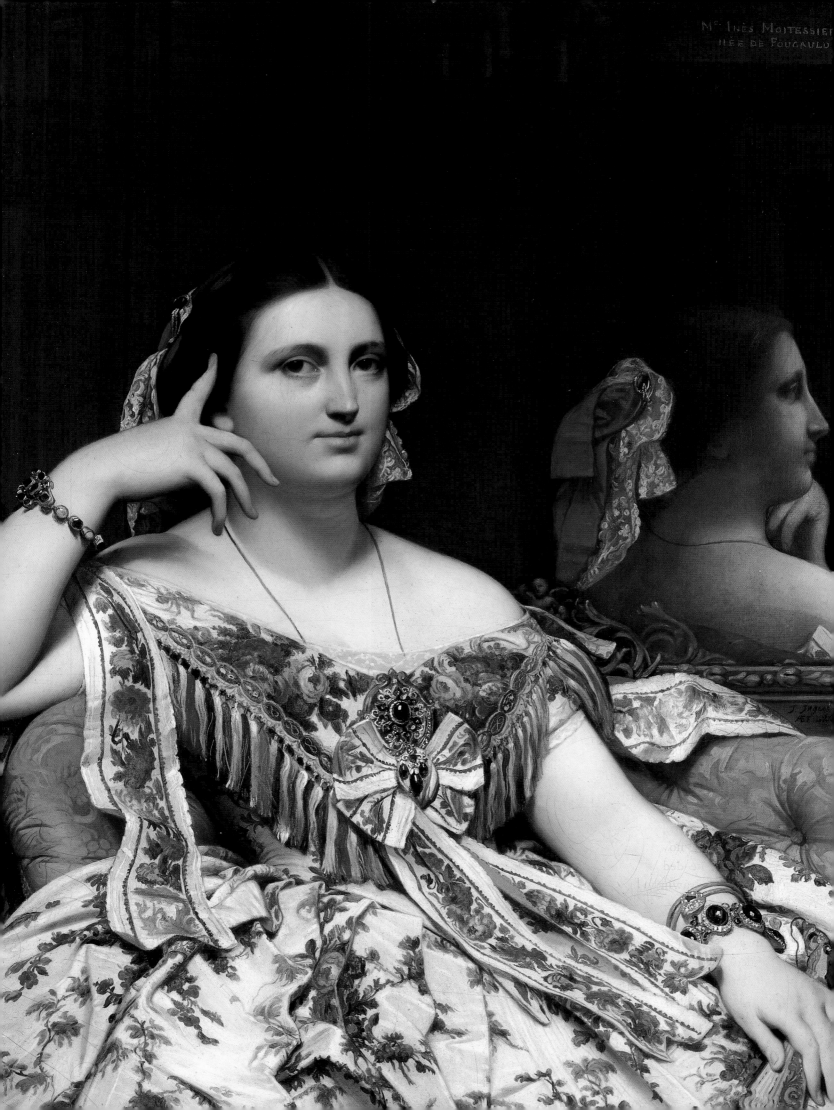

INGRES'S PORTRAITS AND THEIR MUSES

Robert Rosenblum

Toward the end of a century in which the most revolutionary art attempted to annihilate visible, earthbound realities and waft us to more exalted, imaginary domains, it may come as a shock to realize that the venerable traditions of portraiture are once again alive and well. While the conquests of modernism temporarily buried artists' recurrent fascination with the unique data that add up to a particular person, the late twentieth century has witnessed infinite legions of singular people—formerly threatened by Machine Age uniformity and the iconoclasm of abstract art—begging to be scrutinized once more. Wherever we look in the last decades, particular faces keep turning up, whether in the paparazzi portraiture of Andy Warhol, the private worlds of Gilbert & George, the disarmingly magnified mug shots of Thomas Ruff and Chuck Close, or the self-portrait disguises of Cindy Sherman and Yasumasa Morimura. And, as usual, the concerns of new art change the way we look at old art. Amazingly, we had to wait until 1996 for eight decades of Picasso's art to be surveyed for the first time as the work of an important portraitist,[1] much as other recent exhibitions have turned to older masters such as Degas and Renoir[2] in order to focus exclusively on their achievement as interpreters of specific people. In this recent rearrangement of subject priorities, many artists once neglected by modernism have taken on unexpected allure, so that, for instance, the cosmopolitan territory of high-society portraiture circa 1900—the world of Sargent, Boldini, Zorn, Blanche[3]—has begun to take shape as an important chapter in the history of art.

As for Ingres, however, his achievement as a portraitist hardly needed to be rediscovered. Both in his paintings and drawings, the scrupulous depiction of his contemporaries—whether family, friends, wealthy patrons, or sitters as famous as Napoleon and Cherubini—had always formed a major category of his work that demanded equal time with his intellectually more ambitious paintings. Given Ingres's own position as guardian of the academic faith that put the depiction of mere con-

temporary mortals on a far lower level of subjects than, say, the idealized recreation of Jupiter or the Virgin, posterity's clear preference for his portraiture over his history painting would presumably have made the master turn in his grave. Yet, like his own teacher David, Ingres never stopped making portraits, mirroring through his sitters the rapidly changing fashions, decor, and personalities of two-thirds of the nineteenth century, from 1800 to 1867, the year of his death. Moreover, like David, he gave his portraits almost as much prominence in the official displays of his work as he did his narratives from mythology, the Bible, or history; they usually figured in the Paris Salons, where he exhibited regularly from 1802 to 1834, as well as in later group shows or one-man exhibitions that took place outside the Salon.

Most telling was what was shown at Ingres's official apotheosis, a major retrospective of sixty-nine[4] paintings held in 1855 on the occasion of the Exposition Universelle. Though he often grumbled about wasting his time on something as lowly as portraiture—after being cajoled back to earth by the entreaties of the rich and the famous, the high and the mighty, when he should have remained in the company of Homer and the Virgin—he apparently had no objections at all to mixing together with his most ambitious history paintings more than a dozen portraits of his contemporaries. And this number would total more than forty if one expanded the definition of his portraiture to include a state portrait and an allegory of Napoleon I, a Neo-Roman profile bust of Prince Napoleon, two scenes of Pope Pius VII holding services in the Sistine Chapel, and a group of Neo-Gothic portraits of members of Louis-Philippe's family masquerading as their namesake Christian saints in the guise of cartoons for stained-glass windows.

Installation shots of the 1855 retrospective (figs. 2, 3) show clearly how Ingres's portraits were integrated into the totality of his work rather than being relegated to a different part of the display; they also demonstrate with equal clarity the continually shifting proportions of the facts of portraiture and the fictions of ideal art that he

Opposite: Fig. 1. Detail of *Madame Moitessier Seated* (cat. no. 134)

3

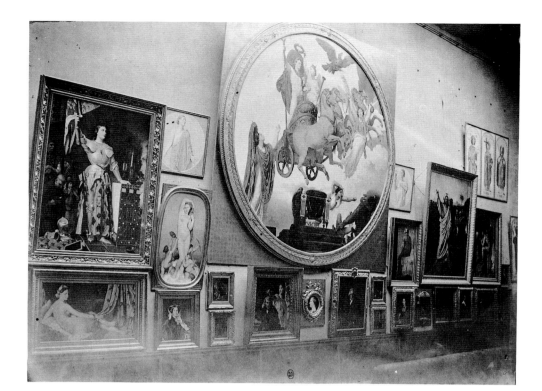

often juggled to blur the distinction between these two realms. Even looking at the most famous symbol of Ingres's academic orthodoxy, *The Apotheosis of Homer* (fig. 4), which had originally been designed as a ceiling painting for the Louvre but had been moved for the retrospective from these mythological heavens to a vertical wall much closer to earth, we begin to realize that it, too, is a portrait gallery. Looked at this way, the painting, with its ritualized veneration of eternal classical values, is hardly so incompatible with the portraits of two of Ingres's illustrious contemporaries that were hung directly below

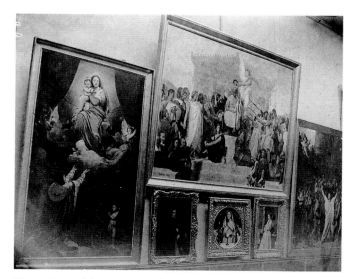

Fig. 3. View of the Ingres installation at the Exposition Universelle, Paris, 1855

it, on either side of *The Virgin with the Host:* those of Comte Mathieu Molé (fig. 158), a prime minister under Louis-Philippe, and Comtesse Louise d'Haussonville (cat. no. 125), a distinguished woman of letters (and granddaughter of Madame de Staël). The attention Ingres has given to the details of his sitters' clothing and hairstyles, for instance, also belongs to the same vision with which he reincarnated the cultural titans of a more recent past— Shakespeare, Poussin, Molière, Gluck, et al.—whose appearances he could reconstruct from historical data copied from portraits made by their own contemporaries. For want of such information, the features of most of the classical men (and one woman, Sappho) in the upper ranks tend to be generically antique. Moreover, cropping these relative newcomers to the classical Hall of Fame at the waist makes them appear to be rising from the gravity-bound domain of the real world below the frame, just beginning their arduous, stepwise ascent to the most idealized heights of classical perfection.

In the 1855 installation, that real world is firmly anchored in Ingres's sharp-eyed depictions of sitters culled from the history of his own lifespan: the First Empire, the Bourbon Restoration, the July Monarchy, and the Second Empire. Yet these nineteenth-century men and women could also be transported by him to a realm of ethereal purity, where the classical gods reside forever. Napoleon, for instance, was presented by Ingres at the 1855 retrospective as both the most palpable of mortals and the most airborne of deities. In a painting of

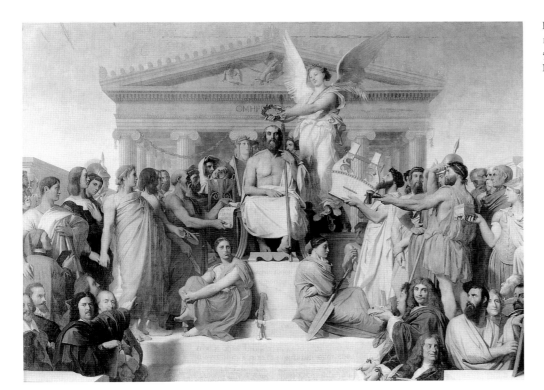

Fig. 4. *The Apotheosis of Homer*, 1827 (W 168). Oil on canvas, 59⅞ × 79⅞ in. (152 × 203 cm). Musée du Louvre, Paris

1804 (cat. no. 2), the thirty-five-year-old emperor-to-be is shown as he appeared in Liège on August 1, 1803, wearing a consular uniform rendered with such precision of red velvet and gilded ornament that we feel it could almost be lifted right out of the painting and placed on a mannequin in a museum vitrine. But in another, posthumous vision of Napoleon I (fig. 5), commissioned in 1853 as a ceiling decoration for the salon of the new emperor, Napoleon III, at the Hôtel de Ville, the ancestral emperor has soared even higher than the empyrean of Homer. Now presented in a state of ideal nudity like an antique god or warrior, Napoleon I, accompanied by a wreath-bearing allegory of Fame, is borne to the Temple of Immortality in a golden quadriga, while on the horizon below, a mountainous view of the exiled Napoleon's final residence, Saint Helena, is left behind, an earthbound memory of nineteenth-century historical fact.[5]

But even in his portraits of people less susceptible to mythmaking than Napoleon, Ingres would often attempt to cross the seemingly unbridgeable gulf between the demands of portrait likeness and the Olympian heights of the academic tradition. In doing so, he was reviving the situation confronted by Sir Joshua Reynolds, who, from the 1760s on, often adjusted the empirical requirements of painting recognizable portraits of friends and aristocratic patrons to his own idealistic dream that Britain might at last absorb the abstract beauty of form and myth that was the legacy of Greco-Roman and Continental art. Working against the nineteenth century's ever-increasing demand

for pictorial truths that were visible, specific, and material, Ingres tried in countless ways to elevate his portraits to more exalted planes than mere mirror images. At times, he would openly quote a broad span of art-historical sources that could cover antiquity and the Middle Ages as well as such old-master paragons as Raphael, Holbein, Bronzino, and Poussin. Elsewhere, he would juxtapose perceived facts with allegorical fictions. And often, he would subtly adjust the posture and expression of his sitter, so that they might evoke the mythic aura of an ideal personage culled from classical or Christian imagery.

So it was that hanging beneath *The Apotheosis of Napoleon* at the 1855 retrospective were three portraits that may well represent the range of Ingres's varying mixtures of the extremities of modern facts and inherited fictions. In the middle hung a portrait of a patron of the arts and one of the primary organizers of the Exposition Universelle, Prince Napoleon (fig. 6). Its placement directly under the apotheosis of the prince's uncle Napoleon I, as well as its repetition of the round format of the lofty allegory, helped to mythologize the newest political branch of the Bonaparte family tree—an allusion further underlined by the transformation of the image of the thirty-three-year-old sitter into a Roman profile portrait bust in trompe l'oeil relief, as if the new prince had assumed the attributes of a Roman ruler. It was the kind of historical disguise that harked all the way back to one of Ingres's earliest portrait drawings, that of the French actor Brochard in the costume of a helmeted Roman (cat. no. 16), also

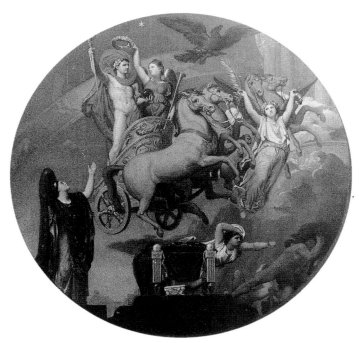

Fig. 5. *Study for "The Apotheosis of Napoleon I,"* 1853 (W 271). Oil on canvas, diam. 19¼ in. (48.9 cm). Musée Carnavalet, Paris

executed in a style that imitated the classical cameos and medallions whose compressed, shadowless spaces so often inspired Ingres.[6] (Ironically, both these ostensibly timeless Napoleonic allegories of 1855 were victims of the rapid reversals of nineteenth-century politics and would be destroyed by fire during the Commune of 1871.)

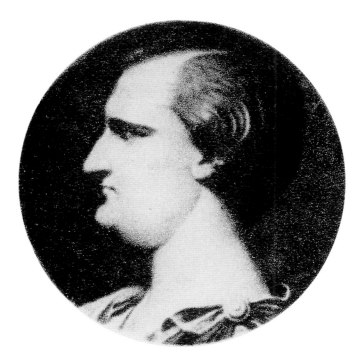

Fig. 6. *Napoléon-Joseph-Charles-Paul Bonaparte, called Prince Napoleon,* 1855 (W 277). Destroyed

Flanking the bust of Prince Napoleon were two portraits of other famous contemporaries that descended to the most empirical world of photographic truth. "Photographic" may be an anachronism in the case of the portrait of the businessman and journalist Louis-François Bertin (cat. no. 99), first shown at the Salon of 1833, since the invention of photography was not officially declared until 1839. But Ingres, like Delaroche, Horace Vernet, and other painters working at the same time as the pioneer photographers, Niepce and Daguerre, often seemed to share their positivist goals of capturing absolute visual truth. Moreover, Ingres's own master, David, had already pointed the way to *Monsieur Bertin.* Some of his male portraits—that of Cooper Penrose (1802; San Diego Museum of Art) and, above all, that of his friend and fellow political exile in Brussels, Emmanuel-Joseph Sieyès (fig. 7)—prefigure Ingres's masterful deception of offering nothing but unedited visual facts. And they also employ the monochromatic tonalities that foreshadow the sepia tints so conspicuous in *Monsieur Bertin* and in early photography. In the portrait of Sieyès, David, though as much a propagandist for classical idealism as Ingres, nevertheless makes us marvel at the rendering of the glints of light that touch the chair arm and the tobacco box and at the painstaking record of every wayward curl of the sitter's closely cropped auburn hair. This hyperrealist vision is pushed further in Ingres's depiction of Bertin, as if we were observing the sitter and his setting with a still more powerful magnifying glass. Now the touches of light on the chair arm and, still more diminutive, on the watch fob contain reflections of a mullioned window; and the myriad locks of disheveled hair, along with the wrinkles and creases of flesh and clothing, appear to have reached an even greater infinity of detail. Moreover, the head-on impact of Sieyès—an almost palpable presence who stares directly at the spectator—is, if anything, further intensified: Bertin's overwhelming bulk and scrutinizing gaze can instantly humble the viewer. Ingres's mimetic genius reaches its fullest statement here. Not only does he create a daguerreotype *avant la lettre,* but he also offers to late-twentieth-century eyes an unexpected ancestry for the quasi-photographic, confrontational portraiture of Alfred Leslie and Chuck Close.

Yet Ingres's illusion of unmediated reality (for which there were, after all, as many preparatory drawings as there were for most of his ideal figures [see cat. nos. 100, 101, figs. 178, 179]) could also echo backward through the corridors of art history. One critic in 1833 was reminded of the obsessively realist portraits of wrinkled old men

and women that had made the modest fame of the German painter Balthasar Denner (1685–1749; fig. 294).[7] But in our century, a far loftier prototype has been cited—Ingres's lifelong idol, Raphael,[8] who, in his portrait of Leo X (almost as weighty a presence as Bertin), had also included a window reflection on the glistening knob of the papal chair. Apart from locating Ingres's inspiration in such contradictory sources as Denner and Raphael, responses to this seemingly unmitigated record of perception could also transform it into a social symbol transcending the particular sitter. So it was that in 1855, Théophile Gautier, surely Ingres's most observant, articulate, and tolerant critic, referred to the then-deceased sitter as a "bourgeois Caesar,"[9] a quip that might have been equally applicable to Prince Napoleon, portrayed nearby. Indeed, for Ingres's contemporaries, as for us, *Bertin* could quickly move from mere looking-glass truth to a social symbol of the July Monarchy, much as the *Comte de Pastoret* (cat. no. 98), with its close paraphrase of the refined demeanor of a portrait by Bronzino (fig. 174),[10] could become a symbol of the revival of ancien régime aristocracy during the Bourbon Restoration.

Paired with Bertin, on the left side of Prince Napoleon, was a portrait of one of the artist's close friends, the renowned Florentine composer Luigi Cherubini, who had lived and worked in Paris since 1788 and whose musical and artistic ties with Ingres had already been confirmed in 1826, when his *Coronation* Mass was performed in the cathedral of Ingres's native city, Montauban, to celebrate the installation of *The Vow of Louis XIII*.[11] Cherubini's portrait exists in two versions, which repeat as well as contradict each other. In one, dated 1841 (cat. no. 119), the sitter, then eighty-one years old, seems to belong to the same quasi-photographic domain as Monsieur Bertin—a largely monochromatic ambience in which we can scrutinize every last wrinkle of the composer's black cape and aging flesh, and every last curl of his white hair and Legion of Honor rosette. Should we choose to look more closely, we can even read the titles on the spines of three of his operatic *scores*—*Médée, Ali Baba, Les Deux Journées*—propped up behind him on a table. These past achievements move into the present tense with the quill pen and blank music score, on which he will soon jot down the (to us) inaudible sounds that must account for his expression and pose of intense concentration (index finger and hand against temple, as in many daguerreotypes of the 1840s). We seem to be intruders here in the cloistered realm of genius at work, where the sitter is consistently anchored to such material facts as a chair and a table.

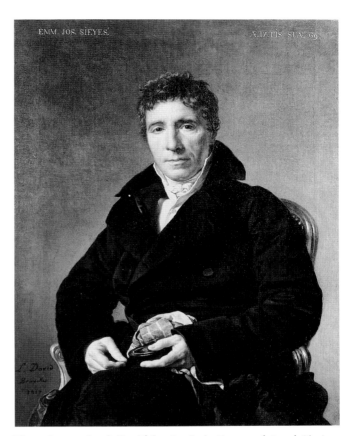

Fig. 7. Jacques-Louis David (1748–1825). *Emmanuel-Joseph Sieyès*, 1817. Oil on canvas, 33⅞ × 28⅜ in. (86 × 72 cm). Fogg Art Museum, Harvard University Art Museums, Cambridge, Massachusetts

That Ingres could aspire to far more exalted climes is revealed by the other version of the portrait (fig. 8).[12] One of the first paintings ever to be recorded as a daguerreotype, in late 1841,[13] it was acquired by the king in June 1842, shortly after the composer's death. When this more ambitious version was exhibited at the 1855 retrospective, to the left of Prince Napoleon, it was subtitled "portrait historique." The use of the word "historique" suggests a shift from the empirical world to the eternal realm of history painting—a feat accomplished not only by removing the modern table and chair from Cherubini's study and letting his arm rest on a polychrome, Neo-Pompeian column base, but, more conspicuously, by including behind him the classical personification of Terpsichore, the Muse of Choral Song and Dance, who with one arm cradles her lyre and with the other inspires and protects her human charge. The conceit recalls Reynolds's earlier efforts to lift from earth to heaven such contemporary sitters as the actor David Garrick, who is torn between the Muses of Comedy and Tragedy, and the actress Sarah Siddons, who is raised to Michelangelesque heights as the Tragic Muse. But in Ingres's vision of modern genius and timeless Muse, the

collision of these separate realms is much harsher, forcing us to seesaw rapidly between sharp-focus truth and classical idealization.

It is a clash that is spatial as well as conceptual, for the startlingly abrupt foreshortening of Terpsichore's arm makes her hover, despite her sculpturesque modeling, like a displaced spirit, oddly compressed between the opposing realms of near and far, fact and fiction. Yet her ideal character, underlined by the marble whiteness of her tunic, is also tinged with a surprising reality, as if she were coming to life. The flesh of this Muse is pink, her lips and cheeks red. And as her features take on a specificity, we begin to realize that they in fact belong to a particular person whose portrait Ingres drew in 1841, Clémence de Rayneval, the sister of the French ambassador to Rome (fig. 9).[14] The Muse, then, begins to slip from Olympus down to the realm of contemporary portraiture, and the painting is almost transformed into a double portrait. She can, however, ascend once again to a different sphere of eternity, evoking another recurrent source of inspiration for Ingres, Poussin's *Self-Portrait* of 1650 (fig. 10). This venerable image of the ancestral deity of French classical painting (whose time-bound features and clothing had already been reincarnated by Ingres on the foreground steps in *The Apotheosis of Homer*) contains at the left a mysterious female profile, an unexpected presence that has

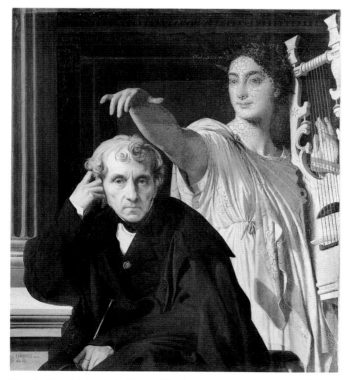

Fig. 8. *Cherubini and the Muse of Lyric Poetry*, 1842 (W 236). Oil on canvas, 41 3/8 × 37 in. (105.1 × 94 cm). Musée du Louvre, Paris

been interpreted most persuasively as a personification of the art of painting,[15] a personal muse who, like Cherubini's Terpsichore, could elevate the sitter to a far higher plane.

Poussin's muse was to trigger Ingres's imagination in a far more magical way when her image later reappeared as a mirror reflection in the 1856 portrait of Madame Inès Moitessier (fig. 1, cat. no. 134). This feminine profile—like Poussin's muse, which might at first be perceived as simply a fragment of a canvas stacked against the walls of the artist's studio—may be read initially as an optical truth that happens to mirror the sitter's own profile at exactly the right angle. Yet the sitter and her reflection swiftly soar far above the laws of optics. For one, Madame Moitessier's pose has been recognized since Ingres's own lifetime as having a Pompeian origin: it is now well known that she is assuming, almost as in a learned charade, the pose of an allegorical figure (usually identified as Arcadia) in a fresco from Herculaneum that was often copied in the nineteenth century.[16] So it is that, for all the material splendor of her setting and costume (her spectacular white silk dress bursting with bouquets of roses was the latest word in Second Empire fashion), Madame Moitessier seems transformed before our eyes into something remote and oracular—a metamorphosis that unfolds still further when we go through the looking glass that covers almost the entire wall behind her. There, the descendant of Poussin's muse presents an even more unapproachable female persona, a filmy vision of ideal beauty and mystery whose eyes, like those of a classical bust, will remain forever open and whose profile, like that on an ancient relief, transports her to the same incorporeal realm in which Ingres, the year before, had located Prince Napoleon. But even in this otherworldly mirror image, we are obliged to return to mid-nineteenth-century reality by the full disclosure of the elaborate lace and ribbons adorning Madame Moitessier's cache-peigne cap. And, back on our side of the mirror, we begin to realize that this motionless sphinx can return to earth as a grande dame seated on a tufted pink damask sofa so palpable that, together with the gilt console and peacock-feathered fan, it might be moved to a period room displaying the conspicuous luxury of Second Empire decorative arts.

In this and many other portraits, the contemporary prose of a sitter's features, clothing, and surroundings could merge seamlessly with the poetic extremes of Ingres's ideals of purity of form and nobility of subject, ideals he attempted to isolate in his many icons of classical and religious perfection. One of the most famous of

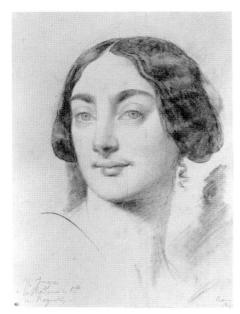

Fig. 9. *Clémence de Rayneval*, 1841. Pencil, charcoal, and white highlights on paper, pasted on Bristol board, 14⅝ × 10⅝ in. (37 × 27 cm). Musée du Louvre, Paris

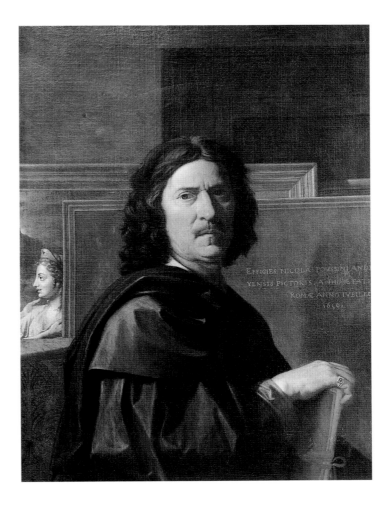

Fig. 10. Nicolas Poussin (1594–1665). *Self-Portrait*, 1650. Oil on canvas, 38⅝ × 29⅛ in. (98 × 74 cm). Musée du Louvre, Paris

these, the 1854 *Virgin with the Host* (fig. 11), was hung directly below *The Apotheosis of Homer* at the 1855 retrospective, affirming in Christian terms the axis of symmetry so conspicuous in the classical hierarchy above it. This inflexible ideal could even be adapted to the images of the wealthy and powerful women who managed to coax Ingres into recording them for posterity. In this, Inès Moitessier was twice blessed. Her reincarnation via Poussin and Roman painting as a modern sibyl was preceded, in the 1851 portrait (cat. no. 133), by her transformation into something akin to Ingres's many fearsome images of the Virgin as the celestial epitome of feminine power and majesty. Holding her pearl necklace and fan as if they were emblems of regal authority, Madame Moitessier seems to reign from a height that would humble a mortal spectator. Her implacable frontal gaze, fixed forever in the perfect oval of a head crowned by a halo of roses, further coincides with Ingres's fantasies of the Virgin's imperious beauty. Yet if Madame Moitessier doubles here as Ingres's queen of a Christian heaven, she might also be transported to Olympus as a descendant of David's 1799 portrait of Madame de Verninac (fig. 41), referred to as a "calm and beautiful Juno."[17]

Juno and Minerva were, of course, no strangers to Ingres, and they, too, provided ideal molds for his portraits. In 1854, when he depicted them as part of a series of six decorative medallions of deities for the Paris residence of the architect Jacques-Ignace Hittorff, his friend and occasional collaborator, Juno subtly bore the features of the architect's wife. As for Minerva, she needed only to remove her helmet to reveal her identity with Hittorff's daughter Isabelle (fig. 12).[18] Isabelle was again painted by Ingres, in precisely the same round-medallion format (fig. 13), not later than 1856, the period of Inès Moitessier's deifications.[19] Here, young Isabelle, in her early twenties, is transformed into one of the more bizarre creatures of Ingres's imagination, a head of such fearful symmetry and egg-shaped perfection that it might belong to an alien race. Beneath the unnaturally pure arcs of her eyebrows, which appear to continue uninterrupted into the bridge of her nose, she looks down from an abstract blue Olympus with the haughty, walleyed gaze that so often prevents Ingres's sitters from communicating with mere earthlings. Again we see that, like a modern Pygmalion, Ingres could turn ideal marbles into living beings or, reversing directions, could metamorphose his sitters into divinities.

In this context, it is telling that one of the most important Ingres discoveries of the last decades was a painting of 1852–53 described by the artist as an "ébauche pour une Vénus, portrait-tableau," that is, a study for a painting of Venus that was also a portrait of a woman who, in fact, can be identified as Antonie Balaÿ, a member of a grand family from Lyons (fig. 14).[20]

These recurrent contacts with Olympian ideals of the human face and body—culled largely from a repertory of painting and sculpture by ancient Romans who themselves had often recreated their imperial rulers as gods and goddesses—may partially account for the way Ingres's sitters, particularly women, so often transcend recognizable likeness, making us wonder about the proportions of modern flesh to ancient marble that fuse miraculously in order to create, for instance, the *Comtesse d'Haussonville* (cat. no. 125). Although we may recognize some of the antique sources—statues of Polyhymnia and Pudicity, among others[21]—that seem part of the sitter's very being, would we recognize this person herself were she to rise from the dead? We are persuaded, however, that we would immediately recognize her dress or the bric-à-brac on her mantelpiece—a guess that was confirmed in 1985 by Edgar Munhall's illuminating study, which brought to light the jewelry, the porcelains, the fabrics that Ingres had fixed forever on the mirrorlike surface of his canvas.[22] Of such tangible facts, costume (whether modern or historical) usually had the lion's share of Ingres's attention. It was certainly one of the reasons for his attraction to Holbein's portraits, which must also have appealed to him for their low-relief modeling as well as their precision of outline, which often silhouetted the sitters against monochrome backgrounds made even flatter by inscriptions giving their names and dates (a device Ingres himself would use in the portraits of Bertin and Madame Moitessier, among others). When Ingres copied one of the versions of Holbein's famous portrait of Henry VIII (fig. 15),[23] he scrutinized every detail of the king's clothing and jewelry as fully as he did the face. But this was precisely what he would also do when drawing living sitters, such as the painter Charles Thévenin (cat. no. 74). With a quick change of wardrobe, Ingres's drawing of Holbein's sixteenth-century king might slip unnoticed into his painstaking accounts of how nineteenth-century people looked and dressed.

Of Ingres's many hybrids of contemporary portraiture and remembered art and history, none reaches more stupefying heights than the state portrait of Napoleon on his imperial throne (cat. no. 10), which, in its willful

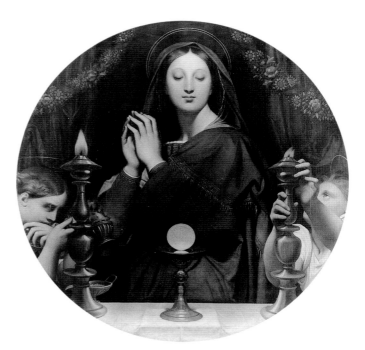

Fig. 11. *The Virgin with the Host*, 1854 (W 276). Oil on canvas, mounted on wood, diam. 44½ in. (113 cm). Musée d'Orsay, Paris

eccentricity, provoked a battery of hostile criticism at the Salon of 1806.[24] By comparison, other official portraits of 1805–6 by Ingres's contemporaries, including David, François Gérard, and Robert Lefèvre, offer relatively conservative solutions to the problem of legitimizing the brand-new emperor of France. Lefèvre's Napoleon, for instance (fig. 68), looks as though he had quietly usurped the throne of a Bourbon monarch. In his ermine and velvet robes (which now, however, bear the symbol of the Napoleonic bee), he stands before the imperial globe, scepter in hand, in a variation of the aloof posture of command and superiority familiar to the succession of eighteenth-century state portraits that begin in 1701 with Rigaud's *Louis XIV* (Musée du Louvre, Paris) and end in 1789 with Callet's *Louis XVI* (Musée Bargoin, Clermont-Ferrand). The turbulent gulf between the ancien régime and the Empire seems to have been bridged uneventfully.

By contrast, Ingres's vision of Napoleon presents a startling, though eerily timeless intruder, whose almost extraterrestrial character is intensified by the icy overhead lighting, which one critic likened to moonbeams.[25] Such otherworldliness is also underlined by the obsessively detailed replication of Napoleon's coronation regalia, an awesome profusion of luxurious textures, patterns, and precious jewels and metals fit for a celestial god—an abundance that, on more earthbound levels, would be a recurrent theme in Ingres's portraiture,

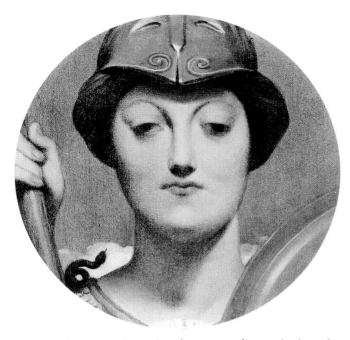

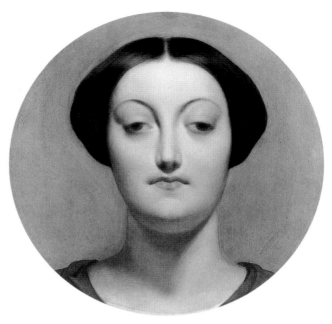

Fig. 12. *Minerva*, 1864 (W 267). Oil on canvas, diam. 13 in. (32 cm). Wallraf-Richartz-Museum, Cologne

Fig. 13. *Isabelle Hittorff, later Madame Gaudry*, before 1856. Oil on canvas, diam. 13 in. (33 cm). Musée des Beaux-Arts, Grenoble

whether in the drawn copy of Henry VIII's doublet or the spectacular painted inventories of his female sitters' wardrobes and jewel boxes. Perhaps most strange is Napoleon's posture, which imposes a titanic immobility upon the swift reversals of political power that marked the origins of modern French history.

Many sources have been proposed for this image of omnipotent authority, including the supreme deities of the classical and the Christian worlds: on the one hand, Phidias's Olympian Jupiter (which Ingres would use more literally for his *Jupiter and Thetis* of 1811 [fig. 92]) and, on the other, Jan van Eyck's God the Father from the Ghent altarpiece (then displayed in Paris as part of Napoleon's loot; fig. 75).[26] To this fusion of classical idealism and Late Gothic hyperrealism can also be added an encyclopedic portrait gallery of pre-Bourbon French monarchs, an association that would permit Napoleon to join a more venerable dynasty. The *Recueil des roys*, a popular late-sixteenth-century compendium of historical texts and images ranging from Clovis to François I (who had commissioned the survey), might well have provided archetypes of French medieval authority that could push Ingres's youthful imagination to still further excesses.[27] Such works as the sixteenth-century fantasy portrait of the sixth-century Frankish king Clotaire I (fig. 16) foreshadow the magical mold of supernatural power and splendor into which Ingres would fit the new emperor, who, during

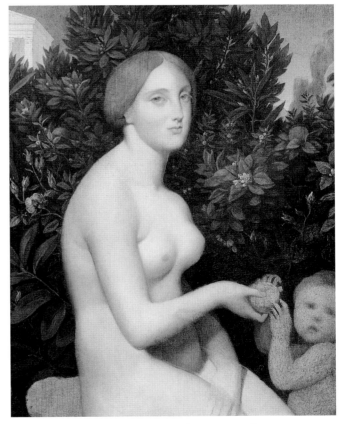

Fig. 14. *Venus on Paphos* (Antonie Balaÿ), 1852. Oil on canvas, 36 × 27¾ in. (91.5 × 70.5 cm). Musée d'Orsay, Paris

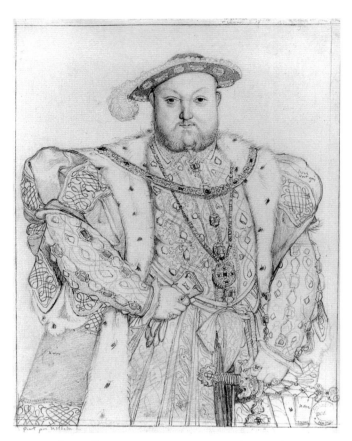

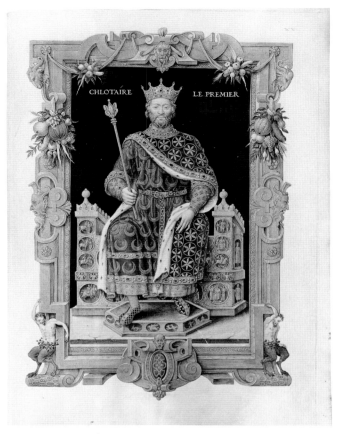

Fig. 15. After Holbein. *Henry VIII*, ca. 1815–20(?). Graphite on paper, 9½ × 6⅞ in. (24 × 17.5 cm). Private collection

Fig. 16. *Clotaire I*, from *Recueil des roys*, late sixteenth century. Bibliothèque Nationale de France, Ms. fr. 2848, fol. 20r

the time his portrait was exhibited, was hardly fixed for eternity in the remote corridors of history but was instead leading his troops against the Prussians. Ingres himself, we might add, also kept one foot in reality. At the same Salon, he exhibited a self-portrait of 1804 (see cat. nos. 11, 147) that, although later repainted, originally showed the artist before a blank canvas. With a greatcoat casually tossed over one shoulder in a preview of the way he would depict the cape of another genius at work, Raphael (fig. 127),[28] he presents himself, cloth in hand, preparing what would in later reworkings of the painting become the underdrawing for the portrait of his friend the lawyer Jean-François Gilibert (cat. no. 5). And this virtual advertisement for his professional credentials was gloriously amplified at the Salon with the family portraits commissioned by a minor civil servant of the Empire, Philibert Rivière (cat. no. 9, figs. 57, 58).[29]

While these early masterpieces clearly announce that Ingres could descend from Napoleon's Valhalla to deal for a moment with less famous contemporary patrons and their offspring, even they hold constant reminders of more high-minded things. In the earliest of the three

Rivière portraits, and the one most indebted to David, the paterfamilias is seated next to a haphazard array of objects that turn out to be calculated references to recent as well as remote genius. The bindings of the books inform us that two of the volumes contain the works of Rousseau, whereas the name on the unbound cahier is Mozart, who, being only twenty-four years Ingres's senior, would later figure in *The Apotheosis of Homer* as the immortal closest to the painter's own generation. In the foreground of this still life of books and papers, art is added to music and literature in the form of a print after Raphael's *Madonna della Sedia* (fig. 17), which had already mesmerized the precocious Ingres by the early 1790s, when he saw a copy of it made by his first art teacher, Joseph Roques—an epiphany he later described as being "like a star that had fallen from heaven."[30] Raphael's painting, in fact, went on to live many different lives in Ingres's work. It could be an appropriate stage prop in his narrative scenes from sixteenth-century historical legend, including *Henry IV Playing with His Children* (W 113; Musée du Petit Palais, Paris) and *Raphael and the Fornarina* (fig. 127), or the source of a headdress he favored, a turban known

as a *scuffia*, which is also worn in Raphael's portrait of La Fornarina (fig. 60) and which turns up often in Ingres's bathers and odalisques as well as in his recreations of the story of Raphael and his legendary love and inspiration.[31]

Formally speaking, the coiling rhythms of flesh and fabric in the *Madonna della Sedia* may also provide a point of departure for Ingres's portrait of Philibert Rivière's wife, Sabine (cat. no. 9), who in fact looks as though she were painted by a far more daring artist than the one who painted her husband. As revealed by X rays,[32] she was originally seated against a chairback, but the perpetuum mobile of arabesques, beginning with the Neo-Gothic quatrefoil pattern inscribed on the furniture frame in the lower right, finally triumphed over such a gravity-bound, sedentary structure. The result is a coloratura aria on a theme by Raphael, in which a dominant motif of the *Madonna della Sedia*—the mixture of a chair fragment with a cushioning roundness of clothing and exposed flesh—is brought to the highest pitch of caressing embellishment. Raphael's lucid circularity becomes a serpents' nest of ovoid patterns; his amply modeled figures and draperies are compressed to shadowless reliefs; his decorative fringes now quiver like sea anemones with delicately pulsating life. As for the robust limbs and soft, plump fingers of Raphael's mother and infants, these normative anatomies are attenuated to audacious extremes, as if the sitters' flesh and bones were elastic enough to obey the artist's every command. In Ingres's hands, Raphael's more generalized rendering of textures takes on the sharp-focus precision of clothing and jewelry perceived as if through a magnifying glass, permitting us to discern every stitch of the cashmere shawl's minuscule pattern of exotically stylized leaves and fruit.

Raphael's ghost would be reincarnated in countless and often unexpected ways throughout Ingres's career, inhabiting his portraits as well as his more explicit homages to what he considered the perfection of the master's religious art. For instance, the portrait of the Rivières' thirteen-year-old daughter, Caroline (fig. 58), has been seen as recalling, in its almost embalmed pose and gesture, Raphael's *La Fornarina* (fig. 60), which also haunted many of Ingres's nudes.[33] Then there is the drama of the parted green curtains that Raphael used to disclose the luminous vision of *The Sistine Madonna* (fig. 18). When he painted *The Vow of Louis XIII* (fig. 146), Ingres resurrected this trompe l'oeil theater as an undisguised acknowledgment of his venerable prototype, but this Raphaelesque motif was also echoed more subtly in his portraiture. The similar curtains in the background of the

1804 *Bonaparte as First Consul* (cat. no. 2), which are drawn back to reveal the cathedral of Saint-Lambert in the Liège suburbs (damaged by Austrian bombardment in 1794 and later reconstructed, thanks to Napoleonic benevolence), might be only a coincidental parallel to the religious revelation of the Raphael's heavenly draperies. However, their appearance in the uncommonly dramatic portrait of Caroline Murat (cat. no. 34) is probably a much closer paraphrase. Here, the parted green curtains create the sudden illusion of grandeur, allowing us to see for a moment the queen of Naples, who reigns above us in an image that, as Carol Ockman has pointed out,[34] mirrors almost exactly Ingres's consular portrait of Bonaparte, the sitter's brother. Caroline's head, framed by window mullions and crowned by a flurry of black plumes, rises even higher than the clouds of Vesuvian smoke that are disclosed against the spectacular, blue-skied view of her kingdom's most famous landmark. Later, in 1828, Ingres used the same curtains descended from Raphael's Christian skies in a harem bathing scene (fig. 19), where they produce the clandestine effect of a gentleman's peephole view into an erotic paradise.

Ingres would have claimed that his greatest and most sustained loyalties were to Raphael, but, like Picasso, he could find inspiration in any chapter of art history and could use his sources in the most overt as well as covert ways. His portraits, as much as his subject paintings,

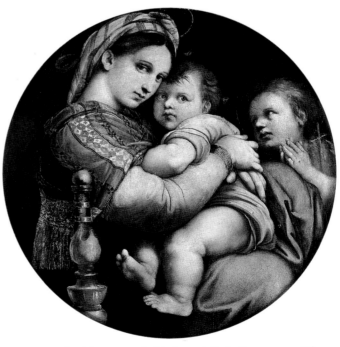

Fig. 17. Raphael (1483–1520). *Madonna della Sedia*, ca. 1512. Oil on wood, diam. 28 in. (71.1 cm). Palazzo Pitti, Florence

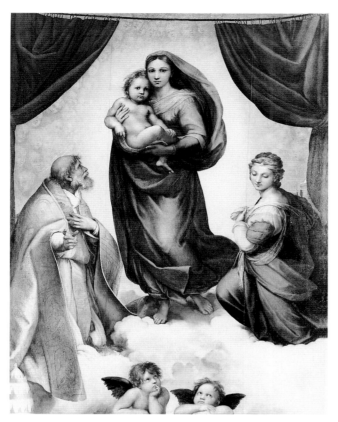

Fig. 18. Raphael (1483–1520). *The Sistine Madonna*, ca. 1512–13.
Oil on wood, 104⅜ × 77⅛ in. (265 × 196 cm). Gemäldegalerie,
Dresden

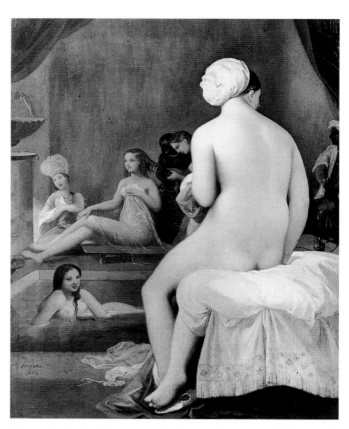

Fig. 19. *La Petite Baigneuse*, or *Intérieur de Harem*, 1828 (W 205). Oil
on canvas, 13¾ × 10⅝ in. (35 × 27 cm). Musée du Louvre, Paris

reflect this encyclopedic diversity of references. Raphael
and Poussin might be predictable ancestors, but others,
like Boucher, may come as a surprise, especially for an
artist who was a student of David. Ingres had entered the
master's studio in 1797 as a seventeen year old, just in
time to share the welling dissension of those fellow stu-
dents who felt David had not gone far enough in purging
himself of the lingering decadence of the ancien régime.
As for David's heroic effort at regressing to a more puri-
fied realm of Greek rather than Roman art, *The Interven-
tion of the Sabine Women* of 1799 (fig. 42), these young
Turks hurled such insults as "Vanloo," "Pompadour,"
and "Rococo."[35] Indeed, many of Ingres's paintings and
drawings from 1800 to 1806 (including the double por-
trait of the stiffly posed, cylinder-necked Harvey sisters
[cat. no. 22]) reflect the preference for archaic art and lit-
erature that would give David's most rebellious students
the name "Les Primitifs."

Yet the Rococo traditions the younger generation
wanted to exterminate in art as in politics would keep
emerging in unexpected guises. In his study of the
Comtesse d'Haussonville, Munhall introduced as one source
of inspiration Boucher's famous 1756 portrait of Madame

de Pompadour (fig. 20), which provides a lineage for the
mirror background to the sitter's meditative pose.[36] Espe-
cially for an artist like Ingres, who had worked on David's
austere portrait of Madame Récamier in 1800 (fig. 306),[37]
Boucher's painting could hardly have symbolized better
the detested art of the Rococo. But its legacy in Ingres's
portraiture was continually fruitful, starting about 1814,
with *Madame de Senonnes* (cat. no. 35), which offers a
virtual Western pendant to the exotic luxury and indo-
lence of the famous odalisque Ingres painted at the same
time (fig. 101). Like Boucher's portrait, *Madame de
Senonnes* contrasts the material opulence of the sitter's
dress and jewelry with a filmy mirror background that
also reflects a *profil perdu* and a bit of the billowing uphol-
stery that cushions her pose of studied relaxation, a far
cry from Madame Récamier's tense, upright posture on
the hardest of chaises longues. As in the Boucher portrait,
the potentially cloying surfeit of Madame de Senonnes's
wardrobe (which includes, as a throwaway, the same
kind of cashmere shawl worn by Madame Rivière) is
instantly alleviated by the gold-framed vista of another
room, hazily defined by rectilinear fragments of pilasters.
The foreground congestion of feminine fashions, almost

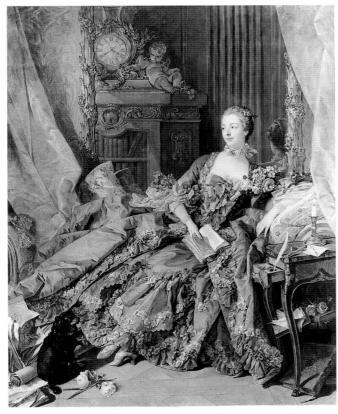

Fig. 20. François Boucher (1703–1770). *Madame de Pompadour*, 1756. Oil on canvas, 79 × 62 in. (200.7 × 157.5 cm). Alte Pinakothek, Munich

accessible to touch, shifts abruptly to an atmospheric void, a welcome breathing space for the eye and the imagination. This shifting contrast of near and far, of material density versus glassy illusion, became one of Ingres's most evocative themes, brought to further heights in his portraits of the Comtesse d'Haussonville (cat. no. 125) and Madame Moitessier (cat. nos. 133, 134).

In view of the intense nostalgia for Rococo luxury that characterized so many aspects of Second Empire life and style, it is also plausible to consider the late portrait of Madame Moitessier (cat. no. 134)—a full-scale resurrection of the *style Pompadour* so hated by David and his students—the more chiseled counterpart of Winterhalter's fashion-plate portraits of Empress Eugenie and her entourage. Here again, Ingres turned his master's swans into peacocks, leaving decades behind him the spare, white sinuosity of style and costume that marked so many Davidian paragons of femininity from the early century. Indeed, his rendering of Madame Moitessier's fringed and beribboned dress, with its tumbling roses, may find its closest rival in Boucher's loving description of Madame de Pompadour's extravaganza of green taffeta, festooned with lace and garlands of roses.

Whether he was faced with a queen of the drawing room or an emperor of France, a businessman or a bourgeois family, Ingres, throughout seven decades of painting and drawing his contemporaries, never stopped adapting the facts of living people and ephemeral fashions to a multitude of references in the history of Western portraiture. Moreover, the taut contours and crystalline perception that marked his style could immobilize these mirrorlike images, transforming a variety of social and psychological types into icons. His genius, of course, was inimitable, but his portraits constantly provided themes for countless variations that would be reflected in the work not only of his own students but of many later generations.[38] Such is the case in the 1838 portrait of Isaure Chassériau by Amaury-Duval, the first student to enroll in the atelier Ingres opened in Paris in 1825 (fig. 21).[39] The young sitter, herself the niece of an Ingres student, Théodore Chassériau, offers a precocious painted version of that hybrid of sacred and secular divinity Ingres so often created for his patrons. The girl's hypnotic stare and fixed symmetry are also found in earlier portrait drawings by Ingres of young women whose aura of sanctity suggests they may be playing the role of a Vestal Virgin or a novice in a nunnery. Already members of this pious sorority are Mademoiselle Jeanne Hayard (1815; cat. no. 51) and Mademoiselle Louise Vernet (1835; cat. no. 112), each of whom becomes a figure in an imaginary shrine. In Amaury-Duval's portrait, the framelike molding on the rear wall further distances the sitter from prosaic reality, much as the wreath of roses in her hair strengthens the aura of ritual mystery. This transformation into an ideal cult object is enforced by the Ingresque purities of line and contour, the perfect symmetry of her sloping shoulders matching the cylindrical clarity of her folded arms. On reaching maturity, Isaure, we feel, might well turn into the haughty, standing divinity that Ingres envisioned in his first portrait of Madame Moitessier (cat. no. 133).

Ingres's iconic portrait formulas were reflected as well in the work of still later nineteenth-century generations. The portraits of Gérôme, for instance, often rely as closely on Ingres's prototypes as do his marmoreal nudes. In one of an unidentified woman, perhaps the artist's wife (fig. 22), we may again feel the ghost of Ingres.[40] It was a particularly topical presence, given the fact that the painting probably dates from the years just after the master's death on January 14, 1867, which was quickly commemorated with a huge retrospective (584 works) that permitted the Parisian art world to see, among other things, Ingres's long-term achievement as a portraitist.[41]

The 153 portraits shown—25 paintings and 128 drawings—included the 1806 *Napoleon I on His Imperial Throne* (cat. no. 10), whose political and aesthetic excesses prompted Cézanne's parodistic response, a grotesquely "enthroned" portrait of his pitifully deformed painter friend, the dwarf Achille Emperaire (fig. 23).[42] But Gérôme's position, of course, was one of respect, not youthful rebellion, and his portrait from the late 1860s seems, with its assorted memories of the comtesse d'Haussonville and Madame Moitessier, almost a reverent composite of Ingres's achievement. Nevertheless, the master's poetry has been translated into a far more literal prose, with Gérôme playing Ter Borch to Ingres's Vermeer. Typically, Gérôme adds more information to Ingres's more selective realities, including the full-length display of the sitter's dress and train, a mirror reflection not only of the back of her head but of a family portrait (possibly the sitter's father), and a beloved dog clutched over her heart. To be sure, Ingres, too, could occasionally include a pet dog in a portrait drawing, as in *Mademoiselle Henriette-Ursule Claire and Her Dog Trim* (cat.

Fig. 21. Eugène-Emmanuel Amaury-Duval (1808–1885). *Isaure Chassériau*, 1838. Oil on canvas, 46 × 35¾ in. (117 × 90 cm). Musée des Beaux-Arts, Rennes

no. 73), but in the painted portraits, his more high-minded self would always win out.

If Ingres's definitive depictions of well-to-do contemporary women were reliable points of departure for nineteenth-century establishment portraiture, as they often were, in subtler ways, for the milieu of Degas, Tissot, and Whistler, his no less decisive characterizations of men also cast a long shadow. As just one example, there is the unforgettable portrait of Bertin (cat. no. 99), which created a norm for depictions of prominent men of action and power, whether intellectual or executive. Two official portraits of the 1890s may illustrate this legacy. One is Constant's depiction of a major patron of the Louvre, Alfred Chauchard (fig. 24),[43] who scrutinizes us from his quasi-photographic monochrome setting as severely as did Bertin, whose portrait, in fact, entered the Louvre in the same year (1897) that Chauchard's stern image appeared at the annual Salon. Another is the commemorative portrait of Ernest Renan, painted by Léon Bonnat in 1892, the year of the great historian's death (fig. 25). He, even more than Chauchard, has inherited Bertin's probing gaze and hands-on-thighs energy, as well as his no-nonsense simplicity of setting and monochrome palette.[44] The Renan portrait was exhibited at the Paris Exposition Universelle of 1900, where it might well have reinforced the authority of the Bertin portrait for two artists who must have seen it there, Vallotton and Picasso. Both of them, it turned out, would soon absorb Bertin's image in their portraits of Gertrude Stein. Picasso, in 1906, deftly reincarnated this formula for heavyset men of action and letters in what is perhaps, among other things, a joking comment on Stein's ponderous bulk and sexual preference (fig. 26). One year later, Vallotton turned to the same source for his portrait of Stein (fig. 27), pointing out the resemblance, right down to the pudgy fingers, in an even more direct way than Picasso.[45]

It was Picasso, above all, who rejuvenated Ingres's portraiture for the twentieth century in ways both apparent and stealthy; in fact, his ongoing dialogue with the master is so long and so complex that it warrants a full-length study. For instance, he recreated his own mirror image in 1917 in the guise of Ingres's early self-portrait of 1804;[46] he transformed Marie-Thérèse Walter into the seated Madame Moitessier;[47] he mimicked Ingres's portrait drawing style as an appropriate language to record an upwardly mobile milieu of the Parisian art world, including the wives and children of the dealers Georges Wildenstein and Paul Rosenberg, who handled modern artists as well as Ingres.[48]

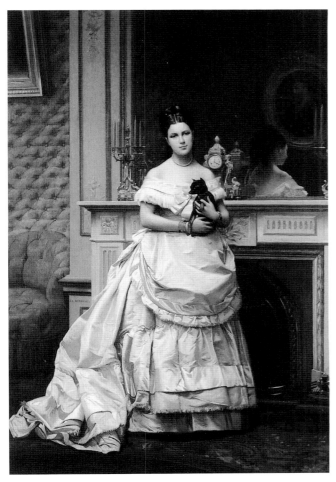

Fig. 22. Jean-Léon Gérôme (1824–1904). *Portrait of a Lady (Marie Gérôme?)*, ca. 1866–70. Location unknown

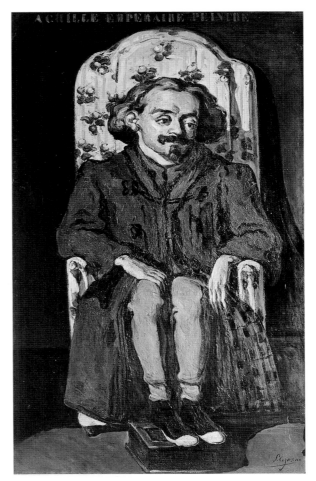

Fig. 23. Paul Cézanne (1839–1906). *Achille Emperaire*, 1867–68. Oil on canvas, 78¾ × 47¼ in. (200 × 120 cm). Musée d'Orsay, Paris

Picasso particularly loved to materialize the specter of Ingres within his own domestic confines, envisioning his wife or lover in the role of this or that Ingres sitter. His first wife, Olga Khokhlova, was the constant object of this pictorial alchemy that blurred the boundary between art and life. Just before their marriage in June 1918, he had Olga pose seated in an upholstered armchair, fan in hand, as if she were in the lap of Ingresque luxury, and then photographed her (fig. 28). The photograph, in turn, was transformed into a painting (fig. 29; now datable as spring 1918, not 1917)[49] that appears to be an eerie resurrection of the 1807 portrait of Madame Duvaucey (fig. 87). Suddenly, Olga has inhabited the body and spirit of Ingres's sitter, whether one looks at the part in the center of the smoothly groomed dark hair that crowns the perfectly oval head, or the cameolike modeling of porcelain flesh that runs from the neck through the tubular arms in sensual contrast with the inky blackness of the dress. And the strange expression of wistful aloofness mixed with confrontation adds yet another echo of Ingres.

With Olga as medium, Ingres's ghosts often turned into flesh in Picasso's new domestic milieu. During the summer of 1920 at Juan-les-Pins, he could see his wife relaxing in a peignoir, instantly transform her head, shoulders, and décolletage into the imperious standing portrait of Madame Moitessier (cat. no. 133), and then bring this exalted reference back to earth with the joke of an obtrusive pair of bare feet (fig. 30). Or, as he spied Olga reading, one shoe on and one shoe off, in the cushioning embrace of an armchair (fig. 32), he might see, instead, the seated Madame Moitessier (cat. no. 134), one finger of her unforgettably invertebrate hand on her temple. Olga can also appear in the guise of Madame Marcotte de Sainte-Marie (cat. no. 97), reenacting her dour countenance and withdrawn posture in an odd collage of paper drawings mounted on canvas (fig. 31).

Such adaptations of Ingres's portraiture seem to quote not only his sitters' postures and moods but also his own wide pictorial vocabulary, which can move from an almost pure outline to an illusion of fully modeled

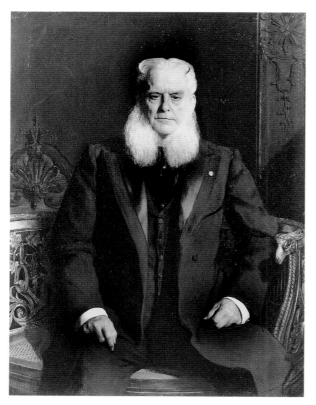

Fig. 24. J.-J.-B. Benjamin-Constant (1845–1902). *Alfred Chauchard*, 1896. Oil on canvas, 51 1/2 × 38 1/4 in. (130.5 × 97 cm). Musée d'Orsay, Paris

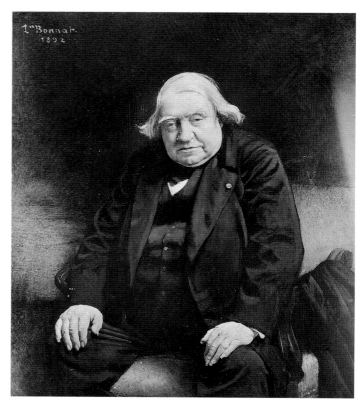

Fig. 25. Léon Bonnat (1833–1922). *Ernest Renan*, 1892. Oil on canvas, 43 1/4 × 35 3/8 in. (110 × 90 cm). Musée Renan, Tréguier, France

anatomy and clothing that is nevertheless undermined by the insistent spatial compression. The 1918 portrait of Olga (fig. 29), for instance, provides just such a parallel, creating almost a collage effect of juxtaposed fabric and flesh patterns. Such illusory textures and volumes are immediately contradicted by the surprising expanse of unfinished canvas marked here and there by tentative pencil and paint marks, a reminder of the plain paper background exposed in a rapidly improvised papier collé. It is an effect related to such an overtly Cubist painting as that inspired in the summer of 1914 by an earlier lover, Eva Gouël, generally titled *Portrait of a Young Girl* (fig. 33), a "portrait" that might be considered a witty update of Ingres's *Madame Rivière* (cat. no. 9). Picasso here translates the master's decorative profusion of shawls, lace, upholstery, and jewelry into his own Cubist patchwork quilt, which includes a feathery, serpentine boa rhyming with the upholstered curves of the armchair; an elaborate hat adorned with flowers that match the corsage on her breast; a jabot of speckled lace falling over her elongated, puffy sleeves; and snippets of a floral wallpaper pattern.[50] As for the sitter herself, her head and body have disappeared under this surfeit of feminine fashions, leaving exposed only one ungloved hand which, in its relieflike

modeling, recalls the flattened anatomies of Madame Rivière's visible flesh.

It should be remembered that when it was first exhibited, *Madame Rivière* shocked critics because of its rejection of conventional modeling, its anatomical distortions, its effect of blond, unshadowed flatness—all characteristics that would, to Cubist eyes, give the painting a surprisingly topical look.[51] Seen this way, *Madame Rivière* has that quality of abruptly colliding patterns which Picasso explored in his pasted-paper cutouts, a scrapbook style that he imitated in the completely painted surface of the 1914 "portrait." Picasso's attraction to *Madame Rivière* and its progeny was, in fact, articulated clearly in 1921 in an article written for *L'Esprit nouveau* by Roger Bissière, who, in the aftermath of Cubism, tried to bridge the gap between new and old masters. Referring to *Madame Rivière*, among others, Bissière stressed how Ingres's portraits anticipated those of Cézanne and Picasso by challenging, with their "living geometry, everything that was once understood by aerial perspective," and by asserting how "the painting remains an inflexibly flat surface in which distant planes are wrenched to the foreground."[52] Picasso had clearly seen this point earlier, and he may also have found inspiration in *Madame Rivière*'s

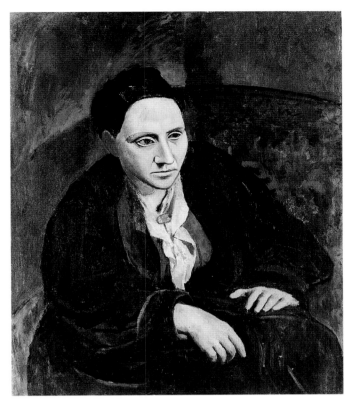

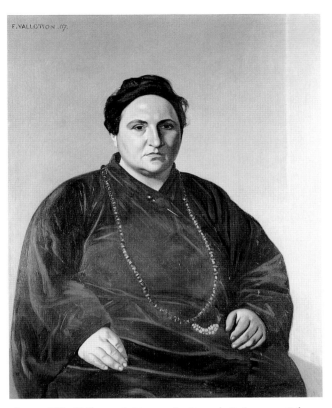

Fig. 26. Pablo Picasso (1881–1973). *Gertrude Stein*, 1906. Oil on canvas, 39⅜ × 32 in. (100 × 81.3 cm). The Metropolitan Museum of Art, New York, Bequest of Gertrude Stein

Fig. 27. Félix Vallotton (1865–1915). *Gertrude Stein*, 1907. Oil on canvas, 39½ × 32 in. (100.3 × 81.2 cm). Baltimore Museum of Art

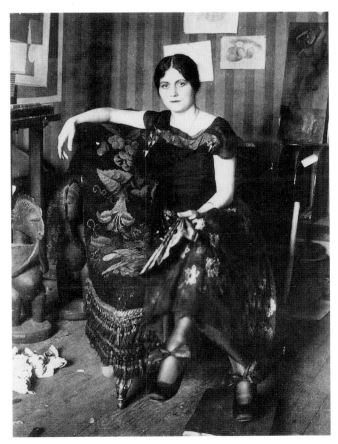

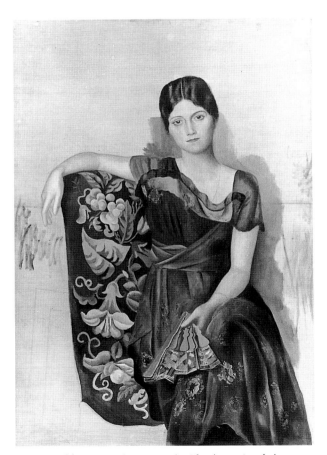

Fig. 28. Pablo Picasso (1881–1973). *Olga*, spring 1918. Photograph. Musée Picasso, Paris

Fig. 29. Pablo Picasso (1881–1973). *Olga in an Armchair*, spring 1918. Oil on canvas, 51⅛ × 35 in. (130 × 88 cm). Musée Picasso, Paris

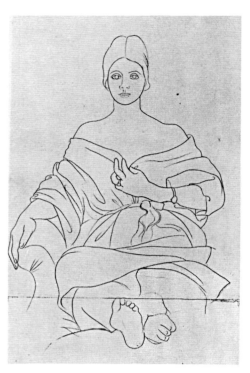

Fig. 30. Pablo Picasso (1881–1973). *Olga in a Robe*, summer 1920. Graphite on paper, 15 ¼ × 12 ⅝ in. (38.5 × 32 cm). Private collection

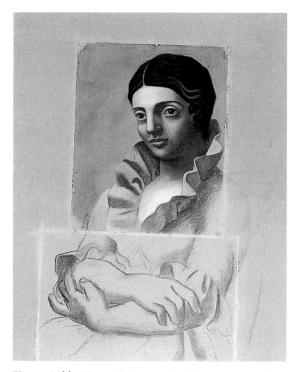

Fig. 31. Pablo Picasso (1881–1973). *Olga*, 1921. Pastel and charcoal on paper, mounted on canvas, 50 × 38 in. (127 × 96.5 cm). Musée Picasso, Paris, on extended loan to the Musée des Beaux-Arts, Grenoble

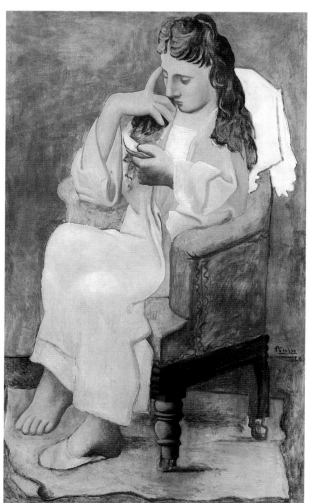

Fig. 32. Pablo Picasso (1881–1973). *Woman Reading (Olga)*, 1920. Oil on canvas, 65 ⅜ × 40 ⅛ in. (166 × 102 cm). Musée National d'Art Moderne, Centre National d'Art et de Culture Georges Pompidou, Paris

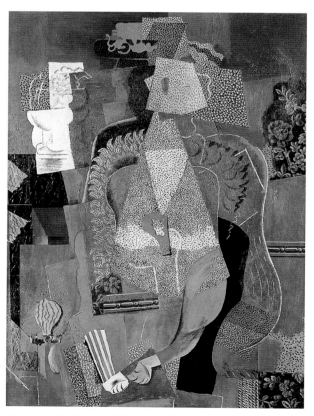

Fig. 33. Pablo Picasso (1881–1973). *Portrait of a Young Girl*, summer 1914. Oil on canvas, 51 ¼ × 38 ⅛ in. (130 × 97 cm). Musée National d'Art Moderne, Centre National d'Art et de Culture Georges Pompidou, Paris

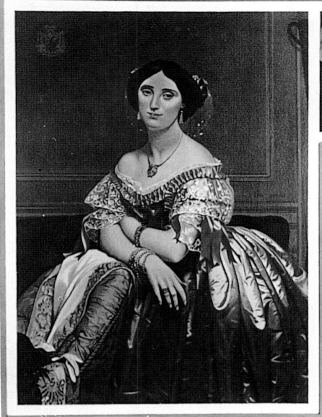

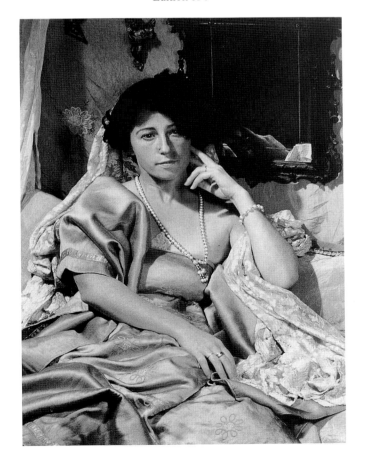

oval format, which he often used for Cubist figure paint-
ings and still lifes, whose buoyant vocabulary of weight-
less, floating fragments was particularly suited to a tapered
shape that minimized the downward pull of gravity. And
in his mock portrait of an invisible Eva, he also revived
most humorously Ingres's familiar lesson that "clothes
make the woman."

Like other museum-goers, artists have never stopped
marveling at the miraculous fusion of visible truths and
abstract fantasies that marks the greatest of Ingres's por-
traits. Even during the evolution of the antirealist lan-
guages created by de Kooning and Gorky, Ingres's
portraiture was often a talisman. We know, for example,
that these two masters, on their frequent visits to the
Metropolitan Museum, particularly venerated *Madame
Leblanc* (cat. no. 88), whose walleyed gaze and fluid ana-
tomy would often be resurrected in their figure paintings
of the 1940s.[53] Much younger generations made other
surprising deductions from the premises of Ingres's por-
traiture. Richard Pettibone, a pioneer of the art of repli-
cation who, as early as the 1960s, had made diminutive
copies of works by such contemporaries as Stella and

Warhol, would in the next decade try his meticulous hand at creating equally small color reproductions of both the whole and the fragmentary details of paintings by Ingres, with results that look like jeweler's-glass views of the *Comtesse d'Haussonville* or the *Princesse de Broglie* (fig. 34).

The fullest homage to Ingres's portraiture, however, is surely found in one of Cindy Sherman's many anthologies of self-portraits, the 1989–90 series of old-master portrait icons. Turning to Ingres from Fouquet and Botticelli, Raphael and Holbein, she recreates herself as a synthesis of decors, wardrobes, and postures culled from the most opulent of the master's society women (fig. 35). From *Madame de Sennones* (cat. no. 35), for instance, she borrows the papers wedged into the mirror frame and reflected there together with the sitter's back; from *Madame Rivière*

(cat. no. 9), the rising and falling embrace of a sinuous shawl and the casual display of idle fingers adorned with precious-metal rings; from the first *Madame Moitessier* (cat. no. 133), the willfully wayward, off-center turn of a pearl necklace against a commanding bosom; from the second *Madame Moitessier* (cat. no. 134), the pensive head elegantly supported by an index finger and a curling wrist.[54] From these and many other Ingres quotations, Sherman fashions and then physically inhabits a new Ingres portrait—one that rushes back and forth from contemporary (now literally photographic) reality to the remote sanctuaries of history and art museums, shuffling past and present in what is diagnosed these days as a symptom of postmodernism. But, current categories aside, isn't that what Ingres was doing, too?

1. See New York, Paris 1996–97.
2. See Zurich, Tübingen 1994–95, and Ottawa, Chicago, Fort Worth 1997–98.
3. Beginning in the 1980s, all of these once fashionable painters who depicted an international Who's Who of sitters have had exhibitions devoted to their work.
4. Sixty-eight works by Ingres are listed in the catalogue of the Exposition Universelle of 1855 (there are twenty-five works under no. 3340 and four under no. 3375, as well as one portrait in the supplement, no. 5048); see Paris 1855. However, the installation shot also shows the unlisted portrait of Prince Napoleon, bringing the tally up to sixty-nine.
5. For Ingres's own description of the details of this complex allegory, see Delaborde 1870, no. 33.
6. For more on the origins of Ingres's attraction to bas-relief, see Cambridge (Mass.) 1973.
7. Maynard 1833, p. 58. For more on Denner and *Bertin*, see Rosenblum 1967a, fig. 117 and p. 137.
8. Pope-Hennessy 1970, p. 255.
9. Quoted on p. 514 in this catalogue.
10. Such a comparison is already found in Rosenblum 1967a, pp. 36, 114.
11. See Vigne 1995b, p. 174.
12. For the fullest account of this version, see Paris 1985, pp. 79–84.
13. See Lowry and Lowry 1998, pl. 48 and p. 122.
14. On the related portrait studies of Clémence de Rayneval, see Paris 1985, pp. 95–96.
15. See, for example, Paris, London 1994–95, p. 271 (English ed.), where Ingres's derivations from the painting are also mentioned.

16. For the first full account of the classical source for *Madame Moitessier*, see Davies 1936; see also Paris 1967–68, no. 251.
17. "belle et calme Junon." Maurois 1948, no. 26. Gautier (June 27, 1847) also referred to Madame Moitessier, when he saw the unfinished portrait in 1847, as "junonien" ("Junoesque"); see Rosenblum 1967a, p. 164.
18. On this commission, see Ternois and Camesasca 1984, pp. 118–19.
19. For a full discussion of the portrait of Isabelle Hittorff, see Paris 1985, pp. 124–28.
20. See ibid., pp. 129–33. For more about the *Venus on Paphos*, see Vigne 1995b, p. 280.
21. The classical Polyhymnia and one of its nineteenth-century sculptural reincarnations by Jean-Marie-Bienaimé Bonnassieux are illustrated in Rosenblum 1967a, p. 33. For a much fuller account of sources for this pose, see New York 1985–86, chap. IV.
22. New York 1985–86, especially chaps. VI and VII.
23. For a full account of this copy, see New York 1988c, no. 51.
24. For some of these antagonistic comments, see pp. 499–500 in this catalogue.
25. Voïart 1806, pp. 25–26.
26. See Rosenblum 1967a, p. 68, and Paris 1985, pp. 32–36.
27. This illustrated history of the French monarchy is fully discussed in Brown and Orth 1997, pp. 7–24.
28. As seen in the lifelong series of variations, begun in 1813, on the theme of a Bohemian young Raphael in his studio, balanced between the inspiration of love, in the form of La Fornarina in his lap, and the unfinished portrait on his easel.

29. On this family trio, see Paris 1985, pp. 18–31. Because the portrait of Monsieur Rivière was unmentioned by the critics, it has been suggested that it was either not included with the group or was too conservative to provoke comment.

30. "comme un astre du ciel." Ingres to Roques, July 29, 1844, in Boyer d'Agen 1909, pp. 374–75. For a rich anthology concerning the shadow Raphael cast on Ingres and his contemporaries, see Paris 1983–84, pp. 122–23.

31. See Ribeiro 1995, p. 180.

32. Paris 1985, p. 28.

33. Ibid., p. 30.

34. Ockman 1995, p. 45.

35. Delécluze 1855, p. 421.

36. New York 1985–86, p. 118.

37. Ingres is known to have made drawings of some of the accessories in *Madame Récamier* (Musée Ingres Montauban, inv. 867.2531, 2532), and it has even been proposed that a drawing he made of the entire painting (fig. 307) may have been executed before rather than after David conceived the sitter's pose. See Momméja 1891, p. 564, and Boyer d'Agen 1909, p. 13.

38. The impact of Ingres's portraiture on later nineteenth-century generations is a rich topic. For some early comments, see Rosenblum 1967b.

39. For more on this portrait, see Montrouge 1974, no. 3, and Nantes, Paris, Piacenza 1995–96, p. 328.

40. On the identity of the sitter, see Ackerman 1986, no. 167.

41. See Paris 1867.

42. The satirical meaning of Cézanne's portrait vis-à-vis Ingres's *Napoleon* is discussed in Athanassoglou-Kallmyer 1990, pp. 482–92.

43. On this, see Rosenblum 1989, p. 398.

44. On the Renan portrait and its lineage, see Rosenblum 1967a, pp. 136–37.

45. For more on the Vallotton portrait, see John Klein in New Haven, Houston, Indianapolis, Amsterdam, Lausanne 1991–93, pp. 117–18.

46. See Kirk Varnedoe in New York, Paris 1996–97, pp. 142–43.

47. For a full discussion of the dialogue between these two paintings, see Rosenblum 1977, pp. 100–105.

48. On this, see particularly Michael C. FitzGerald in New York, Paris 1996–97, pp. 314–16.

49. For the revision of the date (from 1917 to 1918) and a discussion of the relation of the photographic portrait to the painted one, see Houston 1997–98, p. 162.

50. For the liveliest and most detailed account of this painting, see Richardson 1996, pp. 334–36. For further details on the collage accessories absorbed into the finished painting, see Paris 1998, pp. 58–65.

51. For some early remarks on the relationship of *Madame Rivière* to Cubism, see Rosenblum 1967a, p. 64.

52. "géométrie vivante, tout ce qu'on entendait jadis par perspective aérienne"; "le tableau demeure une surface inflexiblement plane où les plans éloignés sont violemment ramenés en avant." Bissière 1921, p. 399. For more on Bissière and Ingres, see Ockman 1995, pp. 112–13.

53. On this, see Yard 1986, p. 71. Ingres's portrait of Cherubini apparently left its effect on this circle, too, as evidenced in John Graham's *Poussin m'instruit* (1944); see ibid., p. 96.

54. Three of these Ingres sources for Sherman's portrait are illustrated in Krauss 1993, pp. 173–74.

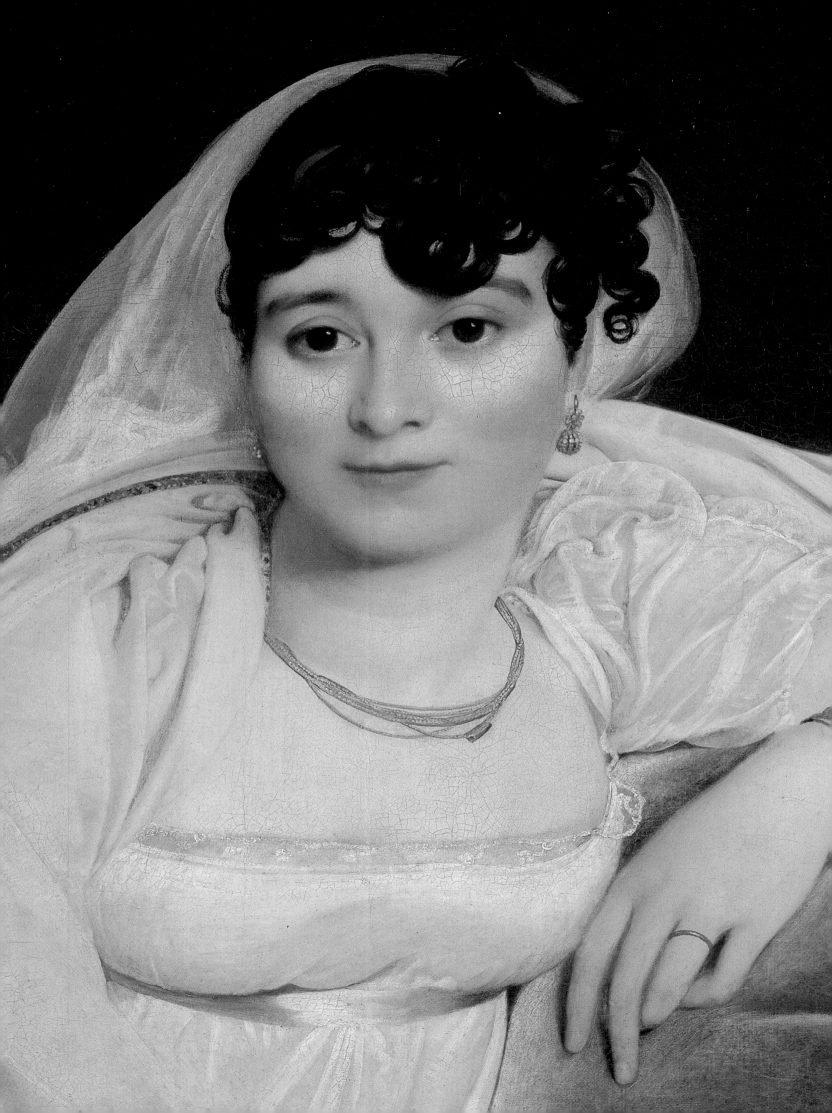

MONTAUBAN–TOULOUSE–PARIS, 1780–1806

Philip Conisbee

I was raised in red chalk,"[1] Ingres once remarked, evoking both smudgy-fingered infant mayhem and the decorous world of ancien régime drawings typically done in that medium. Indeed, the earliest-known surviving work of art from his hand is just such a drawing of his maternal grandfather, Jean Moulet, a master wigmaker from Montauban (fig. 37). Carefully copied at the age of eleven from a drawing made by his father, it is in a well-established eighteenth-century tradition of modest but carefully observed portrait drawings in profile, of which Charles-Nicolas Cochin the younger was perhaps the best-known exponent in the second half of the century.

The artist's father, Jean-Marie-Joseph Ingres (1755–1814), was originally from the regional capital of Toulouse.

He had established himself in the country town of Montauban as a successful jack-of-all-trades—sculptor, painter, decorative stonemason, and architect—who worked on a wide variety of local civic, religious, and private commissions. Doubtless he intended his first child, Jean-Auguste-Dominique, born on August 29, 1780, to follow in his footsteps; the boy was encouraged to draw, for instance, by making copies of his father's own drawings and small collection of engravings. Such domestic instruction may also have compensated for the deficiencies of formal schooling in Montauban, which had been disrupted by events in the early years of the French Revolution. Nevertheless, Ingres later expressed regret for his lack of conventional education, which hampered his ability to express himself both verbally and in writing.[2]

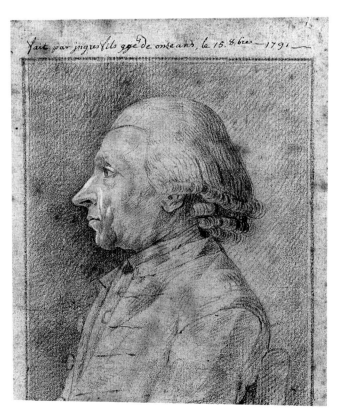

Fig. 37. *Jean Moulet*, 1791. Red chalk on paper, 5⅜ × 4⅛ in. (13.6 × 11.1 cm). Musée Ingres, Montauban (867.335)

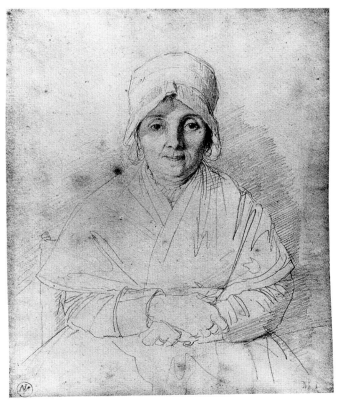

Fig. 38. *Madame Ingres Mère*, 1814 (N 143). Graphite on paper, 7⅞ × 5⅞ in. (20 × 15 cm). Musée Ingres, Montauban (867.276)

His easiest and most directly emotional form of expression, after drawing and painting, was making music: he was a talented violinist, even as a child.

Although his parents were not completely happy in their marriage, the artist retained a strong affection for them both, which is borne out in his correspondence and in his portraits of them. Certainly closely bonded with his father, as both son and pupil, he retained a strong, affectionate memory of the man who was largely responsible for his own love of art and music. His mother, Anne (1758–1817), seems to have been long-suffering and was neglected by her inconsiderate and often absent husband. After Joseph Ingres's death in 1814, she was left in severe financial hardship, which perhaps accounts for her somewhat pinched features in the portrait drawing Ingres made of her when she visited Rome that year (fig. 38). Her looks contrast strikingly with the healthy, confident appearance of her late husband when Ingres painted him ten years earlier (cat. no. 4).

In 1791 Joseph Ingres decided it was time for his son to receive more formal instruction in art. Abandoning Madame Ingres to look after two small siblings,[3] the father set off with the boy for Toulouse, an important administrative, legal, religious, university, and cultural center. Joseph, who was justifiably proud of his native city, planned to remain there for a couple of years to supervise the young student. The eleven-year-old was enrolled at the Académie Royale de Peinture, Sculpture et Architecture for the 1791–92 academic year. As the Revolution progressed, the Académie lost its royal patronage, but Ingres continued to study there until 1797, practicing drawing and receiving instruction in the theory and history of art. At the same time, he was taught painting by several local artists, his principal instructor being the history and portrait painter Joseph-Guillaume Roques. In the late 1770s Roques had studied in Rome, where he had been a protégé of Joseph-Marie Vien, director of the Académie de France there, and where he must also have encountered the young Jacques-Louis David and other rising stars from Paris. Roques's work displays a certain gritty realism that is characteristic of the Toulouse school and that also lies behind Ingres's own acute eye.[4] At the Académie in Toulouse, the young student performed well and carried off a number of prizes for drawing during his six years of study. From his teachers there, and from Roques and other masters, he learned that history painting was supreme among the artistic genres, while also observing, on a more practical level, that being able to paint or draw a good portrait likeness was necessary to make a living.

It was a fact of life for eighteenth-century painters who took the academic tradition seriously that their high aspirations as history painters were rarely matched by a desire on the part of their potential patrons for such intellectually demanding work. Most collectors were more interested in decorative pictures, light-hearted mythologies, recognizable scenes of everyday life, landscapes, still lifes, or likenesses of men and women of their own class. This preference persisted throughout the nineteenth century, as academically oriented artists waited and hoped for the patronage of state or church to satisfy their more elevated ambitions. The situation was particularly acute during the period of social unrest, war, and economic uncertainty in which Ingres began his artistic career. By 1800 a good many critics deplored the excessive numbers of portraits appearing at the Salon, especially when they diverted history painters from their higher calling: "It is often through vanity alone that so many people have themselves painted, and if there is anything useful about this behavior, one can say that it benefits painters, who thereby try to compensate for the few opportunities they have to exercise their talents and turn these to good account."[5] Admiring Anne-Louis Girodet's portrait *Monsieur Bourgeon* (fig. 39) at the Salon of 1800, another reviewer regretted that "I know only one thing wrong with this artist, and that is to have painted this portrait with so much skill and realism that it seems to have cost him a great deal of time. What he has lost in polishing a suit of clothes could have been better spent in polishing a masterpiece of history painting."[6] Ingres himself would certainly come to share such feelings, when necessity all too often drove him to make likenesses rather than to create works of art imbued with the classical ideal.

A number of Ingres's portrait drawings survive from his years in Toulouse, some of them depicting friends, and others likely done to earn a little money. Several small heads in profile (see, for instance, cat. no. 14) show a gemlike hardness and precision of observation that give them the quality of carved reliefs or cameos. By their very nature as images in profile, their contours are bold, while the internal modeling is done with fine hatched lines. The exacting scrutiny and the precise response of the hand required in making these little portrait drawings were disciplines that would prove to be of inestimable importance for the rest of Ingres's long career as a draftsman and portraitist. The drawings are usually signed "Ingres fils," perhaps as an act of filial homage but also as a way to distinguish them from Joseph's works. Although

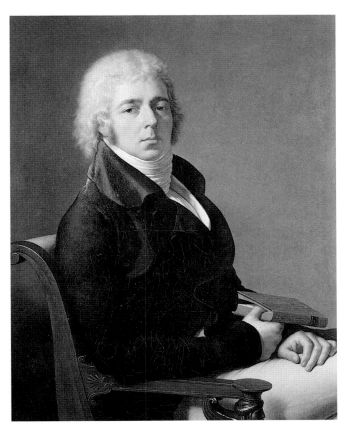

Fig. 39. Anne-Louis Girodet (1767–1824). *Monsieur Bourgeon*, 1800. Oil on canvas, 36¼ × 28⅜ in. (92 × 72 cm). Musée de l'Hôtel Sandelin, Saint-Omer

a drawing of the actor Brochard (cat. no. 15), which still exists in its original mount, proclaims with pride Ingres's authorship and his association with Toulouse, the young artist's proficiency as a draftsman clearly marked him for a destiny that was more than local.

It was a normal progression for artists of talent to graduate to Paris to complete their professional training. In Ingres's time, a number of painters had made the journey from Toulouse to receive instruction in the busy studio of the celebrated David, for over a decade the virtual dictator of elevated painting in France.[7] What was the experience of Paris and David's studio like for the young Ingres, when he arrived in the city in August 1797? It must have been daunting to encounter a master who had voted for the death of a king—even though the former Jacobin David had been tried, imprisoned, and released by Revolutionary tribunals two years before. Yet by this time, the atmosphere of social unrest and political tension (which Ingres himself had experienced in Montauban and Toulouse) had been replaced by a greater equilibrium, both in Paris and elsewhere. Optimism was in the air, as the ongoing Revolution metamorphosed into the distant rumbling of expansionist foreign wars, and news was coming back from south of the Alps of the triumphs of a precocious General Bonaparte and his youthful armies.

Thanks to these foreign campaigns, the mid-1790s saw Paris transformed into the greatest museum city ever, and over the next twenty years remarkable quantities of war booty arrived there from abroad. The French military campaign in Belgium and Holland during 1794–95 had already brought to Paris such masterpieces as Van Eyck's *Adoration of the Lamb* altarpiece from the church of Saint Bavo in Ghent, Rubens's *Descent from the Cross* from Antwerp Cathedral, and Rembrandt's *Night Watch* from the Amsterdam town hall. Between 1796 and 1799 the Italian campaigns brought altarpieces by Correggio from Parma; Titians, Veroneses, and Tintorettos from Venice; and Raphaels from Florence and Rome. It must surely have been heaven for any young artist to see on display in one place—the old royal palace of the Louvre, renamed the Musée Napoléon in 1803—so many great works from the European canon, from antiquity to modern times.[8] This treasure continued to arrive throughout the triumphant days of the Empire, and the experience for Ingres cannot be overestimated. To see such works as Raphael's *Madonna della Sedia* from the Pitti Palace in Florence (fig. 17), *The Coronation of the Virgin* from the Vatican, and *Saint Cecilia* from the Pinacoteca in Bologna must also have made the black-and-white engravings in his father's collection in Montauban seem like pale reflections indeed. The experience also provided the young painter with a bewildering variety of aesthetic choices: true as he was to the Neoclassical heritage of David, and steadfast in his devotion to Raphael, Ingres was exposed to so many historical options in his formative years that he had a large repertoire of historical styles to draw on when occasion demanded.

Ingres arrived in Paris in the wake of David's brilliant first generation of students, notably Girodet, François-Xavier Fabre, and François Gérard, and in time to hear stories of the rising star in Italy, Antoine-Jean Gros. In the hothouse atmosphere of David's studio, these now mature artists (ten or more years older than Ingres) had experienced a period of intense rivalries, both among themselves and with their master, as they strove to establish their own individual voices as well as the collective artistic voice of the post-Revolutionary era.[9] Such high ambitions arose in part from David's own encouragement of his students to be true to their personal vision, as he himself had been: "Do what you feel, copy what you see, study what you understand, because a painter's reputation depends only on the great quality he possesses,

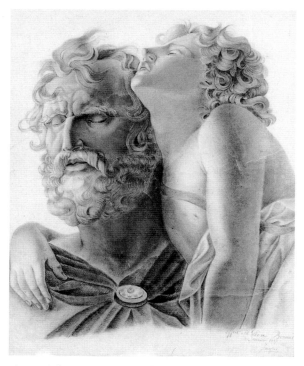

Fig. 40. After François Gérard (1770–1837). *Belisarius*, ca. 1797. Charcoal, black chalk, and graphite on paper, 24¾ × 19⅜ in. (62.9 × 49.3 cm). Phyllis Hattis Fine Arts, New York

whatever it may be."[10] The very self-reliance David fostered created friction with the best of his pupils, because they inevitably rejected his forceful artistic precepts in favor of their own: both Girodet and later Ingres, for instance, produced works whose independent aesthetic was scarcely comprehended by their master.

Another pupil of David, Étienne Delécluze (who would shortly abandon painting for a career as a writer and critic) had joined the studio early in 1797 and soon befriended Ingres. In his recollections of this period, Delécluze expressed a sense of regret that the heroic era of David's mentorship—the early and mid-1790s—had passed by the time he had arrived and that the previously mentioned students of that era "were already considered masters."[11] Nevertheless, the neophytes Ingres and Delécluze were still confronted in the Paris of the 1790s with a wide choice of stylistic models. Aside from the whole spectrum of European art represented in the Louvre museum, David's studio offered a full range of variations on the classical style, developed by the master and his pupils. Ingres could thus decide, for instance, to explore the idea of a sculptural style, as he did when he made a magnificent drawing after Gérard's *Belisarius* (fig. 40), a painting that had been admired at the Salon of 1795 for its purity of form, expression, and feeling.[12] Perhaps as a result of such studies, Ingres's 1798 portrait drawing

of Pierre-Guillaume Cazeaux (cat. no. 19) shows a new confidence, marked by the sitter's turning from profile into fuller, more volumetric view. More ambitious in scale, but no less confident in its varied touch, sense of volume, and lively play of chiaroscuro, is the three-quarters view of the artist's friend the architect Jean-Charles-Auguste Simon (cat. no. 21), drawn a few years later.

In his rooms at the Louvre David displayed his earlier, already legendary monumental scenes from ancient history, such as *The Oath of the Horatii* (which Ingres copied in a drawing) of 1784 and *Lictors Bringing Brutus the Bodies of His Sons* of 1789. But ever since 1795 the master had been working on his great Roman history painting representing the topical theme of political and personal reconciliation, *The Intervention of the Sabine Women* (fig. 42); completed in 1799, David's painting was to leave a lasting impression on Ingres. Although this enormous, complex, friezelike composition was criticized for the improbability of its Roman heroes engaging in battle in the nude, clad only in helmets, sandals, and strategically placed scabbards, David was aspiring here to create something that was even more pure in its classicism than his celebrated works of the late 1780s. "Perhaps I showed too much anatomical art in my picture of the *Horatii*," he is

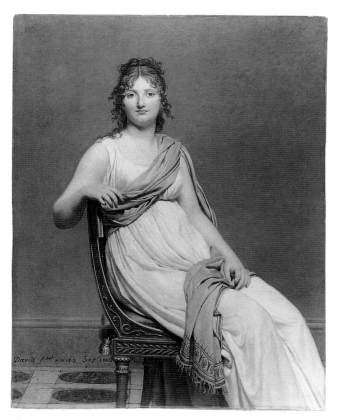

Fig. 41. Jacques-Louis David (1748–1825). *Madame de Verninac*, 1798–99. Oil on canvas, 57⅜ × 44⅛ in. (145.7 × 112 cm). Musée du Louvre, Paris

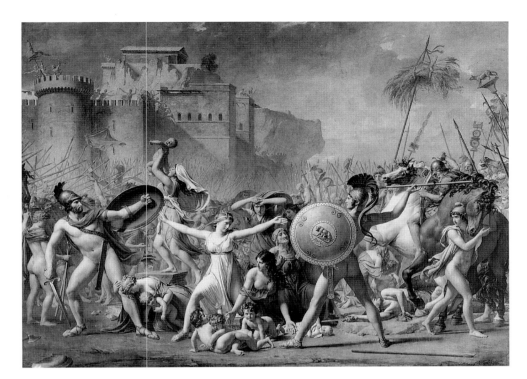

Fig. 42. Jacques-Louis David (1748–1825). *The Intervention of the Sabine Women*, 1799. Oil on canvas, 151⅝ × 205½ in. (385 × 522 cm). Musée du Louvre, Paris

Fig. 43. Thomas Piroli (ca. 1752–1824), after John Flaxman (1755–1826). *The Fight for the Body of Patroclus* (*The Iliad*, 17.325), 1793. Engraving (image), 6½ × 13¼ in. (16.5 × 33.6 cm)

reported as saying.[13] "In that of the *Sabine Women*, I will conceal it with more skill and taste. This *picture will be more Greek*. . . . It is necessary therefore to go back to the source. . . . I want to do *pure Greek*."[14] David was striving to cast his scene from ancient history in a convincingly appropriate form. His desire for purity was inspired by the flat, linear style of drawing found on so-called Etruscan vases, which had aroused the interest of connoisseurs and artists since their excavations in Italy early in the century and which were taking on ever greater interest as archaeological investigations revealed their true Greek origins.

David was also responding to a radical faction among his own students—led by Maurice Quaï and Jean Broc, and known as the Primitifs or the Penseurs—who sought to renew and purify his potent classical pictorial language by advocating "the return of simple, true, in a word *primitive*, taste,"[15] which they thought might be found in early Greek art before the time of Phidias. This younger group admired David as the begetter of the Neoclassical reform in art, but felt he lacked the energy to complete it.[16] According to Delécluze, Ingres kept himself apart from the factions in David's studio and led an isolated, studious existence.[17] The artist was to maintain a certain solitary independence throughout his life, but such isolation from collegial exchange early in his career meant that public criticism of his exhibited works came as an unexpected and unpleasant shock. It may also account for the narrow-minded dogmatism of his aesthetic utterances later on. Despite his solitariness, the awkward and impressionable seventeen-year-old from Montauban must have

soaked up new ideas. He would have been no less struck than other young artists of the day by the tight outlines, radical planarity, and spare purity of form of the English artist John Flaxman's outline engravings after *The Iliad* (1793) and *The Odyssey* (1795), which drew their inspiration from the Etruscan vases.[18] David himself, researching purer forms for his *Sabines*, seems to have taken into consideration these latest interpretations of the ancient world (fig. 43). Their wide dissemination and the great interest their "beautiful style of antiquity"[19] aroused among advanced artists in the 1790s were certainly not lost on Ingres.

There is little surviving visual evidence of Ingres's activities in David's studio before he won the coveted Prix de Rome in 1801. He assisted David with his celebrated portrait of Madame Récamier (figs. 306, 307), although the work was left unfinished because of disagreements between the master and his sitter. Ingres was never to forget this painting, and particularly its striking simplicity of concept

Fig. 44. *Male Torso*, 1800 (W 4). Oil on canvas, 40⅛ × 31½ in. (102 × 80 cm). École Nationale Supérieure des Beaux-Arts, Paris

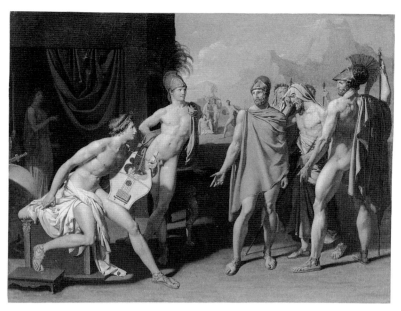

Fig. 45. *The Ambassadors of Agamemnon*, 1801 (W7). Oil on canvas, 43¼ × 61 in. (110 × 155 cm). École Nationale Supérieure des Beaux-Arts, Paris

and design. He noted the care devoted to the psychological presentation of the sitter, who is alluring but distant, and to her fashionable Greek-style costume and classical furnishings. He must have been no less impressed with David's *Madame de Verninac* (fig. 41), a finished portrait that nonetheless also remained in the master's studio. Again there is an engaging simplicity of design, with the sitter in her white dress now more directly engaged with the viewer, an elegant shawl helping to define her form in space. When Ingres made his first full-length portrait drawing, which depicts the painter Barbara Bansi distracted for a moment from watching balloons drift by (cat. no. 20), it was clearly a homage to David, not only in its signature—"jngres. eleve de David"—but also in its formal indebtedness to the master's portraits.

One of the first figures Ingres painted (probably an academic study of a male nude) was admired by Delécluze for "the refinement of the contour, the true, deeply felt sense of the form, and an extraordinarily apt and vigorous relief."[20] A *Male Torso* (fig. 44), with which Ingres won a prize for half-length figure painting in January 1801, is typical of several such studies, which were routine teaching exercises in matching eye and hand and in portraying the human form in different lights. The work shows that Ingres was by that time an accomplished painter of conventional academic figures, but also that he was already treating them in a personal way, emphasizing the silhouette and flattening the forms by bringing the

figure close to the picture plane in a raking light. In fact, of all David's pupils, it was Ingres who most radically transformed into paint and canvas the Flaxmanesque graphic ideal. This influence is quite apparent in *The Ambassadors of Agamemnon* (fig. 45), the painting with which he won the Prix de Rome: its frieze of figures is almost a translation into paint of Flaxman's linear interpretation of Homer's text (fig. 46). With neat historical symmetry, this very painting was admired by Flaxman, who reportedly commented during a visit to Paris in 1802 that it "seemed to him preferable to anything he had yet seen of the contemporary French school."[21] However, this encomium from one of the most famous artists in Europe did nothing to endear Ingres to his master, David. Even

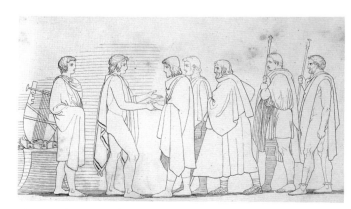

Fig. 46. Thomas Piroli (ca. 1752–1824), after John Flaxman (1755–1826). *The Embassy to Achilles* (*The Iliad*, 9.260), 1793. Engraving (image), 6⅝ × 11¾ in. (16.8 × 29.8 cm)

though Ingres had borrowed Madame Récamier's Greek footstool for Achilles, it can hardly have compensated for the shallowness of his frieze of flaccid ancients, their forms flattened by strong illumination, the minimally planar composition, and the bright colors barely modulated by the Davidian convention of *frottis,* or scumbled paint in the shadows.[22] Some of the same features would elicit much more public criticism when Ingres exhibited only a few years later at the Salon of 1806 (see pages 499-500).

David, for all his encouragement of individuality, had already recognized in the young Ingres "a tendency toward exaggeration in his studies."[23] Yet this remark should be seen in light of Delécruze's phrase "the refinement of the contour," which hints at Ingres's search for perfection of form through line. The artist's commitment to drawing—both in the narrow sense of applying pencil to paper and in the broader sense of championing *disegno* over *colore,* in a debate at least as old as the Renaissance—was to be lifelong. This search for perfection continued in the next few years as Ingres prepared for his trip to Rome, which was to be long postponed because the government's coffers had been depleted by its international wars. After *The Ambassadors of Agamemnon,* Ingres toyed with a few more pictorial ideas illustrating ancient literature, including the jewel-like painted panel *Aphrodite Wounded by Diomedes* (fig. 47), whose composition also is clearly inspired by the outline engravings of Flaxman. He even made some Flaxmanesque drawings from Greek vases, such as *The Vengeance of Medea* (Musée Ingres, Montauban), after the design on a South Italian amphora that had been brought as war booty to Paris from Munich in 1800. Other drawings in pen and ink, done in the years after 1800 and usually illustrating martial subjects, are quite bold and slashing (fig. 48).[24] But one portraying a scene from the story of Antiochus and Stratonice (fig. 49), executed probably on the eve of Ingres's departure for Rome in 1806, shows a radically refined version of the spare Flaxmanesque contour.

During the same period, Ingres began to apply this economical linear style to portrait drawings such as *The Forestier Family* (cat. no. 23). His choice of a relieflike format here accords perfectly with the spare, Flaxmanesque style of the drawing, which makes as much creative use of the white paper as of the graphite lines. This work, executed with a sharp pencil on smooth white paper,[25] defines Ingres's portrait drawing style for years to come. And, as Agnes Mongan put it succinctly, "Ingres' manner of drawing was as new as the century."[26] With a graphite line that is constantly and finely adjusted—now

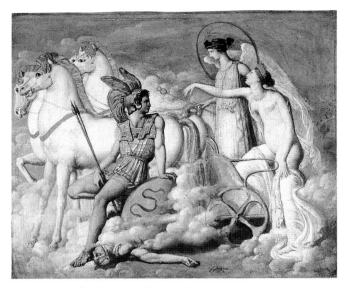

Fig. 47. *Aphrodite Wounded by Diomedes,* ca. 1805 (W 28). Oil on wood, 10⅜ × 13 in. (26.5 × 33 cm). Kunstmuseum, Basel

Fig. 48. *Napoleon at the Kehl Bridge,* before 1806. Graphite and pen on paper, 11 × 14⅞ in. (28 × 37.7 cm). Musée Ingres, Montauban (867.2773)

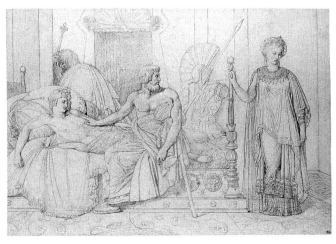

Fig. 49. *Antiochus and Stratonice,* ca. 1806. Graphite and brown wash on paper, 11⅜ × 15¾ in. (29 × 40 cm). Musée du Louvre, Paris

Fig. 50. *Young Man with an Earring*, 1804 (W 19). Oil on canvas, 16⅛ × 13 in. (41 × 33 cm). Musée Ingres, Montauban

narrow, now thick, pressing firmly or more softly—he defines contours with a remarkable range of modulations; form is described above all by such calibrations of contour, as well as by the direction of a line. Ingres draws with a more subtle and various line than any of his contemporaries. Shading is sometimes done with fine hatching, sometimes by smoothing with the stump, and there is an occasional discreet touch of wash. But these types of modeling are kept to a minimum: line is supreme. That the silhouette of a figure was important is evidenced by a close examination of the many drawings in which erasures and adjustments can be detected.[27] As a means of improving the overall composition of the drawings, such changes were probably prompted by aesthetic motivations, but their ultimate result was often to enhance the expressive presence of a sitter. In fact, Ingres's success as a portrait draftsman and painter came as much from his ability to capture the likeness and presence of a person as from the formal qualities that are so admired in his art today. Paying close attention to the expression of eyes and mouths, he conveys a strong sense of his sitters' personalities and even captures their self-consciousness in posing or an unusually focused stare, as they meet his own intense scrutiny.

Aside from his planned studies at the Villa Medici, winning the Prix de Rome gave Ingres from 1801 onward a modest stipend and a studio in the Couvent des Capucines, one of the many monasteries in Paris that had been disbanded during Revolutionary secularization. He shared the convent with a number of David's other pupils: Girodet and Gros, the latter recently returned from Italy; the sculptor Lorenzo Bartolini (figs. 53, 135), who had been Ingres's most intimate friend in David's studio; and François-Marius Granet (see cat. no. 25), a young painter from Aix-en-Provence, with whom he was later to become close in Rome. Also living at the convent were two artists from David's studio who had become enamored of all things medieval: Pierre Révoil and Fleury Richard.[28] During their frequent visits to the recently created Musée des Monuments Français, Révoil and Richard studied the fragments and artifacts gathered there from the French churches and monasteries that had been destroyed and disbanded during the Revolution. The art of both men was marked by a strong element of nostalgia for times past, especially for the medieval and Renaissance periods in France, with all their conservative political and religious implications. Ingres was later to adapt this taste to works of his own, as he began to explore new themes and markets during the penurious years in Rome.

Ingres's standing as a winner of the Prix de Rome also entitled him to send a painting to the Salon of 1802. Its listing in the *livret* (as "portrait d'une femme") and a brief critical comment are all we know of this long-lost painting. The small panel representing the comtesse de La Rue (W 13), Ingres's earliest surviving painted portrait of a woman, may give us some idea of the appearance of the work he exhibited in 1802: the precise observation found in his early portrait drawings in profile is combined here with a certain alluring elegance learned from David and Gérard. A recently discovered drawing (fig. 308) may be a study for, or a record of, another early portrait, the lost *Madame Béranger*.[29]

Perhaps *Madame Béranger* (which seems from the drawing to have been quite ambitious) was the work exhibited at the Salon that brought Ingres an important commission in July 1803: a portrait of Napoleon intended as a gift from the First Consul to the subject town of Liège, which had been annexed to France in 1794. Living as he was on a very modest stipend until the government could find the funds to send him to Italy, Ingres must have been as grateful for the 3,000 francs this commission brought as for the recognition it represented. *Bonaparte as First Consul* (cat. no. 2) is an impressive effort for a first

essay in full-length, life-size portrait painting by the twenty-three-year-old artist. Since the First Consul probably did not give the unknown painter more than the briefest of sittings for a portrait that was after all merely a routine propagandistic image destined for the provinces, Ingres must have been relieved that there was an established pattern for this type by Antoine-Jean Gros (see fig. 62) upon which to model his work.[30] Ingres may have hoped to exhibit this portrait at the Salon of 1804, but by the time it was completed (July 1804), Napoleon had declared his Empire and his image as First Consul was already politically out-of-date.

With the exception of *Bonaparte as First Consul*, all of Ingres's first painted portraits seem to have been of his own intimate circle, and it may be that he was consciously developing his vocabulary as a portraitist by painting these relatively undemanding sitters. The earliest of these works is a rather stiff rendering of the scientist Pierre-François Bernier (cat. no. 1), which most likely dates from 1800, when Bernier was in Paris for a few months. But in 1804, under the stimulus of the consular commission, Ingres became much more proficient in portraiture. *Young Man with an Earring* (fig. 50) is approximately the same size as the portrait of Bernier, but its close focus and vigorous execution give it the quality of a more spontaneously and confidently undertaken study; even the signature—"Moi, Ingres pinxit 1804"—is correspondingly assertive. The boldly impasted highlights and sketchy shadows reflect the lessons Ingres had learned in painting academic life studies under David's tutelage (see fig. 44), including his apprenticeship working on the master's portrait of Madame Récamier (fig. 306).

When Ingres's father paid a visit to Paris the same year—perhaps to say farewell before his son departed for Rome—the artist used the occasion to paint a more meditatively executed, tenderly observed commemorative portrait (cat. no. 4). Although the work lacks the sketchy brio of *Young Man with an Earring*, its handling is much more refined, and the father's features are carefully and lovingly described. This portrait, with its hint of powder on Joseph's collar, gracefully conveys the fact that Joseph Ingres was very much a man of the eighteenth century. Stylistically, it falls somewhere between the finished portraits of David's pupils from the previous decade, such as Girodet's *Monsieur Bourgeon* (fig. 39) of 1800,[31] and Greuze's last *Self-Portrait* (fig. 51), which was exhibited at the Salon of 1804.

The *Père Desmarets* (cat. no. 7) of 1805, with the sitter posing in his shirtsleeves, is evidently a private and intimate portrait. Brilliantly mastering the careful modeling of head and features in light and shade, Ingres also shows an unexpected painterliness in his handling of the creamy white shirt. The ascetic appearance of this man, with his penetrating gaze, has understandably reminded viewers of Philippe de Champaigne's seventeenth-century portraits of Jansenist clerics, an association perhaps encouraged by Ingres's own designation of the sitter as "Père" (Father). It would not be surprising if, at this period in his development, Ingres looked beyond the immediately obvious Davidian prototypes to study the work of an earlier great French portrait painter whose sharp observation and severe style have much in common with the Neoclassical aesthetic of David and his school.

The lively, expressive portrait of Ingres's compatriot Belvèze-Foulon (cat. no. 6), dated 1805, has an amicable informality and freshness of touch reminiscent of the *Young Man with an Earring*. Its bust-length format, which Ingres was often to employ, is found again in the more formal portrait of Joseph Vialètes de Mortarieu (fig. 52). Mortarieu (1768–1849), who came from an old, established family in Montauban for whom Joseph Ingres had worked,[32] was in Paris in 1805–6, when Ingres would

Fig. 51. Jean-Baptiste Greuze (1725–1805). *Self-Portrait*, ca. 1785. Oil on canvas, 28¾ × 23¼ in. (73 × 59.1 cm). Musée du Louvre, Paris

Fig. 52. *Joseph Vialètes de Mortarieu*, 1805 (W 29). Oil on canvas, 22 × 18⅛ in. (56 × 46 cm). Norton Simon Museum, Pasadena

have painted his portrait. In April 1806 he was appointed mayor of Montauban and two years later negotiated with Napoleon for the creation of the administrative department of Tarn-et-Garonne, with Montauban as its capital;[33] he was made a baron in 1813.[34] Ingres has placed the thirty-seven-year-old Mortarieu against a striking bright blue sky, which seems to convey an air of fresh-

ness and hope. The artist himself probably had expectations of future patronage from this quarter, and eventually, in 1820, the mayor (along with Ingres's old friend Jean-François Gilibert and the deputies of Tarn-et-Garonne) did solicit for Ingres the government commission of *The Vow of Louis XIII* for Montauban Cathedral. Mortarieu's donation of his modest art collection to his native town in

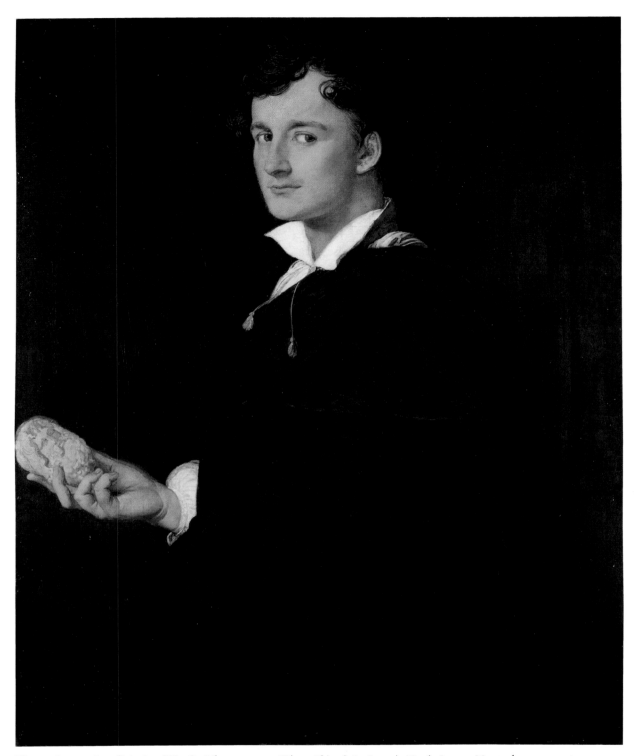

Fig. 53. *Lorenzo Bartolini*, 1805 (W 26). Oil on canvas, 38⅝ × 31½ in. (98 × 80 cm). Musée Ingres, Montauban

1843 laid the foundation for the art museum that later became the Musée Ingres. Ingres employed the cheerful device of a bright summer sky once more. As the background of the so-called *Madame Aymon* (cat. no. 8), it sets off to gay effect a rather forthright young woman sporting rouge, reddened lips, and a scarlet shawl. The decorative allure of the image is enhanced by the oval frame and by the echoes of its shape in the sitter's face, neck, necklace, bosom, and saucy curls.

In 1804 Ingres also experimented with a series of half-length portraits, beginning with the *Self-Portrait* (see cat. nos. 11, 147) and its likely pendant, painted shortly thereafter, representing the lawyer Gilibert (cat. no. 5); a third work, depicting the sculptor Bartolini in 1805 (fig. 53),

Fig. 54. Jean-Louis Potrelle (1788–1824) (?), after Ingres. *Self-Portrait of 1804*, before 1850. Etching, retouched by Ingres in graphite and white gouache, 18⅝ × 11¾ in. (47.4 × 29.8 cm). Musée Ingres, Montauban (68.2.6)

Fig. 55. Jean-Louis Potrelle (1788–1824), after Ingres. *Lorenzo Bartolini*, 1805. Engraving (image), 9½ × 7⅞ in. (24.1x 20 cm)

belongs with the other two in a category known at the time in Germany as *Freundschaftsbilder* (friendship paintings). During their student days in Paris, Ingres, Gilibert, and Bartolini were close friends; years later, when he tried to persuade Gilibert to join Bartolini and himself in Florence, Ingres recalled with nostalgia their happy days of student camaraderie in Paris.[35] It seems that Ingres's three portraits were conceived as companion pieces,[36] and originally all three had the same format, with the figures similarly proportionate to the pictorial spaces they inhabit. That the *Self-Portrait* rhymes visually with each of the others suggests that Gilibert may have returned to Montauban rather soon, taking his portrait with him, and that Ingres may have made the portrait of the sculptor as a second pendant to his own.

The *Self-Portrait* now in the collection of the Musée Condé (fig. 209) is a substantially reworked and smaller version of the picture Ingres first painted in 1804. Something of its original appearance is known from an etching (fig. 54), a photograph by Charles Marville (fig. 282), and a copy made in 1807 by Julie Forestier (cat. no. 11); another copy (cat. no. 147), made about 1850–60, is now in the collection of The Metropolitan Museum of Art. As initially conceived, the work showed the artist with a

light-colored overcoat draped over his right shoulder: when it was exhibited at the Salon of 1806, a malicious critic observed that the heavy coat must be encumbering the inspiration of the moment.[37] The engraving suggests that Ingres may originally have intended to portray himself at work on Gilibert's portrait, with its primed canvas sitting on the easel before him. Is he perhaps attempting a witticism by appearing to rub the lines out with the cloth in his left hand? In the reworked version in the Musée Condé, besides cropping the canvas, Ingres replaced the overcoat with a dark cloak, erased the image of his friend to create a more generalized effect, and improved the rather clumsy juncture of his right arm and body. Some of these alterations may have been occasioned by the criticisms the work received at the Salon, including comments that it was too highly contrasted (see page 500).[38]

Compared with the carefully wrought *Self-Portrait*, the portrait of Gilibert (cat. no. 5) is quite sketchy in execution: parts of the costume, the table on which Gilibert leans, and especially his right hand are left in the state of an *ébauche*, or loosely brushed-in sketch. While this affectionate portrayal is a moving testimony to the friendship between the two young men, its unfinished and even experimental air suggests that the artist was

employing his willing model to explore his abilities as a portrait painter on a relatively ambitious scale. This informal, private image remained in Gilibert's family until its donation to the Musée Ingres. It is perhaps significant that the artist never requested it for any of the exhibitions of his work that he organized in Paris, although he was happy to have it shown locally in Montauban in 1862 and even referred to it as "the best of my portraits" at that time.[39]

To understand the original appearance of Ingres's portrait of Bartolini (fig. 53), which was considerably painted over at a later but unknown date, one must again take recourse to an engraving (fig. 55), made in 1805, the same year as the painting. Radiography reveals that the work was originally signed and dated "Ingres / à son ami Bartolini / 1805," while the present signature and date of 1806 were added when the surface was reworked. In its first state *Lorenzo Bartolini* shares certain features with the *Self-Portrait:* over his left shoulder, Bartolini wears a light-colored cape, the counterpart to Ingres's pale overcoat; the sculptor holds a small antique head of Jupiter, instead of the tools of the painter's trade. The youthful Bartolini looks tentative and intense, glancing over his shoulder as if engaged in a dialogue about the meaning or attribution of the sculpture.

The austerity of the image, with Bartolini in silhouette against a plain background (which was originally lighter), holding a simple object that alluded to his taste, learning, and vocation, has justly reminded later commentators of sixteenth-century Italian portraits depicting connoisseurs and scholars. An appropriate example is Bronzino's *Portrait of a Young Sculptor* in the Louvre (fig. 56), with which Ingres would have been familiar.[40] Although the Renaissance portrait clearly provided a compositional model for the relatively inexperienced portrait painter, it seems that Ingres must also have been consciously evoking his friend's patrimony and aspirations. After returning to his native Florence in 1807, Bartolini became one of the most prominent Neoclassical sculptors in Italy. When Ingres—not without a degree of envy—painted his friend a second time in Florence in 1820 (fig. 135), he depicted him as an establishment figure, brimming with confidence, success, and a certain self-satisfaction. As for his first depiction of Bartolini, Ingres also reportedly considered it "one of my best works before my departure for Rome."[41]

Having failed to exhibit at the Salon of 1804, Ingres was still waiting to establish a public reputation and therefore probably set his sights on producing something for the next Salon, scheduled for 1806. The previously discussed portraits from 1804 and 1805 could be considered preparatory essays toward the more complete statement he must have hoped to make in public on that occasion.

Ingres was represented at the Salon of 1806 by the *Self-Portrait* and at least three other new portraits. It is not known whether the first, *Napoleon I on His Imperial Throne* (cat. no. 10), was commissioned or undertaken on the artist's own initiative. Ingres's driving ambition—he once characterized himself as having "an excessive sensibility and an insatiable desire for glory"[42]—could have led him to attempt on his own a definitive image of the most powerful man in Europe. But such propagandistic imagery was rigorously controlled at the time, and it would have been presumptuous, not to say foolish, for a barely recognized young painter to assert himself in this way. No documents have so far come to light to prove a commission, but there probably was some kind of official approval, considering that the work was acquired by the Corps Législatif to be displayed in its rooms at the Palais Bourbon and that Ingres was permitted to send it to the Salon.

Fig. 56. Agnolo Bronzino (1503–1572). *Portrait of a Young Sculptor*, ca. 1540–50. Oil on canvas, 43¾ × 35⅞ in. (111.1 × 91.1 cm). Musée du Louvre, Paris

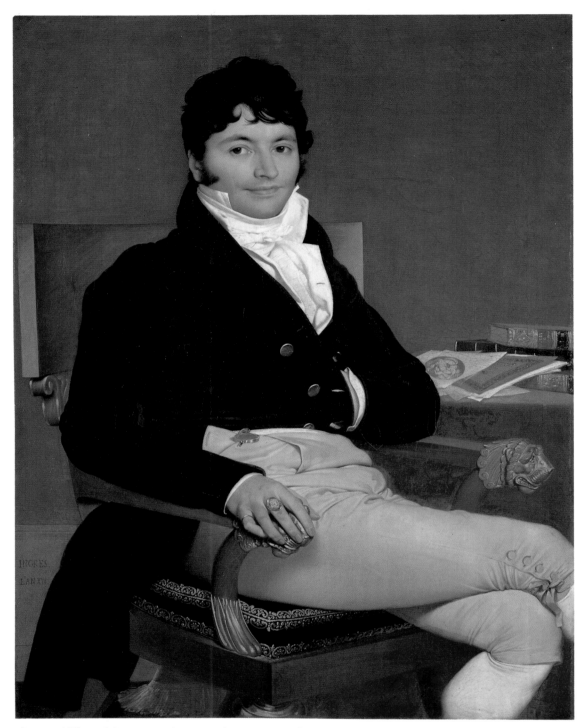

Fig. 57. *Philibert Rivière*, 1804–5 (W 22). Oil on canvas, 45¼ × 35⅜ in. (115 × 90 cm). Musée du Louvre, Paris

Two of the three portraits commissioned by Philibert Rivière—those of Madame Rivière (cat. no. 9) and of the couple's daughter Caroline (fig. 58)—were also exhibited in 1806; it is likely that Ingres withheld Philibert's portrait (fig. 57) from the Salon, perhaps on account of the sitter's royalist sympathies.[43] These sympathies may account for the fact that the latter portrait seems to have been intentionally modeled on David's depiction of

Philibert-Laurent de Joubert (fig. 59), a prominent financier during the ancien régime. Ingres certainly knew this portrait from David's studio, where it was left unfinished, either because of the sitter's death in March 1792 or for political reasons. The poses and color harmonies in the two works are strikingly similar, as are various details, including the books on a table. Ingres's portrait is meticulously finished, however, even more

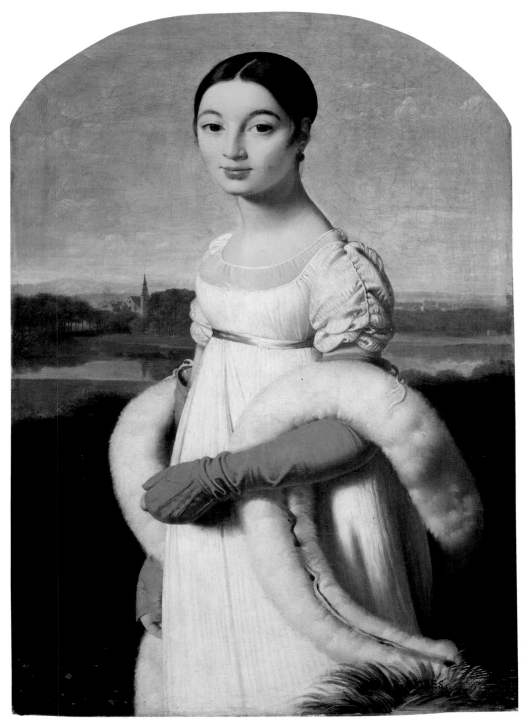

Fig. 58. *Mademoiselle Caroline Rivière*, 1806 (W 24). Oil on canvas, 39⅛ × 25⅜ in. (99.5 × 64.5 cm). Musée du Louvre, Paris

so than David's completed and otherwise comparable portraits of the 1790s, such as *Gaspar Meyer* (Musée du Louvre, Paris).

Philibert Rivière came from a family whose members served as royal administrators during the ancien régime. His father, who remained loyal to the crown, was persecuted during the Revolution and eventually arrested in 1792. Young Philibert's brother Jacques supported the Revolution and was a member of the Committee of Public Safety, but Philibert himself, on his marriage contract in 1792, gave his name as Rivière de l'Isle—surely an act of provocation at a time when the noble particle "de" was more than suspect. The Rivières had close social connections in southwestern France, in particular in the Rouergue region, where Philibert and his new bride took refuge from Revolutionary events in Paris. Their daughter

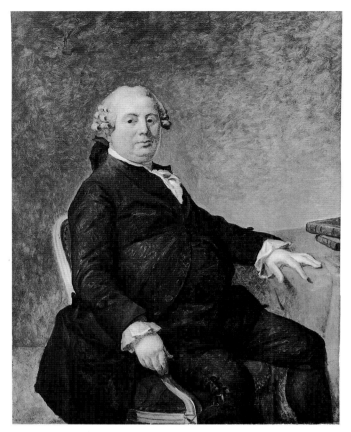

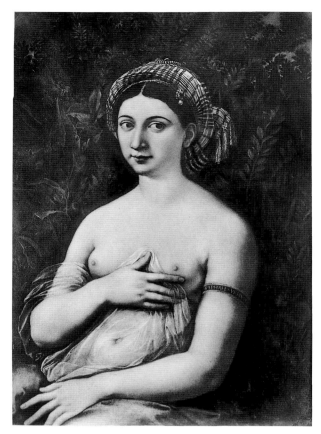

Fig. 59. Jacques-Louis David (1748–1825). *Philibert-Laurent de Joubert*, ca. 1790. Oil on canvas, 50 × 37⅞ in. (127 × 96.2 cm). Musée Fabre, Montpellier

Fig. 60. Raphael (1483–1520). *La Fornarina*, ca. 1518. Oil on wood, 33½ × 23⅝ in. (85.1 × 60 cm). Galleria Nazionale d'Arte Antica (Palazzo Barberini), Rome

Caroline was born in Villefranche-de-Rouergue, near Montauban, in 1793, just two weeks after the execution of Louis XVI. There is little doubt that some Montalbanais connection—the Vialètes de Mortarieu family, perhaps—brought the Rivières and Ingres together in Paris after they ended their exile and the young painter arrived in the capital. Whether or not the mayor of Montauban was involved, it was surely enlightened self-interest that led Philibert Rivière to commission his family portraits in 1804 (probably at a reasonable price) from the young Prix de Rome laureate: he must have expected to see them exhibited prestigiously at the Salon, in the company of Ingres's portrait of the emperor.

The Rivière family portraits are certainly more ambitious in conception, and more highly wrought, than those of any of Ingres's intimate friends. Forty-year-old Philibert, relaxed, nonchalant, and worldly—he had a reputation for professional and sexual opportunism[44]—sits in a superb Empire armchair, which was fine enough to have been inventoried after his death. The lettering on a calf-bound volume on the table, *Rousseau Oeuvres*, probably alludes to a manuscript of Jean-Jacques Rousseau's

Nouvelle Héloïse owned by Philibert.[45] The blue-covered score of music by Mozart is perhaps meant to suggest an enthusiasm shared by the painter and his sitter. While Rivière had an important collection of paintings by Northern masters of the seventeenth century and may very well have owned the engraving after Raphael's *Madonna della Sedia* lying on the table, its inclusion is more likely a conceit introduced by Ingres. These attributes all add up to designate a man of taste and high culture. But the allusion to Raphael would connect the alert viewer to the image discreetly woven into the carpet of *Napoleon I on His Imperial Throne* and subtly incorporated into the composition itself in the portrait of Madame Rivière (cat. no. 9).

Ingres brilliantly suggested gender distinctions in his portraits of Monsieur and Madame Rivière. While Monsieur is all angles and straight lines (which take their cue from the rectangular format of the canvas itself), Madame is all padded roundness and looping curves, as plump as the sofa on which she reclines. Encircled by her gorgeous cashmere shawl—one of a large collection that was compensation, perhaps, for Philibert's many

dalliances[46]—she is the prototype for a succession of voluptuous portraits of pampered women, which have become some of the most admired icons of Ingres's art. The skillful integration of her figure into the oval frame marks her as one of Ingres's first but most discreet homages to his preferred old master, Raphael. In this modern *Madonna della Sedia*, one can see Ingres already creating what Baudelaire wickedly and perceptively identified as "an ideal that is a provocative adulterous liaison between the calm solidity of Raphael and the affectations of the fashion plate."[47]

No less original is Ingres's depiction of the thirteen-year-old Mademoiselle Rivière (fig. 58). Dressed in virginal white, she is strikingly silhouetted against a limpid blue sky and a river landscape, which is not only allusive to her surname but surely emblematic in its purity. However, her idealized features and something of her pose are cleverly adapted from Raphael's famous portrait *La Fornarina* (fig. 60). Caroline's slender form is sensuously encircled and given volume by a white fur stole, while its chaste austerity is given piquancy by the mustard-colored gloves, cut at the fingers. The highlights on these gloves and the slight flourishes on her gathered sleeve are Ingres's only concessions to painterliness in this otherwise smoothly executed work. This moving image of innocence on the cusp of womanhood gains a certain poignancy with the knowledge that Caroline Rivière died in June 1807, within a year of the painting's exhibition at the Salon.

Of Ingres's works exhibited at the Salon of 1806, *Mademoiselle Rivière* fared the best at the hands of the critics. Her fresh beauty struck a sympathetic chord and invited a comparison with the art of Correggio.[48] But the portrait of the Emperor was attacked mercilessly for being "Gothic," largely on account of its hieratic frontality, its accumulation of symbolic and archaeological details, and its meticulous technique evocative of Jan van Eyck's. While Ingres's portrait of Madame Rivière is today ranked among his masterpieces, it too was ridiculed upon its exhibition in 1806. Ingres's avoidance of conventional chiaroscuro effects, his preference for strong illumination, flattened pictorial space, and pale color harmonies, and his reliance on the arabesque of line to define form were taken as presumptuous assertions of artistic individuality.[49] By contrast, the prevailing aesthetic of the school of David[50] was more typically represented by the gently modeled forms of a work such as Gérard's *Madame Regnault de Saint-Jean-d'Angély* (fig. 61), which had been greatly admired at the Salon of 1799.

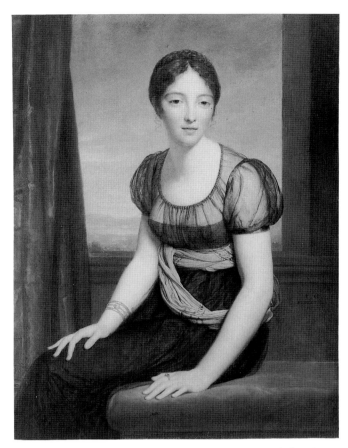

Fig. 61. François Gérard (1770–1837). *Madame Regnault de Saint-Jean-d'Angély*, 1799. Oil on canvas, 40⅜ × 29⅛ in. (102.5 × 74 cm). Musée du Louvre, Paris

In the more private world of the portrait drawing, however, Ingres was able to break new ground without criticism. He made his group portrait *The Forestier Family* (cat. no. 23), in our time one of his most admired and famous drawings, during the summer of 1806, just a few months before his departure for Rome. It was an important personal as well as artistic statement, for he was betrothed to the twenty-four-year-old painter Marie-Anne-Julie Forestier that same summer. Surrounded by her doting family—father, mother, and uncle—and with the family maid Clotilde in the background, Julie adoringly regards her intended. Both of the men portrayed here were eminent lawyers, and the marriage would obviously have been an advantageous one for the young painter from Montauban.[51] However, Ingres's long-awaited Italian trip was not to prove the best way to cement the young couple's engagement. Absence did not make Ingres's heart grow fonder, and with the benefit of hindsight, the modern viewer may easily see in Julie's eyes a well-founded wistfulness at her fiancé's imminent departure.

The painted self-portrait (see cat. nos. 11, 147) Ingres sent to the 1806 Salon was no less criticized than his other

submissions: one observer noted cuttingly that the "dark and wild" look of the artist must have been caused by the "terrifying subjects" he was about to paint.[52] Ingres had finally left for Rome in September, just days before the opening of the Salon, but when he read the clippings sent to him by his prospective father-in-law he was mortified and never forgot their insults. Needless to say, he felt shamed and embarrassed, but his reactions were typically defensive and even a touch paranoid in the face of unexpected criticism: "I am the victim of ignorance, bad faith, calumny. . . . The scoundrels, they waited until I was away to assassinate my reputation."[53] In this and other letters to Pierre Forestier, Ingres hinted at prejudice against him on the part of Baron Dominique Vivant Denon, director-general of the Louvre and overseer of the Salon exhibitions, lack of support from David, and a cabal led by the more fashionable portrait painter

Robert Lefèvre, "my rival, my intriguer."[54] The feeling that outside forces were against him dogged Ingres for years: he continued to fear Denon's opposition, when he was considering submitting works to the Salon of 1814, and blamed his friend Granet and the latter's protector, the comte de Forbin (who succeeded Denon at the Louvre) for not acting in his best interests, when his works were attacked again at the Salon of 1819.

Even as Ingres worked on his portraits for the Salon of 1806, he must have been dreaming all the while of his postponed trip to the land of Raphael—and of the history paintings he would rather have been painting. It was all the more galling, then, that the portraits were vilified. But, anxious as Ingres was to establish a reputation as the rising star of the French school at the turn of the new century, he would have to wait almost twenty years for public recognition.

1. "J'ai été élevé dans le crayon rouge." Silvestre 1856, p. 5.

2. See his letter to Jean-François Gilibert, dated February 27, 1826, in Boyer d'Agen 1909, p. 130.

3. For new light on Ingres's brothers and sisters, see Vigne 1997. After Jean-Auguste-Dominique, Madame Ingres gave birth to Anne (1782–1784), Jacques (1785–1786), Augustine (1787–1863), Anne-Marie (1790–1870), Pierre-Victor (1799–1803), and Thomas-Alexis (1799–1821).

4. On Ingres and his early teachers, see Toulouse, Montauban 1955.

5. "Ce n'est souvent que par vanité que quantité de personnes se font peindre, et s'il y a quelque chose d'utile dans cette conduite, on peut dire qu'elle est avantageuse aux peintres qui par là tâchent de se dédommager du peu d'occasion qu'ils trouvent d'exercer leur talent et de le faire valoir." Anon. 1800, quoted in Paris, Detroit, New York 1974–75, p. 450. See also pp. 498–99 in this catalogue.

6. "Je ne connais qu'un tort à cet artiste, c'est d'avoir rendu ce portrait avec tant d'art et de vérité qu'il paraît lui avoir coûté beaucoup de temps. Celui qu'il a perdu à lustrer un habit aurait pu être employé à lustrer un chef-d'oeuvre historique." Chaussard 1800, quoted in ibid., p. 450.

7. On David's pupils from Toulouse, see Mesplé 1969.

8. For a concise account of the creation of the Musée Napoléon, see Gould 1965.

9. On David's studio before Ingres's arrival, see Crow 1995.

10. "Fais comme tu sens, copie comme tu vois, étudie comme tu l'entends, parce qu'un peintre n'est réputé tel que par la grande qualité qu'il possède, quelle qu'elle soit." Delécluze 1855, pp. 60–61.

11. "étaient déjà considérés comme maîtres." Ibid., p. 48. Delécluze gives the fullest firsthand account of life in David's studio during the period in which he and Ingres were students there.

12. See Cambridge (Mass.) 1973 and Crow 1995, p. 206.

13. "Peut-être ai-je trop montré l'art anatomique dans mon tableau des Horaces." Delécluze 1855, p. 71.

14. "Dans celui-ci des Sabines, je le cacherai avec plus d'adresse et de goût. Ce tableau sera plus grec. . . . C'est donc à la source qu'il faut remonter. . . . Je veux faire du grec pur" (emphasis in the original). Ibid., pp. 71–72, 61–62.

15. "le retour du goût simple, vrai, primitif enfin." Ibid., p. 90.

16. Ibid., p. 89. On the Primitifs, see Levitine 1978.

17. Delécluze 1855, p. 84.

18. Ingres himself assembled a modest collection of Greek vases, probably acquired during his periods of residence in Rome; they are now in the Musée Ingres.

19. "beau stile de l'antique." Anne-Louis Girodet to John Flaxman, October 5, 1814, quoted in Banks 1979, p. 101.

20. "la finesse du contour, le sentiment vrai et profond de la forme et un modelé d'une justesse et d'une fermeté extraordinaires." Delécluze 1855, pp. 84–85.

21. "lui paraissait préférable à tout ce qu'il avait vu encore de l'école française contemporaine." Delaborde 1870, p. 213.

22. See also the remarks on Ingres's earliest work in Amaury-Duval 1993, p. 160.

23. "une disposition à l'exagération dans ses études." Quoted in Delécluze 1855, p. 85. This was perhaps a characteristically ambiguous remark: the painter Pierre-Théodore Suau, a former pupil of David and a son of Jean Suau, one of Ingres's professors in Toulouse, once observed that "David speaks in an enigmatic fashion . . . it takes practice to understand him" ("David parle de façon énigmatique . . . il faut être habitué pour le comprendre"), quoted in Mesplé 1969, p. 97.

24. See also the drawing Minerva and Neptune Restraining the Anger of Achilles in Vigne 1995b, p. 43, fig. 21.

25. On the papers Ingres preferred, see Marjorie B. Cohn in Cambridge (Mass.) 1967, pp. 240–49.

26. Agnes Mongan in ibid., p. xiii.

27. See, for instance, Cohn in ibid., pp. 245–46.

28. Ingres made a portrait drawing of Révoil while they were in David's studio; see Naef 1977–80, vol. 4 (1977), no. 16. On Révoil and Richard, see Chaudonneret 1980.

29. The drawing was first published in Vigne 1995b (p. 340, fig. 281); see Ingres's Notebook IX, where a "madame Berenger" is listed (ibid., p. 325), and Notebook X, where she appears as "m^e Beranger en Pied. grande Ebauche," which suggests the portrait was not finished (ibid., p. 327). Vigne 1995a (no. 2609, ill.), has also drawn attention to a small inscribed drawing (Musée Ingres, inv. 867.202) that shows the back of Madame Béranger's head reflected in a mirror, a feature just discernible in the newly found drawing.

30. See cat. no. 2 for a fuller discussion of this work, including the report that Ingres was granted a brief sitting by the First Consul.

31. *Monsieur Bourgeon* is indebted to such portraits by David as *Jacobus Blauw* of 1795 (National Gallery, London).

32. On Mortarieu, see *Biographie des hommes vivants* 1818, p. 515, and Lamathière 1875–1911, vol. 13, pp. 184–85.

33. Ligou 1984, pp. 246–47.

34. Mortarieu's decorations were added to Ingres's portrait at a later date. The cross of the Legion of Honor hangs by its red ribbon, but Mortarieu was made chevalier only in 1808 and officer in 1814 (Légion d'Honneur dossier L/2703/096, Archives Nationales, Paris). The Décoration de Lys, with its fleur-de-lis, and the Spanish Order of Charles III, which Mortarieu wears as chevalier and commander, must have been awarded sometime after the Bourbon Restoration (this order is identified in the files of the Norton Simon Museum, Pasadena).

35. See Ingres's letter to Gilibert, June 1819, in Boyer d'Agen 1909, pp. 39–40.

36. As suggested by Daniel Ternois in Paris 1967–68, p. 38.

37. Anon., October 11, 1806 (C.), p. 77, quoted in Siegfried 1980a, p. 85.

38. Chaussard 1806, p. 180.

39. "le meilleur de mes portraits." Ingres to Armand Cambon, April 27, 1862, in Boyer d'Agen 1909, p. 445.

40. In Ingres's day Bronzino's *Portrait of a Young Sculptor* (Musée du Louvre, Paris, inv. 131) was attributed to Sebastiano del Piombo.

41. "un de mes meilleurs ouvrages avant mon départ pour Rome." Delaborde 1870, p. 244.

42. "une extrême sensibilité et un désir insatiable de gloire." Ingres to Pierre Forestier, January 17, 1807, in Boyer d'Agen 1909, p. 53.

43. Naef 1972 ("famille Rivière"), p. 193, n. 1.

44. According to Thiébault 1893–95, quoted extensively in ibid., but see especially pp. 196–97.

45. The present location of the manuscript by Rousseau is unknown; my discussion of *Philibert Rivière* is especially indebted to Hélène Toussaint in Paris 1985, pp. 23–26.

46. Ibid., pp. 26, 137, n. 39.

47. "un idéal qui mêle dans un adultère agaçant la solidité calme de Raphaël avec les recherches de la petite-maîtresse." Baudelaire 1961, p. 964.

48. See, for instance, Chaussard 1806, p. 182.

49. For the best discussion of this critique, see Siegfried 1980a, pp. 85–88.

50. For further discussion of the critical reception of Ingres's portraits at the Salon of 1806, see pp. 499–501 in this catalogue.

51. See the letter from Joseph Ingres to Pierre Forestier, requesting Julie's hand in marriage for his son, quoted in Lapauze 1910, pp. 26–28.

52. "sombre et farouche." Anon., October 11, 1806 (C.), p. 77, quoted in Siegfried 1980a, p. 85.

53. "Je suis victime de l'ignorance, la mauvaise foi, la calomnie. . . . Les scélérats, ils ont attendu que je sois parti pour m'assassiner de réputation." Ingres to Pierre Forestier, October 22, 1806, in Boyer d'Agen 1910, p. 48.

54. "mon rival, mon cabaleur." Ingres to Pierre Forestier, November 23, 1806, in Boyer d'Agen 1910, p. 52.

1. Pierre-François Bernier

ca. 1800
Oil on paper mounted on canvas
17¾ × 14½ in. (45 × 37 cm)
Memorial Art Gallery, University of Rochester,
Rochester, New York
Marion Stratton Gould Fund 55.176

W 3

The boyish face of the scientist Pierre-François Bernier (1780–1803), tilted slightly to the left, stares wide-eyed past the viewer. He is almost expressionless, the smooth surface of his skin interrupted by a Cupid's-bow mouth and crowned with unruly curls of hair. His soft features play against crisp delineations in the cravat, lapels, and collar.

In size and format the portrait is related to the slightly larger painting of the artist's father (cat. no. 4) and especially to the *Young Man with an Earring* (fig. 50), both of which are documented to the year 1804. In each the sitter is presented bust length before a dark background. While the handling in the *Young Man with an Earring* is freer than that seen here, the poses of the two figures are virtually identical. The Bernier painting, however, is traditionally dated to 1800, when the sitter is known to have been in Paris.

In his Notebook X Ingres refers to Bernier as a childhood friend,[1] although Pierre-François Bernier, an exact contemporary of the artist, is recorded in Montauban only after the young Ingres had departed his native city for the Académie Royale de Peinture, Sculpture et Architecture in Toulouse and, subsequently, Paris. Bernier was already publishing scientific articles in the journal *La Connaissance des temps* in Montauban, in collaboration with an amateur astronomer named Duc-Le-Chapelle, in 1797, the same year that Ingres entered Jacques-Louis David's studio in Paris.[2] Bernier, too, has been associated with David's studio, in which not only painters but scientists and draftsmen were to be found, but this suggestion may be apocryphal. Bernier's extensive obituary notice, which recounts his career, makes no mention of study with David.[3]

In January 1800, following his scientific pursuits in Montauban, the young Bernier moved to Paris, where he remained less than seven months. On August 5 of that year he was named to a South Seas naval expedition that departed Paris on September 28. Bernier conducted astronomical and meteorological research during the voyage, which was fraught with trouble almost from its beginning. Disputes among the crew led many scientists to leave the mission and return to France. Perhaps Bernier should have done so as well; on June 6, 1803, he died of fever off the coast of Timor at the age of twenty-three.[4]

Ingres doubtless met with the sitter during Bernier's few months in Paris in 1800 and most likely completed the portrait before his departure in September. The anchor emblem on Bernier's lapel must refer to the naval expedition on which he secured a post in August 1800, a date supported by an inscription visible on the back of the portrait at the time of the Haro sales.[5] However, the portrait itself is not dated, and its appearance in Ingres's Notebooks IX and X among other portraits from 1804–5,[6] as well as its stylistic similarity to portraits from these years, has led to speculation about a later date.[7] Such a date supports the theory that the portrait was commissioned by Bernier's family following the news of his death, but it would then have had to be based on drawings made from life in 1800 and now lost. The conception and the somewhat tentative execution of the painting—which is cautiously handled and carefully impasted—suggest the earlier date, when Bernier and Ingres were both living and possibly studying together in Paris.

P.C. / N.Y.

1. Fol. 22. Vigne 1995b, pp. 327, 330.
2. For a biography of Bernier, see Rosenthal 1984, which is the source for this catalogue entry.
3. Lalande 1804, pp. 256–70.
4. Historians of the voyage note that Bernier died at twenty-three years, seven months, and seventeen days, which places his birth date in 1780, the same year as Ingres's. See Péron and Freycinet 1807–16, vol. 2 (1816), pp. 284–85.
5. The inscription is recorded in the 1911 Haro *fils* sale catalogue as follows: "Portrait of Pierre-François Bernier, astronomer, painted by his friend Ingres—1800." ("Portrait de Pierre-François Bernier, astronome, peint par son ami Ingres—1800.")
6. Fols. 123 and 22, respectively.
7. Delaborde (1870, pp. 261–62, no. 158, as *Vernier*), who did not know the picture,

1

placed it in 1805. Rosenthal (1984) also explored the possibility of a later date.

PROVENANCE: Probably Pierre-François Bernier (1780–1803); possibly his family; Haro *père et fils* sale, Galerie Sedelmeyer, Paris, May 30–31, 1892, no. 120, bought in; Haro *père* sale, Hôtel Drouot, Paris, April 2–3, 1897, no. 168, bought in; Haro *fils* sale, Hôtel Drouot, Paris, December 12–13, 1911, no. 218; Henry Lapauze, Paris; his posthumous sale, Hôtel Drouot, Paris, June 21, 1929, no. 60; H. S. Southam, Ottawa, by 1934; M. Knoedler & Co., New York; purchased by the Memorial Art Gallery, University of Rochester, Rochester, N.Y., 1955

EXHIBITIONS: Paris 1911, no. 2; Copenhagen 1914, no. 119; Paris 1914; New York 1931, no. 6 [EB]; Buffalo 1932, no. 31; Ottawa, Toronto 1934, no. 64; New York 1946–47, no. 6 [*sic*] [EB]; Richmond 1947, no. 15; Dallas 1951, no. 52; Palm Beach 1951, no. 23; Fort Worth 1953, no. 12; Winnipeg 1954, no. 8; New York 1961, no. 1; Utica 1967; New York 1977, p. 51, ill.

REFERENCES: Delaborde 1870, pp. 261–62, no. 158; Lapauze 1911a, pp. 36–37; *Masterpieces of Ingres* 1914, p. 18; Alexandre 1921, ill. p. 198; Fröhlich-Bum 1924, fig. 2; Hourticq 1928, p. II; Pach 1939, p. 12, ill. opp. p. 15; Malingue 1943, ill. p. 27; Courthion 1947–48, vol. 2, p. 169; Wildenstein 1954, no. 3, fig. 13; Schlenoff 1956, p. 91; Rosenthal 1984, pp. 23–29, fig. 1; Peters 1988, pp. 112–13, ill.; Fleckner 1995, p. 81, fig. 19; Vigne 1995b, pp. 43, 325, 327, 330

2. Bonaparte as First Consul

July 12, 1804
Oil on canvas
89⅜ × 57⅞ in. (227 × 147 cm)
Signed and dated lower right: Ingres. an XII [Ingres. (Revolutionary) Year XII]
Musée d'Art Moderne et d'Art Contemporain de la Ville de Liège, on deposit at the Musée d'Armes, Liège

W 14

Bonaparte, wearing a gold-embroidered red silk velvet double-breasted cutaway coat and knee breeches, stands in the pose of a state portrait, in front of a chair of office, notionally in the prefecture of Liège. His ceremonial sword, known as the Régent, had been specially designed in 1803 and encrusted with diamonds by court jeweler Étienne Nitot. With his right hand he points to a decree: "Fau[bourg] d'Amercoeur rebâti" ("Faubourg Amercoeur rebuilt"); his felt or beaver bicorne and white kid gloves are on the table, along with quill pens and the edict awaiting his signature. In his bright red outfit Bonaparte cuts a striking figure, yet there is a certain austerity in this presentation, as if he were an executive officer signing off on this important document. Through the window is a view of the quarter of Liège called Amercoeur, dominated by the cathedral of Saint-Lambert, and the citadel on the distant hill. Ingres did not visit Liège, so the setting—the plain but richly furnished room and the composite view of the town—is based on engravings and the artist's invention.[1]

In the summer of 1803 Bonaparte, accompanied by his wife, Josephine de Beauharnais, made a tour of the northern departments of France, visiting the towns of Dunkerque, Bruges, Gand (Ghent), Anvers (Antwerp), Brussels, and Liège. These were the prefectural towns of their respective departments—all, with the exception of Dunkerque, in present-day Belgium—which had been recognized as belonging to France in the Treaty of Lunéville of 1801. As these regions were somewhat marginal to France, it was felt advisable after the consular visit to dispatch to each an official portrait of the head of state, reminding the citizens of his visit and of their loyalty to the new regime.[2]

Bonaparte visited Liège, in the department of the Ourthe, during the first two days of August.[3] The attention of the First Consul was drawn to the ruins of the faubourg Amercoeur, bombarded by Austrian troops retreating from the French some nine years earlier, in 1794. Petitioned by the local inhabitants for reparation, Bonaparte signed a decree on August 2, 1803, designating 300,000 francs for the reconstruction of the devastated area.[4] The signing took place in the prefecture (today the Musée d'Armes, the current home of this portrait), where the official party was staying.

After Bonaparte's return to Paris, five painters—Ingres, Jean-Baptiste Greuze, Robert Lefèvre, Charles Meynier, and Marie-Guilhemine Benoist—received commissions from the minister of the interior to paint full-length portraits of the First Consul for distribution, respectively, to Liège, Anvers, Dunkerque, Brussels, and Gand. Later in the year, the prefecture of Bruges made its own request for a

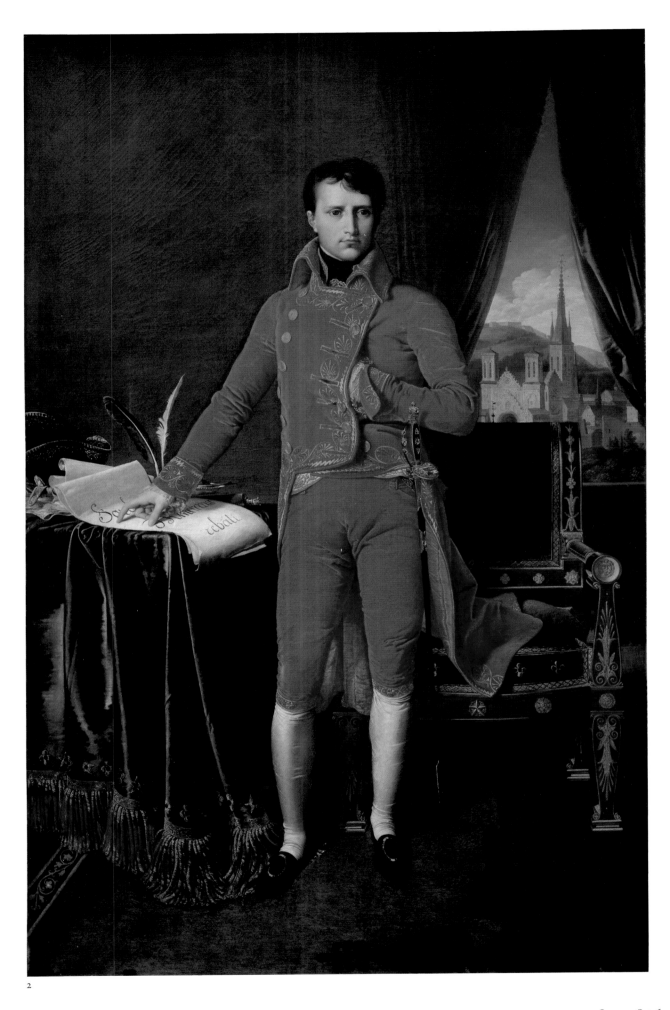

2

portrait, which was painted by Joseph-Marie Vien *fils*.

According to one early account, the First Consul granted a brief sitting at Saint-Cloud to Ingres and Greuze:

> Bonaparte, accompanied by officers, did indeed enter the room where the artists awaited him. He went up to them, examined them with a quick glance, and addressed his entourage: "These are the painters who are to do my portrait?" And in front of Ingres, who was standing bolt upright and regarding him fixedly: "This one here is very young! As for the other . . ." and he eyed poor Greuze in his lace cuffs and jabot, with his powdered hair and painted face, who was making his bow with arms rounded and leg extended in the fashion of the previous century— "As for the other, that one there is very old!" Whereupon the great man turned abruptly on his heel and went off, disappearing into the depths of the palace.[5]

While the story is certainly piquant, there is no other evidence of such a "sitting." Ingres's portrait is hardly a speaking likeness, and it is more plausible that he took

Fig. 62. Antoine-Jean Gros (1771–1835). *Bonaparte as First Consul,* 1802. Oil on canvas, 80¾ × 50 in. (205 × 127 cm). Musée National de la Légion d'Honneur et des Ordres de Chevalerie, Paris

as his model—and indeed followed rather closely—an earlier portrait of the First Consul painted by Antoine-Jean Gros in 1802 (fig. 62). Gros's portrait was the initial propagandistic painting of Napoleon as First Consul, in which he presides over a veritable sheaf of treaties on the table. Giving this prime version his personal endorsement by presenting it as a gift to Second Consul Cambacérès, Bonaparte ordered three copies from Gros, which were sent to the cities of Lyons, Rouen, and Lille. Even for this important commission Bonaparte seems not to have posed, so Gros adapted an earlier portrait of his own, the celebrated bust-length *Bonaparte at Arcola* (Musée du Louvre, Paris), painted in Italy in 1796 after an actual encounter with the dashing young general.

Gros was the rising artistic star of the moment, and the aged, now rather enfeebled Greuze was a living legend. The young Ingres must have been especially grateful for his prestigious commission. He had won the Prix de Rome in 1801, but due to lack of government funds his trip was postponed. In Paris he was biding his time in the studio complex of the former Couvent des Capucines, where Gros was his neighbor. The 3,000 francs the portrait brought Ingres was far from the 15,000 francs that his teacher David could demand for his portrait of the emperor that Napoleon commissioned in 1805; yet the official recognition must have augured well for Ingres's future career.

Ingres completed the painting, which is dated "Year XII" of the Revolutionary calendar, on July 25, 1804. However, the administration moved surprisingly slowly in sending it off, considering that one purpose of such an image was to assert the legitimacy of Napoleon's rule. Nor was it exhibited at the Salon of 1804—perhaps because Napoleon had already declared himself emperor in May that year. Not until November 8 did Baron Dominique Vivant Denon, director general of the Musée Napoléon, inform the mayor of Liège that the portrait was ready for shipping; on February 1, 1805, the painting arrived in Liège; on May 12 the prefect of the Ourthe announced that the work would be publicly displayed at the town hall on

the occasion of Napoleon's coronation as King of Rome. Finally, on May 23, 1805, the portrait was exhibited to the citizens of Liège.[6] To them it still had resonance as a reminder not only of the First Consul's munificence to loyal subjects but also of the republican days of the 1790s, when Liège and the Ourthe suffered for France.

Ingres clearly took immense pains over this important commission. It is immaculately executed—unlike his more private portraits made during this period, which are relatively freely brushed—with careful attention paid to details as well as to the finish of surfaces and textures. Considering the destination of this work, we might imagine that Ingres examined the finish and saturated colors of early Netherlandish paintings and their landscape backgrounds. But portraits of about 1800 by David and other pupils, such as Anne-Louis Girodet and François Gérard, are often equally vividly observed and precisely crafted. Ingres's composition is boldly frontal in design and states its meaning clearly yet discreetly, with the First Consul poised between his decree and the view through the window of the restored town. The carpeted floor in the foreground tilts disconcertingly toward the viewer—another feature suggestive of fifteenth-century prototypes—but its apparent maladroitness also serves to impress the image of the subject upon us.

Ingres was proud enough of this portrait to borrow it for his gallery at the Exposition Universelle in 1855. It must have been a matter of regret for the young artist that it was sequestered for so many months after its completion and that he was not able— presumably because political events had intervened—to exhibit it in Paris at the Salon of 1804. An ink-and-wash drawing (cat. no. 3) may have been executed as a presentation drawing; considering its fidelity to the final painting, however, it is more likely a record made by Ingres before the picture was transported to Liège. P.C.

1. The Musée Ingres, Montauban, has a drawing (inv. 867.207) of the church copied from an engraving: see Vigne 1995a, p. 468, no. 2618, ill.
2. On these commissions, see Lilley 1985, pp. 143–56, and Hubert 1986, pp. 23–30.

3. For a detailed account of Bonaparte's visit
 to Liège, including official documents, see
 Lissingen 1905, pp. 3–20, 59–78. I am grate-
 ful to Claude Gaier for bringing this publica-
 tion to my attention.
4. One hundred thousand francs came from the
 government; one hundred thousand from taxes
 levied in Liège; and one hundred thousand
 francs from the sale of treasures stolen by the
 French from the cathedral of Saint-Lambert!
5. "Bonaparte, accompagné d'officiers, entra
 effectivement dans la pièce où les artistes
 l'attendaient. Il va à eux, les examine d'un
 coup d'oeil rapide, et s'adressant à son
 entourage: 'Ce sont les peintres qui doivent
 faire mon portrait?' Et devant Ingres qui le
 regarde fixement, droit sur les jarrets: 'Celui-
 çi est bien jeune! Quant à l'autre . . .' et il
 toise le pauvre Greuze en manchettes et
 jabot, poudré, fardré, déployant, les bras
 arrondis, la jambe tendue, les grâces du siècle
 précédent — 'Quant à l'autre, celui-là est
 bien vieux!' Sur quoi le grand homme tourne
 brusquement les talons, s'éloigne et se perd
 dans les profondeurs du palais." Merson and
 Bellier de la Chavignerie 1867, pp. 13–15;
 Peinture française au XVIIᵉ et au XVIIIᵉ siècle
 n.d., p. 315. Olivier Merson (1822–1902)
 probably knew Ingres, but we do not know
 the source of his story.
6. On these dates, see Gaier 1980, pp. 1–5.

PROVENANCE: Commissioned by the First
Consul on 29 Messidor, Year XI (July 17, 1803);
given by him to the city of Liège; deposited at the
Musée d'Armes, Liège

EXHIBITIONS: Paris 1855, no. 3344; Paris
1900b; Paris 1911, no. 6; Saint Petersburg 1912;
Paris 1921, p. 18, no. 9, ill. p. 13; Brussels 1925–26,
no. 6; London 1932, no. 401; Paris 1937, no. 346;
Brussels 1947–48, no. 19; Rotterdam 1951, no. 19,
ill.; Brussels 1953; Recklinghausen, Amsterdam
1961; Bruges 1962, no. 307, ill.; Munich 1964,
no. 144; Paris 1967–68, no. 8

REFERENCES: Magimel 1851, pl. 9; Renouvier
1863, p. 493; Merson and Bellier de la Chavignerie
1867, pp. 13–15; Delaborde 1870, p. 24, no. 144;
Uzanne 1906, p. ix, pl. 9; Lapauze 1911a, pp. 56–58,
ill. p. 63; Bénédite 1921, p. 334, ill. p. 333; Fröhlich-
Bum 1924, p. 6, pl. 6; Hourticq 1928, fig. 13;
French Art 1933, no. 408, pl. 87; Jourdain 1949,
pl. 16; Alazard 1950, p. 31; Wildenstein 1954, no. 14,
pls. 3, 5 (detail); Schlenoff 1956, p. 54, fig. VI;
Ternois 1959a, nos. 17, 18; Koenig 1963, no. 106,
pl. I; Rosenblum 1967a, p. 60, pl. 3; Radius and
Camesasca 1968, no. 15, ill.; Connolly 1980,
pp. 52–68; Picon 1980, p. 102, ill. p. 32; Mainz
1983, p. 11, ill. p. 10; Eitner 1987–88, p. 159; New
York 1989–90a, p. 84, ill. p. 70, pl. 61; Zanni 1990,
p. 20, no. 8, ill. p. 21; Vigne 1995a, p. 468; Vigne
1995b, p. 48, fig. 27; Roux 1996, pp. 8, 32, ill.
p. 33, ill. p. 32 (detail)

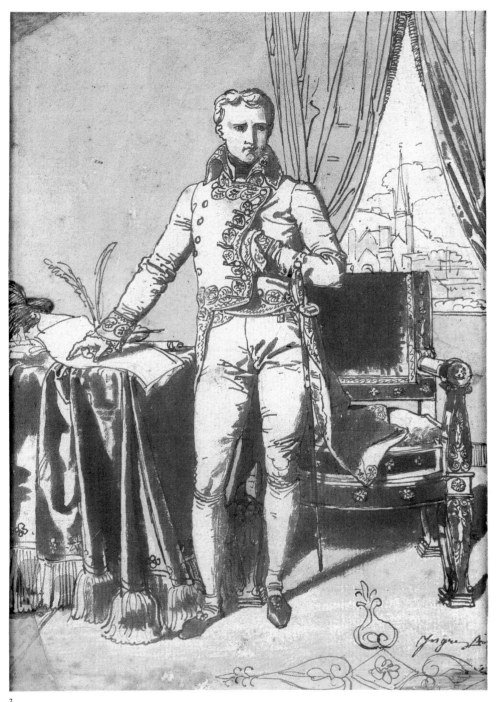

3

3. Bonaparte as First Consul

1803–4
Brown ink and gray wash
8⅞ × 6 in. (22.5 × 15.2 cm)
Signed lower right: Ingres ft [Ingres made (this)]
Private collection
New York and Washington only

This drawing—relatively unusual for Ingres in that it is executed in ink and wash—follows closely the composition of the finished painting *Bonaparte as First Consul* (cat. no. 2). For this reason it is more likely to be a record of the completed painting than a study for it, as has been suggested, for example, by Joseph Baillio.[1] There are two preparatory drawings for the painting in the collection of the Musée Ingres, Montauban. One is a pencil sketch for the sitter's legs.[2] The other is a more detailed pencil drawing for the facade of the cathedral of Saint-Lambert in the background of the painting.[3] It was probably made from an engraving, as the cathedral was destroyed in 1794. P.C.

1. In New York 1989–90, p. 107.
2. Vigne 1995a, no. 2617, inv. 867.206.
3. Ibid., no. 2618, inv. 867.207. Vigne identifies the church as the abbey church in Amercoeur, which was designated in 1802 to replace the destroyed Saint-Lambert as Liège's cathedral .

PROVENANCE: M[onsieur] L. de Saint-Vincent [EB]; his heirs [EB]; their sale, Hôtel des Ventes, Paris, March 8–9, 1852, no. 125 [EB]; probably purchased at that sale by Jules Boilly (1796–1824) [EB]; his sale, Hôtel des Commissaires-Priseurs, Paris, March 19, 1869, no. 147; purchased at that sale for 760 francs, probably by Monsieur Sch—— [EB]; his sale, Hôtel Drouot, Paris, February 28, 1870, no. 18; probably sold to the comte de Reiset [EB]; Comte de Reiset, Château de Breuil-Benoît (Eure); bequeathed to his wife, the comtesse de Reiset; after her death, the comte de Reiset's posthumous sale, Hôtel Drouot, Paris, January 30, 1922, no. 21; sold for 2,200 francs; private collection

EXHIBITIONS: Paris 1874, no. 1060; New York 1976, no. 26; London 1979; New York 1989–90, no. 108, ill.

REFERENCES: Delaborde 1870, p. 308, no. 380; Lapauze 1911a, ill. p. 62; *Dessins de Jean-Dominique Ingres* 1926, fig. 4; London 1932, p. 190, under no. 401; *French Art* 1933, p. 96, under no. 408; Ternois 1959a, preceding no. 17; Paris 1967–68, p. 14, under no. 8; Baillio 1989, p. 37, no. 17, ill.; Ingres 1994, ill. opp. p. 28

4. Jean-Marie-Joseph Ingres

1804
Oil on canvas
21⅝ × 18½ in. (55 × 47 cm)
Musée Ingres, Montauban

W 16

Our primary source of information about Jean-Marie-Joseph Ingres (1755–1814) is a biography written by Édouard Forestié, first published in 1860 in *La Biographie de Tarn-et-Garonne*. Forestié's authority, in turn, was the younger Ingres, to whom he wrote for information in 1855. Ingres's oft-cited response, which outlines Joseph's biography and artistic career, shows both pride in the senior Ingres's accomplishments and recognition of the debt the by then famous painter owed to his father for support and encouragement: "If M. Ingres *père* had had the advantages that he gave his son to be able to come to Paris to study with the greatest of our masters, he would have been the leading artist of his day."[1] Indeed, the artist's father seems to have fostered the talents of this son at the expense of the rest of his family.[2]

Born in 1755 in Toulouse, the elder Ingres trained at the Académie Royale there. His studies in drawing, painting, sculpture, and architecture prepared him well for a life as a provincial jack-of-all-art-trades. After the Académie he embarked on a few years of travel, going—according to his son—as far south as Marseilles before settling in Montauban in 1775. Two years later he married Anne Moulet (1758–1817), the daughter of a master wigmaker.

Joseph Ingres had no shortage of work in Montauban. He taught drawing at a variety of institutions in town, painted accomplished portrait miniatures,[3] and was commissioned to work on the interior and exterior embellishment of secular and religious buildings in the area. In 1778 he executed the decoration of the sanctuary of the nearby church of Falguières, which

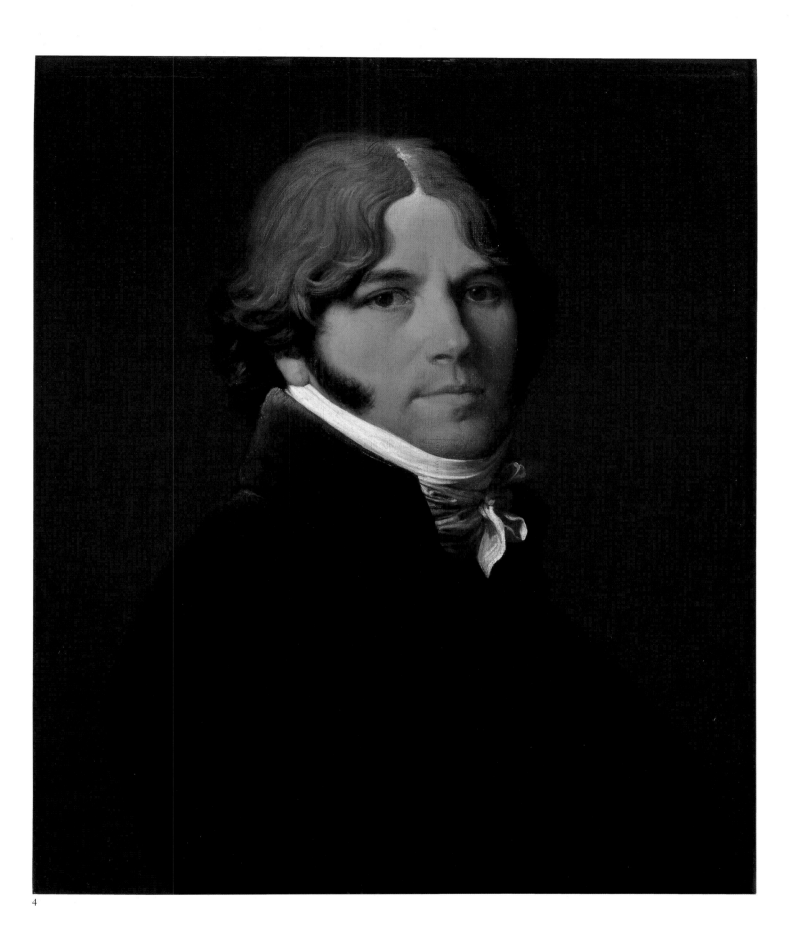

4

included a sculpture of its patron saint, Mary Magdalen. He also undertook various types of decorative work for the local nobility, among them Baron Joseph Vialètes de Mortarieu, and made a portrait miniature of the baronne.[4] In the courtyard of the Musée Ingres today, the visitor can admire several terracotta figures from a set of garden statues that adorned the property of the Belvèze family.[5] (Local Montauban names, such as Mortarieu and Belvèze, would turn up among the younger Ingres's first patrons in Paris.) Joseph Ingres is best remembered for his participation in the decorations for Bretolio, the château near Montauban of Monseigneur Anne-François-Victor Le Tonnelier de Breteuil, bishop of Montauban. For this same patron Joseph provided interior ornamentation for several rooms of the episcopal palace, later the Hôtel de Ville and now the Musée Ingres. In 1790 he was accepted as a member of the Académie in Toulouse, in whose drawing school he enrolled his son the following year.

Jean-Auguste-Dominique was the oldest survivor of seven children born over the course of nineteen years to Anne Moulet and Joseph Ingres. Two siblings died in infancy (Anne, 1782–1784; Jacques, 1785–1786). The artist barely knew his surviving sisters (Augustine, 1787–1863; Anne-Marie, 1790–1870) and never knew at all his twin brothers born in 1799 (Pierre-Victor, d. 1803; Thomas-Alexis, d. 1821).[6] The senior Ingres's marriage was a less than happy one, and the couple spent long periods of time living apart; from 1788 to 1792, for example, Joseph lived principally in Moustiers, then moved to Toulouse to supervise his son's artistic education. The elder Ingres appears to have been uninterested, to the point of neglect, in his younger children and his wife. In January 1803, during the three-year-old Pierre-Victor's final illness, Madame Ingres wrote to a lawyer, "I am without my husband's recognition. I have not been shielded from the countless infamous words and abusive things that he said to me this morning."[7] The death of Joseph Ingres in 1814 left his widow in penury, as a letter to her son in Rome makes clear.[8]

The portrait *Jean-Marie-Joseph Ingres* dates from a visit Ingres's father made in 1804 to Paris, probably in anticipation of the younger artist's impending trip to Rome. As portrayed by his son, he appears more youthful than his forty-nine years. Joseph's sharp eyes engage the viewer directly, while his pursed lips and slightly narrowed eyebrows give the appearance of a considered assessment of what he sees. Yet the face, softened by the curling lines of hair and sideburn, retains a gentle quality. Gradations of tone in the modeling of the face, and the somber palette, contribute to the solemn mood, which may have reflected the sitter's personality. Ingres *père*'s evaluating gaze likely reflects the artist's perception of his father at that moment, when the son was on the threshold of his career, eager for success. Ingres evidently made a special effort with this portrait, which was surely a tribute to a proud father from a grateful son. Its subdued style is indebted to portraits by Jean-Baptiste Greuze (fig. 51) and Jacques-Louis David (for example, *Monsieur Gaspar Meyer*; Musée du Louvre, Paris). It lacks the hard-edged look of portraits Ingres would produce shortly thereafter, such as those of Baron Vialètes de Mortarieu (fig. 52) and Madame Aymon (cat. no. 8).

An engraving of this portrait published in 1851 by Achille Réveil differs significantly from the painting.[9] In it the sitter is shown in three-quarters length, his left arm slung behind a visible chair back and his right hand resting on his knee. The engraving may have been made after a drawing, now lost. The only other image of Joseph that Ingres is known to have executed is a small portrait drawing in profile (Musée Ingres, Montauban)[10] from 1792, somewhat in the style of the father's own works at that period.

Ingres kept his painting *Jean-Marie-Joseph Ingres* as a sentimental reminder of its subject, whom he did not see again after its creation. Ingres *père* died in 1814, while the artist was living in Rome. Writing in 1818, a year after his mother's death, to his old friend Jean-François Gilibert, Ingres had the portrait of his father before him: "My poor father, he was very fond of you! Yet his portrait is still my consolation; I think I see him as he was in life."[11] The artist kept this likeness of his father in his possession until his own death, when he bequeathed it to the museum in Montauban as part of his personal collection, which included a number of drawings by Joseph Ingres. P.C./N.Y.

1. "Si M. Ingres père avait eu les advantages qu'il donna à son fils de pouvoir venir étudier à Paris chez le plus grand de nos maîtres, il eût été de son temps le premier artiste." Ingres to Forestié, January 20, 1855, quoted in Lapauze 1911a, pp. 9–11. For a more recent study of Joseph Ingres, see Bosson et al. 1992.
2. For the most recent research on the Ingres family, see Vigne 1997, pp. 13–39.
3. Lapauze (1911a, pp. 4–7, 10) reproduces five of Ingres *père*'s portrait miniatures.
4. The Ingres family may have been living in a dependency of the Mortarieus in the 1790s; see Vigne 1997, p. 32, n. 4.
5. Forestié 1886, pp. 14–16.
6. For recent information on Ingres's family, especially his complex relationship with his sisters and their illegitimate children, see Vigne 1997.
7. "Je suis sans laveu de mon mari, je ne suis pas ettee a labry de mille infamies et mauvais traitements quil ma dit se matins." Lapauze 1911a, p. 5.
8. See Madame Ingres's letter to the artist in Rome, dated August 5, 1814, in Boyer d'Agen 1909, pp. 23–26.
9. Magimel 1851, pl. 6. A scientific examination of the painting would be necessary to determine if it was cut down at a later date or if Réveil was simply being inventive in his engraving.
10. Musée Ingres, inv. 867.275a; reproduced in Vigne 1995a, no. 2674.
11. "Mon pauvre père, il t'aimait bien! Son portrait fait cependent encore ma consolation; je crois le revoir vivant." Ingres to Gilibert, July 17, 1818, in Boyer d'Agen 1909, p. 34.

PROVENANCE: The artist's bequest to the city of Montauban; Musée Ingres, Montauban, 1867

EXHIBITIONS: Possibly Paris (Salon) 1806; Paris 1855, no. 3374; Montauban 1862, no. 544; Paris 1867, no. 94; Paris 1878, no. 839 [EB]; Paris 1885, no. 155 [EB]; Paris 1900a, no. 379 [EB]; Paris 1911, no. 3; Paris 1921, no. 4; New York, Manchester, Detroit, Cincinnati, Cleveland, San Francisco 1952–53, no. 1; Toulouse, Montauban 1955, no. 97, ill.; Montauban 1967, no. 11; Montauban 1980, no. 5

REFERENCES: Magimel 1851; Blanc 1870, p. 231; Delaborde 1870, p. 24, no. 128; Gonse 1900, p. 194; Momméja 1904, p. 37; Momméja 1905a, no. 4; Uzanne 1906, ill. p. 37; Wyzewa

1907, p. 6, fig. II; Boyer d'Agen 1909, p. 445; Lapauze 1911a, p. 43; Alexandre 1921, ill. p. 197; Bouisset 1926, pp. 24, 52, ill. p. 37; Hourticq 1928, p. III, ill. p. 5; Fouquet 1930, p. 30; Alazard 1950, p. 26; Wildenstein 1954, no. 16, fig. 11; Schlenoff 1956, fig. V; Ternois 1965, no. 150, ill.; Radius and Camesasca 1968, no. 14, ill.; Rizzoni and Minervino 1976, p. 9, ill.; Naef 1977–80, vol. 1 (1977), p. 59, ill.; Tokyo, Osaka 1981, ill.; Rosenthal 1984, pp. 23–29, fig. 2; Zanni 1990, no. 7, ill.; Fleckner 1995, p. 81, fig. 20; Vigne 1995b, p. 48, fig. 28, pp. 325, 327, 330–31

5. Jean-Pierre-François Gilibert

1804–5
Oil on canvas
39 × 31 ⅞ in. (99 × 81 cm)
Musée Ingres, Montauban

W 15

The aged Ingres, on the occasion of this painting's exhibition in Montauban in 1862, pronounced the portrait to be his best,[1] an opinion certainly influenced by sentiment for his childhood friend, then dead some twelve years. Ingres's letters to Gilibert, with whom he corresponded for almost three decades, are a fundamental source of information on the artist.[2] Unfortunately Gilibert's responses, which might have allowed some insight into the personality of this most loyal of confidants, have not survived.

Jean-Pierre-François Gilibert was born in Montauban on January 27, 1783, to Jean Gilibert, a wigmaker, and his wife, Marguerite Revel. Early biographers assumed that Ingres met Gilibert, almost four years his junior, at the Christian Brothers' school in Montauban, which Ingres is known to have attended; more recent scholarship has revealed this as unlikely.[3] Regardless of the circumstances of their initial encounter, Gilibert was to become a devoted, lifelong friend to the artist.

Ingres's formal education, as well as his residence in Montauban, ended in 1791. He and his father left for Toulouse, where the young artist was enrolled at the Académie Royale de Peinture, Sculpture et Architecture for six years. Gilibert did not see Ingres again until they were reunited in Paris in 1797, when the artist was studying at the studio of Jacques-Louis David and Gilibert was completing his legal training.

A lover of art and music, Gilibert participated in the creative circle in which Ingres moved. The group included the future critic Étienne-Jean Delécluze, the painter François-Marius Granet (see cat. no. 25), and the sculptor Lorenzo Bartolini (see fig. 53), who would later share his studio in Florence with Ingres. A book of caricature sketches, depicting Gilibert, Ingres, and other students of David, documents their time together in Paris.[4] The days of student camaraderie lasted until Ingres left for Rome in September 1806.

Gilibert initiated his correspondence with the artist following the death of Ingres's mother in 1817. Remorseful at his neglect of his friend since leaving Paris, Ingres affirmed their relationship in his response: "you are my oldest (since we knew each other as children) and only real friend; and so we shall remain, I hope, as long as we live."[5] However, Ingres saw his friend in person on only three occasions after their student days in Paris, as Gilibert was as resolute in his desire to remain in Montauban as Ingres was in his continued absence from his native city. Throughout the course of their correspondence, Ingres pleaded with Gilibert to visit him, either in Italy or in Paris. He wrote, "Why may I not hope that you will come and join me?" and "Do we enjoy all the gifts of friendship, with four hundred leagues always between each other?"; later still, he asked, "Must such good friends live continually separated from one another?"[6]

Ingres's first reunion with Gilibert was prompted by the 1826 installation of *The Vow of Louis XIII* in Montauban Cathedral (fig. 146), a commission that Gilibert had been instrumental in obtaining for his friend. Ingres's letters to Gilibert from Florence, where he lived from 1820 to 1824, document the tribulations the artist experienced in the creation of the painting, ranging from the implementation of the theme to the payment he was to receive from the state. Six years after the commission, and two years following its resounding success at the 1824 Salon, Ingres accompanied his masterpiece home, where he

rejoined Gilibert. Upon his return to Paris the artist wrote, "And even though I have been in Montauban, as in a dream, everything is in my heart in utter reality."[7]

A portrait drawing now in the Musée Ingres, Montauban (fig. 161),[8] commemorates a trip Gilibert made to Paris in 1829, at Ingres's insistence, following the death of Gilibert's father the preceding year. Ingres kept the drawing as a memento, frequently referring to the comfort the image gave him in the absence of the sitter.[9] By April of 1829 Gilibert had returned to Montauban, and shortly thereafter he married Antoinette-Pauline-Catherine-Virginie Lacaze-Rauly. Their daughter Pauline, with whom Ingres would correspond following Gilibert's death, was born in 1830.

Despite pleas from Ingres, most notably after the premature death of Madame Gilibert in 1832, Gilibert remained in Montauban until 1842, when, after urging by both Ingres and his wife, Gilibert and Pauline traveled to Paris. Monsieur and Madame Ingres became devoted to the child, whose portrait (N 386; Musée Ingres, Montauban)[10] Ingres drew during the Giliberts' short stay. Ingres never saw his friend again after this visit. Gilibert was stricken with paralysis at the end of 1847 and was ill for three years. He died on April 13, 1850, a loss Ingres felt deeply.

Jean-Pierre-François Gilibert was painted during Ingres's first years in Paris, when he and Gilibert cemented their relationship. It served as a souvenir for the sitter and perhaps also as an announcement to potential patrons in Montauban, with whom Gilibert would later negotiate on behalf of his friend. A preliminary outline sketch of this portrait at one time appeared on the artist's canvas in the self-portrait Ingres sent to the Salon in 1806.[11]

Although few but the painter would consider this his best likeness, glimpses of Ingres's more mature portraits can be seen in *Gilibert*. Almost lifesize, the sitter is presented in three-quarters view, his hat tucked under his right arm to form a rather awkward silhouette. Ingres's command of line is already manifest in the careful contours of the young man's cheek, shoulders,

and left hand, as well as in the delicate wave of his hairline, repeated in the ruffle of his shirt. An uncharacteristic sketchiness in the lower third of the portrait gives it an unfinished appearance.[12] The eyes do not engage the viewer as they do in other early portraits. Yet the image has an immediacy and sincerity that attest to the close relationship between artist and sitter. P.C./N.Y.

1. Ingres to Armand Cambon, April 27, 1862: "I am glad to see the best of my portraits, that of our dear Gilibert, being shown there at last." ("Je suis heureux aussi d'y voir figurer enfin le meilleur de mes portraits, celui de notre cher Gilibert."). In Boyer d'Agen 1909, p. 445.

2. Some of these letters are published in Boyer d'Agen 1909; a more complete edition is desirable. Lost during World War II, many letters were found in 1953 in the possession of Gilibert's descendants; see Naef 1977–80, vol. 3 (1979), p. 56.

3. Schlenoff (1956, pp. 29–32) has documented that the Christian Brothers' school closed after the school year of 1790–91, when Gilibert would have been too young to attend. The resources of the Gilibert family, as well as circumstantial evidence in the *Séances publiques du Lycée* of Year VIII, suggest that Gilibert attended the private school of Monsieur Pastoret in Montauban.

4. Now in a private collection in Montauban, the sketchbook was exhibited in Montauban 1967, as no. 130, and was first discussed in M.-J. Ternois 1956, pp. 30–32.

5. "tu es pour moi le plus ancien (puisque nous nous sommes connus enfants) et le seul véritable ami; et tels nous serons toujours, j'espère, tant que nous vivrons." Ingres to Gilibert, July 7, 1818, in Boyer d'Agen 1909, p. 34.

6. "pourquoi ne puis-je espérer que tu ne viennes me rejoindre?" Ingres to Gilibert, from Florence, January 2, 1821, in Boyer d'Agen 1909, p. 65; "joissons-nous de tous ces dons de l'amitié, toujours à quatre cents lieues l'un de l'autre?" Ingres to Gilibert, from Rome, July 10, 1839, in ibid., p. 286; "faut-il que de si bons amis vivent continuellement séparés l'un de l'autre?" Ingres to Gilibert, from Paris, February 19, 1842, in ibid., p. 307.

7. "Et quoique j'aie été à Montauban, comme en rêve, tout est dans mon coeur en bien parfait réalité." Ingres to Gilibert, December 13, 1826, in ibid., p. 184.

8. Inv. 867.253; Vigne 1995a, p. 477, no. 2658, ill.

9. "I have felt and thought often, like yourself,

together with my wife in front of your portrait." ("J'ai senti et pensé souvent, comme toi, de concert avec ma femme en face de ton portrait.") Ingres to Gilibert, August 12, 1830, in Boyer d'Agen 1909, p. 223.

10. Inv. 867.254; Vigne 1995a, no. 2659, ill.

11. The complicated history of this painting is discussed in Vigne 1995b, p. 48, n. 25, and in Cazelles and Lefébure 1979, p. 42, among others. See also cat. nos. 11 and 147 in this book. As exhibited in 1806 and commented upon by Salon reviewers, the painting depicted the artist standing before a blank canvas. However, an etching retouched by Ingres and an 1841 photograph by Charles Marville (figs. 54, 282) show a sketch of the Gilibert composition in front of Ingres. The artist subsequently made several changes to the composition; today the painting again presents a blank canvas (fig. 209).

12. Ingres appears to have considered the work complete. For an analysis of its function as an intimate portrait, see Fleckner 1995, pp. 87–89. The very fact of its seeming incompleteness, however, permits firsthand analysis of Ingres's working method, as described in Vigne 1995b, p. 44.

PROVENANCE: Jean-Pierre-François Gilibert (1783–1850); his daughter, Mme Émilien Montet, née Pauline Gilibert, Montauban; her daughter, Mlle Montet-Noganets, Montauban; Mme Fournier, granddaughter of the sitter; bequeathed by her to the Musée Ingres, Montauban, 1937

EXHIBITIONS: Montauban 1862, no. 547; Paris 1911, no. 8; Paris 1921, no. 7; New York, Manchester, Detroit, Cincinnati, Cleveland, San Francisco 1952–53, no. 3, ill.; Rome, Florence 1955, no. 58, fig. 24; Toulouse, Montauban 1955, no. 98; Malmö, Göteborg, Stockholm 1965, no. 64, ill.; Montauban 1967, no. 12; Paris 1967–68, no. 11, ill.; Florence 1968, no. 1, ill.; Montauban 1980, no. 7

REFERENCES: Magimel 1851; Delaborde 1870, no. 121; Momméja 1904, p. 37; Boyer d'Agen 1909, pp. 416, 444–46; Lapauze 1911a, p. 42, ill. p. 61; Hourticq 1928, ill. p. 8; Pach 1939, p. 11; Alain 1949, ill.; Alazard 1950, p. 28; Wildenstein 1954, no. 15, fig. 13; Schlenoff 1956, fig. V; Ternois 1959a, under nos. 60, 61; Ternois 1959b, p. 19, fig. 18; M.-J. Ternois 1959, p. 120, fig. 1; Ternois 1965, no. 151, ill.; Radius and Camesasca 1968, no. 18, ill.; Naef 1977–80, vol. 3 (1979), p. 38, ill.; Siegfried 1980a, vol. 1, p. 47; Tokyo, Osaka 1981, ill.; Zanni 1990, no. 10, ill.; Fleckner 1995, pp. 87–90, fig. 25; Vigne 1995a, p. 476; Vigne 1995b, p. 44, fig. 24, pp. 327, 330

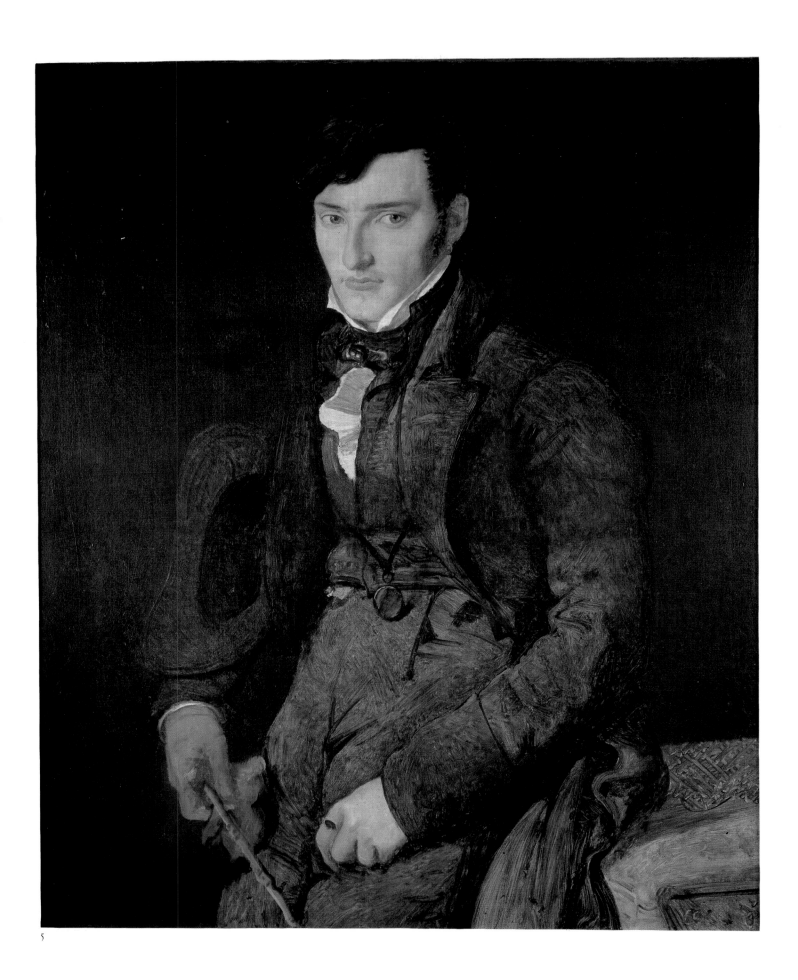

5

6. Monsieur Belvèze-Foulon

1805

Oil on canvas
21 ⅝ × 18 in. (55 × 46 cm)
Signed and dated lower left, on the chair back:
Ingres / 1805
Musée Ingres, Montauban

W 20

Although he has frequently been described as the son of a consul of Montauban, the exact identity of this member of the Belvèze family continues to elude scholars.[1] Well established in Montauban, the Belvèze family was wealthy enough to have commissioned garden statuary from Ingres's father, Joseph (see cat. no. 4). It is likely that this young man, who appears to be about the same age as the artist, was a childhood friend from Montauban. Ingres mentions the painting three times in Notebook X, once as "Belvese Poulon."[2] The sitter looks confidently and candidly at the viewer, and an amicable smile plays about his mouth. Dated 1805 on the chair back, the portrait bears a marked resemblance to that of Joseph Vialètes de Mortarieu (fig. 52), mayor of Montauban from 1806 to 1815, whom Ingres depicted in 1806. The subjects are shown in virtually identical bust length, each turned in three-quarters view to the viewer's left. Particularly striking in each portrait is the deep shadow, delineated from the sitter's left eyebrow to the tip of his nose, cast by the strong light on the face. The heavily lidded eyes of both young men stare frankly at the viewer. Belvèze-Foulon, indoors, drapes his right arm over the back of a chair, while Vialètes de Mortarieu appears before a windswept sky, in a slightly abbreviated bust length.

Monsieur Belvèze-Foulon is one of a succession of likenesses of young companions painted by Ingres prior to his departure for Rome in 1806. These include images of his close friend Jean-François Gilibert (cat. no. 5), the astronomer Pierre-François Bernier (cat. no. 1), the sculptor Lorenzo Bartolini (fig. 53), and Vialètes de Mortarieu. The circumstances of this portrait's execution are unknown; it may have been commissioned by the sitter's family or done simply out of friendship while Belvèze-Foulon was in the capital. However, the name Belvèze-Foulon does not appear in the artist's correspondence with other Montauban friends, such as Gilibert. A drawing after the portrait (fig. 63), included among Ingres's bequest to the museum in Montauban,[3] was likely kept by the painter as a souvenir. p.c. / n.y.

1. Neither Henri Delaborde (1870) nor Jules Momméja (1905a) proffers suggestions regarding the sitter's given name or occupation. Henry Lapauze (1911a, p. 42) appears to have been the first to append "Foulon" to his name and to have called him "son of a Montauban consul of 1789" ("fils d'un consul montalbanais de 1789"). Schlenoff (1956, p. 92, n. 3) found two Belvèze families among the Montauban archives, a "Belvèze attorney" ("Belvèze-avocat") and a "Belvèze warehouse keeper" ("Belvèze-entreposeur"). Daniel Ternois (in Paris 1967–68, no. 12) discovered a Belvèze listed in the *Annuaire du Tarn-et-Garonne* among the officers of the prefecture and later a councillor there.
2. All on fol. 22; see Vigne 1995b, pp. 327, 331, nos. 24, 25, 39.
3. Inv. 867.201. The drawing is not mentioned in Cambon 1885 or in Momméja 1905a. It is catalogued in Ternois 1959b, no. 12, and in Vigne 1995a, no. 2608.

PROVENANCE: By inheritance and descent through the family of the sitter; acquired from the Belvèze family by the city of Montauban, 1844; Musée Ingres, Montauban

EXHIBITIONS: Montauban 1862, no. 546; Paris 1867, no. 83; Paris 1911, no. 5; Paris 1921, no. 8; New York, Manchester, Detroit, Cincinnati, Cleveland, San Francisco 1952–53, no. 2; Toulouse, Montauban 1955, no. 99; Tokyo, Kyoto 1961,

Fig. 63. *Drawing after the Portrait of Belvèze-Foulon*, 1805. Graphite on paper, 4¾ × 3⅞ in. (12 × 9.9 cm). Musée Ingres, Montauban (867.201)

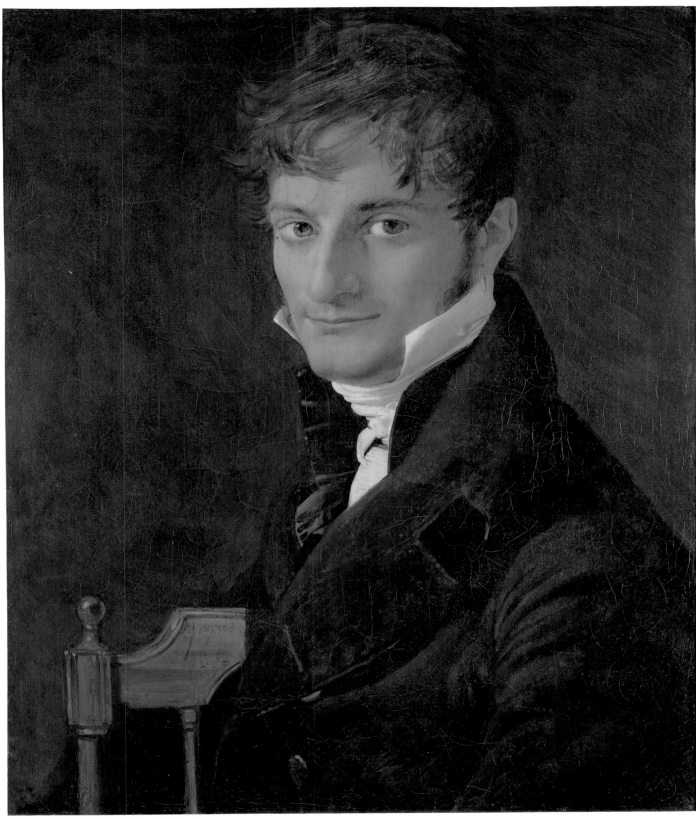

6

no. 19; Montauban 1967, no. 13; Paris 1967–68, no. 12; Montauban 1980, no. 9; Tokyo, Osaka 1981, no. 64

REFERENCES: Blanc 1870, p. 231; Delaborde 1870, no. 106; Cambon 1885, no. 29; Gonse 1900, p. 194; Mommėja 1904, p. 37; Mommėja 1905a, no. 5; Uzanne 1906, ill. p. 27; Lapauze 1911a, p. 42, ill. p. 57; Bouisset 1926, p. 50; Hourticq 1928, p. III, ill. p. 9; Alain 1949, ill.; Alazard 1950, p. 29; Wildenstein 1954, no. 20, fig. 15; Schlenoff 1956, p. 92; M.-J. Ternois 1956, p. 21; Ternois 1959a, no. 12; Ternois 1959b, p. 19; Ternois 1965, no. 152, ill.; Radius and Camesasca 1968, no. 19; Zanni 1990, p. 23, no. 11; Fleckner 1995, p. 81, fig. 22; Vigne 1995a, p. 466, ill.; Vigne 1995b, p. 44, fig. 25, pp. 327, 331

7. Père Desmarets

1805
Oil on canvas
25½ × 21½ in. (64.8 × 54.5 cm)
Signed and dated left: Ingres / 1805
Musée des Augustins, Toulouse
D. 1952.1 (MNR 15b)
Recuperated by the Allies in 1945

W 21

Ingres refers to this sitter as "Le Père Desmarets" in his Notebook X,[1] but the man's identity remains a mystery. When the portrait first appeared in public, shortly after Ingres's death in 1867, the subject was described in the Danlos sale catalogue as "the friend and foremost protector of Monsieur Ingres,"[2] but as this is the sole reference to such a protector, the suggestion is at best an overstatement of his role in Ingres's career. He was at one time identified as the rather obscure engraver Sébastien Desmarets (active 1800–1820),[3] who, while an unlikely "protector," could conceivably have been portrayed as a fellow artist in an informal and intimate portrait such as this. Most recently Hélène Toussaint has tentatively proposed the name of Pierre-Marie, called Charles, Desmarest (1764–1832), Napoleon's trusted chief of police,[4] but it is hard to imagine Ingres painting this private and personal likeness of such a powerful official.

The painter Frédéric Desmarais (1756–1813) has also been suggested;[5] he won the Prix de Rome in 1785 but spent the rest of his life in Italy, where he died in Carrara. Desmarais would have known the young sculptor Lorenzo Bartolini in Florence, before Ingres and Bartolini became acquainted in Paris in the studio of Jacques-Louis David. Desmarais later became a colleague of Ingres's close friend when in 1808 Napoleon sent Bartolini to set up a sculpture school in Carrara, where Desmarais was by then a professor at the academy. Desmarais exhibited two classical history paintings at the Paris Salon of 1806: *Cleombrotus Fleeing the Anger of Leonidas* (no. 140) *and The Abduction of Briseis* (no. 141). Thus, it is likely he was in Paris in 1806; he may even have been "my M. Desmarets," a person known to Ingres and encountered on a visit to the Salon by Ingres's prospective father-in-law, as briefly mentioned in their correspondence that year.[6] If the fifty-year-old painter did associate with Ingres and Bartolini at this time, Ingres may have called him affectionately "Father Desmarets" as an artistic mentor, rather than in the clerical sense the name first brings to mind. Delaborde says Ingres retouched this work, adding the gray cloak "toward the end of his life." He signed and dated it then also, on top of the cloak; so the given date of 1805 may not be a precise recollection and 1806 could be the true date of the portrait.[7]

This portrait is consistent in format with others made by Ingres in the years 1804 to 1806, before leaving for Rome; these works include *Monsieur Belvèze-Foulon* (cat. no. 6), *Young Man with an Earring* (fig. 50), *Jean-Marie-Joseph Ingres* (cat. no. 4), and *Joseph Vialètes de Mortarieu* (fig. 52). There is great stylistic variety within this group, however, and the austere presentation of Desmarets is not embellished with conceits of stylized line or bold color. Simplicity of pose and background is matched by the sitter's attire, a white shirt that has been alternately interpreted as an artist's smock or, more convincingly, as the casual dress of an intimate portrait. The severely limited palette is broken only by the gray of the mantle, a later addition by Ingres.[8] Desmarets's gaze is as direct as his presentation, conveying a forceful personality and an air of moral rectitude. Lapauze understandably said it was "worthy of Holbein."[9] The fine modeling of Desmarets's features, the subtle transitions from light to shade, and the overall acuity of observation certainly suggest that Ingres had been studying German and above all Flemish art of the fifteenth and early sixteenth centuries.

Père Desmarets also recalls a French tradition, notably Philippe de Champaigne's

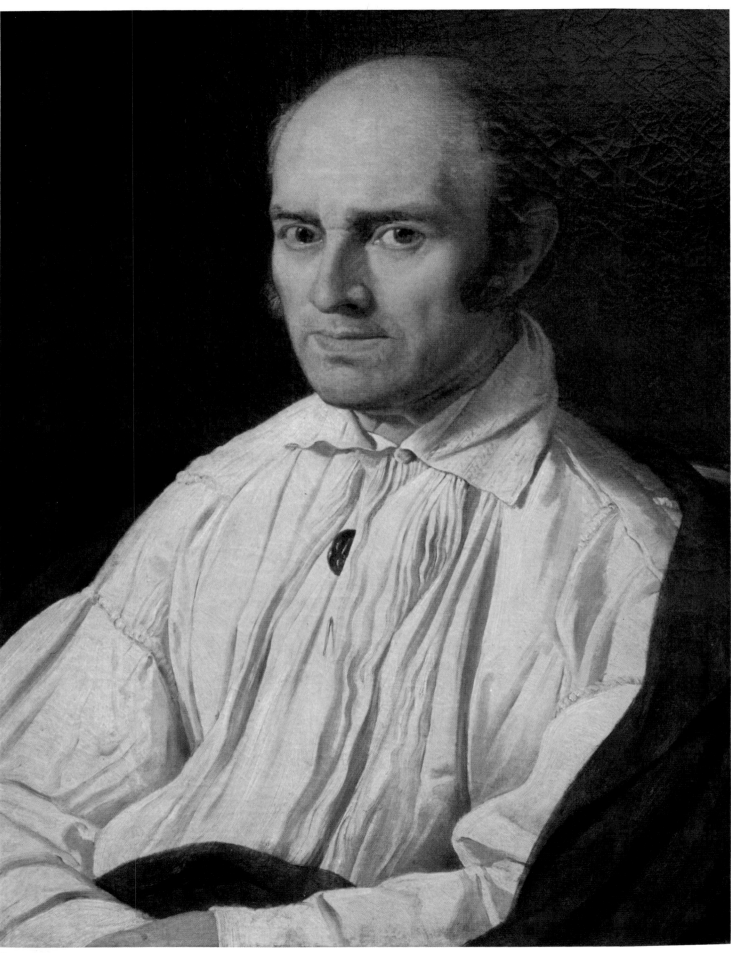

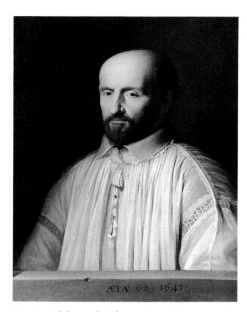

Fig. 64. Philippe de Champaigne (1602–1674). *Abbé de Saint-Cyran*, 1647–48. Oil on canvas, 29⅛ × 22½ in. (74 × 57 cm). Musée de Peinture et de Sculpture, Grenoble

comparable austere portraits of the Jansenist community at Port-Royal in the seventeenth century. A resemblance has been suggested between Ingres's *Père Desmarets* and Champaigne's *Abbé de Saint-Cyran* (fig. 64), an image that was widely disseminated through copies and engravings.[10]

P.C.

1. Fol. 22. Vigne 1995b, pp. 327, 330.
2. "l'ami et le premier protecteur de M. Ingres." Danlos *l'aîné* sale, Paris, March 2, 1867, no. 17.
3. Lapauze 1911a, p. 59.
4. Hélène Toussaint in Paris 1985, pp. 14–15, on whose research this discussion is based; nonetheless, for Toussaint, "'Père Desmarets' remains an unknown." ("'Père Desmarets' demeure au inconnu.")
5. Wildenstein 1954, no. 21; Toulouse 1989–90, no. 122. On Desmarais, see Friedrich Noack's biography in Thieme and Becker 1907–50, vol. 9 (1913), p. 137.
6. Ingres alludes to the meeting with "mon M. Desmarets" in his letter to Forestier of November 23, 1806; in Boyer d'Agen 1909, p. 51.
7. "Vers la fin de sa vie"; Delaborde 1870, p. 249. See also Toulouse 1989–90, p. 109, where the signature and date are said to be added on top of the cloak.
8. Delaborde 1870, no. 118.
9. Lapauze 1911a, p. 52.
10. Hélène Toussaint in Paris 1985, p. 17.

PROVENANCE: Danlos *l'aîné*; his sale, Paris, March 2, 1867, no. 17; J. V. sale, Paris, March 19, 1877, no. 13; Maurice Delacre, Ghent, by 1911; Robert Delacre; his sale, La Madeleine (Lille), December 15, 1941, no. 46; purchased for 300,000 Reichsmarks through Hildebrandt Gurlitt, January 29, 1944, for the Linz Museum; exported by Theo Hermssen against the recommendation of the French Museums; recovered by the Allies in 1945; transferred to the Musée du Louvre, Paris, by the Office des Biens Privés; on deposit at the Musée des Augustins, Toulouse, since January 1952, D1952.1 (MNR 156)

EXHIBITIONS: Paris 1867, supplement, no. 438; Paris 1911, no. 7; Paris 1946a, no. 27; Brussels 1947, no. 20, fig. 16; Toulouse, Montauban 1955, no. 100, ill.; Warsaw 1956, no. 54, fig. 16; Copenhagen 1960, no. 25; Montauban 1967, no. 14; Paris 1967–68, no. 13, ill.; London 1972, no. 144; Antwerp 1972–73, no. 23; Montauban 1980, no. 8, ill.; Sydney, Melbourne 1980–81, no. 81; Paris 1985, no. I, ill.; Toulouse 1989–90, no. 122, ill.

REFERENCES: Blanc 1870, p. 231; Delaborde 1870, no. 118; Lapauze 1910, p. 65; Lapauze 1911a, p. 52, ill. p. 59; Hourticq 1928, p. III, ill. p. 8; Malingue 1943, ill. p. 30; Alazard 1950, p. 29; Wildenstein 1954, no. 21, fig. 16; Radius and Camesasca 1968, no. 20, ill.; Zanni 1990, no. 12, ill.; Vigne 1995b, p. 44, fig. 23, pp. 325, 327, 330

8. Madame Aymon, *known as* La Belle Zélie

1806
Oil on canvas
23¼ × 19¼ in. (59 × 49 cm)
Signed and dated lower left: Ingres / 1806
Musée des Beaux-Arts, Rouen 870.1.1

W 25

Although clearly signed and dated, this portrait is not listed in Ingres's notebooks, unless it should be identified with one of a pair of portraits of an unnamed husband and wife.[1] The painting first appeared in the Eudoxe Marcille sale of 1857 but became widely known only through its inclusion in the 1867 Ingres exhibition and its subsequent acquisition, in 1870, by the Musée de Rouen (now Musée des Beaux-Arts). By that time the subject had acquired a proper name, Madame Aymon, as cited in Delaborde's catalogue of Ingres's works. She was also known as "La Belle Zélie," a reference to a popular song of the 1870s. The basis for her name remains obscure, however, and no biographical information has been discovered regarding such a sitter.

One of the last likenesses painted before his departure for Rome in September 1806, *Madame Aymon* embodies formal elements that would distinguish Ingres's portrait style

for the remainder of his life, particularly the distortion of anatomy in the interest of design and the use of strong color that is nevertheless subordinate to line. In *Madame Aymon* the composition is organized in curvilinear patterns, beginning with the oval shape of the image itself and repeated in the oval of the sitter's head, the spirals of her curls, the almond shape of her eyes, and the loop of her pearl necklace. The teardrop shapes of her twisted gold filigree and diamond earrings and the double arcs of eyelid and eyebrow reinforce the curved structure.

Placed before a blue sky with white clouds, the sitter looms large in the pictorial space. No background landscape elements ground her or distract from her. She is strikingly presented; her black hair is held back with a tortoiseshell comb and arranged in fashionable curls on her forehead; she wears a brown silk dress, fitted

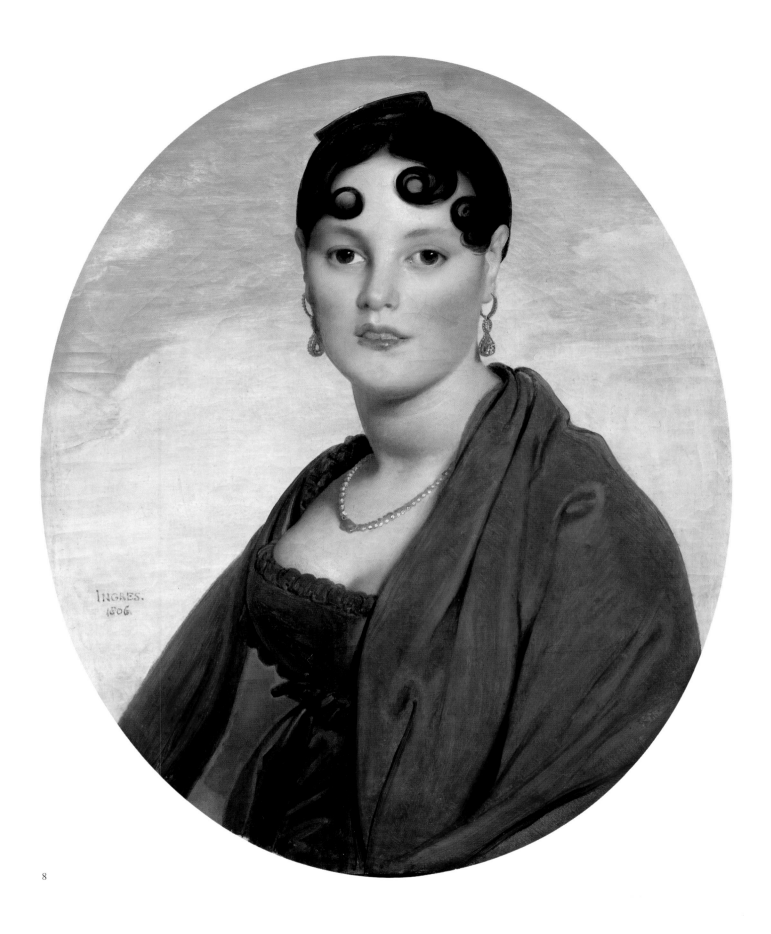

INGRES.
1806.

8

around the waist and tied with a bow; the bodice is short and square-necked; the blazing crimson of her shawl heightens the drama. Yet her face, with its slightly parted lips and flushed cheeks, exudes a charming youth and naïveté. Closer examination reveals how Ingres has manipulated the figure itself for his expressive purposes. Though her swanlike neck is unnatural in its curves, in combination with the perfect oval of her head it contributes to her allure. The interrelated swirls in her abnormally elongated ear harmonize perfectly with the curves throughout the composition. Ingres even seems to have employed several viewpoints: the bust is posed in three-quarters view, in contrast with the frontal presentation of the face, and within the face itself slightly different points of view interplay between the right and the left sides.[2]

P.C./N.Y.

1. Ingres's Notebook IX, fol. 123, and Notebook X, fol. 22; Vigne 1995b, pp. 325, 327, 331. Wildenstein (1954, nos. 42, 43) suggests one of them might be *Madame Aymon;* in that case, the portrait of the sitter's husband remains to be found.
2. Attention is particularly drawn to Ingres's anatomical and spatial distortions by Rosenblum (1956, p. 175) and Fleckner (1995, pp. 74–76).

PROVENANCE: Eudoxe Marcille; his sale, Paris, January 12–13, 1857, no. 84; Prince T[roubetskoy] [EB]; his sale, Hôtel Drouot, Paris, January 11, 1862, no. 29 [EB]; purchased at that sale by Jacques Reiset; his sale, Hôtel Drouot, Paris, April 29–30, 1870, no. 43; purchased at that sale by M. Féral-Cussac; acquired from him by the Musée de Rouen (now the Musée des Beaux-Arts, Rouen), 1870

EXHIBITIONS: Paris 1867, supplement, no. 435; Paris 1889a, no. 442 [EB]; Paris 1911, no. 10; Copenhagen, Stockholm, Oslo 1928, no. 90 [EB]; London 1932, no. 281; Paris 1933b, no. 50; Brussels 1935, no. 948; Paris 1937, no. 347 (album, fig. LXXII); Paris 1952b, no. 33 [EB]; Paris

1967–68, no. 18; London 1972, no. 145; Montauban 1980, no. 11, cover ill.

REFERENCES: Blanc 1870, p. 231; Delaborde 1870, p. 244, no. 103; Gonse 1900, ill. p. 293; Momméja 1904, p. 37, ill. opp. p. 12; Lafond 1905, p. 65, ill. p. 63; Uzanne 1906, ill. p. 28; Wyzewa 1907, fig. IX; Lapauze 1910, pp. 103–4; Lapauze 1911a, pp. 54, 56, 510, ill. p. 67; Nicolle 1920, p. 14, ill. p. 46; Alexandre 1921, ill. p. 204; Fröhlich-Bum 1924, fig. 8; Würtenberger 1925, p. 15, ill.; Hourticq 1928, p. III, ill. p. 14; Fouquet 1930, p. 4; *French Art* 1933, no. 409, fig. 89; Cassou 1936, ill. p. 162; Malingue 1943, ill. p. 31; Gatti 1946, ill. opp. p. 49; Cassou 1947, ill. p. 19; Courthion 1947–48, vol. 1, ill. opp. p. 48, vol. 2, pp. 123, 154, 184; Alain 1949, ill.; Bertram 1949, fig. IV; Jourdain 1949, fig. 17; Roger-Marx 1949, p. 26, fig. 7; Scheffler 1949, fig. 7; Alazard 1950, pp. 32–33; Wildenstein 1954, no. 25, pl. 10; Rosenblum 1956, p. 175, fig. 40; Rosenblum 1967a, p. 35, fig. 37; Rizzoni and Minervino 1976, p. 46, ill.; Picon 1980, p. 32, ill. p. 23; Jullian 1986, p. 10; Zanni 1990, no. 19, ill.; Fleckner 1995, pp. 74–81, fig. 17; Vigne 1995b, p. 48, fig. 30; Roux 1996, ill. p. 9

9. Madame Philibert Rivière, née Marie-Françoise-Jacquette-Bibiane Blot de Beauregard

1806
Oil on canvas
45 1/4 × 35 3/8 in. (116 × 90 cm)
Musée du Louvre, Paris M.I. 1446
London only

W 23

Madame Philibert Rivière, one of the most splendid images in French portraiture, presages a succession of stunning portrayals of women that Ingres would produce during the course of his career. Her almost shadowless presentation, subtly distorted anatomy, and luxuriously rendered costume and jewels are all characteristics to which Ingres would repeatedly return in his depictions of women. Frozen in time, the sitter represents a privileged class of French society in the early days of the Empire. The accessory from which this painting derives its colloquial title, "Woman with a Shawl," in itself identifies Madame Rivière as a woman of wealth and position.[1]

Born Marie-Françoise-Jacquette-Bibiane Blot de Beauregard in 1773 or 1774, the future Madame Rivière was known as Sabine. Her lineage was of Lyons and Toulouse, a geographical origin she shared with Ingres, which may account for the Rivières' eventual patronage of the young artist. In 1792 Sabine married Philibert Rivière (1766–1816); their children, Caroline and Paul, were born in the two succeeding years.

Although the exact circumstances of the commission are not known, and no preparatory drawings have been discovered, Ingres's portraits of Philibert (fig. 57), Sabine, and their daughter, Caroline (1793–1807; fig. 58), were completed well before Ingres left for Rome in 1806. Philibert's portrait is dated "l'An XIII" (Year XIII, September 1804–September 1805), while the undated portrait of Caroline was probably the last of the three to be completed. Why the Rivières' son, Paul, was not included in the series remains a mystery.

The relationship between the sitters unites the three portraits, yet the paintings themselves are varied in style and format. Philibert Rivière is presented in a conservative, Davidian tradition, seated beside a table with hand in vest, an echo of Napoleon's imperial pose. Attesting to Philibert's station as a man of culture are the books and a print after Raphael on the table beside him (see fig. 17). Usually referred to as a councillor of state under the Empire, Philibert held a variety of positions within the succession of governments in power during his life, displaying an adept

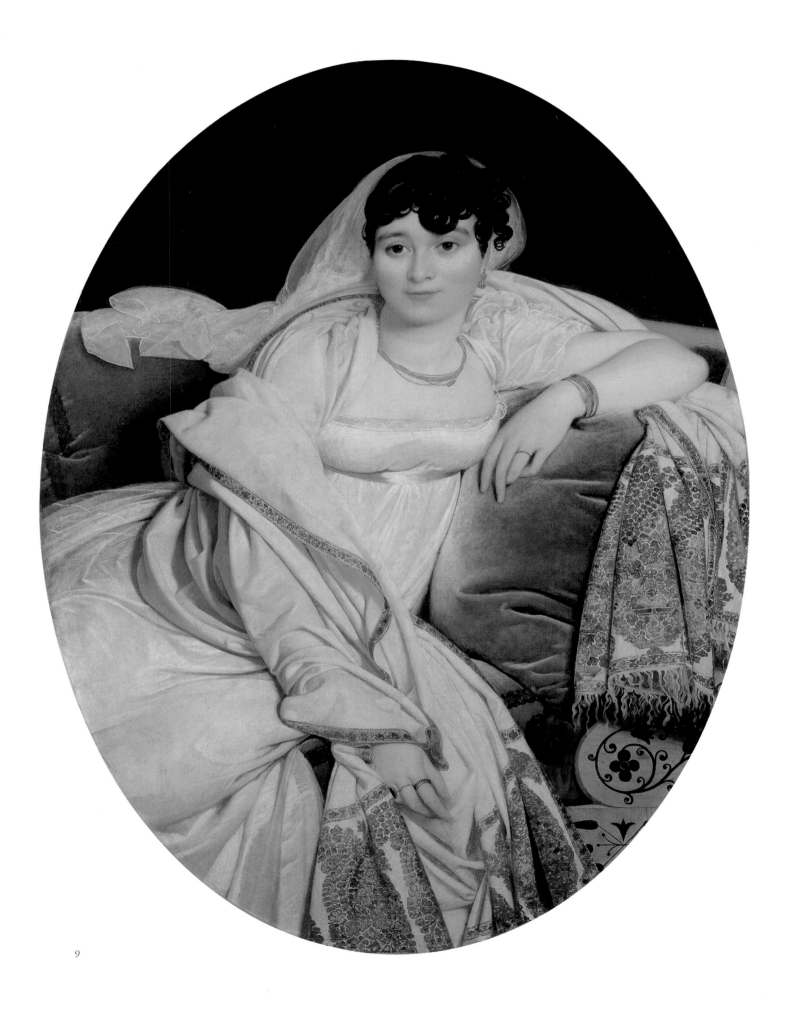

9

opportunism. At the time of his marriage he was a tax collector. He served in the Directorate administration, was imprisoned late in the Empire for his royalist sympathies, and was subsequently named to a high office under the Bourbon Restoration.[2]

The portrait of Madame Rivière, in contrast to that of her husband, is more typically Ingresque in its subservience of sitter to design. Like Madame Aymon in her portrait (cat. no. 8), Sabine is placed within an oval that defines an animated curvilinear composition. The superb lines formed by her attire—the luxurious cashmere shawl, diaphanous white satin dress tied beneath the bust with a ribbon sash, and translucent veil of white silk net—swirl around her as she lounges imperturbably upon velvet cushions. Like a butterfly pressed under glass, she remains immobile in her airless shallow space. Ingres has elongated her right arm, transforming it into an extended arc around which the lush shawl is entwined. The corkscrews of her jet-black Neoclassical curls (held in place with a glossy grease known as *huile antique*, or "ancient oil") are repeated in the marquetry scrollwork on the front of the divan on which she reclines. The loops of her necklace and bracelets give volume to the figure and, with the curving patterns formed by the folds of her dress, continue the restless movement that envelops her. Technical analysis of the painting indicates that Ingres initially placed Madame Rivière on a round-backed chair, with her left arm draped across it.[3] Through revisions, the artist employed her shawl to accomplish an arched outline behind her head, contributing to the circular movement throughout the picture. The amended position of her arm necessitated the addition of the almost translucent scarf to mask the awkward joining of the arm to her body.

Ingres's conception of the young Caroline, Mademoiselle Rivière, differs from his presentation of her parents. In a vaulted frame, she stands upright before an expansive river landscape. Yet the same impulse that led Ingres to the unnatural length of Sabine's arm here results in the perfect oval shape of Caroline's head balanced above her impossibly narrow shoul-

ders. Her ermine wrap and golden gloves rival her mother's cashmere shawl in their lavish rendering. She looks directly at the viewer, simultaneously naive and sensuous. In his Notebook X, Ingres refers to her as the Rivières' "ravishing daughter."[4]

At least two of the Rivière portraits accompanied Ingres's *Napoleon I on His Imperial Throne* (cat. no. 10) to the Salon of 1806.[5] The artist could not have imagined the negative response these submissions would receive from reviewers. Already in Italy, he was devastated by the criticism, which characterized his painting as primitive and Gothic.[6] The shallow, shadowless space occupied by Madame Rivière was too dramatic a rejection of traditional modeling and chiaroscuro effects. Her pale palette and intricate attire were mocked: she was "painted without shadows and so enveloped in draperies that one spends a long time in guesswork before recognizing anything there."[7] Only the portrait of Caroline earned a few kind words, primarily due to the landscape before which she stands and her fresh young face: "this is a lovely young person, daughter of Madame Rivière, fresh as a rosebud."[8]

Ingres never again set eyes on the Rivière portraits after sending them to the Salon. He sought to include them in his gallery at the 1855 Exposition Universelle but could not locate the Rivière family.[9] Each of the sitters had died by that time: Caroline, prematurely in 1807; Philibert, in 1816; Sabine, the last, in 1848. The paintings themselves were, ironically, in Paris in 1855, in the possession of Paul Rivière and his wife, Sophie Robillard. They remained lost to public view until Madame Rivière bequeathed them to the state in 1870, three years after the artist's death.

P.C. / N.Y.

1. Lapauze (1911a, pp. 49–50) says, "It is called *The Woman with a Shawl*. What a shawl!" ("On l'appelle *La Femme au châle*. Quel châle!") The popularity of cashmere shawls began with the 1799 Napoleonic campaign in Egypt, but their importation was banned in 1806, which served only to increase their novelty and rarity (see Delpierre 1986). An inventory of the Rivière household conducted following Philibert's death, in 1816, included a number of cashmere shawls; see Hélène Toussaint in Paris 1985, p. 26.

2. Rivière's career is recounted by Hélène Toussaint in Paris 1985, pp. 23–24, and in more detail in Naef 1972 ("Famille Rivière"), pp. 193–203.

3. Hélène Toussaint in Paris 1985, p. 28. See also Toussaint and Couëssin 1985, pp. 197–98, for additional results of technical analysis.

4. "ravissante fille" (fol. 22); Vigne 1995b, p. 327.

5. Press reviews of the Salon of 1806 refer specifically to the portraits of Madame and Mademoiselle Rivière. Philibert Rivière's is not known to have been included, as no. 273 in the Salon *livret* for that year simply mentions "several portraits" ("plusieurs portraits"). Hélène Toussaint (in Paris 1985, p. 25) speculates that the traditional style of Monsieur Rivière's portrait may have accounted for its omission in the reviews and that this omission does not prove that the portrait was not exhibited; but see Naef 1972 ("Famille Rivière"), p. 194, n. 1, where it is suggested that the portrait was omitted from the Salon on account of the sitter's known royalist leanings.

6. For an analysis of Ingres's treatment by the critics, see Siegfried 1980a, particularly pp. 82–85, on the Rivière portraits; in this catalogue see pp. 41 and 500.

7. "peinte sans ombres et si enveloppée de draperies, qu'on est longtemps à deviner avant d'y reconnoître quelque chose." Clarac 1806, pp. 127–28.

8. "c'est une jeune et belle personne, fille de madame Rivière, fraîche comme le bouton de rose." Chaussard 1806, p. 182.

9. Amaury-Duval (1878, pp. 159–60) recounts his attempts to locate the Rivière family on behalf of the artist.

PROVENANCE: Mme Philibert Rivière until 1848; by inheritance to Mme Paul Rivière, née Catherine-Sophie Robillard, her daughter-in-law; bequeathed by her to the state in 1870 and deposited at the Musée du Luxembourg, Paris; transferred to the Musée du Louvre, Paris, 1874

EXHIBITIONS: Paris (Salon) 1806, no. 273; Amsterdam 1938, no. 132; Paris 1946c, no. 139 [EB]; Paris 1967–68, no. 15, ill.; Paris 1985, no. III, ill.

REFERENCES: Delaborde 1870, no. 152; Amaury-Duval 1878, pp. 159–60; Both de Tauzia 1879, no. 794; Momméja 1904, p. 37, ill. p. 2; Uzanne 1906, ill. p. 22; Wyzewa 1907, p. 6, fig. V; Huysmans 1908, pp. 213–14; Boyer d'Agen 1909, pp. 16, 44, 52; Lapauze 1910, pp. 46, 52–53; Lapauze 1911a, pp. 48, 50, 56, 64, ill. p. 55; Raffaelli 1913, p. 79; Alexandre 1921, ill. p. 201; Marangoni 1922, p. 785, ill.; Brière 1924, no. 427; Desazars de Montgailhard 1924, pp. 54–55; Fröhlich-Bum 1924, fig. 3; Hourticq 1928, p. III, ill. p. 11; Fouquet 1930, p. 4; Cassou 1936, ill. p. 163; Lord 1938, p. 254, fig. IIC; Pach 1939, p. 20, ill. opp. p. 18; Longa 1942, p. 21; Malingue 1943, ill. p. 29;

Cassou 1947, pp. 61, 68, 69, fig. 17; Courthion 1947–48, vol. 1, p. 14, ill. opp. p. 11, vol. 2, pp. 89, 164, 169, 184; Alain 1949, fig. 12; Bertram 1949, p. 4, fig. II; Jourdain 1949, fig. 14; Roger-Marx 1949, p. 26, fig. 4; Scheffler 1949, p. 8, fig. 4; Alazard 1950, pp. 29–30, fig. V; Wildenstein 1954, no. 23, pl. 8; Sterling and Adhémar 1960, no. 1094, fig. 395; Rosenblum 1967a, p. 64, pl. 5; Radius and Camesasca 1968, no. 22, ill.; Rizzoni and Minervino 1976, p. 37, ill.; Picon 1980, pp. 32, 65–67, 77, 102, ill. p. 16; Siegfried 1980a, pp. 49, 83–85; Bryson 1984, pp. 116–23, ill. p. 122; Toussaint and Couëssin 1985, p. 198, ill.; Delpierre 1986, p. 80; Jullian 1986, p. 10; Eitner 1987–88, p. 159; Zanni 1990, no. 14, ill.; Fleckner 1995, pp. 28–32, fig. II; Vigne 1995b, pp. 48, 54–56, fig. 34, pp. 325, 327, 330; Roux 1996, fig. 4

10. Napoleon I on His Imperial Throne

1806
Oil on canvas
102 × 63¾ in. (259 × 162 cm)
Signed and dated lower left and lower right:
Ingres Pxit / Anno 1806 [Ingres painted (this) / in the year 1806]
Musée de l'Armée, Paris 5420

W 27

No evidence has yet come to light to prove whether *Napoleon I on His Imperial Throne* was a commissioned work or was painted by Ingres on his own initiative. Ingres had been one of several artists honored previously, in 1803, with an official commission to paint the portrait *Bonaparte as First Consul* (cat. no. 2). This earlier work, however, was never shown in Paris and hence brought him none of the acclaim he might have anticipated. The fact that the exhibition of this imperial portrait at the Salon of 1806 marked Ingres's public debut—an important step in any young artist's career—may explain why he reacted with such pain and anger to the adverse critical reception it suffered.[1]

Following most earlier writers, Hélène Toussaint believes the painting to have been commissioned,[2] while Susan L. Siegfried has made the suggestion that Ingres painted the emperor's portrait on speculation, in the hope of attracting the admiration of the public and soliciting favorable official attention.[3] The quite contrary reactions of the critics may have been prompted in part by Ingres's very presumption in painting for public display without official endorsement such a grandiose image of the emperor in his full regalia. Yet there was sufficient recognition of the young artist's talent for no less a body than the Corps Législatif to purchase the portrait just before its exhibition at the 1806 Salon,[4] despite high-level misgivings about the style and content of this singular likeness.

With the declaration of the Empire in May 1804, and the splendiferous *Sacre*, or coronation, held in the cathedral of Notre-Dame at Paris on December 2 of that year, French artists were encouraged to celebrate the new order of things and to glorify the emperor. Jacques-Louis David, nominated First Painter to the Emperor the same year, obeyed Napoleon's instructions and began work on the sanctioned version of the inaugural event in his monumental reconstruction of the coronation of the emperor and the empress (fig. 66), not completed until 1808. Baron Dominique Vivant Denon, the emperor's personal adviser on the arts and director general of the Musée Napoléon, used his powerful influence to marshal artists into the service of imperial propaganda. David,[5] François Gérard,[6] and Robert Lefèvre[7] were all commissioned to paint full-length standing portraits of Napoleon in his ceremonial robes in 1805 and 1806. Ingres's closest friend from his days in David's studio, the young Italian sculptor Lorenzo Bartolini, received a commission from Denon in 1805 to create a monumental portrait bust of the emperor *all'antica*, to be displayed in the pediment of the Pavillon Sully, over the main entrance of the Musée Napoléon. (The bust is still in place today.) In this heady atmosphere of artistic aggrandizement, we can imagine that Ingres planned to make an impression with his own portrait of the emperor, which he could hope to exhibit at the Salon of 1806.

David received his commission to paint the full-length portrait *Napoleon in His Imperial Robes* in 1805; it is now known only through a small preparatory oil study (fig. 67). The lifesize image was intended to be sent to Genoa to celebrate the recent accession of Liguria to the Empire. On seeing the full-size sketch of his portrait in

Fig. 65. Thomas Piroli (ca. 1752–1824), after John Flaxman (1755–1826). *Jupiter Sending the Evil Dream to Agamemnon* (*The Iliad*, 2.9), 1793. Engraving (image), 6⅝ × 9⅝ in. (16.7 × 24.3 cm)

July 1806, however, Napoleon rejected it, to David's great embarrassment. Ingres's painting is nevertheless indebted to that of his master and is perhaps a response to it. Was Ingres even daring to challenge his thwarted master for imperial favor? Ingres has inflated the throne, enlarging its mandorla-like back and the ivory globes on the arms (there are small modifications, too, such as the decoration of the pilasters). Although Ingres, differing from David, has seated the emperor on the throne, he has given Napoleon both a costume and attributes—scepter, hand of justice, and Charlemagne's sword—that correspond closely to those in the older artist's portrait. In the background of Ingres's picture, the imperial coat of arms is displayed on the left, while on the right are the emblems of the Italian states assimilated into the empire. They are much more prominent in a presentation drawing (private collection),[8] but were played down in the painting.

The portraits by David, Gérard, and Lefèvre (see figs. 67–69)—each showing Napoleon standing imperiously within an opulently curtained setting, executed with boldly handled paint and richly modeled in light and shade—revive a traditional type of royal Bourbon portraiture in the Baroque manner, well established from the reign of Louis XIV through that of Louis XVI. In contrast with the conventional swagger and pictorial unity of those depictions, the image Ingres created is frontal and iconic, loaded with symbolic attributes, and the artist has posed the emperor so that he seems but a prop for his robes and regalia. It is the carefully

studied accoutrements that appear to have absorbed the painter's attention, creating the effect of a religious icon that has attracted many tributes. We can perhaps understand how Gérard, who occupied a neighboring studio, paid Ingres the backhanded compliment of comparing his imperial portrait with the celebrated, jewel-encrusted medieval statue of *Our Lady of Loreto* (once attributed to Saint Luke himself), at that time on view in the Cabinet des Médailles in Paris as part of Napoleon's war booty.[9]

With the aid of authorized engravings and popular prints of the new regal imagery—but most likely with only limited access to the actual regalia and without the advice of the creators of official propaganda—Ingres had to rely on his own invention. He chose to focus on the trappings of imperial symbolism and to allude heavily to Charlemagne as Napoleon's precursor. David, in his *Bonaparte Crossing the Great Saint Bernard* (Château de Malmaison), painted in 1800, had already alluded to the man's imperial ambitions by showing the medieval emperor's name, KAROLUS MAGNUS, carved in the rock at the feet of Bonaparte's fiery steed. At the coronation in 1804 there were overt references to Charlemagne, for his colossal portrait statue decorated the temporary porch constructed for the event across the west front of Notre-Dame. The

imperial seal, newly designed in 1804, had on one side an image of Napoleon seated in majesty like a Roman emperor and on the other a reconstruction of the Carolingian coat of arms, surely studied by Ingres.[10] In 1806 Denon had a medal struck that represented the juxtaposed profiles of Napoleon and Charlemagne as emperors.[11] Such appeals to the nation's medieval past to legitimize its present were radical departures in government propaganda since the Revolution. Inspired by this antiquarianism put at the service of modern politics, Ingres leafed through publications by the comte de Caylus, Bernard de Montfaucon, or the more obscure Antonio-Francesco Gori in search of late Roman and Carolingian imperial imagery. Among those pages he studied and traced such objects of the antique as a Roman gem representing Jupiter, derived ultimately from Phidias's monumental sculpture of the god at Olympia (fig. 71).[12] Ingres's Jupiter-like imagery, however, with the now-imperial eagle ingeniously woven into the carpet at Napoleon's feet, could have been adapted from any number of sources, ancient or modern, including the line engravings of John Flaxman (fig. 65). Ingres traced a medieval representation of the French king Saint Louis enthroned[13] and a Byzantine ivory showing a military consul seated between Rome and Constantinople (fig. 72).[14] He also drew such items as the ivory

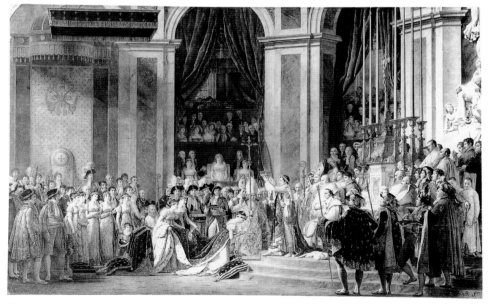

Fig. 66. Jacques-Louis David (1748–1825). *The Coronation of Napoleon*, 1808. Oil on canvas, 20 × 32 ft. (6.29 × 9.79 m). Musée du Louvre, Paris

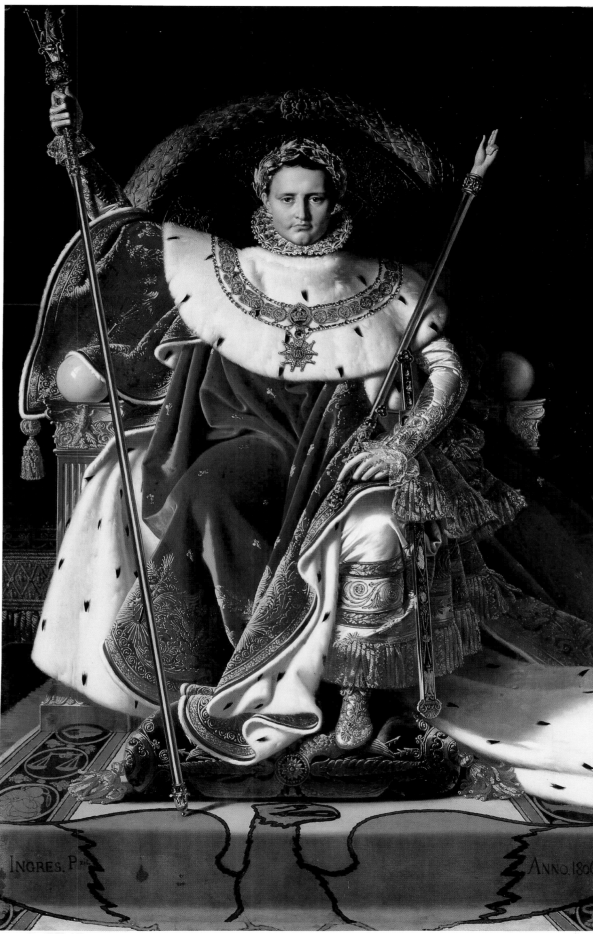

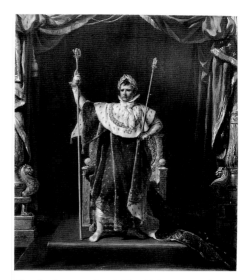

Fig. 67. Jacques-Louis David (1748–1825). *Napoleon in His Imperial Robes*, 1805. Oil on canvas, 22⅝ × 19½ in. (57.5 × 49.5 cm). Musée des Beaux-Arts, Lille

hand of justice carried by the new emperor, which had purportedly belonged to Charlemagne and had been engraved by Montfaucon (fig. 73);[15] the Charlemagne statuette surmounting the scepter of Charles V (fig. 74);[16] and so on. The border of Ingres's carpet includes signs of the zodiac, with Virgo represented at left by a schematic adaptation of Raphael's *Madonna della Sedia*, a conceit signifying the artist's own devotion.[17]

Ingres's absorption in this often recondite imperial Roman, Byzantine, and medieval imagery diverted him into a personal fantasy realm of arcane symbols, away from the reality of the modern world of the coronation (which, in any case, he had not been privileged to attend) and its contemporary political implications. The result was the strangely static, hieratic, imaginatively invented and obscurely symbolic figure of *Napoleon I on His Imperial Throne*.

The artist's heraldic colors, polished technique, and fanatical attention to details and reflections, as well as the iconic figure of the emperor himself, are also reminiscent of the art of such fifteenth-century Netherlandish painters as Jan van Eyck— a point not lost on contemporary critics, who found such a source bizarrely archaic. Van Eyck's celebrated Ghent altarpiece, with its commanding central panel representing God the Father enthroned (fig. 75), was available for study among Bonaparte's looted trophies of war in the Musée Napoléon. Although these qualities of keen observation and impeccable execution are already apparent in Ingres's 1804 *Bonaparte as First Consul* (cat. no. 2), the reflections here of a window in the ivory globe at left and of the woven zodiacal symbol of Cancer in the gilding at the

foot of the throne suggest that Ingres has paid special attention to the earlier masters of high finish.

In an idiom of its own, Ingres's portrait was quite unlike the Baroque manner then favored for likenesses of the emperor and his court,[18] as promoted in official circles by artists including David, Gérard, and Lefèvre. It was an extraordinary, original, and personal work: too much so. We could say it was ahead of its time in its Pre-Raphaelitism, except that it looks like nothing else in nineteenth-century painting. Fascinated by the historic imperial and nationalistic symbolic imagery he researched, Ingres fused them with van Eyckian precision and technique into an icon of remarkable and even disconcerting power.

However, it was not only Ingres's archaic style but also the Carolingian imagery he employed that led to criticism. Between the coronation year of 1804, when Ingres probably conceived *Napoleon I on His Imperial Throne*, and the time of its exhibition at the Salon of 1806, government policy itself had shifted from justifying the new regime by reference to a glorious "French" imperial past to a more modern presentation of the emperor. For example, the celebratory Napoleonic column to be

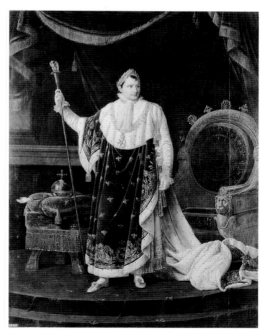

Fig. 68. Robert Lefèvre (1755–1830). *Napoleon in His Imperial Robes*, 1811. Oil on canvas, 109½ × 81 in. (278 × 206 cm). Versailles, Musée National du Château, Versailles

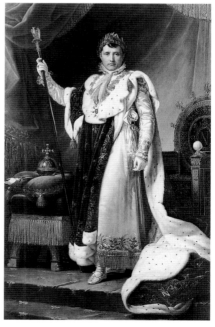

Fig. 69. François Gérard (1770–1837). *Napoleon in His Imperial Robes*, 1805. Oil on canvas, 89⅜ × 57⅛ in. (227 × 145 cm). Musée du Louvre, Paris

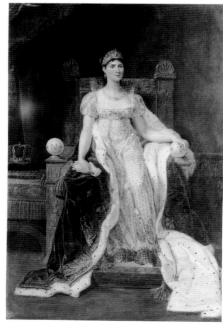

Fig. 70. Guillaume Guillon Lethière (1760–1832). *Empress Josephine Enthroned*, 1807. Oil on canvas, 84⅝ × 58⅝ in. (215 × 149 cm). Musée National du Château, Versailles

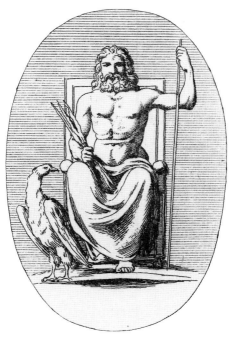

Fig. 71. Comte de Caylus (1692–1765). *Jupiter*, 1752–67. Engraving (image), $3\frac{1}{4} \times 2\frac{1}{4}$ in. (8.3 x 5.6 cm)

François-Léonor Mérimée submitted his diplomatically worded yet no less damning report to the ministry of the interior. Mérimée rather condescendingly praised the ability and promise of this young artist "in the student class," and did not wish to discourage a nascent talent; but, as he emphasized, his knowledge of what had happened to David—doubtless an allusion to the recent rejection by the emperor himself of David's imperial portrait—"must make me tremble." Mérimée recognized the daring originality of Ingres's image, because he remarked that it had many qualities appreciated only by artists; nevertheless, he concluded, "I do not think that this picture can have any success with the court." For one thing—and although Mérimée admitted he himself had not set eyes on the sitter for three years—the portrait did not resemble the emperor. In addition, Ingres had gone too far in trying to avoid imitating portraits of modern sovereigns—presumably the Baroque type in favor at the imperial court—not only in type but also in style: "In adopting the type of Images of Charlemagne, the author has chosen to imitate even the style of this period of art. Some artists who admire the grand and simple style of our early painters will praise him for having dared to make a fourteenth-century picture. Society will find it Gothic and barbarous."[19] And that is exactly what happened at the Salon.

Apparently an interest in the portrait had been expressed by the recently (1806) appointed mayor of Montauban, Joseph Vialètes de Mortarieu, who was visiting Paris at this time and had had his portrait painted by his friend Ingres the year before (fig. 52). Did the artist solicit his attention and support? Was it Ingres's original hope that *Napoleon I on His Imperial Throne* would find its triumphant way to his hometown? Having read Mérimée's report, Minister Champagny wrote to the mayor on August 27 that the portrait was "too insufficient as a likeness and too flawed for it to be presented to H. M. the Emperor."[20]

Nevertheless, Ingres had some support in high places. At its session on August 26, the Corps Législatif—abandoning an earlier idea to hold a competition to attract a variety of artists—came to his rescue and

erected in the Place Vendôme was originally conceived in 1803 to be topped by a monumental statue of Charlemagne, with allegorical low reliefs below. But in 1806, after Napoleon had won the Austerlitz campaign against the Holy Roman Empire, Charlemagne was replaced by a statue of Napoleon himself as a Roman emperor, and the column's reliefs were changed to represent the contemporary heroic exploits of his Grande Armée. To whatever extent Ingres's symbolism might once have borne some relation to sanctioned propaganda, by 1806 it was out-of-date.

This predicament was explicitly expressed even before the critics at the Salon went to work on *Napoleon I on His Imperial Throne*. Denon had begun to exert his authority as artistic adviser to the imperial court by vetting proposed Salon exhibits, in order to bring them into conformity with official policy. A few weeks before the mid-September opening of the 1806 Salon, an inspector was sent to review Ingres's portrait. On August 24 Jean-

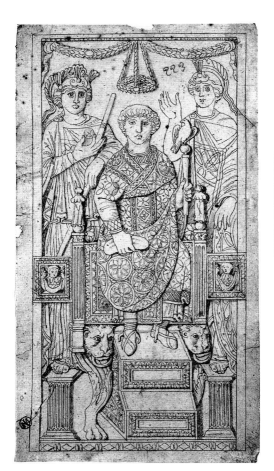

Fig. 73. *Symbolic Objects (Hand of Justice; Scepter of "Dagobert")*, 1806. Graphite on paper, $4\frac{3}{4} \times 3\frac{1}{2}$ in. (12.1 × 8.8 cm). Musée Ingres, Montauban (867.351)

Fig. 72. After a Byzantine ivory, *An Emperor Seated on His Throne*, 1806. Graphite on tracing paper, $10\frac{3}{8} \times 5\frac{5}{8}$ in. (26.5 × 14.2 cm). Musée Ingres, Montauban

Fig. 74. *The Scepter of Charles V*, 1806. Graphite on paper, 11¾ × 4⅛ in. (30 × 10.6 cm). Musée Ingres, Montauban (867.350)

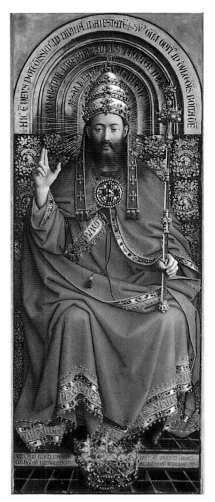

Fig. 75. Jan van Eyck (act. by 1422, d. 1441) and Hubert van Eyck (ca. 1385–90, d. 1426). *God the Father*, from the Ghent altarpiece, 1432. Oil and tempera on wood, 82 × 31 in. (208 × 79 cm). Sint-Baafs, Ghent

absolute ruler rather than the national leader who had fulfilled the goals of the Revolution. Where was Napoleon the man of the people and soldier of the ranks?

Some of the most sustained critical remarks came from the pen of Pierre Chaussard, a supporter of Napoleon and the Empire who felt that Ingres had perverted his talent to flaunt his originality: "How, with so much talent, a line so flawless, an attention to detail so thorough, has M. Ingres succeeded in painting a bad picture? The answer is that he wanted to do something singular, something extraordinary. . . . In leaving the path traced by the great masters, one risks going astray," as had architects such as Borromini and Oppenord, who strayed from classic models to Baroque and Rococo extravagance; "Here in another style no less execrable, since it is Gothic, M. Ingres's intention is nothing less than to make art regress by four centuries, to carry us back to its infancy, to revive the manner of Jean de Bruges [Jan van Eyck]."[23] Nor did Chaussard like the religious and hieratic character of Ingres's imagery: "The figure turns out to be wrapped up like the Italian madonnas, who for all their being bundled in brocades of gold, velvet, and satins, are no better rendered. . . . This throne is bulky and awkward, the hand holding the scepter is infelicitously executed. It looks as if the artist has taken this pose, along with the rest, from some Gothic medallions."[24]

By the time Ingres read the universally negative reviews of his Salon debut, he had moved to Italy to take up his Prix de Rome scholarship. His friends in Paris sent him the clippings. We know of his pained reactions from the letters he wrote to his prospective father-in-law, Pierre Forestier. The notice that particularly stung the artist was by Jean-Baptiste Boutard, writing in the widely read *Journal de l'Empire,* who joined Chaussard in attacking Ingres's willful archaism:

Still to be found, in private collections and with antique dealers, are old pictures, works that date to the Gothic period, in which *chiaroscuro* and aerial *perspective* are completely lacking . . . all is polished and

purchased the picture, intending to display it in the Palais Bourbon, in the "salon of the President, where in the name of the Corps Législatif he has the honor of receiving His Majesty the Emperor when he comes to open the annual session."[21] At the same time this body commissioned Ingres's friend Guillaume Guillon Lethière to paint a companion portrait, *Empress Josephine Enthroned* (fig. 70). The next day Denon's permission was requested, and granted, to display Ingres's painting at the Salon, due to open in a couple of weeks. On September 2, however, Denon may have asserted official taste by also granting permission to the Senate to exhibit Lefèvre's large *Napoleon in His Imperial Robes* (see fig. 68, a variant of the lost original), which the emperor himself had presented to this other government body. Intrigue was doubtless

at play here: Lefèvre's portrait may have been included in the Salon at the last minute not only as a critique of Ingres's work but also to ensure that the upstart younger painter would not appear to be the exclusive portraitist of the emperor.

Ingres's presentation of Napoleon pleased not a single critic. Siegfried has subtly analyzed the degree to which the various negative commentaries were colored by political partisanship and by the repressive censorship of the day, which allowed only voices sympathetic to the emperor to be heard.[22] Fundamentally, the likeness was not found to be convincing; the style was considered peculiarly archaic or "Gothic" rather than progressively modern; and the hieratic Carolingian imagery was unacceptable because it implied the tyrannical ambition of an

finished with equal care, everything—fabrics, forms, jewels, down to the smallest accessories—is meticulously imitated. For the artists (like Jean de Bruges) were almost entirely ignorant of what has since become so well known: the ideal in the arts of imitation.[25]

Mortified by this public humiliation, Ingres never requested *Napoleon I on His Imperial Throne* for inclusion in any of the several exhibitions of his work organized during his lifetime. After the fall of the Empire, it was moved from the Palais Bourbon to the Louvre, from whence it was deposited in 1832 at the Hôtel des Invalides.

P.C.

1. See, for example, Ingres's letters of October and November 1806, and even January 1807, to his prospective father-in-law, Pierre Forestier, in Boyer d'Agen 1909, pp. 47–53.
2. Hélène Toussaint in Paris 1985, p. 35. Charles Blanc (1870, p. 11) was the first to describe it as a commission.
3. Siegfried 1980b, pp. 69–81.
4. On the source of the funds, which came at the last minute from an abortive competition, see Boyer 1936, pp. 91–123, especially pp. 105–6. Boyer suggests that Ingres's portrait was purchased by the Corps Législatif, not commissioned.
5. See Bordes and Pougetoux 1983, pp. 21–34, for a full discussion; the small study in Lille (fig. 67) is our only record of David's 1805 portrait. On David's portraits of the emperor, see also Antoine Schnapper in Paris 1989–90, pp. 433–36.
6. Gérard's original portrait of 1805 is lost. We reproduce a replica (fig. 69), which belonged to Bonaparte's sister Caroline Murat (see cat. no. 34).
7. The original version of Lefèvre's portrait, exhibited at the Salon of 1806, included in the background "a gallery in which the statues of Charlemagne, Alexander, Julius Caesar, Scipio Africanus, etc., are to be seen" ("une galerie où l'on apperçoit les statues de Charlemagne, Alexandre, Jules-César, Scipion l'Africain, etc."), according to Chaussard 1806, p. 283. The original is lost, but the replicas, such as the one illustrated here dated 1811 (fig. 68), do not include the imaginary gallery in the background.
8. Illustrated in Paris 1985, p. 37, fig. V 1; the devices were first identified in Connolly 1980.
9. Gérard's comments were reported by Ingres's friend and colleague Pierre Nolasque Bergeret (1848, pp. 72–73).
10. The recto and verso of Guy-Antoine Brenet's design for the seal of the Napoleonic Empire (Archives Nationales, Paris) are illustrated in

Siegfried 1980a, fig. 17.

11. The medal is illustrated in Connolly 1980, fig. 15.
12. Caylus 1752–67, vol. 1, pl. 46; this source was first pointed out by Agnes Mongan (1944, p. 408, n. 28).
13. A tracing in the Musée Ingres, Montauban, is illustrated in Paris 1985, p. 36. Not catalogued in Vigne 1995a, the tracing is after an engraving in Montfaucon 1729–33, vol. 2, p. 154, pl. 20.
14. Siegfried 1980b identified the source as Gori 1759, vol. 2, fig. 2.
15. Montfaucon 1729–33, vol. 1, pl. 3. Gaborit-Chopin (1973, pp. 94–101) shows that the "Carolingian" staff and ivory hand were fabricated for Napoleon's coronation in 1804 (employing Montfaucon's engraving as a model!), although some of the jewelry in its settings can be dated to medieval times.
16. Montfaucon 1729–33, vol. 5, pl. 5. Paris 1985 (p. 39, no. V 4, p. 40, no. V 6) relates two other drawings at the Musée Ingres, Montauban, to Ingres's *Portrait of Napoleon I on His Imperial Throne;* Vigne (1995a, p. 420, nos. 2374, 2375) says they are for Ingres's unpublished commemorative volume of the coronation of Charles X.
17. The zodiacal and Masonic imagery incorporated into Ingres's portrait are discussed in more detail in Connolly 1980.
18. For discussion and illustrations of the imposing portrait series of members of Napoleon's cabinet, commissioned in 1806 for the Salle des Maréchaux in the Palais des Tuileries, see Zieseniss 1969, pp. 133–58.
19. "dans la classe des élèves"; "doit me faire trembler"; "je ne pense pas que ce tableau puisse avoir aucun succès à la cour." "L'auteur en adoptant le type des Images de Charlemagne a voulu imiter jusqu'au style de cette époque de l'art. Quelques artistes qui admirent le style simple et grand de nos premiers peintres le loueront d'avoir osé faire un tableau du 14^ème siècle: les gens du monde le trouveront gothique et barbare." The documents were first published in Bessis 1969, pp. 89–90. Ironically, Mérimée later wrote an important early study of fifteenth-century painting techniques, *De la peinture à l'huile; ou, Des procédés matériels employés dans ce genre de peinture depuis Hubert et Jean Van-Eyck jusqu'à nos jours* (Paris, 1830).
20. "trop peu ressemblant, et trop peu perfectionné pour qu'on puisse le présenter à S.M. l'Empereur." Bessis 1969, p. 90.
21. "salon du Président où il a l'honneur de recevoir au nom du Corps législatif Sa Majesté l'Empereur lorsqu'elle vient faire l'ouverture de la session annuelle." Quoted in Paris 1985, p. 34; Archives of the Palais Bourbon, Paris.

22. Siegfried 1980a and Siegfried 1980b.
23. "Comment, avec autant de talent, avec un dessin aussi correct, une exactitude aussi parfaite, M. Ingres est-il parvenu à faire un mauvais tableau? C'est qu'il a voulu faire du singulier, de l'extraordinaire. . . . En quittant le chemin des grand maîtres . . . on risque de s'égarer"; "Voici que dans un autre genre non moins détestable, puisqu'il est gothique, M. Ingres ne tend à moins qu'à faire retrograder l'art de quatre siècles, à nous reporter à son enfance, à réssusciter la manière de Jean de Bruges." Chaussard 1806, p. 177.
24. "La figure se trouve empaquetée comme des vierges d'Italie, qui pour être engoncées dans les brocarts d'or, les velours et les satins, n'en sont pas mieux faites. . . . Ce trône est lourd et massif, la main qui tient le sceptre n'est pas d'une heureuse exécution. On dirait que l'artiste a été prendre cette attitude, ainsi que le reste, dans quelques médailles gothiques." Ibid., p. 179.
25. "On rencontre encore, dans les cabinets de curiosité et chez les antiquaires, de vieux tableaux, ouvrages des temps gothiques, où le *clair-obscur* et *la perspective* aérienne manquent entièrement . . . tout y est poli et terminé avec un soin égal; étoffes, formes, joyaux, et jusques aux moindres accessoires, tout y est scrupuleusement imité: car les artistes (comme Jean de Bruges) ignoraient presqu'entièrement ce qui a été si bien connu depuis eux, l'idéal dans les arts d'imitation." Boutard 1806, quoted in Siegfried 1980a, p. 81. Called *Le Journal de l'Empire* during the Empire, but originally, and subsequently, known as *Le Journal des débats*, this influential daily review had been owned by the Bertin family since 1799, when it was purchased by Louis-François Bertin (1766–1841) and his brother Louis-François Bertin de Vaux (1771–1842). The elder Bertin had his portrait painted by Ingres in 1832; see cat. no. 99. (For Ingres's pained reactions to his Salon critics in 1806, see his letters to Pierre Forestier of October 22 and November 23, 1806, quoted in Lapauze 1910, pp. 43–46, 57–66.)

PROVENANCE: Acquired by the Corps Législatif (Palais Bourbon, Paris), August 26, 1806; transferred to the Musée du Louvre about 1815; loaned to the Hôtel des Invalides, Paris, by Comte Auguste de Forbin, director of the Musées Royaux, 1832; deposited at the Musée de l'Armée, Paris

EXHIBITIONS: Paris (Salon) 1806, no. 272; Paris 1867, no. 102; Paris 1885, no. 151 [EB]; Paris 1889a, no. 440 [EB]; Paris 1900a; Paris 1911, no. 9; Saint Petersburg 1912, no. 656; Paris 1921, no. 10; Paris 1935d [EB]; New York 1939, no. 333; Paris 1952c, no. 44b; Paris 1967–68, no. 17, ill. p. 33; Paris 1969, p. 52, no. 160; London 1972, no. 147;

Paris, Detroit, New York 1974–75, pp. 498–500, no. 104, ill. p. 193; Paris 1985, no. V, ill.; Atlanta 1996, p. 236, ill. p. 237

REFERENCES: Anon. 1806; Anon., September 27, 1806 (C.), pp. 596–602; Anon., October 4, 1806 (C.), pp. 26–31; Anon., October 11, 1806 (C.), pp. 74–80; Anon., October 17, 1806; Boutard, October 4, 1806; Chaussard 1806; Flâneur 1806; Fabre 1806; Voïart 1806; Bergeret 1848, pp. 71–72; Magimel 1851, pl. 10; Merson and Bellier de la Chavignerie 1867, p. 103; Blanc 1870, p. 11;

Delaborde 1870, no. 145; Momméja 1905a, nos. 32–38; Uzanne 1906, pp. ix–x; Boyer d'Agen 1909, p. 47; Lapauze 1910, pp. 46, 150–51; Lapauze 1911a, pp. 64–66, 68, ill. p. 535; Monod 1912, p. 301; Bénédite 1921, p. 334; Fröhlich-Bum 1924, p. 6, ill. pl. 9; Hourticq 1928, ill. p. 15; Boyer 1936, pp. 105–6; Pach 1939, pp. 19–20; Mongan 1944, pp. 409–10; Alain 1949, no. 13, ill.; Bertram 1949, pl. 6; Roger-Marx 1949, pl. 5; Scheffler 1949, pl. 5; Alazard 1950, p. 31; Wildenstein 1954, p. 165, no. 27, pl. 6; Schlenoff 1956, p. 91; Ternois 1959a, nos. 149–54; Naef 1965

("Gravures"), p. 5; Rosenblum 1967a, p. 68, pl. 7; Radius and Camesasca 1968, no. 36, ill.; Rome 1968, p. xix; Bessis 1969, pp. 89–90; Méras 1969, p. 118; Rosenblum 1969, pp. 101–2; Naef 1975 ("Ingres et Bergeret"), no. 37, fig. 3; Barousse 1977, p. 159; Connolly 1980, pp. 52–68; Siegfried 1980b, pp. 69–81; Foucart 1982, pp. 89–90; Foucart 1983, pp. 83–86; Eitner 1987–88, pp. 160–62; New York 1989–90a, pp. 86–89, ill. p. 22, pl. 5; Zanni 1990, pp. 31–32, no. 18, ill.; Vigne 1995b, p. 56, fig. 35; Roux 1996, p. 8

11. Copy after Ingres's 1804 Self-Portrait

Marie-Anne-Julie Forestier
1807
Oil on canvas
25⅝ × 20⅞ in. (65 × 53 cm)
Private collection, Europe

Julie Forestier became engaged to Ingres in the summer of 1806, just a few months before his September departure to study at the Académie de France in Rome (see p. 97). Born in 1782, she was twenty-four years old, he was twenty-six. A secure date for her copy of her fiancé's *Self-Portrait* is provided by an unpublished letter from Ingres to her father, dated January 12, 1807, in which he asks her to make the copy: "I would even venture to ask Mademoiselle Julie something that I have not yet requested, to make a little copy of my painted portrait, drawn or painted as she wishes, and small in scale,

and, of course, to do it when she has time and leisure."[1] Ingres made his request at a time when he still had every intention of returning to Paris to take Julie's hand in marriage. He was not happy in Rome, and, just a month after his arrival, he had been on the point of packing his bags and heading back to Paris: "I cordially detest the city of Rome."[2]

The *Self-Portrait* in question was the one Ingres had painted in 1804 and exhibited at the Salon of 1806. We know of its original appearance not only through Forestier's copy but also from an etching, perhaps by Jean-Louis Potrelle (in a

Fig. 76. *The Forestier Family*, 1850–51 (N 35). Graphite on tracing paper, 11¾ × 14⅝ in. (30 × 37.2 cm). Fogg Art Museum, Harvard University Art Museums, Cambridge, Massachusetts

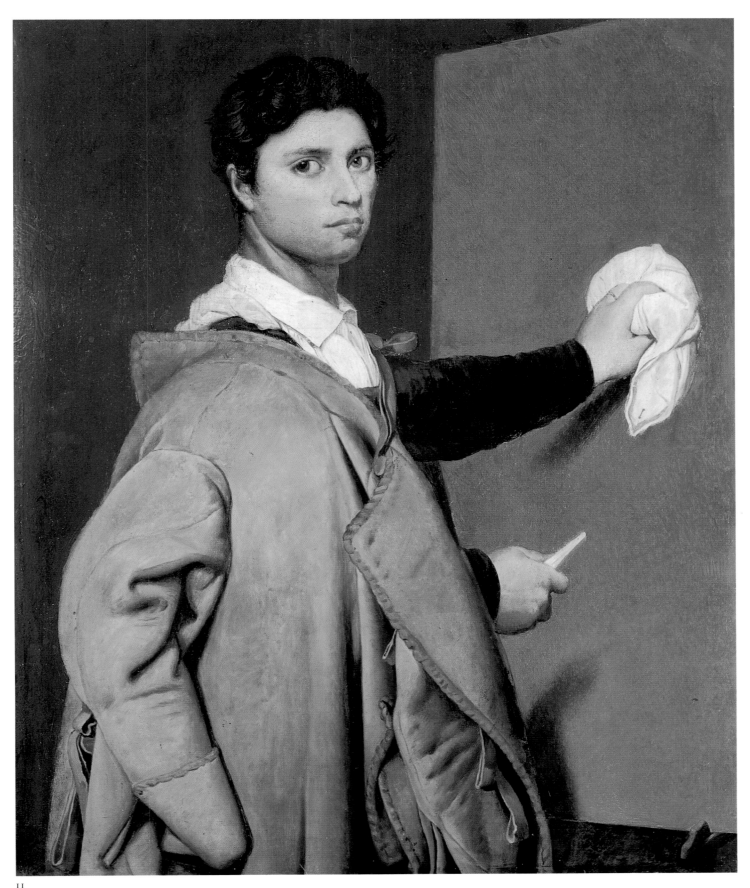

unique impression, retouched by Ingres with pencil and white heightening [fig. 54], perhaps after his return to France in 1824, as proposed by Gary Tinterow in this book [cat. no. 147]),[3] and a photograph by Charles Marville taken between 1849 and 1851 (fig. 282).[4] Ingres showed himself standing at work before an easel; a description of the picture at the Salon of 1806 refers to "a canvas that is still blank" (see fuller description below). Yet in the etching we see on the primed canvas an outline image of his friend Gilibert, indicating preparation for the portrait Ingres painted in 1805 (cat. no. 5) which was probably conceived as a pendant of the 1804 *Self-Portrait*. In Marville's photograph the canvas also shows outlines sketched in white. It is possible that these outlines were added to the etching and the original painting at a later date. Forestier's copy depicts a blank canvas on the easel and contains all of the essential features of the 1804 picture: the artist has a cumbersome, light-colored coat slung over his right shoulder; he holds a piece of chalk in his right hand and a white cloth in his left; and he is posed as if he is about to erase something or as if rubbing down the canvas before him in preparation. The somewhat awkward coat looks as if it might slide off Ingres's shoulder, and the implied junction of his left arm with his body—implied, because it is in fact out of sight—is not at all convincing spatially.

At an unknown date—but probably either in 1824, at the time he modified Potrelle's etching, or about 1850–51, when he was reworking the 1804 *Self-Portrait*—Ingres made a pencil copy (perhaps a tracing) of his head in the painted portrait (cat. no. 12). He slightly modified his hair, his left eye, and the profile of his nose, and in general softened the rather wild expression of the painting. Years later he dedicated this drawing to his second wife, Delphine Ramel.

The 1804 *Self-Portrait* was ridiculed as a caricature by an anonymous critic at the Salon of 1806:

An artist is seen before his easel. In one hand he holds a handkerchief which he applies for no apparent reason to a canvas that is still blank but that is no doubt destined to represent the most terrifying sub-

jects, to judge from the dark and wild expression on his face. Thrown over one shoulder is a voluminous drapery which must inconvenience him mightily in the heat of composition and in the kind of crisis that his genius seems to be undergoing. The catalogue does not name the model for this caricature.[5]

It is likely that Ingres left his *Self-Portrait* in the care of the Forestier family after the Salon of 1806 was over; there was clearly no problem for Julie to gain access to it to make her copy in January 1807. Ingres must have been stung by the criticism his work received at the Salon, and it is perhaps surprising that he asked her to make a copy of it at all. It is just possible, however, that the copy was intended for his own father. In July 1807 Pierre Forestier arranged for it to be shipped to Montauban, where it arrived in August, as attested by a letter of thanks from Joseph Ingres, dated August 9:

I received in due course the crate that you mentioned in your kind letter of last month, containing a copy of my son's portrait and two views of Rome. Although I suspected your daughter would be quite talented, I must say it surpassed every expectation. Anyone who can copy like that must certainly be able to compose with the genius that characterizes great artists. Everything about this portrait makes it dear to me: both the person it represents and the hand that was good enough to draw him. Please accept my deepest thanks and be assured that my gratitude is equal to the pleasure this gift affords me.[6]

There is no incontrovertible evidence either way, by which we can know if Julie's copy of the *Self-Portrait* was originally intended for Ingres's father, or if, far from its being an amicable gift, the Forestier family simply could no longer stand the sight of it. Joseph Ingres's letter is full of gratitude, and he appears blissfully ignorant of correspondence that had been passing between Paris and Rome since May, although he does allude to worries expressed by Forestier about his future son-in-law's progress in Rome and when he might return to Paris. The truth was that by the spring of 1807 Ingres was beginning to enjoy Rome and was feeling

less inclined to return to Paris—and Julie—in the near future. Moreover, Julie's father was having serious doubts about Ingres's ability (or willingness) to execute the required works of art in Rome, whose completion as part of his academic program would enable the young painter to return to Paris and marry his daughter—within a year, as he had promised. Indeed, Ingres's true intentions were now so unclear that Monsieur Forestier offered to free him from his obligations to Julie.[7] In a letter of July 2, Ingres at last made it clear he was not contemplating a return to Paris in the foreseeable future.[8] In a letter dated August 8, Ingres declared his final separation and his determination to remain in Rome: "I ask you on both knees—it is impossible for me to leave such a marvelous country so soon."[9] Perhaps Ingres wrote this letter the very day his father received the crate from Paris containing Julie's copy.

Julie Forestier studied with the minor master Jean-Baptiste Debret and exhibited for the first time, designated as his pupil, at the Salon of 1804.[10] She may have studied for a while in the studio of Jacques-Louis David. Other than her copy after Ingres, little is known of her art. She exhibited at the Salon from 1804 to 1819, showing portraits, classical subjects such as *Minerva, Goddess of Wisdom and the Fine Arts* (Salon of 1804, no. 184), or works, probably in the medievalizing troubadour style, such as *The Princess of Nevers at the Abbey of Graville* (Salon of 1814, no. 400). Her last painting to be exhibited was *Milton's Daughters Reading to Their Blind Father* (Salon of 1819, no. 449). It is not known how long Julie Forestier lived, but, from correspondence published by Hans Naef,[11] we know she had financial difficulties and suffered ill health in the early 1820s. At that time she had to sell possessions to make ends meet and offered for sale copies she had made after Raphael's *Madonna della Sedia* and *Madonna dell'Impannata*, subjects that, we may be sure, would have been dear to Ingres's heart. It was perhaps Ingres's public success with the Paris exhibition of his *Vow of Louis XIII* in 1824 (fig. 146) that prompted Forestier in that year to write her thinly veiled autobiographical

roman à clef, a story of unrequited love called *Emma, ou la fiancée*.[12] According to Henry Lapauze, when Forestier was asked why she had never married, she replied, "When one has had the honor of being engaged to M. Ingres, one does not marry."[13]

Edgar Degas's passion for Ingres's art is well known and has recently been thoroughly explored in a major exhibition and catalogue devoted to his collection. There, Julie Forestier's portrait of her fiancé was exhibited for the first time along with many works by Ingres himself, collected by Degas. Degas eagerly seized the opportunity to acquire the likeness from the dealer Durand-Ruel in 1898: "I really need it," Degas wrote. "It is a little soft, but I like that."[14] When Degas's estate was sold after his death, the painting was acquired by the great Ingres scholar Lapauze. Among many drawings by Ingres, Degas also owned one of his three group portraits of the Forestier family, with Julie at the center of attention (see cat. no. 23); the version in Degas's collection (fig. 76) was a tracing Ingres had made, most likely in anticipation of an engraved illustration in Albert Magimel's monograph on him, published in 1851.

The painting retains its original frame, presumably selected by Ingres. It is identical to the frame on Ingres's *Self-Portrait* of 1864–65 (cat. no. 149). P.C.

1. "J'oserais encore prier mademoiselle julie, chose que je n'ai pas encore demandé de faire une petite copie de mon portrait peint, comme elle voudra, dessiné ou peint et au petit et cela, bien entendu, quand elle aura le temps et à son aise." Ingres to Pierre Forestier, January 12, 1807, Fondation Custodia, Paris, inv. 1972.A.42.

2. "Je déteste bien cordialement la ville de Rome." Ingres to Pierre Forestier, November 23, 1806, quoted in Lapauze 1910, p. 58.

3. Jean-François Gilibert's outline appears in the etching. When Ingres retouched the sheet—which was probably a trial proof—he redrew his own three-quarters profile in pencil, and added a note to "modify the movement of the eye" ("modifier le mouvement de l'oeil"). Vigne 1995a, no. 2679. The etching was attributed to Jean-Louis Potrelle (1788–1824) in Siegfried 1990a, pp. 96, 97, n. 11. If Potrelle was the author of this etching, then his death in 1824 may explain why it was never published in its final form.

4. Ingres considerably reworked his 1804 *Self-Portrait* in 1850–51, when it was engraved in its new form by Achille Réveil (Magimel 1851, pl. 1); this reworked and somewhat cut down *Self-Portrait* is now in the Musée Condé, Chantilly (fig. 209); see cat. no. 147 for a discussion of the Chantilly picture and a copy of it in The Metropolitan Museum of Art.

5. "On y voit un artiste devant son chevalet. Il tient à la main un mouchoir qu'il porte, on ne sait trop pourquoi, sur un toile encore blanche, mais destinée sans doute à représenter les objets les plus effrayans, si l'on juge par l'expression sombre et farouche de son visage. Sur son épaule est jetée un volumineux draperie qui doit prodigieusement le gêner dans le feu de la composition, et dans l'espèce de crise que son génie paroît éprouver. Le livret ne nomme pas le modèle de cette caricature." Anon., October 11, 1806 (C.), p. 77.

6. "J'ai reçu en son temps la caisse que vous m'avez annoncée par votre chère lettre du mois dernier, contenant une copie du portrait de mon fils et deux vues de Rome. Quoique j'attendisse beaucoup du talent de Mlle votre fille, je puis dire qu'il surpasse l'idée que j'en avais conçue. Qui copie de cette manière doit certainement composer avec ce génie qui caractérise les grands artistes. Tout concourt à me rendre cher ce portrait, et celui qu'il représente et la main qui a bien voulu le tracer. Recevez-en mes remerciements et soyez assuré d'une reconnaissance égale au plaisir que ce cadeau m'a fait éprover." Joseph Ingres to Monsieur Forestier, August 9, 1807, quoted in Lapauze 1910, pp. 190–91.

7. Pierre Forestier to Ingres, May 29, 1807, quoted in ibid., p. 163.

8. Ingres to Pierre Forestier, July 2, 1807, quoted in ibid., pp. 167–74.

9. "Je vous demande à deux genoux, il m'est impossible de quitter si tôt un pays si merveilleux." Ingres to Pierre Forestier, August 8, 1807, quoted in ibid., p. 187.

10. On Julie Forestier, see Naef 1977–80, vol. 1 (1977), pp. 127–36.

11. Ibid., pp. 134–36.

12. *Emma, ou la fiancée* is published in full in Lapauze 1910, pp. 199–242.

13. "Quand on a eu l'honneur d'être fiancée à M. Ingres, on ne se marie pas." Ibid., p. 197; however, Lapauze does not give the source of this statement.

14. "J'en ai vraiment *besoin*. . . . C'est un peu mou mais ça me plaît." Degas 1931, no. 230.

PROVENANCE: Forestier family; Jean-Marie-Joseph Ingres (1755–1814), the artist's father, 1807; presumably bequeathed to J.-A.-D. Ingres, Paris, until 1867; Durand-Ruel & Cie., Paris; acquired from them for 3,000 francs by Edgar Degas (1834–1917), February 3, 1898; his sale, Galerie Georges Petit, Paris, March 26–27, 1918, no. 63; purchased at that sale for 8,000 francs by Henry Lapauze (1867–1925); his posthumous sale, Hôtel Drouot, Paris, June 21, 1929, no. 63; M. Chaffardon; by bequest to the present owner

EXHIBITION: New York 1997–98 ([vol. 2], no. 474, ill.)

REFERENCES: Degas 1947, no. 230; Naef 1977–80, vol. 1 (1977), p. 133

12. Self-Portrait

Date unknown
Graphite on tracing paper glued to paper
12 3/8 × 8 1/8 in. (31.3 × 20.6 cm)
Signed and inscribed lower left: Ingres à sa chère
Delphine
*At lower right, the artist's posthumous atelier
stamp (Lugt 1477)*
Musée du Louvre, Paris
Département des Arts Graphiques RF 3507
London only

This drawing is discussed under cat. no. 11.

PROVENANCE: The artist's widow, née
Delphine Ramel (1808–1887) in 1867; her
nephew Fernand Guille (1851–1908) ; Mme
Pennata; acquired by the Musée du Louvre,
Paris, 1908

EXHIBITIONS: Brussels 1936, no. 1, ill.;
Vienna 1950a, no. 146; Paris 1967b, no. 24

REFERENCES: Guiffrey and Marcel 1911, vol.
6, p. 127, no. 5045, ill.; Lapauze 1911a, p. 38, ill.;
Mathey 1945, p. 10, frontis.; Alazard 1950, pl. II
(reversed); Pansu 1977, no. 1, ill.; Naef 1977–80,
vol. 3 (1979), p. 203, fig. 2; Picon 1980, p. 7, ill.;
Mráz 1983, p. 39, fig. 1; Tübingen, Brussels 1986,
fig. 14.

INDEPENDENT PORTRAIT DRAWINGS, 1780–1806

13. Portrait of a Boy

ca. 1793–94
*Graphite with touches of red watercolor and a
band of green watercolor at the edge of the paper*
Diameter 4¼ in. (10.8 cm)
*Signed lower right (possibly retraced at a later
date):* Ingres
The Pierpont Morgan Library, New York
*Gift of the Sunny Crawford von Bülow
Fund, 1978 1982.2*
New York and Washington only

N 6

The majority of Ingres's earliest portrait drawings, produced while he was still a pupil at the Académie Royale in Toulouse or shortly before his departure for Paris, are in the form of profile medallions. Although they record a steadily increasing sensitivity and refinement, they all reflect the manner of the waning eighteenth century, a style that the artist abandoned as soon as he entered the atelier of Jacques-Louis David. Since a number of them are undated, when they might have been done can be judged only on the basis of their style and their subjects' clothing.[1]

For the present portrait of a young boy wearing an outlandish hat, one of the first in the series, a date of 1793–94 is probable. The child is not necessarily wearing a uniform. Suits with buttoned lapels, imitated from military costumes, were being worn by civilians several years before the Revolution. The bonnet is a Revolutionary one, but it too does not seem to belong to a uniform. If the sitter's jacket was blue with white lapels, it might have been the kind worn by the National Guard.

As is not the case with the other early medallion drawings, there are traces of red watercolor—along the edge of the left lapel and epaulette, in the folds of the light-colored cloth that forms the headband of the bonnet, and around the small ornament on its crown. Aesthetically, these lines in red are virtually insignificant, and it is difficult to know what to make of them. The work is signed, but the handwriting lacks spontaneity; it is as though it had been retraced or even added at some later date. Yet there is no reason to suspect in this any dishonest motive. These early Ingres portraits are so little known and of such modest importance that they hardly represent an attractive field for forgery. Moreover, until 1972 the drawing had been in the possession of a single family that can be traced back to Montauban during the period in which the drawing was made.

It is the only portrait of a child in the series and the only likeness that extends nearly to the waist. Possibly Ingres was concerned to include as much of the showy coat as the circular shape of the paper allowed. In this work, the stiffness of still-earlier drawings by the artist has begun to soften and the personality of the subject is more fully revealed.

A somewhat later drawing in the series (cat. no. 14) was executed on parchment, suggesting—as do the complete signature and date—that the artist attached particular significance to the work. The sitter is a middle-aged man who has loosened his tie and opened his collar. Such casualness may indicate that he was an artist of some kind. Ingres's growing proficiency in violin playing had opened to him the worlds of the concert hall and the theater in Toulouse; since two other profile medallions of the same year portray an actor (cat. nos. 15, 16), it is altogether possible that the subject of this painstaking portrait was one as well.

Two medallion portraits of 1797 demonstrate an even greater assurance. They bear identical signatures, and both were once in the collection of David David-Weill. One of them (cat. no. 17) is precisely dated in an inscription—not in Ingres's hand—on the back of the mount.[2] The drawing shows a man carefully attired, though not fashionably dressed. This subject has been identified repeatedly in exhibition catalogues as the artist's father,[3] but even a cursory glance at a profile portrait of Ingres *père* produced by his twelve-year-old son in 1792 (N 3; Musée Ingres, Montauban) reveals that this is not the same man.

The other profile medallion from the David-Weill collection (cat. no. 18) has also been associated—mistakenly—with Joseph Ingres; the collector purchased it thinking it to be the work of Ingres's father, and as recently as 1961 it was still attributed to him.[4] Proof that it cannot possibly have been executed by the elder

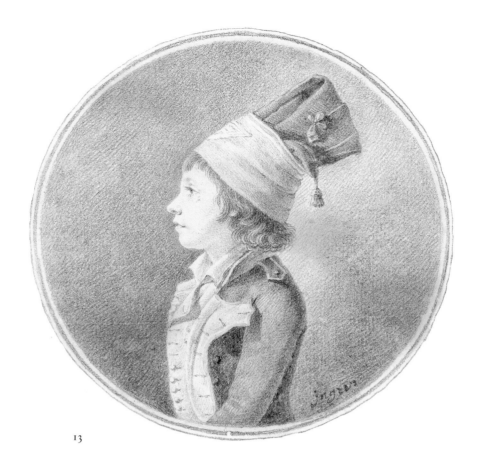

13

Ingres is the fact that there is nothing in his known oeuvre approaching such refinement. For that matter, none of the other medallion profiles by the younger Ingres are at the artistic level of the two 1797 drawings. In them he achieved virtually all that he possibly could in the portrait manner he was soon to leave behind. Again, we have no way of knowing who the subject of this second accomplished drawing may have been. In the catalogue of the David-Weill collection the work was identified as the portrait of a legislator,[5] but there is nothing to support such a designation. The subject's black tie and the vest buttoned to the collar have a military look, but in the absence of color, it is impossible to identify the uniform.

H.N.

For the author's complete text, see Naef 1977–80, vol. 1 (1977), chap. 1 (pp. 35–51).
1. For her expert analysis of the costumes of the sitters in these early drawings, the author is indebted to Mademoiselle Madeleine Delpierre.
2. Translated, the inscription reads: "Drawn in graphite by M. Ingres *fils*, before his departure

for Paris. The third of July, 1797." Quoted in Naef 1977–80, vol. 4 (1977), p. 30.
3. Toulouse, Montauban 1955, no. 77; Paris 1956–57, no. 99.
4. London 1961, no. 97.
5. Henriot 1926–28, vol. 3, p. 261.

PROVENANCE: By descent through the Jeanbon family, Montauban, to Mme Mathias-Édouard Pauvert, née Marie Prunetis-Castel; Mme Abel Marche, née Louise Pauvert, her daughter; by descent to her daughter Mme Carrive, née Hélène Marche; her son Jean Carrive, Sainte-Foy-la-Grande, 1963; Mme Jean Carrive, née Charlotte Behrendt, his widow, Sainte-Foy-la-Grande; purchased from her by Germain Seligman, New York, 1972; acquired by E. V. Thaw & Co., New York, 1978; purchased by The Pierpont Morgan Library, with the Sunny Crawford von Bülow Fund, 1978

EXHIBITIONS: Sainte-Foy-la-Grande 1970; New York 1984, no. 99; New York 1995–96, no. 28, ill.

REFERENCES: Naef 1970 ("Profilbildnisse"), pp. 223–25, no. 4, p. 234, fig. 5, on p. 226; Naef 1977–80, vol. 4 (1977), pp. 16–17, no. 6, ill.; MacGregor 1979, p. 740, ill.; Richardson 1979, no. 34, ill.

14. Unknown Man

1796
Graphite on parchment, with a band of green
watercolor at the edge of the paper
Diameter 5⅜ in. (13.7 cm)
Signed and dated lower right, within the inner-
most band: ingres fils. f. 13 [7]ᵇʳᵉ 1796 [*Ingres*
fils made (this) ——ber 13, 1796]
National Gallery of Art, Washington, D.C.
Rosenwald Collection 1954.12.82
New York and Washington only

N 10

This drawing is discussed under cat. no. 13.

PROVENANCE: Jean Ningres, Toulouse, by
1939 at the latest; Henri Petiet gallery, Paris, by
1953 at the latest; purchased by Lessing Rosen-
wald, Jenkintown, Pa., 1953; his gift to the
National Gallery of Art, Washington, D.C., 1954

EXHIBITIONS: Toulouse 1939, no. 121 as
Portrait d'homme; Washington 1966; Cambridge
(Mass.) 1967, no. 2, ill.

REFERENCES: Toulouse, Montauban 1955,
no. 169 (a photograph of the drawing), as *Un por-
trait d'homme;* Ternois 1959a, under no. 78; Mar-
jorie B. Cohn in Cambridge (Mass.) 1967,
technical appendix, p. 241; Mongan 1969,
pp. 137–38, fig. 2, p. 136 (identified as an actor);
Naef 1970 ("Profilbildnisse"), p. 225, no. 5,
pp. 234–35, fig. 6, p. 227; Naef 1977–80, vol. 4
(1977), pp. 24–25, no. 10, ill.; Miles 1994, p. 33,
fig. 2:9

15. Monsieur Brochard

1796
Graphite
Diameter 3 ⅛ in. (7.9 cm), framed
Signed and dated center right: J Ingres 1796
At lower right, the Georges Dormeuil collection
stamp (Lugt 1146a)
Private collector, Canada
Courtesy of R. M. Light & Co., Inc.

N 11

Two of Ingres's early medallion profiles are of particular interest in that they clearly represent the same subject and do so in such a way as to confirm his identity. Both are signed, and though only this one also bears a date—1796—they were apparently executed at about the same time. An inscription on the back of the dated drawing, in what appears to be Ingres's own mature handwriting, supplies the subject's name but contradicts the date that appears on the front. Translated, it reads: "M. Brochard, skillful interpreter of Molière. J. Ingres made [this]. Toulouse, Fructidor[,] Year V. At age sixteen."[1] "Fructidor, Year V" designates the period between August 18 and September 21, 1797. Ingres was still sixteen for the first few days of that period, to be sure, but celebrated his seventeenth birthday on August 29. What makes this more elaborate dating suspect is a note in Ingres's Notebook X to the effect that he first arrived in Paris about August 4, 1797,[2] which means that the drawing could not have been executed in Toulouse during the period indicated. If Ingres did pen the inscription himself some years later, it is perfectly conceivable that he was by then out of practice in the use of the cumbersome and short-lived Revolutionary calendar and confused the years IV and V. It seems more than likely that the date 1796 is correct and that the actor Brochard did sit for his portrait in Toulouse sometime during the three weeks following the artist's sixteenth birthday.

That the sitter *was* an actor, or at least an artist of some kind, is partially confirmed by the way he wears his shirt open at the neck. More definite proof is provided by a dictionary of eighteenth-century actors[3] that lists a number of Brochards, several of whom are known to have performed in the south of France, and by Ingres's second portrait of the same man in costume (cat. no. 16).

This medallion profile drawing of a man wearing classical armor is so unusual that, were it not for the signature, no one would have dreamed of attributing it to Ingres. For one thing, the background of the drawing is a solid ink wash instead of the complex hatching familiar from other Ingres works in this format. At some point the solid wash was marred—presumably by a drop of water—precisely in the area of the signature, and it was perhaps a retracing of the signature after that accident that makes it appear inauthentic. Yet the name can hardly have been added in an attempt to deceive, for in 1871, when the drawing

was purchased—presumably in its present condition—Ingres's youthful artistic endeavors were virtually unknown.

Nothing helps to establish the identity of a person so well as a strict profile view, and the similarity between the profile of the man in costume in cat. no. 16 and that of the actor Brochard is so striking that no one would deny that the sitters were one and the same. The undated drawing can only represent the "skillful interpreter of Molière" as he appeared in one of his roles, that of Amphitryon, for example.

H.N.

For the author's complete text, see Naef 1977–80, vol. 1 (1977), chap. 1 (pp. 41–44).
1. The original French is quoted in ibid., vol. 4 (1977), p. 26.
2. Fol. 22.
3. Fuchs 1944, pp. 28–29.

PROVENANCE: A. R. sale , Hôtel Drouot, Paris, June 6, 1883, no. 22 ("M. Brochard, habile interprète de Molière"); purchased at that sale for 160 francs by Roux; possibly in an unidentified auction, November 2, 1908, no. 302 (handwritten note on the back of the old mount: "N 302 / 2 Nov 08"); possibly Marius Paulme, Paris, before 1929 (stamp on the back of the old mount: "Catalogue Paulme / N° 46"; not included in the Paulme auctions of 1929 and 1949); Georges Dormeuil, until 1939; Mary and Charles Allan (according to a label dated 1949 on the mount); Galerie Heim, Paris, by 1967 at the latest; anonymous sale, Christie's, London, March 26, 1968, no. 137, not sold; Geoffrey Bennison, London, 1968; Robert M. Light, Santa Barbara, Calif.; the present owner

REFERENCES: Cambridge (Mass.) 1967, under no. 1, as *Brochard;* Mongan 1969, p. 137; Naef 1970 ("Profilbildnisse"), pp. 225–26, no. 6, p. 235, fig. 7, p. 228 (the back of the mount), fig. 8, p. 229 (sitter identified); Naef 1977–80, vol. 4 (1977), pp. 26–27, no. 11, ill.

16. Monsieur Brochard in Classical Costume

ca. 1796
Graphite and gray ink
Diameter 3 ¹¹/₁₆ in. (9.4 cm)
Signed in ink lower right (and apparently gone over in ink by another hand at a later date):
Ingres fils
Crocker Art Museum, Sacramento, California
E. B. Crocker Collection 1871.459

N 12

This drawing is discussed under cat. no. 15.

PROVENANCE: Purchased by Judge Edwin B. Crocker in Dresden or Munich, 1871; his widow, Margaret E. Rhodes Crocker; her gift to the city of Sacramento to establish the E. B. Crocker Art Gallery (now the Crocker Art Museum), Sacramento, Calif., 1885

EXHIBITIONS: Cambridge (Mass.) 1967, no. 1, ill., as *Head of a Warrior* (relationship with cat. no. 15 established); Sacramento 1971, no. 98; Reno 1978, no. 8; Long Beach 1978–79, no. 16; Sacramento 1989; Flint 1992, no. 69

REFERENCES: Mongan 1969, p. 137; Naef 1970 ("Profilbildnisse"), pp. 226–27, no. 7, p. 235, fig. 9 on p. 229 (identified on the basis of its relationship with cat. no. 15); Rosenberg 1970, p. 31; Naef 1977–80, vol. 4 (1977), pp. 28–29, no. 12, ill.

17. Portrait of a Man

July 3, 1797
Graphite
Diameter 3 in. (7.6 cm), framed
Signed center right: jngres.
Musée du Louvre, Paris
Département des Arts Graphiques RF 30743
New York only

N 13

This drawing is discussed under cat. no. 13.

PROVENANCE: David David-Weill (1871–1952), Neuilly, by 1928 at the latest; his gift to the Musée du Louvre, Paris, 1948

EXHIBITIONS: Toulouse, Montauban 1955, no. 77, as *Portrait de Joseph Ingres père;* Paris 1956–57, no. 99, as *Portrait de Jean-Marie-Joseph Ingres père*

REFERENCES: Henriot 1926–28, vol. 3, p. 257, ill. p. 259, as *Portrait d'homme;* Ternois 1959a, under no. 78; Cambridge (Mass.) 1967, under no. 2; Naef 1970 ("Profilbildnisse"), pp. 227–28, no. 8, p. 235, fig. 10, p. 231; Naef 1977–80, vol. 4 (1977), pp. 30–31, no. 13, ill.; Mongan 1996, under no. 206

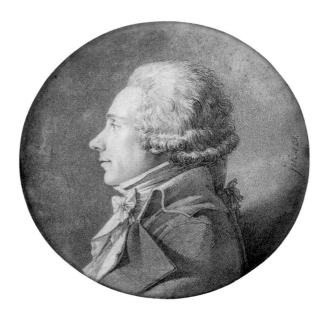

18. Portrait of a Man

ca. *1797*
Graphite
Diameter 3 in. (7.5 cm), framed
Signed center right: jngres
Ashmolean Museum, Oxford
The Visitors of the Ashmolean Museum, Oxford
1986.43
London only

N 14

This drawing is discussed under cat. no. 13.

PROVENANCE: David David-Weill (1871–1952), Neuilly, by 1928 at the latest; purchased from him by Wildenstein & Co., Inc., New York, 1935 ; purchased from them by Sir Charles Clore, London, 1961, until 1979; his posthumous sale, Sotheby's, London, March 17, 1986, no. 109; purchased at that sale by the Ashmolean Museum, Oxford

EXHIBITIONS: London 1961, no. 97, as *Presumed Portrait of a Legislator* (attributed to Ingres's father); Rome, Oxford 1991–92, no. 86, ill.

REFERENCES: Henriot 1926–28, vol. 3, p. 261, ill. p. 263, as *Portrait d'un legislateur*, "called a work by Jean-Marie-Joseph Ingres, but certainly by the same hand as [cat. no. 17]"; David-Weill Collection 1957, no. 97, as *Presumed Portrait of a Legislator* (attributed to Ingres's father); Cambridge (Mass.) 1967, under no. 2; Naef 1970 ("Profilbildnisse"), pp. 227–29, no. 9, p. 235, fig. 11, p. 231; Naef 1977–80, vol. 4 (1977), pp. 32–33, no. 14, ill.; *Annual Report of Ashmolean* 1986, pp. 28, 37; Mongan 1996, under no. 206

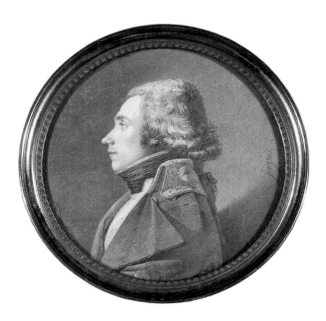

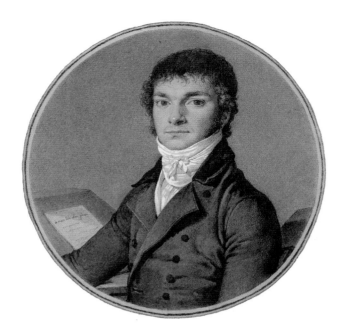

19. Pierre-Guillaume Cazeaux

1798
Black chalk, stumped, with white highlights
10 ¾ × 8 ¼ in. (27.4 × 21 cm) framed; diameter
of the shaded circle inside the two framing lines
7 in. (17.8 cm)
Inscribed on the sheet of paper on the lectern: á
mon trés cher pére. [to my very dear father.]
Private collection
New York and Washington only

N 23

At eighteen, after having studied in the
Paris atelier of Jacques-Louis David for a
year, Ingres drew this unsigned portrait of
the young Pierre-Guillaume Cazeaux.[1] It
is the first known work in which the young
artist's genius is demonstrated to perfection.

Cazeaux was born about 1776 in the
small town of Barbaste, in the south of
France, halfway between Bordeaux and
Toulouse and roughly sixty miles from
Ingres's hometown of Montauban.[2] It is
thought that his father and Ingres's father
were acquainted,[3] and it is possible that
the dedication on the sheet of paper seen
in the drawing was meant to allude to this.
The phrase may have been the title of an
epistolary poem, which would seem to be
consistent with Cazeaux's character, as
he is remembered in the family almost
exclusively for his artistic, ethical, and
philosophical interests.

Cazeaux was especially drawn to the
utopian teachings of Saint-Simon and, after
the social philosopher's death, he even
venerated the fanatical Barthélemy-Prosper
Enfantin as Saint-Simon's apostle. He
was also acquainted with the dramatist
Charles Duveyrier, one of Enfantin's
codefendants in the state's trial of the

Saint-Simonists in 1832. It is not known
whether Cazeaux adopted the sect's pecu-
liar style of dress or subscribed to its more
radical articles of faith—so titillating to the
public during the trial—such as the eman-
cipation of women and "rehabilitation of
the flesh." A letter written to his son-in-law
in 1839 does suggest that Cazeaux remained
true to certain of its ideals even after the
sect was disbanded.

In 1804, without in any way compromis-
ing his socialist convictions, Cazeaux mar-
ried an aristocratic Creole, Caroline Poirel
de la Tour. One of their sons, though
trained as an engineer, published treatises
on economics and philanthropy. Their
daughter Victorine married the attorney
and publicist Félix de Joncières, whose
son Victorin became a composer and music
critic. An older daughter, Anaïs, became
the wife of the politician and publicist
Adolphe Guéroult, who began his long
career as a passionate Saint-Simonist. A
third daughter, Hortense, remained unmar-
ried and essentially devoted her life to
keeping house for her parents.

Family tradition has it that Cazeaux and
his daughter Hortense served as the models
for the father and young girl who appear

in the opening pages of Honoré de Balzac's *La Femme de trente ans*, although their domestic situation hardly accords with the one described in the novel. It is quite possible that Cazeaux was acquainted with Balzac, however, as that writer was drawn to the notions of Saint-Simon. Cazeaux is also said to have been a friend of Jacques-Louis David, possibly thanks to Ingres. David is supposed to have painted for his young admirer a copy of his early self-portrait that was still in the family well into the present century.[4]

If more is known about Cazeaux's acquaintanceship and character than about his career, it is because he apparently failed to achieve any particular worldly success. He was in the shipping business, and for that reason lived for a time in Bordeaux. Large monetary losses, probably resulting from misguided speculations, forced him to end his days as a minor civil servant in the provinces. He died in Pavilly, some twelve miles outside Rouen, in 1850.

H.N.

For the author's complete text, see Naef 1977–80, vol. 1 (1977), chap. 5 (pp. 81–83).

1. In Galichon 1861b, which was published during Ingres's lifetime, the work is dated 1798, and the clothing would seem to confirm that date.
2. The author is indebted to Mademoiselle S. de Joncières, the subject's great-great-granddaughter, for information about his life.
3. Lapauze (1911a, p. 10) reproduces among the works of Ingres's father the medallion portrait of an unknown man whose features re strikingly similar to those of Pierre-Guillaume Cazeaux; Mademoiselle S. de Joncières (see n. 2, above) suggests that it may well be a portrait of Cazeaux's father.

4. Sold Sotheby's, London, December 6, 1967, no. 88, ill.

PROVENANCE: Pierre-Guillaume Cazeaux, Pavilly, until 1850; Mlle Hortense Cazeaux, his daughter (died April 1903); given or bequeathed by her to her nephew Paul Guéroult, April 22, 1884; by inheritance (in accordance with the wishes of his aunt Hortense Cazeaux) to his first cousin Victorin de Joncières, until October 1903; Léonce de Joncières, his son, until 1952; Mlle S. de Joncières, his niece; Dr. Rudolf J. Heinemann, New York, from 1964 to 1975; his widow until 1996; private collection

EXHIBITIONS: Paris 1861 (2nd ser.); Paris 1905, no. 37; Paris 1911, no. 71; New York 1973, no. 16, ill.

REFERENCES: Galichon 1861b, p. 46; Delaborde 1870, no. 268; Lapauze 1911a, ill. p. 29; Naef 1977–80, vol. 4 (1977), pp. 40–41, no. 23, ill.

20. Barbara Bansi

ca. 1797
Black chalk, stumped, with white highlights
21¾ × 15⅞ in. (55.4 × 40.5 cm), framed
Signed bottom right: jngres. eleve de David
[Ingres. Pupil of David]
At lower left, the Musée du Louvre, Paris, collection stamp (Lugt 1886a)
Musée du Louvre, Paris
Département des Arts Graphiques RF 31287
London only

N 26

In 1847, when Ingres began a list of his works, the only portrait drawings he recalled from the period before 1806 were one of Madame Delannoy, the famous group portrait of the Forestier family (cat. no. 23), and this drawing of the young painter Barbara Bansi.[1] Picturing it to himself nearly half a century later, he described it in his list as a watercolor,[2] and it is easy to see why. Although the work was executed with a stick of black chalk rather than a brush, the drapery and especially the sculptured balustrade on which Mademoiselle Bansi is seated are so exquisitely shaded that they give the appearance of painting in grisaille. The drawing is undated; however, the signature—"jngres. eleve de David"—places it sometime before the fall of 1801. That was the year he won the Prix de Rome, and after that triumph it is unlikely that he would have signed himself as a stu-dent. The young woman's gown seems to reflect the fashion of about 1799, when she would have been twenty-two. The background landscape seems more reminiscent of Italy than of the Île de France. It is possible that the artist added the background after he had come to know Italy, yet his earliest views of Rome have a very different look. In the sky one can see a parachute and what appears to be a montgolfier, or hot-air balloon, that has careened out of control. Owing to the latter detail, the sitter was long identified in the Ingres literature as "Mademoiselle de Montgolfier." That she is in fact Barbara Bansi is confirmed by a relief portrait of her executed in 1810.[3]

Bansi appears to have been every bit the free spirit Ingres portrayed in his drawing. Most of what we know of her comes from a biography of the Zurich philanthropist and dreamer Johann Caspar Schweizer,[4]

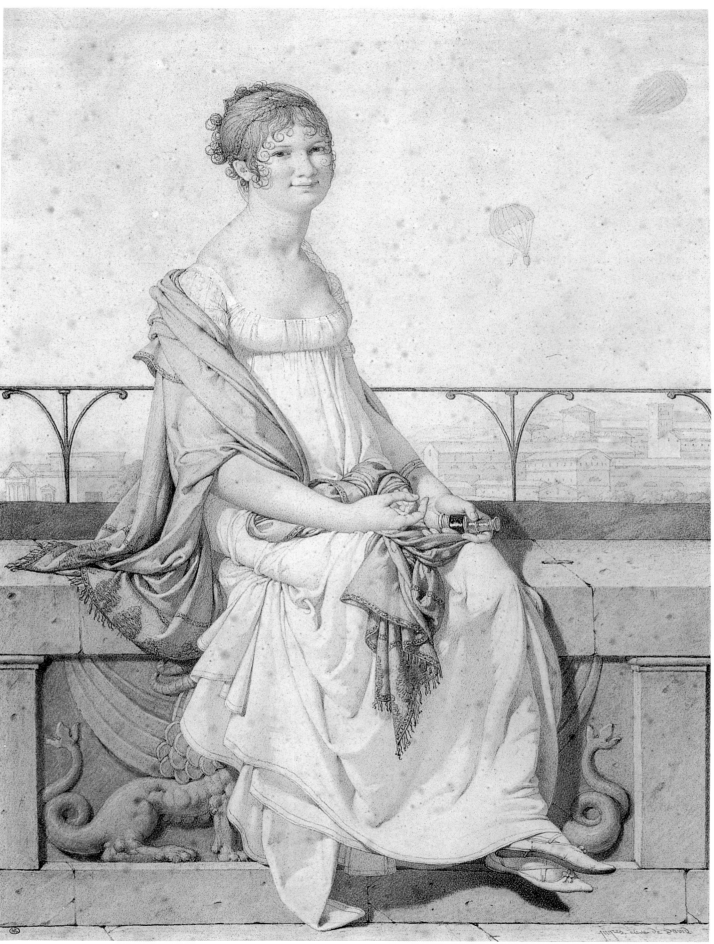

who adopted her in 1783, when she was six years old. Her father, the Swiss pastor Heinrich Bansi, gladly surrendered her to Schweizer and his wife, calculating that she would not only be raised in luxury but would ultimately inherit a fortune. Barbara was a quick child and no doubt talented, but ill-behaved and deceitful. She was as manipulative as her father and soon proved to be unmanageable.

In 1786 Schweizer moved his household to Paris, where he entertained lavishly and fell prey to promoters of all manner of fraudulent schemes. In 1794, close to bankruptcy, he set out for America, commissioned to collect certain state debts and set up trading relations with the New World. Barbara, by now a proper hellion whose only interests were her art studies and her liaisons with artists—François Gérard is said to have been one of her lovers—was left at a boarding school in Revolutionary Paris. In 1795 her father, horrified by her behavior and furious that the Schweizer money had slipped from their grasp, tried to take her back to Switzerland, but she refused to go. By the time Schweizer returned in 1801, Barbara could only treat him with scorn.

In 1802 she set out for Italy, where she became a Catholic and may have traveled in the retinue of Napoleon's mother. In 1804 she lived for a time at the Villa Medici in Rome, and is reported to have had an affair with its director, Joseph-Benoît Suvée.[5] By 1808 she had landed in Florence, for in that year she married the highly respected and much older physician Lorenzo Nannoni. The unlikely pair became estranged in 1811 and Nannoni died in 1812. Two years later Bansi returned to Paris, where she found employment as a teacher of drawing, first in the royal institute for young noblewomen at Saint-Denis and later at Sainte-Clotilde. She died in Paris in 1863.

In 1855 this drawing was photoengraved by Dujardin, using the heliogravure process. H.N.

TRANSLATOR'S NOTE: The first public demonstration of the parachute was staged in Paris by André-Jacques Garnerin on October 22, 1797—the only time during the turn-of-the-century period when such a device was seen in the skies over the capital. That day Garnerin ascended in a hot-air balloon from the Parc Monceau and on reaching an altitude between 2,000 and 3,000 feet he opened the parachute and floated to the ground. Relieved of the weight of man and equipment, the balloon then rose very rapidly until it burst. Since Bansi holds a spyglass in her left hand, it is likely that Ingres's portrait records this specific event. It is easy to imagine the two young artists deciding to make a day of it, arming themselves with a spyglass and drawing materials, and setting off for some height—most probably Montmartre—from which they could look out over the Parc Monceau. The demonstration took place only two and a half months after Ingres's arrival in Paris; being able to sign himself as a student of David would have been something still quite new to him and a source of pride.

For the author's complete text, see Naef 1977–80, vol. 1 (1977), chap. 7 (pp. 87–102).

1. Inscribed in an unknown hand on the back of the former mount of this drawing is the following notation: "Ce dessin de M. Ingres a été donné en cadeau à son élève Mme la Marquise de Lannoy à son retour [1824] de Rome." ("This drawing by M. Ingres was given as a present to his pupil Mme la marquise de Lannoy upon his return [1824] from Rome.")

2. The portrait of Bansi is listed in Ingres's Notebook X, fol. 22, among those works he produced in Paris between 1797 and 1806 ("m^lle Bansi aquarelle").

3. Executed in Florence by Luigi Pampaloni. See Naef 1977–80, vol. 1 (1977), p. 90, fig. 2.

4. See Hess 1884.

5. Guillaume Guillon Lethière to M. Le Breton, April 12, 1808, quoted in Lapauze 1924, vol. 2, pp. 84–85; reprinted in Naef 1977–80, vol. 1 (1977), p. 97.

PROVENANCE: Perhaps presented by the artist after his return from Italy in 1824 to his pupil Mme la marquise de Lannoy; Adolphe Moreau, Paris, by 1858 at the latest; Alfred Stevens, before 1884;* Albert Goupil, Paris, by 1884 at the latest; his sale, Hôtel Drouot, Paris, April 23–27, 1888, no. 336; sold for 2,700 francs to Louis Lefebvre de Viefville; his daughter Mlle S. Lefebvre de Viefville, Paris; her bequest to the Musée du Louvre, Paris, 1961

EXHIBITIONS: Paris 1862 (according to Goncourt 1956–58 and Silvestre 1862); Paris 1884, no. 395, as *Mlle de Montgolfier;* Paris 1967–68, no. 3, ill.; London 1972, no. 649, pl. 85, as *Portrait of a Woman*

REFERENCES: Saglio 1857, p. 76, as *Mlle Bansi* (known from the list of works in Ingres's Notebook X); Feydeau 1858, pp. 297–98 (correct description of the drawing but the subject is inexplicably called an "old woman"); Silvestre 1862, p. 8, as *La Dame à la Montgolfière (Lady with the Balloon);* Delaborde 1870, no. 255, as *Mademoiselle Bansi* (catalogued from the list of works in Notebook X); *Gazette des beaux-arts* 1885, ill. opp. p. 226, as *Mlle de Montgolfier* (the heliogravure by Dujardin); Molinier 1885, p. 388, as *Mlle de Montgolfier;* Muther 1893–94, vol. 1, ill. p. 328, as *Mlle de Montgolfier* (the heliogravure by Dujardin); Lapauze 1901, p. 247, "Mlle Bausi, watercolor" (incorrectly cited from the list of works in Notebook X); Lapauze 1911a, p. 34, n. 2, as *Mlle de Montgolfier* (cited from Silvestre 1862), p. 60, "Mlle Bauri, watercolor" (incorrectly cited from the list of works in Notebook X), p. 75, as *Mlle Bansi* (cited from the list of works in Notebook X), ill. p. 89, as *Mme de Montgolfier* (the heliogravure); Lapauze 1911b, p. 48, ill. p. 33, as *Mme de Montgolfier* (the heliogravure); Saunier 1911, ill. p. 4, as *Mme de Montgolfier* (the heliogravure); Fischel and Boehn 1925a, vol. 1, ill. p. 119, as *Mlle de Montgolfier;* Goncourt 1956–58, vol. 5, p. 107, entry for May 4, 1862;† Anon., June 1, 1958, p. 10; Wiekenberg 1958, p. 18; Naef 1961 ("Schweizer Künstler II"), pp. 5, 7, ill. (sitter identified); Naef 1963 (*Schweizer Künstler*), pp. 7–24, 77–78, no. 1, p. 97, ill. on the book jacket (detail) and on frontis.; Levey 1968, pp. 46–47; Cambridge (Mass.) 1973, p. 24, n. 38, fig. 15; Delpierre 1975, p. 25; Naef 1977–80, vol. 4 (1977), pp. 46–48, no. 26, ill.; Ternois 1980, p. 18; Toussaint in *Actes du Colloque international: Ingres et son influence,* Montauban, septembre 1980, pp. 157–64, 170

*According to a handwritten note in a catalogue of the Albert Goupil auction, Paris, April 23–27, 1888, it was "sold several years ago for 500 francs by Alf. Stevens"; quoted in Naef 1977–80, vol. 1 (1977), p. 48.

†"a portrait of a woman of the Empire period, in chalk, wearing a low-cut dress, her nipples practically knotted around her navel—a fabulously imbecilic and comical drawing" ("un portrait de femme de l'Empire, au crayon, décolletée, les tétons à peu noués au nombril, — un dessin fabuleux d'imbécillité et de comique").

21. Jean-Charles-Auguste Simon

September 23, 1802–September 23, 1803
Black chalk, stumped, with white highlights
16 ¹⁄₁₆ × 14 ¹⁄₄ in. (40.8 × 35.9 cm), framed
Signed and dated lower right: jngres fa / an II
[Ingres made (this) / (Revolutionary) Year 11]
Musée des Beaux-Arts, Orléans 791
New York only

N 30

Jean-Charles-Auguste Simon was the subject of two of the very few known portrait drawings dating from Ingres's first Paris period. They were both left to the Musée des Beaux-Arts, Orléans, by the subject's grand-nephew Hector Delzons, and in the same bequest there is a painted portrait of Simon by Ingres's friend Jean-Pierre Granger.

Simon was born in Paris in 1776, the son of a parliamentary lawyer.[1] The death certificate of his first wife, dated 1828, identifies Simon himself as vice administrator of the collection of indirect taxes.[2] He married again at the age of fifty-nine and died, at sixty-seven, in 1843. His own death certificate identifies him as a man of private means, and his widow was left an estate valued at 10,400 francs.[3]

Nothing in the archives suggests how the young Simon might have met Ingres and become the subject of a portrait by him. Nevertheless, a look at his family tree reveals that Simon was related to a number of prominent artists. His maternal grandfather was the architect Jean-Michel Chevotet (1698–1772), designer of several châteaux (Petit-Bourg, Mareil, Champ-lâtreux, and Arnouville), and also of the Pavillon d'Hanovre, built for Richelieu and now in the park at Sceaux. Chevotet's brother-in-law was the portraitist Jean Valade (1709–1787), a Painter to the King who is remembered primarily for his pastels. One of Chevotet's daughters—that is to say, an aunt of Simon—was married to an Architect to the King, Jean-Baptiste Chaussard (1729–1818). Delzons's bequest to the Musée des Beaux-Arts, Orléans, also included works by Valade and portraits of Chevotet and his wife by Jean-Baptiste Perronneau.

It is also interesting that the art critic Pierre-Jean-Baptiste Chaussard was a son of the architect Chaussard and therefore Simon's cousin. Under the name Publicola, the younger Chaussard wrote a whole book on the 1806 Salon in which he savagely dismissed the work of Ingres.[4]

Another man named Simon is mentioned in Ingres's letters to the Forestier family (see cat. no. 23), which were written only months after he had executed the second of the two portraits.[5] Clearly, that Simon had something to do with painting supplies, and perhaps he was the art supplier and framer named on a label attached to the old mount of the 1806 portrait. Although it is tempting to think that this man could have been the sitter for these portraits, it is difficult to reconcile his occupation with that of a tax collector. Of course the two men could have been related. As noted above, the sitter's father was a lawyer, and since the father of Ingres's fiancée, Marie-Anne-Julie Forestier, also moved in judicial circles, it is conceivable that the artist met the subject of the two portraits at the Forestiers'.

The two Simon portraits, extremely different in format and execution, are important landmarks in Ingres's portrait oeuvre. The earlier one (cat. no. 21), nearly life-size, has the impact of a painting, even though it was produced with a stick of chalk on paper. It is the last dated masterwork Ingres brought to perfection while still under the influence of his great teacher, Jacques-Louis David. In it, the artist's own personal genius and a school style more imposing than the one he himself would later represent are admirably blended.

The smaller Simon portrait (cat. no. 24) was executed in pencil three or four years later (and lithographed at some unknown date by an anonymous artist). It is the work of a beginner, in the sense that Ingres had now set himself on a course that would produce the greatest portrait work of the century and some of the most memorable likenesses of all time. The artist drew Simon shortly before leaving for Rome in September 1806, and in what little was left of that year he made incredible advances that would culminate in his Roman pencil portraits. The Simon portrait was soon surpassed, but it marks the beginning of a tremendous series of works, extending across the artist's entire career. In them, the form Ingres developed early in his life never slipped below the level of vitality that distinguishes style from mere mannerism.

H . N .

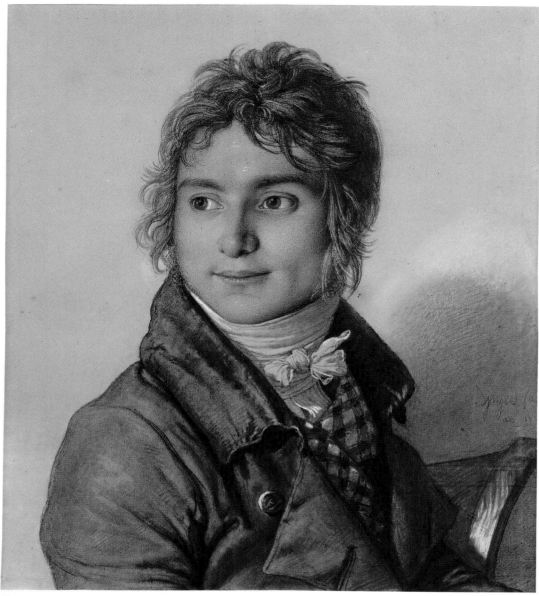

21

EDITOR'S NOTE: Georges Vigne (Vigne 1995b, p. 25) follows Hélène Toussaint (Sydney, Melbourne 1980–81, no. 78) in reading the date on this portrait as "An II" or 1793–94, rather than "An 11," or 1803–4, because "the Revolutionary calendar never used arabic numerals." Toussaint's suggestion was contested by Jacques Foucart (1982, p. 90). The conception and execution of this superb drawing seem too precocious for Ingres at such an early date, and it is difficult to be categorical as to whether the sitter looks seventeen or twenty-seven years old. Naef's date of 1802–3 is therefore retained in this catalogue.

For the author's complete text, see Naef 1977–80, vol. 1 (1977), chap. 10 (pp. 119–23).

1. "Avocat au parlement." Baptismal register, Saint-Germain-l'Auxerrois, Paris, Archives de Paris; quoted in Naef 1977–80, vol. 1 (1977), p. 120.

2. "Sous-chef à l'administration des contributions indirectes." Registry-office notice, Archives de Paris; quoted in Naef 1977–80, vol. 1 (1977), p. 120.

3. Ibid.

4. Chaussard 1806, pp. 178, 181.

5. Lapauze 1910, pp. 31, 75, 95, 97, 126.

PROVENANCE: Jean-Charles-Auguste Simon (1776–1843), Paris; his sister Mme Jacques Ansillion, née Louise-Adélaïde Simon, Fontainebleau, until 1849; Mme Alexis-Octave Delzons, née Adélaïde Ansillion, her daughter; Marie-Jacques-Hector Delzons, her son, Orléans; his bequest to the Musée des Beaux-Arts, Orléans, 1895

EXHIBITIONS: Paris 1900a, no. 1067; Paris 1911, no. 72; Paris 1921, no. 56; Paris 1933b, no. 160, ill.; Brussels, Rotterdam, Paris 1949–50, no. 128; Toulouse, Montauban 1955, no. 93; Hamburg, Cologne, Stuttgart 1958, no. 123; Copenhagen 1960, no. 66, ill.; Warsaw 1962, no. 28, ill.; Montauban 1967, no. 9 bis; Paris 1967–68, no. 7, ill. (sitter identified); London 1972, no. 651, pl. 81; Sydney, Melbourne 1980–81, no. 78; Tübingen, Brussels 1986, no. 1; Kamakura, Tochigi, Ibaraki, Tokyo 1990, no. 87.

REFERENCES: Tourneux 1900, ill. p. 472; Lafond 1906, p. 105; Lapauze 1911a, ill. p. 31; Saunier 1911, ill. p. 10; Ratouis de Limay 1920, p. 107, ill. p. 111; *La Renaissance de l'art français* 1921, ill. p. 194; Vitry 1922, ill. p. 54; Cassou 1936, ill. p. 157; Bouchot-Saupique 1949, p. 437; Lugt 1956, p. 289; Auzas 1958, p. 11, ill.; *Trésors des musées de province* 1958, p. 77, ill.; Sérullaz 1967, p. 210; Naef 1972 ("Révoil"), p. 5; Cambridge (Mass.) 1973, pp. 22, 24, fig. 14; Paris, Detroit, New York 1974–75, p. 153 (French ed.); Delpierre 1975, p. 23; Naef 1977–80, vol. 4 (1977), pp. 54–55, no. 30, ill.; Vigne 1995b, p. 25, fig. 6

22. Henriette Harvey and Her Half Sister, Elizabeth Norton

1804
Gray watercolor and graphite on paper with the
upper corners cut off
11 × 7 1/4 in. (28 × 18.3 cm)
Signed and dated bottom right: Ingres 1804
Inscribed top right: M^elles *harvey*
At bottom right, the collection stamp of Édouard
Gatteaux (Lugt 852); at lower left, the Musée du
Louvre, Paris, collection stamp (Lugt 1886a)
Musée du Louvre, Paris
Département des Arts Graphiques RF 12293
Washington only

N 31

Ingres's depiction of the Misses Harvey and Norton is his only known portrait drawing executed in watercolor with a brush. It appears to be not so much a portrait, in fact, as a swiftly executed impression or preliminary study, and we know from entries in his notebooks that Ingres also produced oil portraits of these young women that have either disappeared or been destroyed.[1] On the back of the sheet there is a superb drawing by the artist of the head of a third young woman (N 32). The ink signature and inscription, which seem to be in the handwriting of Ingres at a later time in his life, were probably added when he presented the work to his friend Édouard Gatteaux. The sheet has since been trimmed; what remains of an additional inscription on the back appears to identify the subject of that drawing as the young women's maid.

Ingres was perfectly correct in identifying the pair as the Misses Harvey, for that is what they called themselves at the time he drew them. As it happens, only the older one, Henriette, bore that name. The daughter of John Harvey and his wife, Elisabeth, née Hill, she had been born in London about 1774. Elizabeth Norton[2] was the illegitimate daughter of the same Elisabeth Harvey, born near Guildford, in Surrey, in 1778. At her baptism, in 1779, she was given the surname of her then-unmarried father, William Norton, later the second Lord Grantley and British ambassador to Switzerland. Mrs. Harvey took the young half sisters to Italy for a number of years, and then—by 1802 at the latest—settled in Paris, first in the city itself and later in the southern suburb of Fontenay-aux-Roses. Her circle of acquaintances included the painter François Gérard, the actor François-Joseph Talma, the poet Jean-François Ducis, and Jacques-Henri Bernardin de Saint-Pierre, author of the romance *Paul et Virginie*.[3]

Very little is known about Henriette Harvey. An artist, like her half sister, she seems to have limited her endeavors to landscapes in gouache and copies on porcelain after old-master paintings. She never married, and died in 1852, leaving her estate to Elizabeth.[4] An anecdote included in the memoirs of the poet Auguste Barbier suggests that he saw Ingres, along with various other prominent gentlemen, at the home of Miss Harvey in 1844.[5] Her death certificate records that she lived at 9, rue de Lille. Ingres lived down the street at number 49.

Elizabeth was more ambitious. A pupil of Gérard, she showed her paintings at the Salon nearly every other year between 1802 and 1812. Her most successful work was a group portrait of the author of *Paul et Virginie* with his family.[6] She also produced narrative paintings illustrating scenes from Ossian, one of which is owned by the Musée des Arts Décoratifs in Paris. She seems to have abandoned painting before she married, in 1818, a widowed young nobleman and father of two. Her husband, Étienne-Babolin Randon de Pully, was born in 1774 and had been a military man like his father, Lieutenant-Général Baron de Pully. The couple first lived on their estate in Eragny, near Pontoise, and then about 1830 moved to Château Puygirault, some thirty miles east of Poitiers. Randon de Pully died there in 1853, Elizabeth in 1858. Through their son, William-Enguerrand, some thirty works by the two sisters have been passed down in the family and in 1969 were owned by a distant relative, Henry de Lanauze-Molines. Portraits in his collection by Elizabeth of herself and her half sister suggest that the seemingly more dominant, dark-haired young woman in Ingres's portrait drawing is Elizabeth and that the more passive blonde is Henriette.

H . N .

For the author's complete text, see Naef 1977–80, vol. 1 (1977), chap. 9 (pp. 106–18).

1. Notebook IX, fol. 66, and Notebook X, fol. 22.
2. The younger woman spelled her own first name with a ʒ.
3. Ducis 1879, pp. 166, 187–88, 190, 200–201, 204–5, 212–13, 232.

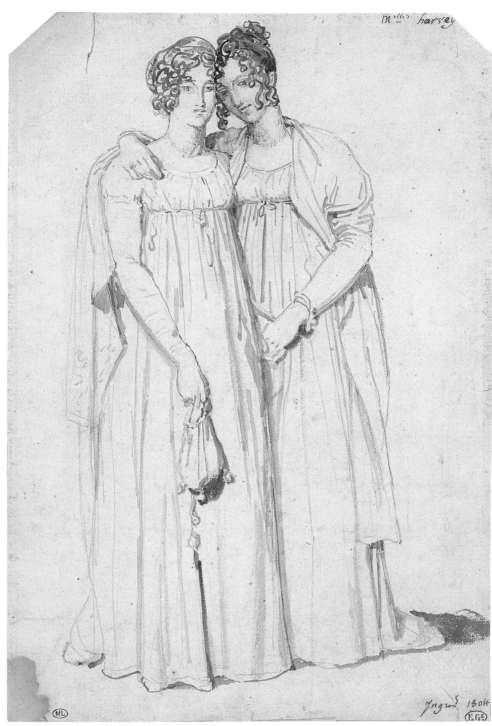

22

4. Archives de Paris.

5. Barbier 1883, p. 273.

6. According to the *livret,* the portrait was exhibited at the Salon of 1804.

PROVENANCE: Probably the artist's gift to Édouard Gatteaux, Paris, until 1881; Jules Claretie, Paris, by 1903, at the latest; his sale, Hôtel Drouot, Paris, May 8, 1914, no. 98, sold for 1,400 francs; Henry Lapauze (1867–1925); his posthumous sale, Hôtel Drouot, Paris, June 21, 1929, no. 30; acquired at that sale for 52,000 francs by the Musée du Louvre, Paris

EXHIBITIONS: Paris 1933a, no. 192; Paris 1935a, no. 87 [EB]; Brussels 1936, no. 2, ill.; Zurich 1937, no. 207, pl. VIII; Toulouse, Montauban 1955, no. 95; Montauban 1967, no. 10; Paris 1967–68, no. 9, ill.; London 1972, no. 652

REFERENCES: Lapauze 1903, no. 35, ill., as *M^{lle} Hervey;* Lapauze 1911a, pp. 39–40, ill. p. 45; *La Renaissance de l'art français* 1921, ill. p. 199; Hourticq 1928, pl. 6; Huyghe 1929, p. 6, ill. p. 5; Alazard 1942, no. 1, ill.; Alazard 1950, p. 26, n. 6, p. 143, pl. IV; Elgar 1951, fig. 2; Wildenstein 1954, p. 170, pl. 11; Mathey 1955, no. 1, ill.; Chicago, Minneapolis, Detroit, San Francisco 1955–56, under no. 101; Boggs 1962, p. 17, n. 89, p. 90; Garrisson 1966, p. 19, n. 8; Cambridge (Mass.) 1967, under no. 4; Naef 1967 ("Demoiselles Harvey"), pp. 7–9, cover ill.; Sérullaz 1967, p. 210; Hoetink 1968, under no. 155; Naef 1968 ("Demoiselles Harvey"), pp. 39–43; Radius and Camesasca 1968, p. 89, ill.; Ternois 1969, p. 207, n. 102; Naef 1971 ("Harvey and Norton"), pp. 79–89, fig. 14, (sitters identified); Ternois and Camesasca 1971, p. 89, ill.; Delpierre 1975, p. 21; Naef 1977–80, vol. 4 (1977), pp. 56–57, no. 31, ill.

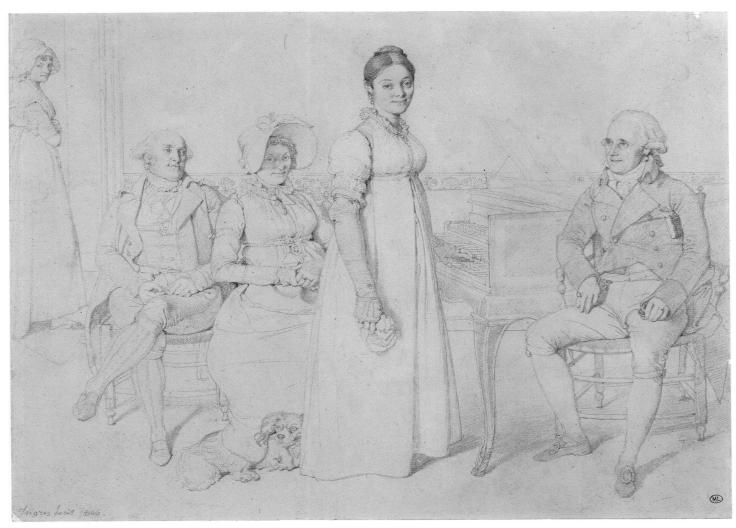

23

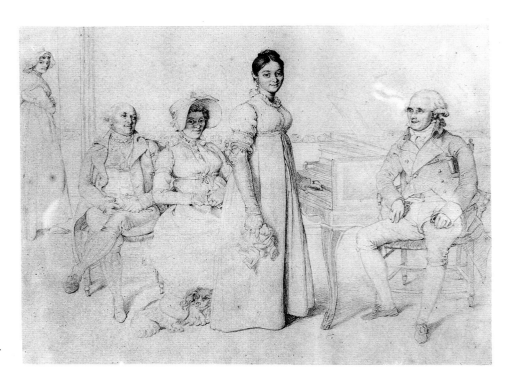

Fig. 77. *The Forestier Family*, n.d. (N 34).
Graphite on paper, 9 ½ × 12 ¾ in. (24.1 × 32.5 cm).
Musée Ingres, Montauban (867.2653)

23. The Forestier Family

1806
Graphite
9 ⅛ × 12 ½ in. (23.3 × 31.9 cm)
Signed and dated lower left: Ingres fecit 1806
[Ingres made (this) 1806]
At lower right, the Musée du Louvre, Paris,
collection stamp (Lugt 1886a)
Musée du Louvre, Paris
Département des Arts Graphiques RF 1450
Washington only

N.33

The central figure in Ingres's incomparable group portrait of the Forestier family is Marie-Anne-Julie Forestier, the young woman to whom the portraitist became engaged before his departure for Italy in 1806. Her father and mother are seated to her left and right. The other two figures are presumed to be her mother's brother and the family maid, Clotilde.[1] Julie was a painter, and Ingres had doubtless come to know her in art circles. She played the clavier as well, so they also shared a love of music. She had introduced Ingres to her family at least by 1804, for when his father visited him that year he was entertained at the Forestiers'. To Ingres, living in somewhat disreputable circumstances while waiting to receive the scholarship awarded him as the 1801 winner of the Prix de Rome, her home must have seemed a haven of order and bourgeois respectability.

The head of the house, Charles-Pierre-Michel Forestier, in his early sixties at the time Ingres portrayed him, was a jurist. Ingres identified Forestier as a former judge in Paris.[2] His wife, born Marie-Jeanne-Julie Sallé, was the daughter of a respected legal scholar and writer. Their daughter Julie was born in 1782. A pupil of Jean-Baptiste Debret—Henry Lapauze tells us she also studied under Jacques-Louis David[3]—she first exhibited at the Salon of 1804. She was twenty-four when, sometime between June and September 1806, she became engaged to Ingres. By that time Ingres had been informed that he could finally draw on his scholarship, and he was scheduled to leave for Rome in the late fall. Part of the agreement with his future in-laws was that he would spend only a year at the Villa Medici, not the four awarded him, then return to Paris and set up his own household.

But the Ingres who arrived in Rome in early October was no longer the self-confident young artist who had set out from Paris in late September. Along the way, he learned that critics had been virtually unanimous in their condemnation of the paintings he had submitted to the Salon, the best works he had produced up to that time. His letters to the Forestiers during the next several months show that he was deeply shaken and uncertain about his future. He felt he could not return to Paris until he had painted the narrative masterpiece that would establish his reputation. He also resented the tone of condescension in Monsieur Forestier's replies, even when he tried to seem consoling. Moreover, Ingres was unconsciously falling under the spell of a rival; increasingly, his letters catalogue the seductive charms of Rome. His last letter to the Forestiers, of August 1807,[4] was obviously written by a man in great turmoil. In it he painted himself as doomed to suffer and bound to cause suffering to those dear to him. Without renouncing Julie in so many words, he made it clear that he wished to be free. There was no reply.

Ingres would stay on in Rome for more than a decade, and in time he put the whole affair behind him. Julie never did: it became the defining misfortune of her life. She never married, and sometime after 1824, when Ingres was suddenly catapulted to fame, she wrote a roman à clef about the episode, *Emma, ou la fiancée.*[5] The manuscript, which she had the good taste not to publish, was discovered early in our own century, along with Ingres's carefully preserved letters from Rome, in the possession of Ingres's nephew Fernand Guille.[6] The work, filled with distortions of fact and motive, reveals that she never did comprehend the depth of the artist's despair following his critical rejection in 1806. Still, there are passages that ring true; the mother in the story, for example, is fully aware that many of her husband's comments in his letters to the absent fiancé were bound to hurt him.

Julie continued to paint, exhibiting her work off and on at the Salon until 1819. Too little of it has been identified to permit any judgment of her abilities. Her father suffered some sort of paralysis in 1812 and was granted a pension, but it is not known just when he died. He was still living when her mother died, in 1815. By the early 1820s Julie's situation appears to

have been desperate, for several letters survive in which she begs officials of the royal household to purchase paintings—in two cases, copies after Raphael. She is last mentioned in an almanac of French artists for 1836.[7] Lapauze relates that she ran an atelier for young women[8] and lived to an advanced age,[9] but there are no documents to confirm his claims.

The Forestier portrait, which is included in the list of works in the artist's Notebook X,[10] survives in three versions: this drawing in the Louvre, dated 1806; an undated copy that once belonged to Lapauze, now in the Musée Ingres, Montauban (fig. 77); and a tracing, dated 1804, in the Fogg Art Museum, Cambridge, Massachusetts (fig. 76). How they relate to one another is uncertain. The discrepancy in dating appears to be an instance of the artist's poor memory in his later years, for analysis of the signatures indicates that they were added long after the drawing was made. Only in the Louvre version, which is undoubtedly the original, do the faces show the spontaneity typical of Ingres's drawings from life. The version in the Musée Ingres appears to be a copy produced at an early date by another artist, possibly Julie Forestier. The tracing, definitely the work of Ingres himself, must have been executed shortly before 1851, in anticipation of the Ingres monograph to be published that year, with the artist's collaboration, by his pupil Albert Magimel, for in that work it is reproduced in a crude line engraving.[11] When making the tracing from the Louvre drawing, Ingres introduced several changes. He lessened the distance between Julie and her father, added more space between her and her mother, and slightly elongated the figures. He also reduced the size of the handkerchief Julie holds in her right hand—an improvement he felt obliged to make in the original as well, for there it is apparent that he erased the handkerchief and redrew it.

H.N.

For the author's complete text, see Naef 1977–80, vol. 1 (1977), chap. 11 (pp. 124–43).

1. Lapauze 1910, pp. 37, 76, n. 1; and Lapauze 1911a, p. 60.
2. An inscription in Ingres's hand on the traced version of the portrait (fig. 76) reads: "ancien juge de Saint-Nicolas à Paris." Naef 1977–80, vol. 1 (1977), p. 125.
3. Lapauze 1911a, p. 60.
4. Ingres to Pierre Forestier, August 8, 1807, quoted in Lapauze 1910, pp. 177–88.
5. Printed in full in Lapauze 1910, pp. 199–242.
6. Ibid., p. 241, n. 1.
7. Guyot de Fère 1836, p. 96.
8. Lapauze 1910, p. 166, n. 1.
9. Ibid., p. 197.
10. Fol. 22. See Lapauze 1901. The portrait may be mentioned in letters from the artist in Rome to Julie Forestier dated October 19, 1806, and February 20, 1807; see Lapauze 1910, pp. 38, 112.
11. Magimel 1851, no. 5.

PROVENANCE: Presented by the artist to his fiancée, Julie Forestier, in 1806 (according to Henry Lapauze);* returned by her to Ingres after August 1807 (according to Lapauze);† presented no earlier than 1824 by Ingres to Louis-Joseph-Auguste Coutan, Paris, until 1830; his widow, née Lucienne Hauguet, Rouen, until 1838; Ferdinand Hauguet, her brother, Paris, until 1860; his widow, née Jane Lucy Agnes Cole Martin, Paris, until 1869; their son Albert Hauguet, Antibes, until January 1883; his widow, née Marie-Thérèse Schubert, Antibes, March 1883; her father, Jean Schubert, and her sister, Mme Gustave Milliet, née Henriette Schubert; their gift to the Musée du Louvre, Paris, 1883

EXHIBITIONS: Paris 1861 (1st ser.), no. 54; Paris 1867, no. 337; Paris 1934c, no. 91; Venice 1934, no. 197; Basel 1935, no. 2, ill.; Brussels 1936, no. 3; Zurich 1937, no. 208, pl. IX; Paris 1954, no. 7; Paris 1962, no. 108; Montauban 1967, no. 17, fig. 3; Paris 1967–68, no. 19; Vienna 1976–77, no. 3, ill.

REFERENCES: Magimel 1851, no. 5 (illustration based on the tracing by Ingres); Silvestre 1856, pp. 6 (unless the tracing is meant), 36; Gautier 1857, p. 5; Saglio 1857, p. 76; Blanc 1861, p. 191; Delaborde 1861, p. 267; Galichon 1861a, p. 358; Merson and Bellier de la Chavignerie 1867, pp. 13, 81; Blanc 1870, pp. 8 (unless the tracing is meant), 43, 96, 236; Delaborde 1870, no. 301; Gatteaux 1873 (2nd. ser.), no. 107, ill.; Montrosier 1882, p. 11; Chennevières 1882–83, vol. 2, p. [72]; Chennevières 1883, p. 359; Both de Tauzia 1888, p. 141, no. 2124; Chennevières 1889, p. 60; Mabilleau 1894, p. 184; Leroi 1894–1900b, p. 838, ill. p. 837; Paris, Musée du Louvre 1900, no. 2124; Lapauze 1901, p. 247 (cited from the list of works in Ingres's Notebook X); Chennevières 1903, p. 133; Lapauze 1903, pp. 10–12, no. 20, ill.; Momméja 1904, p. 37, ill. p. 21; Alexandre 1905, pl. 10; Doucet 1906, p. 118; Wyzewa 1907, p. 5; Lapauze 1910, p. 16, n. 1, pp. 37, 38(?), 76, n. 1, p. 112 (?), n. 1, ill. opp. p. 112; Guiffrey and Marcel 1911, vol. 6, no. 5040, ill. p. 125; Lapauze 1911a, pp. 60, 182, 285, n. 1; Lapauze 1918, p. 350; Fröhlich-Bum 1924, p. 11, pl. 7; Fischel and Boehn 1925a, ill. p. 123; *Dessins de Jean-Dominique Ingres* 1926, p. [6], pl. 5; Martine 1926, vol. 5, no. 14, ill.; Hourticq 1928, ill. on pl. 16 (erroneously identified as the property of Lapauze); Waldemar George 1929, pp. xxxi, xxxii, fig. VI; Zabel 1929, p. 116; Fouquet 1930, p. 32; Pfister 1935, ill. p. 329; Christoffel 1940, ill. pp. 104, 105 (detail); Alazard 1942, no. 2, ill.; Mongan 1944, pp. 388–90; Courthion 1947–48, vol. 2, ill. opp. p. 11; Berger 1949, p. 12, fig. 4; Jourdain 1949, fig. 47; Roger-Marx 1949, p. 22, pl. 6; Scheffler 1949, p. 9, pl. 6; Alazard 1950, pp. 30–31, 64, n. 19, p. 144; Montauban 1951, under no. 9; New York, Manchester, Detroit, Cincinnati, Cleveland, San Francisco 1952–53, under no. 20; Wildenstein 1954, ill. p. 25; Toulouse, Montauban 1955, under no. 103; Ternois 1959a, vol. 3, preceding no. 54; Naef 1960 *(Rome)*, pp. 14, n. 22, p. 26; Cambridge (Mass.) 1961, under no. 1; Viguié 1965, p. 105; Sérullaz et al. 1966, no. 25, ill.; Cambridge (Mass.) 1967, under no. 5; Picon 1967, p. 70; Waldemar George 1967, ill. p. 87 (detail); Champa 1968, ill. p. 44; Radius and Camesasca 1968, p. 122, ill.; Ternois and Camesasca 1971, p. 122, ill.; Clark 1973, p. 121, fig. 90; Delpierre 1975, p. 25; Naef 1977–80, vol. 4 (1977), pp. 60–62, no. 33, ill.; Picon 1980, p. 35, ill.; Ternois 1980, pp. 18, 27, ill.; Hráz 1983, p. 39, fig. 2; Tübingen, Brussels 1986, fig. 2; Fleckner 1995, pp. 144–49, fig. 52; Vigne 1995b, p. 63, fig. 38

*Lapauze 1910, p. 112, n. 1.

†Lapauze 1918, p. 350.

24. Jean-Charles-Auguste Simon

1806
Graphite, with white highlights
10 5/8 × 8 1/2 in. (26.9 × 21.5 cm), mounted;
dimensions within the drawn border 6 11/16 ×
5 5/16 in. (17 × 13.4 cm)
Signed, dated, and inscribed upper right: Dessiné
par son ami / Ingres avant son depart / pour
Rome. 1806 [Drawn by his friend / Ingres
before his departure for Rome. 1806]
Numbered bottom center: 792
At lower left, the Musée des Beaux-Arts,
Orléans, collection stamp (Lugt 1999c)
Musée des Beaux-Arts, Orléans 792
New York only

N 36

This drawing is discussed under cat. no. 21.

PROVENANCE: The same as for cat. no. 21

EXHIBITIONS: Paris 1900a, no. 1068; Paris 1911, no. 77; Paris 1921, no. 60; Washington, Cleveland, Saint Louis, Cambridge (Mass.), New York 1952–53, no. 111; Toulouse, Montauban 1955, no. 102; Montauban 1967, no. 19; Paris 1967–68, no. 21, ill. (sitter identified); Pittsburgh, Memphis, Saint Petersburg, Salt Lake City 1986–87, no. 45

REFERENCES: Lafond 1906, p. 105; Lapauze 1911a, p. 34, ill. p. 66; Ratouis de Limay 1920, p. 107, ill. p. 110; Hourticq 1928, ill. on pl. 16; Cassou 1936, ill. p. 147; Mathey 1955, no. 4, ill.; Lugt 1956, p. 289; Auzas 1958, p. 11; *Trésors des musées de province* 1958, p. 77; Paris, Detroit, New York 1974–75, p. 153 (French ed.); Delpierre 1975, p. 23; Naef 1977–80, vol. 4 (1977), pp. 68–69, no. 36, ill.; Tübingen, Brussels 1986, p. 249, ill. p. 41

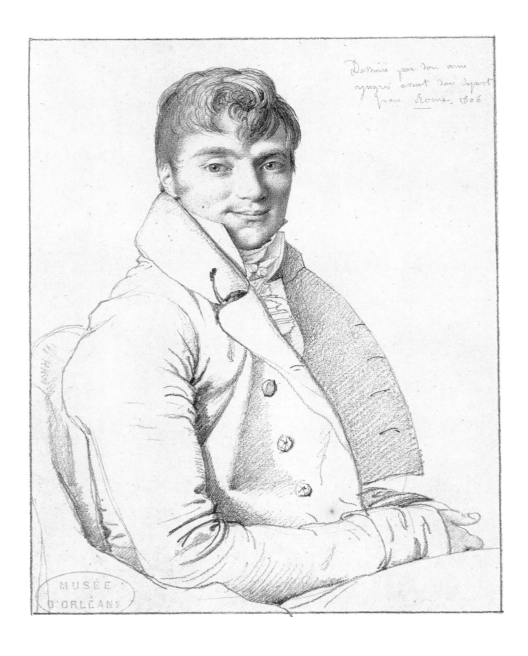

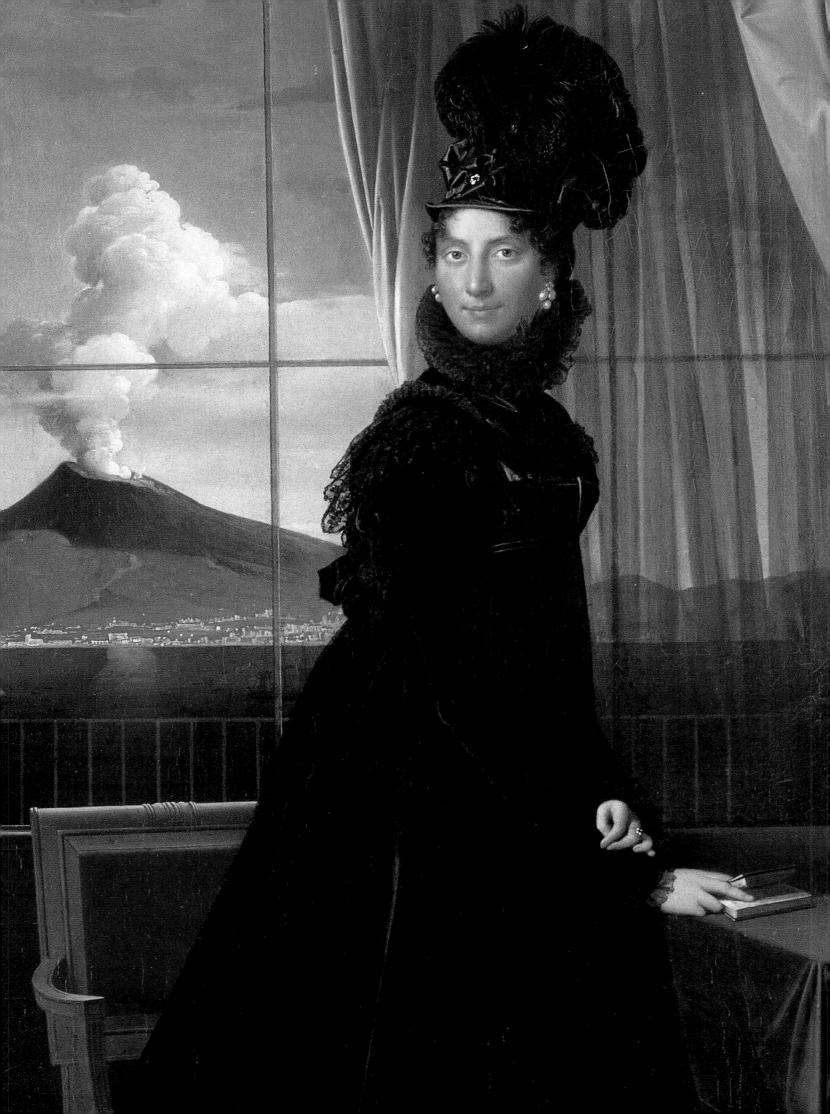

ROME, 1806–1820

Philip Conisbee

In September 1806 Ingres left Paris with his government stipend from the Prix de Rome, traveling via Milan, Bologna, and Florence, and arriving in Rome on October 11. During his first few weeks there, he resided in the splendid new seat of the Académie de France, the Villa Medici, acquired from the duke of Tuscany in 1804.[1] His letters from Rome to Pierre Forestier, his prospective father-in-law, indicate that it took him some unhappy weeks to settle down: ten days and even a month after his arrival, he was ready to return to Paris and to Julie.[2] After all, the young couple had only recently become engaged. Gradually, however, Ingres's discovery of the natural and artistic glories of Italy and his absorption into the world of students and artists in Rome made the distance from Paris a psychological as well as a physical one. There was also nothing in the reception of his public debut in Paris to encourage an ambitious young artist to return; he agonized, with embarrassment, shame, bitterness, and anger, over the critical diatribes his works had suffered at the Salon[3] and vowed never to exhibit there again.

No doubt ominously from Julie Forestier's point of view, Ingres began by January 1807 to express positive feelings about Rome, stating that he could not envisage returning within the year: "This is an environment and a city overflowing with all sorts of beauties, with picturesque architecture above all and with beautiful effects."[4] Perhaps to assuage his mounting guilt at the gradual transference of his emotions from Julie to the novel seductions of Rome, Ingres asked her at this time to make a copy of his 1804 self-portrait (cat. no. 11).[5] He also sent her some drawings of Roman views (one of which can be identified for certain today [fig. 79]), as if to confirm the legendary attractions of his surroundings. Ingres soon moved from the Villa Medici itself to the pavilion of San Gaetano on the grounds, with its attached studio. This brought him privacy and some enchanting views of Rome (see fig. 80),[6] as he remarked in a letter home to Paris: "I am going to live in a small house at the end of the garden, where I shall be alone and as a consequence freer, where I have a more beautiful view than before, and, what is invaluable, a beautiful studio facing north."[7] It was from his window that the view drawn for Julie was taken. Yet, by August 1807, in his last letter to Forestier, one that mixes anguish with joy, Ingres was unashamedly anticipating the full term required to complete his studies in

Fig. 79. *View of the Villa Medici, Rome*, ca. 1806. Graphite on paper, $4\frac{3}{4} \times 7\frac{7}{8}$ in. (12 × 20 cm). Fogg Art Museum, Harvard University Art Museums, Cambridge, Massachusetts

Fig. 80. *The Villa Medici Seen from the San Gaetano Pavilion*, 1807. Graphite and sepia wash on paper, $11\frac{3}{8} \times 9$ in. (28.9 × 23.1 cm). Musée Ingres, Montauban (867.4414)

Opposite: Fig. 78. Detail of *Queen Caroline Murat* (cat. no. 34)

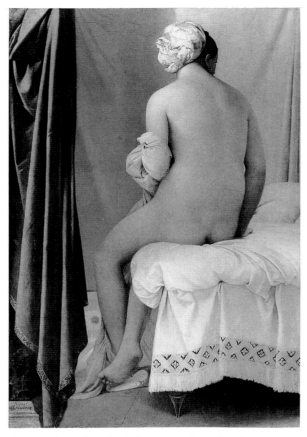

Fig. 81. *The Bather of Valpinçon*, 1808 (W 53). Oil on canvas, 57½ × 38 in. (146 × 97 cm). Musée du Louvre, Paris

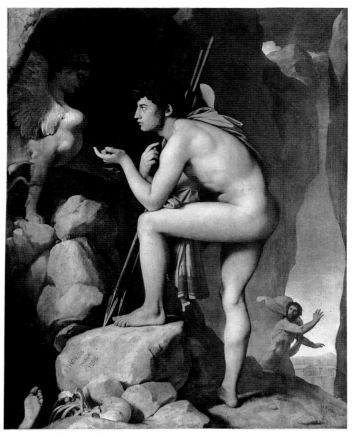

Fig. 82. *Oedipus and the Sphinx*, 1808 (W 60). Oil on canvas, 74⅜ × 56¾ in. (189 × 144 cm). Musée du Louvre, Paris

Rome: "I ask you on both knees—it is impossible for me to leave such a marvelous country so soon."[8] Julie was slipping from his mind and, in effect, was gone from his life forever. She was never to marry, and perhaps sublimated some of her pain by writing a roman à clef of lost love and dashed hopes.[9]

At the Académie, Ingres established a good relationship with Joseph-Benoît Suvée, the sympathetic and liberal-minded director. Primarily concerned with reestablishing the school in its new home on the Pincio, Suveé was more preoccupied with extracting the necessary funds from Paris than with supervising his students in Rome. Ingres and his graduate colleagues were thus relatively free to draw from the life models provided at the Académie and to study the antiquities and works by modern masters found in abundance in and around Rome. The painting pensioners were also expected to ground themselves intellectually, by studying history and literature, in preparation for their careers as history painters in the tradition of Poussin and David. As he had done in David's studio in Paris, Ingres kept himself rather apart from the other pensioners: he held them in low esteem, and indeed

their names have more or less disappeared from history. He mentions only Jean-Pierre Granger and Joseph-Denis Odevaere, whom he had known already in Paris. Ingres's friendships were with architects and musicians or with artists outside the Académie, such as the landscape painters Thomas-Charles Naudet (fig. 89) and François-Marius Granet (cat. no. 25), Frenchmen who lived in Rome but pursued independent careers in the large international artistic community there.

Ingres immediately absorbed himself in studying the sites and monuments of ancient, Renaissance, and contemporary art, to which hundreds of sketches, now in the Musée Ingres, are testimony. He lost no time in preparing his *envois*, required student exercises in figure and history painting, which were to be sent back to Paris for official assessment. By 1808 Ingres was working on, and had perhaps completed, four such paintings: a half-length male academic study, eventually given to Granet (*Study of an Old Man*, W 52; Musée Granet, Aix-en-Provence); a reclining female nude (fig. 85); a seated nude woman seen from the back, now known as the *Bather of Valpinçon* (fig. 81); and *Oedipus and the Sphinx* (fig. 82). Only the last two

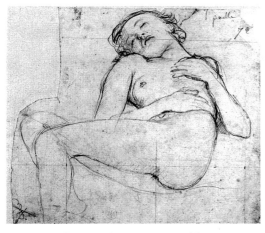

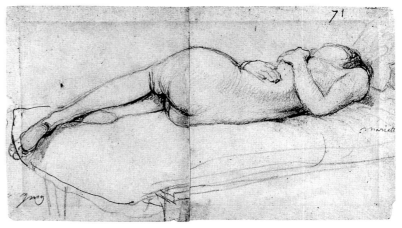

Fig. 83. *Reclining Nude*, ca. 1808. Graphite on paper, 5⅞ × 6½ in. (15 × 16.6 cm). Musée Ingres, Montauban (867.3069)

Fig. 84. *Reclining Nude*, ca. 1808. Graphite on two joined sheets of paper, 3¾ × 6½ in. (9.5 x 16.5 cm). Musée Ingres, Montauban (867.3068)

Fig. 85. *The Sleeper of Naples*, ca. 1808. Graphite on paper, 4⅞ × 8⅞ in. (12.4 × 22.6 cm). Private collection.

Fig. 86. Antonio Canova (1757–1822). *Pauline Borghese as Venus Victorious*, 1804–8. Marble, l. 78¾ in. (200 cm). Palazzo Borghese, Rome

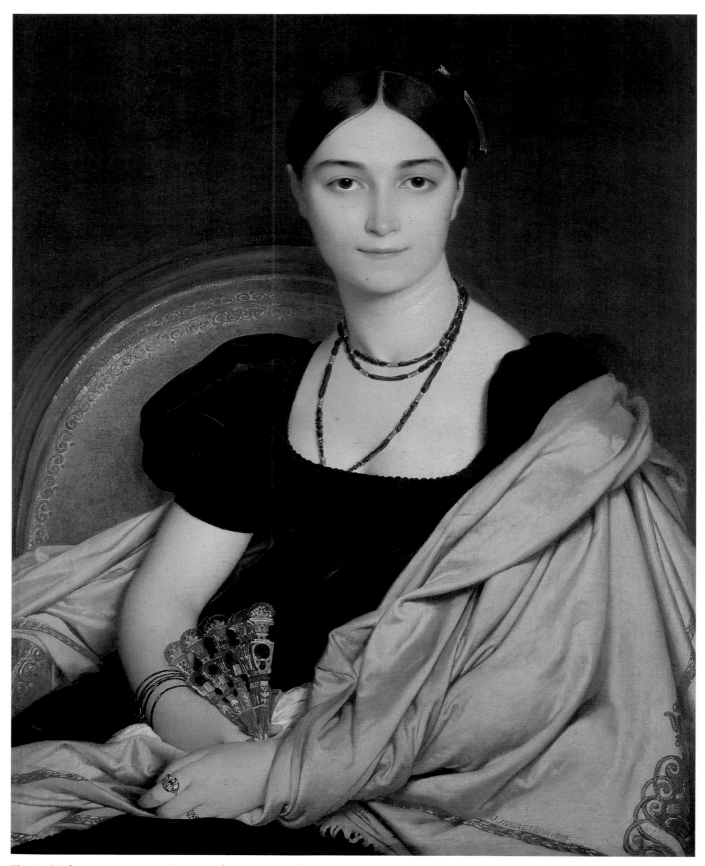

Fig. 87. *Madame Duvaucey*, 1807 (W 48). Oil on canvas, 29⅞ × 23¼ in. (76 × 59 cm). Musée Condé, Chantilly

were actually sent that year to Paris, where they were mildly criticized for inconsistencies of drawing and lighting and for insufficient idealization. "One would wish that he had been more imbued with the beautiful character of antiquity and with the grand and noble style, which the beautiful productions of the great masters during the finest days of the Roman School should inspire," reported the director of the Académie des Beaux-Arts in Paris.[10] If *Oedipus and the Sphinx* is a personal variation on the well-established academic theme of the historiated male nude, the *Bather of Valpinçon* is more remarkable for the fine balance Ingres maintains between description and idealization, voluptuous presence and discretion. These serpentine lines of female beauty would recur many times throughout his long career, but in this of all his surviving painted nudes, his own sensuality is most immanent.

This sensuous world, which Ingres apparently discovered during his first few years in Rome, is also revealed in drawings he made there of a favorite model (figs. 83, 84). These studies culminated in the remarkably candid painting of a reclining nude known as *The Sleeper of Naples*, after its acquisition by Joachim Murat, king of Naples, in 1809 (fig. 85). This work was shown in November 1809—as "Donna nuda che dorme"—in an exhibition held in the Campidoglio by an international committee of the artistic community in Rome.[11] The president of that committee, Guillaume Guillon Lethière, had become the director of the Académie de France in October 1807. This exhibition certainly had a political dimension, since the next year Rome was proclaimed the second capital of the French Empire. Murat's visit to the exhibition on November 14, along with General Sextius-Alexandre-François Miollis, the governor of Rome, was likely orchestrated to assert the city's international artistic hegemony under French rule. Ingres must have been overjoyed to engage the interest of a patron as important as the brother-in-law of the emperor, and even General Miollis came back to him two years later with significant commissions. The 1809 exhibition also serves as a reminder that Rome was a truly cosmopolitan artistic center: its committee included artists from France, Italy, several German states, the Netherlands, Sweden, Denmark, Austria, and Russia, and these were later joined by Spanish and Flemish artists in the exhibition itself. Only the British were absent, isolated from the Continent as they had been for over a decade by war with Napoleon and his allies.

The two presiding geniuses of early-nineteenth-century Rome were sculptors: Antonio Canova and a younger artist from Denmark, Bertel Thorvaldsen (the

Fig. 88. *Madame Duvaucey*, ca. 1807. Graphite and sepia wash on paper, 4½ × 3⅜ in. (11.3 × 8.7 cm). Musée du Louvre, Département des Arts Graphiques, RF 1443

latter's work featured prominently in the 1809 exhibition). Canova, whose talents were sought throughout Europe, had been summoned to Paris in 1802 to make a portrait of Bonaparte and was to be again in 1810, to portray the new empress, Marie-Louise. Ingres was certainly familiar with the artist's *Pauline Borghese as Venus Victorious* (fig. 86), perhaps the most famous portrait completed in any medium in Rome in the early nineteenth century. The languorous lines and delicately modeled surfaces of this marble likeness of the sister of the emperor—a celebrated beauty with a reputation for amorous intrigue—cannot have been lost on Ingres.[12]

The Roman critic Francesco Aurelio Visconti admired *The Sleeper of Naples* as well as two portraits, "imitating the Flemish style," that Ingres exhibited at the Campidoglio in 1809. He praised the portraits for "a liveliness, and a singular coloring, which although it retains a certain edge taken from life, still produces an attractive harmony."[13] While Ingres must have winced to hear his portraits still being called "Flemish," it is of the greatest interest to know that in Rome, as in Paris, they were found to be singular in color and were admired for their acuity of observation. Of Ingres's extant or recorded

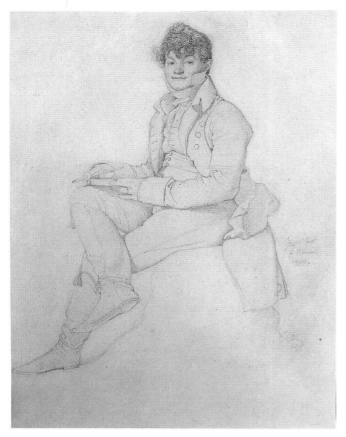

Fig. 89. *Thomas-Charles Naudet*, 1806 (N 42). Graphite on paper, 9⅜ × 6⅞ in. (23.8 × 17.5 cm). Museum of Art, Rhode Island School of Design, Providence

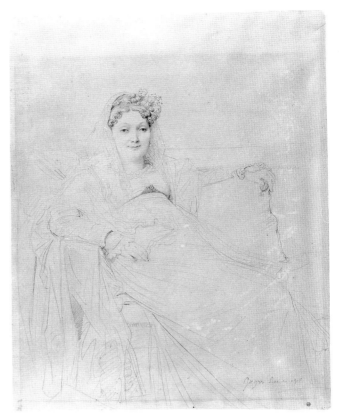

Fig. 90. *Madame Lucien Bonaparte*, 1815 (N 147). Graphite on paper, 14⅞ × 11⅝ in. (37.8 × 29.5 cm). Musée Bonnat, Bayonne

portraits, the only two that he can have exhibited in 1809 are those of Granet (cat. no. 25) and Madame Duvaucey (fig. 87), the mistress of the French ambassador to the Holy See, Monsieur Alquier. Several preparatory drawings for Madame Duvaucey's seductive portrait survive, including an early one in which she sits in a rectilinear chair (fig. 88). Yet Ingres ultimately softened the forms, as he had in his image of Madame Rivière (cat. no. 9), and continued the curve of Madame Duvaucey's shoulder and neck in the arched back of her chair. Dressed in soft, dark velvet and encircled by her beige shawl, the dark-eyed sitter confronts the viewer directly in this extraordinary portrait, which is at once voluptuous and restrained.

The portrait of Granet, a warm testimony to the friendship between the two artists, is no less attractive. Granet himself exhibited five of his characteristic scenes at the Campidoglio exhibition, works depicting cloisters, catacombs, and members of the clergy going about their devotions. The style of the landscape background in Ingres's portrait of Granet, and especially the fluid, watercolor-like application of paint in an area at the left, suggests that it was painted by Granet himself. Thus, his name inscribed on the sketchbook under his arm becomes

a sort of signature, as well as a witty conceit when we recall that the painter François Gérard once observed that the artist "has all of Rome in his portfolio."[14] Granet was indeed a talented landscape painter, and dozens of his open-air landscape studies painted in Rome are now in the collection of the museum bearing his name in Aix-en-Provence.[15] It has sometimes been suggested that he also painted the landscape backgrounds in Ingres's other Roman portraits. Although Ingres did later develop a studio practice, in which his pupils and assistants undertook some of the more routine passages and accessories in his paintings, there is no sound evidence—documentary or visual—that he generally employed, or needed, such assistance with his landscape backgrounds during his first period in Rome.[16]

Indeed, Ingres was in Rome at a time when all the pensioners at the Académie were being encouraged to study landscape. In October 1807 the outgoing director of the Académie, Pierre-Adrien Pâris (himself an accomplished landscape draftsman and the owner of great landscape drawings by Fragonard and Hubert Robert),[17] wrote a report to the minister of the interior in Paris, commenting that "this country is one of the richest in diverse and piquant

settings: the climate gives colors a vigor and a brilliance that are unknown in northern countries . . . buildings and the most majestic ruins mingle with the most beautiful spontaneous productions of Nature to fashion a landscape in the grandest and noblest style."[18] Pâris continues that landscape painters should be encouraged at the Académie, because "their example will inspire history painters to develop landscape well enough so that they will not treat it too much as an accessory when it enters into their compositions."[19] Working in such an atmosphere, Ingres may very well have absorbed the example of his friend Granet.

Although the 1809 exhibition clearly revealed Ingres's abilities to a larger audience, his clientele at this time remained limited to the French community. The terms of his stipend did not allow him to undertake outside work of any ambition; for an extramural activity such as the portrait of Madame Duvaucey, he must have obtained special permission from Guillon Lethière. However, he did make a few portrait drawings, the first of his subjects being his friend Naudet (fig. 89) and the young architect Jean-François-Julien Ménager (cat. no. 37), both of whom he depicted in 1806. Among the artist friends and colleagues at the Académie whom he continued to draw while in Rome was the Lethière family (cat. nos. 52–55). No doubt, it was Guillon Lethière who introduced Ingres to the emperor's brother Lucien Bonaparte, who had been living in luxurious exile in Rome since 1804. In 1807 Lucien had asked Ingres to make drawings of antiquities, but the young painter, newly arrived in Rome, considered this type of work beneath his dignity as an aspiring history painter.[20] He nevertheless took special care over a portrait drawing of Lucien (cat. no. 38); he also drew

Madame Bonaparte (fig. 90) and a brilliant group portrait of the family (fig. 91).

Lucien Bonaparte is the first of Ingres's Roman portrait drawings with a landscape setting, a feature that visitors and longer-term residents alike welcomed as a souvenir of their stay in the Eternal City. Here, Lucien is portrayed as seated on a cinerarium in the Forum, with the Quirinal hill and the Torre delle Milizie in the background. There is no good reason to think that Ingres did not draw the landscape himself, so consistent is its style and so seamless its continuity with the portrait; in fact, it is clearly similar in style to the *View of the Villa Medici, Rome* (fig. 79), which Ingres sent back to the Forestier family in Paris. Of course, Ingres cannot be considered an assiduous landscape draftsman: he did make a number of sketches on his travels, but, seeing himself as a history painter, he would have looked down on the less elevated genre. Among the thousands of drawings of all kinds bequeathed by Ingres to the museum in Montauban, there are several groups of landscape drawings by other contemporary but unidentified artists, which Ingres had collected in Rome. In a few cases, he seems to have copied and adapted such works for use as landscape backgrounds in his portrait drawings (see cat. nos. 60, 62, 64).[21]

November 1810 brought an end to Ingres's studentship at the Académie. However, illness delayed the completion of his last student exercise, a large history painting *Jupiter and Thetis* (fig. 92), which was not sent to Paris for review until 1811. It is hard to imagine that Ingres did not expect the harsh criticisms this remarkable large-scale work would receive from his superiors. Strongly influenced by John Flaxman's outline engravings (see figs. 43, 46),

Fig. 91. *The Family of Lucien Bonaparte*, 1815 (N 146). Graphite on paper, 16⅛ × 21 in. (41 × 53.2 cm). Fogg Art Museum, Harvard University Art Museums, Cambridge, Massachusetts

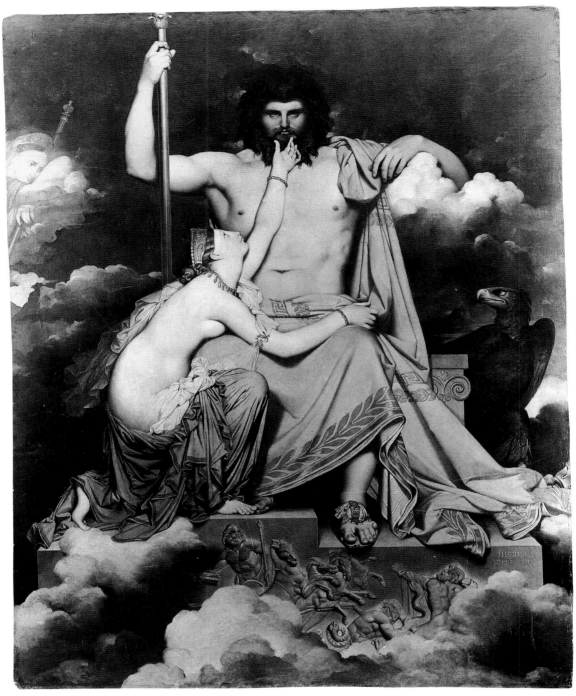

Fig. 92. *Jupiter and Thetis*, 1811 (W 72). Oil on canvas, 131 × 102 ³⁄₈ in. (327 × 260 cm). Musée Granet, Aix-en-Provence

Jupiter and Thetis was attacked for its lack of relief and depth, its bold, unmodulated color, and the curious proportions of its figures.[22] The artist surely would have taken heart, however, if he had read the comments of the great Danish connoisseur T. C. Bruun-Neergaard, who most likely saw *Jupiter and Thetis* in Rome and who in 1811 wrote that Ingres "is very well trained and is incontestably one of the young painters who holds out the most hope for the revival of the modern French school."[23] However, the negative reaction of his less enlightened

professors north of the Alps may again have checked any thoughts Ingres had of returning to Paris. Enamored as he was with Rome, he decided to stay on beyond his studentship and moved out of the Académie's precincts into rooms nearby on the Pincio.

Ingres was now free of academic responsibilities but not of the necessity to earn his living. Seeking to develop the contacts he had made from his appearance at the 1809 exhibition, he found his main patrons, perhaps inevitably, in the community of senior French officials who had

Fig. 93. *Charles-Joseph-Laurent Cordier*, 1811 (W 78). Oil on canvas, 35⅜ × 25⅝ in. (90 × 60 cm). Musée du Louvre, Paris

come to Italy to administer the second capital of the Empire as well as other appropriated states on the peninsula. The most important of these for Ingres would prove to be Charles Marcotte (Marcotte d'Argenteuil; see cat. no. 26), who was inspector general of forests and waterways for Rome. Marcotte arrived in Rome in 1810—just at the time Ingres was seeking patronage—and, wanting a portrait of himself to send home to his mother, was introduced to Ingres by their mutual friend Édouard Gatteaux, an engraver and student at the Académie. Formally dressed

and posed with nonchalant self-confidence, Marcotte is presented in his portrait as a pillar of the French establishment, a somber and serious man intent on performing his duty to the Empire. With its plain background, restrained palette, and powerful draftsmanship, this work suggests a modern-day Renaissance courtier and is in fact adapted from portraits by sixteenth-century masters such as Jacopo da Pontormo and Agnolo Bronzino.[24] Ingres and Marcotte were to develop a close friendship, one that is reflected in their correspondence over many years.[25]

Through his family and professional connections, Marcotte led Ingres to many of his portrait sitters in Rome, including other French civil servants such as Joseph-Antoine Moltedo (cat. no. 27), Charles-Joseph-Laurent Cordier (fig. 93), and Baron de Montbreton de Norvins (cat. no. 33); among those Marcotte introduced to Ingres later in Paris were the composer Luigi Cherubini and Madame Moitessier (see cat. nos. 119–120, 133–144). Even Ingres's second wife was related to the Marcottes.

Although Ingres was yearning to prove himself as a history painter in Rome, his sitters must have been grateful that he was driven by necessity to make a living as a portrait painter and draftsman. His portraits during this period, as epitomized by that of Cordier (fig. 93), a thirty-four-year-old administrator in the land registry in Rome, follow a well-established eighteenth-century prototype. Its greatest practitioner was Pompeo Batoni, who specialized in depictions of northern Europeans on the grand tour, setting them in evocative landscapes of famous sites and monuments in Rome or the Campagna. Here, the storm-swept hills of Tivoli, its famous temple caught in a flash of light, provide a dramatic setting for the handsome Cordier. Casually leaning on a rock, the sitter dominates the picture space, his head like an exotic flower blooming from his white shirt and collar and silhouetted against the thundery sky.

Fortune finally smiled on Ingres when General Miollis at last granted him the kinds of commissions that must have featured in his most ambitious dreams. For his own residence at the Villa Aldobrandini, Miollis requested a

Fig. 94. *Virgil Reciting from "The Aeneid,"* 1812 (W 83). Oil on canvas, 121 × 129 in. (304 × 323 cm). Musée des Augustins, Toulouse

large Poussinesque history painting, *Virgil Reciting from "The Aeneid"* (fig. 94).[26] Anticipating a visit of the emperor to Rome, Miollis in his official capacity also commissioned two even larger history paintings—*The Dream of Ossian* (fig. 95) and *Romulus, Conqueror of Acron* (fig. 96)—as part of a new decorative scheme for the official residence, the Palazzo del Quirinale. In order to provide Ingres with enough space to execute *Romulus*, a large studio was set aside in the tribune of Santissima Trinità dei Monti, a church much used by the French community. A charming watercolor (fig. 97) shows the little man, complete with violin and bow for moments of musical diversion, tackling the big painting there. The finished work, an impressive friezelike composition, looks back to paintings by Domenichino and Raphael, but even more so to *The Intervention of the Sabine Women* by his old teacher David (fig. 42). Yet, for all the high ideals that had been drummed into Ingres at the academies in Toulouse, Paris, and Rome, such commissions were exceptions to the rule, for in reality there was little demand for history paintings in the grand manner, even in the city of Raphael and Michelangelo. In 1813 Ingres expressed hopes that he might triumph at the Salon in Paris with *Romulus* and a selection of other works: "You see, my dear sir, that Ingres can make his entry into the world . . . ," he wrote to Marcotte.[27] But he would still have to wait a long time—until 1824—for this triumphal entry.

Such issues became all the more pressing because Ingres married during this period. After he had broken with Julie Forestier, he had had another failed relationship—with Laura Zoëga, the daughter of a famous Danish archaeologist—and then had become attracted to Adèle Nicaise-Lacroix, wife of Jean-François Maizony de Lauréal, a senior official at the imperial court in Rome. Adèle saved an awkward situation by recommending a cousin, a shopkeeper from Guéret named Madeleine Chapelle (see cat. no. 36), who apparently bore a close resemblance to her.[28] There was a brief courtship by correspondence, during which Ingres sent Madeleine a portrait drawing of himself that she characterized, many years later, as considerably flattering to the artist.[29] Ingres's epistolary accounts of himself must have been of the same nature, because even before she met him, Madeleine wrote to her sister in August 1813, "He is a painter. Not a house painter, but a great history painter, a great talent. He makes ten to twelve thousand livres a year; you can see that with that there is no chance of starving. He is good-natured, very sweet; he is not a drinker, nor a gambler, nor a libertine; he has no faults to be afraid of; he promises

to make me very happy, and I like to believe him."[30] On that slender acquaintance, Madeleine came to Rome in September, and the couple were married in December.

The Ingres household on the Via Gregoriana was memorialized five years later in a small painting by a friend of the couple, Jean Alaux (fig. 98). It seems to have remained a happy union; even in the years of financial penury to come in Rome, Ingres could write to his friend Jean-François Gilibert in 1818, "I have joined my lot with an excellent wife, who is my continual happiness. In her very self she has brought me a real dowry, and our household is, I venture to say, held up as an example. In this respect, I am experiencing complete happiness."[31] Madeleine was economical and industrious—one of Ingres's most charming drawings (cat. no. 96) shows her sewing—and ever the supportive spouse. When the couple returned to Rome to run the Villa Medici years later, she played admirably the role of director's wife and surrogate mother to the students. Madeleine was not all sweetness and light, however, and there are several accounts of her mean-spirited and jealous behavior when she and Ingres were staying with the sculptor Lorenzo Bartolini in Florence in 1820 (see page 242). While her petit bourgeois side came to the fore in the opulent household of the worldly, successful bachelor, there was also revealed a certain dogged loyalty to her much less successful husband, who was, in her eyes and his own, at least as deserving of recognition and material reward. Madeleine often sat for Ingres, for portraits—both painted (cat. no. 36) and drawn (cat. nos. 96, 108, 109, 118, figs. 131, 186)—and as a model, but she never posed on a more extraordinary occasion than for the tender and erotic painted study that is recorded only in a daguerreotype made many years later (fig. 99). Ingres probably destroyed the original out of a sense of propriety in 1852, when he married for a second time.

Needing now to increase his income, but not wishing to paint more portraits than necessary, Ingres explored ways of satisfying his ambitions to work in a more elevated mode. He grew envious of the increasing success his friend Granet had been enjoying, ever since the fateful Salon of 1806, with his scenes of real and imaginary cloisters and church interiors.[32] It may thus have been in a spirit of rivalry that Ingres painted his own church interior, *The Sistine Chapel* (fig. 100), showing a service being conducted by Pope Pius VII. The work was completed in 1814, the same year that Granet exhibited to great acclaim in his Rome studio the first of a series of large-scale views of the choir of the Capuchin church in Piazza Barberini.[33]

Fig. 95. *The Dream of Ossian*, 1813 (W 87). Oil on canvas, 139 × 108¼ in. (348 × 275 cm). Musée Ingres, Montauban

Ingres's novel modern historical-genre painting, which also contained diminutive portraits of the pope and many officials of the Vatican Curia, had been commissioned by his friend Marcotte.[34] Its miniature representations of some of the great Renaissance frescoes in the chapel, including part of Michelangelo's *Last Judgment*, suggest that Ingres may have been counting on a little reflected glory. He certainly hoped *The Sistine Chapel* would create a sensation and draw crowds at the Paris Salon someday, and he imagined that his colleagues Gérard, Anne-Louis Girodet, and even David would admire it there.[35] He wished to prove to the "genristes"—mere genre painters, such as he considered Granet to be—that history painters could beat them at their own game: "I too want to make a stir at the Salon. Having, besides, my own great reasons for proving to the gentlemen genre painters that supremacy over every genre belongs to history painters alone."[36] Perhaps Ingres was also recalling David's comments, years before, on the historical genre works of Pierre Révoil and Fleury Richard: "It is much better to make good genre pictures than mediocre history paintings."[37]

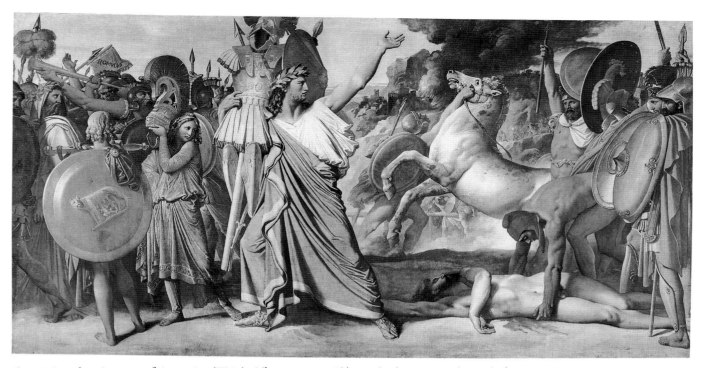

Fig. 96. *Romulus, Conqueror of Acron*, 1812 (W 82). Oil on canvas, 108⅝ × 212 in. (276 × 530 cm). Musée du Louvre, Paris

Ever since Joachim Murat had acquired *The Sleeper of Naples* in 1809, Ingres had had great expectations of patronage from the king and queen of Naples. And indeed in 1813 they did commission the celebrated *Grande Odalisque* (fig. 101), a sumptuous nude seen from the back, as a pendant to the earlier frontal nude. Early in 1814, Ingres spent a few months in Naples, where he painted the portrait of the queen, Caroline Murat (cat. no. 34), and began work on a group portrait of her family. For the Murats he also pursued his idea of small anecdotal historical genre paintings and produced *The Betrothal of Raphael* (fig. 102) and *Paolo and Francesca* (fig. 103). These subjects—and others such as *Raphael and the Fornarina* (fig. 127), *Henry IV Playing with His Children* (W 113; Musée du Petit Palais, Paris), *The Death of Leonardo da Vinci* (W 118; Musée du Petit Palais, Paris), and *Don Pedro of Toledo Kissing the Sword of Henry IV* (W 101, painted for Marcotte; location unknown) drawn from medieval and Renaissance literature and history—did indeed find admirers, among them the comte de Blacas, the French ambassador to Rome from 1816 on, who became a valuable champion of Ingres. There was a growing taste for such scenes, especially after the fall of Napoleon and the restoration of the Bourbons in France, as people began to feel nostalgia for the imagined stability of social and religious life in earlier times and for an old Europe before kings were derided and beheaded by mobs. The ambassador's interest and intervention were responsible for

Ingres's being commissioned in 1817 to paint the large *Roger Freeing Angelica* (fig. 104) as part of a scheme for the redecoration of Versailles for Louis XVIII.

The artist did manage to have several works, including portraits, some historical genre scenes, the *Grande Odalisque*, and *Roger Freeing Angelica*, variously exhibited at the Salons of 1814 and 1819, but they were still neither understood nor well received by Parisian critics. Again the reviewers employed such terms as "bizarre . . . Gothic . . . devoid of harmony . . . barbarous"[38] and, not

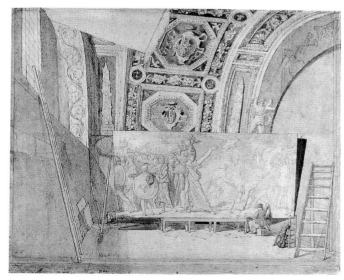

Fig. 97. Unidentified artist, *Ingres Painting "Romulus, Conqueror of Acron,"* 1812. Pen and watercolor on paper, 18⅜ × 22¼ in. (46.6 × 56.6 cm). Musée Bonnat, Bayonne

Fig. 98. Jean Alaux (1786–1864). *The Ingres Studio in Rome*, 1818. Oil on canvas, 21⅞ × 18⅛ in. (55.5 × 46 cm). Musée Ingres, Montauban (50.545)

Fig. 99. *Ingres's "Reclining Nude (Madame Ingres),"* 1852. Daguerreotype by Millet. Musée Ingres, Montauban

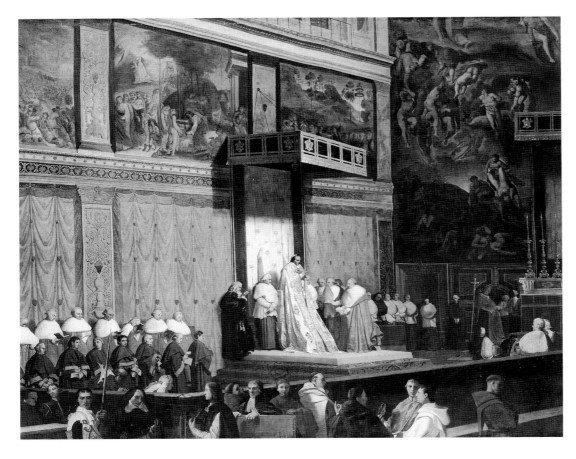

Fig. 100. *The Sistine Chapel*, 1814 (W 91). Oil on canvas, 29¼ × 36½ in. (74.5 × 92.7 cm). National Gallery of Art, Washington, D.C.

Fig. 101. *Grande Odalisque*, 1814 (W 93). Oil on canvas, 35⅞ × 63¾ in. (91 × 162 cm). Musée du Louvre, Paris

Fig. 102. *The Betrothal of Raphael*, 1813–14 (W 85). Oil on canvas, 23¼ × 18⅛ in. (59 × 46 cm). Walters Art Gallery, Baltimore

Fig. 103. *Paolo and Francesca*, 1814 (W 100). Oil on wood, 13¾ × 11 in. (35 × 28 cm). Musée Condé, Chantilly

Fig. 104. *Roger Freeing Angelica*, 1819 (W 124). Oil on canvas, 57⅛ × 73⅝ in. (145 × 187 cm). Musée du Louvre, Paris

complimentarily, "original and mannered."[39] Yet it is clear how Ingres's works could have seemed archaic to hostile Salon critics raised in the classical tradition, as *Roger Freeing Angelica* did in 1819. This radical image does seem to owe as much to such Early Renaissance masters as Paolo Uccello or Vittore Carpaccio as it does to Ingres's master, David.

Ingres's fortunes in Italy remained tied to contemporary politics, and his world of patronage began to collapse in 1815, with the murder of Murat and the fall of his regime in Naples. The general disintegration of the Napoleonic empire in 1814–15 left Ingres somewhat stranded in Rome, and he felt his parlous financial situation all the more keenly with Madeleine to support. Personal tragedy came, too, in 1814, when his father (whom he had not seen for nearly a decade) died and Madeleine gave birth to a stillborn son. During these difficult and often penurious times, his deeply affectionate relationship with Madeleine sustained them both.

Having honed his skills as a portrait draftsman on images of his French compatriots, Ingres was able at least to stay afloat by drawing portraits of the new postwar visitors to Rome, notably the British—victorious, wealthy, and starved of Mediterranean light for more than twenty years. Thus, in the years 1815 to 1818, his production of portrait drawings increased considerably. Needless to say, Ingres was not entirely happy as one swaggering tourist after another beat a path to his door. "Is this where the man who draws the little portraits lives?" they would ask. "No," was the reply, "the man who lives here is a painter!"[40] Ingres even received solicitations to go to England, where he was assured he could make his fortune by drawing portraits of the British.[41] Despite Ingres's resentment of these endeavors, the results stand among the great portrait drawings in the history of art; they are also marvelous, often witty documents of a particular time, place, and social caste. Some of the finest—"very nice, indeed," as they were termed[42]—are illustrated in this catalogue (cat. nos. 59, 60, 62, 64, 67). The accuracy of the portrait drawings was evidently most appreciated: the daughter of Mrs. Mackie (see cat. no. 60), for instance, commented, "Dear Mama's likeness of Ingre [*sic*] finished and very good."[43] These drawings were taken back home by the British sitters, and most remained in family collections until the twentieth century; only one of them was illustrated in a fundamental monograph on Ingres—the portrait of Lord and Lady Bentinck (fig. 105), which appeared in Henry Lapauze's work in 1911.[44] Since they have been rather a twentieth-century discovery, and because it is relatively rare to have so many British sitters portrayed by a French artist, the drawings are somewhat artificially thought of as a distinct group. But as works of art they can be integrated perfectly well with Ingres's other portrait drawings, mostly of French sitters, made in Rome.

In his last few years in Rome, after the fall of the Empire, Ingres succeeded (if the word may be used at all in light of his real aspirations) in painting only one

Fig. 105. *Lord William Henry Cavendish Bentinck and His Wife, née Lady Mary Acheson*, 1816 (N 175). Graphite on paper, 11⅞ × 8¾ in. (30.1 × 22.2 cm). Musée Bonnat, Bayonne

portrait. It is a modest work representing an artist friend, the sculptor Jean-Pierre Cortot (W 105; Musée du Louvre, Paris), painted in 1815.

If Ingres's reputation, in Rome and Paris, was still somewhat slight, and his dependence on a small group of patrons somewhat precarious, he was at least able, in 1820, to conclude his long Roman sojourn with a major history painting, *Christ Giving the Keys to Saint Peter* (fig. 106), his first official commission in Rome since the fall of the Empire. Ambassador de Blacas, already an admirer of Ingres's small historical-genre pictures, was having Santissima Trinità dei Monti restored at his personal expense, and the architect for the project was Ingres's close friend François Mazois. With the advice of Charles Thévenin, since 1816 the director of the Académie in Rome, Blacas intended to make the church "a sort of sacred National Museum that would demonstrate to foreigners the perfection of our school."⁴⁵ Another of Blacas's aims was to encourage the pensioners of the Académie and other talented French artists in Rome. Thévenin shared the ambassador's admiration for Ingres, while realizing that his was "an original talent, altogether off the beaten track."⁴⁶

Ingres rose to the occasion, and, in painting this large work for an important public space, was no doubt fully conscious that the subject had been treated before in major works by Poussin and Raphael. To modern eyes, the apostles in Ingres's painting display an exaggerated, Raphaelesque idealism that suggests he knew the work of German Nazarene artists in Rome such as Friedrich Overbeck and Peter Cornelius. These artists, working since 1810 in the secularized monastery of San Isidro (not far from the Ingres household on the Pincio), were studying Raphael and earlier Renaissance painters in an attempt to capture the purity and unity of religious feeling they attributed to the pre-Reformation world. Their noble and often moving efforts did not always succeed in bringing past modes of expression back to life, although their heartfelt sincerity and historical revivalism can be attractive to a postmodern sensibility. Ingres's *Christ Giving the Keys to Saint Peter* is notable for its stony-faced apostles, strong colors, monumentally sculpted draperies, and powerful sense of hierarchy. Sympathetically received by contemporaries in Rome,⁴⁷ the work is in fact one of the masterpieces of the religious revival that was taking place both in Italy and in France after the period of secularization during the Empire,⁴⁸ and it remained a cornerstone of such art for the rest of the century. Ingres was exceptionally proud of this painting, and when he at last achieved public recognition in 1824, he began a campaign to have it brought to Paris. The ecclesiastical authorities in Rome refused to release it for the Salon of 1827, but years later it was handed over to the French state in exchange for a copy, and it came to Paris in 1841—just as Ingres, by now a pillar of the conservative establishment, completed his term as director of the Académie de France in Rome. Since Ingres reworked the painting at that time,⁴⁹ it is difficult to judge how it looked in 1820, but in essence the effect was probably as overwhelming as it is today.

Word of the critical success in Rome of *Christ Giving the Keys to Saint Peter* was communicated to Paris in August 1820 by Thévenin, who took the opportunity to solicit from the minister of the interior an official commission for the now-deserving Ingres.⁵⁰ This was surely welcome news to the painter, considering the poor critical reception his works had recently been accorded at the previous year's Salon in Paris (see page 501). But even earlier in the summer of 1820, the artist's old friend Gilibert, now an influential public figure in Montauban, had been negotiating independently on Ingres's behalf between their native town and Paris, seeking financial support for

Fig. 106. *Christ Giving the Keys to Saint Peter*, 1820 (W 132). Oil on canvas, 112 × 85⅜ in. (280 × 217 cm). Musée Ingres, Montauban

the commisssion of an altarpiece for the cathedral of Montauban. It is hard to imagine that Ingres was not aware of these machinations, but their eventual confluence in the commission to paint *The Vow of Louis XIII* (fig. 146) meant that his dream of returning to his homeland in triumph seemed like a real possibility. In any case, Ingres

had had enough of Rome, where life had never been easy for him. For several years there had been fewer opportunities for French artists, and there was a lingering resentment about the recent past of the French occupation and French cultural imperialism. Still contemplating an eventual return to France, Ingres decided to acquaint

himself better with Florence.[51] In 1818 he had been in touch again after many years with Bartolini, his old comrade from David's studio, who was now enjoying fame and fortune in that city. When Ingres and Madeleine paid the sculptor a visit in June 1819, Florence indeed seemed an attractive, manageable alternative to Rome. And it was, after all, nearer to Paris, which would have to be Ingres's ultimate theater of success. In the summer of 1820 the Ingres household finally packed up in Rome and headed off on the first stage of their journey north, leaving behind a period that the artist had characterized as "thirteen years of slavery."[52]

1. On the Villa Medici, see Lapauze 1924, vol. 2, pp. 1–29.

2. Lapauze 1910, pp. 58, 69–70.

3. For Ingres's correspondence with Pierre Forestier, see Boyer d'Agen 1909, pp. 43–53.

4. "C'est un climat et une ville intarissables en beautés de tout genre, en architecture pittoresque surtout et beaux effets." Quoted in Lapauze 1910, pp. 69–70.

5. For the dating of Julie's copy, see the unpublished letter, dated January 12, 1807, in the Fondation Custodia, Paris (inv. 1972.A.42): "I would even venture to ask Mademoiselle Julie something that I have not yet requested, to make a little copy of my painted portrait, drawn or painted as she wishes, and small in scale, and, of course, to do it when she has time and leisure." ("J'oserais encore prier mademoiselle julie, chose que je n'ai pas encore demandé de faire une petite copie de mon portrait peint, comme elle voudra, dessiné ou peint et au petit et cela, bien entendu, quand elle aura le temps et à son aise.")

6. Georges Vigne (1995a, no. 3062) dates this drawing to 1817, but the inscribed date, "187," could equally well be 1807; furthermore, the drawing can be compared with a similar view sent to Julie Forestier in 1807 (see fig. 79).

7. "Je vais habiter une petite maison, au bout du jardin, où je serai seul et par conséquent plus libre, où j'ai une bien plus belle vue qu'auparavant et, chose inappréciable, un bel atelier au nord." Ingres to Pierre Forestier, December 25, 1806, quoted in Lapauze 1911a, p. 76.

8. "Je vous demande à deux genoux, il m'est impossible de quitter si tôt un pays si merveilleux." Quoted in Lapauze 1910, p. 187.

9. The novel is published in Lapauze 1910.

10. "On désirerait qu'il se pénétrât davantage du beau caractère de l'antiquité et du style grand et noble que doivent inspirer les belles productions des grands maîtres des beaux temps de l'École Romaine." Quoted in Lapauze 1911a, pp. 96–97.

11. This exhibition has been studied in part by Elena di Majo and Stefano Susinno in Rome 1989–90, pp. 3–23. I thank Dr. Chiara Stefani for her transcription of parts of the 1809 exhibition catalogue (see Rome 1809); Ingres exhibited "58. Donna nuda che dorme" and "59. Due ritratti sotto lo stesso no."

12. Canova worked only reluctantly for Bonaparte and his family, for as an Italian patriot he resented their pillage of art in his homeland. In 1814 he returned to Paris, this time to negotiate the restitution of such looted works.

13. "imitanti lo stile fiamingo"; "una vivacità, ed un colorito singolare, che sebbene conservi un certo tagliente preso dal vero, pure produce un accordo piacevole." Visconti 1809, pp. 289–90. I thank Dr. Chiara Stefani for her transcription of this material.

14. "a tout Rome dans son portefeuille." Gérard 1867, p. 95.

15. On Granet's Roman landscapes, see especially Néto-Daguerre and Coutagne 1992.

16. For a fuller discussion of Ingres's landscape backgrounds, see cat. no. 25; the strongest case for Granet's participation is made in Toussaint 1990b, pp. 18–24. Georges Vigne also takes this position in Vigne 1995b, p. 87, and in this catalogue, p. 526.

17. Pâris bequeathed his collection to his native town, Besançon (most of his own drawings are deposited in the Bibliothèque Municipale there); for his collection in the Musée de Besançon, including the drawings by Fragonard and Robert, see Cornillot 1957.

18. "ce pays est un des plus riches en sites variés et piquants: le climat y donne à la couleur une vigueur et un éclat dont on n'a pas l'idée dans les pays septentrionaux . . . les fabriques et les ruines les plus majestueuses, se mêlent aux plus belles productions spontanées de la nature pour composer le paysage du style le plus grand et le plus noble." Quoted in Lapauze 1924, vol. 2, p. 78.

19. "leur exemple excitera les peintres d'histoire à se former assez dans la partie du paysage, pour ne pas la traiter trop en accessoire, lorsqu'il entre dans leur composition." Ibid.

20. Lapauze 1911a, p. 97.

21. Georges Vigne has identified several different hands among the landscape drawings at the Musée Ingres—see, for instance, his so-called Master of the Little Dots (1995a, nos. 2814–2854) and his Master of the Gardens of the Villa Medici (ibid., nos. 3015–3032)—and has returned to the theme more recently in Montauban 1998. He has also suggested that a number of these drawings were adapted by Ingres as backgrounds for the portrait drawings done in Rome; see pp. 526–28 in this catalogue. For one drawing by Ingres in which the sitter himself may have provided the prototype for a complex architectural perspective in the background, see the portrait of the engineer Charles-François Mallet (cat. no. 42).

22. Lapauze 1911a, p. 100.

23. "est très-instruit et sans contredit un des jeunes peintres dont on peut le plus espérer le renouvellement de l'Ecole française moderne." Bruun-Neergaard 1811, quoted in Naef 1977–80, vol. 1 (1977), p. 168.

24. For instance, Bronzino's Portrait of a Young Man (fig. 174), which in Ingres's day was in the collection of Lucien Bonaparte in Rome.

25. For the correspondence, see Ternois 1999; the letters themselves are kept at the Fondation Custodia, Paris.

26. This painting was, however, considerably reworked by Ingres at a later date.

27. "Vous voyés mon cher monsieur que Ingres peut faire son entrée dans le monde. . . ." Ingres to Marcotte, July 18, 1813; Ternois 1999, letter no. 2.

28. The resemblance is borne out by a comparison of Ingres's portrait drawings of the two cousins—among them N 97, 127, and 128 for Madeleine in 1813 and 1814, and N 102–105, for Adèle during the same period. But the two women were obviously not identical—their noses, for instance, differ in Ingres's drawings. Georges Vigne's recent suggestion (in Montauban 1996–97, no. 75) that N 102 and 103 represent Madeleine is not convincing.

29. Amaury-Duval 1993, p. 78.

30. "C'est un peintre. Non un peintre en bâtiment, mais c'est un grand peintre d'histoire, un grand talent. Il se fait de dix à douze mille livres de rente; tu vois qu'avec cela on ne meurt pas de faim. Il est d'un bon caractère, très doux; il n'est ni buveur, ni joueur, ni libertin; il n'a pas de défauts à craindre; il promet de me rendre bien heureuse, et j'aime à le croire." August 30, 1813, in Boyer d'Agen 1909, pp. 18–19.

31. "J'ai uni mon sort à une excellente épouse, qui fait mon continuel bonheur. Elle m'a apporté une véritable dot en elle-même et notre ménage est, j'ose le dire, cité en exemple. J'éprouve, de ce côté, le bonheur le plus parfait." Ingres to Gilibert, July 7, 1818, in ibid., p. 35.

32. See, for instance, his comments in a letter to Gilibert dated June 3, 1821, in ibid., pp. 74–75.

33. For this series, see Néto-Daguerre and Coutagne 1992, pp. 139–57.

34. In an annotation to Ingres's letter to him of December 20, 1812, Marcotte notes that he commissioned *The Sistine Chapel;* Ternois 1999, letter no. 1.

35. Ingres to Marcotte, May 26, 1814; ibid., letter no. 3.

36. "Je veux faire du bruit moi aussi au Salon. Ayant d'ailleurs mes grandes raisons de prouver à messieurs les genristes que la suprématie sur tous les genres appartient aux seuls peintres d'histoire." Ingres to Marcotte, December 20, 1812; ibid., letter no. 1.

37. "Il vaut bien mieux faire de bons tableaux de genre que de médiocres peintures d'histoire." Quoted in Delécluze 1855, p. 244.

38. "bizarre . . . gothique . . . sans harmonie . . . barbare." Gault de Saint-Germain 1819, quoted in Lapauze 1911a, p. 196.

39. "original et maniéré." Jal 1819, quoted in Lapauze 1911a, p. 198.

40. "Est-ce ici que demeure le dessinateur de petits portraits? Non, celui qui demeure ici est un peintre!" Boyer d'Agen 1909, p. 26. There are several versions of this story, including Blanc 1870, p. 45, and Delaborde 1870, p. 36.

41. Delaborde 1870, p. 41; David d'Angers 1891, p. 45; and Amaury-Duval 1993, pp. 53–54.

42. Blanc 1870, p. 45.

43. Quoted in Naef 1977–80, vol. 1 (1977), p. 18.

44. Lapauze 1911a, p. 158.

45. "une sorte de Muséum National et sacré qui attesterait aux étrangers le perfectionnement de notre école." Blacas to Thévenin, January 2, 1817, quoted in Lapauze 1924, vol. 2, p. 132.

46. "un talent original et tout à fait hors de la route battue." Quoted in Lapauze 1911a, p. 192.

47. Ibid., p. 202.

48. On the Catholic revival and history painting in nineteenth-century France, see Foucart 1987.

49. Georges Vigne's suggestion (1995b, p. 145) that *Christ Giving the Keys to Saint Peter* owes more to Philippe de Champaigne than to the Nazarenes is not convincing, neither visually nor given the fully Roman context of this commission. The reworking of 1841, mentioned under Wildenstein 132 but deserving further investigation, should perhaps be taken into consideration.

50. For Thévenin's recommendation, see Lapauze 1911a, pp. 205–6.

51. See Ingres's letter to Gilibert, July 7, 1818, in Boyer d'Agen 1909, pp. 33–38.

52. "treize ans d'esclavage." Ingres to Gilibert, June 1819, in ibid., p. 39.

25. François-Marius Granet

1809
Oil on canvas
29⅜ × 24⅞ in. (74.5 × 63.2 cm)
Signed lower right: J. A. Ingres
Musée Granet, Aix-en-Provence

W 51

Fig. 107. *François-Marius Granet Seated*, 1812
(N 85). Graphite on paper, 11 × 8⅜ in. (28.1 ×
21.4 cm). Musée Granet, Aix-en-Provence

Ingres would have first met François-Marius Granet (1775–1849) in Paris, during Granet's brief course of study in the studio of Jacques-Louis David.[1] In 1798 Granet had been encouraged to come to the capital by his childhood friend Comte Auguste de Forbin (1777–1841), who had already joined David's studio in 1797. Forbin's family paid the expenses of Granet's trip to Paris from his native Aix-en-Provence. Forbin himself not only helped Granet gain acceptance into David's studio but also paid Granet's fees for his first few months. The seventeen-year-old Ingres had also entered David's studio early in 1798; moreover, the two young painters shared a provincial background in southern France, which may in itself have been a bond. After some months, however, Granet was forced to leave the studio due to his inability to pay his fees. Nevertheless, by about 1800 the two young painters were sharing work spaces in the Couvent des Capucines, a convent secularized during the Revolution and given over to artists. Although their contemporary Étienne Delécluze wrote that Ingres kept himself apart from the other artists

there, Ingres and Granet cannot but have continued their acquaintance.[2]

Thrown on his own resources, Granet had to teach himself, and he made a modest living copying works of art in the Louvre. Granet did not aspire to history painting in the grand manner as taught by David: he was attracted by the realism of the Dutch and Flemish genre painters of the seventeenth century and named David Teniers the Younger's *Prodigal Son* (Musée du Louvre, Paris) as one of his favorites.[3] Granet soon developed his own specialty as a painter, depicting real and imaginary medieval church interiors, crypts, and cloisters. This interest in the Middle Ages was shared by other David pupils at this time, among them Fleury Richard (1777–1852) and Pierre Révoil (1776–1842). Their romantic nostalgia for the France of remote times past was in part inspired by the recent creation of the Musée des Monuments Français, which housed the remains and contents of religious establishments sacked during the Revolution. Granet first exhibited his paintings of medieval church interiors at the Salon in 1799 and 1800.

Fig. 108. François-Marius Granet (1775–1849), *The "Manica Lunga" of the Palazzo del Quirinale, Rome*, by 1809. Oil on paper, mounted on canvas, 8⅝ × 11⅜ in. (22 × 29 cm). Musée Granet, Aix-en-Provence

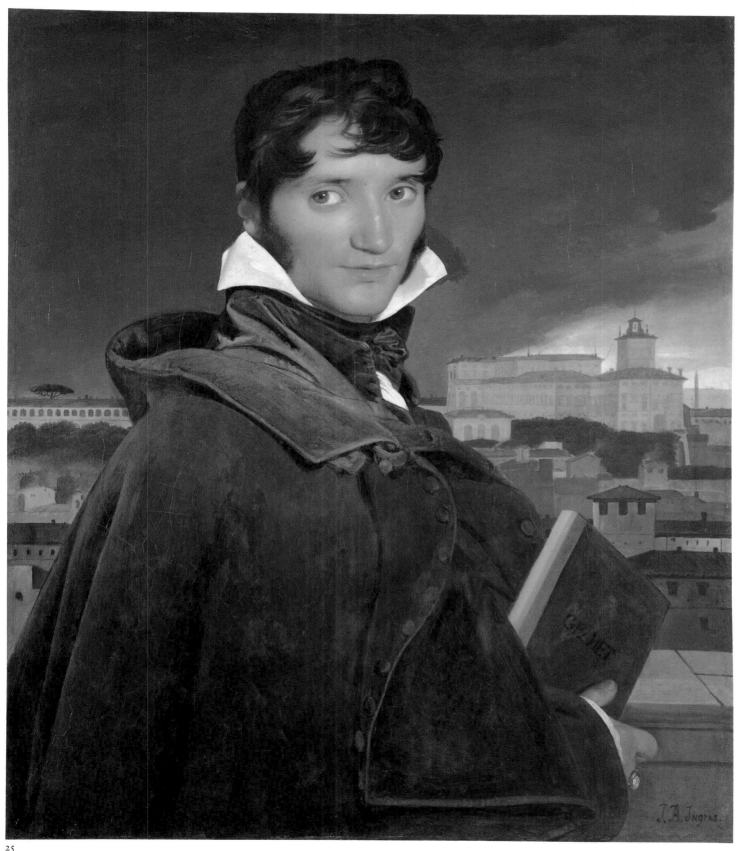

25

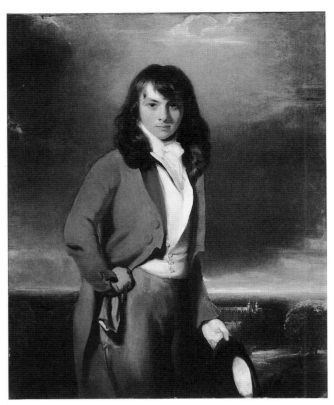

Fig. 109. Thomas Lawrence (1769–1830). *Arthur Atherly as an Etonian*, 1792. Oil on canvas, 50 × 40⅛ in. (127 × 102 cm). Los Angeles County Museum of Art

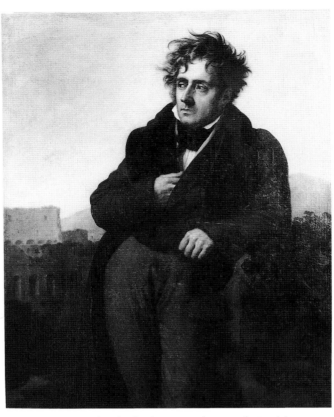

Fig. 110. Anne-Louis Girodet (1767–1824). *François-René de Chateaubriand*, 1807–8. Oil on canvas, 47¼ × 37¾ in. (120 × 96 cm). Musée d'Histoire et du Pays Malouin, Saint-Malo

In 1802 Granet and Forbin departed for Rome together, arriving in October. There Granet was as enchanted by crypts and subterranean churches as he was by the picturesquely crumbling remains of antiquity. He took rooms near Santissima Trinità dei Monti, a church frequented by the French community in the shadow of the Villa Medici, the new seat of the Académie de France in Rome. Granet soon found a free studio in the adjacent convent. Ingres, who had arrived in Rome in October 1806 to study at the Académie, would join Granet at the convent in 1810, after his scholarship at the Villa Medici expired. The two artists maintained studios there until rents were imposed in 1814.

Once settled in Italy, Granet lost no time in creating a market for his evocative pictures of crypts, cloisters, and cata-combs, and he also began to paint small views of Rome and its ruins for the many visitors to the Eternal City.[4] In this he was encouraged by the Belgian artist Simon Denis (1755–1813), who had a well-established practice painting real and imaginary landscapes of Rome and its environs. Granet also made quantities of drawings, to the extent that François Gérard could remark in 1804 that Granet "has all of Rome in his portfolio."[5] According to his own memoirs, Granet made a brief trip to Paris in 1805 with the intention of exhibiting some works at the Salon; the paintings were damaged in transit, however, so the artist made no income on them. Despairing of the trip back to Rome, Granet was fortunate to join the escort of Cardinal Fesch, Napoleon's ambassador to the Holy See, who was just then returning to Italy. Fesch became a protector of Granet, acquiring a number of the artist's works and taking his advice on building his extensive art collection.[6]

By the time Ingres arrived in Rome in October 1806, Granet had secured a steady livelihood and was again sending works for exhibition at the Salon in Paris. Unlike Ingres at the Salon of 1806, however, Granet enjoyed considerable success: for instance, the critic Pierre Chaussard, who derided Ingres's works (see p. 500 and cat. no. 10), wrote admiringly of Granet, "It was from the burning sky of Italy that Granet drew the warm and lively tone of his paintings, the accuracy of his settings, and the severity of his style."[7] Yet there is no reason to think the two friends were not delighted to be reunited in Rome. Years later Granet wrote to Ingres in the most affectionate terms, recalling their youth in Rome: "It is quite true that I'm in that beautiful Rome, where we spent the finest days of our lives."[8] They even exhibited side by side in Rome in 1809, when an international exhibition was mounted on the Campidoglio.[9] Granet showed five characteristic works depicting scenes of religious devotions, cloisters, and catacombs.[10] Ingres exhibited *A Nude Woman Sleeping* and two portraits; one of the latter was likely the present portrait of his friend François-Marius Granet.

Ingres has represented Granet at half length, wearing a carrick, a heavy overcoat with a short cape attached.[11] The starched collar of his white shirt flares past his side-burns and is held in place by a generous

black silk cravat. On the second finger of his right hand he wears a gold ring set with a large baroque pearl. A bound sketchbook with the name GRANET (the *N* is reversed) inscribed on the cover rests in his arms. Standing at an elevated site with a wall or parapet behind him, in the vicinity of the Villa Medici and Santissima Trinità dei Monti on the Pincio Hill, Granet turns away from a view across rooftops to the north front of the Palazzo del Quirinale, the papal summer palace in Rome, which was constructed and modified from the sixteenth through the eighteenth centuries. The dark sky and erratic light flickering across the city and over Granet's handsome features induce a vivid feeling of Rome on a heavy, thunderous day. By silhouetting Granet's head against the threatening clouds, Ingres created an intense yet engaging portrait, in whose directness we can feel the strong bond of affection between the two artists. This painting takes its place among the great Romantic portraits of the early nineteenth century, such as Anne-Louis Girodet's *François-René de Chateaubriand* (fig. 110) and Thomas Lawrence's *Arthur Atherly as an Etonian* (fig. 109), in which landscape and the elements help convey a sense of passion and expansiveness of mind.

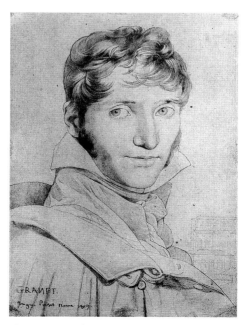

Fig. 111. *François-Marius Granet*, 1809. Graphite on tracing paper, 17 × 12⅝ in. (43.4 × 32.2 cm). Musée Ingres, Montauban (867.256)

In the background of Ingres's portrait, the broad handling and subtle tonality of the facades, rooftops, and occasional breaks of foliage suggest the landscape paintings of Granet himself. There has been considerable discussion about the authorship of the landscape background in this portrait, along with those in *Joseph-Antoine Moltedo* (cat. no. 27), *Count Nikolai Dmitrievich Gouriev* (cat. no. 86), and *Charles-Joseph-Laurent Cordier* (fig. 93). It was suggested as early as the nineteenth century—by Cordier's daughter—that Granet had painted the background of her father's portrait.[12] On the basis of this suggestion, Hélène Toussaint proposed that Granet painted the landscape backgrounds in all four Italian portraits.[13] Scholarly opinion has been divided on this issue.[14] Among Granet's numerous plein-air oil studies at the Musée Granet, there is indeed one that represents the "Manica Lunga" of the Palazzo del Quirinale, Rome (fig. 108)[15] much as we see it in the right background of Ingres's portrait. A close comparison between the landscape sketch and the background of the portrait shows that the two views are executed in a very similar technique, with thin, fluid paint floated in places such as the hillside and the long architectural structure over the ground, like watercolor. This observation belies Edgar Munhall's view that they are different in touch.[16] In general, the evidence that Granet painted all these landscape backgrounds, however, seems rather slim, and the transition from figure to landscape is seamless in each one. Ingres was a versatile artist, and it is likely that he normally painted his own landscape backgrounds, adapting their manner to the overall concept of the portraits. In *Bonaparte as First Consul* (cat. no. 2) and *Queen Caroline Murat* (cat. no. 34), for example, the style differs according to the character and circumstances of the sitters. As Granet was a distinguished landscape painter in his own right, it is plausible that in this unique case Ingres had his sitter supply the landscape setting of their beloved Rome. It is an amusing conceit that would have been appreciated by their circle, not least because Granet could be said to have added his own signature on the cover of the portfolio,

as confirmation of their collaboration. That said, it would hardly be surprising if Ingres modeled his own landscape backgrounds in the portraits of Cordier and Moltedo on Granet's example.[17]

Georges Vigne has persuasively suggested that the painting of François-Marius Granet should be dated to 1809.[18] A drawing in the Musée Ingres, Montauban (fig. 111), made after the painting, was signed and dated by Ingres, "Roma. 1809." Although this is not conclusive proof that the painting also dates to that year, consideration of the painting's position in the manuscript lists that Ingres compiled of his own works shows it to be convincing.[19] Moreover, Bernard Terlay has drawn attention recently to a letter written by Ingres to the director of the Musée Granet in 1850, when he was trying to locate the portrait of "my illustrious friend Granet," in which he refers to "the portrait I painted of him about 1809."[20] So far as we know, all of Ingres's Roman painted portraits are documented, and only two of them—*François-Marius Granet* and *Madame Duvaucey* (fig. 87)—can date before 1810; presumably, these are the two he exhibited in 1809 on the Campidoglio.

In 1812 Ingres made a second portrait drawing of Granet (fig. 107), depicting his friend seated in an informal pose, palette in hand, in front of an easel and canvas. His gaze is no less intense than in the painted portrait, but the context of the scene as the artist pauses from his work, shirt open at the neck, gives the drawing a more informal air. Ingres made a copy of it for Forbin, which is still with his descendants (N 86). He also drew Forbin's portrait, facing the other way (N 87), and perhaps considered these last two as pendants. They were both engraved by Marius Reinaud in 1812.

Ingres and Granet still had studios at Santissima Trinità dei Monti when on December 4, 1813, Granet witnessed his friend's marriage to Madeleine Chapelle. By this date Granet was enjoying considerable success. An anecdotal historical painting called *The Painter Stella in Prison in Rome* (Pushkin Museum, Moscow) had earned Granet considerable acclaim when he exhibited it in 1810 in his Rome studio,

and again in 1811 at the Paris Salon; it was acquired by Empress Josephine for the imperial château of Malmaison. Among his other patrons Granet numbered Cardinal Fesch; the countess of Albany; and Caroline Murat, queen of Naples (see cat. no. 34). In 1812 he was nominated Painter to the Queen of Naples. When Ingres made a visit of his own to Naples early in 1814, he carried with him a painting Granet had completed for the queen.

In this same year Granet painted the first of many versions of what was to become his most popular and famous canvas, *The Choir of the Capuchin Church in the Piazza Barberini*. He painted a second version in 1815, which he exhibited to acclaim in his studio. Now that the occupying Bonapartists had left Rome, Granet was exposed to much wider international attention and was presented by the French ambassador Cortois de Pressigny (see cat. no. 61) to such dignitaries as Pope Pius VII and Charles IV of Spain. Following the restoration of the Bourbons, Granet's old friend Forbin was named director of the Musées Royaux. He used this powerful position to further Granet's interests in Paris, securing for him good places to exhibit his works at the Salon and acquiring several works for the crown, including *Interior of the Church of San Benedetto, near Subiaco* (Salon of 1819; Musée Municipal d'Art et d'Histoire, Dreux). Granet was protected by another of his—and Ingres's—Roman acquaintances, the vicomte de Senonnes (see cat. no. 35), who as director general of the Musées Royaux commissioned from Granet *Saint Louis Buying Back French Prisoners in Damietta* for the royal château of Fontainebleau in 1817.

Granet's success, however, began to strain his friendship with Ingres. Ingres struggled for recognition and did his best to keep to the difficult high road of history painting (while having to earn his living making the portraits he despised), but he increasingly resented what he perceived as Granet's easy success through his appeal to common taste for the low genres of anecdotal historical scenes and touristic views of Rome and its environs. In December 1812 Ingres had hoped to beat

Granet at his own game by triumphing at the Salon with his own painting of a church interior, *The Sistine Chapel* (fig. 100). Writing to his patron Charles Marcotte (see cat. no. 26), Ingres said, "I want to make some noise at the Salon, too. Having, moreover, my good reasons to prove to those genre painters that supremacy over all the genres belongs to historical painters alone."[21] Ingres's resentment of Granet came to a head in 1821, as he smarted from the scant attention being paid to his *Christ Giving the Keys to Saint Peter* (fig. 106), a monumental altarpiece in the grand manner recently unveiled in the church of Santissima Trinità dei Monti. In Florence Ingres was having an uncomfortable time visiting his even more successful friend, the sculptor Lorenzo Bartolini. Charged to send his friend Jean-François Gilibert (see cat. no. 5) a couple of Granet's drawings, Ingres commented with bitter sarcasm that Granet, "with all that *talent*, has earned himself a fortune and a *European reputation*." He continued

Fashion and infatuation have loaded him with goods and honors since he did a painting of the *Capuchins*. . . . He is a compound of selfishness and ambition such that, with his *Capuchins*, he has always pushed me aside in Rome, knowing full well, at least in the depths of his soul, that my painting of *Saint Peter* is a fine historical work and, consequently, of greater quality than all the capuchins in the world; that not only this painting, but even its smallest component parts should have won me a veritable medal of honor and fortune. And yet, my bad luck is due in part to him and to Forbin, because of the *poca cura* they took of my works at the last Salon. They basely betrayed me.[22]

However, the election of Ingres as a corresponding member of the Académie de France in 1823 and the success of *The Vow of Louis XIII* (fig. 146) at the Salon of 1824 heralded the resumption of friendly relations. In 1830 Granet returned to Paris, where he was honored with a chair at the Institut de France. He held a succession of official positions as curator at the Louvre, at the Musée du Luxembourg, and at Versailles. Both Granet and Ingres were now members of the establishment, as well as

the last representatives of the school of David; as such, they had long lost any reputation for originality or independence they may have enjoyed in their earlier Roman days. Granet's letters to Ingres, during the latter's tenure as director of the Académie in Rome from 1835 to 1841, show Granet burdened with administrative responsibilities in Paris and Versailles and longing for Rome, his spiritual home.

In 1835 Granet arranged an exchange, sending from Versailles to the museum in Aix-en-Provence the large painting *Jupiter and Thetis* (fig. 92), one of Ingres's most radical works when he was a student in Rome and acquired by the state only in the previous year. The death of Granet's friend and protector Forbin in 1841, followed by the death in 1847 of Nena di Pietro—a married woman who had been Granet's companion since his early days in Rome—plunged Granet into nostalgia and melancholic reminiscence. His fascinating *Memoirs* are the lasting product of these final years, spent at his estate of Le Barben (also known as Les Granettes) near Aix-en-Provence. P.C.

1. The most reliable information on Granet is now Néto 1995; on his relations with Ingres, especially with regard to their correspondence, see ibid., pp. 315–20. For Granet's memoirs, translated into English by Joseph Focarino, see New York, Cleveland, San Francisco 1988–89, pp. 3–60.
2. Delécluze 1983, p. 297.
3. New York, Cleveland, San Francisco 1988–89, p. 13; Granet says he made a copy of Teniers's *Prodigal Son*.
4. On Granet's work in Rome, see especially Néto-Daguerre and Coutagne 1992.
5. "a tout Rome dans son portefeuille." Gérard to the painter Pierre-Narcisse Guérin, August 8, 1804, quoted in Gérard 1867, p. 95.
6. On Fesch and Granet, see Néto 1995, pp. 298–300.
7. "C'est sous le ciel brûlant d'Italie que Granet a puisé ce ton vigoureux et chaud de ses tableaux, la vérité des sites et la sévérité du style." Chaussard quoted in Néto-Daguerre and Coutagne 1992, p. 83.
8. "Il est bien vrai que je suis dans cette belle Rome où nous avons passé les plus beaux jours de notre vie." Granet to Ingres, January 15, 1830, in Néto 1995, p. 154.
9. On the Campidoglio exhibition, see p. oo.
10. Granet's paintings at the Campidoglio exhibition were: *Early Christians Taking*

Communion in the Catacombs, no. 44; *Beatrice Cenci Leaving Prison to Go to the Scaffold on 11 September 1599*, no. 45; *The Cloister of the Certosa in Rome, When the Brothers Return from the Choir*, no. 46; *A Monk Writing in His Cell*, no. 47; and *A Monk in Meditation*, no. 48. Rome 1809, p. 7. The present locations of these works are unknown.

11. See Edgar Munhall in New York, Cleveland, San Francisco 1988–89, pp. 141–43, for an excellent description and discussion of this portrait.

12. Hans Naef (1970 ["Ingres et Cordier"], p. 83) first published a letter of April 14, 1886, in which a Senator Denormandie announced to the undersecretary of state that Comtesse Mortier, Cordier's daughter, had just bequeathed to the Louvre her father's portrait by Ingres, "depicting in the background the Temple of the Sibyl painted by Grasset [sic]" ("représentant au fond du tableau le temple de la Sibyl peint par Grasset [sic]"). Hélène Toussaint (in Paris 1985, p. 50) published an extract from the countess's will, where it is stated, "The background was painted by Granet and depicts the Temple of Sibyl at Tivoli" ("Le fond a été peint par Granet et représente le temple de la Sibylle à Tivoli").

13. Toussaint 1990b, pp. 18–24.

14. For example, Ternois (in Montauban 1967, p. 78), Naef (1970 ["Ingres et Cordier"], p. 84; 1977–80, vol. 1 [1977], pp. 263–64), and Munhall (in New York, Cleveland, San Francisco 1988–89, p. 142) do not accept that Granet painted the landscape backgrounds. In addition to Toussaint, Rosenblum (1967a, p. 88), Shackelford and Holmes (in Houston 1986–87, p. 84), Néto (1990, p. 5), and Vigne (1995b, p. 77) think he did.

15. Inv. no. 849–1-G.172; exhibited Rome 1996–97, no. 17, color ill.

16. New York, Cleveland, San Francisco 1988–89, p. 142.

17. As for the portrait of Count Nikolai Dmitrievich Gouriev (cat. no. 86), which Ingres painted in Florence in 1821, there is no evidence that Granet was there with Ingres; indeed, relations were cool between the two artists at that time. However, Granet probably passed through Florence early in 1820 on a return trip from Paris to Rome. It seems clear to the author that Ingres painted the landscape background of *Count Gouriev* on the basis of the anonymous drawing of a view of Palombara (fig. 312), published in Toussaint 1990b, p. 19, color ill. on the cover. Most likely, Gouriev provided Ingres with this drawing of a favorite site: the hand appears to be French, but as yet the author is unidentified.

18. Vigne 1995a, p. 478, no. 2661.

19. The portrait *François-Marius Granet* appears in the two manuscript lists of works drawn up by Ingres (Notebook IX, fol. 124; Notebook X, fol. 23), which are transcribed in Vigne 1995b, pp. 325, 326.

20. "mon illustre ami Granet"; "le portrait que j'ai peint d'après lui vers 1809." Ingres to Henri Gibert, 1850, quoted in Terlay 1992, p. 11.

21. "Je veux faire du bruit moi aussi au Salon. Ayant d'ailleurs mes grandes raisons de prouver aux messieurs les genristes que la suprematie sur tous les genres appartient aux seuls peintres d'histoire." Ingres to Marcotte, December 20 [1812], in Ternois 1999, letter no. 1.

22. "avec ce *talent*, s'est fait une fortune et une *reputation européenne*. La vogue et l'engouement le font regorger de biens et d'honneurs pour avoir fait un tableau de *Capucins*. . . . Il est un composé d'egoïsme et d'ambition telle qu'il m'a, avec ses *Capucins*, toujours mis de côté à Rome, sachant bien, néanmoins au fond de son âme, que mon tableau de *Saint Pierre* est un bel ouvrage historique et, par conséquent, au dessus par la qualité de tous les capucins du monde; que, non seulement ce tableau, mais une des plus petites parties de ce tableau devraient me donner la véritable croix d'honneur et la fortune. Et pourtant, c'est à lui et au Forbin que je dois une partie de ma mauvaise fortune, par la *poca cura* qu'ils ont eu de mes ouvrages au dernier Salon. Ils m'ont trahi vilainement." Ingres to Gilibert, June 3, 1821, in Boyer d'Agen 1909, pp. 73–74. Ingres refers to the Salon of 1819, where his *Grande Odalisque* and *Roger Freeing Angelica* were not well received by the critics.

PROVENANCE: François-Marius Granet (1775–1849); his bequest to the city of Aix-en-Provence, 1849; Musée Granet, Aix-en-Provence

EXHIBITIONS: Rome 1809, no. 59?; Paris 1900a, no. 366; Paris 1913, no. 182 [EB]; Paris 1921, no. 14, ill.; Montauban 1967, no. 23, ill.; Paris 1967–68, no. 26, ill.; Rome 1968, no. 8, ill.; Louisville, Fort Worth 1983–84, no. 57, ill.; Houston 1986–87, no. 26, ill.; New York, Cleveland, San Francisco 1988–89, no. 61, ill.; Rome 1996–97

REFERENCES: Magimel 1851, pl. 14; Gibert 1862, no. 620; Silbert 1862; Merson and Belier de la Chavignerie 1867, p. 103; Blanc 1870, p. 231; Delaborde 1870, p. 250, no. 125; Pontier 1900, no. 360; Lapauze 1901, p. 109; Momméja 1905a, under no. 75; Uzanne 1906, p. xiii, pl. 44; Lapauze 1911a, pp. 88–89, ill. p. 79; Bénédite 1921, pp. 329–31; Fröhlich-Bum 1924, pp. 4, 7, pl. 10; Hourticq 1928, ill. p. 19; Gillet 1932 in Courthion 1947–48, vol. 1, p. 154; Ripert 1937; Pach 1939, p. 35, ill.; Malingue 1943, p. 15; du Rivau 1947, vol. 1, p. 14; Courthion 1947–48, vol. 1, pp. 153–54; Alain 1949, no. 16, ill.; Bertram 1949, p. 13, pl. 5; Jourdain 1949, pl. 18; Roger-Marx 1949, pl. 8; Scheffler 1949, pl. 8; Alazard 1950, p. 37, pl. X; Wildenstein 1954, no. 51, pls. 18, 23 (detail); Schlenoff 1956, p. 94, n. 3; Viguié 1958, pp. 565, 568; Picon 1967, ill. p. 27; Rosenblum 1967a, p. 76, pl. 11; Radius and Camesasca 1968, no. 15, ill.; Naef 1970 ("Ingres et Cordier"), p. 84; Picon 1980, pp. 102, 122, ill. pp. 28, 123 (detail); Eitner 1987–88, p. 161; Zanni 1990, p. 38, no. 24, ill. p. 38; Vigne 1995a, p. 478; Vigne 1995b, p. 77, fig. 52; Roux 1996, pp. 10, 41, ill. pp. 40, 41 (detail)

26. Charles-Marie-Jean-Baptiste Marcotte (Marcotte d'Argenteuil)

1810

Oil on canvas

36⅞ × 27¼ in. (93.7 × 69.4 cm)

Signed lower right: Ingres. pinx. Rom. 1810
[Ingres painted (this in) Rome. 1810]

National Gallery of Art, Washington, D.C.

Samuel H. Kress Collection 1952.2.24

W 69

Charles Marcotte, called Marcotte d'Argenteuil (1773–1864), who came from a line of distinguished civil servants established in the reign of Louis XV, was appointed inspector general of forests and waterways[1] for Rome and the other French-occupied Italian states in 1807. Before moving to Rome in 1810, Marcotte set up administrative offices in Genoa, Parma, and Tuscany. He intended this portrait as a gift for his mother and had considered giving the commission to Ingres's friend Merry-Joseph Blondel (see cat. no. 41), the history painter who had won the Prix de Rome in 1803 and was in 1810 residing at the Académie de France. At the home of Edme Bochet, another Napoleonic official in Rome, who was shortly to become Marcotte's brother-in-law, Marcotte frequently met Édouard Gatteaux, a sculptor and engraver of portrait medals. Gatteaux was a friend of Ingres, whom he recommended to paint Marcotte's portrait.[2]

The occasion of this commission introduced Ingres to a man who was to become one of his most loyal supporters. Marcotte soon recommended Ingres to his professional colleagues and to his relatives, initiating lifelong relationships between the

artist, the Marcotte family, and their acquaintances.[3] Immediately Ingres was commissioned to paint the portrait of Edme Bochet (cat. no. 30) and of Bochet's sister Madame Panckoucke (fig. 117), completed in Rome in 1811. The Marcotte and Bochet circle in Rome included other high officials of the French occupation government who were to be portrayed by Ingres, including Joseph-Antoine Moltedo (cat. no. 27), Charles-Joseph-Laurent Cordier (fig. 93), Hippolyte-François Devillers (cat. no. 31), and Jacques Marquet, baron de Montbreton de Norvins (cat. no. 33). Marcotte himself posed for two pencil portraits in 1811 (figs. 112, 113).[4]

Charles Marcotte is shown standing before a plain, gray-green background, leaning with his left elbow on a table draped with a red cloth. He is dressed in a heavy blue carrick, with its cape and black velvet collar, beneath which he wears a dark brown coat. His crisp white shirt, black cravat, and starched collar emerge from the top of a bright yellow waistcoat. His hair has a casually ruffled appearance. His bicorne with a golden tassel lies on the table beside him; his little finger is adorned with a single, narrow ring;[5] from beneath

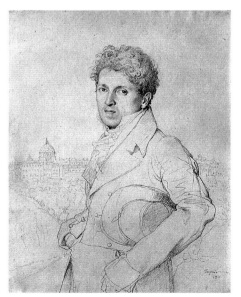

Fig. 112. *Charles Marcotte*, 1811 (N 65). Graphite on paper, 9⅞ × 7½ in. (25 × 19.2 cm). Private collection

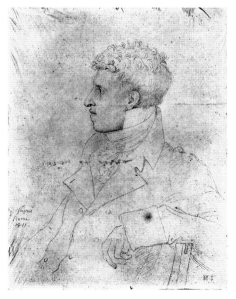

Fig. 113. *Charles Marcotte*, 1811 (N 64). Graphite on paper, 8⅝ × 6⅛ in. (21.9 × 15.7 cm). Private collection

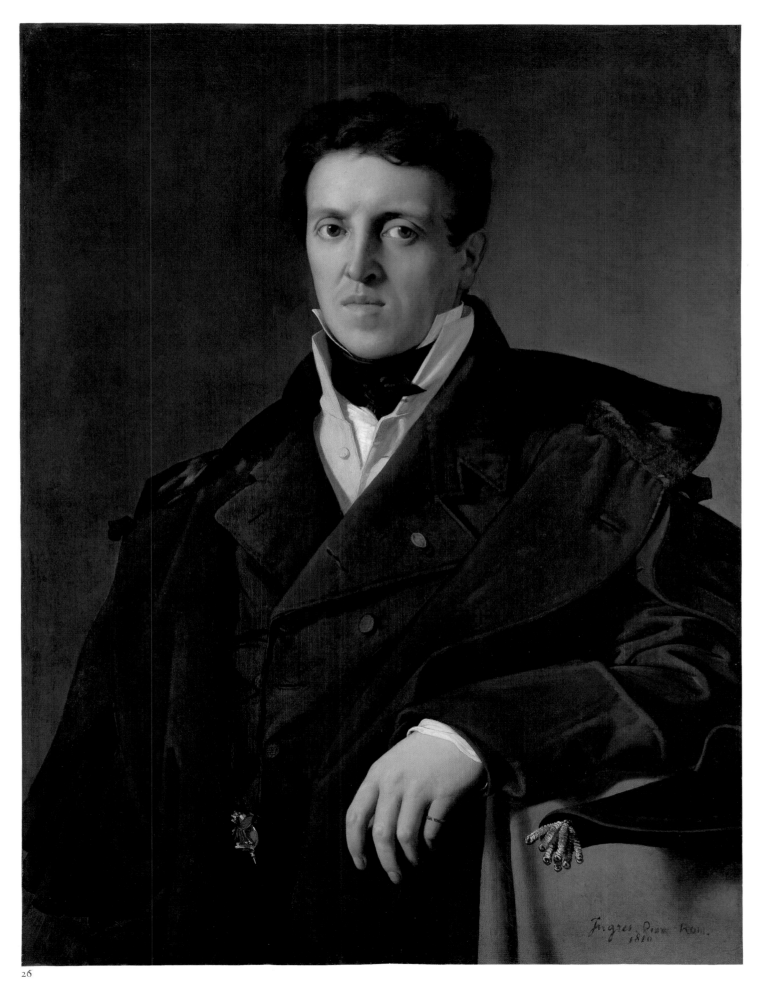

26

his coat hang a golden watch fob and seals. The crimson rosette of an officer of the Legion of Honor was added later; Marcotte received that decoration in 1836.[6]

Marcotte looks down on the viewer from above, giving him an air of distance and formality. He seems both uneasy and morose, his brow concentrated as if beginning a disdainful frown. His small mouth is turned down at the corners. The two pencil drawings show the same features in different views and confirm by their close correspondence to the painting the unflattering objectivity with which Ingres regarded the strikingly individual and not particularly attractive features of his friend. Henry Lapauze found in Ingres's interpretation of Marcotte's features a resemblance to those of Ingres in his *Self-Portrait* of 1804 (see cat. no. 11): "The face is no doubt lacking a smile. But Ingres, painting his own portrait at the age of twenty-four, did not depict himself smiling, either. In M. Marcotte's dark eyes, in the slight pout of his lips, in the energy of his features and their willful concentration, there is a certain something that recalls the unsociable youth of Chantilly."[7] Lapauze understandably admired the somber color harmonies of this portrait[8] and, as Lorenz Eitner has observed, "It is from the subdued opulence of its colors, no less than from its tensely controlled design, that the portrait derives its peculiar expressive force."[9] The restrained costume and palette, and Marcotte's sallow complexion and haughty mien, are suggestive of Italian Renaissance portraiture of the early sixteenth century,[10] and especially the Florentine painters Jacopo Pontormo and Agnolo Bronzino. Eitner has pointed to Bronzino's *Portrait of a Young Man* (fig. 174) as such a source: Ingres could have known this very picture in Rome, in the collection of Lucien Bonaparte, whose portrait he had drawn about 1807 (cat. no. 38).[11]

Letters sent by Ingres from Rome to Marcotte in Paris, where the latter had returned by 1814, indicate that Marcotte had requested permission to have a change made in the color of the costume. In the first letter, Ingres consented to having the proposed change carried out and observed only, "all that needs to be done is to follow

the same folds, but in a different color."[12] In the second, he specified the area affected by the change as the segment of Marcotte's trousers visible beneath his coat and between the folds of his overcoat, and requested that Marcotte "ask someone to glaze the trousers and repaint them with the same folds."[13] Examination of this small area has revealed that this glazing and repainting was, in fact, carried out in compliance with the wishes of Ingres's fussy patron.[14]

In these same letters, Ingres also gave permission to have the portrait exhibited at the forthcoming Salon of 1814. According to the Salon catalogue he exhibited "No. 535. Several portraits."[15] But from contemporary reviews it is apparent that only one portrait was actually shown, and Daniel Ternois has confirmed that it was the portrait under discussion.[16] The two critics who noticed it were not very flattering. The one who signed himself "M." (Edme Miel) spoke of it as "white, dry, and raw, in keeping with the artist's usual system,"[17] while the other, Jean-Baptiste Boutard, advised the artist to desist from his archaizing affectations.[18]

In 1812 Marcotte had commissioned a painting of the Sistine Chapel (fig. 100), a rich evocation of traditional religious life continuing in modern Rome. The painting, completed early in 1814, was dispatched to Marcotte in Paris. This work was important to Ingres, as was his intention to exhibit it at the Salon of 1814: it was his answer to the scenes of church interiors for which his friend François-Marius Granet (see cat. no. 25) had been winning critical praise and financial success for several years. Ingres, who was still smarting from the critical lashes he had received at the Salon of 1806, wanted desperately to make his mark at the Salon of 1814 and hoped Marcotte would use his influence to see that his works were well placed.[19] At this time Ingres also made a gift to Marcotte of one of his first small historical genre scenes, *Don Pedro of Toledo Kissing the Sword of Henry IV* (W 101; location unknown).[20] But Marcotte did not like it, a fact which Ingres asked him not to make public![21]

P. C.

1. Inspecteur-Général des Eaux et Forêts.
2. This story is told variously in Blanc 1870, pp. 33–34; Delaborde 1870, pp. 254–55; and Lapauze 1911a, p. 106. It is confirmed in a note by Marcotte, on a letter addressed to him by Ingres, dated December 20 [1812], in Ternois 1999, letter no. 1. This portrait has been thoroughly catalogued on two occasions: in Eisler 1977, and in 1996 by Lorenz Eitner, for his *French Paintings 1800–1860*, a forthcoming volume of the Systematic Catalogue of the Collections of the National Gallery of Art, Washington, D.C.; The author is indebted to their researches; the present entry has been adapted from Eitner 1996.
3. On the Marcotte family, their circle, and their continuing importance for Ingres, see Naef 1958 ("Marcotte Family"); Naef 1977–80, vol. 2 (1978), pp. 503–33; and Warrick 1996.
4. N 64, 65; There is a tracing of N 64 in the Musée Ingres, Montauban (Vigne 1995a, no. 2717).
5. In Eisler 1977, p. 365, this is described as a "mourning ring."
6. Lorenz Eitner (1996) observes that the rosette must have been crushed into an oval shape when it was forced through the buttonhole: a strikingly realistic touch. The rosette identifies the wearer as holding the superior rank of officer in the Legion of Honor, while the ribbon is the mark of the lower rank, that of chevalier. It is unlikely that Marcotte had been received into the Legion by 1810. The two pencil portraits of 1811 still show him without ribbon or rosette. In a third portrait, dated 1828 (N 308), he wears the ribbon of a chevalier, and it is in this rank that he is still listed in Gabet 1831, p. 364. Marcotte's obituary notice (Vicaire 1864, pp. 100–105) mentions that he was awarded the cross of a commander by Louis-Philippe only in 1836, on the occasion of his retirement from the Administration of Forests and Waterways. It thus appears that the rosette was added to the portrait no earlier than 1836. Such later insertions were not unusual in Ingres's portrait practice. *Charles-Joseph-Laurent Cordier* (fig. 93), for example, painted in 1811, shows the sitter wearing the ribbon of the Legion of Honor that was awarded to him only in 1841 (Paris 1985, p. 50).
7. "Ce visage, il y manque sans doute le sourire. Mais Ingres, se peignant lui-même à vingt-quatre ans, ne se fit pas sourire non plus. Il y a, dans les yeux foncés de M. Marcotte, dans un peu de maussaderie à sa lèvre, dans l'énergie de ses traits et leur concentration volontaire, on ne sait quoi de rappelant le farouche jeune homme de Chantilly." Lapauze 1911a, pp. 107–10.

8. Ibid., pp. 106–7.

9. Eitner 1996.

10. Colin Eisler (1977, pp. 365–66) thought especially of portraits by Raphael, the painter Ingres most admired.

11. Eitner also mentions that the Bronzino was engraved in Fontana 1812.

12. "il n'y a qu'à suivre les mêmes plis, mais d'une autre couleur." Ingres to Marcotte, May 26, 1814, in Ternois 1999, letter no. 3.

13. "priés quelqu'un de glacer la culotte et de la repeindre sur les mêmes plis." Ingres to Marcotte, July 7, 1814, in ibid., letter no. 4.

14. Eitner (1996) notes that when Geraldine van Heemstra of the National Gallery's Painting Conservation Department examined the area in the painting mentioned by Ingres she found that the original color of Marcotte's breeches was a light, warm brown. Over this, a dark brown glaze was applied, presumably in the course of the color change requested by Marcotte. Age cracks corresponding to those on the original painting surface run through this glaze, indicating its early date. But abrasions in this old glaze apparently prompted a further overpainting with dark brown paint as part of a more recent restoration treatment. Report dated March 20, 1996, Curatorial Records and Files, National Gallery of Art, Washington, D.C.

15. "No. 535. Plusieurs portraits."

16. Daniel Ternois to Lorenz Eitner, February 26, 1996, in Curatorial Records and Files, National Gallery of Art, Washington, D.C. The "Registre d'inscription des productions des artistes vivants presentées à l'Exposition, Salon 1814," in the Archives du Musée du Louvre, Paris, notes Marcotte's submission of the portrait under number 27 (of 660 submissions) as "1 tableau Portrait de Mr. Marcotte."

17. "blanc, sec et cru, suivant le système adopté par l'auteur." Anon., February 15, 1815 (M.).

18. Boutard, November 11, 1814.

19. Ingres to Marcotte, July 7, 1814, in Ternois 1999, letter no. 4.

20. Marcotte's version of "my little painting of Henry IV" ("mon petit tableau d'Henry 4"), as Ingres called it in his letter of May 26, 1814 (in ibid., letter no. 3), is known only through Achille Réveil's engraving (Wildenstein 1954, no. 101, fig. 129).

21. Ibid.

PROVENANCE: Charles-Marie-Jean-Baptiste Marcotte (Marcotte d'Argenteuil; 1773–1864); Joseph Marcotte, his son (1831–1893); his widow, née Paule Aguillon, until 1922; her daughter, Mme Marcel Pougin de la Maisonneuve, née Élisabeth Marcotte, Paris, until 1939; private collection, London; Wildenstein & Co., Inc., New York; acquired from them by the Samuel H. Kress Foundation, New York, 1949; the foundation's gift to the National Gallery of Art, Washington, D.C., 1952

EXHIBITIONS: Paris (Salon) 1814, no. 535; Paris 1867, no. 440; Paris 1874, no. 871 (in the Catalogue supplémentaire as Portrait de M[onsieur] Marcotte père) [EB]; Paris 1911, no. 14; New York 1951, no. 31, ill.; Louisville, Fort Worth 1983–84, no. 63

REFERENCES: Magimel 1851, pl. 15; Vicaire 1864, pp. 100–105; Merson and Bellier de la Chavignerie 1867, pp. 17, 104; Blanc 1870, pp. 33–34, n. 1, pp. 38, 231; Delaborde 1870, pp. 254–55, no. 139; Montrosier 1882, p. 12; Lapauze 1901, pp. 235 ff.; Lapauze 1903, pp. 63–64; Momméja 1904, pp. 39, 68–69; Lapauze 1911a, pp. 102, 106–12, ill. p. 95; Fröhlich-Bum 1924, p. 9, pl. 14; Hourticq 1928, pp. IV, 125, ill. p. 25; Fouquet 1930, pp. 69–70; Pach 1939, pp. 42–43, ill. p. 56; Alazard 1950, pp. 45–48; Frankfurter 1951, p. 35; Washington 1951, p. 236, no. 106; Soby 1952, p. 162, ill.; Wildenstein 1954, no. 69, pl. 21; Naef 1958 ("Marcotte Family"), pp. 339–42; Ternois 1959a, preceding no. 119; Seymour 1961, pp. 195–96, ill.; Rosenblum 1967a, p. 82, pl. 14; Radius and Camesasca 1968, no. 59, ill.; Eisler 1977, pp. 365–66, fig. 336; Whiteley 1977, p. 38, fig. 21; Naef 1977–80, vol. 2 (1978), pp. 503–4, fig. 1; Ternois 1980, p. 46, ill. p. 71; Vigne 1995b, pp. 80, 327, 331, fig. 53; Eitner 1996; Warrick 1996

27. Joseph-Antoine Moltedo

ca. 1810

Oil on canvas

$29\frac{5}{8} \times 22\frac{7}{8}$ *in. (75.2 × 58.1 cm)*

The Metropolitan Museum of Art, New York

H. O. Havemeyer Collection, Bequest of Mrs. H. O. Havemeyer, 1929 29.100.23

W 71

Joseph-Antoine Moltedo (or Multedo, in its Corsican form), born in 1775, was the nephew of the better-known Joseph-André-Antoine Moltedo (1751–1829), who held many important positions as a high-level public functionary during the Revolution and Empire. Joseph-Antoine, also a *haut fonctionnaire*, was for a time treasurer of the army and from 1803 to 1814 inspector and director of the mail in Rome. An entrepreneur as well, he owned a lead mine in Tivoli and a fur-trading business near Rome[1] and ran an import-export business and a bank, which had its seat in the Piazza Sant'Eustacio in Rome. He is credited with the invention of both a fire engine and a machine for spinning hemp. Hélène Toussaint observed that Ingres's painting was cut at the bottom at a later date, reducing the visibility of what she perceived as a rosary,[2] dangling from Moltedo's left hand. This could allude to another position of his, that of general agent to the French clergy at the Holy See. More likely, however, it is a ring. The painting has a somewhat squat appearance, not only attributable to the shape of the sitter but also to the fact that

Fig. 114. François-Marius Granet (1775–1849). *The Colosseum, Rome, with a Cypress*, by ca. 1810. Oil on paper, mounted on canvas, 8⅜ × 10⅞ in. (21.3 × 27.6 cm). Musée Granet, Aix-en-Provence

datable to 1809. *Moltedo* is usually, and convincingly, dated to about 1810, as suggested by the position of its listing in Ingres's notebooks.[3] P.C.

1. The sitter was identified by Georges Oberti (1954, p. 6). The biographical information in this entry is derived from that work.
2. Toussaint (1990b, pp. 22, 24, no. 9) suggests the motivation was to reduce the rosary in order to make the painting more salable and proposes the painting lost about 15 centimeters in height and about 12 centimeters in width. A recent examination of the painting confirms that it has been cut on all sides.
3. Notebook IX, fol. 124, Notebook X, fol. 23; See Vigne 1995b, pp. 324, 327, 331.

PROVENANCE: Probably the Moltedo family, Corsica; Théodore Duret, Paris, until 1916; purchased from him by Louisine Havemeyer (1855–1929), New York, by 1916; her bequest to The Metropolitan Museum of Art, New York, 1929

EXHIBITIONS: New York 1926, no. 21, as *Portrait of Chevalier X* (lent anonymously); New York 1930 [EB]; San Francisco 1939–40, no. L-129, as *Portrait of a Gentleman* [EB]; New York 1941b, no. 21; Seattle 1951; Paris 1967–68, no. 50; Boston 1970, p. 73, ill.; Saint Petersburg, Moscow 1975, no. 55; New York 1988–89; New York 1993, no. A330, ill.

REFERENCES: Silvestre 1856, p. 34; Delaborde 1870, no. 138, as *Maltedo;* Momméja 1904, p. 40; Bénédite 1908, p. 164; Lapauze 1911a, pp. 102–3; Cortissoz 1930, pp. 201, 203–4, ill.; Mather 1930, p. 470, ill. p. 482; Pach 1939, pp. 43–44, ill. opp. p. 38; Tietze 1939, p. 327, ill.; Oberti 1954, p. 6, ill.; Rousseau 1954, p. 44, ill.; Wildenstein 1954, no. 71, pl. 22; *Havemeyer Collection* 1958, p. 27, no. 154, ill.; Sterling and Salinger 1966, pp. 6–7, ill.; Metken 1967, p. 1283; Radius and Camesasca 1968, no. 61, ill.; Paris, Detroit, New York 1974–75, p. 492; New York 1975, p. 497; Rizzoni and Minervino 1976, ill. p. 43; Baetjer 1980, vol. 1, p. 89, vol. 3, ill. p. 544; Ternois 1980, pp. 24, 46, 72, 175, no. 69, ill.; Weitzenhoffer 1986, pp. 238–39, 255, ill.; Toussaint 1990b, pp. 22, 24, no. 9; Zanni 1990, no. 34; Baetjer 1995, p. 399, ill.; Vigne 1995b, p. 87, fig. 60; Roux 1996, pp. 26–27, 48, ill. p. 49

it has indeed been trimmed on all sides at an unknown date.

Moltedo was typical of Ingres's clientele in Rome, a senior civil servant of the Empire and a colleague of men such as Charles Marcotte (cat. no. 26), Baron de Montbreton de Norvins (cat. no. 33), and Edme Bochet (cat. no. 30), to name three others whose images are included in this catalogue. Every inch the successful administrator and businessman, the portly Moltedo is portrayed by Ingres with all the bluff confidence the artist would later attribute to the elder Louis-François Bertin (cat. no. 99). Moltedo is dressed in a leather overcoat worn over a brown coat with notched lapels, an elegant white shirt with high collars secured with a white cravat, and a white waistcoat with a standing collar. Under his arm is a black beaver bicorne decorated with a gold ornament and a cockade. Set against a stormy sky, he is flanked by a glimpse of the Roman Campagna on one side and the Colosseum on the other. The landscape backdrop is very much in the manner of François-Marius Granet's Roman landscapes, cleverly adapted by Ingres to give his portrait a sense of specific time and place. We can imagine the two young artists passing daily in and out of each other's studios in the convent of Santissima Trinità dei Monti. In Granet's studio Ingres certainly saw his friend's oil sketches made in and around Rome, such as *The Colosseum, Rome with a Cypress* (fig. 114), not necessarily a source but a parallel for the background in Ingres's portrait. The format and execution of this likeness can be compared with Ingres's depiction of Granet (cat. no. 25), which is

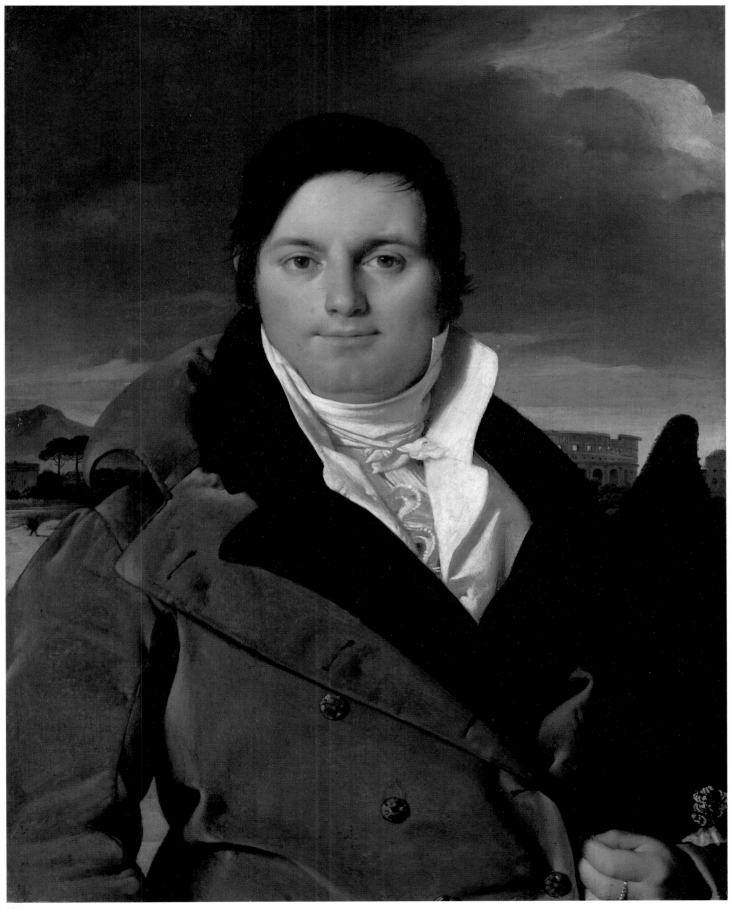

27

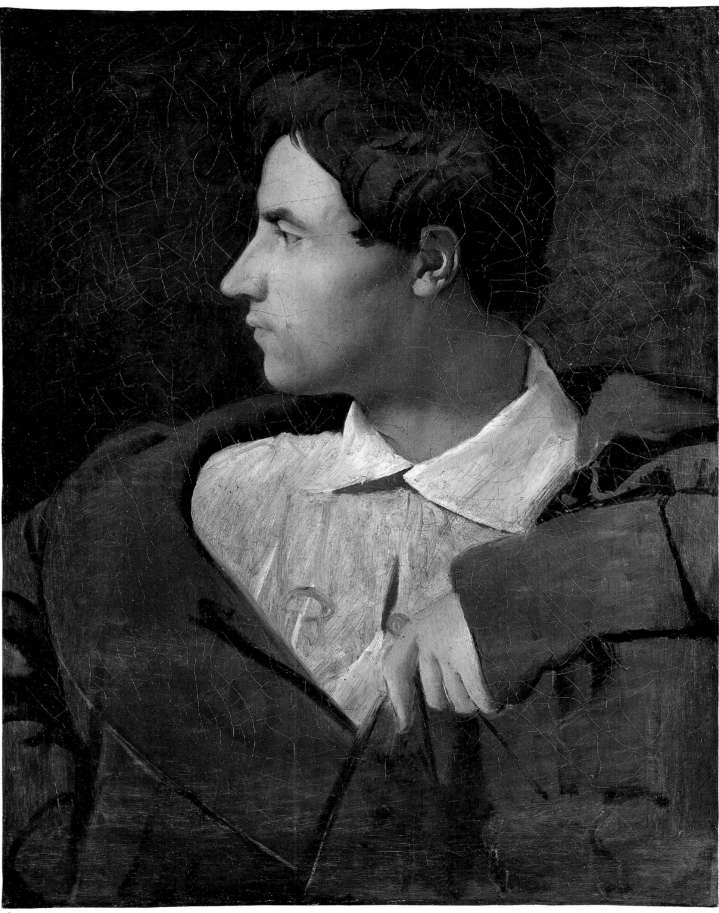

28

28. Jean-Baptiste Desdéban

ca. 1810
Oil on canvas
24¾ × 19¼ in. (63 × 49 cm)
Musée des Beaux-Arts et d'Archéologie,
Besançon 896.1.166

W 70

Jean-Baptiste Desdéban (1781–1833) trained as an architect in Paris with Charles Percier and Laurent Vaudoyer. He won the Prix de Rome in 1806 and, although he did not begin to receive his scholarship to attend the Académie de France in Rome until 1809, he traveled to Rome in 1806, the same year as Ingres. Little seems to be recorded of Desdéban's relatively brief career, and his name has been remembered mainly thanks to the fact that Ingres painted this likeness. From its position in Ingres's list of his own works in his Notebook X, it must date from about 1810–11.[1]

The free execution and lack of finish of this portrait suggest that it was an informal work, painted more out of friendship than as a commission. The canvas is primed in a traditional way with a red ground, which is still visible throughout the picture. The fine modeling of Desdéban's face and his brushily executed white shirt make dramatic contrasts with the dark ground and the black sketched-in outlines. The shallow pictorial space and the strict profile view of the sitter's head recall some of the painted academic studies Ingres executed in David's studio (see, for example, fig. 44) and as part of his required student exercises

in Rome (such as *Seated Man*, about 1808, Musée Granet, Aix-en-Provence). The profile view also evokes several drawings Ingres made early in his first Roman sojourn, and it is especially similar in concept to his portrait *André-Marie Chatillon* (fig. 115), drawn in 1810.[2]

The artist seems to have given this unusual portrait not to the sitter but to a mutual friend in Rome, the sculptor Paul Lemoyne, probably before Ingres left Rome for Florence in 1819. The painter Hippolyte Flandrin visited the octogenarian Lemoyne in January 1864:

> He showed me many works left to him by the artists who had spent time in Rome at various periods . . . but especially a portrait by M. Ingres, of Débedan [*sic*], an architect of his day. Most of the portrait is merely sketched in, but the face is finished, and it has an incomparable delicacy, suppleness, and beauty. ah! I'm sure M. Ingres would be pleased to see it again, and he will be able to since M. Lemoyne is thinking of sending the canvas to Paris, with all the other works of art he owns.[3]

It was indeed sold by Lemoyne in Paris in 1865[4] and acquired by the painter Jean Gigoux, along with Ingres's portrait of Paul Lemoyne (cat. no. 29). Gigoux later recalled a visit the aged Ingres made to his lodgings on the quai Voltaire in Paris to see the two portraits; on seeing Desdéban, "'Ah! it's Debedau [*sic*],' he cried; 'Flandrin went to see it every day in Rome. It's the best thing I ever did!'"[5] Flandrin had entered Ingres's studio in Paris in 1829 and, after going to Rome to study at the Académie de France in 1833, saw Ingres again in 1835, when the latter returned to Rome as the Académie's director. From Gigoux's account of his interview with Ingres, it seems Flandrin was already able to see the portrait in Lemoyne's possession in Rome, even though he does not mention until 1864 that he did so. P.C.

Fig. 115. *André-Marie Chatillon,* 1810 (N 58). Graphite on paper, 8⅞ × 6½ in. (22.4 × 16.5 cm). Baltimore Museum of Art

1. Fol. 23. See Vigne 1995b, pp. 327, 332.
2. Naef 1977–80, vol. 4 (1977), pp. 110–11, no. 58, ill.
3. "Il m'a montré beaucoup des choses que lui ont laissés les artistes qui ont séjourné à Rome,

à diverses époques . . . mais surtout un portrait fait par M. Ingres, de Débedan [*sic*], un architecte de son temps. L'ensemble de ce portrait n'est qu'ébauché, mais le masque est fini, et il a une finesse, une souplesse, une beauté incomparables; ah! je crois que M. Ingres aurait plaisir à revoir cela, et la chose sera possible, car M. Lemoyne pense à envoyer cette toile à Paris avec tous les autres ouvrages d'art qu'il possède." Hippolyte Flandrin to Paul Flandrin, January 28, 1864, quoted in Delaborde 1865, p. 471.

4. *Catalogue d'une intéressante collection de tableaux, esquisses et dessins, composée pour la plus grande partie de souvenirs des grands prix de Rome offerts à M. P. L. résidant à Rome depuis longtemps,* sale cat., Hôtel Drouot, Paris, April 3, 1865, no. 66.

5. "Ah! c'est Debedau [*sic*], s'écria-t-il; Flandrin allait le voir tous les jours, à Rome. C'est ce que j'ai fait de mieux!" Gigoux 1885, p. 84.

PROVENANCE: Given by the artist to the sculptor Paul Lemoyne (1783–1873); his sale, Hôtel Drouot, Paris, April 3, 1865, no. 66; purchased at that sale by Jean Gigoux; his bequest to the city of Besançon, 1894; deposited at the Musée des Beaux-Arts et d'Archéologie, Besançon

EXHIBITIONS: Paris 1867, no. 437; Paris 1883, no. 143, as *Todeban* [*sic*], *architecte* [EB]; Paris 1911, no. 13; Basel 1921, no. 101, as *L'Architect Dedeban* [*sic*], [EB]; London 1932, no. 339; Paris 1933b, no. 49; Paris 1937, no. 348; Amsterdam 1938, no. 133, cover ill.; Buenos Aires, 1939a, no. 75; Montevideo 1939, no. 57 [EB]; Springfield, New York 1939–40, no. 18 [EB]; Rio de Janeiro 1940, no. 55 [EB]; San Francisco 1940–41, no. 57 [EB]; New York 1941a, no. 71; Portland 1941, no. 55 [EB]; San Francisco 1941–42, no. 57 [EB]; Brussels 1947, no. 21, ill.; Paris 1952c, no. 44a, ill.; New York, Manchester, Detroit, Cincinnati, Cleveland, San Francisco 1952–53, no. 16; Toulouse, Montauban 1955, no. 115; Paris 1957c,

no. 71, fig. XXIII; Munich 1964, no. 145, ill.; Montauban 1967, pp. 49–50, no. 39; Paris 1967–68, no. 41, ill.; Rome 1968, no. 21, ill.; Montauban 1980; Louisville, Fort Worth 1983–84, no. 58, ill.

REFERENCES: Blanc 1870, p. 234; Delaborde 1870, no. 117, as *Dédeban* [*sic*], *architecte;* Gigoux 1885, p. 84; Momméja 1904, pp. 68–69; Wyzewa 1907, p. 11, fig. VII (painted about 1806); Lapauze 1911a, pp. 102–3, 162–64, ill. p. 99; Magnin 1919, pp. 59, 240, fig. 26; Hourticq 1928, ill. p. 26 (painted in 1810); Chudant 1929, no. 154; *French Art* 1933, no. 410; Pach 1939, ill. opp. p. 54; Malingue 1943, p. 123, ill. p. 33; Alain 1949, p. [17]; Roger-Marx 1949, fig. 13; Scheffler 1949, fig. 13; Alazard 1950, pp. 45, 145, n. 35; Wildenstein 1954, no. 70. fig. 44; Cambridge (Mass.) 1967, under no. 48; Radius and Camesasca 1968, no. 60, ill.; Le Normand 1977, p. 32; Zanni 1990, p. 47, fig. 33; Fleckner 1995, pp. 84–87, fig. 24; Vigne 1995b, p. 80, fig. 54

29. Paul Lemoyne

ca. 1810–11
Oil on canvas
18 ⅛ × 13 ¾ in. (46 × 35 cm)
The Nelson-Atkins Museum of Art, Kansas City, Missouri
Purchase: Nelson Trust 32-54

W 130

Traditionally this portrait has been dated to about 1817–20. But Ingres probably painted it in about 1810 or 1811, when the sculptor Paul Lemoyne arrived in Rome.[1] Its style is much more consistent with the earlier date, and it is difficult to imagine Ingres continuing to paint in so free a manner toward the close of his first Roman period. The portrait is broad and sketchy in handling and comparable with only one other informal portrait painted by Ingres, one executed in 1810 depicting the architect Jean-Baptiste Desdéban (cat. no. 28). The informality of *Paul Lemoyne* suggests it was done out of friendship, and indeed Lemoyne was its first owner; the sketchy portrait of Desdéban was also a gift from Ingres to Lemoyne, most likely at the same time.

Lemoyne is presented close to the spectator, his features and clothing boldly brushed in, with dramatic contrasts of light and shade and shadowed eyes that convey a sense of mystery. The background is dark, with the paint scumbled on, reminiscent of the life studies Ingres had painted in David's studio barely a decade before (see fig. 44). Lemoyne is

informally dressed—even disheveled—his shirt open, and without a necktie. A cape or overcoat is slung casually across his shoulders. He might be a partially dressed version of François-Marius Granet, another artist friend, in Ingres's more finished and

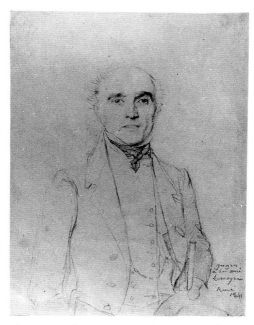

Fig. 116. *Paul Lemoyne*, 1841 (N 379). Graphite on paper, 9 ¼ × 7 in. (23.6 × 17.8 cm). Musée Grobet-Labadié, Marseilles

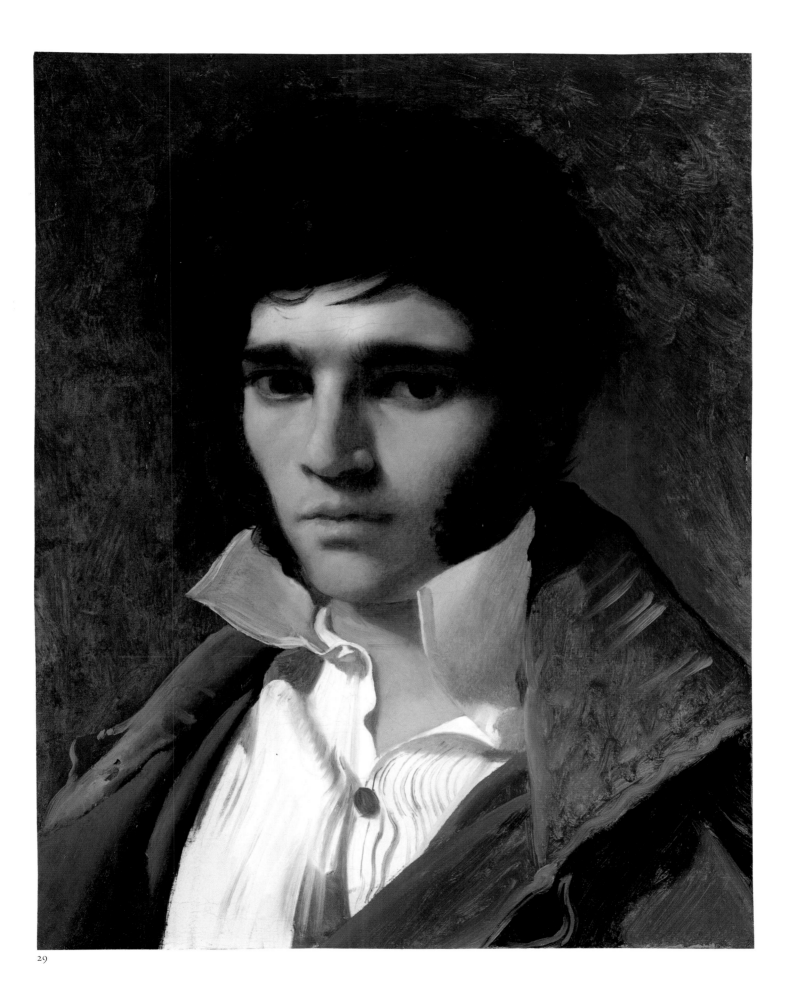

29

formal portrait of 1809 (cat. no. 25). The sitter's dishevelment belongs also to a pictorial tradition, well established since the eighteenth century,[2] signifying the unfettered genius of the creative artist.

Lemoyne was born in Paris in 1783; his father was a master goldsmith, and his godfather (a paternal uncle) was an architect. Paul trained in Paris in the early 1800s and made three unsuccessful attempts, in 1807, 1808, and 1809, to win the Prix de Rome. It may have been the antiquarian and art theorist Antoine-Chrysostome Quatremère de Quincy who encouraged Lemoyne eventually to make the trip to Rome at his own expense; Quatremère provided an introduction to Antonio Canova, the leading sculptor in Rome at that time. Correspondence between Quatremère and Canova in 1810 and 1811 contains admiring references to Lemoyne.[3] According to Lemoyne himself, he had an unusually close and friendly relationship with the great Italian sculptor, who generally kept himself aloof from the French, whom he understandably resented as a foreign occupying force in Rome.[4] But he admired the candor of Lemoyne's manner and opinions. Something of the liveliness of Lemoyne's self-expression is captured in a letter, written some years after Ingres's portrait, to the painter Granet, in which Lemoyne complains about the jealousy that soured the friendship of Ingres and the Italian sculptor Lorenzo Bartolini in Florence in 1821–22, and which he attributes in large part to Madeleine Ingres:

> I've definitively broken with him, or rather with his wife. She's a vile hussy, a viper of the worst kind. But I hope she won't carry into heaven the wicked acts of which in my eyes she's guilty. I fought for a long time before breaking off relations, and at this point I don't even speak to her when I happen to run into her at someone's home. As for Ingres, I admire his talent, but I'd doff my hat more readily to his works than to the man himself. He is presently at daggers drawn with Bartolini. Both of them have gotten only what they deserve.[5]

Lemoyne frequented the Académie de France in Rome at the Villa Medici,

although he was not one of its official pensioners. But he had close connections with the French administrative and diplomatic community. Lemoyne was one of the young artists invited to contribute to the embellishment of the French church of Santissima Trinità dei Monti, a project sponsored by Comte Pierre de Blacas, the French ambassador to Rome: among his collaborators were the architect François Mazois, who supervised the architectural restoration works, and Ingres, who painted the altarpiece *Christ Giving the Keys to Saint Peter* (fig. 106). Lemoyne executed a plaster group of the Virgin and Child (location unknown). But this project was not brought to completion before Blacas was called back to Paris in 1822.

Lemoyne established a successful sculptural practice in Rome, receiving a number of commissions there and elsewhere in Italy, and executing works for the numerous foreign visitors, whom he called "visiting swallows."[6] But his main circle remained that of French artists, especially those connected with the Académie, and other French officials and visitors. He benefited from the support of Auguste de Forbin, director of the Musées Royaux, and exhibited regularly at the Salon in Paris from 1814 through the 1830s. Lemoyne also enjoyed the protection of several ambassadors after Blacas, including François-René de Chateaubriand, who initiated the idea of erecting a monument to Poussin in San Luigi dei Francesi in 1828, a project coordinated by Lemoyne and completed in 1837. For the ambassador Septime La Tour-Maubourg, Lemoyne designed a monument to Claude Lorrain (completed in 1840) and, on the diplomat's untimely death in 1837, he conceived a monument for him, also installed in San Luigi dei Francesi. In this same church Lemoyne erected monuments to his friends Pierre-Narcisse Guérin, who died while serving as director of the Académie in Rome in 1833, and the landscape painter Nicolas-Didier Boguet, who died in 1839.

When Ingres returned to Rome as director of the Académie in 1835, the two men and their wives reestablished their friendship, and Ingres made a portrait drawing of Lemoyne (fig. 116).[7] To cele-

brate a return visit to Rome of their mutual friend Victor Schnetz, Lemoyne threw a riotous party, which was not entirely appreciated by the stuffy Ingres couple. The painter Ernest Hébert recalled

> M. and Mme. Ingres seated next to each other, silent and impassive like statues in the midst of that false gaiety. . . . But M. Lemoyne, seeking to pull us away from our worrisome group, urged us with charming joviality to take our places at the gaming tables and to do honor to the refreshments that the old domestics, themselves looking rather stunned, offered us with embarrassed faces.[8]

Lemoyne assembled an art collection—which we know from the catalogue of its auction in Paris in 1865[9]—for the most part, according to Hippolyte Flandrin,[10] made up of gifts from the several generations of French artists who had passed through Rome and enjoyed Lemoyne's hospitality and guidance. It included this portrait painted by Ingres and Ingres's portrait of Jean-Baptiste Desdéban, mentioned above. Ingres was incensed when he heard from the painter Jean Gigoux, the new owner of his portrait of Paul Lemoyne, that it had been sold: "The wretched man has sold himself!" Ingres cried.[11] The octogenarian Lemoyne may have put his art collection up for sale because he was preparing to move back to France, to stay with a goddaughter in Bordeaux. He died there in 1873.

P.C.

1. On Lemoyne, see Le Normand 1977, pp. 27–41; on pp. 27, 36, n. 2, Le Normand establishes that Lemoyne arrived in Rome in 1810 or 1811. Delaborde (1870, p. 254, no. 136) dated Ingres's portrait "vers 1819"; but "Lemoyne" and "Dedeban" [*sic*] are listed consecutively in Ingres's Notebook X, fol. 23, in the same grouping as "moltedo./cordier/de norvins." Vigne 1995b, p. 327. Vigne (ibid., p. 332) still dates *Paul Lemoyne* to "c. 1819," in spite of its juxtaposition in Ingres's notebook to the portrait of Desdéban, which he dates "1810." See also the biography in Naef 1977–80, vol. 3 (1979), pp. 301–11.
2. For a similar example of such informal artistic dress, see Marie-Louise-Élisabeth Vigée-Lebrun's 1788 portrait of Hubert Robert (Musée du Louvre, Paris), although this was a more finished picture, intended for presentation to the Académie des Beaux-Arts.

3. Le Normand 1977, pp. 28, 36, n. 15, p. 37, n. 16.

4. See ibid., pp. 28, 37, n. 17.

5. "J'ai rompu définitivement avec lui, ou plutôt avec sa femme. C'est une coquine infâme, une vipère de la plus grosse espèce. Mais j'espère qu'elle ne portera pas en paradis les traits de noirceur dont elle s'est rendue coupable à mon égard. J'ai bataillé longtemps avant que de rompre, et maintenant je ne la salue même pas dans les maisons où j'ai l'occasion de la voir. Quant à Ingres, j'estime en lui le talent, mais j'ôterais plus volontiers mon chapeau devant ses ouvrages que devant lui. Il est présentement à couteau tiré avec Bartolini. Ils n'ont, l'un et l'autre, que ce qu'ils méritent." Lemoyne to Granet, dated December 22, 1822, in Néto 1995, p. 109.

6. "hyrondelles visiteuses."

7. Naef 1977–80, vol. 5 (1980), pp. 246–47, no. 379, ill.

8. "M. et Mme Ingres assis l'un près de l'autre, silencieux et impassibles comme des statues au milieu de cette fausse gaïeté. . . . Mais M. Lemoyne, cherchant à nous tirer de notre groupe inquiétant, nous pressait avec une jovialité charmante de prendre place aux tables de jeu et de faire honneur aux rafraîchissements que les vieux domestiques, un peu ahuris eux-mêmes, nous presentaient avec des mines embarrassées." Hébert quoted in Le Normand 1977, p. 32.

9. *Catalogue d'une intéressante collection de tableaux, esquisses et dessins, composée pour la plus grande partie de souvenirs des grands prix de Rome offerts à M. P. L. résidant à Rome depuis longtemps*, sale cat., Hôtel Drouot, Paris, April 3, 1865.

10. Delaborde 1865, p. 171.

11. "Le malheureux s'est vendu lui-même!" The portraits of Lemoyne and Desdéban were both purchased at the 1865 sale by the painter Jean Gigoux, who told the story of Ingres's angry reaction in Gigoux 1885, pp. 84–85.

PROVENANCE: Paul Lemoyne (1783–1873); his sale, Hôtel Drouot, Paris, April 3, 1865, no. 32; purchased at that sale by Jean Gigoux; P.-A. Chéramy; Chéramy sale, Paris, May 5–7, 1908, no. 212; Henri Haro; his sale, Hôtel Drouot, Paris, December 12–13, 1911, no. 217; purchased at that sale by Fauchier Magnan; Henry Lapauze (1867–1925), 1914; his posthumous sale, Hôtel Drouot, Paris, June 21, 1929, no. 54; M. Knoedler & Co., New York, 1931; The Nelson-Atkins Museum of Art, Kansas City, Missouri, 1932

EXHIBITIONS: Paris 1867, no. 439; Paris 1911, no. 24; Copenhagen 1914, no. 118; Paris 1922a, no. 2, cover ill.; Kansas City 1930, no. 27; Pittsburgh 1930, no. 23; San Francisco 1934, no. 114; Springfield, New York, 1939–40, no. 24; Cincinnati 1947; Winnipeg 1954, no. 9, fig. 11; Omaha 1956–57; Atlanta 1959; New York 1961, no. 26, ill.; Cambridge (Mass.) 1967, no. 48; Chapel Hill 1978, no. 43, fig. 48; Louisville, Fort Worth 1983–84, no. 59, ill.

REFERENCES: Blanc 1870, p. 234; Delaborde 1870, p. 254, no. 136; Momméja 1904, pp. 68–69; Uzanne 1906, p. xiii; Lapauze 1911a, pp. 162–64, ill. p. 179; Hourticq 1928, p. IV; Burrows 1931, pp. 237–38, ill.; Gillet 1932 in Courthion 1947–48, vol. 1, p. 169; Alain 1949, p. 17; Wildenstein 1954, no. 130, fig. 82; Radius and Camesasca 1968, no. 100, ill.; Taggart and McKenna 1973, p. 153; Le Normand 1977, p. 32; Rosenthal 1984, pp. 23–29, fig. 5; Zanni 1990, p. 85, no. 65, ill.; Ward and Fidler 1993, p. 199; Fleckner 1995, pp. 83–87, ill.; Vigne 1995b, pp. 144, 327, 332

30. Edme-François-Joseph Bochet

1811

Oil on canvas

37 × 27 ⅛ in. (94 × 69 cm)

Signed and dated lower right: Ingres/Roma 1811 [Ingres / Rome 1811]

Musée du Louvre, Paris RF 194

New York and Washington only

W 76

Edme-François-Joseph Bochet, born in 1783, was twenty-eight years old when Ingres painted his portrait. With the designation of Rome as the second city of the French Empire in February 1810, Bochet was one of the many civil servants dispatched from Paris to administer Rome and the northern Italian states along Napoleonic lines. In 1811, the date of Ingres's portrait, Bochet was in Rome, supervising a branch of the Administration de l'Enregistrement et des Domaines established there by his father, who was also called Edme Bochet (1742–1837), and who was a senior official of the ministry of finance in Paris. A very able civil servant, the elder Bochet negotiated a brilliant career for himself, working for a succession of regimes, from that of Louis XV in the 1760s through that of Charles X in the 1830s. Through his only son and his five daughters he propagated a dynasty of public figures who played a variety of important roles in government administration and in the arts throughout the nineteenth century.[1] In 1852 Ingres was to take as his second wife one of the senior Bochet's granddaughters, Delphine Ramel; the sitter for the present portrait was a witness at that wedding.

The younger Bochet's father facilitated his son's placement, from the age of eighteen, in a series of administrative posts that progressively prepared him for the greater responsibilities that would come his way in 1810.[2] Once settled in Rome, he met and married in 1812 an Italian, Elisabetta Galli (1789–1847). They were to have eleven children. After the fall of the Empire in 1814, Bochet returned to Paris, where he continued his career as a public official, eventually becoming Conservateur des Hypothèques (commissioner of mortgages) in Paris in 1837. As an elderly man, he fled Paris during the Franco-Prussian War (1870–71) and died in 1871 in the Château de Maronnes, in Meuvennes, Normandy, home of his eldest son.

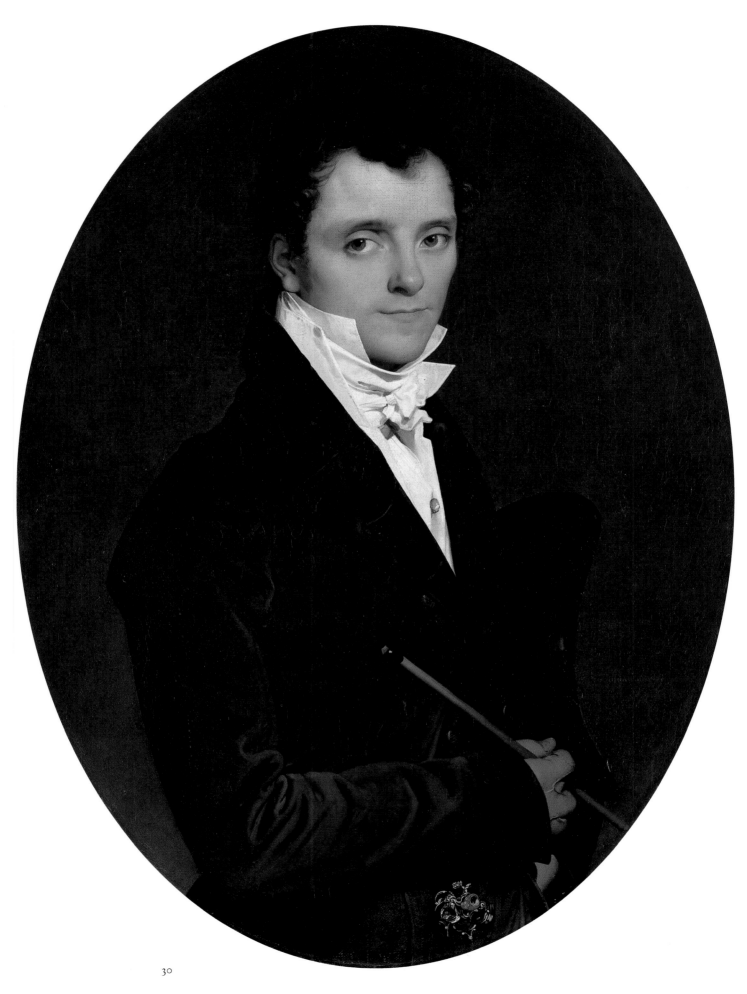

30

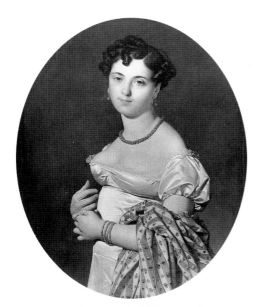

Fig. 117. *Madame Henri-Philippe-Joseph Panckoucke, née Cécile-Françoise Bochet*, 1811 (W 77). Oil on canvas, 36 5/8 × 26 3/4 in. (93 × 68 cm). Musée du Louvre, Paris

In Ingres's portrait—the only one in which the artist shows a male sitter in an oval frame—Bochet cuts a dashing figure. His pale face emerges from crisp, immaculately white standing collars and cravat, set off by a pearl stud. He sports an elegant, dark maroon velvet coat, with a fashionably notched collar, cut away to reveal dark blue pantaloons or britches emblazoned with a cluster of seals. A Baudelairean dandy before his time, Bochet is dressed as if he is about to set off for a stroll, with his cane and top hat tucked under his left arm and wearing exquisite soft gray

leather gloves. The portrait has a certain psychological edge, due to its transient, almost momentary air, as if the sitter were impatient to be off. Ingres painted several of Bochet's colleagues and associates, who were bringing Napoleonic order to the administration of Italy, but in spite of the limitations of the theme he managed to play interesting variations on it: compare his treatments of *Joseph-Antoine Moltedo* (cat. no. 27), *Jacques Marquet, Baron Montbreton de Norvins* (cat. no. 33), and *Charles-Marie-Jean-Baptiste Marcotte* (cat. no. 26).

It has sometimes been said that Ingres exhibited this portrait of Bochet at the Salon of 1814, but Daniel Ternois has shown that the artist only exhibited his portrait of Marcotte d'Argenteuil that year.[3]

Ingres painted a pendant to this portrait, representing Bochet's sister Cécile, Madame Panckoucke (fig. 117), who was two years his junior. Her husband, Henri Panckoucke, worked in the same administration of land registry in Rome as her brother; unfortunately, he died the next year at the young age of thirty-two. The oval format of *Madame Henri-Philippe-Joseph Panckoucke* had been employed before by Ingres in his portraits *Comtesse de La Rue* (W 13), the so-called *Madame Aymon* (cat. no. 8), and *Madame Philibert Rivière* (cat. no. 9). The artist clearly felt this form was particularly appropriate for certain portraits of women, enabling him to enhance the play of graceful serpentine

lines, soft curves, and the encircling forms of necklaces, bracelets, and shawls.

P. C.

1. On the Bochet family, see Naef 1977–80, vol. 1 (1977), chap. 28 (pp. 251–54); Paris 1985; and Warrick 1996.
2. See Warrick 1996, based on documents still with Bochet's descendants.
3. See cat. no. 26, n. 16.

PROVENANCE: Edme-François-Joseph Bochet; his bequest to the Musée du Louvre, Paris, 1871, his seven surviving children retaining life interest, which they surrendered in 1878 in exchange for copies.*

EXHIBITIONS: Paris 1867, no. 85; Chicago 1934; Paris 1938a, no. 34 [EB]; Pittsburgh 1951; Montauban 1967, no. 40; Paris 1967–68, no. 53; Paris 1980, no. 70; Paris 1985, no. VI, ill.

REFERENCES: Blanc 1870, p. 232; Delaborde 1870, no. 109; *La Chronique des arts*, January 1878, p. 26; *La Chronique des arts*, February 1878, pp. 35–36; Momméja 1904, pp. 68–69; Lapauze 1905a, pp. 121, 171; Uzanne 1906, fig. 38; Wyzewa 1907, p. 11, ill.; Lapauze 1910, p. 176; Lapauze 1911a, pp. 157, 461, 462, ill.; Fröhlich-Bum 1924, p. 8, ill.; Hourticq 1928, pp. 4, 31, ill.; Pach 1939, p. 113; Gatti 1946, p. 110; Bertram 1949, fig. IX; Jourdain 1949, fig. 23; Alazard 1950, p. 48; Wildenstein 1954, no. 76, pl. 9; Toulouse, Montauban 1955, p. 15; Rosenblum 1967a, p. 86, fig. 87; Radius and Camesasca 1968, no. 62, ill.; Rome 1968, p. 21; Naef 1977–80, vol. 1 (1977), p. 252; Zanni 1990, no. 35, ill.; Vigne 1995b, p. 82, ill.; Warrick 1996, vol. 1, pp. 36–37, 62, n. 103

*Five of the copies were executed by Ingres's pupil Paul Flandrin and the artists in his studio.

31. Hippolyte-François Devillers

1811

Oil on canvas
38 × 30 7/8 in. (96.5 × 78.5 cm)
Signed and dated lower left: Ingres à rome / 1811 [Ingres in Rome / 1811]
Foundation E. G. Bührle Collection, Zurich
London only

W 79

More than any other foreign city under Napoleon's control, Rome was the focus of his imperial aspirations: was not his only son its designated king? Given its central role in the emperor's plans, the Eternal City became a place where provincial strivers could make their mark. There, young Frenchmen without titles of nobility or lively prospects in Paris, but full of ambition and ready to work hard in the imperial cause, could anticipate professional recognition and social and financial advancement. One such was Ingres, who at the end of his tenure at the Académie de

France in 1810 chose not to return to the French capital but to remain in Rome for the foreseeable future, working on imperial commissions such as the vast *Romulus, Conqueror of Acron*, of 1812 (fig. 96),[1] and painting portraits of important members of the French occupation government and their families (see cat. nos. 26, 27, 30, 32, 34). Another was Hippolyte-François Devillers, Directeur de l'Enregistrement et des Domaines (director of probate and estates) in Rome from 1811 to 1813, whose portrait Ingres painted or drew on three separate occasions.[2] Born in 1767, the son

of a notary, in the provincial market town of Bouclans (Franche-Comté), and trained in bureaucratic administration, he spent his early career in the provinces.[3] It is not clear what drew the attention of the French administration to Devillers or when he arrived in Rome. Nor would his stay there last long. Soon after his appointment, however, and following the lead of his friend and fellow administrator Charles Marcotte (see cat. no. 26), the proud new imperial bureaucrat commissioned Ingres to paint his portrait dressed in the ostentatious finery of his freshly minted official uniform.

The three-quarters-length portrait shows Devillers, a bachelor of forty-five, wearing a black dress coat known as a *frac,* richly embroidered with sheaves of silver wheat at collar, cuffs, and tails. The white lace of his jabot spills down the front of his white blouse and embroidered vest and over his wrists as well. Right arm thrust into vest, he holds with his left arm a more simply embroidered cocked hat and grasps what has been identified as a gold snuffbox in his hand.[4] At bottom, the bejeweled hilt of a ceremonial sword juts into the picture; its shadow and the shadow cast by the snuffbox on Devillers's trousered leg subtly establish the space of the composition and the figure's three-dimensionality. Against the darkness of background and dress coat, the glinting touches of silver embroidery and jewels and the white of Devillers's vest and lace create a broken S-curve of brightness curling flamelike up the center of the painting where it frames and supports, somewhat unsteadily, the nervous and delicate features of the sitter.

Unlike Marcotte or Charles Cordier (see fig. 93), Roman administrators with aristocratic connections who confronted Ingres with fixed and confident gazes, Devillers's hesitation is evident in his eyes and in the prim set of his sensual mouth. Bags under his eyes and a wispily receding hairline suggest the rigors of the position to which he had so recently ascended. Not quite confident of his new status, he seems to seek not only the legitimation that Ingres's portrait was meant to confer but the approval of the artist himself, to whom he tentatively turns. Ingres, too, was a provincial parvenu who had made

his way to the same extraordinary place; he would understand. Ingres's is indeed a deeply sympathetic portrait of one of the "new men" in Rome, uncertain in the face of his success, as the artist shows, but ready to grasp it tight and announce it to the world. Himself the most insecure and ambitious of men, Ingres continued to feel an affinity for his sitter long after Devillers had departed Rome. In letters over the years to Marcotte, the artist would ask to be remembered to their mutual friend, "expressing my warm memory of him, my sincere attachment, and my affectionate recollection of all his kindness toward me."[5]

Ingres's two portrait drawings of Devillers, one of 1811, the other made the following year, both half-length and still in private collections, show a more self-assured official who, dressed in civilian clothes, turns to confront his friend Ingres with an even gaze. In the earlier drawing, Devillers grasps the same snuffbox as in the portrait painting—and what better indication of cosmopolitan taste than such a costly bibelot? In the later drawing, books are piled high on the table next to him. A greater informality reigns, as if the artist and the sitter were coming to appreciate each other's struggles more intimately still.

By 1816 Napoleon had fallen and Devillers had returned to the provincial town of Vesoul in the Franche-Comté, where for more than twenty years he led a quiet, respectable life as a landowner, municipal official, and upstanding member of the meritocracy whose sophisticated experience of the wider world no doubt was valued, or at least acknowledged, as a rare local commodity. In 1827, at almost sixty years of age, Devillers married the mother of his four children, and he fathered two more before his death ten years later, in 1837. He lived in the center of town in a large house which at his death contained a library devoted exclusively to the law and—a sure sign of self-esteem—no fewer than seven family portraits.[6] No snuffbox is recorded in his estate inventory. One of the portraits, however, was Ingres's elegant, haunting image of the high French official in occupied Rome, magnificently arrayed, that Devillers once

had been. It was a treasured memento of a brief moment—not quite at the center of the world's stage, but near enough to abash the neighbors—when Devillers had flourished as an attendant lord in the great Napoleonic panoply. C.R.

1. The painting would decorate the Palazzo Quirinale, intended to serve as Napoleon's Roman residence.
2. These works are the present painting and two drawings (N 77, 78).
3. The information offered here on Devillers's life and career derives principally from Naef 1977–80, vol. 1 (1977), chap. 29 (pp. 255–61).
4. Washington, Montreal, Yokohama, London 1990–91, no. 12.
5. "en lui marquant bien l'expression de mon tendre souvenir et le fort attachement et ma reconnaissance de toutes ses bontés pour moi." Ingres to Marcotte, July 25, 1822, quoted in Naef 1977–80, vol. 1 (1977), p. 255; in Ternois 1999, letter no. 7.
6. Naef 1977–80, vol. 1 (1977), p. 258.

PROVENANCE: Hippolyte-François Devillers (1767–1837); his descendants until at least 1842; M. Lang collection; Bernheim-Jeune & Cie., Paris, from 1911; a New York art dealer; Galerie Nathan, Zurich, April 18, 1955; purchased from that gallery by Emil G. Bührle (1890–1956), 1955; transferred to the Foundation E. G. Bührle Collection, Zurich, 1960

EXHIBITIONS: Paris 1911, no. 17; Zurich 1917, no. 116; Paris 1921, no. 16; Paris 1923b, no. 2364 [EB]; Copenhagen, Stockholm, Oslo 1928, no. 91 (Copenhagen), no. 80 (Stockholm), no. 84 (Oslo); Paris 1934a, no. 214; Paris 1934d, no. 46; Paris 1935c, no. 11 [EB]; Amsterdam 1938, no. 134 [EB]; Buenos Aires 1939, no. 74 [EB]; Montevideo 1939, no. 56 [EB]; Rio de Janeiro 1940, no. 54 [EB]; San Francisco 1940–41, no. 58; Chicago 1941, no. 84; Los Angeles 1941, no. 70; Portland 1941, no. 57 [EB]; San Francisco 1941–42, no. 58 [EB]; Zurich 1958b, no. 102; Munich 1958–59, no. 87; Edinburgh, London 1961, no. 1; Washington, Montreal, Yokohama, London 1990–91, no. 12

REFERENCES: Lapauze 1911a, pp. 111–14, 156–57, ill.; London 1914, no. 30 [EB]; Bernheim-Jeune and Bernheim-Jeune 1919, ill.; Lapauze 1921, ill. p. 192; Fröhlich-Bum 1924, p. 8, pl. 18; Hourticq 1928, pl. 28; Malingue 1943, ill. p. 34; Wildenstein 1954, no. 79, pl. 41; Delpierre 1958, pp. 2–23; Naef and Lerch 1964, pp. 5–14; Ternois and Camesasca 1971, no. 66; Naef 1977–80, vol. 1 (1977), pp. 255–61, ill.; Ternois 1980, pp. 47, 58, ill. p. 74; Reidemeister in Bührle Collection 1986, no. 5; Amaury-Duval 1993, p. 46; Vigne 1995b, p. 82

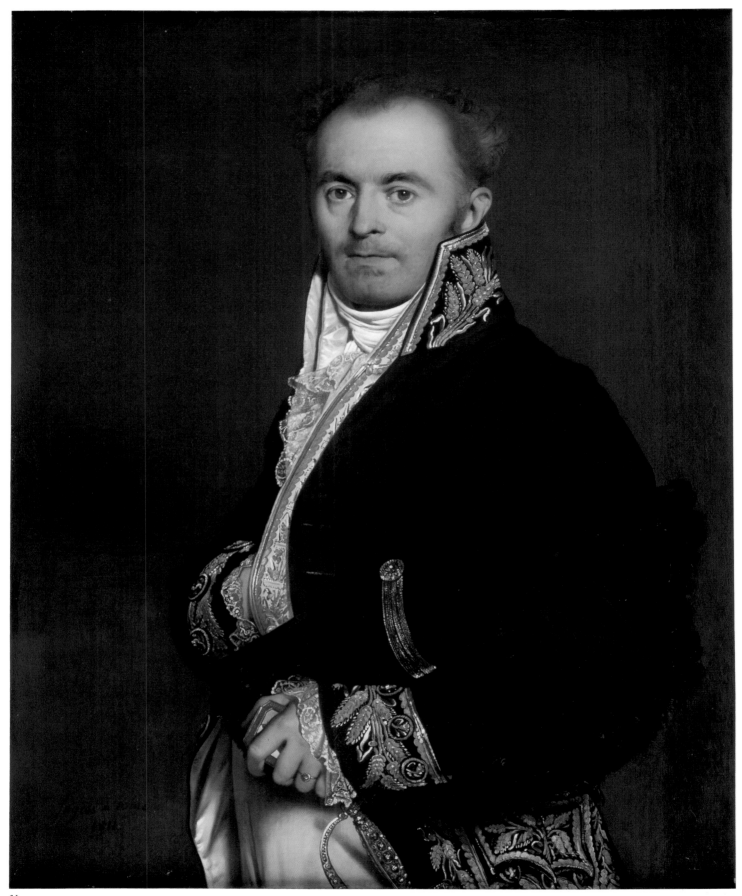

31

32. Comtesse de Tournon, née Geneviève de Seytres Caumont

1812
Oil on canvas
36 ¼ × 28 ¾ in. (92 × 73 cm)
Signed and dated lower right: Ingres, Rome. / 1812.
Philadelphia Museum of Art
The Henry P. McIlhenny Collection in Memory of Frances P. McIlhenny 1986-26-22

W 84

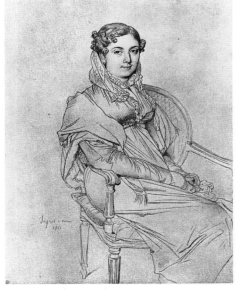

Fig. 118. *Madame Henri-Philippe-Joseph Panckoucke, née Cécile-Françoise Bochet,* 1811 (N 73). Graphite on paper, 12 ⅜ × 9 ⅜ in. (31.5 × 23.9 cm). Musée Bonnat, Bayonne

Comtesse de Tournon is a rare portrait by Ingres of an older woman. His subject was approximately sixty years old when she sat for the artist.[1] This portrait was commissioned not by the sitter but by her son, Comte Philippe-Camille-Marcellin-Casimir de Tournon (1778–1833). A member of a noble family of the Languedoc, the comte de Tournon had been awarded a baronetcy by Napoleon I on March 9, 1810, and was named Prefect of Rome that same year, serving in that capacity until 1814.[2] The comtesse de Tournon and her son were members of Rome's French society, comprised in large part of high officials within the French occupation government and their families.

In this portrait Ingres successfully balances the conflicting impulses of veracity and flattery. Walter Friedlaender has likened it in its realism to the "gruesome" portraits of Francisco de Goya, declaring this to be a "pitiless description of a forceful and witty ugliness."[3] Although there is a certain kinship between the two in terms of the candor of the portrayal, Ingres's painting lacks the harshness of Goya's sometimes merciless portraits. It is ultimately closer in spirit to the rather forthright likenesses of his teacher Jacques-Louis David. Robert Rosenblum's analogy to the frank but sympathetic depiction of David's aging wife, *Madame David* (National Gallery of Art, Washington, D.C.), which was painted in 1813, one year after Ingres's portrait, is a perceptive one.[4] In Ingres's *Comtesse de Tournon*, the sitter, who had almost certainly never been a great beauty even in her youth, is not idealized; Ingres faithfully records her full, rather prominent nose and the slightly sagging flesh beneath her eyes and chin, even as he artfully camouflages the most egregious signs of his sitter's age. Wrinkles on her forehead are hidden beneath a fringe of curls, possibly a wig; her neck—that most telling indicator of age—is concealed behind an elaborate lace ruff that also serves to minimize her double chin.[5] Beneath the ruff her chest is modestly

covered with a chemisette of fine muslin that contrasts noticeably with her bare arms. Throughout the painting Ingres creates a subtle play of line and texture, juxtaposing the graceful curves of the cashmere shawl, the sumptuous, heavy folds of her velvet dress, and cascade of the embroidered muslin veil falling across her shoulder and along her left arm. We can imagine that Madame de Tournon was proud of her arms; with their firm, rounded flesh and pale, lustrous skin, they seem to belong to a much younger woman. Perhaps they are the one concession to the sitter's vanity, or to the painter's love of sensuous forms.

Despite the visual appeal of such details, this portrait's effectiveness derives from the thoughtful delineation of the comtesse's rather forceful character. Ingres successfully communicates the intelligence and cool, patrician manner of his subject through her proud bearing, straightforward gaze, and slightly ironic half smile. She is clearly a formidable woman. An air of circumspection is apparent in her carriage. Ingres wisely avoids the coquettish poses and graceful hand gestures that he often favored in his depictions of younger women, choosing instead a more stolid, almost masculine pose, very similar to that used in the portrait of Philibert Rivière (fig. 57).[6] It is also similar to the pose he used for a drawing of Madame Panckoucke in 1811 (fig. 118). Whereas the much younger Madame Panckoucke is shown in an almost casual manner, her body tucked into the corner of her chair and her hands placed demurely in her lap, the comtesse is seated firmly and squarely in her chair, her arms resting comfortably at her sides. This drawing also includes many of the elements that Ingres would incorporate, albeit in a more subdued manner, in his portrait of Madame de Tournon the following year: the chair, the position of the body in a three-quarters view, the shawl, the ruff around the neck, the veil falling across the sitter's left arm, and even the enigmatic intimation of a smile.

K. J.

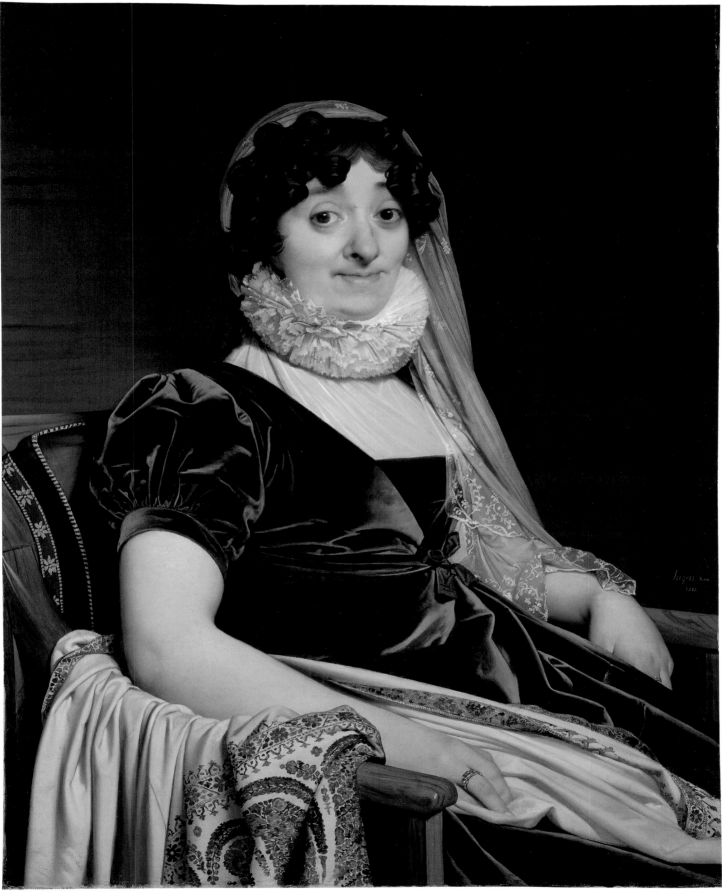

32

1. Delaborde 1870, p. 261.
2. Ruvigny 1914, p. 1462.
3. Friedlaender 1952, p. 79.
4. Rosenblum 1967a, p. 92. On the influence of David, see also Alazard 1950, p. 49.
5. Lapauze 1911a, p. 116.
6. As suggested in Vigne 1995b, p. 82.

PROVENANCE: Comte Philippe-Camille-Marcellin-Casimir de Tournon (1778–1833); his heirs [EB]; Comte Jean de Chabannes-la-Palice; the dealer Paul Rosenberg, Paris, in 1935; bought from him by Henry P. McIlhenny, Philadelphia, in 1936; his bequest to the Philadelphia Museum of Art, 1986

EXHIBITIONS: Paris 1867, no. 443; Paris 1885, no. 162 [EB]; Brussels [sic]* 1890, no. 101 [EB]; Paris 1911, no. 19; Paris 1921, p. 20, no. 18, ill.; Paris 1924, no. 18, ill.; Cambridge (Mass.) 1936; Paris 1936, no. 31 [EB]; Philadelphia, Washington 1937–38; New York 1941a, p. 23, no. 72, ill.; Philadelphia 1947, p. 72, no. 2, ill.; Paris 1955, no. 36, pl. 3; San Francisco 1962, no. 26, ill.; Allentown 1977, p. 20, ill.; Pittsburgh 1979; Atlanta 1984, p. 24, no. 6, ill.; Boston 1986; Philadelphia 1987–88; Philadelphia 1994

REFERENCES: Blanc 1870, p. 232; Delaborde 1870, p. 261, no. 157; Lapauze 1911a, pp. 56, 115–16, ill.; Fröhlich-Bum 1924, p. 8, pl. 19; Würtenberger 1925, pp. 51, 112, ill. p. 53 (the drawing); Gillet 1932 in Courthion 1947–48, vol. 1, p. 169; Pach 1939, p. 44, ill. opp. p. 63; Sizeranne in Courthion 1947–48, vol. 1, pp. 115, 121, 122–23, 128; Alain 1949, p. [17]; Bertram 1949, p. 14, pl. 14; Roger-Marx 1949, p. 27; Scheffler 1949, p. 15; Alazard 1950, pp. 49, 50, 145, n. 9, pl. XXI; New York, Manchester, Detroit, Cincinnati, Cleveland, San Francisco 1952–53, pp. [2–3]; Wildenstein 1954, no. 84, pl. 27; Toulouse, Montauban 1955, p. 15; Picon 1967, p. 70; Rosenblum 1967a, p. 92, pl. 19; Paris 1967–68, p. xxvii; Radius and Camesasca 1968, p. 93, no. 68, ill. p. 93; Rome 1968, p. xxi; Zanni 1990, p. 55, no. 40, ill.; Vigne 1995b, p. 82, fig. 55

*The first two "Portraits du Siècle" exhibitions were held in Paris [EB].

33. Jacques Marquet, Baron de Montbreton de Norvins

1811; reworked after 1814
Oil on canvas
38¼ × 31 in. (97.2 × 78.7 cm)
Signed lower right: Ingres P. Ro. [Ingres p(ainted this). Ro(me).]
The Trustees of the National Gallery, London NG 3291

W 81

Jacques Marquet, baron de Montbreton de Norvins (1769–1854), was the youngest of four sons of a wealthy Gascon family.[1] By the age of twenty, he had become a councillor at the Châtelet law court in Paris. His career was cut short by the Revolution, however, and in 1791 he resigned his position and left France, emigrating first to Koblenz and later settling in Switzerland, where he remained for five years. In 1797 he returned to France but was arrested as an émigré and confined for two years in the Prison de la Force. Released following Napoleon Bonaparte's seizure of power, Norvins continued his checkered career; first he followed General Leclerc, the brother-in-law of First Consul Bonaparte, to the island of Santo Domingo as his secretary-general; following the death of Leclerc from yellow fever, Norvins joined Napoleon's army at Mainz as a member of an elite cavalry unit, known as the Gendarmes d'Ordonnance. His service earned him membership in the Legion of Honor (April 16, 1807) and a lieutenancy (November 4, 1807).[2]

Leaving the military behind on November 24, 1807, Norvins began a career in the civil service of the new kingdom of Westphalia. During his three years there, he held a variety of positions, including secretary-general for the council of state, and the queen's chamberlain. In April 1810 he accompanied the royal family of Westphalia to Paris for the wedding of Napoleon and Marie-Louise, after which Norvins chose to remain in France. Within months, he at last returned to political service when he was named Chief of Police for the Roman States. He took office in Rome in January 1811 and remained there for the next three years. Norvins proved to be ill-suited to his politically sensitive post. Though

Fig. 119. Infrared photograph of *Jacques Marquet, Baron de Montbreton de Norvins*

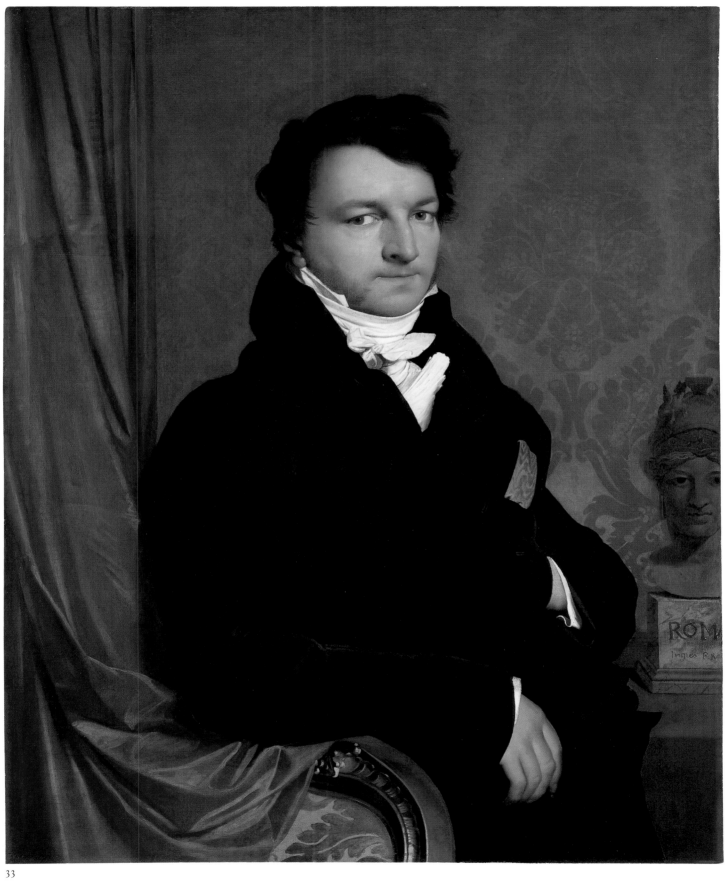

33

admired for his zeal, he was perceived as being somewhat frivolous.[3] Socially, however, Norvins was generally recognized for his quick wit and affability. Writing in 1813, Madame Récamier observed, "That M. Norvins is certainly a witty man. . . . Moreover, he is perfectly attentive and pleasant toward me."[4] Stendhal, however, was more critical of the director of police: "M. N[orvins] seemed quite nasty and talked nonstop. I was so repelled by his personality that I decided not to go see him."[5]

In this painting, perhaps in response to Norvins's detractors, Ingres has portrayed his subject as the very embodiment of the stolid police official.[6] His posture is stiff, his demeanor serious and controlled. His steely gaze and tightly compressed lips suggest a man who brooks no nonsense. The severity of Norvins's expression is matched by his somber garb—a simple black suit against which his white cravat and collar and the edges of his shirt cuffs stand out in vivid contrast. The only hint of color on his person comes from the ribbon denoting a chevalier in the Legion of Honor, which is fixed on the lapel of his black redingote and echoes the deep red damask fabric covering the chair and the wall behind him. His right elbow rests on the arm of his chair, while the left hand is tucked into the breast of his jacket, in a gesture reminiscent of Emperor Napoleon, of whom Norvins was an ardent admirer. The only other object in the room, apart from the sitter and the chair against which he leans, is a bronze bust of Minerva, a copy after a marble in the Vatican. Inscribed on the marble pedestal beneath are the letters "ROM," presumably standing for "Rome," or "Roma," in reference to the sitter's province of authority.[7] The relative opulence of the setting, so different from the landscapes or neutral backgrounds favored by the artist for his male portraits of the period, seems curiously at odds with the sitter's rigid pose, further underscoring the severity of his appearance. But Ingres may have accentuated these characteristics to give a sense of the sitter's important standing.

By comparison, a portrait drawing Ingres made of Norvins at this time (cat. no. 46) shows more the social face of the sitter. In this drawing, now in the Virginia Museum of Fine Arts, Richmond, Norvins is positioned almost full face; his pose is relaxed; and his manner and countenance are both open and engaging.[8] In fact, it is the wiry little dog seated in his lap, and not Norvins himself who seems forbidding in this drawing. These two works underscore the distinction between the informal and often intimate character of Ingres's drawings and the sobriety of their more formal painted counterparts.

Although the painting itself is undated, the date of 1811 put forth by Henri Delaborde and upheld by Henry Lapauze has never really been disputed.[9] The portrait of Norvins is one of a group by Ingres depicting members of Rome's French society and of high officials within the French occupation government, such as Joseph-Antoine Moltedo (see cat. no. 27), Charles-Joseph-Laurent Cordier (see fig. no. 93), and Hippolyte-François Devillers (see cat. no. 31), who commissioned their portraits from Ingres, perhaps following the example and recommendation of Charles Marcotte (see cat. no. 26), who had sat for the artist in 1810.[10] In the case of the painted portrait of Norvins, a date of 1811 would seem to be corroborated both by the Richmond drawing, which is dated 1811 by Ingres and Norvins himself, and by a piece of later correspondence that has recently come to light. Eric Bertin makes reference to a letter of November 29, 1844, from Norvins to M. Guérin in which Norvins regrets not to have engraved the "magnificent portrait Ingres did of him in Rome in 1811."[11] There is also a second, more contemporary, piece of documentation concerning the creation of the painting. In a letter from Ingres to Marcotte dated July 18, 1813, he described his intention to exhibit a number of works at the upcoming Salon, including his portrait of Monsieur de Norvins.[12] This letter confirms that the portrait was completed by this time, though it gives no indication of how much earlier it had been finished. Martin Davies, who considers the date of 1811 as "about right," also mentions the letter of 1813. More recently, other scholars have modified the proposed dating of this painting, including Georges Vigne,

who suggests 1813; Hans Naef, who gives the compromise date of about 1812; and Christopher Baker and Tom Henry, who suggest 1811–12.[13] However, Daniel Ternois has shown that Ingres exhibited only one portrait at the Salon of 1814, *Charles-Marie-Jean-Baptiste Marcotte* (cat. no. 26), and not *Jacques Marquet, Baron de Montbreton de Norvins*, as he had planned in 1813.[14] In light of these recent discoveries, the initial date of 1811 appears indisputable.

This portrait was heavily repainted in places by the artist, and there are a number of pentimenti. In addition to minor alterations around the sitter's head and to the coat collar, which was slightly higher at one point, there are other more substantial changes to the composition,[15] most notably the addition of a rather awkward length of dark red fabric that hangs down the left side of the canvas and extends over the top of the chair upon which Norvins rests his arm. The drapery is rather rapidly and thinly painted, in marked contrast to the wall covering and chair, which are both meticulously studied. Part of the wood frame of the chair can be seen, and there is craquelure throughout the upper portion of the drapery. This drapery was added in order to hide a bust resting on a tall pedestal that is still visible to the naked eye and can be seen quite clearly in infrared photographs (fig. 119). Baker and Henry have suggested that the bust depicted the King of Rome, the son of Napoleon I, who was born on March 20, 1811.[16] This would have been a logical addition to a portrait of a loyal supporter of the emperor such as Norvins. It would also explain the need for its removal. Following the abdication of Napoleon in April 1814 and the subsequent return to power of the Bourbons, such an imperial homage would have been injudicious for an aspiring artist such as Ingres. Another major change within the composition is the inclusion of the bust of Minerva. Thinly painted—the pattern of the wallpaper is now clearly visible through the gray-green paint surface of the bust— and precariously inserted at the extreme right edge of the picture plane, this sculpture was almost certainly added at the same time as the drapery along the left-hand side of the canvas. The inscriptions

on the base are not truncated because the canvas was cut down, as Davies proposed,[17] but rather owing to the lack of space to the left of the sitter and Ingres's somewhat awkward attempt to introduce a sculpture—and a signature—to replace the one that he had painted out.[18]

Norvins returned to France in February 1814. Despite the reestablishment of the Bourbons, he remained steadfast in his admiration of Napoleon. On May 31, 1815, during Napoleon's brief return to power known as the Hundred Days, Norvins published a brochure critical of the government of the Bourbon king Louis XVIII, an action that earned its author a year's exile in Strasbourg under police surveillance—an ironic turn of events for a former chief of police.[19] During the Restoration and the July Monarchy, Norvins became a staunch Napoleonic apologist and wrote a number of historical texts, including a four-volume *Histoire de Napoleon* (1827–28), the first serious biography of the emperor. The work proved highly successful, appearing in twenty-one editions before its author's death.

Norvins apparently maintained at least a loose association with Ingres throughout this period, perhaps through their mutual friend Marcotte. In 1829 Ingres designed the frontispiece for a new edition of Norvins's epic poem *L'Immortalité de l'âme ou les quatre âges religieux.*[20] In 1842 Norvins wrote to the artist to congratulate him on his portrait of the duc d'Orléans and, in typical fashion, compared the recent funeral for the popular prince with the transfer of Napoleon's remains to Paris in 1840.[21]

Norvins died in Pau in 1854 at the age of eighty-five. His portrait remained in his family until 1890, when it was sold at auction. In 1898 it was acquired by the French painter Edgar Degas, a fervent admirer of Ingres who already owned three other portraits by the artist. In addition to the painting itself, Degas also owned a lithograph of Norvins presumably from the hand of Ingres.[22] This lithograph, a bust-length portrait of Norvins, is similar to the painting rather than to the drawing, and was perhaps executed after the painting.

K. J.

1. The biographical material that follows is extracted from Lanzac de Laborie 1896–97 and is quoted at length in Naef 1977–80, vol. 1 (1977), pp. 240–45.
2. Archives Nationales, Paris, LH 1750/32 (Marquet Norvins Montbreton, Jacques).
3. Naef 1977–80, vol. 1 (1977), p. 243.
4. "Ce M. de Norvins est certainement un homme d'esprit. . . . Du reste, il est parfaitement soigneux et aimable pour moi." Madame Récamier, quoted by Sainte-Beuve (1884, p. 326); reprinted in Naef 1977–80, vol. 1 (1977), p. 246.
5. "M. N[orvins] paraissait bien méchant et parlait toujours. Son caractère m'inspira tant de répugnance que je n'allai pas le voir." Stendhal 1955, p. 1146.
6. Lapauze 1911a, p. 114.
7. The sculpture was identified by Otto Kurz (1950, p. 240), who corrected Lapauze's earlier identification of the bust as a figure of Rome from the gardens of the Villa Medici. Lapauze 1911a, p. 114. See also Davies 1970, p. 77, n. 5.
8. In the École des Beaux-Arts in Paris there is a second version of this drawing, with the same composition shown in reverse and without any inscription. Originally believed to be by Ingres, this drawing is now recognized as a copy. See Mathey 1933, pp. 117–22. In addition to these two drawings, there are also two lithographs by J.-B. Muret of this composition, facing different directions. Naef 1977–80, vol. 1 (1977), pp. 237, 239, figs. 4, 5.
9. Delaborde 1870, p. 258; Lapauze 1911a, p. 106.
10. Lapauze 1911a, pp. 110–11.
11. "magnifique portrait qu'Ingres a fait de lui à Rome en 1811." Quoted in Bertin 1998, p. 40.
12. The letter is published in Delaborde 1870, pp. 333–34; Boyer d'Agen 1909, p. 106; and Ternois 1999, letter no. 2.
13. Davies 1970, p. 76; Vigne 1995b, p. 87; Naef 1977–80, vol. 1 (1977), p. 237; Baker and Henry 1995, p. 323.
14. Daniel Ternois to Lorenz Eitner, February 26, 1996, Department of Curatorial Records and Files of the National Gallery of Art, Washington, D.C. The "Registre d'inscription des productions des artistes vivants presentées à l'Exposition, Salon 1814," in the Archives du Musée du Louvre, confirms the inclusion of the portrait of Marcotte under number 27 as "*1 tableau Portrait de Mr. Marcotte.*"
15. Davies 1970, p. 76.
16. Baker and Henry 1995, p. 323.
17. Davies 1970, p. 76.
18. Information regarding the physical state of the painting was communicated to the author by David Bomford, conservator at the National Gallery, London.
19. See *Biographie des hommes vivants* 1818, p. 549.
20. Completed during his exile in Strasbourg, this poem was first published in 1822. In a letter to Édouard Gatteaux, Marcotte recalled seeing a small sketch for the piece (see Naef 1977–80, vol. 1 [1977], pp. 248–49), but its present whereabouts are unknown. The frontispiece is reproduced in Schlenoff 1956, p. 208, pl. XXV.
21. Lapauze 1911a, pp. 373–74.
22. New York 1997–98 [vol. 2], p. 81, no. 724. The lithograph is included in Delteil 1908, no. 7, as *Portrait d'homme.*

PROVENANCE: Jacques Marquet, baron de Montbreton de Norvins (1769–1854); by descent to Mme Gengoult de Clairville, née Norvins; her sale, Paris, May 8, 1890, no. 4; probably purchased at that sale by Henri Haro *père;* purchased from him by Baron Joseph Vitta, Lyons; retrieved from him by Henri Haro *père* and sold to Edgar Degas (1834–1917), June 3, 1898; his sale, Galerie Georges Petit, Paris, March 26–27, 1918, no. 53; acquired at that sale by the National Gallery, London

EXHIBITIONS: Paris (Salon) 1824; Paris 1867, p. 21, no. 101; London 1996, no. 26, ill. p. 21

REFERENCES: Blanc 1870, p. 234; Delaborde 1870, p. 258, no. 148, pp. 267–68, no. 169 (as author of poem accompanying an engraving of an Ingres drawing), p. 334; Momméja 1904, pp. 39, 68–69; Uzanne 1906, p. xiii; Boyer d'Agen 1909, p. 106; Lapauze 1911a, pp. 105, 111, 114, 146, 153, 161, 373, ill. p. 106; Fröhlich-Bum 1924, p. 8; Hourticq 1928, p. iv; Gatti 1946, p. 110; Bertram 1949, pp. 9, 14, pl. XII; Alazard 1950, pp. 47, 48, 145, n. 4; Wildenstein 1954, no. 81, pl. 32; Rosenblum 1967a, p. 90, pl. 18; Paris 1967–68, p. xxvii; Radius and Camesasca 1968, p. 94, no. 71, ill.; Rome 1968, p. xxi; Davies 1970, pp. 76–77, no. 3291; Naef 1977–80, vol. 1 (1977), pp. 237–50, fig. 1; Tübingen, Brussels 1986, pp. 30–31; Zanni 1990, p. 59, no. 43, ill.; Baker and Henry 1995, p. 323; Vigne 1995b, pp. 82, 87, 137, 186, fig. 58; New York 1997–98 [vol. 1], pp. 3, 7, 12, 26, 146, 279–80, 304, ill. p. 145, fig. 186, p. 303 (detail), fig. 386, [vol. 2], pp. 68–69, no. 618, ill.

34. Queen Caroline Murat

1814
Oil on canvas
36 1/4 × 23 5/8 in. (92 × 60 cm)
Signed lower left: Ingres P.ˣⁱᵗ Roma 1814
[Ingres painted (this in) Rome 1814]
Private collection

W 90

Fig. 120. *Head of Queen Caroline Murat,* 1814. Graphite on paper, 1 3/4 × 1 7/8 in. (4.6 × 4.9 cm). Musée Ingres, Montauban (867.341)

Hans Naef published an exhaustive article on this portrait shortly after its rediscovery in 1987, and any scholar following him is deeply in his debt.[1] Caroline Bonaparte (1782–1839) was the youngest and most intelligent sister of Napoleon (see cat. nos. 2, 10). She met her brother's brilliant general Joachim Murat (1767–1815) in Italy in 1797; they were married in 1800. Murat was made king of Naples in 1808, thus extending Napoleonic rule to the southern states of Italy and Sicily. The royal couple, and notably Queen Caroline, took a keen interest in the arts and assembled an important collection of contemporary painting and sculpture, which was dispersed after their fall from power in 1815. They were closely connected to the circle of French artists in Rome and, among others, acquired several works by Ingres's friend François-Marius Granet (see cat. no. 25), who was named the queen's official painter in 1812. The architect François Mazois, another of Ingres's intimates, advised them on their collection, and on archaeological and architectural matters, such as the excavation and restoration of Pompeii.

Joachim Murat acquired his first work by Ingres in 1809, when in November he visited an exhibition on the Campidoglio in Rome and there purchased the lifesize figure of a nude woman seen from the front (fig. 85), exhibited as *Donna nuda che dorme;* it later became known as *The Sleeper of Naples* after its association with the royal collection in Naples. Caroline subsequently commissioned Ingres to paint a pendant, with a nude seen from the back: his famous *Grande Odalisque,* which he completed in 1814 (fig. 101). He also painted for the Murats two small historical-literary scenes: *The Betrothal of Raphael* and *Paolo and Francesca* (figs. 102, 103). The disruption of political events during the year before the collapse of their regime made it impossible for the Murats to take delivery of *Grande Odalisque,* and Ingres was not paid for it. The loss of these patrons was a serious financial setback for the impecunious artist, who had just married in December 1813; he was concerned, because by July 1814 a child was on the way.

Ingres traveled to Naples in February or early March 1814 and remained until late May. Some years later, as he was leaving Rome for Florence in 1819, Ingres recalled making a visit of "three months to Naples."[2] A letter from Granet to Mazois, dated no more precisely than March 1814, noted that Ingres was bringing one of Granet's paintings to Naples for the queen.[3] Ingres referred to this visit as a recent event in a

Fig. 121. *Studies of Queen Caroline Murat,* 1814. Graphite on paper, 10 1/8 × 9 in. (25.9 × 23 cm). Musée Ingres, Montauban (867.403)

Fig. 122. *Landscape with Vesuvius,* 1814. Graphite on paper, 7 1/4 × 10 1/4 in. (18.3 × 26.1 cm). Musée Ingres, Montauban (867.4294)

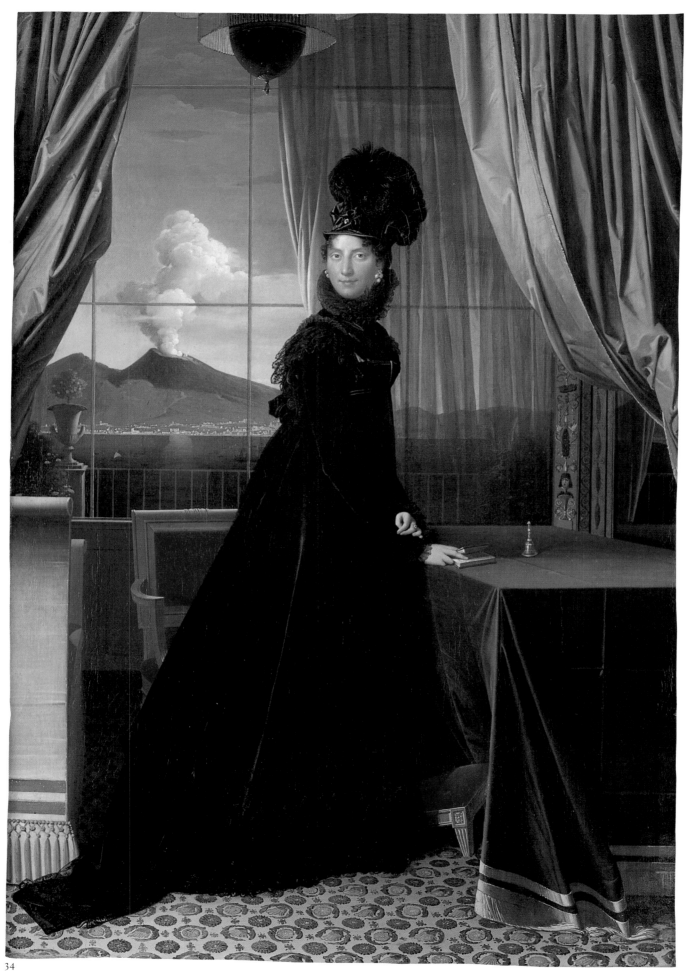

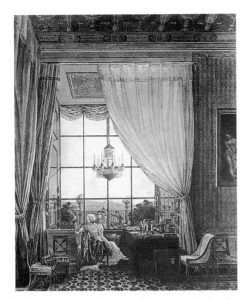

Fig. 123. Comte de Clarac (1777–1847). *Caroline Murat in the Royal Palace, Naples*, ca. 1808–13. Watercolor on paper. Private collection

Fig. 124. François Gérard (1770–1837). *Caroline Murat and Her Children*, 1808. Oil on canvas, 84 1/4 × 67 in. (214 × 170 cm). Private collection

letter from Rome to his friend Marcotte on July 7, 1814:

> It was roughly six weeks ago that I arrived in Naples. . . . I've just finished a small full-length portrait of her [Caroline Murat] and am also finishing for her the companion piece to the sleeping female figure that the king bought from me 5 years ago. Truth to tell, she asked me for all her portraits, hers and her children's, but all that depends on the circumstances, as you can well imagine. I was received beautifully here, and this work could become an asset to my fortune. But for the moment I'm just trying to survive. I'm soon going to be a father. . . . After the two works I have with me, I'll know what to do with the other one. I owe all this to my friend M. Mazois.[4]

This is the first mention of Ingres's portrait of Caroline Murat, a picture that was completed and delivered to his patron, but for which he was never to receive payment.[5] Indeed, the portrait of Caroline Murat turned out from the first to be an "unhappy success," because the queen's head and hat were found to be unsatisfactory, and he had to repaint this area "for the third time"; in this undated letter of 1814, Ingres asked Mazois on his next trip to Rome to bring back the portrait, "which I'd pay dearly to have here so I could start over on the defective part."[6]

Caroline Murat is shown standing, dressed all in black, in a high-waisted velvet pelisse, lace ruff, and mantle, with *girandole* earrings and a hat trimmed with ostrich feathers. It is possible she is dressed in mourning for her former sister-in-law the Empress Josephine, who had died earlier the same year. She is in her private audience chamber in the Palazzo Reale, Naples, with a view of a terrace, the bay of Naples, and Vesuvius beyond. The room is also recorded in a contemporary watercolor, showing the queen looking out onto the terrace where her four children are at play, which confirms the accuracy of Ingres's representation (fig. 123).[7] For example, we see the same velvet-draped table, the Neoclassical couch at left, and the hanging lamp, among other details; at a later date, Ingres's painting may have been slightly cut down at the top, as the lamp there is now oddly cropped. The walls are lined with silvery satin above the red and green dado. The reveals to either side of the large window have mirrors, to reflect light and the glinting waves of the bay. The memoirs of Contessa Rasponi, the Murats' daughter Louise, recall this room:

> Little receptions took place . . . in the room known as the *grand cabinet* of the queen. Nothing could be more enchanting than the arrangement of the latter. The little

picture painted by Monsieur Clarac, which is in my bedroom, is quite a faithful representation of it, but still gives only an imperfect idea. The end of the room, where my mother's writing desk stood, was all of mirrors and opened onto the famous terrace which, along with the view of the bay, was reflected infinitely on those crystal walls. The queen gave audiences in this room, but despite the charm of the view, did not stay there as a rule.[8]

Ingres signed and dated the portrait in Rome. He may have begun it in Naples, and certainly he made a series of preparatory drawings there: he drew such details as the chair[9] and the footstool and folds of the tablecloth,[10] and made studies for the figure of the queen (fig. 121). He also drew a tender study of the queen's features (fig. 120), which survives in a fragmentary little pencil drawing, perhaps cut by Ingres from a larger sheet at a later date. In the final painting her face seems more stern, although her expression suggests intelligence, humor, and wit. Ingres also made a drawing of the view out the window, looking across the bay to the smoking Vesuvius (fig. 122). The existing preparatory drawings were rather directly transposed into the painting.

The composition of *Queen Caroline Murat* is strongly reminiscent of Ingres's earlier *Bonaparte as First Consul* (cat. no. 2): each sitter stands in a sharply delineated Neoclassical interior with table and chair, and a window with open curtains looking out on a landscape that plays an important role in denoting a particular place. Even the painting technique is similar in each work, with a precise, descriptive touch that betrays no painterly flourishes. Their brightly lit landscapes share a freshness and clarity of touch that set them apart from the more moody and atmospheric landscape backgrounds painted by Ingres in the style of Granet in other portraits of the Italian years (see cat. nos. 25, 27). The portrait of Caroline Murat has a cool and detached air, expressed both in the sitter's physical distance and in the objectivity of its execution, which is only fitting for a ruler with whom Ingres may not have felt on close terms: her image lacks the aura of complicity we sense in portraits of less elevated sitters, such as Madame Duvaucey (fig. 87) or

Madame de Senonnes (cat. no. 35). This observation is somewhat belied, however, by the small drawing of her face already mentioned above (fig. 120). Ingres's portrait is very different from François Gérard's earlier *Caroline Murat and Her Children* (fig. 124), with its warm familial atmosphere, painted in France in 1808 at the time of Murat's accession to the throne. But there is an uncanny prescience in the solitary isolation of Ingres's figure, apparently dressed in mourning: in little more than a year she was to lose her husband and would be forced to abandon her beautiful palace and their Neapolitan domains forever.

In his letter of July 7, 1814, to Marcotte quoted above, Ingres expressed confidence—unfounded, as it turned out—in receiving payment for the two completed works, the *Grande Odalisque* and *Queen Caroline Murat*. But he was already justifiably wary of the contingencies surrounding the small-scale group portrait, or conversation piece, representing the royal family he mentions in the same letter. Six rather careful existing portrait drawings Ingres made in Naples of the queen (including fig. 120) and her children seem to be preparations for it.[11] From his letter to Mazois we learn that Ingres had begun to paint the family group portrait, or at least had laid in its broad outlines, on the basis of the drawings:

> I've sketched out a small portrait of the noble family, from all the drawings I made of them, and I believe that when it's finished this little painting would be, I have no doubt, of great interest. If you were here, you could tell me if I should put the finishing touches on it immediately or turn to the other works I've begun, one of which [*Grand Odalisque*] is the companion piece to the figure for the king, already quite far along.[12]

But the sketch for the family group no longer survives, nor is it even mentioned in any of Ingres's later notebooks or lists of works done. We can imagine it would have been a finely painted work, in composition something like the finished portrait drawing of *The Family of Lucien Bonaparte* (fig. 91).

As Napoleon began to taste defeat on the eastern front, in Russia in 1812 and at the battle of Leipzig in 1813, the once loyal Murat and his queen undertook a treacherous alliance with England and Austria in January 1814. With the consent of the Allies, Murat at the same time took control of the Papal States. The imperial troops left Rome; but Napoleon released Pope Pius VII from his five-year captivity in France, in order to promote his legitimate return to Rome, thwarting the ambitions of the traitorous Murat. In May 1814, a few weeks after Napoleon's first abdication, Pius VII returned triumphantly to the Vatican. As so many of his Bonapartist clients were now leaving Rome, Ingres still put some of his hopes in Naples, even as he returned from there to Rome in May and was continuing to work for Caroline in July. But by May the next year, after Murat had tried unsuccessfully to realign himself with Napoleon during the emperor's three-month return to France (from March 1, 1815, to June 18, the day of Napoleon's final defeat at the battle of Waterloo), the Murat rule of Naples was over. Murat left his queen and fled Naples on May 18; only a few days later, facing a popular uprising, Caroline had to take refuge on a British ship, beginning a long exile that took her to Trieste and finally to Florence, where she died in 1839. Murat was captured by royalist troops in Calabria in October 1815, and summarily executed by a firing squad.

P.C.

1. Naef 1990 ("Caroline Murat").
2. "trois mois à Naples"; Ingres to Jean-François Gilibert, June 1819, in Boyer d'Agen 1909, p. 39.
3. Granet to Mazois, March 1814, in Néto 1995, p. 30.
4. "Il y a six semaines environ que je suis arrivé de Naples. . . . Je viens de terminer un petit portrait en pied d'elle [Caroline Murat] et suis à terminer aussi pour elle le pendant à cette figure de femme endormie que le roi m'acheta il y a 5 ans, elle m'a à la vérité demandé tous ses portraits, eux et les enfans, mais tout celà est subordonné aux circonstances comme vous devés bien le penser. J'y ai été parfaitement reçu, et cet ouvrage pourrait devenir avantageux à ma fortune. Mais en attendant je cherche à vivre. Je vais être bientôt père. . . . Après les deux ouvrages que je tiens, je saurai à quoi m'en tenir sur l'autre. Tous celà, je le dois à mon ami M. Mazois." Ingres to Marcotte, July 7, 1814, quoted in

Naef 1990 ("Caroline Murat"), p. 12; in Ternois 1999, letter no. 4.
5. Hans Naef (1977–80, vol. 1 [1977], p. 382) published an invoice for these works, dated September 9, 1819 (MS. Masson 59, Bibliothèque Thiers, Paris); Naef (1990 ["Caroline Murat"], p. 12) does not give a date for this same document. However, Ingres was likely still pursuing payment in 1819, according to correspondence between de Mercy, the Paris agent of the Comtesse de Lipona (anagram of "Napoli"), as Caroline Murat now styled herself, and August de Coussy, Murat's former secretary; see Bulit 1993.
6. "malheureux succès"; "pour la troisième fois"; "que je donnerais beaucoup d'avoir ici pour recommencer la partie défectueuse." Ingres to François Mazois, undated letter, first published in Lapauze 1910, pp. 265–69.
7. The watercolor by the comte de Clarac was first published in Praz 1964, p. 42, fig. 16. See also Naef 1990 ("Caroline Murat"), p. 18, fig. 10.
8. Spaletti 1929, quoted in Praz 1964, p. 43. Praz reproduced Ingres's *Queen Caroline Murat* (p. 199, fig. 166), but did not know it was by Ingres or who the sitter was (he called her a "Bourbon Princess")!
9. Musée Ingres, Montauban, inv. 867.3845–46; Vigne 1995a, no. 2738.
10. Musée Ingres, Montauban, inv. 867.2973; Vigne 1995a, no. 2737.
11. Naef 1977–80, vol. 4 (1977), pp. 210–21, nos. 116–21, ill. Ternois (1959a, nos. 139–44, 146–48) catalogues a group of tracings and sketchy portraits, including additional works that also appear to relate to the Murat family portrait. See also Vigne 1995a, nos. 2741–49.
12. "J'ai ébauché un petit portrait de la noble famille, d'après tous les croquis que j'en ai faits et je crois que ce petit tableau terminé seroit, je ne doute pas, d'un grand intérêt. Si vous étiez ici, vous me diriez si je devrais de suite y mettre la dernière main, ou m'occuper des autres ouvrages commencés, dont j'en ai un [*La Grande Odalisque*] qui est le pendant de la figure pour le Roi très avancée." Ingres to Mazois, undated letter, quoted in Lapauze 1910, p. 268.

PROVENANCE: Commissioned by Caroline Murat in early 1814; purchased about 1850 by Conte di Gropello, Terlizzi, Puglia; thence by family descent, to Conte Gianni di Gropello Figarolo, Rome, about 1964; Galerie Chauveau, Brussels; acquired by a private collector, Belgium; Galerie d'Arenberg, Belgium, 1988; the present owner

EXHIBITION: New York 1996, pp. 69–70, 102–3, no. 19, ill.

REFERENCES: Blanc 1870, pp. 38, 39, 232; Delaborde 1870, no. 143; Momméja 1904,

pp. 39–40, 67; Momméja 1905a, pp. 48–49; Uzanne 1906, p. xiii; Lapauze 1910, pp. 264–69; Lapauze 1911a, pp. 102, 105, 148, 150–52, 157; Fröhlich-Bum 1924, p. 11; Hourticq 1928, p. iv; *Dessins de Jean-Dominique Ingres* 1930 p. [2]; Fouquet 1930, p. 77; Gatti 1946, pp. 94, 103, 104, 105; New York, Manchester, Detroit, Cincinnati, Cleveland, San Francisco 1952–53, p. [3]; Wildenstein 1954, no. 90; Toulouse, Montauban 1955, under no. 132; Ternois 1959a, under nos. 139–48; Praz 1964, p. 199; Cambridge (Mass.) 1967, p. xx; Montauban 1967, under no. 50; Paris 1967–68, under nos. 67, 68; Rosenblum 1967a, p. 50; Florence 1968, p. 23; Radius and Camesasca 1968, no. 77; Rome 1968, p. xxi, under no. 45; Houston, New York 1986, under no. 14; Naef 1990 ("Caroline Murat"), pp. 11–20, ill.; Zanni 1990, p. 149; Bulit 1993, pp. 8–10; Rome, Paris 1993–94, pp. 156–60; Ockman 1995, pp. 33–47, 152, n. 11, p. 154, n. 26, fig. 23; Vigne 1995a, p. 494; Vigne 1995b, p. 112, fig. 82

35. Madame de Senonnes, née Marie-Geneviève-Marguerite Marcoz, later Vicomtesse de Senonnes

1814

Oil on canvas
41¾ × 33⅛ in. (106 × 84 cm)
Signed on the paper tucked in the mirror frame:
Ing. Roma. [Ing(res). Rome.]
Musée des Beaux-Arts, Nantes 1028

W 109

Marie-Geneviève-Marguerite Marcoz was born on June 29, 1783, in Lyons, where her parents were affluent drapers.[1] On April 19, 1802, she married Jean Talansier, whose family was in the hatting and fabric business in Lyons; she gave birth to a daughter the following year. Business took the young Talansiers to Rome. But their marriage came to an unhappy end there, and they divorced in 1809. Jean Talansier left to join the imperial army, and was later twice wounded in the important engagements at Wagram and Leipzig. Marie seems to have passed herself off as Italian—perhaps initiating the rumor that she was a native of the Trastevere quarter in Rome. By 1810 she was established as the mistress of Alexandre de la Motte-Baracé, vicomte de Senonnes, a collector and amateur artist, who had been living in Rome since 1805. It is possible that Senonnes's royalist sympathies initially prompted his voluntary exile to Rome, after the declaration of the Empire in 1804. It was probably when Napoleon's regime began to crumble in March 1814 that the couple returned to France;[2] they were married in Paris in August 1815, and their union met with strong disapproval from the Senonnes family. The vicomte was made inspector general of the Musées Royaux in 1816, and he later held a number of other high public positions, such as secretary-general of the Ministère de la Maison du Roi, and Maître des Requêtes at the Conseil d'État. He died in 1840. The vicomtesse predeceased her husband in Paris on April 25, 1828.

Marie Marcoz was thirty-one years old when Ingres completed her portrait during the summer of 1814. The artist had already made a portrait drawing of her in 1813 (fig. 125). He refers to the painted portrait in a letter of May 26, 1814, and mentions its near completion in a letter of July 7.[3] It seems likely it was commissioned before

Fig. 125. *Marie Marcoz*, 1813 (N 95). Graphite on paper, 10½ × 7¾ in. (26.6 × 19.7 cm). Detroit Institute of Arts

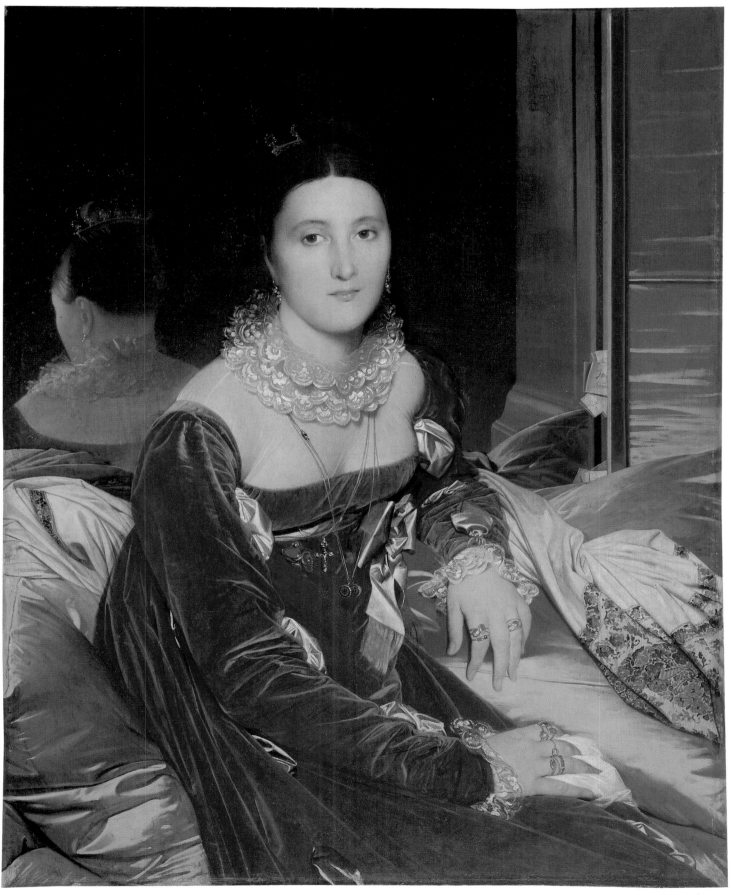

35

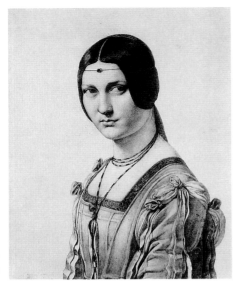

Fig. 126. After Leonardo da Vinci. *La Belle Ferronière*, before 1806. Charcoal on paper, 20⅛ × 16½ in. (52.5 × 41.8 cm). Barber Institute of Fine Arts, Birmingham University, U.K.

Fig. 127. *Raphael and the Fornarina*, 1814 (W 88). Oil on canvas, 26¾ × 21⅝ in. (68 × 55 cm). Fogg Art Museum, Harvard University Art Museums, Cambridge, Massachusetts

Ingres went to Naples in March, and perhaps even during the winter of 1813–14, if progress on the picture before Ingres's visit to Naples in April should be taken into consideration.

At first it seems curious that a painter who disdained portraiture at this time should have lavished such a degree of attention on an attractive but surely not influential client. It is only because Ingres painted Marie—in this, one of his greatest portraits—that she is remembered at all. Perhaps the aristocratic standing of Senonnes encouraged Ingres to outdo himself, in the hopes of attracting future patronage. In the July letter, Ingres expresses the hope of exhibiting *Madame de Senonnes* at the Salon: that may be sufficient reason to explain the great care he evidently devoted to the portrait. But it

was not exhibited, and remained sequestered in the Senonnes family, until it was sold, somewhat ignominiously, to an antique dealer in Angers in 1852. It was astutely acquired by the Musée de Nantes from the dealer in 1853.

Madame de Senonnes was Ingres's most psychologically complex and engaging female portrait to date. It is difficult not to imagine some elective affinity between the artist and his sitter. Nor should we discount the possibility that a certain air of scandal may have surrounded her liaison with the viscount, adding a knowing piquancy to Ingres's representation. But art reveals its student, and if Ingres destined the work for the Salon, the above remarks may be romantic invention. Nevertheless, the portrait of Madame de Senonnes has a mood, difficult to define, shifting almost imperceptibly between warm voluptuousness and calm detachment. Was Ingres recalling a lesson in nuances of expression, which he must have learned when he made a ravishing drawing after Leonardo da Vinci's *La Belle Ferronière* some years before (fig. 126)? Marie's asymmetrical eyes carry an expression at once engaging and ineffable, and her lips are parted as if to take a breath; or is it the shadow of a smile? We are drawn down into her silk-cushioned world, but a glance at a slip of paper pushed into the frame of the mirror reveals that Ingres has been there before us. She is shown in an evening ensemble with an alluring décolletage, which a gossamer-light sheer silk chemisette does little to conceal. An elaborate blond ruff is attached to her chemisette. Her luxurious gown, high-waisted and full at the back, was made from a generous length of red velvet, whose slashed sleeves and pocket-slit, revealing silver satin, appear to be a tribute to Raphael's *La Fornarina*—as imagined by Ingres (fig. 127). No less than Ingres's homage to Raphael, Madame de Senonnes's costume demonstrates a revival of interest in the Renaissance. Her hairstyle "à la Madonna" is pulled into a chignon with a jeweled comb, which is matched by her earrings. Madame de Senonnes is all baubles, bangles, and beads, wearing a rich array of rings and chains with pendants and a cross, and bejeweled with diamonds, rubies,

figure, by assuring us of an ambient space. It was a device he would employ again in several later portraits, such as *Madame Moitessier Seated* (cat. no. 134) and *Comtesse d'Haussonville* (cat. no. 125). In *Madame de Senonnes*, however, the mirror hardly reflects the room: rather, it creates a shadowed and ambiguous space, bringing an air of mystery—Leonardesque, one is tempted to say—to the painting, and to the sitter.

P.C.

1. The main source for the biographical information in this entry is Gernoux 1931, pp. 96–106, as excerpted in Naef 1977–80, vol. 1 (1977), pp. 330–33.
2. In a letter from Rome on July 7, 1814, to his friend Marcotte d'Argenteuil in Paris (Ternois 1999, letter no. 4), Ingres makes it clear that the vicomte de Senonnes—and Marie presumably with him—was in Paris by that date; Alfred Gernoux (see n. 1, above) says they returned to France in 1815. Until Hans Naef read the date of this letter correctly (Naef 1977–80, vol. 1 [1977], pp. 333–34), it was thought to date from 1816; the letter mentions the near completion of the portrait, with the consequence that it, too, was sometimes erroneously dated to 1816 in the earlier literature.
3. On the letter of July 7, 1814, see n. 2, above; the letter of May 26, 1814, is no. 3 in Ternois 1999. In his May letter, Ingres says he has recently returned from a six-week visit to Naples (see cat. no. 34).
4. Inv. 867.379; Vigne 1995a, no. 2779.

peridots, and aquamarines, as she leans relaxedly on the nest of cushions of the yellow silk sofa.

An early drawing (fig. 128) shows that Ingres initially thought of showing Marie reclining in a pose derived from David's famous portrait of Madame Récamier (fig. 306), which Ingres certainly knew well from his days in David's studio in Paris. A second sketch (Musée Ingres, Montauban) shows her lying on her front.[4] Ingres abandoned this languorous prototype, to develop his own ingenious solution. A particularly sensuous drawing (fig. 130) follows the sinuous outlines of the sitter's bare shoulders, arms, and décolletage, exploring the contours of a figure who seems to wear little else but an underslip. Another drawing (fig. 129) follows the relationship between her chest and her

clothed left arm and hand. Likely there were many other drawings through which Ingres gradually refined his design. In the final image Ingres seems to have exaggerated the length and curve of Marie's right shoulder, while her arm is extended to a remarkable and unnatural degree. From head to knee, she strikes a serpentine figure. This sinuous motif is echoed in the cashmere shawl that twists and turns behind her. *Madame de Senonnes* is almost a sister to the *Grande Odalisque* (fig. 101), on which Ingres was also working at just this time, but with her clothed body turned toward us.

Ingres's most striking pictorial device is his use of the large mirror behind the sofa, in which we see reflected part of the sitter's back and her lost profile from behind. This effect brings a sense of volume to the

Fig. 129. *Study of Madame de Senonnes*, 1813–14. Graphite on paper, 5¼ × 3¼ in. (13.4 × 8.1 cm). Musée Ingres, Montauban (867.381)

Fig. 130. *Study of Madame de Senonnes*, 1813–14. Graphite on paper, 5⅛ × 6 in. (13 × 5.3 cm). Musée Ingres, Montauban (867.383)

Fröhlich-Bum 1924, p. 11, fig. 24; Würtenberger 1925, p. 51; Hourticq 1928, p. iv, ill. p. 37; *Dessins de Jean-Dominique Ingres* 1930; Fouquet 1930, pp. 49, 82; Gernoux 1931, pp. 87–95, 101–3; Pach 1939, pp. 48, 49, 50, 67, 100, 111–13; Malingue 1943, p. 125, ill. opp. p. 64; Gatti 1946, pp. 93–94, ill. opp. 144; Cassou 1947, pp. 67, 75, ill. opp. p. 97; Courthion 1947–48, no. 6, ill.; Hanotaux in Courthion 1947–48, pp. 151–52; Jamot in Courthion 1947–48, p. 154; Sizeranne in Courthion 1947–48, pp. 110, 121; Alain 1949, ill.; Bertram 1949, fig. XV; Jourdain 1949, cover ill.; Roger-Marx 1949, p. 26, fig. 20; Scheffler 1949, p. 15, fig. 20; Alazard 1950, pp. 50–51, 146, n. 13, fig. XXVI; Benoist 1953, p. 124, no. 1028, cover ill.; Naef 1954 (*Antwortende Bilder*), pp. 101–8, ill; Wildenstein 1954, no. 109, pls. 40, 45 (detail); Toulouse, Montauban 1955, under no. 133; Ternois 1959a, under nos. 176–84; Cambridge (Mass.) 1967, under no. 24; Picon 1967, pp. 32–33, 67–68, ill. p. 47; Rosenblum 1967a, p. 108, pl. 25; Florence 1968, p. 13; Radius and Camesasca 1968, no. 92, ill.; Rome 1968, pp. xxi, xxii; Rizzoni and Minervino 1976, pp. 48–49, ill.; Naef 1977–80, vol. 1 (1977), pp. 323–37, fig. 1; Picon 1980, ill.; New York 1985–86, p. 114, ill.; Zanni 1990, no. 58, ill.; Cousseau 1991, pp. 61–65, ill.; Fleckner 1995, pp. 124–41, ill.; Vigne 1995a, p. 504; Vigne 1995b, p. 100, fig. 72; Roux 1996, pp. 27–29, 54, ill. pp. 54–55

36. Madame Jean-Auguste-Dominique Ingres, née Madeleine Chapelle

Probably early 1814
Oil on canvas
26 3/8 × 21 5/8 in. (68 × 54 cm)
Foundation E. G. Bührle Collection, Zurich
London only

W 107

The woman who was destined to make Ingres the most contented husband imaginable was born in Châlons-sur-Marne in 1782, the sixth and last child of the cabinetmaker Joseph-Mathieu-Lambert Chapelle. Her mother, née Jeanne Nicaise, was Chapelle's second wife. Nothing is known about the lives of her three brothers. Her half sister, Marie, the eldest of the daughters, married a cabinetmaker, who took over her father's business. Madeleine's older sister Sophie married an itinerant musician named Pierre-Antoine Dubreuil. Eventually the couple settled in Guéret, in the Marche, where Dubreuil first worked as a theater director and later opened a café. At some point after 1804, when their second child was born, the Dubreuils sent for Madeleine, back in Châlons, to help out.

It can be assumed that on her trip south Madeleine stopped over in Paris and stayed with her mother's brother. On that occasion she either first met or renewed her acquaintance with her cousins Adèle and Joséphine, and everyone must have marveled at how much alike she and Adèle looked.

In Guéret, Madeleine found plenty to do. In addition to helping her sister with the children, she may have worked as a cashier in the café, and toward the end of her stay she also ran her own linen shop. She was already over thirty when her fate was decided in a most unexpected manner. Adèle had married a man by the name of Jean-François Maizony de Lauréal and moved with him to Rome, where he had been posted as secretary of the French tribunal. He was artistic, and the couple numbered among their acquaintances a small, serious painter named Ingres. The story goes that Ingres fell head over heels in love with his hostess and that she, thinking that he might find her look-alike—and unattached—cousin equally desirable, suggested he get in touch with Madeleine. Astonishing as it sounds, Ingres accordingly sent the following letter off to Guéret:

Rome, August 7, 1813

. . . I'm afraid I've been overly flattered in the way people have described me to you. To counterbalance that, I'm sending you, first, a sketch of my small physique, as you yourself so kindly asked me to. In addition, I will try to draw for you my psychological portrait. Here we go, then: of vices, I'm not known to have any; I have neither fortune nor a handsome face but I daresay a distinguished and recognized talent, which needs only the first opportunity to flourish, and so I hope for fortune someday, [with] a little *order* (this might concern you). I am naturally gentle by nature and yet I am easily moved to anger when people argue with me and I think I'm in the right. They say that my face gets all red, white, and yellow; personally, I don't notice this at the time: only after a while, when I come down with a high bilious fever. In addition, I tend to throw my money out the window, as I never know the value of it. I am neither sad nor happy, sometimes preoccupied with my art, which is quite natural when one is as passionate as I am, but I'm so inordinately sensitive that the slightest thing makes me at that moment the

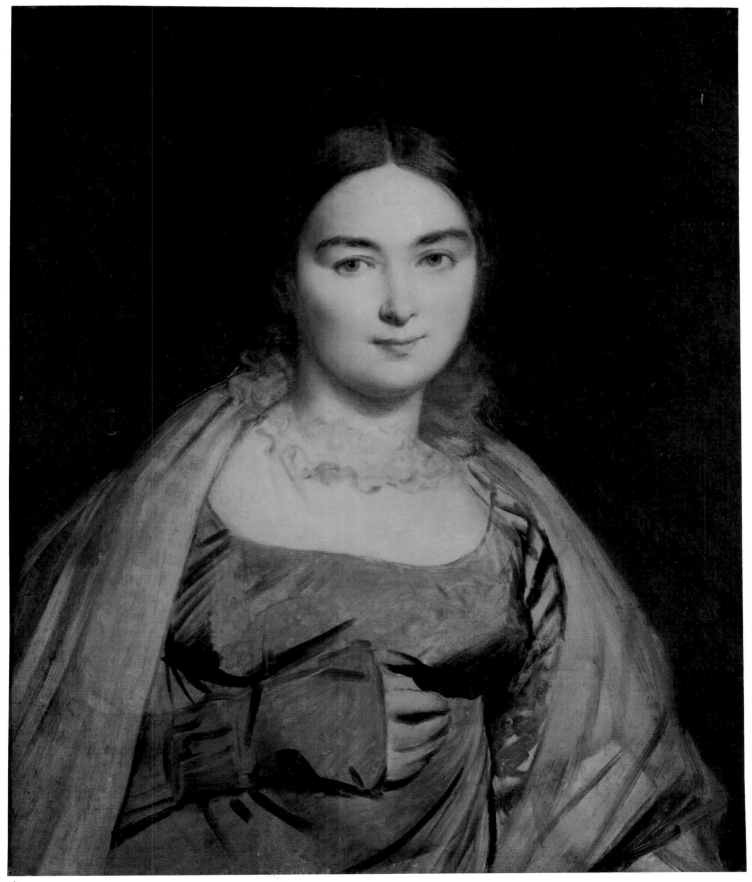

36

unhappiest man in the world. At such times I think that I'll never be happy and that I was born under an unlucky star. Please don't be put off by all these imperfections; I hope that you will make them all dissipate by bringing with you everything that makes for an excellent wife, as I believe you are. If so, you will complete my happiness.[1]

Less than six weeks later, Madeleine arrived in Rome. Ingres's pupil Amaury-Duval recounted the circumstances of their first meeting as he heard them later from his teacher:

He was sad, isolated in Rome. He confided in one of his friends about the depression he was feeling; that friend happened to have in his family a young woman gifted with all the qualities that could ensure his happiness. Everything was arranged by correspondence. One day, they told him that his fiancée was about to leave for Rome, and that he should await her arrival. The date was fixed. M. Ingres went all the way to Nero's tomb to meet up with her, and there he saw the woman who was going to be his wife climbing down from a carriage. "And [she has] kept," he added, looking at her, "all [my] friend's promises, and more."[2]

They were married on December 4, 1813, in the church of San Martino ai Monti. So began the most harmonious of marriages, one that provided Ingres with constant joy for thirty-six years. There is nothing she would not have done for him with alacrity, nothing about her that did not nourish his love for her. Their sole disappointment was their lack of children; the infant they looked forward to so eagerly in the year following their marriage was stillborn, and no more followed. Ingres never spoke of Madeleine except with affection. In his letters he rarely refers to her simply as his wife, but as "ma bonne femme."

In May 1849 his beloved Madeleine suddenly was taken ill, and though her symptoms seemed harmless enough at first, they had clearly worsened by early July. On July 27, to Ingres's immense sorrow, she was taken from him. On August 2 the artist's favorite pupil, Hippolyte Flandrin

(see cat. nos. 155, 158), described her death to his brother Paul: "You can't imagine the painful scenes we've witnessed these past few days.... Up to her last breath, the dear and worthy woman recognized us. A cruel spectacle, but one that also has its consolations!"[3] Ingres was devastated. On the day after her death he wrote to his old friend Charles Marcotte:

It is in the most horrible despair that I must now break your heart: Yesterday I lost my wife, my poor wife, and I too could die from a pain that nothing can express. You loved her so much, you, my worthy friend, all your loved ones, and everyone who knew her. But for me, for me, she is dead, and I will never see her again. My dear friend, my dear friend, never again! It's horrible and I rage against everything, against Heaven itself, but what is to become of me! Everything is finished. I no longer have her, no longer have a home. I am broken and all I can do is weep in despair.[4]

It is only natural that Madeleine's portraits should figure most prominently in the artist's oeuvre. She not only appears in this painted portrait and nine portrait drawings[5] but also served as the model for any number of figures in Ingres's narrative paintings. The painted portrait of Madeleine was surely done not long after the couple married in December 1813. She has a fresh and youthful air, and there is no visible suggestion of her pregnancy, which was well under way by the following summer. The perfect oval of Madeleine's face and the gentle idealization of her features are reminiscent of Raphael's Madonnas. But the presentation is immediate and direct, as Madeleine looks candidly at the spectator. It is indeed one of the tenderest portrait paintings of the early nineteenth century.

The feeling of intimacy is enhanced by the fact that the painting is unfinished; clearly it was intended for the couple's eyes only. Madeleine's features are quite complete, albeit thinly painted. But her body and costume—a high-waisted dress, diaphanous chemisette, and ruff, and a shawl casually draped across her shoulders—are only broadly indicated with dark brush marks, and sketchily filled in with thin washes of ocher and beige, in places transparently

Fig. 131. *Madame Jean-Auguste-Dominique Ingres, née Madeleine Chapelle*, probably 1813 (N 97). Graphite and watercolor, 8½ × 5⅞ in. (21.5 × 14.8 cm). Musée Ingres, Montauban

revealing the ground. In its free execution and lack of finish, this portrait recalls Ingres's two earlier likenesses of friends in Rome, those of the architect Desdéban (cat. no. 28) and the sculptor Paul Lemoyne (cat. no. 29).

The Raphaelesque quality of the portrait can no doubt be attributed to the fact that at the time Ingres and Madeleine met, the artist was painting a cycle of pictures on the life of Raphael, and in *Raphael and the Fornarina* (fig. 127) he delighted in giving the features of his own bride to La Fornarina ("the baker's daughter"), who was the great love of his venerated master. A sketch of Madeleine in preparation for the figure of La Fornarina (The Metropolitan Museum of Art, New York, Lehman Collection) is one of the most beautiful drawings he ever made. It is more difficult to recognize Madeleine in other works, but her ample physical type is represented throughout Ingres's oeuvre, especially among his nudes. The artist recalled her even at the end of his long career in *The Turkish Bath* (fig. 220), his last masterpiece.

Ingres's portrait drawings of Madeleine record the passage of nearly three full decades. The earliest of them, undated (fig. 131), was executed shortly after her

arrival in Rome, probably before their marriage.[6] It is his only pencil portrait that is tinted in watercolor. Although she was not exactly a goddess and her costume—especially the incredible hat—shows her to be a child of the provinces, her face radiates a purity and warmth that Ingres achieved in no other portrait.

The young woman soon became part of Ingres's everyday surroundings, and his subsequent portraits of her, whatever the occasion, appear to have been produced out of the very air he breathed rather than with the objectivity of the classical portraitist. One drawing of Madame Ingres from the 1820s is unusual in that it is so spontaneous (cat. no. 96). The artist seems simply to have come upon his wife as she was completely absorbed in her sewing. The Florentine lamp suggests that the drawing was executed before Ingres returned to Paris from Italy at the end of 1824, and the dress Madeleine wears dates it to that year at the earliest.

Another likeness (cat. no. 108) also recalls the couple's sojourn in Florence, for the artist inscribed it, in his wife's name, with the dedication: "Madame Ingres à sa bonne amie Madame Thomeguex." This must have been Madame Pyrame Thomeguex, née Jeanne Gonin, whose portrait Ingres painted in Florence in 1821, the year before her marriage (cat. no. 87). A series of portrait drawings made between 1821 and 1841, of which this is one of the later ones, attests to Ingres's gratitude to the Gonin and Thomeguex families for their kindness during his stay in Florence. In none of the artist's other portraits of his wife does she look as bosomy, kind, and lovable as she does here.

The first two dated portraits of Madeleine were executed not long after the one for Madame Thomeguex. One of these, in the Musée Municipale, Guéret (N 327), bears the dedication "Ingres à Sophie Dubreuil, sa chère soeur, 1830." The other, also of 1830 (cat. no. 109), is sketchier and not

composed with such forethought. It is enriched with a self-portrait of the artist in the background, apparently an afterthought. The dedication reads: "Ingres . . . à ses bons amis Taurel, 1830" ("Ingres for his good friends [the] Taurels, 1830"). The engraver André-Benoît Barreau Taurel and his wife were old friends of the Ingreses from their early years in Rome (see cat. no. 73). By this time they were living in Amsterdam. Madeleine was the godmother of their first child, and their second had been named Auguste in honor of Ingres. These close ties may explain the casual nature of the drawing.[7]

In none of his other later portraits of Madeleine did Ingres focus as intently on her eyes as he did in one executed in Rome in March 1835, three months after assuming the directorship of the Villa Medici (fig. 186). He apparently undertook the drawing at Madeleine's request, for it was she who inscribed it "Mme Ingres à Mlle Maille." The recipient was Caroline Maille, the daughter of an old friend of Ingres, who in 1836 married Jean-Henri Gonse. She would herself be immortalized in a portrait drawing by Ingres in 1845 (N 402) and a painted one in 1852 (fig. 208). Madeleine's face is framed by the latest in millinery, but her eyes reflect the goodness and constancy that were such a blessing to Ingres in their life together.

Ingres's last portrait of Madeleine dates from 1841, near the end of their stay at the Villa Medici in Rome (cat. no. 118). Approaching sixty, she had grown thinner, and age had begun to leave its traces on her features. Again it was a present for a woman friend; the dedication reads "Ingres for Madame Lepère." The recipient was the wife of the well-known architect Jean-Baptiste Lepère and the mother-in-law of his even more famous colleague Jacques-Ignace Hittorff (Ingres executed portrait drawings of Madame Lepère herself, her husband, her daughter, and her son-in-law).[8] Madeleine, the least affected of

women, again wears an elaborate hat that belies her simple nature, yet in the midst of all the frills her countenance glows with the same purity as always.

H.N./P.C.

For the author's complete text, see Naef 1977–80, vol. 1 (1977), chap. 40 (pp. 358–78).

1. Lapauze 1910, pp. 251–52; reprinted in Naef 1977–80, vol. 1 (1977), p. 359.
2. Amaury-Duval 1878, pp. 177–78; reprinted in Naef 1977–80, vol. 1 (1977), p. 361.
3. Flandrin 1902, pp. 146–47; reprinted in Naef 1977–80, vol. 1 (1977), p. 364.
4. Ingres to Marcotte, July 28, 1849, quoted in Naef 1977–80, vol. 1 (1977), p. 364; in Ternois 1999, letter no. 62.
5. Cat. nos. 96, 108, 109, 118; figs. 131, 186; N 127; N 128 (Musée du Louvre, Paris); N 327 (Musée Municipal, Guéret).
6. It was engraved in 1851 by Achille Réveil and early in the twentieth century by Jean Coraboeuf (Salon of 1906).
7. It was photoengraved by E. Charreyre in 1896.
8. All are in the Musée du Louvre, Paris; N 337, N 338, N 321, N 320.

PROVENANCE: Mme Pierre-Antoine Dubreuil, née Jeanne-Sophie Chapelle, Guéret; by descent to M. Mingasson; purchased from him by Henry Lapauze (1867–1925), Paris, 1910; his posthumous sale, Hôtel Drouot, Paris, June 21, 1929, no. 53; acquired at that sale by Paul Rosenberg and Co., New York; acquired from that gallery on September 22, 1952, by Emil G. Bührle (1890–1956); transferred to the Foundation E. G. Bührle Collection, Zurich, 1960

EXHIBITIONS: Paris 1911, no. 23; Saint Petersburg 1912, no. 657; Paris 1913, no. 185 [EB]; Copenhagen 1914, no. 120; Paris 1922c, no. 48 [sic] [EB]; Paris 1923b no. 5 [EB]; Paris 1928, no. 100 [EB]; London 1932, no. 299; New York 1934, no. 25 [EB]; Zurich 1958b, no. 104; Munich 1958–59, no. 86

REFERENCES: Lapauze 1911a, pp. 166–68, ill.; Möller 1914, p. 159; French Art 1933, no. 411 [EB]; Scheffler 1949, pl. 22; Wildenstein 1954, no. 107, pl. 48; Radius and Camesasca 1968, no. 87 ("1815?"); Naef 1977–80, vol. 1 (1977), pp. 358–78, ill.; Ternois 1980, p. 79, no. 119, ill.; Vigne 1995b, p. 119, pl. 87

37. Jean-François-Julien Ménager

1806
Graphite
9 ½ × 6 ⅞ in. (24.2 × 17.5 cm)
Signed and dated right, below center: Ingres.
1806 / a Rome [Ingres. 1806 / in Rome]
Private collection
New York only

N 41

A small exhibit at the École des Beaux-Arts in Paris in 1889, titled "Portraits d'Architectes," included two Ingres pencil portraits of Jean-François-Julien Ménager—this one dating from 1806 and the other from 1810 (N 60).[1] At that time they belonged to the architect's son, Henri Ménager. They were passed down in the family through the first half of the twentieth century. This drawing was still owned by the subject's great-granddaughter in 1963. The later drawing, then owned by a relative of hers, is known today only in the form of a copy by an unknown artist.[2]

Ménager was born in Paris in 1783, the son of a cabinetmaker. Even as a boy he aspired to become an architect. He studied under Claude-Mathieu Delagardette and Laurent Vaudoyer and at fifteen entered the École des Beaux-Arts.[3] Two years later, in 1800, he won the Prix de Rome. As we know from the biography of Ingres, who was awarded the same prize in 1801, the state coffers were so depleted that prizewinners in those years were forced to wait to claim their scholarships. Ménager arrived in Rome in 1805 and remained there for the full five-year term of his award. Since he had no money of his own, his studies were restricted to Rome and its environs, save for a four-week visit to Florence in 1808 and another of about the same length in Naples in 1810. He left for home in October 1810, stopping in Bologna, Venice, Vicenza, Milan, and Turin on the way.

Life in earnest began for the young architect back in Paris, and he proved to be fully prepared for it. The year after his return, he accepted a position in the civil service. He married in 1816, and in time the union produced two sons and a daughter. In 1831 he was promoted to chief architect, fourth section, for public works in Paris,[4] the highest rank he would achieve. In 1838 he was elected to the Legion of Honor,[5] and after nearly half a century of public service he retired in 1859. The last years of

his life he spent in Saint-Germain-en-Laye, where he died in 1864.

In his family he is remembered as a solid, scrupulously honest man who behaved according to strict principles. As an architect, however, he is not so easy to characterize. His certificate of service shows that he was not presented with any particularly important tasks, and apparently he was not ambitious enough to go after them on his own. His Prix de Rome was almost the only prize that lends his career a certain distinction. Even in his youth he appears to have been rather sober; his letters home to his parents reveal no particular enthusiasm, and his many surviving drawings of Italian motifs are uninspired.

Thanks to those letters home, it is possible to date this portrait drawing within a few weeks:

> Rome, March 8, 1806
> I am very touched by your wish to have my portrait. Rest assured that if I can send it to you before Ingres gets here, I'll be more than happy to do so. In any case, Ingres promised me he would do it, so you can be sure that as soon as he arrives he will keep his word and I'll send it on to you.

> Rome, October 4, 1806
> I've learned with great pleasure of Ingres's departure. We received news of him from Lyons, and we hope to welcome him here in ten days. . . . When Ingres has done my portrait, I will send it to you the first chance I get.

> Rome, November 12, 1806
> People are perhaps right to say that "time spent in Rome is the most wonderful time of one's life." If I were fortunate enough to have you all here, I wouldn't doubt the truth of that for an instant. I love Rome because of what I'm studying and because for artists it's the most beautiful land in the world. But when I think how far I am from you, I feel that I'd gladly return to France. In the meantime, I'm working—not to the point of ruining my health but enough to get the most out of my trip and, I hope, to return from it with some talent.

M. Callamard, a sculptor and one of our best friends,[6] left for Paris this morning. He is supposed to pay you a visit, and he'll bring you the little portrait that Ingres made. The model for that portrait loves you all and sends you his fondest kisses. . . .

P.S. The drawing I'm sending needs to be framed very carefully, since it was done in pencil. M. Simon, whom I've already mentioned, can handle it, especially since he knows M. Ingres and knows the best way to frame his drawings. When you bring it to him for framing, please be careful not to roll it up. The safest way to carry it would be to put it in one of the sketchbooks I left with you.

Rome, January 30, 1807
You haven't said anything about M. Callamard, either. Did he bring you the drawing in question? You didn't expect me to be so small. That isn't my fault. Ingres is a bit capricious (just between us). In Paris he had promised to paint my portrait, but by the time he got to Rome he was mentioning it only as a drawing. You can understand how I couldn't allow myself to remind him of his promise, given that such things shouldn't be forgotten in the first place.[7]

Ingres's second portrait of Ménager was executed in the year Ménager's scholarship ended. It attests to the fact that the artist and his sitter had developed a warm friendship in the years they spent together at the Villa Medici. It is one of a group of profile likenesses—a type of composition that suddenly turns up in Ingres's work in 1810, only to disappear again, equally mysteriously, in 1813. H.N.

37

For the author's complete text, see Naef 1977–80, vol. 1 (1977), chap. 13 (pp. 159–64).

1. Paris 1889b, p. 11.
2. Naef 1977–80, vol. 4 (1977), ill. p. 115.
3. Delaire 1907, p. 346.
4. "Architecte en chef de la 4ᵉ section des travaux de la ville de Paris," unpublished certificate of service, dated December 5, 1859, formerly in the possession of Ménager's great-granddaughter Madame Charles-Henri Boud'hors.
5. Bauchal 1887, p. 698.
6. Charles-Antoine Callamard (1776–1821).

7. Unpublished letters, formerly in the possession of Madame Charles-Henri Boud'hors; quoted in Naef 1977–80, vol. 1 (1977), p. 163.

PROVENANCE: Jean-François-Julien Ménager (1783–1864), Saint-Germain-en-Laye; Henri Ménager, his son, Paris, until 1910; Mme Rodolphe Koch, née Ménager, his daughter, Paris, until 1914; Rodolphe Koch, her widower, Paris; presented by him after 1914 and before his death, in 1926, to his cousin Mme Berthet, née Jeanne Person, later Mme Charles-Henri Boud'hors, great-granddaughter of the subject; sold out of the family, 1972; private collection

EXHIBITION: Paris 1889b, p. 11

REFERENCES: Jouin 1888, p. 128 (unless Ingres's 1810 portrait of Ménager is meant); Anon., June 22, 1889 (T. W.), p. 189; Naef 1966 ("Portrait Drawings"), pp. 255–58, no. 1, p. 280, pl. 1; Naef 1977–80, vol. 4 (1977), pp. 78–79, no. 41, ill.

38. Lucien Bonaparte

ca. 1807
Graphite
9¼ × 7¼ in. (23.6 × 18.5 cm), framed
Apocryphal signature lower right, added in 1928
at the earliest:[1] *Ingres*
Private collection

N 45

Lucien Bonaparte (1775–1840), six years younger than Napoleon and the most gifted of his brothers, took up residence in Rome in 1804. He had secured his small place in history five years before, when as president of the Council of Five Hundred, at the age of twenty-four, he had saved his brother's skin during the coup d'état of 18 Brumaire (November 9, 1799). In the intervening years, while serving successively as minister of the interior and ambassador to Madrid, the ardent republican had watched with disgust as his brother assumed increasingly dictatorial powers. The ultimate breach had come as a result of Lucien's defiance of the First Consul's dynastic ambitions. Bonapartes were supposed to marry royalty and sire future monarchs, but in 1802 Lucien had lost his heart (for the second time—he was by then already a widower with two small daughters) to a woman of highly ambiguous origins only recently abandoned by her husband, a ruined speculator who had gone off to Santo Domingo to seek his fortune. Marie-Laurence-Charlotte-Louise-Alexandrine Jouberthon also had a young daughter, and in the spring of 1803 she presented Lucien with an illegitimate son. Despite Napoleon's fulminations, the two were secretly married five months later. Under the circumstances, exile was the only option. Lucien and his family set out for Italy only days after Napoleon had himself crowned emperor, and by early May 1804 they were safely in Rome.

Lucien had amassed a fortune while ambassador to Spain and later added to it as a senator, so that he was able to establish himself in princely style in the Palazzo Nuñez, furnishing it with his extensive art collection. Alexandrine kept busy bearing and rearing their children—they would ultimately have nine of their own, in addition to the three from their former marriages—while her husband was buying up villas and estates outside the city. Their home was a virtual court of the Muses, with a private theater in which the couple performed before guests, and with any number of artists on retainer. Lucien's chief adviser in artistic matters was the painter Charles de Chatillon, whom he had taken into his service while minister of the interior and who remained in the post for twenty years.

Reconstructing Ingres's relations with this elaborate household is largely a matter of guesswork, as the surviving documents are both scanty and puzzling. The name "Sénateur Lucien" appears in the young artist's letters home as early as January 1807, only months after his own arrival in Rome.[2] From their tone, it appears that Lucien had been advised of Ingres's exceptional talents by someone back in Paris—possibly the painter Guillaume Guillon Lethière (see cat. no. 52), who had helped him acquire paintings in Spain years before—but the only work the senator offered seems to have been as a copyist, something Ingres rightly felt was beneath him. Ingres's superb portrait drawing of Lucien, undated but apparently executed later that same year, thus comes as a surprise. In it the senator is seated on a Roman cinerarium—an allusion to his fascination with antiquities—his left leg crossed over his right. Behind him stretches an exquisite view of Rome: the Torre delle Milizie and in front of it two buildings, separated by the Via della Dataria, belonging to the Quirinal complex. He dangles a pair of spectacles in his right hand; Lucien was notoriously nearsighted, a fact Ingres deftly registers in his portrait.

There are only two other Roman portrait drawings in which Ingres shows his model seated, in full figure, turned toward the left but facing the viewer, and seen from below eye level so that the figure takes on a distinct monumentality. They are his portraits of the architect Jean-François-Julien Ménager (cat. no. 37) and the painter Thomas-Charles Naudet (fig. 89), both done in 1806. Ingres seems to have abandoned the formula after this sitting with Lucien Bonaparte. The portraits of Ménager and Naudet reveal a more casual execution

typical of Ingres's renderings of artist friends. In his drawing of Lucien, however, the young artist engaged every refinement of eye and hand of which he was capable. It is almost as though he were determined to present the great man who dared think of him as a mere copyist with a work no other artist in the world could have matched. Yet, given the absence of a signature and date, one has to wonder whether Ingres's imposing sitter actually accepted the portrait. It may simply have disappeared into one of Chatillon's portfolios.

The artist's next known contact with the family was eight years later, in 1815. The Bonapartes had only recently returned to Rome from four years of internment in England, following their capture during an attempted escape to America. To welcome him back, the pope had bestowed on Lucien the title of Prince of Canino. Then, in March, at the beginning of the Hundred Days, Lucien had set out for Paris eager to effect a reconciliation with his brother. On his homeward journey in June, he was detained by the Allies and held prisoner in Turin until September. In his absence Madame Bonaparte commissioned two more Ingres portrait drawings, one showing her surrounded by eight of their children (fig. 91) and one of herself alone (fig. 90). The first of them must have been executed in the early summer—within weeks of Waterloo—for in it Alexandrine is not visibly pregnant. In the second she is clearly within weeks or even days of being delivered of her son Pierre, an event her husband was able to celebrate in early October, shortly after his release. The group portrait is the richest of all Ingres's portrait compositions and unquestionably one of the supreme achievements of his career.

Lucien spent the remaining years of his life out of the spotlight, devoting himself to his studies, to archaeology, and to his collections. He died in Viterbo in 1840. Alexandrine lived another fifteen years, until felled in a cholera epidemic in 1855.

In early 1843 she contacted Ingres, asking if he would agree to authenticate various

38

works of art she intended to sell. In her letter she relates that his magnificent group portrait drawing had recently been stolen but that the trusty Chatillon had managed to buy it back at a public sale in Paris[3] and place it in the hands of her agent, Comte de Chaumont-Quitry.[4] Much as he must have been cheered by her news, Ingres seems to have been annoyed by her request, and when Chaumont-Quitry called on him several days later, he put him off, claiming he was "prodigiously busy."[5] Informed of this by her emissary,

the princess responded with an anecdote that confirms Lucien's shocking indifference toward Ingres and his art:

What you say about Ingres's coldness doesn't surprise me very much. . . . I know he hadn't been treated well by Lucien over a certain portrait he did of me, and in which we have to admit that he failed, at least as far as the resemblance is concerned. My husband, too biased in favor of his Laurence-Alexandrine, made me three or four *enemies* among the artists who have painted my portrait.

I believe he punctured Ingres's, among others, or that he threw it in the fire! . . .

While Lucien was in Paris, Ingres seemed to bear no ill will toward us. It's true that back then he was only a student at the Académie, when he did *the drawing* that you have.[6] H.N.

For the author's complete text, see Naef 1977–80, vol. 1 (1977), chap. 55 (pp. 504–38).

1. The illustration in Goulinat 1928, p. 113, does not show it.
2. Lapauze 1910, pp. 97–99, 129, 158, 182–83, 186.
3. This auction has never been identified.
4. Langle 1939, pp. 40–41.
5. Ibid., p. 42; quoted in Naef 1977–80, vol. 1 (1977), p. 536.
6. Ibid.

PROVENANCE: Possibly Lucien Bonaparte (1775–1840); perhaps the painter Charles de Chatillon until after 1843; anonymous private collection, south of France, until about 1928; acquired by H. R. Stirlin, Saint-Prex, Switzerland (according to Jean-Gabriel Goulinat); sold by him, 1960; purchased by John Goelet from Wildenstein & Co., Inc., New York, 1963; deposited at the Museum of Fine Arts, Boston; purchased from Goelet through Wildenstein & Co., Inc., by the present owners, 1975

EXHIBITIONS: Zurich 1937, as *Marquis de Chatillon* (not in catalogue); Geneva 1954, no. 238, as *Marquis de Chatillon;* Zurich 1958a, no. B3; Cambridge (Mass.) 1967, no. 11, ill.; Paris 1967–68, no. 33, ill.; Kansas City 1969, no. 61, ill. p. 68; Washington, New York, Philadelphia, Kansas City 1971, no. 142, ill.; London 1972, no. 662

REFERENCES: Goulinat 1928, ill. p. 113, as *Portrait d'homme;* Alaux 1933, ill. p. 163, as *Le Peintre Isabey;* Cassou 1936, ill. p. 147, as *Portrait d'homme;* Naef 1960 ("Ingres-Zeichnungen"), pp. 36–40, ill. p. 39 (sitter identified); Vermeule 1964, p. 192, n. 21; Naef 1966 ("Portrait Drawings"), p. 257; Radius and Camesasca 1968, p. 122, ill.; *Gallery Events* 1969, ill.; Ternois and Camesasca 1971, p. 122, ill.; Delpierre 1975, p. 25; Naef 1977–80, vol. 4 (1977), pp. 84–85, no. 45, ill.; Pansu 1977, pl. 22; Whiteley 1977, p. 30, no. 14, ill.; Borowitz 1979, pp. 257–59, ill.; Ternois 1980, p. 34, ill.; Mráz 1983, p. 41, pl. 10; Tübingen, Brussels 1986, p. 29, ill.

39. Victor Dourlen

1808
Graphite
12 × 9⅜ in. (30.4 × 23.8 cm); 6 × 4⅝ in. (15.2 × 11.6 cm), within the drawn border
Signed, dated, and inscribed lower right:
A DOURLEN. PAR / SON AMI INGRES. / A ROME. 1808. / villa medici. [For Dourlen by / his friend Ingres. / Rome. 1808. / Villa Medici.]
Private collection

N 48

This likeness of the composer Victor Dourlen is the second in the series of portraits that Ingres drew of his fellow boarders at the Académie de France in Rome. The first, of the architect Ménager (cat. no. 37), dates from 1806; there are none from the following year.

Dourlen was born in 1780 in Dunkerque, the son of a respected merchant.[1] At the age of twelve he had watched Revolutionary mobs plunder his family home. His father survived the crisis and later sent his son to apprentice at a Paris banking house, expecting him to follow in his own footsteps. Drawn to music, however, Dourlen studied at the Conservatoire instead. He was awarded the Prix de Rome in 1805 and arrived at the Villa Medici in 1806, the same year as Ingres. His opera *Philoclès* had been performed at the Opéra-Comique in October, shortly before his departure. Although a critical success, it failed to captivate the public.

It was no doubt Dourlen's seriousness that led to the friendship with Ingres to which this portrait attests. Dourlen found the Roman climate detrimental to his

health and returned to France prematurely in the summer of 1808; the drawing was possibly produced as a farewell present. With his portrait the composer took with him not only a reminder of an important period in his life but also of his Roman lodgings, for Ingres posed his subject in front of one of the windows of the Académie with a view of the towers of Santissima Trinità dei Monti and the obelisk above the Spanish Steps.

When leaving Rome, Dourlen hoped to be allowed to use the balance of his scholarship for study in Germany, as the musical life of the North appealed to him more than that of Italy. In this he was fully in agreement with Ingres, who wrote:

Music! what a divine art! honest, for music, too, has its mores. Italian music has only bad ones: but German music! . . . Never anything Italian! To the devil with that vulgar, trivial [style], where everything—even "I'll see you damned!"— is said in a warble![2]

Back in Paris, Dourlen was extremely productive, by 1822 writing another eight

operas, in addition to numerous instrumental works. It was as a teacher, however, that he found his true calling. He began teaching part time at the Conservatoire in 1811 and was promoted to professor of harmony in 1816. In 1838 he published a treatise on harmony written long before, which was promptly adopted as the official conservatory textbook. It was apparently for that work that he was named a chevalier of the Legion of Honor in the same year.

Dourlen retired in 1842 and died in 1864. A twentieth-century encyclopedia of music includes the following summary of his career:

> As a cultivated and clever musician who deeply pondered the fundamentals of his art, Dourlen was one of the most intelligent composers of his generation. Endowed with a gift for the theater, he wrote enchanting opéras comiques and followed in the line of Méhul and Boieldieu. Along with Hérold and the young Auber he upheld the brilliant tradition of French opera. His works for piano are also praiseworthy, very well written and exceedingly elegant. Yet his greatest influence was as a theoretician. . . . Perhaps it was the excess of scholarship and the somewhat exaggerated severity of his style that caused his compositions to be forgotten so soon after his death. One has to concede that though his music is well constructed it is a rather calculated "Rome prize music," and that his intelligence too often triumphs over his emotions. Nevertheless, he deserves a place of honor among the immediate precursors of Berlioz.[3]
>
> H.N.

For the author's complete text, see Naef 1977–80, vol. 1 (1977), chap. 15 (pp. 170–73).

1. The following biographical details are drawn from Carlier 1864.
2. Quoted in Delaborde 1870, pp. 167, 170; reprinted in Naef 1977–80, vol. 1 (1977), p. 171.
3. Georges Favre in Blume 1949–79, vol. 3 (1954), col. 716.

PROVENANCE: Victor Dourlen (1780–1864), Paris; by 1911, Émile Blondont; Mme Émile Blondont, his widow, Paris, until 1957; her daughter, Mme Yvon Delatour, née Madeleine Blondont; purchased from her in Paris by the present owner, 1957

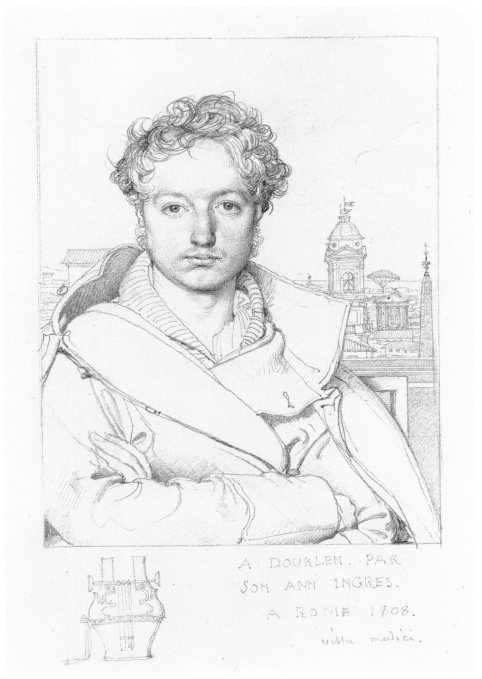

39

EXHIBITIONS: Paris 1911, no. 78; Stockholm 1958, no. 258; Zurich 1958a, no. B2; New York 1988b, no. 20, ill.

REFERENCES: Naef 1957 ("Notes I"), pp. 180–83, ill.; Naef 1960 *(Rome)*, p. 27, n. 52; Naef 1977–80, vol. 4 (1977), pp. 90–91, no. 48, ill.

40. Auguste-Jean-Marie Guenepin

1809
Graphite
8 ¼ × 6 ⅜ in. (21 × 16.3 cm)
Signed and dated lower left: Ingres f. roma
1809. [Ingres (made this in) Rome 1809.]
National Gallery of Art, Washington D.C.
Gift of Robert H. and Clarice Smith 1975.77.2
Washington only

N 52

The profundity of an Ingres portrait derives in part from the way the sitter's body, however obscured by clothing, contributes to the expression of a personality. Striking in this portrait is the stiffness of Guenepin's body and its awkwardness. A viewer might even be tempted to question the authorship of the work if it did not otherwise display such obvious reflections of Ingres's hand. The explanation lies in the future architect's childhood, when he suffered a developmental disorder that marked him for life. Thus, Guenepin's posture in the drawing is not the result of a momentary lapse on the part of the artist but rather an example of his absolute candor in registering what he saw before him.

The architect won the Prix de Rome in 1805, and his stay at the Villa Medici corresponded precisely with that of Ingres (in the background of the portrait can be seen the garden facade of the palace at the villa). The two men again became colleagues when Guenepin was inducted into the Académie des Beaux-Arts in 1833. He won that honor not so much for his own works, few of which had been realized, as in recognition of his outstanding reputation as a teacher and head of an atelier. At the time of Guenepin's death, his pupil Paul Lequeux—himself a winner of the Prix de Rome who lived at the Villa Medici when Ingres was director—recounted his master's experience of Italy:

> During the first years of his stay in Italy, M. Guenepin collected much information; he measured and sketched many buildings, putting off until the end of his Italian sojourn the task of copying out neatly all the precious documents that he wanted to keep with him. But after three years, a virulent fever suddenly attacked the artist and took him down with it. In periods of remission, M. Guenepin worked all the more fervently, only to sink even lower when the fever raged anew.
>
> Imagine, gentlemen, how keen must have been the love of study driving M. Guenepin to sustain him in that almost continual struggle for more than two years. But finally, he was forced to return, to leave Rome; he took with him, in notes

and manuscripts, drawings that demonstrate the exquisite taste of the man who executed them, and that make us sorry that time, and especially his health, did not allow him to develop them for everyone's benefit.

> Among many other works, M. Guenepin made one very interesting sketch of the ruins of Hadrian's Villa, where the emperor-architect caused to be built, from his own drawings, reproductions of such Greek and Egyptian monuments as the Athenian Poecile Stoa, Academy, Lyceum, and Prytaneum, the Canopus of Alexandria, and so on, as he had seen them during excursions into the provinces of his vast empire. You understand, gentlemen, how important this work is from the dual perspective of art and archaeology, and how well it suited M. Guenepin, whose talents as an investigator were so well reinforced by [familiarity with] classic studies by the ancient authors.
>
> M. Guenepin had also planned to publish, and make more widely known, buildings by the famous architect [Giacomo] Barozzi da Vignola, whose name has become familiar almost exclusively through his writings, namely, his treatise on the five orders of architecture. But forced to abandon that project, for which he had gathered much material, M. Guenepin lost no time in sending to other artists (who later conceived the same idea) all the drawings he had made strictly out of love for art—the same sentiment that inspired him to donate the drawings so generously.
>
> In 1810, then, M. Guenepin left Italy, with the sincere good wishes of his colleagues, who were eager to give him a parting token of their friendship: a precious album, in which architects, painters, sculptors, engravers, and musicians expressed—each with the resources of his art—their feelings for their friend.[1]

H.N.

For the author's complete text, see Naef 1977–80, vol. 1 (1977), chap. 17 (pp. 178–83).

1. Lequeux 1842, pp. 7–9; reprinted in Naef 1977–80, vol. 1 (1977), pp. 179–80.

PROVENANCE: Auguste-Jean-Marie Guenepin (1780–1842), Paris; Auguste-Louis-Jean-Étienne Guenepin, his son, until 1890; Mme Georges-

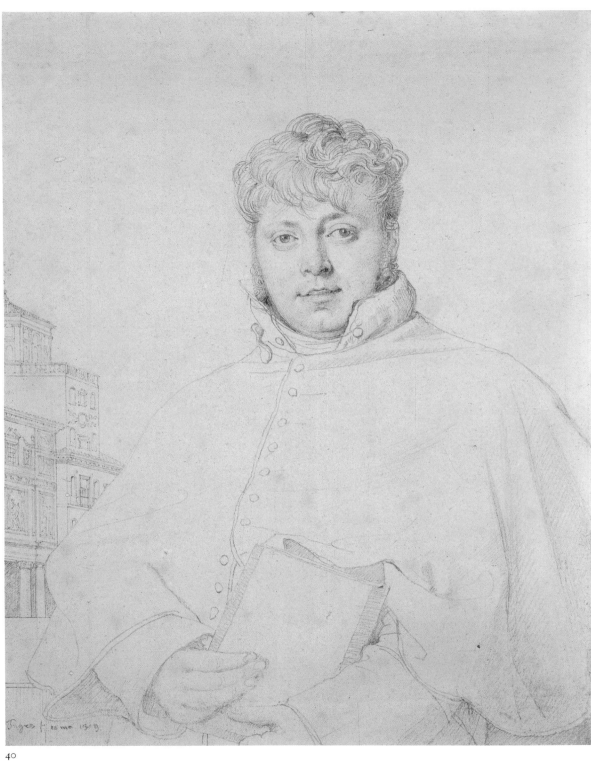

40

Fernand Chevillard, née Jeanne-Marie-Gabrielle Guenepin, his daughter, until 1948; Gaston Delestre, her grandson, Paris, until 1970; his heirs; Robert H. and Clarice Smith; their gift to the National Gallery of Art, Washington, D.C., 1975

EXHIBITIONS: Geneva 1951, no. 156, pl. XIX; Paris 1952–53, no. 154, pl. XXV; Toulouse, Montauban 1955, no. 112; Paris 1967a, no. 23; Washington 1978, p. 92

REFERENCES: Diehl 1950, ill. p. 51; Santa Barbara 1959, no. 95 (copy by another hand); Naef 1960 *(Rome)*, p. 27, n. 52; *Connoisseur*, March 1962, ill. p. CXVI in the advertising section (copy by another hand); Naef 1977–80, vol. 4 (1977), pp. 98–99, no. 52, ill.

41. Merry-Joseph Blondel

1809
Graphite
6 ⅞ × 5 ½ in. (17.6 × 14 cm)
Signed and dated lower left: Ingres / a rome
1809. [Ingres / in Rome 1809.]
The Metropolitan Museum of Art, New York
Bequest of Grace Rainey Rogers, 1943 43.85.8
New York only

N 54

Ingres's portrait of Merry-Joseph Blondel dates from the year in which the two artists became fellow students in Rome. The palace of the Villa Medici, where they boarded, appears in the background of this drawing. Blondel had won the Prix de Rome in 1803, two years after his colleague, but arrived only in 1809 at the villa where Ingres had been living since 1806. In her interesting assessment of Blondel's long friendship with Ingres, Germaine Guillaume presented the following account of the young artist's background and early years.

> Merry-Joseph Blondel, born in Paris on July 25, 1781, was the younger son of Joseph-Armand Blondel, a painter and decorator and a member of the Académie de Saint-Luc, and Marie-Geneviève Marchand. His brother was Charles-François-Armand, Architect to the King, and his sister was Marie-Anne-Félicité, who married [the bronze-caster] Lucien-François Feuchère. On the advice of his maternal uncle, Merry-Joseph went to work for a notary at the age of fourteen, where he spent nearly "two excruciating years."
>
> At the child's fervent insistence, his father took him out of the notary's office and, with all good intentions, got him a job at the Dihl et Guerhard porcelain manufactory, where young apprentices studied drawing and learned how to become porcelain painters. [Charles-Étienne] Leguay taught figure drawing there, and in very little time Blondel made remarkable progress. "Five days out of ten were devoted to that study, and the other five to painting decorations." But once the Revolutionary upheaval had passed, the drawing section was eliminated, and to meet the growing demand for porcelains, especially from abroad, the students had to stand in for the workers in executing the commissioned paintings.
>
> Blondel convinced his father to break his apprenticeship contract and entered [Jean-Baptiste] Regnault's studio, where in one year he was awarded the prize for best torso, the prize for best expressive figure, and several medals besides, which led his friends to nickname him Monsieur de Cinq-Prix [Mr. Five-Prizes].

The following year, 1803, he won first Grand Prize for the subject of Aeneas Rescuing His Father from Burning Troy. But no one was sent to Rome that year, and Blondel did not leave for Italy until 1809, with Regnault's backing.[1]

We do not know why Blondel used only three of the four years of his Roman scholarship, but it is apparent that in the eyes of his contemporaries the painter had spent his time well. He was awarded important state commissions, and the resulting works in public buildings can be admired to this day. The frescoes he executed in and around Paris—in the Louvre, in Notre-Dame de Lorette, at the Paris Bourse, in the château at Fontainebleau, and in the church of Saint-Thomas-d'Aquin—show him to have been an artist who never managed to break the mold of his time but who worked within his school with competence and aplomb.

Blondel was honored with a professorship at the École des Beaux-Arts in 1824,[2] and after the Salon of that same year he received—along with Ingres—the cross of the Legion of Honor from the hand of Charles X. In 1825 Blondel competed for a seat in the Académie des Beaux-Arts,[3] but the choice fell to Ingres, and he was forced to wait for that distinction until 1832.

In that same year, having lost his first wife three years before, Blondel married the daughter of the well-known bronze-caster Pierre-Maximilien Delafontaine. In March of 1839 Blondel and his young wife undertook a trip to Rome. Ingres, then nearing the end of his tenure as director of the Académie de France, was delighted to put them up in the Villa Medici for the four months of their stay. In May, Ingres took the vacation trip to the Marches and Umbria that is documented by a series of small travel sketches in the Musée Ingres, Montauban.[4] From Blondel's correspondence it is apparent that he went along.[5]

Blondel appeared to be the favored candidate to succeed Ingres at the Villa Medici when the latter's term expired in 1841, but he was ultimately passed over.

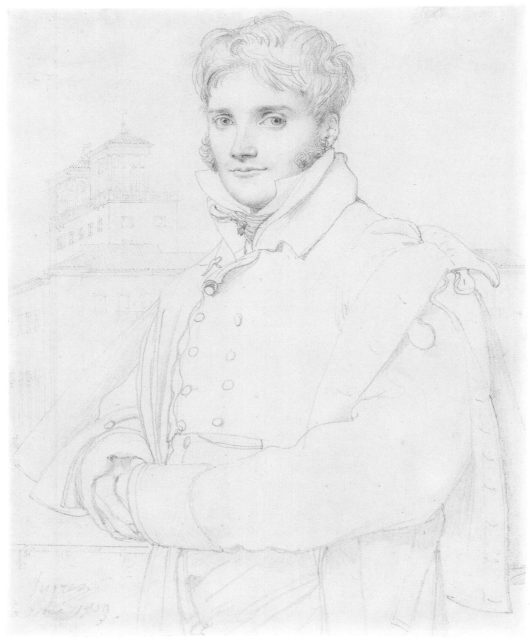

41

Ingres wrote him a letter of condolence in December 1840, and it is filled with genuine feeling for his old colleague.[6] In 1853 Blondel died while completing his fresco cycle at Saint-Thomas-d'Aquin, the church where Ingres's own funeral service would be held fourteen years later.

<div style="text-align:right">H.N.</div>

For the author's complete text, see Naef 1977–80, vol. 1 (1977), chap. 19 (pp. 189–94).

1. Guillaume 1937, pp. 74–76; quoted in Naef 1977–80, vol. 1 (1977), p. 189.
2. Thieme and Becker 1907–50, vol. 4 (1910), p. 137.
3. Lapauze 1911a, p. 240.
4. Ternois 1956, pp. 166–67.
5. Guillaume 1937, p. 83.
6. Ibid., pp. 87–88.

PROVENANCE: Merry-Joseph Blondel (1781–1853), Paris; Mme Merry-Joseph Blondel, née Louise-Emélie Delafontaine, his widow, Paris, until 1882; Mme Alfred Wittersheim, née Emélie-Louise-Eudoxie Blondel, her daughter, until 1920; Mlle Marie Wittersheim, her daughter; her sale, Hôtel Drouot, Paris, room 1, February 22, 1934; acquired from an unknown collector by the Galerie Wildenstein in Paris, 1936; purchased from Wildenstein & Co., New York, by Mrs. Grace Rainey Rogers (1867–1943), New York, 1940; her bequest to The Metropolitan Museum of Art, New York, 1943

EXHIBITIONS: Paris 1861 (2nd ser.); Paris 1867, no. 548; San Francisco 1947, no. 4, ill.; Cambridge (Mass.) 1967, no. 15, ill.; New York 1970, no. 41; Washington, New York, Philadelphia, Kansas City 1971, no. 146, ill.; New York 1988–89

REFERENCES: Galichon 1861b, p. 46; Blanc 1870, p. 235; Delaborde 1870, no. 261; Jouin 1888, p. 14; Burroughs 1946, p. 161, ill.; Mongan 1947, no. 3, ill.; Naef 1960 *(Rome)*, p. 27, n. 52; Anon., March 11, 1967, ill. p. 22; Waldemar George 1967, ill. p. 31; Mongan 1969, p. 141, fig. 11 on p. 145; Naef 1977–80, vol. 4 (1977), pp. 102–3, no. 54, ill.

42. Charles-François Mallet

1809
Graphite
10¾ × 8¼ in. (26.6 × 21.1 cm)
Signed and dated lower right: Ingres fecit /
roma 1809. [Ingres made (this in) / Rome
1809.]
The Art Institute of Chicago
The Charles Deering Collection 1938.166
New York and Washington only

N 55

Although the artist did not include his subject's name on this drawing, scholars agree that it is indeed a portrait of Charles-François Mallet, who was a civil engineer, as Henri Delaborde indicated in a reference to the engraving made after it by Boucheron and Dien.[1] The entry on Mallet in Didot's *Nouvelle Biographie générale* reads as follows:

> Mallet (Charles-François), French engineer, born in Paris on July 4, 1766, died in the same city on October 19, 1853. Appointed civil engineer in 1791, in 1805 he went to Naples with King Joseph [Bonaparte], who made him one of three members of the General Commission on Civil Engineering. Chief engineer as of 1808, he was sent to the Dora [River] region and, several months later, was transferred to the Po region. A handsome bridge in Turin, the straightening of the Po near Moncalieri, a hospice on the Sestriere mountain pass, a barometric survey undertaken jointly with M. d'Aubusson (which was the subject of a very favorable report to the Institute): these are the principal works that marked the engineer's stay in Piedmont. In 1814, he went to Rouen to oversee construction of the great stone bridge. When, in 1824, the government conceived the project of using water from the Ourcq to clean Paris and provide water to private dwellings, Mallet made a full study of the undertaking; he took several trips to England and published *Notice historique sur le projet d'une distribution générale d'eau à domicile dans Paris* (Paris, 1830), a historical essay on the widespread distribution of water to Parisian homes. In 1840, he retired from the service with the title of honorary inspector general. His other writings include *Mémoire sur la minéralogie du Boulonnais* (Paris, Year III [1795]); and several reports in the *Annales des Ponts et Chaussées*.[2]

It appears that Ingres deliberately posed Mallet in a setting that would allude to his expertise in building bridges. The engineer stands on the left bank of the Tiber, not far from the Ponte Rotto. In the background is the Ponte Fabricio, which connects the Isola Tiberina with Trastevere.

The bridge that Mallet built later in Turin is still today one of that city's most remarkable structures. H.N.

EDITOR'S NOTE: Georges Vigne has recently suggested that a drawing in the Musée Ingres, Montauban (see n. 1, below, and fig. 132), which seems to be a prototype for the architectural landscape background in Ingres's portrait of Mallet, may have been made by Mallet himself. As an engineer, he would have been used to creating such architectural perspectives—and perhaps more proficient at them than Ingres. Ingres would then have copied Mallet's sketch for the final portrait drawing. The Montauban drawing does betray a hardness that is foreign to Ingres's usual delicate touch. Daniel Ternois (Paris 1967–68, no. 38, p. 66) considered the Montauban drawing to be a tracing made from the drawing in the Art Institute of Chicago. See Vigne 1995a, no. 2716, p. 490.

For the author's complete text, see Naef 1977–80, vol. 1 (1977), chap. 20 (pp. 195–97).
1. Delaborde 1870, no. 359. Begun by Angelo Boucheron, who died at some time after 1830, the unfinished plate was completed in 1856 by Claude-Marie-François Dien. An incomplete tracing of the drawing, illustrated in Ternois 1959a, fig. 118, is in the collection of the Musée Ingres, Montauban (inv. no. 867.313 bis).
2. *Nouvelle Biographie générale* 1853–66, vol. 33 (1860), cols. 81–82; reprinted in Naef 1977–80, vol. 1 (1977), pp. 195–96.

PROVENANCE: Possibly Baroness Mathilde von Rothschild, Frankfurt, before 1914; perhaps the Goldschmidt-Rothschild family; possibly the royal family of Württemberg;* purchased in 1938 from the dealer Jacob Hirsch, New York, by the Art Institute of Chicago

* "The drawing, I was told, used to be in the collection of Baroness Mathilde von Rothschild in Frankfurt and the Goldschmidt-Rothschild family. Baroness Mathilde von Rothschild died before the great war [World War I]. She was the mother of the wife of Baron Edmond de Rothschild, the head of the Paris branch [of the family]. It was later owned by a member of the royal family of Württemberg." Dr. Jacob Hirsch to the Art Institute of Chicago, February 21, 1938.

EXHIBITIONS: Springfield, New York 1939–40 (not in catalogue); Chicago 1946, no. 30, pl. XI; Paris 1955, no. 80, pl. 5; Kansas City 1958,

Fig. 132. J.-A.-D. Ingres?, *View of Rome*, 1809. Graphite on paper, 11 × 8½ in. (27.8 × 21.7 cm). Musée Ingres, Montauban (867.313 bis)

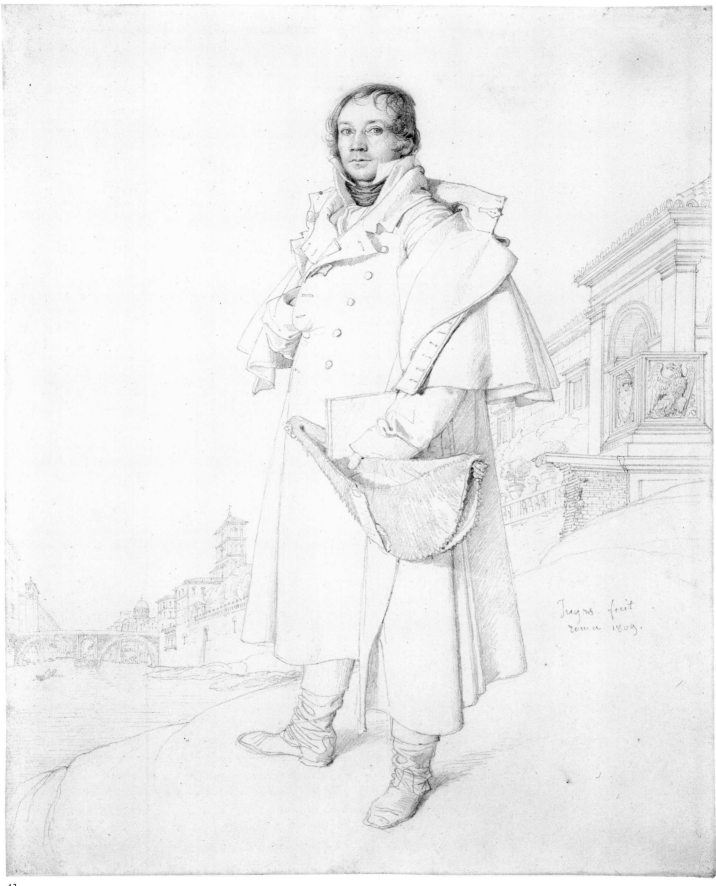

no. 17, ill. p. 8; Chicago 1961, no. 85; New York 1963, no. 75; Cambridge (Mass.) 1967, no. 14, ill.; Paris 1967–68, no. 38, ill.; Washington, New York, Philadelphia, Kansas City 1971, no. 145, ill.

REFERENCES: Blanc 1870, p. 246 (known from the engraving by Boucheron and Dien); Delaborde 1870, no. 359 (catalogued on the basis of the engraving); Lapauze 1901, p. 267 (known from the engraving); Lapauze 1911a, ill. p. 98 (the engraving); Lapauze 1911b, p. 48; Anon., October 1, 1938, p. 13, ill.; Miller 1938, p. 14, n. 25, p. 15; Rich 1938, pp. 65–69, ill. pp. 65, 67, detail ills. pp. 66, 68; Combs 1939, p. 21, ill. p. 170; Siple 1939, p. 249, ill. p. 247; Alazard 1950, pp. 37, 51–52, 62, n. 20, p. 146, pl. XVIII; Seligman 1952, p. 44, ill. p. 45; Mathey 1955, p. 11, under no. 15; Riley 1955, ill. p. 28; Ternois 1959a, preceding no. 118, see also fig. 118; Naef 1960 (Rome), p. 27, n. 52; Anon., October 1963, ill. p. 464; Mongan 1967, p. 29; Schlenoff 1967, p. 376; Radius and Camesasca 1968, p. 122, ill.; Wittkop 1968, ill. p. 212, as General C. F. Mallet; Jullian 1969, p. 89; Mongan 1969, p. 141, fig. 10, p. 145; Ternois and Camesasca 1971, p. 122, ill.; Delpierre 1975, p. 22; Naef 1977–80, vol. 4 (1977), pp. 104–5, no. 55, ill.; Bro 1978, fig. 2.5; Ternois 1980, p. 26; Ingres Portrait Drawings 1993, p. 15, ill.; Fleckner 1995, p. 111, ill.; Vigne 1995a, p. 490, ill.

43. Madame Guillaume Mallet, née Anne-Julie Houel

1809
Graphite
11 3/8 × 7 3/4 in. (29 × 19.6 cm), framed
Signed and dated lower right: J J Ingres D. / roma / 1809 [J. J. Ingres d(rew this) / Rome / 1809]
André Bromberg

N 56

The Mallet banking dynasty traces its origins to a Jacques Mallet from Rouen who converted to Protestantism during the Reformation and was forced to emigrate to Geneva. There he was given resident status in 1558, became a cloth merchant, and attained such prominence that he was named a member of the Council of the Two Hundred in 1594.

The actual founder of the French banking house,[1] which rose to greatness in the eighteenth century and still survives, was probably Isaac Mallet, born in the 1600s. His son Jacques, born in 1724, had two sons, under whose leadership the business took on international importance. The elder son, Guillaume, lived from 1752 to 1826, ending his brilliant career as Régent de la Banque de France, a post subsequently held by one of his sons and one of his grandsons, as well.

Widowed as a young man, Guillaume married again in 1785. His bride, Anne-Julie Houel, is the subject of Ingres's superb portrait drawing. From her appearance, somewhat lacking in feminine charm but altogether imposing, she must clearly have been a woman of courage and determination. During the Reign of Terror, when her husband and brother-in-law were taken into custody and charged with illicit dealings abroad, Madame Mallet took the business in hand and ran it herself until the two brothers were released. A circular letter survives in which she informs the bank's clients that they are to have no doubts about the two men's innocence, and that until they are exonerated, which will surely be soon, the business will continue to function normally.

Ingres's portrait of Madame Mallet bears the date 1809. In the following year, Napoleon named her husband Baron de l'Empire, and, after Bonaparte fell from power, the Restoration government confirmed Mallet's hereditary title Baron Mallet de Chalmassy. The baroness died in Paris in 1849, nearly ninety years old.[2]

We do not know what occasioned the lady's trip to Rome and her encounter with Ingres, who was then still living at the Villa Medici. When she commissioned her portrait from the young artist, she was doubtless not so much interested in attaining immortality as in securing a small memento of her visit.[3] That it was intended as a souvenir is reason enough for the magnificent background view of the dome of Saint Peter's as seen from the palace of the Villa Medici. Pierre Lièvre has written—with no supporting documentation—that the prospect of the Vatican is an allusion to the lady's interview with the pope, and that the letter she holds is a letter of introduction to the Holy Father.[4] It would have been very unusual for a woman from such a staunchly Protestant family to seek such a meeting; no one in the family has any knowledge that she did so. In this regard, it must also be noted that on

July 6 of the year in question Pius VII was spirited away into exile in Savona at Napoleon's command.

On June 14, 1867, Ingres's friend Édouard Gatteaux wrote to the painter Pierre-Antoine Labouchère, who had lent this drawing to the Ingres commemorative exhibition that year. Gatteaux was perhaps personally acquainted with Madame Mallet, for in his letter he observed that at the exhibition her portrait had been "much admired for the sureness of touch with which the artist captured the energetic character of the subject."[5] H.N.

For the author's complete text, see Naef 1977–80, vol. 1 (1977), chap. 21 (pp. 198–99).

1. For the history of the firm, see *Mallet frères et Cie* 1923.
2. Death certificate, Archives de Paris.
3. There is an inscription on the back of the old mount that reads: "B^nne Mallet par Ingres. Portrait fait à Rome en 1809. Il existe une lettre dans laquelle elle dit se décider à laisser faire son portrait par un petit peintre." ("Baroness Mallet by Ingres. Portrait done in Rome in 1809. A letter exists in which she says she has made up her mind to have her portrait done by a minor painter.")
4. Lièvre 1934, pp. 5–6.
5. Gatteaux enclosed his letter to Labouchère with Ingres's drawing when he returned it after the exhibition. Bibliothèque Municipale, Nantes. Quoted in Naef 1977–80, vol. 1 (1977), p. 199.

PROVENANCE: Mme Guillaume Mallet, née Anne-Julie Houel (1761–1849); Louis-Jules Mallet, her son, Paris, until 1866; Mme Pierre-Antoine Labouchère, née Nathalie Mallet, his daughter, Paris, until 1884; Émile-Georges Mallet, her nephew; his widow, née Marie Hartung, who died after 1934; Charles Mallet, her son; Mme Charles Mallet, née Marcelle Lemarquis, his widow; Mme Pierre Rosetti Balanesco, née Odile Mallet, their daughter; acquired from her by the present owner, 1992

EXHIBITIONS: Paris 1867, no. 563; Paris 1934a, no. 526; Paris 1947b, no. 208; Paris 1956, no. 121; Paris 1967–68, no. 39, ill.; Rome 1968, no. 18, ill.

REFERENCES: Blanc 1870, p. 238; Delaborde 1870, no. 360; Lièvre 1934, pp. 5–6, ill. p. 5; Alazard 1950, pp. 37, 51–52, 62, pl. XIX (the sitter erroneously identified as the wife of Charles-François Mallet [cat. no. 42]); Mathey 1955, no. 5, ill. (the sitter erroneously identified

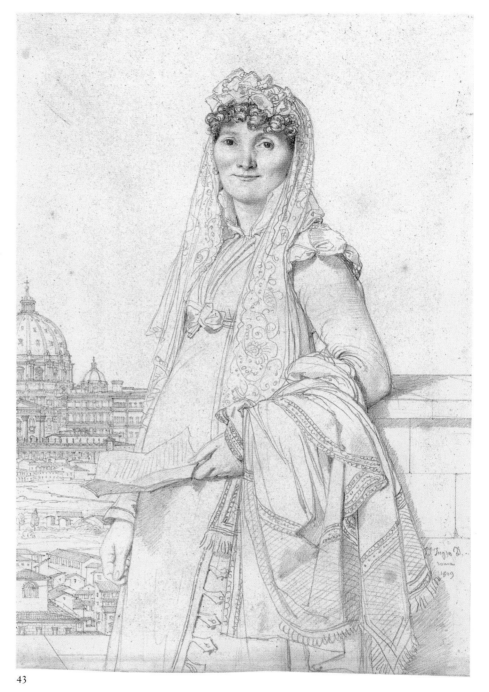

43

as Mme Charles-François Mallet); Ternois 1959a, preceding no. 118; Naef 1960 *(Rome)*, p. 27, n. 52; Radius and Camesasca 1968, p. 124, ill. (the sitter erroneously identified as Mme Charles-François Mallet); Ternois and Camesasca 1971, p. 124, ill.; Delpierre 1975, p. 24; Naef 1977–80, vol. 4 (1977), pp. 106–7, no. 56, ill.

44. Dr. Jean-Louis Robin

ca. 1810
Graphite
11 × 8¾ in. (28.1 × 22.2 cm)
The Art Institute of Chicago
Gift of Emily Crane Chadbourne 1953.204
New York and Washington only

N 57

The dealer who purchased this drawing at auction in 1927 came into possession of the following document, as well:

The portrait of Doctor Robin, chief physician at the French Hospital in Rome, was drawn by Ingres, in that city, in 1811 or 1812. It bears no signature, as it appears that the rendering of the architecture is actually the work of a prizewinning architect and friend of Ingres; normally, Ingres signed at bottom left, but he was unable to sign this particular drawing.

This information was communicated by Doctor Robin himself, along with the drawing, to his relative M. Mérandon, justice of the peace in Autun, from whom M. Eugène Froment bought it in 1875 for M. Amaury Duval. The last bequeathed it to M. Froment, along with two others (those of M. and Mme Guyet-Desfontaines), which today are in the collection of M. Bonnat [N 385, 407; Musée Bonnat, Bayonne]. M. Froment's daughter, Mme Mazeran, gave this drawing to her cousin, M. Maurice Bouts, with all the above-cited information, in 1902, as a token of gratitude for having settled her father's estate.

Certified: October 15, 1912
Maurice Bouts[1]

The information provided by this one-time owner of the work is not altogether trustworthy. Especially suspect is his notion that the background view of Rome is not the work of Ingres, but rather that of an architect acquainted with him. Enough is known about Ingres's mastery in the depiction of Roman cityscapes that this magnificent view of Saint Peter's from the Villa Medici serves as a virtual signature. No one close to him would have been capable of rendering such a motif with so much artistry. It is also absurd to assume that Ingres failed to sign the work simply because there was no room in the lower left; Ingres regularly signed his drawings either at the bottom or the top, left or right, wherever he felt like signing them—least often, as here, not at all.

Jean-Louis Robin was born in Nevers in 1775, in seemingly modest circumstances, for his baptismal certificate records that his godfather was a cooper and his father "in the service of M. de Givry."[2] He rose to the rank of surgeon major in the army and saw a great deal of the world during the Napoleonic wars. A copy of his service record in the archives of the Legion of Honor, to which he was named only days before Napoleon's first abdication, relates that he took part in any number of campaigns, including those in Italy in 1806, the Kingdom of Naples in 1807, Romania in 1808, Austria in 1809, Italy in 1810–11, Russia in 1812–13, and Italy and Belgium in 1814.

Although Maurice Bouts's certificate quoted above states that Robin's portrait was executed in either 1811 or 1812, this service record places the doctor in Italy only in 1810–11. It must also be noted that the earliest dated example of a portrait as magnificent as this—the one of Madame Guillaume Mallet (cat. no. 43), which is very similar in composition and has a similar view of Saint Peter's in the background—was produced in 1809. The two drawings have a greater resemblance to each other than to anything else in the Ingres oeuvre, so it seems logical to place the undated portrait as close in time as possible to the dated one, or in 1810—and the style of the sitter's clothing bears this out, as well. Moreover, the view of Saint Peter's is rendered from the precise angle offered by the palazzo of the Villa Medici, and Ingres moved out of the palace when his scholarship expired in November 1810.

In none of the other portrait drawings enriched with Roman views are the figure and landscape combined to such superb effect. The prospect of Saint Peter's, itself a masterpiece, forms such a low horizon that the figure takes on a monumental grandeur. Its majesty might have seemed inappropriate had it not been matched by a countenance of such forcefulness and calm. H . N .

For the author's complete text, see Naef 1977–80, vol. 1 (1977), chap. 22 (pp. 200–202).
 1. Quoted in ibid., p. 200.
 2. Baptismal register, Saint-Étienne, Nevers, entry for February 5, 1775, Archives

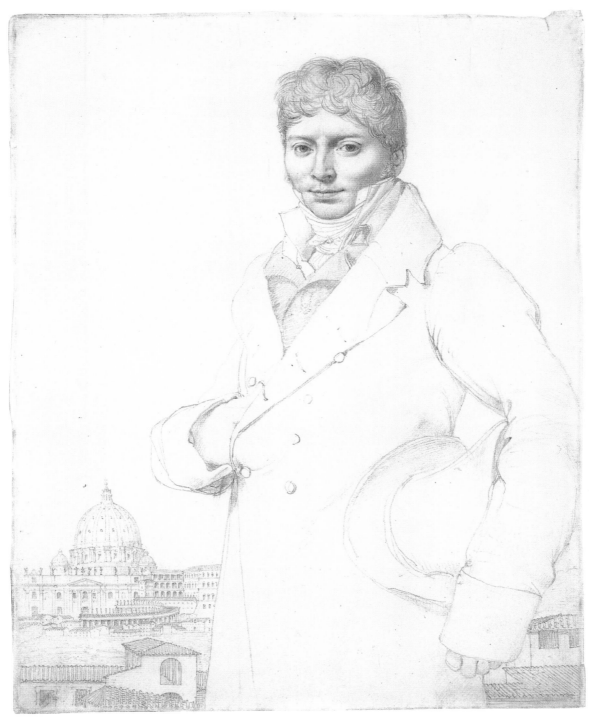

44

Départementales de la Nièvre, Nevers; quoted in Naef 1977–80, vol. 1 (1977), p. 201.

PROVENANCE: Jean-Louis Robin (1775–1846), Paris; given or bequeathed by him to M. Mérandon, a relative in Autun; purchased from him by the painter Eugène Froment-Delormel for Ingres's pupil Amaury-Duval (1808–1885), 1875; bequeathed by him to his pupil Eugène Froment-Delormel, Paris, until 1900; Mme Mazeran, his daughter; given by her to her cousin Maurice Bouts, 1902; anonymous auction, Hôtel Drouot, Paris, room 10, June 29, 1927, no. 31, sold for 7,000 francs to César Mange de Hauke; purchased from César de Hauke & Co., Paris, and Jacques Seligmann & Co., New York, by Mrs. Emily Crane Chadbourne, Washington, D.C., 1927; her gift to The Art Institute of Chicago, 1953

EXHIBITIONS: Chicago 1961, no. 86; New York 1963, no. 76, pl. XXXI; Cambridge (Mass.) 1967, no. 13, ill.; Dayton 1971, no. 44, ill.; Washington, New York, Philadelphia, Kansas City 1971, no. 144, ill.

REFERENCES: Delaborde 1870, no. 409; Lapauze 1911b, p. 48, ill. p. 51; Zabel 1930, p. 382, ill. p. 379; Alazard 1950, p. 36; Naef 1960 *(Rome)*, p. 27, n. 52; Cummings 1965, ill. p. 70; Marjorie B. Cohn in Cambridge (Mass.) 1967, pp. 243–44; Mendelowitz 1967, pp. 153, 155, 340, 375, 379, ill. p. 375; Waldemar George 1967, ill. p. 55; Mongan 1969, p. 141, fig. 9, p. 143; *Art International* 1971, ill. p. 53; Naef 1977–80, vol. 4 (1977), pp. 108–9, no. 57, ill.; Ternois 1980, p. 35, ill.; *Ingres Portrait Drawings* 1993, p. 14, ill.; Fleckner 1995, p. 122, ill.

45. Portrait of a Man

1811

Graphite

8 × 6 in. (20.4 × 15.3 cm), framed

Signed and dated lower left: Ingres / rome / 1811

At lower right, the François Flameng collection
stamp (Lugt 991)

Philadelphia Museum of Art

Henry P. McIlhenny Collection in Memory of
Frances P. McIlhenny 1986-26-23

New York only

N 68

Because this portrait has traditionally been referred to as *Monsieur Jal,* the unknown subject has occasionally been misidentified as the writer Auguste, or Gustave, Jal (1795–1873). H.N.

PROVENANCE: François Flameng, Paris, by 1911; his sale, Galerie Georges Petit, Paris, May 26–27, 1919, no. 116, as *M. Jal, critique d'art;* purchased at that sale for 5,600 francs by Henry Lapauze (1867–1925); his posthumous auction, Hôtel Drouot, Paris, June 21, 1929, no. 35, as *Portrait d'homme;* purchased at that sale for 46,000 francs by M. Knoedler & Co.; purchased from M. Knoedler & Co., New York by Henry P. McIlhenny, Philadelphia, 1935; his bequest to the Philadelphia Museum of Art, 1986

EXHIBITIONS: Paris 1911, no. 80, as *Gustave Jal;* Cambridge (Mass.) 1934, no. 41; Springfield, New York 1939–40, no. 37, as *Monsieur Jal;* Cincinnati 1940; Rochester 1940; Philadelphia 1947, no. 108; Philadelphia 1949; Cambridge (Mass.) 1958, no. 29; New York 1961, no. 7, ill.; San Francisco 1962, no. 27, ill., as *M. Jal;* Allentown 1977, pp. 18, 19, ill., as *M. Jal;* Atlanta 1984, no. 5, ill.; Boston 1986

REFERENCES: Lapauze 1911a, ill. p. 110, as *M. Jal;* Saunier 1911, ill. p. 10, as *Gustave Jal;** Saunier 1918, p. 24; *La Renaissance de l'art français* 1921, ill. p. 221, as *M. Jal;* Anon., October 1929, p. 62; Lane 1940, p. 7; Naef 1966 ("Portrait Drawings"), p. 258; Naef 1977–80, vol. 4 (1977), pp. 128–29, no. 68, ill.; Philadelphia 1987–88, p. 61, ill.

*On the illustration at upper left is the handwritten note "Jal," which is not visible on the original drawing.

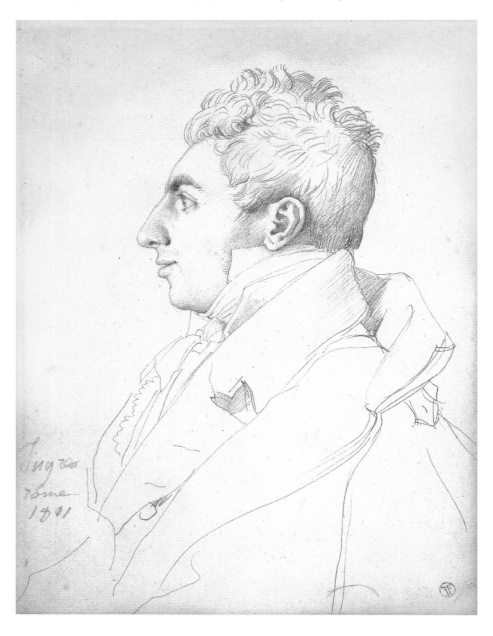

46. Jacques Marquet, Baron de Montbreton de Norvins

1811
Graphite
10 ⅝ × 8 ⅜ in. (26.8 × 21.1 cm)
Signed and dated bottom center: Dessiné a
Rome / par Ingres / 1811 [Drawn at Rome /
by Ingres / 1811]
Inscribed bottom right by Norvins: 1er Mai / jour
de ma fete / Rome / 1811 [May 1st / my name
day / Rome / 1811]
Virginia Museum of Fine Arts, Richmond
Adolph D. and Wilkins C. Williams Fund
London only

N 71

In this rather informal pencil drawing of
Norvins, Ingres has portrayed the Direc-
tor of Police for the Roman States seated
in front of a lightly sketched view of Rome
with a small dog, possibly a griffon, rest-
ing in his lap. As in Ingres's painted por-
trait (cat. no. 33), the ribbon of a chevalier
of the Legion of Honor is affixed to the
sitter's left jacket lapel. According to the
inscription in ink, apparently in Norvins's
own hand, this drawing was executed in
commemoration not of the sitter's birth-
day (June 17) but rather of the feast day of
his namesake, Saint Jacques le Mineur
(James the Less), which was traditionally
celebrated on May 1.[1]

There exists a related drawing (École
des Beaux-Arts, Paris) identical in compo-
sition but shown in reverse. This drawing,
which is somewhat awkward in its tech-

nique and lacks the landscape background
as well as the secondary inscription on the
drawing in Richmond, is similarly signed
and dated "Ingres 1811." Although ini-
tially accepted as an original, the drawing
in Paris is now recognized as a copy—
possibly by Norvins's widow—of a litho-
graph executed by Jean-Baptiste Muret
after this drawing in Richmond.[2]

P.C.

1. Following the modification of the calendar of
the Catholic Church in 1969, this feast day
was moved to May 3.
2. Mathey 1933, p. 117. See also Naef 1977–80,
vol. 1 (1977), pp. 237–39, figs. 3, 5.

PROVENANCE: Jacques Marquet, Baron de
Montbreton de Norvins (1769–1854); Albert
Goupil, Paris, by 1885; his posthumous sale, Hôtel
Drouot, Paris, April 23–27, 1888, no. 340, sold

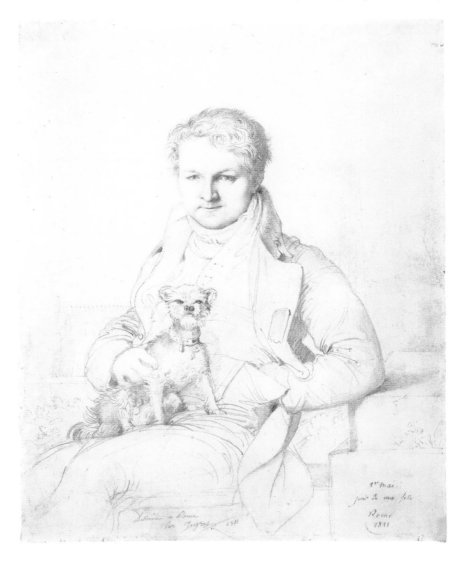

for 2,750 francs; Alfred-Louis Lebeuf de Mont-germot, Paris, by 1913; his posthumous sale, Galerie Georges Petit, Paris, June 16–19, 1919, no. 119, sold for 11,100 francs, bought in; by inheritance to his daughter Princesse Louis-Antoine-Marie de Broglie, until 1929; by inheritance to her daughter Comtesse Bernard de Laguiche; by inheritance to her husband, until 1974; their son Armand de Laguiche; placed on the art market by him after his father's death; purchased from Colnaghi & Co., London, by Robert H. Smith, Washington, D.C., 1974; Artemis Fine Arts Ltd., London, by 1984; purchased from that gallery by the Virginia Museum of Fine Arts, Richmond, with the Adolph D. and Wilkins C. Williams Fund, 1985

EXHIBITIONS: Paris 1913, no. 333; Paris 1949b, no. 70; London 1975, no. 107; London 1984, no. 37, ill.

REFERENCES: Blanc 1870, p. 246; Delaborde 1870, no. 385; Molinier 1885, p. 388; Lapauze 1901, p. 267; Mathey 1932, p. 197; Mathey 1933, pp. 117–18, 120, ill.; Chicago, Minneapolis, Detroit, San Francisco 1955–56, p. 45; Davies 1957, pp. 116–18, no. 3291; Schwarz 1959, p. 335; Naef 1960 (Rome), p. 27; Davies 1970, p. 76; Naef 1977–80, vol. 1 (1977), p. 237, vol. 4 (1977), pp. 134–36, no. 71, ill.; Tübingen, Brussels 1986, p. 30, ill. p. 31; Arts in Virginia 1989, pp. 4–5; Near 1990, pp. 262–69

47. Madame Charles Hayard, née Jeanne-Susanne Alliou

ca. 1812
Graphite
10 1/2 × 7 1/6 in. (26.6 × 18 cm)
Signed lower right: Ingres.
Fogg Art Museum, Harvard University Art Museums, Cambridge, Massachusetts
Bequest of Paul J. Sachs, Class of 1900, "a testimonial to my friend Grenville L. Winthrop"
1965.0298
New York only

N 82

It was long thought that the seven portrait drawings associated with the name Hayard were simply a series of splendid souvenirs commissioned from a down-and-out compatriot by some unknown, well-to-do French family during an extended stay in Rome. As it happens, however, the Hayards were permanent residents in Rome and a family to which Ingres was particularly close.

Charles-Roch Hayard was born near Paris, the son of a shoemaker, in 1768.[1] In 1796, by which time he had married, he is documented as being employed in Paris in the office of the École Centrale.[2] Sometime between 1799 and 1805, and after the births of two daughters, he moved with his family to Rome, where another two daughters were born. Soon after their arrival, Hayard began selling art supplies, presumably in the vicinity of the Piazza di Spagna. In 1830 the Hayard shop was located at 46 Via de' due Macelli.[3] It was the best art-supply store in Rome, and Hayard was thus known to scores of artists, especially the French ones housed only minutes away at the Villa Medici. It is also apparent that Hayard's charming daughters were among the shop's attractions, for two of them married artists.

Ingres was obviously a regular customer. The three most splendid of his drawings of the family—one of Hayard with his daughter Marguerite (cat. no. 50), one of Madame Hayard with her daughter Caroline (N 132; Fogg Art Museum, Cambridge, Massachusetts), and one of their daughter Jeanne, called Jeannette, alone (cat. no. 51)—date from 1815, the artist's most difficult year in Rome. He had lost his French patrons with the fall of the Empire, and with a new wife to support he could barely scrape by. The quality of the 1815 drawings suggests that Hayard commissioned them as a way of putting some much-needed money in his young friend's pocket. Unlike the drawings Ingres produced as gifts for friends, which tend to be more spontaneous, these have a degree of finish typical of works for which he was paid.

Madame Hayard appears to have taken over the shop soon after it was established, for as early as 1810 her husband was employed as superintendent of the papal gunpowder and saltpeter administration. In painting circles she was fondly referred to as "the artists' mother,"[4] so she must have been especially kind in her dealings with regulars. She and her husband welcomed Ingres back to Rome when he returned in 1835, as the director of the Villa Medici. Hayard died in 1839, and Ingres must surely have attended his funeral.

Born Jeanne-Susanne Alliou in 1775,[5] Madame Hayard spent her last years in Paris and died there in 1854. In addition to the double portrait in which her youngest daughter clings to her skirts—obviously intended as a pendant to the drawing of her husband with their next-youngest daughter—Ingres produced this portrait of her alone about 1812.

The earliest dated Hayard portrait presents the oldest of the girls, Albertine, in strict profile (N 81). Within weeks of its execution, in 1812, the shy, innocent girl of fourteen or fifteen would marry the much older landscape painter Pierre-Athanase Chauvin (1774–1832). A second drawing

of her dates from two years later, and there she is in an advanced stage of pregnancy (N 112; Musée Bonnat, Bayonne). Chauvin served as one of the witnesses at Ingres's marriage in 1813. Albertine died in 1833.

The second Hayard daughter, Jeanne, the subject of one of the 1815 drawings, would marry the wealthy jeweler Charles-Alexandre Fouquerelle, and at some point the pair moved to Paris, where she died in 1862.

Marguerite, who appears at the age of nine in the double portrait with her father, became the wife of Félix Duban, winner of the Prix de Rome for architecture in 1823. Duban is remembered as the architect of the École des Beaux-Arts in Paris and of part of the Seine tract of the Louvre. He died in 1870, Marguerite in 1881.

Caroline, the youngest daughter, was only four when Ingres drew her with her mother. She also appears alone in a portrait, done in 1841, shortly after she had been widowed (N 377). Ingres had accompanied her to the altar as witness in 1838 when she married the young Belgian nobleman Edmond Duvivier, who died two years later. A fascinating cache of letters survives in which Duvivier describes his fiancée and her family to his mother in Belgium, and begs her to give her blessing to their marriage.[6] Caroline later married the sculptor and medalist Frédéric Flachéron. She was the Hayard whom Ingres must have felt closest to, for he had known her from the time she was born. She would have been ten when he and his wife left for Florence in 1820. The drawing of her done in 1841, when Ingres turned over the Villa Medici to his successor, was doubtless executed as a parting gift on his return to France.

Ingres's double portrait of Charles and Marguerite Hayard was photoengraved by E. Charreyre in 1896. H. N.

For the author's complete text, see Naef 1977–80, vol. 1 (1977), chap. 49 (pp. 451–69).

1. Baptismal register, Aulnay-lès-Bondy, Archives Départementales de Seine-et-Oise, Versailles.
2. Marriage certificate of his sister Hélène Hayard, Aulnay-lès-Bondy, September 26, 1796, Archives Départementales de Seine-et-Oise, Versailles.
3. Keller 1830, p. 137.
4. Edmond Duvivier to his mother, Marie-

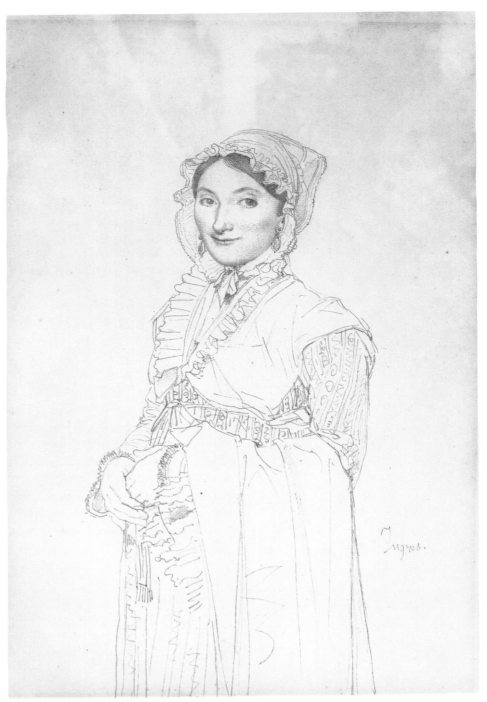

47

Thérèse-Josèphe-Dieudonnée Renoz Duvivier de Streel, December 12 [1837]; Naef 1977–80, vol. 1 (1977), p. 461.
5. Tomb inscription, Cimetière Montparnasse, section 13.
6. A selection is published in Naef 1977–80, vol. 1 (1977), pp. 459–69.

PROVENANCE: Perhaps Mme Charles Hayard, née Jeanne-Susanne Alliou (1775–1854); her son-in-law Félix Duban (according to the 1867 Ingres exhibition catalogue), Paris and Bordeaux until 1870; his wife's nephew Alexandre Flachéron, who was also a grandson of the sitter, Paris, by 1911; Galerie Georges Bernheim, Paris, by 1921; purchased from the John Levy

Galleries, New York, by Paul J. Sachs, 1922; deposited by him at the Fogg Art Museum, Cambridge, Mass.; bequeathed to the Fogg Art Museum, Harvard University Art Museums, by Paul J. Sachs, 1965

EXHIBITIONS: Paris 1867, no. 557; Paris 1921, no. 71; Cambridge (Mass.) 1929, no. 87; Providence 1933; Saint Louis 1933; Cambridge (Mass.) 1934, no. 42; Brooklyn 1939; Springfield, New York 1939–40, no. 44 (according to M. Knoedler & Co.'s records, the drawing was not shown in New York); Washington 1940 (catalogue not seen by the author); Grosse Point Farms 1941, no. 43; Williamstown 1946; New York 1947; San Francisco 1947, no. 2; Detroit 1951, no. 46, ill.;

Richmond 1952 (catalogue not seen by the author); Winnipeg 1954, no. 11; Amherst 1958, no. 24; Rotterdam, Paris, New York 1958–59, no. 129, pl. 105, see also pl. 97; Berkeley 1960, p. 58; New York 1961, no. 11, ill.; Dallas 1962 (not in catalogue); Cambridge (Mass.), New York 1965–67, no. 43, ill.; Cambridge (Mass.) 1967, no. 18, ill.; Tokyo 1979, no. 82

REFERENCES: Blanc 1870, p. 237; Delaborde 1870, no. 323; Lapauze 1911a, ill. p. 123; *La Renaissance de l'art français* 1921, ill. p. 217; Siple 1927, p. 309, fig. D, p. 307; Zabel 1930, p. 381; Miller 1938, p. 7; Mongan and Sachs 1940 (1946 ed.), vol. 1, no. 699, vol. 2, fig. 370; Cassou 1947, pl. 34; Mongan 1947, no. 5, ill.; Huyghe and Jaccottet 1948, p. 173, ill. p. 11; Alazard 1950, p. 51, n. 16, p. 146, pl. XXII; Anon., March 1952, ill. p. [1], as *Madame Suzanne Hayward*; Ternois 1959a, vol. 3, preceding no. 72; Anon., summer 1960, ill. p. 378; Miotti 1962, fig. 101; Capers and Maddox 1965, p. 265, ill. p. 266; White 1965, p. [3], fig. 3; Cambridge (Mass.), Fogg Art Museum 1966, p. 33; Naef 1966 ("Hayard"), pp. 40–41, fig. 1 (sitter identified); Schlenoff 1967, p. 376; Mongan 1969, pp. 141–42, fig. 13, p. 147; Naef 1977–80, vol. 4 (1977), pp. 150–52, no. 82, ill.; Cambridge (Mass.) 1980, no. 11, ill.; Newman 1980, p. 38, ill.; Picon 1980, ill. p. 37; Ternois 1980, p. 60; Mongan 1996, no. 215, ill.

48. Philippe Mengin de Bionval

1812

Graphite

10⅛ × 7¾ in. (25.6 × 19.6 cm)

Signed and dated lower right: Ingres a Rome / 1812 [Ingres in Rome / 1812]

National Gallery of Art, Washington, D.C.

Woodner Family Collection 1991.182.21

Washington only

The identification of the subject of this drawing as Philippe Mengin de Bionval is traditional and came from his family, in whose possession the drawing remained until 1985. Nothing further is known about this young Frenchman who sat for Ingres in Rome in 1812 beyond what the portrait itself indicates. One can guess from the size and number of his collars and his forward-swept hairstyle, for example, that he was a modish young gentleman, but the intense gaze of his deep-set eyes suggests that he had a serious and perhaps studious side to his character as well. The drawing was most likely done on commission, one of many such that Ingres made to support himself during his fourteen-year first stay in Rome.

The presentation of Mengin de Bionval in perfect profile connects his portrait with a small series of arresting portrait drawings made by Ingres between 1810 and 1812, in which the sitters are all presented in profile facing to the left.[1] Presumably Ingres was interested, for that very limited period, in exploring the artistic and expressive possibilities and complexities of the profile, a pose he had used for his portrait drawings in the 1790s, but with markedly different results.[2] Whereas those small, early profile portraits in circular or oval format clearly belong to the eighteenth-century tradition of medallion portrait prints and drawings by such artists as Augustin de Saint-Aubin and Charles-Nicolas Cochin II, the larger, rectangular profile portraits in Ingres's later series have a more modern flavor, combining the classical purity of the profile pose with some of the spirit of the new romanticism. For some reason Ingres virtually abandoned profile portraits soon after drawing Mengin de Bionval. Only three later ones are known—made in 1814, 1816, and 1841—none of which has quite the same intensity as those in the 1810–12 group.[3] Ingres continued to use profile poses for many of the figures in his history paintings, presumably because they heightened the classical flavor of—and were appropriate to—the ancient history subjects he loved best.

Like so many of Ingres's graphite portraits, that of Mengin de Bionval is a study in precision and subtlety. The planes, curves, and hollows of the face are drawn with the most delicate touches of a finely sharpened pencil, with some careful blending and smudging of the lines to give the skin an alabaster smoothness. Characteristically, Ingres drew Mengin de Bionval's face with minute care and almost photographic clarity, while executing the rest of the drawing with a freer touch. The hair, for example, is suggested with a combination of fine hatchings and loose, wavy lines, while the clothing is even more broadly sketched, with just a few strokes for the outlines and some rough scribbles and hatchings to give them shape. Attention is thus focused on the physical likeness, and the exquisite finish and sculptural relief of the face are intensified. It is a measure of Ingres's consummate skill as a portraitist and draftsman that he could create with the simplest means such a striking drawing of someone whom he may have known only for the time it took to execute his portrait. M.M.G.

1. See N 58–60, 62, 64, 66, 67, 68 (in the present exhibition, cat. no. 45), 69, 70, 80, 81. Only

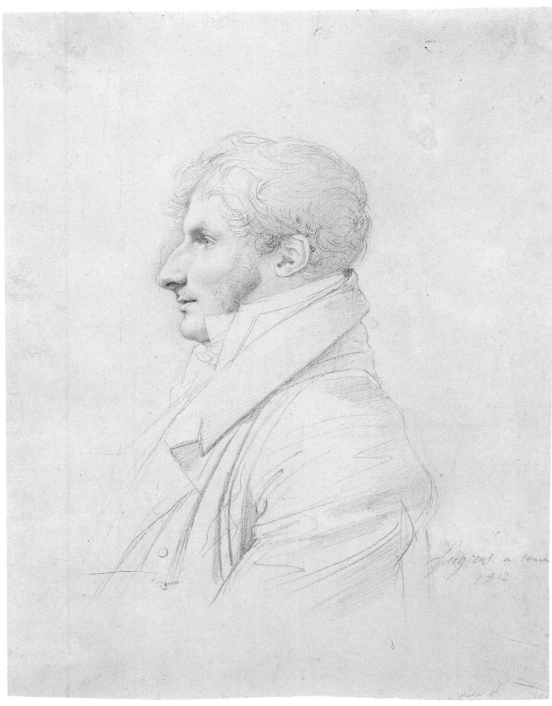

48

the last two, a lost portrait of Monsieur Beljame and a portrait of Mademoiselle Albertine Hayard, later Madame Pierre-Athanase Chauvin (now in the collection of Maria Luisa Caturla, Madrid), were made in 1812, the same year as the portrait of Mengin de Bionval. For a discussion of the profile group see Naef 1977–80, vol. 1 (1977), p. 203.

2. See, for example, N 6, 10, 11, 14: in the present exhibition, cat. nos. 13–15, 18.

3. See N 109, 184, 385.

PROVENANCE: The family of the sitter; anonymous sale, Nouveau Drouot, Paris, December 16, 1985, no. 3; purchased at that sale by Marianne Feilchenfeldt; purchased from her by Ian Woodner (1903–1990), New York, 1987; by inheritance to his daughters, Andrea and Dian Woodner, New York, 1990; their gift to the National Gallery of Art, Washington, D.C., 1991

EXHIBITIONS: New York 1990, no. 106, ill.; Washington 1995–96, no. 102, ill.

REFERENCE: Jones 1995, pp. 49–53, fig. 10

49. Portrait of a Man, possibly Edme Bochet

1814
Graphite
8⅝ × 6½ in. (21.8 × 16.6 cm)
Signed and dated lower left: Ingres. 1814
At lower right, the François Flameng collection
stamp (Lugt 991); at lower left, The Metropoli-
tan Museum of Art, New York, collection stamp
(Lugt 1943)
The Metropolitan Museum of Art, New York
Rogers Fund 1919 19.125.1
New York only

N 115

In 1810, some months before Ingres left the Villa Medici and took rooms of his own, he became acquainted with a new arrival at the Académie de France in Rome, the medal engraver Édouard Gatteaux, who would become and remain one of the artist's greatest champions for the rest of his long life. Gatteaux promptly introduced Ingres to Edme-François-Joseph Bochet, an old friend from Paris who was living nearby with his father, the highest tax authority in the French administration of Rome, and to the young man's sister and brother-in-law Monsieur and Madame Henri-Philippe-Joseph Panckoucke. Those introductions proved to be of tremendous importance to the impoverished young painter, for the majority of the portrait commissions with which he supported himself through the next few years came from Bochet's family, friends, and colleagues. The first of these, thanks to Gatteaux's recommendation, was from another brother-in-law of Bochet, Charles Marcotte, who had recently come to Italy to reform the administration of the country's forests and waterways. During the sittings for his portrait (cat. no. 26), Marcotte and Ingres developed a bond that—like the painter's friendship with Gatteaux—strengthened over the course of the following decades.

Following Marcotte's example, Bochet and his sister Madame Panckoucke commissioned painted portraits, which are now in the Louvre (cat. no. 30, fig. 117). At this same time Ingres also produced a drawing of Madame Panckoucke that has become one of his most famous pencil portraits (fig. 118).[1] A whole series of paintings and pencil likenesses of other officials in the French community in Rome soon followed.

It is quite possible that this is a drawing of Bochet's father. A portrait of the elder Edme Bochet painted by J.-F.-M. Bellier was published in a history of the family in 1918,[2] and the likeness there bears a certain similarity to the older man in the present drawing, dated 1814. Bochet's father would have been in his early seventies at that time (born in 1742, he died in 1837) and was about to be recalled from Rome along with the rest of the French imperial administration. Unfortunately, the resemblance between the two portraits is not so strong as to permit a firm identification.

H.N.

For the author's complete text, see Naef 1977–80, vol. 1 (1977), chaps. 28 (pp. 251–54), 39 (pp. 338–57).
 1. Gruyer 1902, no. 242.
 2. Moreau-Nélaton 1918, vol. 3, fig. 336; Naef 1977–80, vol. 1 (1977), p. 254, fig. 1.

PROVENANCE: François Flameng, Paris, by 1911; his auction, Galerie Georges Petit, Paris, May 26–27, 1919, no. 118; purchased at that sale for 8,000 francs by Jacques Seligmann & Co., New York, for The Metropolitan Museum of Art, New York

EXHIBITIONS: Paris 1911, no. 89; Springfield, New York 1939–40, no. 39; San Francisco 1947, no. 7; Cambridge (Mass.) 1967, no. 27, ill.; New York 1970, no. 45; New York 1988–89

REFERENCES: Lapauze 1911a, ill. p. 138; Saunier 1918, p. 24, ill.; Burroughs 1919, pp. 246–47, ill. p. 229; Zabel 1930, p. 382, ill. p. 381; Millier 1955, ill. p. 25; Feinblatt 1969, p. 262, fig. 5 on p. 265; Naef 1977–80, vol. 4 (1977), pp. 208–9, no. 115, ill.

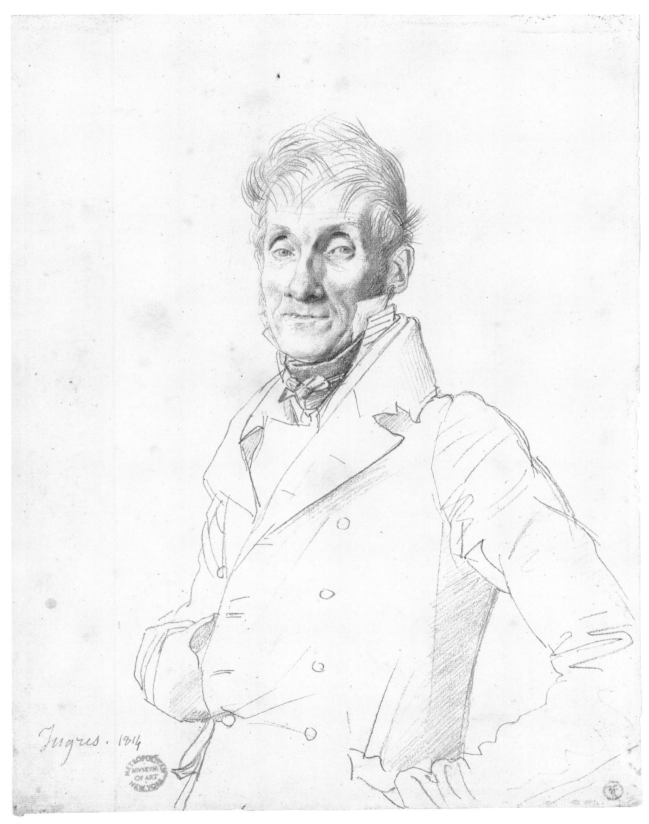

Ingres. 1814

49

50. Charles Hayard and His Daughter Marguerite

1815
Graphite
12⅛ × 9 in. (30.8 × 22.9 cm)
Signed and dated lower right: Ingres à /
Madame hayard / rome 1815 [Ingres to /
Madame Hayard / Rome 1815]
The British Museum, London *1968-2-10-19*
London and Washington only

N 133

This drawing is discussed under cat. no. 47.

PROVENANCE: Mme Charles Hayard, née
Jeanne-Susanne Alliou (1775–1854); her son-in-
law Félix Duban (according to the catalogues
of the 1861 and 1867 Ingres exhibitions); Mme
Théodore Maillot, née Félicie-Charlotte Duban,
his daughter, Paris, until 1898; Félix Flachéron,
her cousin, Paris, until 1927; Joseph Gillet until
1923; Edmond Gillet, his son; Mme Edmond
Gillet, née Motte; sold by her to César Mange
de Hauke, Paris, until 1965; his bequest to
The British Museum, London, 1968

EXHIBITIONS: Paris 1861 (1st ser.), no. 60;
Paris 1867, no. 352; Lyons 1921 (according to
Hélène Toussaint in the catalogue of London
1972); London 1968, no. 2, ill.; London 1972,
no. 663; London 1974, no. 309

REFERENCES: Galichon 1861a, p. 359; Blanc
1870, p. 237; Delaborde 1870, no. 321; Both de
Tauzia 1888, p. 141, as *M. Hazard et sa fille;* Leroi
1894–1900b, p. 818; Duplessis 1896, no. 12, ill.
(the photoengraving by E. Charreyre); Lapauze
1901, p. 266 (known from the photoengraving);
Lapauze 1911a, ill. p. 154; Ternois 1959a, preced-
ing no. 72; Naef 1966 ("Hayard"), pp. 37–50,
fig. 5; Hulton 1968, no. 2, ill.; Roberts 1968,
p. 475; Rowlands 1968, p. 44, fig. 2, p. 43; Naef
1977–80, vol. 4 (1977), pp. 242–43, no. 133, ill.

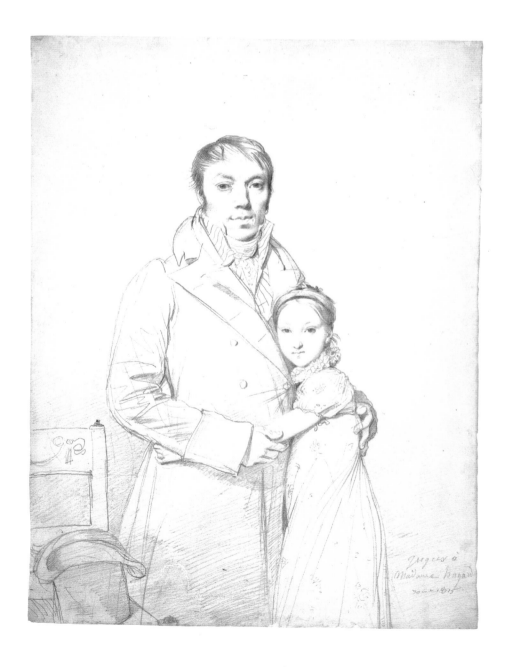

51. Mademoiselle Jeanne Hayard

1815
Graphite
11¼ × 8¼ in. (28.5 × 21 cm), framed
Signed and dated lower left: Ingres. a Mademoi-
selle / jeannette hayard / rome 1815 [Ingres.
To / Mademoiselle / Jeannette Hayard /
Rome 1815]
Private collection

N 134

This drawing is discussed under cat. no. 47.

PROVENANCE: Mlle Jeanne Hayard, later
Mme Charles-Alexandre Fouquerelle (1799–
1862); Gilbert Lévy gallery, Paris; purchased
from them in 1946 by César Mange de Hauke,
Paris, until 1965; private collection

EXHIBITIONS: Paris 1949b, no. 46; Winterthur
1955, no. 252

REFERENCES: Mathey 1945, p. 11, ill.; Mathey
1955, no. 5, ill.; Ternois 1959a, preceding no. 72;
Naef 1966 ("Hayard"), pp. 37–50, fig. 7; Radius
and Camesasca 1968, p. 124, ill.; Ternois and
Camesasca 1971, p. 124, ill.; Naef 1977–80,
vol. 4 (1977), pp. 244–45, no. 134, ill.

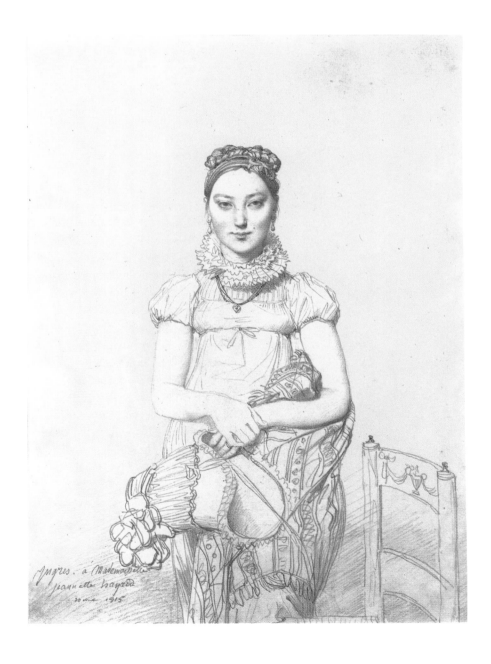

52. Guillaume Guillon Lethière

1815

Graphite

10⅝ × 8½ in. (27.1 × 21.1 cm), framed

Signed and dated lower right (erased): Ingres
rome 1815

*Inscribed by Ingres above the erased signature,
in the name of his wife:* M.^{de} Ingres /
à Mad.^{lle} Lescot. [Madame Ingres / to
Mademoiselle Lescot.]

The Pierpont Morgan Library, New York
*Bequest of Therese Kuhn Straus in memory of
her husband, Herbert N. Straus 1977.56*
New York only

N 135

The painter Guillaume Guillon Lethière
was born in Guadaloupe in 1760, the ille-
gitimate child of a King's Prosecutor and a
mulatto woman. Having demonstrated a
gift for drawing at an early age, the boy
was sent to France in 1774. Ten years after
his arrival in Paris, where he studied under
Gabriel-François Doyen, he won second
prize in the competition for the Prix de
Rome, and although he failed to achieve a
first in the following years, he was awarded
a four-year scholarship at the Villa Medici
in 1786. He first exhibited his work in the
Salon in 1793, three years after his return
from Italy.[1] His narrative paintings, none
of them especially well known, reveal a
workmanlike assimilation of the Revolu-
tionary ideals of Jacques-Louis David.

Today he is remembered more for his
associations than for his own achievements.
By 1799, at the latest, he had come to the
attention of Lucien Bonaparte, Napoleon's
younger brother, for in the following year
Lucien took him to Spain as an artistic
adviser for the year he spent as ambas-
sador to the court of Madrid.[2] Seven years
later, it was doubtless largely thanks to
Lucien, who was by then living in exile in
Rome, that Lethière was appointed direc-
tor of the Villa Medici.[3]

When the new director assumed his post
in October 1807, Ingres was beginning his
second year at the Académie. His arrival
is immediately reflected in the younger
man's work by the portrait drawing of
Lucien Bonaparte (cat. no. 38), which
appears to have been executed before the
end of that year. That nothing more came
of Ingres's encounter with Lethière's emi-
nent friend does not seem to have affected
their relationship. The superb series of
Ingres portraits of the Lethière family—at
least ten in all—extends from 1808 to 1818,
suggesting that the two men must have
become even closer friends after 1810,
when Ingres left the Villa Medici and set
himself up in rooms nearby.

There are two portraits of Lethière him-
self. The first of them, a bust likeness in
strict profile, dates from 1811, a time when
Ingres briefly—and inexplicably—

reverted to the profile view for some of his
portraits. The original drawing is in the
Fogg Art Museum, Cambridge, Massachu-
setts (N 69); a copy, also by Ingres, is pre-
served in the Musée Bonnat in Bayonne
(N 70). The second portrait composition,
from 1815, is far more impressive. Lethière
is here seen from the front, and one gets a
sense of his formidable presence. Of this
composition there are three surviving ver-
sions,[4] of which the present drawing in the
Pierpont Morgan Library is the only one
certain to have been executed by Ingres
himself. Alexander von Steuben made a
pencil drawing of the composition, and
Frédéric Legrip lithographed it, in reverse.[5]
Mademoiselle Hortense Lescot, to whom
the original drawing is dedicated, was a
pupil of Lethière, and it was rumored that
she and the director had had an affair.
Ingres had drawn her portrait the year
before (N 124).

Lethière remained as director at the
Villa Medici for nearly eight years. The
various distinctions one might have
expected him to bring with him to such a
post—membership in the Legion of
Honor, a professorship at the École des
Beaux-Arts—came to him only after his
return to France. He died in Paris during
the cholera epidemic of 1832.

Ingres's double portrait of the director's
wife and their young son, Lucien, from
1808, was one of the first of his portrait
drawings to be enriched with a back-
ground view of Rome (cat. no. 53). He
posed the two figures in the garden of the
Villa Medici, with its palace visible on the
left and the church of Santissima Trinità
dei Monti on the right. A second, undated
drawing of Madame Lethière alone, now
in the Fogg Art Museum, Cambridge,
Massachusetts (N 50), must have been
produced at about the same time.

The subject of these drawings, born
Marie-Joseph-Honorée Vanzenne, was
some years older than her husband. She
had been married before—her daughter
from that earlier union, a trained painter
who exhibited in the Salon for years,
appears in the standard dictionaries of

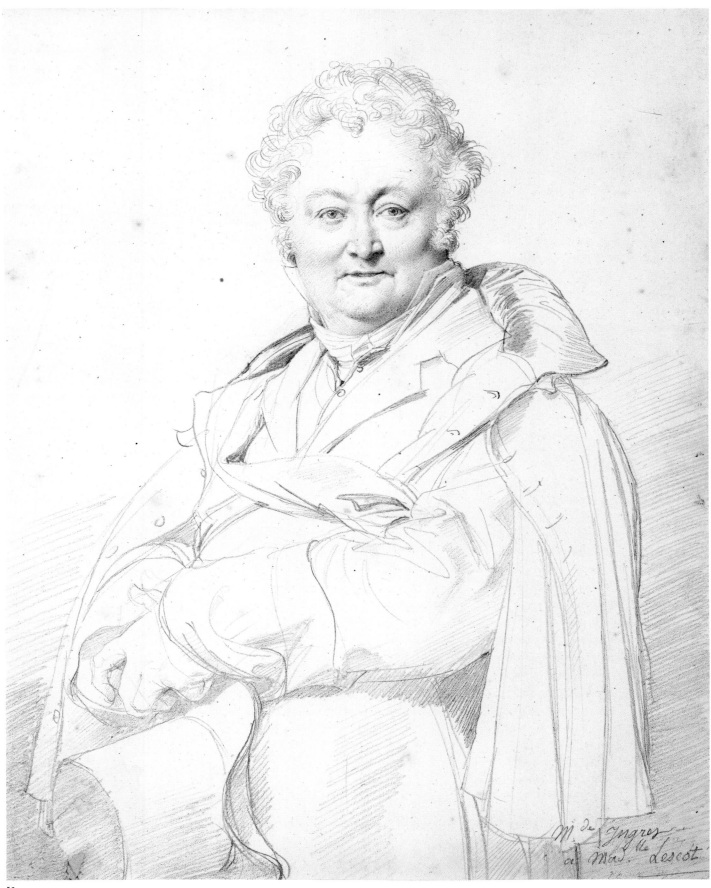

artists under the name Eugénie Servières. (Madame Lethière bequeathed Ingres's drawing of herself and Lucien to Eugénie, as indicated by an inscription on the former mount.) Lethière had married Madame Vanzenne in 1799, after fathering a son by her in 1796. Their illegitimate son, Auguste, is the subject of an Ingres portrait from roughly 1815, now in the Carnegie Museum of Art in Pittsburgh (N 141).

The jewel of the Lethière series is the drawing of a young man and wife with their child in the Museum of Fine Arts, Boston (cat. no. 55).[6] The work is, in fact, a conflation of two earlier portrait drawings, both from 1815. One of these, showing the husband alone, is now in the Musée Bonnat in Bayonne (N 138). The other, in the Metropolitan Museum (cat. no. 54), depicts the mother and child. A quick tracing Ingres made in order to determine how the two might be combined is preserved in the Musée Ingres, Montauban.[7] In it he changed none of the outlines but omitted Alexandre's walking stick and hat. He then proceeded to the finished drawing, making only slight alterations to improve the composition. There, the wife rests her hand lovingly on her husband's arm, and the child, barely visible before, is now seated on her mother's lap—a change that doubtless required an additional sitting. The result is an extraordinary image of connubial affection and contentment.

The strapping man in the family portrait is Lethière's son Alexandre, born in Paris in 1787. Nothing is known of his mother except her name, and the extant documents do not tell us whether the elder Lethière was married to her. After having served as a sailor in the Napoleonic Wars and survived imprisonment by the English, Alexandre joined his father at the Villa Medici, where he promptly fathered a child by one of the housekeepers—a woman who also appears in an Ingres portrait.[8] Three years later, he married Rosa Meli, the fifteen-year-old daughter of an apothecary who lived near the Académie. Their daughter, Letizia—the child in the family portrait—was born in August 1814, and a son, Charles, in 1816.

Charles is pictured separately as a two-year-old in a charming Ingres portrait in the Musée des Arts Décoratifs in Paris (cat. no. 81). He was the only member of the family, seemingly so blessed, to live a long and productive life. His mother had already died, not yet twenty, when Ingres did the drawing of him. His father died in Paris in 1824 as a result of his war wounds and maltreatment at the hands of his captors. Charles's sister, Letizia, lived only to the age of thirteen.

Charles ultimately became a respected doctor in Paris and died at seventy-three in 1889. H.N.

For the author's complete text, see Naef 1977–80, vol. 1 (1977), chap. 43 (pp. 403–20).

1. Thieme and Becker 1907–50, vol. 23 (1929), p. 138.
2. Piétri 1939, p. 130.
3. Lapauze 1924, vol. 2, p. 79. Lethière's portrait of Empress Josephine (fig. 70) dates from the same year.
4. They are: the present drawing (N 135), an unsigned drawing in a private collection (N 136), and a third, signed drawing (N 137), known only from reproductions in Martine 1926, vol. 5 (no. 66), in the catalogue of the J[acques-Auguste] Boussac sale, Galerie Georges Petit, Paris, May 10–11, 1926, no. 246, ill. p. 111, and in Naef 1977–80, vol. 1 (1977), p. 409, fig. 5.
5. For the lithograph by Legrip, see Chennevières 1853, ill. opp. p. 43. For the drawing by Steuben, see Paris 1964, which includes the following statement about item no. 75: "Alexandre Joseph de Steuben: *Le peintre Guillon-Lethière*, black pencil drawing with white highlights, 230 × 300, has been lithographed in reverse by R. [sic] Legrip." Steuben's copy after Ingres was sold before 1967 by Prouté's to Jean Furstenberg, Paris.
 The catalogue of an anonymous auction, Hôtel Drouot, Paris, room 7, November 13, 1922, mentions under no. 12 (withdrawn) an authentic drawing by Ingres from the former collection of Dr. [Charles] Lethière, grandson of the subject, who died in Paris in 1889; in 1961 the author [H.N.] saw the drawing that is related to the lithograph by Legrip in the collection of Baron Pierre Ordioni, a relative of the subject.

6. See the catalogue of an anonymous sale, Hôtel Drouot, Paris, room 7, November 13, 1922, no. 13, which is described as *Portraits de Guillon Lethière fils et de sa famille*, withdrawn. In 1952 the Parisian art expert Gaston Delestre saw this drawing in the collection of the Pierre Ordioni family, who are related to the Alexandre Lethières. He also saw in the Ordioni collection a copy, not by Ingres, of the present drawing in the Museum of Fine Arts, Boston.
7. Naef 1977–80, vol. 1 (1977), p. 412, fig. 12.
8. See ibid., chap. 44 (pp. 421–27).

PROVENANCE: Mlle Hortense Lescot, later Mme Louis-Pierre Haudebourt, Paris, until 1845; Adrien Fauchier-Magnan, Cannes, from 1913 at the latest to at least 1921; unknown collector; acquired in 1929 by Galerie Wildenstein, Paris, and from them in 1930 by Mr. and Mrs. Herbert N. Straus, New York; Bequest of Therese Kuhn Straus (1884–1977) to The Pierpoint Morgan Library, New York, in memory of her husband, Herbert N. Straus, 1977

EXHIBITIONS: Paris 1913, no. 332, ill. opp. p. 80; Paris 1921, no. 64; Buffalo 1935, no. 95, ill.; Springfield, New York 1939–40, no. 47; possibly exhibited briefly in 1955 at the Fogg Art Museum, Cambridge (Mass.), while on deposit there from the collection of Mrs. Herbert N. Straus; New York 1961, no. 6, ill.; Cambridge (Mass.) 1967, no. 30, ill.; New York 1984, no. 100, ill.; Paris, New York 1993–94, no. 102, ill.

REFERENCES: Chennevières 1853, ill. opp. p. 43 (the lithograph, in reverse, by Frédéric Legrip); Jouin 1888, p. 119 (if not a reference to another portrait of Lethière);* Lecomte 1913, ill. p. 18; *La Renaissance de l'art français* 1921, ill. p. 228; Zabel 1930, ill. p. 379; Bonnaire 1937–43, vol. 3 (1943), ill. opp. p. 192 (the lithograph by Legrip); Louchheim 1944, p. 129, ill. p. 132; Mongan 1947, no. 9, ill.; Naef 1963 ("Familie Lethière"), pp. 65–78, fig. 1, p. 67; Paris 1964, no. 75, ill. (the drawing by Steuben); Schlenoff 1967, p. 379; Feinblatt 1969, p. 262, fig. 4; Mongan 1969, p. 141; Naef 1972 ("Villa Medici"), p. 660, ill.; Naef 1977–80, vol. 4 (1977), pp. 246–48, no. 135, ill.; New York, Morgan Library 1978, pp. 244, 269, ill.; Denison and Mules 1981, pp. 129–30, no. 120, ill.; Van Witsen 1981, ill.; *Ingres Portrait Drawings* 1993, ill.

*See Jouin 1888, p. 204: "drawing by Steuben, Louvre." The author has been personally informed that the Louvre does not have any drawings by Steuben in its collection.

53. Madame Guillaume Guillon Lethière, née Marie-Joseph-Honorée Vanzenne, and Her Son Lucien Lethière

1808

Graphite

9 ½ × 7 ⅜ in. (24.1 × 18.7 cm)

Signed and dated lower right: Ingres. rome /
1808.

*At lower left, The Metropolitan Museum of Art,
New York, collection stamp (Lugt 1943)*

*Inscribed by Madame Guillaume Guillon
Lethière on the former mount:* pour ma fille /
Servière. [for my daughter / (Eugénie
Servières).]

*The Metropolitan Museum of Art, New York
H. O. Havemeyer Collection, Bequest of
Mrs. H. O. Havemeyer, 1929 29.100.191*
New York and Washington only

N 51

This drawing is discussed under cat. no. 52.

PROVENANCE: Mme Guillaume Guillon
Lethière, Paris, until 1838; given by her to her
daughter, Mme Eugénie Servières, née Charen
(according to an inscription on the former mount),
Paris, until her death in 1855; purchased from a
private collection in France by Henry O. Have-
meyer (1847–1907); his widow, Louisine W.
Havemeyer (1855–1929); her bequest to The
Metropolitan Museum of Art, New York, 1929

EXHIBITIONS: New York 1930, no. 190, ill.;
Springfield, New York 1939–40, no. 38; San
Francisco 1947, no. 1, ill.; Philadelphia 1950–51,
no. 82, ill.; Rotterdam, Paris, New York 1958–59,
no. 127, pl. 93, and see also pl. 101; Cambridge
(Mass.) 1967, no. 10, ill.; Paris 1967–68, no. 36,
ill.; New York 1970, no. 40; Washington, New
York, Philadelphia, Kansas City 1971, no. 143,
ill.; New York 1978, no. 60; New York 1988–89

REFERENCES: *Kunst und Künstler* 1930, ill.
p. 381; *Havemeyer Collection* 1931, p. 190, ill.
p. 187; Wilenski 1931, p. 198, pl. 82; Clarke 1939,
ill. p. 9; Rewald 1943, ill. p. 10; Holme 1944,
p. 13, pl. 93; Mongan 1944, p. 392; *Art Digest*
1946, ill. p. 13; Mongan 1947, no. 2, ill.; Daven-
port 1948, vol. 2, no. 2285, p. 816, ill. p. 817
(detail); Alazard 1950, pl. XVII; Slatkin and
Slatkin 1950, p. 110, pl. 62; Parker 1955, pp. [13–
14], ill. p. [14]; Bouchot-Saupique 1958, ill. on
pl. [22]; Naef 1960 *(Rome)*, p. 27, n. 52; Naef
1963 ("Familie Lethière"), pp. 65–78, fig. 4
(both sitters identified); Anon., March 11, 1967,
ill. p. 22; Levey 1968, p. 44; Paisse 1968, pp. 17, 18;
Radius and Camesasca 1968, p. 122, ill.; Gilles 1969,
p. 155, fig. 4, p. 149; Jullian 1969, p. 89; Mongan
1969, p. 141; Hattis 1971, ill. p. 29; Ternois and
Camesasca 1971, p. 122, ill.; Delpierre 1975,
pp. 21–22; Naef 1977–80, vol. 4 (1977), pp. 96–98,
no. 51, ill.; Ternois 1980, p. 35; Mráz 1983, p. 41,
no. 11, ill.; Vigne 1995b, p. 91, ill. p. 94

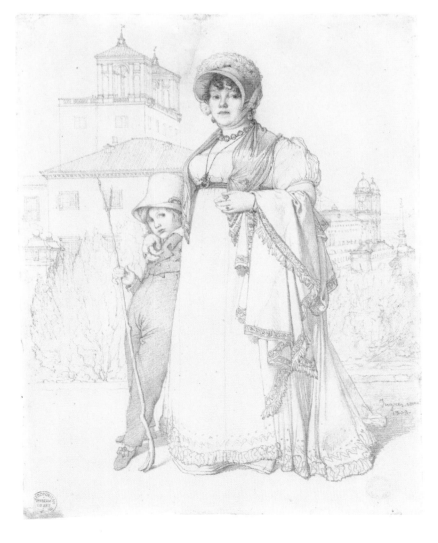

54. Madame Alexandre Lethière, née Rosa Meli, and Her Daughter, Letizia

1815
Graphite
11⅞ × 8¼ in. (30 × 22 cm)
The Metropolitan Museum of Art, New York
Bequest of Grace Rainey Rogers, 1943 43.85.7
New York only

N 139

This drawing is discussed under cat. no. 52.

PROVENANCE: Marquis de Biron;* by 1921, Galerie Wildenstein, Paris; sold about 1940 by Wildenstein & Co., Inc., New York, to Mrs. Grace Rainey Rogers (1867–1943), New York; her bequest to The Metropolitan Museum of Art, New York, 1943

EXHIBITIONS: Paris 1921, no. 66, ill. p. 35, as *La Fille et la petite-fille du peintre Guillon-Lethière;* New York 1961, no. 18, ill., as *Mme Guillon-Lethière and Her Son Charles;* Cambridge (Mass.) 1967, no. 31, ill.; Paris 1967–68, no. 81, ill.; New York 1978, no. 61; New York 1988–89

REFERENCES: *La Renaissance de l'art français* 1921, ill. p. 229, as *La Fille et la petite-fille du peintre Guillon-Lethière;* Burroughs 1946, ill. p. 159; Ternois 1959a, preceding no. 63, see also fig. 63; Naef 1963 ("Familie Lethière"), pp. 65–78, fig. 7 (sitter identified), see also ill. p. 78; Anon., March 11, 1967, ill. p. 25; Marjorie B. Cohn in Cambridge (Mass.) 1967, pp. 243, 244; Cohn 1968, p. 58; Levey 1968, p. 44, pl. 33; Paisse 1968, pp. 17, 19; Mongan 1969, p. 144, fig. 16, p. 152; Paisse 1971, pp. 13–19; Delpierre 1975, pp. 23, 24; Naef 1977–80, vol. 4 (1977), pp. 252–53, no. 139, ill.; Burn 1984, pp. 9, 106, ill. p. 8

*According to Burroughs 1946; not in the catalogue of the Biron auction, Paris, June 9–11, 1914.

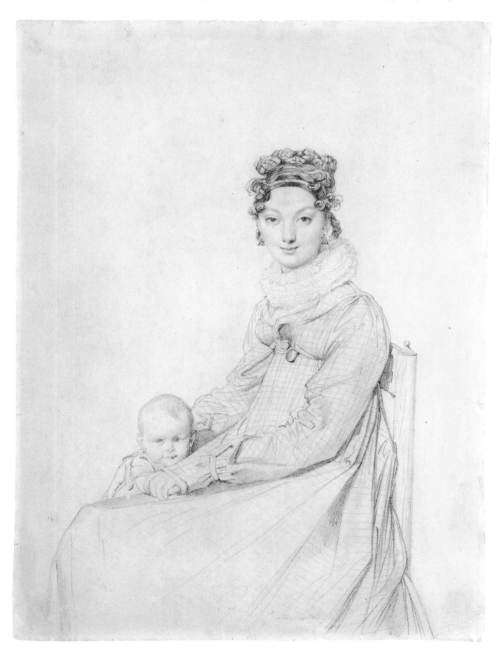

55. The Alexandre Lethière Family

1815
Graphite
$10\frac{5}{8} \times 8\frac{3}{8}$ in. (27.1 × 21.4 cm), framed
Signed and dated lower left: Ingres — à /
Monsieur Lethière / rome 1815 [Ingres —
for / Monsieur Lethière / Rome 1815]
Museum of Fine Arts, Boston
Maria Antoinette Evans Fund 26.45

N 140

This drawing is discussed under cat. no. 52.

PROVENANCE: Probably either Alexandre
Lethière, Paris, until 1827, or his father, Guil-
laume Guillon Lethière (1760–1832), Paris, until
1832; Dr. Charles Lethière, son of Alexandre
Lethière, Paris, until 1889; Mme Charles Lethière,
née Clémence Laurent, his widow, Guichainville
(Eure), until 1901; unknown collector; purchased
from that collector in 1913 by Carlos de Bestegui
for 45,000 francs (according to Lapauze 1918);
purchased from the Wildenstein gallery by the
Museum of Fine Arts, Boston, 1926

EXHIBITIONS: Paris 1861 (1st ser.), no. 67;
Cambridge (Mass.) 1934, no. 43; Buffalo 1935,
no. 94, ill.; Philadelphia, Washington 1937–38;
San Francisco 1940, no. 56, ill.; Worcester
1951–52, no. 39; Montreal 1953, no. 184, ill.; Paris
1955, no. 81, pl. 4; New York 1961, no. 17, ill.;
Cambridge (Mass.) 1967, no. 32, ill.; Paris
1967–68, no. 82, ill.; Paris 1973–74, no. 52, ill.,
pl. 9; Boston 1988; Boston 1992

REFERENCES: Blanc 1861, p. 191; Delaborde
1861, p. 267; Galichon 1861a, p. 360; Delaborde
1870, no. 354; Both de Tauzia 1888, p. 141; Mom-
méja 1905a, p. 54, under no. 318; Lapauze 1918,
p. 349; *La Renaissance de l'art français* 1921, ill.
p. 218; Anon., June 1926, p. 38, ill. p. 37; McKee
1927, p. 93; Zabel 1929, p. 116; *Kunst und Künstler*
1930, ill. p. 381; Zabel 1930, p. 381, ill. p. 382;
Benson 1937, p. 11, ill. (supplement); Clarke
1939, ill. p. 9; Pach 1939, ill. opp. p. 102; Frank-
furter 1940, ill. p. 14; Slatkin and Slatkin 1942,
p. 547, fig. 507; Holme 1944, p. 13, pl. 92; Mongan
1947, no. 8, ill.; Tietze 1947, p. 248, no. 124, ill.
p. 249; Alazard 1950, p. 63, pl. XXXI; Slatkin
and Slatkin 1950, p. 114, pl. 64; Ternois 1959a,
preceding and under no. 65, see also fig. 65; Naef
1963 ("Familie Lethière"), pp. 65–78, fig. 5 on
p. 71 (sitter identified), see also ill. p. 78; *Boston
Museum Bulletin* 1967, no. 34, ill.; Durbé and
Roger-Marx 1967, ill. p. [3]; Mongan 1967, ill.
p. 26; Pincus-Witten 1967, p. 48; Waldemar
George 1967, ill. p. 61; Butler 1968, ill. p. 270;
Cohn 1968, pp. 55, 58; Paisse 1968, p. 18, n. 12;
Radius and Camesasca 1968, p. 122, ill.; Mongan
1969, p. 144; Naef 1969 ("Louise Lafont"), p. 35,
pl. 25; Paisse 1971, pp. 13–19; Ternois and Came-
sasca 1971, p. 122, ill.; Delpierre 1975, p. 23; Naef
1977–80, vol. 4 (1977), pp. 254–56, no. 140, ill.;
Condon 1996, p. 838, fig. 2

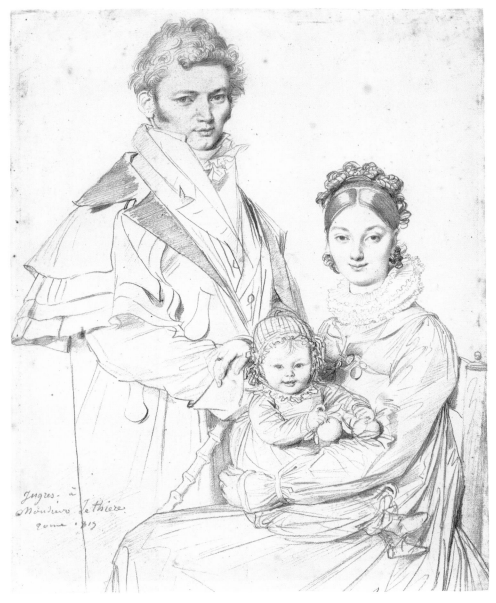

56. Frau Johann Gotthard Reinhold, née Sophie Amalie Dorothea Wilhelmine Ritter, and Her Two Daughters, Susette and Marie

1815
Graphite
11 5/8 × 8 1/2 in. (29.6 × 21.7 cm), framed
Signed and dated lower right: Ingres Del. rome 1815. [Ingres drew (this in) Rome 1815.]
Private collection

N 149

Johann Gotthard Reinhold, Dutch ambassador to Rome from 1814 to 1827, commissioned at least three portraits from Ingres: this one of his wife and daughters, one of his sister-in-law (N 200), and one of his unmarried sister (N 185; Städelsches Kunstinstitut, Frankfurt am Main). As the name suggests, Reinhold was actually German. He was born in Aachen in 1771, but his father, a merchant, moved the family to Amsterdam soon afterward. The boy was sent back to Germany for his schooling, first to Heidesheim and subsequently to the Karlsschule in Stuttgart, where he became acquainted with the playwright Friedrich von Schiller, whom he fervently admired the rest of his life, and formed a close friendship with Johann Georg Kerner, later an ardent republican and physician in Hamburg.

Reinhold left the Karlsschule in 1783 to prepare for a mercantile career in Frankfurt am Main, but he soon realized that such a vocation was wholly unappealing to him, and instead volunteered for military service in the Netherlands. In 1795 his friend Kerner convinced him that he would make better use of his knowledge and talents as a diplomat and secured him a job as secretary to the Dutch legation in Hamburg. By 1800 Reinhold had himself become ambassador, and he held that post until 1809, when he was transferred to Berlin as minister plenipotentiary. In Hamburg he moved in liberal, intellectual circles, and was admired for his poetic and noble character and unpretentious competence. There, in 1808, he married Sophie Amalie Dorothea Wilhelmine (called Minna) Ritter, from Nienburg, near Hannover. Their daughter Susette was born in Hamburg in 1808, and a second daughter, Marie, in Berlin in 1810. (Susette is on her mother's left in the family portrait, Marie on her right.)

When Holland became a part of France in 1810, Reinhold's antipathy to Napoleonic world rule made it impossible for him to transfer to the French foreign service, and

he therefore returned to private life and moved to Paris. There he devoted himself to writing and study. After the fall of Napoleon, the king of the Netherlands appointed him ambassador to Rome and Florence, and then in 1827 he was transferred to Bern. He retired in 1832, settling again in Hamburg. He died in 1838, and an unpublished obituary concludes: "He was more scholar than soldier, more man of the world than scholar, but in truth more poet than man of the world and scholar."[1]

Ingres's first work for Reinhold, this portrait of his wife and children, is dated 1815. With the collapse of the Napoleonic empire, the still relatively unknown artist had lost his most important patrons and was forced back on his pencil portraits for income. Given the ambassador's reputation for kindness and his artistic nature, it is understandable that he would have wished to help Ingres. Reinhold's other commissions followed in 1816 and 1817.

The Reinholds' older daughter, Susette, died at thirteen and was buried in the Protestant cemetery in Rome. Marie returned with her parents to Hamburg, where three years after her father's death she married the merchant Louis Köster. With her husband, she commissioned the publication of her father's writings.[2] As edited by the German author and diplomat Karl August Varnhagen von Ense, the first volume contains Reinhold's own poems and a selection of his translations of English verse, the second his translations from the Italian, most notably the sonnets and canzone of Petrarch.

Varnhagen visited the Kösters in Hamburg in 1850, possibly in connection with the publishing project. His diary includes the tantalizing entry: "June 17, 1850: Called on Herr Köster and his wife, née von Reinhold. Portraits of Reinhold, the family, drawn by Ingres in Rome; refined, genuine culture."[3] Clearly, Varnhagen saw the group portrait and the portrait of Reinhold's sister-in-law, but not necessarily the one of Reinhold's sister. Was there also one of

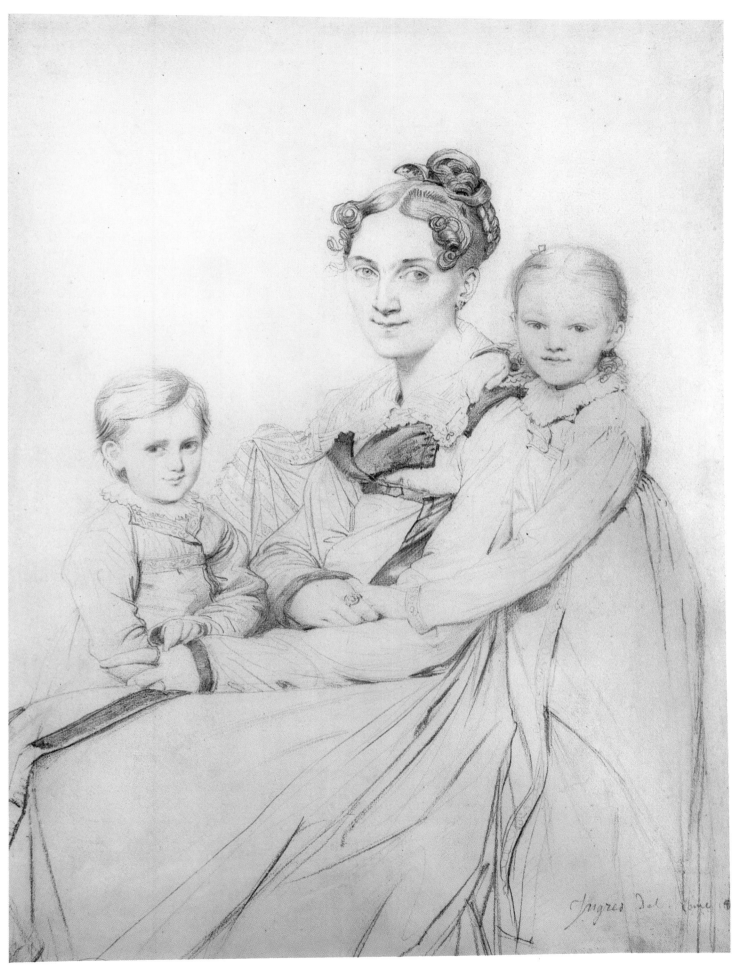

Reinhold himself? It only makes sense that Ingres, after having produced likenesses of the rest of the household, should also have portrayed his patron. However, it is known that the man was self-effacing, and one of his friends remarked that he was physically unattractive,[4] so it is altogether conceivable that he chose not to sit for the young Frenchman.

The jewel of the Reinhold drawings is the group portrait. It is made especially enchanting by one of the most charming arabesques Ingres ever conceived: Frau Reinhold holds her arms crossed on her lap, grasping the arms of her children in such a way that the three are linked together in a knot of affection. Moreover, the faces of the two daughters are as pure and loving as any in the Ingres oeuvre.

H. N.

For the author's complete text, see Naef 1977–80, vol. 1 (1977), chap. 54 (pp. 491–503).
1. Unattributed quote in Beneke 1889, p. 81.
2. Reinhold 1833.
3. Varnhagen von Ense 1861–1905, vol. 7 (1865), p. 220.
4. Rist 1884–88, vol. 2 (1886), pp. 25–26.

PROVENANCE: Johann Gotthard Reinhold, Hamburg until 1838; his widow, née Minna Ritter, Hamburg, until 1846; their daughter, Frau Louis Köster, née Marie Reinhold, Hamburg, until 1873; probably her husband, Louis Köster, Hamburg, until 1880; the New York art dealer Martin Birnbaum; purchased from him, by Mrs. John D. Rockefeller II, née Abby Aldrich (1874–1948), 1931; Mr. and Mrs. John D. Rockefeller II, until the death of Mrs. Rockefeller; John D. Rockefeller II (1874–1960); his son David Rockefeller, New York; the present owner

EXHIBITIONS: New York 1953; Cambridge (Mass.) 1967, no. 34, ill.

REFERENCES: Varnhagen von Ense 1861–1905, vol. 7 (1865), p. 220 (entry for June 17, 1850); Anon., Easter 1956 (V.), p. 8; Naef 1956 (Reinhold), pp. 649–54 (sitter identified); Naef 1958 ("Meisterwerk"), p. 9; Birnbaum 1960, p. 188; Naef 1967 ("Musée Fogg"), p. 6, n. 1; Mongan 1969, p. 144, fig. 18, p. 153; Naef 1977–80, vol. 4 (1977), pp. 274–75, no. 149, ill.; Potter 1984, pp. 100–101, no. 15, ill.

57. John Russell, Sixth Duke of Bedford

1815
Graphite
14⅞ × 11¼ in. (37.8 × 28.5 cm), framed
Signed and dated lower left: Ingres. fec. Roma 1815. [Ingres made (this in) Rome 1815.]
The Saint Louis Art Museum
Purchase 354:1952

N 152

Six of the roughly thirty Ingres portraits of Englishmen were executed in 1815. The first is that of the Honorable Frederick North (N 150; Art Gallery of New South Wales, Sydney), which appears to have been done in November. It is not surprising that the artist's portrait of John Russell, sixth duke of Bedford was among the earliest, for he had been in Italy since 1813 and moved in French circles there. By January 1815, at the latest, he and his wife were regularly in touch with Lucien Bonaparte (see cat. no. 38), and that May he was in Naples, where he saw to it that Bonaparte's sister Queen Caroline Murat (see cat. no. 34) was safely transported into exile. Either Lucien or Caroline could have shown him superb examples of the young Frenchman's work, and the magnificent portrait he soon obtained for himself cannot have failed to meet his high expectations.

It appears that Bedford promptly gave the artist another commission, the design of a tomb monument for his wife's niece, Lady Jane Montagu, who had died in Italy in September.[1] Since the Bedfords were on friendly terms with Mrs. John Theophilus Rawdon in Rome, it is also more than likely that it was he who recommended Ingres to her. Sadly, the drawings the artist did of her (see cat. no. 58) and her daughter Elizabeth Anne, who would soon marry one of the duke's sons, have disappeared.

The fortune of the Russells, one of the most famous and wealthy families in England, derived from gifts of confiscated monastic lands presented by Henry VIII to his Lord Privy Seal, John Russell, in 1550, at the time he named him earl of Bedford. The fourth earl of Bedford engaged Inigo Jones to design London's Covent Garden Square, and the fifth duke was responsible for both Russell and Tavistock squares. The ducal seat is magnificent Woburn Abbey, in Bedfordshire.

The John Russell who sat for Ingres was born in London in 1766. After tours of duty as an officer in the Bedfordshire militia and the Third Regiment of Footguards, he entered politics, winning election to the

House of Commons in 1788 and serving there until 1802. In that year, when his unmarried older brother, Francis, died unexpectedly at the age of thirty-four, he succeeded to the dukedom. In 1806–7 Russell served as lord lieutenant of Ireland, then withdrew from political life to devote himself to improving the agricultural yield on his estates. During his stay in Italy, he added significantly to the art collections at Woburn Abbey by commissioning works from Antonio Canova and Bertel Thorvaldsen, among others.

His first wife, Georgina Elizabeth Byng, died in 1801, leaving him three sons, the youngest of whom, John, would become the great liberal prime minister and states-man. Two years later, he married a woman also named Georgina, the daughter of the fourth duke of Gordon, with whom he had seven sons and three daughters. He remained a committed Whig and a pro-gressive until his death, in 1839, but none-theless chose to live in feudal comfort. In 1959 the thirteenth duke wrote of him:

> The sixth Duke had remained sufficient of an eighteenth-century survival to adopt a distinctly lofty attitude towards his ten-antry. It is of his *ménage* at Woburn dur-ing some of the hungry years of the eighteen-twenties and -thirties that the story is told of starving people standing outside his dining-room windows having the remains of his sumptuous meals shov-elled out to them. Something of this atti-tude remained in the family until my day.[2]

The most notable member of the family in our own century was the philosopher Bertrand Russell, a great-grandson of the duke portrayed by Ingres.

A detail of this portrait drawing, with the composition in reverse, was engraved by J. H. Wiffen in 1824. H.N.

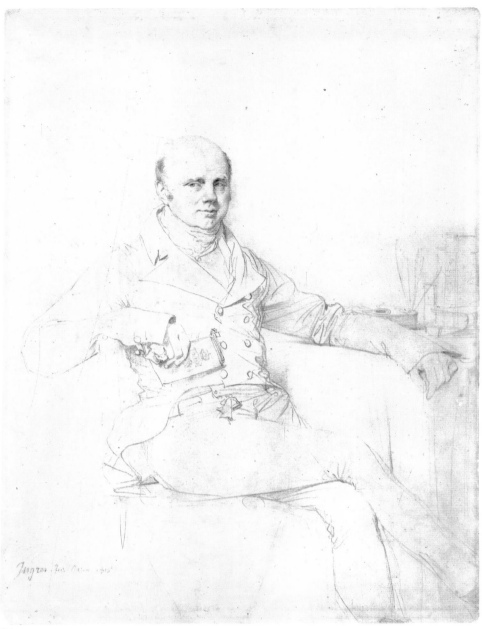

57

For the author's complete text, see Naef 1977–80, vol. 1 (1977), chap. 57 (pp. 563–70).
1. See ibid., vol. 2 (1978), pp. 5–6, fig. 2.
2. Bedford 1959, pp. 114–15.

PROVENANCE: John Russell, sixth duke of Bedford (1766–1839), Woburn Abbey, Bedford-shire; descendants of the sitter or, by inheritance, the dukes of Bedford at Woburn Abbey until 1952, at the latest; consigned by the twelfth duke of Bedford before June 1952 to the Edward

Speelman gallery, London, and sold by them before July to the Otto Wertheimer gallery, Paris; acquired by the City Art Museum of Saint Louis (now The Saint Louis Art Museum), Saint Louis, Mo., December 1952

EXHIBITIONS: Rotterdam, Paris, New York 1958–59, no. 130, ill.; Newark 1960, no. 61, ill.; Los Angeles 1961, no. 68, ill. p. 63; Cambridge (Mass.) 1967, no. 35, ill.; Paris 1967–68, no. 86, ill.; Saint Louis 1973; Saint Louis 1992

REFERENCES: O'Donoghue 1908–25, vol. 1 (1908), p. 157 (the engraving by J. H. Wiffen); Naef 1952, pp. 438–40, ill.; Anon., February 1953, ill.; Comstock 1953, p. 69, ill.; Eisendrath 1953, pp. 14–16, ill.; Anon. 1954, ill. p. 189; Naef 1956 ("English Sitters"), p. 428, fig. 10, p. 433; Bouchot-Saupique 1958, p. [7]; Mongan 1969, p. 146, fig. 21 on p. 154; Blakiston 1972, ill. opp. p. 79; Naef 1977–80, vol. 4 (1977), pp. 280–81, no. 152, ill.; Steiner 1991, p. 135; Edinburgh 1995, p. 39, fig. 43; Madrid 1997–98, ill. p. 81

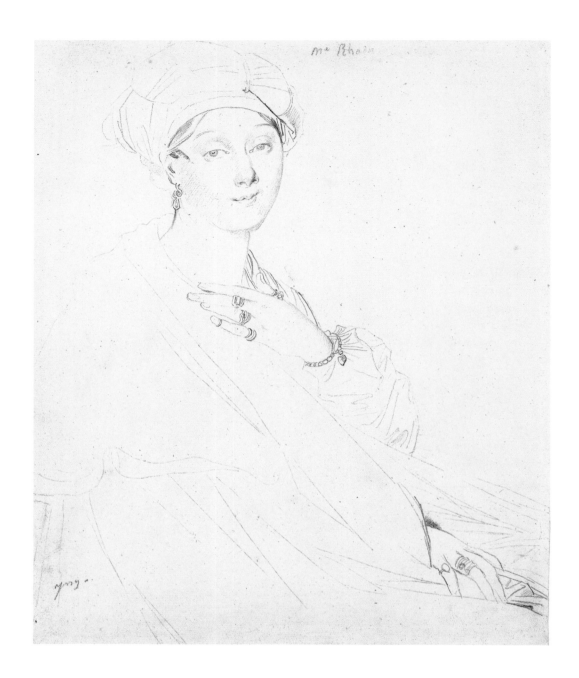

58. Madame R———, possibly Mrs. John Theophilus Rawdon, née Frances Hall-Stevenson

ca. 1815–30
Graphite
8 × 6½ in. (20.4 × 16.6 cm), framed
Signed lower left: Ing ———.
Inscribed top, right of center: m^e Rhodn *[?]*.
The Metropolitan Museum of Art, New York
Robert Lehman Collection, 1975 1975.1.649
New York only

N 157

According to costume expert Madeleine Delpierre, the clothing the sitter wears in the drawing would date it to about 1825–30, but the restrained elegance of the depiction is more reminiscent of the portraits of English subjects that Ingres began drawing in Rome in 1815. The name of the subject cannot be deciphered with certainty; it appears to be English, but the question is complicated by the fact that Ingres was a notoriously bad speller. Accordingly, the sitter is still unidentified, though it is possible that she was Frances Hall-Stevenson, wife of John Theophilus Rawdon, second son of the earl of Moira.

Interpretation of the drawing is made more difficult by its unusual execution, with only a minimum of shading. The abbreviated signature, which is frequently found on drawings from Ingres's own

collection, suggests that the artist drew the portrait not for his model but for himself, and in fact the work was in the possession of Ingres's widow after his death. Conceivably a richer, more energetically executed version of the portrait was produced for the sitter and has disappeared. It was not unprecedented for Ingres to keep for himself a more modest version of a portrait presented to the subject.

H.N.

PROVENANCE: The artist's widow, née Delphine Ramel (1808–1887); perhaps by 1905* or by 1911, Camille Groult; his auction, Galerie Georges Petit, Paris, June 21–22, 1920, no. 165, as *Madame Rhode*, sold to Dr. Lucien-Graux; Mme Lucien-Graux, née Flavigny, Paris, his widow; sold or consigned for sale by her about 1956; Robert Lehman, New York, by 1957; his bequest to The Metropolitan Museum of Art, New York, 1975

EXHIBITIONS: Paris 1957b, no. 138, pl. LXVIII, as *Madame Rhoda;* Cincinnati 1959, no. 275, as *Madame Rhode;* New York 1980–81, no. 52, ill.; Copenhagen 1986, no. 1; New York 1988a; New York 1988–89

REFERENCES: Delaborde 1870, no. 241, as *Madame Rha——;* Lapauze 1911a, ill. p. 122, as *Mme Rhode;* Fröhlich-Bum 1924, pl. 20, as *Mme Rhode;* Miller 1938, p. 7, fig. 1, p. 2, as *Mme Rhode*, dated 1809 without substantiation; Gasser 1943, ill. p. 30, as *Mme Rhode;* Berger 1949, p. 13, fig. 5, as *Mme Rhode;* Bertram 1949, pl. XIII, as *Mme Rhode;* Naef 1950, ill. p. 5; Naef 1956 ("English Sitters"), pp. 432–33, fig. 12, as *Mrs. Rhode*, a version of a more fully worked up drawing; Heise 1959, pp. 79, 80, fig. 60, as *Mme Rhode;* Naef 1977–80, vol. 4 (1977), pp. 286–88, no. 157, ill.

*In the 1905 exhibition at the Grand Palais, Paris, no. 17, which may have been this drawing, is described as in the collection of M. Camille Groult.

59. Lady William Henry Cavendish Bentinck, née Lady Mary Acheson

1815
Graphite
16⅛ × 11¼ in. (40.9 × 28.7 cm)
Signed and dated lower left: Ingres Del. /
rome 1815 [Ingres drew (this) / Rome 1815]
Rijksprentenkabinet, Rijksmuseum,
Amsterdam RP-T-1953-209
London and Washington only

N 159

Among Ingres's Roman portraits of English subjects is a drawing, dated 1816, depicting Lord William Bentinck and his wife, née Lady Mary Acheson (fig. 105). It was the only one of the group known to Ingres scholars in the nineteenth century,[1] and even today it is the only one in a public collection in France.[2] Bentinck was one of the most prominent of Ingres's English sitters, and unlike the many Englishmen who flocked to Rome after Napoleon's fall, having been prevented from making a visit to Italy during his reign, he had been serving his country in the Mediterranean region for years.

Born in 1774, the second son of the third duke of Portland, William Henry Cavendish Bentinck had begun his career as a soldier and participated in many of the most important allied engagements against the French armies.[3] In 1803 he had married Lady Mary Acheson, the second daughter of the first earl of Gosford, and been dispatched to India as governor of Madras. Recalled in 1807, he had again fought the French—in the Peninsular War—then in 1811 had been ordered to Sicily as ambassador to the court and as commander of allied units on the island. After the fall of Napoleon, he retired to private life and took up residence in Rome for a time, and thus it was that he and his wife came to be immortalized by Ingres.

In 1828 Bentinck was again sent to India, first as governor of Bengal and ultimately as governor-general. Ill health forced him to resign his post and return home in 1835, where he refused a peerage so as to be able to advance his liberal ideas in the House of Commons. He died in 1839 in Paris, where he appears to have spent most of the last two years of his life.

The wife who mourned him appears to have provided him with all the domestic happiness such a man could have wished for, except children. Born into an aristocratic Irish family, Lady Mary Acheson was not especially intelligent, but her lack of brilliance was more than compensated by her ingenuous kindness. In the exalted status she attained at her husband's side she shone, not because she pretended to be something she was not, but rather thanks to her utter lack of guile, which ultimately disarmed her more worldly critics. Countess Harriet Granville wrote of her in 1824

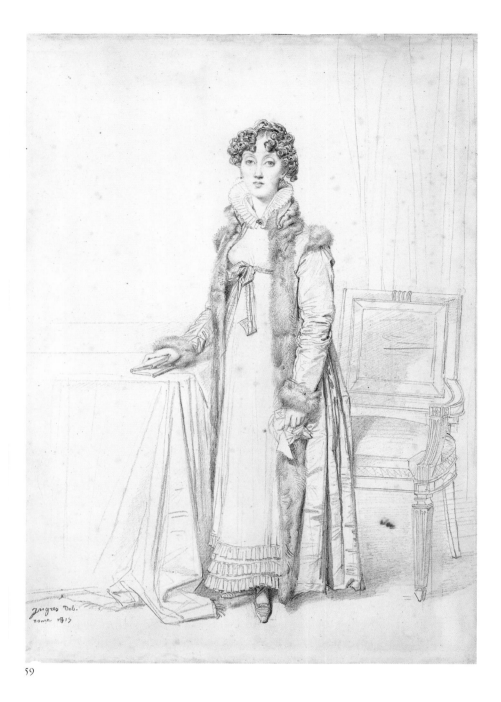

59

Ingres produced three portraits of Lady William Bentinck. This one, from 1815, is the most lavish, depicting her at full length. The other two date from 1816, one in half-length (cat. no. 63) and one in three-quarters length, seated next to her husband (fig. 105). The large-format portrait of 1815 was first exhibited in London in 1917, at which time it was owned by a Mrs. Edward Stapleton.[6]

The second portrait of Lady William Bentinck alone was first published by Henry Lapauze in 1919.[7] He had acquired it from an English collection a short time before, but he never revealed where he found it. On the back of its former mount are four old notations in various, barely legible, hands. They are, in sequence:

1. the gift of great lady Gosford to [?] / Hariet [sic] Gratt[an?].
2. lady Gosford mariée à lord Bentinck.
3. Jesus died for the [...edge of the paper] / and for [?] yo[...].
4. Ingres dessina deux ou trois / portraits de la même.

The first notation suggests that the sitter had the drawing made for her mother, Lady Gosford, who then presented it to a Harriet Gratt[an?]. As noted above, Lady William Bentinck's family was Irish, and Grattan is an Irish name. Its most illustrious bearer was the statesman and champion of independence for Ireland, Henry Grattan (1746–1820), of whom Lady Gosford may well have been an admirer. As it happens, he did have a daughter named Harriet, who married a Reverend William Wake.[8]

The second notation, probably written by a French person, is simply confused: the wife of Lord Bentinck was never a Lady Gosford but rather the daughter of one.

The third could possibly be a reflection of either the parsonage milieu into which Harriet Grattan married or of Lady William Bentinck's many demonstrations of Christian charity.

The final notation confirms, seemingly unintentionally, that Ingres drew three portraits of Lady William Bentinck.

H. N.

For the author's complete text, see Naef 1977–80, vol. 2 (1978), chap. 63 (pp. 39–47).

to Lady Morpeth: "What a good-natured, kind-hearted, potatoe-headed woman she is, always in a bother, every second word a blunder! She calls Mr. Stangways, Mr. Stapleton, Mr. Tierney, Mr. Burdett, and seems scarcely to know if her head is on her shoulders or not."[4]

Lady William Bentinck may not have been able to hold her own in the conversational pyrotechnics of Europe's salons, but in remote India, where there was work to do, her performance was universally admired. She died after a long illness in 1843, and a week after her death her nephew Charles C. F. Greville wrote in his diary:

A more amiable and excellent woman never existed in the world. She was overflowing with affections, sympathies, and kindness, not only perfectly unselfish, but with a scrupulous fear, carried to exaggeration, of trespassing upon the ease or convenience of others....With the death of her husband all her happiness was clouded, never to admit of sunshine again, and she passed two years of mild and moderated grief with alternations of partial ease and severe bodily pain, but nothing ever disturbed the serenity of her temper, her uncomplaining gentleness, her warm and considerate affections, and her unaffected piety.[5]

1. Both de Tauzia 1888, p. 141, and Paris 1889a, no. 333 (erroneously dated 1810).

2. The drawing was given to the Musée Bonnat, Bayonne, by the artist Léon Bonnat in 1922.

3. A full account of Bentinck's career is included in *Dictionary of National Biography*, vol. 4 (1885), pp. 292–97.

4. Granville 1894, vol. 1, p. 296.

5. Greville 1903, vol. 5, pp. 160–61.

6. London 1917, no. 85.

7. Lapauze 1919, pp. 8–10, ill.

8. *Dictionary of National Biography*, vol. 22 (1890), p. 424.

PROVENANCE: Mrs. Edward Stapleton, England, by 1917; acquired in England by the Paris art dealer Édouard Jonas, 1918; Ernest Cognacq, Paris, from 1921 until 1928; by 1934, Édouard Jonas, Paris; Fritz Mannheimer, Amsterdam; confiscated by the Nazis during World War II; recovered in Germany by the Commission de Récupération Artistique, 1946; turned over to the Rijksmuseum, Amsterdam, 1953

EXHIBITIONS: London 1917, no. 85; Paris 1921, no. 83; Paris 1934c, no. 19 (erroneously as signed lower right); Paris 1946a, no. 139 (erroneously dated 1817); Paris, Amsterdam 1964, no. 140, pl. 114; Paris 1967–68, no. 87, ill.; Liverpool, Kingston-upon-Hull, London 1979–80, no. 25, ill.; Tübingen, Brussels 1986, no. 5

REFERENCES: Lapauze 1919, pp. 8–10, ill. p. 9; Lapauze 1922, p. 649, n. 1; Ford 1939, p. 7; Mongan 1944, p. 396; *Répertoire des biens spoliés* 1947, vol. 2, no. 939, as *Portrait de femme* (erroneously dated 1817); Alazard 1950, p. 62; *Verslagen der Rijksverzamelingen* 1953, p. 64, ill.; Frerichs 1963, no. 89, ill.; Gimpel 1963, pp. 76–77, entry for October 17, 1918, as *Portrait de la duchesse de Portland* (erroneously dated 1817); Sass 1963–65, vol. 1, p. 223, vol. 3, p. 151, n. 34; Cambridge (Mass.) 1967, under no. 38; Delpierre 1975, p. 22; Naef 1977–80, vol. 4 (1977), pp. 292–93, no. 159, ill.

60. Mrs. John Mackie, née Dorothea Sophia Des Champs

April 1816
Graphite
8 1/4 × 6 7/16 in. (20.9 × 16.4 cm)
Signed and dated lower right: Ingres à / Rome 1816
The Board of Trustees of the Victoria & Albert Museum, London E 230-1946

N 169

Two of Ingres's portrait drawings of Englishwomen feature background views of the palace of the Villa Medici as seen from somewhere near the artist's apartment on the Via Gregoriana. One of the ladies, Mrs. Charles Badham (see cat. no. 62), is known to have been staying only a few doors down the street from him, but whether or not Mrs. Mackie requested the view as a reminder of her Roman lodgings is unknown. As it happens, both women, sojourning in Rome as part of their grand tour, were married to prominent doctors.

Mrs. Mackie's husband, a Scotsman, had had a highly successful practice in Southampton since about 1792 but had left it in 1814, when he was in his mid-sixties. During his tour of the Continent he curtailed his professional activities, by and large, though he did consent to see "the queen of Spain, the ex-king of Holland, and other persons of rank."[1] After his return to England, he spent several winters at Bath and finally settled in Chichester, where he died in 1831 at the age of eighty-three.

While sitting for Ingres, Mrs. Mackie was able to converse with him in his native tongue. Although English by birth, she was descended from a long line of militant, even heroic, French Protestants. A great-grandfather on her mother's side, Daniel Chamier, had fled to Switzerland after the revocation of the Edict of Nantes and taken a Swiss wife. He then settled in England, where, like his father and grandfather before him, he served as a pastor. Her paternal grandfather had sought refuge in Germany, where her father, Jean Des Champs, was born, in 1709. Des Champs studied in Marburg, was ordained a minister in Kassel, and acted as tutor in Berlin to the sons of Prince Friedrich of Prussia before moving to London in 1747. Two years later he, too, accepted a pastorate, which he held until his death, and in 1753 he married Judith Chamier.

Dorothea Sophia, born in 1755, was the couple's second child. Her older brother, John Ezekiel, inherited the estate of his mother's brother, the Anthony Chamier who is remembered as a close friend of the painter Joshua Reynolds and the literary giant Samuel Johnson. She married Dr. Mackie in 1784 and eventually had a son and a daughter. Drawing on her French heritage, she published, in 1802, an English translation of the letters of Madame de Sévigné. To judge from Ingres's portrait, she cannot have been particularly attractive even in her youth, yet her face betrays a lively, even droll, intelligence, as well as a distinctly Huguenot probity.

Thanks to the journal kept by her daughter, Anna Sophia, we know precisely when the portrait sitting took place: "9. April 1816.—Mama kindly consented to have a séance of Ingre [sic]. . . . 18. April 1816.—Dear Mama's likeness of Ingre finished and very good. I am delighted to have it."[2]

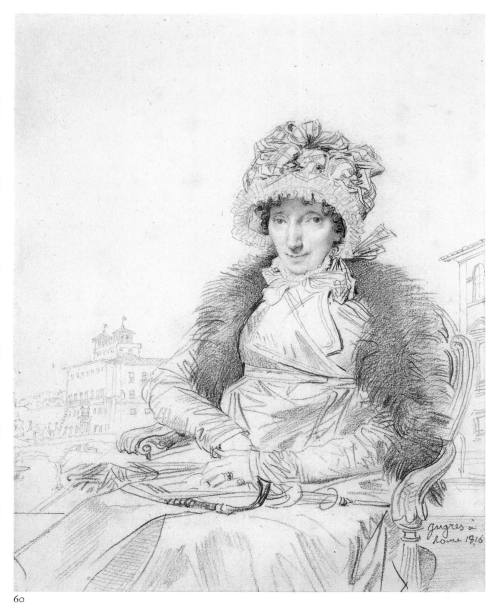

60

The wording of these entries suggests that Anna Sophia was the one who commissioned the portrait, one that must have become even more precious to her three years later, when her "dear Mama" died in Vevey at the age of sixty-four.

H. N.

EDITOR'S NOTE: Georges Vigne (1995a, p. 514, no. 2845, ill.) has suggested that Ingres adapted the landscape background in his portrait of Mrs. Mackie from a drawing he owned by the so-called Master of the Little Dots (fig. 313).

For the author's complete text, see Naef 1977–80, vol. 2 (1978), chap. 69 (pp. 85–88).
1. *Dictionary of National Biography*, vol. 35 (1893); quoted in Naef 1977–80, vol. 2 (1978), p. 85.
2. Naef 1956 ("English Sitters"), p. 428.

PROVENANCE: By descent through the family of the sitter to Miss Winifred M. Giles, great-grandniece of Dr. John Mackie, the sitter's husband; given by her to the Victoria & Albert Museum, London, in memory of her sister Miss Alice M. Giles, 1946

EXHIBITIONS: Paris 1967–68, no. 90, ill.; Liverpool, Kingston-upon-Hull, London 1979–80, no. 26, ill.; Tübingen, Brussels 1986, no. 13

REFERENCES: London, National Art-Collections Fund 1947, p. 31, no. 1435, ill. p. 30; London, Victoria & Albert Museum 1948, pl. 19; London, Victoria & Albert Museum 1949, p. 45; Naef 1956 ("English Sitters"), p. 428, fig. 8, p. 430; Naef 1960 *(Rome)*, p. 27, n. 52; Delpierre 1975, p. 24; Naef 1977–80, vol. 4 (1977), pp. 310–11, no. 169, ill.

61. Monsignor Gabriel Cortois de Pressigny

Before the end of May 1816
Graphite and watercolor
10⅞ × 7⅝ in. (27.5 × 19.5 cm)
Signed and dated lower left, on the original mount: J.A. Ingres fecit Romae 1816 [J.A. Ingres made (this) in Rome 1816]
Private collection

In 1816 Ingres was given an opportunity to portray the French ambassador to Rome, Monsignor Cortois de Pressigny. He repaid this honor with not one but two master-works, for he made two almost identical versions of this portrait drawing. One (N 170), now in a private collection in Paris, was formerly in the collection of the ambassador's secretary, Alexis Artaud de Montor: that work may either have been a gift from Pressigny to his loyal servant

or a commission by an admiring Artaud de Montor himself.

The present drawing reappeared only in 1993, when it was presented for auction as by direct descent through the sitter's family. It differs from the other drawing in that the sitter's smile is less evident, the pompom of his biretta is less cropped by the edge of the paper, there is a slight variation in the position of the paper in his left hand, and the armchair is also more cropped. We do

not know whether this drawing was commissioned or created as a parting gift from the artist to a kind and generous compatriot.

The portrait has become world famous, not as a drawing but rather as an etching, which Ingres executed himself the same year—his only known work in the medium.[1] It is easy to imagine that the etching was commissioned because the ambassador was so pleased with the portrait drawing. The work is a superb example of Ingres's skills as a portraitist in a year that found him at the height of his powers. The prelate's handsome face, his noble carriage, and the splendor of his episcopal vestments all contribute to make the portrait seem very much out of the ordinary; however, this perception would not be so overwhelming had the artist not rendered its unusual details with such mastery.

Cortois de Pressigny was born in Dijon in 1745, the son of prominent though not titled parents.[2] Unlike so many men who entered the priesthood because of family considerations, he felt a genuine calling in his early youth. His parents sent him to Paris to the college of Saint-Sulpice, where he performed brilliantly, and as a young priest he soon attracted the attention and admiration of his superiors. In 1786, at only forty-one, he was named bishop of Saint-Malo by Louis XVI. Though extremely popular with his congregation, Cortois remained in that office less than four years. When the leaders of the Revolution confiscated church properties in 1790 and demanded that the clergy swear allegiance to a secular state, he chose to go into exile rather than execute such an oath. He spent the next ten years in Germany, following with sorrow the tempestuous developments in his homeland.

Once Bonaparte had managed to quell political chaos and bring order, Cortois returned to France, yet he still felt he could not reclaim his high office in a state that owed its existence to the murder of the king who had awarded it to him. Immediately after the monarchy had been restored, Cortois was dispatched to Italy to try to effect a revision of Napoleon's Concordat with Rome. He arrived in Rome in the summer of 1814 and stayed only two years. His negotiations with the Vatican were largely unfruitful, but this

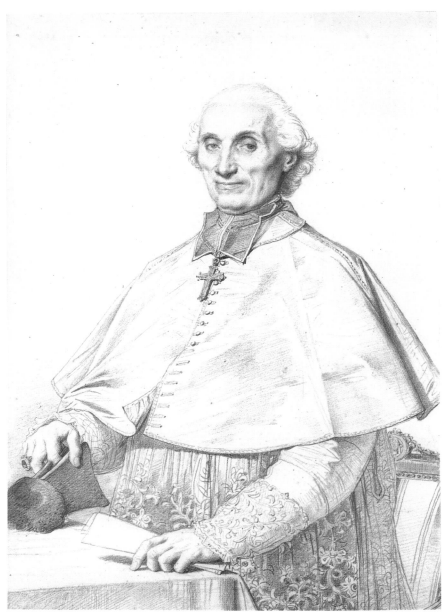

61

lack of success was by no means interpreted as a personal failure. On the contrary, he won the respect of all who had dealings with him in Rome, from his fellow churchmen to the small community of French artists who worked in the city. He was positively revered by the members of his staff, several of whom Ingres also immortalized in portrait drawings.

Back in France, Cortois de Pressigny was accorded new honors. In 1817 Louis XVIII made him a count and peer of France and appointed him archbishop of Besançon. Although poor health forced him to spend much of his time in Paris, he managed to endear himself to his see with the gentle-

ness and probity that had characterized his actions all his life. He died in Paris in 1823 and was buried in the church of Saint-Roch.

In 1825 the portrait was lithographed, in reverse, by Ulysse Mathey,[3] and in 1851 Achille Réveil made a steel engraving of it, also in reverse. There is a pencil sketch of the prelate's right hand in the Musée Ingres, Montauban.[4] H.N.

For the author's original text, see Naef 1977–80, vol. 2 (1978), chap. 74 (pp. 109–13).

1. On the etching, which betrays slight differences from both versions of the drawing, see ibid., chap. 60, p. 23, fig. 2, p. 109, n. 1. See also Paris 1867, no. 383; Blanc 1870, p. 239

("etching and counterproof retouched and colored by Ingres, for M. Gatteaux"); Delaborde 1870, no. 430; Dodgson 1935, p. 281, ill. p. 280; *Mémoires de l'Académie des Sciences et Belles-Lettres de Dijon* 1937, ill. opp. p. XLIX; Pach 1939, ill. opp. p. 110; Malingue 1943, ill. p. 77; Goncourt 1956–58, vol. 17, p. 217, entry for March 5, 1891;

Schwarz 1959, pp. 335–37, fig. 5, p. 334; Vigne 1995b, p. 91, fig. 63.

2. Details of the archbishop's life have been taken from Sèze 1824.
3. On the lithograph, see Duplessis 1881, p. 274.
4. Inv. no. 867.369; Vigne 1995a, no. 2642.

PROVENANCE: Monsignor Gabriel Cortois de Pressigny (1745–1823), Paris; by descent in the sitter's family; Hôtel Drouot, Paris, April 16, 1993, no. 55; private collection; Hôtel Drouot, Paris, April 25, 1997, no. 143; the present owner

REFERENCES: Ternois 1959a, under no. 45; Vigne 1995a, p. 472

62. Mrs. Charles Badham, née Margaret Campbell

1816
Graphite
10 3/8 × 8 5/8 in. (26.3 × 21.8 cm)
Signed and dated lower left: J Ingres. Del Roma 1816. [J Ingres. Drawn (in) Rome 1816]
National Gallery of Art, Washington, D.C.
The Armand Hammer Collection 1991. 217. 20
London and Washington only

N *171*

Ingres's drawing of Mrs. Charles Badham is one of his finest portraits of English subjects. A richly dressed woman in her best years is seen seated out-of-doors on what appears to be a terrace, her back turned to one of the Roman cityscapes that add incomparable richness to a number of the drawings in Ingres's English series. (From left to right are the Roman obelisk at the top of the Spanish Steps, the palace of the Villa Medici, and the steps leading to the church of Santissima Trinità dei Monti.) Doubtless for the sake of that background the artist employed a most unusual composition: the subject is shifted to the right of center, and this eccentricity is compounded in that the lady also turns to the right.

What makes the drawing so brilliant, however, is Ingres's use of the pencil. In addition to registering with his accustomed precision the subtlest details of the woman's countenance, the artist has conjured from his humble instrument a graphic richness rarely equaled in his oeuvre, and since the work has been perfectly preserved one can experience this draftsmanly tour de force in all its original glory.

For all its technical virtues, the drawing sheds little light on the sitter's character. She may well have been considered a beauty, but it would have been easier for the artist to suggest something of her inner substance if her features had not been so regular. She was thirty-five when she sat for her portrait, and although virtually nothing is known about her there is every reason to suspect that she was far from ordinary, for she was married to an unusually well educated physician and the mother of two highly gifted sons.

Her husband, a year older than she, had begun to practice in London in 1803 and was shortly afterward appointed physician to the duke of Sussex.[1] In 1815 he set off for an extended tour of the Continent, proceeding by way of Naples to Albania, where he was consulted by Ali Pasha, and on to Athens. On his return he was elected a Fellow of the Royal Society and admitted to the Royal College of Physicians. In 1827 he was appointed to a chair in medicine at the University of Glasgow, by which time he may have lost his lovely wife, for he married again about 1833. He published a translation of the *Satires* of Juvenal in addition to numerous medical articles and died in London in 1845.

The older of the Badhams' sons, Charles David (1806–1857), became a naturalist and wrote important books on insects, mushrooms, and classical zoological lore. The younger son, Charles (1813–1884), came to be regarded as the finest English classical scholar of his age. He knew all the extant Greek poetry by heart and had an almost equal mastery of Latin, English, French, and Italian literature. Before emigrating in 1867 from England to New South Wales, where he was appointed professor of classics and logic at the University of Sydney, he published valuable annotated editions of Euripides and Plato.

During their stay in Rome the Badhams resided at 25 Via Gregoriana.[2] They must therefore have been familiar figures to Ingres, who was then living on the same street at number 34. This doubtless explains why the artist chose to pose his sitter only a few steps away from their respective lodgings. H . N .

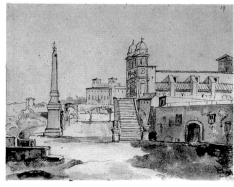

Fig. 133. Master of the Gardens of the Villa Medici, *Santissima Trinità dei Monti*, before 1816. Graphite on paper, 4 3/8 × 5 1/2 in. (11 × 13.9 cm). Musée Ingres, Montauban (867.4398)

EDITOR'S NOTE: Georges Vigne (1995a, p. 543, no. 3015, ill.) has suggested that Ingres adapted the landscape background in his portrait of Mrs. Badham from a drawing he owned by the so-called Master of the Gardens of the Villa Medici (fig. 133).

For the author's complete text, see Naef 1977–80, vol. 2 (1978), chap. 70 (pp. 89–93).

1. The life sketches of Charles Badham and his sons Charles David and Charles are drawn from their respective entries in the *Dictionary of National Biography*, vol. 2 (1885).
2. Domicile register of the San Andrea delle Fratte congregation for 1816, Archivio del Vicariato, Rome.

PROVENANCE: By inheritance and descent, through the family of the sitter, to C. Badham Jackson, Esq., her great-grandson; his sale, Sotheby's, London, December 12, 1928, no. 145, sold for 820 pounds sterling to Dr. Tancred Borenius, London; Wildenstein & Co., Inc., New York; purchased from that gallery by Mrs. Jesse I. Straus, New York, 1929; her sale, Parke-Bernet Galleries, New York, October 21, 1970, no. 49; purchased at that sale for $65,000 by Dr. Armand Hammer (1897–1990); the Armand Hammer Foundation; gift of the foundation to the National Gallery of Art, Washington, D.C., 1991

EXHIBITIONS: New York 1961, no. 22, ill.; Cambridge (Mass.) 1967, no. 37, ill.; Washington, New York, Philadelphia, Kansas City 1971, no. 147, ill.; Los Angeles, London, Dublin 1971–72, no. 74, ill.; Washington 1974, no. 72; Paris 1977, no. 75L-1, ill.; Washington 1978, p. 93

REFERENCES: Zabel 1930, ill. p. 378; Cassou 1934, fig. 15, p. 157; Ford 1939, pp. 8–9, pl. III C, p. 11; Naef 1960 *(Rome)*, p. 27, n. 52; Schlenoff 1967, fig. 64, p. 378; Mongan 1969, p. 146, fig. 20, p. 154; *Apollo* 1970, ill. p. 128; Anon., April 1971, ill. p. 335; *Art at Auction* 1971, ill. p. 90; White 1972, p. 460, fig. 7, p. 461; Naef 1977–80, vol. 4 (1977), pp. 314–15, no. 171, ill.; Brown 1982, pp. 68–69, 86–88, ill.; Walker 1984, no. 1091

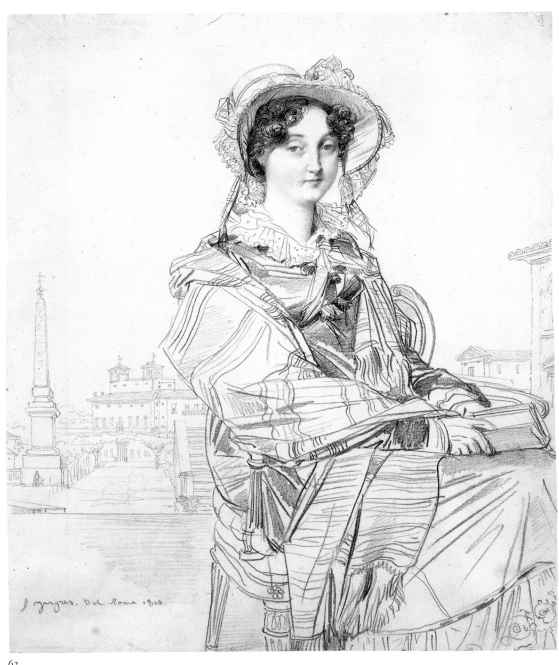

62

63. Lady William Henry Cavendish Bentinck, née Lady Mary Acheson

1816
Graphite
8⅝ × 6¾ in. (21.9 × 17 cm)
Signed and dated lower left (the first two lines are written over an erased signature): Ingres fecit / roma / 1816 [Ingres made (this) / Rome 1816]
The Metropolitan Museum of Art, New York
Bequest of Grace Rainey Rogers, 1943 43.85.6
New York only

N 174

This drawing is discussed under cat. no. 59.

PROVENANCE: Lady William Henry Cavendish Bentinck, London, until 1843; Hariet [?] Gratt[an?] (according to an inscription on the back of the former mount); acquired from an unknown English collection by Henry Lapauze (1867–1925) by 1919; his posthumous auction, Hôtel Drouot, Paris, June 21, 1929, no. 33; purchased at that sale for 205,000 francs by M. Knoedler & Co., New York; purchased from Knoedler by Mrs. Grace Rainey Rogers (1867–1943), New York, 1931; her bequest to The Metropolitan Museum of Art, New York, 1943

EXHIBITIONS: Richmond 1947, no. 16; San Francisco 1947, no. 8; Cambridge (Mass.) 1967, no. 38, ill.; New York 1970, no. 47; New York 1988–89

REFERENCES: Lapauze 1919, p. 8; Ford 1939, p. 7; Mongan 1944, p. 396; Alazard 1950, p. 62, pl. XXXIII; Mathey 1955, no. 15, ill.; Mongan 1969, p. 146; Naef 1977–80, vol. 4 (1977), pp. 320–21, no. 174, ill.

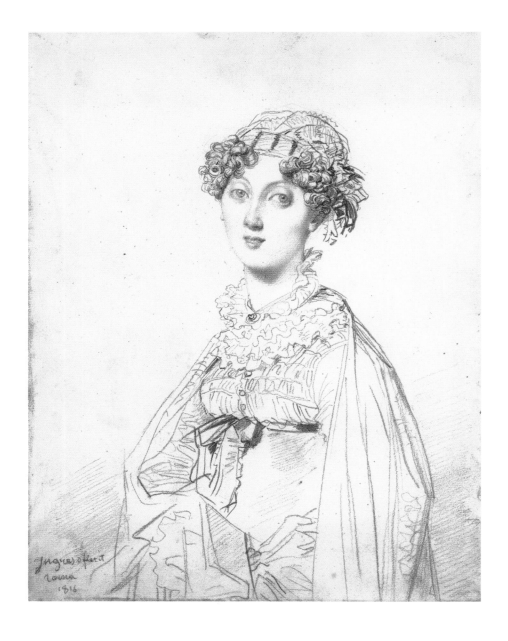

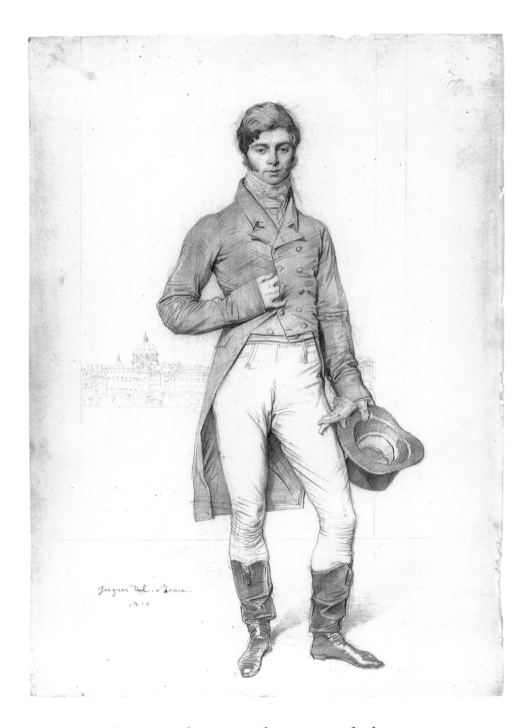

64. Lord Grantham (Thomas Philip Robinson)

1816

Graphite

15⅝ × 10¼ in. (39.8 × 26.1 cm), framed

Signed and dated lower left: Ingres Del. Rome. / 1816 [Ingres drew (this in) Rome. / 1816]

The J. Paul Getty Museum, Los Angeles, California 82.GD.106

London and Washington only

N 177

Though he certainly did not wish to be thought of as a souvenir portraitist, Ingres must have had to behave like one when negotiating prices with his English sitters. Was the drawing to be large or small? Was it to be a bust, include the hands, or show the whole figure? And what about the background? A Roman cityscape or an interior would, of course, be extra.

For Lord Grantham, who called on the struggling artist in 1816, only the deluxe treatment would do. His is the second-largest portrait in Ingres's English series, exceeded in size only by the artist's drawing of Lady William Bentinck (cat. no. 59) done the previous year. And Grantham chose to be portrayed full length, standing in front of a window with a view of Saint Peter's. Grantham had every reason to be confident of his appearance. He was blessed with regular features and a handsome head of hair, and was in the habit

of engaging only the finest of London's tailors and bootmakers.

A man like Lord Grantham is not made in a day, but is rather the product of centuries of breeding. The illustriousness of his ancestry is attested by the multiple titles that converged on his person over the years.[1] At the age of five, in 1786, he became the third Baron Grantham on the death of his father, Thomas Robinson. When he was eleven, a cousin died without issue, making him the sixth Baronet Robinson, and from an uncle, William Weddell, he inherited the splendid country seat Newby Hall, in Yorkshire. On the attainment of his majority, he officially adopted the Weddell name, as well. Finally, the death of his mother's sister in 1833 meant that he was at once both the fifth Baron Lucas and the second Earl Grey, and he accordingly changed his name, this time to De Grey.

The young baron set out on his first tour of the Continent after leaving Cambridge in 1801, but was forced to cut it short by the outbreak of war in 1803. He then joined the yeomanry and by the end of that same year was a major in a Yorkshire regiment. In 1805 he married a daughter of the first earl of Enniskillen, and in time they had two daughters and a son. Such was the fashionable gentleman of thirty-

five who turned up in Rome in 1816; his accomplishments were in no way exceptional, given his aristocratic birth.

Grantham's subsequent career took him somewhat higher. In 1831, in recognition of his diligence to duty in the cavalry guard, King William IV created especially for him the rank of King's Aide-de-Camp for the Yeomanry Service, one confirmed on the accession of Queen Victoria in 1837. Although he was a lackluster member of the House of Lords, his politics placed him on the side of Robert Peel, who appointed him Lord of the Admiralty in 1834 and lord lieutenant of Ireland in 1841. De Grey resigned from the latter post—the highest he would attain—in 1844. Widowed in 1845, he spent his last years writing and tending to his obligations as a member of various learned societies. He had been appointed president of the Royal Institution of British Architects on its founding, in 1834, and he remained in that office until his death, at seventy-eight, in 1859.

H.N.

EDITOR'S NOTE: Georges Vigne (1995a, p. 515, no. 2853, ill.) has suggested that Ingres adapted the landscape background in his portrait of Lord Grantham from a drawing he owned by the so-called Master of the Little Dots (Musée Ingres, Montauban; inv. no. 867.4400).

For the author's complete text, see Naef 1977–80, vol. 2 (1978), chap. 68 (pp. 79–84).

1. The following biographical information is drawn from the *Dictionary of National Biography*, vol. 23 (1890), p. 208, s.v. "Grey"; and from *Burke's Peerage, Baronetage and Knightage*, 63rd ed. (1901), p. 1280, s.v. "Ripon"; 104th ed. (1967), p. 1567 s.v. "Lucas."

PROVENANCE: Thomas Philip Robinson, third Baron Grantham, later second Earl De Grey and fifth Baron Lucas (1781–1859), London; Mrs. Henry Vyner, née Lady Mary Gertrude Robinson, his daughter, Newby Hall, Yorkshire, until 1892; Robert Charles De Grey Vyner, her son, Newby Hall, until 1915; Lady Alwyne Frederick Compton, née Mary Evelyn Violet Vyner, his daughter, until 1957; Major Edward Robert Francis Compton, her son; Robert Compton, his son, Newby Hall; Somerville and Simpson, London; The J. Paul Getty Museum, Los Angeles, Calif., 1982

EXHIBITIONS: London 1956–57, no. 693; New York, London 1993–94, no. 63 (New York), no. 109 (London)

REFERENCES: Ford 1939, pp. 9, 11, fig. A on pl. 3; Honour 1955, p. 247, fig. 4, p. 249; Anon., December 1, 1956, ill. p. 950; Naef 1960 *(Rome)*, p. 27, n. 52; Musgrave 1974, p. 13, ill. p. 12; Naef 1977–80, vol. 4 (1977), pp. 326–27, no. 177, ill.; Goldner 1988, pp. 172–73, no. 76, ill.

65. Charles Thomas Thruston

66. Mrs. Charles Thomas Thruston, née Frances Edwards

65. Charles Thomas Thruston
1816
Graphite and watercolor
8¼ × 6⅜ in. (20.8 × 16.1 cm), framed
Signed lower left: ingres. a / Rome / 1816.
Private collection
London and New York only
N 178

66. Mrs. Charles Thomas Thruston, née Frances Edwards
ca. 1816
Graphite
8⅛ × 6¼ in. (20.6 × 15.8 cm), framed
Private collection
London and New York only
N 179

It is odd that Ingres's drawings of Mr. and Mrs. Charles Thomas Thruston were not conceived as pendants. The portrait of Mrs. Thruston is undated, but it must have been executed at about the same time as the one of her husband, in 1816.

His angelic appearance notwithstanding, Thruston was a seasoned naval officer with years of heroic service behind him when he posed for Ingres at the age of thirty. He was born in Suffolk in 1786. His father, a member of Suffolk's landed gentry who had also practiced law, died when the boy was only three. In 1792

his widowed mother married the naval officer Valentine Gardner, a brother of Baron Alan Gardner, who would later serve as Lord of the Admiralty. Patterning himself after his stepfather, Charles Thomas joined the Royal Navy at the age of twelve.

His military career was brief but eventful. His first triumph came in 1809, when he was serving as a lieutenant on the *Endymion*. Shortly after the ship had helped to rescue the remnants of General Moore's army at La Coruña, its crew was asked to come to the aid of a group of

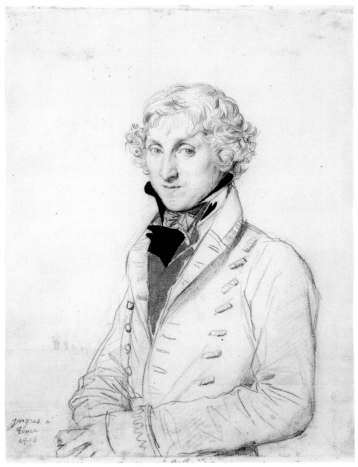

65

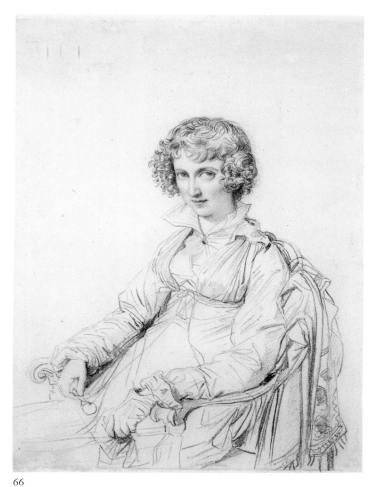

66

Spanish patriots rebelling against French occupation forces. Thruston, the only officer who spoke Spanish, accordingly played a key role in the operation, demonstrating a rare combination of intelligence and cool recklessness.[1]

In 1811, having escaped death by a hair in Spain, he sailed to the South Seas, where the British navy was taking possession of the Dutch colonies. In 1812, after the Dutch surrender, Thruston was given command of the corvette *Hester* and ordered to Bali to watch for the expected arrival of the French fleet. Monsoon winds drove his ship toward Timor instead, and he was forced to drop anchor at Kupang. The island's Dutch governor had not been informed of the British victory, and it was only thanks to Thruston's steely handling of the situation that he was able to claim the colony for the British despite the fact that his ship was poorly manned and his crew weakened by illness.[2]

Thruston himself fell victim to a severe liver ailment from which it was feared he

might not recover. He was taken home to England, where he was nursed for the next several years. In the summer of 1815 his health was sufficiently restored to permit him to marry the twenty-five-year-old Frances Edwards, an heiress from Merionethshire, in the north of Wales. Thruston owned an estate in the same county, but whether he had come into possession of it by the time they met is unknown. The couple's visit to Rome was part of their wedding trip.

It appears that Thruston told his portraitist something about his seafaring past, for above a straight horizon line in the background can be seen a small fleet of ships. The drawing is the only one in Ingres's series of English portraits that includes any allusion to the sitter's occupation. Thruston's black shirt is an equally unusual feature—found nowhere else in the artist's oeuvre. As Ingres scholar Marjorie B. Cohn has suggested, the artist probably used oxydized lead white, a pigment that turns dark under certain conditions.

The artist's portrait of Thruston's pretty young wife is less commanding. Although the drawing is impeccable, it reveals little of the sitter's personality. What she may have been like is in any case a mystery, for only the most superficial details of her life are known. She died of a fever in 1828, leaving her husband with four small children. Thruston married again in 1829, and his new wife bore him yet another child. He died in London in 1858 as the result of an accident.[3] H.N.

For the author's complete text, see Naef 1977–80, vol. 2 (1978), chap. 71 (pp. 94–99).
 1. Marshall 1823–35, vol. 4, pt. 1 (1833), pp. 37–64.
 2. Ibid., pp. 59–63.
 3. *Gentleman's Magazine* 1858, p. 315.

Cat. no. 65. *Charles Thomas Thruston*

PROVENANCE: Charles Thomas Thruston (1786–1858); Charles Frederick Thruston, his son, Talgarth Hall, Merionethshire, until 1882; Mrs. William Edward Allen, née Mary Frances

Thruston, his daughter, until 1922; her daughter Miss Dorothy Mary Allen, Beccles and London; purchased from her by Baron Elie de Rothschild in 1956; the present owner

EXHIBITIONS: Paris 1967–68, no. 88, ill.; New York 1988b, no. 22, ill.

REFERENCES: Naef 1958 ("Unpublished English Sitters"), pp. 61–62, fig. 23 on p. 63; Delpierre 1975, p. 23; Naef 1977–80, vol. 4 (1977), pp. 328–29, no. 178, ill.

Cat. no. 66. *Mrs. Charles Thomas Thruston, née Frances Edwards*

PROVENANCE: The same as for cat. no. 65

EXHIBITIONS: Paris 1967–68, no. 89, ill.; New York 1988b, no. 23, ill.

REFERENCES: Naef 1958 ("Unpublished English Sitters"), pp. 61–62, fig. 24 on p. 63; Naef 1977–80, vol. 4 (1977), pp. 330–31, no. 179, ill.

67. Joseph Woodhead and His Wife, née Harriet Comber, and Her Brother, Henry George Wandesford Comber

1816

Graphite

12 × 8⅞ in. (30.4 × 22.4 cm)

Signed and dated lower right: Ingres a / rome 1816. [Ingres in / Rome 1816.]

Lent by the Syndics of the Fitzwilliam Museum, Cambridge, England PD. 52-1947

N 180

Ingres's portrait of the Woodheads and Mrs. Woodhead's brother, Henry Comber, is one of the artist's finest drawings of English visitors to Rome. One of his rare group portraits, it is unusually large. A young woman seated in the center of the composition rests her right hand on the arm of an older man, who bends toward her. Behind her towers the figure of a youth as elegant and handsome as any in the artist's oeuvre. The drawing is a graphic delight; Ingres's pencil never tarries over detail but moves on unhesitatingly, freely piling rhythm upon rhythm, form upon form. In his desire to capture the bond of affection between husband and wife, he drew Joseph Woodhead's arm too long and failed to render Harriet Woodhead's right elbow convincingly, but these faults are minor, given the richness of the composition as a whole.

The Comber siblings were descended from a long line of churchmen, the most notable of whom, their great-grandfather Thomas Comber, was a major force in the English church in the seventeenth century as dean of Durham. At the time they were born—Harriet in 1793, Henry in 1798—their father was the vicar at Creech St. Michael, in Somerset, but in 1813 he moved to Yorkshire to become rector of the parish of Oswaldkirk. He had inherited a sizable manor house in Yorkshire but at some point sold it, thereby assuring himself and his children of a comfortable living.

The year after he posed for his portrait in Rome, Henry Comber began his studies at Cambridge. He married a parson's daughter in 1820, took his degree in 1821, and was made a deacon in York in 1822. When his father died in 1835, he took over the parish in Oswaldkirk, where he served as rector until his death in 1883.

His brother-in-law, Joseph Woodhead, born about 1774, worked as an agent for the Royal Navy. He must have prospered, for in marrying the highly refined and much younger Harriet Comber he appears to have reached above his station. Moreover, he was able to combine his honeymoon with a proper grand tour, at least part of which the newlyweds shared with the bride's eighteen-year-old brother. The Woodheads had at least one son and a daughter, and in their later years they appear to have lived in Brighton, where Joseph died in 1866, Harriet in 1872.

H.N.

For the author's complete text, see Naef 1977–80, vol. 2 (1978), chap. 73 (pp. 104–8).

PROVENANCE: Mr. and Mrs. Joseph Woodhead, Brighton, until Harriet Woodhead's death, in 1872; Mrs. Young, née Woodhead, their daughter; Miss Grace Woodhead, their niece, until 1933; Henry Alexander Walker, her nephew and a great-grandson of the Joseph Woodheads; purchased from him for 1,200 pounds sterling by the National Art-Collections Fund and presented to the Fitzwilliam Museum, Cambridge, 1947

EXHIBITIONS: London 1959, no. 74; London 1965b, no. 37, fig. b on pl. 5; Liverpool 1968, no. 46, pl. 20; London 1970 (not in catalogue); Paris, Lille, Strasbourg 1976, no. 50, ill.; New York, Fort Worth, Baltimore, Minneapolis, Philadelphia 1976–77, no. 108, ill.; Liverpool,

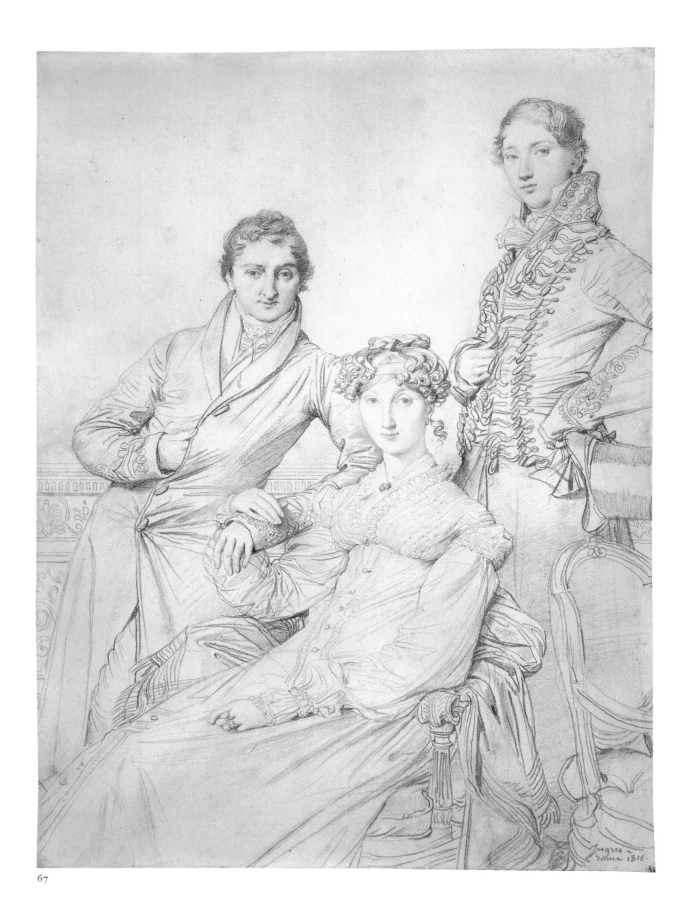

67

Kingston-upon-Hull, London 1979–80, no. 28, Tübingen, Brussels 1986, no. 16

REFERENCES: Ford 1939, pp. 7–8, pl. I, p. 2; London, National Art-Collections Fund 1948, p. 20, no. 1459, ill. p. 23; Alazard 1950, p. 63, n. 14, p. 147, pl. XXXVI; Blunt and Whinney 1950, p. 182; Winter 1958, p. 392, no. 99, pl. 99; Schurr 1976, ill. p. 163; Naef 1977–80, vol. 4 (1977), pp. 332–33, no. 180, ill.; Delpierre 1986, pp. 76, 82, n. 20

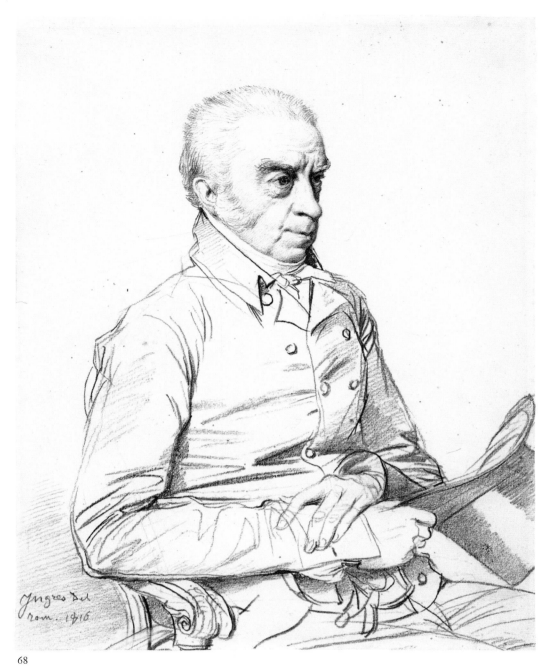

68

68. Dr. Thomas Church
69. The Reverend Joseph Church

68. Dr. Thomas Church
1816
Graphite
8 × 6¼ in. (20.4 × 16 cm)
Signed and dated lower left: Ingres Del / rom.
1816. [Ingres drew (this in) / Rome 1816.]
Los Angeles County Museum of Art
Purchased with funds provided by the Loula D.
Lasker Bequest and Museum Associates
Acquisition Fund M.67.62
New York and Washington only

N 183

In all of Western portraiture there is noth-
ing to compare with Ingres's astonishingly
realistic drawing of a feisty, spindle-thin,
ugly old man named Thomas Church. It
was executed in Rome in 1816 as a com-
panion piece to the portrait drawing of his
equally unprepossessing brother, Joseph.
If the latter depiction fails to inspire the
same degree of admiration, it is doubtless
only because its subject was less forceful,
for the drawing is equally magisterial in
its artistry. The two take on added interest

as pendants; the contrast between the dull
brother and the more volatile one could
not be greater.

Some former owner, perhaps even the
subjects themselves, apparently assumed
that the creator of these two masterworks
was unknown, for at one time there was
a label on the mount of the drawing of
Thomas Church that read: "Thomas
Church Esq^re / brother of / Rev^d Joseph
Church / Died 1821. / Painted in Rome
by Italian / artist — 1816." It is quite

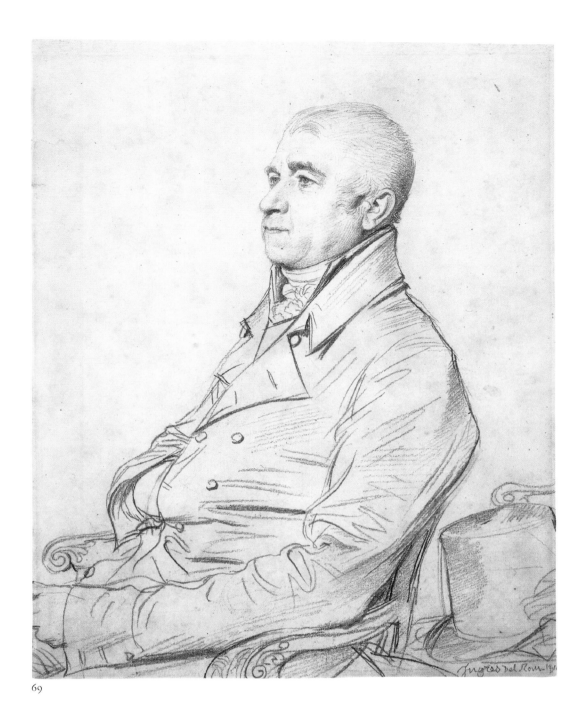

69

69. *The Reverend Joseph Church*
1816
Graphite
7⅞ × 6¼ in. (20 × 16 cm)
Signed and dated lower right: Ingres Del Rom.
1816. [Ingres drew (this in) Rome 1816.]
Virginia Museum of Fine Arts, Richmond
Collection of Mr. and Mrs. Paul Mellon
95.35
New York only

N 182

conceivable that the two brothers had no idea who the artist really was. In the desperate years between 1815 and 1817, securing commissions for portrait drawings from English tourists was all that kept food on his table, and one biographer alleges that Ingres went so far as to hire a tout:

> Reduced to drawing small portraits, [Ingres] was able only in this way to obtain some kind of credit with the foreigners who came to Rome. And even then, in order to win their favor and procure a

small income from them, he first had to secure the services of an influential domestic, who, for one ecu skimmed off the price of each drawing—eight ecus (roughly forty-two francs) for a bust, twelve ecus for a full-length portrait—would recommend Ingres to his own clients.[1]

If such a man existed, he would have found especially easy pickings among provincials such as the Church brothers.

The two men were the oldest and youngest sons, baptized in 1758 and 1765,

respectively,[2] of a John Church, who worked as a doctor in the tiny village of Coltishall, near Norwich. Thomas became a country doctor like his father, and as the oldest son he inherited his father's property. There he appears to have led the uneventful life of a bachelor, interrupted only by a trip to Italy in his later years. He was fifty-eight when he sat for Ingres, and he died five years later.[3]

His brother, the Reverend Joseph Church, then rector in the neighboring village of Frettenham, was his sole heir, suggesting that their four intervening siblings had died in the meanwhile. Joseph had studied at Cambridge University, receiving a bachelor's degree in 1788 and a master's degree in 1791, and stayed on as a fellow until 1804.[4] He was appointed to the post in Frettenham in 1807, and in the following year he married a Norwich widow. A second marriage was recorded in 1823; apparently both marriages were without issue. He died at age sixty-four in 1830.[5]

A most unusual document came to light at the time the two drawings were auctioned at Sotheby's in 1966. Pasted on the back of the original mount of Thomas's portrait was a small slip of tracing paper with an inscription in Ingres's hand:

> To reach the drawing itself, you have to remove the light sheet of paper covering it. In order for the drawing to be lit correctly, the light must be coming in from the left-hand side of the person observing it.[6]

The artist had obviously cut these instructions from a larger piece of tracing paper that he folded over the drawing for protection before handing it over. It indicates how deeply he cared for even those works he was obliged to produce in order to survive. H. N.

For the author's complete text, see Naef 1977–80, vol. 2 (1978), chap. 67 (pp. 73–78).
1. Delaborde 1870, pp. 35–36; quoted in Naef 1977–80, vol. 2 (1978), p. 74.
2. Baptismal register, Coltishall. The information was kindly provided in a letter to the author by the Reverend Leslie J. Lee, rector of Coltishall, October 14, 1971.
3. *Norwich Mercury* 1821, p. 3, col. 4.
4. Venn 1944, p. 37.
5. *Norfolk Chronicle* 1830, p. [3].
6. Quoted in Naef 1977–80, vol. 2 (1978), p. 78.

Cat. no. 68. *Dr. Thomas Church*

PROVENANCE: Presumably Thomas Church and Joseph Church, Frettenham, Norfolk, until 1821; Joseph Church until 1830; apparently given or bequeathed by him to his godson John Longe; John Longe, Spixworth, until 1872; presumably his brother and heir, the Reverend Robert Longe, Spixworth, until 1890; his son Robert Bacon Longe, Spixworth, until 1911; his auction, Spixworth Park, Norfolk, March 19–22, 1912, under no. 198; purchased at that sale for 22 guineas, together with its pendant, by the Honorable Miss Adele Emily Anna Hamilton; the Honorable Miss Hamilton, later the Honorable Mrs. Clement Eustace Macro Wilson, until 1946; her sons David C. Wilson, Sheffield, and the Reverend Michael Wilson, Ndola, Northern Rhodesia*; David C. Wilson sale, Sotheby's, London, December 1, 1966, no. 74; purchased at that sale for 10,500 pounds sterling by the Walter Feilchenfeldt gallery, Zurich; purchased from that gallery in 1967 by the Los Angeles County Museum of Art

EXHIBITIONS: Los Angeles 1975, no. 85, ill.; Austin 1977; Los Angeles 1978–79; Los Angeles 1983; Louisville, Fort Worth 1983–84, no. 65; Los Angeles 1984; Los Angeles 1987; Los Angeles 1997–98, no. 47, ill.

REFERENCES: Duleep Singh 1928, vol. 2, p. 307, no. 14; Ford 1939, p. 9, ill. D on pl. III, p. 11; *Critica d'arte* 1966, p. 20, fig. 61; Anon., February 1967, p. 122, fig. 6; *Art News* 1967, ill. p. 22; Naef 1967 ("L'Ingrisme"), p. 31; *Members' Calendar* 1968, p. [2], ill. p. [1]; Anon. 1969 [Director], p. 13, ill. p. 14; Anon., summer 1969, p. 215, ill. p. 231; *Antiques* 1969, ill. p. 684; Feinblatt 1969, pp. 262–65, fig. 2, p. 263; Feilchenfeldt 1972 [no. 1], ill.; Young 1975, p. 221, fig. 15, p. 224; Naef 1977–80, vol. 4 (1977), pp. 338–39, no. 183, ill.

Cat. no. 69. *The Reverend Joseph Church*

PROVENANCE: The same as for its pendant, cat. no. 68, until 1966; David [C.] Wilson auction, Sotheby's, London, December 1, 1966, no. 75; purchased at that sale for 9,000 pounds sterling by Colnaghi & Co., London, for Paul Mellon; Mr. and Mrs. Paul Mellon, Upperville, Va.; their gift to the Virginia Museum of Fine Arts, Richmond, 1995

REFERENCES: Duleep Singh 1928, vol. 2, p. 307, no. 13; Ford 1939, p. 9; Naef 1956 ("English Sitters"), p. 428, fig. 9, p. 430; *Critica d'arte* 1966, p. 20, fig. 60; Schurr 1968, p. 13, fig. 4; Feinblatt 1969, p. 262, fig. 3, p. 264; Naef 1977–80, vol. 4 (1977), pp. 336–37, no. 182, ill.

*From 1939 to 1948, on loan to the Tate Gallery, London

70. Alexander Baillie

1816
Graphite
8½ × 6½ in. (21.5 × 16.5 cm), mounted
Signed and dated lower right: Ingres. Del /
Rome 1816 [Ingres drew (this) / Rome 1816]
Private collection

N 186

The odd-looking man who sat for Ingres in his fur-trimmed coat in the early months of 1816 was the oldest child, born in 1777, of the wealthy merchant James Baillie, from the Scottish family Baillie of Dochfour. The opulence in which the young Alexander grew up is suggested by a family portrait painted by Thomas Gainsborough for the exhibition at the Royal Academy in London in 1784.[1] Like his father, the younger Baillie was uncommonly tall, for which reason Lord Byron, a school comrade, called him "Long Baillie":

> Baillie (commonly called Long Baillie, a very clever man, but odd), complained in riding to our friend Scrope B. Davies, "that he had a *stitch* in his side." "I don't wonder at it" (said Scrope) "for you ride *like a tailor*." Whoever had seen B. on

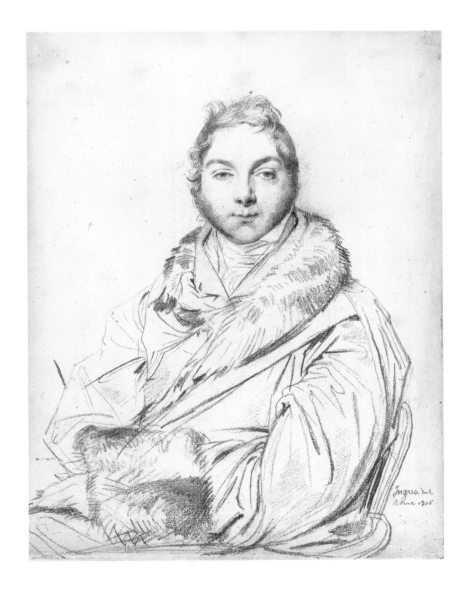

horseback, with his very tall figure on a small nag, would not deny the justice of the repartee.[2]

On a journey to Jamaica in 1808, presumably in connection with his father's trading interests, Baillie met the love of his life. As fate would have it, his ship rescued a number of people who had been shipwrecked, and among them was a young Norwegian, Jørgen von Capellen Knudtzon, who would become Baillie's inseparable companion.

Knudtzon was seven years younger than Baillie and, like him, the son of a wealthy merchant. The two were thus freed from any obligation to work for a living and could devote much of their time to travel, favoring spots noted for natural beauty, healthy climate, stimulating art, and cultivated society. Knudtzon's biographer Hroar Olsen describes his subject as lively, cheerful, enthusiastic, and full of energy, unlike Baillie, who tended to be quiet, reserved, and phlegmatic. Their first two years together were spent in Spain and Italy; then, in 1813, they set out for Saint Petersburg. Lady Sarah Lyttelton, later governess to the children of Queen Victoria, relates in her diary how she crossed paths with the two men on her own trip to Russia:

> The inn at Bjorkby, where we found Mr. Baillie and Mr. Knudzen, his Norwegian ally, both going to bed in the only appartment [*sic*]. Dark night, bad roads, impossibility of getting on—therefore dilemma. But gallantry of Messrs. Baillie and Knudzen. They contract themselves into one room and leave us place enough.[3]

Once it became possible to travel on the Continent again after Napoleon's abdication at Fontainebleau in April 1814, the two friends set off across France for Italy. On that trip Knudtzon paid a visit to Napoleon on Elba. It is not known whether Baillie went along. They spent the winter of 1815–16 in Rome, where Knudtzon formed a close friendship with the sculptor Bertel Thorvaldsen. In his letters to Thorvaldsen, Knudtzon indicates that he and Baillie left Rome for Venice in March of 1816, so Baillie must have sat for Ingres in

January or February—at roughly the same time that the Danish sculptor was producing portrait busts of the two men. There is nothing to suggest that Ingres might also have drawn a portrait of Knudtzon; the highly unusual strict frontal pose in the Baillie drawing would seem to preclude a possible pendant.

Knudtzon's subsequent correspondence with Thorvaldsen provides a record of the friends' continued travels, for it includes letters addressed from Venice, London, Trondheim (the Norwegian's hometown), Florence, Naples, Teplitz, Bagnères-de-Bigorre, Livorno, Milan, Interlaken, Lausanne, Paris, and Malta. The two owned a house in Naples, where they generally spent the winter; during the summer months they could most often be found in the Swiss Alps.

Their idyllic life together ended in 1854, when Knudtzon took ill in Naples in April and was taken by his brother for treatment to Paris, where he died in July. Baillie, who had stayed in Naples, survived him by a mere six months. H.N.

For the author's complete text, see Naef 1977–80, vol. 2 (1978), chap. 62 (pp. 33–38).
 1. Davies 1946a, no. 789.
 2. Byron 1901, p. 419.
 3. Lyttelton 1912, p. 167.

PROVENANCE: Presumably Alexander Baillie (1777–1855); François Flameng, Paris, by 1911; his sale, Galerie Georges Petit, Paris, May 26–27, 1919, no. 120, as "Alexandre Boyer, né à Londres en 1777, mort à Naples en 1855"; purchased at that sale for 19,000 francs by Mori for Dr. Lucien-Graux; Dr. and Mme Lucien-Graux, née Flavigny, Paris; sold or consigned for sale by Mme Lucien-Graux about 1957, after the death of her husband; the present owner since 1961

EXHIBITIONS: Paris 1911, no. 101, as *Alexandre Boyer;* Paris 1921, no. 81, as *Alexandre Boyer;* Zurich 1973 (not in catalogue); Liverpool, Kingston-upon-Hull, London 1979–80, no. 30, ill.; Tübingen, Brussels 1986, no. 12

REFERENCES: Lapauze 1911a, ill. p. 161, as *Alexandre Boyer, 1777–1855;* Saunier 1918, p. 24, ill., as *Alexandre Boyer; La Renaissance de l'art français* 1921, ill. p. 231, as *Alexandre Boyer;* Naef 1956 ("English Sitters"), p. 435, fig. 14, p. 434 (sitter identified); Sass 1963–65, vol. 1, pp. 252–53, ill., vol. 3, p. 154, n. 152; Naef 1977–80, vol. 4 (1977), pp. 344–45, no. 186, ill.

71. Sir John Hay and His Sister Mary

1816
Graphite
11 ½ × 8 ⅝ in. (29.1 × 21.9 cm)
Signed and dated lower right: Ingres Del. / a Roma / 1816. [Ingres drew (this) / at Rome / 1816.]
The British Museum, London 1938-8-17-1
London and Washington only

N 187

The Ingres drawing now identified as a double portrait of John and Mary Hay was acquired by the British Museum in 1938 and promptly published in the *Illustrated London News*.[1] As it had been passed down in the Hay family, there was little doubt about the identity of the male figure; given the date of the drawing and the man's apparent age in it, he could only be Sir John, sixth Baronet Hay (1788–1838). Since he wears a flower in his lapel and the woman a matching one pinned to her bosom, and since she clearly wears an engagement ring, it was assumed that the work commemorates a betrothal and that the female figure was therefore the Anne Preston whom Hay married in 1821.

That identification was thrown into question when it was learned that a granddaughter of Sir John Hay's sister Mary owned a reproduction of the female figure alone, which she had been told was a portrait of her grandmother. It thus appeared that the subjects were brother and sister, despite the evident symbols of an engagement.[2]

The puzzle was nicely resolved the following year, thanks to the diligence of a British Museum curator. She contacted another granddaughter of Mary Hay, who related the story of the drawing as told to her by her father. According to her, Mary's fiancé, George Forbes, was in Rome with her family, and he commissioned Ingres to do a portrait drawing of himself and Mary Hay as a betrothed couple. Forbes was called away from Rome at the time arranged for the final sitting, and Ingres refused to reschedule. Mary's brother John was therefore drafted to stand in for him, but the artist also refused to alter the composition. The male figure is thus a hybrid formed of John Hay's head on George Forbes's body. Forbes was so annoyed at the artist's high-handedness that he refused to accept the work, though he later had a photograph made of his wife's figure, with that of his brother-in-law blanked out, and gave copies to each of his children.[3]

Although the overall impact of the drawing is powerful, closer inspection does indeed reveal that something is amiss. Erasures in the area of the man's head have compromised the surface of the paper so that the pencil lines here lack the exquisite clarity of those in the rest of the work. The lines that describe John Hay's left cheek, for example, are positively unsightly. The artist was doubtless irritated not only by the damage to the paper but also by the occasion for the erasures.

Both the Hays and the Forbeses were Scottish aristocrats. John Hay did little enough to enhance the family name, and his marriage to the above-mentioned Anne Preston produced no children. He inherited the baronetcy on the death of his father in 1830 and served in Parliament as a representative of Peebles—without distinction—from 1831 until his death in 1838.

George Forbes, whom Mary Hay married in 1819, was a worthy son of the highly regarded Scottish banker Sir William, sixth Baronet Forbes of Pitsligo. George eventually became the head of the bank, and he died in 1857. The couple appears to have had eleven children. Mary died in Cockermouth, Cumbria, in 1877. H. N.

For the author's complete text, see Naef 1977–80, vol. 2 (1978), chap. 66 (pp. 67–72).

1. *Illustrated London News* 1938, p. 357, ill.
2. Senior 1939c, pp. 1–2.
3. Senior 1939b, p. 128.

PROVENANCE: Sir John, sixth Baronet Hay (1788–1838); Sir Adam, seventh Baronet Hay, his brother, until 1867; Sir Robert, eighth Baronet Hay, his son, until 1885; Athole Stanhope Hay, his son, until 1933; Athole Hay, his son, until 1938; purchased from his family for £493 1 s. 6d. through the law firm Trower, Still & Keeling, London, and the auction house Christie's, London, by the National Art-Collections Fund and presented to The British Museum, London, 1938

EXHIBITIONS: Sheffield;* Paris 1967–68, no. 91, ill. (with erroneous provenance); London 1972, no. 346; London 1974, no. 311; Southampton, Manchester, Hull, London 1995 (exhibited only in Hull and London), no. 100, ill.

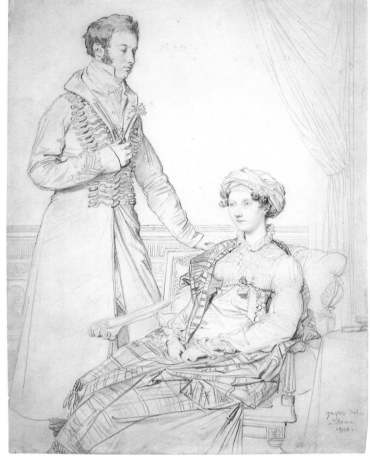

71

REFERENCES: *Illustrated London News* 1938, p. 357, ill. ("a portrait drawing believed to be Sir John Hay, 6th baronet, and Miss Anne Preston, whom he afterwards married"); Ford 1939, p. 8, fig. A on pl. II, p. 6, as *Sir John Hay and His Sister Mary* [or] *His Future Bride;* Senior 1939a, p. 32, no. 1097, ill. p. 33, as *Sir John Hay and His Sister Mary;* Senior 1939b, p. 128, as *Sir John Hay and His Sister Mary;* Senior 1939c, pp. 1–2, frontis., as *Sir John Hay and His Sister*

Mary; Davenport 1948, vol. 2, no. 2321, p. 826, ill.; Alazard 1950, pl. XXXIV; Sitwell 1973, p. 262, ill. p. 261; Delpierre 1975, p. 22; Naef 1977–80, vol. 4 (1977), pp. 346–47, no. 187, ill.; London, British Museum 1984, p. 139, no. 131, ill. p. 138

*"Hung for some time at the Graves Art Gallery at Sheffield, where it was on loan"; *Daily Independant* 1938.

72. Madame Louis-Nicolas-Marie Destouches, née Armande-Edmée Charton

1816
Graphite
$16\frac{7}{8} \times 11\frac{1}{4}$ *in. (43 × 28.5 cm)*
Signed and dated lower right: Ingres Delineavit / rome 1816 [Ingres drew (this) / Rome 1816]
At lower left, the Musée du Louvre, Paris, collection stamp (Lugt 1886a)
Musée du Louvre, Paris
Département des Arts Graphiques RF 1747
New York only

N 192

When this portrait drawing of Madame Destouches was first exhibited, in 1861, it was immediately recognized as one of Ingres's masterworks. It radiates an aura of luxurious comfort, and one would never suspect that its lovely subject, dressed in the height of fashion, was the wife of an ordinary student.

She was born Armande-Edmée Charton in Sainte-Croix de la Charité, Nièvre, in 1787. At that time her father was Président

Trésorier au Bureau des Finances de Lyon; thus she undoubtedly had considerable resources of her own. She was first engaged to Pierre-Charles Destouches de Migneux, the son of a high financial official in Paris, but the young man, an officer in Napoleon's Grande Armée, was killed in Silesia in 1813. In his will, Pierre-Charles requested that she marry his younger brother instead. Thus it was that she became the wife of the more-than-willing Louis-Nicolas-Marie

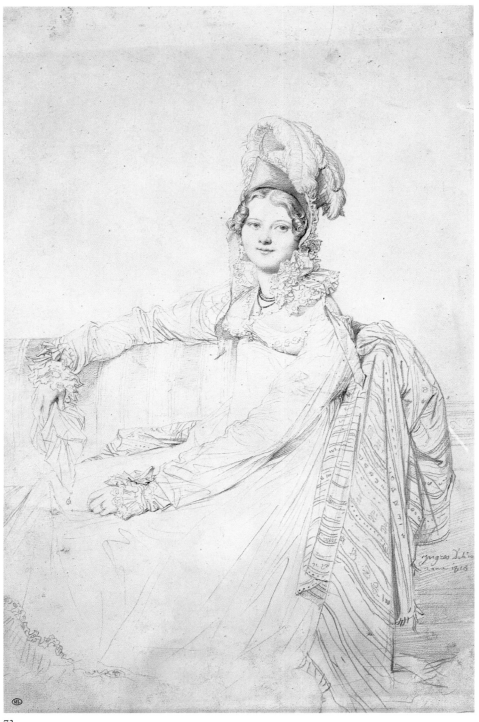

72

made me almost a pretty woman. The portrait painted in oils is lifesize and extends below the knees. This was also by a friend of Delile,[2] who, wishing to paint a woman's portrait from life before starting on a large canvas, was nice enough to choose me.[3] The engraving will also be done by a pensioner [at the Villa Medici],[4] who must copy M. Ingres's drawing, which we'll send you an example of as soon as we have one. If I were better, people could accuse me of being immodest, from having reproduced my image so many times. But I was only following Delile's wishes, who, in the guise of having his wife's portrait done, has acquired samples by some good artists.[5]

One gathers that Destouches had commissioned the work. In doing so he had the good taste—or the good fortune—to engage the most important portraitist of the epoch at the height of his powers.

Madame Destouches, who seems the picture of health in her portrait, would die an early death in 1831, at only forty-four, before her husband had achieved any notable success in his career. Destouches would be named architect of the Panthéon in Paris at the time of the July Monarchy, but it was in his designs for private residences that he best displayed his talents. He was inducted into the Legion of Honor in 1841 and died in 1850. The couple had two sons and a daughter. The older son became an architect like his father, the younger a civil servant—it was he who left his mother's portrait to the Louvre. Their daughter, Nancy Destouches, became the wife of Hector-Martin Lefuel, the architect who realized the centuries-old dream of connecting the Louvre to the Tuileries.

Jean Coraboeuf engraved this drawing in 1895.[6]

H. N.

Destouches, who was also well-to-do, in 1815.

Her husband, a pupil of Laurent Vaudoyer and Charles Percier, had won the Prix de Rome in architecture the previous year. The young couple arrived in Rome in April 1816, and Ingres executed the portrait drawing of the young matron a short time afterward. In December she wrote of the work to her father-in-law:

I remember, dearest papa, that you were kind enough to regret not having enough portraits of me. When we see each other again, you won't have [the] same regret, for I now exist as a sculpture, a drawing, a painting, and soon an engraving! The sculpture is courtesy of a friend of my husband's, who did both our portraits.[1] The portrait drawing was done by a famous artist, M. Ingres, who, incidentally, was so flattering in his rendering of me that he

For the author's complete text, see Naef 1977–80, vol. 2 (1978), chap. 78 (pp. 134–38).

1. The winners of the Prix de Rome in sculpture between 1812 and 1815 were François Rude, James Pradier, Louis Petitot, and Étienne-Jules Ramey.
2. Madame Destouches's name for her husband.
3. Presumably the painter Léon Pallière.
4. Possibly the engraver François Forster. The engraving is unknown.
5. Madame Louis-Nicolas-Marie Destouches to her father-in-law, December 11, 1816, quoted

in Naef 1977–80, vol. 2 (1978), p. 136. The letter was discovered among his family's papers by Olivier Le Fuel, the great-great-grandson of Madame Destouches, and he kindly allowed the author to publish it.

6. Anon., April 1, 1968, ill. p. 296.

PROVENANCE: Louis-Nicolas-Marie Destouches (1789–1850), Paris; Adrien-Aimé Destouches, his son, Neuilly; his bequest to the Musée du Louvre, Paris, 1891

EXHIBITIONS: Paris 1861 (1st ser.), no. 51; Paris 1867, no. 554, Stockholm, Oslo 1928, no. 153 (Copenhagen), no. 142 (Stockholm); London 1932, no. 869; Paris 1934c, no. 92; Venice 1934, no. 196; Paris 1935a, no. 85, ill.; Brussels 1936, no. 6, ill.; Paris 1937, no. 669 [EB]; Brussels, Rotterdam, Paris 1949–50, no. 132; Washington, Cleveland, Saint Louis, Cambridge (Mass.), New York 1952–53, no. 112, pl. 33; Rome, Milan 1959–60, no. 120, pl. 59; Montauban 1967, no. 54, fig. 8; Paris 1967–68, no. 94, ill.; Rome 1968, no. 59, ill.; Montauban 1980, no. 34, ill.; Mráz 1983, p. 45, fig. 30; Tübingen, Brussels 1986, no. 10, ill.

REFERENCES: Blanc 1861, p. 191; Delaborde 1861, p. 267; Galichon 1861a, p. 357; Blanc 1870, pp. 43, 44, 236; Delaborde 1870, no. 285; Gatteaux 1873 (2nd ser.), no. 108, ill.; Both de Tauzia 1888, p. 141; Chennevières 1903, p. 136, ill. p. 127; Lapauze 1903, pp. 12, 29, 33, no. 15, ill.; Alexandre 1905, pl. 3; Momméja 1905b, pp. 411–13, ill. opp. p. 412 (detail of the engraving by Jean Coraboeuf); *Dessins du Musée du Louvre* n.d., pl. 294; *Masters in Art* 1906, p. 25 (277), pl. IV; Boyer d'Agen 1909, pl. 37 opp. p. 280; Guiffrey and Marcel 1911, no. 5038, ill. p. 125; Lapauze 1911a, pp. 184–85, ill. p. 159; Fontainas and Vauxcelles 1922, ill. p. 46; Fröhlich-Bum 1924, pl. 27; Lapauze 1924, vol. 2, p. 105, n. 4; Fischel and Boehn 1925a, vol. 1, ill. p. 181; *Dessins de Jean-Dominique Ingres* 1926, p. [7], pl. 21; Martine 1926, no. 15, ill.; Hourticq 1928, pl. 46; Alaux 1933, ill. p. 165; *French Art* 1933, no. 863; Christoffel 1940, ill. p. 127 (detail); Alazard 1942, no. 4, ill.; Gasser 1943, ill. p. 29; Malingue 1943, ill. p. 71; Cassou 1947, pl. 35; Bertram 1949, pl. XIX; Bouchot-Saupique 1949, p. 437; Jourdain 1949, fig. 52; Roger-Marx 1949, pl. 23; Scheffler 1949, pl. 23; Alazard 1950, p. 64, n. 19, p. 147; Labrouche 1950, pl. 9; Sainte-Beuve 1950, p. 1, ill.; Elgar 1951, fig. 37, p. 8; Wildenstein 1954, ill. p. 27; Mathey 1955, no. 20, ill.; Novotny 1960, pl. 11B; Boucher 1965, fig. 903, p. 353; Sérullaz et al. 1966, no. 27, ill.; Berezina 1967, fig. 37; Sérullaz 1967, p. 211; Waldemar George 1967, ill. p. 59; Courthion 1968, ill. p. 12; Radius and Camesasca 1968, p. 123, ill.; *Encyclopaedia universalis* 1970, ill. p. 1030; Ternois and Camesasca 1971, p. 123, ill.; Delpierre 1975, pp. 24–25; Naef 1977–80, vol. 4 (1977), pp. 356–58, no. 192, ill.; Picon 1980, p. 39, ill.; Vigne 1995b, p. 96, fig. 66

73. Mademoiselle Henriette-Ursule Claire (Thévenin?) and Her Dog Trim

1816
Graphite
12 × 8¾ in. (30.4 × 22.1 cm)
Signed and dated lower right: Ingres Del. / à Monsieur / Thevenin. à rome 1816 [Ingres drew (this) / for Monsieur / Thévenin. Rome 1816]
Gemeentemuseum, The Hague
New York and Washington only

N 191

By 1816 Ingres's situation was desperate. With the fall of the Empire, he had been robbed of his patrons in the French administration in Rome, and to scrape by he was reduced to producing pencil portrait drawings, primarily of English visitors to Rome. Compounding his worries in that year was the prospect of a change at the Académie de France. Although he had moved out of the Villa Medici six years before, he remained on the friendliest of terms with its director, Guillaume Guillon Lethière (see cat. no. 52), and now Lethière was due to be replaced by an unknown. As it happened, the new director, Charles Thévenin, proved to be the soul of kindness and an ardent admirer of the younger artist. In his efforts to secure for Ingres the sorts of commissions he yearned for, he even surpassed his predecessor. Less than two months after his arrival, he wrote an unsolicited letter to the minister of the interior in Paris in which he highly recommended his new acquaintance:

> M. Ingres, a history painter and former student at the Académie Royale de France, where he acquitted himself with distinction in his required assignments, stayed on in Rome because of his liking for the masters who revived and elevated art to a summit that has not been surpassed since. He is endowed with a fine and delicate sensibility; his manner is firm and polished. So far he has not had the chance to show just what he can do. It is up to the Government to give him the opportunity to develop his talent, which is original and wholly out of the ordinary. Lately, he has executed two small paintings in a very refined style; he is contemplating something much larger, but this would require the kind of time and tranquillity that his lack of resources makes impossible. He needs to be supported and encouraged, and he fully deserves the Government's attention and benevolence.[1]

In the following year, Thévenin urged the new French ambassador to Rome to entrust Ingres with one of the paintings he planned to commission for the church of Santissima Trinità dei Monti. The resulting composition, *Christ Giving the Keys to Saint Peter* (fig. 106), was later acquired by the Musée du Louvre, Paris, in 1842. On

the strength of that work, Ingres was asked to produce a painting for the cathedral in his hometown of Montauban, *The Vow of Louis XIII* (fig. 146), which would finally bring him fame when exhibited at the Salon in 1824. As long as he stayed in Rome, Ingres was able to rely on Thévenin's energetic support, and even after he had risen far above him in stature, he retained gratitude to and affection for the man.

Like Lethière, Thévenin was a relatively undistinguished artist who had attained none of the usual honors before being awarded the directorship in Rome. Born in Paris in 1764, he had studied painting under François-André Vincent. His best-known composition is *The French Army Crossing the Saint Bernard Pass*, painted in 1806. At the completion of his uneventful term at the Villa Medici he returned to Paris, where he ended his career as curator of the Cabinet des Estampes at the Bibliothèque Nationale. There he is remembered to this day for his habit of limiting his appearances primarily to paydays. He died in Paris in 1838.

Thévenin was rewarded for his exertions on Ingres's behalf with two portrait drawings that have done more to recommend him to posterity than anything he accomplished himself. The first of them was executed the year he arrived in Rome, and it is among the works that demonstrate that Ingres was then at the height of his powers as a portraitist (N 190; Musée Bonnat, Bayonne). The second is dated 1817 (cat. no. 74). (A copy in the Cleveland Museum of Art since 1934 was erroneously attributed to Ingres until 1965.)[2] Its dedication, "to Jenni Delavalette," is only one of several indications that Thévenin's domestic situation was, at best, unusual. Nothing is known about the lady beyond the fact that Ingres drew her portrait the same year and dedicated it to Thévenin (N 202; Museum of Western Art, Tokyo). Her name appears nowhere in the documents relating to the birth of Thévenin's illegitimate son by a Roman woman, possibly a model, in 1819.[3] The boy, fully recognized by his father, ultimately became an engraver and worked alternately in Italy and France until he died, in Rome, in 1869.

More puzzling is Thévenin's "daughter," who was roughly twenty when Ingres made this portrait drawing of her in 1816. It appears that she was born Henriette-Ursule, the daughter of a François Le Claire (or Claire) in Andilly, near Montmorency,[4] and must have chosen to be called by her original surname. How she came to be adopted by a bachelor—Thévenin's death certificate identifies him as such[5]—is unexplained.

Three years later, Ingres produced a portrait of Mademoiselle Claire's fiancé, André-Benoît Taurel (cat. no. 84). A pupil of Pierre-Narcisse Guérin, Taurel was born in Paris in 1794 and had first attended the École des Beaux-Arts. Having won the Prix de Rome for engraving in 1818, he had arrived at the Villa Medici late that same year and promptly fallen in love with the director's daughter. According to Taurel family tradition, Ingres drew the young man's portrait in anticipation of his marriage to Mademoiselle Claire, which took place in Rome on June 26, 1819.[6] He is posed in Ingres's drawing on the garden terrace of the Villa Medici; behind him on the left can be seen the cupola of Sant'Agnese in Agone,[7] and on the right is the garden facade of the palace.

The Taurels returned to Paris in 1823, in time to provide a place for Ingres to live when he arrived with his painting for Montauban the following year. In 1828 they moved to Amsterdam, where Taurel had been invited to establish a school of engraving at the art academy. They stayed there the rest of their lives. Hers would be brief, for she died in 1836, leaving her husband with four young sons. After ten years as a widower Taurel remarried and had four more children; he died in 1859. In his later years he regaled his son Charles-Édouard with reminiscences of Rome, and the latter faithfully recorded them in a book published in Holland in 1885, which he illustrated with his own engravings after Ingres's portraits of his mother and father. He also described the relationship between his parents and their illustrious portraitist:

Fortunately, Mme. Ingres adored her husband and the peculiarities of his character; his minor jealousies and moments of artistic oversensitivity seemed only natural to her. For her, nothing in the world was as important as her husband's talent and glory, and no sacrifice seemed too great. They lived more than modestly and saw few people, but they had close ties with the director of the Académie and his daughter. Charles Thévenin was a true friend to Ingres, helping him with advice and performing a number of small favors for him, and when Mlle. Claire became Mme. Taurel, their friendly encounters became more and more frequent and the two households soon merged into a single family. Thévenin and his son-in-law showed Ingres all the signs of consideration with which one likes to surround unrecognized talent and genius, and perhaps, without realizing it themselves, they greatly contributed toward maintaining in his mind the fixed idea of future success and fame. The idea might be vain for many others, but it is the only thing capable of sustaining an artist's courage through difficult periods.[8]

The Taurels's first child, Charlotte-Madeleine, was born at the Villa Medici in October 1820, and Ingres drew her when she was about five, to judge from the portrait (cat. no. 102). In the form of an engraving titled *Child with a Kid*, made in 1861 by Claude-Marie-François Dien, the composition became extremely popular in the second half of the nineteenth century. The work seems charming at first, but over time its sentimentality cloys—something that can be said of virtually no other drawing in Ingres's portrait oeuvre. It appears that the girl died young, for she is not included in the list of grandchildren in Thévenin's will. H . N .

For the author's complete text, see Naef 1977–80, vol. 2 (1978), chap. 88 (pp. 206–22).

1. Charles Thévenin to M. Lainé, July 15, 1816, quoted in Lapauze 1911a, pp. 192–94; reprinted in Naef 1977–80, vol. 2 (1978), p. 209.
2. The literature and exhibition history for this copy includes: Cleveland 1927; *International Studio* 1928, ill. p. 81; New York 1928, no. 1; Cleveland 1929, p. 159; Zabel 1930, p. 382, ill. p. 372; Francis 1932, p. 168; Cleveland 1932–33; Anon., August 1934, p. 6, ill.; Mongan 1947, no. 15, ill.; San Francisco 1947, no. 3; Francis 1948, p. 36, ill. p. 34; Alazard 1950, p. 62, pl. XXXIX; Detroit 1950b, no. 26; Oberlin 1967, p. 156, no. 7, fig. 7.

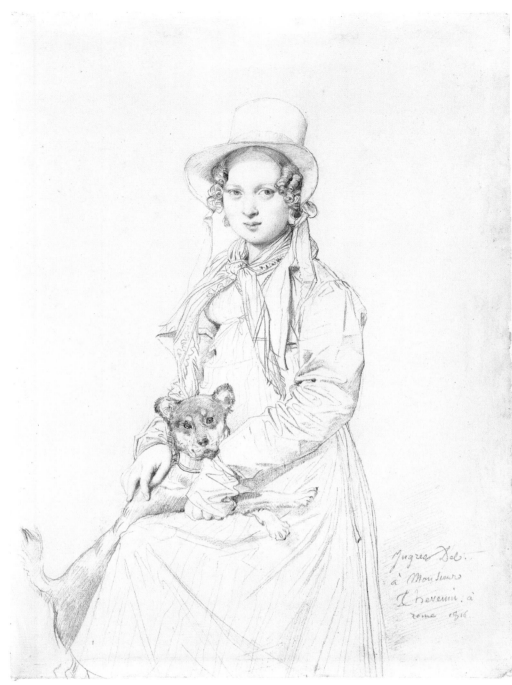

73

3. Parish register, San Martino ai Monti, Rome, fol. 43r, entry for May 22, 1819, Archivio del Vicariato, Rome.
4. Marriage register, San Lorenzo in Lucina, Rome, fol. 75v, Archivio del Vicariato, Rome.
5. Archives de Paris.
6. Taurel 1885, pp. 14–15.
7. In the Musée Ingres, Montauban, there is a pencil sketch for the background view on the left. See Naef 1960 *(Rome)*, p. 27, n. 52, fig. 7.
8. Taurel 1885, pp. 16–17; quoted in Naef 1977–80, vol. 2 (1978), p. 218.

PROVENANCE: Charles Thévenin (1764–1838), Paris; his gift to his adopted daughter, Henriette-Ursule Claire (ca. 1794–1836), and André-Benoît Barreau Taurel (1794–1859) in Rome in 1819, on the occasion of their marriage; André-Benoît Barreau Taurel, Amsterdam, from 1836 to 1859; his heirs; in 1885, at the latest, given or sold by one of the subject's sons to Jozef Israëls, The Hague, until 1911; Isaac Israëls, his son, The Hague, until 1934; his sister Frau Cohen Tervaert-Israëls, until about 1945; her gift to H. E. van Gelder; his heirs; their gift to the Gemeentemuseum, The Hague, 1946

EXHIBITIONS: Paris, Amsterdam 1964, no. 142, pl. 115; Rome 1968, no. 60, ill.; Tübingen, Brussels 1986, no. 11

REFERENCES: Taurel 1885, pp. 2, 15, ill. opp. p. 13 (the engraving by Charles-Édouard Taurel); Lapauze 1911a, ill. p. 163 (the engraving); H. E. van Gelder 1950, pp. 2–10, fig. 1; Wijsenbeek 1956, pp. 32–35, ill.; Naef 1965 ("Thévenin und Taurel"), pp. 119–57, no. 3, fig. 3; Naef 1977–80, vol. 4 (1977), pp. 354–55, no. 191, ill.

74. Charles Thévenin

1817

*Graphite with white highlights on two joined
sheets of yellowish paper**
11 7/8 × 9 1/2 in. (29.9 × 24 cm)
*Signed and dated lower left over an erased
signature and date, including the still-legible
"rome 1817"*: Ingres et / Sa grosse à /
madame — / Jenni Delavalette / rome 1817.
[Ingres and / his old lady for / Madame — /
Jenni Delavalette / Rome 1817.]
André Bromberg

N 201

This drawing is discussed under cat. no. 73.

PROVENANCE: Mme Jenny Delavalette;
Charles Thévenin (1764–1838), Paris; Jean-
Charles Thévenin, his illegitimate son, Rome,
until 1869; his sale, Hôtel des Commissaires-
Priseurs, Paris, October 30, 1869, no. 8, with-
drawn; his sale, Hôtel des Commissaires-
Priseurs, Paris, November 26, 1869, no. 15, sold
for 630 francs to Georges Danyau, Paris, until
1894; Mme Perrier, née Danyau, his daughter,
until 1963; her daughter Mme Hervé du Couëdic
de Kerérant, née Laurence Perrier; sale, Hôtel
Drouot, Paris, March 22, 1983, no. 10; acquired
at that sale by the present owner

EXHIBITIONS: Paris 1867, no. 577; Paris
1949b, no. 76 (not in catalogue)

REFERENCES: Blanc 1870, p. 239; Delaborde
1870, no. 419; Naef 1965 ("Thévenin und
Taurel"), pp. 119–57, no. 2, fig. 2; Naef 1977–80,
vol. 4 (1977), pp. 374–75, no. 201, ill.

*The sheets are joined vertically, roughly half an
inch from the right edge.

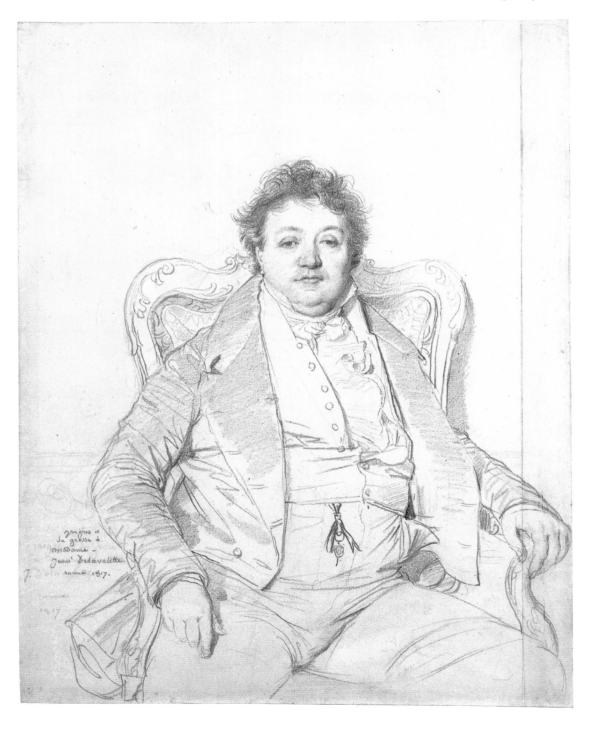

75. Charles Robert Cockerell

1817
Graphite
$7\frac{5}{8} \times 5\frac{3}{4}$ *in.* *(19.4 × 14.6 cm)*
Signed and dated upper left: Ingres a Messieurs
/ Lynk et Stackelberg. / rome 1817. [Ingres
for Messrs. / Lyn(c)k(h) and Stackelberg. /
Rome 1817.]
The Visitors of the Ashmolean Museum, Oxford.
Purchased with the assistance of Hazlitt, Gooden
and Fox in memory of Hugh Macandrew (1931–
1993) with the support of the Heritage Lottery Fund,
the National Art Collections Fund, the MGC/
V&A Purchase Grant Fund, and the Friends of
the Ashmolean Museum 1998.179
London only

N 212

Although Ingres is known to have produced roughly thirty portrait drawings of English sitters during the lean years between 1815 and 1817, only two bear dedications. Both of them are likenesses of the architect and archaeologist Charles Robert Cockerell, clearly a close acquaintance. One of them (N 195) is dedicated to Cockerell's mother, to whom Cockerell wrote on February 12, 1817, that it was "just finished."[1] In an earlier letter to his father, apparently written in 1816, the Englishman explained that he had "befriended a French painter of great talent named Ingres" and that the two of them met frequently to discuss matters of painting and of art in general.[2]

In 1810, at the age of twenty-two, Cockerell had set out for Greece, eager to study its antiquities. He spent the winter of that year in Athens, where he frequently saw several distinguished fellow countrymen, including Lord Byron, and became acquainted with a group of like-minded young men from northern Europe. Among these were the artists Jakob Linckh, from Württemberg, and Baron Otto Magnus von Stackelberg, from Estonia. In the spring of 1811, accompanied by several of these new friends, he discovered the remains of the temple of Aphaia on the island of Aegina, and in the following year he uncovered the frieze sculptures at the temple of Apollo at Bassae, in Arcadia. After further travels in Turkey and Sicily, Cockerell arrived in Rome in 1814, where he stayed on and off for the next two years.[3]

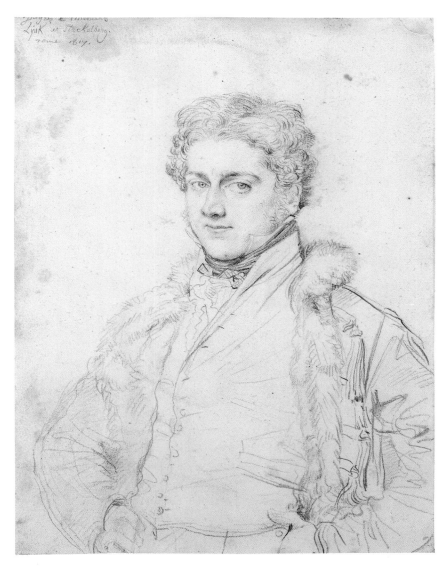

This second Ingres drawing of Cockerell is also dated 1817. It is dedicated to Linckh and Stackelberg. The two young men were also in Rome at the time and would stay on after Cockerell returned to England. The work was clearly a companion piece to the portrait of Stackelberg and a friend (possibly Linckh) that Ingres produced as a farewell memento for Cockerell (cat. no. 76).

Ingres remained on friendly terms with Cockerell long after their meeting in Rome. A copy of Luigi Calamatta's 1839 engraving of Ingres's 1835 self-portrait that was passed down in the architect's family bears the artist's handwritten dedication "Ingres for his great friend, Monsieur Coquerel."[4] Cockerell's grandson assures us that the two occasionally corresponded through the years. Although Ingres never went to London, Cockerell from time to time visited Paris, where he was a member of the Académie des Beaux-Arts. Over the course of his long career, the architect left his stamp on any number of important buildings, including the University Library and the Ashmolean Museum in Oxford and the Bank of England on Threadneedle Street, London. He also designed several country mansions. His work reflects his profound knowledge of historical styles, a subject to which he devoted many of his lectures as professor at the Royal Academy, London, from 1840 to 1857. He died in 1863 and was buried in Saint Paul's Cathedral next to his father-in-law, John Rennie, engineer of Waterloo Bridge, and near Sir Christopher Wren, architect of the cathedral. H.N.

For the author's complete text, see Naef 1977–80, vol. 2 (1978), chap. 80 (pp. 147–53).

1. This information was communicated to the author in a letter of March 13, 1958, by Eugene Merrick Dodd. The drawing is illustrated in Naef 1977–80, vol. 2 (1978), p. 147, fig. 1.
2. This information was communicated to the author in a letter of August 15, 1958, by Eugene Merrick Dodd, who said that Cockerell's 1816 letter to his father had been given to him by a descendant of Cockerell.
3. Biographical details are taken from the article on the architect in the *Dictionary of National Biography*, vol. 11 (1887), pp. 195–98.
4. Henriot 1926–28, vol. 3, p. 269.

PROVENANCE: Jakob Linckh and Otto Magnus von Stackelberg, until the latter's death, in 1837; Jacob Linckh, Stuttgart, until 1841; his widow, née Friederike Bilfinger, Germany, until 1876; her great-grandsons the barons von Pappus, until 1930 at the latest; Graphisches Kabinett Guenther Franke, Munich, by 1930; purchased from Franke by the book dealer Erhard Weyhe, New York City, 1930; Arthur Weyhe, his son, by 1966; Sotheby's, New York, May 7, 1998, lot no. 14; purchased at that sale by Hazlitt, Gooden and Fox on behalf of the Ashmolean Museum, Oxford

EXHIBITIONS: Springfield, New York 1939–40, no. 55 (New York only [EB]), as *Jacob Linckh*; Cincinnati 1940, as *Jacob Linckh*; Rochester 1940, as *Portrait of Jacob Linckh;* San Francisco 1947, no. 9, as *Jacob Linckh*

REFERENCES: *Art News*, April 1930, ill. in advertising section, as *Portrait of the Archaeologist Jacob Linckh*, "Graphisches Kabinett Munich, G. Franke, Briennerstrasse 10, New York: J. B. Neumann, 9 East 57th Street"; *Art News*, May 1930, ill. p. 14, as *Portrait of the Archaeologist Jacob Linckh*, "Courtesy of the Graphisches Kabinett, Munich"; Goessler 1930, p. 67, as *Bleistiftporträt Linckhs*, "half of a double portrait, the lost half showing Otto Magnus von Stackelberg"; Rodenwaldt 1930, col. 257, n. 2; *Goya bis Beckmann* n.d., p. [4], ill. p. [5], as *Hofrat Jacob Linckh*; Naef 1970 ("Griechenlandfahrer"), pp. 428–33, 438–39, fig. 2, p. 431 (sitter identified); Naef 1977–80, vol. 4 (1977), pp. 394–95, no. 212, ill.

76. Otto Magnus von Stackelberg and, possibly, Jakob Linckh

1817

Graphite

7¾ × 5⅝ in. (19.6 × 14.4 cm), framed

Signed and dated lower left: Ingres Del. / rome 1817 / à Coquerel [Ingres drew (this) / Rome 1817 / for Co(ckerell)]

Musée Jenisch, Vevey, Switzerland

Drawings Department A 437

N 213

The "Coquerel" to whom Ingres dedicated this double portrait of two male friends, one with his hand resting on the other's shoulder, was the English architect and archaeologist Charles Robert Cockerell, who left Rome in 1817, the year in which the drawing was executed.[1] Ingres knew him as the celebrated discoverer of the pediment sculptures at the temple of Aphaia on the island of Aegina and of the frieze sculptures at the shrine to Apollo at Bassae, near Phigalia (now in the Staatliche Antikensammlungen, Munich, and the British Museum, London, respectively). The French artist was also well acquainted with Cockerell's closest friends in Rome, Otto Magnus von Stackelberg and Jakob Linckh, with whom the Englishman had shared many of his experiences in Greece between 1810 and 1814. It would be reasonable to suppose that Ingres's double portrait was produced as a memento for Cockerell to take back with him to England, a counterpart to Ingres's portrait drawing of Cockerell from that same year dedicated "à Messieurs Lynk et Stackelberg" (cat. no. 75).

Unfortunately, the situation appears to be more complex, for though other portraits of Stackelberg[2] show that he is definitely the man on the right in the double portrait, the only known likeness of Linckh[3] indicates that he looked not at all like the man on the left. None of the other participants in the Grecian adventure were in Rome in 1817, and one wonders

which of Stackelberg's other close friends in the city might have been so well acquainted with Cockerell as to be deserving of a commemorative portrait. Stackelberg's diaries would doubtless resolve the matter, but they have been missing since World War II.[4]

Linckh, a German landscape painter, was the least important of the comrades who explored Greece together. Otto Magnus von Stackelberg, by contrast, was perhaps the most gifted of the group, a dilettante in the best sense: man of the world, art lover, painter, poet, musician, and scholar. Born in 1786 in the city in Estonia now called Talinn, he was the sixteenth child of a wealthy baron. Although his father died when he was five, the family fortunes were such that his education and a life devoted to art and travel were assured.

Stackelberg first arrived in Rome in 1808, and it was there that he was invited to join a quartet of Danish and German artists and archaeologists, including the somewhat older architect Baron Haller von Hallerstein, from Nuremberg, on a tour of Greece. The group arrived in Athens in the fall of 1810. When they disembarked in Piraeus, they were able to see some of the Elgin Marbles awaiting shipment to England. In Athens they became acquainted with Lord Byron and the passionate philhellene Frederick North, whose portrait Ingres also drew, in 1815 (N 150; Art Gallery of New South Wales, Sydney). They also met the English architects Cockerell and John Foster, and decided to join forces with them. The discoveries for which Cockerell would receive most of the credit were both made in 1811. Stackelberg spent that year and the two following ones wandering through central Greece, the Troad, and the Peloponnese, executing countless landscape drawings as well as paintings. In 1813 he had a close brush with death when he was captured and held by Albanian pirates until he could be ransomed by Haller von Hallerstein. By 1814 he was back in his northern homeland, where he spent two years on the family estates and in Saint Petersburg. Then followed twelve years in Rome, during which time he oversaw the engraving and printing of many of his Greek landscapes.

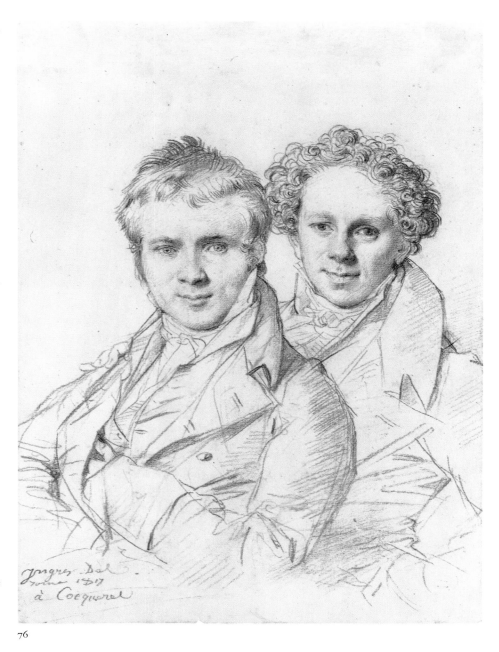

76

Most of the rest of his life, in fact—he died in 1837—was devoted to publishing his impressions of Greece. On the strength of those impressions, one biographer goes so far as to credit him with the actual "discovery" of the Greek landscape.[5] H.N.

For the author's complete text, see Naef 1977–80, vol. 2 (1978), chap. 81 (pp. 154–63).

1. Inscribed on the back of the old mount: "Herr Linckh (in front) and Baron Stackelberg—traveller companions of R. C. C[ockerell] and codiscoverers of the Aeginetan and Phigalian Marbles." Also on the back of the mount there is a label with the following inscription: "Royal Academy of Arts, Exhibition of French Art, 1932, The two Brothers Coquerel. Miss Sargent, 10 Carlyle Mansions, Cheyre [sic, for Cheyne] Walk, SW 3."

2. Geller 1952, nos. 1348–59, figs. 524, 525, 527.
3. Ibid., no. 780, fig. 264; Naef 1977–80, vol. 2 (1978), p. 149, fig. 3.
4. See Rodenwaldt 1957, p. 42, n. 18.
5. Ibid.

PROVENANCE: Charles Robert Cockerell (1788–1863), London; his widow, née Anna Maria Rennie, until 1873; Frederick Pepys Cockerell, their son, Paris, until 1878; his widow, née Mary Homan-Mulock, until 1918 at the latest; their son Frederick William Pepys Cockerell; presumably between 1918 and 1921, Sir Philip Sassoon, London; the Édouard Jonas gallery, Paris, by 1921 at the latest; anonymous auction, Christie's, London, July 27, 1923, no. 55, as Linckh and Stackelberg; purchased at that sale for 189 pounds sterling by Thos. Agnew & Sons, London; John Singer Sargent (1856–1925), London, until 1925; Miss Emily Sargent, his sister, London, until

1936; Mrs. Francis Ormond, née Violet Sargent, their sister, until 1955; her son Jean-Louis Ormond, Corseaux-sur-Vevey; his gift to the Musée Jenisch, Vevey, 1984

EXHIBITIONS: London 1917, no. 76; Paris 1921, no. 80, ill. p. 14, as *M. Linck et le baron de Stackelberg;* London 1932, no. 883, as *Herr Linckh and Baron Stockelberg;* Zurich 1958a, no. B5

(Stackelberg identified and Linckh's identity questioned); Paris 1967–68, no. 97, ill.; Bern, Hamburg 1996, no. 3, ill; Vevey 1997–98, no. 84, ill., as *Otto Magnus von Stackelberg and Jacob Linckh*

REFERENCES: Anon., August 1918, pp. 72–74, ill. p. 72, as *Linckh and Stackelberg;* Reinach 1918, pp. 214–15, "von Linckh from Wurttemberg and the Estonian von Stackelberg"; Lapauze 1919,

p. 10, n. 3, "Linck of Wurtemberg and the baron Stackelberg"; *La Renaissance de l'art français* 1921, ill. p. 230, as *M. Linck et le baron Stackelberg;* Rodenwaldt 1930, col. 257, n. 2; *French Art* 1933, no. 864, as *Herr Linckh and Baron Stackelberg;* Naef 1970 ("Griechenlandfahrer"), pp. 433–40, fig. 3, as *Otto Magnus von Stackelberg und ein Unbekannter;* Naef 1977–80, vol. 4 (1977), pp. 396–97, no. 213, ill.; Ternois 1980, pp. 80–81

77. The Kaunitz Sisters

1818
Graphite
11⅞ × 8¾ in. (30.1 × 22.2 cm)
Signed lower left: Ingres del. [Ingres drew (this)]
Dated lower right: rome 1818.
At lower left, a note for the framer: Partie dans le cadre. [This section under the frame.]
At lower right, the Anton Schmid collection stamp (Lugt 2330b)
The Metropolitan Museum of Art, New York
Gift of Mrs. Charles Wrightsman, in honor of Philippe de Montebello, 1998 1998.21
New York only

N 224

In this drawing, one of Ingres's rare group portraits, three charming young women are grouped in front of a piano and gaze out at the viewer. An inscription on the back, which dates after 1860, clearly identifies them as the daughters of the Austrian ambassador in Rome, Wenzel, Fürst (Prince) von Kaunitz-Rietberg, and his wife, Franziska, Gräfin (Countess) Ungnad von Weissenwolf.[1]

The sisters, Caroline, Leopoldine, and Ferdinandine, were born in 1801, 1803, and 1805, respectively, and at the time Ingres drew them they ranged in age from thirteen to seventeen. Without the inscription it would be difficult to distinguish which of the older girls is which, but the youngest of the three is certainly the one standing closest to the piano on the right.

Ingres's decision to pose them next to a piano cannot have been arbitrary. The painter was as yet little known in 1818, and it is likely that his passion for music and his considerable skills as a violinist were the qualities that procured him his first invitation to the home of the Austrian ambassador. When the violinist Niccolò Paganini first visited Rome in 1818, he would not have been able to perform in public if the Austrian diplomatic families had not opened doors for him, for the foreigners were far more appreciative of serious music than were the pillars of Roman society. Paganini gave a private recital at the Kaunitzes' in 1819,[2] and he drafted Ingres to play second violin in private performances of Beethoven quartets he organized in Rome.[3] It seems perfectly plausible, then, that the famous musician—of whom Ingres later produced a portrait (cat. no. 82)—first encountered the musical painter at the Kaunitzes'.

Prince Wenzel was the grandson of Maria Theresa's famous chancellor, Wenzel Anton von Kaunitz, and publicly he tried to present himself as a credit to his lineage. In fact, however, the father of the three sheltered young women in Ingres's drawing was a psychopathic lecher. Early in 1819, Prince Metternich, who was related to him by marriage,[4] explained in a letter to the comtesse de Lieven that since the age of eighteen Kaunitz had been unable to get through a day without having "three, four, five, even six women."[5] Kaunitz was forced to appear before the judicial authorities in Vienna in 1822, and was ultimately exiled. He died in Paris in 1848.

This must have cast a shadow on the lives of his daughters. Thanks to their princely name, however, and possibly also to the determination of their sorely tried mother,[6] they all found titled husbands. In 1831, Caroline married the widowed Graf (Count) Anton Gundakar von Starhemberg, a much decorated soldier a generation older than she and already retired. He died childless in 1841. Twenty years later, she married Pierre d'Alcantara, duc d'Arenberg, another widower. She died in 1875.

Leopoldine, to judge from the Ingres drawing the loveliest of the three, became the wife of Graf—later Fürst—Anton Karl Pálffy in 1820. The couple spent the years 1821–28 in Dresden, where he served as ambassador to the court of Saxony. She was appointed lady-in-waiting to the empress of Austria and died, also childless, in 1888.

The youngest of the sisters, Ferdinandine, married Graf Ladislaus Károly at seventeen. Like Leopoldine, she became a lady-in-waiting to the empress. Her husband had studied law and worked to improve the lives of the people living on his estates.

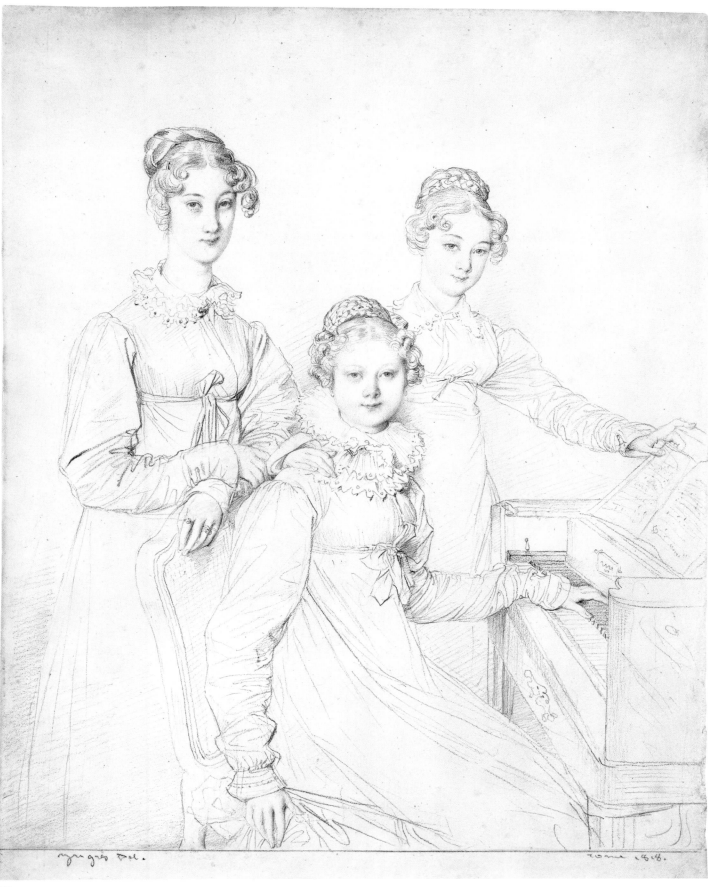

Ingres Del. rome 1818.

Their marriage, which produced two sons, was dissolved in 1846. Ferdinandine died in Vienna in 1862.

The drawing is particularly interesting because of what it reveals about Ingres's choice of materials. The edges of the drawing paper, a little more than an inch wide, are wrapped around a wood panel and glued to the back. The unattached paper on the front, stretched tight as a drum, made an ideal drawing surface. Ingres used such elaborately mounted papers only when creating finished works, not when making studies. The Kaunitz drawing shows that the mounting was done before the artist began to draw, for in this case the composition did not fill the paper, and with a horizontal pencil line and hatching Ingres marked off as superfluous the empty strip at the bottom. In the hatched area he then indicated in a note to the framemaker that this section was to be covered up. If the paper had been stretched over the wood backing after the drawing was completed, he could simply have cut off the bottom strip.

A second horizontal line appears just above the first, marking off the drawing at the bottom. The empty band between them was doubtless meant to contain the sisters' names or some kind of motto. As this involved calligraphy, it too was left as a job for the framer.

Ingres is thought to have purchased his drawing paper in Rome from his friend Charles Hayard, who ran a well-stocked art-supply store on the Piazza di Spagna (see cat. no. 47), but on the wood backing of the Kaunitz drawing there is an advertising label printed with the name of the Paris shop of Alphonse Giroux, a painter and dealer and a former pupil of David.[7] It is conceivable that Hayard did not know how to fabricate the kind of mountings produced by Giroux and therefore imported them from him. H.N.

For the author's complete text, see Naef 1977–80, vol. 2 (1978), chap. 99 (pp. 300–306).

1. Translated from German, it reads: "From left to right: (1) Leopoldine Gräfin Kaunitz-Rietberg (Fürstin Anton Pálffy); (2) Caroline Gräfin Kaunitz-Rietberg (Gräfin Stahremberg, later Fürstin Peter Aremberg); (3) Nandine Gräfin Kaunitz-Rietberg (Gräfin Louis Károlii)." Quoted in Naef 1977–80, vol. 2 (1978), p. 300. Although several of the names in the inscription are misspelled, there is no reason to doubt the identification of Ingres's subjects.
2. Courcy 1957, vol. 1, pp. 192, 193–94.
3. Amaury-Duval 1878, p. 234.
4. Metternich had married Eleonore von Kaunitz-Rietberg, a cousin of the ambassador, in 1795.
5. Metternich 1909, pp. 215–16.
6. Fürstin (Princess) von Kaunitz-Rietberg died in 1859.
7. Thieme and Becker 1907–50, vol. 14 (1921), p. 192.

PROVENANCE: Presumably, Fürst and Fürstin von Kaunitz-Rietberg; Fürstin von Kaunitz-Rietberg until 1859; by descent, their daughters, ultimately Fürstin Anton Karl Pálffy, until 1888; Nicolaus Pálffy, Schloss Marchegg, Austria, by 1931; his heirs; purchased from them by the Viennese collector Anton Schmid shortly after World War II; purchased from him by the H. M. Calmann gallery, London, between 1961 and 1966; sold by them to Alfred Strölin, Paris, 1966; Alfred Strölin until 1974; Mrs. Charles Wrightsman; her gift to The Metropolitan Museum of Art, New York, in honor of the Museum's Director, Philippe de Montebello, 1998

EXHIBITION: Tübingen, Brussels 1986, no. 22

REFERENCES: Steiner 1931, pp. 4–5, pl. 6; Ford 1939, p. 7; Paris 1967–68, under no. 112; Naef 1977–80, vol. 4 (1977), pp. 420–21, no. 224, ill.

78. Comte Lancelot-Théodore Turpin de Crissé
79. Comtesse Lancelot-Théodore Turpin de Crissé, née Adèle de Lesparda

78. Comte Lancelot-Théodore Turpin de Crissé
Probably 1818
Graphite
10¾ × 8 in. (27.1 × 20.2 cm), framed
Signed lower left: Ingres
The Metropolitan Museum of Art, New York
Bequest of Walter C. Baker, 1971 1972.118.218
New York only

N 227

79. Comtesse Lancelot-Théodore Turpin de Crissé, née Adèle de Lesparda
Probably 1818
Graphite
10¾ × 8 in. (27.3 × 20.4 cm), framed
Signed lower left: Ingres
The Metropolitan Museum of Art, New York
Bequest of Walter C. Baker, 1971 1972.118.221
New York only

N 228

Ingres's splendid drawing of Lancelot-Théodore Turpin de Crissé captures the kindness and modesty that are said to have been among the most striking aspects of this aristocratic painter's character. Other appealing qualities were his devotion to his mother and wife and a profound commitment to his art.

Turpin's career was anything but predictable. Born in 1782, he was only a child when the Revolution drove his father into exile and to an early death and robbed the family of their property.[1] The boy, his mother, and his sister were left with nothing but were kindly taken in by a titled relative and spent several years at her château in Anjou. On their return to Paris, they found new protectors in Napoleon's wife, Josephine de Beauharnais, and the former French ambassador to Constantinople, Comte Marie-Gabriel de Choiseul-Gouffier. The latter was a passionate art lover and, recognizing the young Turpin's talent, took him in 1801 or 1802 on a tour of Switzerland, where Turpin produced his first landscape studies. The count also financed a two-year tour of Italy for the young artist beginning in 1807.

Back in Paris, Turpin managed to sell a number of the paintings he had done in Italy, but to ensure a living for himself and his mother he applied to Empress Josephine for a position in her household. She promptly appointed him her chamberlain, a post that he held for nearly five years. His new financial security allowed

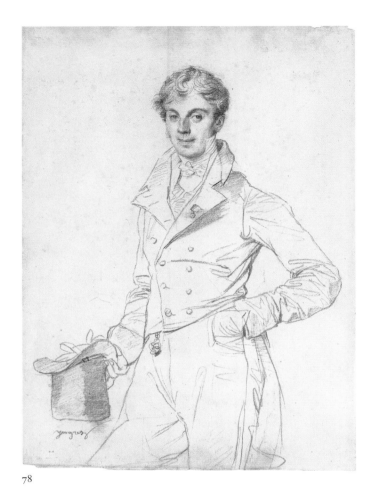

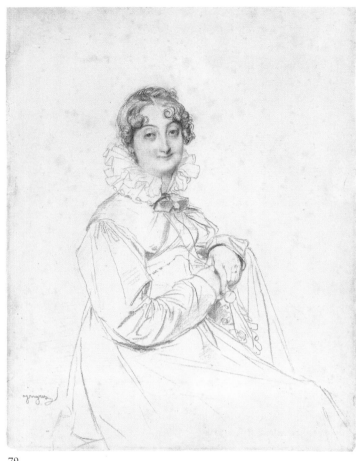

78

79

him to marry Adèle de Lesparda, a cousin seven years younger than he, in 1813. Josephine's death the following year and the return of the monarchy left him unemployed again and penniless. At just that moment he had the good fortune to inherit a portion of the estate of a cousin, the marquis de Lusignan, and was able to take up painting again. In short succession he was named an honorary member of the Académie des Beaux-Arts, member of the Commission des Beaux-Arts for the Seine prefecture, and a member of the Conseil des Musées. In 1816 he returned to Switzerland with his wife and in 1818 traveled with her in Italy, where he again devoted himself to studying the country's art and antiquities and executed a number of drawings that are now in the Musée du Louvre. It was apparently during this sojourn that Ingres's undated pendant portrait drawings of the couple were commissioned.

Turpin had occasion to be reminded of his portraitist shortly after his return to

France. In 1819, desperate for money, Ingres sold for 500 francs the loveliest of his paintings based on Dante's story of Francesca da Rimini to the Société des Amis des Arts, a group in Paris that regularly purchased works of art for auction among its members. Although it now seems difficult to understand, the majority of the society's supervisory committee, of which Turpin was a member, found *Paolo and Francesca* (W 121) unacceptable, whereupon the count volunteered to exchange it for one of his own. Perfectly aware of Ingres's genius, Turpin treasured the work, which he ultimately left to the museum in Angers (now the Musée des Beaux-Arts).

In 1825 Turpin was appointed inspector general for fine arts to the royal household, in which capacity he supervised the court porcelain and tapestry works, theaters, and mints, and dispensed royal commissions to sculptors and painters. His fortunes changed once again when the

Revolution of 1830 robbed him of his position and cast him into obscurity. He spent the rest of his days traveling, finishing paintings begun long before, and publishing collections of lithographs after his own works. Both while he was in power and afterward, he championed Ingres's work, steering commissions his way and recommending him to others. He died in Paris in 1859. His beloved wife died two years later. They were buried together in Père Lachaise cemetery in Paris.

H.N.

For the author's complete text, see Naef 1977–80, vol. 2 (1978), chap. 97 (pp. 286–95).
1. This brief biography is based on the count's own autobiographical sketch (Turpin de Crissé 1834, pp. 210–13), and the reminiscences (dated June 2, 1859) of his friend Charles Lenormant (1861, vol. 1, pp. 416–30).

Cat. no. 78. *Comte Lancelot-Théodore Turpin de Crissé*

PROVENANCE: Lancelot-Théodore Turpin de Crissé (1782–1859), Paris; his widow, née

Adèle de Lesparda, Paris, until 1861; her sister Louise de Lesparda, Paris, until 1875; Auguste de Lesparda, her brother; Baroness Auguste de Lesparda, née Louise-Pauline de Magallon, his widow, until 1903; their son Paul de Lesparda, until 1929; anonymous auction, Hôtel Drouot, Paris, room 6, November 20, 1929, no. 8, sold for 32,000 francs; Jacques Mathey, Paris, by 1934; Gilbert Lévy gallery, Paris, by 1936; Matthiesen gallery, London, by 1939; offered in 1939 by the Galerie Cailleux, Paris, to Dr. Oskar Reinhart, Winterthur, Switzerland; César de Hauke & Co., Paris and New York; purchased from them by Walter C. Baker, New York; his bequest to The Metropolitan Museum of Art, New York, 1971, his widow retaining life interest

EXHIBITIONS: Paris 1934a, under no. 530; Paris 1934c, no. 12; Brussels 1936, no. 29; London 1938a, no. 90; Cambridge (Mass.) 1948–49, no. 55; Philadelphia 1950–51, no. 83, ill.; New York 1960b, p. 14; Poughkeepsie, New York 1961, no. 82, ill.; Cambridge (Mass.) 1967, no. 45, ill.; Paris 1967–68, no. 104, ill.; New York 1981; New York 1984–85; Tübingen, Brussels 1986, no. 19, ill.; New York 1988–89

REFERENCES: Anon., January 1930, p. 37, ill. p. 38; Senior 1938, p. 308, ill. p. 306; Huyghe and Jaccottet 1948, p. 173, ill. p. 12; Mongan 1949, p. 134, ill. p. 135; Virch 1960, p. 316, fig. 6, p. 314; Virch 1962, p. 7, no. 91, ill.; Mongan 1969, p. 146; Naef 1977–80, vol. 4 (1977), pp. 426–27, no. 227, ill.

Cat. no. 79. *Comtesse Lancelot-Théodore Turpin de Crissé, née Adèle de Lesparda*

PROVENANCE: The same as for cat. no. 78.

EXHIBITIONS: Paris 1934a, under no. 530; Paris 1934c, no. 13; Brussels 1936, no. 28; London 1938a, no. 91; Cambridge (Mass.) 1948–49, no. 56; New York 1960b, p. 14; Poughkeepsie, New York 1961, no. 81, ill.; Cambridge (Mass.) 1967, no. 44, ill.; Paris 1967–68, no. 105, ill.; New York 1981; New York 1984–85; Tübingen, Brussels 1986, no. 18, ill.; New York 1988–89

REFERENCES: Anon., January 1930, p. 37, ill. p. 38; Mongan 1949, p. 136, ill. p. 137; Virch 1960, p. 316; Virch 1962, p. 7, no. 92; Mongan 1969, p. 146; Naef 1977–80, vol. 4 (1977), pp. 428–29, no. 228, ill.

80. Jean-Pierre Cortot

1818
Graphite
$8\frac{1}{4} \times 6\frac{3}{8}$ *in. (20.8 × 16.1 cm)*
Signed and dated lower right: Ingres / à Cortot. / 1818 / rome. [Ingres / for Cortot. / 1818 / Rome]
Memorial Art Gallery, University of Rochester, Rochester, New York
Gift of Dr. and Mrs. James H. Lockhart, Jr.
83.118
Washington only

N 230

Jean-Pierre Cortot was born in Paris in 1787. His parents were poor and could do little to cultivate the boy's artistic gifts, which were evident at an early age. Fortunately, Cortot was endowed with a degree of perseverance equal to his talent. He managed to apprentice himself at thirteen to the sculptors Charles and Pierre Bridan and went on to study at the École des Beaux-Arts in Paris. He was only twenty-two when he won the Prix de Rome for sculpture in 1809. His first impressions of Rome are preserved in letters written to his close friend Michel-Martin Drölling back in Paris (Drölling would join him at the Villa Medici the following year as winner of the Rome prize in painting). Cortot's letters reveal a remarkable lack of sophistication, not only in their impossible syntax and spelling but also in their observations. It is a naïveté that cannot be attributed to his humble background alone; artist through and through, he appears to have developed only those skills required in the practice of his craft. His original four-year scholarship was extended by another five years, giving him ample time in which to study every piece of sculpture in Rome and to create an astonishing amount of work of his own.

Cortot's output continued to be prodigious after he returned to Paris.[1] It is said that he curtailed his own expenses in his early years so as to be able to support his beloved parents, but his tastes were simple in any case. He remained a bachelor, and his sole attachments in addition to his parents were a sister and her daughter. He worked with equal ease in stone, marble, and bronze, in bas-relief and sculpture in the round. He produced all kinds of sculpture in great numbers—classical statues, religious images, portraits of historical figures. Among his more notable works (all in Paris) are *Ecce Homo* (Saint-Gervais), *Pietà* (Notre-Dame de Lorette), and *Religion Consoling Marie Antoinette* (Chapelle Expiatoire). These are now virtually ignored, as are many other works by the artist that adorn Paris monuments and are seen by untold thousands every day. Comparison of his high-relief sculpture *The Triumph of 1810* on the Arc de Triomphe with its far more compelling companion, *The Departure of the Volunteers in 1792 (The Marseillaise)* by François Rude, gives an indication why this is so. In his own day, however, he was highly regarded. The sculptor died in 1843.

Ingres captured the Cortot of the Roman years in two magnificent portraits, a painting (W 105; Musée du Louvre, Paris), and the present drawing. The painter obviously felt especially close to the young sculptor, for Cortot's is one of only two painted portraits he produced of fellow

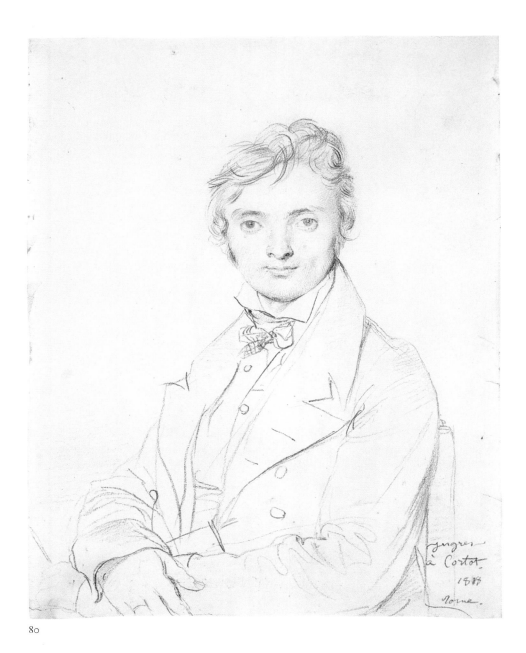

80

prizewinners. The painting dates from 1815, and before Cortot left Rome, either late in 1818 or at the beginning of 1819, Ingres presented him with this pencil portrait as well. In a long letter written in January 1820, the painter assured him of his continuing affection and regard:

The wife and I always speak of you with the friendship that you know we feel toward you, and as far as we're concerned you will never be as happy as you deserve. I'd love to have news of your beautiful children—your works—what you're doing now and what you have coming up. I will always consider myself their god-father and comrade, for I have so much respect and friendship for you, my dear friend, as well as for your fine talent,

which surely no one values as highly as I do. So *viva*, you're on your way, with a wonderful road ahead of you.[2]

For the author's complete text, see Naef 1977–80, vol. 2 (1978), chap. 100 (pp. 307–17).
1. See the list of his works in Lami 1914–21, vol. 2 (1914), pp. 126–28.
2. Ingres to Cortot, January 12 [1820]; quoted in Naef 1977–80, vol. 2 (1978), p. 316.

PROVENANCE: Jean-Pierre Cortot (1787–1843), Paris; his niece, Mlle Désirée-Marie-Charlotte Eymery, later Comtesse Désiré-François-Brice de Comps, Versailles, until 1884; Mlle Marguerite-Cécile-Elisabeth de Comps, her daughter, until 1911; the art firm M. A. McDonald, New York; Dr. James H. Lockhart, Jr. (b. 1912), Geneseo, N.Y.; his gift (and that of his wife) to the Memorial Art Gallery of

Rochester, University of Rochester, Rochester, N.Y., 1983

EXHIBITIONS: Paris 1861 (1st ser.), no. 48; Paris 1867, no. 328; Lawrenceville 1937; Pittsburgh 1939, p. 133, ill. p. 132; Pittsburgh 1958; Rochester 1959; Cambridge (Mass.) 1967, no. 46, ill.; Princeton 1981; Rochester 1995–96, no. 76, ill.

REFERENCES: Galichon 1861a, p. 357; Blanc 1870, p. 236; Delaborde 1870, no. 274; Duplessis 1870, p. 353;* Gatteaux 1873 (2nd ser.), no. 78, ill.;† Jouin 1888, pp. 36–37; Lapauze 1911a, ill. p. 174; Hourticq 1928, ill. on pl. 50; McDonald 1939, ill. p. 39; Alazard 1950, p. 62, n. 8, p. 147; Naef 1977–80, vol. 4 (1977), pp. 432–33, no. 230, ill.; Paris 1985, no. X 1, ill.

* Duplessis describes it as allegedly lost in the fire that destroyed the Gatteaux house.

† Described as in the Édouard Gatteaux collection, perhaps following Duplessis 1870.

81. Charles Lethière

1818
Graphite
10 × 7⅝ in. (25.5 × 19.5 cm), framed
Signed and dated lower left: Ingres. Rom. /
1818.
Musée des Arts Décoratifs, Paris
London and New York only

N 232

This drawing is discussed under cat. no. 52.

PROVENANCE: The artist's student Henri Lehmann (1814–1882); his posthumous sale, Hôtel Drouot, Paris, March 2–3, 1883, no. 198, as *L'Enfant au fauteuil,* sold for 2,550 francs; Baron de B[eurnonville]; his sale, Hôtel Drouot, Paris, February 16–19, 1885, no. 333, as *L'Enfant au fauteuil,* sold for 3,150 francs; Émile Perrin, Paris, until 1885; H. E. Perrin, his son; his gift to the Musée des Arts Décoratifs, Paris, in memory of his father, 1909

EXHIBITIONS: Paris 1949a, no. 269, ill., as *L'Enfant au fauteuil;* Paris 1967–68, no. 106, ill.; Rome 1968, no. 72, ill.; Tübingen, Brussels 1986, no. 17

REFERENCES: Bouyer 1909, p. 103 ("pencil [drawing] by Ingres dating from 1818"); Paris, Musée des Arts Décoratifs 1934, p. 84, as *Portrait d'enfant;* Naef 1963 ("Familie Lethière"), pp. 65–78, fig. 8 on p. 74 (sitter identified); Radius and Camesasca 1968, p. 124, ill.; Paisse 1971, p. 14, n. 7; Ternois and Camesasca 1971, p. 124, ill.; Delpierre 1975, p. 22; Naef 1977–80, vol. 4 (1977), pp. 436–37, no. 232, ill.

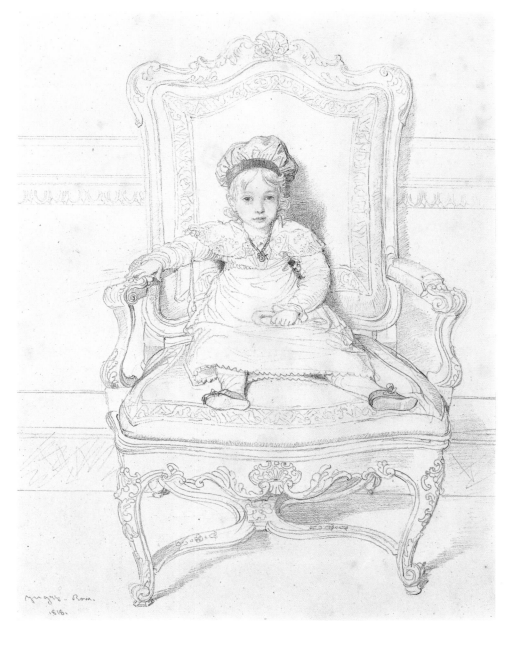

82. Niccolò Paganini

1819
Graphite
11¾ × 8⅝ in. (29.8 × 21.8 cm)
Signed and dated lower left: Ingres Del. / roma
1819. [Ingres drew (this in) / Rome 1819.]
At lower right, the Léon Bonnat collection stamp
(Lugt 1714); at lower left, the Musée du Louvre,
Paris, collection stamp (Lugt 1886a)
Musée du Louvre, Paris
Département des Arts Graphiques RF 4381
Washington only

N 239

Ingres's portrait of Paganini in the Musée du Louvre, Paris, has spawned a bibliography of monstrous proportions, in part because it is so clearly one of his most magnificent drawings and in part because its subject is so well known. Yet for all that has been written about it, the circumstances under which it was executed are virtually unknown.

Two years younger than Ingres, Paganini was thirty-six when he first arrived in Rome, on November 3, 1818.[1] Although he had been lionized in the cities of northern Italy, he was not nearly so famous as he would become. Rome, by comparison, was a musical backwater, and far from welcoming. As late as the following January the violinist had failed to obtain permission to stage a public performance, and he would have simply given up if some of the influential figures who had meanwhile heard him at private performances had not taken up his cause. Thanks to their appeals to Cardinal Alessandro Albani, he was finally allowed to appear at the Teatro Argentina on February 5, 12, and 19. His purse nicely filled, he then proceeded to Naples, the original goal of his journey, on March 2.

The influential figures in question were doubtless prominent members of Rome's Austrian community, who tended to be far more sophisticated musically than the Romans themselves. No one would have been in a better position to influence Albani than Austria's ambassador to the Holy See, Prince Kaunitz, and from Ingres's drawing of the prince's three daughters in front of a piano (cat. no. 77) we get a sense of the musical circle in which the French artist— who was himself a competent violinist— could well have made the Italian virtuoso's acquaintance. In Amaury-Duval's recollections of his teacher, he claims that Ingres told him he played Beethoven quartets with Paganini in Rome.[2]

That Paganini owed his ultimate success in Rome to prominent Austrians seems confirmed by the fact that he returned from Naples in April of that same year to perform at two official functions in honor of the Austrian emperor, one on April 20

and another on May 4. By May 19 he was back in Naples, and during the rest of Ingres's stay in Italy the two men never met again.

Amaury-Duval assures us that Ingres did see the celebrated violinist at least once more, probably only at a performance in Paris. Most likely this was at Paganini's concert at the Théâtre des Italiens on April 10, 1831.[3] Ingres's pupil relates that he was seated in an adjacent box and witnessed the artist's reaction to the music:

> From the moment the first deep, low notes flowed from his instrument, we understood whom we were dealing with, and M. Ingres began to express the pleasure he was feeling in a series of admiring gestures. But when Paganini launched into those exercises of prestidigitation, those tours de force that have inspired an utterly ridiculous school, M. Ingres's brow darkened, and, his anger rising in . . . proportion to the public's enthusiasm, he soon could not contain himself: "That isn't him," he said. I heard his feet stamping on the floor with impatience, and the words *turncoat* and *traitor* spilling from his indignant lips.[4]

Obviously Ingres had expected to hear the Paganini he remembered from Rome, not the demon-driven, egotistical performer he had become. In the meantime the painter had befriended the violinist Pierre Baillot (see cat. no. 107), a consummate musician who approached the works of the masters with the self-effacing reverence Ingres felt they deserved. Small wonder, then, that he found the Italian's antics treasonous.

Some scholars see Ingres's portrait of Paganini as virtually the supreme expression of his genius. Others praise the work as a drawing but criticize it as a portrait, possibly because it fails to capture what they like to think of as Paganini's diabolical nature. It is true that Ingres registered the performer's appearance with his usual classical composure, subjecting Paganini to the rules of a world closed to the virtuoso violinist. To put it another way, Ingres was too naive to think of venturing into emotional realms foreign to his nature, yet

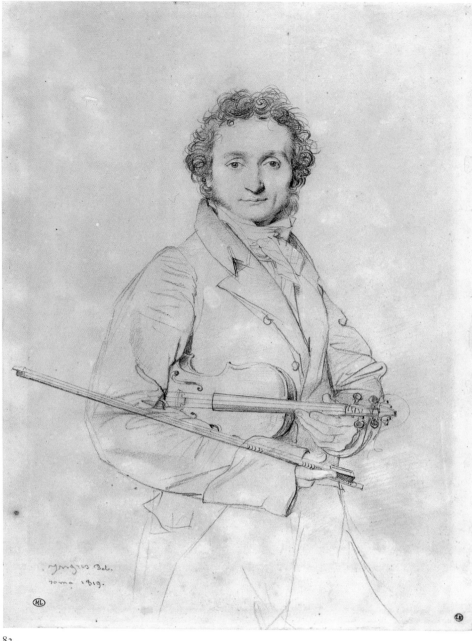

82

since he was a superb portraitist, his eyes registered time and again things that were outside his experience. Like all Ingres's best works, this drawing exposes his sitter's very soul, not at the heights or depths of expressiveness, to be sure, but as a latent force.

Ingres's portrait of Paganini was engraved in 1831 by Luigi Calamatta, who worked from a now-lost copy of Ingres's 1819 drawing.[5] A counterproof of the lost copy (that is, a reversed image of it produced by pressing tracing paper against the original so as to pull off some of its substance) was made about 1830 (cat. no. 83).[6] Other reproductions include a

reduced pencil copy of the Louvre drawing in the author's collection and an engraving of unknown date and in reduced size, also of the Louvre composition, by an anonymous artist. H.N.

For the author's complete text, see Naef 1977–80, vol. 2 (1978), chap. 102 (pp. 326–32).

1. All the following dates are taken from Courcy 1957, vol. 1, and Courcy 1961.
2. Amaury-Duval 1878, p. 234.
3. Courcy 1961, p. 48.
4. Amaury-Duval 1878, p. 235; reprinted in Naef 1977–80, vol. 2 (1978), p. 328.
5. The engraving is illustrated in Naef 1977–80, vol. 2 (1978), p. 331, fig. 3.
6. Instead of a counterproof, it might be a

reworked tracing. Ingres's involvement in such a reworking has not been determined.

PROVENANCE: An unknown collector in Rome; acquired from that collection by Achille Benouville (according to E. Saglio), Paris, by 1857 at the latest; his posthumous sale, Hôtel Drouot, Paris, January 16, 1901, no. 269; purchased at that sale for 5,600 francs by Léon Bonnat, Paris; donated by him to a charity auction to benefit war victims organized by the Syndicat de la Presse, Petit Palais, Paris, June 13, 1917, no. 127; acquired for 46,000 francs at that sale by the Musée du Louvre, Paris

EXHIBITIONS: Paris 1884, no. 405; London 1908, no. 514; Paris 1911, no. 113, ill. opp. p. 56; Paris 1919, no. 291 [EB]; Copenhagen, Stockholm, Oslo 1928, no. 156 (Copenhagen), no. 145 (Stockholm); London 1932, no. 857; Paris 1934a, no. 537; Brussels 1936–37, no. 72; San Francisco 1947, no. 11, ill.; Montauban 1967, no. 57, fig. 9; Paris 1967–68, no. 112, ill.; Rome 1968, no. 72, ill.; Paris 1969a, no. 121; Vienna 1976–77; no. 5, ill.; Tübingen, Brussels 1986, no. 26, ill.

REFERENCES: Saglio 1857, p. 79; Blanc 1870, p. 246 (known from the engraving by Luigi Calamatta); Delaborde 1870, no. 387 (erroneously dated 1818); Leroi 1881, p. 340 (known from the engraving by Calamatta or a photograph); Michel 1884 (March), p. 318, (May), ill. opp. p. 386 (heliogravure by Dujardin); Corbucci 1886, p. 181, under no. 14 (?); Jouin 1888, p. 141; Muther 1893–94, vol. 1, p. 330, ill. p. 327 (after the heliogravure by Dujardin); Leroi 1894–1900b, p. 817; La Chronique des arts 1901, p. 40; Lapauze 1901, p. 267 (known from the engraving by Calamatta); Lapauze 1903, pp. 20, 25, 26, 29, no. 75, ill. (erroneously dated 1818); Gonse 1904, p. 89; Alexandre 1905, pl. 13; Dumas 1908, p. 148; Beaunier 1909, ill. p. 451; Boyer d'Agen 1909, pl. 40; Lapauze 1911a, pp. 184, 368, ill. p. 177; Saunier 1911, ill. p. 7; Dreyfus 1912, ill. p. 147; Saunier 1918, p. 24; Flameng sale 1919, under no. 129; Paris, Musée du Louvre 1919–20, vol. 2, pl. 54; La Renaissance de l'art français 1921, ill. p. 237; Fontainas and Vauxcelles 1922, ill. p. 46; Pincherle 1922, ill. p. 113; Fröhlich-Bum 1924, pl. 30; Dessins de Jean-Dominique Ingres 1926, p. [7], pl. 13; Martine 1926, no. 21, ill.; Hourticq 1928, ill. on pl. 50; Zabel 1929, pp. 111, 115, ill. p. 108; Cortissoz 1930, p. 192; Alaux 1933, ill. p. 145; French Art 1933, no. 866; Spellanzon 1934, vol. 2, ill. p. 783 (the engraving by Calamatta); Pach 1939, p. 84; Alazard 1942, no. 5, ill.; Degenhart 1943, no. 142, pl. 142; Malingue 1943, ill. p. 84; Howe 1947, p. 91, ill. p. 90; Rewald 1947, ill. p. 29; Courthion 1947–48, vol. 1, ill. opp. p. 160; Barzun 1949, ill. p. 244; Bertram 1949, pl. XXII; Jourdain 1949, ill. p. 50; Alazard 1950, p. 63, n. 18, pp. 93, 147, pl. XL; Labrouche 1950, pl. 15; Sachs 1951, pp. 93, 95, pl. 55; Wildenstein 1954, ill. p. 31; Mathey 1955, no. 24, ill.; Courcy 1957, vol. 1, p. 187, ill.

opp. p. 240, vol. 2, p. 25, n. 51; Heise 1959, p. 79, ill. p. 59; Courcy 1961, p. 27 (in the German translation erroneously called a pastel); Blume 1949–79, vol. 10 (1962), ill. between cols. 629, 630; Hníková-Malá 1963, p. 39, pl. 45; Schuler, Häusler, and Seifert 1963, pl. 97; Hale 1964, p. 214, ill. p. 215; Berezina 1967, fig. 36; Sérullaz 1967, p. 211; László and Mátéka 1968, ill. p. 42; Radius and Camesasca 1968, ill. p. 123; Sérullaz, Duclaux, and Monnier 1968, no. 68, ill.; Kemp 1970, pp. 49–65, fig. 1; Ternois and Camesasca 1971, p. 123, ill.; Clark 1973, pp. 123–24, fig. 91; Werner 1973, ill. p. 30; Delpierre 1975, p. 23; Naef 1977–80, vol. 4 (1977), pp. 445–48, no. 239, ill.; Picon 1980, p. 41, ill.; Ternois 1980, p. 91, ill.; Mráz 1983, p. 47, fig. 38; Vigne 1995b, p. 96, fig. 67

83. Niccolò Paganini

Before 1831
Graphite with white highlights on tracing paper; drawing on both sides of the sheet, which is pasted on thin cardboard; the inscriptions appear reversed
$9\frac{3}{8} \times 7\frac{1}{8}$ *in. (23.8 × 18.2 cm)*
Signed lower right, possibly not by the artist:
fecit Ingres [Ingres made (this)]
Inscribed lower left, not by the artist: Paganini
At lower right, the François Flameng collection stamp (Lugt 991)
The Metropolitan Museum of Art, New York
Bequest of Grace Rainey Rogers, 1943 43.85.10
New York only

N 238

This drawing is discussed under cat. no. 82.

PROVENANCE: Possibly Luigi Calamatta (1801–1869); perhaps his posthumous sale, Hôtel Drouot, Paris, room 8, December 18–19, 1871, no. 128, "Portrait drawing of Paganini," sold for 600 francs to an unknown collector; probably offered for sale at an anonymous auction, Hôtel Drouot, Paris, room 1, April 20, 1898, no. 76, as *Portrait de Paganini*, "counterproof 23 × 17 cm"; François Flameng; his auction, Galerie Georges Petit, Paris, May 26–27, 1919, no. 129, "Drawing thoroughly worked over by Ingres on a counterproof of an earlier drawing by the artist," sold for 9,000 francs to Kélékian; Dikran Khan Kélékian; his auction, American Art Association, Palace Hotel, New York, January 30–31, 1922, no. 10, sold for $1,300 to the Fearon Galleries, New York; acquired by Mrs. Grace Rainey Rogers (1867–1943), New York; her bequest to The Metropolitan Museum of Art, New York, 1943

EXHIBITIONS: Brooklyn 1921, no. 134; New York 1988–89

REFERENCES: Saunier 1918, p. 24;* Gaston Brière in Paris, Musée du Louvre 1919–20, vol. 2, pl. 54; Alexandre 1920a, no. 44, ill.;† Spellanzon 1934, vol. 2, ill. p. 783 (the engraving by Luigi Calamatta); Paris 1967–68, under no. 112; Rome 1968, under no. 72; Naef 1977–80, vol. 4 (1977), pp. 444–45, no. 238

*Described as a counterproof pulled for engraving but so thoroughly reworked by Ingres that it constitutes an original artwork.

† Described as a drawing intended as a model for the engraver Calamatta, worked up in pencil by Ingres on a counterproof of an earlier drawing by the artist.

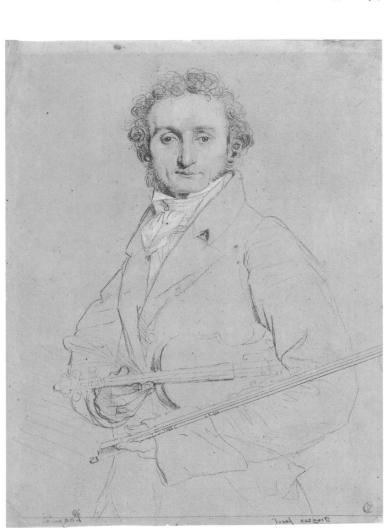

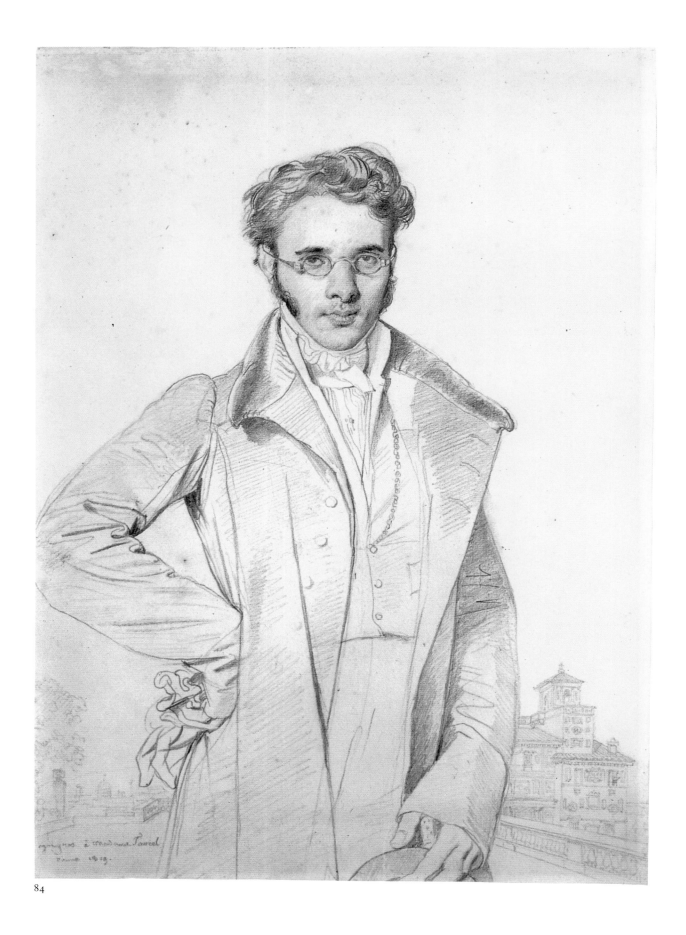

84

84. André-Benoît Barreau, called Taurel

1819
Graphite
$11\frac{3}{8} \times 8\frac{1}{8}$ in. (28.8 × 20.5 cm)
Signed and dated lower left: Ingres à Madame
Taurel ╱ rome 1819. [Ingres for Madame
Taurel / Rome 1819.]
Collection Yves Saint Laurent and Pierre Bergé,
Paris

N 241

This drawing is discussed under cat. no. 73.

PROVENANCE: Mme André-Benoît Barreau Taurel, née Henriette-Ursule Claire (ca. 1794–1836), Amsterdam; André-Benoît Barreau Taurel (1794–1859), her widower, Amsterdam; his heirs until at least 1885; Raimondo de Madrazo y Garreta (1841–1920), Versailles; Comtesse de Behague; her auction, Sotheby's, London, June 29, 1926, no. 101, sold for 310 pounds sterling to Colnaghi & Co., London; acquired from that firm, 1926; by M. Knoedler & Co., 1926; purchased by John Nicholas Brown, Providence, Rhode Island, 1927; David Tunick, New York; Yves Saint Laurent and Pierre Bergé, Paris

EXHIBITIONS: Cambridge (Mass.) 1929, no. 85; Springfield, New York 1939–40, no. 28, ill.; Cincinnati 1940; Rochester 1940; New York 1961, no. 28, ill.; Cambridge (Mass.) 1962, no. 17; Cambridge (Mass.) 1967, no. 49, ill.; Paris 1967–68, no. 113, ill.; Washington, New York, Philadelphia, Kansas City 1971, no. 148, ill.

REFERENCES: Taurel 1885, pp. 2, 15, ill. opp. p. 3 (the engraving by Charles-Édouard Taurel); Lapauze 1901, p. 268 (known from the engraving); Lapauze 1911a, ill. p. 178 (known from the engraving); Lapauze 1911b, p. 48; Zabel 1930, p. 381; Siple 1939, p. 249; Alazard 1950, p. 37, n. 4, p. 144; H. E. van Gelder 1950, pp. 2–10, fig. 4 (the engraving); Naef 1960 (Rome), p. 27, n. 52, p. 122, under no. 24, see also nos. 23, 24, pp. 121–22, fig. 7, pl. 16; Naef 1965 ("Thévenin und Taurel"), pp. 119–57, no. 4, fig. 4; Jullian 1969, p. 89; Mongan 1969, p. 146, fig. 24, p. 156; Hattis 1971, ill. p. 29; Naef 1977–80, vol. 4 (1977), pp. 450–51, no. 241, ill.

85. Ursin-Jules Vatinelle

1820
Graphite
$7\frac{1}{8} \times 5\frac{1}{2}$ in. (18.1 × 13.9 cm)
Signed and dated lower right: Ingres / rom /
1820 [Ingres / Rome/ 1820]
The Metropolitan Museum of Art, New York
Bequest of Grace Rainey Rogers, 1943 43.85.9
New York only

N 246

In one of his last Roman pencil portraits, Ingres portrayed Ursin-Jules Vatinelle, who was doubtless recommended to the artist as a pupil of Édouard Gatteaux.[1] Gatteaux, who had won the Rome prize as a medalist in 1809 and developed a close friendship with Ingres at the Villa Medici, had the pleasure of seeing Vatinelle similarly honored in 1819, and he surely would not have failed to ask his pupil to convey best regards to his old colleague upon arrival in Italy. On January 12, 1820, Ingres wrote to the sculptor Jean-Pierre Cortot in Paris:

> I have just received your kind letter from M. Vatinelle. . . .
> M. Vatinelle is a young man who strikes me as gentle and honest. I have already seen a small sample of his talent, which seems to me to come from a good source, if only from his teacher and you, whose praises he never stops singing, to my delight. Our good friend and comrade Gatteaux, who also sent a letter, overwhelms me with his wonderful friendship.[2]

If Vatinelle is remembered today at all, it is because of the portrait Ingres gave him in Rome before leaving for Florence.

In Vatinelle, Ingres was confronted with an unusually handsome model, and in a few simple strokes he did the man full justice. Of the sitter's later life, however, only the barest facts are known.

He had been born in Paris in 1798 and was twenty-one when he received the scholarship to Rome. The medalist prize had been established fourteen years before and awarded only six times.[3] Ingres indicated Vatinelle's specialty in his portrait by showing him holding a medal in his right hand, but, absent such a clue, the subject's identity would still be clear, inasmuch as the drawing, fully labeled, was exhibited in the Paris Salon des Arts-Unis in 1861, while both Vatinelle and Ingres were still alive.[4]

The most extensive catalogue of Vatinelle's works is found in Forrer's dictionary of medalists.[5] Given the advanced age he attained, the list is extremely short: it contains sixteen items, all of them dating between 1819 and 1831. Since Vatinelle lived another fifty years after this brief period of activity, the question arises whether he abandoned his artistic career or had sufficient wealth to live a life of leisure.

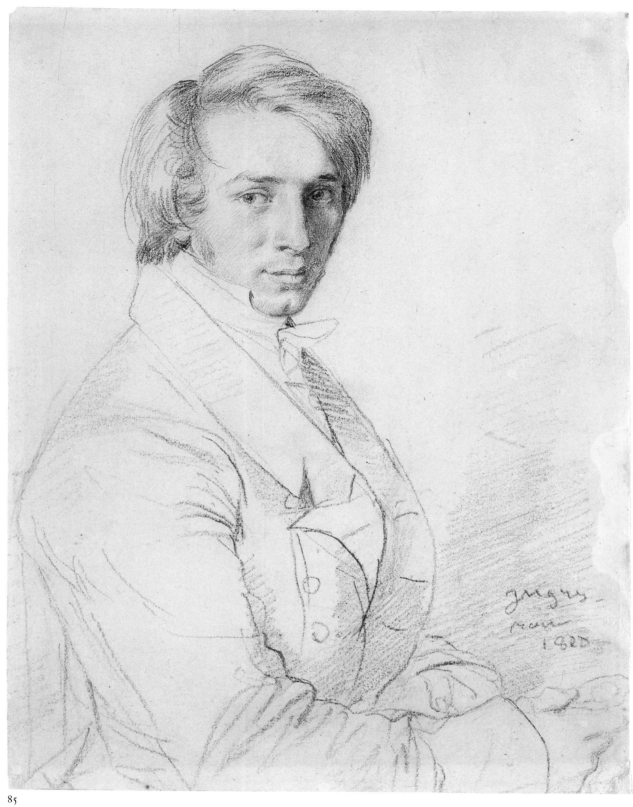

85

He died in 1881 at the age of eighty-three and is buried in the Montmartre cemetery, along with his parents and an older brother who is identified on the tombstone as "former director of painting on glass at Sèvres."[6]

Vatinelle never married and thus left no direct heirs. His entire estate was inherited by a distant cousin, Antoinette-Joséphine Dupuis, and her husband, the architect Anatole-Gabriel-Joseph Gautier. There is no documentation confirming that they thereby came into possession of the Ingres portrait, but it is probable that they did. Madame Gautier died in 1909, leaving her estate to the architect Alexandre-Jean Jacob and his daughter and son, her grandniece and grandnephew. Future research may be able to trace the provenance of the drawing through this line of inheritance. The work appeared in the major Ingres exhibition in Paris in 1921, by which time it was already owned by an art dealer.

H.N.

For the author's complete text, see Naef 1977–80, vol. 2 (1978), chap. 106 (pp. 351–52).

1. Vatinelle is mentioned as a pupil of Gatteaux in Thieme and Becker 1907–50, vol. 34 (1940), p. 136.
2. Ingres to Cortot, January 12 [1820]. The letter is quoted in full in Naef 1977–80, vol. 2 (1978), pp. 316–17.
3. Lapauze 1924, vol. 2, p. 146.
4. Galichon 1861b, p. 47.
5. Forrer 1902–30, vol. 6 (1916), p. 208.
6. "Ex-chef de la peinture sur vitraux de Sèvres." Jouin 1886, p. 110.

PROVENANCE: Presumably Ursin-Jules Vatinelle (1798–1881), Paris; probably the artist's cousin Antoinette-Joséphine Dupuis and her husband, Anatole-Gabriel-Joseph Gautier, until 1909; probably Alexandre-Jean Jacob, by inheritance, and his children, Marguerite-Joséphine-Angèle and Paul-Anatole-Louis-Joseph Jacob, by descent; Paul Rosenberg & Cie., Paris, by 1921; Mme de C[assigneul]; her sale, Hôtel Drouot, Paris, rooms 9–10, March 28–29, 1925, no. 25; purchased at that sale for 23,000 francs by Charles Picard for Jacques Seligmann & Co., New York and Paris; sold through César Mange de Hauke by Jacques Seligmann & Co. to Wildenstein & Co., Inc., New York, 1927; Mrs. Grace Rainey Rogers, New York; her bequest to The Metropolitan Museum of Art, New York, 1943

EXHIBITIONS: Paris 1861 (2nd ser.); Paris 1867, no. 394; Paris 1921, no. 92; New York 1925, no. 107 [EB]; Cambridge (Mass.) 1967, no. 53, ill.; New York 1970, no. 48; New York 1988–89

REFERENCES: Galichon 1861b, p. 47 (erroneously dated 1823); Blanc 1870, p. 240; Delaborde 1870, no. 423; *La Renaissance de l'art français* 1921, ill. p. 240; Anon., March 1946, ill. p. 17; Burroughs 1946, ill. p. 160; Waldemar George 1967, ill. p. 39; Mongan 1969, p. 146; Naef 1977–80, vol. 4 (1977), pp. 458–59, no. 246, ill.

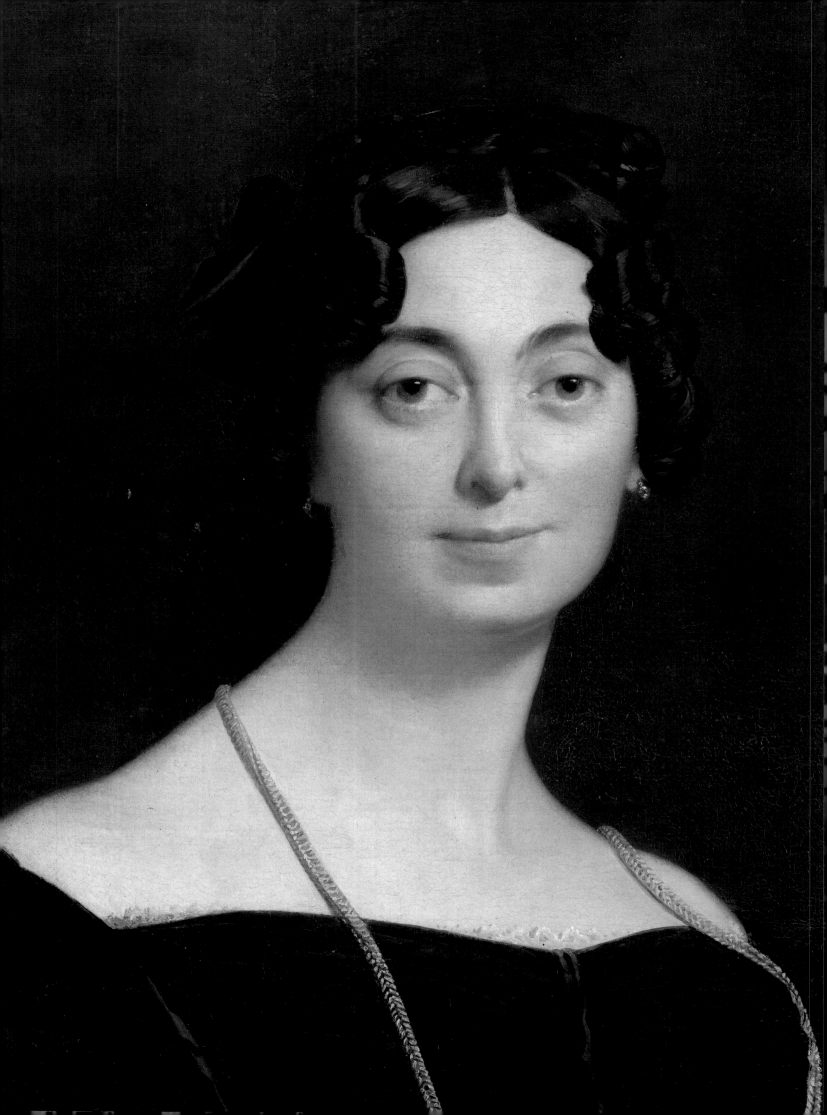

FLORENCE, 1820–1824

Christopher Riopelle

ngres saw Florence for the first time in early October 1806, as he traveled from Paris to Rome to take up his long-delayed residence at the Académie de France. He stayed there for a week as the guest of the father of his most intimate artist friend in Paris, the sculptor Lorenzo Bartolini, a native of Tuscany. In a long letter to Pierre Forestier, the father of his fiancée, Ingres described his mixed reactions to *"Florence la belle."*[1] He reported that he had attended the opera at the famous Teatro della Pergola, although—always a severe critic in such matters—he had not been impressed by the quality of the music. He spoke of visiting the churches of the city, whose "Oriental luxuriousness"[2] he admired, and of studying Renaissance frescoes. Ingres's appreciation of Italian Renaissance painting had been formed by his studies in the galleries of the Louvre and by long, enthusiastic discussions with Bartolini and other young artists in David's studio, where the art of fifteenth-century Florence was highly esteemed.[3] Now he was able to examine such works in abundance and on a monumental scale. Every day, Ingres reported to Forestier, he made a pilgrimage to the church of Santa Maria del Carmine, "where there is a chapel that could be called the antechamber to paradise."[4] The Brancacci Chapel had been painted in the 1420s by Masaccio and Masolino, and Ingres responded powerfully to the stately scenes from the lives of the apostles that he saw there. It was also during this short stay in Florence that Ingres had his first chance in Italy to deepen his knowledge of the art of Raphael. Contemporary Florentine artists failed to impress him, however: "As for painting, I've seen works by the leading modern painters. Unfortunately for them, they are thirty years behind the times and would bring a blush, a deep blush, to the ashes of Michelangelo, etc., etc."[5] Fourteen years later, when Ingres decided to leave Rome, it was to Florence that he made his way; he would try his luck in the city of Masaccio, Raphael, and Michelangelo.

Why, in 1820, did Ingres choose the smaller, more provincial city over Rome? Florence boasted neither the pageantry of the papal court, which he had found a compelling subject for modern history paintings, nor the monumental achievements of antiquity and the High Renaissance, for which he, like generations of French artists before him, had traveled to Italy. However, Ingres's career was at a low ebb in 1820. As Georges Vigne suggests, the dispersal of the French bureaucratic community in Rome after the fall of Napoleon and the end of French occupation had dried up an important source of patronage for the artist.[6] Furthermore, Ingres himself reported that French artists now faced the enmity of their Italian counterparts, who, no longer under the French yoke, "are waging another kind of war against us, because we're better than they are."[7] His primary source of income in Rome had been the portrait drawings he had made of foreigners on the grand tour (many of them British and, after the Napoleonic Wars, again free to travel on the Continent), but this was not where his ambitions lay. Opportunities to work as a history painter, which he had resolved to remain, had been only intermittent. Although Paris under the Bourbon Restoration clearly offered history painters impressive possibilities for state patronage, Ingres realized that it was not yet time to return there. His most successful history painting of the Roman years, *Christ Giving the Keys to Saint Peter* (fig. 106), completed in 1820 and originally installed in the convent at Santissima Trinità dei Monti, was generally admired by the few who saw it there, but the works he had sent back to Paris—notably those, such as *Roger Freeing Angelica* (fig. 104), that were submitted to the Salon of 1819—were by and large dismally received by the critics, and indeed found to be bizarre (see pages 500–501). His immediate chances of success in Paris seemed slim.

The painter also still harbored happy memories of his earlier visit to the Tuscan capital; according to Mathieu Méras, "Between Ingres and Florence, one could speak of a preestablished harmony."[8] The cost of living was cheaper there than in either Rome or Paris, and the city contained masterpieces by the artists he most admired, as well as countless other treasures. In June 1819, in advance of a return visit to Florence, but with the possibility of relocating already firmly in mind, Ingres spoke of Tuscany as a "place richer than any other in art

objects, libraries, *cabinets* of all kinds. I'm going there myself at the end of the month, to adopt it, if I can have the same access there as I do in Rome to *models,* which are such essential objects in art."[9] Moreover, the intimate, medieval character of the city accorded well with the historical genre scenes, set in the sixteenth century and earlier, that he was painting at the time. Perhaps the deciding factor for Ingres was that Bartolini, his dear friend from Paris days, had returned to Italy in 1807, moving permanently to Florence in 1814, and had since flourished there. Although the two had not seen each other since Ingres left Paris in 1806, they had begun to correspond in 1818, and the friendship was warmly renewed when Ingres revisited Florence the following year. Both artists remembered the time at the beginning of the century when they and other friends, including François-Marius Granet, had shared studios and a richly creative, bohemian life at the former Capuchin monastery in Paris, and both began to hope that those happy days could be revived beside the Arno.

With such thoughts in mind, both Ingres and Bartolini attempted to persuade a third friend from their youthful days in Paris, Jean-François Gilibert, a lawyer then living in his native Montauban, to join them in Florence. All three were passionate and discriminating connoisseurs of music, and music making was the lure. "Just think, my dear friend, how enjoyable it would be to play together the divine quartets of Haydn, Mozart, Beethoven, with your old friend," Ingres wrote to Gilibert, "and I believe we could train our Bartolini to play second violin or the tenor violin, since I've learned he is studying that instrument."[10] In a letter of jumbled French and Italian, Bartolini cited remembered airs: "You love music and cannot have forgotten the 'two Journées, Je suis le plus Vieux Savoyard,' whose finale builds to a beautiful crescendo; we could distribute the parts wonderfully. You cannot deny me this interesting memento with which to end my days, still beloved and surrounded by the dearest of friendships."[11] The equation of harmony in music with that in the home and among friends is a long-established trope in painting and poetry, and, whether consciously or not, both men now evoked it as they made plans for the future. In the end Gilibert was not persuaded. Nor did the harmony long survive Ingres's relocation. Nor, indeed, did Ingres ever consider Florence a permanent home— an acceptable temporary alternative to Paris, it would always be "a city I passed through."[12]

Beyond the attraction of friendship renewed, Florence offered Ingres the promise of work. As early as 1818,

writing to Gilibert, he had cited the example of Bartolini's success: "You will hear that he is very happy in Florence; his portraits in marble have become very fashionable. All the foreigners are having their portraits done by him."[13] Indeed, Bartolini himself seems to have advised Ingres that he too would find a steady stream of clients in Florence.[14] As much as he disliked making portrait drawings on commission, Ingres would have understood that, for all practical purposes, such works were likely to remain as essential to his financial welfare in Florence as they had been in Rome. He would also have known, however, that the Tuscan city housed another French expatriate painter who was himself making a living portraying wealthy foreign visitors. François-Xavier Fabre had fled to Florence from Rome in 1793 and had quickly become well established with powerful and brilliant friends. For Ingres, Fabre was "a character well known .. for his nastiness."[15] For his part, Fabre detested what he held to be Ingres's abusive stylization of forms.[16] The two would inevitably find themselves in competition over the relatively small, seasonal, and primarily itinerant tourist clientele for portrait paintings and drawings, and the advantage was sure not to lie with the newcomer. Nonetheless, following his preliminary visit in 1819 and further attempts to lure Gilibert to join them—Ingres spoke of "the triumvirate of friendship" that linked the two of them with Bartolini[17]—the artist secured his visa for Florence on July 19, 1820, and left Rome with his wife, Madeleine, soon thereafter.[18]

In Florence, Monsieur and Madame Ingres took up residence in the home of Bartolini himself. Ingres's early letters from the city spoke of the warmth of the sculptor's welcome and the attention he lavished on his old friend and on his wife, who in fact had never met Bartolini before she moved into his house. Soon after their arrival, however, Ingres fell ill with a mysterious complaint and was prevented from working and exploring the city. In August he wrote to Granet in Rome, describing the conflicting emotions occasioned by illness, homesickness for Rome, pleasure at being in Florence, and joy at reuniting with their mutual friend Bartolini:

> I can finally send word to you, my dear Granet, for, thanks to my unlucky star, I've come down in Florence with a kind of illness, the cruelest kind for an artist, which is to lose the use of his head and legs. The former spins and causes horrible vomiting, up until today when I've started to feel better. . . . You can imagine my bad mood and my rage at finding myself surrounded by such beautiful objects that are so new to me, and forced

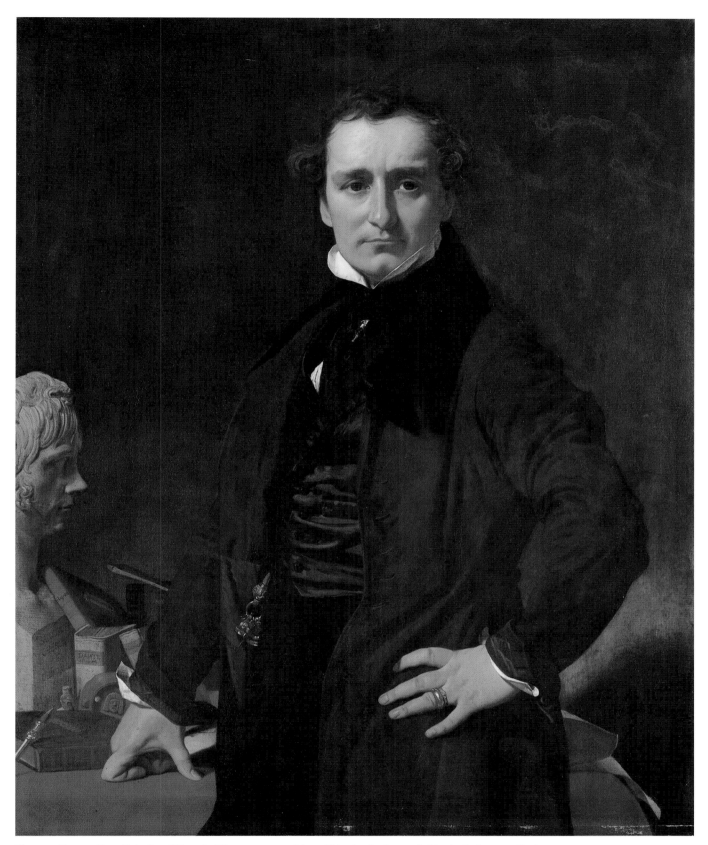

Fig. 135. *Lorenzo Bartolini*, 1820 (W 142). Oil on canvas, 41¾ × 33½ in. (106 × 85.1 cm). Musée du Louvre, Paris

imperiously to keep to my room. Certainly, without the care and good nursing given me by my good wife, I would, I think, have headed back to beautiful Rome, which one appreciates so much better after having left it—with all due respect even to the excellent, beautiful, gracious, rich, clean, and, in conclusion, the happiest epithets I can find to depict Florence. And to crown my displeasure, my friend Bartolini wasn't here. He had given orders to welcome us and show us the most sumptuous hospitality. Finally, after fourteen years of absence, he arrived, and we rediscovered in him a friend as prized as you. That says it all.[19]

Ingres's life chez Bartolini proved to be very different from the one the artists had shared earlier in Paris, as indeed it was from the humble, hardworking existence of Ingres's Roman years. The bachelor sculptor, now rich and successful, lived in splendor in a palazzo where he received guests grandly. Ingres was dazzled by his friend's success and the manner of living it afforded him. On October 7 he wrote to Gilibert in Montauban (he was still trying to lure the lawyer to Florence), declaring Bartolini to be "the greatest sculptor of this century, rivaled only by the Ancients."[20] Indeed, Bartolini had become a studio master of a kind that Ingres had not seen since leaving David. "It's like a little ministry, his studios, his correspondence, and eight or nine marble monuments

that he has to make. And so, while waiting for you, he is taking his revenge on us, putting us up like royalty (for that's how he lives), and showering us with a friendship that is every bit as good as his word."[21] In a subsequent letter Ingres described for Gilibert a typical day in his Florentine life, with both artists rising at six A.M., taking coffee at seven, then going off to work in their respective studios. They met once more for dinner at seven, "a moment of rest and conversation until it's time for the theater, where Bartolini goes every evening of his life. We see each other again the next morning for breakfast, and so on day after day."[22] Bartolini's flamboyant manner of living and working—"his sound character makes him disdainful of everything *bourgeois,*" Ingres said of him[23]—could only throw into relief Ingres's own more meager prospects: "Finally, to avoid repeating myself, that is my life, too—except for the fact that he is, despite everything, making a fortune, in other words earning three or four thousand livres in income or, so to speak, in freedom; whereas I, poor devil, with all my hard and, if I may say so, *distinguished* work, find myself at thirty-eight having managed to put aside barely a thousand ecus."[24]

Ingres's most important painting during his first months in Florence was the portrait of Bartolini (fig. 135) that he completed soon after his arrival. A monument to the friendship that had drawn him to the city, it is a

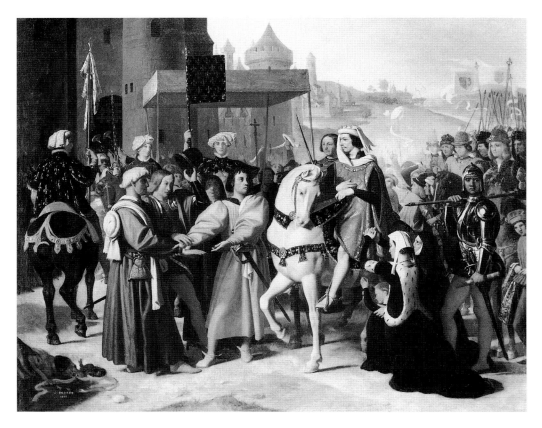

Fig. 136. *The Entry into Paris of the Dauphin, the Future Charles V*, 1821 (W 146). Oil on wood, 18½ × 22 in. (47 × 55.9 cm). Wadsworth Atheneum, Hartford

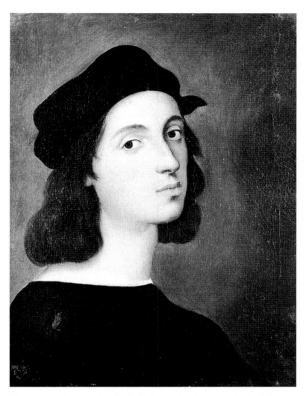

Fig. 137. After Raphael. *Self-Portrait*, 1820–24 (W 163). Oil on canvas, 16⅞ × 13⅜ in. (43 × 34 cm). Musée Ingres, Montauban

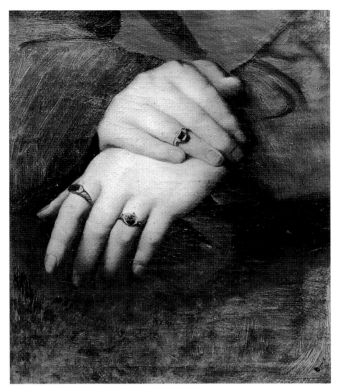

Fig. 138. After Raphael. *Maddalena Doni, Study of a Woman's Hands*, 1820–24 (W 151). Oil on canvas, 11 × 9 in. (28 × 23 cm). Musée Bonnat, Bayonne

compelling record of his friend's less than perfect but intensely vivid features. The forty-two-year-old sculptor confronts his portrayer—and the viewer—with a steady, intelligent gaze. Calm, assured, dressed soberly in brown, though wearing expensive rings and a jeweled pin in his cravat, he rests one hand on his hip and presses the other firmly to the tabletop. As Vigne has pointed out, the Bartolini seen here is no longer the bohemian artist whom Ingres had depicted in a portrait of 1805 (fig. 53) but someone who more closely resembles a wealthy patron.[25] The handsome and wittily Romantic poseur of the youthful days in Paris has become a mature man, aware of his accomplishments and of the authority they give him. He is an aristocrat of art, like a Medici prince who has come into his domain, and indeed, the painting owes an obvious debt to the portraits of nobles by such sixteenth-century Florentine artists as Bronzino and Salviati, which Ingres admired.[26] The work is also a record of the passions that the painter and the subject shared: their love of art, music, and epic poetry is reflected in the objects arrayed on the tabletop, which include Bartolini's bust of the composer Luigi Cherubini (a mutual friend), a violin bow, musical scores, and volumes of Homer, Machiavelli, and Dante, in addition to a small classical vase

and a mask of Tragedy. The critic and historian Henry Lapauze could rate this work no higher: "Never has he painted more truthfully than he does here. He will never surpass this. . . . The *Bartolini* from Florence, painted in 1820, is perfection itself."[27]

During his first several months in the new city, despite the illness that affected him upon his arrival, Ingres also completed two small history paintings that he had begun in Rome. The first was a variant for the comte de Forbin of *The Sistine Chapel* (W 131; Musée du Louvre, Paris), which he had first painted in 1814. He also brought to completion a complex and strange painting, *The Entry into Paris of the Dauphin, the Future Charles V* (fig. 136), which had been commissioned by his patron Comte Amédée-David de Pastoret (see cat. no. 98) in celebration of a fourteenth-century forebear, Jean Pastourel. The latter, a president of the Parlement de Paris, is depicted greeting the Dauphin at the gates of the city following the suppression of an insurrection in 1358; this image of ancestral loyalty to the medieval monarchy was intended by its patron to subtly advertise the contemporary allegiance to the restored Bourbon monarchy of Pastoret himself and his family. Details derive from Bernard de Montfaucon's *Les Monuments de la monarchie française* (1729–33) and other historical sources, which Ingres

assiduously studied as he painted the work. Stylistically the most self-consciously medieval of the artist's historical scenes, the *Entry of the Dauphin* bears a resemblance to manuscript illuminations by the fifteenth-century French artist Jean Fouquet and to the contemporary Neo-Gothic compositions of the German Nazarene painters.[28] In fact, it would be the last of the small-scale history paintings for which Ingres appropriated stylistic elements from early, more "primitive" eras of painting; henceforth, he

would increasingly find inspiration in the more naturalistic classical art of the Italian High Renaissance.[29]

That the *Entry of the Dauphin* marks a moment of transition in Ingres's use of artistic sources is suggested by an annotation on a preparatory drawing for the painting (Musée Ingres, Montauban), in which he remarked on the necessity of composing such a multifigure composition in the manner of Raphael.[30] Although the archaizing *Entry of the Dauphin* actually shows little evidence of Raphael's

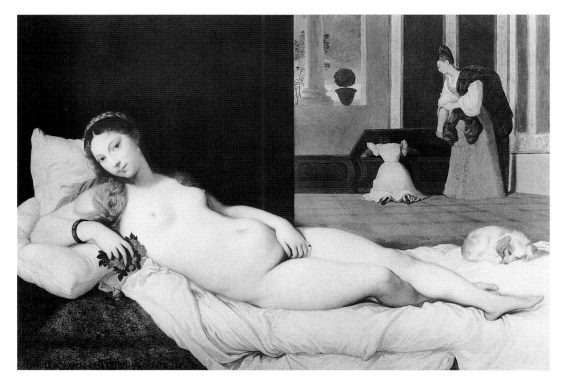

influence, it is clear that, soon after arriving in Florence, Ingres was intently studying that master's works as well as those of other major artists of the High Renaissance. In the Pitti Palace he copied three works by Raphael: a presumed self-portrait, the hands in the *Portrait of Maddalena Doni,* and the *Madonna del Granduca* (figs. 137, 138, 145). In 1823 Ingres and the writer Étienne Delécluze studied the monumental frescoes by another High Renaissance master, Andrea del Sarto, in the forecourt of the church of the Santissima Annunziata in Florence. In one sketch, Ingres sought to capture the complex torsion of four figures from the frescoes (fig. 139), their heads turning in a graceful countermovement to their bodies. Delécluze, concerned that the great artist was not well enough known in France, devoted a newspaper article to Sarto, which he quickly sent back to Paris and which may well reflect conversations that he had shared with Ingres: "It was [Sarto] who first in Florence and, without knowing the works of Raphael, formed the concept of *that modern grace* [of which] the *Virgins of Raphael* became the type. . . . The modern schools could study [these frescoes] to advantage."[31] Finally, in the Uffizi, Ingres copied Titian's *Venus of Urbino* (fig. 140), a sensuous work perhaps intended as a model for Bartolini to follow as he carved a marble *Recumbent Venus* (Musée Fabre, Montpellier).[32] Indeed, the new naturalism that Bartolini was then introducing into Florentine sculpture—which, like that city's painting, was still marked by a rigid Neoclassicism—must also have influenced Ingres.[33] Comparing Bartolini's art to that of his Florentine contemporaries, Ingres characterized the former as "like a beautiful and bright light in the midst of chaos."[34] Long an admirer of Raphael, Ingres came to appreciate more fully in Florence both the achievements of the monumental, naturalistic High Renaissance art and those of his contemporary and friend Bartolini. As Delécluze had counseled, he also began to question how those Italian achievements, old and new, might inform his own artistic aspirations and by extension those of the modern French school.

On August 29, 1820, not long after arriving in Florence, Ingres gained an important opportunity to act on his enthusiasm for the art of Raphael and the High Renaissance. In the most momentous commission of his career, the French ministry of the interior invited him to paint a large-scale altarpiece for the cathedral of his native town, Montauban, depicting the ritualization in 1638 of the vow that King Louis XIII had made two years earlier, when he dedicated France to the Virgin. *The Vow of Louis XIII* (fig. 146) would occupy much of Ingres's time and attention over the next four years, and its creation was fraught

with difficulty.[35] After some initial confusion over the subject, Ingres devoted long and often discouraging study to the composition, attempting to reconcile the earthly plane, in which the king kneels at the foot of the altar and gazes upward, with the visionary realm of the Virgin and Child and attendant angels, who hover above. He often scraped off areas of the canvas and started again. Concerned with correct historical detail, he was pleased when he found in the Uffizi a portrait of King Henry IV on which he could model the robes worn in the painting by Henry's son, Louis. "I believed I could, without offense, dress the son in the father's robes, but nothing more."[36] Completion of the painting, postponed and postponed again, would long be the determining factor in Ingres's plans for an eventual return to France. He would not go before the painting was finished, for he hoped that, when it was shown at the Paris Salon, the *Vow* would finally and incontrovertibly establish his reputation as a history painter and as the champion of the classical style.

Bartolini's was not the only elegant and artistic Florentine home into which Ingres seems to have been invited. In a letter of August 1820 to Granet in Rome, he mentioned having seen a painting by his old friend Nicolas-Didier Boguet in the collection of the countess of Albany.[37] Long resident in Florence, the countess was an ornament of the international beau monde. The German-born estranged wife of the dissolute Young Pretender, Prince Charles Edward Stuart, she had been for many years the mistress of the poet Vittorio Alfieri. After his death in 1803, she became the mistress of Fabre, who had been their mutual friend. Fabre advised the countess on her art collection and may well have persuaded her to purchase the painting by Boguet that Ingres had seen, for he admired Boguet's art and compared his landscapes to those of Poussin.[38] Until the countess's death in 1824, she and Fabre lived lavishly, surrounded by a considerable art collection, at the center of a cosmopolitan circle that often included aristocratic visitors passing through Florence. Bartolini would not have introduced Ingres to this circle, since he and Fabre had feuded in 1812 when the latter sided with the painter Pietro Benvenuti in a dispute with Bartolini about the posing of models at the Accademia di Belle Arti in Florence.[39] It may have been Fabre himself who invited his fellow Frenchman, new to Florence, to see the collection. Soon after arriving in the city, then, Ingres was connected with two adjacent artistic circles, both wealthy and in both of which bourgeois convention was flouted, aristocratic extravagance the order of the day. It would not have been easy for the artist—nearing middle age but not yet notably successful, with few financial

Fig. 141. *Pyrame Thomeguex*, 1821 (N 258). Graphite on tracing paper, 10½ × 8⅛ in. (26.7 × 20.7 cm). Private collection

Fig. 142. *Louise Gonin, Young Girl from the Gonin-Kreis Family*, 1821 (N 257). Graphite on paper, 8⅛ × 6 in. (20.8 × 15.3 cm). Musée d'Art et d'Histoire, Geneva

resources, and dependent on friends (but also quick to take offense at any perceived slight)—to see himself surrounded by ostentatious displays of prosperity and ease. Nor could it have been comforting for Madeleine—domestic, conventional, little traveled, fierce in defense of her husband—to find herself moving in such alien worlds.

This way of life quickly proved unsatisfactory to both of them. Citing "a rivalry over portraits," Ingres broke with Fabre and began turning his back on him in the street.[40] More seriously, by the end of 1820 Ingres and Bartolini were quarreling as well, and sometime in the spring the painter and his wife left Bartolini's house, to take up residence on the third floor of 6550, via della Colonna (Ingres also occupied two studios not far away in the via delle Belle Donne, near Santa Maria Novella). Ingres later railed against Bartolini's "impertinence, abruptness, whims, and boasting. . . . His life is totally given over to his passions and his shady dealings";[41] Madame Ingres seems to have objected in particular to the dissipations attendant on Bartolini's way of life. For his part, the sculptor largely blamed Madeleine for the split, telling Gilibert: "My friendship with him is unwavering, but I can't say the same for his wife, because her

personality contributes much to her husband's downfall; she has done me many wrongs, but I suffered them all for my friend's sake, which I would do under any circumstances and I would even ask you to maintain a strict silence on this subject."[42]

The failure to find the clients that Bartolini had promised, and now the need to fend for themselves, led to hardship for the artist and his wife. Years later, Madame Ingres recalled to Amaury-Duval: "Well! my dear friend, we have indeed known poverty, and the worst kind. . . . Would you believe that in Florence, we often had no bread in the house, and no credit left at the baker's?"[43] The break with Bartolini was never final, however. The two artists respected each other's talent too much for that, and attempts at reconciliation were made. In June 1822 the painter-sculptor Louis-Marie Dupaty reported to Granet in Rome: "I've been assured that Ingres adores Bartolini again and that Bartolini once more adores Ingres. I can forgive them this ridiculous little business because of their marvelous talent."[44] Nevertheless, by the end of the year, Paul Lemoyne was informing the same friend: "[Ingres] is now at daggers drawn with Bartolini. Both of them have gotten only what they deserve."[45] In fact, the

two would remain on distant terms, rarely seeing each other, throughout Ingres's remaining time in Florence. Only years later did they reunite as friends—in the 1830s, when Ingres, himself famous and successful, returned to Italy as the director of the Académie de France in Rome.

After their break with the artistic beau monde, Ingres and Madeleine found another, more compatible circle of friends in the family of the Swiss-born Jean-Pierre Gonin, a manufacturer of straw hats whose factory was located in Florence. The couple also became acquainted with the Thomeguex and Guerber families (see cat. nos. 87, 150, figs. 141, 142), into which the Gonins had married, and through these families with many members of the Florentine expatriate community, including Monsieur and Madame Jacques-Louis Leblanc and Dr. Cosimo Andrea Lazzerini and his French-born wife. These new friends—prosperous, sober, and industrious people, family-oriented and convivial, several of them with former connections to the court of the Tuscan grand duchess Élisa Bacciochi, sister of Napoleon—were warmly appreciated by Ingres. His sketch of Madeleine in conversation with Madame Leblanc and her daughter Isaure is evidence of the easy amiability between the families

(fig. 143). And when he left Florence to return to Paris late in 1824, it was into the hands of "the excellent and good Gonin-Thomeguex, such good, good, good friends" that he entrusted the care of his wife until she could rejoin him.[46] Yet, as fond as he was of his new friends, Ingres was fonder still of his independence and of the solitude he found in his studio. In August 1822 he informed Gilibert: "One thing is inimical to my peace of mind: I am not at all a social person, and they want me to go out into society. . . . I would rather be unknown here."[47] The center of Ingres's existence remained his art, and almost anything that impinged on the time and the painstaking energy he devoted to it was ultimately suspect.

The new circle did supply the artist with important opportunities for portrait commissions, both painted and drawn, and Ingres's portraits of his Florentine friends—pervaded by a sense of amiability and uncomplicatedly amusing social intercourse—are among the most beguiling of his career. The 1821 portrait of Jeanne Gonin (cat. no. 87), the sister of the family patriarch, was probably commissioned to celebrate her bethrothal to fellow Geneva native Pyrame Thomeguex. Its simplicity, intimacy, and relatively small scale bespeak sympathy between painter and subject, as well as the directness that privacy and

Fig. 143. *Madame Ingres Conversing with Madame Leblanc and Her Daughter*, 1822–23. Black chalk on paper, 5⅞ × 7⅜ in. (14.8 × 18.7 cm). Musée Ingres, Montauban (867.296)

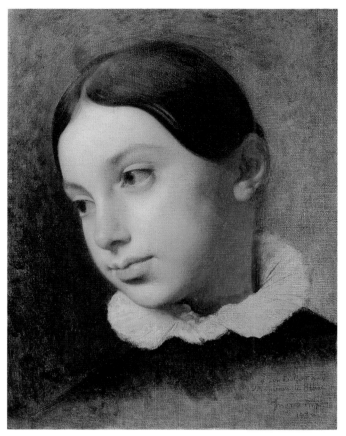

Fig. 144. *Isaure-Juliette-Joséphine Leblanc*, 1823 (W 154?). Oil on canvas, 15 × 11¾ in. (38 × 30 cm). Mokhtar Museum, Gezira, Cairo

Fig. 145. After Raphael. *Madonna della Granduca*, 1821–24 (W 150). Oil on paper, mounted on canvas, 34 × 24 in. (86 × 61 cm). Musée Ingres, Montauban

friendship allow. While more grandly conceived and public in intent, the pendant portraits of 1823 depicting the banker Jacques-Louis Leblanc and his wife (cat. nos. 88, 89) are also marked by the convivial sense that an amusing conversation has been momentarily arrested. Both sitters turn sympathetic half-smiles on their portrayer, the few elegant accessories that surround them establishing that we are meeting them in the intimacy of their home. The recently rediscovered portrait of their youngest daughter, five-year-old Isaure, eyes averted (fig. 144), is a vivid sketch of childhood innocence and shyness. Similarly, Ingres's 1822 group portrait of Dr. Lazzerini, his wife, and baby daughter (cat. no. 90), all of whom look out at the viewer with spontaneous amusement, is one of the finest portrait drawings of the Florence years.

Of the six portraits Ingres painted in Florence, five are of friends (cat. nos. 87–89, figs. 135, 144) and only one depicts a stranger. The latter was a Russian nobleman, Count Nikolai Dmitrievich Gouriev, who beginning in 1821 would serve successively as ambassador to The Hague, Rome, and Naples. After he and his new wife arrived in Italy in the fall of 1820, word of their interest in

acquiring contemporary art spread through the peninsula. The painter Boguet wrote his friend Fabre in Florence: "M. de Gourieff is in Rome. He has already made his tour of the studios and ordered paintings."[48] In 1821, after Gouriev had sat for Ingres in Florence, the painter tried to interest the count in the works of his friend the Belgian painter François-Joseph Navez, living in Rome, but was disappointed: "I've learned to my great displeasure that Count Gourief, a rich Russian whom I had strongly urged to go see your works, did not do it, even though he'd been well advised to do so by [] and written note. *But that's the way they are.*"[49] In Florence itself, however, the ambassador was generous with his commissions: Bartolini was called on to carve a marble seated statue of his wife, *Maria, Countess Gourieva* (State Hermitage Museum, Saint Petersburg), and Ingres was selected to paint the portrait of the count himself (cat. no. 86). While Ingres might have hoped that he would also be asked to provide a pendant portrait of the countess, in fact that commission went to Fabre instead (private collection, France).[50] Was this the "rivalry over portraits" to which Ingres had referred in relation to his split with Fabre?

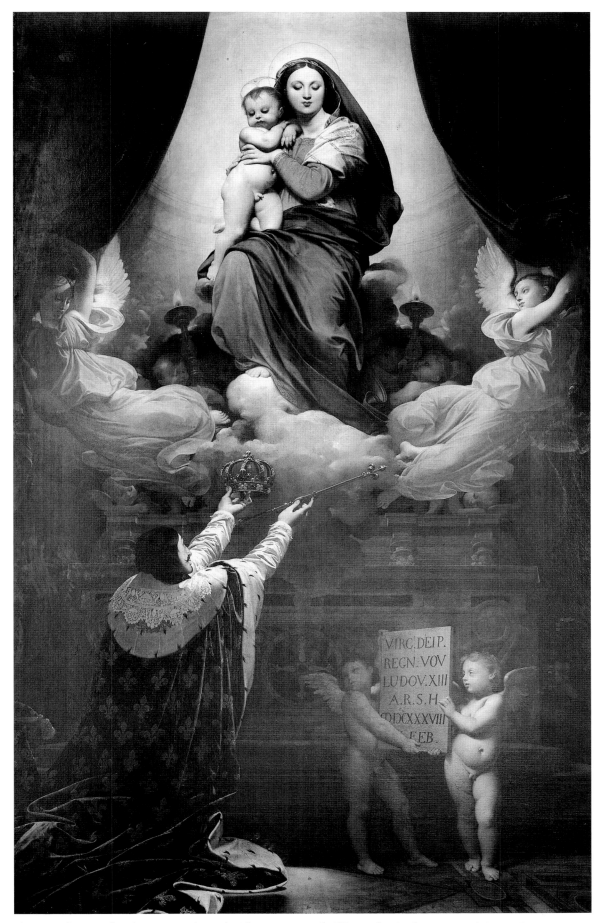

Fig. 146. *The Vow of Louis XIII*, 1824 (W 155). Oil on canvas, 14 ft. ½ in. × 8 ft. 7 in. (421 × 262 cm). Notre-Dame
Cathedral, Montauban

The text within the painting reads:

VIRG. DEI P.
REGN. VOV
LUDOV. XIII
A. R. S. H.
CIƆIƆCXXXVIII
FEB

Ingres's portrait seems to have been largely completed in late 1820, though signed only the following year.[51] In painting it, he returned to the romantic conceptions of such earlier works as the 1809 portrait of Granet (cat. no. 25), dramatically silhouetting the sitter's head against a stormy sky and animating the dark, moody canvas with a brilliant flash of red in the lining of the cloak. Unlike the sense of intimacy that characterizes Ingres's other painted portraits of the Florence years, the feeling here is of a chill and distant figure. As Daniel Ternois has remarked, "The portrait has great authority. The gaze is straightforward, the expression severe. The head is isolated against the sky as if seen from below."[52] Ingres would not paint another such image of aristocratic hauteur until, more than a decade later, he portrayed the heir to the French throne, Ferdinand-Philippe, duc d'Orléans (cat. nos. 121, 122).

As at Rome, commissions for portraits, especially drawings, continued to furnish Ingres with the means of making a living and, also as at Rome, Ingres complained of his weariness with the task. In 1823 he excused himself for not finishing a self-portrait drawing by explaining that "I am stricken by a kind of horror for anything that has to do with *drawing*, having done too much of it, and it reminds me of periods of ruinous lethargy when I did nothing but *that*, out of necessity, using up the best years of my career in Rome."[53] Indeed, he turned down the opportunity, proposed by an English client, to spend two lucrative years as a portraitist in Britain.[54] Ingres was determined to make his mark as a history painter, and the completion of *The Vow of Louis XIII* remained the overriding concern of his Florentine years, the vital center of his creative life. "I am not wasting a moment. I have no time to lose if I want to get into the Salon. The canvas *is painting itself;* I am counting heavily on it,"[55] he wrote to Gilibert early in 1822, some seventeen months after receiving the commission. Eighteen months later, in July 1823, Ingres was still feverishly working on the *Vow* when Delécluze visited his studio. Years later, the writer described Ingres at that moment as "poor and quite discouraged . . . experiencing uncertainties . . . at the thought of finishing his project. Struck with the beauty of the Virgin, [I] urgently pressed him to put the last touches on a painting which incontestably would be relished in Paris by all who were enlightened and impartial connoisseurs."[56] Such praise would have reassured the painter, as did the unexpected news that on December 27, 1823, he had been elected a corresponding member of the Académie des Beaux-Arts in Paris—to which he responded, "Well, I no longer have the right to complain about people!"[57] Prospects seemed good for a successful return to Paris in time for the Salon of 1824. In February of that year, however, Ingres's friends still worried about whether he would indeed finish the picture in time for the Salon and were even more troubled about how he might react to negative criticism if it were not well received there. As Charles Marcotte wrote to Granet: "I don't know if M. Ingres will make good on his plan to come in the spring. It will be a great pleasure to see him, and yet, he is so sensitive to remarks and criticism that I don't know whether, for his own sake, I should hope that he comes during the run of the exhibition."[58] Eight more months would elapse before, in October 1824, Ingres was able to leave Florence for Paris with *The Vow of Louis XIII* (fig. 146), finished at last.

With its majestic, slow, and dramatic confrontation between king and Virgin, the *Vow* owes a debt to the "modern grace" that Delécluze had identified as beginning with Andrea del Sarto and the other masters of the High Renaissance, including the greatest, Raphael. Indeed, it was in Florence, at work on this painting, that Ingres effected the decisive reconciliation of his art with the classical tradition of sixteenth-century Italy. As he had long hoped but hardly dared expect, the painting was rapturously received when, on November 12, 1824, it finally went on exhibition at the Salon. Ingres's greatest satisfaction was to see it praised in terms of its Italian sources: "The name of Raphael (unworthy as I might be) is mentioned in the same breath as mine. They say that I took inspiration from him without in any way copying him, but rather was imbued with his spirit."[59] The enormous success of the *Vow* marked Ingres's triumphant return to his homeland and his assumption of the leadership of the classical school. He had been away from Paris for eighteen years, the last four of them in Florence. There he had painted what his contemporaries immediately recognized as his first masterpiece; in retrospect, the Florentine sojourn was the protracted but necessary staging ground of that triumph.

1. Ingres to Pierre Forestier, October 5, 1806, in Boyer d'Agen 1909, p. 46.

2. "luxe oriental." Ibid.

3. For the appreciation of Italian Renaissance art in the circle of David and in the generation that succeeded it, see Alazard 1936, pp. 167–75, and Daniel Ternois in Amaury-Duval 1993, pp. 385–406.

4. "où est une chapelle que l'on peut nommer l'antichambre du paradis." Ingres to Pierre Forestier, October 5, 1806, in Boyer d'Agen 1909, p. 46.

5. "Pour la peinture, j'ai vu les ouvrages des premiers peintres modernes. Malheureusement pour eux, ils sont en arrière de trente ans et font rougir, bien rougir, la cendre de Michel-Ange, etc., etc." Ibid.

6. Vigne 1995b, p. 148.

7. "nous font une autre espèce de guerre, parce que nous valons mieux qu'eux." Ingres to Gilibert, July 7, 1818, in Boyer d'Agen 1909, p. 36.

8. "Entre Ingres et Florence, on peut parler d'harmonie pré-établie." Mathieu Méras, "Ingres in Florence," in Florence 1968, n.p.

9. "pays riche plus qu'aucun en objets d'art, bibliothèques, cabinets en tous genres. Je m'y rends moi-même, à la fin de ce mois, pour l'adopter si j'y ai les mêmes ressources qu'à Rome pour les *modèles*, objets si essentiels dans l'art." Ingres to Gilibert, June 1819, in Boyer d'Agen 1909, pp. 39–40. After he moved to Florence, Ingres mentioned his problems finding male models in a letter to Gilibert dated April 20, 1821: "The strange thing is, they are very scarce in a city where there are many female ones, and very good-looking." ("Chose singulière, ils font défaut dans une ville où il y en a beaucoup de femme et de très beaux.") Ibid., p. 67. Ingres and Bartolini would solve the problem by bringing a male model up from Rome to pose for the two of them exclusively.

10. "Songe, mon cher ami, au seul plaisir de faire ensemble les divins quatuors de Haydn, Mozart, Beethoven, avec ton vieux ami et je crois que nous pourrions dresser notre Bartolini à faire un second violon ou la quinte, car j'ai appris qu'il a travaillé cet instrument." Ingres to Gilibert, June 1819, ibid., p. 40.

11. "Tu ami la musica e non devi esserti dimenticato delle 'due Journées, Je suis le plus Vieux Savoyard' qui attend le bel effet du crescendo de la finale, il y aura de quoi distribuer les rôles à merveille. Non mi priverà di questo interessante momento per terminare i mei giorni sempre amorosi e in sino della piu cara amicizia." Bartolini to Gilibert, May 2, 1820, quoted in Méras 1973, p. 12.

12. "Une ville de passage." Ingres to Gilibert, November 12, 1823, in Boyer d'Agen 1909, p. 115.

13. "Tu sauras qu'il est très heureux à Florence; il a une grande vogue pour les portraits en marbre. Tous les étrangers se font pourtraicturer par lui." Ingres to Gilibert, July 7, 1818, ibid., p. 37.

14. In a letter to Gilibert dated June 3, 1821 (in ibid., p. 76), Ingres strongly criticized Bartolini for having misled him with false promises of a flourishing Florentine clientele.

15. "un caractère bien connu . . . par sa méchanceté." Lapauze 1911a, p. 223.

16. Pellicer 1979, p. 165.

17. "le triumvirat d'amitié." Ingres to Gilibert, June 1819, in Boyer d'Agen 1909, p. 39.

18. Angrand and Naef 1970a, p. 17, n. 29.

19. "Je puis enfin causer avec vous, mon cher Granet, car, à ma mauvaise étoile, je suis venu faire à Florence une espèce de maladie, et la plus cruelle pour un artiste, c'est de ne pas avoir les facultés de sa tête et de ses jambes. Celle-ci tourne et provoque d'affreux vomissements, et cela jusqu'à ce jour où je commence à mieux me sentir. . . . Vous pouvez juger de ma mauvaise humeur et de ma rage de me voir entouré de choses si belles et si nouvelles pour moi, et forcé impérieusement à rester dans ma chambre. Certes, sans les soins et la bonne garde que me fait ma bonne femme, j'aurais, je crois, repris le chemin de la belle Rome, que l'on apprécie d'autant mieux lorsqu'on est sorti. N'en déplaise même à l'excellente, belle, gracieuse, riche, propre, avec, en finissant, les épithètes les plus heureuses que je puisse trouver pour peindre Florence. Pour surcroît de déplaisir, l'ami Bartolini n'y était point. Ses ordres étant donnés pour nous recevoir et nous prodiguer l'hospitalité la plus somptueuse. Enfin, après quatorze ans d'absence, c'est arrivé, et retrouvons en lui un ami dans vos prix. C'est tout dire." Ingres to Granet, August 1820, in Néto 1995, letter no. 93.

20. "le plus grand sculpteur de ce siècle, qui n'a toujours pour rival que les Anciens." Ingres to Gilibert, October 7, 1820, in Boyer d'Agen 1909, p. 54.

21. "C'est un petit ministère que ses ateliers, sa correspondance et huit ou neuf monuments de marbre qu'il a à faire. Enfin, en t'attendant, il se venge sur nous, nous héberge comme des seigneurs, (car il vit ainsi), et nous comble d'amitié dont les preuves sont au bout des paroles." Ibid.

22. "moment de repos et de conversation jusqu'à l'heure du théâtre, où Bartolini va tous les soirs de sa vie. On se retrouve le lendemain, à déjeuner, et ainsi tous les jours." Ingres to Gilibert, April 20, 1821, ibid., p. 67.

23. "son esprit juste lui fait mépriser tout ce qui est *bourgeois*." Ingres to Gilibert, October 7, 1820, ibid., p. 54.

24. "Enfin, pour éviter des redites, voilà aussi mon histoire; à cela près cependant qu'il est en train, malgré tout, de faire fortune, c'est-à-dire d'acquérir trois ou quatre mille livres de rente ou, pour autant dire, la liberté; et que moi, pauvre diable, avec le travail le plus assidu et j'ose dire *distingué*, je me trouve, à trente-huit ans, n'avoir encore pu mettre de côté qu'à peine mille écus." Ibid., pp. 54–55.

25. Vigne 1995b, p. 150.

26. Pointing to the similarity of the sitters' poses and demeanors, Hélène Toussaint (in Paris 1985, p. 62) compared the *Bartolini* to Bronzino's *Portrait of a Young Man* (fig. 174), a work that Ingres saw in the collection of Lucien Bonaparte. She also speculated on Bartolini's collaboration with the painter in the choice of pose: "Is it not possible to deduce from this . . . that Bartolini might have chosen, as a rather vain ploy, an admired image in which he wanted to be reincarnated?" ("Ne pourrait-on déduire . . . que Bartolini aurait pu choisir, dans un jeu assez vain, une image admirée dans laquelle il lui plaisait d'être réincarné?")

27. "Jamais il ne mit plus de vérité qu'ici. Il n'ira jamais plus loin. . . . le *Bartolini* de Florence, peint en 1820, c'est la perfection même." Lapauze 1911a, p. 211.

28. For a recent discussion of the painting, see New Haven and Paris 1991–92, no. 144.

29. One reason for Ingres's laying aside of such small-scale works may well have been financial. As he reported to Gilibert in a letter dated April 20, 1821 (in Boyer d'Agen 1909, p. 72): "I'll tell you, my dear friend, that small paintings are longer and more painstaking than large ones, and that, doing them as I have up until now, I haven't earned enough to buy drinking water, since their small size means you never get paid what they're worth." ("Je te dirai, mon cher ami, que les petits tableaux sont plus longs et plus vétilleux que les grands et que, les faisant comme jusqu'ici, je n'y ai pas gagné de l'eau à boire, parce qu'étant petits ils n'ont jamais été assez payés.")

30. Inv. no. 867.1381. The annotation is transcribed in Vigne 1995a, no. 1222.

31. "C'est lui qui le prémier à Florence, et sans connoître les ouvrages de Raphaël, a donné l'idée de *cette grâce moderne*, si je puis dire ainsi, dont les *Vierges de Raphaël* sont devenues depuis le type; . . . les écoles modernes devroient étudier davantage." Delécluze, January 2, 1824. The drawing is catalogued, and the article quoted in translation, in Cambridge (Mass.) 1980, no. 26.

32. See Johnston 1982, no. 5.

33. For a discussion of Florentine art during Ingres's residence in the city, see Spalletti 1990, pp. 258–333.

34. "comme une belle et vive lumière au milieu du chaos." Ingres to Gilibert, October 7, 1820, in Boyer d'Agen 1909, p. 54.

35. Ingres told the story of his struggle to paint the *Vow* in a series of letters he sent from Florence to his friend Gilibert, ibid., pp. 53–120.

36. "J'ai cru pouvoir, sans rien choquer, habiller le fils de l'habit du père, mais rien de plus." Ingres to Gilibert, December 24, 1822, ibid., p. 103. The portrait Ingres found is by Frans Pourbus the Younger and is dated 1613 (Uffizi Ic640).

37. Ingres to Granet, August 1820, in Néto 1995, letter no. 93.

38. Pellicer 1979, p. 177.

39. Bordes 1979, p. 191.

40. "une rivalité de portraits." Lapauze 1911a, p. 223.

41. "impertinences, brusqueries, caprices et gasconnades. . . . Il vit abandonné à ses passions et à ses mauvaises affaires." Ingres to Gilibert, October 1823, in Boyer d'Agen 1909, p. 113.

42. "Mon amitié avec lui est inaltérable, mais je ne puis dire de même avec sa femme par ce qu'elle est d'un caractère qui contribue beaucoup à la perte de son mari, elle a eu bien des torts envers moi mais j'ai tout souffert pour l'ami, ce que je ferai dans toutes occasions et même je te prie de garder un profond silence à ce sujet." Bartolini to Gilibert, December 7, 1823, quoted in Méras 1973, p. 16. Bartolini was not the only artist friend of Ingres whom his wife alienated. On December 24, 1822, the sculptor Paul Lemoyne, living in Florence, wrote to Granet in Rome: "How can you believe that the illness affecting Ingres could be passed on to me? I am very distant from a contagion like that since I've definitively broken with him, or rather with his wife. She's a vile hussy, a viper of the worst kind. But I hope she won't carry into heaven the wicked acts of which in my eyes she's guilty. I fought for a long time before breaking off relations, and at this point I don't even speak to her when I happen to run into her at someone's home. As for Ingres, I admire his talent, but I'd doff my hat more readily to his works than to the man himself." ("Comment pouvez-vous croire que la maladie dont Ingres est affecté puisse m'être transmise? Je suis si éloigné d'une pareille contagion que j'ai rompu définitivement avec lui, ou plutôt avec sa femme. C'est une coquine infâme, une vipère de la plus grosse espèce. Mais j'espère qu'elle ne portera pas en paradis les traits de noirceur dont elle s'est rendue coupable à mon égard. J'ai bataillé longtemps avant que de rompre, et maintenant je ne la salue même pas dans les maisons où j'ai l'occasion de la voir. Quant à Ingres, j'estime en lui le talent, mais j'ôterais plus volontiers mon chapeau devant ses ouvrages que devant lui.") In Néto 1995, letter no. 200.

43. "Eh bien! oui, mon cher ami, nous avons connu la misère, et la plus complète. . . . Croiriez-vous qu'à Florence, nous n'avions souvent pas de pain à la maison, et plus de crédit chez le boulanger?" Amaury-Duval 1993, p. 125.

44. "On assure qu'Ingres a recommencé à adorer Bartolini et que Bartolini a recommencé à adorer Ingres. Je leur pardonne ce petit ridicule en faveur de leur beau talent." Dupaty to Granet, June 10, 1822, in Néto 1995, letter no. 178.

45. "Il est présentement à couteau tiré avec Bartolini. Ils n'ont, l'un et l'autre, que ce qu'ils méritent." Lemoyne to Granet, December 22, 1822, in ibid., letter no. 200.

46. "les excellents et bons Gonin-Thomeguex, si bons et bons et bons amis." Ingres to Madame Ingres, January 11, 1825, quoted in Lapauze 1910, p. 277, and in Naef 1977–80, vol. 2 (1978), p. 385.

47. "Une chose est ennemie de mon repos; je ne suis point un homme de société, et on veut que je voie le monde. . . . J'aurais voulu être ici inconnu." Ingres to Gilibert, August 29, 1822, in Boyer d'Agen 1909, pp. 85–86.

48. "M. de Gourieff est à Rome. Il a déjà parcouru des ateliers et ordonné des tableaux." The undated letter is quoted in Lapauze 1911a, p. 214, n. 1.

49. "Je sais à mon grand déplaisir que M. le Comte de Gourief, riche russe et que j'avais fortement engagé à voir vos ouvrages, ne l'a pas fait, quoique bien averti d'ainsi faire par [] et note écrite. *Mais les voilà.*" Quoted in Naef 1974 ("Navez"), p. 15. Ingres may also have been annoyed because, having ignored his own advice, Gouriev seems to have followed that of Fabre in acquiring a Boguet painting; see Pélissier 1896, pp. 321, 323.

50. Spoleto 1988, p. 12.

51. Vigne 1995b, p. 157.

52. "Le portrait a une grande autorité. Le regard est droit, l'expression sévère. La tête se détache sur le ciel comme si elle était vue par en-dessous." Daniel Ternois in Paris 1967–68, no. 120.

53. "je suis attaqué d'une espèce d'horreur pour tout ce qui est *dessin*, pour en avoir trop fait, et ce qui me rappelle de ruineuses léthargies où je n'ai fait que *ça*, et par nécessité, et qui ont employé les plus belles années de ma carrière, et à Rome." Ingres to Charles Marcotte, January 15, 1823, quoted in Naef 1977–80, vol. 1 (1977), p. 14, and Ternois 1999, letter no. 8.

54. Delaborde 1870, p. 41.

55. "Je ne perds pas un moment. Toutes mes heures sont comptées pour pouvoir arriver au Salon. Le tableau *va tout seul;* je compte beaucoup sur lui." Ingres to Gilibert, January 1822, in Boyer d'Agen 1909, p. 61, where the letter is mistakenly dated to January 2, 1821.

56. "pauvre et assez découragé. . . . éprouvant des incertitudes . . . à l'idée de compléter son ouvrage. Frappé de la beauté de la Vierge, Étienne pressa vivement l'artiste de mettre la dernière main à un tableau qui devait incontestablement être goûté à Paris par tout ce qu'il y avait de connaisseurs éclairés et impartiaux." Delécluze 1855, p. 394, translated in Cambridge (Mass.) 1980, no. 26.

57. "Allons, je n'ai plus le droit de me plaindre des hommes!" Lapauze 1911a, p. 228.

58. "Je ne sais si M. Ingres réalisera le projet qu'il a formé de venir au printemps. J'aurai grand plaisir à le voir, et cependant, il est si sensible aux observations et à la critique que je ne sais si, pour son bonheur, je dois désirer qu'il vienne pour l'époque de l'exposition." Marcotte to Granet, February 17, 1824, in Néto 1995, letter no. 221.

59. "Le nom de Raphaël, (bien indigne que j'en sois), est rapproché du mien. On dit que je m'en suis inspiré sans en rien copier, étant plein de son esprit." Ingres to Gilibert, undated, in Boyer d'Agen 1909, p. 121. As Andrew Shelton notes in this catalogue (p. 287, n. 3), Boyer d'Agen's dating of this letter to the very day the painting first went on view is improbable.

86. Count Nikolai Dmitrievich Gouriev

1821

Oil on canvas

42⅛ × 33⅞ in. (107 × 86 cm)

Signed and dated lower left: INGRES. Flor.
1821 [Ingres. Flor(ence). 1821 (*with* N
reversed)]

State Hermitage Museum, Saint Petersburg
5678

W 148

Count Gouriev (1792–1849) was the son of the Russian minister of finance under Czar Alexander I. After a distinguished army career that began in 1810 and included fighting against Napoleon in 1812–14, Gouriev, who had received several prestigious decorations, retired in 1816 with the rank of colonel. Two years later he was appointed an aide-de-camp to Alexander, and in 1821, at age twenty-nine, he began a diplomatic career during which he would serve in succession as the czar's ambassador to The Hague, Rome, and Naples. Gouriev ended his diplomatic service back in Saint Petersburg as a state secretary in the ministry of foreign affairs.[1]

In the autumn of 1820, shortly before assuming his ambassadorial duties, Gouriev and his new bride, Maria, Countess Gourieva, née Narychkina, began their honeymoon visit to Italy. While in Rome and Florence, the aristocratic couple, anxious to form a collection of contemporary art, made the acquaintance of leading artists from Italy and elsewhere. As they visited artists' studios, commissioning and acquiring works, word of their largesse passed from studio to studio; on January 15, 1821, the French painter Nicolas-Didier Boguet wrote from Rome to his friend François-Xavier Fabre in Florence excitedly describing the couple's visits there.[2] The count was no less busy in Florence itself, where he commissioned Fabre to paint a portrait of Countess Gourieva (private collection, France) and asked Ingres's friend the sculptor Lorenzo Bartolini to carve a marble seated portrait of her (State Hermitage Museum, Saint Petersburg). Ingres was given the commission of painting the portrait of the count himself.

It is interesting to speculate as to how such a prestigious commission came to Ingres, who had only recently arrived in Florence and was known to few people there. Noteworthy, perhaps, in this regard is the presence in Florence of a Russian who was an ardent collector of art—the enormously wealthy Count Nikolai Demidov, who had lived in the Villa San Donato since 1815. Demidov served as the Russian

envoy to Tuscany, and protocol, if not previous acquaintance, would have demanded that Gouriev and his wife present themselves at his villa early in their visit. Could it have been Demidov who suggested to the new arrivals which Florentine artists they might wish to patronize? Bartolini and Fabre, both of them socially prominent and successful, surely would have figured among such referrals. Only a few years later, in 1828, Demidov's son, Prince Anatoly Demidov (an even more extravagant collector than his father), would become an important patron of Bartolini when he commissioned a large-scale monument to his father, which today stands at Lungarno Serristori in Florence; however, the sculptor's acquaintance with the family may well predate that commission. If the elder Demidov had directed Gouriev to Bartolini, then Ingres would have been very close at hand, since he and his wife, Madeleine, were living in the sculptor's house at the time. That the Gouriev commissions held a particular significance for both Bartolini and Ingres is suggested by Bartolini's dedication of the plaster version of his portrait of Countess Gourieva (Museo Comunale, Prato): "Bartolini fece e dedicò all'amico Ingres" ("Bartolini made [this] and dedicated [it] to his friend Ingres").[3]

Conversely, Gouriev may have known about Ingres before he arrived in Florence. According to Valentina Berezina, the count and countess first visited Rome upon their arrival in Italy and only later moved on to Florence.[4] Ingres was well known in Rome, having lived there for fourteen years and having left only a few months before. Indeed, Gouriev may have seen some of Ingres's works there, such as the portrait of François-Marius Granet of 1809 (cat. no. 25), which was in Granet's collection there and which anticipates the portrait of Gouriev in its use of a moody landscape background against which the sitter's head is silhouetted. Arriving in Florence, the count then might have sought out the artist whose works had impressed him in Rome.

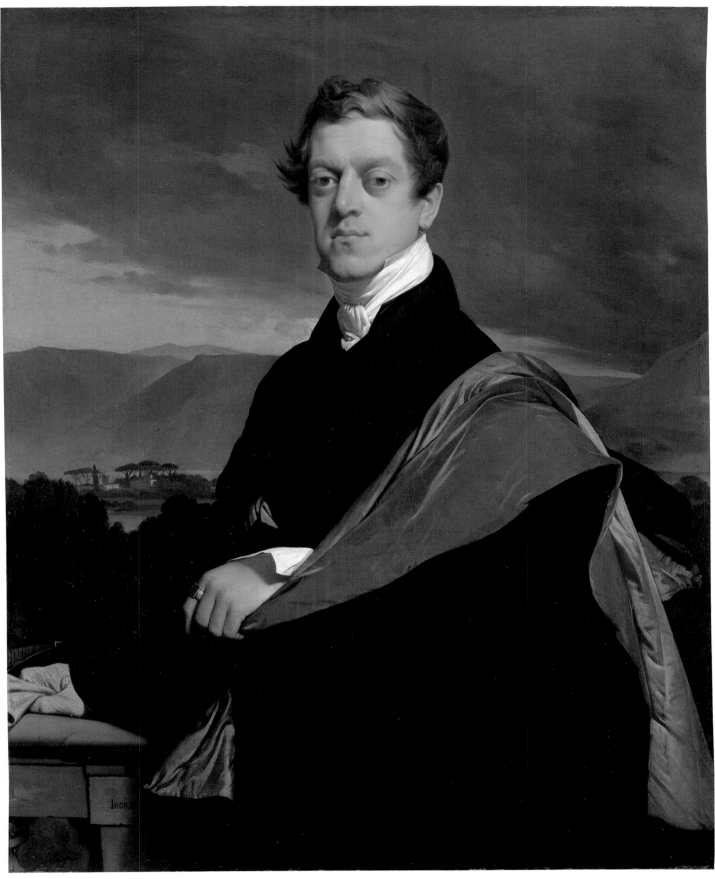

86

Though painted in Florence, the portrait includes a landscape background depicting a site in the Roman campagna. The landscape, with its distinctive plane trees at the left, is based on an anonymous watercolor drawing representing a view of Palombara Sabina (fig. 312), a town near Tivoli in the campagna. Hélène Toussaint has tentatively attributed the drawing to Boguet, while Georges Vigne has suggested that it may be by Granet.[5] Why this site should have been chosen for inclusion in the portrait is unclear, since it has no known connection with Gouriev. Its selection was probably not arbitrary, however—Ingres was meticulous about the backgrounds in his paintings and drawings—and Toussaint has suggested that the view may have been one the count and countess particularly admired.[6] Toussaint and Vigne believe that the landscape background in *Gouriev* is not from Ingres's hand but from Granet's.[7] A decade earlier, Ingres had called on his friend to add an atmospheric landscape background to his own portrait (cat. no. 25), and the landscape here is consistent with Granet's style. Yet, whoever supplied the landscape, there is nothing in the visual evidence of the final painting to suggest that Ingres did not complete that area of the portrait himself.

Ingres signed and dated the painting 1821, on the parapet before which Gouriev stands. Vigne argues that it was largely executed in the autumn of 1820 and that the final touches were added early the following year.[8] Gouriev himself moved back and forth between Rome and Florence more than once in 1820 and 1821. In December 1820, he wrote to Boguet from Florence, saying that he hoped to meet Ingres the next time he visited the Eternal City.[9] Boguet's previously cited letter of January 15, 1821, indicates that Gouriev had left Florence and returned to Rome early in the new year. In a letter sent to his friend Jean-François Gilibert on April 20, 1821, Ingres mentioned "a portrait of a Russian nobleman that I have just painted here."[10] The phrase suggests both that Ingres had recently completed the portrait of Gouriev and that the count was back in Florence once again.[11]

If the drawing is by Boguet or Granet, either one could have given it to Gouriev in Rome. This in turn suggests that Ingres would have brought the portrait to completion, not early in the new year as Vigne has proposed, but some three months later, in or around April 1821.[12]

Whatever the circumstances that brought Gouriev and Ingres together, and whenever Ingres completed his work, the portrait he painted of the Russian nobleman is one of the haughtiest images of aristocratic grandeur that he would ever create. Just before he began it, in the autumn of 1820, Ingres had completed his portrait of Lorenzo Bartolini (fig. 135). If the count needed convincing of Ingres's skills as a portraitist, this masterful canvas would have served as an immediate and compelling demonstration. Indeed, both paintings invest their sitters with a sense of aristocratic presence: Gouriev and Bartolini are poised, self-possessed gentlemen who, aware of their status and abilities, gaze confidently at their portrayer. Though one painting is set in an interior, the other in a landscape, each draws on traditions of aristocratic portraiture. The former evokes sixteenth-century Florentine examples such as works by Agnolo Bronzino (see figs. 56, 174); the latter, as Robert Rosenblum has suggested, calls to mind British portrait traditions, particularly the contemporary art of Sir Thomas Lawrence, in which portrait and surrounding landscape are brought into pictorial equilibrium.[13] While Bartolini is identified as an artist and man of learning by the books and objets d'art on the table at his side, Gouriev's surroundings—the tempestuous sky and dark natural forms—do not so much reveal his interests as suggest a passionate, Romantic temperament beneath the haughty self-possession.

As in Ingres's portraits executed with Granet's help in Rome a decade earlier (particularly the *Granet* of 1809), the subject's head rises high above the landscape here and is detached from it by the brilliant white of a collar. A slash of pale blue sky cuts diagonally into the composition from the left, intersecting with Gouriev's shoulders and further isolating his head against the darker, scudding storm clouds. A flash of light illuminates the count's high, wide forehead and deep-set, hooded eyes. Dominating the bottom half of the portrait is the brilliant red silk lining of Gouriev's cloak, which is grasped in his left hand and which, riding low on his shoulder, cascades down his back. An unexpected note of color is introduced by his orange gloves, one worn and the other held in his right hand. As Daniel Ternois has noted, Ingres depicts Gouriev as if he is seen from below, a view that helps to further invest the sitter with a sense of monumental authority.[14] Unlike the other portrait sitters whom Ingres painted in Florence, Gouriev was not a friend but rather a stranger of wealth and rank. While not unsympathetic to its subject, Ingres's portrait imparts to the Russian nobleman an aura of distance and detachment that, one suspects, is merely a step removed from disdain.

Ingres probably never saw the portrait of Gouriev again after he completed it. However, some eighteen years later, while he was the director of the Académie de France in Rome, he may have been reacquainted with the sitter. In a letter of September 18, 1839, the painter Henri Lehmann informed Marie d'Agoult that Ingres was in fact painting Gouriev's portrait![15] Lehmann was certainly mistaken, but Vigne points out that the reference corresponds to a visit to Rome in that year by the czarevitch of Russia, the future Alexander II, who commissioned a religious painting from Ingres while there. He suggests that Gouriev, experienced both as a diplomat and a traveler, may have accompanied the young prince on his journey and introduced him to the painter.[16] By 1839 Ingres was established as a famous artist, held a prestigious position, and lived in a splendid house. He and Gouriev would presumably have met on a more equal social footing on that occasion than in 1820, when the nobleman had first encountered the penurious painter in Florence.

C. R.

1. Biographical details come from Berezina 1983, p. 271.
2. "M. de Gourieff is in Rome. He has already made his tour of the studios and ordered paintings." ("M. de Gourieff est à Rome. Il a déjà parcouru des ateliers et ordonné des

tableaux.") Boguet to Fabre, dated January 15, 1821, quoted in Lapauze 1911a, p. 214, n. 1, and Pélissier 1896, p. 328.

3. Florence 1968, p. 155.

4. Berezina 1983, p. 271.

5. See Toussaint 1990b, pp. 20, 22, and p. 526 in this catalogue.

6. Toussaint 1990b, p. 20

7. Ibid.; Vigne 1995b, p. 157, and p. 526 in this catalogue.

8. Vigne 1995b, p. 322, chap. IV, n. 5.

9. The letter is quoted in Toussaint 1990b, p. 20. Furthermore, it was only after Gouriev and Ingres had met in Florence that the artist would have been able to complain, in an undated letter to his friend the Belgian painter François-Joseph Navez, that Gouriev had ignored his advice to visit Navez's Roman studio. The letter is published in Naef 1974 ("Navez"), p. 15.

10. "un portrait que je viens de peindre d'un seigneur russe, ici." Ingres to Gilibert, April 20, 1821, in Boyer d'Agen 1909, p. 69.

11. Ingres does not mention the painting in a long letter to Gilibert, dated January 2, 1821, written when Vigne suggests that he would have been completing the portrait; see Boyer d'Agen 1909, pp. 58–66.

12. A collaboration with Granet is unlikely to have continued much beyond April, since by June the two artists had fallen out, with Ingres accusing his Roman colleague of disloyalty. See Ingres's aggrieved letter to Gilibert, date June 3, 1821, in Boyer d'Agen 1909, pp. 73–74.

13. Rosenblum 1967a, p. 120.

14. Ternois 1980, p. 65.

15. Quoted by Ternois in Paris 1967–68, p. 172.

16. Vigne 1995b, p. 230.

PROVENANCE: Count N. D. Gouriev, until his death in 1849; his widow, Countess M. D. Gourieva, until her death in 1871; her relative E. D. Narychkina, Saint Petersburg, to 1889; A. N. Narychkina to 1922; entered the State Hermitage Museum, Saint Petersburg, through the State Museum Reserve, 1922

EXHIBITIONS: Saint Petersburg 1923, room 1; Saint Petersburg 1938, no. 322, ill. p. 45; Moscow 1955, p. 62 (in the exh. cat.); Saint Petersburg 1956, p. 62 (in the exh. cat.); Bordeaux, Paris 1965–66, no. 53, pl. 15 (Bordeaux), no. 63, ill. (Paris); Paris 1967–68, no. 120, ill.; Saint Petersburg 1972, no. 402, ill.; Paris, Detroit, New York 1974–75, no. 109, ill. (shown only in Paris); London 1988a, no. 18, ill.; New York, Chicago 1990, no. 23, ill.

REFERENCES: Silvestre 1856, p. 36; Delaborde 1870, no. 123; Mikhailovich 1905–9, vol. 3, pt. 4, pl. 201; Boyen d'Agen 1909, p. 69; Lapauze 1911a, p. 214; Lapauze 1923, p. 446; Réau 1924, p. 344; Réau 1929, no. 134; Stern, Liszt, and Lehmann 1947; Wildenstein 1954, no. 148, pl. 55; Sterling 1957, p. 74, pl. 55; Saint Petersburg, Hermitage 1958, vol. 1, p. 458, ill. p. 373; Kamenskaya 1959, pp. 3–5, ill.; Berezina 1960; Boudaille 1961, ill.; Berezina 1964, no. 149; Saint Petersburg, Hermitage 1966, no. 1, ill.; Berezina 1967, p. 30; Laclotte 1967, p. 194, fig. 5; Picon 1967, pp. 15, 73; Rosenblum 1967a, p. 120, pl. 30; Radius and Camesasca 1968, no. 106, ill., pl. XXXI; Izergina 1969, pp. 16, 278, ill.; Berezina 1972, pp. 82–85, ill.; Saint Petersburg, Hermitage 1972, pl. 41; Saint Petersburg, Hermitage 1976, p. 303, ill.; Berezina 1977, pp. 114–18, ill. pp. 61, 62; Kostenevich 1977, nos. 12, 13; Whiteley 1977, p. 62, ill.; Berezina 1980, no. 68, ill.; Ternois 1980, pp. 65, 92, no. 159, ill.; Berezina 1983, no. 241, ill.; Berezina 1987, no. 68; Kostenevich 1987, nos. 32, 33; Eisler 1990, p. 521, ill. p. 529; *French Painting* 1990, no. 18, ill.; Toussaint 1990b, pp. 18–25, ill.; Vigne 1995b, pp. 156, 230, 325, 328, fig. 130; Roux 1996; p. 58, pl. 15

87. Mademoiselle Jeanne-Suzanne-Catherine Gonin, later Madame Pyrame Thomeguex

1821
Oil on canvas
30 × 23 ¼ in. (76.2 × 59.1 cm)
Signed lower left: D. Ingres, pint. flor. 1821
[D. Ingres painted (this). Flor(ence). 1821]
The Taft Museum, Cincinnati, Ohio
*Bequest of Charles Phelps and Anna Sinton
Taft 1931.414*

W 147

While Ingres made portrait drawings of several members of the family of his friend the Swiss businessman Jean-Pierre Gonin and of the Thomeguex and Guerber families, to whom they were related (see cat. no. 150, figs. 141, 142), this is his only portrait painting of a member of the Gonin clan. Born in Geneva in 1787, Jeanne-Suzanne-Catherine Gonin was the younger sister of the family patriarch and lived with her brother's family in Florence. The portrait probably was commissioned by Pyrame Thomeguex, Gonin's business partner in a hatmaking factory in Fiesole, to celebrate his betrothal to Jeanne. Ingres would make a portrait drawing of Thomeguex himself that same year (fig. 141). The two married the following year at Fiesole, when Jeanne was thirty-five years old, and her husband, also Genevan by birth, two years her junior. After twenty happy years of marriage, which saw the birth of two children (one of whom was to die at age ten), Madame Thomeguex died in 1842, two years before her husband.

Ingres, who himself enjoyed a long, happy, and devoted marriage to Madeleine, would have appreciated the promise of happiness that animated the convivial Jeanne Gonin as she awaited her wedding. Like the simple and vivid portrait of his own wife that he painted about 1814 (cat. no. 36), though brought to a higher degree of finish, his portrait of Jeanne is remarkable for its qualities of candor and intimacy. Shown bust length, her arms folded demurely in front of her, Jeanne faces the viewer confidently. She is no longer in the first bloom of youth, and her plain, broad, but appealing features are in no way idealized; a slight smile plays across her lips as if some pleasantry or confidence has been exchanged. Her dress is simple, her jewelery modest, the setting unarticulated. Ingres employs here none of the rhetorical devices that animate many of his more formal, grandly public portraits—no enamel-like finish, no rich display of clothing, accessories, or surrounding objects to elaborate on the taste and interests of the sitter,

nor, indeed, any of those eye-catching spatial and formal complexities of which he was the master. Rather, the intention is to show Jeanne Gonin as she simply was. The full, frank light that falls on the sitter's face draws attention to her personality, her unique and individual presence. Like Ingres's depiction of his wife, this is a *portrait intime* (intimate portrait), meant to please one pair of eyes alone—in this case, those of her intended, for whom no artifice was needed. Throughout his career, Ingres reserved this "natural" mode of portraiture for the depiction of friends and loved ones, and these works are among his most beguiling.[1]

Jeanne Gonin and Madeleine Ingres were particularly close friends, and indeed a portrait drawing of Madeleine (cat. no. 108) is inscribed "Madame Ingres à sa bonne amie Madame Thomeguex" ("Madame Ingres for her good friend Madame Thomeguex"). The artist and his wife maintained the friendship long after they left Florence for Paris, as they did with all the members of the extended Gonin family. They visited the Thomeguex on their way to Rome in 1834, when Ingres was on his way to assume his duties as director of the Académie de France, and again in 1841 as they were returning from Rome to Paris. This portrait remained in the family of the sitter for more than a century, except for one brief period. Momentarily in need of funds, Antoine Thomeguex (see cat. no. 150), the son of Jeanne Gonin, pawned the painting in 1896 at the Galerie Bernheim-Jeune in Paris. There it was acquired by no less an admirer of Ingres than Edgar Degas. Five months later, however, Degas graciously returned the painting to the gallery when Thomeguex, who had settled his debts, wished to redeem the work.[2] As Georges Vigne has pointed out, this is the only work that the artist ever signed, for unknown reasons, "D. Ingres."[3]

C.R.

1. For a discussion of Ingres's *portraits intimes*, see Fleckner 1995, pp. 113–23.

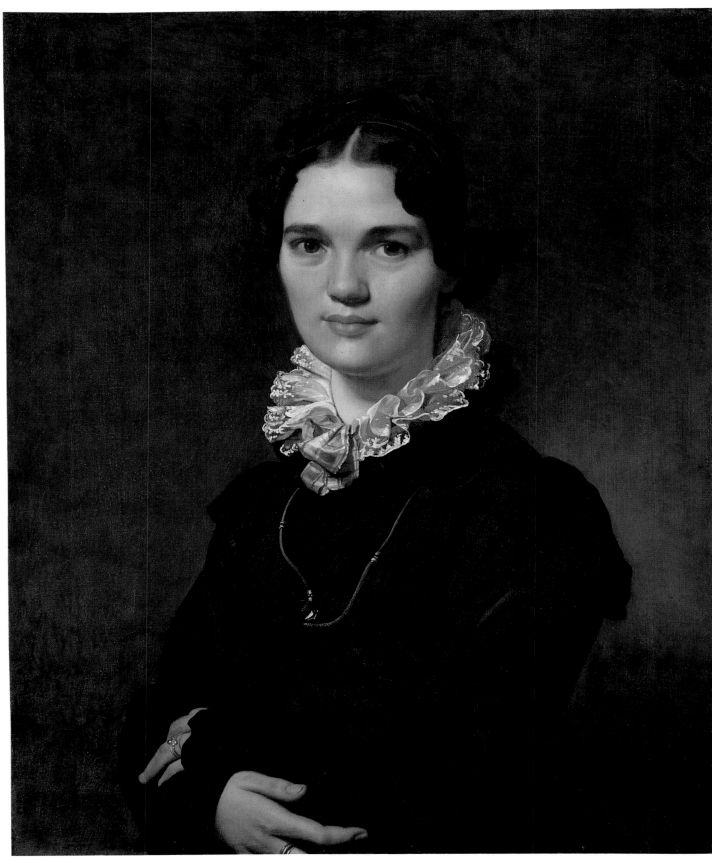

87

2. New York 1997–98 ([vol. 2], no. 635).

3. Vigne 1995b, p. 16.

PROVENANCE: Pyrame Thomeguex, husband of the sitter, until his death in 1844; Antoine Thomeguex, son of the sitter; pawned to the Galerie Bernheim-Jeune, Paris, 1896; acquired from that gallery by Edgar Degas for 5,000 francs; returned to the gallery five months later, when Antoine Thomeguex wished to reclaim it, 1896; his collection until his death in 1899; his son, Albert Thomeguex, until his death in 1918; his sister, Mme Paul-Gaston Pictet, née Alice Thomeguex; sold by her about 1923; Scott & Fowles, New York; purchased by Charles Phelps Taft, Cincinnati, 1924; his bequest to the Taft Museum, 1931

EXHIBITIONS: Paris 1867, no. 442; London 1923, no. 20 [EB]; Chicago 1933, no. 217; San Francisco 1934, no. 112; Toronto 1935, no. 178; Springfield, New York 1939–40, no. 25, ill.; Cincinnati 1940; New York 1946, no. 50 [EB]; Detroit 1950a, no. 20; Omaha 1951; New York, Manchester, Detroit, Cincinnati, Cleveland, San Francisco 1952–53 (shown only in Cincinnati); New Orleans 1953–54, no. 52, ill.; Chicago 1955, no. 22, ill.; Richmond 1961, no. 74, ill.; New York 1961, no. 31, ill.; Indianapolis 1965, no. 28, ill.; Paris 1967–68, no. 122, ill.; Minneapolis 1969, no. 51, ill.; Louisville, Fort Worth 1983–84, no. 72, ill.

REFERENCES: Saglio 1857, p. 77, as *Mlle Gouier*; Blanc 1870, p. 232, as *Mme Thomguet*; Delaborde 1870, no. 124, as *Mademoiselle Gouin*, and no. 156, as *Madame Thomguet*; Lapauze 1901, pp. 235, 248, as *Mlle Gouin*; Lapauze 1911a, p. 213; Lapauze 1923, p. 446, ill. opp. p. 446; Siple 1930, pp. 35–39, ill. p. 25; Burroughs 1932, p. 365; Anon., May 1933, p. 347, ill. p. 348; Anon., September–October 1933, ill. p. 85; Cincinnati, Taft Museum 1939, no. 104, pl. 29; Pach 1939, p. 26, ill. opp. p. 111; Waterhouse 1946, p. 155, pl. B; Alazard 1950, p. 66; Wildenstein 1954, no. 147, pl. 54; Naef 1955 ("westschweizerischen Freunde"), p. 18, fig. 6; Cincinnati, Taft Museum 1958, no. 104, ill. p. 31; Birnbaum 1960, pp. 103–5; Burroughs 1966, pp. 162–72; Naef 1966 ("Gonin, Thomeguex et Guerber"), pp. 153–54, fig. 1; Laclotte 1967, p. 194; Radius and Camesasca 1968, no. 105, ill.; Naef 1977–80, vol. 2 (1978), pp. 389, 391, 400, fig. 15; Ternois 1980, p. 65, no. 158, ill.; *Taft Museum* 1995, vol. 1, pp. 234–35, ill.; Vigne 1995b, pp. 16, 154, 325, 328; New York 1997–98 ([vol. 2], no. 635, ill.)

88. Madame Jacques-Louis Leblanc, née Françoise Poncelle

89. Jacques-Louis Leblanc

88. Madame Jacques-Louis Leblanc, née Françoise Poncelle

1823

Oil on canvas

47 × 36½ in. (119.4 × 92.7 cm)

Signed and dated lower left: Ingres P. flor. 1823 [Ingres p(ainted this). Flor(ence). 1823]

The Metropolitan Museum of Art, New York Catharine Lorillard Wolfe Collection, Wolfe Fund, 1918 19.77.2

W 152

89. Jacques-Louis Leblanc

1823

Oil on canvas

47⅝ × 37⅝ in. (121 × 95.6 cm)

Signed right, below center (on paper): Ingres Pinx. [Ingres painted (this)]

The Metropolitan Museum of Art, New York Catharine Lorillard Wolfe Collection, Wolfe Fund, 1918 19.77.1

W 153

Aside from *The Vow of Louis XIII* (fig. 146), completed in 1824, the most ambitious painting project that Ingres undertook during his four years' residence in Florence was the creation in 1823 of pendant portraits of his friends Monsieur and Madame Jacques-Louis Leblanc. Born in Versailles in 1774, Leblanc was the son of an official in the royal administration; in Florence he served Élisa Bacciochi, grand duchess of Tuscany and sister of the emperor, as secretary, governor of the principality of Piombino, and assistant director of the ducal household. His wife, the former Françoise Poncelle, was born in Cambrai in 1788 and had been a lady-in-waiting to the duchess. Before their marriage in 1811, both had lived in the Palazzo Pitti as fixtures of the court that surrounded Élisa. Following the collapse of the Empire in 1815, and perhaps sensing that no comparable position would be found in post-Napoleonic France, the Leblancs chose to remain in Florence. Leblanc worked as a banker, and the couple, who lived in elegant style, figured prominently in the expatriate community, counting among their friends the families of both Dr. Cosimo Andrea Lazzerini (see cat. no. 90) and the Swiss businessman Jean-Pierre Gonin (see cat. no. 87). Ingres and his wife, Madeleine, were introduced to this convivial circle soon after their arrival in Florence in the summer of 1820; there they found not only patrons who supported them during their years in the Tuscan capital but lifelong friends as well.

Leblanc seems to have met Ingres at the home of Gonin. Quickly showing his generosity to the impecunious artist, the banker commissioned Ingres to complete for him the painting of a *"Vénus naissante avec les Amours"* (*Birth of Venus* with Cupids), begun long before in Rome; the picture, the *Venus Anadyomene* (fig. 201), was not finished until 1848, however, two years after Leblanc's death.[1] Nonetheless, Ingres was clearly flattered by the attentions of this new patron, whom he described in glowing terms as "a Frenchman, very rich and also quite generous and good who has adopted us, to the point of overwhelming us with acts of politeness and also with requests for paintings, portraits,

Fig. 148. *Studies for "Madame Leblanc,"* 1823. Charcoal on paper, 7⅝ × 8⅛ in. (19.4 × 20.7 cm). Musée Ingres, Montauban (867.300)

Fig. 149. *Study for "Madame Leblanc,"* 1823. Charcoal on paper, 5¾ × 5⅞ in. (13.8 × 15 cm). Musée Ingres, Montauban (867.301)

Fig. 147. *Studies for "Madame Leblanc,"* 1823. Charcoal on paper, 13⅜ × 9 in. (34 × 21.9 cm). Musée Ingres, Montauban (867.299)

etc."[2] Ingres would go on to create not only the painted pendant portraits of Leblanc and his wife but portrait drawings of them both and of their eldest living child, a son, Félix (cat. nos. 92–94). A painted portrait sketch of their youngest daughter, Isaure, recorded in Ingres's Notebook X, has recently come to light as well (fig. 144).[3] In all likelihood dating from the same moment, it is a remarkably spontaneous image that captures the shyness of a child as she turns her head away from eyes that are too inquisitive.

The earliest work in the Leblanc series is probably the full-length portrait drawing of Madame Leblanc, dated 1822, which shows her in a day dress, standing with arms folded, curly hair enframing her lively face (cat. no. 92). The portrait of her husband, drawn the following year on March 9, depicts him outdoors, wearing a cloak and top hat against the late winter chill (cat. no. 93). Despite the different settings, the drawings were intended to function as pendants. The bodies of husband and wife are inclined toward each other, and indeed the subtle suggestion that the wider public

world was the man's domain while the domestic sphere was the wife's was common in such images. Moreover, Ingres inscribed each drawing to the other partner. The drawing of ten-year-old Félix portrays him in a long coat, a book clutched in his right hand—an intimation perhaps of his later distinguished career as a scientist (cat. no. 94). The frank, open gaze he turns on Ingres is full of natural intelligence, and the artist responded to it warmly, capturing subtle nuances of expression, as he often did when his subjects were clever, animated children.

The painted portraits of Monsieur and Madame Leblanc are marvelously interrelated. Both show figures seated at an angle to the picture plane but turning their heads to gaze directly at their portrayer. Leblanc's left arm rests on a carpeted table, with the massive, indeed pneumatic, fingers hanging down. His right hand, which holds open a small leather-bound book, exhibits a tension that contrasts with the torpor of the left. Looping down and across his chest is a gold watch chain, whose tighter loop at the right accentuates the downward movement of his dangling hand. While he is soberly dressed in black, the striped vest that peaks through at three points across his stomach and chest suggests an appreciation of more ostentatious garb. At the right, the Turkish carpet covering the table establishes the foreground plane and offers the highest note

of color in the composition; the background, however, is largely undefined, the sitter seeming to emerge out of darkness.

As is very often the case in pendant portraits of a husband and wife, the woman is the more resplendent creature. Spatial compressions, such as Madame Leblanc's radically foreshortened right arm, as well as the stylization of her form—her impossibly long neck, pale skin, and enormous eyes—endow the sitter with a sense of otherworldly mystery, flattering to an elegant woman of taste but quite different from the more prosaic presence of her husband. Nonetheless, the portrait of Madame Leblanc is subtly inflected to echo and complement that of her spouse. She too seems to emerge out of darkness. One of her hands—in her case the right—also hangs limply. Like her husband, she wears a brilliant gold chain that loops across her chest. Like the carpet in her husband's portrait, the cashmere shawl draped over her chair (and embroidered with the letter *E* for Grand Duchess Élisa) establishes the foremost plane of the picture and provides the brightest notes of color. Like her husband, Madame Leblanc is soberly dressed, in a black gown elaborately ruched across the bodice.

Ingres gives a bravura display here of his mimetic skills in depicting cloth stuffs, as he paints the transparent black gauze of the sleeves, through which the sitter's plump arms are visible. Through such rhyming

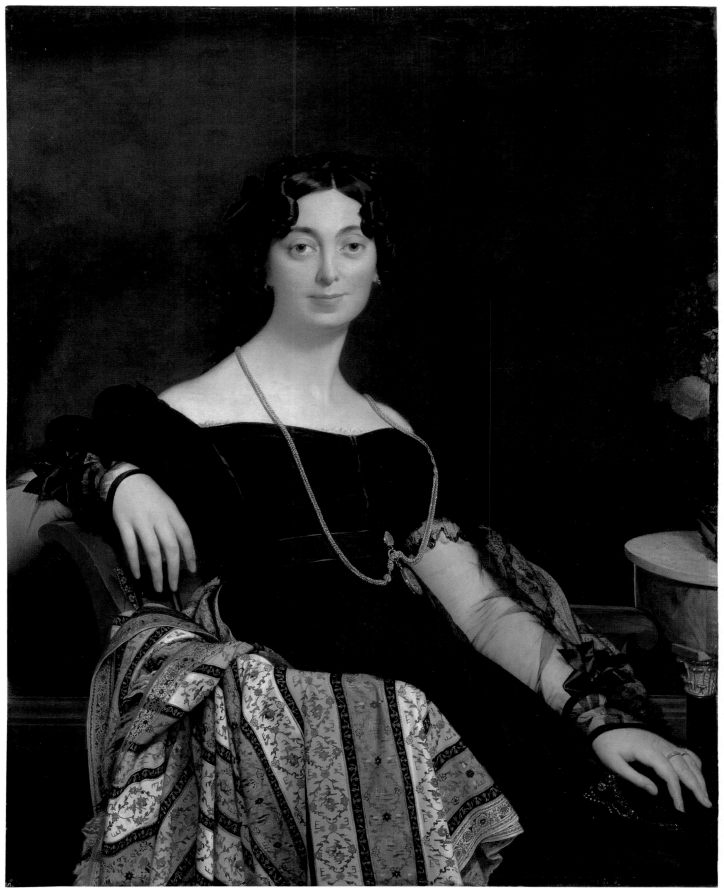

88

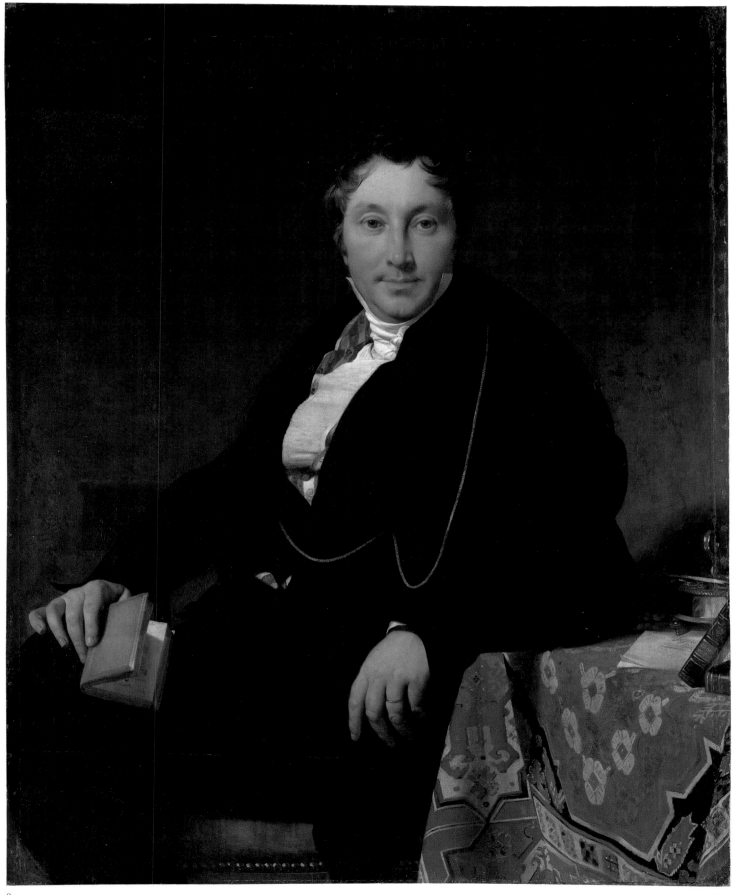

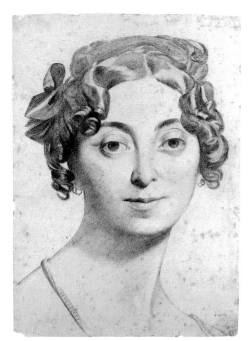

Fig. 150. *Study for "Madame Leblanc" (Head)*, 1823. Graphite and red chalk on paper, 15⅛ × 10¼ in. (38.4 × 26 cm). Musée Ingres, Montauban (867.310)

forms and colors, Ingres skillfully emphasizes the familial and emotional bonds that unite the couple. In this regard, Robert Rosenblum quite rightly sees in the portrait of Madame Leblanc "the new mood of bourgeois respectability that began to permeate Ingres's female portraiture from the 1820's on."[4] Ingres's life as well as his art reflected such a change: in Florence he and his wife deliberately turned away from the bohemian circles in which colleagues such as Lorenzo Bartolini and François-Xavier Fabre moved and sought out a new coterie of upstanding, family-minded friends like the Leblancs and Gonins. These splendid pendant portraits thus celebrate the artist's growing admiration for bourgeois life and the quieter pleasures of the domestic realm.

Ingres prepared for the portraits of the Leblancs with a surprisingly large number of drawings, which are now in the Musée Ingres, Montauban. Of the three studies of Monsieur Leblanc, two portray his crossed legs, and the third his limp left hand (figs. 153, 154).[5] Some fifteen drawings prepare for the portrait of his wife. They reveal that Ingres's first thought was to depict her with Isaure (fig. 152), but this idea was abandoned. Rosenblum has located the origin of Madame Leblanc's pose, including the foreshortened right

arm, in Jacques-Louis David's 1799 portrait of Madame de Verninac (fig. 41),[6] but Ingres seems to have arrived at that motif only slowly, over time. A number of drawings show the arm resting on the right arm of the chair, where the cashmere shawl would later lie (figs. 147, 148).[7] Since this position more or less paralleled the placement of the left arm, Ingres opted for the more dynamic, visually ambiguous solution, as seen in other drawings that explore the foreshortening (fig. 149).[8] In addition, the museum at Montauban contains depictions of Madame Leblanc's head and left hand that may be full-scale student copies (figs. 150, 151).

Not long after leaving Florence in 1824, Ingres wrote to Leblanc assuring him that "my heart, my memories, my eyes and ears are always at your home and with you."[9] The Leblanc family remained in Italy until 1832, when they returned to Paris and soon resumed friendly relations with Ingres and his wife. In 1833 Ingres hoped to exhibit the portrait of Madame Leblanc at the Salon, but it had not yet arrived from Florence.[10] He did show it the following year, however, along with his monumental *Martyrdom of Saint*

Fig.151. *Study for "Madame Leblanc" (Hand)*, 1823. Graphite on tracing paper, 8⅝ × 7¾ in. (22 × 19.8 cm). Musée Ingres, Montauban (867.304 bis)

Fig. 152. *Study of Isaure-Juliette-Joséphine Leblanc*, 1823. Charcoal on paper, 4¾ × 2¾ in. (12.2 × 7 cm). Musée Ingres, Montauban (867.297)

Symphorian (fig. 169). The reviewers were highly critical of the latter work, and their negative tone carried over to the portrait as well, with particular vehemence being devoted to the distortions of the figure; one reviewer even called Madame Leblanc a monster.[11] Since that time, though, the paintings have found ardent defenders. Jean Alazard said of them that they were "among the freest that [Ingres] created."[12] No one was more passionate in his appreciation than Edgar Degas, who in 1896 was able to acquire both portraits through Durand-Ruel at the sale of Isaure's collection. Designating them as the very centerpiece of the museum he planned to establish, he kept them with him for the rest of his days.[13] C.R.

1. Ingres mentions the painting in a letter to Jean-François Gilibert of January 2, 1821; see Boyer d'Agen 1909, p. 60 (although Boyer d'Agen thought Ingres was referring not to Leblanc but to Pastoret).

2. "Un Français, très riche et tout aussi bon et généreux et qui nous a épousés, au point de nous accabler de politesses et aussi de demandes de tableaux, portraits, etc." Ibid.

3. Notebook X, fol. 24, reproduced in Vigne 1995b, p. 328. The portrait was first seen in

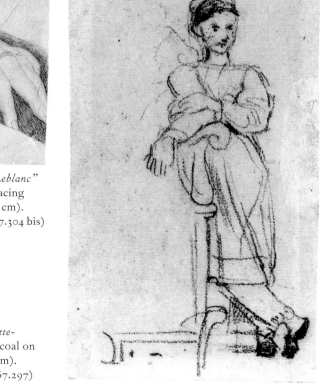

Fig. 153. *Study for "Jacques-Louis Leblanc"* *(Hand)*, 1823. Charcoal on paper, 2³⁄₄ × 3¹⁄₄ in. (7 × 8.2 cm). Musée Ingres, Montauban (867.309 bis)

Fig. 154. *Study for "Jacques-Louis Leblanc,"* 1823. Graphite on paper, 6⁵⁄₈ × 7¹⁄₄ in. (16.7 × 18.4 cm). Musée Ingres, Montauban (867.295)

the exhibition "Les Oubliés du Caire, Ingres, Courbet, Monet, Rodin, Gauguin . . . : Chefs-d'oeuvre des musées du Caire" (Paris 1994–95, no. 1, ill.). It carries an inscription dedicating it to Monsieur Leblanc and bearing the date 1832, which indicates not the time of execution but the year when Ingres gave the painting to his friend, who returned to live in Paris in 1832. Two years later, Ingres made a portrait drawing of Isaure, who was by then Madame Jean-Henri Place, and that drawing he also dedicated to Leblanc (N 359; Musée Bonnat, Bayonne).

4. Rosenblum 1967a, p. 122.
5. The third study is Musée Ingres inv. no. 867.294.
6. Rosenblum 1967a, p. 122.
7. Another such study is Musée Ingres inv. no. 867.309.
8. Among the other drawings in this category are Musée Ingres inv. nos. 867.302, 305, and 306.
9. "mon coeur, ma mémoire, mes yeux et oreilles sont toujours chez vous et avec vous." Quoted in Naef 1977–80, vol. 2 (1978), p. 446.
10. With thanks to Georges Vigne for this information.
11. Quoted in Rosenblum 1967a, p. 122; see also p. 504 in this catalogue.
12. "parmi les plus libres qu'il ait crées." Alazard 1950, p. 66.
13. On Degas's love of Ingres's art and of these paintings in particular, see Ann Dumas, "Degas and His Collection," in New York 1997–98 [vol. 1], pp. 3–73.

Cat. no. 88. *Madame Jacques-Louis Leblanc, née Françoise Poncelle*

PROVENANCE: The sitter, her husband, Jacques-Louis Leblanc (1774–1846); his daughter, Mme Jean-Henri Place, née Isaure-Juliette-

Joséphine Leblanc, Paris, 1846–1895; her posthumous sale, Hôtel Drouot, Paris, January 23, 1896, no. 47; purchased at that sale by Durand-Ruel & Cie., on behalf of Edgar Degas, for 7,500 francs; Edgar Degas, Paris, to 1917; his posthumous sale, Paris, Galerie Georges Petit, March 26–27, 1918, no. 55; purchased by The Metropolitan Museum of Art, New York

EXHIBITIONS: Paris (Salon) 1834, no. 999, as *Portrait de femme;* Paris 1855, no. 3368, as *Portrait de Mᵐᵉ L.B. . . . ;* Paris 1867, no. 98, as *Portrait de Mme Leblanc;* New York 1952–53, no. 140; Paris 1967–68, no. 128, ill.; Paris, Detroit, New York 1974–75, no. 110, ill.; Saint Petersburg, Moscow 1988, no. 2, ill.; New York 1988–89; New York 1997–98 ([vol. 1], pp. 3, 6, 12, 19, 26, 76, 271, 273–74, 276–80, 294, figs. 21, 352; [vol. 2], no. 620, ill.)

REFERENCES: Anon. 1834a, letter II, pp. 19–21; Laviron 1834; Peisse, May 3, 1834; Vergnaud 1834; Du Camp 1855, p. 82; Silvestre 1856, pp. 36, 39; Duret 1867, p. 14; Merson and Bellier de la Chavignerie 1867, p. 109 (as painted in 1821); Blanc 1870, pp. 33, 82–83, 232; Delaborde 1870, no. 135; Anon., February 1, 1896, p. 38; Momméja 1904, p. 71; Alexandre 1905, p. 15; Finberg 1910, p. 45; Lapauze 1911a, pp. 212–14, 316; Burroughs 1918, p. 119; Lapauze 1918, p. 11, ill. p. 10; Anon., November 1919, p. 15, ill. p. 16; Burroughs 1919a, pp. 133–34, ill. p. 135; Zabel 1930, pp. 374–75, ill. p. 376; Pach 1939, pp. 51, 52, ill. opp. p. 115; Lemoisne 1946, p. 175, ill. opp. p. 176, fig. a; Alazard 1950, pp. 66, 148, n. 31, pl. L; Rousseau 1954, p. 6; Wildenstein 1954, no. 152, pls. 58, 60, 61; Schlenoff 1956, p. 140; Canaday 1957, pp. 43–44, 46, 48, 49, ill.; Halévy 1960, pp. 97–98; Naef ("Familie Leblanc") 1966, pp. 121–34, fig. 4; Sterling and Salinger 1966, pp. 10–11, ill. p. 9; Laclotte 1967, p. 194; Rosenblum 1967a, p. 122, pl. 31; Radius and Camesasca 1968, no. 109, ill., pl. XXXII; Wichmann 1968, pp. 117, 129; Naef

1970 ("Unpublished Letter"), pp. 179, 183, ill. p. 178; Russoli and Minervino 1970, under no. 224; Clark 1971, p. 359, fig. 5; Huyghe 1976, p. 463; Naef 1976 ("Degas et Leblanc"), pp. 11–14, ill.; Reff 1976, pp. 54, 88–89; Reff 1977, p. 49, fig. 94; Naef 1977–80, vol. 2 (1978), p. 438, ill., fig. 1; Baetjer 1980, vol. 1, p. 89, vol. 3, ill. p. 545; Picon 1980, pp. 98, 143; Ternois 1980, pp. 65, 94, no. 163, ill.; Yard 1981, pp. 139, 143, n. 26, ill. p. 138; Paris, Ottawa, New York 1988–89, p. 491, fig. 280; Madoff 1989, p. 106, ill. p. 105; Zurich, Tübingen 1994–95, p. 97; Baetjer 1995, p. 401, ill.; Bailey 1995, p. 685; Vigne 1995b, pp. 157, 160, 197, 325, 328, fig. 133; Kimmelman 1996, pp. C1, C25, ill.; Roux 1996, p. 59, pl. 16

Cat. no. 89. *Jacques-Louis Leblanc*

PROVENANCE: The sitter; his daughter Mme Jean-Henri Place, née Isaure-Juliette-Joséphine Leblanc, Paris, 1846–1895; her posthumous sale, Hôtel Drouot, Paris, January 23, 1896, no. 48; purchased at that sale by Durand-Ruel & Cie., on behalf of Edgar Degas, for 3,500 francs; Edgar Degas, Paris, to 1917; his posthumous sale, Galerie Georges Petit, Paris, March 26–27, 1918, no. 54; purchased by The Metropolitan Museum of Art, New York

EXHIBITIONS: Minneapolis 1952; Paris 1967–68, no. 127, ill.; New York 1988–89; New York 1997–98 ([vol. 1], pp. 3, 6, 12, 19, 26, 76, 271, 273–74, 276–80, 294, fig. 22; [vol. 2], no. 619, ill.)

REFERENCES: Silvestre 1856, p. 36; Merson and Bellier de la Chavignerie 1867, p. 109 (as painted in 1821); Blanc 1870, pp. 82–83, 232; Delaborde 1870, no. 134; Anon., February 1, 1896, p. 38; Momméja 1904, p. 71; Alexandre 1905, p. 15; Finberg 1910, p. 45; Lapauze 1911a, pp. 212–14; Burroughs 1918, p. 119; Lapauze 1918, p. 11, ill.; Anon., November 1919, p. 15, ill. p. 17; Burroughs 1919a, pp. 133–34; Zabel 1930, pp. 374–75, ill. p. 377; Pach 1939, pp. 51, 52; Lemoisne 1946, p. 175, ill. opp. p. 176, fig. d; Alazard 1950, pp. 66, 148, n. 31; Rousseau 1954, p. 6; Wildenstein 1954, no. 153, pl. 59; Halévy 1960, pp. 97–98; Naef 1966 ("Familie Leblanc"), pp. 121–34, fig. 5; Sterling and Salinger 1966, pp. 9–10, ill.; Laclotte 1967, p. 194; Rosenblum 1967a, p. 124, pl. 32; Radius and Camesasca 1968, no. 110, ill.; Wichmann 1968, p. 117; Naef 1970 ("Unpublished Letter"), pp. 179, 183, ill. p. 178; Naef 1976 ("Degas et Leblanc"), pp. 11–14, ill.; Reff 1976, pp. 54, 88–89; Naef 1977–80, vol. 2 (1978), p. 438, ill. p. 439, fig. 2; Baetjer 1980, vol. 1, p. 89, vol. 3, ill. p. 545; Picon 1980, p. 143; Ternois 1980, pp. 65, 94, no. 164, ill., p. 95; Paris, Ottawa, New York 1988–89, p. 491, fig. 279; Madoff 1989, p. 106; Zurich, Tübingen 1994–95, p. 97; Baetjer 1995, p. 401, ill.; Bailey 1995, p. 685; Vigne 1995b, pp. 157, 325, 328, fig. 132

90. The Cosimo Andrea Lazzerini Family

1822

Graphite

11 1/4 × 8 1/4 in. (28.7 × 20.8 cm)

Signed and dated lower right: Ingres à Monsieur
Lazzerini / florence 1822. [Ingres for Monsieur
Lazzerini / Florence 1822.]

*At lower left, the Musée du Louvre, Paris,
collection stamp (Lugt 1886a)*

Musée du Louvre, Paris

Département des Arts Graphiques RF 1061

London only

N 264

Cosimo Andrea Lazzerini was born in
1785 in Treggiaia, a small hamlet in the
municipality of Palaia, between Pisa and
Empoli. His parents appear to have been
well connected, even though they lived in
such an out-of-the-way village. They
may even have been well-to-do, for when
their son married at twenty-four he was
described as a landowner,[1] and it is unlikely
that he could have acquired significant
property on his own while still so young.
His bride, three years younger than he, was
a young woman from Paris whose parents
had sent the necessary documents but did
not attend the ceremony. At that time
Florence was ruled by Napoleon's sister
Élisa Bacciochi, and it is quite possible that
Marguerite-Lucile-Antoinette Gervais
L'Hoest had been one of her ladies-in-
waiting. The couple's first child, born three
months after their wedding, was given the
name Élisa,[2] possibly in an effort to placate
the grand duchess for having introduced
a minor scandal into her household.

Madame Lazzerini bore two more
daughters and a son over the next few
years, but by the time her fifth and last
child was born, in 1820,[3] the older ones
had died.[4] This last daughter, Carolina, is
doubtless the child who looks out at the
world with such eagerness in Ingres's
portrait drawing.

Ingres moved to Florence in 1820, and
immediately after his arrival he consulted
Dr. Louis Foureau de Beauregard, who may
have introduced him to Lazzerini, who was
also a physician. Another connection was the
merchant Jean-Pierre Gonin, with whose
large family Ingres became acquainted the
following year (see cat. nos. 87, 150). When
Gonin's sister married Pyrame Thomeguex
in 1822, Lazzerini was among the witnesses
to the ceremony.[5] In those years Lazzerini
must already have enjoyed considerable
stature, both socially and professionally,
for since 1819 he had been a professor of
medicine as well as a practicing physician.
He died in Florence in 1841, leaving a

sizable fortune. His wife survived him, but
within a year she disappears from public
documents. Possibly she died shortly after-
ward or returned to France as a widow.

At only fifteen Carolina married Baron
Hector de Garriod, from Chambéry.[6]
Garriod, then thirty-two, had studied law
but never practiced. Instead, he devoted
himself to art as a connoisseur and collec-
tor. He published several essays on paint-
ing, and at his death in 1886 he left more
than four hundred works of art to the
museum in his native town. He was also
an art dealer, for about 1860 we find him
engaged in buying up paintings for the
galleries of the kings of Holland and
Sardinia.[7] Carolina died in 1861 at the
age of forty.

A detail of this drawing, showing
Cosimo Lazzerini alone, was engraved
by Fortuné de Fournier in 1829, and in
the twentieth century Jean Coraboeuf
engraved it unaltered (Salon 1906).

H.N.

For the author's complete text, see Naef 1977–80,
vol. 2 (1978), chap. 115 (pp. 419–23).

1. "possidente"; marriage register, Archivio di
 Stato, Florence.
2. Birth register, Archivio di Stato, Florence.
3. Baptismal register, Santa Maria del Fiore,
 Florence.
4. According to the records of the congregation
 of Ognissanti, the family of three lived on
 the Via Garofano from 1820 to 1822.
5. Copy of the Jeanne Gonin–Pyrame
 Thomeguex marriage certificate, dated
 May 9, 1822, Municipal Archives, Geneva.
6. San Michele Visidomini, Matrimoni, Denuncie.
7. Fleming 1973, p. 7, n. 34.

PROVENANCE: Cosimo Andrea Lazzerini
(1785–1841); probably his widow, née Marguerite-
Lucile-Antoinette Gervais L'Hoest; presumably
their daughter, Mme Hector de Garriod, née
Carolina Lazzerini (1820–1861, Florence); prob-
ably her widower, Hector de Garriod, Florence,
until 1883; purchased from the art expert J. Féral
for 1,500 francs by the Musée du Louvre, Paris,
December 1880

EXHIBITIONS: Brussels 1936, no. 11; Vienna
1950b, no. 149; London 1952, no. 92; Montauban

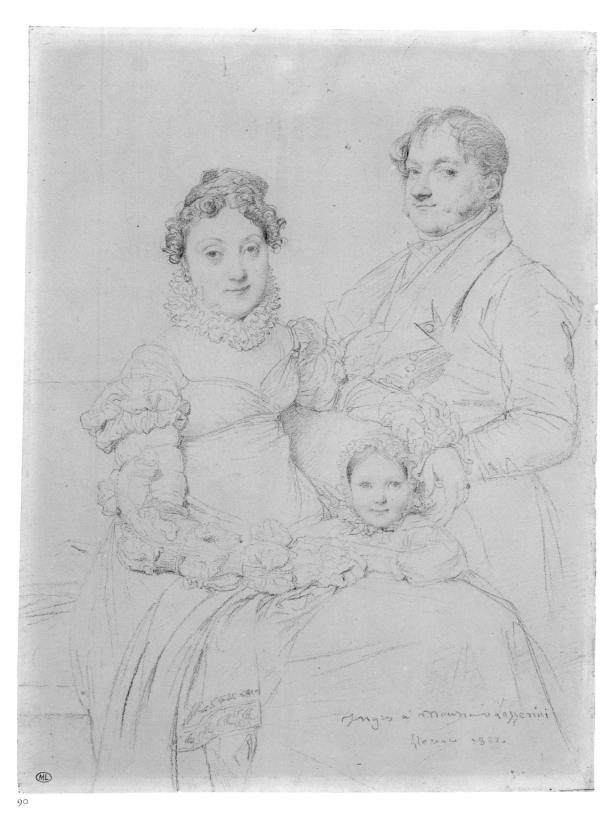

90

1967, no. 73; Paris 1967–68, no. 124, ill.;
Darmstadt 1972, no. 54, ill.

REFERENCES: Blanc 1870, p. 245 (discussed
on the basis of the engraving by Fortuné de
Fournier); Delaborde 1870, no. 344 (catalogued
on the basis of the engraving by Fournier);
Gatteaux 1873 (2nd ser.), no. 109, ill.; Anon.,
August 6, 1881, p. 218; Chennevières 1882–83,
p. [71]; Chennevières 1884, pp. 61–62; Both

de Tauzia 1888, no. 2127; Chennevières 1889,
p. 59; Paris, Musée du Louvre 1900, no. 2127;
Lapauze 1901, p. 111 (discussed on the basis of the
engraving by Fournier, p. 266); Chennevières
1903, p. 136, ill. p. 131; Lapauze 1903, no. 49, ill.;
Alexandre 1905, pl. 22; Guiffrey and Marcel 1911,
no. 5050, ill. p. 1; Lapauze 1911a, p. 213, ill. p. 221;
Maraini 1924, p. 64, ill. p. 65, as *Famiglia Gaspe-
rini*; Boyer d'Agen 1926, p. 15, n. 1; *Dessins de
Jean-Dominique Ingres* 1926, p. [7], pl. 14; Martine

1926, no. 16, ill.; Hourticq 1928, ill. on pl. 57;
Waldemar George 1929, p. 33, fig. 10; Courthion
1947–48, vol. 2, ill. opp. p. 108; Alazard 1950,
p. 66, n. 32, p. 148; Ternois 1959a, preceding and
under no. 98; Naef 1966 ("Gonin, Thomeguex et
Guerber"), p. 124; Naef 1966 ("Lazzerini"),
pp. 77–84, pl. 64 (sitters identified); Sérullaz
1967, p. 212; Paisse 1968, pp. 17, 20–21; Naef 1974
("Navez"), p. 14; Delpierre 1975, p. 24; Naef
1977–80, vol. 5 (1980), pp. 32–33, no. 264, ill.

91. Self-Portrait

1822

Graphite

7⅞ × 6¼ in. (20 × 15.9 cm)

Signed bottom center: Ingres à Son ami
Monsieur Marcotte. [Ingres for his
friend Monsieur Marcotte.]

Dated lower right: florence 1822.

*National Gallery of Art, Washington, D.C.
Collection of Mr. and Mrs. Paul Mellon
1995.47.51*

New York and Washington only

N 265

Ingres was not especially intrigued by his own image. He portrayed himself only rarely—in most instances at the request of others—and none of the resulting works offers particularly profound insights into his personality. Aside from two sketches related to painted portraits of himself, one of uncertain date (cat. no. 12) related to the *Self-Portrait* of 1804 (fig. 209) and the other (École des Beaux-Arts, Paris) done in connection with the *Self-Portrait* of 1858 (cat. no. 148), there are only three known self-portrait drawings.

The first was this one, done in Florence in 1822. Ingres's good friend Charles Marcotte in Paris had asked him for a self-portrait to add to the small collection of Ingres drawings—of himself and of his colleagues Charles-Joseph-Laurent Cordier (N 76) and Hippolyte-François Devillers (N 77)—that he had commissioned in Rome some eleven years before. Even for Marcotte, the artist was somewhat reluctant to undertake such a task, and he put it off. In a letter to Marcotte sent in July 1822 Ingres assured his friend that he was enclosing the requested drawing,[1] but apparently he failed to do so. He finally executed the work in the last days of the year and sent if off in January 1823.[2] A tracing of a detail of this drawing was found in the artist's collection after his death (Musée Ingres, Montauban).[3]

The next pencil likeness is the simple sketch of himself that Ingres added, seemingly as a lighthearted afterthought, to a portrait drawing of his wife, Madeleine (cat. no. 109), in 1830. That work was made as a memento for the couple's good friends the Taurels, then living in Amsterdam. Charming as it is, the likeness is by no means a full-fledged self-portrait.

The last work to qualify as such is a drawing made in Rome in 1835, shortly after Ingres had assumed the directorship of the Académie de France (cat. no. 111). He had always enjoyed presenting pupils he cared for with samples of his art, and now, with so many younger artists under his tutelage, he hit upon the idea of having his friend Luigi Calamatta make an engraving from a

self-portrait for that purpose. He must have sent the drawing to Calamatta in Paris as soon as he finished it, but it was some three years before he received a trial impression of the corresponding engraving, which was published in 1839. In 1855 Charles-Philippe-Auguste Carey produced another engraving of this self-portrait of the artist in his middle age.

One other self-portrait drawing we know the artist made has apparently been lost. Ingres enclosed it in a letter of August 7, 1813, to Madeleine Chapelle, back in France, by way of introducing himself as a suitor for her hand. Three weeks later Madeleine referred to it in a letter to her half sister in Châlons-sur-Marne.[4] Ingres's pupil Amaury-Duval also mentions it in an anecdote about the artist and his wife shortly after they had settled into the Villa Medici. At a party in 1835, Ingres brought up the subject of their unusual courtship:

"It's true, gentlemen, I didn't know her. . . . She was sent to me from France," he said, laughing. "And she didn't know me, either . . . that is . . . I had sent her a little sketch I'd done of myself . . . "

"And which was, in fact, quite flattering to yourself," Madame Ingres said, without lifting her head from her knitting.

You can imagine our laughter, in which M. Ingres joined with enthusiasm.[5]

H.N.

For the author's complete text, see Naef 1977–80, vol. 3 (1979), chap. 151 (pp. 203–7).

1. Ingres to Marcotte, July 25, 1822, quoted in Naef 1977–80, vol. 3 (1979), p. 204; in Ternois 1999, letter no. 7.
2. Ingres to Marcotte, January 15 [1823], quoted in Naef 1977–80, vol. 3 (1979), pp. 204–5; in Ternois 1999, letter no. 8.
3. Inv. 867.268; Ternois 1959a, no. 74, ill.
4. Madeleine Chapelle to Marie Borel, August 30, 1813, quoted in Lapauze 1901, p. 107, n. 1; reprinted in Naef 1977–80, vol. 3 (1979), p. 207.
5. Amaury-Duval 1878, p. 177; reprinted in Naef 1977–80, vol. 3 (1979), p. 207.

PROVENANCE: Charles-Marie-Jean-Baptiste Marcotte (1773–1864), Paris; Joseph Marcotte, his son (1831–1893), Paris; his widow, née Paule

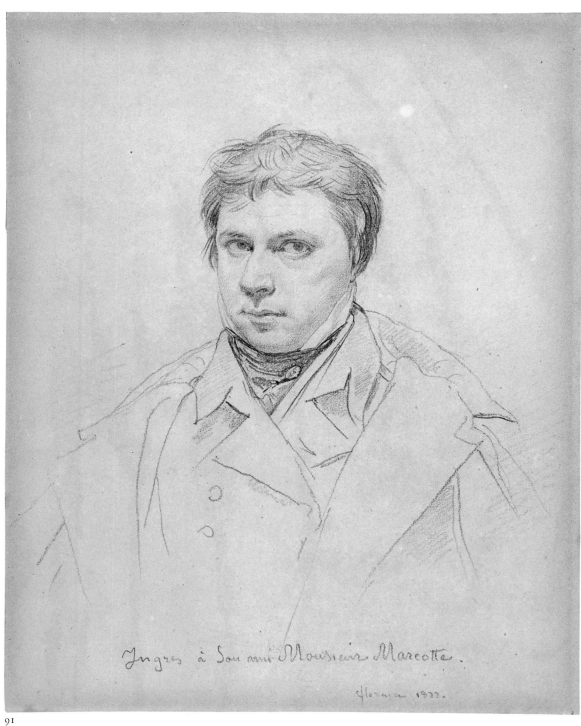

Ingres à son ami Monsieur Marcotte.

Florence 1822.

91

Aguillon, until 1922; her daughter, Mme Marcel Pougin de la Maisonneuve, née Elisabeth Marcotte, until 1939; given by her into the care of Mme Xavier de la Maisonneuve, née Yolande de Beauregard, later Mme François de Calmels-Puntis; her family until at least 1963; purchased in 1963 from the Galerie Hector Brame, Paris, by Paul Mellon; Mr. and Mrs. Paul Mellon, Upperville, Va.; their gift to the National Gallery of Art, Washington, D.C., 1995

EXHIBITIONS: Paris 1867, no. 359; London 1878–79, no. 686 [EB]

REFERENCES: Blanc 1870, p. 237; Delaborde 1870, no. 332; Jouin 1888, p. 95; Lapauze 1903, no. 41, ill.; Lapauze 1911a, ill. p. 217; Lapauze 1913, pp. 1073, 1074–75; Boyer d'Agen 1926, p. XV, n. 1; Ingres 1947, ill. opp. p. 56; Ternois 1959a, under no. 74; Angrand 1967, pl. III; Naef 1971 ("Doktor Martinet"), p. 19, ill.; Naef 1972 ("Ingres Royiste"), ill. p. 25; Naef 1977–80, vol. 5 (1980), pp. 34–35, no. 265, ill.; Ingres 1994, ill. opp. p. 8

92. Madame Jacques-Louis Leblanc, née Françoise Poncelle

1822

Graphite and watercolor

17 ⅞ × 13 ¾ in. (45.3 × 35 cm)

Signed lower left: J. Ingres Delineavit [J. Ingres drew (this)]

Dated lower right: à Monsieur Leblanc 1822. florence.

At lower right, the Léon Bonnat and Musée du Louvre, Paris, collection stamps (Lugt 1714, Lugt 1886a)

Musée du Louvre, Paris

Département des Arts Graphiques RF 5643

New York only

N 268

This drawing is discussed under cat. nos. 88, 89.

PROVENANCE: Jacques-Louis Leblanc (1774–1846); his daughter Mme Jean-Henri Place, née Isaure-Juliette-Joséphine Leblanc, Paris; purchased, presumably from her, by Léon Bonnat (1883–1922) in 1890,* together with a drawing of Jacques-Louis Leblanc (cat. no. 93), for 10,000 francs the pair; his bequest to the Musée du Louvre, Paris, 1922

EXHIBITIONS: Paris 1891, no. 478 [EB]; Paris 1900a, no. 1075; London 1908, no. 513; Paris 1911, no. 117; Paris 1921, no. 230; Paris 1935a, no. 88 [EB]; Brussels 1936–37, no. 73; Zurich 1937, no. 210; Montauban 1967, no. 75; Paris 1967–68, no. 125, ill.

REFERENCES: Blanc 1870, p. 245 (discussed on the basis of a Fortuné de Fournier engraving, under the mistaken impression that the engraving was based on Ingres's painted portrait of Mme Leblanc [cat. no. 88]); Delaborde 1870, no. 346; Anon., February 1, 1896, p. 38; Lapauze 1901, p. 267 (discussed on the basis of the engraving); *Les Maîtres du dessin* 1901, pl. LXXV; Lapauze 1903, pp. 23, 33, no. 52, ill.; Alexandre 1905, pl. 15; Momméja 1905a, preceding no. 557; Dumas 1908, p. 148, ill. p. 150; Lapauze 1911a, p. 213; Guiffrey 1923, p. 220; *Dessins de Jean-Dominique Ingres* 1926, p. [7], pl. 15; Martine 1926, no. 20, ill.; Zabel 1929, p. 115, ill. p. 109; Paris 1934c, p. 63, no. 25; Alazard 1942, no. 8, ill.; Courthion 1947–48, vol. 2, ill. opp. p. 101; Alazard 1950, p. 66 (erroneously as in the Musée Bonnat, Bayonne); Labrouche 1950, pl. 5; Wildenstein 1954, pl. 63; Ternois 1959a, preceding no. 99; Naef 1966 ("Familie Leblanc"), pp. 121–34, fig. 3; Sterling and Salinger 1966, p. 10; Naef 1970 ("Unpublished Letter"), p. 179, fig. 3, p. 178; Clark 1971, p. 365, n. 2; Delpierre 1975, p. 22; Naef 1976 ("Degas et Leblanc"), pp. 13, 14, n. 15; Naef 1977–80, vol. 2 (1978), pp. 438–48, vol. 5 (1980), pp. 40–41, no. 268, ill.; Mráz 1983, p. 47, fig. 40

*Bonnat recorded the drawing in his handwritten list of purchases, fol. 10v, Musée du Louvre, Paris.

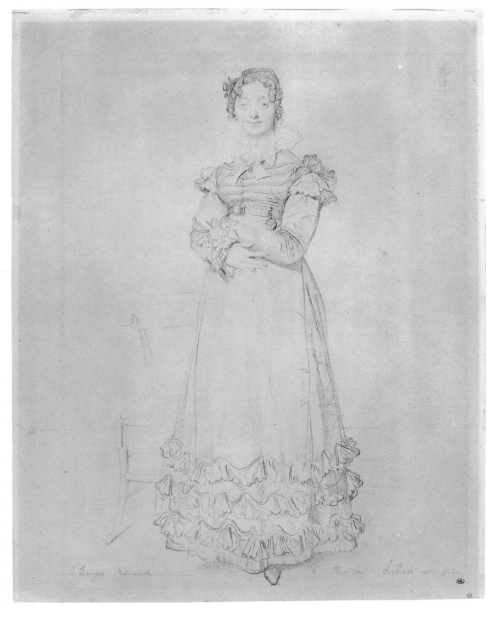

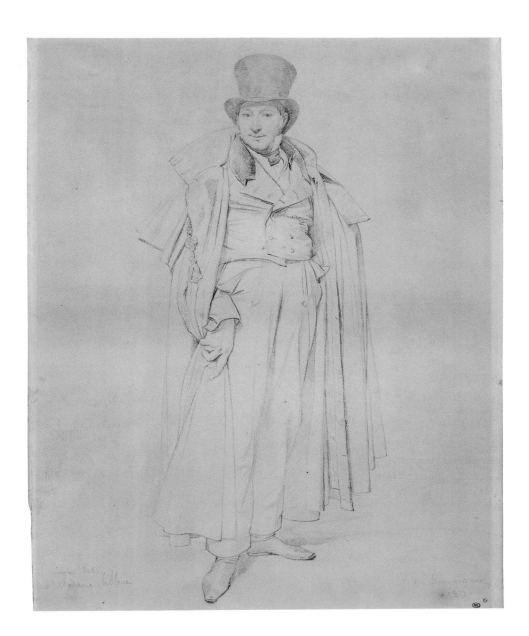

93. Jacques-Louis Leblanc

March 9, 1823
Graphite
18 × 14 in. (45.7 × 35.5 cm)
Signed lower left: Ingres Del. / à Madame
Leblanc [Ingres drew (this) / for Madame
Leblanc]
Dated lower right: florence 9 mars / 1823.
[Florence March 9 / 1823.]
*At lower right, the Léon Bonnat and Musée du
Louvre, Paris, collection stamps (Lugt 1714,
Lugt 1886a)*
Musée du Louvre, Paris
Département des Arts Graphiques RF 5642
New York only

N 278

This drawing is discussed under cat.
nos. 88, 89.

PROVENANCE: Mme Jacques-Louis Leblanc,
née Françoise Poncelle (1788–1839), Paris;
Jacques-Louis Leblanc (1774–1846); their
daughter Mme Jean-Henri Place, née Isaure-
Juliette-Joséphine Leblanc, Paris; purchased,
presumably from her, by Léon Bonnat in 1890,*
together with a drawing of Mme Jacques-Louis
Leblanc (cat. no. 92), for 10,000 francs the pair;
his bequest to the Musée du Louvre, Paris, 1922

EXHIBITIONS: Paris 1891, no. 477 (if this
drawing and not N 277 is meant); Paris 1900a,
no. 1077 (if this drawing and not N 277 is meant);
London 1908, no. 512; Paris 1911, no. 119, ill. opp.
p. 48; Paris 1921, no. 94 (with incorrectly repro-
duced signature); London 1932, no. 859; Brussels

1936, no. 12, ill.; Paris 1937, no. 671; Montauban
1967, no. 74; Paris 1967–68, no. 126, ill.

REFERENCES: Anon., February 1, 1896, p. 38;
Les Maîtres du dessin 1901, pl. LXXXIV; Lapauze
1903, p. 23, no. 50, ill.; Momméja 1904, ill. p. 77;
Alexandre 1905, pl. 16; Momméja 1905a, pre-
ceding no. 557; *Masters in Art* 1906, p. 25 [277],
pl. III; Dumas 1908, p. 148, ill. p. 151; Lapauze
1911a, p. 213, ill. p. 219; Saunier 1911, p. 23;
Bénédite 1921, ill. p. 337; Anon., February 15,
1923, ill. p. 39; Guiffrey 1923, p. 220; Fröhlich-
Bum 1924, p. 16, pl. 32; Fischel and Boehn 1925b,
ill. p. 22; Boyer d'Agen 1926, p. XV, n. 1; *Dessins*

*Bonnat recorded the drawing in his handwritten
list of purchases, fol. 10v, Musée du Louvre,
Paris.

de Jean-Dominique Ingres 1926, p. [7], pl. 16; Martine 1926, no. 19, ill.; Hourticq 1928, ill. on pl. 57; Zabel 1929, ill. p. 108; *French Art* 1933, no. 867, ill. on pl. 186; Paris 1934c, p. 63, no. 26; Alazard 1942, no. 7, ill.; Malingue 1943, ill. p. 96; Mathey 1945, p. 12, ill.; Courthion 1947–48, vol. 2, ill. opp. p. 100; Bertram 1949, pl. XXIII; Jourdain 1949, fig. 55; Alazard 1950, p. 66; Labrouche 1950, pl. 4; Wildenstein 1954, pl. 62; Schramm 1958, ill. p. 11; Heise 1959, p. 76, fig. 58; Ternois 1959a, preceding no. 99; Naef 1966 ("Familie Leblanc"), pp. 121–34, fig. 2, p. 124 (sitter identified); Sérullaz et al. 1966, no. 31, ill.; Sterling and Salinger 1966, p. 9; Sérullaz 1967, p. 212; Cohn 1969, p. 17; Naef 1970 ("Unpublished Letter"), p. 179, fig. 4, p. 178; Clark 1971, p. 365, n. 2; Clark 1973, pp. 123–24; Delpierre 1975, p. 22; Naef 1976 ("Degas et Leblanc"), pp. 13, 14, n. 15; Naef 1977–80, vol. 2 (1978), pp. 438–48, vol. 5 (1980), pp. 56–58, no. 278, ill.; Mráz 1983, p. 47, fig. 41; Vigne 1995b, p. 157, fig. 131

94. Félix Leblanc

1823

Graphite

15 3/8 × 11 3/8 in. (39.2 × 28.9 cm)

Signed and dated lower left: Ingres Del. à Monsieur Leblanc. flor. 1823 [Ingres drew (this) for Monsieur Leblanc. Flor(ence) 1823]

At lower right, the Musée du Louvre, Paris, collection stamp (Lugt 1886a)

At lower left, the Musée du Louvre, Paris, inventory number

Musée du Louvre, Paris

Département des Arts Graphiques RF 29485

New York only

N 279

This drawing is discussed under cat. nos. 88, 89.

PROVENANCE: Jacques-Louis Leblanc (1774–1846); probably his son, Félix Leblanc (1813–1886), Paris; Albert Goupil, Paris, by 1884 at the latest; his auction, Hôtel Drouot, Paris, April 23–27, 1888, no. 338; purchased at that sale for 2,500 francs by Paul Mathey (1844–1929); Princesse de Polignac by 1911 at the latest; her bequest to the Musée du Louvre, Paris, 1945

EXHIBITIONS: Paris 1884, no. 394; Paris 1911, no. 123; Paris 1921, no. 95; Paris 1945, no. 173; Paris 1957e, no. 35; Paris 1967–68, no. 129, ill.

REFERENCES: Molinier 1885, p. 338; Baker 1913, p. 193; Ternois 1959a, preceding no. 99; Naef 1966 ("Familie Leblanc"), pp. 121–34, fig. 7, p. 129 (sitter identified); Naef 1970 ("Unpublished Letter"), p. 179, fig. 5, p. 178; Delpierre 1975, p. 23; Naef 1976 ("Degas et Leblanc"), p. 14, n. 15; Naef 1977–80, vol. 5 (1980), pp. 58–59, no. 279, ill.

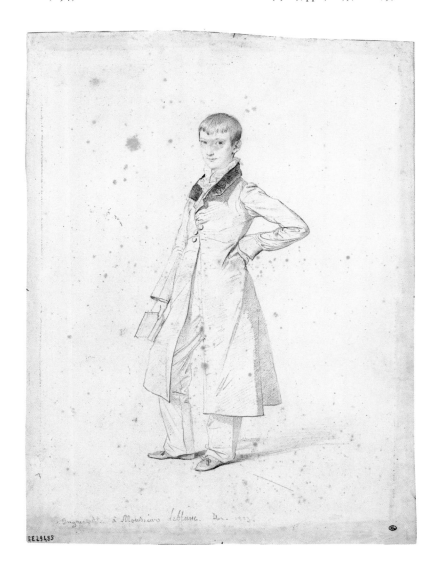

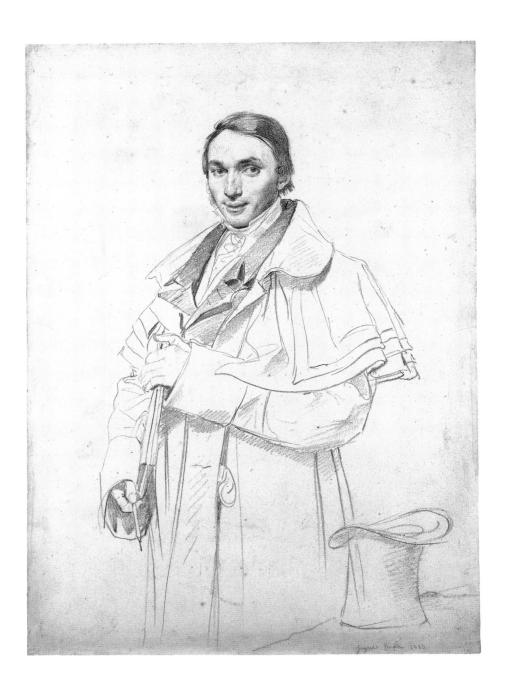

95. Jean-François-Antoine Forest

1823
Graphite
12 7/16 × 8 3/4 in. (31.6 × 22.3 cm), framed
Signed and dated lower right: Ingres Firense
1823 [Ingres Florence 1823]
Ashmolean Museum, Oxford
The Visitors of the Ashmolean Museum, Oxford
1936.223
London only

N 280

Despite its inaccuracies, the inscription on the old frame of this drawing made it possible to identify its subject as Jean-François-Antoine Forest.[1] The work was not executed in Rome as the inscription claims, but rather in Florence, just as Ingres indicated at the time he signed and dated it. The artist had already been in the Tuscan capital for three years by the time he met Forest. Nor was the touring architect named Alexandre; whoever penned the inscription apparently confused him with his father. Finally, the doctor referred to as Forest's father-in-law was named Mermet, not Mormet. From the few documents so far discovered, it is possible to construct the following brief biography.

Jean-François-Antoine Forest was born in Lyons in 1789, the son of the silk dyer Alexandre Forest.[2] He spent much of the year 1823 in Italy, for he called at the French Embassy in Rome to have visas stamped in his passport on January 13, April 10, and October 17.[3] In 1825 he married Louise-Pulchérie, daughter of the physician Joseph Mermet.[4] In the following

year the couple had a son, Alexandre-Céphas, who died, only six months old, in January 1827.[5] The boy's young mother died less than three months later. Forest did not have long to grieve; he died in Lyons in 1831.

Forest's early death sufficiently explains why no works of his are known. That he was indeed an architect is confirmed by Ingres's drawing, in which he is pictured holding a large sketchbook and a pencil. How artist and subject might have met is unknown. Possibly Ingres was recommended to Forest by the Lyonnais architect Antoine-Marie Chenavard, whose portrait Ingres had produced in 1818 (N 229; location unknown) and who at some point designed the Forest family tomb. It is also possible that one of the two merchants from Lyons portrayed by Ingres in 1815—Jean-Joseph Fournier and Joseph-Antoine de Nogent[6]—had put him in touch with the artist who would lend him an immortality he was not permitted to achieve on his own.

Forest's portrait is drawn on the reverse of a lithograph by L. Ridolfi.

<div style="text-align: right">H.N.</div>

For the author's complete text, see Naef 1977–80, vol. 2 (1978), chap. 120 (pp. 455–57).
1. The inscription reads, according to K. T. Parker (1938): "Alexandre Forest de Lyon / architecte gendre de M. Mormet (?) / Docteur Medecin / Dessiné à Rome en 1823 / par Mᵉ Ingres / Son ami / le portrait signé par Ingres" ("Alexandre Forest from Lyons / architect son-in-law of M. Mormet [?] / Doctor of Medicine / Drawn in Rome in 1823 / by Mᵉ Ingres / his friend / the portrait [is] signed by Ingres").
2. Birth certificate, Archives du Rhône, Lyons.
3. Register of visas, French embassy to the Holy See, IV, 187/652, 1487/652, 2054/652.
4. Marriage certificate, Archives du Rhône, Lyons.
5. The child's death date, like those of his parents, is taken from inscriptions on the Forest family tomb. See Péricaud 1834, pp. 122–23.
6. The artist's portrait of Fournier (N 148) is a drawing in a private collection. His likeness of Nogent is a painting (W 106), now in the Fogg Art Museum, Cambridge, Massachusetts.

PROVENANCE: Presumably Jean-François-Antoine Forest (1789–1831); by 1926, Galerie André Weil, Paris;* purchased for 540 pounds sterling from that gallery by the National Art-Collections Fund, London, and given to the Ashmolean Museum, Oxford, 1936

EXHIBITIONS: London 1965b, no. 38, as *Portrait of a Man;* Paris 1967–68, no. 130, ill. (sitter identified); London 1972, no. 667; New Brunswick, Cleveland 1982–83, no. 97, ill.; Tokyo 1992, no. 5, ill.

REFERENCES: London, National Art-Collections Fund 1937, p. 31, no. 1010, ill. p. 30, as *Alexandre Forest;* Parker 1937, p. 26, pl. VIII opp. p. 28, as *Alexandre Forest;* Parker 1938, no. 594, pl. XCIX; Oxford, Ashmolean Museum n.d., p. [3], fig. 25; Naef 1974 ("Ingres-Modelle"), pp. 66–70, fig. 4 (sitter identified); Delpierre 1975, p. 23; Oxford, Ashmolean Museum 1979, p. 9, ill.; Naef 1977–80, vol. 5 (1980), pp. 60–61, no. 280, ill.

*André Weil said he purchased the drawing from an art broker in Paris who had acquired it from another dealer; Weil to National Art-Collections Fund, London, October 26, 1936.

96. Madame Jean-Auguste-Dominique Ingres, née Madeleine Chapelle

ca. 1824
Graphite
6⅛ × 4⅞ in. (15.6 × 12.5 cm)
Signed lower left: Ingres—
At lower right, the École des Beaux-Arts, Paris, collection stamp (Lugt 829)
École Nationale Supérieure des Beaux-Arts, Paris
EBA 1096
Washington only

N 283

This drawing is discussed under cat. no. 36.

PROVENANCE: Alfred Armand, Paris, until 1888; his nephew Prosper Valton; his widow; given by her to the École des Beaux-Arts, Paris, 1908

EXHIBITIONS: Paris 1913, no. 357; Paris 1921, no. 79; Paris 1934b, no. 142; Brussels 1936, no. 33, ill.; Zurich 1937, no. 221 [EB], as *Madame Ingres, née Ramel,* "after 1852"; Paris 1946d; Paris 1949b, no. 231; Paris 1949c, no. 23; Montauban 1967, no. 77; Florence 1968, no. 42, ill.; Rome 1968,

no. 102 ("executed in Florence about 1820–24"), ill.; Paris, Malibu; Hamburg 1981–82, no. 126; Paris 1992; Mexico City 1994, no. 75

REFERENCES: Gatteaux 1873 (2nd ser.), no. 117, ill., as *Portrait* (erroneously as in the collection of the Musée du Louvre, Paris); Lapauze 1911a, ill. p. 490, as *Mme Ingres, née Ramel;* Lavallée 1917, p. 430, n. 4; Amaury-Duval 1924, ill. opp. p. 32; Martine 1926, no. 24, ill.; Hugon 1942, p. 310, n. 10; Cassou 1947, pl. 7; Naef 1977–80, vol. 5 (1980), pp. 66–67, no. 283, ill.; Brugerolles 1984, no. 408, ill.

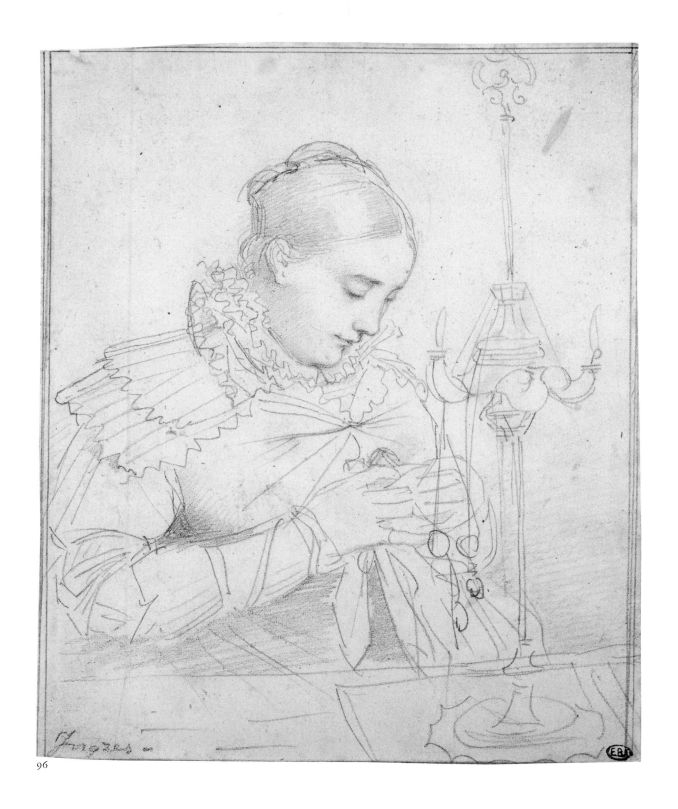

96

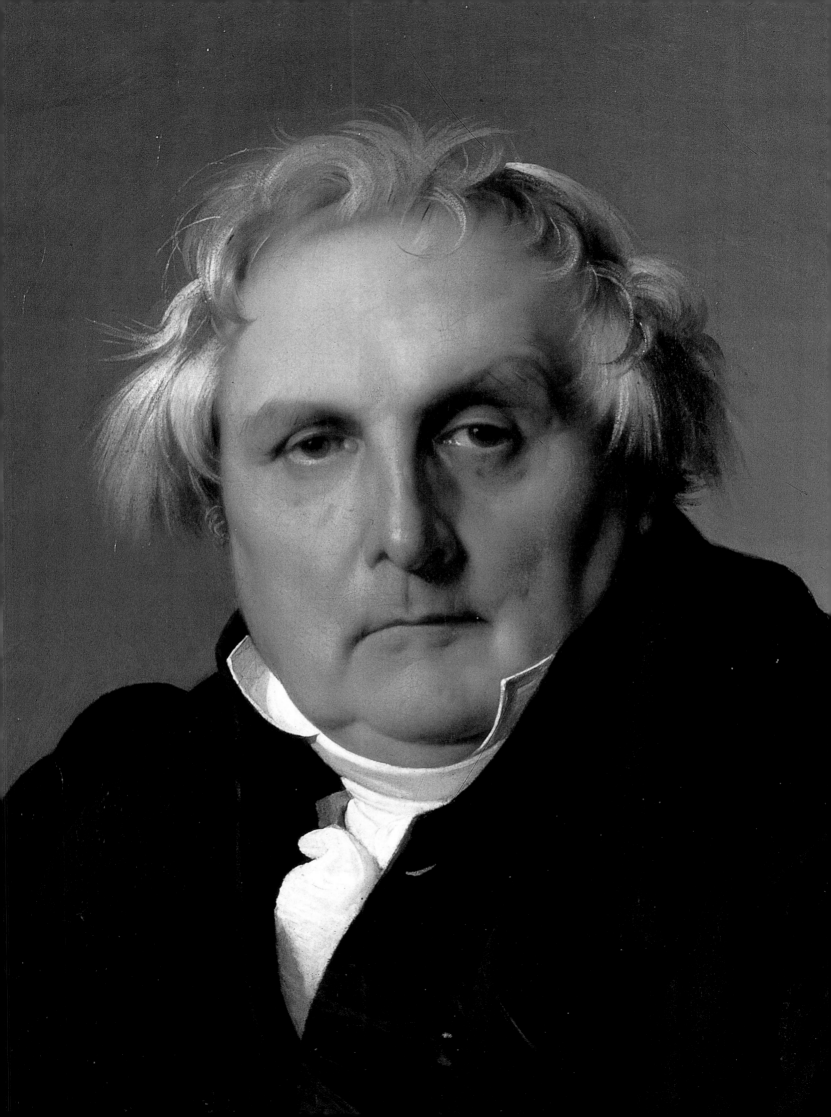

PARIS, 1824–1834

Andrew Carrington Shelton

ew artists undergo the kind of dramatic career transformation that Ingres experienced at the end of 1824. Within the span of a few short weeks in November, he went from being one of the most maligned artists of his generation to one of the most celebrated. The catalyst for this sudden reversal of fortune was the appearance at the Salon of *The Vow of Louis XIII* (fig. 146), a monumental religious painting that had been commissioned by the state to hang in the cathedral of the artist's native town, Montauban. As one of several dozen provincial commissions meted out by the government to struggling artists each year, the *Vow* was hardly a plum assignment.[1] Ingres, who could scarcely afford to be discriminating when it came to opportunities for employment, resolved to make the most of the situation and seems even to have come to look upon the commission as his last chance to salvage a faltering career. He slaved over the work for four long years in Florence, painting and repainting it, hesitating over every aspect of the composition from the general outline of the subject to the costumes and poses of the figures.[2] Just how much stock Ingres put in the project is further suggested by his decision to accompany the *Vow*—the first monumental history painting by his hand ever to appear at the Salon—to Paris.

The welcome Ingres and his new production received in the capital was overwhelming, as a feverish letter that the artist penned to his oldest and dearest friend, Jean-François Gilibert (fig. 161), makes clear:

> I cannot begin to tell you how flattering and honorable the welcome I've received here has been, and what a prominent place I've been assigned. The true believers say that this painting, which is entirely *Italian*, has arrived just in time to put an end to poor taste ["le mauvais goût"]. The name of Raphael (unworthy as I might be) is mentioned in the same breath as mine. They say that I took inspiration from him without in any way copying him, but rather was imbued with his spirit. The praise came first from the mouths of the most important masters, Gérard, Girodet (him especially), Gros, Dupaty, and finally from everybody. I'm being congratulated on all sides, loved and honored much more than I ever expected, believe me.[3]

In this enthusiastic (and rather charmingly immodest) report, Ingres perfectly assesses the new enthusiasm for his work: *The Vow of Louis XIII* was hailed in Paris both as the creation of a latter-day Raphael and as a much-needed antidote to the growing threat of Romanticism—what the artist alludes to rather obliquely as "le mauvais goût."

And indeed, in this painting, Ingres seems to have made a concerted effort to turn over a new leaf. Gone, or at least radically attenuated, are the formal oddities and stylistic mannerisms that had provoked so much controversy early on in his career: the pale, almost colorless palette; the compressed spaces and contorted, distorted bodies; the affected archaisms that had prompted critics to denigrate his works as "Gothic."[4] By 1824 Ingres had decided to cast his lot with an officially sanctioned master, shamelessly appropriating—some would say plagiarizing—Raphael's decidedly more normative, generically classicizing style. And for once in his life, Ingres's timing was perfect. However belated the execution of the *Vow* might have been in terms of his own personal development (he was forty-four years old at the time of his first unambiguous Salon success), within the broader context of the history of the contemporary school, such a painting could not have come at a more opportune moment. Ingres arrived on the scene just as the battle between the rearguard classicists and the emerging generation of Romantics was reaching a fever pitch. As Ingres himself clearly recognized, his painting was quickly co-opted into the depleted arsenal of the traditionalists—the established artists and their allies in the administration—who did not hesitate to reward their new hero with a string of prestigious honors. At the close of the Salon Ingres received the officer's cross of the Legion of Honor from the hands of King Charles X himself (fig. 156);[5] six months later he captured the ultimate prize—a seat in the all-powerful Académie des Beaux-Arts.

The apparent abruptness of the transformation of Ingres's reputation in 1824 belies a more complex process in which both the arts administration and, to a lesser degree, the press participated. Despite his marginalized status while living and working in Italy, Ingres had maintained powerful connections back in Paris, at the

Académie (where he had been elected a corresponding member in December 1823) as well as in the administration. Most helpful with regard to his triumph in 1824 was the protection of Comte Auguste de Forbin, an old studio mate from David's atelier who had been appointed director of the Musées Royaux in 1816.[6] It was Forbin who allowed Ingres to enter *The Vow of Louis XIII* late—a privilege normally reserved for Academicians and/or artists whom the government had a special interest in promoting—and who assured that the work received an advantageous hanging.[7] Forbin's enthusiasm for the *Vow* undoubtedly had more than a little to do with its politics. The painting was a blatant piece of pro-Bourbon propaganda, celebrating the union of church and state via the historical event of 1636 (ritualized in 1638) by which Louis XIII placed the realm of France under the protection of the Virgin Mary.[8] That such a subject was pleasing to the powers that be is evident from the efforts that were made to keep the canvas in Paris after the close of the Salon. The museum of contemporary art in the Palais du Luxembourg, Notre-Dame de Paris, and the newly restored church of Val-de-Grâce were all proposed as more appropriate repositories for the painting than a cathedral in the cultural backwater of Montauban.[9] Ingres resisted attempts to secure the *Vow* for the capital—at least that is what he told his friends back home[10]—and insisted that it be forwarded to its original destination.[11]

Among the more fortuitous results of the *Vow*'s late entrance into the Salon was its having escaped the scrutiny of many of the critics. By the time the painting went on display on November 12, almost three months into the run of the exhibition, many reviews had already appeared, with the result that the *Vow* occupies a far less prominent place in the critical discussion of the 1824 Salon than its historical importance would seem to warrant. Such reticence (or perhaps laziness) on the part of the critics was probably a good thing, however; for even though Ingres seems finally to have conquered artistic officialdom with his new Raphaelesque manner, he was still far from vanquishing his nemeses in the press. With a few exceptions—most notably Étienne Delécluze, the reviewer for the *Journal des débats* and yet another connection from Ingres's student days with David—most of

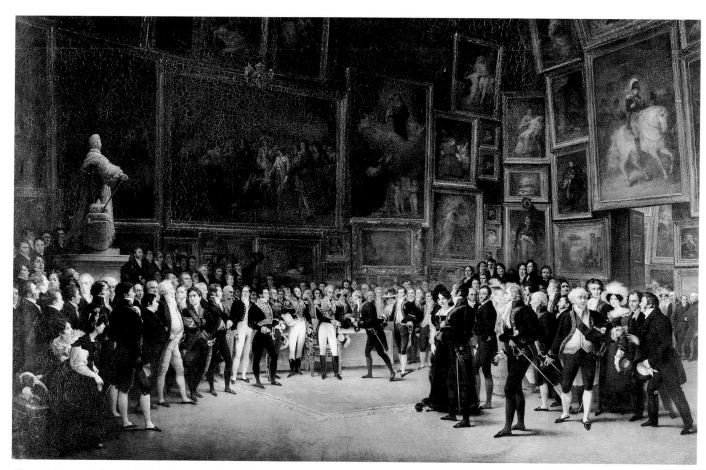

Fig. 156. François-Joseph Heim (1787–1865). *Charles X Distributing Awards at the Salon of 1824*, 1827. Oil on canvas, 68⅛ × 101⅛ in. (173 × 256 cm). Musée du Louvre, Paris

the critics who bothered to write about the *Vow* were less than enthusiastic.[12] Ingres's boast to Gilibert notwithstanding, the most frequently voiced complaint was that the artist had copied Raphael too literally, that the *Vow* was nothing but a pastiche of the Renaissance master's many celebrated Madonnas.[13] Thus was inaugurated a critique that would hound the artist for the rest of his long career: bereft of imaginative powers, Ingres was, it was widely argued, not a creator but a mere plagiarist of the old masters.

It is a testament to the strength of Ingres's support elsewhere that these attacks in the press failed to discourage the notoriously thin-skinned artist. Far from it—no sooner had the public, or at least the official, enthusiasm for the *Vow* manifested itself than Ingres decided to repatriate himself.[14] His decision to remain in Paris must have been motivated at least in part by the flood of prestigious commissions that suddenly came his way. Before the close of the 1824 Salon the government had offered him a commission for a second monumental religious painting, *The Martyrdom of Saint Symphorian*, destined for the famous Romanesque cathedral in Autun (fig. 169). By the following spring he had also been asked to produce a history painting for the Maison du Roi and to decorate (in fresco, no less!) a chapel in the church of Saint-Sulpice in Paris.[15] Ingres was also one of the few artists invited to commemorate the lavishly anachronistic, neomedieval coronation ceremony of Charles X, which was held at Rheims Cathedral on May 29, 1825.[16]

The most immediate result of this wealth of official commissions—the majority of which, it must be admitted, came to naught[17]—was that Ingres no longer had to spend his talent on what he considered to be less honorable endeavors. He thus produced no original genre paintings (historical or otherwise) during his second Parisian sojourn, in stark contrast to his years in Italy, when small-scale works in the so-called troubadour style had been one of his principal pursuits.[18] He was also determined to free his brushes from the drudgery of portraiture. "After a couple of portraits that I've already done here of some pleasant individuals [cat. nos. 97, 98], and that I did very easily, I don't want to do any more," he announced to Gilibert on February 27, 1826. "It's a considerable waste of time, fruitless effort, given the dryness of the subject matter, which is decidedly anti-beautiful and unpicturesque, and also given the small reward that one derives from it."[19]

True to his word, Ingres completed only five painted portraits during his second Parisian sojourn (see cat. nos.

97–99, figs. 157, 158), a mere fraction of the number he had produced during the first twenty years of his career. And just as his history paintings became more normatively classical after 1824, so too do his portraits grow more generically (but certainly no less thrillingly) realistic. Although never entirely devoid of the formal quirks and visual disjunctions that differentiate his works from those of his colleagues in the Académie, Ingres's portraits of 1824–34 feature less audacious spatial and anatomical distortions than many of his earlier works in the genre. As several contemporary critics remarked, with varying degrees of approval or regret, the portraits from this period also lack the light, "blond" tonality and archaizing stiffness of many of their predecessors (see, for instance, figs. 58, 87). Ingres's mature portraiture did not become in any way rote or formulaic, however: he continued to experiment in the genre, constantly adjusting his style in accordance with the character and social position of the man or woman sitting before him. Thus, whereas the almost ferociously direct and art-historically unencumbered portrait of Louis-François Bertin (cat. no. 99) seems to epitomize modern "bourgeois" Realism, that of

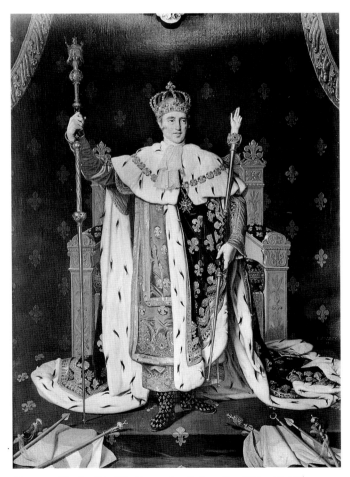

Fig. 157. *Charles X in His Coronation Robes*, 1829 (W 206). Oil on canvas, 50¾ × 35½ in. (128.9 × 90.2 cm). Musée Bonnat, Bayonne

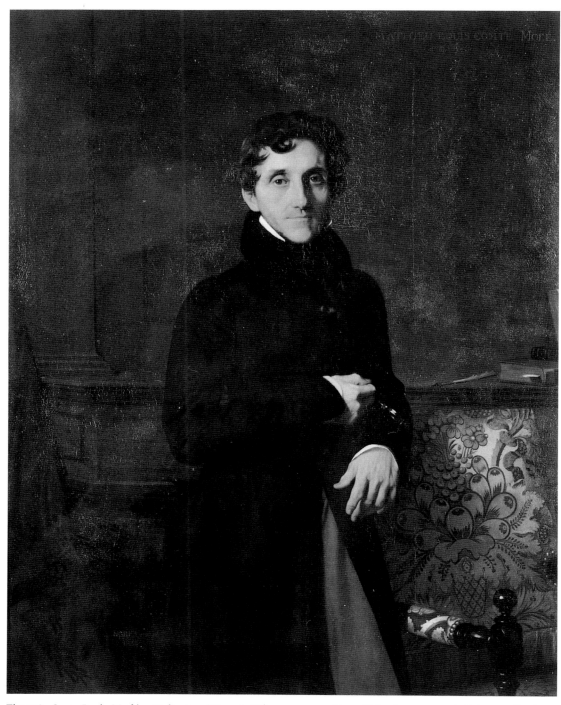

Fig. 158. *Comte Louis-Mathieu Molé*, 1834 (W 225). Oil on canvas, 57⅞ × 44⅞ in. (147 × 114 cm). Private collection

the comte de Pastoret (cat. no. 98) deploys an extravagant, neo-Mannerist style to convey the somewhat ridiculous pretensions of Ingres's parvenu aristocratic sitter.

Ingres's production of portrait drawings also fell off sharply after his return to Paris. From 1825 until 1834 he drew only about seventy-five portraits,[20] the majority of which were not commissioned works but rather personal mementos presented as gifts to friends and acquaintances.[21] Judging from these drawings, which provide a convenient index of the social circles in which Ingres moved, it would appear that he associated almost exclusively with men and women of his own class—artists (see cat. no. 105, fig. 159), architects (see fig. 163), musicians (see cat. no. 107), and other cultivated professionals (see cat. no. 104, fig. 160). These works often come in pairs, Ingres having characteristically drawn the portrait of a wife to accompany that of her husband, or vice versa (see figs. 162, 163). He even seems to have sometimes

Fig. 159. *François Forster*, 1825 (N 289). Graphite on paper, 12⅜ × 9⅜ in. (31.6 × 23.8 cm). Musée Bonnat, Bayonne

Fig. 160. *Alexandre-Victor Martin*, 1825 (N 293). Graphite on paper, 10¼ × 8¼ in. (26.2 × 21 cm). Musée du Louvre, Paris

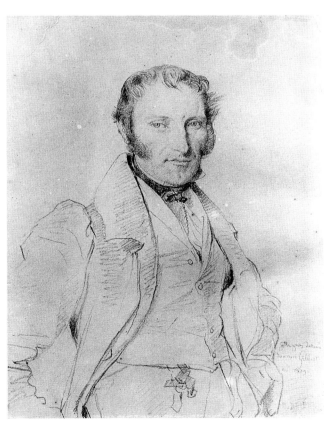

Fig. 161. *Jean-François Gilibert*, 1829 (N 319). Graphite on paper, 8¼ × 6¼ in. (20.9 × 15.9 cm). Musée Ingres, Montauban

undertaken the portrayal of entire families, as, for instance, in the series of exquisite drawings depicting virtually every member of the Marcotte and Bertin clans (see, for instance, cat. nos. 103, 110, figs. 182–84).[22] As the personalized inscriptions on almost all of these sheets indicate, they were produced largely as a matter of noblesse oblige, if not exactly as a labor of love. In any case, Ingres was clearly determined to rid such works of the commercialism with which they had been tainted during those troubled years in Italy when portrait drawings of haughty English tourists provided his primary source of income.

Ingres's next opportunity to pursue what he called his "glorious and purely historical goal"[23] did not occur until the end of 1827, when his most celebrated history painting, *The Apotheosis of Homer* (fig. 164), was unveiled. The work had been commissioned in 1826 as a ceiling decoration for the newly constituted museum of Egyptian and Etruscan antiquities in the Louvre. The decoration of the Musée Charles X (as this suite of rooms came to be known) brought together the most celebrated masters of the contemporary school. In addition to Ingres, Antoine-Jean Gros, François-Joseph Heim, A.-D. Abel de Pujol, Horace Vernet, François-Édouard Picot, Alexandre-Évariste Fragonard, and Charles Meynier all took part in

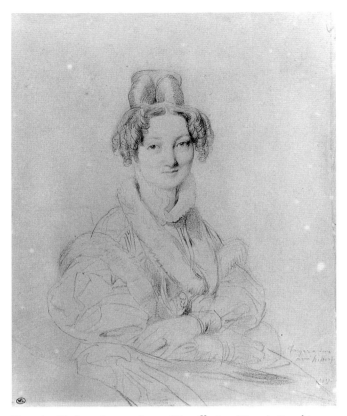

Fig. 162. *Madame Jacques-Ignace Hittorff*, 1829 (N 321). Graphite on paper, 10⅝ × 8½ in. (27 × 21.5 cm). Musée du Louvre, Paris

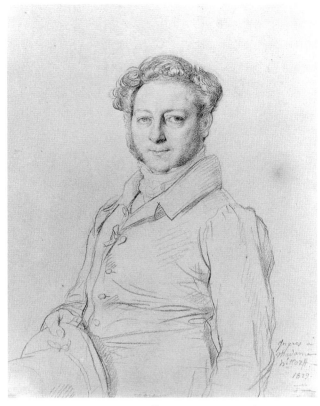

Fig. 163. *Jacques-Ignace Hittorff*, 1829 (N 320). Graphite on paper, 10⅝ × 8½ in. (27 × 21.5 cm). Musée du Louvre, Paris

the project.[24] These artists were working under severe time constraints, since Forbin, the official in charge of the project, insisted that the decoration be completed in time for the opening of the 1827 Salon. Despite the director's constant prodding, this deadline was not met: the Musée Charles X was not officially inaugurated until mid-December, more than a month into the run of the exhibition.[25]

Somewhat surprisingly, given the art-historical stature of the *Apotheosis,* it has never been determined how Ingres arrived at the subject of his ceiling—whether the theme was invented by the painter himself or imposed on him by the commissioning authorities.[26] The most likely scenario lies somewhere in between, for the subject was probably developed by Ingres in close consultation with Forbin. Whatever the exact circumstances of its genesis, Ingres was able to transform this most official of commissions into a highly personalized aesthetic manifesto.[27] The painting attempts nothing less than a summary of the great classical tradition of the West, running from its alleged foundation in the epic poems of Homer through Periclean Athens and Renaissance Italy to the flowering of classical culture in seventeenth-century France. This pictorial paean to classicism—created, it must be remembered,

when the supremacy of the tradition was coming increasingly under attack—takes the form of a massive group portrait of the forty-one men and one woman (the poet Sappho) whom Ingres deemed most worthy of representing the artistic and intellectual legacy of Homer. The ancient bard himself sits hieratically enthroned at the very center of the canvas. He is crowned by a winged Victory, while personifications of his two masterpieces, *The Iliad* and *The Odyssey,* sit broodingly at his feet.

The exclusive, doctrinal, rabidly partisan nature of Ingres's painting is clearly reflected in the contentiousness of its critical reception. Many reviewers found the work lifeless, boring, and totally bereft of the visual enticements (most particularly color) that justified the pain of craning one's neck to look at a painting on the ceiling.[28] To others, it was noble, dignified, and refreshingly free of the vulgar attractions that titillated the crowd; they deemed Ingres's exquisite drawing and restrained, refined sense of color the exclusive province of the elite sensibilities of artists and connoisseurs.[29] It is not hard to imagine the lines along which these evaluations divided: even though a few self-proclaimed progressive, "Romantic" critics professed admiration for the

Apotheosis, its most consistent and enthusiastic supporters belonged to circles that were decidedly conservative, both aesthetically and politically.[30] Thus, the longest and most considered explanation of the painting's complex iconography was published in the conservative pro-Bourbon political daily *La Gazette de France*.[31] Similarly, the *Journal des artistes*, a stridently classicist supporter of the school of David, announced that the *Apotheosis* confirmed Ingres's reputation as "the premier draftsman of our time."[32] Finally, Delécluze, who was quickly emerging as the principal spokesman for the aesthetic rear guard, used the work to illustrate that most fundamental of all academic doctrines, the *beau idéal*, according to which imitation is necessarily subordinated to idealization in the arts. This critic did not shrink from comparing Ingres's ceiling to the most venerated artistic and literary achievements of the Renaissance—to works by Raphael, Dante, and even Petrarch—all the while insisting that the painter had managed to maintain his originality and remain fully engaged with the most pressing artistic issues of the nineteenth century.[33]

While Ingres was busy establishing a public reputation as the leader of the classical cause at the Salon, he was also carving out an increasingly prominent place for himself within the all-important artistic institutions of the day. In the autumn of 1825, just months after being elected to the Académie, he opened a teaching atelier—"a drawing school," according to his own pointedly conservative characterization[34]—which soon emerged as one of the largest and most influential establishments of its kind in Paris.[35] Four years later, Ingres was elected professor at the École des Beaux-Arts; he was later selected to serve as that institution's vice president (1833) and president (1834). While the principal attraction of these posts was undoubtedly honorific, Ingres's interest in the financial rewards that went along with them was more than passing. In 1825, for instance, he wrote to Gilibert in anticipation of being elected to the Académie:

> Certainly, apart from the honor of belonging to such a great Company, and in addition to what it gives me by way of true consideration in the world, it would earn me 1,500 livres in steady income and, later on, a position

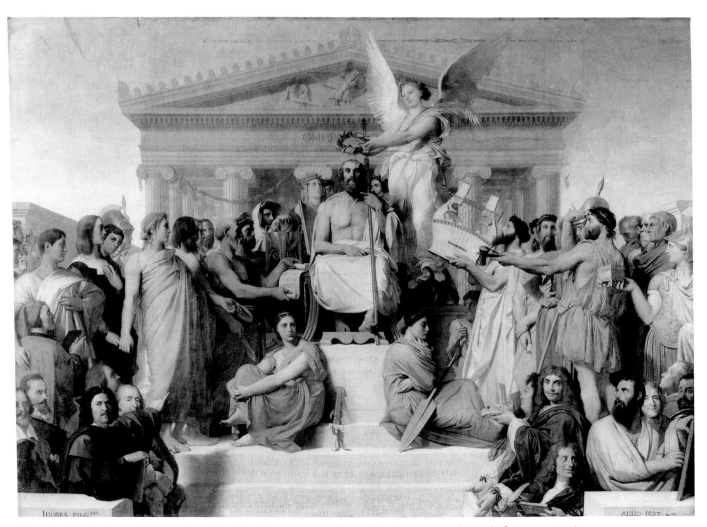

Fig. 164. *The Apotheosis of Homer*, 1827 (W 168). Oil on canvas, 59⅞ × 79⅞ in. (152 × 203 cm). Musée du Louvre, Paris

as professor at the Académie des Beaux-Arts, which pays 100 louis. These revenues would make my life very happy and would fulfill my desires and ambitions since, with my simple tastes, I would have enough to live decently even in Paris, and since, on top of that, anything I earned from works of my own choosing might someday even ensure me a comfortable existence."[36]

In addition to its betrayal of Ingres's thoroughly bourgeois economic outlook, this passage is significant as an expression of his lifelong ambition to achieve artistic autonomy. Ingres was interested in the financial perquisites of institutional affiliation not simply because they promised increased wealth but also because they lessened the onus of having to make a living with his art. With his material needs taken care of by the income from his academic and pedagogical posts, he believed he would no longer have to bow before the demands of patrons or pander to the tastes of the public, but could paint what he wanted—"works of my own choosing."

This equation of financial well-being with personal and professional liberty recurs frequently in Ingres's correspondence, particularly in letters to the financially more secure Gilibert. "You have a position that ensures your freedom: appreciate how hugely fortunate you are," the artist wrote somewhat enviously in February 1832. "That's why I and so many others wear a chain around our necks, constantly tugged at by a host of fatal dependencies. When we want to indulge our noble leanings, our rightful desires, the love of truth, when we try to resist, our chain becomes tighter and tighter and the torture begins anew."[37] With every new honor or official post, Ingres hoped that this chain would be loosened a bit. "The hour of my independence has just sounded," he had written to Gilibert on January 1, 1830, just two days after being elected professor at the École des Beaux-Arts.[38] Thus, Ingres regarded his induction into the academic inner circle not as a tethering of his art to a preconceived, institutional aesthetic but as a means of liberating his painting from the dictates of convention and fashion. As his subsequent troubles with academic colleagues would indicate, however, this belief was more than a little naive.

Outside the Académie, Ingres soon learned that professional success was accompanied by a whole array of annoying social obligations. As the latest artistic celebrity to emerge from the Salon, he was thrust into the beau monde almost immediately upon his return to Paris. The somewhat shy and retiring, passionate but frequently inarticulate painter felt ill at ease in the salons of high society. "And the *people*, which I'm obliged to see too often and much too much, for official and professional reasons!" he complained to Gilibert in May 1825. "It calls for any number of precautions and requires a head, a memory, an attention to etiquette that is quite difficult for me, who live among men to whom I am beholden for everything and from whom I can expect nothing. I walk upon the volcano of personal pride, the source of every obstacle and compromise you can imagine. And it is I, I, my dear friend, who have to practice this trade!"[39] Within months of his triumphal return to Paris, the chronically dissatisfied artist began dreaming of the peace and tranquillity that were the exclusive province of the obscure. "Twenty times a day," his complaint to Gilibert continues, "I envy the man of the woods and the fields: what I see here, with my own eyes, is that the higher one rises, the more miserable one is."[40]

The only social engagements the painter truly relished were those involving music. Attending operas and concerts seems to have been one of the few extravagances the otherwise rather frugal Madame Ingres allowed her husband, and so Ingres became a regular, and quite demonstrative, auditor in the theaters and concert halls of Paris.[41] He could further indulge his passion for music via the informal concerts that were a prominent feature of Parisian salon society at this time. On many of these occasions Ingres may actually have taken part in the music making, playing second violin in string quartets alongside some of the most celebrated musicians of the day (see, for instance, cat. no. 107).

Ingres's ability to endure the social obligations thrust upon him was undoubtedly facilitated by the tranquillity he enjoyed at home. Having summoned Madame Ingres to Paris in the wake of his success at the 1824 Salon, the artist began what turned out to be a rather long and arduous search for lodgings and a studio. The couple settled first at 49, quai des Augustins before moving at the end of 1825 to an apartment on the rue du Bac, passage des Dames-Sainte-Marie. Ingres also rented two adjacent studios on the nearby rue des Marais-Saint-Germain (the present-day rue Visconti), one for himself and the other for his students. Finally, in the spring of 1827 he and his wife moved into an apartment in the Institut de France, where the painter was later accorded a studio.[42] The Ingres household was comfortable but unostentatious. The childless couple lived with a single servant, named Adélaïde, and usually kept one or more cats.[43] Their entertaining was limited to simple dinners and intimate musical soirees along with regular receptions, usually on Sundays, for Ingres's growing stable of students.

Ingres's rather meager output during his second Parisian sojourn would suggest that he devoted a considerable amount of time to his new academic and pedagogical responsibilities. Regular meetings and committee work at the Académie undoubtedly occupied much of his time, as did service on the Salon jury, a task he came utterly to disdain.[44] He was also occasionally called on to advise the government in artistic affairs. In 1831 he found himself on the committee charged with the hugely controversial task of reviewing the Académie's administration of the École des Beaux-Arts and the Académie de France in Rome. Needless to say, nothing came of this reformatory movement, born in the heady days following the 1830 Revolution (Ingres, and all the other Academicians named to the committee, quickly resigned).[45] In 1832 Ingres served on the committee dispensing commissions for the decoration of the important new Parisian church of Notre-Dame de Lorette, assigning himself a prime component of the commission—a painting of the Coronation of the Virgin for the apse.[46]

After his appointment as professor at the École des Beaux-Arts in 1829, Ingres would have devoted a month of every year to the instruction of students aspiring to the all-important Prix de Rome.[47] Yet the bulk of his pedagogical efforts would undoubtedly have been reserved for the students in his own atelier. The size of Ingres's teaching studio and the exact character of his instruction have been notoriously difficult to pin down, despite the relative wealth of eyewitness accounts left behind by his students;[48] most of this testimony is either blatantly hagiographic or anecdotal in character, and thus of limited historical value. It would appear, however, that Ingres followed the standard pedagogical routine of the day, requiring his students to undergo rigorous training in drawing, proceeding systematically from two-dimensional to three-dimensional models, before allowing them to pick up the palette and brush.[49] The master's own contribution to this process consisted largely of regular visits to the studio, during which he would correct his pupil's drawings (often by scratching on their paper with his fingernail) while dropping artistic bons mots and piquant aphorisms along the way. Despite the rather impersonal nature of this regime, Ingres seems to have been a warm and devoted master who was both loved and respected by his students. "At fifty-three, this man has all the feverish energy of a youth," one of his disciples remarked approvingly. ". . . He puts all the fire of a southerner into his artistic enthusiasm, and his lessons are never cold or dull; he is severe in the interests of art, kind and

Fig. 165. *The People, Victorious in July 1830*, 1830. Ink on paper, 10¾ × 9 in. (27.3 × 22.8 cm). Musée Ingres, Montauban (867.2791)

affable in his relations with his students, and easy to approach."[50]

Ingres's personal and professional routine was threatened in the summer of 1830 by the outbreak of political unrest. Protests over the policies of the increasingly despotic King Charles X gave way at the end of July to three days of street fighting that culminated with the overthrow of the restored Bourbon regime. As a middle-aged painter with an eminently pacifistic disposition, Ingres kept his distance from the fighting. His activities during the unrest seem to have been limited to a single sleepless night in the Louvre, where he and other prominent artists had gathered voluntarily to keep watch over the royal collection.[51] Not that Ingres was opposed to the Revolution: quickly forgetting the preferential treatment he had received from the ministers and administrators of Charles X, he greeted the overthrow of the Bourbon regime with unbridled enthusiasm. "Let us rejoice in these sublime effects," he wrote to Gilibert on August 12, 1830. "Has there ever been anything like it in all of recorded history? Who are we like? Like ourselves! To that thunderous sounding of the call—truly a divine work, which only grows louder as it recedes—we can finally call ourselves French again and stop suppressing our long-held indignation."[52] At one point, Ingres even seems to have contemplated executing an allegorical painting of the so-

called Trois Glorieuses, for which there is a hastily sketched, feverishly annotated sheet in Montauban that shows the French people in the form of a giant Hercules trampling underfoot a personification of despotism (fig. 165).[53]

Despite this brief burst of Revolutionary enthusiasm, Ingres's political outlook remained fundamentally conservative. He adopted the position of those who espoused a limited rather than an expansive view of the Revolution. "The revolution carried out, finished, order everywhere, everything replaced!" he proclaimed in a letter to Gilbert, railing against those "stupid and mean" people (namely, republican agitators) "who, even today, still want to soil and disturb the order and happiness of a freedom so gloriously, so divinely won."[54] This conservative view of the Revolution eventually triumphed, as an ostensibly reformed, more genuinely constitutional monarchy was the ultimate result of the 1830 Revolution—not a republic, as liberals had hoped. The throne was not abolished but simply offered to a new occupant: Charles X's cousin Louis-Philippe, scion of the house of Orléans, the lesser and traditionally more liberal branch of the extended royal family. In the end, this change of regime hardly affected Ingres's career, since the Orléanists proved to be as receptive to his work as their Bourbon cousins had been.

Ingres did not participate in the Salon of 1831, the first to be organized under the new regime. This was partly because he was having trouble completing his latest work in progress, *The Martyrdom of Saint Symphorian* (see figs. 167–69). Although such inability to resolve a major work was typical of Ingres, who was notoriously slow and hesitant to let go of his paintings, it appears that he was also grappling with a severe bout of depression and disillusionment. The Revolution had not, in the end, resulted in the utopian state of unbridled peace and prosperity that Ingres had originally predicted. "The men of today are really not worth the trouble one takes for them," he complained in a long, tormented letter to the ever-patient Gilibert in March 1831. ". . . Self-interest, ego, and treason reign."[55] As for the more narrowly circumscribed realm of the arts, Ingres considered the situation hardly less dire. He saw himself as the lone champion of true Beauty in the contemporary school, an artistic prophet crying in the wilderness: "And I still go, all alone, to confront the ignorant, self-interested, and brutal masses. I can shout as much as I want, no one listens to me *anywhere*. Raphael himself could come, and no one would listen to him."[56] Such a display of self-righteous indignation (Ingres goes on to complain that he had not been sufficiently

recompensed for the blood and sweat he had poured into his paintings) is the residue of the persecution complex developed early in his career when he was, in fact, a misunderstood, even vilified, outcast. That Ingres was still sporting such an attitude as late as 1831 demonstrates the tenacity of this self-image. Indeed, in spite of his unprecedented success during the second half of his long career, he would never entirely abandon the contention that his efforts had not been properly rewarded. In Ingres's mind, the persecution of his genius was never-ending.

Ingres's spirits must have been revived, at least temporarily, by the stunning success he experienced at the 1833 Salon. Somewhat ironically, given his frequently professed disdain of the genre, this success—the most spectacular of his career to date—was due to a portrait: the celebrated representation of Louis-François Bertin (cat. no. 99), publisher of one of the most important newspapers in Paris, the solidly Orléanist *Journal des débats*. The extraordinary success of *Monsieur Bertin* arose in part from the circumstances under which it was exhibited. Unlike *The Vow of Louis XIII*, the portrait did not enter the exhibition late, and unlike *The Apotheosis of Homer*, it was not tucked away discreetly on the periphery of the Salon. From the moment the doors of the exhibition opened, *Monsieur Bertin* was very prominently displayed near the entrance of the Salon Carré, the main room of the exhibition.[57] Such a central location brought an unprecedented amount of critical attention, as the painting was consistently touted in the press as a highlight of the exhibition. More important, for the first time in his career, Ingres found himself dominating the critical discourse: he was the subject of entire articles or even series of articles in the periodical press and of long sections or chapters in independently published reviews. For better or worse, he had finally arrived as an object of intense critical inquiry.

The reviewers' reactions to *Monsieur Bertin*, as well as to Ingres's other entry in the 1833 Salon, the 1807 portrait of Madame Duvaucey (fig. 87), are discussed elsewhere in this catalogue (see pages 502–5). Of greater concern here is the way in which the public's perception of the artist and his increasingly prominent position within the contemporary art world were evolving. For it is clear that much of the interest in Ingres in 1833 was provoked not so much by the quality of the actual works on display at the Salon but by his growing power and prestige. As the prominent critic Gustave Planche explained to readers of the highbrow intellectual journal *Revue des deux mondes*, the "very special importance" of considering *Monsieur*

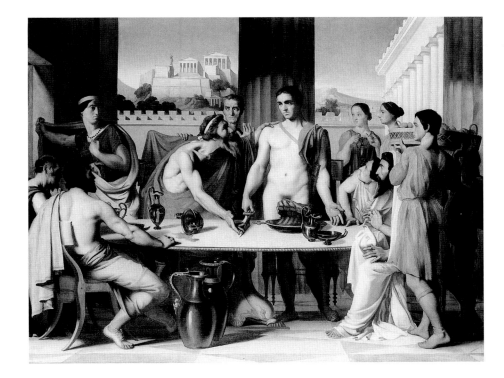

Fig. 166. Hippolyte Flandrin (1809–1864). *Theseus Recognized by His Father*, 1832. Oil on canvas, 45 1/4 × 57 1/2 in. (115 × 146 cm). École Nationale Supérieure des Beaux-Arts, Paris

Bertin lay not in any inherent attributes of the painting itself but "because we are talking about a master, the head of a school that today is flourishing and venerated, because we are talking about M. Ingres."[58]

This notion of Ingres as an all-powerful head of a school developed partly because of the increased prominence of his coterie of followers. Although he had been operating a teaching atelier since the end of 1825, it was only in the early 1830s that his studio emerged as the center of a unified aesthetic movement. This was largely the result of the prominence of Ingres's pupils at the Salon and, more crucially still, of their success in that most prestigious of academic competitions, the annual Prix de Rome. After having failed in his two previous attempts, Ingres's favorite pupil, Hippolyte Flandrin, finally took the prize in 1832 with a decidedly Ingresque production, *Theseus Recognized by His Father* (fig. 166). The following year, artists from Ingres's atelier swept the awards in the preeminent category of history painting, thereby solidifying their master's reputation as a major force to be reckoned with.[59]

With the growing celebrity of Ingres's acolytes came fears that the painter was becoming a despot intent on imposing his manner on the entire contemporary school. "If M. Ingres walked alone, if he did not have students who adored him and slavishly tried to imitate him, we could take him on his own terms, and consider ourselves extremely fortunate that the present age possessed a man of such stature," a reviewer for the popular liberal daily

Le Constitutionnel explained. "But M. Ingres has created a school, and this proud school is denigratory; it pushes intolerance to the point of fanaticism; it forbids painters to depict nature in any way other than how M. Ingres sees it."[60] In the wake of the July Revolution, when the relative merits of divine-right rule, constitutional monarchy, and republicanism were still being hotly debated, the specter of despotism in any sphere was bound to resonate politically. Several critics, in fact, adopted pointedly political analogies to describe the current state of the art world and Ingres's alleged aspirations within it. The reviewer for the centrist *France nouvelle*, for instance, prefaced his analysis of *Monsieur Bertin* with a long defense of artistic (and political) relativism—"For me, in art theory as in politics, it is in the *juste-milieu* [golden mean] that I believe I have found the truth"—and pledged to persecute any artist who sought to transform his personal manner into an "absolute system."[61] For him and many other critics, Ingres was the most prominent example of this despotic impulse: "A single name, proclaimed with enthusiastic admiration, seems to have been hoisted as the banner of a school, and adopted as the symbol of a doctrine. I am speaking of M. Ingres."[62]

An assessment of Ingres's agenda from a vantage point further to the left of this writer's *"juste-milieu"* was provided by Louis de Maynard, liberal critic for the deluxe literary journal *L'Europe littéraire*. "Art has been emancipated and does not need a prince or charter to be bestowed upon it," Maynard declared. ". . . Now, more

Fig. 167. *Study for "The Martyrdom of Saint Symphorian,"* 1833. Oil, graphite, and red chalk on canvas, mounted on wood, 24⅛ × 19⅜ in. (61.3 × 49.3 cm). Fogg Art Museum, Harvard University Art Museums, Cambridge, Massachusetts

Fig. 168. *Study for "The Martyrdom of Saint Symphorian,"* 1833. Oil and graphite on canvas, mounted on aluminum, 24⅜ × 20⅛ in. (61.8 × 50.1 cm). Fogg Art Museum, Harvard University Art Museums, Cambridge, Massachusetts

than ever, it wants to be a republic, and does not wish to be stifled in the name of Raphael or Rubens."[63] While such a remark might have been aimed at extremists on both ends of the aesthetic spectrum, the real object of Maynard's ire was Ingres, whose growing hegemony in the contemporary school the author caricatured most bitingly: "At present, he reigns over a bloodstained altar like some cruel Mexican god. All our critics, decked out as priests, surround him respectfully and sing paeans to his glory. Every newspaper is a censer. One by one, they sacrifice to his divinity a holocaust of little colorist painters. No one is spared. Even the fairest and the strongest must die."[64] Such talk was not idle speculation on the part of a few paranoid critics, for there were rumors afloat in 1833 that Ingres was in collusion with the powers that be and that he was going to be appointed First Painter to the King.[65] Naturally such a notion scandalized Maynard: "No, M. Ingres will not gain power. . . . The king's painter must be popular, prolific, and historical, so to speak. But M. Ingres, who in other respects has such great merits, does not possess these three qualities."[66]

To the relief of Maynard and countless other artists and critics, Ingres was never offered the title of First Painter. And in retrospect, reference to this post serves as an ironic reminder of just how little the artist's status was

perceived as having depended on his connections with the official art world at this time. For despite all his conservative, institutional credentials, Ingres was rarely portrayed in 1833 as having unduly benefited from preferential treatment by the authorities. Quite the contrary, he was most consistently represented as an outsider, a tenaciously self-made man whose success was a completely personal achievement. "Today, M. Ingres stands on the pedestal that he has so laboriously built for himself," the critic Théophile Gautier declared in his first published remarks on the artist. "He has become a legend."[67]

Gautier's salute to Ingres's hard-won success reflects the emergence in 1833 of what would eventually become a central component of the highly codified hagiography of "Monsieur Ingres": the story of his perseverance in the face of excruciating hardship at the beginning of his career. As a former fellow student in David's atelier, Delécluze was able to offer his readers a firsthand account of Ingres's early sufferings. He recounts how the young painter stubbornly resisted the dictates of David and endured public neglect and misunderstanding as a result. Yet Ingres stood pat: "Poor as he was, he clung to his ideas and made no concessions to prevailing tastes."[68] Conveniently glossing over the fact that Ingres had won the prestigious Prix de Rome and spent four years living

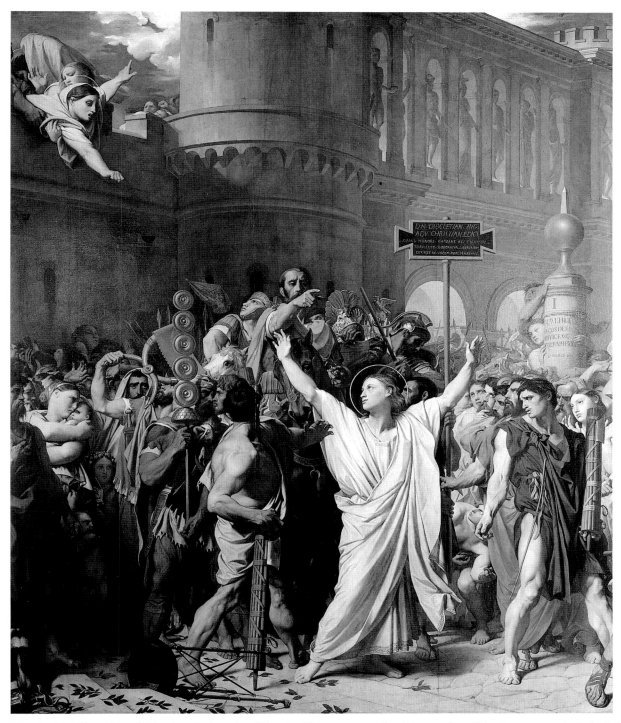

Fig. 169. *The Martyrdom of Saint Symphorian*, 1834 (W 212). Oil on canvas, 13 ft. 4¾ in. × 11 ft. 10½ in. (407 × 339 cm). Cathedral of Saint-Lazare, Autun

and working in Italy at government expense, Delécluze concentrated on the artist's subsequent years on the peninsula, a period during which he heroically faced "poverty and neglect, never ceasing to cultivate his art with a sincere love."[69] Now, in 1833, a successful Ingres represented for Delécluze the ultimate in professional dignity and artistic conscientiousness; he, along with several other cultural luminaries of the day (Delécluze specifies Lamartine, Victor Hugo, Victor Schnetz, and Léopold Robert), offered living proof that one could be successful without

violating the rules of bourgeois propriety, that "one could be an *artist* while living as a respectable head of a family, without running barefoot through the fields, nor even strangling the woman one loves."[70] Would-be artistic dictator or model of professional integrity? The battle lines over Ingres's reputation were thus established in 1833.

Despite the enormous amount of attention directed toward Ingres's contributions to the 1833 Salon, there remained a nagging feeling among the critics that the jury was still out on the artist. More was needed than a couple

Fig. 170. *Madame Adolphe Thiers*, 1834 (N 344). Graphite on paper, 12½ × 9⅜ in. (31.9 × 23.9 cm). Allen Memorial Art Museum, Oberlin, Ohio

of portraits in order to make a definitive pronouncement on Ingres and his legacy.[71] The opportunity to make such an assessment came the very next year, when Ingres finally unveiled his long-awaited *Martyrdom of Saint Symphorian* at the Salon (fig. 169). Commissioned in the wake of the spectacular success of *The Vow of Louis XIII,* this painting depicted a much more remote episode in the religious history of France. Symphorian, the first Christian martyr of Gaul, was sentenced to death in the late second century for refusing to sacrifice to the pagan gods in his native Augustodunum (present-day Autun). Ingres represents the most poignant episode in this otherwise conventional martyrdom story—the moment at which Symphorian's mother, Augusta, climbs atop the ramparts of the city and encourages her son's resolve to sacrifice his life for the sake of his religion.[72]

As the product of nearly a decade's gestation, *Saint Symphorian* was eagerly awaited by the public. The painting had, in fact, been expected at the Salon as early as 1827, when it was first announced in the *livret.*[73] The air of suspense was increased by the immoderate boasting of Ingres's supporters, according to whom the picture was destined to become not only the artist's greatest work but one that would settle once and for all the aesthetic

controversies that had racked the French school for the last twenty years.[74] Unfortunately for Ingres, the painting did not settle anything: it only heightened the controversy surrounding the artist, fragmenting the art world into ever more polarized groups of pro- and anti-*ingristes.*[75]

As always, the response to Ingres's work was politically motivated. Critics on the Left resented seeing this long-overdue child of the Bourbon Restoration gracing the walls of the post-Revolutionary Salon. The republican reviewer Jean-Barthélemy Hauréau, for instance, vilified Ingres as the head of a reactionary "Catholic school," the roots of which he pointedly traced back to "the final years of divine right."[76] Other liberal critics dismissed the painting's religiosity as a ridiculous anachronism. "And here someone has tried to summon up our religious emotions again; someone has tried to invoke our admiration for a martyr who braved tortures for the Holy Trinity, for the divinity of the one they called the Son of Man," an incredulous Alexandre Decamps remarked, "but we no longer believe in anything! We hardly even believe in ourselves!"[77] At the opposite end of the political spectrum, conservative critics hailed *Saint Symphorian* as an unrivaled masterpiece of religious art. The reviewer for the legitimist *Gazette de France* characterized the painting as "the highest sublimity of human thought, . . . the poetry of Homer, applied to Christianity."[78] The same critic had mischievously suggested in an earlier review that the decision to allow Ingres's painting into the Salon must have been a difficult one for the current regime because of the incriminating analogies that could be drawn between the action recorded in the picture and France's more recent Revolutionary history: "With his blood [Symphorian] watered this earth, which, sixteen centuries later, would offer to the world equally sublime acts of maternal and filial devotion, and equally cruel persecutions from its new proconsuls."[79] Thus, for some critics at least, Ingres had enlisted his brushes in the commemoration of political as well as religious ideals and was praised or denigrated accordingly.

Ultimately, however, it was not politics that dominated the critical discussion of *Saint Symphorian* (at least not on the surface) but rather the painting's thoroughly unorthodox style. Ingres's detractors in the press—and by 1834 there were many—vied with one another in ridiculing the painting's alleged shortcomings: its overall dull, murky gray-brown tonality (chocolate and mud were the preferred analogies);[80] its confused, airless composition, which led one critic to liken the crowd of onlookers to a macaroni of serpents;[81] and its outrageous

anatomical distortions, particularly in the two hyper-musculated lictors flanking the martyr in the foreground.[82]

Such insults proved more than Ingres could take. Within weeks of the Salon's opening, he had fled Paris, taking an impromptu vacation on the coast of Normandy.[83] This retreat provided little solace, however, and when he returned to Paris he let it be known that he wanted nothing more to do with the public. "What saddens me is to see M. Ingres so deeply discouraged," his student Georges Lefrançois wrote on March 24, 1834, "it is in his nature not to take anything half-heartedly. Scarcely had he seen the caricatures of the foot of one of his lictors [from *Saint Symphorian*], which Gros's students had scrawled on the walls of the Institut, than he is beside himself, wanting to give up government commissions and the Salon, to no longer work on anything but small canvases and projects for his friends and to return to Italy as soon as he can."[84] These were not empty threats. By the end of the year Ingres had divested himself of two prestigious official projects—the Coronation of the Virgin for Notre-Dame de Lorette and a scene depicting the Battle of Fornovo for Louis-Philippe's famous Galerie des Batailles at Versailles.[85] He also refused to allow his latest production, a portrait of the aristocratic statesman the comte Mathieu Molé (fig. 158), to be exhibited at the 1835 Salon.[86] "But as for being, me, ever again, a public figure—never!" Ingres emphatically declared before the protests of friends and supporters who attempted to convince him to exhibit.[87] And so began the artist's lifelong boycott of the Salon; with the exception of the 1855 Exposition Universelle, a painting by his hand never again appeared at an official exhibition.

The most immediate result of the "*Saint Symphorian* affair" was Ingres's decision to seek the directorship of the Académie de France in Rome. He presented his candidacy for the post on May 17, was selected by his colleagues in the Académie des Beaux-Arts two weeks later, and was officially appointed on July 5 by Adolphe Thiers, who, as the minister of the interior, had ultimate jurisdiction over the Villa Medici. Typically, Ingres considered Thiers's delay in ratifying his appointment an insult and

threatened to withdraw his candidacy in protest.[88] That all was smoothed over between the two men—there was a history of bad blood between them[89]—is suggested by the ravishing portrait drawing the artist executed of Madame Thiers, in appreciation, perhaps, of her husband's belated support (fig. 170).[90] This was one of many portrait drawings Ingres executed during the months leading up to his departure for Rome and presented as gifts to the friends and acquaintances he was about to leave behind.

The artist had not, however, recovered from his profound bitterness over the public's failure to rally around *Saint Symphorian;* in assuming the Roman post, Ingres actually fancied himself punishing his ungrateful homeland by going into a kind of voluntary exile.[91] There is, of course, an obvious discrepancy here, for in accepting the lucrative and prestigious position of director of the Académie de France in Rome, Ingres was ultimately making himself more, rather than less, accountable to the public. He was, in effect, becoming a government functionary, a cultural bureaucrat. That Ingres failed to recognize this is yet another manifestation of his hesitation between two mutually exclusive notions of self. On one level, the beleaguered artist wanted to continue to play the romantic role of neglected genius; at the same time, however, he could not bear to sacrifice the official trappings of power and authority he had laboriously accrued over the previous decade. Thus, instead of making a genuine break with artistic officialdom as he claimed, Ingres merely sought refuge in a foreign—but eminently official—post.

To whatever extent Ingres's acceptance of the directorship of the Académie in Rome constituted a genuine break with the public, his departure for Italy in December 1834 did mark a turning point in his career. It brought to an end his ten-year stewardship of a major faction of the contemporary school. After 1834 it was not so much classicism or academicism that Ingres represented but rather something much more personal and idiosyncratic. "Ingrism" was the new standard under which the artist and his increasingly fanatical troop of students were prepared to battle.

1. See Siegfried 1980a, pp. 365–66. Ingres was initially offered only 3,000 francs for the picture, half the going rate for monumental history paintings at the time. He would eventually receive the standard 6,000-franc fee.

2. Ingres's struggles over the painting are documented in his correspondence for the years 1820 to 1824; see Boyer d'Agen 1909, pp. 53–120 passim, and p. 246 in this catalogue.

3. "Je ne puis te dire l'accueil flatteur et honorable que je reçois ici, et quelle belle place on m'y donne. Les vrais croyants disent que ce tableau, qui est tout *italien*, est heureusement arrivé pour arrêter le mauvais goût. Le nom de Raphaël, (bien indigne que j'en sois), est rapproché du mien. On dit que je m'en suis inspiré sans en rien copier, étant plein de son esprit. Enfin, les éloges ont commencé par la bouche des premiers maîtres, Gérard,

Girodet (et surtout celui-ci), Gros, Dupaty, et tous enfin. Je suis de tous les côtés félicité, aimé et considéré bien plus que je ne m'y attendais, je t'assure." Ingres to Gilibert, undated, in ibid., pp. 120–21. Boyer d'Agen improbably dates the letter to November 12, 1824, the very day the *Vow* went on display at the Salon. For corrections to this mistake and others that Boyer d'Agen makes in his transcription of Ingres's letters to Gilibert, see Ternois 1986b, pp. 187–200.

 Here, as elsewhere in this essay, the translation of Ingres's letters is more or less literal; little effort has been made to correct the uneducated artist's occasionally awkward but eminently expressive prose style.

4. For the critical response to Ingres's early works and the artist's adoption of a pointedly Raphaelesque manner after 1820, see Siegfried 1980a.

5. On January 15, 1825, Ingres described this ceremony in a touching letter to his "dear little mother." See Lapauze 1910, pp. 281–87.

6. On Forbin, see Angrand 1972.

7. See Amaury-Duval 1993, pp. 215–16, for Ingres's recognition of Forbin's role in this affair.

8. On the politics of the painting, see Duncan 1978.

9. See Lacambre 1977.

10. See the letter from Ingres to Gilibert dated February 27, 1826, in Boyer d'Agen 1909, pp. 133–34: "More than once they have demonstrated a desire to keep it [the *Vow*] for Notre-Dame or the church of Val-de-Grâce, which they've reopened. But I've always protested. The subject has been dropped." ("On ait manifesté plus d'une fois le désir de le retenir pour Notre-Dame ou pour le Val-de-Grâce dont on a rouvert l'église. Mais j'ai toujours protesté. On n'en parle plus.")

11. The painting did not reach Montauban until November 1826. Ingres went along to supervise its installation and, on this last visit to his childhood home, was accorded a hero's welcome.

12. For Delécluze's unmitigated praise of Ingres and his painting, see Delécluze, November 23, 1824, and Delécluze, December 12, 1824. The only other entirely positive reviews of the *Vow* came from equally conservative, anti-Romantic critics such as Pierre-Alexandre Coupin and Jean-Marie Mély-Janin; see Coupin 1824, pp. 589–90, and Mély-Janin, December 1, 1824. Thus, the frequently expressed opinion in the art-historical literature that the "Romantics" received the *Vow* as enthusiastically as the "classicists" is not borne out in the criticism. Indeed, in what was perhaps the most polemical discussion of the Romantic/classic controversy in 1824, Delécluze cites Ingres as the veritable embodiment of classicism (which the critic christens the Homeric style ["le style homérique"]) in contrast to Horace Vernet—and not, it should be noted, Delacroix—who epitomized Romanticism or the *Shakespearean* genre ("le genre *shakespearien*"); see Delécluze, December 12, 1824. The persistent notion that Ingres's major works of the 1820s and 1830s were hailed by the Romantics seems to have originated with the artist's first posthumous biographers, particularly Blanc and Delaborde. It has remained attractive to art historians primarily as a means of differentiating Ingres from his more run-of-the-mill academic colleagues—the bêtes noires of modernist art history.

13. This opinion is voiced most vociferously in Anon. 1825 (M.), p. 151. But see also Anon. 1824 (N.), p. 232; Anon., December 11, 1824 (F.); and L'Amateur sans prétention 1825, p. 103.

14. On January 11, 1825, Ingres discussed his decision to stay in Paris in a breathless letter to his wife, who had remained in Florence. See Lapauze 1910, pp. 272–81.

15. Ingres boasts of these new commissions in a letter to Gilibert dated May 13, 1825, in Boyer d'Agen 1909, pp. 122–29.

16. Ingres was assigned to execute three drawings: portraits of King Charles X and Cardinal Jean-Baptiste-Marie Latil, the archbishop of Rheims, as well as an allegory entitled *The Alliance of Royalty and Religion*. He seems to have been less than thrilled with this assignment, complaining to Gilibert in a letter dated February 27, 1826, that he was "weighed down by little drawings, especially for work on the *Sacre;* projects that, as small as they are, do not inspire me very much" ("accablé de petits dessins, notamment pour l'ouvrage du *Sacre;* tous travaux qui, par leur petitesse, m'inspirent peu"); see ibid., p. 132. Engravings after these drawings, which are now in the Louvre (inv. 27203–5), were to illustrate an elaborate album commemorating the coronation ceremony.

17. Neither the fresco decoration for Saint-Sulpice nor the history painting for the Maison du Roi was executed, although *The Apotheosis of Homer* (fig. 164) eventually metamorphosed out of the latter commission; see Angrand 1982, pp. 23–24. The album commemorating the *Sacre* of Charles X was aborted because of the 1830 Revolution. Only the commission for Autun was brought to fruition, although certainly not with the results that Ingres and his supporters anticipated; see below, pp. 286–87.

18. All seven of the genre paintings Wildenstein dates to the period 1824–34 are variations upon themes Ingres had treated earlier in his career: *Antiochus and Stratonice* (W 164, 224), the *Bather* (W 165, 205), *Henry IV Playing with His Children* (W 204), *Don Pedro of Toledo* (W 207), and the *Odalisque* (W 226). The only original subject paintings Ingres produced during this period that were not official commissions were two paired devotional pictures representing Christ and the Virgin Mary, for the comte de Pastoret (W 211, 203).

19. "Après une couple de portraits que j'ai déjà faits ici de gens aimables et que j'ai eu tout à fait à la main, je n'en veux plus faire. C'est une perte de temps considérable, des efforts infructueux par la sécheresse de la matière qui, décidément, est anti-belle et pittoresque, et aussi en raison du peu de gain qu'on en retire." Ingres to Gilibert, February 27, 1826, in Boyer d'Agen 1909, pp. 132–33. Ingres makes a similar case for the abandonment of genre painting in a letter to Pastoret dated December 9, 1824; see Angrand and Naef 1970b, p. 8.

20. Naef 1977–80, vol. 5 (1980), nos. 285–360.

21. In a letter dated July 2, 1825, Ingres proposes to execute for Madame Louis-Joseph-Auguste Coutan, an avid collector of his work, "that which I intend only for my friends, *a portrait drawing*" ("ce que je destine uniquement à mes amis, *un portrait dessiné*"). See Lapauze 1911a, p. 284, and Naef 1977–80, vol. 5 (1980), no. 297.

22. For Ingres's portrait drawings of the Marcotte and Bertin families, see Naef 1977–80, vol. 2 (1978), chap. 127, and vol. 3 (1979),

chap. 143, respectively. More recently, Paula Warrick has devoted a stimulating Ph.D. thesis to Ingres's depiction of the Marcotte clan; see Warrick 1996.

23. "but glorieux et purement historique." Ingres to Gilibert, February 27, 1826, in Boyer d'Agen 1909, p. 132.

24. See Aulanier 1961.

25. It is often asserted in the literature on Ingres that the ceilings in the Musée Charles X were ready for the opening of the Salon on November 4. However, contemporary sources prove that the museum did not open to the public until December 15; see, for instance, Delécluze, December 16, 1827. Even after this date, the majority of critics considered Ingres's ceiling unfinished. According to Amaury-Duval (1993, p. 227), the canvas had to be forcibly removed from Ingres's studio. After the exhibition, the artist managed to have scaffolding constructed so that he could complete the picture in situ but limited his retouching to a change in the color of Molière's drapery.

26. Most of the literature on Ingres assumes the former. However, Aulanier (1961, p. 36) claims that the theme was suggested by the vicomte Sosthène de La Rochefoucauld, Chargé du Département des Beaux-Arts. Unfortunately, she offers no documentation for this assertion. In the lengthy and remarkably authoritative account of the painting published the day before its public unveiling, it is noted that "the painter has made an effort to expand rather than contract [his subject] *in the narrow framework of the program that had been defined for him*" ("le peintre s'est plutôt efforcé d'agrandir que de restreinde *dans le cadre étroit du programme qui lui était donné*") [emphasis added]; see Anon., December 15, 1827.

27. According to Vigne (1995b, p. 179), "a personal profession of aesthetic faith."

28. See, for instance, Anon. 1828, p. 124; Anon., April 13, 1828; and Vergnaud 1828, pp. 42–43.

29. See, for instance, Jal 1828, pp. 198–202.

30. Here again one must resist the persistent myth that it was the "Romantics" who hailed Ingres's painting as much as, if not more than, the "classicists." This notion seems to have grown out of the isolated remark made by the critic Arnold Scheffer, brother of the allegedly "Romantic" painter Ary, that Ingres was most viciously criticized by those who found his work to be insufficiently imitative of the Greeks (that is, the hard-core followers of David), whereas "the painters of the so-called Romantic school applauded this new success by a man who sometimes treated them with unfair harshness" ("les peintres de l'école dite romantique ont applaudi à ce nouveau succès d'un homme qui fut quelquefois injuste envers eux"); see Scheffer 1828, p. 208.

31. Anon., December 15, 1827. Ingres found this critique authoritative enough to repeat excerpts from it in the 1851 illustrated catalogue of his works; see Magimel 1851, pl. 54.

32. "le premier dessinateur de notre époque." Anon., January 13, 1828, p. 19.

33. Delécluze, January 2, 1828.

34. "une école de dessin." See his letter to Gilibert dated February 27, 1826, in Boyer d'Agen 1909, p. 132. That Ingres referred to

his teaching atelier in these terms is indicative of his adherence to the archacademic contention that drawing was the foundation of art. He stubbornly maintained this belief throughout his life (it is expressed in his most celebrated aphorism, "Drawing is the probity of art" ["Le dessin est la probité de l'art"; Delaborde 1870, p. 123]), most particularly in 1863, when he publicly protested the institution of instruction in painting and sculpture at the École des Beaux-Arts; see Ingres 1863.

35. See Angrand 1982.

36. "Certes, outre l'honneur d'appartenir à une aussi grande Compagnie, en plus de ce qu'elle donne de véritable considération dans le monde, elle m'apporterait quinze cents livres fixes et, plus tard, la place de professeur à l'Académie des Beaux-Arts, qui est de cent louis. Ces revenus feraient le bonheur de ma vie et combleraient mes désirs et mon ambition puisque, avec mes goûts simples, j'aurais de quoi vivre et honorablement même à Paris, et puisque d'ailleurs tout ce que je pourrais gagner par des ouvrages de mon choix pourrait m'assurer même de l'aisance, un jour." Ingres to Gilibert, May 13, 1825, in Boyer d'Agen 1909, p. 127.

37. "Tu as une position qui assure ta liberté: apprécie l'étendue de ce bonheur. C'est par cela que, moi et tant d'autres, nous portons une chaîne au col, tirée continuellement par mille sujets de dépendance fatale. Quand nous voulons nous livrer à nos nobles penchants, à nos justes désirs, à l'amour de la vérité, quand nous voulons résister, notre chaîne se resserre de plus en plus et le supplice recommence." Ingres to Gilibert, February 27, 1832, in ibid., pp. 230–31. For other instances in which Ingres linked financial security to professional freedom, see two letters to Gilibert in ibid., pp. 55, 61.

38. "L'heure de mon indépendance vient de sonner." Ibid., p. 221.

39. "Et le *monde*, que je suis obligé de voir trop et bien trop, par état et affaires! Cela occasionne bien des soins et demande une tête, un mémoire, un esprit de conduite bien pénible pour moi qui vis parmi des hommes de qui je dois tout tenir et rien espérer. Je marche sur le volcan des amours-propres, source de tous les embarras et compromis possibles; et c'est moi, moi, mon cher, qui suis à faire ce métier-là!" Ingres to Gilibert, May 13, 1825, ibid., p. 124. For similar complaints over his increasingly onerous social responsibilities during these years, see ibid., pp. 130–31, 190, 202.

40. "J'envie, vingt fois le jour, l'homme des bois et des champs quand je vois, ici, de mes yeux, que, plus on est élevé, plus on est malheureux." Ibid., p. 124.

41. See Amaury-Duval 1993, pp. 141, 332–34, for accounts of Ingres's quite visceral reactions to a performance of Rossini's *William Tell* and a concert by Paganini.

42. For the locations of Ingres's apartments and studio, see Daniel Ternois's commentary in Amaury-Duval 1993, pp. 70–71.

43. In a charming addendum to a letter dated April 7, 1829, from Ingres to Gilibert, who had just visited Paris, Madame Ingres sends the regards of both her maid and the cat. See Boyer d'Agen 1909, pp. 209–10.

44. Ingres's aversion to the Salon—and to the Salon jury in particular—is legendary. His most official pronouncements on this matter came in the years 1848–49 when, as a member of the

Commission Permanente des Beaux-Arts, he recommended that the Salon jury be suppressed; see Fouché 1908. During the later years of his life, Ingres, like many of his most illustrious fellow Academicians (among them, Paul Delaroche and Horace Vernet), regularly refused to serve on the jury; see Rosenthal 1987, pp. 43–44.

45. See Rosenthal 1987, pp. 5–6.

46. See Ternois 1988. Ingres would eventually renounce this commission, as explained below, p. 287.

47. Each of the twelve professors at the École des Beaux-Arts was responsible for one month of instruction per year; see Grunchec 1983, pp. 87–90.

48. The most frequently consulted primary sources on life in Ingres's atelier are Amaury-Duval 1993 and Balze 1880. The best art-historical account remains Angrand 1982, although Daniel Ternois has recently provided a useful overview of the topic with references to the most pertinent literature; see his introduction to Amaury-Duval 1993, pp. 28–33.

49. The best account of pedagogical practices in the nineteenth century remains Boime 1971.

50. "Cet homme, avec ses cinquante-trois ans, a toute l'activité fiévreuse d'un jeune homme. . . ; il a tout le feu des méridionaux dans son enthousiasme d'artiste et jamais ses leçons ne sont froides ni languissantes; il est sévère dans l'intérêt de l'art, doux et affable dans tous ses rapports avec ses élèves, d'un facile accès." Georges Lefrançois to Jean-Pierre-Henri Élouis, dated August 15, 1833, quoted in Lapauze 1911a, p. 256.

51. Étex 1878, pp. 71–73.

52. "Jouissons de ces effets sublimes. Y a-t-il rien de comparable, dans toutes les histoires connues? A qui ressemblons-nous? A nous-mêmes! A ce coup d'appel qu'à poussé la foudre,—oeuvre divine vraiment, et qui grandit plus elle s'éloigne,—nous pouvons enfin nous redire Français et ne plus contenir notre longue indignation." Boyer d'Agen 1909, p. 224.

53. For the most thorough analysis of this drawing, see Marrinan 1988, pp. 48–49.

54. "La révolution opérée, finie, l'ordre partout, tout remplacé!"; "stupides et méchants"; "qui, aujourd'hui même, voudraient salir et troubler encore l'ordre et le bonheur d'une liberté si glorieusement, si divinement acquise." Ingres to Gilibert, August 12, 1830, Boyer d'Agen 1909, pp. 223–24. Angrand (1967, p. 77) aptly characterizes the political outlook expressed in this letter as nothing but an echo of the position taken by the centrist, Orléanist *Journal des débats*.

55. "Les hommes d'aujourd'hui ne valent pas, vraiment, la peine que l'on prenne parti pour eux. . . . L'intérêt, le moi et la trahison, règnent." Ingres to Gilibert, March 15, 1831, in Boyer d'Agen 1909, p. 226.

56. "Et moi j'irais encore, moi tout seul, affronter des masses ignorantes, intéressées et brutales. J'ai beau crier, on ne m'écoute *nulle part*. Raphaël viendrait lui-même, il ne se ferait pas entendre." Ibid., p. 227.

57. See Anon., March 28, 1833, p. 45, and Jal 1833, pp. 1–2.

58. "importance toute spéciale"; "parce qu'il s'agit d'un maître, du chef d'une école aujourd'hui florissante et vénérée, parce qu'il s'agit de M. Ingres." Planche 1833, p. 89.

59. Grunchec 1983, pp. 208–15. The Grand Prix winner in 1833 was Eugène Roger, who had transferred to Ingres's studio when that of his former master, Louis Hersent, closed in 1832. The runners-up were Philippe Comairas and Louis-Victor Lavoine, both students of Ingres.

60. "Si M. Ingres marchait seul, s'il n'avait pas des élèves qui l'adorent et cherchent servilement à l'imiter, il faudrait le prendre tel qu'il est, et s'estimer bien heureux que le temps présent possède un homme de cette valeur. Mais M. Ingres fait école, et cette école fière est dénigrante; elle pousse l'intolérance jusqu'au fanatisme; elle défend à la peinture de reproduire la nature autrement que M. Ingres ne la voit." Anon., March 9, 1833.

61. "Pour moi, en théorie de beaux-arts, comme en politique, c'est dans le *juste-milieu* que je crois trouver la vérité"; "système absolu." Anon., March 15, 1833.

62. "Un seul nom, proclamé par des admirations enthousiastes, semble arboré comme drapeau d'une école, et adopté comme symbole d'une doctrine. Je veux parler de M. Ingres." Ibid.

63. "L'art est émancipé et n'entend pas qu'on le gratifie d'un prince et d'une chartre. . . . Maintenant, plus qu'en aucun temps, il veut que son domaine soit une république, et qu'on ne le garrotte pas au nom de Raphaël ou de Rubens." Maynard 1833, p. 38.

64. "A présent, pareil à je ne sais quel dieu cruel des Mexicains, il trône sur un autel ensanglanté. Tous nos critiques, vêtus en sacrificateurs, l'entourent respecteusement et chantent des feuilletons à sa louange. Chaque journal est un encensoir. D'instans en instans on immole à sa divinité un holocauste de petits peintres coloristes. Grâce n'est faite à personne. Les plus beaux et les plus forts meurent aussi." Ibid., p. 85.

65. The inevitability of Ingres's appointment to the highest artistic position in the land is discussed in Anon., March 9, 1833. This critic can only hope that Ingres will be tolerant "when the authorities, who will naturally go to him, as they have gone successively to David and M. Gérard [the two previous First Painters], to ask his advice, on which the lives and futures of artists will depend" ("quand le pouvoir, qui ira naturellement à lui, comme il est allé successivement à David et à M. Gérard, lui demandera un avis d'où devront dépendre la vie et l'avenir des artistes").

66. "Non, le pouvoir n'ira pas à M. Ingres. . . . Le peintre d'un roi doit être populaire, fécond et historique pour ainsi parler. Or, M. Ingres, d'un mérite d'ailleurs si élevé, ne réunit pas ces trois titres." Maynard 1833, p. 58. Maynard went on to promote Horace Vernet for the post.

67. "Aujourd'hui, M. Ingres est sur le piédestal qu'il s'est si laborieusement construit. Il est devenu un mythe." Gautier 1833, p. 152.

68. "Tout pauvre qu'il était, il tint à ses idées et ne fit aucune concession au goût régnant." Delécluze, March 22, 1833.

69. "la pauvreté et l'oubli, sans cesser de cultiver son art avec un amour sincère." Ibid.

70. "l'on peut être *artiste* en vivant en bon père de famille, sans courir les champs pieds nus, ni même étrangler la femme que l'on aime." Ibid.

71. See, for instance, Lenormant 1833, vol. 2, p. 166: "We needed to see M. Ingres not only as a portrait painter, but also as a painter of history. . . . All this will fall into place with the fortunately very imminent unveiling of *The Martyrdom of Saint*

Symphorian." ("Il fallait considérer M. Ingres non seulement comme portraitiste, mais encore comme peintre d'histoire. . . . Tout cela trouvera sa place à l'apparition heureusement très prochaine du *Martyre de saint Symphorien*.")

72. The iconography of the painting was spelled out in a long letter from the bishop of Autun to the minister of the interior, who undoubtedly passed it on to Ingres; see Lapauze 1911a, pp. 305–7.

73. See Paris (Salon) 1827, no. 577. The painting had also been announced for the 1832 Salon, which was canceled because of a cholera epidemic; see Anon. 1831, pp. 265–66.

74. Something of the expectations for *Saint Symphorian* can be gleaned from the correspondence of Ingres's students. On March 1, 1833, Hippolyte Flandrin wrote from Rome to his brothers Paul and Auguste in Paris: "Oh, my God! How afraid I am that this painting [*Symphorian*] will not make it to the Exhibition [the 1833 Salon]! It's just that if it appeared now, it would be so fitting! Everyone's eyes are on our master, they're waiting, and I truly believe that this sublime work would be appreciated. Oh! this would be the fatal blow, the blow that would decide the victory!" ("Oh! mon Dieu! que je crains que ce tableau ne soit pas à l'Exposition! C'est que s'il paraissait maintenant, il arriverait si à propos! Tout le monde a les yeux sur notre maître, on attend, et vraiment je crois que cette oeuvre sublime serait goûtée. Oh! ce serait là le grand coup, le coup qui doit décider la victoire!") Delaborde 1865, pp. 196–97.

75. For a detailed analysis of the critical reception of *Saint Symphorian*, see Shelton 1997, pp. 32–104.

76. "école catholique"; "les dernières années du droit divin." Hauréau, March 15, 1834.

77. "Et l'on vient nous rappeler aux émotions religieuses, l'on vient invoquer notre admiration devant un martyr bravant les supplices pour la Sainte-Trinité, pour la divinité de celui qui s'appelait le Fils de l'Homme; mais nous ne croyons plus à rien! à peine croyons-nous à nous-même!" Decamps 1834, p. 22.

78. "la plus haute sublimité de la pensée humain, . . . la poésie d'Homère, appliquée au christianisme." Anon., March 25, 1834.

79. "Il arrosa de son sang cette terre qui, seize siècles plus tard, devait offrir au monde d'aussi sublimes dévouemens dans les mères et dans les fils, et d'aussi cruelles persécutions dans de nouveaux proconsuls." Anon., March 10, 1834.

80. See, for instance, Anon., March 6, 1834: "M. Ingres apparently dipped his brush in his hot chocolate when he painted his *Martyrdom of Saint Symphorian*" ("M. Ingres avait probablement trempé son pinceau dans son chocolat quant il faisait son *Martyre de saint Symphorien*"); and Anon. 1834, p. 7: "It's painting with mud" ("on peignit avec de la boue").

81. Anon., March 13, 1834: "macaroni whose strands are entwined like serpents" ("un macaroni dont les fils s'enlacent comme des serpens").

82. See, for instance, Anon., March 9, 1834, pp. 150–51: "The lictor to Symphorian's right enters fully into the realm of the *extraordinary*. He is more than Herculean, he is bulging, mountainous. . . . The other lictor is so tormented in his gestures, his muscles are so contracted, and his expression is so dolorous that he seems to be the victim rather than the torturer." ("Le licteur, à la droite de Symphorien, entre de plein-pied dans le domaine de l'*extraordinaire*. Il est plus qu'Herculéen, il est bossué, il est montagneux. . . . L'autre licteur est si tourmenté de geste, si contracté de muscles et si souffreteux d'expression, qu'il semble être la victime au lieu d'être le bourreau.")

83. See Shelton 1998.

84. "Ce qui me chagrine, c'est que M. Ingres est profondément découragé; il est dans son essence de ne rien prendre à demi. A peine il a vu la charge du pied d'un de ses licteurs, que les élèves de Gros ont crayonné sur les murs de l'Institut, et le voilà tout hors de lui, qui veut renoncer aux travaux du gouvernement, aux Salons, ne plus travailler que sur de petites toiles et pour ses amis et retourner en Italie sitôt qu'il le pourra." Quoted in Lapauze 1911a, pp. 317–18.

85. Ingres renounced the Versailles commission in a letter to the director of fine arts dated July 12, 1834; see ibid., p. 320. The painting for Notre-Dame de Lorette eventually went to François Picot. According to Ternois (1980, p. 82), Ingres also renounced a commission for the Pantheon; Lapauze (1911a, p. 318) refers to this project as only a potential commission: work "that they were discussing with him for the Pantheon" ("dont on lui parlait pour le Panthéon").

86. On January 29, 1835, Ingres wrote to Forbin formally requesting that none of his works be allowed into the exhibition; see Lapauze 1924, vol. 2, p. 229.

87. "Mais quant à être, moi, dorénavant l'homme du public,— jamais!" Ingres to Édouard Gatteaux, undated, quoted in Ternois 1986a, p. 29.

88. See Angrand 1982, p. 57, n. 58, for excerpts from a letter Ingres sent Thiers on June 30, 1834, withdrawing his candidacy.

89. See Amaury-Duval 1993, chap. 4, for a humorous account of a tumultuous dinner party during which the artist and the politician disputed the merits of Raphael.

90. The exact date on which the drawing was executed is unknown. However, Angrand (1967, p. 93, n. 2) has reasonably suggested that it was drawn after Ingres's appointment to the directorship in Rome.

91. Ingres often referred to his directorship as a "voluntary exile" ("exil volontaire") in his correspondence from Rome. See, for instance, his letters dated July 23, 1836, to Désiré Raoul-Rochette, quoted in Naef 1977–80, vol. 3 (1979), p. 92, and June 21, 1836, to Charles Marcotte, quoted in Lapauze 1913, p. 94, and Ternois 1999, letter no. 31.

97. Madame Marie Marcotte (Marcotte de Sainte-Marie), née Suzanne-Clarisse de Salvaing de Boissieu

1826
Oil on canvas
36⅝ × 29⅛ in. (93 × 74 cm)
Signed and dated left, below center: Ingres 1826.
Musée du Louvre, Paris R.F. 2398
New York and Washington only

W 166

Little is known about the subject of this portrait. Born into a solidly bourgeois family (her father was a naval engineer) in the Norman town of Ingouville in 1803, Suzanne-Clarisse de Salvaing de Boissieu married a man exactly twice her age in 1823. The bridegroom was Marie Marcotte, called Marcotte de Sainte-Marie (1783–1859), a functionary of the Treasury and, more important for our purposes, the youngest brother of Ingres's close friend and patron Charles Marcotte, called Marcotte d'Argenteuil (cat. no. 26). Childless for the first nine years of her marriage, Madame Marcotte delivered her only child, Henri, in 1832. She died in Paris in 1862.

Lack of more precise biographical data has not prevented art historians from speculating on the character of Madame Marcotte. The tone was set in 1911 when Henry Lapauze, Ingres's most authoritative biographer, claimed that she was an exceedingly frail and nervous young woman—so much so that she found the ordeal of posing for her portrait unbearable. Thus, Ingres was forced to employ his wife as the model for the hands in the painting.[1] Armed with this information, Lapauze proceeded to cast a pall over the entire picture. "Too many difficulties arose for the painter to execute his work with any pleasure," he lamented. "The portrait is shrouded in the sullenness of its sitter. . . . Before M^me Marcotte de Sainte-Marie, his brush turned austere. This is the brush of a painter of the Port-Royal."[2]

The analyses of subsequent art historians have tended to be elaborations—sometimes strangely malevolent—of Lapauze's initial (and totally unconfirmed) remarks.[3] "This rather unprepossessing sister-in-law of M. Marcotte was in poor health, which made the sittings very trying for her," Louis Hourticq remarked in 1928. "But in that case, why sit for her portrait? And would it not have been better to stay at home, on her chaise longue, than to drag such a gloomy figure to a painter?"[4] More

recently, Robert Rosenblum has highlighted the discrepancies between *Madame Marcotte* and Ingres's earlier female portraits (most particularly *Madame de Senonnes* [cat. no. 35]), detecting in the later work "a disturbing aura of almost neurotic melancholy and frailty" that evoked the "cloistered privacy of a sickroom" rather than the hothouse opulence of a salon or boudoir.[5] Rosenblum went on to enumerate the sitter's less than enticing features—"the large and anxious eyes, the long nose, the pale and unsmiling lips"[6]—and to liken the profusion of jewelry adorning her person to religious paraphernalia—"the rosaries and crucifixes that might be reverently cherished by a nun."[7] The end result of all this, according to Rosenblum, was "an ascetic gloom unique in Ingres's portraiture."[8]

Without necessarily denying the validity of these psychobiographical interpretations of the portrait, the analysis of *Madame Marcotte* may be expanded to include an examination of how the work might originally have functioned as a *social* document—to consider what kinds of meanings it was expected to generate when initially placed before the Parisian public at the Salon of 1827–28. As Paula Warrick has pointed out in a recent study of the portraits of the entire Marcotte clan, it seems unlikely that the family would have sanctioned the public exhibition of *Madame Marcotte* had it denoted nothing but dourness and neuroses.[9] Certainly, the image must have offered something that was positive, even flattering, for its well-heeled sitter and her increasingly powerful relatives.

Many historians have noted that the picture, completed only three years after the Marcottes' marriage, may have been a kind of belated wedding portrait. If so, its primary function would have been to celebrate the specifically wifely virtues—the modesty and reserve—of its sitter rather than her physical charms and seductiveness. It is the latter attributes that are most

Fig. 171. *Study for "Madame Marcotte,"* ca. 1826. Graphite on paper, 6⅞ × 5⅜ in. (17.6 × 13.5 cm). Musée Ingres, Montauban (867.247)

97

frequently emphasized in Ingres's earlier female portraits, most particularly those of Madame Duvaucey (fig. 87) and Madame de Senonnes (cat. no. 35), the two works to which *Madame Marcotte* is so frequently and, for the most part, so unfavorably compared.[10] Yet here it must be noted that at the time of their depiction both of these earlier sitters were, in striking contrast to Madame Marcotte, not virtuous young brides but celebrated beauties who had become the mistresses of powerful Frenchmen living in Italy during the Napoleonic occupation. Thus, the much commented upon differences in the degree of erotic allure between the Roman portraits and *Madame Marcotte* may be less a function of the specific personalities of the sitters than of their contrasting positions within contemporary French society.[11]

The alleged dourness of *Madame Marcotte* relative to Ingres's earlier female portraits must also be examined in light of the dramatic developments that occurred in feminine fashion during the 1820s. By 1826 the exaggeratedly simple, high-waisted "Empire" dress, with its provocatively low neckline and sheer, diaphanous material (see, for instance, cat. no. 9), was a distant memory. During the 1820s, necklines had begun to rise and materials became both more colorful and more opaque.[12] Madame Marcotte's deep brown satin day dress, with its wide, neck-hugging collar and flaring "gigot" sleeves, is fully representative of these trends. Thus, instead of indicating an almost neurotic modesty—as many historians accustomed to the sexier décolletages of Ingres's earlier female sitters have come to assume—Madame Marcotte's choice of costume in this portrait attests to her eminent modishness.[13] And whatever note of priggishness one might want to attach to this style of dress vis-à-vis the more form-revealing fashions of the first two decades of the century must ultimately be attributed to the conservatism of Restoration society as a whole, not simply to the "fierce modesty"[14] of a single bourgeois woman.

Had *Madame Marcotte* deviated markedly from conventional notions of femininity, it would almost certainly have elicited a strong reaction in the press.

Yet only one reviewer of the 1827 Salon bothered to comment on the portrait at length. Attempting to explain why *Madame Marcotte* pleased him less than the *Comte de Pastoret* (cat. no. 98), the other portrait by Ingres in the exhibition, Pierre-Alexandre Coupin, the usually sympathetic critic of the *Revue encyclopédique*, surmised that it might have been because the former canvas was too large and thereby magnified its sitter's lack of exceptional beauty. "Unless a woman has the marks of a truly great character," he somewhat euphemistically explained, "she is bound to lose by this system [large-scale portraiture], which must, it seems to me, attenuate whatever there might be in her physiognomy that is fine and delicate. . . . I find, too, that the contours have a certain dryness; there is something unrealistic about the color of the eyes."[15] That Ingres—and/or his patron—may also have found the portrait less than satisfactory is suggested by the fact that it was never again exhibited during the artist's lifetime, nor was it included in the monumental illustrated oeuvre catalogue published by his friend Albert Magimel in 1851.[16]

Only three drawings relating to the portrait have been identified. A fully resolved portrait drawing (cat. no. 103) shows the sitter in an almost identical pose and wearing the same dress, but in a slightly different interior setting. Infrared photographs of the Louvre canvas show that the original version of the painting was quite close to this sketch: Madame Marcotte was initially seated on a high-backed banquette instead of the bright electric-yellow cushions that cradle her in the final version.[17] Technical analysis has also revealed that the featureless wall behind the sitter's head was originally decorated with a brocade floral pattern. The other two related drawings, which are in the Musée Ingres in Montauban, show Madame Marcotte seated in a more erect posture in an outdoor setting; in one of these (fig. 171) she appears to hold a large open book on her lap.[18]

A.C.S.

1. Lapauze 1911a, p. 278. As Hélène Toussaint has noted, the position of Madame Marcotte's hands seems to have been inspired by those in Raphael's *Portrait of Maddalena Doni* in the Pitti Palace in Florence. An oil copy by

Ingres of these hands, probably based on an engraving as opposed to the original painting, which did not enter the Pitti Palace until 1826, is in the Musée Bonnat in Bayonne (fig. 138); see Toussaint in Paris 1985, p. 70.

2. "Trop de difficultés s'élevèrent pour que le peintre accomplît son oeuvre dans la joie. Le portrait s'enveloppe de la maussaderie du modèle. . . . Devant M^me Marcotte de Sainte-Marie, son pinceau se fit austère. C'est le pinceau d'un peintre de Port-Royal." Lapauze 1911a, p. 278. The Port-Royal was a famous convent in Paris.

3. Hans Naef, one of the few historians to question the reliability of Lapauze's claims, noted that as of 1954 the current descendants of Madame Marcotte had no precise information concerning the character of Ingres's sitter; see Naef 1977–80, vol. 2 (1978), p. 514.

4. "Cette peu avenante belle-soeur de M. Marcotte avait une faible santé qui lui rendait les séances de pose très pénibles. Mais alors, pourquoi poser? Et ne vaudrait-il pas mieux rester chez soi, sur sa chaise longue, plutôt qu'apporter si maussade figure chez un peintre?" Hourticq 1928, p. 66.

5. Rosenblum 1967a, p. 128.

6. Ibid. Compare Lapauze 1911a, p. 278: "M^me de Sainte-Marie had big, round eyes, the eyes of one who is nearsighted, a prominent nose, and thick lips. Ingres certainly did not betray nature, for he rendered her exactly as she was." ("M^me de Sainte-Marie avait de grands yeux ronds, des yeux de myope, le nez fort et la bouche charnue: Ingres n'a point trahi la nature, car il l'a rendue telle quelle.")

7. Rosenblum 1967a, p. 128. Rosenblum, following Lapauze, suggests that the small book in Madame Marcotte's right hand is a prayer book.

8. Ibid.

9. Warrick 1996, p. 161. My analysis owes much to the insights contained in this study.

10. One of the few exceptions to this is found in Whiteley 1977, p. 60: "Holding her lorgnette aside for an instant, Mme. de Marcotte looks up with a quizzical look in her extraordinary eyes, which draw the spectator's attention, while Mme. de Senonnes's vacuous face fails to compete with the splendour of her accessories."

11. It is noteworthy that the only other identifiable portrait by Ingres of a married woman to have been exhibited at the Salon, the rather daringly sensuous *Madame Rivière* (cat. no. 9), was attacked in 1806 as being indecent; see p. 500.

12. For an overview of developments in feminine fashion in the 1820s, see Payne 1965, pp. 488–97.

13. See Warrick 1996, pp. 29, 150, 157–60, where it is also noted that Madame Marcotte's jewelry and "Apollo"-style coiffure were on the cutting edge of fashion.

14. "pudeur farouche." Lapauze 1911a, p. 278.

15. "A moins qu'une femme n'ait des traits d'un très-grand caractère, elle doit perdre à ce système qui me semble devoir atténuer ce qu'il peut y avoir de fin et de délicat dans sa physionomie. . . . Je trouve aussi que les contours ont un peu de sécheresse; la couleur des yeux a quelque chose qui semble manquer de vérité." Coupin 1828, p. 865.

16. Magimel 1851. The lack of publicity accorded this picture may also be attributed to Ingres's lifelong reticence about advertising his prowess as a portraitist.

17. See Toussaint and Couëssin 1985, p. 202.

18. The other drawing (inv. 867.248) represents a slightly different detail of the sitter's torso and lap.

PROVENANCE: Mme Marie Marcotte de Sainte-Marie (1803–1862); bequeathed by her to her son, Henri Marcotte de Sainte-Marie (1832–1916), 1862; bequeathed by him to his children, 1916; purchased from the latter by the Musée du Louvre, 1923

EXHIBITIONS: Paris (Salon) 1827, no. 576; Paris 1923 [EB]; Prague 1923, no. 9; Copenhagen, Stockholm, Oslo 1928, no. 94 (Copenhagen), no. 83 (Stockholm), no. 88 (Oslo); Paris 1930, no. 166; Paris 1934c, no. 5; Los Angeles 1934, no. 11 [EB]; San Francisco 1934, no. 111; Baltimore 1934–35, no. 18 [EB]; New York 1935, no. 9; Paris 1946c, no. 145 [EB]; Paris 1953a, no. 35; Montauban 1967, no. 101; Paris 1967–68, no. 139; Montauban 1980, no. 50; Tokyo, Osaka 1981, no. 84; Paris 1985, no. XII

REFERENCES: Anon., December 18, 1827a, p. 927; Béraud 1827, p. 150; Delécluze, December 23, 1827; Anon., January 13, 1828, p. 19; Coupin 1828, pp. 864–65; Farcy 1828, p. 67; Vergnaud 1828, p. 20; Lapauze 1911a, pp. 277–78, ill. p. 263; Guiffrey 1923a, p. 71, ill.; Hourticq 1928, p. 66, ill.; Malingue 1943, p. 11, ill. p. 44; Cassou 1947, p. 68; Wildenstein 1954, no. 166, pl. 69; Naef 1958 ("Marcotte Family"), p. 338; Rosenblum 1967a, p. 128, pl. 34; Clark 1971, p. 359, fig. 6; Whiteley 1977, p. 60, pl. 43; Naef 1977–80, vol. 2 (1978), p. 513, fig. 10; Ternois 1980, p. 76, no. 177, ill. pp. 111–13; Ternois and Camesasca 1984, no. 118, ill.; Toussaint and Couëssin 1985, p. 202, figs. 13–15; Compin and Roquebert 1986, p. 324, ill.; Zanni 1990, no. 77, ill.; Vigne 1995b, p. 183, figs. 122, 151; Warrick 1996, pp. 29–30, 150–65

98. Amédée-David, Comte de Pastoret

1826

Oil on canvas

40 ½ × 32 ⅞ in. (103 × 83.5 cm)

Signed and dated lower left: Ingres 1826

Inscribed upper left: A M.ᶦˢ de Pastoret/
Ætat.ˢ 32. [To M(arqu)is de Pastoret/Age 32.]

The Art Institute of Chicago

Estate of Dorothy Eckhart Williams, Robert Allerton, Bertha E. Brown, and Major Acquisitions endowments 1971.452

W 167

It is unclear when Ingres first encountered Amédée-David, comte (later marquis)[1] de Pastoret (1791–1857), the subject of this portrait. The surviving correspondence between the two men, published nearly three decades ago in a marvelously informative article by Pierre Angrand and Hans Naef,[2] begins about 1818; however, Naef has more recently speculated that the two may have met as early as 1809, when the eighteen-year-old count arrived in Italy as Secrétaire-Général du Gouvernement Provisoire des États Romains.[3] Whatever the precise date of their initial encounter, Pastoret and Ingres went on to form a remarkably productive partnership.

At the time of his death, Pastoret had accumulated no fewer than seven works by Ingres; in addition to the present portrait, he owned The Entry into Paris of the Dauphin, the Future Charles V (fig. 136), a painting in the so-called troubadour manner trumpeting the Pastoret family's longstanding (but hardly uninterrupted) allegiance to the crown; a charming portrait drawing of Louise-Alphonsine de Pastoret (1796–1876), Amédée's wife (fig. 172), executed during the couple's visit to Florence in 1822; an undated tondo of the head of the nude subject of the Grande Odalisque (W 96; location unknown); a watercolor sketch of The Apotheosis of Homer (Musée des Beaux-Arts, Lille); and a pair of bust-length paintings of Christ and the Virgin Mary (W 211, 203; Museu de Arte, São Paulo).[4] Had Ingres cooperated, the Pastoret collection would have been richer still in works by his hand, for the count sought unsuccessfully to coax the artist to execute several other paintings, including a pendant to The Entry into Paris of the Dauphin[5] as well as repetitions of some of his most celebrated genre and history paintings.[6] Although Ingres was unable to fulfill all of Pastoret's requests, he was careful not to alienate one of his most important patrons. "I am always glad to see you in possession of my works—you who are distinguished by such enlightened taste and who at every turn honor me with uncommon friendship and benevolence, the value of which I greatly appreciate."[7]

Amédée was not the first member of his family to demonstrate such an intense interest in art. Both of his parents are commemorated in portraits by two of Ingres's most illustrious contemporaries. Jacques-Louis David represented Pastoret's mother, the celebrated socialite Adélaïde de Pastoret (1765–1843), in an austere Revolutionary portrait of the early 1790s now in the Art Institute of Chicago (fig. 175)—the infant in the cradle at the right is Amédée-David. Nearly four decades later,

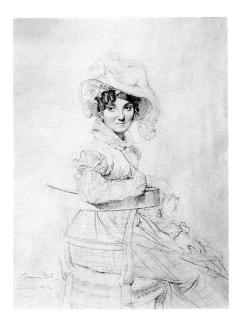

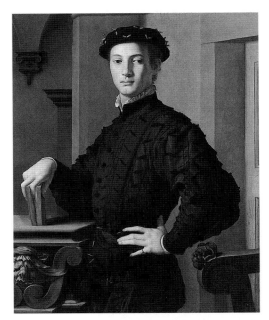

Fig. 172. *Comtesse de Pastoret*, 1822 (N 263). Graphite on paper, 11⅛ × 8 in. (28.4 × 20.4 cm). Private collection

Fig. 173. *Study for "Comte de Pastoret,"* ca. 1826. Charcoal, graphite, and white highlights on paper, 14¾ × 9⅛ in. (37.5 × 23.2 cm). Musée Ingres, Montauban (867.363)

Fig. 174. Agnolo Bronzino (1503–1572). *Portrait of a Young Man*, ca. 1540. Oil on wood, 37⅝ × 29½ in. (95.5 × 74.9 cm). The Metropolitan Museum of Art, Bequest of Mrs. H. O. Havemeyer, 1929, H. O. Havemeyer Collection, 29.100.16

Paul Delaroche executed a magisterial portrait of Amédée's father, Emmanuel (1756–1840; fig. 176).

Ingres's interest in maintaining a good relationship with Pastoret had as much to do with the count's social and political influence as with his artistic proclivities. The scion of an exceedingly ambitious (and unabashedly opportunistic) family, Amédée first rose to prominence as a promising young bureaucrat during the Empire.[8] His attachment to Napoleon did not prevent him from rallying to the Bourbons in 1814, however, and he was rewarded for this abrupt change of allegiance with a string of prestigious posts during the Restoration: Maître des Requêtes au Conseil d'État (1814), Commissaire du Roi près la Commission du Sceau de France (1817), Gentilhomme Titulaire de la Chambre du Roi (1820), and Conseiller d'État en Service Extraordinaire (1825).

Apart from his administrative ambitions, Pastoret fancied himself a writer and, beginning in 1813, penned a series of poems and historical novels.[9] On March 22, 1823, he was elected an associate member of the Académie des Beaux-Arts, in which capacity he almost certainly lobbied for Ingres's election as a corresponding member just nine months later.[10] Having refused to

swear allegiance to the Orléanist regime in the aftermath of the 1830 Revolution, Pastoret lost most of his political credentials. During the July Monarchy, he became a leader of the legitimist opposition and served as one of the principal agents in France of the exiled Bourbon court. His status as an internal émigré did not prevent Pastoret, now a marquis, from presiding over the lavish banquet commemorating Ingres's return to Paris after six years of service as director of the Académie de France in Rome.[11] Changing political allegiance once again in 1852, the marquis rallied to the Second Empire and was made a senator by Napoleon III.

Ingres's portrait shows Pastoret at the height of his power and prestige. Although the work is dated 1826, there is reason to believe that it was begun as early as 1823.[12] Only two preparatory drawings relating to the painting have been identified. A spectacular costume study for the count's torso and left arm (fig. 173) and a sketch of his left hand are in the Musée Ingres in Montauban.[13] The portrait is mentioned only twice in Ingres's correspondence with the sitter. On December 9, 1824, the artist reaffirmed the price of the picture at 1,000 francs; in a subsequent letter, he changed an appointment for a sitting and

asked the count to send him a pair of his gloves, which would figure prominently in the still life in the lower left corner of the painting.[14]

The *Comte de Pastoret* is relatively unusual among Ingres's male portraits in its emphasis on costume and accessories. Pastoret wears the black embroidered uniform of councillor of state, the understated elegance of which, if we are to believe Amaury-Duval, was conditional for Ingres's agreement to execute the painting.[15] The relative sobriety of this shimmering black costume is relieved by the cross of the Legion of Honor hanging from a scarlet ribbon at Pastoret's neck, as well as by the elaborate gold and mother-of-pearl sword suspended from his waist.[16] An official-looking document and a ceremonial black bicorne rest beside the count's pale yellow gloves on the chair at the left. The decor is otherwise rather sparse. Pastoret poses before a wall covered with green striped damask above gray-and-gold wainscoting. A length of green drapery hanging rather limply along the right edge of the picture is all that remains of the standard accoutrements found in more traditional grand-manner portraits.

As Robert Rosenblum first pointed out, the count's swaggering hand-on-hip pose

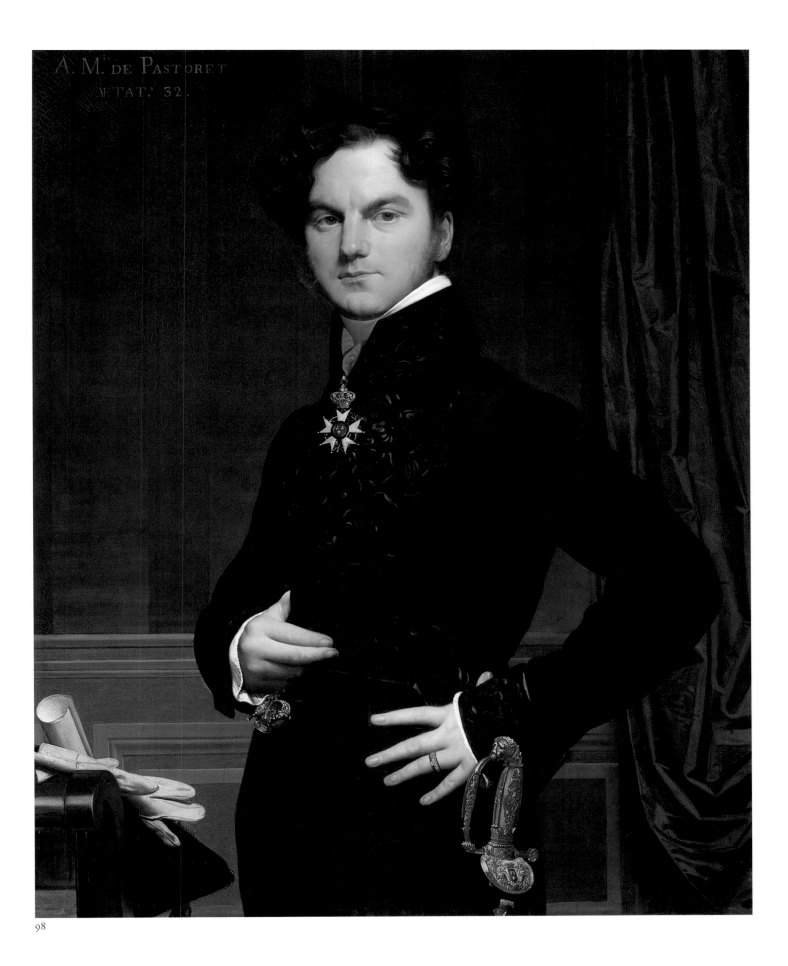

A. M.ᵈ DE PASTORET
ÆTAT.· 32·

98

and disdainful expression seem to have derived from Agnolo Bronzino's celebrated *Portrait of a Young Man*, now in the Metropolitan Museum (fig. 174).[17] The resulting air of aristocratic hauteur is perfectly in keeping with the character of the sitter, who was notorious among his contemporaries for a lack of social and political skill, combined with unrestrained ambition and pretentiousness. The *Mémoires de ma vie* by Charles de Rémusat, a childhood friend of Pastoret, contains a devastating description of Ingres's sitter:

> In general, society judged him harshly. His downfall was his excessive pretension, particularly to qualities and accomplishments that belonged neither to him nor to his times. While pursuing an administrative career, he fancied himself a poet, a man of the world, a gallant knight, and a brave and faithful lover, the very incarnation of the romantic troubadour. But all the while, women found his complexion too ruddy and his legs too fat, and he managed to be a mediocre bureaucrat, a poet for the *Almanach des Muses*, a man of vulgar good fortune, and a social-climbing sycophant.[18]

It was Pastoret's vanity and dubious social and political reputation that dominated discussion of Ingres's portrait when it first went on display at the 1827 Salon.[19] "It seems to me that the artist intended here to compose a *type*, the ideal of a particular kind of character," the critic for *La Pandore* facetiously wrote:

> with his conceited air, his proud head propped up by a stiff cravat, and his dramatic pose, we immediately recognize a person of *importance*. The figure and all his accessories, such as the scroll of paper thrown on the table [*sic*], place us in a diplomatic setting. Who does not recall, in the *Théâtre de Clara Gazul*, the baron Amédée de Pacaret, junior official at the imperial Council of State, residing in Fiouie and charged with keeping an eye on Gypsies and Spaniards? It is he whom I see brought to life in M. Ingres's canvas. He has evidently made his way in the world since the Restoration. A social climber who has forgotten his origins, he seeks to gain his fortune from dowagers. No doubt they had him in mind when they coined the phrase: "A duchess is never older than thirty."[20]

The comments of Auguste Jal—a soldier under Napoleon, who, in marked contrast to Pastoret, had refused to rally to the Bourbons and was therefore forced into premature retirement—were no less bitingly sarcastic. Besides Pastoret's rather bumbling, heavy-handed conservatism, his foppery and literary pretensions were also caricatured by Jal:

> Good-looking, curly-haired, slightly stooped, with proud eyes, he looks a little like David as portrayed by Guido [Reni]. The Goliath he has slain is some liberal argument that strayed into the Council of State; his sling is an oration, weightier than the stone that struck the forehead of the Philistine giant, and from which may the God of Mercy preserve us! M. Amédée de Pastoret has composed a history of the Neapolitan revolution in the time of Mazaniello; the book is full of contradictions, minor points, and *concetti*, and is devoid of thought. It reads as if written under the Regency for the edification of the ladies of the court.[21]

Jal went on to repeat what by 1827 was becoming a critical platitude on the subject of Ingres's paintings, complaining that even though the portrait was beautifully drawn, it was absolutely devoid of life-giving color. In this particular instance, however, the fault was not entirely Ingres's: "What is one to do with hands scrupulously whitened with almond paste, with a face that the sun's ardors have never tanned?"[22]

Some twenty years after its execution, the portrait of Pastoret occasioned one of the more curious episodes in Ingres's colorful career. Early in 1846, in the presence of the artist himself, a certain Monsieur Pommereux unwittingly criticized the work as it hung in Pastoret's residence. This embarrassing incident made its way into the press—an almost inevitable eventuality that Pommereux accused Ingres of instigating. The animosity between the two men escalated, and a duel was declared. King Louis-Philippe himself had to intervene to keep this farcical encounter from taking place.[23] A.C.S.

1. Amédée inherited the title of marquis upon the death of his father in 1840, thus, some fourteen years after Ingres completed this portrait.
2. Angrand and Naef 1970a; Angrand and Naef 1970b.
3. Naef 1977–80, vol. 2 (1978), p. 434, n. 2.
4. For a contemporary account of the Pastoret collection, see Thoré, August 19, 1845.
5. Allusions to this unexecuted project are contained in Ingres's letters to Pastoret; see Angrand and Naef 1970a, pp. 20–21, 23.
6. In a letter dated February 15, 1827, to

Fig. 175. Jacques-Louis David (1748–1825). *Adélaïde de Pastoret*, ca. 1791. Oil on canvas, 52³⁄₈ × 39³⁄₈ in. (133 × 100 cm). Art Institute of Chicago

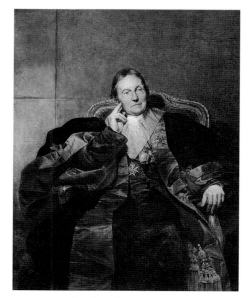

Fig. 176. Paul Delaroche (1797–1856). *Emmanuel de Pastoret*, 1829. Oil on canvas, 61 × 49¼ in. (133 × 100 cm). Museum of Fine Arts, Boston

Pastoret, Ingres discusses providing his "Maecenas" with repetitions of a small *Bather* ("petite baigneuse") and *Raphael and the Fornarina* (fig. 127), as well as a sketch of the picture ("tableau") on which he was currently working (possibly *The Martyrdom of Saint Symphorian* [fig. 169] or, more likely, *The Apotheosis of Homer* [fig. 164]); see Angrand and Naef 1970b, pp. 13–14. In a letter to Marcotte d'Argenteuil dated February 21, 1824, Ingres also mentions a *Virgin and Child* that he was trying to complete for Pastoret in time for the Salon; see Lapauze 1913, p. 1083, and Ternois 1999, letter no. 10. Could this be the lost work, apparently never finished and subsequently defaced by the artist, catalogued by Delaborde (1870, no. 10; W 229) as a "première pensée" (preliminary sketch) for *The Virgin with the Host* (fig. 11)? Whatever the case, Ingres seems to have abandoned this subject for the Pastoret commission in favor of the more iconic *Virgin with the Blue Veil* in São Paulo.

7. "C'est moi qui suis toujours heureux de vous voir possesseur de mes ouvrages, vous que distingue un goût si éclairé et qui m'honorez d'une amitié et d'une bienveillance rares, en toute occasion et dont j'apprécie vivement tout le prix." Ingres to Pastoret, February 15, 1827, quoted in Angrand and Naef 1970b, p. 13.

8. For an overview of Pastoret's administrative career, see Bassan 1969, pp. 27–30.

9. For a list of Pastoret's literary productions, see ibid., pp. 31–32.

10. In a letter dated April 10, 1824, Ingres refers to previous correspondence in which he had thanked Pastoret for the part he played in the artist's election to the Académie; see Angrand and Naef 1970a, p. 22.

11. On this banquet, which took place on June 16, 1841, in the Salle Montesquieu, see Angrand and Naef 1970b, pp. 18–21, and Shelton 1997, pp. 229–45.

12. Daniel Ternois was the first to point out that the age of the count inscribed on the canvas ("Aetat. 32") does not coincide with Pastoret's actual age in 1826. Ternois surmised that the inscription refers to the date when the painting was begun, that is, 1823; see Paris 1967–68, no. 140.

13. Inv. 867.363 and 867.364, respectively. The costume study is almost certainly the same drawing that was exhibited at the Salon des Arts-Unis in Paris in 1861—and not a separate study as suggested by Susan Wise in Chicago 1978, no. 15. See Galichon 1861b, p. 43: "a fine study of M. de Pastoret's left arm. It is repeated twice in black pencil, on violet-colored paper, with a few highlights in white on the cravat. (Height 335 m.; Width 235 mm)" ("une belle étude pour le bras gauche de M. de Pastoret. Il est répété deux fois au crayon noir, sur un papier violet, avec quelques rehauts de blanc à la cravate. [Haut. 335 millim. Larg. 235 millim.]")

14. Angrand and Naef 1970b, pp. 8, 15.

15. In a much-quoted (and perhaps apocryphal) passage from *L'Atelier d'Ingres*, Amaury-Duval recounts that he congratulated Ingres "on having painted a suit whose embroideries did not detract from the head, as a councillor of state's uniform at the time was embroidered with black silk on black. 'If they had been green or blue palms, as on certain official costumes . . .' He cut me off: 'I wouldn't have painted it.'" ("d'avoir eu à peindre un costume dont les broderies ne faisaient aucun tort à la tête, l'habit de conseiller d'État étant alors brodé de soie noire sur noir: 'Si c'eût été des palmes vertes ou bleues, comme à certains costumes officiels . . .' il m'arrêta: 'Je ne l'aurais pas fait.'") Amaury-Duval 1993, pp. 102–3.

16. Pastoret was made commander in the Legion of Honor on August 3, 1824; in 1853 he was elevated to the rank of grand officer by Napoleon III.

17. Rosenblum 1967a, p. 36. More recently, Georges Vigne has argued that Ingres used an architectural detail from Bronzino's portrait in one of his versions of *The Death of Leonardo da Vinci*; Vigne 1995b, p. 183.

18. "Il a, en général, été jugé sévèrement dans le monde. Ce qui l'a perdu, c'est son excessive prétention, particulièrement à des mérites et à des succès qui n'allaient ni à lui ni à sons temps. Ils s'imaginait, tout en courant la carrière de l'administration, d'être un poète, homme du monde, un galant chevalier, un amant fidèle et brave, la réalisation d'un troubadour de romance. Et pendant que les femmes lui trouvaient le teint trop rouge et les jambes trop grosses, il a réussi à être un fonctionnaire médiocre, un poète d'almanach des muses, un homme à vulgaires bonnes fortunes, un courtisan parvenu." Rémusat 1958–67, vol. 1, p. 69, quoted in Angrand and Naef 1970b, p. 16. The *Almanach des Muses* (1765–1833) was a popular literary journal that specialized in the publication of "light" poetry, mostly by second-rate authors.

19. Both of Ingres's portrait submissions, this one and *Madame Marcotte de Sainte-Marie* (cat. no. 97), entered the Salon late. *Pastoret* was hung very prominently in the corner of the Salon Carré near the entrance to the Grande Galerie. See Anon., December 18, 1827a, and Anon., December 18, 1827b.

20. "il me semble que l'artiste a voulu composer ici un type, l'idéal d'un caractère: à cet air avantageux, à cette tête haute que soutient une cravate empesée, à cette pose dramatique on reconnaît d'abord l'*Important*. La figure et tous les accessoires, par exemple ce rouleau de papier jeté sur la table nous transportent dans une atmosphère diplomatique. Qui ne se rappelle, dans le *Théâtre de Clara Gazul*, le baron Amédée de Pacaret, cet auditeur au conseil d'état impérial, résidant en Fiouie, et chargé d'y surveiller la Romano et ses Espagnols? C'est lui que je vois revivre sur la toile de M. Ingres. Sans doute il aura fait son chemin

depuis la restauration. Parvenu oublieux de son origine, il court les bonnes fortunes auprès des douairières; c'est pour lui qu'on a dit ce mot: 'Une duchesse n'a jamais que trente ans.'" Anon., December 18, 1827b. The *Théâtre de Clara Gazul* was a collection of plays, ostensibly by a Spanish actress but in reality penned by the young Prosper Mérimée. One of its characters, baron Amédée de Pacaret, was based on Ingres's sitter. (The surname Pacaret refers to a notorious faux pas that the socially inept Pastoret committed at the table of Louis XVIII.) The final section of the quote refers to the count's equally discreditable amorous adventures; see Bassan 1969, pp. 32–33.

21. "Beau, frisé, penché, l'oeil fier, il a quelque chose du David représenté par le Guide. Le Goliath qu'il a tué, c'est quelque argument libéral égaré au conseil d'État; sa fronde est une oraison, plus lourde que la pierre qui frappa au front le géant philistin et dont le Dieu de bonté veuille vous préserver! *M. Amédée de Pastoret* a fait une histoire de la révolution de Naples au temps de Mazaniello; c'est un livre rempli d'antithèses, de petites pointes, de concetti, et vide de pensées; on le dirait écrit sous la régence pour l'instruction des femmes de la cour." Jal 1828, pp. 291–92. "Un histoire de la révolution de Naples" refers to one of Pastoret's principal literary productions: *Le Duc de Guise à Naples; ou Mémoires sur les révolutions de ce royaume en 1647 et 1648* (1825).

22. "Que voulez-vous qu'on fasse d'après des mains soigneusement blanchies à la pâte d'amande, d'après une figure que les ardeurs du soleil n'ont jamais brunie?" Jal 1828, p. 292. For a less forgiving assessment of Ingres's stylistic mannerisms, see Vergnaud 1828, p. 20: "In these portraits [*Pastoret* and *Madame Marcotte de Sainte-Marie*] are found the anatomical and pretentious drawing style—though always fine, expressive, and accurate—that is characteristic of M. Ingres. The accessories are well handled in the man's portrait, but his face, colored with more attention to detail than to veracity, lacks relief and the breath of life. In these portraits, which some might call *Raphaelized*, we see rounded fingers, rendered with a precious and stuffy technique that seems only to have *Ingresized* Raphael." ("On trouve dans ces portraits le dessin anatomique et prétentieux, quoique toujours fin, expressif et correct, de M. Ingres. Les accessoires sont bien traités dans le portrait d'homme, mais la figure, colorée avec plus de soin que de vérité, manque de relief et de vie. Dans ces portraits, *Raphaëlisés*, dit-on, nous voyons des doigts ronds et d'un faire précieux et compassé qui nous semblent seulement avoir *Ingresié* Raphaël.") This attack on Ingres's portraits is rebutted in Farcy 1828, p. 67.

23. Several accounts of this humorous episode exist. They have been gathered together in Naef 1969 ("Ingres duelliste") and Naef 1974 ("Ingrisme"), p. 38.

PROVENANCE: Amédée-David, marquis de Pastoret (1791–1857); his wife, Louise-Alphonsine de Pastoret (1796–1876); her daughter, Marie, marquise du Plessis-Bellière (1817–1890), Château de Moreuil-en-Picardie; her sale, Hôtel Drouot, Paris, May 10–11, 1897, no. 85; purchased at that sale for Edgar Degas by Durand-Ruel & Cie., Paris, for 8,715.10 francs; Edgar Degas (1834–1917), Paris; his sale, Galerie Georges Petit, Paris, March 26–27, 1918, no. 52; purchased at that sale by David David-Weill, Neuilly, for 90,000 francs; sold by him to Wildenstein & Co., Inc., New York; purchased from them by the Art Institute of Chicago, June 21, 1971

EXHIBITIONS: Paris (Salon) 1827, no. 575; Paris 1855, no. 3371; Paris 1921, no. 25; Paris 1931, no. 46; Paris 1934c, no. 4; Paris 1967–68, no. 140; Paris, Detroit, New York 1974–75, no. 111; Chicago 1978, no. 15; Louisville, Fort Worth, 1983–84, no. 66; New York 1997–98 ([vol. 2], no. 617)

REFERENCES: Anon., December 18, 1827a, p. 927; Anon., December 18, 1827b; Béraud 1827, p. 150; Anon., January 13, 1828, p. 19; Farcy 1828, p. 67; Jal 1828, pp. 291–92; Vergnaud 1828, p. 20; Thoré, August 19, 1845; Anon., March 15, 1846, p. 35; Karr 1846, p. 61; Magimel 1851, no. 49; About 1855, p. 132; Belloy, June 10, 1855; Boiteau d'Ambly 1855, p. 472; Gautier 1855, p. 166; Lacroix 1855, p. 207; Mantz 1855, pp. 225–26; Nadar, September 16, 1855; Perrier 1855, p. 45; Vignon 1855, p. 190; Duval 1856, p. 49; Delaborde 1870, no. 150; Claretie 1873, p. 20; Retaux 1884, p. 191, no. 158; Chennevières 1885, p. 251; Delignières 1890, p. 494; Lapauze 1901, p. 112; Boyer d'Agen 1909, pp. 132–33, 195; Lapauze 1911a, pp. 280–81, ill. p. 257; Henriot 1926–28, vol. 1, pp. 205–8, ill. p. 209; Hourticq 1928, pp. vi, 67, ill.; Giard 1934, p. 166; Malingue 1943, ill. p. 43; Alazard 1950, pp. 84–85, fig. 56; Wildenstein 1954, no. 167, pl. 68; Rosenblum 1967a, p. 36, fig. 48; Bassan 1969, p. 31; Naef 1969 ("Ingres duelliste"); Angrand and Naef 1970b, pp. 8, 15–17, 22; Cunningham 1972, ill. p. 3; Naef 1974 ("Ingrisme"), p. 38; Whiteley 1977, pp. 62–63, ill.; Naef 1977–80, vol. 2 (1978), pp. 434–37, fig. 2; Picon 1980, ill. p. 99; Ternois 1980, pp. 76, 93, 145, no. 178, ill. p. 109; Ternois and Camesasca 1984, no. 119, ill.; Zanni 1990, no. 78, ill.; Amaury-Duval 1993, pp. 102–3; Vigne 1995b, pp. 183, 199, 254, pl. 152

99–101. Louis-François Bertin

99. Louis-François Bertin
1832
Oil on canvas
45⅝ × 37⅜ in. (116 × 95 cm)
Signed and dated upper left: J. INGRES PINXIT. / 1832. [J. Ingres painted (this). / 1832.]
Inscribed upper right: L.-F. BERTIN.
Musée du Louvre, Paris R.F. 1071

W 208

100, 101. Studies for "Louis-François Bertin" (see p. 307)

This portrait is not only Ingres's most famous but also one of the most celebrated likenesses in the history of Western art. Initially hailed as a breathtaking translation into paint of an extraordinary individual, the work quickly came to symbolize the central sociological event of the nineteenth century: the rise to economic and political preeminence of a tenaciously self-made and unapologetically self-satisfied bourgeoisie.

Ingres's sitter, Louis-François Bertin (1766–1841), called "Bertin *l'aîné*" to distinguish him from a younger brother with the same given names, was among the most powerful newspapermen of his age. Although initially enthusiastic about the prospects of 1789, he reacted with horror to the subsequent radicalization of the Revolution and first rose to prominence in the mid-1790s as an anti-Jacobin polemicist.[1] Shortly after Napoleon's coup d'état in November 1799, Bertin, along with his younger brother, Bertin de Vaux, purchased the publication with which his reputation would eventually be made, the *Journal des débats*. The paper's royalist slant proved intolerable to Bonaparte, however, and Bertin was arrested and sent into exile on the island of Elba in 1801. Having received permission to travel to Italy soon after his arrival on the island, he was befriended by other royalist expatriates living on the peninsula, most notably Chateaubriand and the painter François-Xavier Fabre, who executed a portrait of the exiled journalist in 1803 (fig. 177).[2] Illegally reentering France in 1804, Bertin managed to coexist peacefully with the emperor until 1811, when his paper, which had been temporarily renamed the *Journal de l'Empire*, was confiscated by the government, leading to his financial ruin.

It was only with the return of the Bourbons in 1814 that the Bertins regained control of the *Journal des débats*, which, despite its owners' constant political troubles, had become one of the most influential publications of its kind in France. The Restoration did not entirely end the intrigue, however, for an article attacking the policies of the increasingly reactionary Charles X landed Bertin in court once again in August 1829. After having been initially convicted of attacking the king and sentenced to six months in prison, he was acquitted on appeal in a spectacular defeat for the government. With the overthrow of the Bourbons and the ascent to the throne of their more liberal cousin Louis-Philippe the following year, Bertin's lifelong dream of a moderate, constitutional regime seemed finally to have been realized. His newspaper became one of the

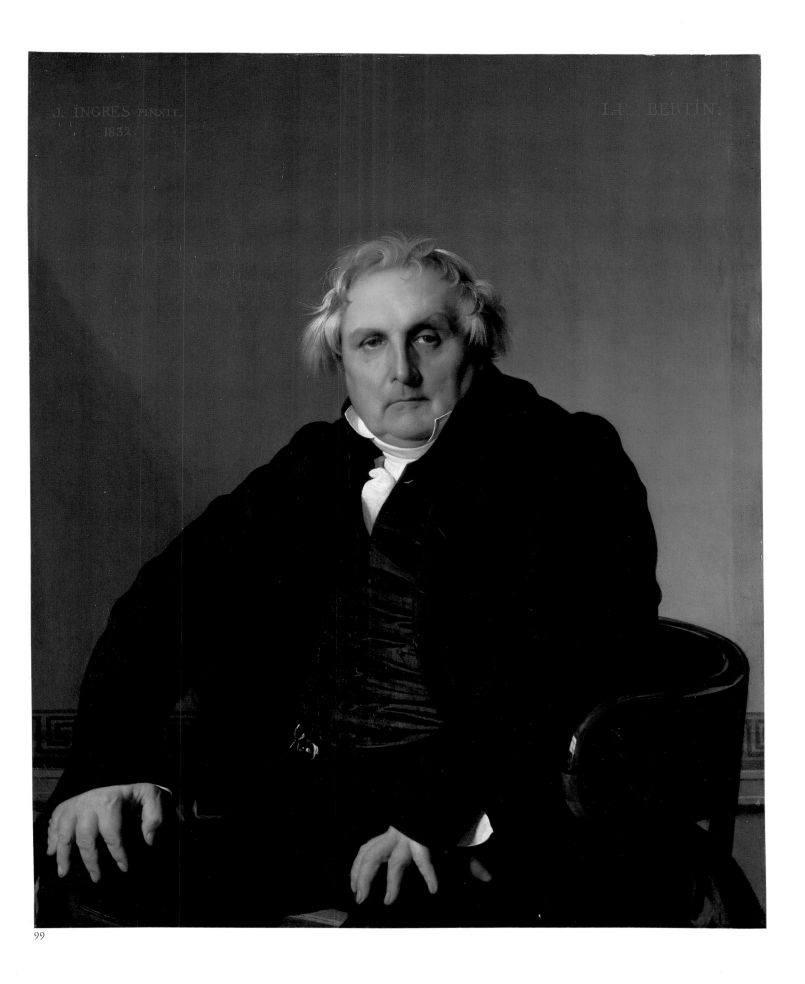

99

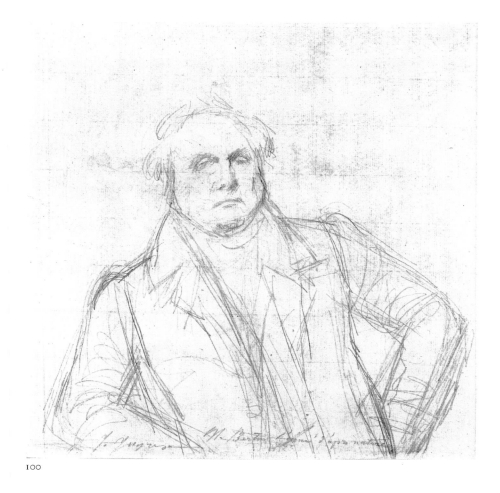

100

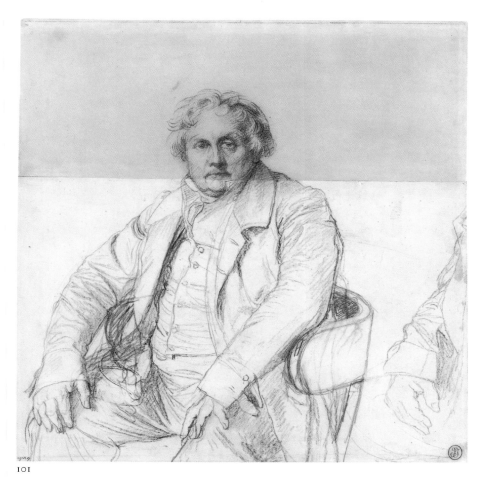

101

most ardent supporters of the new government and the principal mouthpiece of the class that had brought it to power, the economically and politically ascendant *haute bourgeoisie*. Bertin died in September 1841, less than seven years before Louis-Philippe was toppled from the throne during yet another episode of Revolutionary tumult.

It is not known how Ingres first came into contact with Bertin. As Hélène Toussaint has suggested, the two may have met through the journalist's older son, the landscape painter Édouard-François (1797–1871), who studied with Ingres in the late 1820s.[3] The circumstances surrounding the portrait's commission are equally unclear. Henri Delaborde makes the intriguing but unsubstantiated assertion that the work had been undertaken "to keep an already old promise";[4] the historical record is otherwise completely silent on this count.

While details of the portrait's commission remain cloudy, the story of its gestation has become something of an art-historical legend. In the most frequently cited account, Amaury-Duval, who claims to have gotten his information directly from Bertin, tells how Ingres was so distraught by his inability to settle on a final pose for his illustrious sitter that he actually broke down in tears before Bertin. One day, however, in the course of enjoying an outdoor luncheon with Bertin and another, unnamed gentleman, the artist had an epiphany: he caught a glimpse of his sitter in the exact posture we see in the portrait. "Come pose tomorrow," the artist told his long-suffering patron, "your portrait is done."[5]

Subsequent historians have been unable to resist this charming account, even though it exists in at least two different versions. According to Delaborde—who received his information from Frédéric Reiset, director of the Louvre and a friend and important patron of Ingres during the latter part of his career—the decisive moment occurred not during an afternoon luncheon in the open air but rather in the course of a soiree at Bertin's salon. "A political discussion had gotten under way between the master of the house and his two sons," Delaborde writes, "and while

the latter energetically defended their position, M. Bertin listened to them in the posture and with the expression of a man who is not annoyed by contradiction as much as inspired by it to an overarching confidence in the authority of the words he has already spoken or in the eloquence of his forthcoming rejoinder."[6]

It would be futile to speculate which—if, indeed, either—of these two equally authoritative accounts is authentic. It is also unnecessary, since the precise circumstances that prompted Bertin to strike the pose have been less crucial to traditional art-historical readings of the portrait than the fact that he did so of his own volition. For the contention that Bertin spontaneously assumed this pose in the natural milieu of his own garden or salon, and not in response to the directives of the artist in the studio, enhances the illusion that the portrait represents unalloyed truth—lived experience rather than studio-concocted artifice.[7] Of course, this is purely an illusion: whatever the circumstances surrounding Ingres's "discovery" of the pose, the painting remains exquisitely wrought fiction rather than passively observed fact. Indeed, Ingres's alleged whispering of "Come pose tomorrow" into Bertin's ear registers the artist's need to recreate the scene he had just witnessed within the controlled, and patently artificial, world of the atelier.

The compulsion to read this work as a record of unvarnished truth ultimately owes less to the legend surrounding its

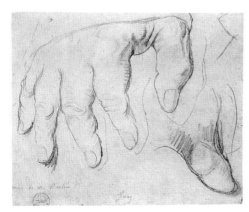

Fig. 179. *Study for "Louis-François Bertin" (Hands)*, ca. 1832. Graphite on tracing paper, 6⅞ × 8⅛ in. (17.6 × 20.6 cm). Fogg Art Museum, Harvard University Art Museums, Cambridge, Massachusetts

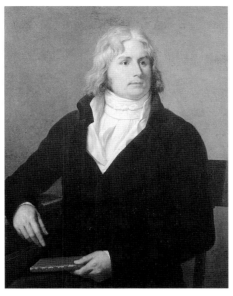

Fig. 177. François Xavier Fabre (1766–1837). *Louis-François Bertin*, 1803. Private collection

generation than to the disarming immediacy of the portrait itself. Bertin sits before the viewer in a gleaming, curved-back mahogany chair.[8] There is otherwise nothing to distract the viewer's attention from his massive frame, which is silhouetted against a nearly featureless blank wall.[9] The aging journalist's impressive bulk is contained with some difficulty by a straining waistcoat and voluminous redingote, the inelegantly jagged outline of which must have severely tested the artist, whose love of long, continuous contours often provoked the most outrageous violations of his sitters' anatomies. Here such distortions are kept to a minimum, there being little to disturb the mesmerizing trompe l'oeil illusionism of the image as a whole. No detail—from the individual strands of Bertin's erratically shorn locks to the tiny reflection of a window on the arm of his chair—has been neglected by the artist. While historians have traditionally regarded such attention to detail as residual of Ingres's youthful enthusiasm for fifteenth-century Northern painters,[10] recent scholarship has suggested that many of the most meticulously treated details in his mature portraits (the famous reflection on Monsieur Bertin's chair not excluded) are actually the work of studio assistants.[11]

While traditional accounts of the painting's spontaneous generation seem

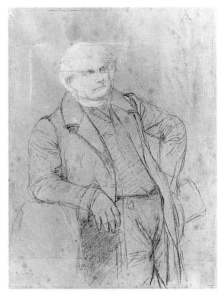

Fig. 178. *Study for "Louis-François Bertin,"* ca. 1832. Charcoal and graphite on paper, 14¾ × 10½ in. (37.6 × 26.7 cm). Musée Ingres, Montauban (1943.853)

apocryphal, the contention that Ingres hesitated over the sitter's pose—an occurrence hardly unusual in his activities as a portraitist—is fully documented by existing preparatory drawings. A pair of sketches (cat. no. 100, fig. 178) show Bertin assuming a more elegant but decidedly less expressive standing position. That Ingres worked with (and, if we are to believe Amaury-Duval, wept over) this pose for a considerable amount of time is suggested by an additional drawing detailing the sitter's right arm and hand.[12] The definitive pose is established in a marvelously energetic drawing in the Metropolitan Museum (cat. no. 101), with details of the hands and legs being worked out in separate sheets in Cambridge (fig. 179) and Montauban, respectively.[13] Closely related to these sketches is an independently produced portrait drawing in the Louvre (fig. 182), in which Bertin assumes a slightly more relaxed, less bristling pose than the one we see in the Metropolitan study and the final canvas.

Shortly after completing the painting, Ingres placed it on view in his studio, initiating a mode of presentation that would become habitual after his renunciation of the Salon two years later. In a letter dated October 30, 1832, to Bertin's daughter Louise, Victor Hugo—who may have seen Ingres working on the portrait during one

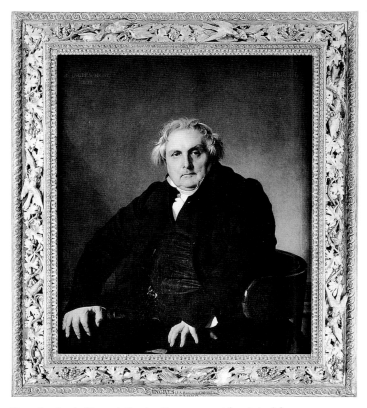

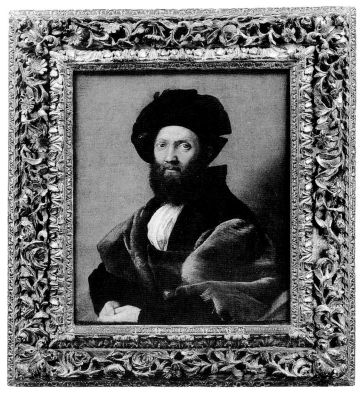

Fig. 180. *Louis-François Bertin.* Cat. no. 99 with original frame

Fig. 181. Raphael (1483–1520). *Baldassare Castiglione,* ca. 1514–15. Oil on canvas, 32¼ × 26⅜ in. (82 × 67 cm). Musée du Louvre, Paris

of his many visits to Bertin's country estate, Les Roches, near Bièvres[14]—inquired about this exhibition.[15] Mademoiselle Bertin may well have been hesitant to respond, since she reportedly disliked the portrait, complaining that Ingres had transformed her father from "a great lord" into "a fat farmer."[16] Others within Ingres's inner circle were more enthusiastic. Amaury-Duval relates an anecdote in which an unnamed admirer scandalized the painter by comparing *Bertin* to a work by Raphael.[17] Another pupil, Raymond Balze, claimed that it was a comparison with Titian that had upset the (falsely) modest artist.[18] The desire to flatter Ingres is less an issue in a letter by Louis Lacuria, one of the painter's least starry-eyed pupils, who described his reaction to the portrait to his former studio mate Hippolyte Flandrin: "Let me tell you that I was ruined, dumbfounded, shattered, when I saw the portrait of M. Bertin de Vaux, when I saw that full and complete obedience to nature, that absolute self-denial by the painter, that brush so completely mastered, I couldn't believe it."[19] The young artist went on to predict, how-

ever, that "people will find the coloring a bit dreary."[20]

Lacuria's reaction was prophetic. When the painting made its official debut at the Salon of 1833, the crowd stood mesmerized before its unrelenting naturalism, while the critics denounced what they regarded as yet another demonstration of Ingres's programmatic disdain of color.[21] And indeed, the portrait is largely monochromatic, its rather dull earthen tonalities being interrupted only by the stark whiteness of the sitter's starched collar and cuffs and the startling detail of a scarlet seat cushion just visible between his rather indecorously spread thighs. Yet such coloristic restraint seems eminently suitable to the personality of the sitter, whose demeanor is as direct and unencumbered as the blank wall behind him. (It is perhaps noteworthy in this regard that Bertin *l'aîné,* unlike his more worldly younger brother Bertin de Vaux, was famously disdainful of social and political honors, having at one point even refused to host Louis-Philippe at his country estate.)[22] The celebrated journalist confidently

returns the viewer's gaze, the note of aggression etched into his emphatically unidealized face being echoed in his no-less-menacing hands (fig. 179), which commentators have likened to everything from the claws of a crab to gurgling intestines.[23]

While many critics in 1833 limited their remarks to purely aesthetic concerns, the social and political significance of the portrait by no means went unmentioned. As I have noted elsewhere in this catalogue (see pages 503–4), several reviewers made reference—both bitingly sarcastic (see fig. 296) and fawningly reverential—to Bertin's storied journalistic and political career. Others, attending more closely to matters at hand, attempted to decode the significance of the journalist's intimidating demeanor in Ingres's portrait. The anonymous critic for the legitimist *Gazette de France,* for instance, regarded Bertin's attitude as epitomizing the rampant opportunism and cynicism characterizing the modern, Orléanist age. "How many things there are in that image!" he exclaimed. "What bitter irony it expresses, what hard-

ened skepticism, sarcasm, and—the word must be said, since it is inscribed in the portrait—what pronounced cynicism!"[24] Inevitably, discussion of the portrait's hyperexpressivity degenerated into parody. The most piquant—if utterly conventional —account of the ferocity with which the corpulent Bertin stared down on unsuspecting visitors from the walls of the exhibition occurs in *Prométhéides*, a satirical review of the 1833 Salon in the form of a long mock-epic poem:

> But what cries of horror
> Emit from the fervent crowd off in the
> corner?
> "How come that big man up there wants
> to hurt me?"
> Cried out a small child, who then tried to
> flee.
> I approach, and all's clear . . . O magical
> force
> Of a subject whose poetry the author well
> understands!
> That larded potbelly, those claws like
> harpoons,
> That back rounder still than the back of a
> spoon,
> That arm that looks more like the grip of
> a jug,
> That brow dull and sallow, that gaze flat
> and smug,
> Cause even the dimmest to judge the
> combats
> And favorite tastes of the father of *Débats*.
> The child, awestruck by the portrait he'd
> spied,
> Must have seen as an ogre our gastro-
> nomic scribe!! . . .
> So bravo, dear Ingres, and remember this
> well:
> That the words of a child the truth often
> tell.
> Later, when France, so thrifty and fertile,
> Sifts through the debris of this century so
> futile,
> Your work will portray him, like a sacred
> book,
> As the pompous exemplar of this honored
> epoch.[25]

The final lines of this passage proved more prescient than their right-wing authors probably intended. When the portrait reappeared in 1846 as part of Ingres's miniretrospective on the boulevard Bonne-Nouvelle, it was recognized as a veritable

icon of the triumphant middle class.[26] By the time it was exhibited again, in 1855, this interpretation had become universal, and the portrait was regarded somewhat nostalgically as a poignant memento of a bygone era—the short-lived "bourgeois" monarchy of Louis-Philippe.[27]

Finally, a word about the portrait's frame (fig. 180), which features an array of fauna clamoring about an undulating grapevine.[28] As several scholars have previously contended,[29] it seems to be original and was probably designed by Ingres himself, who normally took great care in such matters.[30] In their illuminating study of European picture frames, Paul Mitchell and Lynn Roberts relate the selection of this frame for *Bertin* to the long-standing practice in France of placing austere masculine portraits within exuberantly carved frames.[31] Among the most prominent examples of this is Raphael's *Portrait of Baldassare Castiglione* in the Louvre (fig. 181), which has a seventeenth-century frame strikingly similar to Ingres's in featuring a richly carved vine motif.[32] Surely this is not coincidental. In choosing a frame so similar to that on one of Raphael's most celebrated portraits, might Ingres have been declaring his pride in having created an updated, modernized version of the Renaissance masterpiece? Such ambition would also help explain two of the most prominent characteristics of Ingres's portrait—its virtuoso illusionism and uniform brown tonality, both of which are also found in *Baldassare Castiglione*.[33]

A.C.S.

1. For details of Bertin's biography, see Say 1889.
2. Bertin's interest in the arts is further indicated by his purchase of both Fabre's *Judgment of Paris* (1808; Dayton Institute of Art) and Anne-Louis Girodet's *Funeral of Atala* (1808; Musée du Louvre, Paris) after the 1808 Salon; see Ternois 1993, pp. 8–9. In direct anticipation of Ingres (see cat. no. 110, figs. 182–84), Girodet also executed portrait drawings of various members of the Bertin clan; see Bordes 1974, p. 398, n. 20.
3. Toussaint in Paris 1985, p. 71. Ingres's later inclusion in the Bertin social circle was charmingly documented in a group portrait by Victor Mottez (unfortunately destroyed) that originally decorated the salon of Édouard's younger brother, Armand (1801–1854); Foucart 1971.

4. "pour tenir une promesse déjà ancienne"; Delaborde 1870, p. 245.
5. "Venez poser demain . . . votre portrait est fait." Quoted in Amaury-Duval 1993, p. 239.
6. "Une discussion s'était engagée sur les affaires politiques entre le maître de la maison et ses deux fils, et tandis que ceux-ci soutenaient vivement leur opinion, M. Bertin les écoutait dans l'attitude et avec la physionomie d'un homme que la contradiction irrite moins encore qu'elle ne lui inspire un surcroît de confiance dans l'autorité des paroles déjà prononcées par lui ou dans l'éloquence prochaine de sa réplique." Delaborde 1870, pp. 245–46.
7. See, for instance, Ternois 1993, p. 29, which attributes the astounding lifelikeness of the painting to the fact that "Bertin is not posing, he is surprised by the painter's eye." ("Bertin ne tient pas la pose, il est surpris par l'oeil du peintre.")
8. The chair was sold at Nouveau Drouot, Paris, on October 11, 1984; see *La Gazette de l'Hôtel Drouot* 1984, p. 30.
9. Gaeton Picon (1980, p. 100) has ingeniously compared this wall to the gold-leaf backgrounds of Early Renaissance paintings.
10. Daniel Ternois (1993, pp. 39–44) provides the most exhaustive rehearsal of the potential sources for the portrait among the so-called primitive paintings available to Ingres in Paris.
11. On the issue of studio collaboration in Ingres's portraits, pp. 523–42.
12. Private collection; see Paris 1985, no. XIII 3.
13. The sheet in Montauban (inv. 867.204) has a fragmentary draft of a letter to Bertin scrawled on the verso; see Vigne 1995a, no. 2611.
14. See excerpts from Madame Hugo's memoirs quoted in Naef 1977–80, vol. 3 (1979), pp. 120–21.
15. Excerpt from Hugo's letter quoted in Schlenoff 1956, p. 213.
16. "un grand seigneur"; "un gros fermier." Quoted in Say 1889, p. 17.
17. Amaury-Duval 1993, pp. 240–41. That Ingres might well have intended such a comparison is discussed below.
18. Balze 1921, p. 216.
19. "Je vous dirai que j'ai été abymé, confondu, éreinté, quand j'ai vu le portrait de M. Bertin de Vaux, quand j'ai vu cette docilité pleine et entière à la nature, cette abnégation absolue du peintre, ce pinceau maîtrisé si entièrement, je ne pouvais pas le croire." Lacuria to Flandrin, December 10, 1832, quoted in Hardouin-Fugier 1985, p. 44. Here Lacuria, like many contemporary critics, is confused about the sitter's identity (or at least about his name). Bertin de Vaux, cofounder of the *Journal des débats*, was the younger brother of Ingres's model.
20. "on le trouvera un peu triste de couleur." Ibid.

21. The reviewers' repeated complaints about the overall purplish-blue tonality of the painting seem strange in light of its present golden hue. For an explanation of this enigma, we must again turn to Amaury-Duval, who himself admitted having initially been repulsed by the portrait's "purplish tone" ("ton violacé"): "The varnishes that M. Ingres was in the habit of using are not very durable, and light tends to absorb them; oil, on the contrary, turns things yellow, and his older paintings, in losing their purplish tones and taking on a golden cast produced by the effects of time on oil, have benefited, if not in color, at least in overall appearance." ("Les laques dont M. Ingres avait l'habitude de se servir sont de peu de durée, la lumière tend à les absorber; l'huile au contraire jaunit, et ses peintures anciennement faites, en perdant leurs tons violacés et en prenant une teinte dorée par l'action du temps sur l'huile, ont gagné, sinon comme couleur, du moins comme aspect général.") Amaury-Duval 1993, pp. 239–40. Or, as Ingres himself put it more epigrammatically, "Time applies the finishing touches to my works." ("C'est le temps qui se charge de finir mes ouvrages.") Quoted in ibid., p. 240.

22. According to Madame Victor Hugo, as quoted in Naef 1977–80, vol. 3 (1979), p. 120.

23. Waroquier 1959, p. 14: "those crablike claws that are Monsieur Bertin's fingers, emerging from the tenebrous caverns that are the sleeves of his coat" ("les sortes de pinces de crabe que sont les doigts de Monsieur Bertin, sortant des cavernes ténébreuses que sont les manches de son habit"); Nadar, September 16, 1855: "that fantastic bundle of flesh . . . under which, instead of bone and muscle, there can only be intestines; that flatulent hand, which I can hear rumbling!" ("ce fantastique paquet de peaux . . . sous lesquelles au lieu d'os et de muscles, il ne peut y avoir que des intestins, cette main qui a des flattuosités et dont j'entends les borborygmes!") For a provocative analysis of this latter comment in relation to the critical reaction to other anatomical distortions in Ingres's paintings, see Ockman 1995, pp. 85–109.

24. "Que de choses il y a dans cette image! Comme elle exprime une amère ironie, un dur scepticisme, le sarcasme, et il faut bien dire le mot, car il est écrit dans le portrait, un cynisme prononcé!" Anon., May 1, 1833.

25. "Mais quels cris d'épouvante / Partent d'un coin garni d'une foule fervente? /— "Pourquoi ce monsieur-là veut-il m'égratigner?" / S'écrie un jeune enfant qui cherche à s'éloigner. / J'approche, et tout s'explique . . . O puissance magique / D'un sujet dont l'auteur comprend la poétique! / Oui, ce ventru truffé, ces griffes en harpon, / Ce dos plus rebondi que le dos d'un chapon, / Ce bras qui d'une cruche a l'air de former l'anse, / Ce front jaune et boueux, cet oeil sans transparence, / Aux plus inattentifs font juger des ébats / Et des goûts favoris du père des *Débats*. / L'enfant, qu'un tel portrait a dû frapper en somme, / Pour un ogre aura pris l'écrivain gastronome!! . . . / Reçois donc mes bravos, Ingres, et souviens-toi / Que parole d'enfant est article de foi. / Plus tard, lorsque la France économe et fertile / Fouillera les débris de ce siècle futile, / Ton oeuvre lui peindra comme un livre sacré / Le type doctrinaire en ce temps révéré." Auvray and Chatelain 1833, pp. 33–34.

26. For the critical reception of the portrait in 1846, see p. 508. This unabashedly sociological approach to the painting was anticipated in 1833 by the claim of the anonymous reviewer for *L'Artiste* that only Ingres was capable of making a truly epic portrait of the modern bourgeoisie: "It was given to only one man to create an original portrait with the head of a bourgeois of our era. This is because he took that bourgeois as the most elevated example of the class he represents and impressed upon him all the most salient and least vulgar characteristics that personify it. And thus we have the portrait of M. Bertin by M. Ingres." ("Il n'a été donné qu'à un homme de faire un portrait original avec la tête d'un bourgeois de notre époque, c'est qu'il a pris ce bourgeois comme le type le plus élevé de la classe qu'il représente, il lui a imprimé tous les caractères les plus saillans et les moins vulgaires qui la personnifient, et nous avons eu le portrait de M. Bertin par M. Ingres.") See Anon. 1833b, p. 154. This critique and those that followed thirteen years later belie the attempt by Ternois (1993, pp. 55–56) and, to a lesser extent, Hans Naef (1977–80, vol. 3 [1979], p. 115) to depoliticize the painting by claiming that such sociological readings were (inappropriately) imposed on it only later in the nineteenth century.

27. See p. 514.

28. Mitchell and Roberts 1996, pl. 27.

29. Hélène Toussaint in Paris 1985, p. 75, followed by Ternois 1993, p. 48.

30. A series of letters written by Ingres in 1839–40 from Rome to his friends in Paris include instructions on the design of the frames for *Antiochus and Stratonice* and *Odalisque with Slave*; see Ternois 1986a, nos. 23–25, and Boyer d'Agen 1909, p. 298.

31. Mitchell and Roberts 1996, p. 54.

32. Ibid., pl. 26.

33. While Raphael is often mentioned as a source for *Bertin*, it is usually his portrait of Pope Leo X in the Uffizi, Florence, that is cited as the closest analogue; see, for instance, Ternois 1993, p. 43.

Cat. no. 99. *Louis-François Bertin*

PROVENANCE: Louis-François Bertin (1766–1841); bequeathed by him to his daughter Louise Bertin (1805–1877); bequeathed by her to her niece Mme Jules Bapst, née Marie-Louise-Sophie Bertin (1836–1893); bequeathed by her to her daughter Mme Georges Patinot, née Cécile Bapst; purchased from her in 1897 for 80,000 francs by the Musée du Louvre, Paris

EXHIBITIONS: Paris (Salon) 1833, no. 1279; Paris 1846, no. 74; Paris 1855, no. 3372; Paris 1867, no. 84; Paris 1874, no. 257; Paris 1878, no. 802 [EB]; Paris 1883, no. 137; Paris 1934c, no. 147 [EB]; Rome, Milan 1962, no. 107; Montauban 1967, no. 105; Paris 1967–68, no. 156; Paris 1985, no. XIII

REFERENCES: Annet and Trianon 1833, p. 89; Anon. 1833 (C.), p. 402; Anon. 1833a, p. 2; Anon. 1833b, pp. 57, 129–30, 154; Anon., March 1833, p. 93; Anon., March 8, 1833; Anon., March 9, 1833; Anon., March 10, 1833 (D.); Anon., March 10, 1833 (H. H. H.); Anon., March 15, 1833; Anon., March 16, 1833a, p. 248; Anon., March 16, 1833b; Anon., March 17, 1833; Anon., March 24, 1833; Anon., March 28, 1833, p. 45; Anon., March 31, 1833 (D.); Anon., April 3, 1833 (E.); Anon., April 5, 1833, p. 151; Anon., April 14, 1833; Anon., April 20, 1833 (J. H.), p. 212; Anon., May 1, 1833; Anon., May 15, 1833; Aragon 1833, p. 147; Artaud, March 2, 1833; Auvray and Chatelain 1833, pp. 33–34; Cazalès 1833, p. 302; Delécluze, March 3, 1833; Delécluze, March 22, 1833; Desains 1833, pp. 88–91, pl. 46; Farcy 1833, pp. 175–76; Galbacio, March 11, 1833; Gautier 1833, pp. 152–54; Hauréau, March 20, 1833; Jal 1833, pp. 2–4, 9–10, 19–20, 30–31; Laviron and Galbacio 1833, pp. 61–63; Le Go 1833, pp. 211–13; Lenormant 1833, vol. 2, pp. 158–59, 163–66; Maynard 1833, pp. 38, 58, 69, 85; Mennechet 1833, p. 127; Nisard, March 9, 1833; Nisard, April 7, 1833; Philipon, April 11, 1833; Pillet, March 4, 1833; Pillet, March 19, 1833; Planche 1833, pp. 88–91; Raoul, April 24, 1833; Amaury-Duval 1846, pp. 86, 91–92; Anon. 1846, pp. 10, 50, 61–62; Anon., January 12, 1846; Anon., January 15, 1846; Anon., January 30, 1846 (H. M.), p. 236; Anon., February 1846, p. 183; Anon., February 1, 1846 (G. G.), p. 5; Anon., February 1, 1846, p. 1; Anon., February 11, 1846 (C. A. D.); Anon., February 14, 1846, p. 379; Anon., March 8, 1846 (F. C. A.), pp. 41–42; D'Arnaud 1846; Delécluze, January 28, 1846; Jal 1846, pp. 201–2; Jubinal 1846, p. 61; La Fizelière, February 1, 1846; Lagenevais 1846, pp. 534, 538–39; Lenormant 1846, p. 670; Lestelley 1846, pp. 257–58; Mantz 1846, p. 200; Pillet, January 16, 1846; Popeson 1846, p. 246; Ronchaud, February 19, 1846; Thoré 1846, pp. 51, 55; Ver-Huell, January 25, 1846; Magimel 1851, pl. 59; About 1855, pp. 131–32; Anon., September 8, 1855; Belloy, June 10, 1855; Boiteau d'Ambly 1855, p. 472; Calonne 1855, p. 112; Cheron, August 25, 1855; Delécluze, October 27, 1855; Du Camp 1855, pp. 84–85; Du Pays 1855, p. 422; Gautier 1855, p. 164;

Gebauër 1855, pp. 26–27; Guyot de Fère 1855, p. 68; Lacroix 1855, pp. 204, 207, 213; Lavergne, October 25, 1855; Loudun 1855, pp. 121–22, 154; Mantz 1855, pp. 225–26; Mornand 1855, p. 227; Nadar, September 16, 1855; Nibelle 1855, p. 147; Niel, June 17, 1855; Niel, July 15, 1855; Perrier 1855, pp. 44–45; Pesquidoux, September 2, 1855; Petroz, May 30, 1855; Planche 1855, pp. 1141, 1143; Thierry 1855, p. 203; Vignon 1855, p. 190; Duval 1856, p. 49; Delécluze 1862, p. 154; Delaborde 1865, pp. 198, 200; Blanc 1866, pp. 245–46; Anon., April 15, 1867; Castagnary, May 15, 1867; Castagnary, May 18, 1867; Lagrange 1867, p. 67; Leroy, April 17, 1867; Madelène, April 16, 1867; Montrosier, May 9, 1867; Pontmartin 1867, p. 258; Ronchaud 1867, p. 445; Yriarte 1867, p. 235; Heine 1868, pp. 230–31; Blanc 1870, pp. 98–99, 233; Delaborde 1870, pp. 12, 84, no. 108; Goncourt 1893, p. 192; Anon., April 1, 1897, ill. opp. p. 332; Lapauze 1901, p. 113; Momméja 1904, pl. 89; Boyer d'Agen 1909, pp. 302, 509–11, ill. opp. p. 336; Lapauze 1911a, pp. 290–98, ill.; Balze 1921, p. 216; Bérard 1921, pp. 222–24; Fröhlich-Bum 1926, p. 25, pl. XLI; Hourticq 1928, pp. VI, 73, ill.; Fouquet 1930, p. 132; Cassou 1934, p. 163; Pach 1939, pp. 14, 72–75, ill. opp. p. 162; Malingue 1943, p. 11, ill. opp. p. 80; Cassou 1947, pp. 67–68; Courthion 1947–48, vol. 1, pp. 12–13, 191–98, ill. opp. p. 208; Alain 1949, pl. 32; Alazard 1950, pp. 74–75, 85–86, pl. LXIII; Jourdain 1954, fig. 33; Wildenstein 1954, no. 208, pls. 88, 89; Waroquier 1959, p. 14; Schlenoff 1965, pp. 211, 213; Rosenblum 1967a, pp. 134–37, ill.; Ternois 1967, p. 196, fig. 9; Dupouy 1969, pp. 42–43; Florisoone 1969, p. 55; Hugo 1970, p. 884; Delpierre 1975, p. 23; Barousse 1977, pp. 160–61; Whiteley 1977, pp. 68–69, ill.; Naef 1977–80, vol. 3 (1979), pp. 114–15, 118–21, fig. 1; Milhau 1980, p. 116;

Picon 1980, pp. 13, 54, 64, 98–100, 104, 132, ill. p. 55; Ternois 1980, pp. 76–78, 93, 131, 146, 153–54, ill. p. 115; Thévoz 1980, pp. 155–57, ill.; Froidevaux-Flandrin 1984, p. 60; Ternois and Camesasca 1984, no. 124, pl. 39; Boime 1985, p. 64; Hardouin–Fugier 1985, p. 44; Toussaint and Couëssin 1985, p. 202, figs. 16–18; Compin and Roquebert 1986, p. 324, ill.; Baudelaire 1990, pp. 76 (Salon of 1845), 93 (Bonne-Nouvelle), 159 (Salon of 1846); Zanni 1990, no. 83, ill.; Amaury-Duval 1993, pp. 235–40, 339–41, fig. 205; Ternois 1993; Fleckner 1995, pp. 71, 229, fig. 80; Ockman 1995, pp. 80, 97–98, 108–9, fig. 47; Vigne 1995b, pp. 160, 170, 186–89, 196, 250, 254, fig. 156; Mitchell and Roberts 1996, pp. 54–59, pl. 27 (with frame); Wrigley 1998, pp. 145–49, fig. 6.3

Cat. no. 100. *Study for "Louis-François Bertin"*

ca. 1832
Graphite
11 7/8 × 12 3/4 in. (30.3 × 32.5 cm)
Signed lower left: J. Ingres
Inscribed along center bottom: M. Bertin l'aîné d'après nature [M. Bertin the elder from life]
Collection Jan and Marie-Anne Krugier-Poniatowski
New York and Washington only

PROVENANCE: Stephen Richard Currier and Audrey Bruce Currier; their estate sale, Christie's London, April 3, 1984, no. 70; Jan and Marie-Anne Krugier-Poniatowski

EXHIBITIONS: Tübingen, Brussels 1986, no. 42; New York 1988b, no. 25a

REFERENCE: Paris 1985, no. XIII 1, ill.

Cat. no. 101. *Study for "Louis-François Bertin"*

ca. 1832
Black chalk and graphite
13 3/4 × 13 5/8 in. (34.9 × 34.5 cm)
Signed lower left: Ing
Artist's posthumous atelier stamp at lower right (Lugt 1477)
The Metropolitan Museum of Art, New York
Bequest of Grace Rainey Rogers, 1943
43.85.4
New York and Washington only

PROVENANCE: The artist's bequest to his wife, Delphine Ramel (d. 1895), 1867; her bequest to her brother, Albert Ramel (d. 1907); Grace Rainey Rogers (1867–1943), New York; her bequest to The Metropolitan Museum of Art, New York, 1943

EXHIBITIONS: Paris 1921, no. 140; New York 1952–53, no. 68; Paris 1955, no. 82; Paris 1967–68, no. 159; London 1969, no. 296; New York 1970, no. 50; Paris 1973–74, no. 53; New York 1981; New York 1988–89

REFERENCES: Zabel 1930, ill. p. 375; Burroughs 1946, p. 156, ill. p. 157; Tietze 1947, no. 125, ill.; Alazard 1950, pl. LXII; Anon., June 1950, ill. p. 301; Anon., February 1959, ill. p. 167; Bean 1964, no. 65, ill.; Swenson 1966, p. 69; Sérullaz 1967, p. 213; Reff 1976, p. 50, fig. 27; Reff 1977, p. 32, fig. 61; Paris 1985, no. XIII 4, ill.

102. Charlotte-Madeleine Taurel

ca. 1825
Graphite
6⅝ × 5 in. (16.9 × 12.8 cm)
Signed, probably not by the artist, lower right,
over three erased and illegible lines: Ingres Del
[Ingres drew (this)]
At lower left, the Musée du Louvre, Paris,
collection stamp (Lugt 1886a)
Musée du Louvre, Paris
Département des Arts Graphiques RF 4624
New York only

N 294

This drawing is discussed under cat. no. 73.

PROVENANCE: The family of Charlotte-
Madeleine Taurel until 1861, at the latest; Émile
Galichon, Paris, until 1875; his son, Roger
Galichon, Paris, until 1918;* his bequest to the
Musée du Louvre, Paris, 1918

EXHIBITIONS: Paris 1861 (1st ser.), no. 74;
Bordeaux 1865, no. 306; Lille 1866, no. 837; Paris
1867, no. 318; Paris 1913, no. 340; Paris 1919,
no. 289; Versailles 1931, no. 186 [EB]; Zurich
1937, no. 217; Buenos Aires 1939, no. 198; Paris
1957d, no. 90 [EB]

REFERENCES: Delaborde 1861, p. 267; Galichon
1861a, p. 356, ill. opp. p. 356 (the engraving by

Claude-Marie-François Dien); Burty 1865, p. 467;
Blanc 1870, pp. 42–43, 240, ill. p. 38 (the engrav-
ing); Delaborde 1870, no. 418; Taurel 1885,
pp. 15, 18; Both de Tauzia 1888, p. 141; Lapauze
1901, p. 268 (known from the engraving); Boyer
d'Agen 1909, pl. 86 opp. p. 528; Paris, Société de
reproduction de dessins 1909–14, vol. 5 (1913),
pl. [20]; Paris, Musée du Louvre 1919–20, vol. 2,
ill. on pl. 53; Martine 1926, no. 22, ill.; Christoffel
1940, ill. p. 138; Alazard 1942, no. 6, ill.; H. E.
van Gelder 1950, pp. 2–10, fig. 3 (the engraving);
Naef 1965 ("Thévenin und Taurel"), pp. 119–57,
no. 5, fig. 5; Radius and Camesasca 1968, p. 124,
ill.; Ternois and Camesasca 1971, p. 124, ill.; Naef
1977–80, vol. 5 (1980), pp. 84–85, no. 294, ill.

*See the catalogue of the Eugène Lecomte post-
humous sale, Hôtel Drouot, Paris, June 11–13,
1906, no. 19, "attributed to Ingres: *Fillette
caressant un mouton*," sold for 1,700 francs to
R. Lecomte.

103. Madame Marie Marcotte (Marcotte de Sainte-Marie), née Suzanne-Clarisse de Salvaing de Boissieu

ca. 1826

Graphite

12¾ × 9½ in. (32.4 × 24 cm);
10¾ × 8½ in. (27.3 × 21.6 cm), framed
Signed lower right: Ingres Del. [Ingres
drew (this)]

Musée du Louvre, Paris
Département des Arts Graphiques RF 41393
New York only

N 302

The friendship Ingres formed in Rome with Charles Marcotte, called Marcotte d'Argenteuil (see cat. no. 26) would be of inestimable importance to him, both professionally and in his personal life, until the older man's death in 1864. It was only after his return to Paris in 1824 that the painter came to know his friend's mother and numerous siblings, and over the next thirty years or so he produced a whole gallery of portrait drawings of the Marcottes, their spouses, and their children. Charles's

youngest brother, Marie Marcotte, called Marcotte de Sainte-Marie, was clearly eager to own an imposing work from the hand of his new acquaintance—and was willing to pay for it. The portrait of his wife that he commissioned now hangs in the Musée du Louvre (cat. no. 97).

The painting is dated 1826 and thus helps to date this portrait drawing of the same sitter, which Ingres failed to date himself. In both works Madame Marcotte de Sainte-Marie wears the same dress—

obviously the height of fashion—and if she was so attuned to the dictates of haute couture, it is probable that the pencil drawing was executed in the same year. Her pose also is quite similar in the two portraits, clearly suggesting that the pencil drawing was produced as a preliminary study for the painting. Nevertheless, it is by no means merely a sketch; it is as fully finished as any other Ingres pencil portrait and bears his signature.

In his biography of the painter, Henry Lapauze claims that because of this sitter's ill health, Ingres was obliged to use Madame Ingres as the model for the hands in this drawing.[1] Since the biographer does not reveal his sources, it is impossible to verify his last assertion. In the pencil portrait, certainly, the treatment of the sitter's hands is no different from that in countless other portrait drawings. It is true that Madame Marcotte appears to be sickly and that she was by no means a beauty. Yet such considerations only give one added reason to marvel at Ingres's artistry, especially in the drawing. Without flinching

from the truth, but at the same time without overstepping the bounds of tact, he captured in his model's features the essence of a unique human being.

Madame Marcotte had been married only three years when she sat for her portrait. She was born Suzanne-Clarisse de Salvaing de Boissieu in Ingouville (Seine-Inférieure, now Seine-Maritime) in 1803.[2] Her husband, twenty years her senior, had entered the world of financial administration. In 1832 they had a son, Henri, who would leave a number of descendants. The couple appear to have spent their married life in Paris and may have seen Ingres fairly often over the years. In the artist's letters to Marcotte d'Argenteuil he does not mention any special relationship with the pair, though he occasionally asks to be remembered to them. Marie died in a clinic in Passy in 1859,[3] Madame Marcotte in Paris in 1862.[4]

H.N.

For the author's complete text, see Naef 1977–80, vol. 2 (1978), chap. 127 (pp. 503–33).

1. Lapauze 1911a, p. 278.
2. Marriage certificate, Archives de Paris.
3. Death certificate, Archives de Paris.
4. Inscription on a tomb in the family plot at Père Lachaise cemetery, Paris.

PROVENANCE: Marie Marcotte de Sainte-Marie (1783–1859), Paris, until 1859; his widow, née Suzanne-Clarisse de Salvaing de Boissieu (1803–1862), Paris; their son, Henri Marcotte de Sainte-Marie, until sometime after 1917; his son, Joseph Marcotte de Sainte-Marie, Paris, until 1942; his widow, née Madeleine Neveu-Lemaire, Paris, before 1969; her grandson Hubert Marcotte de Sainte-Marie; purchased by the Musée du Louvre, Paris, 1987

EXHIBITIONS: Paris 1934c, no. 27; Brussels 1936, no. 16; Paris 1985, no. XII 1, ill.; Paris 1990, no. 181, ill.

REFERENCES: Delaborde 1870, no. 411 (mentions a note by Ingres dating the portrait about 1824); Lapauze 1911a, p. 278, ill. p. 261; Hourticq 1928, ill. on pl. 66; Alazard 1950, p. 84, n. 32, p. 149; Naef 1958 ("Marcotte Family"), pp. 336–45, fig. 6; Ternois 1959a, preceding no. 119, and see also no. 120, ill.; Naef 1977–80, vol. 5 (1980), pp. 98–99, no. 302, ill.

104. Dr. Louis Martinet

1826
Graphite
$12\frac{11}{16} \times 9\frac{3}{4}$ in. (32.3 × 24.7 cm)
Signed, dated, and inscribed lower right: Ingres à Son cher Docteur / et ami. 1826. [Ingres for his dear doctor / and friend. 1826.]
National Gallery of Art, Washington, D.C. Collection of Mr. and Mrs. Paul Mellon
1995.47.50
Washington and London only

N 306

Dictionaries of medical biography relate that Louis Martinet was born in Paris in 1795, received his medical degree in 1818, accompanied Prince Francisco Borghese to Italy as his personal physician in 1821–22, became director of the faculty clinic at the Hôtel-Dieu in Paris, served as editor of the *Revue médicale,* contributed numerous articles to that journal and others, was a chevalier in the Legion of Honor, and died in Vannes, in Brittany, in 1875.[1] They do not explain why the doctor chose to spend his last days in Vannes after such a long and distinguished career in Paris. That information is contained in a letter written by Dr. Glosmadeuc, of Vannes, to the *Union médicale* on the day of Martinet's death:

Let us go back to the year 1826. Dr. Martinet is thirty years old, at the height of his maturity and talent, already known in the scientific world for his important

work and for his position as editor-in-chief of the *Revue médicale.* He is senior hospital lecturer at the Hôtel-Dieu and a friend of Récamier.[2] *In illo tempore,* a great lady, of established nobility, the marquise de Querroent [*sic,* for Querhoent], developed a malignant tumor in her breast. They summoned Récamier. The latter, unable to attend, sent in his place his senior lecturer, Martinet, who arrived in Vannes and convinced the noblewoman to make the journey to Paris, where she could be treated by Récamier and Lisfranc.[3] Doctor Martinet was in charge of the daily changing of bandages. The marquise had with her her young daughter, a charming girl of nineteen. You can imagine what happened. The two young people fell in love. The girl's mother died after several months, and she returned to her family in Vannes. Having been given the young woman's pledge, Martinet soon made a first request

for her hand in marriage. Her father, the old marquis, refused: a gentleman of his lineage does not give his daughter's hand to the son of a simple *paulmier* [tennis instructor]. Martinet and the young lady held fast for several years, and returned to the attack more than once; but the marquis would not budge. Finally, after three years, Dr. Martinet released the girl from her promise, and this time, according to her father's wishes, she married a gentleman, M. de K———.

Now we'll jump ahead some fifty years, to about 1875. The fresh young girl of 1826 has become an old dowager, thick-set and jowly, a widow for many years, living in Vannes, alone and with almost no family.

Throughout his long career, Dr. Martinet had never forgotten the young lady to whom he declared his love in 1826, under the lindens and oak trees of the Château de Limoges. In these latter years, there came a day when the old doctor, pushed by who knows what fantasy, liquidated his modest holdings, sold his furniture, packed up his collection of paintings, left Paris, and dropped like a bomb on Vannes, where he would live from then on. He chose lodgings just opposite the window of the widow de K———, and it was there that he, now in his eighties, intended to live for several years more—what am I saying? It was there that he firmly hoped to convince his old beloved to take him as a husband.[4]

Strangely, the childless Dr. Martinet did not present the great love of his life with his precious portrait by Ingres, executed in the year they met, but gave it to a colleague, Dr. Auguste Goupil. One can only speculate how the work came to be produced in the first place. The dedication "à son cher docteur et ami" would suggest that Ingres was moved to create it out of friendship. It is possible that the two men had met in Florence at the time the young doctor was touring Italy with Prince Borghese. Martinet's close friend and colleague Berlinghieri[5] worked in nearby Pisa, and since Ingres made portrait drawings of two doctors in Florence,[6] he must have moved in medical circles there. A further link between artist and sitter, whether in those early years or later, was the Italian engraver Luigi Calamatta (see cat. no. 105). Ingres had come to know

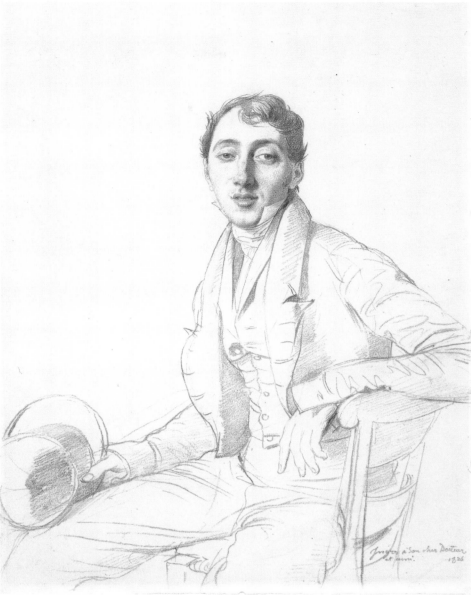

104

Calamatta in Rome, and their paths had crossed again in Florence. Once Ingres was back in Paris, the two became close friends. It can hardly be a coincidence that, in 1835, Calamatta produced a lithograph of Ingres's Martinet portrait and that his once famous engraving after the *Mona Lisa* hung in the doctor's bedroom in Vannes. The friendship between the engraver and the doctor is attested by the fact that Martinet served as one of the witnesses at Calamatta's marriage in 1840. It is also worthy of mention that Ingres included Dr. Martinet in the list of addresses he kept in his Notebook X.[7]

H.N.

For the author's complete text, see Naef

1977–80, vol. 2 (1978), chap. 130 (pp. 554–58).

1. Haberling, Hübotter, and Vierordt 1932, vol. 4, pp. 97–98; Vapereau 1880, p. 1244.
2. Dr. Joseph-Claude-Anthelme de Récamier.
3. Dr. Jacques Lisfranc de Saint-Martin.
4. Dr. Glosmadeuc's letter was reprinted in a Paris newspaper two months after Martinet's death. Caffe 1875, pp. 158–60; reprinted in Naef 1977–80, vol. 2 (1978), pp. 555–56.
5. Andrea Vacca Berlinghieri (1772–1826).
6. *The Cosimo Andrea Lazzerini Family* (cat. no. 90) and *Louis Foureau de Beauregard* (N 250; Musée Bonnat, Bayonne).
7. Fol. 35v: "Dʳ Martinet. anjou Sᵗ honoré 76."

PROVENANCE: Louis Martinet (1795–1875); presented by him to the physician Goupil (presumably Dr. Auguste Goupil) before 1870; Dr. Goupil, Paris, until 1877; possibly sold at

auction in France;* by 1903, Arthur Veil-Picard, Paris, until 1944; his son Arthur Veil-Picard, Paris; purchased from him in 1954 by the Georges Seligman gallery, New York; sold by them in 1954 to Mr. and Mrs. Paul Mellon, Upperville, Va.; their gift to the National Gallery of Art, Washington, D.C., 1995

REFERENCES: Blanc 1870, p. 246 (known from the lithograph by Luigi Calamatta, 1835); Delaborde 1870, no. 372 (catalogued from the lithograph); Corbucci 1886, no. 94 (known from the lithograph); Lapauze 1901, p. 267 (known from the lithograph); Lapauze 1903, p. 24, no. 70, ill.; Lapauze 1911a, p. 286, ill. p. 251 (the lithograph); Naef 1971 ("Doktor Martinet"), pp. 17–21, ill.; Naef 1977–80, vol. 5 (1980), pp. 106–7, no. 306, ill.

*No. 118 (clipping from the catalogue on the back of the old mount).

105. Luigi Calamatta

1828

Graphite

11 × 9 in. (28.1 × 22.9 cm), framed

Signed and dated lower left: Ingres à Son / ami / Calamatta. / 1828. / Paris. [Ingres for his / friend / Calamatta. / 1828. / Paris.]

Musée de la Vie Romantique, Paris D 89.63

Washington only

N 313

The bond linking Ingres and the famous engraver Luigi Calamatta is nicely characterized in an essay published in the *Gazette des beaux-arts* shortly after the latter's death. It was written by Charles Blanc, who began his career as a pupil of Calamatta and who published a monograph on Ingres that is still of importance today. His memorial to his former teacher begins:

> Standing beside any strong figure, there is always someone who loves and understands him well enough to make others love him, or at least understand him. Great artists in particular have found the interpreters they deserved. Every master has had such an interpreter, and one thing that has often been noted is that the great painters' truest engravers have almost always been their contemporaries, [who] therefore have been able to receive their inspiration directly from the artist whose works they were meant to diffuse and whose glory they set out to popularize.
>
> Next to Raphael, in his studio and before his eyes, Marcantonio[1] engraved plates whose lines were retouched by Raphael himself. Titian disciplined the burin of Cornelis Cort, whom he lodged in his own home and whose work he guided. Martin[o] Rota published his print *The Last Judgment* very soon after the death of Michelangelo. . . . Finally, Calamatta as engraver of *The Vow of Louis XIII* was for Ingres the most faithful of interpreters, the most perfect of engravers.
>
> Yes, Ingres and Calamatta were meant for each other.[2]

Calamatta was born in 1801 in Civitavecchia, near Rome. His father, originally from Malta, was employed there as port engineer. The boy was orphaned when only two,[3] and just how he came to be steered toward art and ended up in Rome is unknown. That he knew Ingres's work while still in his teens is attested by an engraving, said to have been executed about 1818, after an Ingres composition, *Saint Fidèle, Martyr*, now lost.[4]

In 1818 the engraver André-Benoît Barreau Taurel arrived at the Villa Medici and became a pensioner. The following year, he would be immortalized in an Ingres portrait drawing (cat. no. 84), presented to him on the occasion of his marriage to the adopted daughter of the director of the Académie, Charles Thévenin (see cat. no. 73). Taurel was greatly gifted, and with this new connection to Thévenin his future was assured. It is thus perfectly conceivable that while still enjoying his scholarship he had more commissions than he could handle. In any case, Calamatta's biographer relates that Taurel engaged the eager young Luigi as an assistant.[5] When Taurel left Rome in the spring of 1823 to return to Paris, he proposed to Calamatta that he come along. The younger man agreed, and during a stopover in Florence, thanks to Taurel he must have become more closely acquainted with Ingres, who had settled there three years before.

Ingres returned to Paris himself the following year, bringing with him the painting that would become the sensation of the 1824 Salon and change his life. He stayed for some months with Calamatta and Taurel on the rue du Bac, until his induction into the Legion of Honor and the Institut de France in the following year put an end to his material worries. The painting in question, his *Vow of Louis XIII* (fig. 146) was hung in the cathedral at Montauban in 1826, by which time Calamatta had executed a drawing of it that was widely admired—especially by Ingres

himself. With that drawing as a basis, he set to work on an engraving of the composition financed by Ingres's good friend Charles Marcotte. The work was completed more than ten years later, in 1837, earning its engraver all the acclaim he could have hoped for. He was promptly invited by the Belgian government to establish and direct a school of engraving in Brussels. In 1840 Calamatta married Joséphine Raoul-Rochette, a granddaughter of the sculptor Jean-Antoine Houdon and daughter of the well-known archaeologist Désiré Raoul-Rochette. One of the witnesses to the ceremony was Dr. Louis Martinet,[6] whose portrait by Ingres (cat. no. 104) was long known only from Calamatta's lithograph of it. The marriage turned out to be a disaster, but not before a daughter, Lina, was born, who grew up in the custody of her father.

Ingres was not the only celebrity to figure in Calamatta's biography. In 1836 the engraver was asked to make a print of George Sand's portrait by Delacroix. The writer was delighted with it and immediately began to take a lively interest in the artist's welfare. A close friendship developed, one that naturally included young Lina, whom Sand adored. It is not surprising, then, that the man Lina married, in 1862, was the novelist's son, Maurice Dudevant Sand.

Calamatta spent his last days in his beloved Italy, where he died in 1869. Vittorio Corbucci's catalogue of his works lists no fewer than eighteen engravings and one lithograph after compositions by Ingres.[7] Sixteenth on the list is an engraving of this drawing by Ingres of his friend Calamatta, described there as the work of David-Joseph Desvachez, but undoubtedly executed with Calamatta's collaboration.[8]

In a private collection in Paris there is a pencil copy of Ingres's portrait of Calamatta by an unknown hand, but the drawing does not conform to the original in its internal measurements.[9]

H.N.

For the author's complete text, see Naef 1977–80, vol. 2 (1978), chap. 131 (pp. 559–72).
1. Marcantonio Raimondi (ca. 1480–ca. 1534).
2. Blanc 1869, p. 97; reprinted in Naef 1977–80, vol. 2 (1978), p. 559.

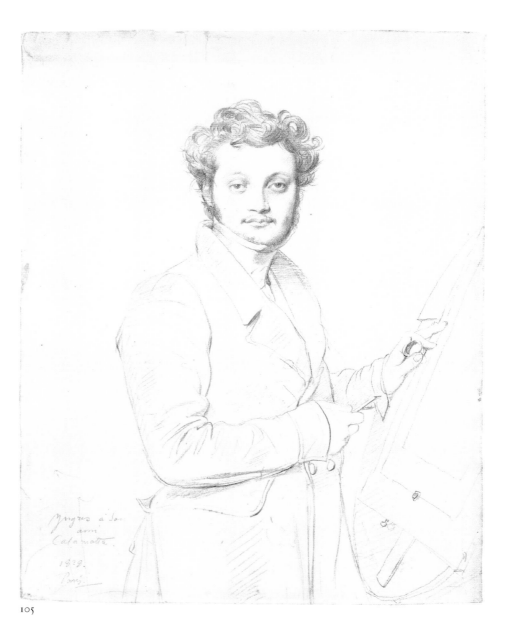

105

3. Calamatta's marriage certificate, Archives de Paris.
4. Alvin 1882, p. 233, no. 2; Corbucci 1886, p. 179, n. 2.
5. Corbucci 1886, p. 33.
6. Calamatta's marriage certificate, Archives de Paris.
7. Corbucci 1886, pp. 179–87.
8. See Naef 1977–80, vol. 2 (1978), p. 571.
9. It measures 12 1/16 × 9 9/16 in. (31.9 × 24.3 cm), framed. Ibid., p. 572, fig. 2. See also Hourticq 1928, ill. on pl. 68; and Paris 1934c, no. 28 (erroneously catalogued as the Ingres portrait).

PROVENANCE: Luigi Calamatta (1801–1869); his widow, née Joséphine Raoul-Rochette, Paris, until 1893; their daughter, Mme Maurice Dudevant Sand, née Lina Calamatta, Paris, until 1901; her daughter, Mme Frédéric Lauth, née Aurore Dudevant Sand, Nohant; her gift in 1923 to the Musée Carnavalet, Paris; on deposit at the Musée de la Vie Romantique, Paris, since 1983

EXHIBITIONS: Paris 1911, no. 133; Paris 1946b, no. 182

REFERENCES: Blanc 1870, p. 246 (listed on the basis of the engraving by David-Joseph Desvachez); Delaborde 1870, no. 266 (catalogued on the basis of the engraving); Lapauze 1901, p. 265 (known from the engraving); Lapauze 1903, no. 8, ill.; Lapauze 1911a, p. 286, ill. p. 271; Paris, Musée Carnavalet 1928, p. 51; Delpierre 1954, p. 33, n. 178, ill. p. 33; Naef 1971 ("Doktor Martinet"), p. 20, ill.; Naef 1974 ("Fanny Hensel"), p. 22, n. 8; Naef 1977–80, vol. 5 (1980), pp. 120–121, no. 313, ill.; Ternois 1980, p. 65, ill.

106. Madame Louis-François Godinot, née Victoire-Pauline Thiollière de l'Isle

1829
Graphite
8½ × 6½ in. (21.9 × 16.5 cm)
Inscribed lower right: Ingres Del [Ingres drew (this)]
André Bromberg

Victoire-Pauline Thiollière de l'Isle (1804–1869) married Louis-François Godinot (1795–1876), scion of an ancient family of silk merchants, at Saint-Étienne, near Lyons, on March 21, 1827. According to family tradition the couple traveled to Rome on their wedding trip and Ingres, who had met Godinot on an earlier visit to the Eternal City, offered this portrait as a wedding gift; however, Ingres was living in Paris at the time. Since the young Godinots lived in Lyons, it is more likely that they met Ingres through a mutual friend, perhaps Hippolyte or Paul Flandrin

(see cat. nos. 155, 158), or another of the artist's pupils from Lyons.

Still on its original mount, this beautiful drawing only recently reappeared at a sale in 1990. Previously unknown to art historians, it was not included in Hans Naef's great compendium of Ingres's portrait drawings. G.T.

PROVENANCE: Mme Louis-François Godinot, née Victoire-Pauline Thiollière de l'Isle (1804–1869); her family until 1990; sale, Drouot Montaigne, Paris, March 20, 1990, no. 2; André Bromberg, Paris

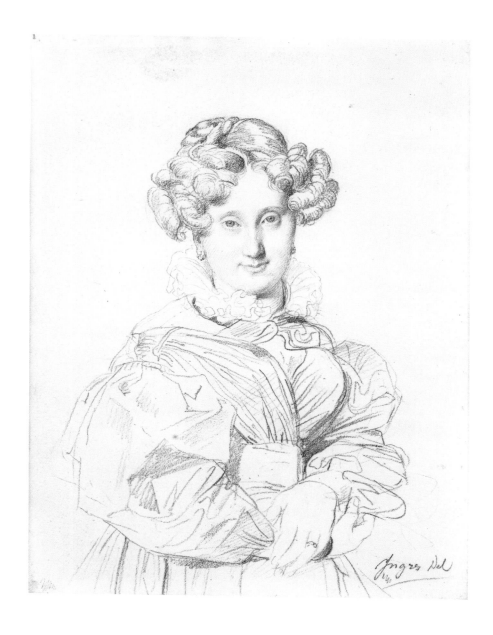

107. Pierre-Marie-François de Sales Baillot

August 25, 1829

Graphite

14 × 10¾ in. (35.4 × 27.3 cm), framed

Signed, dated, and inscribed lower left: Ingres Delin,^{vit} / en hommage / a Madame Baillot. / 25 aoust 1829. [Ingres (drew this) / in homage / to Madame Baillot. / August 25, 1829.]

The score on the music stand is inscribed: moz[art] / Qartet

Prat Collection, Paris

N 323

To appreciate the depth of Ingres's feeling for music and his views on musical performance, it is useful to study his relationship with Pierre Baillot, whom he eulogized as "the Poussin of the violin." Everything about the man confirmed Ingres in his belief that art and life are meant to enrich each other.

Baillot was born in Passy in 1771. His musical gift was evident in early childhood, and his father, a lawyer, saw to it that he was given violin lessons beginning at the age of seven. At ten, the boy happened to hear one of the first Paris performances of Giambattista Viotti, an experience that made him determined to strive for nothing less than perfection. Attaining it would be a struggle, for in the following year Baillot lost his father and, with him, his support. He was taken in by a magistrate who managed to give him a year's study in Rome with Pollani, who had been a pupil of Pietro Nardini and was an excellent musician, but that would be the end of his formal training.

Left on his own when the Revolution removed his guardian from office, Baillot had no choice but to try to make his way in Paris. There, he auditioned for Viotti, then director of the Théâtre Feydeau, who praised his playing and engaged him for the orchestra. But the theater was closed five months later, and the violinist was obliged to accept a clerical position in the civil service. Even then, as he would during the twenty months of his military service, he continued to devote all his spare time to the violin. Only after his discharge from the army did he finally risk a public Paris recital.

His concert was so well received that others followed, and though he was now convinced that he could support himself with his music and resigned from his clerical job, he had no desire to become a mere virtuoso. In 1795 he was asked to fill in for the famous violinist Pierre Rode at the Paris Conservatoire, where, with Rode and Rodolphe Kreutzer, he was commissioned to write the text on the violin method that would be taught at the school for decades. From then on, he managed to maintain a balance between teaching and performance that he felt was beneficial to both endeavors. Only once did he upset that balance by agreeing to make a concert tour of Russia. Though he was everywhere acclaimed, the experience convinced him that such a life was not for him. His only positive memories of the three-year undertaking were of brief meetings in Vienna, on his eastward journey in 1805, with both Haydn and Beethoven.[1]

By the time Ingres returned to Paris in 1824, Baillot's reputation was immense, and it was only natural that the artist for whom music was as necessary as breathing

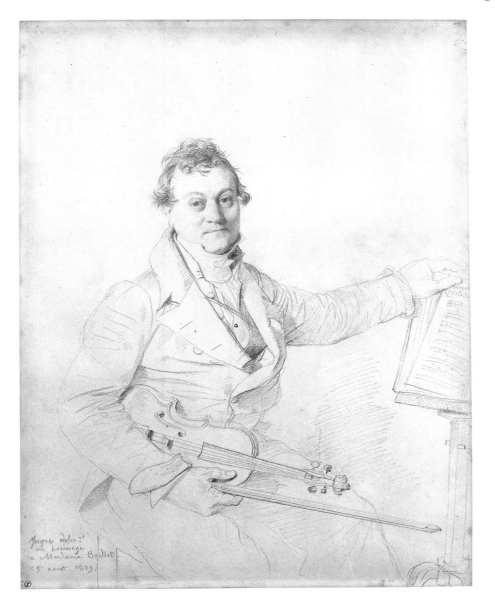

should have fallen under his spell. A first expression of Ingres's great admiration for Baillot is found in a letter of 1827 to his friend Jean-François Gilibert: "I attended a musical soiree of quartets by Baillot. What he played is beyond compare, as is the man himself: he is sublime."[2]

A letter from the artist to Baillot himself in August 1828 makes it clear that Ingres had meanwhile become personally acquainted with the violinist: "The value I place on the respect with which you honor me is infinite, for nothing can compare with a man of your character and admirable talent."[3]

In the following year, Ingres drew this deeply felt portrait of Baillot, and from its dedication it is obvious that the two had become good friends. The work was executed for Baillot's wife and presented to her on her birthday. With his precious gift Ingres enclosed the following lines:

Would you be so good as to present to Madame Baillot, whose birthday we have the honor of celebrating, this attempt I have made to draw your portrait. If only it were better. It would fulfill our intentions toward Mme. Baillot, whom we love with all our heart, and would better corroborate the immense admiration that I have for you personally, which nothing can properly convey.

It is with such sentiments that I have the privilege, Monsieur, of being your very humble and honored friend.[4]

As a performer, Baillot was very different from Niccolò Paganini (see cat. nos. 82, 83). Whereas the latter exploited the works of the masters as a means to display his skill, Baillot approached them with humility, subordinating his own personality to the spirit of the composer. This was what made him Ingres's favorite interpreter, and when Baillot died, in 1842, there was no one more devastated by the news than his portraitist, who wrote to Gilibert: "And that great and worthy artist, the Poussin of the violin, has succumbed, and it's the modern world that killed him. Farewell, farewell, divine performer of Boccherini, Haydn, Mozart, Beethoven. From now on, we will hear him only in memory."[5]

The portrait was engraved by Achille Réveil in 1851. H.N.

For the author's complete text, see Naef 1977–80, vol. 3 (1979), chap. 137 (pp. 58–65).
1. Baillot 1864, pp. 349–50.
2. Ingres to Gilibert, February 19, 1827, in Boyer d'Agen 1909, p. 192; reprinted in Naef 1977–80, vol. 3 (1979), p. 61.
3. Ingres to Baillot, August 20, 1828, quoted in Lapauze 1911a, p. 287; reprinted in Naef

1977–80, vol. 3 (1979), p. 61.
4. Ingres to Baillot, August 25, 1829, quoted in Lapauze 1911a, p. 288; reprinted in Naef 1977–80, vol. 3 (1979), p. 61.
5. Ingres to Jean-François Gilibert, October 30, 1842, in Boyer d'Agen 1909, p. 352; reprinted in Naef 1977–80, vol. 3 (1979), p. 65.

PROVENANCE: Mme Pierre-Marie-François de Sales Baillot, née Antoinette-Louise Raincour, until 1842–45; her son, Paul-René Baillot, Paris, until 1889; his son René Baillot; purchased from him before 1888 by his cousin Julien Sauzay, Paris, until 1909; his widow, née Mathilde Petit de Joly, until 1927; her daughter Mme Georges Lainé, née Pauline-Marie-Henriette Sauzay, Paris, until 1976; her son Daniel Lainé; Prat Collection

EXHIBITIONS: Paris 1867, no. 545; Paris 1913, no. 348; Paris 1988, no. 271, ill.

REFERENCES: Magimel 1851, no. 56, ill. (the engraving by Achille Réveil); Mirecourt 1855, p. 73, n. 1; Silvestre 1856, p. 36; Gautier 1857, p. 6; Saglio 1857, p. 78; Merson and Bellier de la Chavignerie 1867, pp. 21, 112; Blanc 1870, p. 235; Delaborde 1870, no. 251; Montrosier 1882, p. 16; *Baillot* n.d., p. [4]; Both de Tauzia 1888, p. 141; Jouin 1888, p. 6; Lapauze 1901, p. 264 (known from the engraving); Lapauze 1911a, pp. 286, 287–88, 368, ill. p. 276; Hourticq 1928, ill. on pl. 71; Zabel 1929, p. 111; Soccanne 1938a, p. 744; Soccanne 1938b, p. 41, ill.; *Encyclopédie de la musique* 1958–61, vol. 1 (1958), ill. p. 333 (detail); Kemp 1970, pp. 57, 61–62, fig. 5; Naef 1977–80, vol. 5 (1980), pp. 140–41, no. 323, ill.; *La Chronique des arts* 1990, p. 22, ill.

108. Madame Jean-Auguste-Dominique Ingres, née Madeleine Chapelle

ca. 1829
Graphite
8¼ × 6⅛ in. (21 × 15.6 cm)
Inscribed lower right, in Ingres's hand, in the name of the sitter: Madame Ingres / à Sa bonne amie Madame Thomeguex [Madame Ingres / for her good friend Madame Thomeguex]
Signed lower right: Ingres
Prat Collection, Paris

N 324

This drawing is discussed under cat. no. 36.

PROVENANCE: Mme Pyrame Thomeguex, née Jeanne Gonin (1787–1842), Florence; probably her son Antoine Thomeguex, Bellevue, near Geneva, until 1899; Baron Joseph Vitta Collection from 1911 to 1931; the dealer R. Langton Douglas, London; offered by him to Dr. Oskar Reinhart, Winterthur, Switzerland, 1939; Mrs. R. Langton Douglas; purchased from her in 1947 by Joseph T. Ryerson, New York, until about 1950; his widow, née Annie L. N——, later Mrs.

Hugh N. Kirkland, Santa Barbara, Calif.; Prat Collection, Paris

EXHIBITIONS: Paris 1911, no. 122; Nice 1931, no. 16, as *Mme Gonin;* San Francisco 1947, no. 13; Santa Barbara 1964, no. 21; Cambridge (Mass.) 1967, no. 64, ill.

REFERENCES: Naef 1955 ("westschweizerischen Freunde"), p. 18; Naef 1966 ("Gonin, Thomeguex et Guerber"), p. 144, fig. 7, p. 131; Mongan 1969, p. 148; Naef 1977–80, vol. 5 (1980), pp. 142–43, no. 324, ill.

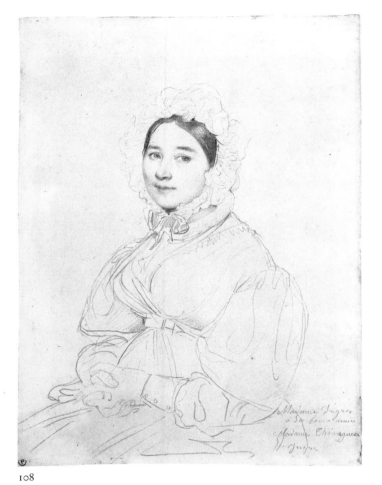

108

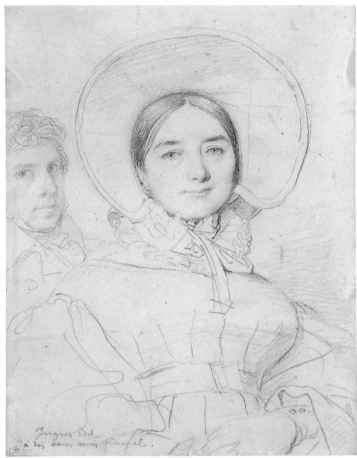

109

109. Madame Jean-Auguste-Dominique Ingres, née Madeleine Chapelle

1830
Graphite
7 3/8 × 5 1/8 in. (18.7 × 13 cm)
Signed and dated lower left: Ingres Del / à Ses
bons amis Taurel. / 1830. [Ingres drew (this) /
for his good friends the Taurels. / 1830.]
Private collection

N 328

This drawing is discussed under cat.
no. 36.

PROVENANCE: André-Benoît Barreau Taurel
(1794–1859) and his wife, née Henriette-Ursule
Claire (ca. 1794–1836), Amsterdam; presumably
their descendants in Holland; by 1870 at the latest,
Hippolyte Destailleur, Paris, until 1893; his post-
humous sale, Hôtel Drouot, Paris, May 19–23,
1896, no. 797 bis, sold for 4,050 francs; Comtesse
de Behague, Paris, by 1921 at the latest; her sale,
Sotheby's, London, June 29, 1926, no. 99; pur-
chased at that sale for 300 pounds sterling by
Colnaghi & Co., London; purchased from them
by M. Knoedler & Co., June 30, 1926; purchased
from them by George F. Baker in New York,
February 1928; his widow, née Edith Kane, Locust
Valley, N.Y.; her posthumous sale, Sotheby
Parke Bernet, New York, October 28–29, 1977,
no. 264; sold at that auction to Galerie Baskett &
Day, London; purchased from them by Mrs.

Sally Aall, New York, by 1978 at the latest;
private collection

EXHIBITIONS: Paris 1921, no. 224, as *Portrait
de Mme Ingres, née Ramel;* Cleveland 1927; New
York 1961, no. 38, ill.; Cambridge (Mass.) 1967,
no. 67, ill.

REFERENCES: Delaborde 1870, no. 336;
Gatteaux 1873 (1st ser.), ill. on pl. 11; Gatteaux 1875,
no. 23, ill.; Taurel 1885, p. 15; Duplessis 1896,
no. 16, ill. (photogravure by E. Charreyre);
Lapauze 1901, p. 266 (known from the photo-
gravure); Boyer d'Agen 1909, ill. on pl. 14 preced-
ing p. 89 (erroneously as in the collection of the
Musée Ingres, Montauban); Lapauze 1911a, ill.
p. 279; Lacrocq 1919–21, p. XXV and n. 4; Bouyer
1921, ill. p. 54; H. E. van Gelder 1950, p. 5, fig. 2;
Naef 1965 ("Thévenin und Taurel"), pp. 146,
148, 157, fig. 8; Mongan 1967, ill. p. 26; Naef
1977–80, vol. 5 (1980), pp. 150–51, no. 328, ill.

110. Madame Louis-François Bertin, née Geneviève-Aimée-Victoire Boutard

1834

Graphite

12⅝ × 9½ in. (32.1 × 24.1 cm)

Signed and dated lower left: Ingres Del, / à Mademoiselle / Louise Bertin / 1834. [Ingres drew (this), / for Mademoiselle Louise Bertin / 1834.]

At lower left, the Musée du Louvre, Paris, collection stamp (Lugt 1886a)

Musée du Louvre, Paris

Département des Arts Graphiques RF 4380

New York only

N 342

Ingres's painted portrait of Louis-François Bertin, publisher of the highly respected newspaper *Journal des débats*, is one of his few works that were as much admired by his contemporaries as they have been by posterity (cat. no. 99). When it was exhibited at the Salon in 1833, the public and critical response was overwhelmingly positive.

A few preliminary studies for that portrait survive (see cat. nos. 100, 101, figs. 178, 179), and Ingres's biographer Henri Delaborde was the first to include among them the portrait drawing of Bertin in the Louvre, which was executed in the same year as the painting (fig. 182).[1] In fact, it is a wholly independent work, fully signed and dated, and as yet it is impossible to determine which portrait was produced first. The poses are similar, but the clothing and other details are not the same. It is important to recognize the independence of the drawing, for it is the first in one of the most splendid series of portraits Ingres produced at the height of his fame. In the Bertin family, the artist discovered the atmosphere of warmth and affability that made it possible for him to produce portrait drawings during his later years.

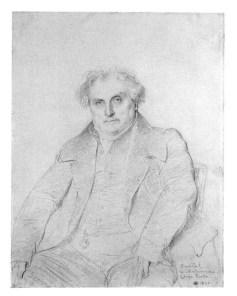

Fig. 182. *Louis-François Bertin*, 1832 (N 339). Graphite on paper, 12⅝ × 9½ in. (32.2 × 24.1 cm). Musée du Louvre, Paris

In 1832, when Ingres portrayed him, Bertin had arrived, advanced in years, at the zenith of his life. Work on the painted portrait appears to have taken the artist frequently to Bièvres, where Bertin had his estate, Les Roches. There, in the circle of his family, the old man kept a simple, patriarchal house whose chief adornments were the large number of distinguished guests he entertained. Along with Ingres, Victor Hugo was among the most famous of them. Life at the Bertins' was later described by Hugo's wife, Adèle:

> At Les Roches, we would get together over meals and after dinner. The rest of the day was free. People spent their time as they wished; they remained in their rooms, or took a walk in the park, full of ancient oaks, lawns, flowers, and pavilions among the branches. A pond in which swans bathed was fed by narrow streams producing a soft, monotonous murmur; peacocks spread their feathers in the sun. One could see the master of the house, up since dawn, overseeing the gardeners at their work, or sitting on a bench with a book in his hand, and sometimes dozing.
>
> And from deep in their nest, 'neath maple and elm,
> The birds admired his head at rest,
> And, trembling singers gay,
> They waited, crept close, hoping to steal away,
> The better to soften their somber nest,
> One of his hairs of gray.[2]

That there were often friendly encounters between the Romantic poet and the Classical painter is apparent from the following passage in Madame Hugo's memoirs:

> At that time, M. Ingres was painting the portrait of M. Bertin; he traveled from Paris every day. When he returned early, he sometimes took Victor Hugo with him, dropping him at the Théâtre-Français.[3]

In 1834, Ingres produced the present unforgettable drawing of his hostess at Les Roches. Born in Paris in 1772, Madame Bertin was the sister of the art critic Jean-Baptiste Bon Boutard, whose review of the

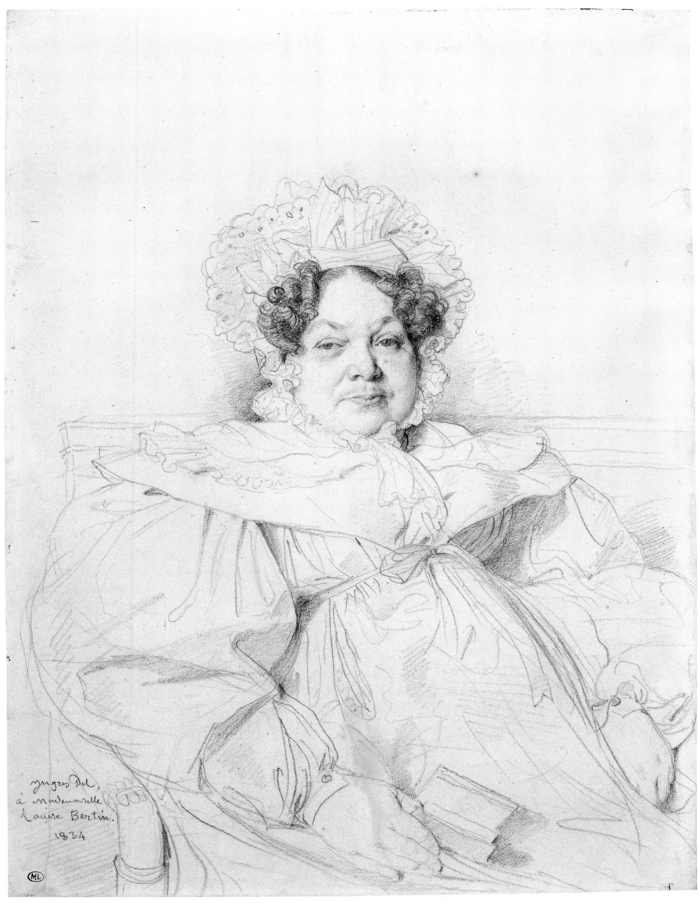

Ingres del,
à Mademoiselle
Louise Bertin.
1834

110

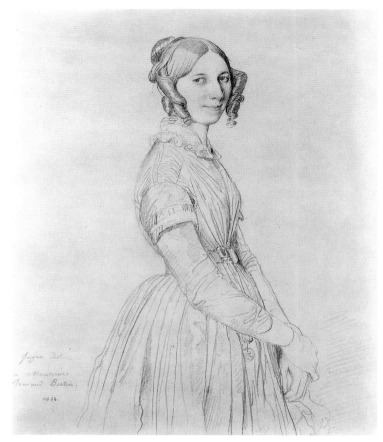

Fig. 183. *Madame Armand Bertin, née Cécile Dollfus*, 1843 (N 392). Graphite on paper, 13⅝ × 10¼ in. (34.5 × 26 cm). Private collection

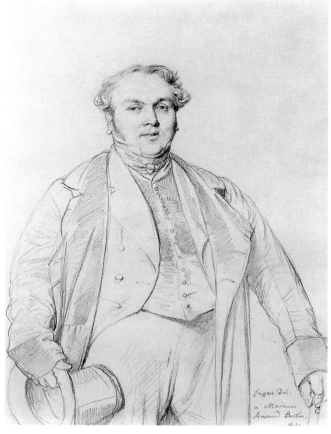

Fig. 184. *Armand Bertin*, 1842 (N 391). Graphite on paper, 12¼ × 9 in. (31.2 × 22.8 cm). Private collection

Salon of 1806 in the *Journal des débats* had helped to make Ingres's life miserable. Although the painter was not above avenging himself in such matters, he surely held no grudge against Madame Bertin, and at most may have joked with her about what her brother had once done to him.

Ingres's portrait of Madame Bertin, created in 1834 as a companion piece to the pencil portrait of her husband, is realistic in the extreme. This extremely overweight woman with her swollen cheeks, her bonnet, her ruffles and ringlets—even a mustache—would only seem ridiculous if depicted by a lesser artist than Ingres. Indeed, the viewer's first response is to laugh, but the work is not a caricature; like all of Ingres's portraits, it seeks to capture and affirm the sitter's essential nature.

Both portraits were dedicated to the Bertins' daughter Louise, a highly ambitious poet and composer of operas, who was herself apparently the subject of an Ingres

drawing, which is known only in the form of an engraving by Delvaux. The original must have been executed, like the portrait of her mother, in 1834.

Her brother Armand is captured in a masterful Ingres portrait from 1842 (fig. 184). The date is proof that the artist's fondness for the Bertins had in no way diminished during the six years he was away in Rome serving as director of the Villa Medici. The drawing is dedicated to Armand's wife, of whom Ingres produced a matching portrait in the following year (fig. 183). She is one of the loveliest women to appear in Ingres's later portraits.

Armand Bertin, the image of his father, was born in Paris in 1801. He succeeded his father at the *Journal des débats* before the older man's death, and was equally generous in his patronage of the arts. Ingres's pupils Victor Mottez and Amaury-Duval both executed important commissions for him.[4] He died in 1854, his wife the year

before. The older of their two daughters later married the jeweler Jules Bapst, who took over the direction of the paper. The younger became the wife of the prominent economist and statesman Léon Say.

H.N.

For the author's complete text, see Naef 1977–80, vol. 3 (1979), chap. 143 (pp. 114–35).
 1. Delaborde 1870, no. 258.
 2. Madame Hugo's description of life at Les Roches, including this passage, may be found in Hugo n.d., vol. 3, pp. 189–92; quoted in Naef 1977–80, vol. 3 (1979), pp. 120–21.
 3. Hugo n.d., vol. 3, p. 162; quoted in Naef 1977–80, vol. 3 (1979), p. 121.
 4. Foucart 1971, pp. 153–73; and Amaury-Duval 1878, p. 242.

PROVENANCE: Mlle Louise Bertin, Paris, until 1877; her niece, Mme Léon Say, née Geneviève Bertin, Paris, until 1917; her bequest to the Musée du Louvre, Paris, 1917

EXHIBITIONS: London 1878–79, no. 678 [EB]; Paris 1884, no. 416; Paris 1905, no. 49; Paris 1911,

no. 143; Paris 1919, no. 294 [EB]; Copenhagen, Stockholm, Oslo 1928, nos. 160 (Copenhagen), 149 (Oslo); Paris 1930, no. 475; Nice 1931, no. 19, as *Mlle Bertin;* Paris 1935a, no. 83 [EB]; Brussels 1936, no. 20; Zurich 1937, no. 212, ill.; Paris 1957d, no. 91 [EB]; Paris 1967–68, no. 160, ill. (sitter identified); Paris 1974–75, 521b [EB]; Paris 1980, no. 57; Tübingen, Brussels 1986, no. 44

REFERENCES: Paris, Musée du Louvre 1919–20, vol. 2, ill. on pl. 51; *Dessins de Jean-Dominique Ingres* 1926, p. [8], pl. 29; Alazard 1942, no. 12, ill., as *Madame Édouard Bertin*; Millier 1955, ill. p. 34; Ternois 1959a, preceding no. 14; Sérullaz 1967, p. 212; Delpierre 1975, p. 24; Pansu 1977, no. 55, ill.; Naef 1977–80, vol. 5 (1980), pp. 176–77, no. 342, ill.; Picon 1980, ill. p. 82; Ternois 1980, ill. p. 117

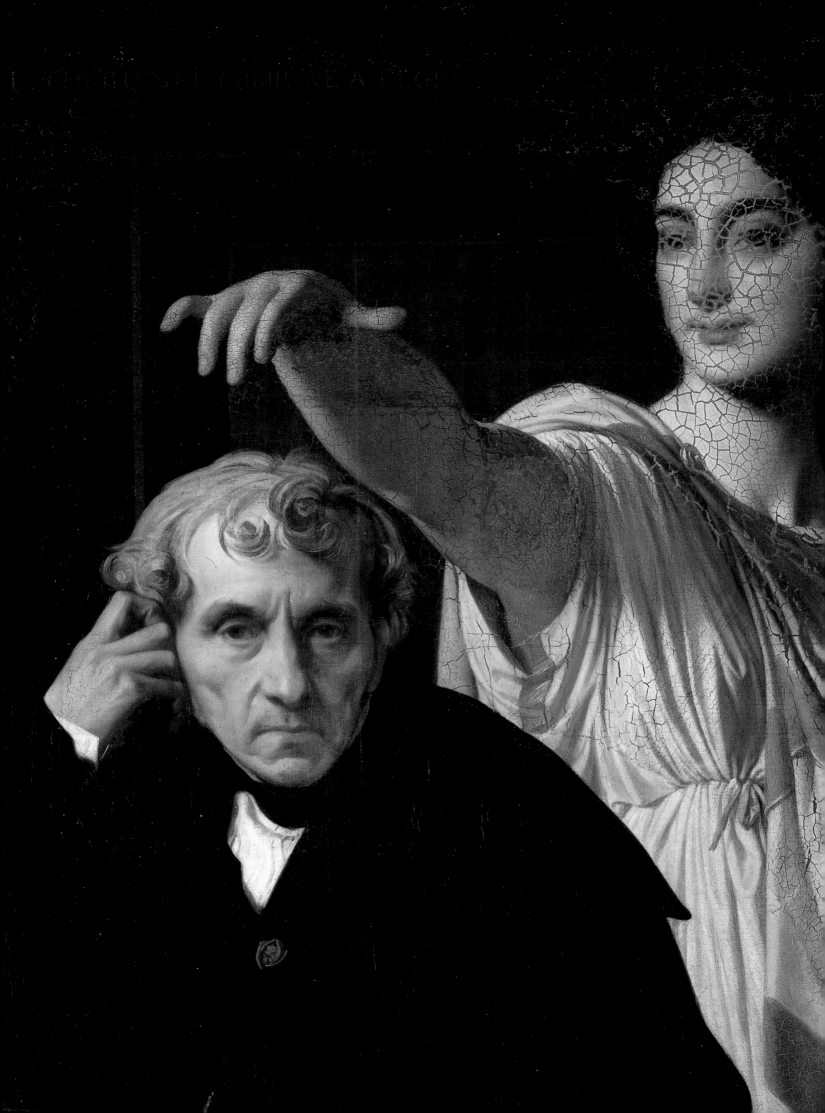

ROME, 1835–1841

Christopher Riopelle

Ingres accepted the directorship of the Académie de France in Rome on July 5, 1834. To the surprise of many, and the disappointment of his students, he had decided to leave Paris once again and return to the city where he had lived from 1806 to 1820. There, he would take charge of another group of students, the winners of the French Prix de Rome, who were sent to Italy annually at government expense for four years of advanced study in the arts. He would return to the Villa Medici on the Pincio, with its delightful gardens and commanding view of the city, where he had been a pensioner (as Prix de Rome winners were known) almost thirty years before. Ingres's appointment followed the critical failure at the Salon of 1834 of his monumental painting *The Martyrdom of Saint Symphorian* (fig. 169), and his decision to return to Italy has been seen as the impetuous act of an angry man.[1] Ingres was notoriously thin-skinned, it is true, and on this occasion—as Andrew Shelton has shown in the preceding essay in this catalogue (see page 287)—he was deeply unsettled by the critics' response.[2] As nettlesome as bad reviews might have been, however, it is also possible to look at Ingres's actions in another light: by 1834 he also would have known that his reputation as an artist no longer lay in the critics' hands alone. He had enjoyed ten years of approbation following the success of *The Vow of Louis XIII* (fig. 146) at the Salon of 1824. Despite the ascendancy of the Romantic school, he was widely recognized as one of the preeminent artistic figures of his day. A steady stream of commissions came his way, not just for portraits but for the history paintings he valued most. In Paris, he had discovered himself to be a brilliant and intuitive teacher (a role he loved) and was surrounded by numerous, devoted students. With their enthusiastic help, his ideas on art were being widely disseminated. Therefore, despite the critics, Ingres's position was relatively strong in the spring of 1834. When Horace Vernet, the painter of military subjects who had served as director of the Académie de France since 1828, made known his plans to retire, the recent hostility between Ingres and the critics was probably only incidental in the artist's decision to seek the post. Although he would express repeated doubts about the decision he had made, even after arriving in Rome,[3] Ingres would nonetheless have appreciated the advantages that the Villa Medici offered him at this juncture in his career.

Ingres's ambition was unwavering: he intended to see his aesthetic opinions prevail in France, especially in the face of challenges by the Romantics. His argument was less with the press than with a government that, to his mind, failed to adequately acknowledge his seminal place in contemporary French art. Yet the directorship of the Académie de France placed him near the top of the French artistic hierarchy and called for him to have frequent and official communication with the arts administration in Paris.[4] Ingres's renewed presence in Rome underscored the vital connection he posited between his art (and by extension contemporary French art) and that of antiquity and the Italian High Renaissance, especially Raphael. Most important, the directorship of the Académie could be a position of considerable influence in that the artists whom the French state had officially recognized as the most promising of their generation—not only in painting but also in sculpture, architecture, printmaking, and music—would come to Rome to sit at his feet, listen to his words, seek his advice. Writing in 1839, Ingres evoked "my firmly held tenets, my profound conviction, the motto of which is on my flag: *The Ancients and Raphael!*"[5] Though far from Paris, he would be able in Rome to secure the allegiance of a new generation of French artists, inculcate them with his aesthetic principles, and consolidate his position as an arbiter of French art. As he would coolly assure his friend Édouard Gatteaux in 1836, "According to you, I have made 'a serious mistake' in going to Rome. The serious mistake is rather theirs who let me leave, the administration first and foremost."[6] Ingres knew his strengths.

Preparing to leave Paris, Ingres made a series of decisions that, in retrospect, can be seen as strategic moves to pave the way for his successful return at the end of his six-year tenure at the Académie. He issued instructions that his works not be exhibited at the Salon while he was

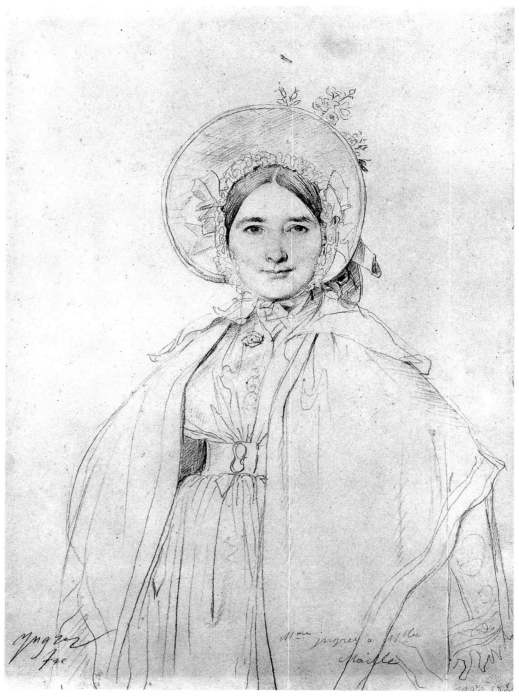

Fig. 186. *Madame Jean-Auguste-Dominique Ingres, née Madeleine Chapelle,* 1835 (N 363). Graphite on paper, 11 7/8 × 8 7/8 in. (30.2 × 22.4 cm). Musée Ingres, Montauban

gone.[7] The critics would have no opportunity to comment on his art: he would be left in peace, and their curiosity could only grow. Quickly finishing his portrait of the comte Molé (fig. 158)—though adamantly refusing to allow it to appear at the Salon either, but instead exhibiting it privately in his studio[8]—he canceled a number of other painting commissions, including two from the government.[9] In Rome, he intended to concentrate on his administrative and pedagogical duties. Indeed, so resolutely

would he attend to those obligations that, years later, he would report of his return to the Villa Medici that "busy with my duties as Director, I did not begin to work on my pictures until three years later."[10]

However, in seeming contradiction to his other decisions, Ingres did not cancel a commission for a painting he had accepted a year earlier. It came from a highly prestigious collector, Prince Ferdinand-Philippe, duc d'Orléans, the eldest son of King Louis-Philippe and heir

to the French throne.[11] The duke, who was earning a reputation in those years as an adventurous patron of contemporary art,[12] had commissioned Paul Delaroche to paint *The Assassination of the Duc de Guise* (fig. 191), a violent scene of political treachery from sixteenth-century French history.[13] He asked Ingres to provide him with a pendant painting based, unexpectedly enough, on an ancient love story—that of Antiochus and Stratonice, told in Plutarch's *Lives* (9.38.1–9). From the beginning of his career, Ingres had intended to depict the story of young Prince Antiochus on his sickbed, dying for love of his stepmother, Queen Stratonice. Like the scenes depicted in *Paolo and Francesca* (fig. 103), *Raphael and the Fornarina* (fig. 127), and *Roger Freeing Angelica* (fig. 104), it was a tale of intense, even bizarre, erotic attraction, a type to which he was powerfully drawn. Moreover, it was the very subject for which his master, Jacques-Louis David, had won the Prix de Rome in 1774 (École Nationale Supérieure des Beaux-Arts, Paris). Ingres had made composition drawings for such a painting in 1801 and again in about 1806 (fig. 49); he even seems to have begun a painting on the theme, now lost and perhaps never completed, in about 1825.[14] Ferdinand-Philippe's request thus gave him the opportunity to fulfill an old ambition. At the same time, the patronage of the heir to the throne could not fail to attract attention and enhance Ingres's reputation. Though not without great difficulty, Ingres would execute *Antiochus and Stratonice* (fig. 194) in Rome, completing it in 1840; privately exhibited in Paris that same year, it would indeed herald his triumphant return in 1841.

Ingres and his wife, Madeleine (fig. 186), accompanied by a student, Georges Lefrançois, left Paris for Rome at the beginning of December 1834, carrying with them a gilded silver cup presented as a token of esteem by the students Ingres was leaving behind. The travelers made a slow progress through Italy, visiting such favorite cities as Milan, Venice, and Florence. Exhausted, they arrived in Rome long after midnight on January 4, 1835, thus disappointing the pensioners of the Académie de France, and other French artists resident in Rome, who had hoped to greet the new director at the city gates. Ingres assumed his duties as director when Vernet left the Villa Medici after the marriage of his daughter Louise to Paul Delaroche on January 24. Among his colleagues was the Académie's newly appointed secretary-librarian, Alexis-René Le Go, who had himself taken up his post only a few weeks before, on January 1.[15] Le Go was both intelligent and highly efficient—indeed, he would remain at the Académie for almost forty years—and the two newcomers

found that they worked well together. Ingres and Le Go quickly set about studying the needs of the Académie and carefully instituting changes. Happily for the new director, he found that he could count on the support of the French ambassador to Rome, Monsieur de La Tour-Maubourg, and, although relations between them were not entirely smooth, of Adolphe Thiers, the government minister responsible for the Académie back in Paris.[16] Insistent when it came to the interests of his students—ever ready to "show my teeth," as he once phrased it[17]—Ingres would frequently call on the aid of these authorities.

Among the changes Ingres introduced, with Le Go's help, was a course on archaeology. He improved student access to live models and worked at enriching the library. He set about repairing and improving the facilities in the villa and its garden, and he sought to reduce crime in the surrounding neighborhood. He also decided to expand the Académie's collection of plaster casts after the antique, although here he found himself in seemingly endless disputes with officials of the Vatican, who opposed and then hindered attempts by the French to take casts from works in the papal collection. The pensioner Xavier Sigalon, for instance, had already been working for a year before Ingres's arrival on an enormous copy for the École des Beaux-Arts in Paris of Michelangelo's *Last Judgment* in the Sistine Chapel and had been encountering difficulties with Vatican officials; Ingres's encouragement eventually helped Sigalon to bring the project to a successful completion. At the behest of Thiers, Ingres also initiated a major project to make copies of the fifty-two paintings of Bible scenes by Raphael and his school that adorn the Loggias of the Vatican. Carried out in part by the brothers Paul and Raymond Balze, these works too were to be sent back to the École des Beaux-Arts. Here again Ingres ran into conflict with Vatican officials, who imposed onerous conditions[18]—especially about the erection of scaffolding— to such a degree that at one point he threatened to resign: "In the meantime, here they are, beginning to harass me over the means of execution, so much so that I am obliged to show my teeth. . . . All these discouragements (even including the loss of the advances paid on the scaffolding and other expenses) might have made me decide to give up this business by resigning. . . . Here I am, then, I who came to Rome in search of an artist's peace and quiet, here I am, already exposed to irritations and setbacks!"[19] Ingres carefully monitored the works the pensioners sent back annually to Paris, ensuring that they reflected well both on the artists themselves and on the Académie as a

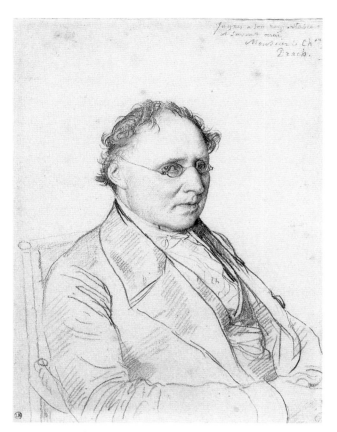

Fig. 187. *David-Paul Drach*, ca. 1840 (N 373). Graphite on paper, 8⅜ × 6⅜ in. (21.4 × 16.3 cm). Musée Bonnat, Bayonne

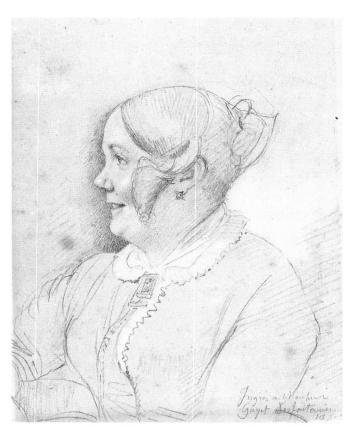

Fig. 188. *Madame Marcellin-Benjamin Guyet-Desfontaines*, 1841 (N 385). Graphite on paper, 8⅝ × 6½ in. (22 × 16.5 cm). Musée Bonnat, Bayonne

whole; he also defended their efforts diligently when he felt the criticism they received from Paris was undeserved. Throughout his stay, Ingres's administration was marked by firmness and consistency, with the best interests of the students always foremost among his concerns.

Ingres was determined to improve the pensioners' way of life, to make the Académie comfortable and safe, a place where hard work and dedication were encouraged, to be sure, but where friendship and a sense of community flourished as well. He made a point of being accessible to the pensioners, opening his quarters to them frequently and inviting many of them to regular, informal evenings of music making. Students he had known in Paris, such as Hippolyte Flandrin, the Prix de Rome winner for 1832, were eagerly embraced again in Rome, as were Hippolyte's brother Paul and one of Ingres's most devoted students from Paris, Amaury-Duval, when they arrived sometime later. The Balze brothers, to whom Ingres gave special encouragement, were particularly close to his heart. He was fierce in the defense of the pensioners, as when a young architect named Charles-Victor Famin was falsely arrested.[20] He was disconsolate in the face of their misfortunes and tragedies, as when

Lefrançois, with whom he had traveled to Rome in 1834, drowned at Venice in 1839: "I am greatly grieved; I am angry at fate, which is almost always bent on destroying what is good, while it spares the human race so many noxious or useless monsters."[21] He could be extravagant in his praise. Speaking to Hippolyte Flandrin about one of Flandrin's less than first-rate works, he enthusiastically remarked, "No, my friend, painting is not lost; I shall not have been useless!"[22] He could also be unforgiving when the calm of the Académie, on which he placed a high premium, was jeopardized: during one tense moment in 1840, he ordered a particularly obstreperous student, an engraver named Victor Pollet, simply to leave the Villa Medici and take himself to Florence.[23] Madeleine was often by Ingres's side, helping with the arrangements, mothering the students, quietly easing events along. Indeed, it was she who monitored the purse strings at the Villa Medici, doling out money to Ingres as he required it for trips or small purchases, lending funds to pensioners when they fell short, and keeping careful account books.[24] Said her husband of her, "She is my little minister of the interior."[25] Ingres was able to achieve an almost domestic sense of intimacy and ease at the Villa Medici,

so much so that Henry Lapauze would conclude of his directorship, "Rarely did the residents of the Villa Medici live in better accord."[26]

Many people passing through Rome, including the painters Henri Lehmann and Théodore Chassériau, were invited to spend time at the Villa Medici during Ingres's years there. Musicians were especially welcome, and Franz Liszt and Charles Gounod both performed there. Gounod remarked on the strength and candor of Ingres's character, as well as on the special regard in which he held his pensioners: "Genuinely humble and unassuming before the masters, but dignified and proud before the conceit and arrogance of stupidity; fatherly toward all the pensioners, whom he regarded as his children and whose status he upheld with jealous affection when visitors, whoever they might be, were entertained in his salons: such was the great and noble artist whose precious teachings I would have the pleasure of receiving."[27] Fellow musician Ambroise Thomas quickly fell under Ingres's spell and, though near the end of his Roman sojourn, arranged to stay on at the Villa Medici, where he frequently organized the musical evenings. A Lady Charlemont, of whom little is known—except that she was beautiful, was born in Benares, and was called by Byron "that blue-winged Kashmirian butterfly of book-learning"[28]—visited Ingres at the villa in hopes of commissioning a portrait. Her memoir, published in 1867, is a precious record of the artist's temperament and manner of living at that time: "In this palace the director leads the life of a prince. . . . [He] had a thousand reasons, therefore, to be happy at the Villa Medici. The pensioner had become the director. Every step of the staircase, every sigh of the fountain, every murmur of the laurel tree, spoke to him of what he had done, gained, and conquered since his youth. . . . What more did he need? . . . He had a school controlled, obsessed by his lessons. It was not even a cult that he commanded, it was fetishism."[29] Nonetheless, she observed that Ingres was not content: "None of that brought happiness, a smile, or peace of mind to this artistic temperament, irritated and irritable, which believed itself dethroned by the criticism of a picture and, I really think, exiled to Rome, this hostelry for every fall from grace."[30]

Portrait drawing assumed a special importance for Ingres at this time. Throughout the eighteen years of his previous stay in Italy, between 1806 and 1824, his steadiest source of income had been the production of such works, most often commissioned by visiting or resident Frenchmen or by wealthy European travelers on the grand tour who wanted an elegant memento of their sojourn in Rome or Florence. As skillful as he was, Ingres came to detest the occupation as beneath the dignity of a history painter. Every now and then, however, he had found time to make uncommissioned portrait drawings of his closest friends, frequently giving them as gifts to the sitters or their families, or keeping them near at hand as souvenirs of absent, longed-for companions. These *portraits intimes* (intimate portraits) are a record of his most intense feelings of camaraderie.[31] As he had written in 1825, when presenting one such drawing to the wife of a friend, he wished "to offer you a souvenir . . . in accepting from me that which I intend only for my friends: *a portrait drawing*."[32] Now, in Rome again, he returned with renewed fervor to the creation of such souvenirs, producing some twenty-three portrait drawings between 1835 and his return to Paris in 1841 (see, for instance, figs. 187–89).[33] He was under no financial obligation to do so, nor were the majority commissioned works. Rather, the portrait drawings of these years were largely of friends or family, the sitters most often the young pensioners of the

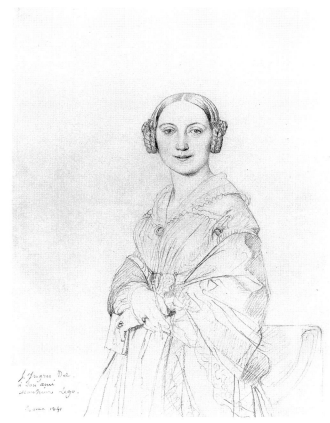

Fig. 189. *Madame Alexis-René Le Go*, 1841 (N 374). Graphite on paper, 12 1/2 × 8 3/4 in. (31.6 × 22.3 cm). Private collection

Académie, of whom Ingres was so fond, their wives and children, or favored visitors who gravitated to the Villa Medici as they passed through Rome. As the recipients knew, such drawings had been prompted by strong feeling, being the emblems and precious tokens of Ingres's personal regard.

Louise Vernet was the subject of perhaps the first drawing Ingres executed in Rome (cat. no. 112); made in January 1835, shortly before her marriage to Delaroche, the work is dedicated to her mother. Ingres drew his secretary, Le Go, the following year (cat. no. 113), dedicating the sheet to the "friend" Le Go had so quickly become; as he prepared to leave Rome in 1841, the artist drew Le Go's wife (fig. 189) and daughter (N 375; location unknown), also presenting them to the sitters as souvenirs of his esteem. In 1836 Ingres offered Victor Baltard—the future architect of Les Halles in Paris—a drawing of his wife and daughter (cat. no. 114) and the following year dedicated a pendant drawing of Baltard himself to the sitter's wife (cat. no. 115). Liszt and Gounod (cat. nos. 116, 117) were both sketched by Ingres, as was the wife of Eugène Viollet-le-Duc (N 370; private collection) when that brilliant architect visited Rome in 1837. Madeleine, too, participated in this portrait exchange: one of the very last drawings Ingres executed before leaving Rome was a portrait of her (cat. no. 118), dedicated and presented to one of her close women friends.

Immediacy and directness characterize the portrait drawings. Most often shown half or three-quarters length, the sitters always confront their limner with a direct, convivial gaze. Attributes are used sparingly in order to characterize the nature of the relationship with Ingres. Thus, Gounod turns to greet the artist while seated at a piano on which lies opened the score of Mozart's *Don Giovanni*, loved by them both. Soon after arriving in Rome, Ingres drew a self-portrait (cat. no. 111) in which, elbow on table, he stares out with passionate directness at the viewer. It, too, is a souvenir of friendship. Inscribed "Ingres / à Ses Eleves," it was intended for engraving and wide distribution to those students—a testament to the affection in which the artist held the young people he had left behind in Paris and the pensioners he was coming to know in Rome.[34] Indeed, Lapauze saw the drawing as something of a manifesto of Ingres's directorship and his relationship with his students: "Despite the injustices of destiny, he is confident of his strength: this is the leader of a school who set the greatest examples before his disciples and who placed all his teachings before them."[35] Taken together, these drawings constitute a kind of group

portrait of the clever, talented, and amiable circle of young artists and their charming families, at the center of which Ingres presided. Through his teaching, leadership, and almost paternal acts of kindness, he sustained them, just us their friendship and warm appreciation of his gifts sustained him in turn.

The most serious crisis of Ingres's tenure—and a stern test of his skills as a leader—occurred in 1837 with an epidemic of cholera in Rome. There had been threats and minor outbreaks in 1833, 1835, and again in 1836, but the following summer the disease struck Rome with a vengeance.[36] At its height, Sigalon arrived back from Paris, where he had just delivered his completed copy of the *Last Judgment;* he fell sick on August 15 and was dead three days later. On September 5, 1837, Ingres wrote a long letter to Gatteaux describing the parlous situation in the city:

> All of us here are in good health; so much for the main thing. That said, here is the status of the disease on the very day that I write to you. There are four to six hundred cases a day, and about two hundred deaths. The disease seems to be on the wane, since a week ago deaths were numbering three hundred and more. The *plebs* are the worst off. No help has been organized, a great many doctors are withholding their services, and because of the unfortunate nature of the contagion, all the Romans avoid one another or fumigate themselves, to the point of giving themselves the disease by that means alone.[37]

Fear was tremendous, especially since it was too late to flee the city. Ingres gathered together the Villa Medici pensioners and staff, including married pensioners and their families (who customarily lived elsewhere in Rome), and sealed off the villa from the world. Everyone huddled together, finding mutual strength and consolation in their work and in one another's company. As Ingres told Gatteaux:

> For our part we form a group at the Villa Medici. We are holding on like frightened birds, but without the shelter of a large tree, until the storm has passed, living plainly and as quietly as possible. As for myself—not to dispel anxiety, for I remain calm in this peril, but to seek a powerful distraction—I work all the time and think about it less. . . . Almost all the pensioners wanted to flee, and, in that situation, so as not to be compromised in this peril, I gave them permission to go to Ancona, Florence, or Bologna, to live as a group; but we are forced to stay in Rome. No one can leave, not even a cardinal, who would in any case be greeted with gunshot in the surrounding countryside, as has happened.[38]

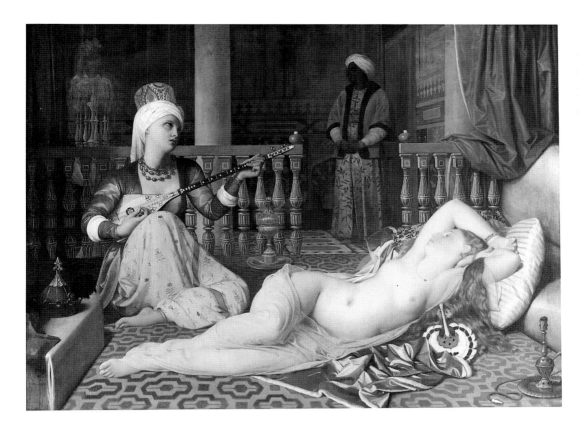

Fig. 190. *Odalisque with Slave*, 1840 (W 228). Oil on wood, 28 ½ × 39 ½ in. (72.4 × 100.3 cm). Fogg Art Museum, Harvard University Art Museums, Cambridge, Massachusetts

Miraculously, with the lamented exception of Sigalon, the group survived the epidemic, the dire experience strengthening the bonds of affection that already existed among them. Ingres himself was widely praised for the exemplary courage and calmness he exhibited during the ordeal. His old friend François-Marius Granet, for instance, wrote from Paris: "There you are in that sad city of Rome, where death has just taken up his abode. . . . Everyone here knows how admirably you are steering your bark, despite all the difficulties that one encounters on this sea of life."[39]

"I work all the time," Ingres had said of the period of quarantine at the Villa Medici. These words probably referred to painting, for he had taken up his brushes again by this time. Two canvases awaited him, the *Antiochus and Stratonice* for the duc d'Orléans and the *Odalisque with Slave* (fig. 190), which Ingres had long promised his old friend and patron, Charles Marcotte. The latter, signed and dated 1839, would be the first painting Ingres completed during his stay in Rome. Filled with echoes of his *Sleeper of Naples* of 1808 (fig. 85)—a work lost by this time but still longed for by Ingres—the *Odalisque* is a work of the most refined ostentation. Within a jewel-like interior, a languorous sleeping nude is tended by a slave and a musician; soft, strange music plays; cool water splashes on glistening tiles; she has just laid her hookah aside. All the senses are evoked here, not least among them vision, as the viewer is invited to trace with the eye

the sleeper's swelling, marmoreal form against its polychrome setting. Given over to sensuality, she is twice a prisoner: held in the claustrophobic depths of a fantastic harem from which no exit is vouchsafed, she is also fixed by Ingres's meticulous painterly control, which extends to every detail of the intensely worked, enamel-like surface in which she is enclosed. The painting's high artificiality is accounted for, in part, by Ingres's reliance on drawings rather than on the live model. As he told Gatteaux, "In fact, a great many things in this picture, if not almost all, were painted from drawings, in the absence of a live model (this is between the two of us), which by your way of thinking—and mine too—is indispensable in giving life to a work and causing its heart to beat."[40] At the same time, the opulent airlessness of the painting is entwined with its eroticism; it is like a fevered dream. When Paul Flandrin painted a replica in 1842 (fig. 324), he relieved the almost unbearable claustrophobia of the original painting by opening up the background to include a garden and a glimpse of sky.

Also meticulously planned and executed, *Antiochus and Stratonice* (fig. 194) was an even more complicated and vexing matter for Ingres—the single most difficult, and defining, project of his Roman years. Although he had made compositional sketches for it before leaving Paris in 1834, he now abandoned these.[41] He began again in Rome by making individual figure studies, using himself, his wife, and friends as models (figs. 192, 193).[42] He

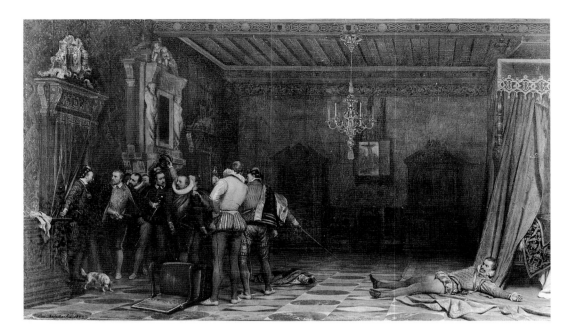

found his model for Stratonice herself in the visiting Lady Charlemont, or at least she later claimed he had.[43] He asked Baltard, then studying ancient Roman architectural ornament, to design the richly detailed "Pompeian" interior in which the scene is set (see fig. 319); he then had someone else sketch it onto the canvas itself, an assignment that seems to have been completed in August 1837.[44] At that point Ingres himself began to work on the canvas, locating his figures in the elegant chamber Baltard had devised, but even then he continued to rely on the assistance of his students. According to Raymond Balze, he and his brother helped Ingres with "the less important parts . . . such as the architectural parts."[45] Nothing satisfied Ingres, Balze elsewhere reported; often reduced to tears of frustration, the master repeatedly ordered details erased, relocated, and painted again and again.[46] Ingres was clearly obsessed by the task, though Lady Charlemont, for one, praised him for being so: "Personally, I admire those childlike natures that have retained the violence and charming boyishness of the passions."[47] Feverishly, Ingres continued to work on the painting for three years, until the summer of 1840, constantly altering and adapting details. Finally, at the last moment, just before sending the picture to Paris in the summer of that year, he decided to add columns across the back of the room.[48]

Even by Ingres's fastidious standards, completion of this relatively small-scale painting was troubled and painstakingly slow. To be sure, he was determined to impress his distinguished patron, the duc d'Orléans, who—patiently waiting to receive the picture he had commissioned in 1833—continued to publicly express his regard for the artist by acquiring his large-scale *Oedipus and the Sphinx* of 1808 (fig. 82), and by commissioning his official portrait, to be executed when Ingres returned to Paris.[49] Moreover, *Antiochus and Stratonice* would be the first new painting by Ingres to be seen in Paris since 1834. Thus, the artist felt pressured to produce what he hoped would be "a work that can be praised, and quite new."[50] At the same time, it has not been widely noted that, again with the help of the Balze brothers, Ingres was painting a second version of *Antiochus and Stratonice* simultaneously with the first. Smaller, more nearly square than the duke's painting, and with numerous altered details in the background, it was meant to serve as the model for an engraving to be executed by Charles-Simon Pradier. Ingres's letters are filled with pained discussions of the difficulties he was experiencing in reconciling these two canvases.[51] He continued to labor over the second version after the duke's painting had been sent to Paris, although in the end the engraving project was abandoned.[52]

Ingres faced one further complication in regard to *Antiochus and Stratonice*, which rendered its completion especially onerous. For the first and only time in his career, he was constrained to create a pendant for another artist's painting. Moreover, that artist was Paul Delaroche, whose *Execution of Lady Jane Grey* (1834; National Gallery, London) had been praised at the Salon of 1834 at the expense of Ingres's *Martyrdom of Saint Symphorian*. Years later, Ingres was still haunted by the—in his eyes—invidious comparison. To Lady Charlemont, "He was possessed, he had the same vision everywhere, a horrible vision."[53]

She went on to relate Ingres's repeated, appalled description of *Lady Jane Grey* and of the appreciative crowds that had gathered around it at the Salon, while ignoring his own painting, of whose superiority he was in no doubt. "These were the standing-up dreams, the waking visions that M. Ingres encountered at the table, in the drawing-room window, in his studio, indoors and out, everywhere, continually. . . . His arms drooped out of discouragement. . . . The artist no longer worked, or if he worked, he erased the next day what he had done the day before."[54] Once again, Ingres had to confront Delaroche, creating a pendant for his *Assassination of the Duc de Guise*—a work that, moreover, had been completed years before, in 1834, thus determining the dimensions, format, and figural scale to which Ingres's painting would need to conform.[55]

Georges Vigne has rightly pointed out that Ingres derived his composition for *Antiochus and Stratonice* from his knowledge of monumental history paintings by Greuze and Poussin, including the latter's *Testament of Eudamidas* (ca. 1644; Statens Museum for Kunst, Copenhagen) and *Death of Germanicus* (1627–28; Minneapolis Institute of Arts).[56] Slowly, brilliantly, Ingres reconciled those impeccable sources with the constraints imposed by Delaroche's composition. Delaroche had depicted the still moment immediately following the murder of the duc de Guise on the morning of December 23, 1588 (fig. 191). He lies at the foot of a bed at the right while at the far left Henri III's henchmen point out their handiwork as the timorous king enters upon the scene. The composition is dominated by the visually tense spatial gap between the group at the left and the single, fallen figure at the right and by the malevolent gaze of one assassin, which spans the gap. Ingres, for his part, chose to depict the still moment following the arrival of Stratonice in the bedroom of Antiochus (fig. 194). She stands alone and pensive at the left just as the doctor, Erasistratus, at the right, his hand on the racing pulse of the prince, realizes that the young man's ailment is lovesickness and stares across the room in recognition at the queen. In order to establish a pendant relationship between the pictures, Ingres brilliantly appropriated and then reversed Delaroche's distinctive distribution of figures, as if in a mirror, placing his figure group at the right and his single figure at the left, at the same time retaining the motif of a penetrating stare that leaps the resonantly empty space between. Not surprisingly, Ingres was anxious to conceal his debt to Delaroche. When *Antiochus and Stratonice* was about to be exhibited for friends in the apartments of the duc

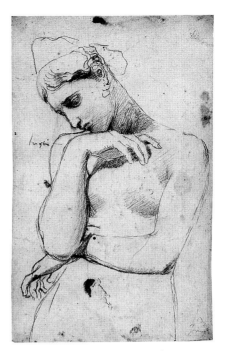

Fig. 192. *Stratonice*, 1840. Graphite on paper, 8¾ × 6 in. (22.3 × 15.1 cm). Musée Ingres, Montauban (867.2198)

Fig. 193. *Study of Drapery for "Antiochus and Stratonice,"* ca. 1840. Graphite on paper, 19⅜ × 12⅝ in. (49.3 × 32.1 cm). The Metropolitan Museum of Art, New York, Purchase, Pfeiffer Fund, 1963 (63.66)

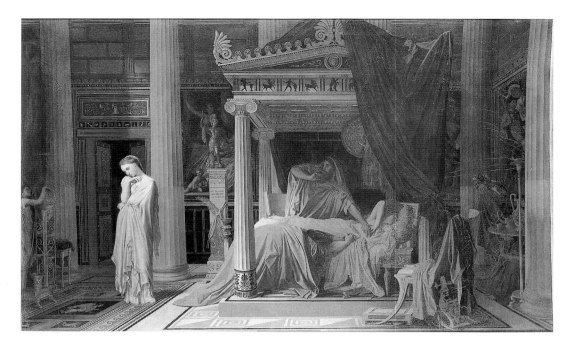

Fig. 194. *Antiochus and Stratonice*, 1840 (W 232). Oil on canvas, 22 1/2 × 38 5/8 in. (57.2 × 98.1 cm). Musée Condé, Chantilly

d'Orléans in the summer of 1840, he wrote to Gatteaux from Rome: "Although I have no idea how this picture will be exhibited *privately*, when it is shown only to my friends, if the prince is agreeable, I should like it to be placed upright, not leaning forward on its easel, and nothing else but well bathed [in light] and with its [natural] shadows."[57] Thus, Ingres obliquely ensured that his painting would not be seen by his friends in the company of its pendant by Delaroche.

Ingres worked on few other paintings during his time in Rome. He sketched a now-lost portrait of Lady Charlemont, of which she recalled "the fifteen sittings that I gave the painter not for my portrait but for the rough sketch of my portrait."[58] He had brought a portrait of Luigi Cherubini, begun by 1834, with him from Paris. With the assistance of Henri Lehmann he expanded it in Rome, using Gounod's hands as a model for the older composer's and adding the figure of Terpsichore, the Muse of Choral Song and Dance (now sadly disfigured by bitumen), but the work was completed only after Ingres returned to Paris (fig. 221). He also received a commission from the heir to the throne of Russia, the future Czar Alexander II, then traveling in Italy, to paint a Virgin with the Host, flanked by Saints Alexander and Nicholas (fig. 200). Inspired in part by Ingres's study of Russian icons, it was not well received when exhibited in Saint Petersburg in 1842. Moreover, Ingres long resented the cavalier treatment he had received at the hands of the czarevitch and his courtiers.[59]

By the time he finished *Antiochus and Stratonice* and sent it to Paris in the summer of 1840, Ingres was nearing the end of his six-year tenure at the Académie de France, and his thoughts were beginning to turn to Paris. His old friend Granet had been keeping him informed of his reputation in the capital, and Ingres could only have been pleased with what he heard: "We are beginning here to assess the effects that your painting has already had on a great many artists. It is at this year's Salon that one sees the seeds you cast on this ground beginning to spring up in favor of the beautiful style of painting [classicism] of which, as no one will ever be able to dispute, you have been the preserver."[60] On another occasion, Granet noted a change in the Paris art world: "I find more young people in the Grande Galerie of the Louvre copying the masters who are dear to us, more than they did in the past. Every time I pass by there and find them in front of a Raphael, I cannot help saying: 'There is the seed that Ingres sowed bearing fruit.'"[61] Many of the pensioners with whom Ingres had been close in Rome had returned to Paris and were spreading word of his teachings and of the intriguing new works he had been painting. Interest in *Antiochus and Stratonice* was keen in Paris in advance of its arrival, and when it appeared it was well received, not least by the duc d'Orléans, who wrote to Ingres personally to thank him for "a picture that the French School is so justly proud of."[62] At the same time, Granet sent word to the master that this was the moment for him to return home: "So come back to us again quickly: here you will find glory, friendship, and respect. That is what awaits you in our fair France."[63]

On April 6, 1841, Ingres and his wife bade farewell to the Villa Medici and their Roman friends and colleagues.

Traveling north, they spent ten days with old friends in Florence, where Ingres made at least four *portraits intimes*, including depictions of Antoine Thomeguex (cat. no. 150) and members of the Gonin family, all of whom had been boon companions of Ingres and Madeleine when they had lived in Florence twenty years earlier.[64] The couple embarked for France by ship from Genoa; as the coastline slipped below the horizon, Ingres had his final sight of Italy, where he had spent some twenty-four years of his life. Ahead lay Paris, where he would arrive in mid-

May and where he would begin the final, richly productive phase of his career. To it he brought renewed vigor but—faced with the obligation of painting the duc d'Orléans's portrait—he brought as well his old ambivalence about the art of portraiture. As he wrote to Gatteaux on August 6, 1840, "Between us . . . despite all the honor I feel over the prince's desire to be painted by no one other than myself, it is still a matter of doing another portrait! You know how far removed I am at present from this genre of painting; but in the end I will do everything for his gracious person."[65]

1. Georges Vigne (1995b, p. 199) notes the prevalent opinion of the 1834 appointment but argues that Ingres was aware of the drawbacks of such a move, since his previous Italian sojourn had not been without frequent disappointments. He concludes, surely correctly, that Ingres would have arrived at his decision only after careful thought.

2. Ingres's student Georges Lefrançois described the master in the wake of the 1834 Salon as "deeply discouraged" ("profondément découragé"); quoted in Lapauze 1911a, p. 317.

3. Soon after arriving in Rome, Ingres wrote to his friend and patron Charles Marcotte asking, "What have I done?" ("Qu'ai-je fait?"), January 24, 1835, quoted in ibid., p. 326, and Ternois 1999, letter no. 25.

4. See p. 287 in this catalogue for a discussion of the ambiguities inherent in Ingres's acceptance of the position.

5. "mes fidèles doctrines, ma profonde conviction, dont la devise est sur mon drapeau: *Anciens et Raphaël!*" Ingres to Jean-François Gilibert, January 10, 1839, in Boyer d'Agen 1909, p. 282.

6. "Selon vous, j'ait fait 'une faute grave' d'aller à Rome. La faute grave est bien plutôt à ceux qui m'ont laissé partir, l'administration la première." Ingres to Gatteaux, June 15, 1836, quoted in Delaborde 1870, p. 339.

7. Lapauze 1911a, p. 320. In fact, Ingres would not exhibit again publicly in Paris until 1846, although both the *Odalisque with Slave* and *Antiochus and Stratonice* (figs. 190, 194), painted in Rome, would be shown privately in Paris in 1840, as well as discussed in the press, on which see pp. 331–32 of this essay.

8. Shelton 1997, p. 246.

9. Lapauze 1911a, p. 320.

10. "occupé de mes devoirs de Directeur[,] je n'ai Comencé à travailler a mes tableaux que 3 ans après." Ingres's Notebook X, p. 25, reproduced and transcribed in Vigne 1995b, p. 328. Ingres misremembered, for Vigne (ibid., p. 200) points out that he did in fact produce portrait drawings from the time of his arrival in Rome. As for paintings, a note in Madame Ingres's account book states that Ingres began work on *Antiochus and Stratonice* on September 12, 1836; see Ternois 1956, p. 175. Nonetheless, Ingres's directorship of the Académie de France was perhaps the least prolific period of his artistic career.

11. The *Moniteur universel* reported the duc d'Orléans's commission of unnamed paintings from Ingres and several other artists,

including Paul Delaroche, on May 19, 1833; see Robert 1991, p. 54, n. 13. Gruyer (1900, p. 402), however, while citing no source, states that Ingres's commission for *Antiochus and Stratonice* coincided with his appointment as director of the Académie de France, on July 5, 1834.

12. On Ferdinand-Philippe as a patron and collector, see Robert 1993.

13. On the painting, see Bann 1997, pp. 190–98.

14. Ingres's earliest treatment of the theme is a pencil drawing of about 1801 (Musée des Beaux-Arts et d'Archéologie, Boulogne-sur-Mer). A drawing from about 1806 is in the Cabinet des Dessins of the Musée du Louvre (R.F. 5022; fig. 49). Amaury-Duval (1993, p. 157) reported seeing a painting of the subject on the easel when he visited Ingres's studio in 1825.

15. On Le Go and his family, see Naef 1977–80, vol. 3 (1979), chap. 153.

16. Lapauze 1911a, p. 328.

17. See n. 19, below.

18. These he describes in a letter to Adolphe Thiers, dated September 5, 1835, in Boyer d'Agen 1909, pp. 241–43; subsequent correspondence on this matter appears in ibid., pp. 243–48.

19. "Cependant, voilà qu'ici on commence à me tourmenter quant aux moyens d'exécution, si bien que je suis obligé de montrer les dents. . . . Tous ces dégoûts (quitte même à perdre les avances d'échafauds et autres) m'auraient déterminé à rendre par démission cette affaire. . . . Me voilà donc, moi qui suis venu à Rome pour chercher un repos d'artiste, me voilà déjà en butte à des chagrins et à des contrariétés!" Ingres to Gatteaux, November 24, 1835, quoted in Delaborde 1870, pp. 336–37.

20. Vigne 1995b, p. 204.

21. "Je suis désolé; je suis furieux contre le sort qui s'acharne presque toujours à détruire ce qui est bon, tandis qu'il épargne tant de monstres nuisibles ou inutiles au genre humain." Ingres to Gatteaux, July 11, 1839, in Boyer d'Agen 1909, p. 276.

22. "Non, mon ami, la peinture n'est pas perdue; je n'aurai donc pas été inutile!" Quoted in Lapauze 1911a, p. 333.

23. See ibid., p. 344.

24. On Madame Ingres's control of finances during Ingres's directorship, see Ternois 1956, pp. 163–76.

25. "Elle est mon petit ministre de l'intérieur." Ingres to A.-L. Dumont, March 9, 1835, in Boyer d'Agen 1909, p. 237.

26. "Rarement les hôtes de la Villa Médicis vécurent en meilleur accord." Lapauze 1911a, p. 328.

27. "Sincèrement humble et petit devant les maîtres, mais digne et fier devant la suffisance et l'arrogance de la sottise; paternel pour tous les pensionnaires qu'il regardait comme ses enfants et dont il maintenait le rang avec une affection jalouse au milieu des visiteurs, quels qu'ils fussent, qui étaient reçus dans ses salons, tel était le grand et noble artiste dont j'allais avoir le bonheur de recueillir les précieux enseignements." Gounod 1896, quoted in Vigne 1995b, p. 207.

28. Byron 1974, p. 228. Thanks to Nicholas Penny for the quotation.

29. "Le directeur mène, dans ce palais, un train de prince. . . . [Il] avait donc mille raisons d'être heureux à la villa Médicis. Le pensionnaire était devenu directeur. Chaque marche d'escalier, chaque soupir de fontaine, chaque murmure de laurier lui disait tout ce qu'il avait fait, gagné, conquis depuis sa jeunesse. . . . Que lui fallait-il de plus? . . . Il avait une école disciplinée, fanatisée par ses leçons. Ce n'était pas même un culte qu'on avait pour lui, c'était du fétichisme." Lady Eglé Charlemont's memoir of Ingres at the Villa Medici, published in the *Revue de Paris* for November 1, 1867, has been partially reprinted, with helpful annotations, in Bertin 1997, pp. 53–60.

30. "Tout cela n'apportait pas de bonheur, de sourire, de calme à cette nature d'artiste, irritée, irritable, qui se croyait détrônée par la critique d'un tableau, et je crois bien, exilée à Rome, cette hôtellerie de toutes les déchéances." Charlemont 1867, quoted in Bertin 1997, p. 54.

31. For a discussion of these portraits, see Fleckner 1995, pp. 113–23.

32. "de vous offrir un souvenir . . . en acceptant de moi, ce que je destine uniquement à mes amis: *un portrait dessiné.*" Ingres to Madame Louis-Joseph-Auguste Coutan, July 2, 1825, quoted in Naef 1977–80, vol. 3 (1979), p. 415.

33. Ibid., vol. 5 (1980), nos. 362–84.

34. Ingres gave the drawing to the engraver Luigi Calamatta, but it was not in fact engraved until 1839; see Vigne 1995b, p. 200.

35. "Malgré les injustices de la destinée, il est sûr de sa force: c'est le chef d'école qui donna à ses disciples les plus hauts exemples et qui leur imposa son enseignement intégral." Lapauze 1911a, p. 326.

36. Ibid., p. 336.

37. "Tous, nous nous portons bien; voilà l'essentiel. Voici, après cela, l'état de la maladie au jour même où je vous écris. Les cas sont de quatre cents à six cents par jour, et les morts à deux cents environ. La maladie paraît décroître, puisque, il y a huit jours, les morts étaient au nombre de trois cents et plus. La *plebe* est plus maltraitée. Aucun secours n'est organisé, une grande partie des médecins se refuse au service, et, par le malheureux système de la contagion, tous les Romains se fuient les uns les autres, ou se fumigent, à se donner par cela seul la maladie." Ingres to Gatteaux, September 5, 1837, quoted in Delaborde 1870, pp. 343–44.

38. "Nous, nous faisons groupe à la villa Médicis; nous nous tenons, comme des oiseaux effrayés, mais sans l'abri d'un grand arbre, jusqu'à ce que l'orage soit passé, vivant sobrement et le plus tranquillement possible. Moi, non pour chasser l'inquiétude, car je suis calme dans ce danger, mais pour chercher une forte distraction, je travaille toujours et j'y pense moins. . . . Les pensionnaires, presque tous, ont voulu fuir, et, dans ce cas, pour ne pas me compromettre dans ce danger, je leur avais permis d'aller à Ancône, à Florence ou à Bologne, vivre en corps; mais nous sommes bloqués à Rome. Personne ne peut en sortir, pas même un cardinal, qui serait d'ailleurs reçu dans les pays environnants à coups de fusil, ce qui est arrivé." Ibid., p. 344.

39. "Vous voilà dans cette triste ville de Rome où la mort est venue faire sa demeure. . . . Tout le monde sait, ici, que vous conduisez votre barque admirablement malgré toutes les difficultés qu'on rencontre sur cette mer de la vie." Granet to Ingres, September 19, 1837, in Néto 1995, letter no. 355.

40. "Enfin, dans ce tableau, bien des choses, sinon presque toutes, sont peintes sur des dessins, en l'absence du modèle vivant (ceci est pour nous seuls), qui, d'après ce que vous pensez, et c'est aussi mon avis, donne indispensablement la vie à une oeuvre et la fait palpiter." Ingres to Gatteaux, December 17, 1840, quoted in Delaborde 1870, p. 239.

41. Upon seeing the completed *Antiochus and Stratonice* in 1840, the critic Jules Varnier remembered having been shown preliminary composition drawings in 1834, before Ingres left for Rome. Varnier compared one of these to the completed painting, pointing out major differences. He dismissed the 1834 sheet as "a poor and mannered conception" ("une conception pauvre et maniérée") and concluded that in Rome Ingres had effected a "revolution" in his treatment of the subject. Varnier 1840, p. 152.

42. Wildenstein 1954, no. 232.

43. Charlemont 1867, quoted in Bertin 1997, p. 56.

44. The portrait drawing of Baltard that Ingres presented to Madame Baltard on August 30, 1837 (cat. no. 115), was later described as a token of appreciation for Baltard's work on *Antiochus and Stratonice;* see Sédille 1874, p. 486. That the drawing also likely signaled completion of Baltard's role in the project and the beginning of Ingres's work on the canvas is indicated by Ingres's letter to A.-L. Dumont of August 14, 1838, in which he referred to *Antiochus and Stratonice* as the painting "that I have been working on for a year" ("que je travaille depuis une année"); in Boyer d'Agen 1909, p. 271.

45. "les parties moins importantes . . . comme les parties architecturales." Flandrin (1911, p. 144, n. 1) quotes from Raymond Balze's papers.

46. Balze 1921, p. 216.

47. "J'admire pour ma part ces natures enfantines qui ont conservé la violence et la puérilité charmante des passions." Charlemont 1867, quoted in Bertin 1997, p. 56.

48. Balze 1921, p. 217.

49. The duke acquired *Oedipus* in 1839; Wildenstein 1954, no. 60. Ingres had received the duke's portrait commission at the latest by midsummer 1840, when he discussed it in a letter to Gatteaux dated August 6, 1840; quoted in Delaborde 1870, p. 259.

50. "un ouvrage que l'on pourra louer, et assez neuf." Ingres to Gatteaux, April 22, 1837, in Boyer d'Agen 1909, p. 261.

51. Ingres discusses both paintings in a letter to Marcotte dated May 10, 1836 (in Boyer d'Agen 1909, p. 253), and in three letters to A.-L. Dumont, dated August 14, 1838, February 2, 1839, and July 25, 1840 (in Boyer d'Agen 1909, pp. 269–71, 273, and 277).

52. On November 17, 1841, Gatteaux informed Marcotte that Ingres was painting a small copy of his *Christ Giving the Keys to Saint Peter* of 1820, and that this work would be engraved by Pradier "instead of the *Stratonice*, which will not be engraved" ("en échange de la *Stratonice* qui ne sera pas gravée"). Quoted in Naef 1969 ("*Odalisque à l'esclave*"), p. 96.

53. "Il était possédé, il avait partout la même vision, une horrible vision." Charlemont 1867, quoted in Bertin 1997, p. 55.

54. "Voilà les rêves debout, les visions du réveil que M. Ingres trouvait à table, à la fenêtre du salon, dans son atelier, dedans, dehors . . . partout, continuellement. . . . Ses bras tombaient de découragement. . . . L'artiste ne travaillait plus, ou, s'il travaillait, il effaçait le lendemain ce qu'il avait fait la veille." Ibid.

55. The duc d'Orléans had paid Delaroche 12,000 francs for his painting on May 24, 1834 (Archives Nationales, Paris, 300 AP 1, 2389, exercise 1834, arts ordre no. 283). If Delaroche had not actually completed the painting by that date, he had certainly done so by June 20, when he left Paris for an Italian sojourn. The *Assassination* remained in Delaroche's studio until it was exhibited at the Salon of 1835, only then going to the duke; see Ziff 1977, p. 137. Thus Ingres had ample time to study it before he too left for Rome, at the end of 1834. Delaroche, preparing to marry Louise Vernet, was in Rome when Ingres arrived early in 1835, and he visited again in 1838. The two artists easily would have been able to discuss their joint commission.

56. Vigne 1995b, p. 226.

57. "Quoique j'ignore tout à fait comment ce tableau sera exposé *privément*, pour le montrer à mes seuls amis, si c'est le bon plaisir du prince, je voudrais qu'il fût placé droit, point penché en avant sur son chevalet, et rien autre chose que bien lavé et avec ses ombres." Ingres to Gatteaux, July 1840, in Boyer d'Agen 1909, p. 293. In a forthcoming article, I will discuss in greater detail the relationship between Delaroche's *Assassination of the Duc de Guise* and Ingres's *Antiochus and Stratonice*, identifying the second version of the latter painted for an engraving by Pradier and suggesting one reason why the duc d'Orléans would have conjoined two such unexpected subjects as pendant paintings.

58. "les quinze séances que je donnai au peintre pour avoir non mon portrait, mais l'ébauche de mon portrait." Charlemont 1867, quoted in Bertin 1997, p. 56.

59. Vigne 1995b, p. 214.

60. "Nous commençons ici à juger des effets que votre peinture a déjà produit sur grand nombre d'artistes. C'est au Salon de cette année où l'on voit que les semences que vous avez jetées sur cette terre commencent à germer au profit de la belle peinture dont personne ne pourra (jamais) vous disputer d'avoir été le conservateur." Granet to Ingres, March 5, 1835, in Néto 1995, letter no. 335. A slightly different citation of this letter is found in Lapauze 1911a, p. 326.

61. "Je trouve plus de jeunes gens dans notre grande galerie du Louvre, copiant nos maîtres à nous, plus qu'on ne faisait autrefois. Toutes les fois que je passe là et que je les trouve devant un Raphaël, je ne puis m'empêcher de dire: voilà les semences que Ingres a semées qui produisent." Granet to Ingres, October 31, 1836, in Néto 1995, letter no. 349.

62. "un tableau dont l'École française s'enorgueillit à si juste titre." Duc d'Orléans to Ingres, September 25, 1840, quoted in Lapauze 1911a, p. 358.

63. "Venez donc bien vite nous retrouver; vous trouverez ici gloire, amitié, et respect. Voilà ce qui vous attend dans notre belle France." Granet to Ingres, November 29, 1840, in Néto 1995, letter no. 396.

64. Naef 1977–80, vol. 5 (1980), nos. 382–85.

65. "Entre nous . . . malgré tout l'honneur que je ressens de la volonté du prince de n'être peint que par moi, il faudra donc encore faire un portrait! Vous savez quel éloignement j'ai à présent pour ce genre de peinture; mais enfin je ferai tout pour son aimable personne." Quoted in Delaborde 1870, pp. 258–59.

111. Self-Portrait

1835
Graphite
11¾ × 8⅝ in. (29.9 × 21.9 cm)
Signed bottom center: Ingres / à Ses Eleves.
[Ingres / for his students.]
Dated lower right: Rome 1835.
*At lower left, the Musée du Louvre, Paris,
collection stamp (Lugt 1886a)*
Musée du Louvre, Paris
Département des Arts Graphiques RF 9
London only

N 364

This drawing is discussed under cat. no. 91.

PROVENANCE: Given by the artist to Luigi Calamatta (1801–1869), Milan; his widow, née Joséphine Raoul-Rochette, Paris; purchased from her for 2,000 francs by the Musée du Louvre, Paris, 1872

EXHIBITIONS: Bucharest 1931, no. 201, ill.; Basel 1935, no. 9; Brussels 1936, no. 23; Bern 1948, no. 73, ill.; Prague 1956, no. 5; Warsaw 1962, no. 29; Montauban 1967, no. 107; Paris 1967–68, no. 171, ill.; Rome 1968, no. 109, ill.; Tübingen, Brussels 1986, no. 1, ill.

REFERENCES: Janin 1840, p. 300; Lacroix 1855, p. 214; Mirecourt 1855, frontis. (the engraving by Charles-Philippe-Auguste Carey); Galichon 1861a, pp. 359–60; Delaborde 1870, p. 301, n. 1, no. 333; Both de Tauzia 1879, no. 1829; Chennevières 1882–83, p. [71], ill.; Pinset and Auriac 1884, ill. p. 222; Jouin 1888, p. 95; Latour 1894–1900, ill. p. 102; Leroi 1894–1900b, p. 817, ill. p. 786; Paris, Musée du Louvre 1900, no. 1829; Lapauze 1901, pp. 8, 266; Chennevières 1903, p. 138; Lapauze 1903, pp. 27–29, no. 42, ill.; Alexandre 1905, pl. 1; Boyer d'Agen 1909, pl. 67 preceding p. 433; Guiffrey and Marcel 1911, no. 5045, ill. p. 126; *Kunst und Künstler* 1911, ill. p. 347; Lapauze 1911a, p. 326, ill. p. 325; Cassirer 1919, ill. p. 483; Alexandre 1920b, ill. p. 401; Fröhlich-Bum 1924, p. 23, pl. 46; *Dessins de Jean-Dominique Ingres* 1926, p. [8], pl. 31; Martine 1926, no. 2, ill.; *J.A.D. Ingres* 1927, ill. opp. p. 3; Hourticq 1928, ill. on pl. 78; Christoffel 1940, ill. p. 137; Alazard 1942, no. 13, ill.; Courthion 1947–48, vol. 2, frontis.; Anon., June 1948 (j.w.), ill. p. 275; Roger-Marx 1949, pl. 38; Scheffler 1949, pl. 38; Labrouche 1950, pl. 23; Mathey 1955, no. 31, ill.; Millier 1955, jacket ill.; Ternois 1962, pp. 12, 15, 16; Berezina 1967, fig. 60; Sérullaz 1967, p. 212; Waldemar George 1967, ill. p. 43; Champa 1968, ill. p. 42; László and Mátéka 1968, ill. p. 69; Radius and Camesasca 1968, ill. p. 83; *Encyclopaedia universalis* 1970, ill. p. 1031; Ayrton 1971, fig. 34; Ternois and Camesasca 1971, ill. p. 83; Naef 1972 ("Villa Medici"), p. 662, ill.; Naef 1977–80, vol. 5 (1980), pp. 218–20, no. 364, ill.; Picon 1980, p. 89, ill.; Vigne 1995b, fig. 167

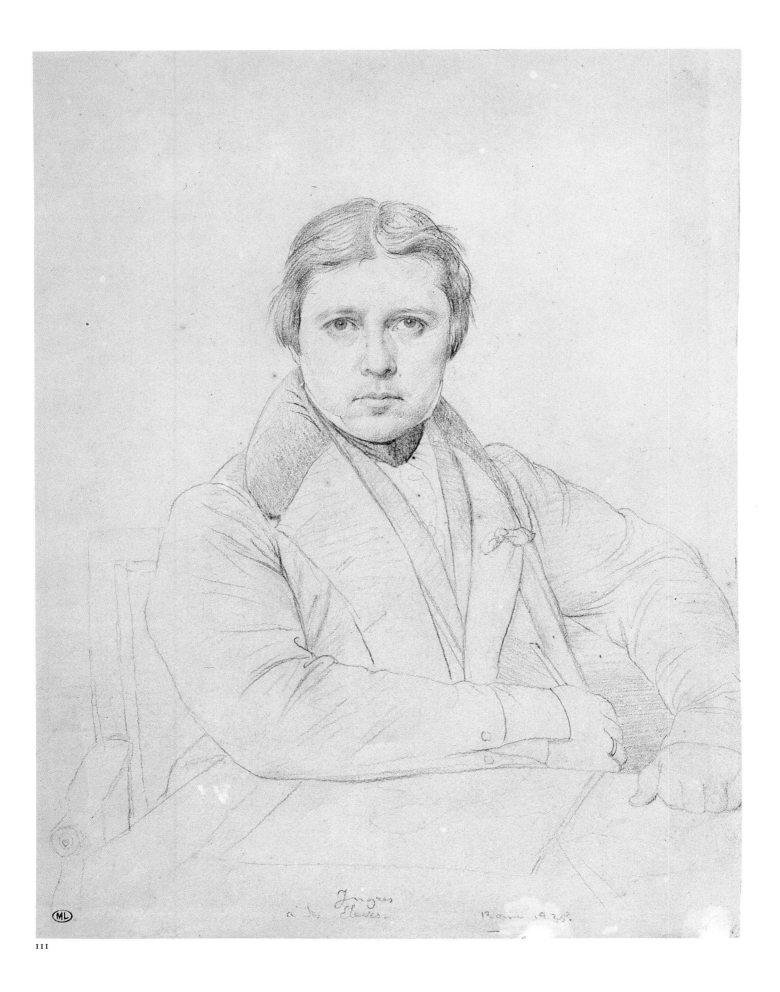

112. Mademoiselle Louise Vernet

1835
Graphite
13 × 10 in. (33 × 25.3 cm)
Signed and dated lower left: à Madame / horace
Vernet, / Ingres Del / 1835 / à Rome. [For
Madame / Horace Vernet, / Ingres drew
(this) / 1835 / in Rome.]
Collection of Dian and Andrea Woodner,
New York
New York and Washington only

N.362

In early January 1835, after an absence of fifteen years, Ingres once again arrived in Rome, this time to take over the direction of the Académie de France. Horace Vernet, the man he was replacing, was a long-standing rival who enjoyed greater popularity as a painter but had reason to resent Ingres for having edged him out in competition for a place in the Institut de France ten years before. There was bound to be some awkwardness when they met, and it appears that very soon after his arrival Ingres sought to smooth things over by presenting his predecessor's wife with a portrait drawing of the Vernets' adored daughter, Louise. In that same month the young woman was married, and the portrait surely commemorates that occasion.

Born in Paris in 1814, Louise was the couple's only child. She had grown up amid the social whirl at the Villa Medici and in that circle had attained a distinct celebrity. According to the testimony of any number of guests at the Académie, her lovely, regular features and sylphlike form made her seem almost ethereal. One of these was Ingres's pupil Amaury-Duval, who called at the Villa Medici in September 1834. He described his first impression of her in his reminiscences:

> Finally, way at the back of the room, half reclining on a sofa, I spotted Mademoiselle Vernet—or rather, for me it was like a kind of apparition, for you could not imagine anything more graceful, more beautiful, more elegant than that young woman, who, with her fine, supple waist and utterly pure features, combined the beauty of ancient statues with the charm of medieval virgins.[1]

The man who won the hand of this vision was the painter Paul Delaroche, who had already made a name for himself with his contributions to the Salons of 1827 and 1831. Commissioned to paint the six nave arcades of the Parisian church of the Madeleine, Delaroche decided to travel to Italy in 1834 in order to study firsthand the works of the great Italian fresco painters. When he made his appearance at the Villa Medici he must have been given a hero's welcome; however, it is likely that Louise was more impressed by the man's seriousness and industry than by his previous successes.

In 1837, after the Delaroches had settled in Paris and celebrated the birth of their first son, the critics began to turn against the painter, and he determined never again to exhibit his work in public. In that same year, even though his popularity had fallen off in the press, Delaroche was awarded the commission to paint the huge curved wall in the hall at the École des Beaux-Arts where the Rome prizes were presented. This was his last work on such a scale, though he continued to be active in the circle he had created around himself. The embittered artist moved in the very highest society, thanks in no small part to the radiance and intelligence of his lovely wife.

Louise bore him a second son in 1841, but in 1845 her delicate health failed and she died at the age of thirty-one. Vast numbers of mourners joined the funeral procession to the Montparnasse cemetery, Ingres among them. On his way home the artist commented to his friend and pupil Victor Mottez, who had lost his own wife only three months before: "These are two murders. What can we make of all this? What's certain is that those two [women] were the most remarkable of all artists' wives, the best suited to fill that difficult role."[2]

Two days later Frédéric Chopin eulogized the deceased in a letter to his family:

> Vernet's daughter, who was married to Delaroche . . . died the other day. All Paris mourns her. She was a person of very delicate wit, young, beautiful, though very thin. In her salon she welcomed the most remarkable personalities Paris has to offer; she was adored by everyone and had happiness, fortune, and respect. Her grief-stricken father was beside himself. For a while we thought her mother might lose her reason.[3]

It is somewhat surprising that in his portrait of Louise Vernet, Ingres appears to be so unaffected by the charms of a woman who was universally admired. Perhaps her ethereal type of beauty, idealized at the

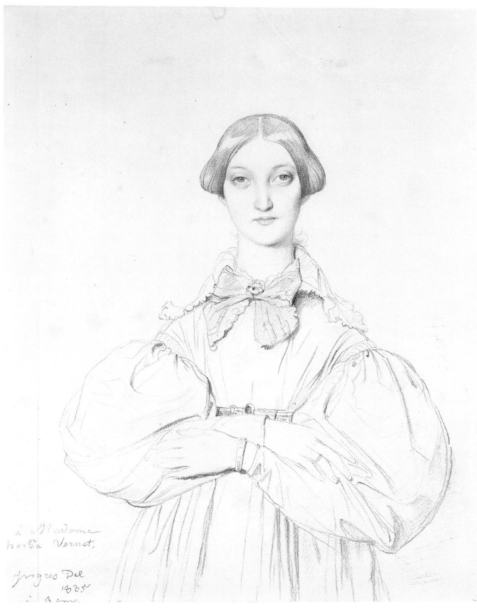

112

time, held no appeal for the somewhat unsophisticated, red-blooded older man. There is no reason to doubt the accuracy of his portrayal, and given the fact that eroticism has no part in it, the work's charm must be attributed entirely to its exquisite matter-of-factness. H . N .

For the author's complete text, see Naef 1977–80, vol. 3 (1979), chap. 152 (pp. 208–15).
 1. Amaury-Duval 1878, pp. 171–72; reprinted in Naef 1977–80, vol. 3 (1979), p. 209.
 2. Mottez to Hippolyte Fockedey, December 31, 1845; quoted in Giard 1934, p. 164; reprinted in Naef 1977–80, vol. 3 (1979), p. 213.
 3. Chopin 1904, p. 26; reprinted in Naef 1977–80, vol. 3 (1979), p. 213.

PROVENANCE: Mme Horace Vernet, née Louise Pujol, Paris, until 1858; Horace Delaroche, her grandson, until 1879; his daughter Mme Georges de Saint-Maurice, née Louise Delaroche; acquired from her by Jean Dieterle & Cie., Paris, 1952; sold by the dealer Jean Dieterle through the agency of M. Walter to M. Knoedler & Co., New York, 1952; purchased from that firm by Mrs. C. Suydam Cutting, née Helen McMahon, 1953; her posthumous auction, Savoy Art and Auction Galleries, New York, June 25–26, 1964, no. 102, as *Mme Vernet;* purchased at that sale for $22,000 by Stanley Moss for Ian Woodner; Ian Woodner, New York; his daughters, Dian and Andrea Woodner, New York

EXHIBITIONS: New York, Manchester, Detroit, Cincinnati, Cleveland, San Francisco 1952–53 (not in catalogue); Newark 1954, no. 1, ill., as *Madame Horace Vernet;* New York 1961, no. 47, ill.; New York 1965; Cambridge (Mass.) 1967, no. 76, ill.; London 1969, no. 196, ill.; Washington, New York, Philadelphia, Kansas City 1971 (not in catalogue); Malibu, Fort Worth, Washington, Cambridge (Mass.) 1983–85, no. 62; Vienna, Munich 1986, no. 86; Madrid 1986–87, no. 102; London 1987, no. 85; New York 1988b, no. 30, ill.; New York 1990, no. 108, ill.

REFERENCES: Delaborde 1870, no. 424; Preston 1953, ill. p. 169, as *Madame Horace Vernet;* Naef 1957 ("Notes II"), pp. 289–91, fig. 1, p. 288 (sitter identified; erroneously described as unpublished); Roskill 1961, pp. 27–28, 58, ill., as *Mme Vernet;* Naef 1977–80, vol. 5 (1980), pp. 214–15, no. 362, ill.; Gaigneron 1981, p. 78

113. Alexis-René Le Go

1836

Graphite

12 ⅛ × 9 in. (30.7 × 22.9 cm), mounted

Signed and dated lower left: offert à Son ami /
mᵣ Lego / Ingres Del. / rome 1836. [offered to
his friend / Monsieur Le Go / Ingres drew
(this) / Rome 1836.]

Private collection
New York only

N 366

Ingres applied for the post of director of the Académie de France in Rome out of frustration with the response to his work in Paris, where at the 1834 Salon his composition *The Martyrdom of Saint Symphorian* (fig. 169) had encountered the sort of criticism he never wished to subject himself to again. When he arrived in Rome he was still nursing his hurt, feeling somewhat martyred himself, and irritable. The last thing he needed to encounter there was a staff that was difficult to work with. As luck would have it, he found in the newly appointed secretary, Alexis Le Go, the most agreeable colleague imaginable, and in no time the two became the best of friends. In his history of the Académie Henry Lapauze wrote of Le Go:

> For nearly forty years, the Académie de France in Rome would have the perfect secretary-librarian, a man of excellent education, who was discreet and obliging, very cultivated, and a consummate administrator of state funds. In M. Le Go, Ingres found more than a highly knowledgeable collaborator; he also found a friend whose devotion never wavered.[1]

Le Go was born in Paris in 1798. It appears that he studied to be an artist, for when he registered at the French Embassy on his first visit to Rome in 1823 he identified himself as a painter. Since the standard art-reference works do not mention him, Le Go must have abandoned painting a short time later. His interest in art continued, however, and in 1833 he was asked to cover the Salon for the *Revue de Paris*. His review, published in eight installments, ran to nearly seventy pages. Ingres's contributions to the exhibition that year were his portraits of Madame Duvaucey and Louis-François Bertin (fig. 87, cat. no. 99). Having no idea that the creator of those masterpieces would soon be his superior, Le Go wrote:

> If all we knew of M. Ingres's work were the two portraits that he was pleased to exhibit at the Salon, we would still be in a position to judge M. Ingres. Beginning with the portrait of the elder M. Bertin, one wonders, first of all, how this composition managed to capture such widespread attention. I do not believe it's the pose, which is neither *heroic* nor *graceful*, as they say; nor the artist's rendering of flesh tones, nor his *transparency*, his *tone*, the *overall effect*, the *richness* or *quaintness* of the costumes—all qualities that usually seem indispensable if one wishes to make a pleasing and prestigious imitation of nature. And yet, everything in this portrait is large, everything is expansive, everything is noble and relatively true to life. . . .
>
> In the juxtaposition of two portraits executed by M. Ingres twenty-six years apart, people have claimed to see a kind of protest, an indirect reproach toward public opinion, which was so slow to understand an artist [who is] finally admitted to the rank of master. Personally, I recognize in these portraits [not only] a legitimate pride at success but [also] the frank exposition of M. Ingres's studies from the day he first glimpsed his goal to the day he attained it; as well as the contrast between the imperfect, not to say indecisive, execution of a talent still finding its way, and the much more polished aspect of a talent in full possession of its expressive means.[2]

Ingres prized Le Go's ability to turn his own somewhat awkward writing into polished documents worthy of the Académie. Because they got on so well, it was not long before Ingres presented him with a pencil portrait, the ultimate token of his friendship. In it the secretary stands in front of one of the columns of the loggia on the garden side of the palace at the Villa Medici. He cuts an elegant figure, his costume complete with top hat, walking stick, and gloves, as though he were about to set off on a stroll down the Corso. One of the two lions flanking the loggia entrance can be seen to his right. His expression reveals him to be a kindly man of utmost competence.

When Le Go arrived at the Académie in 1834 he was a bachelor, but in 1838 he married a Florentine woman, Giulia Serrati, who would bear him a daughter and a son before she died, at only thirty-five, in 1846. In 1841, Ingres's last year in Rome,

the artist produced a portrait of Madame Le Go (fig. 189) to complement the earlier one of husband. In her marriage certificate she is identified as a painter,[3] which explains why Ingres posed her holding a pencil and sketch pad.

Ingres and his wife were named the godparents of the Le Gos' daughter Zéphyrine, born in 1839. In Ingres's letters to Le Go during 1840 he writes of his intention to make a portrait drawing of the child, but there is no proof that he did. Two versions of a portrait of an unidentified infant survive (N 272, 273), and it is altogether possible that the subject is Zéphyrine Le Go and that one likeness was made for her parents, the other for her godparents.

Two days before leaving Rome, Ingres wrote to Comte Charles-Marie Tanneguy Duchâtel, the minister in charge of the Académie, to thank him for his assistance during his tenure. In that letter he includes high praise for his secretary, and it was doubtless thanks to that recommendation that Le Go was awarded the cross of the Legion of Honor only weeks later. By the time he retired, in 1873, Le Go had served under five more directors at the Villa Medici. He died in 1883 in La Seyne-sur-Mer (Var), where his son was employed as an engineer.

Ingres's portrait of Le Go was photoengraved by E. Charreyre in 1896. In a private collection in Youngstown, Ohio, there is a pencil copy by an unknown artist of this drawing. The internal measurements match those of the original.[4]

<div align="right">H.N.</div>

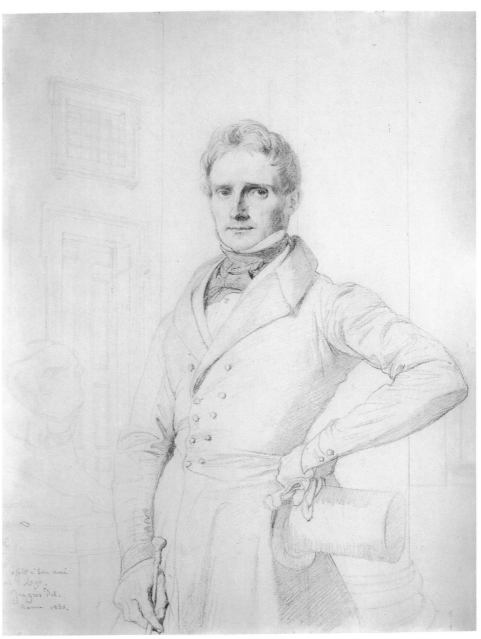

113

For the author's complete text, see Naef 1977–80, vol. 3 (1979), chap. 153 (pp. 216–34).

1. Lapauze 1924, vol. 2, p. 229.
2. Le Go 1833, pp. 211–13.
3. "Pittrice." Archivio di Stato, Florence, no. 108.
4. On the copy, see Cleveland 1929, p. 159; London 1934, no. 51; New York 1961, no. 48, ill.

PROVENANCE: Alexis-René Le Go (1798–1883), La Seyne-sur-Mer; his son, Henri Le Go, Le Val, until 1919; his widow, née Honorine Le Boulleur de Courlon, Le Val, until 1939; by inheritance to their daughter Marie-Louise Le Go and their son Pierre Le Go; Pierre Le Go, Le Val, until 1958; his son, Yves Le Go; private collection

REFERENCES: Duplessis 1896, no. 17, ill. (photoengraving by E. Charreyre); Leroi 1894–1900b, p. 818; Lapauze 1901, p. 267 (known from the photoengraving); Lapauze 1911a, ill. p. 329; Fröhlich-Bum 1924, p. 22; Alazard 1950, p. 94; Naef 1977–80, vol. 5 (1980), pp. 222–23, no. 366, ill.

114. Madame Victor Baltard, née Adeline Lequeux, and Her Daughter, Paule

115. Victor Baltard

114. Madame Victor Baltard, née Adeline Lequeux, and Her Daughter, Paule
1836
Graphite
11⅞ × 8⅞ in. (30.1 × 22.3 cm)
Signed and dated lower left: offert à Son ami /
Mʳ Vʳ· Baltard / Ingres Del. Rom 1836.
[offered to his friend / M. V(ictor) Baltard /
Ingres drew (this in) Rome 1836.]
Private collection, Cambridge, Massachusetts

N.368

115. Victor Baltard
August 30, 1837
Graphite
12½ × 9⅜ in. (31.6 × 23.7 cm)
Signed and dated lower left: offert / à Madame /
Baltard / Ingres Del / Rom. 1837. [offered /
to Madame / Baltard / Ingres drew (this in) /
Rome. 1837.]
Dated lower right: 30 aoust. [August 30.]
Collection Yves Saint Laurent and Pierre Bergé

N.371

Victor Baltard is remembered quite apart from his having been the subject of an Ingres portrait. The builder of Les Halles and the church of Saint-Augustin in Paris was one of the leading figures in French architecture for at least a quarter of a century.

Baltard was born into a family of Parisian artists in 1805. His father, Pierre-Louis Baltard, was an architect and engraver trained in the exalted tradition of the eighteenth century. A man of remarkable gifts and a committed Lutheran, he saw to it—even though his means were limited and there were eleven children to raise—that his most talented son was given a superior education. Victor showed an interest first in mathematics, then in medicine, but his father wanted him to be an architect, and he never disobeyed his father. In the course of his studies he formed a close friendship with the architect Paul-Eugène Lequeux and in time fell in love with Lequeux's younger sister. When he asked his father if he might marry, the older man responded:

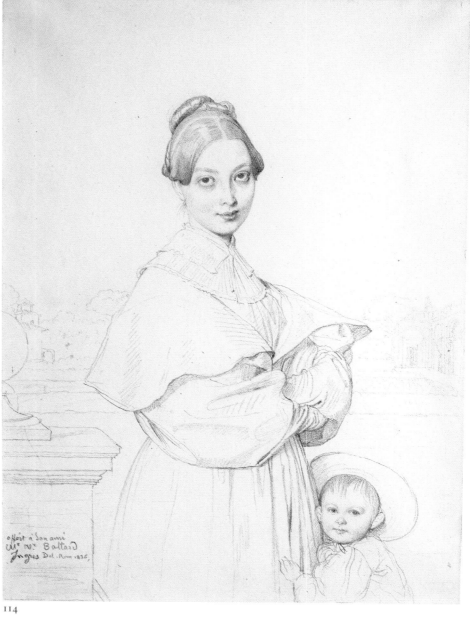

114

"When you win the Grand Prix de Rome."[1] Victor obediently entered the competition, walked away with the first prize, and married Adeline Lequeux in October 1833. In March 1834 the young couple set out for Rome, where a daughter, Paule—their only child—was born the following August.[2]

Since the Villa Medici had no accommodations for married boarders, its director, Horace Vernet, permitted the couple to take rooms nearby. When Ingres took over the directorship in January 1835, one of his first official acts was to ask the minister of the interior for permission to continue that arrangement. He clearly felt an immediate liking for the young architect:

> During the first part of their stay in Rome, the poor [Baltard] family had nothing but iron flatware for their table, and only the affectionate intervention of M. and Mme. Ingres was eventually able to change their situation. Until the end of his life, Baltard religiously preserved the silver table settings that Ingres . . . brought him one day, ordering him, in a tone that brooked no resistance, to accept them "as he would have received them from the hands of his own father, and moreover as the rules of obedience dictated."[3]

The older man not only took an interest in Baltard's domestic situation, he also honored him by requesting his assistance with one of his most famous paintings. The rich architectural background of his *Antiochus and Stratonice* (fig. 194) is largely based on a concept of Baltard's (fig. 319).[4] He also managed to direct more rewarding commissions to the younger man. By the time Ingres drew these pendant portraits of the Baltards, he and his wife had virtually adopted them, along with his pupil Hippolyte Flandrin (see cat. nos. 155, 158), the composer Ambroise Thomas, and the sculptor Pierre-Charles Simart (see cat. no. 162). When these young people returned to Paris he was devastated.

In 1841, thanks to Ingres's recommendation to Édouard Gatteaux, Baltard was named Inspecteur des Beaux-Arts and in that capacity undertook a major restoration of the churches of Paris. In 1853 he was asked to design the great Paris market, known as Les Halles Centrales, and with it created a textbook example of the virtues of structural steel. Under the Second Empire he became chief architect of the city of Paris and later inspector general of municipal structures. Among his surviving works are Ingres's memorial at Père Lachaise cemetery and Hippolyte Flandrin's in the church of Saint-Germain-des-Prés. His most notable accomplishment is the church of Saint-Augustin, built between 1860 and 1871. He died at age sixty-eight, in 1874.

Ingres's portrait of Baltard includes one of the Roman backgrounds of the sort he had frequently used as embellishments in the pencil drawings he made during his earlier years in the city. This one, depicting Saint Peter's Square seen from the southeast, was doubtless intended as an allusion to Baltard's profession. In the background of the pendant portrait of Adeline and Paule Baltard may be seen the now-destroyed Casina di Raffaello in the Villa Borghese on the left and on the right the loggias of the Villa Medici's garden terrace.[5]

Written in an old-fashioned hand on the back of the mount of Madame Baltard's portrait is the following anecdote:

> The two-year-old Paule Baltard was not supposed to figure in the drawing, but while Mme. Ingres was holding her she escaped and threw herself against her mother, crying, "Mama, mama." Whereupon M. Ingres said, "Let her stay," and the painter sketched the child while someone dangled a sugar cube above his head.[6]

Both portraits have been reproduced. The one of Madame Baltard and her daughter

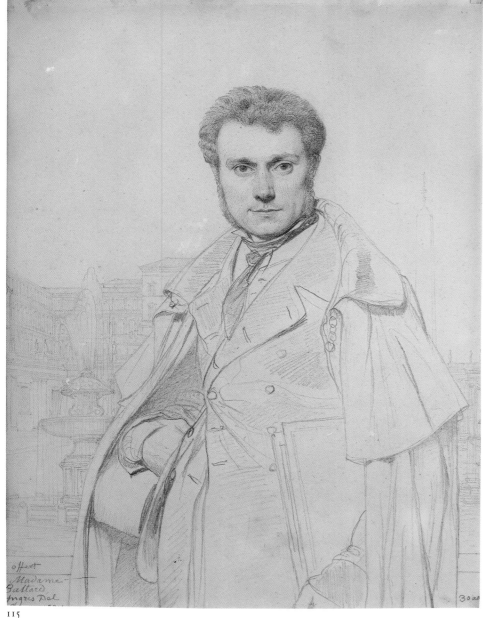

115

was photoengraved by E. Charreyre in 1896. The drawing of Victor Baltard was engraved by Léopold Massard. It was also copied in pencil by Jean Coraboeuf in March 1895 (Musée Ingres, Montauban).

<div align="right">H.N.</div>

For the author's complete text, see Naef 1977–80, vol. 3 (1979), chap. 156 (pp. 250–57).
1. Arnould 1939, p. 4; reprinted in Naef 1977–80, vol. 3 (1979), p. 251.
2. Birth register, French embassy to the Holy See.
3. Delaborde 1874, pp. 793–94; reprinted in Naef 1977–80, vol. 3 (1979), p. 251.
4. Delaborde 1870, p. 219.
5. On Ingres's pencil sketch for this background in the Musée Ingres (inv. 867.4332), see Zurich 1958a, no. 23, and Vigne 1995a, p. 464, no. 2603.
6. Quoted in the original French in Naef 1977–80, vol. 3 (1979), p. 256.

Cat. no. 114. *Madame Victor Baltard, née Adeline Lequeux, and Her Daughter, Paule*

PROVENANCE: Victor Baltard (1805–1874), Paris; his widow, née Adeline Lequeux, until 1889; by descent to their daughter, Mme Edmond Arnould, née Paule Baltard (1834–1916), Paris; her daughter Mme Louis Duval-Arnould, née Paule Arnould, until 1942; her son Dr. Raymond Duval-Arnould; private collection

EXHIBITIONS: Paris 1861 (1st ser.), no. 45; Paris 1867, no. 320; Paris 1884, no. 414; Paris 1921, no. 103; Paris 1934a, no. 540; Paris 1934c, no. 31; Brussels 1936, no. 25; Paris 1949b, no. 53; Paris 1967–68, no. 173, ill.

REFERENCES: Blanc 1861, p. 191; Delaborde 1861, p. 267; Galichon 1861a, p. 357; Blanc 1870, p. 235; Delaborde 1870, no. 253; Both de Tauzia 1888, p. 141; Duplessis 1896, no. 1, ill. (the photoengraving by E. Charreyre); Leroi 1894–1900b, p. 817; Lapauze 1901, p. 265 (discussed on the basis of the photogravure); Lapauze 1903, no. 2, ill.; Lapauze 1911a, ill. p. 331; Hourticq 1928, ill. on pl. 80; Alaux 1933, ill. p. 158; Waldemar George 1934, ill. p. 198; Arnould 1939, p. 6; Pach 1939, ill. opp. p. 178; Alazard 1950, p. 94; Labrouche 1950, pl. 21; Ternois 1959a, preceding no. 8; Naef 1960 *(Rome)*, p. 27, n. 52; Paisse 1968, pp. 17, 21–22; Jullian 1969, p. 89; Naef 1977–80, vol. 5 (1980), pp. 226–27, no. 368, ill.

Cat. no. 115. *Victor Baltard*

PROVENANCE: Mme Victor Baltard, née Adeline Lequeux, until 1889; by descent to her daughter, Mme Edmond Arnould, née Paule Baltard, Paris, until 1916; her daughter Mme Louis Duval-Arnould, née Paule Arnould, until 1942; her son François Duval-Arnould; Yves Saint Laurent and Pierre Bergé

EXHIBITIONS: Paris 1861 (1st ser.), no. 44; Paris 1867, no. 319; Paris 1884, no. 413; Paris 1921, no. 104; Paris 1934a, no. 542; Paris 1934c, no. 32; Brussels 1936, no. 26; Paris 1949b, no. 54; Paris 1951, no. 466, ill.; Paris 1967–68, no. 175, ill.

REFERENCES: Blanc 1861, p. 191; Delaborde 1861, p. 267; Galichon 1861a, pp. 356–57; Blanc 1870, p. 235; Delaborde 1870, no. 252; Gatteaux 1873 (1st ser.), ill. on pl. 12 (detail); Sédille 1874, p. 486, ill. opp. p. 486 (photolithograph by Yves and Barret); Deconchy 1875, ill. opp. p. 233 (the engraving by L. Massard); Both de Tauzia 1888, p. 141; Jouin 1888, p. 6; Lapauze 1903, no. 1, ill.; Lapauze 1911a, ill. p. 333; Alaux 1933, p. 158; Waldemar George 1934, ill. p. 197; Arnould 1939, p. 6; Alazard 1950, p. 94; Labrouche 1950, pl. 11; Ternois 1959a, preceding no. 8; Naef 1960 *(Rome)*, p. 27, n. 52; Sérullaz 1967, p. 212; Jullian 1969, p. 89; Naef 1977–80, vol. 5 (1980), pp. 232–33, no. 371, ill.

116. Franz Liszt

1839
Graphite with white highlights
12 1/8 × 9 in. (30.9 × 22.8 cm), framed
Signed and dated lower right: Ingres à / Madame d'agoult / Rome 29 mai / 1839 [Ingres for / Madame d'Agoult / Rome May 29 / 1839]
Richard Wagner Stiftung, Bayreuth

N 372

When Franz Liszt (1811–1886) arrived at the Villa Medici in January 1839, he was armed with a letter of introduction to the director from Louis-François Bertin de Vaux, brother of the Bertin *l'aîné* famously portrayed by Ingres six years before (cat. no. 99). It was a nice formality but can hardly have been necessary, for Ingres would surely have heard of the young pianist, owing to either his astonishing virtuosity or his scandalous liaison with Comtesse Marie d'Agoult. The lady in question was on the musician's arm, pregnant with their third illegitimate child. Ingres welcomed the couple warmly and over the next several months became genuinely fond of Liszt. The pianist was equally taken with the older man, as is clear from a letter he wrote on March 1 to the violinist Lambert Massart: "I see a good deal of M. Ingres, who is very friendly to me. We naturally play music together. Did you know he is quite good on the violin? We're planning to review all of Mozart and all of Beethoven."[1] Madame d'Agoult gave birth to a son, Daniel, on May 9, and when the couple left Rome on May 29 for the baths at Lucca, Ingres presented the new mother with this portrait drawing of her lover, the finest likeness ever made of him.

Liszt was twenty-seven at the time, less than half as old as his portraitist. With his exquisite manners and graceful, refined appearance he seemed destined to keep company with princes. Yet he was also a man of real warmth and astonishing kindness. Highly receptive to art in all its forms, he spent his time in Rome marveling at the paintings of Raphael and Michelangelo and immersing himself in the writings of Dante and Goethe, occupations that caused him to lament the relative poverty of the arts in his own time. He was also forced to recognize during these months that the passion in his affair with Madame

d'Agoult had cooled. It is remarkable how much of this seems to be expressed in Ingres's portrait, the work of a man wholly unversed in psychology. Although there are any number of other likenesses of the musician, none reflects to the same degree his inner feelings.

The lovers parted in Florence in October of the same year. About the middle of the month Madame d'Agoult set out for Paris, and a few days later Liszt embarked on a triumphant concert tour of Austria and Hungary. Before he left, he met with Ingres's pupil Adolf von Stürler (see cat. no. 154), who had settled in Florence many years earlier, and on October 19 Liszt wrote to Madame d'Agoult:

> St[ürler] says that today's painters make a great fuss over M. Ingres. And still he is criticized somewhat for making people work too hard to understand and admire him. That is, in order to understand and appreciate M. Ingres, one has to gather up everything one knows, everything one has learned and experienced, so as to raise oneself to the level of his genius. He would like people to admire him more spontaneously. (That is not his [failing], I believe, but his idea.) The observation struck me as ingenious.[2]

This dispassionate assessment notwithstanding, Liszt's gratitude to Ingres remained unqualified. In January 1840 he wrote to Ingres's pupil Henri Lehmann from Budapest that he was having his piano transcriptions of Beethoven's Fifth and Sixth symphonies sent to Ingres from Leipzig.[3] He did not indicate in his letter that when the works were published by Breitkopf & Härtel later that year they would bear the printed dedication "À Monsieur Ingres, Membre de l'Institut, etc."

Ingres returned to Paris in the spring of 1841. In June Madame d'Agoult wrote to Liszt about a visit from the man who had been their host during their sojourn in Rome. "M. Ingres spoke much to me about you. He gave your portrait a loving glance."[4]

Nothing is known about any meetings between the two artists in later years; however, in his biography of Liszt, Sacheverell Sitwell indicates that Ingres ultimately became disenchanted with the virtuoso for the same reason he had finally

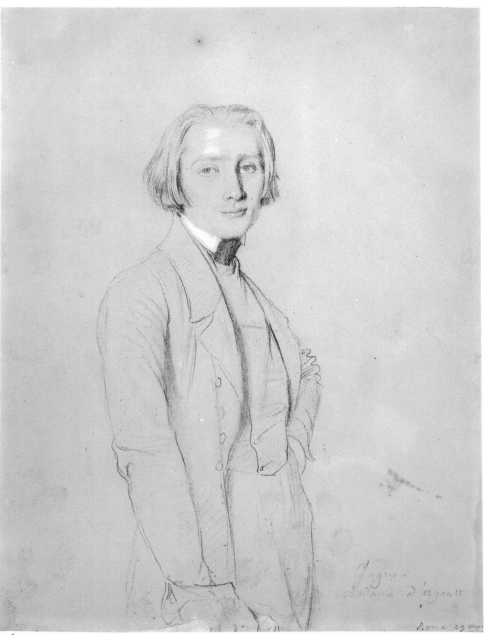

116

rejected Paganini; in his opinion the musicians no longer placed their artistry in the service of the masters.

Liszt was probably unaware of his old friend's change of heart. In 1860 he asked his daughter Cosima to buy an Ingres painting for Princess Sayn-Wittgenstein, the woman who had long since taken the place of Madame d'Agoult in his life. The work was one that Ingres had given to Alexander von Humboldt, and it was being sold at the distinguished naturalist's estate auction. Shortly after the sale Liszt wrote to the princess, "Cosette cables me that she has acquired the painting by Ingres—Francis I at Leonardo da Vinci's

deathbed [W267]—at the Humboldt sale, for 520 talers. My feeling is that it's worth the price."[5]

This drawing of Liszt was engraved by Jean Coraboeuf (Salon of 1912).

H. N.

For the author's complete text, see Naef 1977–80, vol. 3 (1979), chap. 158 (pp. 268–74).
1. Quoted in Vier 1955, p. 416, n. 140; reprinted in Naef 1977–80, vol. 3 (1979), p. 271.
2. Liszt and Stern 1933–34, vol. 1, p. 257; reprinted in Naef 1977–80, vol. 3 (1979), p. 272.
3. Stern, Liszt, and Lehmann 1947, p. 96; reprinted in Naef 1977–80, vol. 3 (1979), p. 272.

4. Liszt and Stern 1933–34, vol. 2, p. 155; reprinted in Naef 1977–80, vol. 3 (1979), p. 273.

5. Liszt 1893–1902, vol. 5 (1900), p. 68; reprinted in Naef 1977–80, vol. 3 (1979), p. 274.

PROVENANCE: Comtesse Marie d'Agoult (1805–1876), Paris; her daughter Frau Richard Wagner, née Cosima Liszt (1837–1930); Siegfried Wagner, her son, until 1930; his widow, née Winifred Williams; consigned for sale in 1965 (without family authorization) by Wolf Siegfried Wagner, her grandson; anonymous auction, Galerie Karl & Faber, Munich, October 19–20, 1965, no. 728, bought back by the Richard Wagner Stiftung, Bayreuth for 105,000 deutsche marks

EXHIBITIONS: Dresden 1904, no. 2138 [EB]; Zurich 1953 (not in catalogue); Paris 1967–68, no. 183; London 1969, no. 149

REFERENCES: Lapauze 1903, no. 58, ill.; Montesquiou 1905, p. 23; La Mara 1911, frontis. (detail); Lapauze 1911a, pp. 330–31, 368, ill. p. 343; Kapp 1916, ill. on pl. 18 (detail); Fröhlich-Bum 1924, pl. 50; *J.A.D. Ingres* 1927, ill. opp. p. 67; Hourticq 1928, ill. on pl. 82 (detail); Liszt and Stern 1933–34, p. 155; Bory 1934, p. 93; Bory 1936, ill. on pl. 89; Aragonnès 1938, p. 124; Gasser 1943, ill. p. 30 (detail); Stern, Liszt, and Lehmann 1947, p. 22; Bertram 1949, pl. XXV; Alazard 1950, p. 93, pl. LXX; Mathey 1955, no. 39, ill.; Sitwell 1958, pp. 47, 74, ill. p. 71 (detail); Weilguny and Handrick 1958, fig. 52, p. 76; Ternois 1959a, preceding no. 1; Schonberg 1963, ill. p. 155; Göpel 1965, p. 1038; Anon., January 12, 1966, ill.; Raum 1966, p. 18; Deslandres 1967, ill. p. 23 (detail); Haraszti 1967, p. 32; Naef 1967 ("Ingres und Liszt"), p. 4, ill.; Sérullaz 1967, p. 212; László and Mátéka 1968, ill. p. 69; Levey 1968, p. 45; Radius and Camesasca 1968, p. 124, ill.; Kemp 1970, p. 62, fig. 6; Ternois and Camesasca 1971, p. 124, ill.; Werner 1973, ill. p. 30; Delpierre 1975, p. 23; Geelhaar 1975a, p. 37; Geelhaar 1975b, p. 2; Naef 1977–80, vol. 5 (1980), pp. 234–35, no. 372, ill.

117. Charles Gounod

1841
Graphite
11¾ × 23 in. (29.9 × 23.1 cm)
Signed, dated, and inscribed lower right: Ingres à Son jeune / ami M^r Gounod / Rom 1841 [Ingres for his young / friend M. Gounod / Rome 1841]
The score on the piano is inscribed: DON / JUAN / de / Mozart [DON / GIOVANNI / by / Mozart]
The Art Institute of Chicago
Gift of Charles Deering McCormick, Brooks McCormick, and Roger McCormick 1964.77
New York and Washington only

N 376

The portrait that Ingres drew of his friend Charles Gounod before departing Rome in April 1841 is a testament to a happy encounter that the composer would also commemorate in his reminiscences. In fact, it is fair to say that no other sitter ever repaid the master portraitist so handsomely as did Gounod in a lengthy chapter of his *Mémoires d'un artiste* (1896).

The circumstances of Gounod's childhood were far from easy.[1] His father was a painter, rather gifted but lacking in ambition and perseverance. He was perfectly happy to leave the final details in his pictures to his wife, Victoire, a full generation younger than he, whom he had married in 1806. Despite her deeply artistic nature, Victoire Gounod was fully capable of dealing with practical matters and guided the development of her highly gifted child with great skill. In the first year of their marriage she bore her husband a son, Louis-Urbain, who became an architect.[2] Their second son, Charles-François, was born more than a decade later, in 1818, when his father was already sixty and had but five years to live. After his death the still-young widow bravely endeavored to give her two sons a proper start in life, supporting the small family by giving lessons in music and drawing.[3]

She was rewarded in 1839 when Charles, her favorite, won the Prix de Rome. It was difficult for Gounod to face being on his own for the first time, but at the Académie de France he came under the influence of an older man who was determined to function as a true father to the artists commended to him. Ingres had been the director at the Villa Medici in Rome since 1835. His fondness for music was legendary, and that alone augured well for his relationship with the new arrival. They also had various acquaintances in common, which would have given them something to talk about at their first meeting. Just then Ingres was working on a portrait of the Italian composer Luigi Cherubini,[4] whom he greatly admired, and as it happened Cherubini had counseled the grateful Gounod before he left Paris.[5] Ingres and his young friend would also have spoken of the marquis de Pastoret, whose portrait Ingres had also painted (cat. no. 98). Pastoret had been a champion of Ingres in the years when the painter was not widely recognized, and Gounod knew Pastoret as the author of the libretto for the music that had won him his scholarship to Rome.[6] Best of all, the new pensioner would discover to his delight that Ingres harbored fond memories of

Gounod's long-dead father from nearly forty years before.

Gounod's recollection of his first meeting with Ingres, which is quoted in part below, speaks for itself:

The director of the Académie de France in Rome at the time was M. Ingres. My father had known him when he was very young. As was expected of us, we went up to the director's office upon our arrival to be introduced to him, each of us by name. No sooner had he spotted me than he cried out, "You must be Gounod! My God, you do look like your father!"

And he began to speak very highly of my father, his talent as a draftsman, his character, the charm of his mind and his conversation, in a way that I was proud to hear from the lips of an artist of that caliber. It was the kindest possible welcome I could have gotten on my arrival. . . .

Our Sunday evenings were usually spent in the director's large salon, which on that day of the week the pensioners were allowed to enter. Music was played. M. Ingres had taken a liking to me. He was passionate about music; he loved Haydn, Mozart, Beethoven, and especially Gluck, who, because of the nobility and affecting cadences of his style, seemed to him a Greek, a descendant of Aeschylus, Sophocles, and Euripides. M. Ingres played the violin: he was no performer, and certainly no virtuoso; but he had, in his youth, played in the string section of the local orchestra in his native city, Montauban, where he had performed some of Gluck's operas. I had read and studied Gluck's works. As for Mozart's *Don Giovanni*, I knew it by heart, and, although I was no great pianist, I could handle myself well enough to treat M. Ingres to a reminiscence of that score he adored. I also knew from memory Beethoven's symphonies, for which he had a passionate admiration; we often spent a portion of the evening quietly discussing the great masters, and before long I was utterly in his good graces.

Whoever has not known M. Ingres well can have only a false and inaccurate picture of him. I saw him from very close up, on familiar terms, often, and for a long time; and I can state that he had a simple, straightforward, open character, full of candor and spirit, as well as an enthusiasm that sometimes bordered on eloquence.

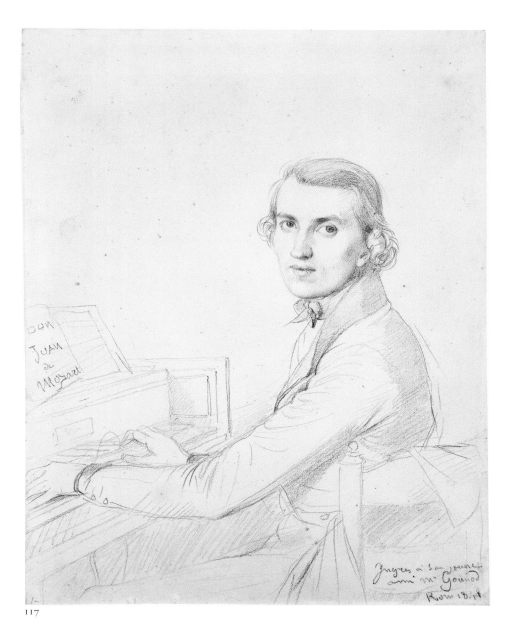

117

He could be tender as a child and indignant as an apostle; he was touchingly naive and sensitive and had a freshness of emotion that one does not find in a *show-off*, as some people like to say he was.

Genuinely humble and unassuming before the masters, but dignified and proud before the conceit and arrogance of stupidity; fatherly toward all the pensioners, whom he regarded as his children and whose status he upheld with jealous affection when visitors, whoever they might be, were entertained in his salons: such was the great and noble artist whose precious teachings I would have the pleasure of receiving.

I loved him very much, and I will never forget that he let drop in my presence several of those luminous phrases that can irradiate the life of an artist when he is fortunate enough to understand them.

We all know M. Ingres's famous remark, "Drawing is the probity of art." He once made another to me that constitutes a whole synthesis: "There is no grace without strength." And grace and strength are indeed complementary in the totality of beauty: strength keeps grace from becoming sentimentality, and grace prevents strength from turning into brutality. It's the perfect harmony of these two elements that marks the summit of art and constitutes genius. . . .

Before leaving the Académie, M. Ingres wished to give me a memento, and I hold it doubly precious, both as a token of his affection and as a souvenir of his talent. He drew my portrait in pencil, in which

he showed me sitting at the piano, the score of Mozart's *Don Giovanni* open before me.[7]

Ingres left Rome to return to Paris on April 6, 1841.[8] The portrait he had intended as a parting gift to his protégé must have been executed only a few weeks or days before, for in a letter to Hector Lefuel written on February 13, 1841, Gounod speaks of the drawing as a promise as yet unfulfilled.[9] Gounod stayed on in Rome another full year under Ingres's successor and then spent the following year traveling and studying in Austria and Germany.[10] Happily, he did not have to worry about the precious drawing while he was living out of a suitcase, for Ingres had volunteered to take it with him to Paris and deliver it to his friend's mother.[11]

One can imagine Madame Gounod's delight at seeing such a lifelike portrait of her long-absent son—and especially the prominent inclusion of her farewell gift to him,[12] the score of *Don Giovanni*. It was she who had made it possible for the sixteen-year-old Gounod to attend his first performance of the opera, and in his *Mémoires* the composer relates that the occasion was nothing less than his musical awakening.[13] Ingres was an equally passionate admirer of Mozart and frequently mentioned him in the same breath with the "divine" Raphael.

A friendship cemented by such an intense spiritual bond was bound to endure.[14] In 1859, when he was nearly eighty, Ingres produced a portrait—one of his very last—of the woman who had become his friend's wife in 1852 (cat. no. 164). Again he dedicated it to his "cher ami Gounod." The work is the finest example of the master's ability, even in advanced age, to approach each human countenance with a fresh eye.

Madame Gounod is somewhat neglected in the biographies of the composer, and Gounod mentions her only fleetingly in his *Mémoires,* as the autobiography is devoted primarily to the years of his apprenticeship. One suspects Madame Gounod would not have minded; she seems to have believed that posterity had no claim on their private affairs, for she destroyed all the letters they received—doubtless including a number from Ingres.[15]

She was born in 1829, the third of four daughters of the pianist Pierre Zimmermann, a highly respected professor at the Paris Conservatoire.[16] Her father's salon was a haven for artists of all kinds; Alexandre Dumas called it one of the very few in which he felt completely at home.[17]

She gave birth to a son, Jean, in 1856 and to a daughter, Jeanne, in 1863. Gounod's daughter inherited the two Ingres drawings. She guarded them for decades until forced to sell them during the turmoil of World War II, only a few years before her death, in 1946.[18]

Gounod died in 1893—by which time he was a grandfather several times over—and was honored with a state funeral. Madame Gounod died in 1906. Ingres's drawing of the composer was engraved by Jean Coraboeuf (Salon of 1934).

H.N.

For the author's complete text, see Naef 1977–80, vol. 3 (1979), chap. 160 (pp. 288–300).

1. See Prod'homme 1910a, pp. 402–19, 443–55.
2. Gounod 1896, pp. 25, 180.
3. Ibid., p. 19.
4. W 236; Musée du Louvre, Paris. Writing about a version of the musician's portrait, dated 1841, now in the Cincinnati Art Museum (cat. no. 119), Charles Blanc observed: "Cherubini's hands, in the absence of the model, were painted by [Ingres's pupil Henri] Lehmann after those of Gounod, then a pensioner at the Académie de France in Rome." Blanc 1870, p. 130; reprinted in Naef 1977–80, vol. 3 (1979), p. 289, n. 4. The hands in that painting correspond to the ones in the better-known version in the Louvre, which is dated 1842. See cat. no. 119 for further discussion of Ingres's portraits of Cherubini.
5. Gounod 1896, p. 66.
6. The competitors for the prize were required to compose a cantata, *Fernand*, on a text by Pastoret; see Prod'homme and Dandelot 1911, vol. 1, pp. 68–71.
7. Gounod 1896, pp. 79–80, 87–90, 132; reprinted in Naef 1977–80, vol. 3 (1979), pp. 290–91, 293.
8. Prod'homme 1911, p. 8.
9. Prod'homme 1910b, p. 836.
10. Gounod 1896, pp. 136, 161.
11. Prod'homme 1910b, p. 836, n. 1.
12. Gounod 1896, p. 59.
13. Ibid., p. 56.
14. Long after their months together at the Villa Medici, Ingres continued to refer to the composer fondly as "Don Juan Gounod"; see Ingres to Hippolyte Flandrin, January 4, 1849, quoted in Ternois 1962, p. 23.

15. Related to the author by Baron Jacques de Lassus Saint-Geniès, November–December 1964.
16. Baron Jacques de Lassus Saint-Geniès to the author, January 13, 1965.
17. Dumas 1852, pp. 114–15.
18. Related to the author by Baron Jacques de Lassus Saint-Geniès, November–December 1964.

PROVENANCE: Charles Gounod (1818–1893), Paris; his widow, née Anna Zimmermann (1829–1906), Paris; their daughter, Baronne Pierre de Lassus Saint-Geniès, née Jeanne Gounod (1863–1946), Saint-Geniès; sold by her to Galerie Hector Brame, Paris, about 1942; sold in 1947 by César Mange de Hauke (Galerie Hector Brame) to Chauncey McCormick, Chicago, until 1954; his widow, Mrs. Chauncey McCormick, née Deering; her sons Charles Deering McCormick, Brooks McCormick, and Roger McCormick; given by them to the Art Institute of Chicago, 1964

EXHIBITIONS: Paris 1900a, no. 1089; Paris 1905, no. 63; Paris 1908, no. 105, ill.; Paris 1934a, no. 544; Rotterdam, Paris, New York 1958–59, no. 133, pls. 107 (Paris), 99 (New York); Cambridge (Mass.) 1967, no. 83, ill.; Paris 1967–68, no. 193, ill.; Sarasota 1969, p. [3]; Paris 1976–77, no. 31, ill.; Frankfurt 1977, no. 41, ill. p. 90; Chicago, Saint Louis 1985–86, no. 48; Tübingen, Brussels 1986, no. 54

REFERENCES: Saglio 1857, p. 79; Pougin 1877, ill. p. 13; Chennevières 1886, p. 93; Pagnerre 1890, pp. 28, 389; Gounod 1896, p. 132; Hébert 1901, ill. p. 271; Lapauze 1903, pp. 20, 24–25, 26, no. 27, ill.; Mourey 1908, p. 6; Bellaigue 1910, p. 21; Prod'homme 1910b, p. 836, n. 1; Lapauze 1911a, pp. 346, 368, ill. p. 357; Prod'homme and Dandelot 1911, vol. 1, ill. on jacket and opp. p. 60, vol. 2, p. 249; Saunier 1911, p. 28; Fröhlich-Bum 1924, p. 24, pl. 51; Lapauze 1924, vol. 2, p. 255; Bücken 1928, ill. p. 273; Hourticq 1928, ill. on pl. 82 (detail); Zabel 1929, p. 111; Alaux 1933, vol. 2, ill. p. 175; Lockspeiser 1937, ill. p. 336; Miller 1938, p. 13, fig. 8, p. 11; Landormy 1942, pp. 28, 273; Courthion 1947–48, vol. 1, ill. opp. p. 209; Adhémar 1949 (mentioned under the engraving by Jean Coraboeuf); Bertram 1949, pl. XXVI; Druilhe 1949, ill. p. 119 (detail); Alazard 1950, p. 93; Blume 1949–79, vol. 5 (1956), ill. between cols. 593 and 594; Bouchot-Saupique 1958, p. [7]; *La Chronique des arts* 1965, p. 55, fig. 222; Lassus Saint-Geniès and Lassus Saint-Geniès 1965, p. 14, ill. p. 15; Naef 1966 ("Gounod"), pp. 66–83, fig. 2; Anon., March 11, 1967, ill. p. 26; Berezina 1967, fig. 61; Sérullaz 1967, p. 212; Waldemar George 1967, ill. p. 35; Kemp 1970, pp. 55, 61, fig. 3; Delpierre 1975, p. 23; Joachim 1978–79, no. 4F6; Naef 1977–80, vol. 5 (1980), pp. 240–42, no. 376, ill.; *Ingres Portrait Drawings* 1993, p. 19, ill.; Vigne 1995b, pp. 207–8, fig. 170

118. Madame Jean-Auguste-Dominique Ingres, née Madeleine Chapelle

1841
Graphite
$10\frac{5}{8} \times 8\frac{1}{2}$ in. (27.1 × 21.7 cm)
Signed, dated, and inscribed lower left: Ingres a
Madame / Lepere / Rome 1841 [Ingres for
Madame / Lepere / Rome 1841]
At lower left, the Musée du Louvre, Paris,
collection stamp (Lugt 1886a)
Musée du Louvre, Paris
Département des Arts Graphiques RF 29100
London only

N 378

This drawing is discussed under cat. no. 36.

PROVENANCE: Mme Jean-Baptiste Lepère,
née Elisabeth Fontaine, Paris, until 1844; her
daughter Mme Jacques-Ignace Hittorff, née
Elisabeth Lepère, Paris, until 1870; her son
Charles-Joseph Hittorff, Versailles, until
1898; Dr. Pierre and Mlle Elisabeth Cartier, by
inheritance; their gift to the Musée du Louvre,
Paris, 1938

EXHIBITIONS: Rome, Milan 1959–60,
no. 124; Copenhagen 1960, no. 68; Rome 1968,
no. 127, ill.

REFERENCES: Naef 1964 ("Familie Hittorff"),
pp. 256, 260, 262, fig. 6, p. 259; Paris, Musée du
Louvre 1966, no. 14, ill.; Hammer 1968, p. 229;
Naef 1972 ("Hittorff"), pp. 17–18, n. 3; Naef
1972 ("Ingres Royiste"), ill. p. 28; Naef 1977–80,
vol. 5 (1980), pp. 244–45, no. 378, ill.

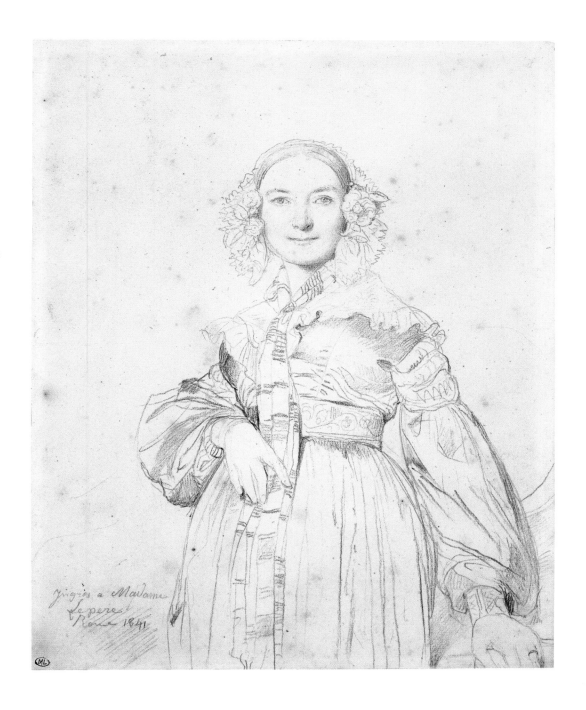

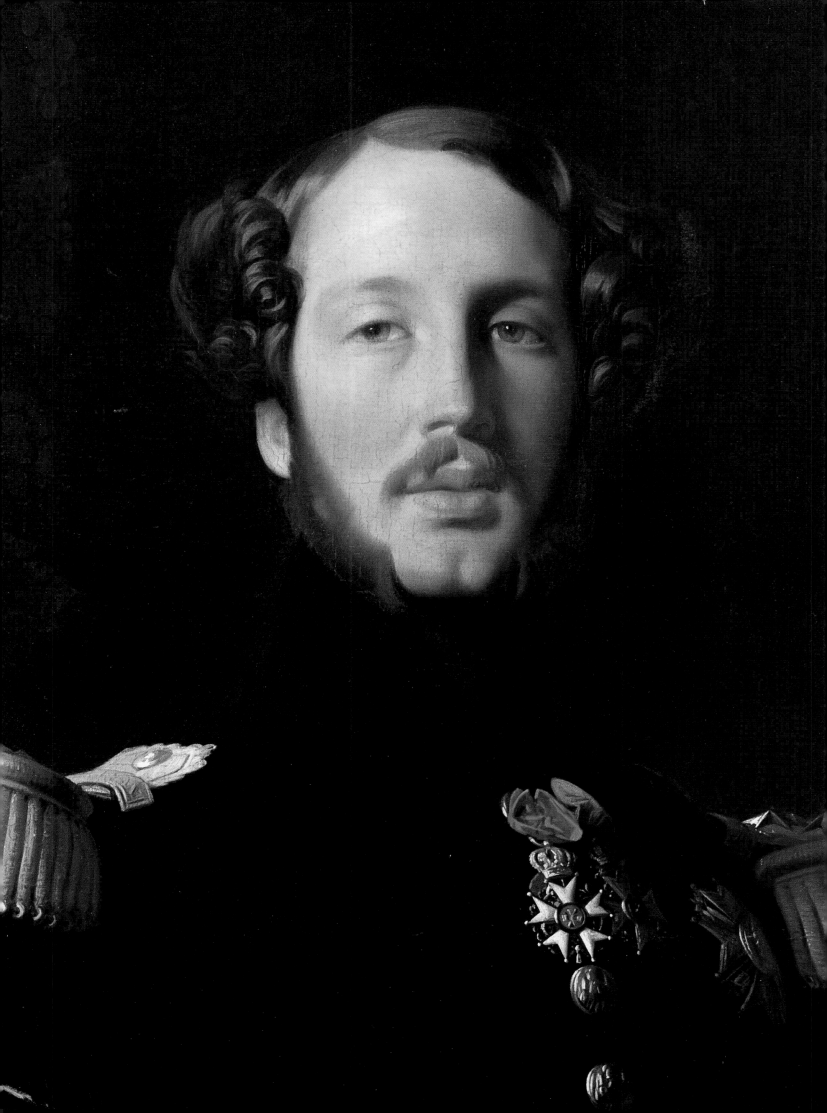

PARIS, 1841–1867

Gary Tinterow

While Ingres and his wife, Madeleine, were at the Villa Medici in Rome, they finally experienced for themselves the princely comfort and financial security that they had briefly tasted while visiting the sculptor Lorenzo Bartolini at his palazzo in Florence in 1820. When they had quit Paris in 1834, they had left behind their modest apartment at the Institut de France, a pair of cold, damp, dark studios off the kitchen court, the contentious faculty at the École des Beaux-Arts, and the ferocious writers who dominated critical discourse. These they had exchanged for an enormous, sparsely furnished but well-staffed apartment at the Villa Medici, a sunny studio perched on the glorious Pincio, complete authority and virtual autonomy over the running of the Académie de France in Rome, and, for the most part, grateful and docile pensioners—painters, sculptors, architects, and musicians, many of whom were former pupils of Ingres—who formed a surrogate family for the loving but childless couple. When they left Rome for Paris in the spring of 1841, what could they anticipate upon their return? Although a letter from their friend François-Marius Granet had promised them "glory, friendship, and respect,"[1] their apartment, the studios, the faculty at the École, and, above all, the pernicious press had not changed in their absence. Ingres's administrative rank and appointment as a professor at the École would ensure a handsome stipend for the sixty-year-old artist, but these means were not sufficient to sustain the frequent dinners and musical soirées that the couple had given in Rome. Perhaps Madame Ingres envisioned a quiet retirement split between country and city, but Monsieur thought otherwise.

Still possessed of the "excessive sensibility and an insatiable desire for glory" that he had described to his then-prospective father-in-law in 1807,[2] Ingres planned nothing less than a complete domination of the Parisian art world—total submission to his creed: *The Ancients and Raphael!*"[3] The artist who had renounced portraits, because of "the dryness of the subject matter, which is decidedly anti-beautiful and unpicturesque,"[4] would execute nearly a dozen canvases portraying the aristocracy of birth, wealth, beauty, power, and prestige. The artist who renounced all public exhibitions of his work after a hostile reception at the Salon of 1834 would exhibit his latest pictures in private studio showings held almost every year. Ingres would also participate in two large retrospectives, in 1846 and in 1855, that exposed his work to the very criticism that he despised. But he knew that such exposure was necessary to obtain the glory he craved and the authority he demanded. He also knew that one crucial thing had changed during his absence: as the creator of highly desired works and as a returning director of the Académie, he could now dictate the terms of his engagement with the world. For his participation in the public life of Paris, he requested and received honors that had never before been given to a painter: in the 1840s he became an intimate of the crown prince, the duc d'Orléans, and the king, Louis-Philippe d'Orléans, leading to unfounded rumors that he would be granted a peerage;[5] in 1855 he became the first painter to be made a grand officer in the Legion of Honor; finally, and quite senselessly, in 1862 he was made a Senator by the emperor, Napoleon III. Even Ingres, who reveled in the latter appointment, saw some irony in it since, as he himself often admitted, he was hardly an orator and very hard of hearing.

Unlike the heroes he immortalized, Napoleon and Homer (see figs. 210, 315), Ingres organized and witnessed his own apotheosis. Above all he wanted to make works on a large scale, and he laid the plans for such paintings while he was still in Rome. Thus, in August 1840, he accepted the commission to portray Ferdinand-Philippe, the duc d'Orléans, the handsome crown prince who had already purchased two of his paintings, *Antiochus and Stratonice* and *Oedipus and the Sphinx* (figs. 194, 82). Ingres knew that this portrait commission would lead to others; in fact, he was immediately rewarded with a contract to provide a great work for the ceiling of the Chambre des Pairs (Throne Room) at the Palais du Luxembourg. That decoration was never realized, but the commission from the duke led to many more from the royal family: innumerable repetitions of the portrait as well as two sets of designs for stained-glass windows to decorate memorial chapels after

the young prince was killed in July 1842 (see cat. nos. 121, 122). While still in Rome, Ingres also toyed with the idea of taking on the project to create a tomb for the ashes of Napoleon, which Louis-Philippe brought back from Saint Helena to France in 1840. As the artist confided to the administrator (sécretaire-perpétuel) of the École des Beaux-Arts, A.-L. Dumont, "I too have become involved in a project for the tomb of Napoleon, on which I have not done anything yet but which, however, is perhaps no worse than any other."[6] It seems that Ingres, who had always been immensely proud of his ceiling painting *The Apotheosis of Homer* (fig. 315), sought to undertake any number of mural decorations upon his return, perhaps hoping to displace Eugène Delacroix, who in 1833 and 1838 had been awarded significant commissions at the Palais Bourbon.

Other plans Ingres made before his departure for Paris were to reinstall some of his former artistic successes or to bring them back with him. He tried, for instance, to arrange the removal of his altarpiece *The Vow of Louis XIII* (fig. 146) from the cathedral at Montauban for installation at the Hôtel de Ville there, where he thought it had "looked so well, and where my glory was so complete."[7] He also made preparations for *Christ Giving the Keys to Saint Peter* (fig. 106), his altarpiece for the church of Santissima Trinitá dei Monti, to return with him to Paris.[8] In 1835 Ingres had abandoned prestigious commissions for the Madeleine and the new church of Notre-Dame de Lorette; now, anticipating his return, he began to seek others. He hinted at this end in a letter to his friend Varcollier, head of fine arts for the Prefecture de la Seine (Municipality of Paris): "From what I hear you are making miracles at the Hôtel de Ville. After architecture, I hope, will come the turn of sculpture and painting, and, above all, fresco. Don't you agree?"[9] In Rome, he accepted a commission to paint upon his return two large murals for the duc de Luynes at Dampierre, *The Golden Age* and *The Iron Age*. And in 1853 Ingres finally received a commission to provide a decoration for the Hotel de Ville, a ceiling depicting the Apotheosis of Napoleon I (see fig. 210), which perhaps derived from his unexecuted plans for the emperor's tomb.

"PAINTER TO THE KING"

Five months after his arrival Ingres wrote a letter to his old friend Jean-François Gilibert in which he described his condition:

> You know Paris. Well, it has fallen on me, and I am overwhelmed. As soon as I think I have climbed to the top of the abyss, I see myself fall right back in. Every hour, every moment is accounted for, all my evenings are preceded by dinners arranged in advance. I am paying for the honors and the problems of a position that is worthy of envy, sure, but that in the end does not make me happy—not in the least. I would prefer the calm and sweetness of home with my chosen friends and my studio, where I am king, where I forget all my troubles and regrets, where I am happy with the difficulties I have to overcome for my beautiful art, sometimes crowned with my own approval, and above all when I see again— long after I have launched them into the world—my children [paintings], who cost me so much in care and solicitude, tender and brave. That is what I need.[10]

This important letter, summarizing Ingres's assessment of his current situation and his plans for the future, strikes all the leitmotifs of his life for the next twenty-five years. He explains, "Since I painted the portraits of Bertin and de Molé [cat. no. 99, fig. 158], everyone wants one. There are six that I have refused or evaded, because I cannot stand them anymore. And it is not to paint portraits that I returned to Paris. I must paint at Dampierre and the Chambre des Pairs. However, I had to agree to paint the duc d'Orléans, this prince, my kind patron, to whom I could never refuse anything. I cannot tell you how the king and all the royal family have honored me. If you could come close to them and know them, you would adore them."[11] Shifting subjects from the agreeable to the disagreeable, Ingres goes on to explain that "I am well vindicated. Although I have always been a modest and humble little boy before the Ancients, before whom I bow and from whom I take all my inspiration, I must admit it is very flattering to see tears flow in front of my works, and by those with good and refined sensibilities: 'You are the first [artist] today!' they tell me. And at my feet I see the envious ones, wicked and ridiculous."[12]

Ingres then lists his assets, starting with his position vis-à-vis other artists: "all that and the conviction of what I am worth compared to the moderns; my position; the most beautiful works of the period, and consequently a fortune, the natural result of these works; honored and recognized in the highest places; surrounded by a crowd of friends who cherish and respect me; influential in many things if I want."[13] However, he adds somewhat disingenuously, "With the exception of my art and music, nothing tempts me. I am flattered, grateful, happy, and glorious, but with modesty. I treat myself with my 'remember you are but a man!' manner with even more severity today because of my imperfections, and, above all, because of what I am lacking in to arrive at the great summit

Fig. 196. *Archangel Raphael*, 1842. Cartoon for stained-glass window in the chapel of Notre-Dame de la Compassion–Saint-Ferdinand, Neuilly, 82⅝ × 36¼ in. (210 × 92 cm). Musée du Louvre, Paris

Fig. 197. *Archangel Raphael*, 1843. Stained-glass window, ca. 82⅝ × 36¼ in. (210 × 92 cm). Chapel of Notre-Dame de la Compassion–Saint-Ferdinand, Neuilly

of the Ancients."[14] Returning finally to his detractors, he writes:

> With such an enviable position, I am thus hounded and surrounded by the envious, who do not forgive me for the humiliations that my noble successes have inflicted on them. I owe my success only to myself: theirs are the fruit of their scheming mediocrity, an impotently hostile and ridiculous academy that I am obliged to repulse with my nails and teeth. The public and the press have come to the correct conclusion about this conflict. But who knows whether the public and the press, so ardently avenging me today, will not give in to the caprices of

taste and chance? They chased the divine Glück [*sic*] from the Opéra, they blasphemed the divine Raphael, and also Racine. . . . Nothing at all has changed here, and good taste is quite rare in so many things.[15]

Ingres's confidence was no doubt a reflection of the grand reception he had encountered upon his return to Paris in mid-May. The king had invited him to Versailles to inspect the new museum of French history (for which Ingres had been invited to contribute a painting, never realized, for the Galerie des Batailles) and to dine at his residence at Neuilly. On June 15, 1841, the marquis de Pastoret, whom Ingres had portrayed in 1826 (cat. no.

98), had presided over an enormous banquet in Ingres's honor, attended by 426 guests drawn from the new royal family, the old aristocracy, the various academies, and the ministries of fine arts and the interior—"the finest names of the intellectual aristocracy," as the press defined it.[16] There the marquis had pronounced a eulogy so extravagant that even Ingres must have blushed: "You were misunderstood, . . . and yet we saw that neither resentment nor bitterness grew within you. Justice was rendered to you, and that justice was glory; yet, as a result, you have been no less lenient nor accommodating for it. This conscientious faith, of which I spoke earlier, has sustained you in good times and in bad. Your life has been good. Let this day be sweet: it reunites in the attentive sympathy of your friends all the admiration for your talent, the esteem for your person, the affection for your character."[17] Berlioz had organized a concert with works by Ingres's "divine" Gluck and Weber, sung by Del Sarte and Massol and performed by former pensioners of the Académie de France in Rome.

So complete was the triumph that, just as Ingres himself might have anticipated, it provoked ridicule. The satiric paper *Le Figaro,* for instance, recalled it as a Last Supper, at which Ingres, as Christ, offered the Host (a piece of burnt toast) to his devoted disciples, saying "Take and paint, for this is my color." Pointing to a sheaf of old engravings, he was made to say "Take and copy, for this is my drawing." Then, the satire continued, he looked at his disciples and said, "In truth, one of you will betray me for the peerage." To Horace Vernet's "Master, is it I?" Ingres replied, "You have said it."[18]

Ingres was never elevated to a peerage, nor, as was also rumored, made official painter to the king. It soon became clear, however, that he occupied the latter position in fact if not in name. Following the death of the duc d'Orléans in a carriage accident, the distraught king and queen immediately turned to Ingres to provide copies of his portrait for the bereaved family and for a nation in mourning (see cat nos. 121, 122, fig. 228). Queen Marie-Amélie vowed to erect a memorial chapel on the site of the accident at Neuilly, just outside Paris, and Ingres was asked to supply cartoons for its stained-glass windows. According to the director of the civil list, the artist was selected "less [for his] admirable talent . . . than [for] the well-known feelings he has for the prince whom we mourn."[19] Working to a strict schedule and a restricted iconographic program, Ingres drew thirteen extraordinary figures—flat, heraldic, playing-card-like designs in which the features of the royal family were substituted for those of their patron saints (fig. 198)—as well as three

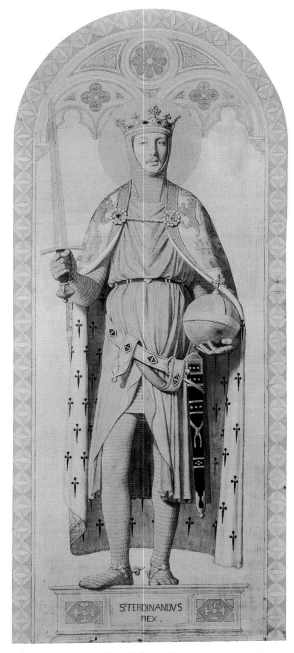

Fig. 198. *Saint Ferdinand of Castille*, 1842. Cartoon for stained-glass window in the chapel of Notre-Dame de la Compassion—Saint Ferdinand, Neuilly, 82⅝ × 36¼ in. (210 × 92 cm). Musée du Louvre, Paris

Virtues (Faith, Hope, and Charity) and the Archangel Raphael, the latter no doubt the suggestion of Ingres (figs. 196, 197). The artist reported, "The King said . . . it was M. Ingres who must make the designs for the windows of this sad place, given that the prince loved me and that I was the friend of his son. The deadline was very short for this work and you will judge by these words the zeal and feeling that I have brought to it. I have just finished it."[20] When the chapel was inaugurated as planned on July 13, 1843, the king was so pleased that he commissioned a new set of windows for the Orléans burial chapel at Dreux, which were completed and installed just

one year later. Repeating four of the designs from Neuilly and creating eight new ones, Ingres continued to draw inspiration from prototypes that ranged from Byzantine mosaics to medieval French glass designs to Giotto, Piero della Francesca, and Raphael—a reflection of the eclecticism that was the hallmark of design in France in the 1830s and 1840s. In 1847 the duc d'Aumale, brother of the duc d'Orléans, commissioned another set of windows for the chapel at the Château de Chantilly.[21] These little-known projects made an important contribution to the renaissance of French stained-glass making, which occurred as a direct result of the patronage of the Orléans family and withered almost immediately after the king abdicated in 1848.

Yet another royal commission was an enormous canvas, *Jesus among the Doctors* (fig. 219), that was requested by the queen in 1842 to decorate the royal chapel at the Château de Bizy. This ambitious work, conceived by Ingres as a religious variant of his *Apotheosis of Homer*, languished in his studio until 1862, when it was finished with much assistance. Perhaps the most significant dividend of Ingres's unofficial status as painter to the court was the purchase by the king of the portrait *Cherubini and the Muse of Lyric Poetry* (fig. 221) in August 1842, six months after Cherubini's death and only one month after the duc d'Orléans's fatal accident. Designated to be the warhorse of his planned assault on Paris—"I will bring with me to Paris the completed portrait of Cherubini, on which I base my hope to succeed"[22]—the portrait of Luigi Cherubini was transformed from a prosaic portrayal begun in Paris before 1834 into a remarkable allegory of the composer's apotheosis in which Ingres projected his own desires onto the unwitting musician. Earmarked by the king for his museum at Versailles, it was placed on permanent view at the Musée du Luxembourg in Paris after an administrative tussle. It was only the second easel painting by Ingres to be so displayed;[23] the work on which Ingres had pinned his hopes of success immediately became a lightning rod of opinion. Although some cartoonists lampooned it (see fig. 199), most of the reviews were laudatory, including that of the often severe Théophile Thoré, who called it "the supreme effort of M. Ingres's talent."[24]

"IT IS NOT TO PAINT PORTRAITS THAT I RETURNED TO PARIS"

The ensuing fame of the allegorical portrait of Cherubini as well as that of the ill-fated duc d'Orléans resulted in an extraordinary demand for portraits by Ingres's hand. As he had explained to Gilibert soon after his arrival, he had

been resisting six commissions, including another portrait of the comte Molé and a new portrait of the duc de Nemours, brother of the duc d'Orléans.[25] In July 1843 he spoke of his exhaustion in a letter to Gilibert:

> When one is painter to the Court and currently in favor, evidently one must get up early, not knowing to whom to speak, for whom to work, nor to whom to listen. The house is full of people, everything is crossing and clashing; sometimes two or three letters to write at the same time; drawing from the model all day, bringing to this elementary work all the required genius, maturity, reason, study, and the most perfect style. And then, harassed by fatigue to the point of falling down from sleepiness, one must often get dressed, go out into the world, and get to bed only at midnight, if not at one o'clock.[26]

In fact, from the moment Ingres unpacked his brushes in Paris and for the next eighteen years, there were almost always at least two unfinished portraits on his

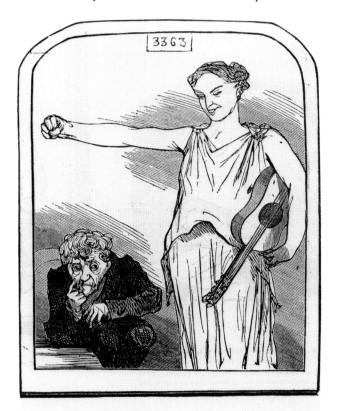

Fig. 199. Unidentified artist. *"Essayez vos forces là, messieurs, par M. Ingres. On tremble pour ce pauvre petit vieux sur lequel est suspendu le poing de mademoiselle Damoclès. —Recevra-t-il un renfoncement! N'en recevra-t-il pas! —Cette belle peinture vous émeut et vous captive."* (*Try your strength, messieurs, by M. Ingres. We tremble for the poor little old man over whom the fist of Mlle Damocles is suspended. —Will it fall? Won't it fall? —This beautiful painting stirs and captivates one.*) *Journal pour rire*, August 18, 1855

easel or hanging over his head. That was true of almost every period of his life, but the tenor of his clientele had changed. After his return to Paris from Rome, Ingres accepted portrait commissions from only the highest echelon of society: the duc d'Orléans, heir to the throne of France; Betty de Rothschild, wife of the richest man in France and de facto minister of finance; the comtesse d'Haussonville and the princesse de Broglie, daughter and daughter-in-law of the duc de Broglie, member of the Académie Française and many times minister in Louis-Philippe's government; Edmond Cavé, director of fine arts; Madame Reiset, wife of an eminent art historian and collector; Madame Moitessier, daughter of an old friend from Marcotte's circle, Armand de Foucauld, and wife of an immensely successful businessman. Indeed, the gallery of Ingres's late portraits, which extend well into the Second Empire, constitutes a Who's Who of Orléanist France. Not since he had painted Napoleon's ministers in Rome about 1810–12 (see, for example, cat. nos. 26, 27, 33, fig. 93) did his portraits correspond so closely with the ruling class of a particular regime.

Maintaining his boycott of the Salon, Ingres opted to exhibit these portraits in his studio at the Institut, one by

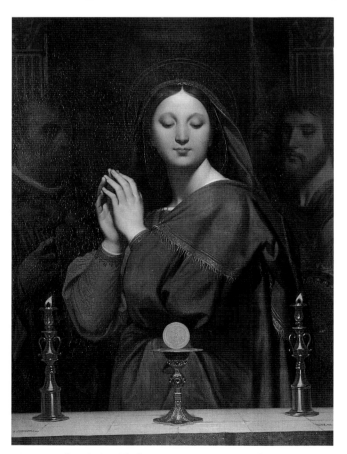

Fig. 200. *The Virgin with the Host*, 1841 (W 234). Oil on canvas, 45⅝ × 33⅛ in. (116 × 84 cm). State Pushkin Museum of Fine Arts, Moscow

one, as they were completed. He had found success when he showed the portrait of Louis-François Bertin to invited guests prior to the Salon of 1833, and he continued to do so after his return. With this method, he could not only refuse to admit the most hostile critics but also encourage those favorable to him. It remains fascinating that he exhibited at all, for he certainly did not need to solicit commissions—he refused more than he accepted—and the portraits themselves could easily have found their private destinations without a public display. Yet Ingres's mission to determine the course of French painting required that he maintain a public presence, at the same time that he struggled to obtain the maximum amount of individual control. Ironically, Courbet, Manet, and many independent artists of the 1850s and 1860s, whom Ingres opposed, also adopted the practice of private display, in part to elude the vote of the jury (from which Ingres was exempt) but also to control the presentation of their work. Alarmed by this tendency, the critic Jules Varnier wrote in a review of *Cherubini and the Muse of Lyric Poetry*:

> We who could admire this new creation of the painter of Homer in the master's studio have hardly any right to reproach M. Ingres for his long grudge against the public and the salon; however, when one is called Ingres, when one has arrived as he has at the summit of talent and fame, one has an obligation to Art, one has an obligation to the general pubic at the Louvre. To refuse to exhibit among contemporary artists is tantamount to separating oneself from the national art, to diminishing the effect of these annual solemnities in which the masters, more than anyone else, are called to compete; above all, it provides a pernicious example to some artists whom the crowd has already distinguished, an example that is gaining ground and that it is our duty to combat and to stop.[27]

At each of these studio exhibitions, Ingres would place on easels two or sometimes three recently completed works. He would often juxtapose a portrait with one of his religious or allegorical works, making strange combinations that reflected the duality of Ingres's artistic practice. In April 1842, for instance, he exhibited the portrait of the duc d'Orléans (cat. no. 121) and *The Virgin with the Host* (fig. 200) alongside *Cherubini and the Muse of Lyric Poetry* (fig. 221), contrasting a portrait and an allegory with an allegorical portrait that bridged the two modes. Such juxtapositions sent all but the most hardened critics reeling. An exception was Charles Lenormant, an enthusiastic supporter of Ingres, who structured his review on the very fact of this opposition:

I am reminded that once one could see at the same time in Raphael's studio the *Madonna della Sedia*, the *Portrait of Leo X*, and the *Musician* of the Palazzo Sciarra. The comparison of these portraits executed by Raphael with his history paintings is, without doubt, what sheds the most light on the mysteries of painting: the same observation applies to the three last works of M. Ingres, which make one's thoughts travel the entire range of art from pure realism to extreme idealism. The unity of talent—what one today calls the *individuality* of the artist—becomes evident upon the simultaneous examination of the three works. It is obviously the same lyre, but the artist has adapted it turn by turn to the most contrasting modes [of expression].[28]

The *Virgin with the Host* that Ingres exhibited was the first of five similar compositions painted by Ingres—and his assistants—in his maturity.[29] Commissioned during a visit to Rome by the czarevitch, the future Alexander II, the devotional image included two Russian saints, Alexander Nevsky and Nicholas, for whom the two Balze brothers are thought to have posed. Ingres based the figure of the Virgin on that of his highly successful *Vow of Louis XIII* (fig. 146) and made his painting rigorously Raphaelesque, regularizing and idealizing features to the point of abstraction and reducing color to strong, simple contrasting planes. Ingres considered the *Virgin* an important work, and by exhibiting it in Paris before sending it to Saint Petersburg, he doubtless hoped to influence the development of religious painting in France. He succeeded—despite the significant contribution that Delacroix also made to the genre during the same period—through the work of his devoted disciples, such as the brothers Balze and Flandrin, whose extensive work in the new Parisian church of Saint-Vincent-de-Paul closely followed their master's chosen mixture of Byzantine abstraction and Raphaelesque geometricization. Ingres's ambition for the picture is reflected in his bitter disappointment in the perfunctory thanks he received from the czarevitch's chamberlain—"as one would do for the upholsterer"—and in its perfunctory placement: "The poor *Virgin with the Host* . . . delivered to a public display in what they call there an Academy of Fine Arts, [was] hung . . . nastily, overwhelmed by contempt, between two horrible daubs in the crossways of a hall."[30] Clearly, Ingres had become spoiled by the solicitous French royal family.

The same sort of abrupt juxtaposition marked Ingres's 1848 studio exhibition of the splendid portrait of Betty de Rothschild (cat. no. 132) along with the *Venus Anadyomene* (fig. 201). While the Rothschild portrait had

Fig. 201. *Venus Anadyomene*, 1808–48 (W 257). Oil on canvas, 76 × 36 1/4 in. (193 × 92 cm). Musée Condé, Chantilly

required nearly seven years to complete, that was nothing compared to the dates inscribed on the Venus: 1808 and 1848. During his first stay in Rome, Ingres had conceived the work as one of the mandatory *envois* (this time a study of a nude) that pensioners of the Prix de Rome were obliged to send to Paris as proof of their progress. The comte de Pastoret had asked Ingres to complete it for him in 1821, as had Jacques-Louis Leblanc two years later. It was Benjamin Delessert who finally commissioned the completion, but he was dissatisfied with the result and in the end the painting was acquired by Ingres's friend Frédéric Reiset. Louis Geofroy, reviewing the joint exhibition in the *Revue des deux mondes*, informed his readers that, in passing from the *Venus* to the baronne, "we are transported from the sphere of dreams to the real world, [to stand] before reality in its most complete expression. It is good that these completely opposite

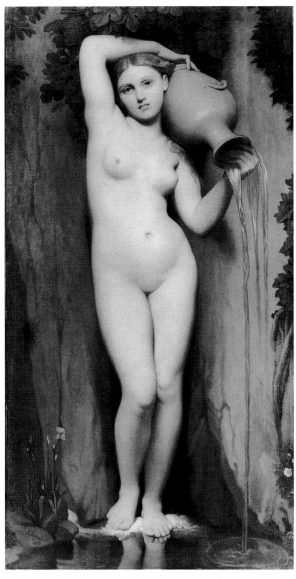

Fig. 202. *La Source*, ca. 1830–56 (W 279). Oil on canvas, 64⅛ × 31½ in. (163 × 80 cm). Musée d'Orsay, Paris

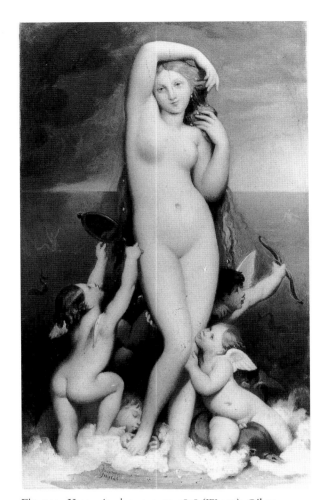

Fig. 203. *Venus Anadyomene*, ca. 1858 (W 259). Oil on canvas, 12⅜ × 7⅞ in. (31.5 × 20 cm). Musée du Louvre, Paris

works were not placed side by side; there are not more than four or five steps separating them in which to prepare for such an abrupt transition."[31] Joining other critics, who once again remarked on the duality of styles, Geofroy noted the "two distinct categories, virtually two styles, in which the art of the painter—sometimes with the model and nature, sometimes with the ideal and tradition—is always maintained at an equal level. In the two pictures that M. Ingres has just exhibited, one finds a complete expression of this contrast. His *Venus Anadyomene* and the portrait of M^me la baronne de Rothschild are two capital works, each treated with a grand superiority, but each with a different feeling and manner, as demanded by the difference in subjects."[32]

Geofroy thought that the "particular and strange" merit of the *Venus Anadyomene* was that it was a "dream

of youth realized with the power of maturity, a happiness that few obtain, artists or others."[33] Théophile Gautier was more extravagant: "Nothing remains of the marvelous painting of the Greeks, but surely if anything could give the idea of antique painting as it was conceived following the statues of Phidias and the poems of Homer, it is M. Ingres's painting: the *Venus Anadyomene* of Apelles has been found."[34] Other critics were less kind, finding in it a naïveté that today we would call kitsch. Ingres, however, must have considered it one of his most successful paintings of the single female nude, for he repeated the figure in *La Source* of 1856 (which he had conceived in 1830) and in another Venus of about 1858 (figs. 202, 203). His collectors agreed: no fewer than five wanted to buy *La Source*, so Ingres drew lots; the comte Duchâtel won and Ingres charged him 25,000 francs. As he wrote the engraver Luigi Calamatta, "All my friends are enchanted with it, and the most ambitious think I might have made an even better deal. For my part I find it almost too much; but certainly not, considering all the noise this little work

has made in Paris, because no one speaks of anything else."[35] Certainly, no one spoke of the extensive collaboration Ingres required for these paintings, as Georges Vigne explains in this catalogue (see pages 534–36).

THE BONNE-NOUVELLE EXHIBITION (1846)

The full range of Ingres's art, including its curious duality, became fully apparent only in 1846. Breaking his prohibition against exhibitions—one critic noted, "Suddenly, it is twelve years that the public has been severed from the works of the master"[36]—he was seduced by excessive flattery and special conditions to contribute to a charity exhibition organized for the aid of indigent artists by Baron Taylor, the extraordinary arts administrator who had formed Louis-Philippe's collection of Spanish paintings. The exhibition was held at a shopping emporium on the boulevard Bonne-Nouvelle, and its stated aim was to show the panoply of painting in France during the previous fifty years; in effect, it became a retrospective of the work of David and his best students, Antoine-Jean Gros, Anne-Louis Girodet, and Ingres. Although there were a few works by Romantic painters—two small paintings by Delacroix, a group of six small paintings and drawings by Théodore Géricault, and three important canvases by Léon Cogniet—they were overwhelmed by the works of David and his followers. The opportunity to be represented in the exhibition must have been an enormous incentive to Ingres, who only recently had begun to consider himself as the successor to David. And, in fact, after David, he had the largest number of works in the exhibition. As the conservative critic Paul Mantz noted, "The sovereign pontiff of modern art, M. Ingres, is the one whose talent is most seriously represented in the exhibition; eleven of his best pictures excite the highest degree of curiosity in the crowd."[37]

Although the organizers had hoped to include the portraits of Pastoret and the duc d'Orléans (cat. nos. 98, 121), neither of which were available, Ingres was able to produce three: those of Bertin (cat. no. 99), Molé (fig. 158), and the comtesse d'Haussonville (cat. no. 125). These were shown with small history pictures in Ingres's troubadour style (*The Sistine Chapel, Antiochus and Stratonice, Paolo and Francesca, Philip V of Spain and the Marshal of Berwick, The Entry into Paris of the Dauphin, the Future Charles V*) and with grand nudes (*Oedipus and the Sphinx, the Grande Odalisque,* and the *Odalisque and Slave*).[38] Ingres had insisted on a separate space for his work to avoid contamination from the work of other, lowlier artists,

and all the critics coyly referred to his display area as a sanctuary or chapel, in which the eye "could embrace . . . his eleven works, each inspired by a completely different period or idea."[39]

Andrew Shelton has admirably treated the critical response to the Bonne-Nouvelle exhibition in his essay in this catalogue (see pages 505–9); it remains worthwhile to note here that much of the criticism focused on the portraits, especially the minutely observed depiction of the comtesse d'Haussonville, which stood in marked contrast to the sober portrayals of Bertin and Molé. Ingres's meticulous technique in the portrait of the countess prompted a new discussion—the relationship of such painting to the art of photography, which had been invented only seven years before (later a cartoon by Nadar would suggest that the rise of photography was "Ingres's fault"; see fig. 342). More important, for Ingres's purposes, is that he emerged from the exhibition triumphant. As one critic observed, "Yes, M. Ingres is our century's master without equal with regard to his portraits. In this exhibition, where one finds a fairly large number of these by David, Gérard, Gros, and Hersent, none surpasses his. More than any of his rivals, he has the gift of thought, the marvelous faculty of lighting materials with the reflection of life."[40]

THE GOLDEN AGE

Ingres and his wife had occupied the same apartment in the large court of the Institut ever since they had been granted it in the spring of 1827. The comtesse d'Agoult left a precious description of it in the article she published in 1842 on the allegorical portrait of Cherubini:

> At the very end of the courtyard of the Institut, on the right, a wooden staircase, never polished and carelessly swept—the true staircase of a scholar or a man of genius—leads you to a landing whose corners should not be examined too closely. You find yourself facing a door marked "Number 1" (sometimes chance has a sense of humor!). You ring. It's a servant who comes to open. She precedes you down a narrow corridor and shows you into a study with neither rug nor wall-hangings. There, you are cordially received by a man short in stature, nonchalantly dressed; he sits you down in an armchair covered with needlework—his wife's doing—and sets about chatting without pretending in the slightest to any special fuss.[41]

Although over the years Ingres had petitioned for money to make repairs and had lobbied for new quarters, his

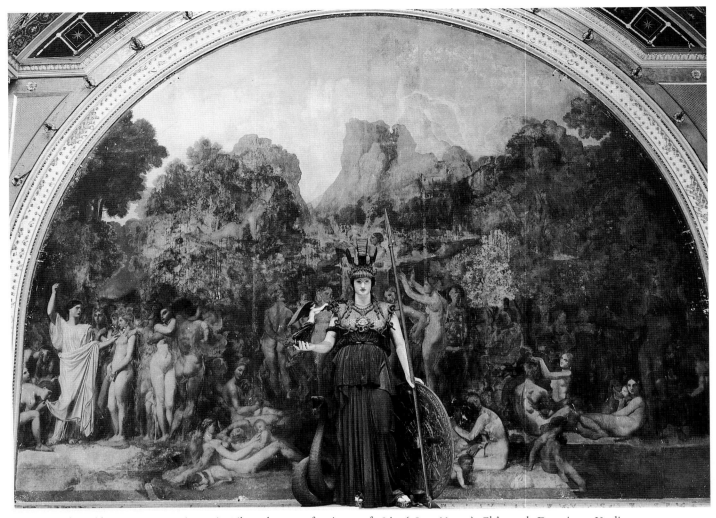

Fig. 204. *The Golden Age*, 1842–47 (W 251). Oil on plaster, 15 ft. 9 in. × 21 ft. 8 in. (480 × 660 cm). Château de Dampierre, Yvelines

efforts came to naught until the death of the architect Laurent Vaudoyer created a convenient vacancy. In November 1846, Ingres and Madeleine moved just a few hundred feet to a larger apartment on the same courtyard, with windows facing both the court and the rue Mazarine, the street behind.

Since the couple's return to Paris in 1841 the small size of their apartment had been ameliorated by their annual stay of several months at the Château de Dampierre, just twenty miles southwest of Paris. There, they were guests of Honoré-Théodore-Paul-Joseph d'Albert, duc de Luynes, who in September 1839 had commissioned two murals from Ingres for the great hall of his castle, then being rebuilt and redecorated under the supervision of the talented architect Félix Duban. The hall was to be dedicated to Minerva, and an enormous reconstruction by Charles Simart of the ancient statue of the goddess was to to be placed before one of the murals. At Dampierre, Ingres and his wife were given a pavilion to themselves, where they entertained their friends in comfort and style. Professing disgust with portraiture, Ingres wanted nothing more than to paint large murals.

He thought he had found the perfect client in the duke, who was long-suffering, rich, and cultivated. Thus it was with great excitement that he embarked on the project. In the summer of 1843, he wrote Gilibert:

Here is the short program I have conceived for my *Golden Age: A bunch of beautiful, lazy people!* I have taken the Golden Age decidedly as the ancient poets imagined it. *The people of that generation hardly knew old age. They lived long lives and were always beautiful. Thus, no old ones. They were good, just, and loved one other. The only food they ate was the fruit of the earth and the water of the fountains, milk and nectar. They lived thus and died while sleeping; afterward, they became the good spirits who took care of mankind. In truth, Astraea visited them often and taught them to love and to practice Justice. And they loved it, and Saturn contemplated their happiness from Heaven.*

I needed a little activity to bring all these people onto the stage. I found it in a religious sensibility. They are all united in an elevated clearing, where there is a trellis and trees heavy with fruit. A man, accompanied by a young boy and girl, voices a noble prayer while his

acolytes hold aloft fruit and a cup of milk that spills a bit. Behind this sort of priest, there is a little religious dance executed by girls who encircle an awkward boy who plays the pipes and is given the beat by the girl who leads the dance with her clapping. Then groups of happy lovers and happy families with their children are scattered about. They are surely waiting for mealtime, around a pool that springs from under the altar. However, at the right [*sic*], the majestic figure of Astraea arrives, with her divine scales. People are grouped around her, and she tells them, "As much as you imitate the justice of this instrument, so will you be happy." . . . All this in a very varied nature, à la Raphael. A young girl crowns her lover with flowers, others kiss their children.

Such are the principal ideas. I have a little model in wax [to study] the effect of the shadows, and I count more than sixty figures.[42]

Although the arched format of *The Golden Age* (fig. 204) was borrowed from Raphael's Vatican *Stanze*, its conception was loosely based on those of Antoine Watteau, whom Ingres considered "a very great painter!"[43] despite the earlier master's dangerous dalliance with Rubensian color; modern scholars have found a closer resemblence to neo-classical compositions by Anton Rafael Mengs and Étienne Delécluze, Ingres's colleague in David's studio. Ingres spent part of every year at Dampierre from 1843 to 1847, working with assistants such as Alexandre Desgoffe and Amédée Pichot, who executed, respectively, the landscape of *The Golden Age* and the architecture of its companion piece, *The Iron Age*, which was never completed. He himself made some five hundred drawings of the individual figures,[44] including some, such as the sheet of lovers now at the Fogg Art Museum (fig. 205), that are of extraordinary quality. But, seeking to rival Raphael, Ingres had decided to execute the murals in oil on plaster, a medium akin to fresco, with which he was not familiar. Requiring a quick and decisive technique, with almost no possibility of reworking, this method was vastly different from Ingres's customary oil-on-canvas technique, which involved laying in, scraping down, revising, and correcting.[45] He made great progress in the summers of 1843 and 1844, but when the duc de Luynes saw *The Golden Age* for the first time at the end of Ingres's stay during the latter year, he was shocked both by the nudity and by the profusion of figures as well as by the slow rate of completion. Work progressed further in 1845, and in 1846 Ingres had Pichot lay in the architectural setting for *The Iron Age*. But the campaign of 1847 was to be the last; as had become habitual with Ingres, the project was not to be completed (much later, in 1862, he contented himself with a small but exquisite reduction to preserve the fruits of his labor; fig. 206).

Fig. 205. *Study for "The Golden Age,"* ca. 1842–47. Graphite on paper, 16 3/8 × 12 3/8 in. (41.6 × 31.5 cm). Fogg Art Museum, Harvard University Art Museums, Cambridge, Massachusetts

Fig. 206. *The Golden Age*, 1862 (W 301). Oil on paper, mounted on wood, 18 1/4 × 24 3/8 in. (46.4 × 61.9 cm). Fogg Art Museum, Harvard University Art Museums, Cambridge, Massachusetts

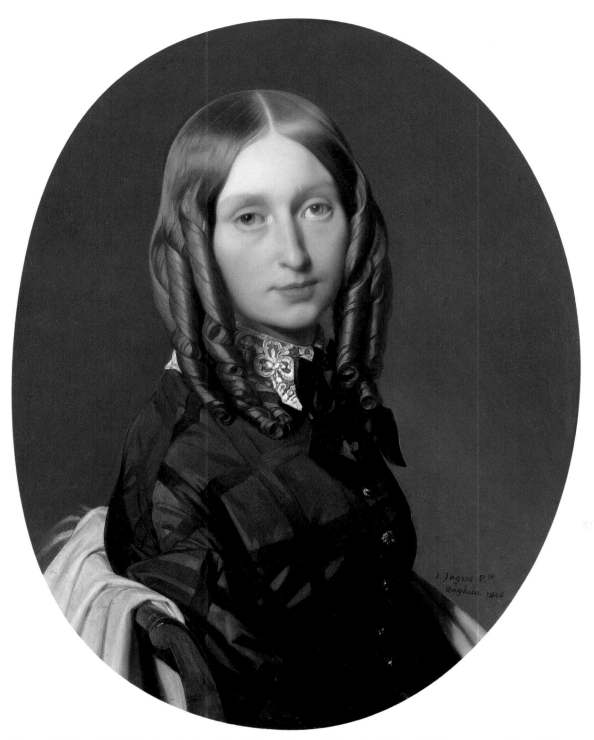

Fig. 207. *Madame Frédéric Reiset, née Augustine-Modeste-Hortense Reiset,* 1846 (W 250). Oil on canvas, 23⅛ × 18½ in. (60 × 47 cm). Fogg Art Museum, Harvard University Art Museums, Cambridge, Massachusetts

In 1846 Ingres executed one of the most direct, unaffected portraits of his later career—that of Hortense Reiset, whose husband, Frédéric, emerged in the 1840s as an important collector of the artist's work, acquiring both the portrait of Madame Devaucey (fig. 87), *Venus Anadyomene* (fig. 201), and Ingres's repainted self-portrait of 1804 (fig. 209). At the Reiset's second house in Enghien, Ingres and Madeleine had enjoyed peaceful country pursuits, and at some point in the early 1840s, Ingres had promised to paint

Hortense. With neither the time nor the inclination to attempt one of his extravagant machines, like the portrait of the comtesse d'Haussonville or Madame Moitessier, he chose a modestly sized canvas and an informal pose, and the likeness he produced (fig. 207) was so startlingly realistic that it has been likened to a daguerreotype.[46] Yet the direction of influence is likely reversed, for it is early photography that was made to resemble contemporary portraiture in paint. The steely tonality of Hortense's portrait is

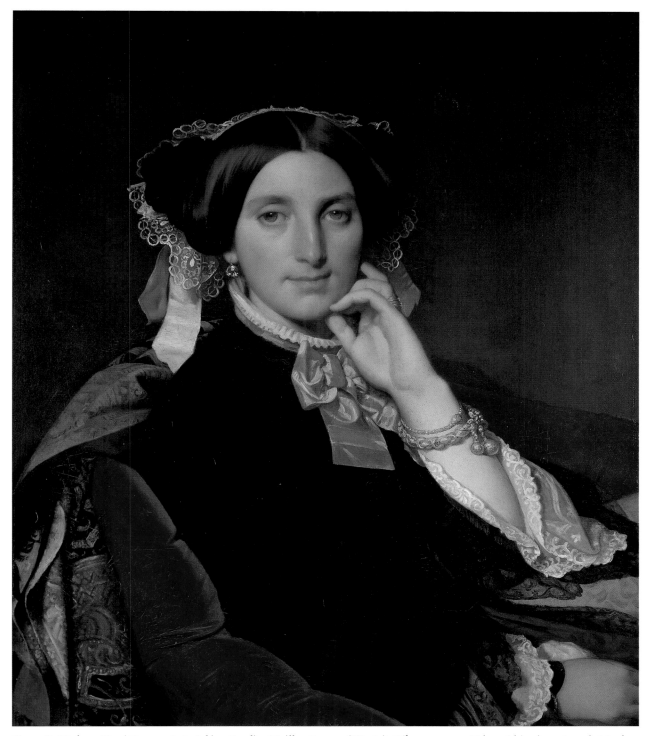

Fig. 208. *Madame Henri Gonse, née Joséphine-Caroline Maille,* 1845–52 (W 269). Oil on canvas, 28 ¾ × 24 ⅜ in. (73 × 62 cm). Musée Ingres, Montauban

closer to that of the comtesse d'Haussonville than to a daguerreotype, and the oval frame, which Ingres had used some forty years before, is simply a flattering shape that photographers had co-opted for their own frames.

Ingres also embarked on another portrait in 1846 that was originally conceived in an informal style (fig. 208). Caroline Gonse, the wife of a jurist in Rheims, was a former student of Ingres and the daughter of an old friend, Monsieur Maille, as well as a close friend of Madame Ingres. Having observed firsthand for herself the master's sluggish pace and painful procrastination, Madame Gonse vainly attempted to take matters in hand to ensure the completion of her portrait. By 1851 she had become quite impatient, attempting to show up for sittings at short notice, but Ingres kept her firmly at bay. In December 1851 he wrote her to say that "I am still quite angry that I have to continue being mean to you, but really, you are not reasonable."[47] By the first weeks of the new year,

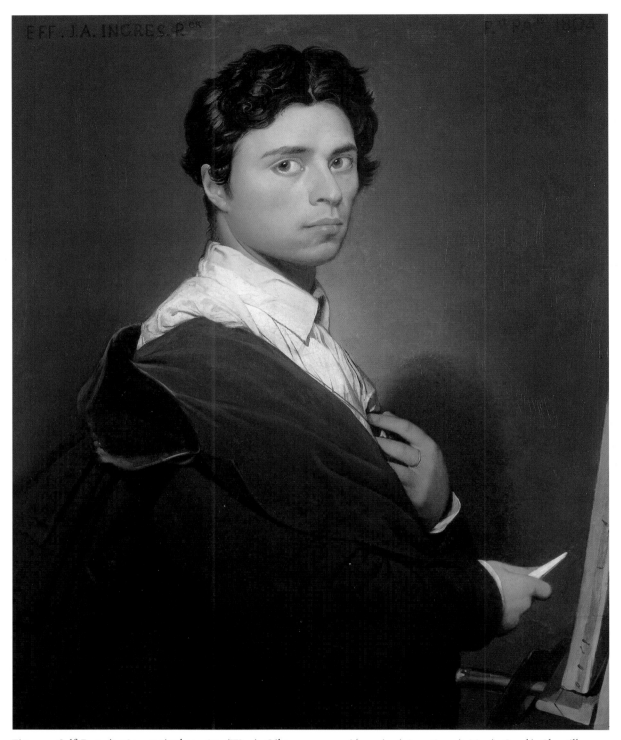

Fig. 209. *Self-Portrait*, 1804, revised ca. 1850 (W 17). Oil on canvas, 30 ¾ × 24 in. (78.1 × 61 cm). Musée Condé, Chantilly

Ingres had finished the portrait, which in its completed form stands halfway between the simplicity of the portrait of Hortense Reiset and the elaborate pretensions of that of the comtesse d'Haussonville. The painting manifests Ingres's insistent regularizaton of features and, above all, his continued fascination with fashion in its most minute details; for instance, the particular pattern of lace on the cache-peigne is recognizable as one popular at the time. This was precisely the quality that Baudelaire

detected in Ingres's work: "an ideal that is a provocative adulterous liaison between the calm solidity of Raphael and the affectations of the fashion plate."[48]

THE END OF THE MONARCHY; THE ADVENT OF THE SECOND EMPIRE

Given Ingres's intimate relations with the royal family, it is not surprising that he was shocked by the February

Revolution. He remained in Paris throughout the tumultuous year of 1848; in May he complained to Gilibert:

> For four months in Paris, all that I have done is to arrange and fix up the new apartment—still with a bedroom for my friend [Gilibert] and his daughter—to arrange my studios, to be sick, and to endure a revolution that has shaken me from head to toe, not to speak of the pecuniary losses that disturb the well-being that has been so painfully amassed. . . . If liberty is the order of the day, it is not so here, for I am more than ever a slave. . . . Anyway, what projects could I work on in this moment of anguish, when we live from day to day, at the edge of a precipice with such a steep descent, at the abyss where one is protected only by the republic that everyone wants, but so many infernal angels would make it red [evil], when we want it to be, like Astraea, beautiful, virgin, noble, and pure? Only God can save us and we believe only in his divine providence.[49]

Ingres's preference for a constitutional republic was encouraged by future developments—elections by universal male suffrage that brought Louis-Napoleon to power—but the death of Madeleine in 1849 ended the world as he knew it.

Ingres had still been laboring on the Dampierre murals, but the duc de Luynes, fearing a change of heart, had proposed a completion schedule of two years for *The Golden Age* and five years for *The Iron Age*, which Ingres signed on June 4, 1849. On July 27, however, Ingres's beloved wife died after a long struggle with a blood disease that had caused the loss of her teeth and gangrene in her extremities. Inconsolable in his grief, he renounced the troublesome project, gave up his apartment, and avoided anything that reminded him of her. He wrote Marcotte, "What will become of me! Everything is finished, I have her no more, no home, I am broken, and all I can do is cry in desperation. . . . Everything is finished for me forever, because my dear life's companion exists no more."[50]

Watching with horror the death of his wife, observing from close quarters yet another revolution, Ingres experienced his own mortality more profoundly than ever before. He slowly began to take stock of his life and work in order to prepare both for destiny. In 1850 and 1851 he resigned the presidency of the École des Beaux-Arts as well as his professorship there; he made his first donations to the city of Montauban, initiating the ultimate bequest of his studio's contents to the town museum; he began to dress the definitive lists of his work in its entirety, now preserved in two versions, Notebook IX (Musée Ingres, Montauban) and Notebook X (private collection, New York);[51] he worked closely with Albert

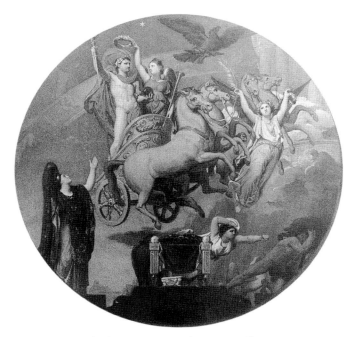

Fig. 210. *Study for "The Apotheosis of Napoleon I,"* 1853 (W 271). Oil on canvas, diam. 19¼ in. (48.9 cm). Musée Carnavalet, Paris

Magimel and the engraver Achille Réveil to make outline engravings of 102 of his compositions, rigorously following the archaic linear style of the Flaxman engravings he had admired in his youth. Ingres also returned to some of his early pictures and revised them; the most important, the self-portrait of 1804 (fig. 209), was completely

Fig. 211. Unidentified artist. *"Un Fragment, de M. Ingres.* D'un trône à surprises sort vivement Némésis, déesse de la vengeance, pour donner à l'anarchie les fameux coups de poing de la fin.——Pour peindre l'anarchie qui met tout sens dessus dessous, M. Ingres l'a représentée la tête en bas et les pieds en haut.——C'est là un trait de génie." (*A Fragment, from M. Ingres*. Nemesis, goddess of vengeance, jumps from a jack-in-the-box throne to give Anarchy the famous knockout.——Since Anarchy turns everything upside down, M. Ingres has painted its head below and its feet on top.——This is a stroke of genius.) *Journal pour rire*, August 18, 1855

Fig. 212. *Self-Portrait at the Age of Seventy-nine*, 1859 (W 292). Oil on paper, mounted on canvas, $25\frac{1}{2} \times 20\frac{1}{2}$ in. (64.8 × 52.1 cm). Fogg Art Museum, Harvard University Art Museums, Cambridge, Massachusetts

reworked. He cut it down on three and perhaps four sides, transforming it from an awkward piece of juvenilia, redolent of the eighteenth century, into a dramatic statement of self-assured bravado, cast in a timeless, classical era. Abandoning the clothing specific to the turn of the century, he dressed himself in a splendid carrick, draped to suggest a Renaissance cape. He removed the unpainted canvas that had originally appeared in the background, suggesting an environment that smacked of the workshop, and brought his hand to his chest as if to clasp a

medal he had just been awarded. More than anything else, in this reworking Ingres declared his independence from his youthful master, David, and pledged an oath of fealty to his new master, Raphael. All that was missing was his motto: *"The Ancients and Raphael!"* This was the image of himself that Ingres wished to project on eternity.

While Ingres was arranging his affairs as if to close up shop, the new government of Louis-Napoleon, first elected president, then prince-president, then emperor, had other plans for him. As the most distinguished artist in France and

Fig. 213. *Madame J.-A.-D. Ingres, née Delphine Ramel*, 1859 (W 290). Oil on canvas, 24 ¾ × 19 ¾ in. (63 × 50 cm). Oskar Reinhart Collection, Winterthur, Switzerland

the sole living link to the First Empire, Ingres was eagerly sought for service by the new regime. In 1851 Napoleon's director of fine arts, Monsieur de Guizard, awarded the artist a contract of 20,000 francs for two works: a new version of *The Virgin with the Host* (fig. 11), to compensate for the loss of his "poor Virgin" to Saint Petersburg, and the completion of a painting of Joan of Arc (fig. 215), originally conceived in 1846. Even before these were completed, in 1854, Ingres was given another commission—one for which he had been yearning for more than a decade. For a

ceiling in the Salon de l'Empereur at the Hôtel de Ville, he was called on to provide an immense roundel representing the Apotheosis of Napoleon, to serve as a pendant to a work by Delacroix in the Salon de la Paix. Finally given an opportunity to compete with Delacroix on equal terms, Ingres reverted to a kind of anti-Romanticism, to the same archaic style he had used for the decoration he had made for the first Napoleon, *Romulus, Conqueror of Acron* (fig. 96). And, remembering his unsuccessful experience at Dampierre, he worked in oil on canvas.

Fig. 214. André-Adolphe-Eugène Disdéri (1819–1889). *Delphine Ramel.* Photographic carte de visite (detail), 1861. Cabinet des Estampes et de la Photographie, Bibliothèque Nationale de France, Paris

Those who loved Ingres loved the painting (only the sketch survived the destruction of the Hôtel de Ville; see fig. 210). The critic Gustave Planche applauded the selection of artist: "Among us there is more than one painter capable of conceiving from this subject something seductive; I do not think that there is anyone who could treat the subject with the same elevated style. Thus one can affirm that the *Apotheosis of Napoleon* has arrived to remind misguided imaginations of the importance of style, and not only do I sustain the firm hope that it will counteract the habits of our school, but even more I believe that it will redirect the taste of the public."[52] Those who did not love Ingres hated it (see fig. 211). Delacroix, for example, who wrote in his journal:

> The proportions of his ceiling give one a real shock: he did not calculate the loss that the perspective of the ceiling brings about in the figures. The emptiness of the whole lower part of the picture is unbearable, and that big solid blue in which the horses—quite nude also— are swimming, with that nude emperor and that chariot going through the air, produce the most discordant effect, for the mind as for the eye. The figures in the panel are the weakest that he has done: awkwardness predominates over all the merits of the man. Pretension and awkwardness, with a certain suavity in details that have charm, in spite of or because of their affectation—and that, I think, is what will remain of this for our descendants.[53]

Ingres, a master courtier, inscribed the steps of the empty throne with IN NEPOTE REDIVIVUS (He Lives Again in His Nephew). The emperor himself translated the phrase for the empress when they arrived on January 31, 1854, at only one hour's notice, to inspect the work in the artist's studio. They were immensely pleased. When the emperor asked Ingres what had served as models for the horses, he replied, "Phidias and the carriage horses."[54]

The person who recorded the interview with the emperor was Delphine Ramel, Ingres's second wife, in whom he found once again a perfect "minister of the interior."[55] It was the ever-faithful Charles Marcotte who, in 1851, had played matchmaker for the seventy-one-year-old artist. He introduced Ingres to Delphine, then forty-three, whose mother was a Bochet (see cat. no. 49); she was also a cousin of the wife of Cherubini's son Salvador. A devout spinster accustomed to living with her elderly parents, Delphine consented to marry him, despite his age and lack of fortune. He wrote Calamatta to announce the wedding: "Here I am . . . I hope, the happiest man in the world . . . what has touched my heart most deeply is that *she alone has chosen me!* that she comes with open arms, despite my age and being less perfect than her, but with the certitude that I will do everything to ensure her happiness, to which I will devote the rest of my life."[56] Ingres did find complete happiness with his buxom bride, enjoying the affluent bourgeois comfort of the Ramel family, taking a country house at Meung-sur-Loire with his new relations, and executing a series of portrait drawings of his wife and her family (see cat. nos. 159, 160).

As Ingres completed his last grand society portraits in the 1850s—portraits of the princesse de Broglie and Madame Moitessier—he repeatedly reminded his friends that the only portrait that remained for his brush was that of Delphine. This he finally painted at Meung-sur-Loire in 1859 (fig. 213). In his portrayal he used his favorite hand-to-face gesture, giving his wife more of the warm intelligence of the baronne de Rothschild than the coquetry of the comtesse d'Haussonville. Nonetheless, he furnished her with what must have been every last piece of jewelry in the house. As a pendant for the portrait of Delphine, Ingres transformed the sketch for his portrait destined for Florence (cat. no. 148) into an elegant picture of an accomplished and worldly painter at the zenith of his career (fig. 212). Perhaps to avoid embarrassing Delphine, he colored his gray hair brown. Ingres evidently remained a vigorous husband; the Goncourts recorded a rumor that on the way home from the Opera, the Ingres's carriage was seen shaking from all the activity within.[57]

THE EXPOSITION UNIVERSELLE (1855)

Ingres's new paintings for the government of Napoleon III—*The Virgin with the Host, Joan of Arc* (fig. 215), and

The Apotheosis of Napoleon I—were exhibited along with sixty-six more of his works at the Exposition Universelle of 1855. The fair was Napoleon's response to the Crystal Palace Exhibition, held in London in 1851: its purpose was to proclaim French superiority, if not in machinery, then at least in the fine arts. Ingres was a crucial component of the propaganda program, but, as in the Bonne-Nouvelle exhibition of 1846, he was a reluctant participant. Only the promise of a separate room (the only one granted), complete control of the contents and the hanging of the installation, and an award of special honors, guaranteed by Prince Napoleon, the emperor's cousin, who was in charge of the fair, succeeded in obtaining his cooperation. At first, Ingres had lobbied for the exhibition to serve as a retrospective of all French painting since 1800, hoping to recreate his success at the 1846 exhibition and wishing to undermine the impact of the Romantic painters. Delacroix recorded the struggle in his journal: "At half past two, meeting of the Commission. Discussion of the rule concerning the exhibition of works produced since the beginning of the century. Aided by [Prosper] Mérimée, I successfully fought that proposition, which was shelved. Ingres was pitiful; his brain is all warped; he can see only one point. It is the same as in his painting; not the slightest logic and no imagination at all."[58] In the end, compromise ruled, and four artists were selected to have special displays: Ingres, Delacroix, Horace Vernet, and, inexplicably, Alexandre Decamps, the popular painter of lowly genre scenes. Everyone recognized that this would be Ingres's last large exhibition; one critic remarked that "for him, apart from any coterie, whether one is friend or foe, posterity begins."[59] Gautier concurred that "M. Ingres has today arrived at the place where posterity will set him, beside the great masters of the seventeenth century, from whom, after three hundred years, he seems to have inherited the spirit."[60] A visit to Ingres's exhibition was virtually obligatory and the subject of innumerable reviews and cartoons (see fig. 216).

In this catalogue, Robert Rosenblum has masterfully analyzed Ingres's display at the 1855 exhibition, and Andrew Shelton has thoroughly treated its critical reception, revealing the political nature of the criticism and underlining the shifting standards by which his achievement was measured (see pages 509–14). Here I would like to underscore the role of the exhibition in publicizing Ingres's rivalry with Delacroix: a matter that had previously been restricted to artistic circles became a subject of widespread public debate (see fig. 217). Both artists had powerful allies in the government, and both used them fully in their negotiations for the exhibition. By providing nearly equivalent spaces and allowing displays of equal number, the government forced the confrontation that had been simmering for years, inviting the critics and the public to choose sides. The result, as one critic put it, was "that it is impossible to cite the name of M. Ingres without that of M. Eugène Delacroix following immediately in the mind."[61] *Le Charivari* published a ditty that went: "Ah! if only M. Delacroix could be M. Ingres, if only M. Ingres could be M. Delacroix! / But M. Delacroix is not M. Ingres and M. Ingres is not M. Delacroix."[62] By now, the two artists felt the rivalry intensely. At every turn, Ingres fought the Romantic tide, blocking official commissions, professorships at the École des Beaux-Arts, and appointments to the Académie of anyone he suspected of Romantic sympathies. Delacroix, for his part, had no real institutional agenda, but he vigorously fought for every advantage for his friends and for liberalism in the administration of the arts.

Owing to the exhibition, things came to a head in 1855. When Ingres caught Delacroix leaving Ingres's display prior to the opening, Delacroix smiled tightly and excused himself. Ingres said to an assistant after Delacroix left, "The odor of heresy is surely here."[63] In his journal,

Fig. 215. *Joan of Arc at the Coronation of Charles VII in the Cathedral of Rheims*, 1851–54 (W 273). Oil on canvas, 94½ × 70⅛ in. (240 × 178 cm). Musée du Louvre, Paris

LA SALLE DE M. INGRES.

— Quelle horreur! un peintre qui a gagné tant d'argent n'avoir pas de quoi habiller ses modèles!

Fig. 216. Unidentified artist. *"La Salle de M. Ingres.*—Quelle horreur! un peintre qui a gagné tant d'argent n'avoir pas de quoi habiller ses modèles!" *(The Room of M. Ingres.*—How awful! A painter who has made so much money doesn't have the resources to clothe his models.) *Le Charivari*, June 19, 1855

Delacroix recorded his feelings of disgust: "I saw Ingres's exhibition. The dominating thing in it, to a great degree, is the ridiculous; it is the complete expression of an incomplete intelligence; effort and pretension are everywhere; there is not a spark of naturalness in it."[64] Two weeks later he formed a different impression: "The group of Ingres' things seemed to me better than it did the first time, and I am thankful to him for many fine qualities that he gets."[65] Ingres was not as tolerant. When the awards for the fair were announced, he was furious to be given the same Grande Médaille d'Honneur as Delacroix: "I, painter of high history, I am on the same rank as the apostle of ugliness?"[66] Delacroix heard about this from Horace Vernet and others: "Ingres . . . had written to refuse the medal because he felt deeply insulted at coming after Vernet, and even more, according to what I was told by several people who are above suspicion in this—insulted at the insolence of the special jury on painting which had placed him on the same line as myself in the preliminary classing of the candidates."[67] Ingres appealed to Prince Napoleon, whose portrait by Ingres suddenly appeared during the last weeks of the exhibition. The prince obtained for him a promotion to the highest rank of the Legion of Honor, never before granted to a painter. He crowed to Magimel, "The Emperor has just named me grand officer in the Legion of Honor! You will agree that I can do no better than to go and receive it from his august hands."[68]

RÉPUBLIQUE DES ARTS.

Duel à outrance entre M. Ingres, le Thiers de la ligne, et M. Delacroix, le Proudhon de la couleur.

Fig. 217. Unidentified artist. *"République des Arts.* Duel à outrance entre M. Ingres, le Thiers de la ligne, et M. Delacroix, le Proudhon de la couleur. Il n'y a point quartier à espérer; si M. Ingres triomphe, la couleur sera proscrite sur toute la ligne, et l'insurgé que l'on trouverait muni de la moindre vessie sera livré aux derniers supplices. Si Delacroix est vainqueur, on interdira la ligne avec tant de rigueur que les gens surpris à pêcher à la ligne sous le Pont-Neuf seront immédiatement passés par les armes. Quelques personnes ont bien osé parler de fusion entre la ligne et la couleur; mais ce projet a paru si ridicule et si extravagant, que nous n'en parlons ici que pour mémoire." (*The Republic of the Arts.* The ultimate duel between M. Ingres, the Thiers of line, and M. Delacroix, the Proudhon of color. There's no side to root for. If M. Ingres triumphs, color will be banned from every line, and any rebel found with a tube of paint will be subject to capital punishment. If Delacroix is the winner, line will be outlawed with such rigor that people found fishing under the Pont-Neuf will be immediately arrested. Some people have dared to speak of a fusion between line and color, but that project seems so ridiculous and eccentric that our mention of it here is just a reminder.) *Journal pour rire*, July 28, 1849

What Delacroix objected to most was Ingres's insistence on the primacy of his own method and the superiority of his own school. As early as 1834, as Shelton has underscored, critics had voiced concern over Ingres's legacy (see page 503). Baudelaire put his finger on it in 1846:

Around M. Ingres, whose teachings must inspire some kind of fanatical austerity, are grouped several men, the best known being Mssrs. FLANDRIN, LEHMANN, and AMAURY DUVAL. But what an immense distance from master to students! M. Ingres is still alone in his school. His method is the result of his nature, and however bizarre and obstinate it might be, it is sincere, which is to say, involuntary. Passionate lover of antiquity and its model, respectful servant of nature, he makes portraits that rival the best Roman sculptures. These gentlemen

have—coldly, willfully, pedantically—translated the unpleasant and unpopular part of his genius into a system; for what distinguishes them is pedantry, above all.[69]

Delacroix concurred: "All these young men of the school of Ingres have something pedantic about them. It seems that there is already a very great merit on their part in having joined the party of serious painting: that is one of the mottoes of the *party*. I told Demay that a whole lot of men of talent had done nothing worth while, with that mass of fixed opinions that they impose on themselves, or that the prejudice of the moment imposes on you."[70] In his projected dictionary of the arts, Delacroix even defined the word *authorities* with Ingres in mind: *"Authorities:* the ruin of great talents, and almost the whole talent of mediocrities. They are the leading-strings which help everybody to walk at the beginning of his career, but on almost everybody they leave ineffaceable marks."[71] He believed that Ingres's instruction had the effect of "resulting in mere technical imitation and thus breeding a horde of followers devoid of any idea of their own."[72] While conceding that some of Ingres's works had "a certain grace recalling that of Raphael; but with the latter one strongly feels that all such qualities emanate from himself and are not sought after,"[73] Delacroix ultimately preferred even the school of David (meaning Girodet and Gros) "to that taste compounded of antiques and mongrel Raphaelism which is that of Ingres and those who follow him."[74] Needless to say, posterity has sided with Delacroix and Baudelaire; despite their talent and their historical interest, all of Ingres's students have been relegated to minor status, and most of their work to storerooms.

MONSIEUR INGRES, SÉNATEUR

In July 1857 Delacroix was finally elected to the Académie des Beaux-Arts, occupying the seat vacated by the death of Paul Delacroche, another artist whom Ingres disliked. As he realized this inevitability, Ingres was frustrated and angry, writing a friend that "today I want to break with my century, that is how ignorant, stupid, and brutal I find it."[75] Hoping to make peace, Delacroix wrote to Ingres to excuse himself for not visiting Ingres on the occasion of his candidacy at the Académie.[76] Ingres was on all public occasions ostentatiously polite: Delacroix noted in his journal on June 2, 1857, that he "met Ingres at [the art dealer] Haro's place, and that he was very cordial and very courteous."[77] Nevertheless, Ingres maintained his institutional opposition. As he had explained to the painter Joseph-Nicolas Robert-Fleury in 1857, Delacroix was "an artist in whom he recognized the talent, the hon-

Fig. 218. *Comte Alfred-Émilien Nieuwerkerke*, 1856 (N 439). Graphite and white chalk on paper, 13 × 9⅝ in. (33 × 24.3 cm). Fogg Art Museum, Harvard University Art Museums, Cambridge, Massachusetts

orable character, and the distinguished mind" but who was someone who held "doctrines and tendencies that I believe to be dangerous and that I must repulse."[78]

In the next few years, however, the danger would come from a new quarter, and Ingres and Delacroix would find themselves united in opposition to the government and to Comte Alfred-Émilien de Nieuwerkerke, an amateur sculptor and arts administrator, who used his companion, Princess Mathilde, sister of Prince Napoleon and cousin of the emperor, to advance his influence. In 1856 Ingres had executed a splendid portrait drawing of the vain count (fig. 218), who was distrusted by Napoleon and disliked by almost everyone at court save the princess. Soon after that, Nieuwerkerke, then called superintendent of fine arts, was caught in a war between the Académie, which at that point controlled the Salon jury as well as the École des Beaux-Arts, and the government of Napoleon III. Artists had been complaining for some time about the Académie's restrictive policies (which reflected in part the hegemony of Ingres), and in 1863 the emperor personally responded to the criticism by creating the Salon des Refusés. Meanwhile, Nieuwerkerke saw in this discontent an opportunity to wrest from the Académie—a bastion of Orléanism—control of the Salon, the École des Beaux-Arts, and even the Académie de France in Rome. This centralization coincided with a campaign to clean paintings at the Louvre, and when the

Fig. 219. *Jesus among the Doctors*, 1842–62 (W 302). Oil study on canvas, 8 ft. 8⅜ in. × 10 ft. 5 in. (265 × 320 cm). Musée Ingres, Montauban

restorers began work on the Raphaels, most of the Academicians, including Delacroix and Ingres, were up in arms. Ingres went straight to the emperor to denounce Nieuwerkerke, saying that "the future will severely judge this assassin!"[79] Although Ingres was named a Senator in 1862—doubtless an attempt by the government to buy his cooperation—the ploy did not work. He continued to oppose Nieuwerkerke vigorously and found himself at odds with the same government that had previously showered him with honors. Nieuwerkerke responded churlishly by banishing Ingres's paintings at the Musée du Luxembourg (*Roger Freeing Angelica* and *Cherubini and the Muse of Lyric Poetry*) to a dark corner.[80]

Ingres wished to believe that he had been named a Senator because "the Emperor wanted, on *his own accord*, to proclaim and pronounce my name; he very much wanted to scatter some honorable flowers on my old age and last days."[81] Nevertheless, he added, "I am even more of an artist than ever before."[82] Ingres spent his last years collecting the numerous honors awarded him—not only from France, which named streets after him in Montauban and Paris and crowned him with a gold wreath paid for by a huge public subscription, but also by fine-arts academies across Europe. In his last decade, he painted self-portraits to send to Florence and Antwerp (cat. nos. 148, 149) as well as his enormous *Jesus among the Doctors* (fig. 219), which he exhibited at the Galerie Martinet in 1862. Given his studio practice and advanced age, his work on large paintings such as *Jesus* could have been finished only with substantial cooperation from his assistants, as Georges Vigne recounts (see pages 534–40 in this catalogue). The poor reception accorded this painting could well be attributed to the great amount of

studio intervention involved in its completion. As the wicked Goncourt brothers noted in their diary, "We stopped, before dinner, at the exhibition on the boulevard des Italiens, to see the latest painting by M. Ingres. . . . Here, perhaps, is the man who, since the beginning of time, has most tricked God: he was born to paint as Newton was born to be a singer! He has all the talent that determination can give and all the genius that patience can give—that is, hardly any genius and a talent of sixth order. . . . There is not a morsel of paint on that big canvas."[83]

That same year, Ingres completed a delicious morsel of painting that even the Goncourts might have appreciated, *The Turkish Bath* (fig. 220). Its history is complex: it was begun about 1848 for Prince Napoleon, but records of 1852 indicate that it was then destined for the Russian collector Count Nikolai Demidov; upon its completion in 1859, the work was delivered to its first intended recipient. Once again, the abundant nudity shocked the sensibility of the new owners, especially the prince's wife, and the painting was returned to Ingres in a complicated exchange negotiated by Frédéric Reiset, in which Ingres's repainted self-portrait of 1804 was substituted for *The Turkish Bath*. Finding his "child" back in his studio, Ingres transformed the rectangular composition into a tondo that, through its strong formal design, counterbalanced the libidinous energy of the painting. Quoting from *The Valpinçon Bather*, *Roger Freeing Angelica*, the odalisques, and even the curious pose of the seated portrait of Madame Moitessier, *The Turkish Bath* became an extraordinary single-painting retrospective of Ingres's study of the female nude.[84]

Ingres's mood was decidedly retrospective in the years before his death. Freed from most of his worldly responsibilities and occupying primarily honorific positions, marvelously cared for by his wife, Delphine, happily ensconced in a fine apartment on the quai Voltaire, he worked concertedly to perfect his principal compositions. To this end, he executed an elaborate, more perfect version of *The Apotheosis of Homer*, entitled *Homer Deified* (fig. 316), hoping (in vain) that its reproduction would establish a canon for future generations; he painted the small version of his unfinished *Golden Age* (fig. 206); he made a watercolor version of *The Dream of Ossian* (Musée Ingres, Montauban), a reduction of his *Oedipus and the Sphinx* (W 315; Walters Art Gallery, Baltimore), and another version, in reverse, of his *Antiochus and Stratonice* (W 322; Musée Fabre, Montpellier), as well as small devotional pictures for his wife. He recorded all of these in the list of his works that he maintained in a notebook. The last annotation, "a large Virgin with the Host and two angels,"

bears the date December 31, 1866.[85] A week later, on January 8, he went to the Bibliothèque Nationale to copy an engraving after Giotto's *Entombment of Christ;* that evening, after enjoying some quartets by Mozart and Cherubini at dinner with friends, he retired. Awakening to open the window to clear the bedroom of smoke, he caught cold; he died after a brief illness on January 14, 1867.

On April 10, a huge posthumous retrospective—organized by Édouard Gatteaux, Jacques-Ignace Hittorf, and Henri Lehmann under the aegis, ironically enough, of Nieuwerkerke—opened at the École des Beaux-Arts. By chance it coincided with the great Exposition Universelle of 1867, where the government of Napoleon III once again sought to display the superiority of French art and industry. The fair was also designed to display the massive reconstruction of Paris that Napoleon and Baron Hausmann, the governor of the region, had wrought. No greater contrast could be imagined than that between the freshly cleaned city—its new, wide boulevards brilliantly lit, its new, tall, luxurious apartment buildings stretching for blocks, its new, grand railroad stations bursting with traffic—and the Ingres exhibition at the École des Beaux-Arts: a temple consecrated to the past, to the old, to Raphael and the Ancients. The exhibition, which was the first to feature the artist's drawings as strongly as his paintings, forced a new generation of critics to grapple with Ingres's strange genius. Albert Wolff, who would later review the Impressionist exhibitions in the 1870s, noted that "the exhibition at the École des Beaux-Arts is more than an event, it is a revelation, because among these canvases, coming from the four corners of France, there are pages unknown to the masses, canvases of his early period that are quite simply superb, and others, very well known to the public, that are quite simply insane."[86] Once again Ingres would be misunderstood, insulted, and once again his paintings

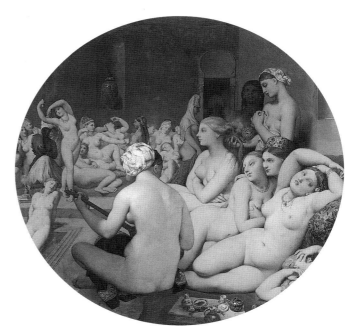

Fig. 220. *The Turkish Bath*, 1862 (W 312). Oil on canvas, mounted on wood, diam. 42 1/2 in. (108 cm). Musée du Louvre, Paris

would be examined admiringly by those susceptible to their peculiar beauty and amazing technique. There was one thing, however, that everyone could agree on: authority had died with Ingres. "His presence among us was a guarantee, his life a safeguard," eulogized Léon Lagrange in the *Gazette des beaux-arts*. "Silent champion of the principles of the Beautiful, he no longer taught, he did not preach, he did not write, he had stopped exhibiting. But he was alive and that was sufficient to impose respect, to slow down the torrent, to avert the storms. His death breaks the last tie of moderation that was holding back anarchy."[87] Little could Lagrange have imagined that the artistic anarchy he feared would, in twenty years, reflect the passion of a new generation of artists—from Renoir and Degas to Cézanne and Gauguin—for the work of J.-A.-D. Ingres.

1. "gloire, amitié, et respect." Granet to Ingres, November 29, 1840, in Néto 1995, letter no. 396.

2. "une extrême sensibilité et un désir insatiable de gloire." Ingres to Pierre Forestier, January 17, 1807, in Boyer d'Agen 1909, p. 53.

3. "The motto . . . is on my flag: *The Ancients and Raphael!* ("la devise est sur mon drapeau: *Anciens et Raphaël!*"). Ingres to Jean-François Gilibert, January 10, 1839, in ibid., p. 282; see also p. 323 in this catalogue.

4. "la sécheresse de la matière qui, décidément, est anti-belle et pittoresque." Ingres to Gilibert, February 27, 1826, in ibid., pp. 132–33.

5. The magazine *L'Artiste* wrote that a peerage would be the "necessary crowning achievement of M. Ingres's brilliant career" ("couronnement nécessaire de la brilliante carrière de M. Ingres") Anon. 1841, p. 414, quoted in Lapauze 1911a, p. 36.

6. "Je me suis mêlé, mon bien cher, moi aussi, de faire un projet pour le tombeau de Napoléon, dont il ne sera encore rien fait, et cependant il n'est peut-être pas plus bête qu'un autre." Ingres went on to state that he wanted to include the architect Félix Duban in the project: "Above all, what I wanted to ensure was the involvement of a man like Duban." ("Ce que j'ai eu surtout le soin de bien arrêter, c'est d'associer à un homme tel que

Duban"). Ingres to Dumont, July 25, 1840, in Boyer d'Agen 1909, p. 280. The sketch of the tomb that Ingres made in his notebook (IX, fol. 53) is reproduced in Vigne 1995b, fig. 244.

7. "où il était si bien, où ma gloire a été si complète." Ingres to Gilibert, 1834 (not 1839 as transcribed), in Boyer d'Agen 1909, p. 291.

8. After some repairs and reworking, he exhibited this work in his studio in January 1843.

9. "Vous faites, à ce qu'il paraît, des merveilles à l'Hôtel-de-Ville. Après l'architecture viendra, je l'espère, le tour de la sculpture et de la peinture, de la fresque surtout. N'êtes-vous de mon avis?" Ingres to Varcollier, August 31, 1841, in Boyer d'Agen 1909, p. 298.

10. "Tu connais Paris. Eh! bien, il m'est tombé dessus, j'en suis accablé. Lorsque je crois pouvoir gagner les bords du gouffre, je m'y vois replongé de plus belle. Toutes mes heures, tous mes moments sont comptés, toutes mes soirées sont précédées de dîners retenus d'avance. J'expie les honneurs et les ennuis d'une position digne d'envie, certes, mais qui au fond ne me rend pas heureux, il s'en faut. J'aimerais mieux le calme et la douceur du foyer avec mes amis choisis et mon atelier, où je suis roi, où j'oublie qu'il est des ennuis, des chagrins; là, où je suis heureux avec les difficultés à vaincre de mon bel art, quelquefois couronné par ma propre approbation et surtout quand je revois longtemps après, dans le monde où je les ai lancés, ces enfants qui m'ont tant coûté de soins, et de sollicitudes tendres et courageuses. Voilà ce qu'il me faut." Ingres to Gilibert, October 2, 1841, in ibid., p. 302.

11. "Depuis que j'ai peint les portraits de Bertin et de Molé, tout le monde en veut. En voilà six que je refuse ou que j'élude, car je ne puis les souffrir. Eh! ce n'est pas pour peindre des portraits que je suis retourné à Paris. Je dois y peindre Dampierre et la Chambre des Pairs. Cependant, j'ai dû accepter de peindre le duc d'Orléans, ce prince, mon aimable Mécène, auquel je ne pourrai jamais rien refuser. Je ne puis t'exprimer, au reste, comme le roi et toute la famille royale m'ont honoré. Si tu pouvais les approcher et les connaître, tu les adorerais." Ibid., pp. 302–3.

12. "Je suis bien vengé: quoique toujours modeste et humble petit garçon devant les Anciens, devant qui je m'incline et dont je tire toutes mes inspirations, il faut avouer qu'il est assez flatteur de voir couler des larmes devant mes ouvrages, et cela par tous le bons esprits délicats: 'Vous êtes le premier aujourd'hui'! me dit-on. Et je vois mes méchants et ridicules envieux à mes pieds." Ibid., p. 303.

13. "tout cela et la conviction de ce que je vaux comparé aux modernes, ma position, les plus beaux travaux de l'époque, par conséquent une fortune, résultat naturel de ces oeuvres, honoré et reconnu en plus haut lieu, entouré d'une foule d'amis dont je suis chéri et respecté, influent si je le voulais en beaucoup de choses." Ibid.

14. "excepté mon art et la musique, rien ne me tente. Je suis flatté, reconnaissant, heureux et glorieux, mais avec modestie, et le 'souviens-toi que tu es homme!' fait que je me traite, aujourd'hui, avec encore plus de sévérité sur mes imperfections et sur tout ce qui me manque pour arriver jusqu'où sont montés les Anciens." Ibid.

15. "Avec une position si enviée, je suis ainsi courbé et entouré d'envieux qui ne me pardonnent pas les humiliations que mes nobles succès leur ont fait subir. Je ne dois ces succès qu'à moi: les leurs sont le fruit de leur médiocrité intrigante, une académie impuissamment hostile et ridicule que je suis obligé de repousser à ongles et dents. Le public et la presse ont fait bonne justice de cette opposition. Mais qui sait si ce public et cette presse si ardents à me venger, aujourd'hui, ne céderont pas au caprice du goût et du sort? On a bien chassé Glück [*sic*] le divin de l'Opéra, on a blasphémé le divin Raphaël et aussi Racine. . . . Rien n'est guère changé ici, et le bon goût y est bien rare en tant de choses." Ibid., p. 304.

16. "les plus beaux noms de l'aristocratie intellectuelle." Laurent, June 18, 1841.

17. "Vous avez été méconnu . . . et l'on ne vous en a vu concevoir ni ressentiment ni amertume. On vous a rendu justice, et cette justice était de la gloire; vous n'en avez été ni moins indulgent, ni moins facile. Cette foi consciencieuse, dont je parlais tout à l'heure, vous a soutenu dans les bons comme dans les mauvais jours. Votre vie a été bonne. Que ce jour-ci vous soit doux: il réunit dans la sympathie empressée de vos amis tout ce qu'il y a d'admiration pour votre talent, d'estime pour votre personne, d'affection pour votre caractère." Quoted in Lapauze 1911a, pp. 366–67.

18. "Prenez et peignez, car ceci est ma couleur"; "Prenez et copiez, car ceci est mon dessin"; "En vérité, je vous le dis, l'un de vous me trahira pour la pairie"; "Maître, est-ce moi?"; "Vous l'avez dit." Laurent, June 18, 1841.

19. "moins encore à l'admirable talent du peintre qu'à ses sentiments bien connus pour le prince que nous pleurons." Montalivet to Alexandre Brogniart, July 22, 1842, quoted in Schlumberger 1991, p. 8.

20. "Le roi a dit . . . que c'était M. Ingres qui devait faire les cartons pour les vitraux de ce triste lieu, attendu que le prince m'aimait et que j'avais été l'ami de son fils. Le délai fut très court pour ce travail et tu juges, par ces paroles, du zèle et du sentiment que j'y ai apportés. Je viens de le finir." Ingres to Gilibert, October 30, 1842, in Boyer d'Agen, 1909, p. 352, and Ternois 1986b, p. 194.

21. See letter from the duc d'Aumale to Ingres, October 1, 1847, quoted in Bertin 1998, p. 20, LR.6.

22. "J'apporterai avec moi à Paris le portrait terminé de Cherubini, sur lequel je fonde l'espoir de réussir." Ingres to Édouard Gatteaux, September 5, 1840, quoted in Delaborde 1870, p. 248.

23. *Roger Freeing Angelica* (fig. 104), now at the Louvre, was the first, although his *Apotheosis of Homer* could be seen installed in the Galerie Charles X.

24. "le suprême effort du talent de M. Ingres." Thoré 1842, p. 801.

25. Ingres proposed to execute the second portrait of Molé with studio collaboration, which Molé refused; Bertin 1998, p. 38, LR.105. In July 1843 he mentioned to Gilibert that he needed to sketch the portrait of the duc de Nemours; Boyer d'Agen 1909, p. 363.

26. "Mais lorsqu'on est peintre de Cour et en faveur, on doit, à ce qu'il paraît, se lever de bonne heure, ne savoir à qui parler, pour qui travailler, ni à qui entendre. La maison est pleine de gens, les affaires se croisent, se heurtent; quelquefois, deux ou trois lettres à écrire au même moment; modèle toute la journée, et il faut apporter à ce travail d'enfantement tout le génie requis, la maturité, la raison, l'étude et le style le plus parfait. Et lorsque, harassé de

fatigue, on en est au point que les jambes n'en veulent plus et que l'on tombe de sommeil, il faut souvent faire toilette, aller dans le monde et se coucher à minuit, si ce n'est pas à une heure." Ingres to Gilibert, July 20, 1843, in Boyer d'Agen 1909, p. 363.

27. "Pour nous, qui avons pu admirer cette nouvelle création du peintre d'Homère dans l'atelier du maître, nous n'avons guère le droit d'accuser M. Ingres de ses longues rancunes contre le public et le salon; cependant, quand on s'apelle M. Ingres, et que l'on est arrivé comme lui au faîte du talent et de la renommée, on se doit à l'art, on se doit au grand public du Louvre: refuser d'exposer au milieu des artistes contemporains, c'est, pour ainsi dire, se séparer de l'art national, c'est amoindrir l'éclat de ces solennités annuelles auxquelles les maîtres sont, plus que personne, appelés à concourir; c'est surtout donner à quelques artistes que la foule a déjà distingués un exemple pernicieux, exemple qui, parmi eux, tend malheureusement à faire des progrès, et qu'il est de notre devoir de combattre et d'arrêter." Varnier 1842, p. 135.

28. "Je me suis rappelé qu'on avait pu voir à la fois dans l'atelier de Raphaël la *Vierge à la chaise*, le *Portrait de Léon X* et le *Musicien* du palais Sciarra. La comparaison des portraits exécutés par Raphaël avec ses tableaux d'histoire est sans contredit ce qui jette le plus grand jour sur les mystères de la peinture: la même observation s'applique aux trois derniers ouvrages de M. Ingres, qui font parcourir à la pensée tout le clavier de l'art depuis la pure réalité jusqu'à l'extrême idéal. L'unité du talent, ce qu'on appelle aujourd'hui l'*individualité* de l'artiste, ressort de l'examen simultané des trois tableaux. C'est évidemment la même lyre; mais l'artiste l'a adaptée tour à tour aux modes les plus opposés." Lenormant 1842, p. 313.

29. There is a version of 1852, painted for Marcotte (W 268); a version of 1854 in tondo format, now at the Musée d'Orsay, Paris (fig. 11); a version of 1860 (W 296), in a private collection; and a version of 1866 at the Musée Bonnat, Bayonne (W 325).

30. "comme on ferait à son tapissier;" "La pauvre *Vierge à l'Hostie* . . . ensuite livrée à une exposition publique dans ce qu'ils appellent là une Académie des Beaux-Arts . . . exposée . . . vilainement, accablée de mépris entre deux affreuses croûtes et dans une embrasure de croisée." Quoted in Lapauze 1911a, p. 352.

31. "Nous sommes transportés de la sphère des rêves dans le monde réel, devant la réalité dans sa plus complète expression. Il est bien de n'avoir pas mis côte à côte ces deux ouvrages si opposés; ce n'est pas trop des quartre ou cinq pas qui les séparent pour se préparer à une aussi brusque transition." Geofroy 1848, p. 447.

32. "deux catégories distinctes, presque deux manières, dans lesquelles l'art du peintre aux prises, tantôt avec le modèle et la nature, tantôt avec l'idéale et la tradition, se maintenant toujours à une égale hauter. On trouve précisément, dans les deux tableaux que M. Ingres vient d'exposer, une expression complète de ce contraste. Sa *Vénus anadyomène* et le portrait de M^me la baronne de Rothschild sont deux oeuvres capitales, traitées chacune avec une grande supériorité, mais chacune d'un sentiment et d'un faire tout-à-fait à part, ainsi que le demandait la différence du sujet." Ibid., p. 442.

33. "particulier et étrange"; "un rêve de jeunesse réalisé dans la puissance de l'âge mûr, bonheur que peu de gens obtiennent, artistes ou autres." Ibid.

34. "Il ne nous est rien resté des merveilleux peintres grecs; mais, à coup sûr, si quelque chose peut donner une idée de la peinture antique telle qu'on la conçoit d'après les statues de Phidias et les poèmes d'Homère, c'est ce tableau de M. Ingres; la *Vénus Anadyomène* d'Apelle est retrouvée." Gautier, August 2, 1848, reprinted in Gautier 1880, p. 246.

35. "Tous mes amis en sont enchantés, et le plus ambitieux croient que j'aurais pu faire encore une meilleure affaire. Quant à moi, je trouve cela presque trop; mais non, certes, pour le retentissement qu'a fait ce petit ouvrage dans Paris, car on ne parlait d'autre chose." Ingres to Calamatta, January 10–28, 1857, quoted in Lapauze 1911a, p. 498.

36. "Voilà douze ans tout à l'heure que le public a été sevré des oeuvres du maître." Anon. 1846, p. 33.

37. "le souverain pontife de l'art moderne, M. Ingres, est celui dont le talent se trouve plus sérieusement représenté à l'exposition; onze de ses meilleurs tableaux excitent au plus haut degré la curiosité de la foule." Mantz 1846, p. 187.

38. For identifications of the specific pictures, see the Chronology, p. 552.

39. "on embrasse, . . . d'un coup d'oeil, ses onze ouvrages inspirés chacun par une époque ou idée absolument différente." Lenormant 1846, p. 670.

40. "Oui, M. Ingres est le maître sans égal de notre siècle en fait de portraits. Dans cette exposition, où l'on retrouve un assez grand nombre de ceux de David, de Gérard, de Gros et d'Hersent, aucun ne surpasse les siens. Plus qu'aucun de ses rivaux, il a le don de la pensée, la faculté merveilleuse d'éclairer la matière des reflets de la vie." Lestelley 1846, p. 258.

41. "Tout au fond de la cour de l'Institut, à droite, un escalier en bois, jamais frotté, balayé avec distraction, véritable escalier de savant ou d'homme de génie, vous conduit à un palier dont il ne faudrait pas trop examiner les recoins. Vous vous trouvez en face d'une porte numérotée. (Numéro 4 [*sic*]; le hasard a quelquefois de l'esprit!) Vous sonnez. C'est une servante qui vient ouvrir. Elle vous précède dans un étroit couloir, et vous introduit dans un cabinet sans tapis ni tenture. Là, vous êtes reçu avec cordialité par un homme de petite taille, négligemment vêtu; il vous fait asseoir sur un fauteuil en tapisserie, ouvrage de sa femme, et se met à causer sans prétendre le moins du monde à une attention particulière." Stern, January 7, 1842, quoted in Naef 1977–80, vol. 3 (1979), p. 397; translation adapted from New York 1995–96 (1998 ed.), p. 83.

42. "Quant à mon *Age d'Or*, voici le court programme que j'ai imaginé: *Un tas de beaux paresseux!* J'ai pris, hardiment, l'âge d'or, comme les anciens poètes l'ont imaginé. *Les hommes de cette génération n'ont point connu la vieillesse. Ils vivraient longtemps et toujours beaux. Donc, point de vieillards. Ils étaient bons, justes et s'aimaient. Ils n'avaient d'autre nourriture que les fruits de la terre et l'eau des fontaines, du lait et du nectar. Ils vécurent ainsi et moururent en s'endormant; après, ils devinrent de bons génies qui avaient soin des hommes. A la vérité, Astrée les visitait souvent et leur enseignait à aimer la Justice et à la pratiquer. Et ils l'aimaient aussi, et Saturne dans le ciel contemplait leur bonheur.*

"Moi donc, pour mettre toutes ces bonnes gens en scène, il me fallait bien un petit brin d'action. Je l'ai trouvé dans un sentiment religieux. Ils sont tous réunis dans un préau élevé, sur

lequel sont une treille et des arbres chargés de fruits. Un homme, acolyté d'un jeune garçon et d'une jeune fille, exprime une noble prière, tandis que ceux-ci élèvent dans leurs bras des fruits et une coupe de lait qu'ils renversent même un peu. Derrière cette espèce de prêtre, s'agite une danse religieuse exécutée par des jeunes filles qui font tourner un jeune garçon maladroit qui joue des flûtes et est ramené à la mesure par la jeune fille qui conduit la danse en battant des mains. Puis, sont échelonnés des groupes d'amants heureux, et des familles heureuses avec leurs enfants. Ils attendent sûrement l'heure du repas, autour d'un bassin qu'alimente une source qui sort au-dessous de l'autel. Cependant, à droite arrive la majestueuse figure d'Astrée, avec ses divines balances. Des hommes sont groupés autour, et elle leur dit: 'Tant que vous imiterez la justesse de cet instrument, vous serez heureux.' . . . Tout cela dans des natures très variées, à la Raphaël. Une jeune fille couronne de fleurs son amant, d'autres font s'embrasser de jeunes enfants.

"Voilà les principales idées. J'ai en cire une maquette, pour l'effet des ombres, et compte près de soixante figures." Ingres to Gilibert, July 20, 1843, in Boyer d'Agen, pp. 364–66.

43. "un très grand peintre!" Quoted in Lapauze 1911a, p. 410.

44. The number represents a count made by Henry Lapauze, who identified some four hundred at Montauban and stated that others were burned in the fire that destroyed Gatteaux's house in 1871; ibid., p. 408.

45. For descriptions of Ingres's painting process, see the discussion in cat. nos. 125 and 133–144.

46. See Scharf 1968 and Hauptman 1977.

47. "Je suis bien encore fâché de devoir continuer à faire le méchant avec vous, mais vraiment, vous n'êtes pas raisonnable." Ingres to Gonse, December 15, 1851, quoted in Lapauze 1911a, p. 456.

48. "un idéal qui mêle dans un adultère agaçant la solidité calme de Raphaël avec les recherches de la petite-maîtresse." Baudelaire, "Exposition Universelle—1855—beaux-arts," in Baudelaire 1975–76, vol. 2 (1976), p. 586.

49. "Depuis quatre mois à Paris, je ne fais qu'aménager et clouer dans mon nouvel appartement,—toujours avec une chambre pour l'ami et sa fille,—arranger mes ateliers, être malade et essuyer une révolution qui m'a ébranlé de fond en comble, sans parler des pertes pécuniaires qui dérangeront ce petit bien-être amassé avec tant de peines. . . . Si la liberté est tout à l'ordre du jour, elle n'est pas pour moi, moi, le plus esclave de tous. . . . Quels projets peut-on, d'ailleurs, faire dans ces moments d'angoisse où l'on vit au jour le jour, au bord du précipice dont la pente est si rapide, sur le gouffre où l'on est seulement appuyé à la république que tout le monde veut, mais que tant d'anges infernaux feraient rouge quand nous la voudrions, comme Astrée, belle, vierge, noble et pure? Il n'y a que Dieu qui puisse nous sauver, et nous n'espérons qu'en sa divine Providence." Ingres to Gilibert, May 1848, in Boyer d'Agen, p. 392.

50. "mais moi, que vais-je devenir! Tout est fini, je n'ai plus elle, plus de foyer, je suis brisé et je ne sais que pleurer de désespoir. . . . Mais tout est fini pour moi à jamais, puisque cette compagne chérie de ma vie n'existe plus." Ingres to Marcotte, July 28, 1849, quoted in Lapauze 1911a, p. 428, and Ternois 1999, letter no. 62.

51. Both have only recently been published fully and correctly, by Georges Vigne; see Vigne 1995b, pp. 324–40.

52. "Il y a parmi nous plus d'un peintre capable de concevoir sur cette donnée quelque chose de séduisant; je ne crois pas qu'il y en ait un seul en état de traiter le sujet avec la même élévation. Il est donc permis d'affirmer que l'Apothéose de Napoléon arrive à propos pour rappeler aux imaginations égarées l'importance du style, et non-seulement je nourris la ferme espérance qu'elle réagira contre les habitudes de notre école, mais encore je crois qu'elle redressera le goût de la foule." Planche 1854, p. 312, quoted in Lapauze 1911a, p. 472.

53. "Les proportions de son plafond sont tout à faits choquantes: il n'a pas calculé la perte que la fuite du plafond occasionne aux figures. Le vide de tout le bas du tableau est insupportable, et ce grand bleu tout uni dans lequel nagent ces chevaux tout nus aussi, avec cet empereur nu et ce char qui est en l'air, font l'effet le plus discordant pour l'esprit comme pour l'oeil. Les figures des caissons sont les plus faibles qu'il ait faites: la gaucherie domine toutes les qualités de cet homme. Prétention et gaucherie, avec une certaine suavité de détails qui ont du charme, malgré ou à cause de leur affectation, voilà, je crois, ce qui en restera pour nos neveux." Delacroix 1932, vol. 2, p. 182, journal entry for May 10, 1854; translated in Delacroix 1948, p. 383.

54. "Phidias et les chevaux de fiacre." Vigne 1995b, p. 289.

55. Boyer d'Agen 1909, p. 237.

56. "Me voilà . . . l'homme, j'espère, le plus heureux de ce monde . . . mais ce qui a droit de toucher mon coeur plus sensiblement encore, c'est *qu'elle seule m'a choisi!* qu'elle vient les bras ouverts, malgré mon âge et bien moins parfait qu'elle, mais avec la certitude de tout employer pour faire son bonheur, auquel je vais consacrer tout le reste de ma vie!" Ingres to Calamatta, April 13, 1852, quoted in Lapauze 1911a, pp. 461–62.

57. Goncourt 1956, vol. 3, p. 742, journal entry for August 11, 1892.

58. "A deux heures et demie, séance à la commission de l'Industrie. Discussion sur le règlement concernant l'exposition des ouvrages faits depuis le commencement du siècle. J'ai combattu avec succès, aidé de Mérimée, cette proposition, qui a été écartée. Ingres a été pitoyable; c'est une cervelle toute de travers; il ne voit qu'un point. C'est comme dans sa peinture; pas la moindre logique et point d'imagination." Delacroix 1932, vol. 2, p. 153, journal entry for March 24, 1854; translated in Delacroix 1948, p. 368.

59. "Pour lui, en dehors de toute coterie, soit amie, soit ennemie, la postérité commence." Étex 1856, p. 45.

60. "M. Ingres est aujourd'hui arrivé à la place où la postérité le mettra, à côté des grands maîtres du seizième siècle, dont il semble, après trois cents ans, avoir recueilli l'âme." Gautier 1855, pp. 142–43.

61. "il est impossible de citer le nom de M. Ingres sans que celui de M. Eugène Delacroix ne vienne immédiatement à l'esprit." Nibelle 1855, p. 147, quoted in Shelton 1997, p. 494.

62. "Ah! si M. Delacroix pouvait être M. Ingres, si M. Ingres pouvait être M. Delacroix. / Mais M. Delacroix n'est pas M. Ingres et M. Ingres n'est pas M. Delacroix." Frémy, October 23, 1855, quoted in Mainardi 1987, p. 73.

63. "Comme on sent le soufre ici." Quoted in Énault, May 25, 1855, and Shelton 1997, p. 482.

64. "J'ai vu l'exposition d'Ingres. Le ridicule, dans cette exhibition, domine à un grand degré; c'est l'expression complète d'une incomplète intelligence; l'effort et la prétention sont partout; il ne s'y trouve pas une étincelle de naturel." Delacroix 1932, vol. 2, p. 327, journal entry for May 15, 1855; translated in Delacroix 1948, p. 462.

65. "Celle d'Ingres m'a paru autre que la première fois, et je lui sais gré de beaucoup de qualités." Delacroix 1932, vol. 2, p. 331, journal entry for June 1, 1855; translated in Delacroix 1948, p. 465.

66. "moi, peintre de haute histoire, je suis sur le même rang que l'apôtre du laid." Ingres to an unnamed correspondent, quoted in Blanc 1870, p. 183.

67. "Ingres . . . a écrit pour refuser la médaille, outragé profondément d'arriver après Vernet, et encore plus, à ce que m'ont dit plusieurs personnes, non suspectes en ceci, de l'insolence du jury spécial de peinture, qui l'avait placé sur la même ligne que moi, dans l'opération préparatoire." Delacroix 1932, vol. 2, p. 409, journal entry for November 5, 1855; translated in Delacroix 1948, p. 499.

68. "L'Empereur vient de me nommer grand officier de la légion d'honneur! Vous sentez donc je ne puis mieux faire que de l'aller recevoir de ses augustes mains." Ingres to Magimel, quoted in Ternois 1989, letter no. 21.

69. "Autour de M. Ingres, dont l'enseignement a je ne sais quelle austérité fanatisante, se sont groupés quelques hommes dont les plus connus sont MM. FLANDRIN, LEHMANN et AMAURY-DUVAL. Mais quelle distance immense du maître aux élèves! M. Ingres est encore seul de son école. Sa méthode est le résultat de sa nature, et, quelque bizarre et obstinée qu'elle soit, elle est franche, et pour ainsi dire involontaire. Amoureux passionné de l'antique et de son modèle, respectueux serviteur de la nature, il fait des portraits qui rivalisent avec les meilleures sculptures romaines. Ces messieurs ont traduit en système, froidement, de parti pris, pédantesquement, la partie déplaisante et impopulaire de son génie; car ce qui les distingue avant tout, c'est la pédanterie." Baudelaire, "Salon de 1846," in Baudelaire 1975–76, vol. 2 (1976), p. 460.

70. "Tous les jeunes gens de cette école d'Ingres ont quelque chose de pédant. Il semble qu'il y ait déjà un très grand mérite de leur part à s'être rangé du parti de la peinture sérieuse: c'est un des mots du *parti*. Je disais à Demay qu'une foule de gens de talent n'avaient rien fait qui vaille, à cause de cette foule de partis pris qu'on s'impose ou que le préjugé du moment vous impose." Delacroix 1932, vol. 1, p. 184, journal entry for February 9, 1847; translated in Delacroix 1948, p. 144.

71. "*Autorités* : la perte pour les grands talents et la presque totalité du talent pour les médiocres. Elles sont les lisières qui aident tout le monde à marcher, quand on entre dans la carrière, mais elles laissent à presque tout le monde des marques ineffaçables." Delacroix 1932, vol. 2, p. 83, journal entry for October 10, 1853; translated in Delacroix 1948, p. 326.

72. "a féconder par l'imitation pure et simple de ses procédés cette foule de suivants dépourvus d'idées propres." Delacroix 1932, vol. 2, p. 342, journal entry for June 17, 1855; translated in Delacroix 1948, p. 470.

73. "une certaine grâce qui rappelle celle de Raphaël; mais on sent bien, chez ce dernier, que tout cela sort de lui et n'est pas cher-ché." Delacroix 1932, vol. 3, p. 196, journal entry for May 26, 1858; translated in Delacroix 1948, p. 630.

74. "à ce goût mêlé d'antique et de raphaëlisme bâtard qui est celui d'Ingres et de ceux qui le suivent." Delacroix 1932, vol. 3, p. 310, journal entry for November 25, 1860; translated in Delacroix 1948, p. 689.

75. "Aujourd'hui, je veux rompre avec mon siècle, tant je le trouve ignorant, stupide et brutal." Ingres to Magimel, August 30, 1856, quoted in Lapauze 1911a, p. 500.

76. Delacroix cites an obstinate indisposition for preventing the visit, "even though habit and etiquette imperiously demand it" ("ainsi que l'usage et les convenances l'exigent impérieusement"). Quoted in Bertin 1998, p. 27, LR.41; see also LR.137.

77. "j'ai trouvé Ingres chez Haro, qui a été très cordial et très bien." Delacroix 1932, vol. 3, p. 106; translated in Delacroix 1948, p. 590.

78. "un artiste dont, au reste, je reconnais le talent, le caractère honorable et l'esprit distingué, des doctrines et des tendances que je crois dangereuses et que je dois repousser." Ingres to Robert-Fleury, February 18, 1857, quoted in Lapauze 1911a, p. 500, mistakenly dated to 1851 [EB].

79. "L'avenir saura juger sévèrement cet assassin!" Quoted in Amaury-Duval 1924, p. 223. Here I follow Mainardi's excellent analysis of art policy under the Second Empire; see Mainardi 1987, pp. 123–27.

80. Eric Bertin has recently found a letter, dated September 6, 1863, from Hippolyte Flandrin to Ingres, in which Flandrin conveys his dismay at this decision; Bertin 1998, p. 28, LR.51.

81. "L'Empereur a voulu, de *lui-même*, proclamer et prononcer mon nom; il a bien voulu verser des fleurs honorables sur la vieillesse de mes derniers jours." Ingres to Cambon, June 4, 1862, in Boyer d'Agen 1909, p. 448.

82. "je suis encore plus artiste que jamais." Ibid.

83. "Nous passons, avant dîner, à l'exposition du boulevard des Italiens, voir le dernier tableau de M. Ingres. . . . Voilà peut-être l'homme qui a le plus trompé Dieu, depuis que le monde existe: il était né pour être peintre comme Newton était né pour être chansonnier! Il a tout ce que la volonté peut donner de talent et tout ce que la patience peut donner de génie,—c'est-à-dire point de génie et un talent de sixième ordre. . . . Il n'y a pas un morceau de peint dans cette grande toile." Goncourt 1956, vol. 1, p. 1071, journal entry for May 4, 1862.

84. These visual quotations were noted by Robert Rosenblum in Rosenblum 1967a, p. 172.

85. "grande vierge à l'hostie et deux anges." Reproduced in Vigne 1995b, p. 329.

86. "L'exposition de l'École des Beaux-Arts est plus qu'un événement: c'est une révélation, car parmi ces toiles, arrivées des quatre coins de la France, il y a des pages inconnues de la masse, des toiles de la première manière qui sont tout simplement superbes et d'autres, fort connues du public, qui sont tout simplement insensées." Wolff 1867.

87. "sa présence parmi nous était une garantie, sa vie une sauvegarde. Champion muet des principes du Beau, il n'enseignait plus, il ne prêchait pas, il n'écrivait pas, il avait cessé d'exposer. Mais il vivait, et c'était assez pour imposer le respect, pour ralentir le torrent, pour conjurer bien des tempêtes. Sa mort brise le dernier lien de pudeur qui retenait l'anarchie." Lagrange 1867a, p. 206.

119, 120. Maria Luigi Carlo Zenobio Salvatore Cherubini

119. Maria Luigi Carlo Zenobio Salvatore Cherubini
1840–41
Oil on canvas
32 × 28 in. (81.3 × 71.1 cm)
Signed and dated lower left: J. Ingres pinx. 1841.
[J. Ingres painted (this). 1841.]
Inscribed: L. CHERUBINI COMP.ᴱᵁᴿ NÉ À
FLOR. 14 SEPT. 1760. / Mᴮᴿᴱ DE L'INST.
D.ᴱᵁᴿ DU CONS.ᴱ COM.ᴱᵁᴿ DE LA LEG.
D'HON. / CHEV.ᴿ DE Sᵀ MIC.ᴸ ET DE
DARMSTADT [L. Cherubini composer born
in Florence September 14, 1760 / Member of
the Institute(,) Director of the
Conservatoire(,) Commander of the Legion of
Honor / Knight of Saint Michael and
Darmstadt]
Cincinnati Art Museum
Bequest of Mary M. Emery 1927.386

W 235

120. Study for "Luigi Cherubini"
(see p. 385)

This canvas is the third of three that Ingres prepared to portray the illustrious composer Luigi Cherubini (1760–1842), who by the 1830s was considered a living monument in Europe. Painted in Rome in the winter of 1840–41 and possibly given its final touches in Paris the following spring, it was based on Ingres's first portrait of Cherubini, itself begun in Paris before his departure in 1834 and later transformed by the artist into a more ambitious composition (fig. 221). Like nearly all of the artist's projects, Cherubini's portrait required a long gestation, and, as a result, the chronology of the related works has been much disputed and confused. However, the recent rediscovery of some letters to Ingres from Cherubini and the

Florentine sculptor Lorenzo Bartolini, as well as an early account by Cherubini's student and close friend Fromental Halévy, can now be used to advance a probable scenario based on the available information.[1]

By 1834 Ingres, in Paris, had evidently begun a small portrait of Cherubini, a canvas that is no longer extant in its original form. In the list of his works that he began to compile about 1847, Ingres referred to this painting as "tête [head] de cherubini."[2] Halévy's article, published in July 1841 and ignored by art historians until Hans Naef republished it in 1979, called it an "ébauche" (oil sketch).[3] By early 1835 Ingres, in Rome, had asked for the canvas to be sent to him for modification. Cherubini wrote to the artist on February 2 to inquire

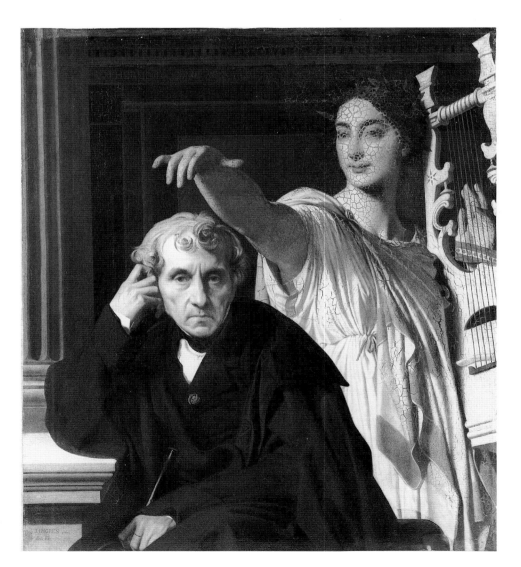

Fig. 221. *Cherubini and the Muse of Lyric Poetry,*
1842 (W 236). Oil on canvas, 41³⁄₈ × 37 in.
(105.1 × 94 cm). Musée du Louvre, Paris

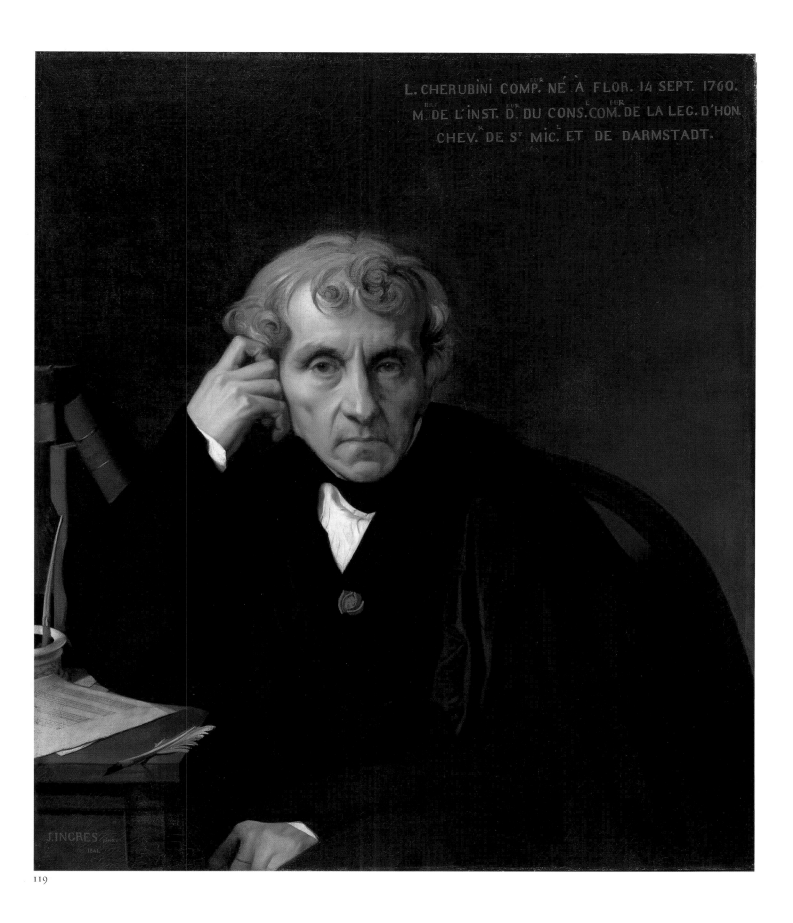

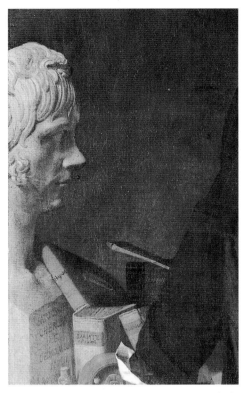

Fig. 222. Bartolini's bust of Cherubini, detail of *Lorenzo Bartolini*, 1820 (fig. 135)

whether it had arrived and to express his anticipated pleasure: "I am delighted that your brushes are taking care of old Cherubini."[4] Almost two years later, Ingres asked Bartolini to lend him a sculpted head of Cherubini, perhaps the bust that appears in Ingres's portrait of the sculptor (fig. 222).[5] Yet, by 1838 Ingres had still not finished his revisions, and it is by no means certain that he had even begun. On February 20, he wrote Alexis-René Le Go, the secretary at the Académie de France in Rome, to ask him to deliver his apologies to Cherubini: "I beg you to place me at the feet of the great master Cherubini with all the esteem and deep devotion that I have for him, feelings that have been soiled by the blackest negligence, which I am going to try to repair if it is possible."[6]

By spring 1840 Ingres had begun to transform the conventional portrait into a remarkable allegory inspired by Poussin's *Self-Portrait* (fig. 10). The pensioner Charles Poran, who saw the work in Ingres's studio, described it in a letter of March 23 as "the portrait of Cherubini in front of a Muse who, standing behind him,

extends her hand over his head. . . . He has made an apotheosis. The head had been painted in France five years ago."[7] The last observation explains the composite nature of Ingres's finished painting (fig. 221), now at the Louvre: a rectangle of canvas on which the composer's head appears has been sewn into the canvas on which the rest of the composition, including Terpsichore, the Muse of Choral Song and Dance, was painted.[8] Ingres had cut this rectangle out of the original portrait sent to him in Rome, effectively destroying it. Technical studies have determined that the Louvre painting was originally inscribed "Paris 1834 Rome 1841," further evidence that the first portrait of Cherubini is embedded in the second.[9]

Work progressed sufficiently on the new allegorical portrait to enable Ingres to write his friend the painter Édouard Gatteaux on September 5, 1840, "I will bring with me to Paris the completed portrait of Cherubini, on which I base my hope to succeed."[10] Ingres's student Raymond Balze noted progress on the picture in a letter of October 1840.[11] On November 5, the artist wrote Cherubini about the painting, but unfortunately the contents of that letter are not known.[12] To ensure completion, Ingres had enlisted his German-born pupil Henri Lehmann to paint certain passages, for which Ingres supplied the working drawings. Although Lehmann was sworn to secrecy, he could not help but reveal the commission to his confidant, Marie d'Agoult, in a letter of October 24: "I am also working for M. Ingres, which you must not repeat, since he intends to pass off what I am doing for him as his own work, after touching it up, of course."[13] Charles Blanc reported in 1870 that "Cherubini's hands, in the absence of the model, were painted by Lehmann after those of Gounod, then a pensioner at the Académie de France in Rome."[14] Time has revealed the collaboration most cruelly, since additives used in the oil paints—perhaps to slow the drying process so that Ingres could rework certain passages—have since produced disfiguring cracks. In 1985 Hélène Toussaint and Charles de Couëssin attributed the entire painting, with the exception of

Cherubini's head, to Lehmann.[15] This is not certain, however, since the Muse had already been painted by spring 1840 and Lehmann did not mention working for Ingres until the end of that year. It is possible that Ingres had secured another, still anonymous, collaborator before soliciting Lehmann's help.

Sometime before returning to Paris in May 1841, Ingres had this version of the portrait, without the Muse, prepared. It is dated 1841, a year earlier than the final date inscribed on the allegory. Since Ingres had high hopes for the allegorical portrait, probably anticipating a sale to the state, and since he must have felt obliged to provide a portrait to Cherubini, who had posed for him more than six years earlier, this copy was most probably made to be given to the composer. Very skillfully and economically executed, it may well have been painted by Lehmann and only retouched by Ingres, although Ingres included it, as a "Copie," in his list of his own works executed in Rome.[16] A squared drawing of Cherubini's head now at the Musée Ingres (fig. 223) was probably used to create this work, and it may also have been employed by Hippolyte Flandrin in 1845 for his bust-length version for the new museum of French history at Versailles.[17]

There are no documents to illuminate the circumstances under which the original 1834 portrait of Cherubini was made, and thus it is not known why Ingres chose to embark on it; there are, however, several drawings that seem to relate to the early portrait. One splendid sheet (cat. no. 120), given by Ingres in 1835 to a student at the Académie de France in Rome, bears all the marks of a drawing from life and thus must have been made in Paris before Ingres's departure. A fine drawing at Bayonne (fig. 224) also seems to belong to Ingres's earliest efforts. On the other hand, most of the relevant drawings now at the Musée Ingres were probably executed about 1840–41, in preparation for the allegorical portrait. In 1855 the photographer Nadar, who disliked Ingres's art, quipped that the painter had required ninety sittings by Cherubini to produce the likeness—a canard that was no doubt repeated in the studios of Paris.[18] It is unlikely that

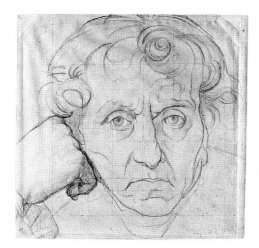

Fig. 223. *Study for "Luigi Cherubini,"* ca. 1840–41. Graphite on paper, 10⅛ × 10 in. (25.8 × 25.4 cm). Musée Ingres, Montauban (867.223)

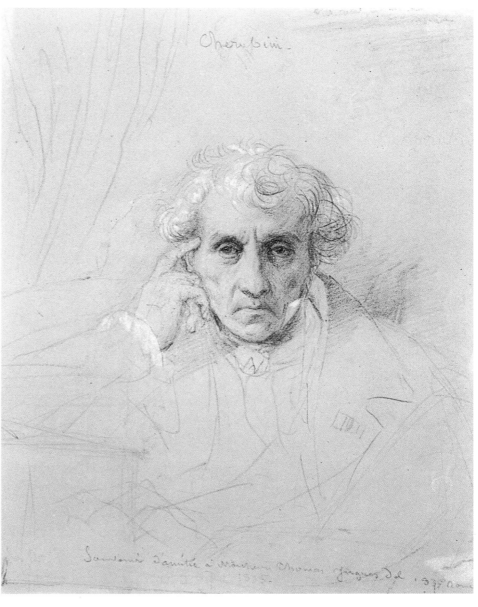

120

Cherubini could have posed so many times in 1834, nor was he available for sittings later in Rome. Yet little did Nadar know that Ingres had actually required nine years, Bartolini's sculpture, the assistance of Lehmann, and the compliance of friends such as Gounod in order to complete the portrait.

A little copy made by Isidore Pils of the allegorical portrait as it appeared in 1841 in Ingres's studio in Rome (fig. 225) shows the painting prior to its final modification in Paris. The most significant change undertaken in Paris was to repaint Cherubini's overcoat from yellow to black. Since technical studies have not yet been made of the present work, it cannot be determined whether it was completed before or after the allegorical painting was

given its final touches. Both paintings do, however, represent the figure of Cherubini in essentially the same way, except that he does not have a baton in his left hand here. Instead of the neo-Pompeian decor that Ingres provided for the portrait with the Muse, a more intimate setting was adopted for this portrait, destined for Cherubini's house. The great composer is shown in a study, about to transcribe some music on an empty sheet; three bound scores of his most famous operas—*Medée, Ali Baba,* and *Les Deux Journées*—stand on the writing table beside him. (The chair in which he sits was eventually painted out of the allegorical portrait.) Clearly posing for a portrait, he addresses the viewer in a manner that is both alert and indifferent— conscious that he is being observed but

more interested in the melody he is about to jot down.

Ingres revealed the allegorical portrait to Cherubini in a private showing in his studio on the quai Voltaire soon after his return to Paris on May 6, 1841; Halévy's account of the event was published on July 25.[19] Out of modesty, Ingres absented himself, and only Madame Ingres was present. Equally modest, Cherubini said nothing, provoking panic.[20] According to a different account given by one of the composer's biographers, Cherubini told his family that it was not Ingres's place to decide where and when the accolade of the Muses would be granted; Halévy was said to have brought Ingres's note of apology to the composer.[21] But Cherubini's change of heart was signaled by the delivery of a

Fig. 224. *Study for "Luigi Cherubini,"* ca. 1833–34. Black chalk on paper, 8⅝ × 7⅞ in. (22 × 20 cm). Musée Bonnat, Bayonne

cantata for three voices that he composed in Ingres's honor, "O Ingres amabile, pittor chiarissimo" ("O beloved Ingres, dearest painter").[22] The composer also organized a private concert for Ingres that summer, described in detail by Halévy. It would be one of his last: Cherubini died on March 15, 1842. Ingres learned of it on the way to a musical dinner organized at the house of his friend the architect Jacques-Ignace Hittorf, and he sobbed through the night.[23]

When Ingres exhibited the allegorical painting in his studio, Lehmann's friend Marie d'Agoult published an extravagant notice under her pen name, Daniel Stern:

The head of this eminent musician is perhaps the most beautiful portrait to come from the brush of M. Ingres. We see that it pleased him to reproduce these squinting Homeric eyebrows, this forehead on which [the physiognomist] Lavater would have recognized the three vertical creases as a certain sign of a noble character. He was not afraid to place in full light, without hiding anything, this old age in repose, giving it an august appearance. As he did in the portraits of M. Bertin and the comte de Molé, he took marvelous advantage of the rough and stiff material of which modern clothing is made. Retaining simple and even correctly bourgeois style, he succeeded in producing large folds, nearly Roman in their fullness, in the fabric of

the overcoat. He finally resolved one of the greatest problems facing art: to ennoble the commonplace while reproducing it with exactitude.[24]

On February 19, 1842, the artist invited members of the Académie to view the work, which was later joined in the studio by the portrait of the duc d'Orléans (cat. no. 121) and *The Virgin with the Host* (fig. 200). On that occasion, the critic Théophile Thoré wrote, "The Portrait of Cherubini seems to me to be the supreme effort of M. Ingres's talent. The face of the illustrious composer is imprinted with the highest character. . . . It has been rightly said that he seems to hear some harmony within himself."[25] Charles Lenormant's sensitive appreciation in *L'Artiste* noted that "a profound feeling of sadness is imprinted on this long-awaited apotheosis of a great genius. . . . In the face of Cherubini, M. Ingres conceals neither age nor weakness; the clothing is of a simplicity that approaches naive truthfulness."[26] It was this honesty that appealed to the Goncourts, who, although they disliked Ingres's style, preferred his male portraits to his female ones: "Monsieur Ingres has

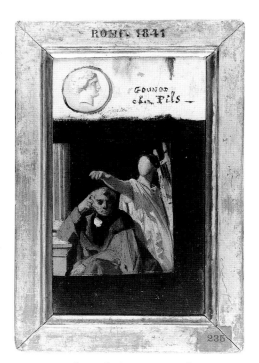

Fig. 225. Isidore Pils (1823–1875), after Ingres. *Allegorical Portrait of Cherubini*, 1841. Oil on canvas, 76¾ × 45¼ in. (195 × 115 cm). Private collection

been more successful in reproducing men's faces, [which are] less morbid, less reworked, and [have] a less fleeting expression than women's faces." The portraits of Bertin and Cherubini, they added, "would be two handsome portraits if the liveliness of the flesh were not frozen by this deplorable porcelain-like painting, hostile to all animating color."[27]

Ingres immodestly confided to his friend Jean-François Gilibert, "You should know that everyone who cares about art is talking about my portrait of *Cherubini and the Muse*. It seems that it will not cede ground to any other work."[28] Later in the year he reported on the enthusiasm of King Louis-Philippe: "The king keeps honoring me with great distinctions, on every occasion. I presented my *Cherubini* to him at the Louvre; he praised it in very flattering terms in front of everyone."[29] The allegorical portrait was bought from Ingres by the state for 8,000 francs in August 1842 and deposited at the Musée de Luxembourg in Paris. Some scholars have suggested that the purchase was made in recognition of the patronage of the young duc d'Orléans, whose portrait Ingres had just completed (cat. no. 121).[30] *Cherubini and the Muse of Lyric Poetry*, then one of only two paintings by Ingres on display in a public museum, quickly became emblematic of Ingres's art. The rhetoric applied to Ingres in general was often appended to this painting in particular, as, for example, when Ingres was shown painting Cherubini in a satirical cartoon published in *Le Charivari* in May 1842 entitled "Ingres or Raphael II" (fig. 338). Little about the portrait of Cherubini would today strike the viewer as Raphael-esque, yet, when Baudelaire discussed Ingres's portraits in 1846, he evaluated the work in comparison to Raphael: "In a certain sense, M. Ingres draws better than Raphael, the popular king of the draftsmen."[31] In his display at the Exposition Universelle of 1855, Ingres gave the allegorical portrait a place of honor at the center of a wall and had it hung as a pendant to the portrait of M. Bertin (see fig. 301).

The composer Ingres depicted was widely considered the most important musician alive, though he was not particularly

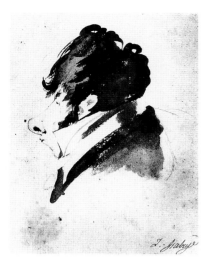

Fig. 226. Jean-Baptiste Isabey (1767–1855). Caricature of Cherubini, ca. 1810. Location unknown

the most popular. Largely ignored today, in the 1830s he was thought to be a living link to the great geniuses of the previous generation, Mozart and Beethoven. Ingres, who was himself a talented musician, wrote to a friend in 1830, "Imagine my happiness: I have never been more delirious than for the divine music of Mozart, Cherubini, Gluck, Haydn. One could say that these masterpieces become ever younger and redouble in their beauty."[32] In France, Cherubini ceded supremacy only to Mozart, with whom he was often compared; in 1817 Beethoven called him the greatest living composer. A Florentine, he moved in 1784 to London, then in 1788 to Paris, where he quickly rose to prominence. At the turn of the century he found commercial success with his work for the theater, conducting and writing operas, most notably *Medée* (1797) and *Les Deux Journées* (1800). Napoleon, however, particularly disliked his music, complaining that it was too complicated. (Indeed, Cherubini's mature music could be characterized as similar to that of Beethoven but somewhat noisier, with much more percussion and shorter melodic lines.) As a result, Cherubini did not win official recognition in France until after the Bourbon Restoration. He was made director of the Conservatoire National Supérieur de Musique in 1822 and retained the post until one month before his death in 1842, enjoying many commissions from the

crown and the church. Despite his success, he was, according to one who knew him,

extremely highly-strung, abrupt, irritable, completely independent, his first reactions were nearly always unfavourable. He quickly regained his natural disposition, which was excellent, and which he tried to conceal under the most forbidding exterior. So, despite his unevenness of temper (some maintained that his temper was very even, because he was always angry), he was worshipped by those who were close to him. The veneration of his pupils approached fanaticism.[33]

In 1841 Cherubini was made a commander in the Legion of Honor, the first musician ever to be given that accolade.

Cherubini's features were not well known, and Ingres's portrait immediately superseded the generic lithographic portraits of the composer. It was reproduced ad infinitum, preserving an austere image of the elderly composer that was far from that of the young musician found in an informal caricature by Jean-Baptiste Isabey (fig. 226). The renowned composer was in many ways the musical equivalent of Ingres, and Ingres's picture can easily be viewed as a kind of self-portrait by projection. As Théophile Silvestre wrote, "These two artists, two sour egos, understand each other perfectly."[34] An Italian who made his career in Paris, Cherubini was always a foreigner there—as was Ingres, who never lost his strong southern accent and poor spelling. Both were strong-willed and irritable. Both clung stubbornly to what they perceived to be the classical tradition, despite the shift of taste toward Romanticism. Both climbed the ladder of arts administration in France, reaching the highest rungs, showered with honors, yet criticized by insolent critics and young artists who considered their work outdated.

It is not known when Ingres met Cherubini, but they may have been introduced by their friend in common, Bartolini, whose bust of the composer (fig. 222) was consulted by Ingres in Rome. Cherubini, a talented amateur, studied painting in Paris in the 1820s, and one of his biographers has suggested that he took instruction from Ingres,[35] an unlikely possibility that cannot be verified. The two seem to have

been acquainted by 1826, when Cherubini's *Coronation Mass* was sung at the cathedral of Montauban to celebrate the installation of Ingres's altarpiece, *The Vow of Louis XIII* (fig. 146). Three years later, Cherubini sent Ingres tickets for an Easter performance of the same mass.[36] In his article of 1841 Halévy suggested that the composer and the painter had known each other for years by the time Ingres began his portrait in 1834: "For a long time a reciprocal friendship and admiration united these two great artists." He also recorded that the completed portrait ultimately gave great pleasure to Cherubini: "In what more touching fashion could Cherubini bear witness to his gratitude to the painter who is going to transmit to posterity a faithful and poetic image of his appearance, his physignomy, than to allow him to hear a choice of the most beautiful passages of the quartets written in his [Ingres's] absence?" Thus, Cherubini arranged for the private concert, which was evidently a highly emotional event:

Finally, what cannot be described, and what imparted to this intimate celebration something sublime and religious, was the manifestation of the general feeling that could be seen in each eye, each face. Seeing the venerable and noble figure of Cherubini listening to his work, and the enthusiasm of his friend, savoring the infinite pleasure that comes from such high inspiration and perfect execution, one could experience a redoubling of passion and respect for art.[37]

There can be no doubt about Ingres's reverence for the composer. He once bragged in a letter to a friend, "The great Cherubini just wrote me a letter so good and so honorable that my feelings have been excited to the utmost; because, imagine if a Mozart were writing to you!"[38] He also signed a lithographic reproduction of the allegorical portrait with the words "Notre grand maître, et à ma gloire, mon illustre ami" ("Our great master, and to my glory, my illustrious friend"). Finally, although the painter could not have known it in 1841, his second wife, Delphine Ramel, whom he would marry in 1852, would be a cousin of the wife of Cherubini's son Salvador.

Fig. 227. Robert Bingham (1825–1870). The composer Fromental Halévy (1799–1862) admiring the portrait of Cherubini by Ingres. Photograph, ca. 1860. Cabinet des Estampes et de la Photographie, Bibliothèque Nationale de France, Paris

Some twenty years after Cherubini's death, Halévy had himself portrayed by the photographer Robert J. Bingham as he stood admiring the portrait, now in Cincinnati but then in the possession of Cherubini's family (fig. 227). At some point later in the century, the family sold the portrait, and it was ultimately acquired by Louisine and H. O. Havemeyer, the New York collectors who assembled the greatest collection of French paintings in the United States. Although most of their collection was purchased through the Durand-Ruel gallery, this work was not; no account of the transaction can be found. For reasons unknown, Mrs. Havemeyer consigned it for sale in 1909. After passing through several galleries, it was acquired by the Ohio collector Mrs. Thomas J. Emery, who bequeathed it to the Cincinnati Art Museum in 1927. G. T.

1. See Bertin 1998 and Halévy 1841.
2. Notebook X, reproduced in Vigne 1995b, p. 328.
3. Halévy 1841, reprinted in Naef 1977–80, vol. 3 (1979), pp. 63–64.

4. "Je suis glorieux que vos pinceaux s'occupent du vieux Cherubini." Quoted in Bertin 1998, p. 25, LR.34.
5. In a note dated December 26, 1836, Bartolini informed Ingres that a Mr. and Mrs. Gearningham would deliver the "mask" of Cherubini to the Villa Medici; quoted in ibid., p. 21, LR.12.
6. "Je vous prie de me mettre au pied du grand maître Chérubini avec tous les sentiments de l'estime et adoration profonde que je professe pour lui mais entaché de la plus noire des négligences que je vais tenter de réparer si cela est possible." Quoted in Naef 1977–80, vol. 3 (1979), p. 228.
7. "le portrait de Cherubini assis devant une Muse qui, debout derrière lui, avance la main au-dessus de sa tête . . . il a fait une apothéose. La tête avait été peinte en France il y a cinq ans." Reprinted in Guiffrey 1880–81, pp. 356–57.
8. See Toussaint and Couëssin 1985, the technical report on the Louvre painting.
9. Ibid., pp. 202, 204.
10. "J'apporterai avec moi à Paris le portrait terminé de Cherubini, sur lequel je fonde l'espoir de réussir." Quoted in Delaborde 1870, p. 248.
11. See Flandrin 1911, p. 151.
12. Catalogued in Bertin 1998, p. 25, LR.35. Bertin calls it "an intimate letter relative to the portrait that Ingres was in the process of completing" ("Lettre intime relative à son portrait qu'Ingres était en train de terminer"). He also notes a letter to Cherubini's widow discussing Pierre Sudre's lithograph of the portrait, as well as another, dated April 29, 1848, to Cherubini's son.
13. "Je travaille aussi pour M. Ingres, ce qu'il ne faut pas dire puisqu'il a l'intention de faire passer pour de lui ce qui je lui fais, bien entendu en y retouchant"; quoted in Paris 1983, p. 26. Lehmann referred again to his work for Ingres in a letter of December 16, 1840: "M. Ingres begged me to help him. I had to choose between not exhibiting or refusing a favor to my old master and not fulfilling an obligation that piety imposed upon me and that, besides, could be very useful for my own art. I thus agreed, and I am giving him all the time he wants while subordinating my own work to his needs. I will not tell you what I am doing for him, because he demanded the most absolute discretion on the subject. All you need to know is that he even trusts me with the most important things, and that he is very happy." ("M. Ingres me pria de l'aider. Il fallait opter entre ne pas exposer ou refuser un service à mon vieux maître et ne pas remplir un devoir que la piété m'imposait et qui, d'ailleurs, pouvait m'être de la plus grande utilité sous le rapport de l'art. J'ai donc promis, et je lui donne tout le temps qu'il veut en subordonnant

mon propre travail à ses besoins. Je ne vous dirai pas ce que je fais pour lui, puisqu'il m'a demandé la plus absolue discrétion à ce sujet. Il vous suffira de savoir qu'il me confie jusqu'aux choses les plus importantes et qu'il est très content.") Quoted in ibid., p. 26.
14. "Les mains de Cherubini, en l'absence du modèle, furent peintes par Lehmann d'après celle de Gounod, alors pensionnaire de l'Académie de France à Rome." Blanc 1870, p. 130.
15. Toussaint and Couëssin 1985; see also p. 534 in this catalogue.
16. Notebook X, illustrated in Vigne 1995b, p. 328.
17. According to Toussaint, Ingres was asked to execute the bust-length copy in 1843 and declined, handing the commission instead to Flandrin; Toussaint in Paris 1985, p. 83.
18. Quoted in Paris, New York 1994–95, p. 71.
19. Halévy 1841, reprinted in Naef 1977–80, vol. 3 (1979), pp. 63–64.
20. Charles Blanc, evidently ignorant of Halévy's article, described the encounter somewhat differently in his article of 1868. He reported that the composer responded "with a maddening calm and maintaining a silence that overwhelmed M^me Ingres" ("avec une tranquilité désespérante et en gardant un silence dont M^me Ingres fut accablée"). Blanc 1867–68, pt. 6 (1868), p. 350.
21. Deane 1965, p. 51.
22. The musical manuscript is at the Musée Ingres, Montauban; it is published in Blanc 1870, pp. 132–33.
23. Blanc 1867–68, pt. 6 (1868), pp. 350–51.
24. "La tête de ce musicien éminent est peut-être le plus beau portrait sorti du pinceau de M. Ingres. On voit qu'il s'est plu à reproduire le froncement homérique de ces sourcils, ce front où Lavater eût reconnu les trois plis verticaux, signe certain d'un noble caractère. Il n'a pas craint de mettre en pleine lumière, sans en rien dissimuler, cette veillesse au repos, à laquelle il a donné un aspect auguste. Ainsi qu'il l'avait déjà fait dans les portraits de M. Bertin et M. le comte de Molé, il a tiré un parti merveilleux des étoffes rudes et cassantes dont se compose le costume moderne. Il est parvenu, en restant simple et même bourgeois comme il convenait, à donner au drap du manteau de larges plis, une ampleur presque romaine. Il a enfin résolu un des grands problèmes de l'art: ennoblir la vulgarité en la reproduisant avec exactitude." Stern, January 7, 1842, reprinted in Naef 1977–80, vol. 3 (1979), p. 398.
Ingres's elaborate portrait drawing of Marie d'Agoult and her daughter (cat. no. 152) was perhaps made in appreciation for this article. Éric Bertin has kindly brought to my attention several articles in the gossipy journal L'Artiste that criticize d'Agoult for speaking of the painting against

Ingres's wishes (January 30, 1842). But in an unpublished letter of February 4, 1842, to *L'Artiste*, the artist expressed his admiration for d'Agoult's article.

25. "Le Portrait de Cherubini nous semble le suprême effort du talent de M. Ingres. La tête de l'illustre compositeur est empreinte du plus haut caractère. . . . On a dit avec justesse qu'il avait l'air d'écouter quelque harmonie au dedans de lui-même." Thoré 1842, p. 801.

26. "un sentiment profond de tristesse est empreint dans cette apothéose anticipée d'un grand génie. . . . Dans la figure de Cherubini, M. Ingres n'a dissimulé ni l'âge ni la faiblesse; le costume est d'une simplicité qui va jusqu'à la vérité naïve." Lenormant 1842, p. 313.

27. "M. Ingres a mieux réussi à reproduire la face de l'homme, moins morbide, moins renouvelée et d'une expression moins fugace que la face de la femme. . . . [Cherubini et Bertin] seraient deux beaux portraits, si la vie de la chair n'y était glacée par cette déplorable peinture porcelainée, hostile à toute coloration animante." Goncourt 1893, pp. 191–92.

28. "Tu sauras que mon portrait de *Cherubini et la Muse* occupe tous les esprits curieux d'art. Il paraît que cet ouvrage ne le cède pas aux autres." Ingres to Gilibert, February 19, 1842, in Boyer d'Agen 1909, p. 307.

29. "Le roi ne cesse de m'honorer de grandes distinctions, en toute occasion. . . . Je lui ai présenté mon *Cherubini* au Louvre; il l'a loué au termes très flatteurs devant tous ceux qui l'accompagnaient." Ingres to Gilibert, October 30, 1842, in Boyer d'Agen 1909, p. 353 and Ternois 1986b, p. 194.

30. Pierre Angrand states that the painting was acquired by the king through the civil list on August 15, 1842—hence after the death of the duc d'Orléans—for Louis-Philippe's museum of French history at Versailles; Angrand 1967, p. 199. However, Toussaint inexplicably gives the date of acquisition as June 1842; Paris 1985, p. 80.

31. "Dans un certain sens, M. Ingres dessine mieux que Raphaël, le roi populaire des dessinateurs." "De quelques dessinateurs," in "Salon de 1846," reprinted in Baudelaire 1975–76, vol. 2, p. 459.

32. "Jugez de mon bonheur: je ne me dérange plus que pour la divine musique de Mozart, Cherubini, Glück, Haydn. On dirait que ces chefs-d'oeuvre rajeunissent et redoublent de beauté." Ingres to Prosper Debia, February 5, 1830, in Boyer d'Agen 1909, p. 217.

33. Adam 1859, as translated in Deane 1965, p. 50.

34. "Ces deux artistes, deux vanités aigres, se comprenaient parfaitement." Silvestre in Bruyas 1876, p. 499, quoted in Paris 1985, p. 79.

35. Deane 1965, p. 51.

36. Madame Ingres bragged to Gilibert: "If you were not so happy at the moment, you would be jealous." ("Si vous n'étiez aussi heureux que vous l'êtes dans ce moment, cela vous ferait envie.") Madame Ingres to Gilibert, April 18, 1829, in Boyer d'Agen 1909, p. 210.

37. "Depuis longtemps une admiration et une amitié réciproques unissaient les deux grands artistes. . . . De quelle façon plus touchante Cherubini pouvait-il témoigner sa reconnaissance au peintre qui va transmettre à la postérité une image fidèle et poétique de ses traits, de sa physionomie, qu'en lui faisant entendre un choix des plus beaux morceaux pris dans les quatuors écrits durant son absence? . . . Enfin, ce qui ne peut se décrire, et ce qui imprimait à cette fête intime quelque chose de sublime, de religieux, c'était la manifestation du sentiment général qui se lisait dans tous les yeux, sur tous les visages. En voyant la vénérable et noble figure de Cherubini écoutant son oeuvre, et l'enthousiasme de son ami, en savourant la jouissance infinie que procurent une inspiration si haute, une exécution si parfaite, on éprouvait un redoublement de passion et de respect pour l'art." Halévy 1841, reprinted in Naef 1977–80, vol. 3 (1979), pp. 63–64.

38. "Le grand Chérubini vient de m'adresser une lettre si bonne et si honorable, qu'elle a excité au dernier point ma sensibilité: car figurez-vous qu'un Mozart vous écrit!" Quoted without name of recipient or date in Delaborde 1870, p. 293.

Cat. no. 119. *Maria Luigi Carlo Zenobia Salvatore Cherubini*

PROVENANCE: Presumably given by the artist to the sitter in 1841; presumably bequeathed to his son Salvador in 1842; his widow, Mme Cherubini, Paris; acquired at an unknown date (probably between 1894 and 1906) by Mr. and Mrs. H. O. Havemeyer, New York; consigned by Mrs. Havemeyer for sale at Durand-Ruel et Cie., Paris, March 10, 1909–May 11, 1910; sold by them to Galerie Barbazanges, Paris, May 11, 1910; sold to M. Knoedler & Co., New York, May 15, 1922; sold to Mrs. Thomas J. (Mary M.) Emery, March 1923; her bequest to the Cincinnati Art Museum, 1927

EXHIBITIONS: Paris 1883, no. 141 [EB]; Springfield, New York 1939–40, no. 19; Cincinnati 1940; Rochester 1940; New York 1940a, no. 237; Cincinnati 1941, no. 43; Detroit 1950a, no. 22; Toledo 1954, no. 10a; Columbus 1956, no. 19; New York 1961, no. 49; Cleveland 1963, no. 78; Louisville, Fort Worth 1983–84, no. 61

REFERENCES: Blanc 1870, p. 130; Delaborde 1870, under no. 114; Lapauze 1911a, p. 370, ill. p. 385; Hourticq 1928, p. 87; Zabel 1929, p. 108; Siple 1930, pp. 35, 39–41, ill. p. 34; Frankfurter 1931, p. 4, ill.; Roos 1937, p. 210, ill.; Pach 1939, p. 95, ill. opp. p. 190; New York, Manchester, Detroit, Cincinnati, Cleveland, San Francisco 1952–53, under no. 36; Wildenstein 1954, no. 235, fig. 147; Cincinnati Art Museum 1956, p. 59, ill. p. 61; Ternois 1959a, preceding no. 27; Anon., April 7, 1961, ill. p. 70; Radius and Camesasca 1968, no. 132b, ill.; Young 1971, p. 302, fig. 4; Naef 1977–80, vol. 3 (1979), p. 289; Rogers 1980, p. 64, ill. p. 65; Ternois 1980, no. 256, ill.; Cincinnati Art Museum 1984, p. 118, ill.; Paris 1985, no. XIV 1, ill.; Zanni 1990, no. 89, ill; New York 1993, no. 331, ill.; Vigne 1995b, pp. 234, 328

Cat. no. 120. *Study for "Luigi Cherubini" (Head)*

ca. 1833–34
Black chalk with white highlights
10 1/4 × 8 1/4 in. (26 × 21 cm)
Inscribed across bottom: Souvenir d'amitié à Monsieur Thomas Ingres del. 1835 [Token of friendship for Monsieur Thomas(.) Ingres drew (this) 1835]
Inscribed top center: Cherubini
Other inscriptions on the sheet have been partially erased
Conservatoire National Supérieur de Musique, Paris CNSPM 1
New York and Washington only

PROVENANCE: The artist's gift to Ambroise Thomas (1811–1896); his widow; her bequest to the Conservatoire National Supérieur de Musique, Paris, 1911

EXHIBITIONS: Paris 1985, no. XIV 2, ill.; Tübingen, Brussels 1986, no. 45; Paris 1988, no. 272

REFERENCES: Delaborde 1870, no. 271; Rome 1968, p. 166; Paris, Lyons 1984–85, under no. 89

121, 122. Ferdinand-Philippe-Louis-Charles-Henri, Duc d'Orléans

Thanks to the prestige of the sitter, a dashing young prince who was heir to the throne of France, a great deal is known about the commission and execution of this portrait. Although the painting met with immediate success upon its exhibition in Ingres's studio in early 1842, the accidental death of the duke in July of that year, two months after the canvas was delivered, elevated the likeness into a veritable relic, of which dozens of copies were made, first by Ingres (cat. no. 122, fig. 228), then by his students, and later by any number of artists.

Ingres's first encounter with Ferdinand-Philippe came in 1833, when, on the eve of the painter's departure for Rome, the twenty-three-year-old prince and his wife, Helene, grand duchess of Mecklenburg-Schwerin, commissioned *Antiochus and Stratonice* (fig. 194) from him. Six years passed before Ingres completed the painting, but the duke was ecstatic with the result once it arrived in Paris in May 1840. (Ferdinand-Philippe had in the meantime arranged, in 1839, to buy Ingres's *Oedipus and the Sphinx* [fig. 82]). Ingres, still in Rome, nervously awaited word of the duke's reaction, and the good news was first communicated to him by his friend the painter Édouard Gatteaux, who had made all the arrangements for delivering the painting to Paris. The duke later wrote personally to the artist "to express my admiration for a work so complete, and my joy to have before my eyes a picture of which the French school will be so justly proud."[1] Ferdinand-Philippe had also resolved to commission his portrait. This was bad news for Ingres: his anxiety over *Stratonice* so recently put to rest, he immediately began to complain about the new obligation. "Between us . . . despite all the honor I feel over the prince's desire to be painted by no one other than myself, it is still a matter of doing another portrait! You know how far removed I am at present from this genre of painting; but in the end I will do everything for his gracious person."[2]

Ingres returned to Paris in May 1841 to find himself inundated with requests for portraits. In October he wrote to his friend Jean-François Gilibert:

> Since I painted the portraits of Bertin and de Molé, everyone wants one. There are six that I have refused or evaded, because I cannot stand them anymore. And it is not to paint portraits that I returned to Paris. I must paint at Dampierre and the Chambre des Pairs [Throne Room at the Palais du Luxembourg]. However, I had to agree to paint the duc d'Orléans, this prince, my kind patron, to whom I could never refuse anything. I cannot tell you how the king and all the royal family have honored me. If you could come close to them and know them, you would adore them.[3]

The *Journal des artistes* reported on November 21, 1841, that Ingres had begun work. By December, Ingres could report, "I have already had seven sessions with the duc d'Orléans; he is charming."[4] Indeed, the duke was known for his charm, his fine classical education, his knowledge of the arts, and his liberal political views.

Preparatory drawings at the Musée Ingres and elsewhere show that Ingres quickly seized the essence of the portrait.[5] The duke, who had distinguished himself in military campaigns in Flanders and in North Africa, would be dressed in the uniform of an army lieutenant general, wearing his decorations and sword and holding his bicorne, yet he would be shown in a civilian setting, standing in his salon at the Palais des Tuileries. He would thus appear rather like the handsome military hero Eugène Lami had depicted in a portrait of 1832 (fig. 229). As usual, Ingres found fault with a detail of the sitter's costume and asked the duke to replace his brass buttons with fabric ones. "That, Monsieur Ingres, is absolutely impossible," replied the duke, who later laughed at the artist's ignorance of military regulations.[6] Initially Ingres explored a relaxed pose in which the duke dangled his hat at his side (figs. 230, 231); in 1843 Franz Xaver

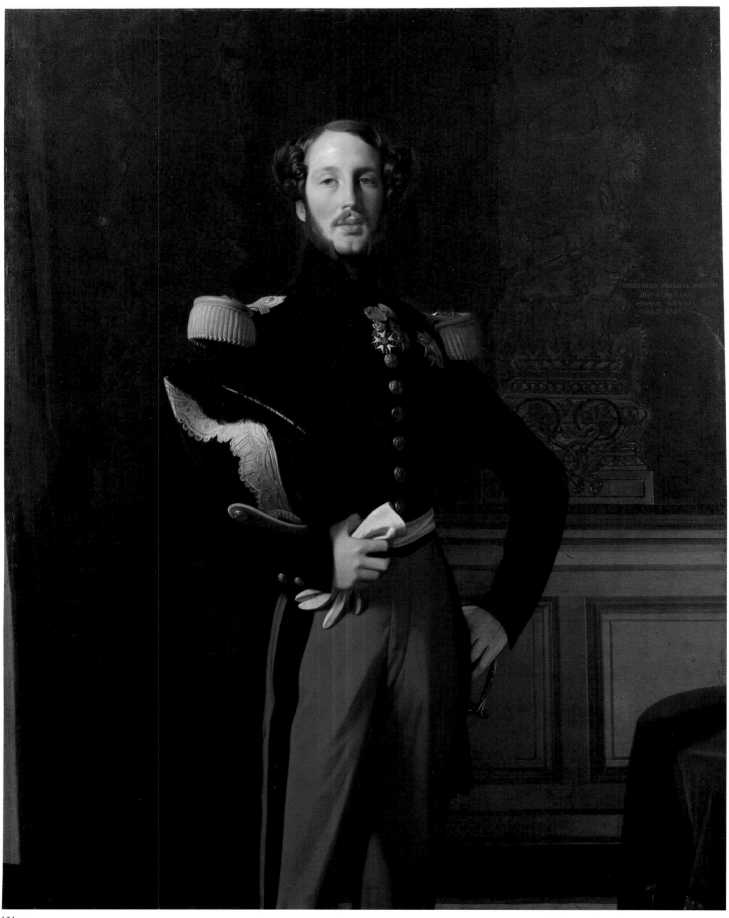

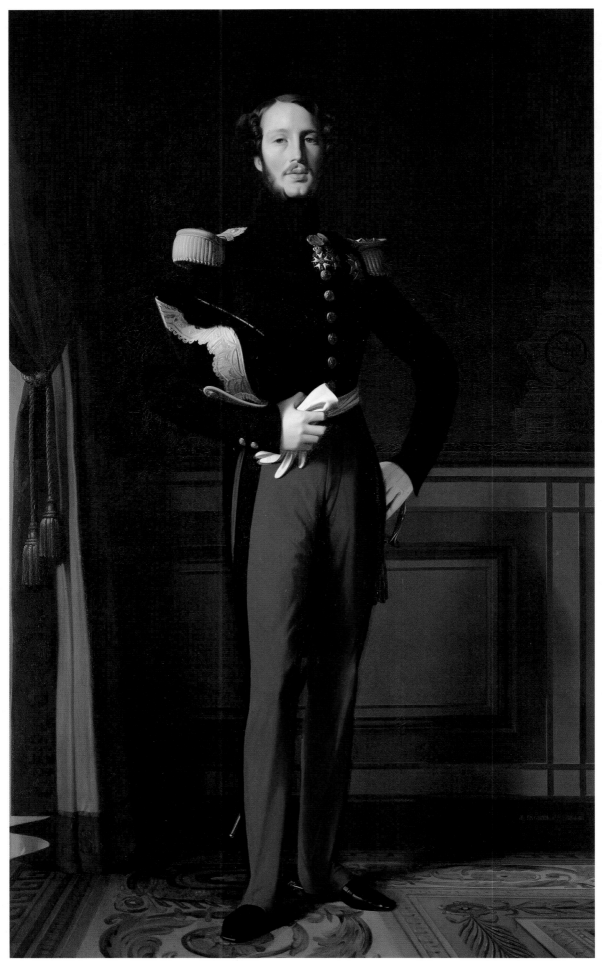

Fig. 228. *Ferdinand-Philippe, Duc d'Orléans*, 1843 (W 242). Oil on canvas, 61 3/8 × 47 1/4 in. (156 × 120 cm). Musée National du Château, Versailles

Fig. 229. Dupont, after Eugène Lami (1800–1890). *Duc d'Orléans*, 1832. Engraving. Cabinet des Estampes et de la Photographie, Bibliothèque Nationale de France, Paris

Winterhalter was to adopt a similar stance for his portrait of the duke (fig. 233). Ingres soon recognized, however, that by resting the hat in the crook of the duke's arm, he could give the young officer a regal air (fig. 232). The definitive pose was in fact closely modeled on that of Ingres's portrait of the comte de Pastoret (cat. no. 98)[7]: the right hand is brought to the waist, the left to the sword at the hip, with the elbow akimbo. In both pictures the figure is bisected by the arrangement of the background, with painted dado below and upholstered silk above. The differences between the two works, however, are even more telling than their similarities. Although Pastoret's direct gaze (and legs cropped at the upper thigh) bring him closer to the picture plane and hence make him more accessible to the viewer, his left shoulder acts as an impediment to our access, producing a sense of hauteur; in contrast, the open alignment of the duke's shoulders and hips creates accessibility for us, his subjects, while his dreamy gaze (and legs cropped just above the knees) provides the inviolable distance requisite to a royal personage.

Ingres subtly underscored Ferdinand-Philippe's royal stature with other details. The table draped with velvet is empty but ready to assume the regalia of the realm.[8]

(Despite France's tumultuous history during the previous fifty years, in 1841 it was widely assumed that the duke would accede to his father's throne.) More fascinating is the message conveyed by the silk wall hangings. Only intimates of the court would have recognized the antique crimson silk, woven with gold and silver threads, that the duke had selected from the reserves of the royal *garde-meuble* (storerooms) to be installed in his salon on the ground floor of the Pavillon de Marsan at the Palais des Tuileries (until 1830 the salon of his cousin the duchesse de Berry). The silks had been woven in Lyons, and some thirty panels of the fabric were delivered to Versailles on April 24, 1692, for presentation to Louis XIV. In 1705 and again in 1723 six panels were installed in the bed alcove of the *chambre du roi*, the epicenter of the suite of royal apartments created for the Sun King at Versailles. Thirteen panels remained unused, miraculously escaping sale or destruction during the Revolution. When Ferdinand-Philippe selected them in 1832 to refurbish his new quarters, he must have been conscious of their association with Louis XIV. He could not have been ignorant of their beauty; in a 1796 inventory they were called "truly masterpieces of the art" ("vraiment des chefs-d'oeuvre de l'art"). For the same

room he chose other superlative examples of French decorative arts, all with royal provenance—from Louis XV's famous "bureau à cylindre" (now at Versailles) to the Fontanieu table (now at the Petit Trianon). To reproduce the pattern of the silks accurately, Ingres had an assistant prepare a drawing that was squared for transfer.[9] The panels were destroyed during the burning of the Tuileries in 1870, but when new hangings were woven for the *chambre du roi* at Versailles a century later, Ingres's portrait was consulted as documentary evidence.[10]

The actual painting of the canvas must have proceeded quickly, because Ingres displayed it in his studio in the spring of 1842 alongside the allegorical portrait of Cherubini (fig. 221) and *The Virgin with the Host* (fig. 200). The reaction of the paying public and press was largely enthusiastic and fell along predictable lines. Those already in Ingres's camp admired it; those who were not found reason to fault it. The republican Théophile Thoré, hostile to the royal family and to the artist, called the figure of the duke "effeminate" and mocked his elongated chin, "soft gaze," and "beautiful soft blond hair, curled with care and apparently coming from the fingers of a capable coiffeur."[11] On the other hand, the comtesse d'Armaillé praised Ingres's duke as "tall, well built, elegantly and nobly turned out, his face long and nicely colored, with an agreeable and distinguished physiognomy," while Madame d'Agoult found in his blond hair and blue eyes "the air of a young English gentleman rather than that of a French prince."[12]

Charles Lenormant, a conservative critic and an enthusiastic supporter of Ingres, wrote an extravagant elegy in *L'Artiste*:

> Public ceremonies are becoming more and more rare: the man of our time is lost in borrowed pomp. M. Ingres preferred to show us Msgr. the duc d'Orléans in his everyday life and in the serious exercise of his profession, dressed in the uniform of a lieutenant general. . . . All the nuances of the moral conception of the portrait are supported and nourished by an imitation of nature that is faithful and full of charm. Never has unity of complexion been better captured; never has the brush

reproduced with more intelligence and suppleness the delicacy of forms and the purity of lines; the modeling of the forehead surpasses everything.

In the careers of artists there comes a day of blossoming when the whole talent flowers. Seeing the portrait of Msgr. the duc d'Orléans, everyone will say that M. Ingres is flourishing again. He was never more capable or sure of himself, never more youthful. Only the sight of it will convey the idea of the spontaneity, of the confidence that reigns in this work. Everything in it is conducted with a harmony, an equilibrium of means, of which there is no comparison. The distribution of light and shade joins a rigorous observation to an incomparable suavity, and the total effect arrives at that degree of magic in which the observer loses track of the methods employed by the painter. I do not know of a work in which the enamel, the metals, and the ribbons have greater merit and splendor.[13]

Almost every critic, whether positive or negative, commented on the verisimilitude of the details in the portrait. Ingres's skill in reproducing textures, especially near the foreground of his pictures, is almost hypnotic. It invites minute observation. Hélène Toussaint, for example, recently noticed that the duke's Legion of Honor medal is turned to show the crossed flags on the verso rather than the profile of Henry IV on the recto. She interpreted this detail as a statement of the duke's liberal (that is, democratic rather than autocratic) leanings.[14] In 1868, once Ingres was dead, Charles Blanc permitted himself to comment on the artful anatomical distortion of the figure—"the arm seems to be detached at the deltoids"—and on "something heavy in the flesh tones," but he could not fail to pay homage to the execution of the "marvelously rendered accessories. No Realist could render more palpable the embroideries of the uniform, the enamel of the sword, the regulation gloves, the green gold of the epaulettes, the red gold of the braid."[15]

Nevertheless, this likeness stands with that of Cherubini (cat. no. 119) at the beginning of a trend in which Ingres dissociates his portrait figures from their backgrounds by heightening surface detail while abandoning a strong sense of surrounding atmosphere. For the remainder of his career, the architecture and accessories seen in the backgrounds of his portraits would be depicted in the flat, consistent light of an architect's rendering. Given that Ingres would rely more and more on his assistants to paint the backgrounds and accessories in his pictures,[16] his decision to abandon the atmosphere expressed in some of his earlier portraits seems to reflect an expedience of collaborative studio work. Yet simple souls continued to be amazed by Ingres's work. In 1843 an account was published of a little girl who remarked, upon seeing the portrait of the duke on exhibition in the artist's studio, "But how, mama, could that handsome soldier be a painting?" Ingres turned to the child, kissed her on the forehead, and said, "What a good little girl."[17]

Ingres notified the duke's secretary that the portrait was ready on April 17, 1842,[18] and delivered it to the Tuileries on May 6, 1842. That same day, the secretary wrote to the painter "to say how much he [the duke] congratulates himself on having his portrait from your hand. It will be not only a precious family monument but a work of art of national importance, which His Royal Highness will always regard with pleasure, even when the years will have altered the resemblance."[19] Sadly, those years were cut short: on July 13, 1842, Ferdinand-Philippe was killed in an accident. While he was traveling in an open carriage from Paris to Neuilly, his horses became frightened and bolted; as the carriage overturned, the duke jumped out. He died of a broken skull. An enormously popular celebrity, the duc d'Orléans in death prompted manifestations of public grief that sound today strikingly similar to those surrounding the death of Diana, princess of Wales, in 1997. Ingres was disconsolate. He wrote Gilibert that

Fig. 230. *Study for "Duc d'Orléans,"* 1841. Graphite on paper, 8⅛ × 4¼ in. (20.8 × 10.7 cm). Musée Ingres, Montauban (867.358)

Fig. 231. *Study for "Duc d'Orléans"* (Pants and Right Hand), 1841. Graphite on paper, 10⅜ × 11 in. (26.2 × 27.9 cm). Musée Ingres, Montauban (867.361)

Fig. 232. *Study for "Duc d'Orléans" (Right Hand and Arm Holding Hat)*, 1841. Black chalk on paper, 5⅞ × 4⅜ in. (15 × 11 cm). École des Beaux-Arts, Paris

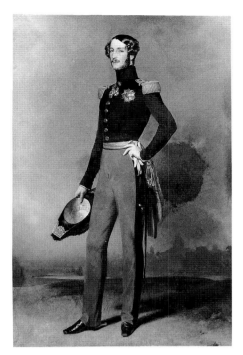

Fig. 233. Franz Xaver Winterhalter (1806–1873). *Ferdinand-Philippe, Duc d'Orléans*, 1843. Oil on canvas, 85⅞ × 55⅛ in. (218 × 140 cm). Musée National du Château, Versailles

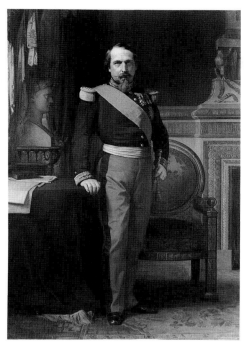

Fig. 234. Hippolyte Flandrin (1809–1864). *Napoleon III, Emperor of the French*, 1862. Oil on canvas, 83½ × 57⅞ in. (212 × 147 cm). Musée National du Château, Versailles

the death of my so very amiable prince has torn my heart, to the point that I cry continuously and remain inconsolable. Cherubini and Baillot [a violinist who often played music with Ingres; see cat. no. 107] have followed him, and many others as well. . . . This dear young man, a worthy prince who never did anything wrong, so good to me, so essential to the happiness of France! Oh, you should have seen this king, this father, sobbing on his throne, surrounded by his other children, and all of us, passing before him, bringing him all our deep sorrow. Neither Aeschylus nor Shakespeare ever drew a more terrible scene.[20]

In his grief, Ingres made some sketches for an allegory, never realized, on the death of the prince.[21]

Queen Marie-Amélie resolved to erect a funerary chapel on the site of the accident and to dedicate it exactly one year after her son's death; Ingres was asked to provide the designs for the stained-glass windows (see figs. 196–98). As the artist recounted to Gilibert:

I did not know that, after his portrait, I would have to deal with the tomb of this poor prince; but the queen is erecting on the fatal site a chapel to Saint Ferdinand,

and the king said to Messrs. de Montalivet and de Cailleux that it was M. Ingres who must make the designs for the stained-glass windows of this sad place, considering that the prince liked me and that I was the friend of his son. The deadline for this work was very short and you will judge by these words the zeal and feeling that I have brought to it. I have just finished it. In two months, I composed and executed twelve saints and patrons of the royal family, and three designs of theological Virtues, all lifesize.[22]

Given the critical success of Ingres's portrait, its convincing likeness, and the proximity of its date of delivery to the duc d'Orléans's death, it is not surprising that a number of copies were ordered. A full-length version was commissioned for the memorial chapel (cat. no. 122), and a three-quarters-length copy (fig. 228) was requested by the minister of the interior. Ingres explained to Gilibert, on December 10, 1842: "But I have lots of loose ends to tie up, a copy of the portrait of the Duke for the King and overseeing another for the Minister of the Interior (this one will serve [as a model] to give copies to the cities of the kingdom)."[23] Not much progress had been made by early

February, when he again wrote to Gilibert: "Between now and the first of June, when I will take possession of Dampierre, I still have to finish: 1st the copy of the portrait of the duc d'Orléans."[24] This manufacturing of replicas became a controversial enterprise. *L'Artiste* noted on February 26, 1843: "Several young artists, students of Monsieur Ingres, are at present busily making, under the direction of this skillful master, copies of the portrait of H. R. H. the duc d'Orléans. These copies are destined for the museums of the principal cities of our *départements* which desire to possess 'the likeness of the prince whom we have lost.'"[25] A week later the *Journal des artistes* complained that this program "was an unusual way to utilize public funds" and regretted that the French people would pay for works that Ingres did not make himself but had manufactured in his studio.[26]

The copy for the memorial chapel, commissioned from Ingres on July 25, 1842, and now at Versailles (cat. no. 122), presents the duke at full length, standing closer to the salon window than in the

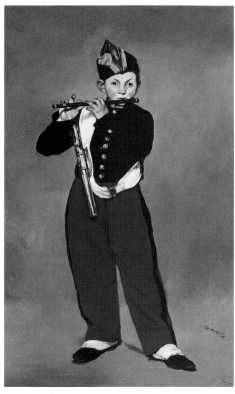

Fig. 235. Édouard Manet (1832–1883). *The Fifer*, 1866. Oil on canvas, 63⅜ × 38⅛ in. (161 × 97 cm). Musée d'Orsay, Paris

original, with slight differences apparent in the paneling as well. Tradition states that the queen considered the original three-quarters-length view bad luck and desired a full-length likeness for the chapel. Ingres made several drawings to study the position of the feet and the draping of the trousers for the copy,[27] but otherwise the figure is identical to the first from the knees up. Following custom, tracings were used to transfer the face and other details from the original canvas to the replica, no doubt with help from his assistants. The painting was delivered on April 3, 1844, and installed in the chapel of Notre-Dame de la Compassion–Saint-Ferdinand, where it remained until the Revolution of 1848. Ingres was paid 10,000 francs for it on July 23, 1844.

The second copy of the duke's portrait—the one commissioned by the minister of the interior—is considered by most scholars to be the painting that shows the duke in three-quarters length in a landscape setting (fig. 228). Ingres was paid 8,000 francs for this work. (Since the painting is dated 1843, it appears that it was delivered before the full-length variant, which is dated 1844 [cat. no. 122]). Most likely this is the painting that was to serve as the model for further replicas to be provided to museums throughout France; today there are copies of it in the museums at Limoges and Perpignan. As in Ingres's portrait of Cherubini, now at the Louvre (fig. 221), the head and shoulders of the figure are painted on a canvas that has been sewn onto a larger one. This suggests that Ingres painted, or at least retouched, the head and torso of the duke, and that this fragment was then inserted in a larger canvas and given a landscape. Auguste Pichon, a student whom Ingres had designated to make the copies ordered by provincial museums, is the author of the landscape in this work. (The park has not been satisfactorily identified; Toussaint has suggested that it represents the Château de Saint-Cloud.)[28] Ingres's letters mention that he was responsible for a total of five portraits of the duke,[29] but the list he made of his autograph works indicates only two copies, by general agreement those now at Versailles.[30]

A number of bust-length portraits were produced for various members of the royal family (now in London; Hartford, Connecticut; and Lyons), and these, with the two at Versailles, might be the five to which Ingres referred. Pierre Angrand has counted some nineteen variants.[31]

Despite the profusion of replicas, Ingres's effigy of the prince largely disappeared from public view after the fall of the Orléans regime in 1848. Nevertheless, in Hippolyte Flandrin's portrait of Napoleon III, exhibited at the Salon of 1863 (fig. 234), the sitter called upon similar imagery to assert his right to rule. Three years later Manet mocked both Flandrin and Ingres with his *Fifer* (fig. 235).

G.T.

1. "pour vous exprimer mon admiration pour une oeuvre aussi complète, et ma joie d'avoir sous les yeux un tableau dont l'École française s'enorgueillit à si juste titre." Duc d'Orléans to Ingres, September 25, 1840, in Boyer d'Agen 1909, p. 296; catalogued in Bertin 1998, p. 40, LR. 110. Bertin reproduces Henry Lapauze's note regarding several small errors in Boyer d'Agen's transcriptions.

2. "Entre nous . . . malgré tout l'honneur que je ressens de la volonté du prince de n'être peint que par moi, il faudra donc encore faire un portrait! Vous savez quel éloignement j'ai à présent pour ce genre de peinture; mais enfin je ferai tout pour son aimable personne." Ingres to Gatteaux, August 6, 1840, quoted in Delaborde 1870, pp. 258–59.

3. "Depuis que j'ai peint les portraits de Bertin et de Molé, tout le monde en veut. En voilà six que je refuse ou que j'élude, car je ne puis les souffrir. Eh! ce n'est pas pour peindre des portraits que je suis retourné à Paris. Je dois y peindre Dampierre et la Chambre des Pairs. Cependant, j'ai dû accepter de peindre le duc d'Orléans, ce prince, mon aimable Mécène, auquel je ne pourrai jamais rien refuser. Je ne puis t'exprimer, au reste, comme le roi et toute la famille royale m'ont honoré. Si tu pouvais les approcher et les connaître, tu les adorerais." Ingres to Gilibert, October 2, 1841, in Boyer d'Agen 1909, pp. 302–3.

4. "J'ai déjà eu sept séances du duc d'Orléans; il est charmant." December 21, 1841, quoted in Delaborde 1870, p. 259. Delaborde does not indicate the addressee.

5. A number of the drawings for this portrait were given by Ingres to Gatteaux. Although they were destroyed when his house burned in 1870, some had been photographed by Marville and were published in 1873 in an

album of 120 reproductions; Gatteaux 1873 (2nd ser.), no. 81.

6. "Pour cela, monsieur Ingres, c'est absolument impossible." Quoted in Amaury-Duval 1993, p. 103.

7. The resemblance does not appear to have been noted by previous writers.

8. The suggestion was made by Hélène Toussaint in Paris 1985, p. 106.

9. Musée Ingres, Montauban, inv. MIC 4 37 L.

10. This account was taken from Coural and Gastinel-Coural 1983, p. 58, and Gastinel-Coural 1990.

11. "efféminée"; "regard mou"; "beaux cheveux blond tendre bouclés avec soin et paraissant sortir des doigts d'un habile coiffeur." Thoré 1842, p. 802, quoted in Angrand 1967, p. 188, and Wildenstein 1956, p. 75.

12. "grand, bien fait, d'une tournure élégante et noble, sa figure longue et colorée, avec une physionomie agréable et distinguée"; "air d'un jeune gentleman plutôt que d'un prince français." Quoted in Wildenstein 1956, p. 76.

13. "Les cérémonies publiques deviennent de plus en plus rares: l'homme, de nos jours, se perd dans leur apparat d'emprunt: M. Ingres a mieux aimé nous faire voir Mgr le duc d'Orléans dans sa vie de chaque jour et dans l'exercice sérieux de sa profession, revêtu du petit uniforme de lieutenant général. . . . Toutes ces nuances de la conception morale du portrait sont soutenues et comme nourries par une imitation de la nature fidèle et pleine de charmes. Jamais l'unité de la carnation n'a été mieux saisie; jamais le pinceau n'a reproduit avec plus d'intelligence et de souplesse la délicatesse des formes et la pureté des traits; le modelé du front surpasse tout.

"Il y a dans la carrière des artistes un jour d'épanouissement où le talent fleurit tout entier. . . . En voyant le portrait de Mgr le duc d'Orléans, tout le monde dira que M. Ingres a refleuri. Jamais il n'a été plus habile et plus sûr de lui-même, jamais il ne s'est montré si jeune. Rien que la vue ne donnera une idée de la spontanéité, de la confiance qui règnent dans cet ouvrage. Tout y est conduit avec une harmonie, un équilibre de moyens dont le peintre n'a pas fourni un autre exemple. La distribution du jour et de l'ombre joint une précision rigoureuse à une incomparable suavité, et l'effet total arrive à ce degré de magie où l'observateur perd la trace des procédés employés par le peintre. Je ne connais pas un ouvrage dans lequel l'émail, les métaux et les rubans aient plus de valeur d'éclat." Lenormant 1842, pp. 314–15.

14. Toussaint in Paris 1985, pp. 105–6.

15. "le bras semble coupé au deltoïde"; dans le ton des chairs quelque chose de lourd"; "les accessoires, qui sont rendus à ravir. Aucun réaliste ne ferait mieux toucher au doigt les passementeries de l'uniforme, l'émail de

l'épée, les gants d'ordonnance, l'or vert des épaulettes, l'or rouge des galons." Blanc 1867–68, pt. 6 (1868), p. 351.

16. See p. 534–40 in this catalogue.

17. "'Comment, maman, est-ce que c'est de la peinture, ce beau soldat?' . . . 'Bonne petite fille.'" Damay 1843, quoted in Lapauze 1911a, p. 373.

18. Ingres to Boismilon, April 17, 1842, quoted in Bertin 1998, p. 19, under LR.2.

19. "de vous dire combien il se félicite d'avoir son portrait de votre main. Ce ne sera seulement un précieux monument de famille, mais une oeuvre d'art nationale sur laquelle Son Altesse Royale reportera toujours ses yeux avec plaisir, même lorsque ses années auront altéré sa ressemblance." Quoted in Lapauze 1911a, p. 372, and Bertin 1998, p. 19, LR.2.

20. "le meurtre de mon si aimable prince a déchiré mon coeur, à tel point que je le pleure continuellement et que je demeure inconsolable. Cherubini et Baillot l'ont suivi, et bien d'autres encore. . . . Ce cher jeune homme, digne prince à jamais regrettable, si bon pour moi, si essentiel au bonheur de la France! . . . Ah! il fallait voir ce roi, ce père, pleurant à chaudes larmes sur son trône, entouré de ses autres enfants; et nous tous, passant devant lui, lui apportant aussi notre vive douleur. Non, Eschyle ni Shakespeare n'ont tracé une plus terrible scène." Ingres to Gilibert, October 30, 1842, in Boyer d'Agen 1909, pp. 351–52, and Ternois 1986b, p. 194.

21. Musée Ingres, Montauban, inv. 867.2763.

22. "Je ne savais pas, après son portrait, devoir m'occuper de son tombeau, à ce pauvre prince; mais la reine a fait ériger sur le lieu fatal une chapelle à Saint Ferdinand, et le roi a dit à MM. de Montalivet et de Cailleux que c'était M. Ingres qui devait faire les cartons pour les vitraux de ce triste lieu, attendu que le prince m'aimait et que j'avais été l'ami de son fils. Le délai fut très court pour ce travail et tu juges, par ces paroles, du zèle et du sentiment que j'y ai apporté. Je viens de le finir. Dans deux mois, j'ai composé et exécuté douze saints et patrons de la famille royale, et trois cartons des vertus théologales, de grandeur naturelle." Ingres to Gilibert, October 30, 1842, in Boyer d'Agen 1909, p. 352, and Ternois 1986b, p. 194.

23. "Mais il me reste bien des queues à arracher . . . une copie du portrait du Duc pour le Roi et la surveillance d'une autre pour le Ministre de l'Intérieur, (celui-ci doit servir à donner des copies aux villes du royaume)." Ingres to Gilibert, December 10, 1842, in Boyer d'Agen 1909, p. 358.

24. "Que, d'ici au premier juin où j'irai prendre possession de Dampierre, j'ai encore à terminer: 1° le portrait copie du duc d'Orléans." Ingres to Gilibert, February 6, 1843, in ibid., p. 360.

25. "Plusieurs jeunes artistes, élèves de M. Ingres, sont en ce moment occupés à faire, sous la direction de cet habile maître, des copies du portrait de S.A.R. monseigneur le duc d'Orléans. Il paraît que ces copies sont destinées aux musées de quelques unes des principales villes de nos départements, qui ont désiré posséder les traits ressemblants du jeune prince que nous avons perdu." Anon. 1843a, p. 144. See also Anon., March 3, 1843, quoted in Wildenstein 1956, pp. 79–80.

26. "singulière manière d'utiliser les fonds publics," Anon., March 5, 1843, quoted in Wildenstein 1956, p. 80.

27. Musée du Louvre, Paris, R.F. 1104, and Musée Ingres, Montauban, inv. 867.362, for instance.

28. Toussaint in Paris 1985, p. 102.

29. "encore une copie (c'est la cinquième) en pied du Duc d'Orléans," Ingres to Gilibert, July 20, 1843, in Boyer d'Agen 1909, p. 363; "la cinquième copie du portrait du Duc d'Orléans," Ingres to Gilibert, December 30, 1843, in Boyer d'Agen 1909, p. 370. These letters suggest that Ingres had still not completed the full-length portrait, which in fact was not delivered until April 1844.

30. Notebook X, fol. 25; Vigne 1995b, p. 328.

31. Angrand 1967, p. 194.

Cat. no. 121. *Ferdinand-Philippe-Louis-Charles-Henri, Duc d'Orléans*

PROVENANCE: Commissioned by the duc d'Orléans (1810–1842) in 1840; accepted and paid for on May 7, 1842 (15,000 francs); passed to the sitter's widow, the duchesse d'Orléans (née Mecklenburg-Schwerin); sequestered in the Palais des Tuileries during the Revolution of 1848; restored to the duchess, December 15, 1848; by descent through the Orléans family to the present comte de Paris; sold by him to the present owner

EXHIBITIONS: The artist's studio, 1842; Paris 1874, no. 252 [EB]; Paris 1883, no. 135 [EB]; Paris 1908, no. 107 [EB]; Paris 1911, no. 44; Paris 1921, no. 37; Paris 1930a, nos. 284, 335 [EB]; London 1932, no. 355 [EB]; Venice 1934, room III, no. 15

(in the 2nd ed. of the exh. cat.) [EB]; Lisbon 1948 [EB]; Paris 1967–68, no. 199; Paris 1974–75, no. 534

REFERENCES: Lenormant 1842, pp. 314–15; Thoré 1842, p. 802; Damay 1843; Bellier de la Chavignerie 1867, p. 59; Blanc 1867–68, pt. 6 (1868), pp. 351–54; Delaborde 1870, no. 149; Boyer d'Agen 1909, pp. 300, 302–3; Lapauze 1911a, pp. 370–76, ill. p. 383; Fröhlich-Bum 1926, p. 29, pl. LII; Pach 1939, p. 135; Alazard 1950, pp. 99–100; Wildenstein 1954, no. 239, pl. 90; Schlenoff 1956, pp. 224–25; Ternois 1956, p. 176; Wildenstein 1956, pp. 75–79; Angrand 1967, pp. 185–89; Cambridge (Mass.) 1967, under no. 84, fig. 10; Radius and Camesasca 1968, no. 133a, ill., pls. XLIII, XLIV; Naef 1977–80, vol. 3 (1979), p. 317; Coural 1980, p. 58, n. 37; Ternois 1980, pp. 101, 132, no. 257, ill., p. 133; Coural and Gastinel-Coural 1983, p. 58; Louisville, Fort Worth 1983–84, p. 144; New York 1985–86, p. 112; Paris 1985, no. XVI 1, ill.; Gastinel-Coural 1990, pp. 25–27, ill.; Zanni 1990, no. 90, ill.; Amaury-Duval 1993, p. 103, fig. 73; Fleckner 1995, pp. 254–69, fig. 90; Vigne 1995b, pp. 238–41, fig. 192; Bertin 1998, p. 19

Cat. no. 122. *Ferdinand-Philippe-Louis-Charles-Henri, Duc d'Orléans*

PROVENANCE: Commissioned on July 25, 1843, for 10,000 francs; placed in a salon adjoining the chapel of Notre-Dame de la Compassion–Saint-Ferdinand, Neuilly, 1844; sheltered after the Revolution of 1848 in an unknown location; given to the Musée de Versailles before 1878

EXHIBITIONS: Chicago, Toledo, Los Angeles, San Francisco 1962–63, no. 56; Montauban 1967, no. 129; Washington 1983–84, no. 38; Paris 1985, no. XV

REFERENCES: Roujon n.d., ill.; Lapauze 1911a, p. 376; Pach 1939, ill. opp. p. 191; Wildenstein 1954, no. 245, fig. 150; Wildenstein 1956, p. 80, fig. 3; Angrand 1967, pp. 190–91, ill. opp. p. 192; Radius and Camesasca 1968, no. 133g, ill.; Ternois and Camesasca 1971, no. 134g; Ternois 1980, no. 262, ill.; Whiteley 1977, no. 55, ill.; Louisville, Frankfurt 1983–84, p. 144, ill. p. 145; Wollheim 1987, p. 269, fig. 262; Zanni 1990, no. 90; Barcelona 1993–94, ill. p. 146; Constans 1995, vol. 1, no. 2731, ill.; Fleckner 1995, pp. 264, 268, pl. VIII; Vigne 1995b, p. 246

123. Madame Clément Boulanger, née Marie-Élisabeth Blavot, later Madame Edmond Cavé

Early 1830s (?)
Oil on canvas
16 × 12⅞ in. (40.6 × 32.7 cm)
Signed and inscribed lower right: Ingres à Madame Cavé
The Metropolitan Museum of Art, New York
Bequest of Grace Rainey Rogers, 1943 43.85.3

W 247

In a century marked by a number of successful female artists—from Élisabeth Vigée-Lebrun to Rosa Bonheur, Berthe Morisot, and Mary Cassatt—Marie-Élisabeth Blavot, later Madame Clément Boulanger and Madame Edmond Cavé, stands out as probably the most influential in her time, yet the least known today. This apparent paradox is easily explained by the fact that her painting, unlike that of the other women just named, is easily forgotten. But as the author of *Le Dessin sans maître* (Drawing without a Teacher, 1850), a widely distributed textbook adopted in the curriculum of French public schools, and through several other instructional publications, ranging from a catechism to a book of beauty tips for women, Cavé had a far-reaching impact on French culture.[1] No less influential was her role as wife and adviser to Edmond Cavé, director of fine arts from 1839 to 1848 and superintendent of palaces and imperial factories from January 1852 until his sudden death on March 30 of that year. Following her marriage to Cavé in 1843,[2] artists as diverse as Ingres and Delacroix curried favor with her, understanding that it was she who recommended artistic policy and commissions for the last five years of the reign of Louis-Philippe.

Although it is not known precisely when Ingres made this exquisite *ébauche* (oil sketch), it was probably painted in the early 1830s. The artist must have encountered Marie-Élisabeth by 1831, when she married her cousin Clément Boulanger, with whom she had had a son, Albert, born in Rome the previous year.[3] Boulanger was a student of Ingres, while Marie-Élisabeth, who took the working name of Élisa Boulanger, studied with Camille Roqueplan. She was, in the words of her first biographer, André Joubin, "ravishing: big, laughing eyes, a mocking mouth, magnificent blond hair. She turned all heads."[4] Keenly aware of the power of her beauty, she allowed men, as Delacroix put it, "to *adore* her."[5] Delacroix himself was among the ones who did: they met at Alexandre Dumas's carnival ball in

1833 and, despite her marriage, he courted her. Remarkable letters survive in which he proclaims his "humble adoration for all that is you or near you" and calls her "belle Madame," while closing with "a thousand affectionate compliments" for her and "a thousand friendly greetings" for her husband, Clément.[6] One letter was coyly signed "Peintre en histoires" rather than the customary "Peintre d'histoire" (a "painter involved in a story" rather than a "history painter"). In 1838 they embarked on an amorous journey to Belgium and Holland, but the trip ended badly and the affair ended quickly.[7] At the height of their romance, Delacroix had given Élisa's sultry features to a figure of the Cumaean Sibyl (1838; Wildenstein & Co., New York) and to Cleopatra in his painting for the Salon of 1839, *Cleopatra and the Peasant* (Ackland Memorial Art Center, Chapel Hill, North Carolina).[8] There seems to have been no bitterness at the end of their romance; over the following decades both parties continued to help each other and to maintain an affectionate relationship. Delacroix executed a splendid pastel portrait of Élisa in 1846 (fig. 236) and presented her with a number of fine watercolors and small paintings.[9] She responded in kind: on New Year's Day in 1862, Delacroix wrote to thank her for a splendid dressing gown "so exquisite that I do not have the courage to say that I am not worthy to wear it."[10]

Élisa Boulanger first exhibited at the Salon of 1835. Two years later, she won a medal for her watercolors, and *L'Artiste* published a favorable review of her ingratiating genre scenes.

Among women artists, M^me E. Boulanger occupies one of the first places. Her graceful and fluent talent gives infinite charm to her small compositions. Above all, one must praise her for understanding very well the nature of her talent and taking on only those subjects of which the naive simplicity and delicate feelings can be rendered within the constraints of a watercolor.[11]

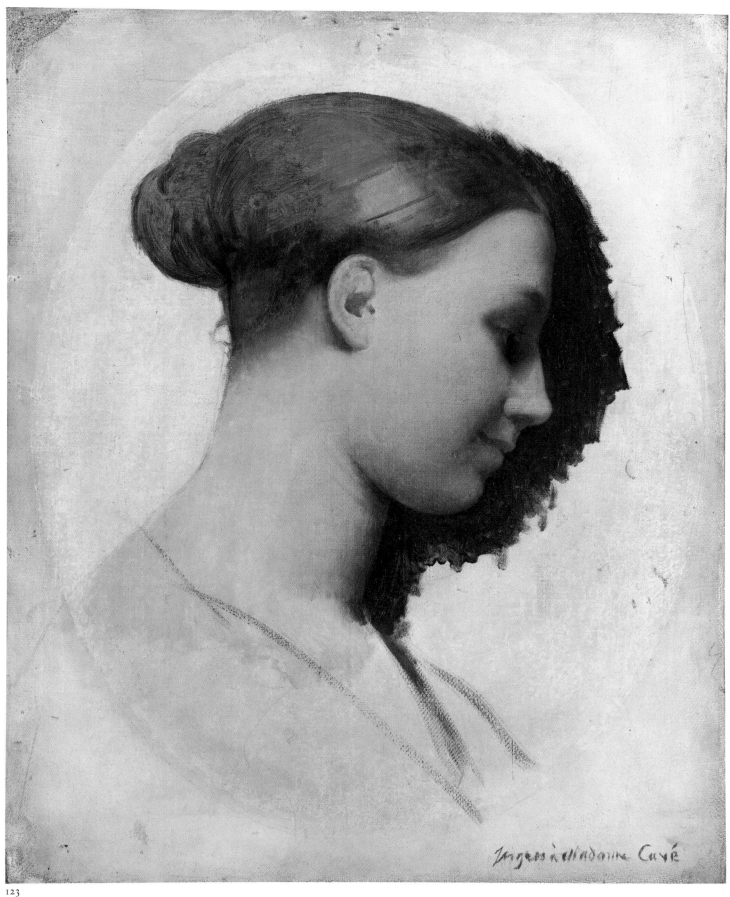

123

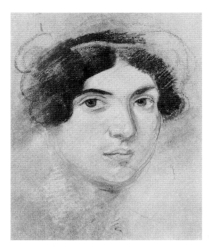

Fig. 236. Eugène Delacroix (1798–1863). *Madame Cavé,* 1846. Pastel on paper, 11 × 9 in. (28 × 23 cm). Sold, Galerie Charpentier, Paris, December 3, 1957, no. 83. Location unknown

In 1839 she won a second medal at the Salon, and in the next decade, during her marriage to Edmond Cavé, the critics were even more flattering: "She is the one woman who knows how to compose a scene with intelligence and with charm, much charm and much intelligence."[12]

Clément Boulanger, for his part, seems to have been preoccupied with his own career during their marriage. Born in Paris in 1805, he debuted at the Salon of 1827 and won a medal. He continued to exhibit grand compositions—troubadour subjects or allegories such as *The Muse of the Arts Prefers Misery to Grandeurs to Preserve Her Independence*—through the 1830s. Boulanger signed up in 1841 to accompany an archaeological expedition to Asia Minor, where he fell ill upon arrival and died on September 28, 1842. Suddenly widowed with a child to support, Élisa did not wait long to remarry: on November 4, 1843, she became the wife of Edmond Cavé (see cat. no. 124). In the words of Joubin, "Mme Cavé became, in the shadow of M. Cavé, the true director of Fine Arts. One strove to please Mme Cavé. Besides, who could have resisted the charm of her eyes and her smile? The greatest masters asked for the honor of reproducing her precious appearance."[13]

Ingres has long been thought to be one of the masters who sought that honor. His portrait of her is not inscribed with a date, but it is dedicated to "Madame Cavé"

rather than "Madame Boulanger." The pendant portrait of Monsieur Cavé (cat. no. 124), similarly dedicated, is dated 1844. Nevertheless, there is good reason to believe that Ingres's sketch of Élisa was made a decade earlier. In a previously unpublished letter of July 1844 in the archives of The Metropolitan Museum of Art (see cat. no. 124 for the full text), Ingres indicated that it was Madame Cavé who had asked him to make a portrait of her husband to accompany the portrait that he had already made of her. Since the artist was in Rome from 1834 to 1841, and Élisa lived in Paris during those years, her portrait was most likely made before his departure for Italy.[14] Her tender and angelic appearance in the profile by Ingres—in marked contrast to the determined adult (complete with a coiffure derived from Leonardo's *Belle Féronnière* [see fig. 126]) Élisa herself depicted in a self-portrait of the late 1830s (fig. 237) or the mature beauty Delacroix portrayed in 1846—is consonant with that of the young bride of Clément Boulanger. Furthermore, in the profile by Ingres her hair is still fair, whereas in every portrait from the late 1830s through the 1850s Élisa is shown with abundant ebony tresses.

Ingres made portrait sketches such as this only rarely. The closest example is the head of a young girl, possibly Ingres's lover Laura Zoëga, painted in 1813 (Musée du Louvre, Paris). Others that survive were often made in preparation for allegorical figures in his history paintings, such as the head of Isaure Leblanc (fig. 144), which Ingres used for one of the angels in *The Vow of Louis XIII*. It is possible that Ingres had asked young Élisa to pose for him in the early 1830s without intending to make her portrait. Perhaps, for example, he considered incorporating her features in the figure of Stratonice for the painting commissioned in 1833 by the duc d'Orléans.[15]

Ingres used a pencil to draw the general outlines of Élisa's head directly on the warm white preparation of the canvas. He carefully built up the flesh tones with several layers of paint, while the hair was only loosely sketched in with transparent washes. The contours of her profile were

defined by the dark strokes he used to indicate a background at the right. Marks on the canvas suggest that it was initially framed as an oval, then reframed as a rectangle when Ingres added his dedication in 1844. A very similar copy of the sketch, in identical dimensions, is still framed as an oval.[16]

In her celebrated treatise on art, Élisa Cavé illustrated a lithographic outline of her portrait by Ingres. Although the "Cavé Method" emphasized quick progress through the tracing of prints in order to arrive at drawing from memory, her caption for the Ingres comments upon its painterly qualities and the skill required to produce them: "An *ébauche* is not an *ébauche* because it is done quickly. My profile, by Monsieur Ingres, is an *ébauche;* he made it in one hour, and nevertheless it is one of his masterpieces."[17]

After the death of Edmond Cavé in 1852, Élisa redoubled her efforts to promulgate her teaching method, for which she found a willing ally in her old friend Delacroix. Joubin went so far as to suggest that Delacroix dictated much of *La Couleur,* the companion volume to *Le Dessin sans maître;* Pierre Angrand demurs on this subject, but it is certain that Delacroix used his influence, first, to promote the method in an important article in the *Revue des deux mondes* and, second, to recommend

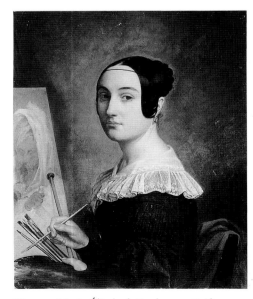

Fig. 237. Marie-Élisabeth Boulanger. *Self-Portrait,* late 1830s. Oil on canvas, 29 × 24 in. (73 × 61 cm). Location unknown

that it be adopted in public-school curriculums.[18] He wrote:

> Here is the first method of drawing that teaches something. In publishing like an essay the remarkable treatise in which she develops, with infinite interest, the fruit of her observations on the teaching of drawing and the ingenious procedures she applies to them, M^me Cavé, whose charming pictures are known to all . . . reveals how the ordinary path is defective and how the results of current teachings are uncertain.[19]

Madame Cavé published industriously throughout the 1860s, and her works open a fascinating window onto the thoughts of an intelligent, well-placed woman in Second Empire France. On beauty, she recommended scrupulous cleanliness, especially of the face, hands, and feet, noting, for instance, that Stratonice's bare foot occupies a singularly important role in Ingres's composition (fig. 194). She also reprinted what she called the "true" recipe for cold cream, indicating that it had been given to her by Delacroix, who had obtained it from the celebrated performer Mademoiselle Mars, a mistress of the comte de Mornay.[20] More ominous was her advocacy of strict adherence to Catholic dogma in her book *La Religion dans le monde*. She considered Protestantism to be "a false position" and "annoying," while condemning "those who remain Jewish" for "associating themselves in thought with those who crucified Jesus Christ."[21] Retiring to Versailles after the fall of the Empire, she published her last work in 1875, *La Vierge Marie et la femme* (The Virgin Mary and Woman).

Ingres's portrait of Élisa passed to her son, Marie-Henry-Albert Boulanger-Cavé.[22] A dilettante and bon vivant, he was the lifelong friend of the librettist Ludovic Halévy and, as such, spent much time in the company of Edgar Degas.

G. T.

1. *Le Dessin sans maître* (1850), *L'Aquarelle sans maître* (1851; 2nd ed., 1856), *La Couleur . . . ouvrage approuvé par M. Eugène Delacroix pour apprendre la peinture à l'huile et à l'aquarelle* (1863), *La Religion dans le monde* (1856), *Beauté physique de la femme* (1868).

2. According to the records in the Archives de la Seine, they were married on November 4, 1843, not 1844, as often indicated.

3. Conflicting dates have been given for Marie-Élisabeth Blavot. Joubin (1930, p. 58), gives 1815 as the date of her birth; Angrand (1966, p. 8) gives 1809, and other sources have 1810. The date of her death is not known. Neither her birth nor death certificate could be found as of this writing, and her tomb could not be located in the cemeteries of Paris and Versailles. Her certificate of marriage to Edmond Cavé does not give her age or date of birth, although she gave her age as forty when her husband died in early 1852. Through letters written to her by the sculptor Auguste Préault, it is known that she was living in Versailles in the 1870s. She seems to have died by 1885, at which time her only child, Marie-Henry-Albert Boulanger-Cavé, was indicated (in Paris 1885a) as the owner of works by Delacroix that had belonged to her. Robert McDonald Parker recently found the death certificate for Albert, which gives some important information. At his death in Paris on July 11, 1910, his age was given as eighty and his birthplace as Rome. That would place his birth sometime between July 1829 and July 1830. If his mother had been born in 1815, she would have been only fourteen or at most fifteen—improbably young—at his birth. It is more likely, therefore, that she was born in 1810 or 1811.

4. "ravissante: de grands yeux rieurs, une bouche moqueuse, de magnifiques cheveux blonds. Elle tournait toutes les têtes." Joubin 1930, p. 58.

5. "Élisabeth . . . se laissa volontiers *adorer*." Quoted in ibid.

6. "humble adoration pour tout ce qui est vous ou près de vous"; "mille hommages bien affectueux," "mille bonnes amitiés." Delacroix's letters to Élisa were published in ibid., pp. 66 ff.

7. Delacroix summed it up with a ditty to his friend the comte de Mornay: "Some painting, a bit of woman, that's my daily life." ("De la peinture, un peu de femelle, voilà pour la vie habituelle.") Quoted in ibid., p. 59.

8. There is a study for *Cleopatra* at the Fogg Art Museum (inv. 1968.61). Mongan (1996, no. 129), notes drawings by Delacroix after a daguerreotype of Élisa (which perforce cannot date before 1839–40) published in Escholier 1929, opp. p. 200. However, Lee Johnson, following Alfred Robaut, instead finds in both the features of the actress Rachel; Johnson 1986, pp. 81–82. Comparison with Delacroix's pastel of Élisa (fig. 236) and with Élisa's self-portrait (fig. 237) seems to confirm the identification to her rather than Rachel. The nude in Delacroix's *Le Lever* of 1850 (Johnson 168;

private collection, Paris), sometimes identified as Madame Cavé, cannot, on the other hand, represent her: Delacroix's nude has blond hair, not brown.

9. *Tiger Reclining by Its Den* (Johnson 171; Mahmoud Khalil Museum, Cairo); *The Entombment* (Johnson 420; Mahmoud Khalil Museum, Cairo); *Charles V at the Monastery of Yuste* (Johnson L142; location unknown); and *Hamlet and Horatio in the Graveyard* (Johnson L158; location unknown).

10. "si exquis que je n'ai pas le courage de me dire que je ne suis pas digne de la porter." Quoted in Joubin 1930, p. 78.

11. "Parmi les femmes artistes, M^me E. Boulanger occupe une des premières places. Son talent gracieux et facile donne à toutes ses petites compositions un charme infini. Ce dont il faut la louer surtout, c'est de comprendre très-bien la nature de son talent, et de ne s'exercer qu'à des sujets dont la simplicité naïve et le sentiment délicat peuvent être rendus dans les limites d'une aquarelle." Anon. 1837, p. 197, quoted in Angrand 1966, p. 20, n. 1.

12. "C'est la seule femme qui sache composer une scène avec intelligence et avec charme, beaucoup de charme et beaucoup d'intelligence." Houssaye 1846, p. 40, quoted in ibid., p. 63.

13. "Mme Cavé devenait, dans l'ombre de M. Cavé, le vrai directeur des Beaux-Arts. On s'ingénia à plaire à Mme Cavé. Qui aurait d'ailleurs résisté au charme de ses yeux et à son sourire? Les plus grands maîtres sollicitèrent l'honneur de reproduire ses traits précieux." Joubin 1930, p. 60.

14. In a 1979 memorandum in the archives of the Department of European Paintings at the Metropolitan Museum, Anne Wagner argued for a date of 1833–35. Avigdor Arikha considers the portrait of Madame Cavé "much earlier" than the 1844 portrait of her husband; Arikha in Houston, New York 1986, p. 85.

15. Marjorie Cohn and Susan Siegfried suggest that Ingres used Madame Cavé as the model for the figure of Eve in a drawing for *The Golden Age*, the unfinished mural at the Château de Dampierre (fig. 205); see Cambridge (Mass.) 1980, p. 124. Indeed, the resemblance is striking. Élisa would probably not have posed in the nude for Ingres in the 1840s, but Ingres may have been inspired when he saw her profile portrait again in 1844 (see cat. no. 124). It would be natural for him to flatter the Cavés by incorporating her features into the mural.

16. The copy could have been painted by either Clément Boulanger or by Élisa herself. It was sold at Christie's, London, July 9, 1976, no. 184.

17. "Une ébauche n'est pas une ébauche parce qu'elle est vite faite. Mon profil, fait par

M. Ingres, serait une ébauche; il l'a fait en une heure et cependant c'est un de ses chefs-d'oeuvre." Cavé 1851; Cavé 1863, quoted in Angrand 1966, p. 22, n. 1.

18. Delacroix's favorable report, dated December 1861, is quoted in Angrand 1966, pp. 118–19, 123.

19. "Voici la première méthode de dessin qui enseigne quelque chose. En publiant comme un essai le remarquable traité où elle développe avec un intérêt infini le fruit de ses observations sur l'enseignement du dessin et les procédés ingénieux qu'elle y applique, M^me Cavé, dont tout le monde connaît les charmans tableaux . . . montre avec évidence combien la route ordinaire est vicieuse et combien incertains les résultats de l'enseignement tel qu'il est." Delacroix 1850, pp. 1139–40; reprinted in Delacroix 1923, vol. 1, p. 9.

20. Angrand 1966, pp. 168–69.

21. "qui n'est pas une position franche et qui est ennuyeux"; "ceux qui restent juifs s'associent de pensée avec ceux qui ont crucifié Jésus-Christ." Quoted in ibid., p. 166, no. 1.

22. See n. 3, above.

PROVENANCE: Given by the artist to the sitter, probably before 1834; her bequest to her son, Marie-Henry-Albert Boulanger-Cavé (1830–1910), Paris, by 1885–1910; his bequest to his cousin Gaston Le Roy, 1910–25; his posthumous sale, Hôtel Drouot, Paris, May 19–20, 1926, no. 53; bought by Paul Rosenberg & Co., Paris and New York; sold to C. Chauncey Stillman, New York; his posthumous sale, American Art Association, New York, February 3, 1927, no. 10; bought by Paul Rosenberg & Co. for 13,000 francs; sold to Grace Rainey Rogers (1867–1943), New York, 1927–43; her bequest to The Metropolitan Museum of Art, New York, 1943

EXHIBITIONS: Paris 1911, no. 46; New York 1961, no. 58; Cambridge (Mass.) 1967, no. 89; Paris 1967–68, no. 229; New York 1988–89

REFERENCES: Cavé 1851; Cavé 1863; Lapauze 1911a, p. 386, ill. p. 389; Fröhlich-Bum 1924, p. 26; Anon., July–August 1926, p. 232, ill.; Anon., July 15, 1926, p. 634, ill. p. 633; Hourticq 1928, p. 89, ill.; Joubin 1930, pp. 60, 62, ill. p. 61; Zabel 1930, ill. p. 368; Wildenstein 1954, no. 247, pl. 94; Ternois 1959a, preceding no. 20; Angrand 1966, pl. II; Sterling and Salinger 1966, pp. 11, 12–13, ill.; Laclotte 1967, p. 194; Picon 1967, p. 72; Trapp 1967, p. 41, n. 7; Radius and Camesasca 1968, no. 137, ill., pl. XLVII; Trapp 1970, pp. 321–22, fig. 199; Baetjer 1980, vol. 1, p. 90, vol. 3, ill. p. 545; Cambridge (Mass.) 1980, under no. 44; Ternois 1980, p. 101, no. 290, ill.; Houston, New York 1986, under no. 39; Zanni 1990, no. 91, ill.; Baetjer 1995, p. 401, ill.

124. Hygin-Edmond-Ludovic-Auguste Cavé

1844
Oil on canvas
16 × 12⅞ in. (40.7 × 32.7 cm)
Signed, dated, and inscribed lower right: Ingres à Madame Cavé. / 1844.
The Metropolitan Museum of Art, New York
Bequest of Grace Rainey Rogers, 1943 43.85.2

W 246

The circumstances surrounding the commission of this portrait of Edmond Cavé (1794–1852),[1] director of fine arts during the reign of Louis-Philippe, can now be understood owing to the discovery of a previously unpublished letter:

> Monsieur [Cavé],
> Madame Cavé has honored me with a visit to remind me of a commitment that it is high time to fulfill, and that I want to do with much pleasure; thus, Monsieur, if next Wednesday at two o'clock is convenient, and if between now and then you could kindly send me the dimensions of the sketch that will serve as its pendant I will be most obliged.
> My fond compliments to Madame, and, while waiting for you, Monsieur, with my perfect consideration [I am]
> your faithful and devoted servant
> Ingres
> Saturday July 27 [1844][2]

The letter reveals that Madame Cavé had visited Ingres in July 1844 to request that he make a portrait of her new husband to serve as a pendant to the likeness that he had already created of her (cat. no. 123). Her portrait, painted as a sketch on a rectangular canvas, had been framed as an oval. No doubt Ingres considered an oval for-

mat inappropriate for Monsieur Cavé, and so he prepared a rectangular support of the same dimensions. Once Cavé's portrait was completed, Ingres dedicated it to Madame Cavé and inscribed his previously

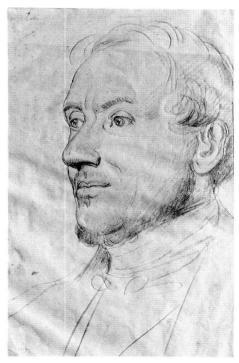

Fig. 238. *Study for "Hygin-Edmond-Ludovic-Auguste Cavé,"* 1844. Graphite on paper, 14¼ × 9 in. (36.2 × 22.8 cm). Musée Ingres, Montauban (867.209)

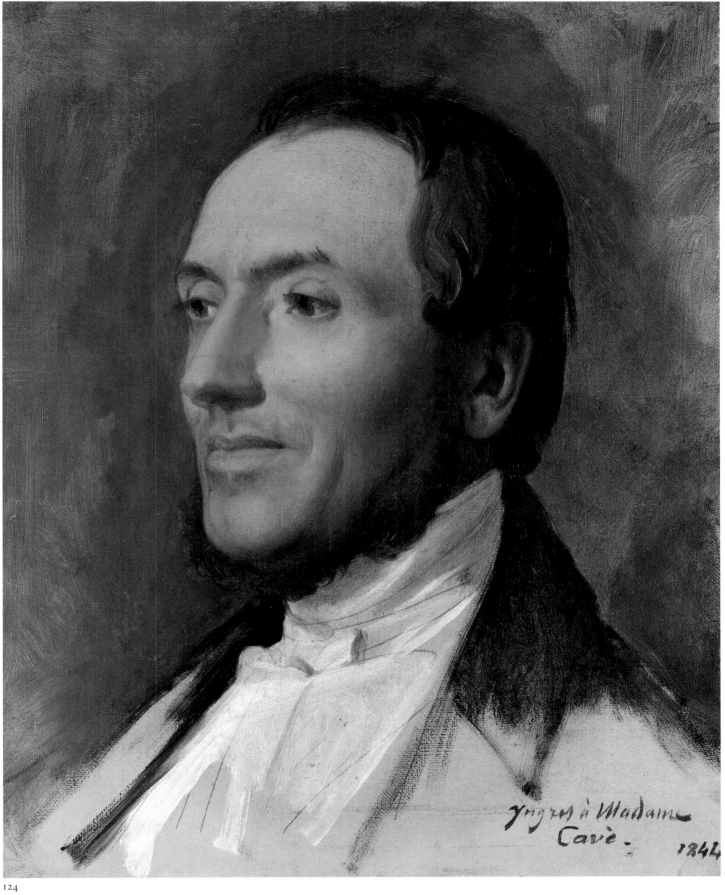

124

unsigned sketch of Madame Cavé (then known as Élisa Boulanger) with a dedication that would require it to be reframed as a rectangle.[3]

After Cavé arrived at Ingres's studio, the artist began a remarkably vivid drawing on paper (fig. 238), in which the fifty-year-old Cavé appears both alert and amiable. Ingres seems to have taken particular pleasure in defining the sitter's large, round, deeply set eyes and handsome nose. On the other hand, he appears to have disliked Cavé's thin beard, for it is only summarily indicated in the drawing and is barely visible in the painting. When he was satisfied with the drawing, Ingres traced its principal contours with a stylus to transfer the image to the small canvas he had prepared to match the dimensions of the sketch of Madame Cavé. Ingres then retraced with a pencil the lines that had been impressed on the canvas and began to apply thin washes of color.[4] Madame Cavé once wrote that Ingres had completed her portrait in an hour, and it is clear that he wished to make this work appear to have been executed just as quickly. In addition to omitting Cavé's beard, Ingres introduced a number of small changes in the painting: the sitter's nose became thinner, his face longer, and his forehead higher, all to give him a distinguished, aristocratic air, which cannot be found in the drawing.

Henry Lapauze wrote in 1901 that Ingres had made the initial pencil drawing in Rome in 1840, during a visit Cavé made to the Académie de France.[5] This suggestion was not substantiated by Lapauze, nor was it mentioned by any of the other early writers, such as Charles Blanc or Henri Delaborde. Jules Momméja in 1905[6] and most subsequent writers, among them Avigdor Arikha, then postulated that Ingres turned to the 1840 drawing when it came time to paint the portrait in 1844.[7] Although this is possible, Ingres's 1844 letter to Cavé would seem to vitiate Lapauze's supposition.

A writer by profession, Cavé produced a wide variety of works, from lighthearted entertainments for vaudeville ("Les Soirées de Neuilly") to anti-Bourbon pamphlets critical of the regime of Charles X. In 1839, after Louis-Philippe came to power,

he was named director of fine arts, the most powerful government position for the administration of policy for the arts. Anyone in such a position was subject to attack, and Cavé was not excepted. Obliged to censor Balzac's play *Le Vautrin* for political reasons, he was roundly criticized by writers and never regained their esteem. Victor Hugo, who considered Cavé arbitrary, wrote a diatribe in verse about him. In 1843 several artists launched an assault, accusing him of favoritism, incompetence, and inertia. His awards of government commissions to Élisa Boulanger in 1842 and again in 1843, the year they married, did not go unnoticed by the press. Citing the delay of the decision on which Salon exhibits would be purchased by the state that year, the revue *L'Artiste* wrote, sarcastically, "What are you complaining about? . . . Do you believe that the director of fine arts would be at the ministry of fine arts in order to take care of the fine arts! Really, he has other things to do! You should ask instead M. Gigoux and Madame Boulanger, his two honorable aides-de-camp."[8]

Cavé, a widower, wed Élisa Boulanger, herself a widow, on November 4, 1843. Artists naturally assumed that his marriage to a painter would improve policy, and Madame Cavé indeed took full advantage of her new position to dispense favors, as well as to obtain them. She renewed her friendship with Delacroix (see cat. no. 123) while boldly requesting that Ingres portray her husband. Monsieur Cavé retained his post until the government of Louis-Philippe fell in the Revolution of 1848. In January 1852 Napoleon III gave him a new appointment, superintendent of palaces and imperial factories, but he held it only three months. Delacroix wrote in his journal on January 27, 1852, that Cavé was "sick, I think, gravely." On the first of April he noted "Burial of poor Cavé. His death hurt me deeply."[9] G.T.

1. There has been much confusion regarding Cavé's given names. On his marriage certificate of 1843, he supplied only Hygin-Auguste, but in his dossier for the Legion of Honor he gave Hygin-Edmond-Ludovic-Auguste Cavé. In 1843 he was living at 1, rue Taitbou in the ninth arrondissement; at his death in 1852, his domicile was at 101, avenue des

Champs-Elysées, in the eighth arrondissement. I thank Robert McDonald Parker for finding these documents.

2. "Monsieur,
 Madame Cavé m'a fait l'honneur de venir me rappeler un engagement qui est bien temps de remplir, ce que je desire faire avec beaucoup de plaisir; ainsi donc, Monsieur, si Mercredi prochain à deux heures vous etant commode, et que d'ici là vous prenniez le soin de m'envoyer la grandeur du carton à qui vous avez pour le pendant je vous serai obligé.
 Mes compliments bien affectueux à Madame, et vous en attendant Monsieur, avec ma parfaite considération,
 votre dévoué et attaché serviteur
 Ingres
 samedi 27 juillet."
This letter is now in the archives of the Department of European Paintings at the Metropolitan Museum.

3. In the letter cited in note 2 above, Ingres requested the dimensions of the "carton" of the pendant; *carton* was a word sometimes used to refer to an *ébauche* (oil sketch).

4. Although some writers have suggested that the drawing was traced from the canvas, Ternois correctly surmised that Ingres traced the preparatory drawing onto the canvas: "Because of the indentations visible under the contours, we think on the contrary that it is really a matter of the original study being made from life, and that Ingres was satisfied with tracing it on the canvas to paint the portrait in New York." ("En raison des traces de pointe qui sont visibles par-dessus les traits de contour, nous pensons au contraire qu'il s'agit bien de l'étude originale d'après nature, et qu'Ingres se contenta de la calquer sur la toile pour peindre le portrait de New-York.") Ternois 1959a, no. 20.

5. Lapauze 1901, p. 113.

6. Reprinted in Vigne 1995a, p. 814.

7. Arikha in Houston, New York 1986, p. 85.

8. "De quoi pouvez-vous vous plaindre? . . . Croyez-vous donc que M. le directeur des beaux-arts soit aux beaux arts pour s'occuper des beaux-arts! Il a bien autre chose à faire vraiment! demandez plutôt à M. Gigoux, à madame Boulanger, ses deux honorables aides de camp." Anon. 1843b, p. 97, cited in Angrand 1966, p. 55.

9. "malade, je crois, gravement"; "Enterrement du pauvre Cavé. Sa mort me fait beaucoup de peine." Delacroix 1960, vol. 1, pp. 445, 463.

PROVENANCE: Given by the artist to the sitter's wife, 1844; her bequest to her son, Marie-Henry-Albert Boulanger-Cavé (1830–1910), Paris, by 1885–1910; his bequest to his cousin Gaston Le Roy, 1910–25; his posthumous sale, Hôtel Drouot, Paris, May 19–20, 1926, no. 54; bought at that sale by Paul Rosenberg & Co.,

Paris and New York, for 126,000 francs; sold to Grace Rainey Rogers (1867–1943), New York, 1926–43; her bequest to The Metropolitan Museum of Art, New York 1943

EXHIBITIONS: Paris 1911, no. 47; New York 1961, no. 57; Cambridge (Mass.) 1967, no. 90; Paris 1967–68, no. 228; New York 1988–89

REFERENCES: Lapauze 1911a, p. 386, ill. p. 375; Fröhlich-Bum 1924, p. 26; Anon., July–August 1926, p. 232, ill. p. 233; Anon., July 15, 1926, p. 634, ill. p. 633; Hourticq 1928, p. 89, ill.; Joubin 1930, p. 60; Zabel 1930, ill. p. 373; Malingue 1943, ill. p. 51; Alazard 1950, p. 106; Wildenstein 1954, no. 246, pl. 95; Ternois 1959a, under no. 20; Sterling and Salinger 1966, pp. 11–12, ill.; Laclotte 1967, p. 194; Trapp 1967, p. 41, n. 7; Radius and Camesasca 1968, no. 136, ill.; Baetjer 1980, vol. 1, p. 90, vol. 3, p. 545; Ternois 1980, p. 101, no. 289, ill.; Jerusalem, Dijon 1981, under no. 42, ill. (Jerusalem), under no. 41 (Dijon); Houston, New York 1986, under no. 39; Zanni 1990, no. 91, ill.; Baetjer 1995, p. 401, ill.

125–131. Vicomtesse Othenin d'Haussonville, née Louise-Albertine de Broglie

125. *Vicomtesse Othenin d'Haussonville, née Louise-Albertine de Broglie*
1845
Oil on canvas
51 ⅞ × 36 ¼ in. (131.8 × 92 cm)
Signed lower left (inside chair): Ingres. 1845.
The Frick Collection, New York 27.1.81

W 248

126–131. Studies for "Vicomtesse d'Haussonville" (see page 413)

As the director of the Académie de France in Rome, Ingres was obliged to entertain distinguished visitors, from France and elsewhere, to the Eternal City. It was in the context of one of these social duties that he met a young diplomat, Vicomte Othenin d'Haussonville, and his new bride, Princesse Louise de Broglie, in July 1840, during Haussonville's posting at the French embassy in Naples.[1] Ingres returned to Paris in the spring of 1841, as did the Haussonvilles later that year; after they had settled in, they invited the artist to dinner. This information, as well as a great deal more about Louise's comings and goings, is known from the reports of her childhood tutor, Ximénès Doudan. On February 23, 1842, Doudan wrote, "Yesterday we *dined* at madame d'Haussonville's with M. Ingres."[2] Under the circumstances, Ingres had reason to believe that a request for a portrait was clearly in the works.

Returning to Paris, he had found himself lionized for the first time in his life: he was being given a huge banquet attended by members of the various academies and presided over by the marquis de Pastoret (see cat. no. 98) and was invited to the grand households in the faubourg St.-Germain of some of the same individuals who had visited him in Rome. Yet he quickly came to realize that it was not simply the pleasure of his company that was sought in those salons, but rather the pleasure of displaying a portrait by his hand over the mantel. Everyone knew that the first new commission accepted by Ingres after his return was to portray the handsome duc d'Orléans, heir to the throne of France

(see cat. nos. 121, 122). No greater trophy could be had for a family that supported the Orléans regime than a portrait by Ingres. By June 22, 1842, Ingres had agreed, despite some hesitation,[3] to paint two more in addition to the already completed portrait of the duke, as Édouard Gatteaux wrote Charles Marcotte: "He has committed himself to doing two portraits, one of madame Rothschild and one of the duc de Broglie's daughter. He has already made an *ébauche* [oil sketch] of one, the other will be sketched soon, but he will not finish them until next winter."[4] Ingres had thus submitted to the richest man in Paris, Baron James de Rothschild (see cat. no. 132), and to one of the most prominent aristocrats associated with the Orléans government, the duc de Broglie (see cat. nos. 145, 146).

Gatteaux's identification of Louise d'Haussonville (1818–1882) was socially acute, since it was the daughter of the duc de Broglie rather than the wife of the vicomte d'Haussonville who had tempted Ingres. Achille-Charles-Léonce-Victor, duc de Broglie (1785–1870), whose wife, Albertine, was the daughter of the celebrated writer Madame de Staël, held a number of important positions in the government of Louis-Philippe. First appointed to the ministry of religion, then to the ministries of public instruction and foreign affairs, he finally assumed the presidency of the Council of State and was sent as ambassador to London, before retiring with the fall of Louis-Philippe in 1848. Evidence of the esteem with which the king regarded him can be measured by his

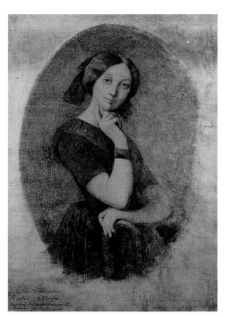

Fig. 239. *First Oil Sketch for "Comtesse d'Haussonville,"* 1842. Oil on canvas, 43⅞ × 29¾ in. (111.5 × 75.5 cm). Galerie Jan Krugier, Geneva

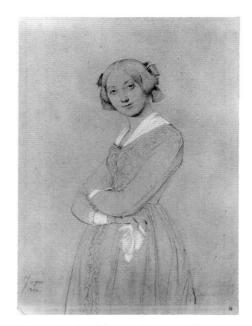

Fig. 240. *Louise d'Haussonville*, 1842 (N 390). Graphite and white highlights on paper, 12 × 8⅝ in. (30.4 × 21.8 cm). Musée Bonnat, Bayonne

1836. At first she did not love her husband: "I wanted to marry young and have a brilliant position in society. And that, basically, was the only reason I wanted to marry him." Summing up her situation, she considered herself "pretty, rich, admired. My parents were distinguished and good. My mother, it is true, did not interest herself in me with sufficient care or regularity, and my father not at all. Finally, what was I missing to be happy?" As a mature woman, she realized that her unhappiness was caused, in part, by a lack of contentment: "I have always spent my life pursuing imaginary benefits and dreams, and neglecting or failing to recognize the real blessings that were all around me."[5]

Handsome and considerate, young Joseph-Othenin-Bernard de Cléron, vicomte d'Haussonville (1809–1884), was

assignment to escort to Paris the crown prince's future bride, Helene, grand duchess of Mecklenburg-Schwerin. Although Victor de Broglie and his son Albert were vocal opponents of the Bonaparte regime, both were elected to the Académie Française, a bastion of Orléanism, during the Second Empire. Albertine de Broglie, who died when Louise was twenty, was—like her mother—intellectual, somewhat reclusive, and a passionate Protestant.

By all accounts, Louise rebelled against her ascetic upbringing. In her remarkable memoirs, recovered by Edgar Munhall, she recalled that "there were two persons inside me, the good and the evil, and the evil usually overcame the good." She described her "taste for society, for flirtation, and for pleasure [which] continued to dominate me. . . . There lay the great misunderstanding between my poor mother and me." As an adolescent, her "secret dream then (a dream I well knew to be more or less forbidden) was a life of society, of triumphs, of flirtation." One of the first men she flirted with was Othenin d'Haussonville. She immediately sensed that he was exactly the kind of young man whom she would eventually marry, and that was "enough to offend [her] whimsical imagination." Encouraged by her mother, she did marry him, in October

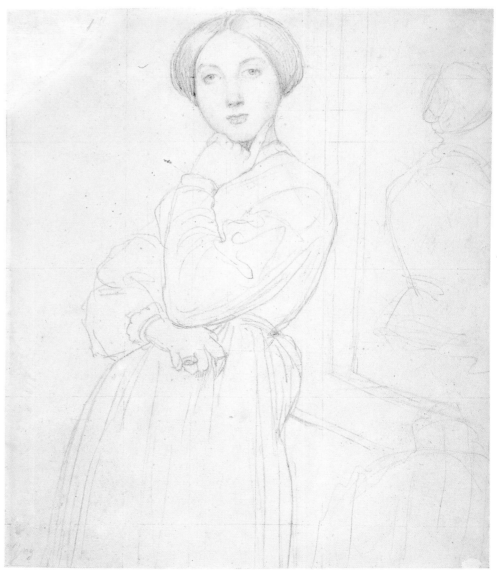

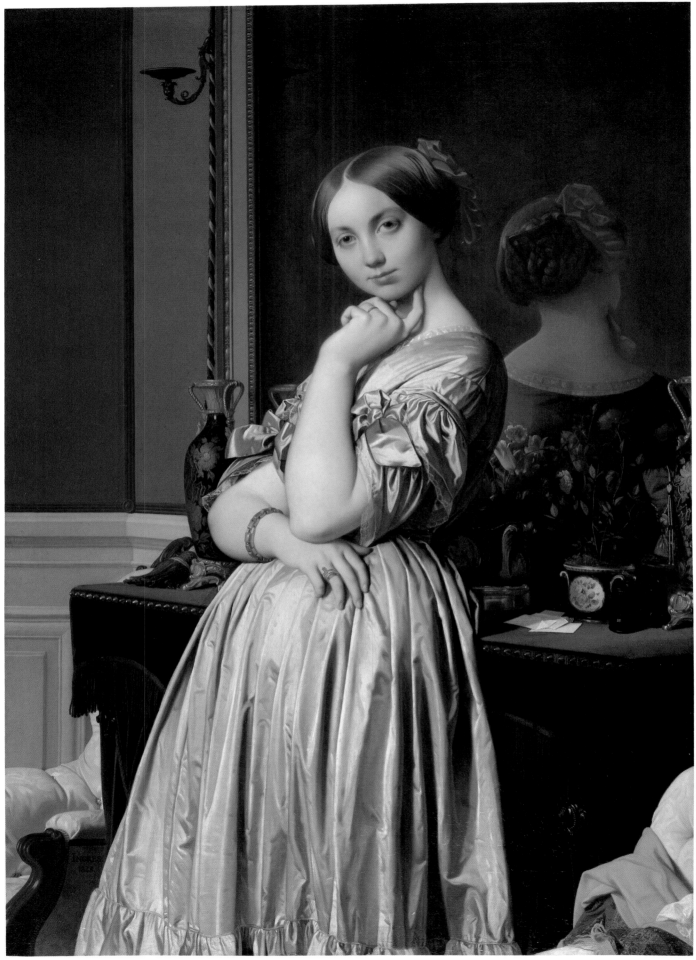

Fig. 241. Lorenzo Ghiberti (1370/1378–1455). *Hannah*, 1425–52. Bronze. East door of the Baptistery, Florence

127

one of those real blessings. Like Louise's brother Albert, Othenin had embarked on a promising career in the ministry of foreign affairs. After their marriage, he was posted in Brussels, where their first child was born; unhappily, the baby lived no more than six months. When Othenin was later posted in Naples, Louise went up to Coppet, the house near Geneva that her mother had inherited from Madame de Staël, to have her second child, Mathilde, in July 1839. Othenin was elected to the

National Assembly in 1842 and again in 1846. Cast into the opposition in 1848, he wrote a history of French foreign relations under the July Monarchy, contributed to the distinguished conservative periodical *Revue des deux mondes*, and was elected to the Académie Française. The couple's third child, Gabriel-Paul-Othenin, born in 1843 while Ingres was working on the portrait of Louise, became a prolific writer as well. He too was elected one of the forty "immortals" of the Académie Française, making

Louise d'Haussonville, in the words of a contemporary, "*daughter, wife, mother* and *sister* of Academicians."[6]

The progress on Louise's portrait that Gatteaux had mentioned on June 22, 1842, was confirmed by Ingres four days later in a letter to his friend Jean-François Gilibert: "I have sketched in the portrait of M^me d'Haussonville."[7] In this oval *ébauche* (fig. 239), he readily captured some of the essential characteristics of the portrait to be: the tilted head, the smile, the index finger

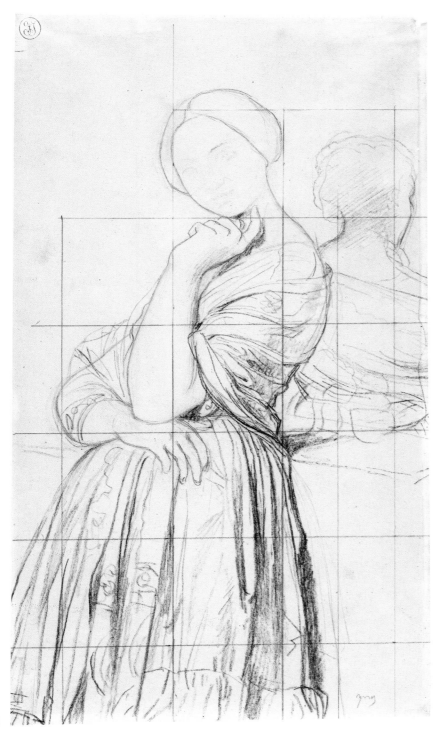

128

Dampierre, I still have to finish: 1st the copy of the portrait of the duc d'Orléans [cat. no. 122]; 2nd the cartoon for the Archangel Raphael [fig. 196]; 3rd, the full sketch for the portrait of Mme d'Haussonville [fig. 239] that I wanted to start over, which will be better beyond comparison."[9] But Ingres could not have known then that Louise had recently become pregnant with her fourth child, expected in September 1843, and thus would be unavailable to pose throughout the entire year and part of the next. Then, for much of the late summer and autumn of 1844, the Haussonvilles traveled in the eastern Mediterranean. "Alas," Ingres wrote, ". . . I cannot finish the portrait of Mme d'Haussonville this year."[10] Ingres could thus not have had access to his model until early 1845, when presumably the *ébauche* made two and a half years earlier (fig. 239) was abandoned. Ingres ultimately obliterated with gray paint the image that he had "wanted to start over" and, at the end of his life, gave the canvas to a student, Raymond Balze, for reuse. By 1882 Balze had removed three obscuring layers of paint to reveal the ghostly sketch, which in the end he sold to the Haussonvilles.[11] (At the same time, Othenin commissioned an exact copy of Ingres's portrait to hang in their Paris residence after the original was moved to Coppet.)

Louise d'Haussonville appears to have become a different person by 1845, and the new studies that Ingres made that year reflect her maturity and refinement.[12] A drawing now at the Fogg Art Museum (cat. no. 126) shows her as thoughtful—her lips parted to tell us something—rather than ingratiating. With her face and figure now fuller and her hair pulled higher on her head, she has a statuesque appearance, as if Ingres were revealing the source of the pose in the famous relief of Hannah on Ghiberti's Baptistery doors in Florence (fig. 241).[13] In the Fogg drawing, Ingres had changed the direction in which Louise faces, from right to left, and placed himself at an angle to the chimney. Louise, for her part, then decided to change her dress. The costume with long, full leg-of-mutton sleeves is replaced by the definitive dress in three subsequent studies (see cat. nos.

placed coyly at the jaw, the simple dress, the hair plainly parted in the middle. It was a flirtatious Louise—confident of her ability to charm, unaware of her vapid expression—who first posed for Ingres. The artist developed his ideas for the portrait in some quick pencil studies, in which he introduced a chimneypiece, a mirror, and a reflection.[8] About the same time, that is, in the first half of 1842, Ingres made an independent pencil portrait of the countess in which she holds a

handkerchief rather than bringing her hand to her face (fig. 240).

Shaken by the accidental death of the duc d'Orléans in July 1842, Ingres was soon completely occupied with the ensuing memorial commissions (see cat. nos. 121, 122). In letters dating from the autumn and winter of 1842, he cited the portrait of Louise as among his unfinished works. Writing Gilibert in February 1843, he mentioned that "between now and the first of June, when I will take possession of

bras de m.e d'haussonville

129

127, 128):[14] a bodice with short but full sleeves, a gathered skirt with a ruffle at the hem, and a shawl wrapped around her shoulders. In these drawings Ingres was most concerned with animating the folds of shawl and dress and distributing highlights and shadows. The last of the three (cat. no. 128) was squared to transfer the design to canvas, a sign that the artist was satisfied; he had already worked out the precise disposition of the fingers, hands, and arms in a large and handsome drawing now at the Musée Ingres (cat. no. 129). But it took one more drawing (cat.

no. 130) for Ingres to find the final pose, showing Louise without her shawl and with a single ribbon in her hair.

Most of the subsequent drawings were full-scale studies for details of the portrait. One of Louise's face, now at Montauban (fig. 242), is covered with annotations; as Munhall has determined, these were used by Ingres for the drawing now at Carpentras (cat. no. 131).[15] A small compositional study (fig. 327) introduced some of the furnishings, such as the chair at the right and the sconce at the left, that figure prominently in the portrait; it may have

been drawn by an assistant.[16] A much more complete drawing of the composition, now at Providence,[17] was made after the painting was finished; traced by Ingres from a photograph of the painting, it was designed to help the engraver Achille Réveil make an outline reproduction. Munhall has catalogued fifteen extant drawings relating to the portrait, but he follows Andrew Carnduff Ritchie, Hans Naef, and Avigdor Arikha in speculating that many more were made, including nude figural studies now lost.[18] While that number would constitute one of the most extensive ensembles of studies for a painted portrait by Ingres, there are also large groups of drawings for the portraits of Madame Leblanc (1823; cat. no. 88), Louis-François Bertin (1834; cat. no. 99), and Luigi Cherubini (1842; fig. 221). Without knowing how many of Ingres's studies are now lost, it is equally impossible to determine which portraits required more drawings.

Ingres announced the completion of the painting in a letter to Marcotte dated June 18, 1845: "I have finally finished the disastrous portrait, which, weary of tormenting me, has given me the most complete success during four days of a little exhibition *chez moi*."[19] Accounts differ on how fast Ingres worked on the portrait. Théophile Silvestre wrote in 1856, "Sometimes he seems to shake off this wretched slowness: a few hours sufficed for adding the arms of the model to the unfinished portrait of madame d'Haussonville."[20] While this passage confirms that Ingres employed a model to supplement sessions with the sitter, Louise herself experienced slowness more than anything else: she told a correspondent that "for the last nine days Ingres has been painting on one of the hands."[21] As usual, Ingres probably made studies at the site of the portrait—a sitting room of the Hôtel d'Haussonville, at 35, rue Saint Dominique—and supplemented them with sessions at his studio at the Institut de France, where he actually painted the canvas. The cool northern light of that studio permeates the picture, even though every detail of the image, as Munhall has observed, seems to conform to actual appearances.

The *garniture de cheminée*, which still exists, comprises a mix-and-match group

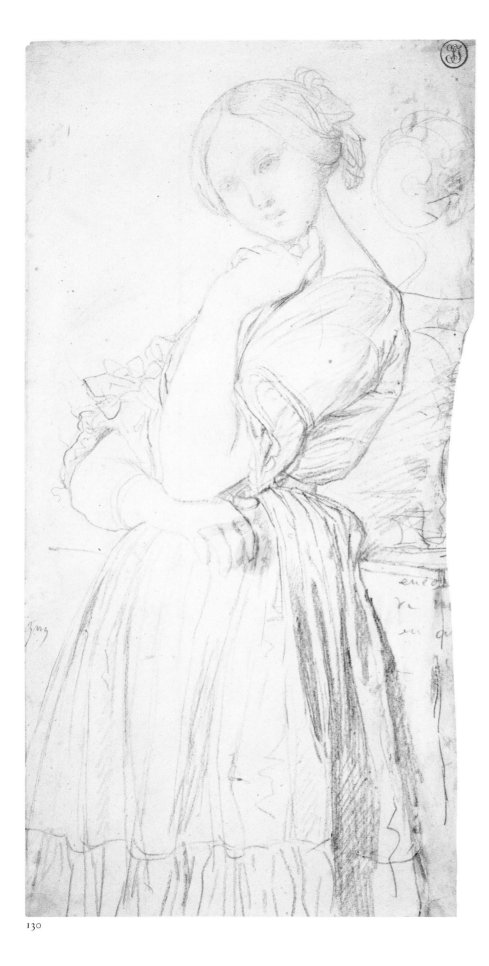

130

of Sèvres, Paris porcelains in the style of Sèvres, and vases of either European or Asian manufacture with French ormolu mounts. Sporting informal arrangements of spring flowers, they rest on a mantel draped with velvet, a mid-nineteenth-century fashion encouraged by upholsterers. Two armchairs, covered in white damask to match the white dado, are placed against the wall. One holds the ocher cashmere scarf and the handkerchief that Louise has discarded. Although the simplicity of her silk-taffeta dress—of a subtle steel gray that is heightened by the dull, warm gray wall covering—suggests an afternoon toilette, most writers agree that she is dressed for evening in a *robe de petit dîner* (the equivalent today of a cocktail dress): for day she would have been obliged to wear a hat, which, even if removed, would probably have been included in the painting. The simple coiffure (a knot of braided hair held by a tortoiseshell comb), the red silk ribbon, and the modest jewelry (a turquoise-mounted bracelet and ring *à la Cléopatre*) bear witness to the sitter's refinement—and perhaps to her strict Protestant upbringing as well. Calling cards, some with dog-eared corners to indicate an unconsummated visit, are strewn on the mantel, but the adjacent opera glasses suggest to Munhall, with good reason, that the countess is either about to leave for or has just returned from the theater. This theory is further supported by the fact that, in the mid-nineteenth century, hats were not worn at the Opéra or the Comédie-Française, women arriving instead with their hair arranged with combs and decorated with a cache-peigne or ribbons, as Louise's is here.[22]

Ingres was relieved that the portrait met with approval when he showed it to members of Louise's family in his studio in the summer of 1845, as he wrote Marcotte in June:

> Family, friends, and above all that loving father (the duc de Broglie) were delighted with it. Finally, to crown the work, M. Thiers [Adolphe Thiers, several times minister and president of the Council of State under Louis-Philippe, and the minister to whom Ingres reported from Rome]—and I was not present—came

Fig. 242. *Study for "Comtesse d'Haussonville" (Face)*, ca. 1845. Graphite on paper, 5⅛ × 5½ in. (13.1 × 14 cm). Musée Ingres, Montauban (867.264)

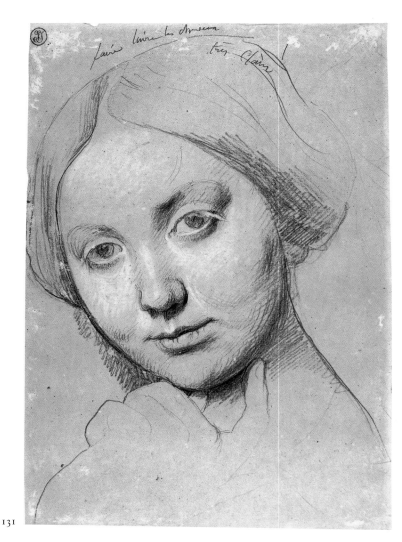

131

to see it with the subject and repeated to her several times this wicked remark, "M. Ingres must be in love with you to have painted you that way." But all this does not make me proud, and I do not feel that I have conveyed all the graces of that charming model.[23]

He reported much the same thing in a letter to Gilibert from Dampierre in July: "Despite all my distaste, the portrait of Madame d'Haussonville has already created a furor of approval, first with M. le duc de Broglie, his family, and his numerous friends in the elite. It was seen four days before my departure [for Dampierre], and it will be there [in my studio] until my return, when we will see it varnished."[24]

These letters confirm that above all Ingres was working for the approval of the duc de Broglie and his "numerous friends in the elite" and also that he sensed that he may have failed to convey adequately his sitter's personality. In fact, not everyone was pleased with the portrait. Louise's tutor, Doudan, wrote Madame de Staël that "M. Raulin is defending the portrait of Madame d'Haussonville as well as he can against the universal attacks, and he is right."[25] A few weeks later, Ingres confessed that he detected some unhappiness in Louise's life. Responding to Marcotte, who had encountered Louise in July 1845 at the spa of Mont-Dore in the Auvergne, he wrote: "As for our lovely, untamed little Vicomtesse, I think that though she is loved, I must on the whole pity her, for

perhaps it is not entirely within her discretion whether or not she is loved."[26]

It is not known whether Ingres delivered the canvas to the Haussonvilles after his return to Paris from Dampierre in the fall of 1845. Nevertheless, he included it in his next exhibition at the Galerie Bonne-Nouvelle, which opened on January 11, 1846.[27] The critical response to the works Ingres displayed—major figure paintings such as *Antiochus and Stratonice* (fig. 194), the *Grande Odalisque* (fig. 101), and *Oedipus and the Sphinx* (fig. 82), as well as three portraits, those of Bertin (cat. no. 99), Molé (fig. 158), and Haussonville—was predictable in its tone, although the Haussonville portrait was especially noted. Théophile Thoré, an ardent republican and champion of Realism, disliked Ingres's stylizations:

The portrait of M^me d'Haussonville demonstrates a new aspect of M. Ingres's talent. Here the artist has sought grace and charm; he has been prodigal with details—the vases of flowers and the mirrors—whereas he affects austerity in his portraits of men. The subject lent herself to this, no doubt; but the manner of M. Ingres is ill adapted to these trifles. The pose of M^me d'Haussonville is almost the same as that of Stratonice. The bare arm supporting the head has charm; it emerges from a lilac bodice whose color clashes violently with the blue velvet that covers the console.[28]

Many subsequent writers have commented on the similarity of Louise's pose to that of Ingres's Stratonice; Munhall discovered that Louise, an amateur artist, even once made a watercolor in which a contemplative Dido assumes Stratonice's pose.[29] More important, as Munhall observed, was Thoré's association of Ingres's willful distortions with the concept of "art for art's sake":

In the end, M. Ingres is the most Romantic artist of the nineteenth century, if Roman-

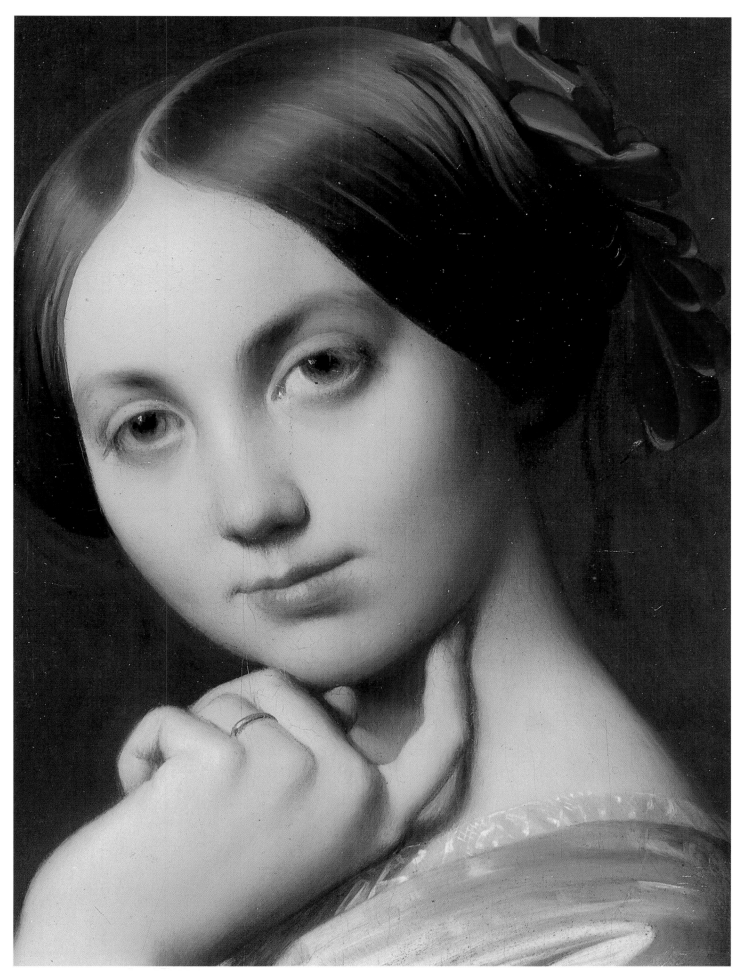

Fig. 243. Detail of cat. no. 125

ticism is an exclusive love of form, an absolute indifference to all the mysteries of human life, a skepticism in philosophy and politics, an egotistical detachment from all common and shared feelings. The doctrine of art for art's sake is, in effect, a sort of materialistic Brahmanism that absorbs its initiates, not into the contemplation of the eternal but into an obsession with external and perishable form.[30]

Baudelaire, always the contrarian, reveled in Ingres's insistent and passionate artfulness. He considered the three portraits on view "true portraits, that is to say, the ideal reconstruction of the individuals."[31] And he countered that as an "impassioned lover of antiquity and of its model, respectful servant of nature, [Ingres] makes portraits that rival the best of Roman sculpture."[32] Above all, Baudelaire felt, Ingres revealed his talent in his depictions of women: "He applies himself to the slightest beauties with the keenness of a surgeon; he follows the lightest undulations of their outlines with the slavishness of a lover. The *Angelica* [fig. 104], the two *Odalisques* [figs. 101, 190], the portrait of Mme d'Haussonville are works of a profound voluptuousness."[33] In another review, he stated: "His libertinism is serious and full of conviction. Ingres is never so happy nor so powerful as when his genius comes to grips with the feminine charms of a young beauty. The muscles, the folds of flesh, the shadows of the dimples, the mountainous undulations of the skin, nothing is missing."[34]

Ingres obtained the loan of the portrait for his monumental display at the Exposition Universelle of 1855 and placed it in a position of honor (fig. 302): just to the right of the center of a wall, it was hung next to *The Virgin with the Host*, beneath *The Apotheosis of Homer*, and as a pendant to the *Comte Molé*. Since the center of the wall opposite was occupied by a portrait of Prince Napoleon and *The Apotheosis of Napoleon I* (fig. 303), the overall effect must have been of an Orléanist delegation at a party given by the Bonapartes. Nevertheless, few of the innumerable articles published on Ingres's display singled out the Haussonville portrait for discussion. One exception was a

piece reprinted in the gossipy *L'Artiste* in which Ingres's besotted student Amaury-Duval remarked that "the play of the mirror in which madame d'Haussonville is reflected and the very exact reproduction of the apartment are the sort of difficulties that M. Ingres enjoys imposing on himself, with the blithe spirit of a confident man."[35] The use of a mirror in Ingres's portraits of women, one of the artists's favorite conceits, can be traced from the depiction of Madame de Senonnes (cat. no. 35) to that of Madame Moitessier seated (cat. no. 134). Deriving from Boucher's extraordinary portrait of Madame de Pompadour (fig. 20), the view with a mirror was so extensively employed in nineteenth-century fashion illustration that it had become a cliché (see fig. 271). Yet Ingres's portrait still carried the weight of authority. Hippolyte Flandrin, a devoted disciple, quoted from it when he portrayed his wife (fig. 244), and Degas, the greatest of Ingres's followers, paid homage to it in his pastel of his sister Thérèse standing in their father's study (fig. 245)—although he gave his picture a typical note of disquiet, in contrast to the confident charm of Ingres's.

In 1867 the Haussonvilles again lent the canvas, this time to Ingres's great memorial retrospective. It was there that the art administrator and theorist Charles Blanc formed the complete view of Ingres's art that resulted in the biography and catalogue he published in 1870. Blanc considered the style of execution of the Haussonville portrait to be a reflection of Ingres's waning years:

> The entire portrait appears to be seen through a thin veil of gray touching on lilac. The eyes of the model have a drowned look that is not without charm. She exudes distinction and an easy grace that the painter, often mannered and stiff, has not always found, but behind this uniform haze, interposed between the painting and the viewer, the life of the model seems numbed. We are in the presence of one of those images that appear in dreams with a mixture of precision in some details and vagueness on the whole. It is a long way from here to the portraits, so firm, so limpid, so well clothed in light, so alive, so palpable in appearance, of M^me de Senonnes [cat. no. 35] and M^me Devauçay

Fig. 244. Hippolyte Flandrin (1809–1864), *Madame Hippolyte Flandrin, née Aimée Ancelot, the Artist's Wife*, 1846. Oil on canvas, 32⅝ × 26 in. (83 × 66 cm). Musée du Louvre, Paris

[*sic;* fig. 87]. It is clear that the master's sight had weakened with age and that the sun that shone for him then was not the sun of Italy.[36]

The gray light and soft focus of the painting have prompted modern writers, such as Aaron Scharf and William Hauptman, to speculate that Ingres used photographs to make this painting and that

Fig. 245. Edgar Degas (1834–1917), *Thérèse de Gas Morbilli*, 1869. Pastel on paper, 20 × 13⅜ in. (50.8 × 34 cm). Private collection

the final appearance is somehow suggestive of photography.[37] This is highly unlikely, for the first daguerreotypes were not made until 1839, just two years before Ingres began work on the portrait. From about 1850 Ingres did use photography to record his work, but there is yet no proof that he employed it in place of live models prior to the late 1850s, when he based a self-portrait on a photograph (cat. no. 148). If the pose and format of Ingres's portraiture are reminiscent of early photography, that is because the early photographers were generally artists trained in the same conventions as painters were.

After her portrait was painted, Louise d'Haussonville established a small reputation as a writer. Inspired by her gifted grandmother—Madame de Staël, who was the subject of one of her early essays—she wrote short romantic novels and studies of historical figures, often women. Her best-known works, however, were about men: *Robert Emmet* (1858), the tale of an Irish revolutionary hanged by the British in 1803, and *La Jeunesse de Lord Byron* (1872), followed by *Les Dernières Années de Lord Byron* (1874). In the last, she revealed her frank assessment of the place of women in contemporary society: "Usually, where women have been put is where they stay, with that vague idea, instilled since infancy, that women are made for suffering—even while they now and then amuse themselves as a distraction from the sad fate society has in store for them."[38] Her portrait hung at the Hôtel d'Haussonville until her death in 1882, but by middle age she no longer resembled it. When she encountered Prosper Mérimée in the mid-1860s, he was shocked to see that she had grown fat. In a sharp repartee that he later recounted to friends, Louise attacked first the emperor for having no brains and then the empress for having unattractive shoulders. Mérimée, an author, historian, and high-ranking official in Bonaparte's government, felt obliged "to tell her that she [the empress] was one of the small number of women who had not put on too much weight with the passing years." He was surprised by the countess's appearance, noting that she had had smallpox and "has hardly any hair left." But the comtesse had not changed the way she wore the hair that remained: "One sees . . . *the rue de la Paix* running down the center of her head."[39]

G. T.

1. According to Louise d'Haussonville's journal, "Voyage à Rome en 1840," quoted in Doudan 1876–77, vol. 3, p. 90, and by Munhall in New York 1985–86 (1998 ed.), p. 51. Edgar Munhall's excellent and exhaustive study of the painting at the Frick (in New York 1985–86; rev. ed., 1998) contributed much new research to the already quite thorough studies by Andrew Carnduff Ritchie and Hans Naef. My account here is based on that of Munhall.
2. "Nous *dînâmes* hier avec M. Ingres chez madame d'Haussonville." Doudan 1876–77, vol. 3, p. 90, quoted by Munhall in New York 1985–86 (1998 ed.), p. 51.
3. See Ingres to Gilibert, October 2, 1841, in Boyer d'Agen 1909, p. 302.
4. "Il s'est engagé à faire deux portraits, celui de madame Rothschild et celui de la fille du duc de Broglie. Il a déjà ébauché l'un des deux, l'autre le sera bientôt, et il ne s'occupera de les finir que l'hiver prochain." Gatteaux to Marcotte, quoted in Naef 1977–80, vol. 3 (1979), p. 335.
5. "Excerpts from the Memoirs of the Comtesse d'Haussonville," quoted by Munhall in New York 1985–86 (1998 ed.), pp. 129, 131, 132. The unpublished memoirs are in a private collection.
6. "*fille, femme, mère* et *soeur* d'académiciens." Pange 1962, p. 250, quoted by Munhall in ibid., p. 32.
7. "J'ai ébauché le portrait de M^me d'Haussonville." Ingres to Gilibert, June 26, 1842, in Boyer d'Agen 1909, p. 349.
8. Musée Ingres, Montauban, inv. 867.257, 258.
9. "Que, d'ici au premier juin où j'irai prendre possession de Dampierre, j'ai encore à terminer: 1° le portrait copie du duc d'Orléans; 2° le carton de l'archange Raphaël; 3° l'ébauche entière du portrait de M^me d'Haussonville que j'ai voulu recommencer et qui sera mieux, sans comparaison." Ingres to Gilibert, February 6, 1843, in ibid., p. 360.
10. "Hélas . . . je ne puis finir le portrait de M^me d'Haussonville, cette année." Ingres to Gilibert, dated June 7, 1844, in ibid., pp. 370–71.
11. Munhall in New York 1985–86 (1998 ed.), p. 56.
12. Of all the related drawings, only the independent portrait drawing (fig. 240) is inscribed with a date (1842). (As Naef noted, it remained in the artist's possession and was never given to Louise or her family and thus was probably made for Ingres's use alone; Naef 1977–80, vol. 3 (1979), p. 328, as quoted by Munhall in New York 1985–86 (1998 ed.), p. 48. Nevertheless, the studies seem to fall into two groups: those made in the first half of 1842, mentioned above, and those made in the first half of 1845, mentioned below.
13. Munhall (in New York 1985–86 [1998 ed.], pp. 69–77) and previous scholars have argued for an additional source of the pose in an antique sculpture of Pudicity at the Vatican. The pose of that sculpture is quite different from that adopted by Ingres for the comtesse d'Haussonville, whereas the Ghiberti is quite close. However, an antique sculpture of Polyhymnia at the Louvre could have inspired Ingres.
14. The third study is in the Frick Collection (acc. no. 59.3.92).
15. Munhall in New York 1985–86 (1998 ed.), pp. 62–66.
16. Musée Ingres, Montauban, inv. 867.2665.
17. Museum of Art, Rhode Island School of Design, inv. 32.227.
18. Munhall in New York 1985–86 (1998 ed.), p. 48.
19. "J'ai terminé ce désastreux portrait, qui, lassé de me tourmenter, m'a donné, pendant quatre jours de petite exposition chez moi, le plus complet succès." Ingres to Marcotte, June 28, 1845, quoted in Delaborde 1870, p. 250. The same letter has been cited somewhat differently by Blanc (1867–68, pt. 6 [1868], p. 361) and Lapauze (1911a, p. 382); see also Ternois 1999, letter no. 49.
20. "Parfois il semble secouer cette pauvre lenteur: quelques heures lui ont suffi pour ajouter les bras d'un modèle au portrait inachevé de madame d'Haussonville." Silvestre 1856, p. 28.
21. Quoted from a letter by the countess in Pach 1939, p. 103.
22. Paris 1982–83, p. 95.
23. "Parents, amis et, pardessus tout, ce tendre père (le duc de Broglie), en ont été ravis. Enfin, pour couronner l'oeuvre, M. Thiers, et je n'y étais pas, est venu le voir avec la personne, et lui a dit plusieurs fois, ce mauvais plaisant: 'Il faut que M. Ingres soit amoureux de vous pour vous avoir peinte ainsi.' Mais tout cela ne m'enorgueillit pas, et je ne crois pas avoir rendu toutes les grâces de ce charmant modèle." Quoted in Blanc 1870, pp. 144–45.
24. "Malgré tous mes dégoûts, le portrait de Madame d'Haussonville a déjà fait fureur d'approbation, d'abord chez M. le duc de Broglie, chez sa famille et ses nombreux amis d'élite. Il a été vu, quatre jours avant mon départ, et le sera jusqu'à mon retour où on le verra verni." Ingres to Gilibert, July 27, 1845, in Boyer d'Agen 1909, p. 379.
25. "M. Raulin défend tant qu'il peut le portrait de madame d'Haussonville contre les attaques universelles, et il a raison." Doudan 1876–77, vol. 3, p. 172, quoted by Munhall in New York 1985–86 (1998 ed.), p. 54.

26. "Quant à notre belle petite sauvage Vicomtesse, je crois, qu'encore qu'elle soit aimée, il me faut plutôt la plaindre, car ça ne dépend peut-être pas tout à fait d'elle d'être aimée." Quoted in Naef 1977–80, vol. 3 (1979), p. 336.

27. See pp. 505–9 in this catalogue.

28. "Le Portrait de Mme d'Haussonville présente encore le talent de M. Ingres sous un nouvel aspect. Ici, l'auteur a cherché la grâce et le charme; il a prodigué les détails, les vases de fleurs et les glaces, tandis qu'il affecte l'austérité dans ses portraits d'hommes. Le sujet y prêtait sans doute; mais la manière de M. Ingres ne s'arrange guère de ces coquetteries. La pose de Mme d'Haussonville est presque la même que celle de Stratonice. Le bras nu qui supporte la tête a de l'agrément; il sort d'un corsage lilas dont la couleur se heurte violemment contre le velours bleu qui recouvre la console." Thoré 1846, pp. 58–59.

29. Munhall in New York 1985–86 (1998 ed.), pl. 8.

30. "Au fond, M. Ingres est l'artiste le plus romantique du dix-neuvième siècle, si le romantisme est l'amour exclusif de la forme, l'indifférence absolue sur tous les mystères de la vie humaine, le scepticisme en philosophie et en politique, le détachement égoïste de tous les sentiments communs et solidaires. La doctrine de l'art pour l'art est, en effet, une sorte de brahmanisme matérialiste qui absorbe ses adeptes, non point dans la contemplation des choses éternelles, mais dans la monomanie de la forme extérieure et périssable." Thoré 1846, p. 42. See Munhall (in New York 1985–86 [1998 ed.], p. 105), who cites a review by Frédéric de Mercey (F. de Lagenevais) in the August 1, 1846, *Revue des deux mondes* in which the term "art for art's sake" is once again used in the context of Ingres's work; see Lagenevais 1846.

31. "de vrais portraits, c'est-à-dire la reconstruction idéale des individus." Baudelaire, "Le Musée Classique du Bazar Bonne-Nouvelle," in Baudelaire 1975–76, vol. 2 (1976), p. 412.

32. "amoureux passionné de l'antique et de son modèle, respectueux serviteur de la nature, il fait des portraits qui rivalisent avec les meilleures sculptures romaines." Baudelaire, "Salon de 1846," in ibid., p. 460.

33. "il s'attache à leurs moindres beautés avec une âpreté de chirurgien; il suit les plus légères ondulations de leurs lignes avec une servilité d'amoureux. L'*Angélique*, les deux *Odalisques*, le portrait de Mme d'Haussonville, sont des oeuvres d'une volupté profonde." Ibid.

34. "Son libertinage est sérieux et plein de conviction. M. Ingres n'est jamais si heureux ni si puissant que lorsque son génie se trouve aux prises avec les appas d'une jeune beauté. Les muscles, les plis de la chair, les ombres des fossettes, les ondulations montueuses de la peau, rien n'y manque." Baudelaire, "Le Musée Classique du Bazar Bonne-Nouvelle," in ibid., p. 413.

35. "le jeu de la glace où se reflète madame d'Haussonville, et la reproduction si exacte de l'appartement, sont de ces difficultés que M. Ingres se plaît à s'imposer de gaieté de coeur en homme sûr de lui-même." First published in Amary-Duval 1846, p. 92; reprinted in Amaury-Duval 1856, p. 177; Amaury-Duval 1921, p. 250; and *Le Baron Taylor* 1995, p. 272.

36. "Le portrait tout entier semble vu au travers d'une gaze légère dont le gris touche au lilas. Les yeux du modèle ont un regard noyé qui n'est pas sans charme. Il y a dans sa personne de la distinction et une grâce facile que le peintre n'a pas toujours rencontrée, lui qui est souvent recherché et tendu; mais derrière cette vapeur uniforme qui s'interpose entre le tableau et le spectateur, la vie du modèle paraît engourdie. On est en présence d'une de ces images qui apparaissent en songe avec un mélange de précision dans quelques détails et de vague dans l'ensemble. Il y a loin de là aux portraits si fermes, si limpides, si bien vêtus de lumière, si vivants et en apparence si palpables, de Mme de Senonnes et de Mme Devauçay. Il est clair que la vision du maître s'était affaiblie avec l'âge et que le soleil qui l'éclairait alors n'était pas le soleil de l'Italie." Blanc 1870, pp. 144–45.

37. Scharf 1968, p. 27; Hauptman 1977, pp. 121–22.

38. Haussonville 1874, p. 30, quoted by Munhall in New York 1985–86 (1998 ed.), p. 41.

39. "de lui dire qu'elle était du petit nombre de femmes qui n'avaient pas trop grossi en prenant des années"; "n'a plus guères de cheveux. On lui voit . . . *la rue de la Paix* au milieu de la tête." Mérimée 1958, pp. 302–3, 340, quoted in Naef 1977–80, vol. 3 (1979), p. 337.

Cat. no. 125. *Vicomtesse Othenin d'Haussonville, née Louise-Albertine de Broglie*

PROVENANCE: Commissioned by Vicomte d'Haussonville in 1842, completed in 1845, at the Hôtel d'Haussonville, Paris, until 1882; bequeathed in 1882 by Vicomtesse d'Haussonville to her daughter Mathilde, who was instructed to place the portrait at the Château de Coppet, in Switzerland, where it remained until 1925; sold in 1925 by the grandchildren of Louise d'Haussonville to Wildenstein & Co., Paris and New York; purchased by the Trustees of the Frick Collection, New York, January 13, 1927

EXHIBITIONS: The artist's studio, 1845; Paris 1846, no. 52; Paris 1855, no. 3365; Paris 1867, no. 93; Paris 1874, no. 261; Paris 1910, no. 96; New York 1985–86, no. 50; New York 1986

REFERENCES: Anon. 1846, pp. 33, 61–62; Anon., January 15, 1846; Anon., January 18, 1846; Anon., January 30, 1846 (H. M.), pp. 236–37; Anon., February 1846, pp. 182–85; Anon., February 1, 1846 (G. G.), pp. 3–6; Anon., February 1, 1846, pp. 1–3; Anon., February 11, 1846 (C. A. D.); Anon., February 14, 1846, p. 379; Anon., March 8, 1846 (F. C. A.), pp. 41–42; Blanc 1846; Delécluze, January 28, 1846; Jal 1846, pp. 201–2; Jubinal 1846, pp. 61–62; La Fizelière, February 1, 1846; Lagenevais 1846, pp. 538, 539; Lenormant 1846, pp. 664–74; Lestelley 1846, pp. 257–58; Mantz 1846, p. 200; Ronchaud, February 19, 1846; Saint-Louis 1846; Thoré 1846, pp. 54, 58, 59; Thoré, March 10, 1846; Ver-Huell, January 20, 1846; Ver-Huell, January 25, 1846; Magimel 1851, no. 67, ill. (engraving by Réveil); About 1855, p. 133; Anon., July 6, 1855, p. 68; Belloy, June 10, 1855; Du Camp 1855, p. 83; Duval 1855, p. 414; Gautier 1855, p. 165; Gebauër 1855, p. 27; Lacroix 1855, p. 207; Mantz 1855, p. 226; Mornand 1855, p. 227; Nadar, September 16, 1855; Niel, June 17, 1855; Niel, July 15, 1855; Perrier 1855, p. 45; Petroz, May 30, 1855; Thierry 1855, p. 203; Amaury-Duval 1856, p. 177; Duval 1856, p. 49; Silvestre 1856, pp. 20, 28, 31, 32, 38, 39; *Visites et études* 1856, p. 116; Anon., April 7, 1867, p. 109; Castagnary, May 18, 1867; Merson and Bellier de la Chavignerie 1867, pp. 23, 116; Ronchaud 1867, p. 445; Blanc 1867–68, pt. 6 (1868), p. 361; Blanc 1870, pp. 144–45; Delaborde 1870, no. 126; Doudan 1876–77, vol. 3, p. 172; Momméja 1904, p. 103; Momméja 1905a, pp. 138–39; Wyzewa 1907, pl. XXXII; Boyer d'Agen 1909, pp. 349, 360, 363, 367, 370–71, 379; Lapauze 1911a, pp. 380–84, ill. p. 393; Amaury-Duval 1921, p. 250; *La Renaissance de l'art français* 1921, ill. p. 262; Bell 1926, pl. III, b; Fröhlich-Bum 1926, pp. 29, 60; Hourticq 1928, p. 88, ill.; Zabel 1930, p. 374, ill. p. 371; Pach 1939, pp. 40, 103–5, 108, ill. opp. p. 198; Ritchie 1940, pp. 119–26, figs. 1, 15; Cassou 1947, p. 68, pl. 23; New York, Frick Collection 1949, pp. 196–200; Alazard 1950, p. 106, pl. LXXX; Wildenstein 1954, no. 248, pls. 91, 92; Mathey 1955, p. 7; Mongan 1957, p. 4; Garrisson 1965, p. 10; Cambridge (Mass.) 1967, under nos. 85, 86, fig. 12; Rosenblum 1967a, p. 148, pl. 40; New York, Frick Collection 1968, pp. 134–40; Radius and Camesasca 1968, no. 138, ill.; Scharf 1968, pp. 26, 27, fig. 18; Clark 1971, pp. 359–60, pl. I; Baudelaire 1975–76, vol. 2 (1976), pp. 412, 460; Hauptman 1977, pp. 121–22, fig. 1; Naef 1977–80, vol. 3 (1979), pp. 327, 332, 334, 335, 336, 426, ill. p. 327, fig. 1; Cambridge (Mass.) 1980, under no. 45; Montauban 1980, under no. 96; Picon 1980, p. 67; Ternois 1980, no. 291, ill.; Louisville, Fort Worth 1983–84, p. 140, ill. p. 141; Bryson 1984, pp. 167–69, fig. 96; Tübingen, Brussels 1986, under nos. 51–52, ill.; Rosenthal 1987, pp. 177, n. 1, 180, 184, 406; Zanni 1990, no. 92, ill.; Innsbruck, Vienna 1991, pp. 41–42, fig. 13; *Le Baron Taylor* 1995, pp. 34, 112, 123, pl. 65; Fleckner 1995, pp. 215–17, 237–49, pl. V; Vigne 1995b, pp. 249–50, fig. 204; Roux 1996, pp. 19, 27, 70, pl. 21

Cat. no. 126. *Study for "Comtesse d'Haussonville"*

ca. 1845
Graphite, squared
9¼ × 7¾ in. (23.4 × 19.6 cm)
Signed lower left: Ing
Fogg Art Museum, Harvard University Art
Museums, Cambridge, Massachusetts
Bequest of Meta and Paul J. Sachs 1965.0294
New York only

PROVENANCE: Alfred Beurdeley; his sale,
Galerie Georges Petit, Paris, December 2, 1920,
no. 242; Wildenstein and Co., Inc., New York;
purchased from them by Paul J. Sachs, 1927; Paul
J. and Meta Sachs; their bequest to the Fogg Art
Museum, Harvard University Art Museums,
Cambridge, Mass., 1965

EXHIBITIONS: Saint Petersburg 1912, no. 664;
Cambridge (Mass.) 1929, no. 86; Saint Louis
1933; Cambridge (Mass.) 1934, no. 47 [EB];
Brooklyn 1939; Springfield, New York 1939–40,
no. 45; Winnipeg 1954, no. 13; Chicago,
Minneapolis, Detroit, San Francisco 1955–56,
no. 107; Bloomington 1957; Rotterdam, Paris,
New York 1958–59, no. 135; New York 1961,
no. 55; Cambridge (Mass.), New York [EB]
1965–67, no. 45; Cambridge (Mass.) 1967, no. 85;
New York 1972, no. 9; Cambridge (Mass.) 1980,
no. 45; Miami 1984, no. 94; New York 1985–86,
no. 39; Tübingen, Brussels 1986, no. 51

REFERENCES: Zabel 1930, pp. 378, 381, ill.
p. 374; Mongan and Sachs 1940, no. 704, fig. 375;
Ritchie 1940, pp. 122, 123, 126, fig. 8; Huyghe
and Jaccottet 1948, p. 173, ill. p. 8; New York,
Frick Collection 1949, p. 199; Alazard 1950,
pl. LXXIX; Slatkin and Slatkin 1950, pp. 18, 66;
Huyghe and Jaccottet 1956, p. 165, pl. 8; Watrous
1957, p. 122, ill. p. 137; Ternois 1959a, preceding
no. 64; Montauban 1967, under no. 123; Paris
1967–68, under no. 234; New York, Frick
Collection 1968, p. 138; McCarthy 1978, pl. 7;
Leymarie, Monnier, and Rose 1979, ill. p. 70;
Ternois 1980, p. 101; Golden 1986, p. 61, fig. 2;
Fleckner 1995, fig. 85; Mongan 1996, no. 242, ill.

Cat. no. 127. *Study for "Comtesse d'Haussonville"*

ca. 1845
Black chalk and graphite
14⅛ × 8⅛ in. (35.9 × 20.4 cm)
Inscribed at right of figure: plus de mouvement /
grand foyer de / lumière / plus [crossed out]
[more movement / great source of / light /
more (crossed out)]
At lower right, the artist's posthumous atelier
stamp (Lugt 1477)
Fogg Art Museum, Harvard University Art
Museums, Cambridge, Massachusetts
Bequest of Meta and Paul J. Sachs 1965.0295
New York only

PROVENANCE: Étienne-François Haro
(1827–1897), Paris; Ernst May (1845–1925),
Paris; Alphonse Kann (1870–1948), Paris and
London, until 1920; purchased from him by Paul J.
Sachs, 1920; Paul J. and Meta Sachs; their bequest
to the Fogg Art Museum, Harvard University
Art Museums, Cambridge, Mass., 1965

EXHIBITIONS: Cambridge (Mass.) 1929,
no. 88; Cambridge (Mass.) 1934, no. 46 [EB];
New York 1961, no. 56; Cambridge (Mass.) 1964,
no. 21; Cambridge (Mass.), New York [EB]
1965–67, no. 46; Cambridge (Mass.) 1967,
no. 86; Paris 1967–68, no. 235; New York 1972,
no. 10; Cambridge (Mass.) 1980, no. 46; New
York 1985–86, no. 42

REFERENCES: Zabel 1930, pp. 378, 381;
Mongan and Sachs 1940, no. 705, fig. 376; Ritchie
1940, p. 123, fig. 10; Cassou 1947, pl. 22; Bertram
1949, pl. XXIX; New York, Frick Collection
1949, p. 199; Alazard 1950, pl. LXXVIII; Millier
1955, pl. 38; Watrous 1957, ill. p. 131; Rosenberg
1959, p. 107, fig. 195b; Ternois 1959a, preceding
no. 64; Montauban 1967, under no. 123; New
York, Frick Collection 1968, p. 138; McCarthy
1978, pl. 8; Picon 1980, ill. p. 90; Ternois 1980,
p. 101; Golden 1986, p. 61, fig. 1; Mongan 1996,
no. 243, ill.

Cat. no. 128. *Study for "Comtesse d'Haussonville"*

ca. 1845
Graphite and black chalk, squared
14 × 8⅛ in. (35.4 × 20.5 cm)
Signed lower right: Ing
At upper left, the artist's posthumous atelier
stamp (Lugt 1477)
Collections of the Société des Arts de Genève, Ing. 2
Gift of M. René Engel
New York only

PROVENANCE: René Engel, Geneva; his gift
to the Société des Arts de Genève, 1925

EXHIBITIONS: Geneva 1963, no. 68; New York
1985–86, no. 43; Tübingen, Brussels 1986, no. 52

REFERENCE: New York, Frick Collection
1968, p. 138; Fleckner 1995, fig. 89

Cat. no. 129. *Study for "Comtesse d'Haussonville"*
(Arms)

ca. 1845
Black chalk
18⅜ × 12¼ in. (46.8 × 31 cm)
Inscribed upper left: bras de me d'haussonville
[arms of Madame d'Haussonville]
New York only
Musée Ingres, Montauban 867.262

PROVENANCE: The artist's bequest to the city
of Montauban, 1867; Musée Ingres, Montauban

EXHIBITIONS: Paris 1867, no. 352; Paris 1921,
no. 148; Malmö, Göteborg, Stockholm 1965,
no. 52, ill.; Montauban 1967, no. 125; Paris
1967–68, no. 236, ill.; Montauban 1970, no. 22;
Liverpool, Kingston-upon-Hull, London
1979–80, no. 35, ill.; Montauban 1980, no. 98;
Tokyo, Osaka 1981, no. 98, ill.; Mainz 1983,
no. 45, ill.; New York 1985–86, no. 40, pl. 6

REFERENCES: Lapauze 1901, pl. 18; Malingue
1943, ill. p. 9; Millier 1955, ill. p. 6; Ternois 1959a,
no. 69, ill.; Cambridge (Mass.) 1967, under
no. 86; Paris 1967–68, under no. 235; Pansu
1977, fig. 68; Picon 1980, ill. p. 91; Ternois 1980,
ill. p. 146; Fleckner 1995, fig. 86; Vigne 1995a,
no. 2667, ill.

Cat. no. 130. *Study for "Comtesse d'Haussonville"*

ca. 1845
Black chalk and graphite
13⅞ × 6⅞ in. (35.1 × 17.3 cm)
Signed center left: Ing
At upper right, the artist's posthumous atelier
stamp (Lugt 1477)
The British Museum, London 1886-4-10-31
New York only

PROVENANCE: Alphonse Wyatt Thibaudeau,
Paris and London; purchased from him by the
British Museum, London, 1886

EXHIBITION: New York 1985–86, no. 44

REFERENCES: Opresco 1928, pp. 243–44;
Ritchie 1940, p. 123, n. 22, fig. 11

Cat. no. 131. *Study for "Comtesse d'Haussonville"*
(Head)

ca. 1845
Graphite
12⅝ × 8⅝ in. (32 × 22 cm)
Inscribed at top: faire luire les cheveux / très
claire [make the hair shine / very light]
At upper left, the artist's posthumous atelier
stamp (Lugt 1477)
Musées de Carpentras, France 1899.407
New York only

PROVENANCE: M. Léonce de Seynes; his gift
to Jules-Joseph-Augustin Laurens, intended for
the museum, Carpentras; given to the Musées de
Carpentras, January 1900

EXHIBITIONS: Montauban 1967, no. 128;
Paris 1967–68, no. 237; New York 1985–86,
no. 48

REFERENCES: Sibertin-Blanc 1960, p. 9, ill.;
Fleckner 1995, fig. 88

132. Baronne James de Rothschild, née Betty von Rothschild

1848
Oil on canvas
55⅞ × 39¾ in. (141.9 × 101 cm)
Signed and dated center left: J. Ingres Pinxit
1848 [J. Ingres painted (this) 1848]
Inscribed upper right above the Rothschild coat of arms: B^ne BETTY DE ROTHSCHILD
Private collection
London only

W 260

"Do you know who is Viceroy and even King of France? It's Rothschild." So wrote the wife of the Russian ambassador to France in 1840.[1] She was speaking of James de Rothschild (1792–1868; figs. 247, 260), the youngest of the five famous sons of the Frankfurt banker Mayer Amschel Rothschild. Known collectively as Metternich's bankers because of their role in the post-Napoleonic restructuring of Europe, the Rothschilds supported the Bourbon government by providing loans for the war damages that the allies had imposed on France. But James rose to prominence during the reign of Louis-Philippe (1830–48), becoming an intimate of the king, dining frequently at the Palais des Tuileries, and investing his private fortune. Perhaps a more significant sign of James's status at court was how warmly his wife was received: "Queen Marie-Amélie herself has received Mme de Rothschild with a welcome regard that is all the more touching since the duchesse d'Angoulême [niece of the former king, Charles X] always refused to receive her; baronne de Rothschild finds herself associated with most of the good ladies who manage the queen and her daughters-in-law."[2]

James de Rothschild participated in many of the major projects launched under the government of Louis-Philippe—from financing in 1833 the first railroad in France, the Paris to Saint-Germain line, and, more spectacularly, in 1845 the Ligne du Nord to Lille and Brussels, to bankrolling new construction and industry in Paris, Lyons, and Marseilles—thus anticipating many of the great changes in the French economy that were realized during the Second Empire. He also lived quite flamboyantly, in a style that foreshadowed another significant aspect of life during the period. In 1817, at the age of twenty-five, he bought a château at Boulogne, on the outskirts of Paris; the following year he purchased a house in the center of town, only to buy another, the grand Hôtel d'Otrante, in December of the same year. The former house and two adjacent to it

on the rue d'Artois (later renamed the rue Lafitte) would become the fortress from which James launched his conquest of Paris. The Austrian ambassador to Paris, Rudolphe Apponyi, noted in his diary a dinner "at the house of the famous banker de Rothschild . . . James is thirty-two, small, ugly, and proud, but he gives parties and dinners. The grand lords make fun of him but are no less charmed to go to dinner there, where he brings together the best company in Paris."[3] For Balzac he served as the inspiration for the baron de Nucingen; for Stendhal, the father of Lucien Leuwen.[4]

On July 11, 1824, James married Betty (1805–1886), the daughter of his eldest brother, Salomon, who lived in Vienna. As James confided, "In our family, we have always tried to keep love in the family: in this sense, it was more or less understood since childhood that children would never think of marrying outside the family, so that our fortune would never leave it."[5] Together they had five children: Charlotte, Mayer-Alphonse, Gustave-Salomon, Salomon-James, and Edmond-James. Known for her beauty and cultivation—Chopin was her piano teacher—Betty maintained a brilliant salon at 19, rue Lafitte, an eighteenth-century house in the Chausée d'Antin quarter, not far from the Stock Exchange. (Her father eventually moved into the house next door, the Hôtel Lannoy, where the emperor Napoleon III had been born.) Balzac, Heine,[6] Liszt, Puccini, Meyerbeer, and Moreau were guests at dinners there prepared by Marie-Antoine Carême, Talleyrand's former chef, who had also worked for the courts at London and Saint Petersburg. In 1836 the Rothschilds commissioned Henri Duponchel, who had worked with the previous architects, to rebuild the house with elaborate interiors in the late-medieval style of the reign of Francis I, recently back in vogue. Joseph-Nicolas Robert-Fleury provided troubadour paintings for one salon,[7] for which the sculptors Jean-Baptiste Klagmann and Jean-Jacques

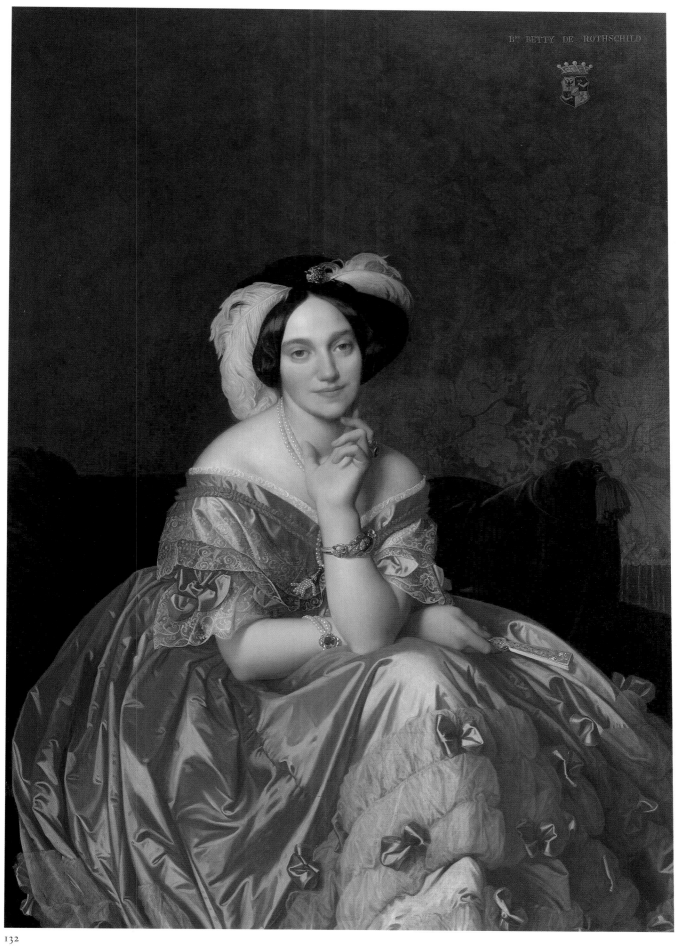

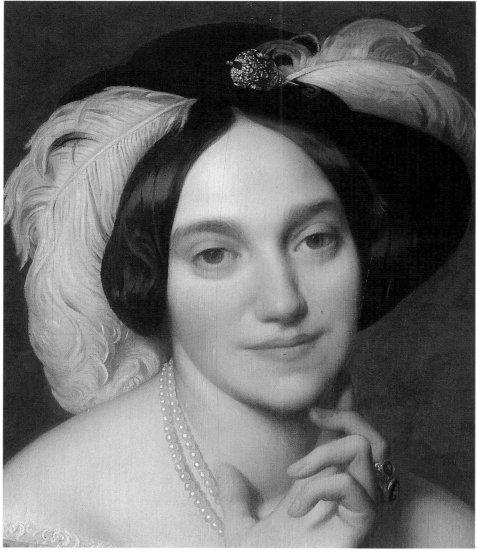

Fig. 246. Detail of cat. no. 132

Feuchère collaborated on the richly carved boiseries. Paintings of troubadour subjects by Ary Scheffer, Delacroix, and Bonington were hung in the various reception rooms, which when not carved were extensively decorated with gilding and paint. To commemorate one of many elaborate fancy-dress balls hosted by the Rothschilds, Betty and her son Alphonse posed in medieval costume for a portrait set in the Salon François I.[8]

Ingres had probably not encountered the Rothschilds prior to his triumphal return to Paris in 1841, but for them, as for other elite intimates of the royal court, he was the most coveted portraitist, growing in desirability each time he refused a commission. The Rothschilds laid siege and seemed to have won a concession by early summer 1842, just after Ingres completed the portrait of the duc d'Orléans. On

June 26 Ingres reported to his friend Jean-François Gilibert, "And Tuesday, I have a definite sitting with Mme de Rothschild, which came at the price of a dozen puerile and sincere letters. Long live portraits! May God damn them . . . !"[9]

Ingres appears to have immediately captured the pose at that first session. The earliest study extant (fig. 249) shows Betty seated, head held in hand in a manner quite similar to that of the comtesse d'Haussonville (cat. no. 125).[10] Just as Ingres adapted the pose of the marquis de Pastoret (cat. no. 98) for the portrait of the duc d'Orléans (cat. no. 121), so he seems to have taken the position of the head and arms of the comtesse d'Haussonville, seen from a different angle, as a point of departure for his depiction of Betty de Rothschild. Ary Scheffer's 1842 portrait of Charlotte de Rothschild (fig. 248) may also have

provided a model for Ingres. In that work, Charlotte is seated, her hand brought to her face, in the same room with green damask wall hangings and deep red upholstered furniture in which her mother was to be depicted; in fact, the portrait of Betty may have been conceived as a pendant to the likeness of her daughter. There are two additional drawings that were probably made during Ingres's initial work on the commission in 1842 (figs. 250, 251), since the dress the baroness wears in them—one with a curved neckline and short, tight sleeves—is different from the one she wears in the final painting.

Work on both the Haussonville and Rothschild portraits was interrupted in July 1842 by the accidental death of the duc d'Orléans. Ingres's energies were to be taken up for some time with royal commissions for repetitions of the duke's portrait and designs for the stained glass of his memorial chapel. In February 1843, he gave "the head of Mme de Rothschild" as the fourth item in a long list of work that needed to be completed before the beginning of June, when he planned to go to the Château de Dampierre to work on his murals for the duc de Luynes.[11] It is not known whether he made any headway. That summer, anticipating his duties in the autumn, he wrote, "Finally, in November, more drudgery: the Rothschild and Haussonville ladies, another copy of the prince (it is the fifth), a *full-length* duc d'Orléans."[12] In December 1843 Ingres mentioned to Gilibert the "two portraits of ladies that are only sketched in," meaning Haussonville and Rothschild.[13] Six months later, he wrote, "Alas! They are naming a street after me and I cannot finish the portrait of Mme d'Haussonville this year, and that of Mme de Rothschild needs to be begun again! I am compelled to do another."[14]

Evidently Ingres intended to discard his original canvas in order to begin again, just as he had done with the portrait of the comtesse d'Haussonville, but this first attempt has never resurfaced; more likely it exists, scraped down, under the present picture. In the summer of 1845, when the Haussonville portrait was finished, the Rothschild portrait remained incomplete: "Before giving myself over to my important work, I still have two portraits of the

Fig. 247. André-Adolphe-Eugène Disdéri (1819–1889). *James de Rothschild*. Photographic carte de visite (detail), 1859. Cabinet des Estampes et de la Photographie, Bibliothèque Nationale de France, Paris

first order to finish: Madame de Rothschild and Madame Moitessier."[15] Work for the Rothschilds finally seems to have progressed during the spring of 1847, for in June of that year he wrote: "I have barely finished M^me de Rothschild, begun again better, and the portrait of M^me Moitessier. Cursed portraits! They always prevent me from undertaking important things that I cannot do any faster, for a portrait is such a difficult thing."[16] Since Ingres repeated that the barely finished portrait had been begun again, it would seem that this new version was in fact quite recent.

The remaining preparatory drawings, four at Montauban and three at Bayonne, appear to date from one prolonged campaign in the first half of 1847 (figs. 252–58). They show Ingres working out the relationship of the arms to the head and of the underlying figure to the voluminous dress. Above all, they show him arranging the elaborate sequence of folds of the skirt as it cascades over the hips and legs of the sitter. The most famous of these studies, a drawing of the skirt in black and white chalk (fig. 255), achieved the status of an independent work of art: it was exhibited

in 1861 and 1867 and was photographed by Charles Marville. A description of the work in 1861 indicates that it had been executed on pink paper (which has now faded to white): "The exhibited drawing shows only the dress, ornamented with numerous bows, of which the smallest pleats are studied with infinite care. Traced with black crayon on pink paper, this sketch is skillfully heightened with white."[17] Nevertheless, Ingres was dissatisfied with how the folds fell over the extended leg. On an additional sheet (fig. 256), he drew the skirt falling from the knees straight to the floor.[18] The face of the baroness does not appear in this second set of drawings, which were probably made from a professional model long after Ingres had completed painting the sitter's features from life on his canvas. One of the last details to be resolved was the position of the right hand: drawings early in the sequence show the hand with folded fingers, while later ones have the fingers extended to hold a fan, the subject of a separate drawing (fig. 257). The study of the left arm (fig. 258) was drawn from a right arm and then reversed, as Georges Vigne has observed.[19]

It has not previously been noted that the two sets of drawings—those circa 1842 and those circa 1847—depict two different dresses. This change of costume is substantiated both by Ingres's own stated resolve to begin the picture anew and by an important commentary from the critic Louis Geofroy. Writing in 1848, after viewing the completed portrait in Ingres's studio, Geofroy reported that the color of the dress had been transformed for aesthetic reasons:

There is a whole story about the dress: it was originally blue, having been selected according to the preference of the model; but once the painting was finished, the artist, unhappy with the effect, suddenly decided to change it without saying a word or asking anyone. Going back to his painting with coats of lacquer, he submitted it to a total transformation in two days. Great disappointment at the news and repeated entreaties brought the artist to the brink of reverting to the preferred color. "Madame," he responded phlegmatically, "I paint for myself and not for you. Rather than change anything, I

would prefer to keep it for myself." And he would have done as he said. M. Ingres, for all that, was right. The light red that he adopted warmed the general tone of the picture, and harmonized better with the pomegranate velvet and dark green damask wall hangings in the background, a background which, parenthetically, is too high. The traces of the operation were not completely erased. The blue underpainting did not disappear in the places covered by gauze or by the lace of the corsage. It results in a bluish tint and, in certain passages of the fabric, violet reflections, which, perhaps intentionally, give the silk a rich effect.[20]

This fascinating story, excerpted from a long account that is reprinted below, must have been largely invented. For one thing, it is inconceivable that Ingres would have threatened the baroness with the words Geofroy ascribes to him, even if he may have boastfully said to others that he had. For another, while there may have been a blue dress (perhaps conforming to the gown of the early drawings) under the present red one, the color change does not appear to have been an arbitrary decision by the artist. A previously unknown account has recently been found of the baroness wearing what may be the very dress that Ingres depicts in the finished portrait.[21] She was observed by a reporter for the

Fig. 248. Ary Scheffer (1798–1858), *Charlotte, Baronne de Rothschild*, 1842. Oil on canvas. Private collection

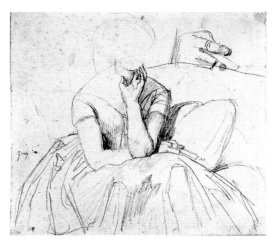

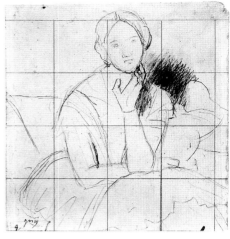

Fig. 249. *Study for "Baronne de Rothschild,"* ca. 1842. Graphite on paper, 2¾ × 2⅜ in. (6.9 × 6 cm). Musée Ingres, Montauban (867.370b)

Fig. 250. *Study for "Baronne de Rothschild,"* ca. 1842. Graphite on paper, 6½ × 7⅛ in. (16.5 × 18 cm). Musée Ingres, Montauban (867.372)

Fig. 251. *Study for "Baronne de Rothschild,"* ca. 1842. Graphite on paper, 5¾ × 4⅞ in. (14.6 × 12.5 cm). Musée Ingres, Montauban (867.371)

Journal des dames et des modes at a musical fête given in Paris by the duc de Nemours in March 1847, just as Ingres was working on the portrait:

> The pretty M^me de R . . . was wearing a dress of rose taffeta, the full length [of the skirt] ornamented with shirred puffs forming four bands; a flat corsage, low cut, the front ornamented with a puff forming a point strewn with small sequins; short sleeves with clumps of satin ribbons on the shoulder falling over the sleeve; a soft cap in green velvet, decorated with a panache of sequined marabou feathers.[22]

Although it is true that this description omits the lace on the bodice as well as the satin bows, the remainder of the report is remarkably close. Even if this is not a description of the dress in Ingres's portrait, there can be no doubt that the baroness owned the dress that we see, since Ingres always scrupulously rendered precisely what was placed before him; it is also probably not a coincidence that a study of the skirt (fig. 255) was executed on pink paper. Furthermore, the blue-gray tint of the lace and the poufs in the portrait are probably not the result of repainting but rather an accurate representation of the colored lace—"blondes de couleur"— and netting then in fashion. The dress, an up-to-date and elaborate ball gown, is very close to several illustrated and described in Paris fashion magazines from the year 1847: "For balls . . . dresses are

excessively low cut and furnished with corsages, bows, flowers, or colored lace. The sleeves descend a bit and are very decorated; the waists are long and quite arched in front and behind; the skirts are layered and very voluminous."[23] Another account states that "these ribbed velvet hats, very simple and having no ornament other than a long plume, are very stylish."[24]

The jewelry of the baroness was no less fashionable: "Pearls have made a strong comeback 'à la mode': we have seen at *Guillion's,* ready to leave for a northern court, a magnificent bracelet composed of five rows of black pearls with a diamond clasp."[25] The bracelet on Betty's right arm is similarly styled but is made of white pearls clasped with an enormous ruby. That on her left arm, a jewel-studded knot in gold and steel, "what one calls *artistic* jewelry, that is to say an obvious mix of *iron* and gold, is the latest style."[26] Betty evidently understood that the great parures of matching tiara, necklace, earrings, and brooches, as worn by Queen Marie-Amélie, were hopelessly out of date. Describing the women at a charity ball held in Paris in August 1847, a fashion reporter noted that "there were diamonds and jewels, but, you understand, they were not worn by the women who have inherited their stones; that luxury is in bad taste, as are all passing fads. The only jewels properly worn are brooches, buckles, pins, and the artistic bracelets of Guillion."[27]

Following his custom, Ingres exhibited the completed painting in his studio in the summer of 1848. Its display along with the *Venus Anadyomene* (fig. 201) made a strange juxtaposition but one that was no less bizarre than, say, the exhibition of the portraits of Cherubini and the duc d'Orléans with *The Virgin with the Host* (fig. 200) in 1842. Needless to say, the portrait of Betty de Rothschild was immediately understood and well received. Théophile Gautier, a worldly critic who probably was acquainted with the baroness, wrote a most appreciative review:

> In a neighboring room, shining on an easel, there was a completely modern painting with a completely different feeling [from that of the *Venus Anadyomene*]. —It was a portrait, the portrait of madame de R. . . .
> It [would be] difficult to make a personality and a social position better understood [than Ingres did] with the choice of the pose and the arrangement of the costume.
> The artist had to paint a woman of the world, the world that bathes in an atmosphere of gold; he knew how to be opulent without being ostentatious, and he corrected the sparkle of the diamonds with the flash of intelligence and wit.
> Madame de R . . . , dressed in a gown of lively and brilliant pink, has just seated herself amid splendid pleats and rich fabrics that still billow; one of her elbows rests on her knee; her right hand casually plays with a closed fan; the left hand, half folded, barely touches her chin. The eye

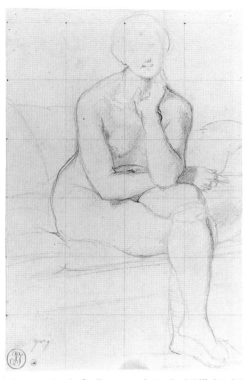

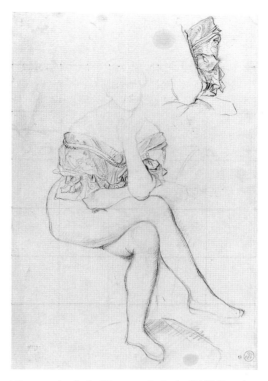

Fig. 254. *Study for "Baronne de Rothschild,"* ca. 1847. Graphite on paper. Musée Bonnat, Bayonne

Fig. 252. *Study for "Baronne de Rothschild" (Nude)*, ca. 1847. Graphite on paper, 11⅞ × 6¼ in. (30 × 15.8 cm). Musée Bonnat, Bayonne

Fig. 253. *Study for "Baronne de Rothschild" (Legs)*, ca. 1847. Black chalk on paper, 15¼ × 10⅛ in. (38.6 × 25.7 cm). Musée Bonnat, Bayonne

sparkles, lit by a retort ready to burst from her lips. It is a spirited conversation, begun in a ballroom or at supper, that is still going on; one can almost hear what the interlocutor is saying just outside the frame.

The headdress comprises a beret of black velvet that graciously accompanies a white feather. —This Athenian of the rue Mazarine [Ingres] had the coquetry to place his grand style at the service of the fashion press, and this beret, which the milliner M^me Baudrand could sign, is, despite its exactitude, [rendered] in the most beautiful Greek style.

Once time has passed its patina over this admirable portrait, it will have color as beautiful as a Titian. At present, it has a vigorous and striking tone that the most lively colorists of our school could obtain only with difficulty.

Never before has M. Ingres made anything so simply bold, more lifelike, or more modern; to extract beauty from one's own milieu is one of the most difficult tasks of art.[28]

It is not certain in which room Ingres set this witty conversation. The walls hung with green damask do not correspond to photographs of the various salons at 19, rue Lafitte prior to its destruction in 1967, nor to drawings of the 1836 reconstruction. But the decor of many of the smaller rooms is no longer known. Betty's portrait, as well as that of Charlotte—if not set at 19, rue Lafitte—may show one of the sitting rooms at their country house at Ferrières before Joseph Paxton and Eugène Lami completely rebuilt it during the Second Empire. After construction at Ferrières was completed in the early 1860s, Ingres's painting of Betty and Hippolyte Flandrin's likeness of James were hung on the green walls of the grand living hall of the palatial mansion (fig. 259).

Like Gautier, Louis Geofroy wrote at length after viewing the portrait of the baroness in Ingres's studio in 1848. His tale of the dress was excerpted above, and the majority of his remarks concerning the portrait are as follows:

Let us pass into the neighboring room. We find ourselves facing the portrait of M^me la baronne de Rothschild. We are transported from the sphere of dreams to the real world, [to stand] before reality in its most complete expression. It is good that these completely opposite works were not

placed side by side; there are not more than four or five steps separating them in which to prepare for such an abrupt transition.

At first sight, this portrait causes a bit of surprise. The eye needs to adjust to the luxurious reds that initially strike it; but once it has entered into this range of colors, it can only admire the precision and the richness. The spectator, captivated by this unexpected color, is reminded of previous portraits by the author, in which the perfection of the drawing, the extreme truthfulness of the gestures, the study of details pushed to the ultimate, sufficed, even in the absence of color, to create works so remarkable. Finding here the same qualities enhanced and completed, he does not hesitate to place this work in the first rank. And in fact the portrait of M^me de Rothschild is as good as that of M. Bertin; that says it all. Same bold stroke, same amplitude, same power. . . . This time M. Ingres could use color, and he did so with verve. . . .

The sitter, seated on a divan, faces the viewer as if in the midst of an attentive discussion, the knees crossed, the left hand lightly supporting the chin, the right arm thrown sideways with abandon, holding a closed fan. The head is dressed with

a soft hat in black velvet, attached in the back and decorated with two white plumes that fall left and right, framing the hair with bluish highlights like those of a raven's wing. The arrangement of the head, which recalls certain portraits of Van Dyck, admirably brings out the whiteness of the forehead and temple and the more vivid color of the rest of the face. Two large eyebrows *à l'orientale* are drawn on the forehead, whose polish glows; in the same manner life and wit sparkle in the eyes. This section is washed with abundant light and studied with extreme care. Evidently the artist has devoted all his skill to highlighting this part and to retaining, by the vivacity of the expression, the irregularity of the lines. There is nothing softer and at the same time more intelligent than her look, which strikes one as that of a sincere woman. How well that goes with the friendly smile that lifts the corners of the mouth! There is nothing more lifelike than this head, which seems to emerge from the canvas to ask us a question; there is nothing more natural than this pose full of ease and casual elegance. M. Ingres excels at giving his models the pose that corresponds to their nature. His choice of a pose is ordinarily the fruit of assiduous observation in his studio, most often studied without clothes, and that is one of the reasons why his portraits are so lifelike. Why do we usually decide, without knowing

the model, that his portraits resemble the sitters? It is because one finds such realism, such truth in technical details. It is because one knows that nothing has been included without a reason, nothing is left to chance, that the picture is life itself, life viewed from the fact. Thus, if we encounter in the portrait of M^me de Rothschild a joint a bit too thick at the left wrist, it is apparently because M. Ingres would never permit himself to omit a defect that he had before his eyes. Should we attribute to the same scruples the change in the skin, which seems to have been caused by a head cold, around the lips? If I remember correctly, the same defect was noticed in the portrait of M^me d'Haussonville. Until it is proved that there was a fortuitous resemblance between two models simultaneously struck by flu, we will blame M. Ingres for this infection.

The arms and the shoulders are handsomely drawn and modeled almost without shadow; yet the eye turns around them. There is the same freshness of color and transparency as in *The Anadyomene*. The dazzling shoulders are richly set off from the dark velvet of the cushions. And the fabrics! They are surely of Venetian manufacture, and would have hardly dishonored the shoulders of a doge. The [dresses] of such a woman as they are made today [do] not lend [themselves] to the grand designs of [antique] drapery; one falls into dryness and minutiae in restrict-

ing oneself to reproducing them exactly as they are. M. Ingres has triumphed over that difficulty. He has wrinkled the satin bows and the gauze marvelously. The silk gown, decorated with gauze in a manner that eliminates large masses, is painted with such truthfulness and amplitude that one does not miss the majestic folds of the [Greek] *stola*. [The story of the dress, quoted above, falls here.]

Rarely has the severe brush of M. Ingres drawn with such compliance and verve the seductive disorder of shimmering fabrics and of jewels of a thousand colors. It is painted *con amore*, and to find respite, as he says, from the nude, to which he has devoted himself at Dampierre. . . . We appreciate that he has proved his need for this riot of color. When twenty-five years will have passed over this magic, when time will have melted these opulent reflections, softened the diamonds of these pins and bracelets, true mosaics in precious stones, when, above all, time will have thrown its golden tan over the magnificent flesh tones, the portrait of M^me de Rothschild will not fear comparison with any left to us by the spirited school of Venice, and it will be a pleasure to place it next to a Tintoretto or a Moroni.[29]

Carol Ockman has recently written a provocative, although unconvincing, analysis of Geofroy's account, in which she finds coded references to the sensual

Fig. 256. *Study for "Baronne de Rothschild" (Dress)*, ca. 1847. Graphite on paper, 8¾ × 8⅝ in. (22.2 × 21.9 cm). Musée Ingres, Montauban (867.374)

Fig. 255. *Study for "Baronne de Rothschild" (Dress)*, ca. 1847. Black and white chalk on paper, 13⅛ × 10¼ in. (33.2 × 25.9 cm). Musée Ingres, Montauban (867.375)

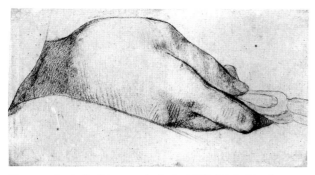

Fig. 257. *Study for "Baronne de Rothschild" (Right Hand)*, ca. 1847. Graphite on paper, 4⅝ × 7⅞ in. (11.2 × 20 cm). Musée Ingres, Montauban (867.376)

Fig. 258. *Study for "Baronne de Rothschild" (Arm)*, ca. 1847. Red chalk on paper, 15¼ × 5 in. (38.7 × 12.6 cm). Musée Ingres, Montauban (867.377)

world of the harem and to conventional stereotypes of Jewish women. It is true, as she states, that in the nineteenth century there was a craze for typology, from Johann Kaspar Lavater's study of expression to generic studies of phrenology; it is also true that in Europe Jewish women, together with those of other Mediterranean cultures, were characterized as "oriental," as belonging to the "other," which is to say "different from us." But different does not always mean worse. In this case, Geofroy is lavish in his praise of Betty de Rothschild's beauty, intelligence, and wit, and he discusses these qualities as flattering terms of respect, not coded references to her sexual availability. The phrases that Ockman finds revelatory— which she translates as "hair with bluish tints like the wing of a raven" and "two large eyebrows 'à l'orientale'"—are slim threads from which to hang a discourse on anti-Semitism in France, regardless of Geofroy's own politics. The conventional stereotype, formulated in the Old Testament, did call for Jewish women to have ivory skin, pomegranate lips, and raven-black hair. Yet abundant documentation exists, in painted portraits and in photographs, to indicate that Betty de Rothschild

did in fact possess each of those attributes. There is no reason to suppose that Geofroy experienced the "portrait's sexual excess," as Ockman sees it.[30] Indeed there is no reason at all to speak of sexual excess: such a description is not only wrong but inflammatory.[31] If the artist gave Betty de Rothschild greater warmth and intimacy than his other sitters, it could well be that she simply exhibited those qualities in abundance.

There has been some question concerning whether Ingres included this portrait in his display at the Exposition Universelle of 1855. The catalogue lists a "Portrait de Mme R . . ." under number 5048, but the painting is not visible in any of the photographs of the exhibit. Paul Lacroix listed the Rothschild portrait among the absentees in 1855,[32] but Émile Bellier de la Chavignerie catalogued it as present and Gustave Planche mentioned it in his review: "The portrait of Mme de Rothschild is full of grace and elegance, but I do not find the same realism that strikes me in the portrait of M. Bertin."[33] However, Planche could have seen Betty's portrait in 1848; the "Madame R." listed in the catalogue was Hortense Reiset (fig. 207), whose likeness was displayed.

While Napoleon III was celebrating his rise to power at the 1855 exposition, the Rothschilds were retreating from public view. Having been so intimately connected to the Orléans regime, it was only natural for them to be wary of change—in business and in society. After the February Revolution, Betty had written to her son Alphonse on December 30, 1848:

> How can we choose a party when the two candidates have so little in common with our sympathies and our beliefs? Must we vote for Louis B[onaparte], ridiculous symbol from an illustrious past, a political nonentity, who has no value other than as a negative power, this varnished socialist who, under the polish of agreeable manners, hides vulgarity? Should we lean toward the other [Louis-Eugène Cavaignac] . . . who, when in power, showed neither sincerity nor ability?[34]

When James met with Louis-Napoleon, he was not impressed. In the same letter, Betty described their interview to her son: "Papa talked with him for a long time and he finds him, between us, a nobody, without any importance whatsoever. He repeatedly insisted that your father come see him often and breakfast with him. Despite all his advances, your father will keep his guard and will not push himself forward along with all those people."[35] At first Betty refused invitations to the Palais de l'Élysée, home of the prince-president, but on April 26, 1849, she wrote, "I have finally broken the ice and have appeared in the salons of the Presidency, from which, without giving the appearance (and the pretension) of political intrigue, it was difficult to stay away any longer."[36]

Louis-Napoleon's finance minister, Achille Fould, feared the Rothschilds and continually counseled Bonaparte that "you must free yourself from the tutelage of the Rothschilds, who rule in spite of you."[37] In 1852 Louis-Napoleon awarded the contract for the Paris to Lyons railway to a consortium of bankers that united the Rothschilds with their rivals the Péreires, but when, in the same year, he allowed the Péreires to organize the Crédit Mobilier against James's recommendations, Rothschild's distrust of his regime was confirmed. The Crédit Mobilier, which financed

Fig. 259. *Hall at the Château de Ferrières*. Photograph, ca. 1880. Private collection

industry and business, and the Crédit Foncier, which financed mortgages, were both founded at the expense of the Banque de France, which was effectively controlled (albeit at arm's length) by James. Although James established the Société Générale in 1864 to compete directly with the Crédit Mobilier, more and more of his attention was directed to banking in Italy. Betty devoted much of the 1850s and 1860s to the building and furnishing of their extraordinary palace at Ferrières, where she recreated the fêtes she had known under Louis-Philippe. When Napoleon III visited Ferrières on December 16, 1862, Rossini himself directed the choir of the Paris Opéra.[38]

In 1851 Betty once again laid siege to Ingres, this time for the purpose of obtaining a portrait of her husband. The artist complained to Charles Marcotte:

> I hope, however, that once I have escaped from this ambush of portraits . . . but what am I saying? A superb hamper from M^me de Rothschild has just seeded terror in my heart, because, without a doubt, the portrait of M. de Rothschild is at the bottom of it. How can I do it? How? If I did not have enough resolve with the women, I certainly will with the men. I will pull out of this one.[39]

He did, and handed the commission instead to his favorite pupil, Hippolyte Flandrin (fig. 260), who since 1842 had been Charlotte de Rothschild's drawing teacher.[40] (Charlotte married her English cousin Nathaniel de Rothschild in 1842; for the occasion, Ingres presented her with a portrait drawing.)[41]

The Rothschilds commissioned copies of Ingres's portrait of Betty to give as gifts to her children and cousins. One of these, by Hippolyte's brother Paul, was recently donated to the Israel Museum.[42] Betty also had the portrait photographed by André-Adolphe-Eugène Disdéri in 1859 so that she could distribute it as a carte de visite; when she herself had sat for Disdéri about two years earlier, she had obligingly adopted the same pose (figs. 261, 262).[43] For her, Ingres's was the essential portrait, as she explained in a letter to the infamous comtesse de Castiglione (the mistress of Napoleon III who was befriended by Alphonse de Rothschild after her fall from grace): "There is no other apart from the one by Ingres, in the pink dress and hat with feathers, which you did not like."[44]

The Rothschilds lent the painting to the posthumous exhibition of Ingres's work in 1867. Curiously, it did not elicit copious comment, although it was always mentioned in the most flattering terms: "Among the numerous and superb portraits to be seen, we will cite those of M^me la baronne de Rothschild, M^me la comtesse d'Haussonville, M^me Fargeot [*sic*], M^me Leblanc, Bertin l'aîné, Bartholoni [*sic*], the comte de Molé, and MM. Bochet and Leblanc."[45] Charles Blanc, writing after the retrospective, echoed some of Geofroy's language in his discussion of the relative importance of accessories to the sitter: "The portrait shows an obliging and caressing execution in the fittings and in the jewelry, without the person shown being crushed by the magnificence with which she dresses and the richness with which she surrounds herself. Surprised in the natural position of a salon conversation, M^me de Rothschild is seated on a sofa of pomegranate velvet." He goes on to compare Ingres's technique with that of Holbein: "The satin dress, the necklace, the pearls, the bracelet, the diamonds and the feathers, despite their execution in the manner of Holbein, enrich the portrait without eclipsing it."[46]

The painting has only rarely been exhibited in public since 1867. After James died the next year, Betty retired to Ferrières, maintaining a certain social presence while involving herself in the lives of her children and grandchildren. It was from one of her

Fig. 260. Hippolyte Flandrin (1809–1864). *James de Rothschild*, 1863. Oil on canvas. Private collection

Fig. 261. André-Adolphe-Eugène Disdéri (1810–1889). *Baronne de Rothschild*. Photographic carte de visite (detail), ca. 1857–58. Cabinet des Estampes et de la Photographie, Bibliothèque Nationale de France, Paris

grandchildren that the portrait—along with most of the Rothschild collections—was seized in France, as Jewish property, during the German occupation of 1940–45. Of the paintings shown in Paris in 1946 in the exhibition of works that had been confiscated by the Nazis and repatriated by the Allies to France, it was one of the most spectacular. In 1967–68 the portrait was displayed in the centennial Ingres exhibition held in Paris, and it has not been lent since. Its presence in the current exhibition provides an extraordinary opportunity to confirm the critic Émile Galichon's appraisal of it in 1861 as "one of the most beautiful portraits of a woman painted by M. Ingres."[47] G.T.

1. "Sais-tu qui est Vice-Roi et même Roi de France? C'est Rothschild." Madame de Nesselrode to her husband, December 11, 1840, quoted in Prevost-Marcilhacy 1995, p. 38.
2. "La reine Marie-Amélie, elle aussi, avait accueilli Mme de Rothschild avec une bien-veillance qui lui était d'autant plus sensible que la duchesse d'Angoulême avait toujours refusé de la recevoir et la baronne s'était trouvée associée à la plupart des bonnes dames que dirigeaient la reine et ses belles-filles." "Notes et documents sur des personnages célèbres," MS no. 5065, Musée Calvet, Avignon, quoted in ibid., p. 286, n. 150.
3. "Chez le fameux banquier de Rothschild . . . James a 32 ans, il est petit, laid, et orgueilleux, mais il donne des fêtes et des dîners. Les grands seigneurs s'en moquent et n'en sont pas moins charmés d'aller dîner chez lui, où il réunit la meilleure compagnie de Paris." Apponyi 1913–26, quoted in ibid., p. 37.
4. Tulard 1995, p. 1132.
5. "Dans notre famille, nous avons toujours essayé de conserver l'amour, l'attachement familial: en ce sens, il était plus ou moins entendu depuis l'enfance que les enfants ne penseraient jamais à se marier en dehors de la famille, de sorte que la fortune n'en sortirait jamais." James de Rothschild to his brother Nathaniel, July 16, 1839, quoted in Prevost-Marcilhacy 1995, p. 24.
6. Betty de Rothschild's beauty is said to have inspired Heine's *The Angel*. Rosenblum 1967a, p. 104.
7. As Jews and foreigners—Betty was born in Vienna and James in Frankfurt—the Rothschilds have been natural targets for racist comments, both in their time and in ours. There has been much ado, for example, over alleged Semitic characteristics in Ingres's portrait of Betty (see Ockman 1995, pp. 67–83, and further in the present catalogue entry). It is interesting to note that Robert-Fleury seems to have made no such racial or religious distinctions in the subjects of the paintings he provided for the Rothschilds's salon: *The Arrival of Charles V in Spain*; *Leo X and Raphael at the Vatican*; *Luther Preaching Reform*; *Henry VIII Expelling Cardinal Wolsey*; *Guillaume Budé Presenting the First Printed Book to Francis I*.
8. Illustrated in Prevost-Marcilhacy 1995, p. 57.
9. "Et, Mardi, j'ai séance définitive avec M^me de Rothschild, au prix d'une douzaine de lettres puériles et honnêtes, pour en venir là! Vive les portraits! Que Dieu confonde les . . . !" Ingres to Gilibert, June 26, 1842, in Boyer d'Agen 1909, p. 349.
10. Georges Vigne is judiciously cautious on the subject of this drawing and believes it may be by another artist and may represent a different sitter; Vigne 1995a, no. 2777. However, most writers, including Cambon and Mommèja, accept this drawing as authentic, if slight, and identify it as the first study for the portrait of the baronne de Rothschild.
11. "la tête de M^me de Rothschild." Ingres to Gilibert, February 6, 1843, in Boyer d'Agen 1909, p. 360.
12. "Enfin, en novembre, autre galère: les dames de Rothschild et d'Haussonville, le Prince, encore une copie (c'est la cinquième) *en pied* du Duc d'Orléans." Ingres to Gilibert, July 20, 1843, in ibid., p. 363.
13. "deux portraits de femme qui ne sont qu'ébauchés." Ingres to Gilibert, December 30, 1843, in ibid., p. 370.
14. "Hélas! on donne mon nom à une rue et je ne puis finir le portrait de M^me d'Haussonville, cette année, et celui de M^me de Rothschild est à recommencer! Je suis forcé d'en faire un autre." Ingres to Gilibert, June 7, 1844, in ibid., pp. 370–71.
15. "Avant de me mettre tout à fait à mes grandes oeuvres, j'ai encore deux portraits de haute volée à terminer: Madame de Rothschild et Madame Moitessier." Ingres to Gilibert, July 27, 1845, in ibid., p. 379.
16. "J'ai à peine terminé M^me de Rothschild recommencée en mieux, et le portrait de M^me Moitessier. Maudits portraits! Ils m'empêchent toujours de marcher aux grandes choses que je ne puis faire plus vite, tant un portrait est une chose difficile." Ingres to Gilibert, June 24, 1847, in ibid., p. 388.
17. "Le dessin exposé ne donne que la robe ornée de noeuds nombreux, et dont les moindres plis sont cherchés avec un soin infini. Tracée, avec un crayon noir, sur un papier rose, cette esquisse est habilement rehaussée de blanc." Galichon 1861b, p. 43.
18. Carol Ockman interprets the crossed knees as a sign of sensuality and potential abandon, but this seems far-fetched to me; see Ockman 1995, p. 68. Charlotte de Rothschild crosses her knees in the portrait by Scheffer, and yet she appears virginal and pure.
19. Vigne 1995a, p. 502.
20. "C'est tout une histoire que celle de cette robe: elle était bleue dans l'origine, ayant été

Fig. 262. André-Adolphe-Eugène Disdéri (1810–1889). *Ingres's Portrait of Baronne de Rothschild*. Photographic carte de visite (detail), 1859. Cabinet des Estampes et de la Photographie, Bibliothèque Nationale de France, Paris

choisie au goût du modèle; mais, le tableau terminé, l'artiste, mécontent de son effet, sans mot dire et sans prendre conseil de personne, se décide subitement à la changer. Revenant sur sa peinture avec des empâtemens [*sic*] de laque, il lui fait, en deux jours, subir une transformation complète. Grand désespoir à cette nouvelle et instances réitérées auprès de l'artiste, qui est presque sommé de rétablir la couleur de prédilection. 'Madame, répond-il flegmatiquement, c'est pour moi que je peins et non pour vous. Plutôt que d'y rien changer, je garderai le portrait,' et il eût fait comme il disait. M. Ingres, du reste, avait raison. Le rouge clair qu'il a adopté a chauffé le ton général du tableau, et s'allie bien mieux au velours grenat et au vert sombre de la tenture damassée qui fait le fond, fond qui, parenthèse, a trop de hauteur. Les traces de l'opération n'ont pu être complétement effacées. Le dessous azuré n'a point tout-à-fait disparu aux endroits qui étaient recouverts par la gaze et les dentelles du corsage. Il en résulte pour celles ci une teinte bleuâtre, et, dans certains passages de l'étoffe, des reflets violets qui étaient peut-être dans l'intention de l'artiste, et qui donnent plus de richesse à la soie." Geofroy 1848, pp. 448–49.

21. I am extremely grateful to Kathryn Gallitz for this discovery as well as for many other insights.

22. "La jolie M^me de R . . . portait une robe en taffetas rose, ornée dans toute sa hauteur de bouillonnés formant quatre montans [*sic*]; corsage plat, décolleté, orné sur le devant d'un bouillonné formant pointe et semé de petits diamans [*sic*]; manches courtes et touffes de rubans de satin posées sur l'épaule et retombant sur la manche; petit bord en velours vert, orné d'un panache en marabous [*sic*] diamantés." Anon., March 13, 1847, p. 173.

23. "Pour le bal . . . les robes sont excessivement décolletées et garnies de berthes, de noeuds, de fleurs, ou de blondes de couleur. Les manches descendent un peu et sont très-ornées; les tailles sont longues et très-busquées devant et derrière; les jupes sont étagées et très-bouffantes." Anon., December 11, 1847, p. 380.

24. "Ses chapeaux en velours épinglé, très-simples et n'ayant d'autre ornement qu'une longue plume, sont d'un grand style." Anon., December 4, 1847, p. 365.

25. "Les perles reviennent aussi fort à la mode: nous avons vu chez *G[u]illion*, prêt à partir pour une cour du Nord, un magnifique bracelet composé de cinq rangs de perles noires avec un fermoir en brillant." Anon., February 19, 1848, p. 125.

26. "Ce qu'on appelle le bijou *artistique*, c'est-à-dire le mélange apparent du *fer* et de l'or, est du dernier style." Anon., December 11, 1847, p. 381.

27. "Il y avait des diamans et des bijoux, mais il est entendu qu'ils n'étaient pas portés par les dames qui ont des pierres héréditaires; ce luxe était de mauvais goût comme tous les luxes de passage. Les seuls bijoux bien et dûment portés étaient les broches, les boucles, les épingles et les bracelets artistiques de Guillion." Anon., August 28, 1847, p. 141.

28. "Dans une pièce voisine rayonnait sur un chevalet une peinture toute moderne et d'un sentiment tout opposé. —C'était un portrait, celui de madame de R . .

"Il est difficile de rendre plus compréhensible par le choix de la pose et l'arrangement du costume un caractère et une position sociale.

"L'artiste avait à peindre une femme du monde, et de ce monde qui nage dans une atmosphère d'or; il a sû être opulent sans être fastueux et a corrigé par l'étincelle de l'esprit les bluettes des diamants.

"Madame de R . . . , vêtue d'une robe de satin rose d'un ton vif et brillant, vient de s'asseoir dans les plis splendides de la riche étoffe qui bouffe encore; un de ses coudes s'appuie sur son genou; sa main droite joue négligemment avec un éventail fermé; la gauche, demi-repliée, effleure presque son menton. L'oeil brille, éclairé par une repartie prête à jaillir de ses lèvres. C'est une conversation spirituelle, commencée dans la salle de bal ou au souper, qui se continue; on entendrait presque ce que dit l'interlocuteur hors du cadre.

"La coiffure se compose d'un béret de velours noir qu'accompagne gracieusement une plume blanche. —Cet Athénien de la rue Mazarine a eu la coquetterie de mettre son grand goût au service du journal des modes, et ce béret, qui signerait M^me Baudrand, est, malgré son exactitude, du plus beau style grec.

"Lorsque le temps aura passé sa patine sur cet admirable portrait, il sera aussi beau de couleur qu'un Titien. Dès à présent, il a une vigueur et un éclat de ton que n'atteindraient que difficilement les coloristes les plus vivaces de notre école.

"Jamais M. Ingres n'a fait rien de plus simplement hardi, de plus vivant, de plus moderne; dégager le beau du milieu où l'on plonge est un des plus grands efforts de l'art." Gautier, August 2, 1848, reprinted in Gautier 1880, pp. 248–49.

29. "Passons dans la chambre voisine. Nous voici en face du portrait de M^me la baronne de Rothschild. Nous sommes transportés de la sphère des rêves dans le monde réel, devant la réalité dans sa plus complète expression. Il est bien de n'avoir pas mis côte à côte ces deux ouvrages si opposés; ce n'est pas trop des quatre ou cinq pas qui les séparent pour se préparer à une aussi brusque transition.

"Le premier aspect de ce portrait cause un peu de surprise. L'oeil a besoin de se faire au luxe de tons rouges qui le frappe d'abord; mais, une fois entré dans cette gamme de couleurs, il ne peut se lasser d'en admirer la précision et la richesse. Le spectateur, captivé par ce coloris inattendu, se reporte par la mémoire aux précédens portraits de l'auteur, dans lesquels la perfection du dessin, l'extrême vérité des attitudes, l'étude des détails poussée à sa dernière limite, avaient suffi, même en l'absence de couleur, à créer des oeuvres si remarquables, et, retrouvant ici ces qualités agrandies et complétées, il n'hésite pas à placer cet ouvrage au premier rang. Et de fait le portrait de M^me de Rothschild vaut celui de M. Bertin; c'est tout dire. Même jet hardi, même ampleur, même puissance. . . . M. Ingres, cette fois, pouvait faire de la couleur; il en a fait avec audace. . . .

"Le modèle, assis sur un divan, se présente de face, dans l'attitude d'une causerie attentive, les genoux croisés, la main gauche soutenant légèrement le menton, le bras droit jeté en travers avec abandon et tenant un éventail fermé. La tête est coiffée d'un *petit-bord* de velours noir, attaché en arrière et orné de deux plumes blanches qui retombent à droite et à gauche, encadrant une chevelure à reflets bleuâtres comme l'aile du corbeau. Cet arrangement de tête, qui rappelle certains portraits de Van Dyck, fait admirablement ressortir la blancheur du front et des tempes, et le ton plus vif du reste du visage. Deux grands sourcils à l'orientale se dessinent sur ce front, d'une pâte brillante; dans les yeux, à l'avenant, pétillent la vie et l'esprit. Cette partie est baignée par une lumière abondante et étudiée avec un soin extrême. Évidemment l'artiste a consacré toute son habileté à la mettre en relief et à sauver, par la vivacité de l'expression, l'irrégularité des lignes. Rien de plus doux et de plus intelligent à la fois que ce regard, qui est à coup sûr celui d'une femme spirituelle. Comme il s'accorde bien avec le sourire aimable qui relève les coins de la bouche! Rien de plus vivant que cette tête, qui sort de la toile et semble nous interroger; rien de plus naturel aussi que cette pose pleine d'aisance et d'un sans-façon élégant. M. Ingres excelle à donner à ses modèles l'attitude qui convient à leur nature. Le choix d'une pose est d'ordinaire, chez lui, le fruit d'observations assidues, faites le plus souvent à la dérobée, et ce n'est pas une des moindres causes de la grande ressemblance qu'il sait donner à ses portraits. Pourquoi juge-t-on le plus souvent, sans connaître les originaux, que ces portraits doivent être ressemblans? C'est qu'on y trouve un tel réalisme, une telle vérité de détails techniques, qu'on sait bien que rien n'est là sans motif, rien n'a été livré au hasard, que c'est la vie, la vie prise sur le fait. Si donc nous rencontrons dans le portrait de M^me de Rothschild une attache un peu épaisse du poignet gauche, c'est qu'apparemment M. Ingres ne se sera pas cru permis de supprimer tout-à-fait une défectuosité qu'il avait

sous les yeux. Faut-il attribuer au même scrupule l'altération de la peau, semblable à celle que produit un rhume de cerveau, qu'on remarque autour des lèvres? Si nous avons bonne mémoire, le même défaut avait été signalé dans le portrait de M^me d'Haussonville. Jusqu'à ce qu'il soit constaté que cet effet est le produit d'une ressemblance fortuite entre deux modèles simultanément enchiffrenés, nous mettrons ce rhume sur le compte de M. Ingres.

"Les bras et les épaules sont d'un beau dessin et modelés presque sans aucune ombre; l'oeil tourne autour. C'est la même fraicheur de coloris que dans *l'Anadyomène* et la même transparence. Les épaules éblouissantes s'enlèvent richement sur le velours foncé des coussins. Et les étoffes! A coup sûr, elles sont de fabrique vénitienne, et n'eussent point déshonoré les épaules d'un doge. Une robe de femme telle qu'on les fait aujourd'hui ne se prête pas facilement aux grands partis pris de draperies; en s'astreignant à la reproduire exactement, il n'est pas rare qu'on tombe dans la sécheresse et la minutie. M. Ingres a triomphé de cette difficulté; il a chiffonné des noeuds de satin et de gaze d'une façon toute magistrale. La robe de soie à volans, garnie de gaze, dans laquelle il ne pouvait trouver de larges masses, est touchée avec une franchise et une ampleur qui ne laissent pas regretter les plis majestueux de la *stola*. . . .

"Rarement le sévère pinceau de M. Ingres s'était joué avec autant de complaisance et de verve dans un fouillis plus séduisant d'étoffes chatoyantes et de bijoux aux mille couleurs. Il a peint tout cela *con amore*, et pour se reposer, comme il dit, du nu auquel il est voué à Dampierre. . . . Nous comprenons qu'il ait éprouvé le besoin de cette petite débauche de couleur. Quand vingt-cinq années auront passé sur toute cette magie, quand le temps aura fondu ces reflets opulens, adouci le brillant de ces épingles et de ces bracelets, vraies mosaïques de pierres précieuses, quand surtout il aura jeté son hâle doré sur ces magnifiques carnations, le portrait de M^me de Rothschild ne craindra la comparaison avec aucun de ceux que nous a laissés la fougueuse école de Venise, et il y aura plaisir à le placer à côté d'un Tintoret ou d'un Moroni." Geofroy 1848, pp. 447–49.

30. Ockman 1995, p. 78.
31. Ibid., p. 80.
32. Lacroix 1855, no. 25, p. 210.
33. Bellier de la Chavignerie 1867, p. 60. "Le portrait de M^me de Rothschild est plein de grâce et d'élégance, mais je n'y trouve pas l'accent de vérité qui me frappe dans le portrait de M. Bertin"; Planche 1855, p. 1143.
34. "Quel parti en effet prendre entre deux candidatures si peu en accord avec nos sympathies et nos convictions? Fallait-il voter pour Louis B., drapeau ridicule d'un illustre passé,

nullité politique qui n'a de valeur que pour une puissance négative, ce socialiste verni qui sous le poli de formes agréables cache des aspérités? Fallait-il appuyer l'autre . . . qui, au pouvoir, n'a montré ni franchise, ni capacité?" Baronne de Rothschild to Alphonse de Rothschild, December 30, 1848, quoted in Prevost-Marcilhacy 1995, p. 82.
35. "Papa a longtemps causé avec lui et il le trouve entre nous nul, sans portée aucune. Il a beaucoup insisté que ton père vienne le voir souvent et déjeuner le matin avec lui. Malgré toutes ses avances, ton père restera sur sa réserve et ne se mettra pas en avant avec tous ces gens-là." Ibid.
36. "J'ai enfin rompu la glace et apparu dans les salons de la Présidence d'où, sans me donner les apparences et la prétention d'une bouderie politique, il m'eût été difficile de rester plus longtemps éloignée." Baronne de Rothschild to Alphonse de Rothschild, April 26, 1849, quoted in ibid., p. 82.
37. "Il faut absolument que vous vous affranchissiez de la tutelle des Rothschild qui règnent malgré vous." Quoted in ibid.
38. Tulard 1995, p. 1133.
39. "J'espère cependant qu'une fois sorti de ces embuscades de portraits . . . mais que dis-je? une bourriche superbe de M^me de Rothschild vient de semer la terreur dans mes esprits, car, à n'en pas douter, le portrait de M. de Rothschild est au bout. Comment faire? comment? si je n'ai pas eu de caractère avec les femmes, je n'en manquerai pas avec les hommes: je m'en tirerai." Ingres to Marcotte, October 1, 1851, quoted in Blanc 1870, pp. 172–73, and Ternois 1999, letter no. 74.
40. Jouvenet 1988, p. 40; Miquel 1975, vol. 2, pp. 411–12. I thank Eric Bertin for drawing my attention to these references.
41. Sold at Sotheby's, London, June 20, 1985, lot 639. I thank Eric Bertin for bringing this work to my attention.
42. See Weiss-Blok 1997.
43. The registers of the Fonds Disdéri at the Bibliothèque Nationale, Paris, leave some doubt as to which Baronne de Rothschild this photograph represents. It is recorded that Betty de Rothschild did sit for Disdéri, but the inventory number for that sitting does not correspond with that of this photograph. Nevertheless, the contact sheet is annotated "Baronne James de Rothschild," and the figure certainly bears a close resemblance to the one in the portrait by Ingres. I wish to thank Sylvie Aubenas, curator in the department of photographs at the Bibliothèque Nationale, for her great help, patience, and kindness.
44. "Il n'en existe pas d'autre que celui d'Ingres, à la robe rose et chapeau à plume que vous n'aimiez pas." Betty de Rothschild to the comtesse de Castiglione, quoted in the catalogue of an auction of manuscripts, Hôtel Drouot, Paris, January 21, 1994, lot 193.

45. "Entre les nombreux et superbes portraits qui s'y verront, nous citerons ceux de M^me la baronne de Rothschild, de M^me la comtesse d'Haussonville, de M^me Fargeot, de M^me Leblanc, de Bertin l'aîné, de Bartholoni [*sic*], du comte Molé et de MM. Bochet et Leblanc." Anon., April 7, 1867, p. 109.
46. "Ce portrait représente une exécution complaisante et caressée dans les ajustements et les pierreries, sans que le personnage représenté soit écrasé par la magnificence de ce qui l'habille et la richesse de ce qui l'entoure. Surprise dans l'attitude naturelle d'une causerie de salon, M^me de Rothschild est assise sur un canapé de velours grenat." "La robe de satin, les colliers, les perles, les bracelets, les diamants et les plumes, bien que d'une exécution à la Holbein, enrichissent le portrait sans l'éclipser." Blanc 1867–68, pt. 7 (1868), pp. 538–39.
47. "l'un des plus beaux portraits de femme faits par M. Ingres." Galichon 1861b, p. 43.

PROVENANCE: Commissioned by Baron James de Rothschild in 1841, completed in 1848; bequeathed by Betty de Rothschild in 1886 to her son Baron Alphonse de Rothschild (1827–1905); bequeathed to his son Baron Édouard de Rothschild (1868–1949); appropriated during the German occupation of France during World War II; returned to the family in June 1946; by descent to the present owner

EXHIBITIONS: The artist's studio, 1848; Paris 1867, no. 103; Paris 1946a, no. 28; Paris 1967–68, no. 240

REFERENCES: Gautier, August 2, 1848; Geofroy 1848, pp. 442, 447–49; Magimel 1851, no. 93, ill. (engraving by Réveil); Callone 1855, p. 112; Lacroix 1855, no. 25, p. 210; Planche 1855, p. 1143; Ponroy 1855, pp. 143–44; Galichon 1861b, p. 43; Anon., April 7, 1867, p. 109; Bellier de la Chavignerie 1867, p. 60; Montrosier, May 9, 1867; Ronchaud 1867, p. 445; Blanc 1867–68, pt. 7 (1868), pp. 538–40; Blanc 1870, pp. 172–73; Delaborde 1870, no. 153; Gautier 1880, pp. 248–249; Momméja 1904, p. 103; Boyer d'Agen 1909, pp. 349, 360, 363, 370, 371, 379, 388; Lapauze 1911a, pp. 388–94, ill. p. 411; Fröhlich-Bum 1926, pp. 29–30; Hourticq 1928, p. 94, ill.; Pach 1939, p. 108; Cassou 1947, pl. 21; Alain 1949, ill.; Alazard 1950, p. 105; Wildenstein 1954, no. 260, pl. 103; Rosenblum 1967a, p. 154, pl. 42; Radius and Camesasca 1968, no. 146, ill.; Clark 1971, pp. 360–61, fig. 13; Whiteley 1977, p. 80, fig. 60; Naef 1977–80, vol. 3 (1979), pp. 335–36; Ternois 1980, p. 150, no. 304, ill.; Zanni 1990, no. 97, ill.; Ockman 1991, pp. 521–39, pl. 24; Fleckner 1995, pp. 229–30, 233, fig. 81; Ockman 1995, pp. 67–83, fig. 32, pl. 4; Prevost-Marcilhacy 1995, pp. 36–37, ill.; Vigne 1995b, pp. 250, 254, fig. 205; Roux 1996, pp. 22, 72–73, pl. 22; Weiss-Blok 1997, pp. 125–30, fig. 1

133–144. Madame Paul-Sigisbert Moitessier, née Marie-Clotilde-Inès de Foucauld

133. Madame Paul-Sigisbert Moitessier, née Marie-Clotilde-Inès de Foucauld, Standing
1851
Oil on canvas
57 ¾ × 39 ½ in. (146.7 × 100.3 cm)
Signed and dated left, below center: J.A.D. INGRES P. ˣⁱᵗ ANº 1851 [J. A. D. Ingres painted (this in the) year 1851]
Inscribed upper right: ME INES MOITESSIER / NEE DE FOUCAULD.
National Gallery of Art, Washington, D.C. Samuel H. Kress Collection 1946.7.18

W 266

134. Madame Paul-Sigisbert Moitessier, née Marie-Clotilde-Inès de Foucauld, Seated
1856
Oil on canvas
47 ¼ × 36 ¼ in. (120 × 92.1 cm)
Signed and dated center right: J. Ingres 1856 / AET LXXVI [J. Ingres 1856 / Age 76]
Inscribed upper right: Mᵉ INÈS MOITESSIER / NÉE DE FOUCAULD.
The Trustees of the National Gallery, London NG 4821

W 280

135–144. Studies for "Madame Moitessier Standing" and "Madame Moitessier Seated" (see pages 445–46)

When Ingres's friend Charles Marcotte approached him about 1844 with the idea of painting a portrait of Madame Sigisbert Moitessier, the daughter of one of Marcotte's colleagues at the ministry of state domains, it must have reminded the artist alarmingly of his former clientele, largely drawn from Marcotte's circle of friends, most of whom were middle-level bureaucrats. Ingres constantly complained that he had not returned to Paris to paint portraits, but a note scribbled by Marcotte on one of his friend's letters explains how his mind was changed in this case: "M. Ingres refused to make the portrait of Madame Moitessier at first. Later he saw her at my house one evening and, struck by her beauty, he wanted to paint her."[1] Ingres could not have known then that he would take twelve years to paint not one but two portraits of the woman whom he called "la belle et bonne" ("the beautiful and good"). The seated portrait was commissioned in 1844, drawn on the canvas by 1847, sketched in by 1848, abandoned in 1849, resumed in 1852, abandoned again in 1853, taken up again in 1854, and finished by January 1857. The standing portrait was begun about June 1851 and completed in December of that year. The two paintings could hardly be more different: standing, Madame Moitessier is austere in her black dress, unsmiling, and imperious; seated, she is opulent in her dress of white silk strewn with flowers, smiling, and majestic. Together the works present two faces of Second Empire high society—pompously serious and seriously ostentatious—rendered in a manner that elevates them from timebound descriptions of a particular moment to the timeless realm inhabited only by the greatest masterpieces.

Marie-Clotilde-Inès de Foucauld (1821–1897) was the daughter of Charles-Édouard-Armand de Foucauld (1784–1849) and Clotilde-Eugénie Belfoy (d. 1864), who had married on February 16, 1819. Her father was an inspector of forests at the department of forests and waterways, of which Marcotte was the inspector general. Ingres must have known Foucauld fairly well, because as he was finishing the standing portrait in 1851, he regretted that neither his first wife, Madeleine Chapelle, nor Foucauld had lived to see it completed.[2] On June 16, 1842, the twenty-one-year-old Inès married Paul-Sigisbert Moitessier (1799–1889), a rich merchant twice her age who had made his fortune as a wholesaler importing Cuban cigars.[3] Their marriage was not, however, quite what it seems. Newly recovered documents open a window onto the Moitessiers, overturning previously held notions about the relative status of the two partners and providing a fascinating insight into the affairs of a prominent businessman at the dawn of intensive capitalist development in France.[4] It has long been thought, for example, that Inès de Foucauld was an aristocrat who betrayed her class by marrying a merchant.[5] Yet the birth records of Inès and Sigisbert reveal that they were both born in the same small town, Mirecourt, in the Vosges. The witness to Inès's birth, on April 24, 1821, was her maternal uncle Claude-François Belfoy, who gave his profession as "négociant en dentelles" (lace merchant). When Sigisbert was born to Françoise Moitessier, née Blehée, on 23 nivôse, an VII (January 12, 1799), his father, Louis, gave his profession as "marchand de dentelles."[6] The families of Moitessier *père* and Foucauld *mère* were thus in the same business and must have been known to each other, if not related.

The wedding contract casts further light on the relationship between the Moitessiers, including an explanation for the difference in age between the groom and the bride. Sigisbert was a widower, his first wife, Victoire-Marie-Louise Bonjean, having died, childless, in Avignon on May 2, 1839. When he married Inès de Foucauld in 1842, she was living with her parents at 3, rue de Castiglione, a fashionable address near the place Vendôme. Armand de Foucauld was by then a conservator of forests and a chevalier in the Legion of

133

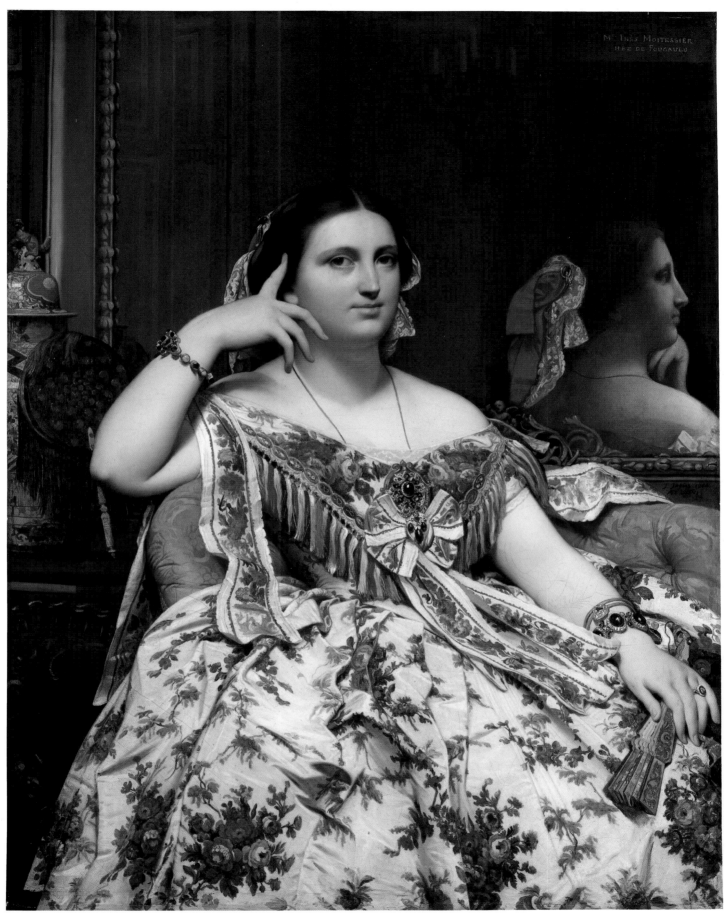

134

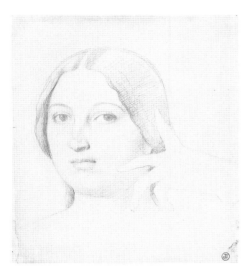

Fig. 263. *Study for "Madame Moitessier Seated,"* ca. 1846–47. Black and red chalk on paper, 14 × 12⅛ in. (35.5 × 30.9 cm). Worcester Art Museum

Honor, but he remained a civil servant, affluent but not rich.[7] He offered as a dowry for his daughter four percent interest on a capital of 30,000 francs. Sigisbert claimed 400,000 francs as his contribution to the marriage, representing his share of the business, Moitesssier Fils et Châtard, that he owned with his partner, Pierre-Henri Châtard. He indicated a cash reserve of 96,000 francs, the expected revenue on a number of loans, and shares of stock of various companies (railways, canals, and mines) as well as stock in marine and fire insurance companies. Inès moved into Sigisbert's house at 31 (now 39), rue de l'Échiquier, just north of the Grands Boulevards near the porte Saint-Denis, a neighborhood that had been extensively rebuilt in the 1820s and 1830s.

No doubt the Moitessiers' wedding prompted the idea of a portrait, but starting in July 1842 Ingres was consumed with royal commissions for the windows of two memorial chapels of the duc d'Orléans and for repetitions of the duke's portrait. Not until 1844 did he relent, and in any event Inès was not fit to sit for her portrait before then. She became pregant in July 1842 and delivered her first child, Clotilde-Marie-Catherine, on March 19, 1843. In July 1845 the artist listed the Moitessier portrait as one of the "two portraits of the first order" that were ahead of him; the Rothschild portrait (cat. no. 132) was the

other work on his easel.[8] Yet nothing happened. A year later, enumerating his priorities, he wrote: "I am going to return to Paris to finish finally (for my sins) my two big enemies, my two portraits, while also working on my grand basilica (already thought out)."[9] By the summer of 1847, work had finally begun, but Ingres expressed his exasperation in a letter to his friend Jean-François Gilibert:

> Alas! yes, how is this miserable life going? I can hardly stand it. Always constrained by the gnawing distractions of details, I never accomplish what I want and my disappointments are great. I have barely finished Mᵐᵉ de Rothschild, begun again much better, and the portrait of Mᵐᵉ Moitessier. Cursed portraits! They always prevent me from undertaking important things that I cannot do any faster, for a portrait is such a difficult thing.[10]

At the least, Ingres must have drawn his composition on the canvas at this time, since Théophile Gautier saw it and published a brief description in *La Presse* on June 27:

> Never has a beauty more royal, more splendid, more superb, of a type more like Juno delivered its proud lines to the trembling crayons of an artist. Already the head lives. A hand of superhuman beauty

presses against the temple and bathes a violently disjointed finger in the waves of hair with the frightening and simple audacity of a genius for whom nothing in nature is alarming.[11]

Gautier takes note of the distinctive characteristic of the portrait, which seems to have been present from the beginning: the strangely unnatural hand with fingers arrayed like the arms of a starfish.[12] What may be the earliest drawing to survive, a portrait head of the young bride now at Worcester, shows the extraordinary pose, but in reverse (fig. 263). Its easily recognized source was a famous antique mural depicting the encounter between Herakles and his son Telephos before the enthroned goddess of Arcadia (fig. 264). Excavated in the Basilica precinct at Herculaneum in 1739 and considered a great discovery (Wincklemann, for example, mentioned it in his letters),[13] the work was installed at the Museo Borbonico in Naples in Ingres's day. Observers from Gautier to Degas to Kenneth Clark have consistently likened the seated Madame Moitessier to an Olympian godess because of the gesture that Ingres borrowed from the wall painting, which he knew in the original as well as from engravings and copies that he owned.[14]

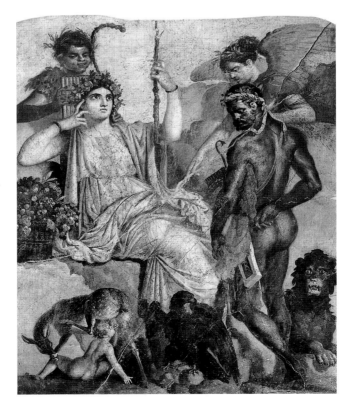

Fig. 264. *Herakles Finding His Son Telephos.* Roman fresco from Herculaneum, 79½ × 63⅜ in. (202 × 171 cm). Museo Nazionale, Naples

Fig. 265. *Study for "Madame Moitessier Seated,"* ca. 1846–48. Graphite on paper, 6⅜ × 4⅝ in. (16.2 × 11.8 cm). Musée Ingres, Montauban (867.318)

135

Henry Lapauze states that the sketch Gautier saw in 1847 depicted the Moitessiers' daughter Catherine at her mother's side.[15] X-radiographs of the finished portrait show no sign of this, but in a drawing now at Montauban (fig. 265), the elliptical head of a child is unmistakable. To learn more, Lapauze contacted Catherine, Comtesse de Flavigny, at the turn of the century, and she responded by sending him some of Ingres's letters to her mother. In one, perhaps the first, since it is quite formal, he invites them to a sitting: "Madame, Would you be so extremely kind as to come tomorrow to a sitting about two o'clock, with bare arms and accompanied by the charming Catherine. I will be very grateful and ask you, in the meantime, to accept my respectful homage and thousands of friendly greetings from my wife. Ingres. Friday morning."[16]

Catherine remembered "a large room that was quite cold. My mother had her hand on my head and I had to be very still. It was very boring. One day, the old man

Fig. 266. *Study for "Madame Moitessier Seated,"* ca. 1846–48. Graphite on paper, 11⅞ × 12⅜ in. (30 × 31.5 cm). Musée Ingres, Montauban (867.317)

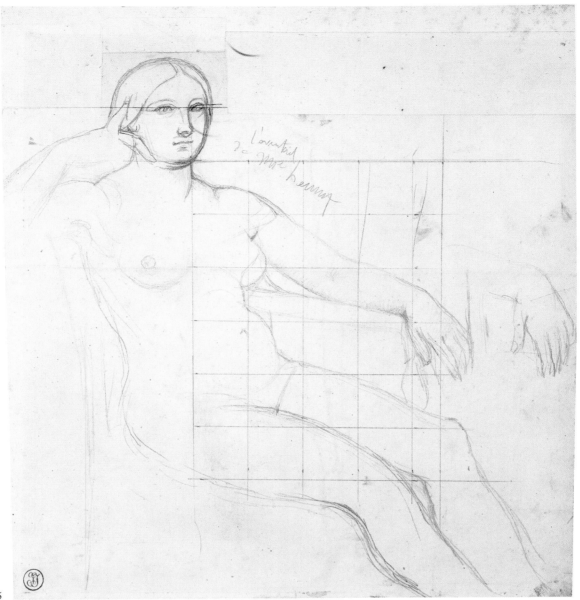

136

137

in his cotton bonnet became angry. He declared that little Catherine was impossible and that he was going to wipe her out."[17] If Catherine could remember the sessions, she could hardly have been less than three years old, and if the room was cold, the sittings probably occurred in the winter of 1846–47, or, at the latest, 1847–48. Another preliminary study, at the Fogg Art Museum (cat. no. 135), was probably made at this time as well.

By the time Ingres made the compositional study at Montauban (fig. 266), Catherine was gone. But this drawing, like cat. no. 135 and fig. 265, shows the original composition: Madame Moitessier seated on a recamier, with the elbow of her right arm supported by a cushion placed on the end of the sofa. An intermediate stage in

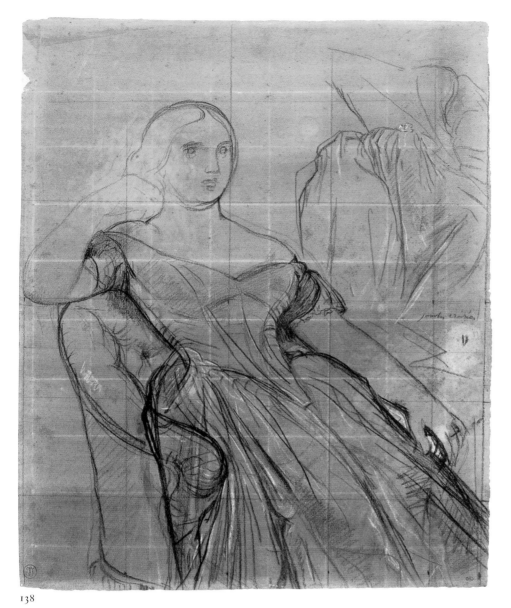

138

the development of the pose is revealed by a nude study, drawn from a professional model, in which the left arm rests on the arm of a chair rather than in the lap (cat. no. 136). Once Ingres had decided to place his subject in a tufted chair, and to let the left arm rest in the lap, he made some studies of the skirt (figs. 267, 268), which are ravishing in their approximation of the appearance of velvet. He also executed some drawings of the right arm to determine the precise angle of the elbow and to work on the contour of the forearm (cat. no. 137).[18] These designs were summarized in a compositional study at the Louvre (cat. no. 138), which probably gives a good indication of the appearance of the portrait when Gautier visited Ingres's studio again in the summer of 1848.

Meeting Ingres at the Institut to see the completed portrait of Baronne de Rothschild, Gautier once again glimpsed the unfinished portrait of Madame Moitessier:

> Another portrait, still in the state of an *ébauche* [oil sketch], is surprising in the boldness of the sketch and the supreme majesty of the pose. This imperial woman, like a Juno, was sculpted with several strokes of the brush on this white canvas, which resembles Carrara marble.
>
> But when will M. Ingres finish it? This respectful host waits for Inspiration to visit without going out to find her if she is late in coming; Inspiration, that beautiful, lofty virgin with whom the convulsive artists of our precipitous epoch have so often been brutal.[19]

Fig. 267. *Study for "Madame Moitessier Seated" (Skirt)*, ca. 1847–48. Black chalk and white highlights on paper, 8 × 12½ in. (20.3 × 31.8 cm). New Orleans Museum of Art

Fig. 268. *Study for "Madame Moitessier Seated" (Skirt)*, ca. 1847–48. Charcoal and white highlights on paper, 8¾ × 11 in. (21.4 × 27.9 cm). Musée Ingres, Montauban (867.319)

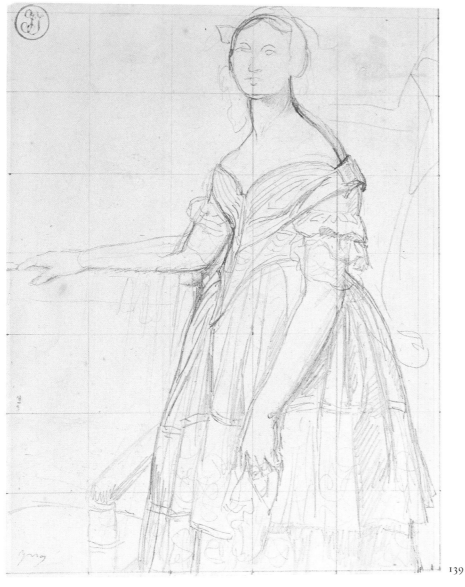

139

Unfortunately, Inspiration stayed away, and Death took Madame Ingres in July 1849. Ingres could finish nothing in the months before her death and for a year afterward. It has not been previously noted, however, that Madame Moitessier was also preoccupied at this time: she endured the loss of her father on March 29, 1849, and later in the year she became pregnant with her second child. Just before the birth of Françoise-Camille-Marie on August 19, 1850, the Moitessiers decided to move to a grand *hôtel particulier* at 42, rue d'Anjou, a small but fine street that ends in the rue du Faubourg Saint-Honoré. Situated in a quiet, aristocratic quarter between the place de la Madeleine and the Élysée palace and said to have been constructed by François Delondres for the politician Antoine-Omer Talon, the house was

acquired by Sigisbert Moitessier at the end of July 1850.[20] With two portes cochères, four floors, and a large garden that extended to the next street, it could accommodate the growing family as well as splendid entertainments. Since the purchase was not completed until January 1851, Inès gave birth at their country house in Villiers, just outside Paris, near Neuilly.

Settling into her new house and resuming her social life after the birth of her daughter, Madame Moitessier began to think about the unfinished portrait. Much to his discomfort, she began to needle Ingres just as he had begun to make some progress on the portrait of the princesse de Broglie (cat. no. 145). He confided to Marcotte in June 1851, "*You see*, I have sketched in Mme de Broglie to everyone's satisfaction and without much trouble; and

this one, our beautiful one, with all of her goodness (Mme Moitessier), cannot stop reminding me that her [unfinished] portrait was begun seven years ago."[21] According to one account, Monsieur Moitessier, who for his new house had ordered and received a painting of *Jupiter and Antiope* (W 265; Musée du Louvre, Paris) from Ingres in 1851, saw the unfinished seated portrait of his wife and demanded that the artist either complete it or destroy it.[22] Evidently Ingres decided to begin again from scratch, as he had done when dissatisfied with the portrait of Madame d'Haussonville. In June or July 1851, work recommenced in earnest. This time Madame Moitessier would wear the elaborate toilette of a *grand soirée* or ball and would stand adjacent to an upholstered mantel in the Salon Rouge of her new house,[23] a tapestry-covered chair at her side to hold her evening accessories. Ingres adopted a three-quarters-length format, which he had also employed for the original portrait of the duc d'Orléans.

One of the earliest drawings (cat. no. 139) depicts Madame Moitessier resting her right arm on the back of a chair, wearing a dress with applied flounces of lace, and looking past the viewer to the space beyond. The next drawing shows her with her head and shoulders turned to direct a smile toward the viewer; both hands rest on her skirt, and her shawl of Chantilly lace is tucked into her neckline (cat. no. 140).[24] This followed current fashion: the *Journal des dames et des modes* reported that shawls in "black lace belong with the simplest ensembles—but they are so large that they cover up, one might say, more than half of a woman."[25] Another study shows a different dress and an intermediate position for the arms.[26] Ingres found the definitive placement of the arms in a subsequent drawing (cat. no. 141), although he continued to study the right arm along the left margin of the sheet. By this point Madame Moitessier had changed her dress again. The lace flounces of the skirt were gone; in place of the pleated bodice with arched neckline visible in cat. no. 139, the new bodice has a flounce of lace that descends from a much lower bateau neckline. The sheet is squared and was thus probably

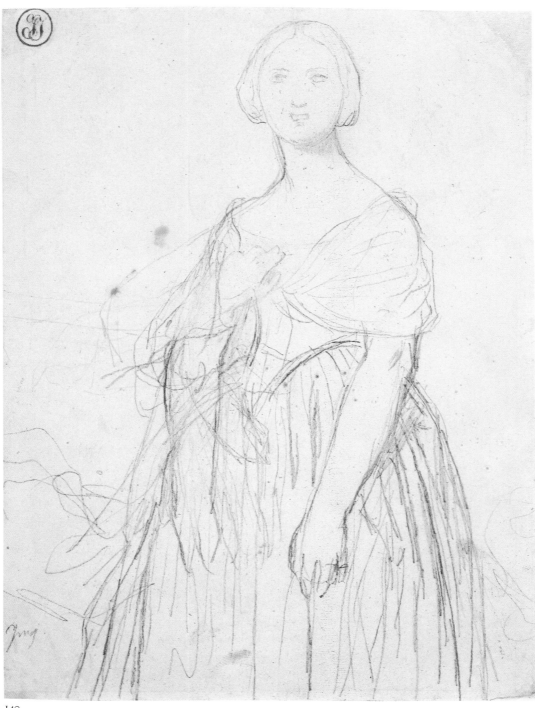

140

transferred to canvas, yet Ingres contin-
ued to study the left arm on a sheet now
at Montauban, on which he adjusts the
dimples at the elbow and the precise dis-
position of the fingers.[27] The artist was
clearly infatuated with his sitter's fleshy
arms, to the point that it became a topic
of discussion among his friends (see
below).

Although he was making progress,
Ingres remained apprehensive, as he told
Marcotte later that same summer:

Despite the splendid phrases employed by
our beautiful and good Madame Moitessier,
it is no less true that the match is not yet
won; it will be decided, however, with a
sitting for that terrible and beautiful head. At
two o'clock, Madame Moitessier will arrive
from Villiers expressly for our appointment,
and I pray that a routine bloodletting by
the *bleeder* Magendie has not altered those
beautiful eyes, that divine face.[28]

One is tempted to associate that session
with the magnificent study of the head,

"terrible and beautiful," now at the Getty
(cat. no. 142).

Ingres must have worked on the portrait
through the summer of 1851 (having
renounced the murals at Dampierre, he
could no longer enjoy his summers as a
guest of the duc de Luynes). In a letter to
Madame Moitessier, he boasted of his
progress:

You will kindly reserve an invitation for
me when I have finished your dress,
which I am beginning today. I have not

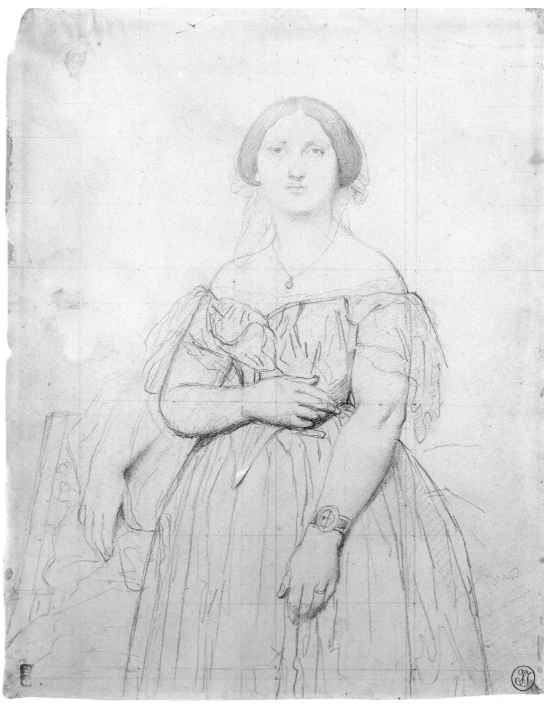

141

wasted my time: your arms are done as I wanted; you are bigger, and that is good. In a word, I am not too unhappy and I am full of courage. Do you want me for dinner Tuesday? I will bring good news of the portrait; we will decide lots of things. In the meantime, beautiful and good Madame, you have my best wishes and all my devotion.[29]

Among the remaining issues to be decided was the delicate question of jewelry. Another drawing, now at the Getty

(cat. no. 143), is a tracing that seems to have been made expressly to consider the effect of the bracelets and of an ornate enamel-and-gold Renaissance-style brooch with cabochon garnets that ultimately disappeared from this work, only to reappear in the seated portrait. The lace shawl gathered around the waist was also introduced here.

Sometime during the summer, Ingres wrote his subject to express his latest thoughts about her costume:

Since you are certainly beautiful all by yourself, I am abandoning, after mature consideration, the projected grand headdress for a gala. The portrait will be in even better taste and I fear that it would have distracted the eye too much at the expense of the head. Same thing for the brooch at your breast; the style is too old-fashioned, and I beg you to replace it with a gold cameo. However, I am not against a long and simple chatelaine, which I could terminate with the pendant of the first one.

142

on the right arm also needs to be done. Everything else is done. But we also need some sort of evening fur—the one you wrap yourself in when you leave the ball—to throw on the corner of the chair.

Believe me, Madame, nothing was sacrificed while waiting for you during the first days of September, as I see it. Thus, the tanned Madame, the Moorish Madame, will be most welcome.[33]

Quite a different impression is given by Ingres's letter to Marcotte two weeks later:

Do you know who I am like? Like someone weighed down by a nightmare that he would like to escape, only he cannot find his legs. Yes, that is what my unhappy portraits do to me! I finally have the last sitting with our "belle et bonne"; but I still have to do the necklace, the rings, the bracelet of her right hand, the fur on the chair, the gloves and handkerchief. Then I will have to take up again the last glazes and the finishing touches of this portrait, which has so painfully occupied my life for the last seven years.[34]

The finishing touches continued until December. Postponing a session with Madame Gonse, a new subject (see fig. 208), Ingres blamed his work on the portrait of Madame Moitessier, "certainly the most important among all my works . . . the work of seven years of hopeless effort, for which critics as well as Parisian society wait with bated breath."[35] But, he added, the portrait could be completed in the next week, "if the winds are good,"[36] and he would need three or four days to show the painting to their intimates. This he did before the end of the year, yet despite the inevitable praise, doubts persisted. On January 7, he wrote Madame Gonse to say that the portrait

Please then be so kind, Madame, as to bring on Monday your jewel chest, bracelets, and the long pearl necklace.[30]

As a postscript, he added, "Let's keep back the justly curious, even Catherine [her daughter], in their own interest and in mine; because finally in the course of the week the iron gates will open, *God willing,* with the additional help of two big sessions."[31]

On October 1, Ingres cautiously informed Madame Moitessier of work that had been done while she was on holiday:

How happy I will be to see you again here, but [I need you] only for a little while; I will be waiting for you in my studio at the Institut on the ninth. Don't get angry, but I still have to add a few improvements to your beautiful image, without destroying that which you want to admire. I have worked a lot, you will see, enough to make myself quite happy, especially since the supreme judges, M. Moitessier and M. Foucauld, have permitted me to think this way.[32]

I will not carry on any further about my work, except that you no longer have the ribbons and white darts in your hair. Only the grapes and leaves remain, to which we will add, I think, the beautiful yellow-orange flowers and the velvet ribbons that I beg you to bring along. The bracelet

seems, pardon my vanity, to please those whose taste and opinion I like. Only as of today will I have it transported [from 17 bis, quai Voltaire] to the Institut, since it will be better there and that is my [usual] private exhibition space.

Good thing for me, the family is delighted. And perhaps you think I am wholly delighted as well, but no, and I can say so only to my discreet friends. That is the way it must be, or I would cease to aim my sights high, and then, good-bye to Art. And if one were perfect, which is not

143

the human lot, one would be so bored that one would kill oneself, as if from spleen.[37]

By the end of January 1852, Ingres was showing his latest work to guests in his studio. On January 31, for instance, he invited the all-powerful superintendent of fine arts, Comte Alfred-Émilien de Nieuwerkerke, to see it at 17 bis, quai Voltaire.[38] Presumably the regular art press came to see it as well, but only one account is known,[39] that written by Auguste Galimard, which appeared in the *Revue des beaux-arts* but has not been reprinted since. After a short exhortation in which the sublime, the beautiful, Raphael, and Leonardo were invoked, Galimard described the painting as he understood it:

> M^me^ Moitessier is shown dressed in black velvet, standing, looking at the spectator; her gesture is simple, in her right hand she holds the end of a sparkling pearl necklace, the other hand falls and holds a scarf of rich black lace. The head is framed by her brown hair, whose silky waves unite in graceful movement. This abundant hair is set off from the background by a crown of flowers, which one might say were of the most gentle perfume, so real do they seem. One finds in the forehead and in the eyes an Olympian character; the nose and the mouth are severe, and the neck has proud contours worthy of Greek statuary; the arms are no less beautiful, the hands are charming.
>
> The general appearance of this portrait has the calm and majesty of antique art. One believes it is Juno with her proud gaze. This admirable composition is set against a violet-damask background, the airy and fleeting tone of which marvelously brings out the golden light falling over the face and shoulders of M^me^ Moitessier. The light is less strong as it descends: the left hand is painted in a soft half-tone, which again underscores the striking complexion, lit by the principal source of light; the bracelets, the jewels that ornament this remarkable figure are executed with the rare perfection that characterizes the talent of M. Ingres. One also sees, at the right of the portrait, a miraculously real furnishing; gloves, a handkerchief, a fur, make for a happy variety of tones.[40]

Galimard's reference to the furnishing at the right, a mantel hung with rich cloth,

144

resolves a problem that has long vexed curators and conservators. Strips of canvas, different in weave and quality from the primary support, have been added to the right and bottom margins of the picture; since damages and repaints also occur in the same areas, it has been suggested that the strips were applied after the painting left Ingres's studio and were painted by someone else.[41] That Galimard's account speaks of the *meuble* (furnishing) at the right, an area largely confined to the added strip of canvas, discredits this theory.

Furthermore, the remarkable photograph of Ingres's studio taken in early 1852, in which the framed portrait is visible in the background (fig. 99), proves that the wide strip at the bottom was also painted in Ingres's studio; calculations of the internal dimensions indicate that the completed painting was the same length then as it is today.

In December 1854 Ingres included the portrait in a small showing at his studio at 11, quai Voltaire, along with the *Princesse de Broglie* (cat. no. 145), *Joan of Arc* (fig. 215),

and other recent works.[42] The Moitessiers subsequently lent the painting to Ingres's special exhibition at the 1855 Exposition Universelle, where it was admired as much for its precision of execution as for its majesty of conception. Edmond About saw in it "a kind of queen. M. Ingres surrounds her with majesty and grandeur, without neglecting either the flowers, the draperies, or the admirable Chantilly lace."[43] Baudelaire did not name the work but clearly described it when he wrote of "delicate figures and simply elegant shoulders

438 CATALOGUE

Fig. 269. Unknown assistant. *Study for "Madame Moitessier Seated" (Furniture)*, ca. 1852. Musée Ingres, Montauban (MIC 446)

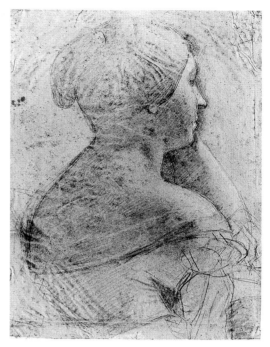

Fig. 270. Ingres (or his assistant). *Study for "Madame Moitessier, Seated" (Reflection in Mirror)*, ca. 1852–56. Charcoal and white highlights on paper, $17\frac{1}{4} \times 2\frac{3}{4}$ in. (43.8 × 32.4 cm). Musée Ingres, Montauban (867.320)

Fig. 271. Fashion plate. *Petit courier des dames*, April 20, 1833

associated with arms that are too robust, too full of a Raphaelesque succulence. But Raphael liked fat arms, and above all one must obey and please the master."[44] When Degas made a pilgrimage to see the painting in 1898 at the house of the Moitessiers' daughter Françoise, Vicomtesse Taillepied de Bondy, he found that "she quite naturally thought the arms too fat, and I wanted to persuade her that they are right like that."[45]

Somehow Ingres's own doubts about the painting must have led him to the extraordinary decision to return to the unfinished seated portrait. Most scholars have suggested that this took place about June 1852, and a letter from Ingres to Madame Moitessier seems to reflect the moment: "Madame, Perhaps I am not as crazy as I seem. I just compared the two portraits, and the joint opinion of my wife and myself is that the last is the best. Thus, Madame, we are still on for tomorrow, bare arms, and, if possible, the yellow dress."[46] Ingres must have been working on the seated portrait in June 1852, when he described the following incident in a letter to Marcotte:

I swear to you on my deepest word of honor that neither I nor Mme Moitessier heard you knock. It is not surprising for me, since I am almost deaf. But that she did not hear you is, all joking aside, quite surprising! Furthermore, when you want to call on a friend, you knock more loudly, you break down the door, if necessary, you yell "Marcotte," and leave your card, no more; and still we had a presentiment that you would come and we even said it . . . But that is enough, dear friend, please excuse me, and next time we will pay more attention so that we will hear you knocking. I have decided on the fabric for the dress and I hope to finish the head before she leaves.[47]

It was perhaps about this time that Ingres asked an assistant to make the painted study for the background of the portrait (cat. no. 144), a work that is too awkward to have been painted by the artist himself. Ingres probably first sketched onto the canvas the outline of the seated figure, still wearing a dress of the late 1840s and not much different from the figure in the drawing at the Louvre (cat. no. 138), although the two different placements of the left arm indicate he was still

undecided about this aspect. He then sent the assistant to the Moitessiers' house at 42, rue d'Anjou with instructions to paint the paneling and multiple reflections that reverberate in the opposing mirrors. The same assistant was most likely also responsible for the studies of the furniture, which are now at Montauban (fig. 269). The room depicted seems to be the Grand Salon described in the inventory prepared after the death of Monsieur Moitessier. Although the seating in that room was upholstered in sky-blue silk damask, it contained gilt furnishings that appear consonant with those depicted in the painted study.[48] No doubt the choice of the room inspired Ingres to enrich the portrait with a reflection of his sitter, for none of the previous studies for the seated portrait include a mirror or a reflection. This trusted device, well known from fashion plates (see fig. 271), had previously been used by Ingres in the portraits of Madame de Senonnes and the comtesse d'Haussonville (cat. nos. 35, 125). The independent study for the ghostly reflection, now at Montauban (fig. 270), is sufficiently strange that Georges Vigne has questioned whether it is by Ingres or an assistant.[49] A rough but more accomplished study of the reflection, sold at auction in 1992, was probably sketched by Ingres himself.[50]

Once again, however, Ingres lost his nerve, and in a letter of March 9, 1853, he renounced his previous work on the portrait:

I have very much wanted to see you, good and kind Madame, to talk about your portrait, which for too long a time has tormented both of us. First, I must tell you, as you no doubt already know, that I am engaged in a big work for the Hôtel de Ville [*The Apotheosis of Napoleon I*, fig. 210], and I have *positively promised* to have it finished by next January 1. You will therefore understand, Madame, that I cannot work on anything else this year. Furthermore, dare I admit to you frankly that I am painfully troubled about the success of this portrait! The more I work on it the more I see that I am far from arriving at the desired goal, and that is extremely depressing and discouraging!

If I had not felt bound to fulfill my promise, I would have informed you long ago of the discouragement that has taken hold of me, but I always persevered in the hope that I would be able to reach the happy ending that I no longer hope for.

Please understand, good and kind Madame, that it is very painful to me to abandon this portrait, which I would have been so happy to offer to M. Moitessier if it were worthy of you and of him. But I would prefer to erase it than to present you with something inferior.

Regarding the oil sketch of M. Moitessier's portrait that I promised, I am quite willing to undertake it after my big project, and I will see that it is promptly done.[51]

Ingres never executed a portrait of Monsieur Moitessier, but sometime in 1854 or early 1855 he must have resumed work on the seated portrait yet again, as a conspiratorial letter from Marcotte to Gatteaux reveals:

Yesterday evening, my dear friend, I received a visit from M. and Mme Moitessier. Mme Moitessier is very happy with the second edition of her portrait which she finds very convincing since our friend lessened the distance between her eyes. I did not hide to whom she owes this improvement.

Now there is something else to take care of. It is the arms, which one finds are still too large. It is certain that they are already too much so in the first portrait. Let's hope that they become smaller in the second. This must come from *you alone*, because if our friend suspected that this came from the Lady, he would be offended.

Bring this reform about quietly. The lady has big arms, it is true, but that is one more reason not to exaggerate them. They could even be rendered a little less than lifesize and no one would reproach the painter. One must also remember that when the portrait was begun, Mme Moitessier was eight years younger and was then less plump.

I told Mme Moitessier that I would write to you about this and that you could arrange to slenderize the arms without wounding his pride, he who treats her with love—which she well deserves because I do not know a better woman.[52]

Marcotte and the Moitessiers probably got what they wanted, for there are a number of pentimenti along the contours of the arms.

A much more remarkable alteration, however, was the decision to abandon the yellow dress for a spectacular one of flowered silk from Lyons, whose riotous pattern completely overshadows Madame Moitessier's limbs. This change conformed to a shift in fashion during the mid-1850s led by the new empress Eugenie, whose husband, Napoleon III, had requested that she dress in brocades from Lyons in order to stimulate the silk-weaving industry. That instruction, combined with Eugenie's own fascination with the unlucky queen Marie-Antoinette, helped revive Rococo patterns unseen for nearly a century, which were now woven with even brighter aniline dyes and more elaborate modern technology. The new dress must have been painted in late 1855 or in 1856, when Ingres signed and dated the portrait, for the design of the bodice (a "bertha") and the skirt supported by a crinoline could not date before 1855, when the crinoline was introduced. This tour de force of trompe l'oeil painting has been more clearly revealed thanks to the recent cleaning of the canvas at the National Gallery. To intensify the rich effect, Ingres brought in the Imari vase at the far left and the silk hand-screen, used by women to prevent a fire from reddening their cheeks, which are not seen in the earlier painted study of the interior (cat. no. 144). In addition, he transformed the tufted chair into a canapé, which allowed him to adopt the lower position of the left hand in the lap while providing the higher horizontal line that he wanted at the back.

Ingres also permitted himself to dip into Madame Moitessier's jewel chest, using the gold-and-enamel Renaissance-style brooch discarded from the standing portrait. Only a gold ring with blue enamel and diamonds (perhaps a wedding or engagement ring) is repeated from the standing portrait; the rest of the jewelry—from the massive cabochon garnet-and-diamond bracelet to the gold, diamond, and emerald bangle to the Byzantine-style bracelet on the right arm—appears for the first time. Every detail is seemingly coordinated to produce the impression of unbridled wealth and luxury, yet, as many contemporaries commented, Ingres exercised control

over them all with his powerful, classicizing hand and strong, classical design. And despite the dazzling textures, patterns, and jewels, the most amazingly painted passages remain Madame Moitessier's shoulders, arms, and unforgettable face, her hair now pulled back "à l'impératrice" to reveal her earlobes. Ingres's enamel-like technique was never more perfectly realized. The artist himself obviously felt he had reached a summit, for he inscribed the painting with his age, seventy-six, rather than that of the sitter, thirty-five.

Ingres exhibited the portrait briefly in his studio in January 1857, along with *La Source* (fig. 202),[53] but it was not widely seen until it was included in the posthumous exhibition of 1867. In the context of that massive display it did not garner much individual commentary. Charles Blanc, writing the following year, cited it only in comparison to the portrait of the baronne de Rothschild, which he felt succeeded where the seated portrait of Madame Moitessier failed: "In the seated portrait of M^me Moitessier, whose beautiful head is shown as a study of the Pompeian Flora (a finger on the cheek), the viewer is distracted by the unfortunate floral design of a light-colored dress, which is all the more disturbing because it is so well rendered."[54] It was not until the twentieth century that the portrait assumed its rightful place in history. In the 1920s, Picasso had alluded to it in a number of studies of pneumatic women, both seated and standing (see fig. 32), but it did not receive the large audience that it deserves until its acquisition in 1936 by the National Gallery. Since then it has been widely appreciated as the penultimate female portrait from the hand of the great artist—"a combination," as Robert Rosenblum put it, "of the most overtly sensual and material wealth with a more covert world of formal order and psychological mystery."[55]

There is an interesting postscript to the story of the portraits, both of which continued to torment the Moitessiers some ten years after Ingres's death. In 1876 the artist's widow, Delphine, consigned a group of drawings to an auctioneer, Monsieur Féral, for sale. Among the lot of works were studies for the Moitessier portraits, which

probably included the drawing of the nude (cat. no. 136). Although this drawing was made from a model, the sale still presented a delicate problem, and so Féral offered the drawings first to Monsieur Moitessier for 3,250 francs. Moitessier, who had obtained the degree of doctor of law on August 19, 1856, and was named attorney-general at the appellate court of Chambéry on December 21, 1877, sued for them to be given to him, without payment, or to be destroyed in his presence.[56] At issue were the rights of a sitter to any reproduction of his or her image versus the rights of an artist to exhibit (and sell) anything that he or she makes. In 1877 the Civil Tribunal in Paris issued a Solomonic decision that remains in force today. It states that "studies, drawings, oil sketches, and in general all the work preparatory to the execution of a portrait, constitute for the artist the most intimate and personal of property, but he could not, without violating the sanctity of domestic privacy, exhibit or place at public sale these studies or sketches without at least the express authorization of the party in question."[57] The public sale was prohibited but Madame Ingres was allowed to keep the sketches, which in time trickled onto the market.

G.T.

1. "M. Ingres avait d'abord refusé de faire le portrait de madame Moitessier. Il la vit ensuite chez moi un soir, et, frappé de sa beauté, il désira la peindre." Quoted in Delaborde 1870, p. 255.
2. "ni ma pauvre femme et le père n'auront pu voir." Quoted in Lapauze 1911a, p. 442.
3. He is listed as a "négociant" (wholesaler) on the marriage contract, signed on June 14, 1842 (Archives Nationales, Paris, MC ET XXIV–1315). On December 10, 1840, Moitessier Fils et Châtard was awarded a license from the ministry of finance "pour la fourniture des cigares de La havane" ("to purvey Havana cigars").
4. These and many other documents relating to this project were found by Robert McDonald Parker, who, as always, has made a substantial contribution through his assiduous research. Hans Naef published a few excerpts from the birth certificates and other papers relative to the Moitessier's *État Civil;* see Naef 1969 ("Moitessier").
5. "She seems to have been keenly aware he was socially her inferior." Wilson 1977, n.p.

6. Both birth certificates were reconstituted after the Paris archives were burned during the Commune. They are in the archives of the Eighth Arrondissement (ancien I Arrondissement, AdvP *cote* V2E–8958).
7. At his death, his personal property, independent of that of his wife, was valued at only 3,838 francs, after the deduction of Inès's dowry of 30,000 francs. The total value of his wife's estate, at her death, was 152,961.42 francs.
8. "Before giving myself over to my important work, I still have two portraits of the first order to finish: Madame de Rothschild and Madame Moitessier." ("Avant de me mettre tout à fait à mes grandes oeuvres, j'ai encore deux portraits de haute volée à terminer: Madame de Rothschild et Madame Moitessier.") Ingres to Gilibert, July 27, 1845, quoted in Boyer d'Agen 1909, p. 379.
9. "Je vais rentrer à Paris pour terminer enfin, (pour mes péchés), mes deux gros ennemis, mes deux portraits, en m'occupant aussi de ma grande basilique (déjà pensée)." Ingres to Gilibert, June 2, 1846, in ibid., p. 387. The "great basilica" reference is to Ingres's commission to decorate the Parisian church of Saint-Vincent-de-Paul.
10. "Hélas! oui, comment se passe cette misérable vie? Elle est cruellement dure à porter. Toujours contraint par les distractions rongeuses des détails, je ne fais jamais ce que je voudrais et mes mécomptes sont grands. J'ai à peine terminé M^me de Rothschild recommencée en mieux, et le portrait de M^me Moitessier. Maudit portraits! Ils m'empêchent toujours de marcher aux grandes choses que je ne puis faire plus vite, tant un portrait est une chose difficile." Ingres to Gilibert, June 24, 1847, in ibid., p. 388.
11. "Jamais beauté plus royale, plus splendide, plus superbe et d'un type plus junonien n'a livré ses fières lignes aux crayons tremblants d'un artiste. Déjà la tête vit. Une main d'une beauté surhumaine s'appuie à la tempe et baigne dans les ondes de la chevelure un doigt violemment retroussé avec cette audace effrayante et simple du génie que rien n'alarme dans la nature." Gautier, June 27, 1847, quoted in Lapauze 1911a, p. 441.
12. Robert Rosenblum first made this apt allusion; see Rosenblum 1967a, p. 164.
13. I wish to thank Mark Benford of the Department of Greek and Roman Art at the Metropolitan Museum for his research on the mural.
14. Degas's unpublished notes on Ingres (private collection) identify *Madame Moitessier, Seated* as the portrait based on the mural at Naples. Clark writes of the "pose of the Arcadian goddess of Herculaneum"; Clark 1971, p. 364. According to Daniel Ternois (in Paris 1967–68, p. 324), a copy of the mural, by Ingres's student Victor-Louis Mottez, is at

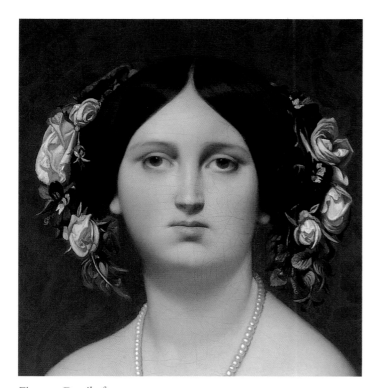

Fig. 272. Detail of cat. no. 133

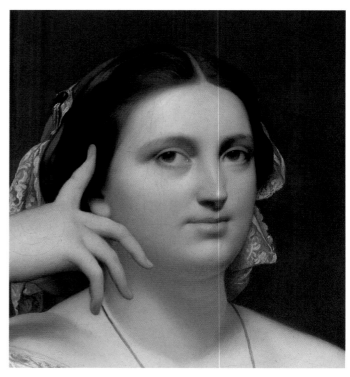

Fig. 273. Detail of cat. no. 134

the École des Beaux-Arts, Paris; Ingres bequeathed a copy, whose author is not known, to the museum at Montauban; and Ingres's student Eugène Roger made a copy (destroyed in 1871) that belonged to Édouard Gatteaux. Hans Naef published an entry, dated October 28, 1837, from Mottez's Roman journal, in which he noted that Ingres "was in heaven" when Mottez showed him three copies and seven tracings that he had made of antique murals. Mottez recorded that Ingres asked his permission to copy one of these, and Naef speculates that Ingres's copy may be the work now in Montauban; Naef 1977–80, vol. 3 (1979), p. 366, n. 3. Taking a contrary position, William Hauptman believes that the distinctive pose derives from contemporary photography. He acknowledeges the mural but states that "there is no specific reason to assume that the antique source was the foremost influence in the conception of the portrait"; Hauptman 1977, p. 122.

15. Lapauze 1911a, p. 440. The excerpt from Gautier's article reprinted by Lapauze (see n. 11, above) makes no mention of the child.

16. "Madame, Auriez-vous l'extrême complaisance de venir demain vers deux heures à la séance, en bras nus et accompagnée de la charmante Catherine; je vous en serai bien reconnaissant et vous prie, Madame, d'agréer, en attendant, mes hommages respectueux et les milles amitiés de ma femme. Ingres. Vendredi matin." Quoted in ibid., pp. 441–42.

17. "d'une grande chambre où il faisait très froid. Ma mère avait la main sur ma tête et il

fallait rester tranquille. C'était bien ennuyeux. Un jour, le vieux bonhomme en bonnet de coton s'est fâché. Il a déclaré que la petite Catherine était insupportable et qu'il allait l'effacer." Quoted in ibid., p. 442.

18. There is a related drawing of the right arm, measuring $14\frac{3}{8} \times 12\frac{5}{8}$ in. (36.5 × 32 cm), formerly in the collections of Henry Lapauze and Alphonse Kann and now in a private collection.

19. "Un autre portrait, encore à l'état d'ébauche, surprend par la fierté de l'ébauche et la suprême majesté de l'attitude. Cette femme impériale et junonienne a été sculptée en quelques coups de pinceau dans cette toile blanche, qui ressemble à du marbre de Carrare.

 "Mais quand M. Ingres le terminera-t-il, lui qui attend, hôte respectueux, que l'inspiration vienne le visiter sans l'aller chercher si elle tarde à venir, de peur de la contraindre, cette belle vierge hautaine à qui les artistes convulsifs de notre époque précipitée ont si souvent fait violence?" Gautier, August 2, 1848, reprinted in Gautier 1880, pp. 249–50.

20. The Archives de la Ville de Paris (V° II, carton 101, rue d'Anjou) indicate a number of proceedings concerning the acquisition of this house, which Moitessier seems to have obtained through the default of a loan or some other business dealing. The first record concerns a judgment of the Tribunal Civil de la Seine on July 27, 1850, recorded on September 10, 1850. The house had been part of the estate of Catherine-Étiennette-Claude d'Aligre, widow of Hilaire-Rouillé de Boissy,

and was owned by the couple's four children. It was valued at 405,000 francs, but Moitessier paid only 370,000 francs, on January 4 and 6, 1851. The balance was forgiven by a judgment in the Moitessiers' favor rendered May 30, 1851.

21. "J'ai ébauché, voyez M^me de Broglie au contentement général et cela sans peine, et celle-ci, notre belle avec toute sa bonté (M^me Moitessier), ne peut s'empêcher de me rappeler qu'il y a sept ans qu'elle est commencée." Ingres to Marcotte, June 16, 1851, quoted in Blanc 1867–68, pt. 7 (1868), p. 537; Lapauze 1911a, p. 464 (partially); and Ternois 1999, letter no. 72.

22. Wilson 1977, n.p.

23. The posthumous inventory of Paul-Sigisbert Moitessier (Archives Nationales, Paris), drawn up on April 5, 1889, lists in the Salon Rouge "un canapé et dix fauteuils et chaise, garnis en étoffes diverses" ("a sofa and ten armchairs and a side chair, upholstered in diverse materials"); the remarkable side chair, visible in the portrait by Ingres would fit this description.

24. A study at the Musée Bonnat, Bayonne (inv. no. 1924–77) also seems to relate to this preliminary stage.

25. "en dentelle noire, appartenaient aux parures plus simples,—mais toutes étaient d'une telle largeur, qu'elles recouvraient, on peut dire, plus de la moitié de la femme." Anon., January 9, 1847, p. 30.

26. Lapauze 1911a, p. 438; formerly in the collection of Jacques Dupont, Paris; with Galerie La Scala, Paris, 1991.

27. Musée Ingres, Montauban, inv. no. 867.2722; Vigne 1995a, p. 491.

28. "Malgré les brillantes expressions dont s'est servie notre belle et bonne madame Moitessier, il n'en est pas moins vrai que la partie n'est pas gagnée encore, ce qui va se décider cependant par une séance de cette terrible et belle tête. A deux heures, madame Moitessier arrive de Villiers tout exprès, et je prie Dieu qu'une saignée ordinaire par le *saigneur* Magendie n'ait rien altéré à ces beaux yeux, à ce divin visage." Ingres to Marcotte, June 16, 1851, quoted in Delaborde 1870, p. 256, and Ternois 1999, letter no. 72.

29. "Vous voudrez bien me la réserver lorsque j'aurai terminé votre robe, que je commence aujourd'hui même; je n'ai pas perdu mon temps: vos bras sont faits comme je le voulais; vous êtes plus grande, et cela fait très bien; en un mot, je ne suis pas trop mécontent et je suis plein de courage. Me voulez-vous mardi à dîner? Je vous apporterai bonnes nouvelles du portrait; nous déciderons bien des choses. En attendant, Madame belle et bonne, agréez l'expression de mes hommages respectueux et de tout mon dévouement. Ingres." Ingres to Madame Moitessier, undated, quoted in Lapauze 1911a, p. 443.

30. "Certes, très belle par vous-même, j'abandonne, après de mures réflexions, le projet des grandes coiffures de soirée. Ce sera encore de meilleur goût pour le portrait et je craindrais que cela n'écrasât trop l'oeil [Lapauze mistakenly transcribed "l'ouïe"] aux dépens de la tête. Voire même le bijou sur la poitrine, d'un style trop vieux, que je vous prie de remplacer par un camée en or. Je ne renonce pas cependant à une longue et simple châtelaine, laquelle je pourrais terminer par la cassolette de la première.

"Ayez donc, Madame, la bonté, lundi, d'apporter la soute de vos bijoux, bracelets et le sautoir de perles sur le cou." Ibid., p. 444.

31. "Retenons les justement curieux, dans leur intérêt même et dans le mien, jusqu'à Catherine; car enfin, dans la semaine, les portes de fer s'ouvriront, *Dio me la mandé buona*, avec encore l'aide de deux grosses séances." Ibid.

32. It is odd that Ingres mentions Foucauld in a letter dated October 1, 1851, since Inès's father had died in 1849. But, as Eric Bertin has kindly pointed out to me, Ingres mistakenly refers to Madame Moitessier as Madame de Foucauld in a letter of October 1, 1851, to Marcotte (quoted in Blanc 1870, p. 172). Evidently, as far as Ingres was concerned, Monsieur Moitessier became a Foucauld upon marriage to Inès.

33. "Que je serai donc heureux de vous revoir ici, mais pour trop peu de temps; je serai le 9 à mon atelier de l'Institut, à vous attendre. J'ai encore, ne vous fâchez pas, à ajouter quelques perfections à votre belle image,

sans rien détruire de ce que vous voulez bien admirer. J'y ai beaucoup travaillé, vous verrez, et assez pour me donner à moi-même plus de contentement, et surtout depuis que le juge suprême, M. Moitessier, et M. de Foucauld, me l'ont permis.

"Je ne vous entretiens pas plus longtemps de mon oeuvre, seulement que vous n'avez plus à votre coiffure les rubans et barbes blancs. Il n'est resté que les raisins et les feuilles, auxquels nous ajouterons, je crois, les belles fleurs jaunes oranges et rubans de velours que je vous prierai d'apporter avec vous. Il me manque aussi le bracelet du bras droit. Tout le reste est fait. Mais il faut aussi une espèce de pelisse du soir, celle qui vous enveloppe lorsque vous sortez du bal, pour jeter sur coin de la chaise.

"Croyez bien, Madame, qu'il n'y a aucun sacrifice à vous avoir attendue dans les premiers jours de septembre, comme je le crois. Ainsi, soyez la bienvenue, Madame la bronzée, la moresque." Ingres to Madame Moitessier, October 1, 1851, quoted in Lapauze 1911a, p. 444.

34. "Savez-vous à qui je ressemble? A quelqu'un qu'oppresse un cauchemar qu'il veut fuir, sans trouver de jambes. Oui, voilà où me mettent les malheureux portraits! J'ai enfin une dernière séance de notre belle et bonne; mais à présent j'ai encore à lui faire sa collerette, ses bagues, le bracelet de sa main droite, sa fourrure sur la chaise, avec ses gants et son mouchoir. Puis il faudra reprendre par les derniers glacis et les dernières touches de ce portrait, qui, depuis sept ans, occupe péniblement ma vie." Ingres to Marcotte, October 16, 1851, quoted in Delaborde 1870, p. 256, and Ternois 1999, letter no. 75.

35. "certainement la plus importante parmi tous mes ouvrages . . . l'oeuvre de sept ans d'un travail déspérant, que la critique attend bouche béante et de l'autre société de Paris." Quoted in Lapauze 1911a, p. 456.

36. "si tous les vents sont bons." Quoted in ibid.

37. "parait l'être, à l'admiration, pardon de ma vanité, de ceux dont j'aime le goût et le suffrage et je le fais porter seulement aujourd'hui même à l'Institut, car il sera mieux et puis c'est là mon lieu d'exposition privée.

"Bonne chose pour moi, les parents sont enchantés: et bien, vous croyez peut-être que je le suis moi entièrement, non mais je ne le dois dire qu'a mes discrets amis; et cela doit être sans cela je cesserais de voir d'en haut, et adieu l'art; et puis si l'on était parfait, ce qui n'est pas le partage humain, on s'ennuierait tant que l'on se tuerait comme par le spleen." Ingres to Gonse, January 7, 1852, quoted in ibid., p. 457.

38. See Ingres to Nieuwerkerke, January 31, 1852, quoted in ibid., p. 446.

39. An anonymous reviewer writing in the *Athénaeum français* in 1854 described the painting once again on view in Ingres's studio. Hans Naef republished the article in Naef 1973 ("Exposition oubliée"), pp. 23–24, noting that no such exhibition was previously known for 1854.

40. "M^me Moitessier est représentée vêtue de velours noir, debout, regardant le spectateur; son geste est simple, de la main droite elle tient l'extrémité d'un chatoyant collier de perles, l'autre main est tombante et soutient une écharpe de riche dentelle noire. Le visage est encadré par des cheveux de couleur brune, dont les ondulations soyeuses réunissent les plus gracieux mouvements. Cette chevelure abondante est détachée du fond par une couronne de fleurs, que l'on peut dire être du plus suave parfum, car elles semblent vraies comme la nature. On retrouve sur le front et dans les yeux le caractère olympien; le nez et la bouche sont d'un type sévère, et le col est d'une fierté de contours digne des statuaires grecs; les bras ne sont pas moins beaux, les mains sont charmantes.

"L'aspect général de ce portrait a le calme et la majesté des productions de l'art antique. On croit voir Junon et son fier regard. Cette composition admirable se détache sur un fond damassé de couleur violâtre, dont le ton aérien et fuyant fait ressortir merveilleusement la lumière dorée répandue sur le visage et sur les épaules de M^me Moitessier. La lumière est moins vive à mesure qu'elle descend: la main gauche est dans une douce demi-teinte, qui rehausse encore l'éclat des carnations, éclairées par le jour principal; les bracelets, les pierreries, qui ornent cette remarquable figure, sont exécutés avec la rare perfection qui caractérise le talent de M. Ingres. On voit aussi, à droite du portrait, un meuble d'une vérité miraculeuse; des gants, un mouchoir, une parure [fourrure?] produisent une heureuse variété de tons." Galimard 1852, pp. 49–50.

41. See Lorenz Eitner's account in the entry for this painting in the forthcoming systematic catalogue of French paintings at the National Gallery of Art; Eitner forthcoming.

42. Naef 1973 ("Exposition oubliée"), pp. 23–25.

43. "un type de reine. M. Ingres l'a entouré de majesté et de grandeur, sans négliger ni les fleurs, ni les draperies, ni une admirable dentelle de Chantilly." About 1855, p. 134.

44. "figures délicates et des épaules simplement élégantes associées à des bras trop robustes, trop pleins d'une succulence raphaélique. Mais Raphaël aimait les gros bras, il fallait avant tout obéir et plaire au maître." Baudelaire, "Exposition Universelle—1855—beaux-arts," reprinted in Baudelaire 1975–76, vol. 2 (1976), p. 587, and quoted in Eitner forthcoming.

45. "Elle trouvait les bras bien gros naturellement et je voulais la persuader qu'ils étaient bien ainsi." Quoted in Paris, Ottawa, New York 1988–89, p. 494.

46. "Madame, Je ne suis peut-être si fou que je le parais: je viens de confronter les deux portraits, et, le conseil de ma femme assemblé et le mien, avons décidé que le dernier est le meilleur. Ainsi donc, madame, toujours à demain, bras nus, et s'il se peut, la robe jaune." Anon., December 15, 1877, p. 369.

47. "Je vous jure ma plus profonde parole d'honneur, que ni moi, ni M^me Moitessier, ne vous avons entendu frapper; moi, cela ne serait pas étonnant, car je suis presque sourd, mais qu'elle n'aye rien entendu, sans plaisanterie, cela est bien étonnant! Au reste, lorsque l'on veut entrer chez son ami, on frappe plus fort, on enfonce la porte, au besoin on crie 'Marcotte'; et, de carte, pas plus; et encore nous avions le pressentiment que vous viendriez et nous nous le sommes dit . . . Mais c'est assez, cher ami, pardonnez-moi, et une autre fois nous serons plus attentifs à vous entendre frapper. J'ai déterminé l'étoffe de sa robe et je compte terminer la tête avant son départ." Ingres to Marcotte, June 19, 1852, quoted in Lapauze 1911a, pp. 448–50, and Ternois, 1999, letter no. 87.

48. Posthumous inventory of Paul-Sigisbert Moitesssier, April 5, 1889; see n. 23, above.

49. Vigne 1995a, p. 492.

50. The pencil drawing, measuring 11 $\frac{3}{8}$ × 8 $\frac{3}{8}$ in. (29 × 21.2 cm), squared for transfer, and stamped with Ingres's atelier stamp was sold by Arcole at the Hôtel Drouot, Paris, June 12, 1992.

51. "J'aurai bien désiré vous voir, bonne et aimable Madame, pour causer de votre portrait, qui, depuis trop longtemps, nous tourmente tous les deux. Je dois d'abord vous dire, ce que vous savez sans doute, que je suis engagé dans un grand travail pour l'Hôtel-de-Ville, et j'ai *promis positivement* de le terminer pour le 1^er janvier prochain; vous comprenez d'après cela, Madame, que je ne puis m'occuper d'autre chose cette année. De plus, oserai-je bien vous avouer franchement que la réussite de ce portrait me préoccupe péniblement! Je vois, plus j'y travaille, que je n'arrive point au but désirable, et cela me désespère et me décourage extrêmement!

"Si je n'avais tenu beaucoup à remplir ma promesse, je vous aurais déjà, depuis longtemps, fait connaître le découragement qui s'est emparé de moi, mais je poursuivais toujours, dans l'espoir que je pourrais arriver à une heureuse fin que je n'espère plus maintenant.

"Croyez bien, bonne et aimable Madame, qu'il m'est très pénible d'abandonner ce portrait, que j'aurais été si heureux d'offrir à M. Moitessier, digne de vous et de lui; mais je préfère l'effacer que de vous le présenter inférieur à ce qu'il doit être.

"Quant à l'ébauche que j'ai promise à M. Moitessier de son portrait, je suis tout disposé à l'entreprendre après mon gros travail, et je ferai en sorte que ce soit promptement fait." Ingres to Madame Moitessier, March 9, 1853, reprinted in Lapauze 1911a, p. 450.

52. "Hier soir, mon cher ami, j'ai eu la visite de M. et Mme Moitessier. Mme Moitessier est très contente de la seconde édition de son portrait qu'elle trouve très ressemblant depuis que notre ami a diminué l'écartement des yeux. Je ne lui ai pas dissimulé a qui elle devait cette amélioration.

"Maintenant il y a encore quelque chose à obtenir. Ce sont les bras qu'on trouve toujours trop forts. Il est certain qu'il le sont déjà trop dans le premier portrait. Tâchez qu'il les diminue dans le second. Il faut que cela vienne de *vous seul,* car si notre ami se doutait que l'observation vient de la Dame, il s'en formaliserait.

"Amenez donc doucement cette réforme. La Dame a les bras forts, c'est vrai, mais c'est une raison de plus pour ne pas les exagérer. Ils seraient rendus même un peu moins que nature qu'on ne pourrait en faire reproche au peintre. Il faut d'ailleurs se rappeler que lorsque le portrait a été commencé, Mme Moitessier avait huit années de moins et qu'alors elle avait moins d'embonpoint.

"J'ai dit à Mme Moitessier que je vous en écrirais et qu'il n'y avait que vous qui puissiez arranger le tout et dégraisser ses bras sans blesser l'amour propre de celui qui la traîte avec amour—au surplus elle le mérite, car je ne connais pas de meilleure femme." Marcotte to Gatteaux, February 24, 1855, reprinted in Naef 1969 ("Moitessier"), pp. 149–50.

53. See Ingres's letter to Luigi Calamatta, dated January 10, 1857, in Boyer d'Agen 1909, p. 453.

54. "Dans le portrait en buste de M^me Moitessier, dont la belle tête est prise dans une étude imitée de la Flore pompéienne (un doigt sur la joue), le regard est distrait par les ramages malencontreux d'une robe fond clair, d'autant plus gênante pour l'oeil qu'elle est mieux rendue." Blanc 1867–68, pt. 7 (1868), p. 539.

55. Rosenblum 1967a, p. 164.

56. Naef 1969 ("Moitessier"), p. 149.

57. "Les esquisses, les dessins, les ébauches, et en général, tous les travaux par lesquels un peintre prélude à l'exécution d'un portrait constituent pour l'artiste la plus intime et la plus personnelle des propriétés, mais il ne saurait, sans porter atteinte à l'inviolabilité du foyer domestique, exposer ou mettre en vente ces esquisses ou ces ébauches, à moins d'une autorisation expresse donnée par l'intéressé." Anon., December 15, 1877, p. 369.

Cat. no. 133. *Madame Paul-Sigisbert Moitessier, née Marie-Clotilde-Inès de Foucauld, Standing*

PROVENANCE: The sitter, 42, rue d'Anjou, Paris, until her death in 1897; said to have been bequeathed to her eldest daughter, Clotilde-Marie-Catherine, Comtesse de Flavigny (1843–1914); however, in 1887 the family house (and presumably the painting) was given by the Moitessiers to their younger daughter, Françoise-Camille-Marie, Vicomtesse Taillepied de Bondy (1850–1934), who sold the house in 1902 and moved with several of her children to 10, avenue Percier, Paris; sold by her heirs after her death to Paul Rosenberg & Co., London, New York, and Paris, 1935; sold to the Samuel H. Kress Foundation, New York, 1945; given to the National Gallery of Art, Washington, D.C., 1946

EXHIBITIONS: The artist's studio, 1854; Paris 1855, no. 3366; Paris 1921, no. 44; London 1936a, no. 2; Paris 1937, no. 351; Amsterdam 1938, no. 137; Belgrade 1939, no. 67; Buenos Aires 1939a, no. 76; Montevideo 1939, no. 13; Rio de Janeiro 1940, no. 56; San Francisco 1940–41, no. 59; San Diego 1941, no. 1; Chicago 1941, no. 85; San Francisco 1941–42, no. 59; Toronto 1944, no. 36

REFERENCES: Delécluze, January 15, 1852 [EB]; Galimard 1852, pp. 49–50; Anon., December 16, 1854 (A. de G.), pp. 1188–89; About 1855, p. 134; Lacroix 1855, p. 207; Nadar 1857, p. 68; Bellier de la Chavignerie 1867, p. 60; Merson and Bellier de la Chavignerie 1867, p. 119; Blanc 1867–68, pt. 7 (1868), pp. 536–37; Blanc 1870, p. 168; Delaborde 1870, no. 140; Anon., December 15, 1877, p. 369; Momméja 1904, p. 103; Boyer d'Agen 1909, pp. 379, 387–88; Lapauze 1911a, pp. 9, 437–48, 454, 456–57, 464, ill.; *La Renaissance de l'art français* 1921, ill. p. 251; Fröhlich-Bum 1924, pl. 58; Hourticq 1928, p. 99, ill.; Davies 1936, pp. 257–58, pls. II, III, b; Pach 1939, p. 111; King 1942, p. 82; Malingue 1943, ill. p. 53; Frankfurter 1946, p. 68, ill.; Alazard 1950, pp. 104–5, pl. XCII; Cairns and Walker 1952, p. 146, ill. p. 147; Wildenstein 1954, no. 266, pl. 104; Mongan 1957, pp. 3–8, ill.; Shapley 1957, pl. 98; Washington, National Gallery 1959, p. 377, ill.; Seymour 1961, p. 195, pls. 186, 187; Walker 1963, p. 244, ill. p. 245; Mongan 1965, pp. 3–4; Cairns and Walker 1966, p. 406, ill. p. 407; Cambridge (Mass.) 1967, under nos. 95–97, fig. 14; Rosenblum 1967a, p. 156, pl. 43; Rosenblum 1967b, p. 77, ill., p. 66; Radius and Camesasca 1968, no. 147, ill., pl. L; Naef 1969 ("Moitessier"), pp. 149–50, fig. 56; Clark 1971, pp. 361, 364, fig. 2; Gere 1972, pp. 81–84, pl. 29; Naef 1973 ("Exposition oubliée"), pp. 23–24; Washington, National Gallery 1975, p. 180, no. 882, ill. p. 181; Baudelaire 1975–76, vol. 2 (1976), p. 587; Wilson 1977, n.p., fig. 4; Naef 1977–80, vol. 3 (1979), pp. 140, 547; Ternois 1980, pp. 102–3, 150, no. 305, ill., p. 151; Washington, National Gallery 1985, p. 208, ill.; Wollheim

1987, pp. 67, 69, 272, figs. 51, 264; Paris, Ottawa, New York 1988–89, p. 494; Zanni 1990, no. 98, ill.; Ockman 1991, pp. 522–23, pl. 25; Washington, National Gallery 1992, p. 178, ill.; Vigne 1995b, pp. 16, 276, fig. 236; Roux 1996, pp. 19, 79; New York 1997–98, [vol. 1], p. 26

Cat. no. 134. *Madame Paul-Sigisbert Moitessier, née Marie-Clotilde-Inès de Foucauld, Seated*

PROVENANCE: The sitter, 42, rue d'Anjou, Paris, until her death in 1897; said to have been bequeathed to her eldest daughter, Clotilde-Marie-Catherine, Comtesse de Flavigny (1843–1914); however, in 1887 the family house (and presumably the painting) was given by the Moitessiers to their younger daughter, Françoise-Camille-Marie, Vicomtesse Taillepied de Bondy (1850–1934), who sold the house in 1902 and moved with several of her children to 10, avenue Percier, Paris; sold by her heirs after her death to Jacques Seligmann & Co., 1935; bought by the National Gallery, London, with the Champney, Florence, Hornby-Lewis, Lewis-Publications, and Temple West Funds, 1936

EXHIBITIONS: The artist's studio, 1857; Paris 1867, no. 99; Paris 1883, no. 140 [EB]; Paris 1921, no. 45; London 1947–48, no. 85; Paris 1967–68, no. 251

REFERENCES: Gautier, June 27, 1847; Gautier, August 2, 1848; Bellier de la Chavignerie 1867, p. 59; Castagnary, May 18, 1867; Blanc 1867–68, pt. 7 (1868), pp. 537, 539; Delaborde 1870, no. 141; Anon., December 15, 1877, pp. 368–69; Gautier 1880, pp. 249–50; Momméja 1904, p. 103; Boyer d'Agen 1909, p. 433; Lapauze 1911a, pp. 9, 440–42, 448–52, 491–93; *Masterpieces of Ingres* 1913, p. 27; *La Renaissance de l'art français* 1921, ill. p. 272; Fröhlich-Bum 1924, pl. 66; Hourticq 1928, p. 109, ill.; Davies 1936, pp. 257–68, pls. I, III, a; Pach 1939, pp. 31, 71, 106, 111, 121, ill. opp. pp. 246, 247, 254; King 1942, p. 82, fig. 23; Malingue 1943, ill. p. 59; Davies 1946, pp. 58–59; Cassou 1947, p. 68; Alain 1949, n.p., ill.; Alazard 1950, pp. 105, 107, pl. XCIII; Wildenstein 1954, no. 280, pls. 109, 112; Davies 1957, pp. 123–25; Mongan 1957, pp. 4, 5; Mongan 1965, pp. 3–8; Cambridge (Mass.) 1967, under nos. 95 and 97, fig. 13; Laclotte 1967, p. 194, ill. opp. p. 192; Rosenblum 1967a, p. 164, pl. 46; Radius and Camesasca 1968, no. 155a, ill., pls. LV, LVI; Naef 1969 ("Moitessier"), pp. 149–50, fig. 55; Davies 1970, pp. 83–85; Clark 1971, pp. 358, 360–61, 364–65, fig. 16; Gere 1972, pp. 80–84, 86, pl. 28; Hauptman 1977, p. 122, fig. 5; McCorquodale 1977, pp. 54–55, ill.; Naef 1977–80, vol. 1 (1977), p. 55; Wilson 1977, n.p., ill.; Naef 1977–80, vol. 2 (1978), p. 494, vol. 3 (1979), pp. 140, 366, 547; Ternois 1980, pp. 102–3, 117, 128–29, 134, 138, 146, 153, 154, 170, no. 317, ill., p. 152; Louisville, Fort Worth 1983–84, ill. p. 149; Wilson 1983,

p. 32, pl. 8; Bryson 1984, pp. 170–75, figs. 97, 99; New York 1985–86, pp. 114, 116; London, National Gallery 1986, p. 287, no. 4821, ill.; Wollheim 1987, p. 272, fig. 265; Vigne 1990, pp. 28–31; Zanni 1990, no. 105, ill.; Vigne 1995b, pp. 10–11, 223, 276, fig. 235; Roux 1996, pp. 19, 22, 79, pl. 25; New York 1997–98, [vol. 1], p. 26, fig. 23

Cat. no. 135. *Study for "Madame Moitessier Seated"*

ca. 1846–48
Black chalk over graphite, partially squared in graphite
$7\frac{3}{8} \times 7\frac{7}{8}$ *in. (18.7 × 20 cm)*
At lower left, the artist's posthumous atelier stamp (Lugt 1477)
Fogg Art Museum, Harvard University Art Museums, Cambridge, Massachusetts
Bequest of Charles A. Loeser 1932.0178

PROVENANCE: The artist's widow; Étienne-François Haro (1827–1897), Paris; Edgar Degas (1834–1917), Paris; his posthumous sale, Galerie Georges Petit, Paris, March 26–27, 1918, no. 183; purchased at this sale by Bernheim-Jeune for 950 francs; Charles A. Loeser; his bequest to the Fogg Art Museum, Harvard University Art Museums, Cambridge, Mass.

EXHIBITIONS: Cambridge (Mass.) 1961, no. 5; Cambridge (Mass.) 1967, no. 97; Cambridge (Mass.) 1980, no. 48; New York 1997–98 ([vol. 2], no. 637)

REFERENCES: Mongan and Sachs 1940, no. 706; Alazard 1950, pl. XCV; Davies 1957, p. 124; Mongan 1957, p. 5, n. 7, fig. 4; Ternois 1959a, preceding no. 124, under no. 125; Mongan 1965, pp. 6, 8; Wilson 1977, n.p.; Vigne 1995a, p. 492, under no. 2723; Mongan 1996, no. 245, ill.

Cat. no. 136. *Study for "Madame Moitessier Seated" (Nude)*

ca. 1846–48
Black chalk
$12 \times 11\frac{5}{8}$ *in. (30.5 × 29.5 cm)*
Inscription at center: l'evantail / de Mᵉ [illegible] [the fan / of Mme Le (illegible)]
At lower left, the artist's posthumous atelier stamp (Lugt 1477)
Paul Prouté S. A.

PROVENANCE: The artist's widow; sale, Hôtel Drouot, Paris, June 18, 1991, no. 95 [EB]; J. Petin; his sale, Hôtel Drouot, Paris, November 21, 1997, no. 111; Paul Prouté S.A.

Cat. no. 137. *Study for "Madame Moitessier Seated" (Right Arm)*

ca. 1846–48
Graphite

$3\frac{3}{8} \times 4\frac{1}{4}$ *in. (8.6 × 10.8 cm)*
At lower left, the artist's posthumous atelier stamp (Lugt 1477)
Lent by the Syndics of the Fitzwilliam Museum, Cambridge, England 2689

PROVENANCE: The artist's bequest to the city of Montauban, 1867; Musée Ingres, Montauban; gift of the director of the museum, Henry Lapauze (1867–1925), to the artist Sir Frank Brangwyn (1867–1956) "in memory of his visits to the Musée Ingres, Montauban, and of my visit to his studio, February 1921";* Sir Frank Brangwyn; his gift to the Fitzwilliam Museum, Cambridge, 1943

EXHIBITION: Paris, Lille, Strasbourg 1976, no. 46, ill.

REFERENCE: Lapauze 1911a, p. 492

*Inscribed in French on the back of an old mount.

Cat. no. 138. *Study for "Madame Moitessier Seated"*

ca. 1846–48
Black chalk with white highlights
$14\frac{5}{8} \times 18\frac{3}{8}$ *in. (37.2 × 46.8 cm)*
Inscribed center right: jambes croisées [crossed legs]
At lower left, the artist's posthumous atelier stamp (Lugt 1477)
Musée du Louvre, Paris
Département des Arts Graphiques RF 11684
London only

PROVENANCE: The artist's widow; Jean-Henri Forain (1852–1931), Paris; his gift to the Musée du Louvre, Paris, 1927

EXHIBITIONS: Paris 1980, no. 86; Montauban 1985

REFERENCE: Méjanès 1980, p. 3, ill.

Cat. no. 139. *Study for "Madame Moitessier Standing"*

1851
Graphite, squared
$7\frac{3}{8} \times 5\frac{3}{8}$ *in. (18.7 × 13.8 cm)*
Inscribed lower left: Ing
At upper left, the artist's posthumous atelier stamp (Lugt 1477)
Private collection, Paris

PROVENANCE: The artist's widow; Henry Lapauze (1867–1925), Paris; his sale, Hôtel Drouot, Paris, June 21, 1929, no. 39; purchased by Georges Wildenstein, Paris; sale, Kornfeld und Klipstein, Bern, June 19, 1980, no. 573; purchased at that sale by Galerie Paul Prouté, Paris; private collector, Paris

EXHIBITION: Paris 1984, no. 34

Cat. no. 140. *Study for "Madame Moitessier Standing"*

1851
Graphite
8 1/8 × 6 1/8 in. (20.7 × 15.5 cm)
Inscribed lower left in an unknown hand: Ingres
At upper left, the artist's stamp (Lugt 1477)
National Gallery of Art, Washington, D.C.
Gift of Paul Rosenberg 1951.14.1

PROVENANCE: The artist's widow; Paul Rosenberg; his gift to the National Gallery of Art, Washington, D.C., 1951

REFERENCE: Eisler 1977, text fig. 125, ill.

Cat. no. 141. *Study for "Madame Moitessier Standing"*

1851
Graphite, squared for enlargement
12 1/2 × 9 1/4 in. (31.8 × 23.5 cm)
At lower right, the artist's stamp (Lugt 1477)
Lyman Allyn Art Museum, Connecticut College, New London, Connecticut 1941.85

PROVENANCE: The artist's widow; his nephew Fernand Guille; his gift in 1892 to M. E. Sylvias; Pierre Geismar; perhaps his sale, Paris, November 15, 1928, no. 33; Jerome Stonborough; his sale, Parke-Bernet Galleries, Inc., New York, October 17, 1940, no 35; purchased at that sale for $1050 by the Lyman Allyn Art Museum, New London, Connecticut

EXHIBITIONS: Paris 1924, no. 174; Andover 1958; Wellesley 1958; Schenectady 1960; Minneapolis, New York 1962, no. 65; Cambridge (Mass.) 1967, p. 67, no. 96, ill.

REFERENCES: Anon., December 15, 1877, pp. 368–69; Mongan 1957, pp. 3–8, fig. 3; Eisler 1977, text fig. 129; Eitner forthcoming

Cat. no. 142. *Study for "Madame Moitessier Standing" (Head)*

1851
Graphite heightened with white
18 × 13 1/4 in. (45.8 × 33.6 cm)
Signed center left: Ingres
Inscribed with color notes at center and upper right
The J. Paul Getty Museum, Los Angeles
89.GD.50
London and Washington only

PROVENANCE: Madame Sigisbert Moitessier, née Marie-Clotilde Inès de Foucauld; her family by descent; Edgar Degas, Paris; his sale, Galerie Georges Petit, Paris, March 26-27, 1918, no. 210; H. Schmidt, Geneva; A. McMillan, New York; acquired on the London art market by The J. Paul Getty Museum, Los Angeles, 1989

EXHIBITION: London 1988, no. 66, ill.

REFERENCES: Bull 1989, p. 50; *Getty Museum Journal* 1990, p. 186, no. 39, ill.; London 1990, p. 22, under no. 10

Cat. no. 143. *Study for "Madame Moitessier Standing"*

1851
Graphite on tracing paper, squared in black chalk
14 × 6 5/8 in. (35.5 × 16.8 cm)
Signed lower left: Ing
At lower right, the artist's posthumous atelier stamp (Lugt 1477)
The J. Paul Getty Museum, Los Angeles
91.GG.79
London and Washington only

PROVENANCE: The artist's widow; Raimundo de Madrazo y Garreta (1841–1920), Versailles; the comtesse de Behague, Paris; her sale, Sotheby's, London, June 29, 1926, no. 97; Wildenstein and Co. by 1951; purchased from that gallery in or before 1967 by Villiers David, London; sale, Christie's, London, July 3, 1990, no. 138; Hazlitt, Gooden and Fox, London; acquired by The J. Paul Getty Museum, Los Angeles, 1991

EXHIBITIONS: Paris 1967–68, no. 247, ill.; London 1990, no. 10

REFERENCES: Eisler 1977, text fig. 127; *Getty Museum Journal* 1992, pp. 158–59, no. 49, ill.

Cat. no. 144. Unknown assistant. *Study for "Madame Moitessier Seated"*

ca. 1852
Oil and graphite on canvas
18 1/8 × 15 in. (46 × 38 cm)
Inscribed top center in ink over pencil: Mme Moitessier
Inscribed lower left in pencil: me moitessier
Musée Ingres, Montauban 867.182

PROVENANCE: The artist's bequest to the city of Montauban, 1867; Musée Ingres, Montauban

EXHIBITIONS: Montauban 1970, no. 31; Turin 1987, no. 115, ill.; Rome, Paris 1993–94, no. 115, ill.

REFERENCES: Lapauze 1911a, p. 49 (ill. in reverse); Davies 1936, p. 261, pl. IV, c; Davies 1946, pp. 123–24; Alazard 1950, pl. XCIV; Ternois 1965, no. 185, ill.; Ternois and Camesasca 1971, no. 156b, ill.; Barousse 1973, p. 25; Ternois 1980, no. 318, ill.; New York 1985–86, fig. 92; Vigne 1990, ill. p. 28

145, 146. Princesse Albert de Broglie, née Joséphine-Eléonore-Marie-Pauline de Galard de Brassac de Béarn

Ingres was well acquainted with Victor, duc de Broglie, and his son Albert, prince de Broglie. Both were committed Orléanists, as was Ingres—at least during the reign of Louis-Philippe d'Orléans. The duke was a member of the Académie Française while Ingres occupied important positions at the Académie des Beaux-Arts. Scions of a distinguished family that traced its roots to a brilliant marshal under Louis XIV (whose grandson, Louis XV, had elevated their title to duke), the Broglies whom Ingres knew continued to be active in affairs of state (see discussion under cat. no. 125). Prince Jacques-Victor-Albert (1821–1901) was secretary to the French ambassador in Madrid and then to the ambassador in Rome, before resigning with the fall of King Louis-Philippe in 1848. During the Second Empire he studied the history of religion and became an outspoken advocate of religious tolerance (his mother was a Protestant); his history of the Christian church in the fourth century won him an appointment to the Académie Française, where he sat next to his father. As an Orléanist, he opposed Louis-Napoleon's rule, and he ran for (and lost) a seat in parliament during the elections of 1869. Following Bonaparte's fall in 1870, he came to power in the Third Republic, becoming prime minister during General MacMahon's presidency (1873–79).

Ingres had completed the portrait of Albert de Broglie's sister, the comtesse d'Haussonville, in 1845 (cat. no. 125). It was inevitable that he would be pressed to make a portrait of her ravishing sister-in-law, Pauline (1825–1860), who had become the princesse de Broglie on June 18 of that year, bringing joy to Albert, his family, and friends. One wrote:

> Albert de Broglie is radiant with happiness. How could he be otherwise? What is lacking to him in his situation? The most distinguished man of his generation, a future of success and ambition, a fine name, a great fortune, and he is marrying a beautiful

young person who has the same social advantages, and who, like himself, was raised with feelings and habits of piety.[1]

Pauline, deeply religious, was also extremely shy; her husband later recalled that her shyness was infectious, causing people to ignore her to spare her the embarrassment of normal social intercourse.[2] In addition to raising five sons, she wrote studies in religious history, an interest she shared with her husband. After Pauline's premature death from consumption at age thirty-five, Albert published her two-volume *Christian Virtues Explained by Examples Drawn from the Lives of the Saints*.[3]

By 1850 Ingres had relented to the pleas of the Broglies. According to an eyewitness, the artist dined with them in January 1850 in order to study his subject: "Yesterday, Monday, M. Ingres came to dine here (at the Broglies) to see the profile of a princess whom he will paint in the month of March, when the days will be light and long. He seemed to be very happy with his model."[4] Perhaps that night, or soon after, he made his first sketches of Pauline seated in an armchair (fig. 274).[5] In one of these drawings, Ingres has already captured the oval of her face, the arch of the eyebrows, the straight line of her nose, and the gesture of folded arms, with one hand disappearing into the folds of a sleeve. He experiments, however, with one hand coyly brought to the neck, a pose he would later use in a finished portrait drawing of Pauline (fig. 275; it is possible that the former drawing was made as a study for the latter, rather than for the painting).

By June 1851, eighteen months after the introductory dinner, Ingres had settled upon the definitive pose and had begun painting. He wrote to his friend Charles Marcotte, "*You see,* I have sketched in Mᵐᵉ de Broglie to everyone's satisfaction and without much trouble; and this one, our beautiful one, with all of her goodness (Mᵐᵉ Moitessier), cannot stop reminding me that her [unfinished] portrait was

145

begun seven years ago. Oh! portraits, portraits, what have I done to you?"[6] Prior to working on this *ébauche* (oil sketch), Ingres had probably already completed the two preparatory drawings now known (and presumably several more now lost). The first of these was a figure study in the nude, for which a professional model must have posed (fig. 277). A faithful student of David, Ingres continued to study nude figures in order to better understand the relationship of the body to the voluminous contemporary costume. He had asked his model to cross her forearms for one pose, but in an additional sketch on the same sheet he arrived at the definitive position of folded arms. He then produced the second, fairly elaborate, preparatory drawing, in which the princess wears her evening dress and jewelry and assumes her final stance (fig. 278).[7] For this study, Ingres did not bother to complete the face; he focused instead on the play of light and shadow and anticipated some of the visual excitement to be provided by the satin skirt and the damask chair. The drawing (which later in the century belonged to Pauline's brother-in-law, the vicomte d'Haussonville) was then squared for transfer to the canvas.

Ingres was experiencing his customary difficulties and anxieties while painting this portrait. On March 21, 1852, he wrote Marcotte:

> I have serious problems with one eye and I am treating it; I am taking strong doses of Sedlitz water, and evenings are prohibited these days, and all of this is bad because I have begun and interrupted the drawing of M^me de Broglie. . . . Ah! if only they knew the trouble I make for myself with their portraits, they would feel sorry for me; but [I] cannot nonetheless lose my eyes to them.[8]

While Ingres probably refers here to the finished portrait drawing (fig. 275), he may also be speaking in general terms of the painting.

In a letter of June 19, 1852, he complained again to Marcotte about his eyes:

> I am working to the point of killing my eyes—since I have so much trouble painting from life because of the sun—on the background of the princesse de Broglie,

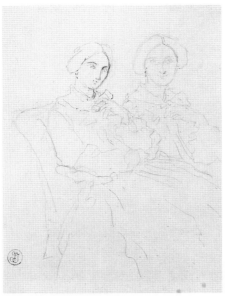

Fig. 274. *Study for "Princesse de Broglie,"* ca. 1850–51. Graphite on paper, 8 × 6 in. (20.4 × 15.3 cm). Sold, Christie's, London, July 1, 1997, no. 204. Location unknown

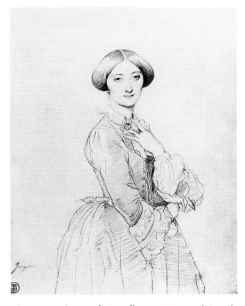

Fig. 275. *Princesse de Broglie,* ca. 1851–52 (N 422). Graphite on paper, 12¼ × 9¼ in. (31.2 × 23.5 cm). Private collection

which I am painting at her house, and that helps me to advance a great deal: but, alas, how these portraits make me suffer, and this will surely be the last one, excepting, however, the portrait of Delphine.[9]

This last comment helps to date the letter, since Ingres did not marry Delphine Ramel until April 15, 1852, making it unlikely that the message was written in June 1851, as some scholars have suggested. The first statement is far more interesting, however, because it tells us that Ingres was painting the background himself at the Broglie residence at 90, rue de l'Université. This was unusual, since the use of studio assistance had become standard for Ingres after his return to Paris in 1824, and with advancing age he participated less and less in nonessential details.[10] His personal involvement with the painting may also explain the small number of surviving preparatory drawings, because more drawings were required when others did the actual painting. One additional working drawing has come to light, a full-scale study on tracing paper of Pauline's arms and hands (cat. no. 146),[11] which was probably traced directly from the painting in progress in order to resolve a particular question of contour and shadow.

The background of this portrait, painted on site, could hardly be simpler. Unlike

the object-charged interiors visible in the depictions of the comtesse d'Haussonville (cat. no. 125) and the portrait of Madame Moitessier seated (cat. no. 134), for which assistance has been documented, this setting offers little to distract the eye: the pale gray paneling heightened with gilding; a panel of blue drapery at the left; a blue-buttoned banquette, or borne, against the wall; and the gold damask armchair with its still life of accessories—a mother-of-pearl and enamel fan, gloves, a white shawl embroidered in gold thread, and a satin-lined black velvet cape trimmed with feathers, fringe, and jet beads. It is unimaginable that Ingres would have given an assistant the pleasure of painting the reflections and folds of the silks in this work. For all of his complaining, he obviously delighted in rendering textiles, a forte already conspicuous at his debut at the Salon of 1806; execution of faces and hands was what required so much effort on his part.

Upon completing the portrait in June 1853, Ingres announced to Marcotte: "Voilà, the painting is finished and finished *to the applause of everyone*. It is, to tell the truth, really beautiful. I say 'everyone': no, until now only relatives and friends have seen it. I am going to sequester it, and for good reason, until the princesse de Broglie returns, that is, until the end of the

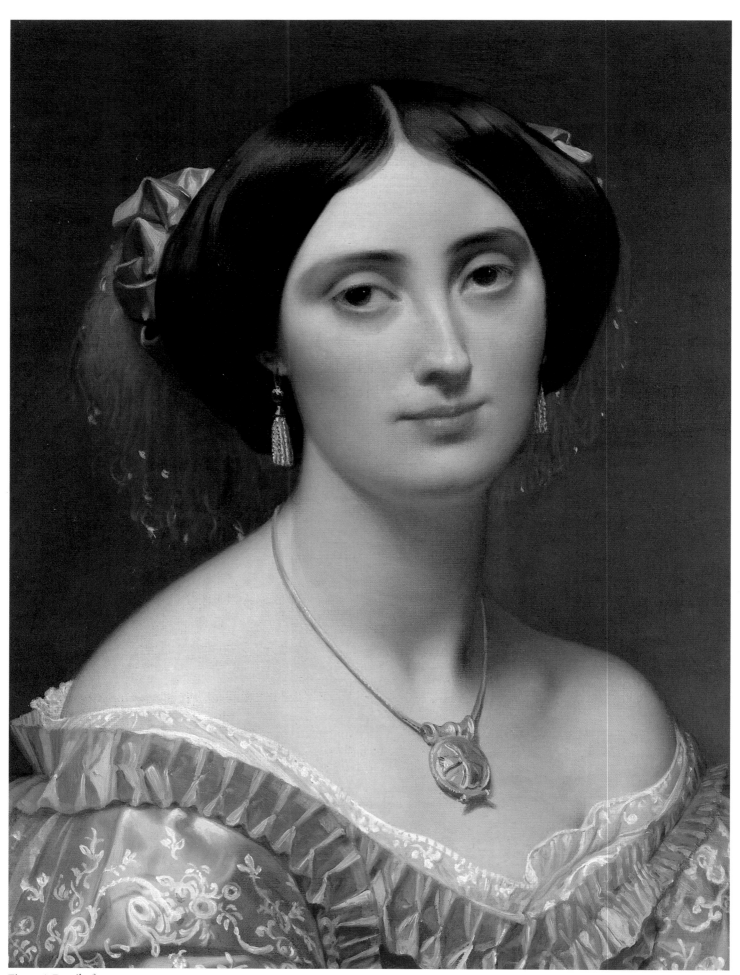

Fig. 276. Detail of cat. no. 145

year. Then I could show it with some others."[12] This he did in December 1854, when he exhibited in his studio on the quai Voltaire not only the portrait of the princesse de Broglie but also the portrait of Madame Moitessier standing (cat. no. 133), the 1805 portrait of Lorenzo Bartolini (fig. 53), and versions of *The Virgin with the Host* and the *Venus Anadyomene* (figs. 200, 201). With its Bronzino-like mannerisms and hallucinatory attention to detail, the portrait of the princess naturally commanded commentary. One wag, no doubt a republican, wrote:

> The second portrait shows us Mme de B. She is a puny, wilted, sickly woman; her thin arms lean on an armchair placed in front of her, she is dressed in blue satin and covered in gemstones and lace. M. Ingres has rendered in an unheard-of manner these large, veiled eyes, deprived of sight. He has given this face a negative expression that he must have seen in real life, and reproduced it with a sure touch. The accessories . . . are painted with a rare happiness. They never have any more value than they should, and they thus leave all the importance of the composition to the principal figure.[13]

When Ingres featured the painting in his exhibition at the Exposition Universelle of 1855, almost every critic, even those hostile to Ingres, found it a masterpiece. Théophile Gautier remarked on the likeness "of madame la princesse de B., so fine, so aristocratic, reproducing so much of the charm of the modern grande dame; what a delicious harmony, those pale and pearly arms and hands setting themselves off from the blue satin of the dress."[14] Edmond About struck a similar note:

> *Mme la princesse de Broglie* is fine, delicate, elegant to the tips of her nails, to sum up, a grande dame in defiance of the new kind behind whom we all obediently march. M. Ingres has expressed these gifts of birth with a rare happiness. Mme la princesse de Broglie is a delicious incarnation of nobility. Her pose alone would betray her breeding even when the finesse of her lines would not. Around this exquisite beauty, the painter spared nothing that could heighten the luster. He attended equally to the costume and to the furniture, that exterior form of dress. The satin

Fig. 277. *Study for "Princesse de Broglie" (Nude)*, ca. 1852–53. Graphite on paper, 11¾ × 6¼ in. (29.8 × 15.9 cm). Musée Bonnat, Bayonne

Fig. 278. *Study for "Princesse de Broglie,"* ca. 1852–53. Graphite and red chalk on paper, 11 × 6⅞ in. (27.8 × 17.5 cm). Sold, Hôtel Drouot, Paris, June 24, 1985, no. 3. Location unknown

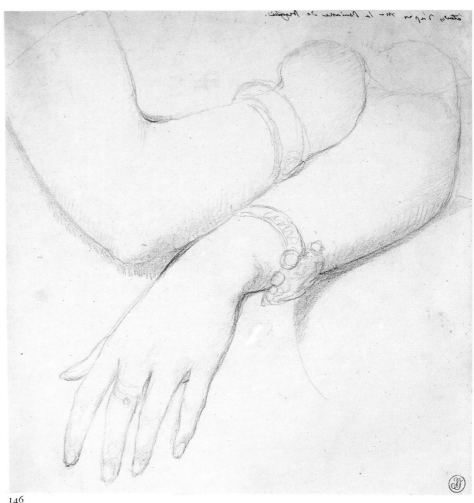

146

Fig. 279. "A Young Lady on the High Classical School of Ornament." *Punch, or the London Charivari*, July 16, 1859

Fig. 280. Lady's hair ornament. French, ca. 1850. Marabou feathers and gelatin sequins. The Metropolitan Museum of Art, Costume Institute

of the gown, the jewels, the lace, and the marabou feathers of her coiffure have a Chinese precision and an English elegance. M. Muller [Charles-Louis-Lucien Muller, 1815–1892] has been given much credit for his skill in painting silks. But as soon as one sees the dress of Mme la princesse de Broglie, all the silks of M. Muller appear to have been bought at the bazaar.[15]

Charles Perrier, writing for the independent-minded *L'Artiste*, found the silks distracting but the realization of the face very fine:

M. Ingres's portraits of women are not the happiest works by this painter. In general I find that the expression does not gain in grace and beauty and that it loses in strength and depth. There are, however, two that we can take as types, one of grace and the other of beauty: the portraits of madame la comtesse d'H[aussonville] and madame la princesse de B[roglie]. . . . In that of madame la princesse de B[roglie] . . . I am sorry to find that M. Ingres was too concerned with the effects of yellow and blue satin. The blue of the dress discolors the hand with a reflection that is excessive. It is disturbing that such a beautiful hand should be spoiled by a puerile affectation. But the faults are amply recompensed by the head alone, taken by itself, whose

beauty is that of a fully formed patrician and the painting of which, at once fine and solid, has all the charm of the most beautiful creations of M. Ingres.[16]

Ingres's artful deformations in the portrait were greeted with characteristic sarcasm by Théophile Silvestre, who noted that "the fingers of madame la princesse de B[roglie] are broken at every knuckle. . . . If M. Ingres's personages could feel and speak their pains, all the cries and moans of a battlefield would emerge from the depths of the paintings."[17] Speaking generally of Ingres's problematic combination of modern costume with classical ideal, Silvestre remarked, "The artist resigns himself to women's costume, but he would prefer to dress them as statues. 'How I suffer to paint this dressed monkey,' he said one day while making a portrait of a woman celebrated for her opulence [Madame Moitessier?]."[18] Baudelaire, a severe judge and no slavish friend of Ingres, disagreed:

In fact it is in this genre [portraits] that he has found his greatest, most legitimate success. . . . M. Ingres chooses his models, and it must be recognized that he chooses, with marvelous tact, the most appropriate models to show off his kind of talent. The most beautiful women, rich in nature, of

calm and flourishing health, there is his triumph and his joy![19]

After his wife's death in 1860, Albert de Broglie is said to have shut her portrait behind curtains.[20] Nonetheless, throughout his life he generously lent the painting to important exhibitions, notably in 1867, 1885, and 1900. His children, grandchildren, and great-grandchildren distinguished themselves in their own rights: Maurice, duc de Broglie, and Louis, prince de Broglie, both physicists, were members of the Académie Française in the early twentieth century; Louis won the Nobel Prize for science in 1929. The family sold the painting in 1958 but is said to have kept Pauline's splendid jewelry—the seed-pearl earrings, the ruby and diamond bracelet, the pearl necklace worn as a cuff, the pendant in the Early Christian style.[21] The pendant, or *bulla*, was probably made by the mid-nineteenth-century Roman jeweler Fortunato Pio Castellani, whose firm single-handedly fashioned a taste for such Byzantine-style jewelry. Contemporary cartoons show that the princess's jewelry accords with the latest style (fig. 279).[22] Her marabou feathers—or, if not hers, an identical set—sprinkled with gelatin sequins, now belong to the Costume Institute of The Metropolitan Museum of Art (fig. 280).

The frame, a deep cove set with a garland of gilt flowers and modeled on the frame for the portrait of Madame Moitessier seated (cat. no. 134), was manufactured in New York in the 1960s. G.T.

1. Quoted by Edgar Munhall in New York 1986, n.p.

2. Ibid.

3. Published as *Les Vertus chrétiennes expliquées par des récits tirés de la vie des saints* (Paris, 1862).

4. "Hier, lundi, M. Ingres est venu dîner ici (chez les Broglie) pour voir de profil une princesse qu'il peindra au mois de Mars, quand le jour sera clair et long. Il a l'air fort content de son modèle." Ximénès Doudan, the former tutor of the comtesse d'Haussonville, to Baronne A. de Staël, dated January 28, 1850, quoted in Garrisson 1965, p. 10. Munhall (in New York 1986) dates the same letter January 17, 1849. It seems impossible to reconcile these two dates.

5. Location unknown; sold at Christie's, London, July 1, 1997, lot 204. It was first

published by Agnes Mongan in Mongan 1958, pl. 1.

6. "J'ai ébauché, *voyez* M^me de Broglie au contentement général et cela sans peine, et celle-ci, notre belle avec toute sa bonté (M^me Moitessier), ne peut s'empêcher de me rappeler qu'il y a sept ans qu'elle est commencée. Oh! portraits, portraits, que vous ai-je fait?" Quoted in Blanc 1867–68, pt. 7 (1868), p. 537, Lapauze 1911a, p. 464 (partially), and Ternois 1999, letter no. 72.

7. This drawing was shown in the 1861 exhibition at the Salon des Arts-Unis and described in Galichon 1861a, p. 355; illustrated in Lapauze 1911a, p. 455.

8. "Moi-même, j'ai mal sérieusement à un oeil et je le soigne; je prends l'eau de Sedlitz à force et les soirées me sont interdites ces jours-ci, et tout cela mal à propos, car j'avais commencé et interrompu le dessin de M^me de Broglie. . . . Ah! si l'on savait le mal que je me donne avec leurs portraits, ils auraient pitié de moi; mais [je] ne puis cependant pas y perdre mes yeux." Quoted in Lapauze 1911a, p. 464.

9. "Je fais, à me tuer les yeux, tant je suis mal pour peindre d'après nature à cause du soleil, le fond de la princesse de Broglie, que je peins chez elle, dans son appartement, ce qui m'avance beaucoup: mais, hélas! que ces portraits me font souffrir, et que c'est bien le dernier, excepté cependant celui de Delphine." Quoted in Delaborde 1870, p. 247, where it is dated to June 1855 even though the painting was completed in 1853. Lapauze (1910, p. 328) places it with letters from 1852; Munhall (in New York 1986, n.p.) dates it to June 1851. The correct date of the letter is June 19, 1852; Ternois 1999, letter no. 87. In an undated letter to Calamatta, dated by some scholars to 1853, Ingres mentions that "tomorrow, to my regret, I must begin my sessions with the princess again, but I am well advanced in this portrait: the accessories are done." ("Je dois demain à mon grand chagrin recommencer mes séances de la princesse, mais je suis avancé dans ce portrait: les accessoires sont faits.") Quoted in Ternois 1980a, p. 88.

10. See p. 529 in this catalogue.

11. Delaborde (1870, p. 246) cited an additional drawing in the Gatteaux Collection, which was destroyed by fire in 1870: "A preparatory drawing, indicating the general pose of the figure and the movement of the modified contours, is in the collection of M. Gatteaux." ("Une étude dessinée, indiquant l'attitude générale de la figure et le mouvement des lignes de l'ajustement, est conservée dans la collection de M. Gatteaux.")

12. "Voilà le portrait fini et fini *a l'applauso di tutti*. Il est, à la vérité, fort joli. Je dis 'de tous': non, il n'y a jusqu'ici que les parents et amis qui l'ont vu. Je vais le séquestrer, et

pour cause, jusqu'au retour de la princesse de Broglie, c'est-à-dire jusqu'à la fin de l'année. Alors je pourrai le montrer avec d'autres." Ingres to Marcotte, June 20, 1853, quoted in ibid., p. 247, and Ternois 1999, letter no. 89.

13. "Le second portrait nous représente Mme de B. C'est une femme chétive, étiolée, maladive; ses bras minces s'appuient sur le fauteuil placé devant elle; elle est vêtue de satin bleu et couverte de pierreries et de dentelles. M. Ingres a rendu d'une manière inouïe ces grands yeux voilés, privés de regard. Il a donné à ce visage une expression négative qu'il a dû prendre sur le fait, à coup sûr. Les accessoires . . . sont touchés avec un rare bonheur. Jamais ils n'ont plus de valeur qu'ils ne doivent en avoir, et ils laissent ainsi à la figure principale toute l'importance de la composition." Anon., December 16, 1854 (A. de G.), pp. 1188–89, discovered by Hans Naef and reprinted in Naef 1973 ("Exposition oubliée"), p. 23.

14. "de madame la princesse de B., si fin, si aristocratique, et reproduisant avec tant de charme la grande dame moderne; quelle harmonie délicieuse que ces bras et ces mains d'une pâleur nacrée, se détachant du satin bleu de la robe." Gautier 1855, pp. 165–66.

15. "*Mme la princesse de Broglie* est fine, délicate, élégante jusqu'au bout des ongles, grande dame enfin en dépit du niveau sous lequel nous marchons tous. M. Ingres a exprimé avec un rare bonheur ces dons de la naissance. Mme la princesse de Broglie est une délicieuse incarnation de la noblesse. Sa pose seule trahirait sa race quand la finesse de ses traits ne nous en avertirait pas. Autour de cette beauté exquise, le peintre n'a rien épargné de ce qui peut en relever l'éclat. Il a soigné également la toilette et le mobilier, cette toilette extérieure. Le satin de la robe, les bijoux, les dentelles et les marabouts de la coiffure sont d'une précision chinoise et d'une élégance anglaise. On a fait in grand mérite à M. Muller de son habileté à peindre les soieries. Mais lorsqu'on vient de voir la robe de Mme la princesse de Broglie, toutes les soieries de M. Muller paraissent achetées au Temple." About 1855, p. 134.

16. "Les portraits de femmes de M. Ingres ne sont pas les plus heureux de ce peintre. Nous trouvons qu'en général l'expression n'y gagne pas en grâce et en beauté ce qu'elle perd de force et de profondeur. Il y en a deux cependant que nous prendrons comme les types, l'un de la grâce, l'autre de la beauté: ceux de madame la comtesse d'H . . . et de madame la princesse de B. . . . Dans celui de madame la princesse de B . . . nous avons regretté de trouver M. Ingres un peu trop occupé de ses effets de satin jaune et bleu. Le bleu de la robe déteint sur la main avec un reflet outré. Il est fâcheux qu'une si belle main soit gâtée par une affectation puérile."

Mais ces défauts sont amplement rachetés par la tête seule prise à part, qui est d'une beauté de patricienne achevée et dont la peinture fine et solide en même temps a tout le charme des plus belles créations de M. Ingres." Perrier 1855, p. 45.

17. "les doigts de madame la princesse de B*** sont brisés à toutes les phalanges. . . . Si les personnages de M. Ingres pouvaient sentir et parler leurs douleurs, il sortirait du fond de ses tableaux tous les cris et les gémissements qui s'élèvent des champs de bataille." Silvestre 1856, p. 23.

18. "L'artiste se résigne au costume des femmes; mais il aimerait mieux les vêtir en statues. 'Que je souffre à peindre ce singe habillé,' disait-il un jour en faisant le portrait d'une femme célèbre par son opulence." Ibid., p. 31.

19. "c'est en effet dans ce genre qu'il a trouvé ses plus grands, ses plus légitimes succès. . . . M. Ingres choisit ses modèles, et il choisit, il faut le reconnaître, avec un tact merveilleux, les modèles les plus propres à faire valoir son genre de talent. Les belles femmes, les natures riches, les santés calmes et florissantes, voilà son triomphe et sa joie!" Baudelaire, "Exposition Universelle—1855—beaux-arts," reprinted in Baudelaire 1975–76, vol. 2 (1976), pp. 586–87.

20. Munhall in New York 1986, n.p.

21. According to Munhall in ibid.

22. I thank Christine Brennan for her help on Castellani.

Cat. no. 145. *Princesse Albert de Broglie, née Joséphine-Eléonore-Marie-Pauline de Galard de Brassac de Béarn*

PROVENANCE: Delivered to Albert, prince de Broglie, 1853; by descent to the subsequent ducs de Broglie; purchased, through Wildenstein & Co., Inc., by Robert Lehman, New York, January 1958; bequeathed by him to the Robert Lehman Foundation, 1969; given to The Metropolitan Museum of Art, New York, 1975

EXHIBITIONS: The artist's studio, 1854; Paris 1855, no. 3367; Paris 1867, no. 436; Paris 1885, no. 152 [EB]; Paris 1900a, no. 370; Paris 1911, no. 53; Paris 1934c, no. 7; Paris 1935b, no. 284; London 1936a, no. 3; New York 1986; New York 1988–89

REFERENCES: Anon., December 16, 1854 (A. de G.), pp. 1188–89; About 1855, p. 134; Anon., July 6, 1855, p. 68; Belloy, June 10, 1855; Du Camp 1855, p. 83; Gautier 1855, pp. 165–66; Lacroix 1855, p. 207; Mantz 1855, p. 224; Nadar, September 16, 1855; Perrier 1855, p. 45; Petroz, May 30, 1855; Ponroy 1855, pp. 143–44; Silvestre 1856, p. 45; *Visites et études* 1856; Nadar 1857, p. 68; Cantaloube 1867, p. 532; Blanc 1867–68, pt. 7 (1868), p. 537; Delaborde 1870, no. 112; Momméja 1904, p. 103; Lapauze 1910, p. 328; Lapauze 1911a, pp. 9, 440, 455, 457, 463–65, 526, ill. p. 459; *Masterpieces of Ingres* 1913, ill. p. 14; *La Renaissance*

de l'art français 1921, ill. p. 268; Fröhlich-Bum 1924, pl. 62; Parker 1926, p. 30, ill.; Hourticq 1928, p. 103, ill.; Davies 1934, p. 241, ill. p. 243; Sterling 1934, pp. 3–4, ill.; Waldemar George 1934, p. 194, ill. p. 193; Laver 1937, p. 17, pl. 7; Pach 1939, p. 114, ill. opp. p. 226; Malingue 1943, ill. p. 54; Cassou 1947, pl. 20; Roger-Marx 1949, pl. 46; Alazard 1950, pp. 105–7, pl. XCVI; Wildenstein 1954, no. 272, pl. 98; Mongan 1957, p. 4; Anon., January 27, 1958, pp. 68, 71, ill.; Mongan 1958, pp. 6–7; Garrisson 1965, pp. 10–11; Rosenblum 1967a, p. 158, pl. 44; Radius and Camesasca 1968, no. 150, ill.; Clark 1971, pp. 360–61, fig. 15; Naef 1973 ("Exposition oubliée"), pp. 23–24;

Hauptman 1977, pp. 122–23, fig. 6; Ternois 1980a, p. 88; Madoff 1989, p. 107, ill. p. 106; Zanni 1990, no. 101, ill.; Michel, Prince of Greece 1992, p. 81, ill.; Bern 1995, p. 13, ill. p. 14; Vigne 1995b, p. 276, fig. 238; New York 1996, p. 84, fig. 56; Roux 1996, pp. 19, 76, pl. 24

Cat. no. 146. *Study for "Princesse de Broglie" (Arms and Hands)*

ca. 1852–53
Charcoal on tracing paper
12 1/2 × 11 5/8 in. (31.6 × 29.5 cm)
Inscribed in reverse at upper right: études d'après

Me la Princesse de Broglie. [studies after the princesse de Broglie.]
At lower right, the artist's posthumous atelier stamp (Lugt 1477)
Konrad Klapheck, Düsseldorf, Germany
New York only

PROVENANCE: René Engel, Geneva; his heirs; Galerie Jan Krugier, Ditesheim & Cie., Geneva; purchased by Konrad Klapheck, Düsseldorf

EXHIBITIONS: Geneva 1951, no. 157; New York 1988b, no. 35

147. Copy after Ingres's 1804 Self-Portrait

Madame Gustave Héquet(?)
ca. 1850–60
Oil on canvas
34 × 27 1/2 in. (86.4 × 69.9 cm)
Inscribed lower left: Ingres / 1804
The Metropolitan Museum of Art, New York
Bequest of Grace Rainey Rogers, 1943 43.85.1
New York and Washington only

W 18

This work is a variant, with several significant changes, of the self-portrait that Ingres painted in 1804 and exhibited at the Salon of 1806. That portrait—known from a copy painted by Ingres's fiancée, Julie Forestier, in 1807 (cat. no. 11), a single proof of an etching retouched by Ingres (fig. 281), and a photograph made about 1850 (fig. 282)—no longer exists. Although there is some disagreement,[1] most scholars believe that the 1804 canvas was transformed by Ingres about 1850 into the painting now at the Musée Condé in Chantilly (fig. 283). The present work, which reproduces elements of both the original and the revised self-portraits, was probably made between 1850 and 1860. It

was executed under Ingres's supervision by one of his students, perhaps Madame Gustave Héquet.[2] Early sources suggest that the master himself retouched it. It seems, however, that he could not have acquired the copy until 1866.

Julie Forestier's copy of the 1804 portrait (cat. no. 11) shows that Ingres had originally depicted himself in his studio, his heavy wool coat slung over his shoulder, a piece of chalk in his right hand, and in his left a cloth, with which he erased an empty canvas. This gesture was ridiculed by the critics of the Salon, among them the reviewer for *Mercure de France*, who wrote, "In one hand he holds a handkerchief which he applies for no apparent reason to

Fig. 281. Jean-Louis Potrelle (1788–1824) (?), after Ingres's 1804 *Self-Portrait*, before 1850. Etching, retouched by Ingres in graphite and white gouache, 18 5/8 × 11 3/4 in. (47.4 × 29.8 cm). Musée Ingres, Montauban (68.2.6)

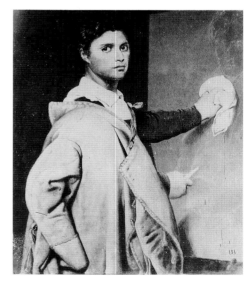

Fig. 282. Charles Marville (1816–1878?). Photograph of Ingres's 1804 *Self-Portrait*, ca. 1850. Private collection

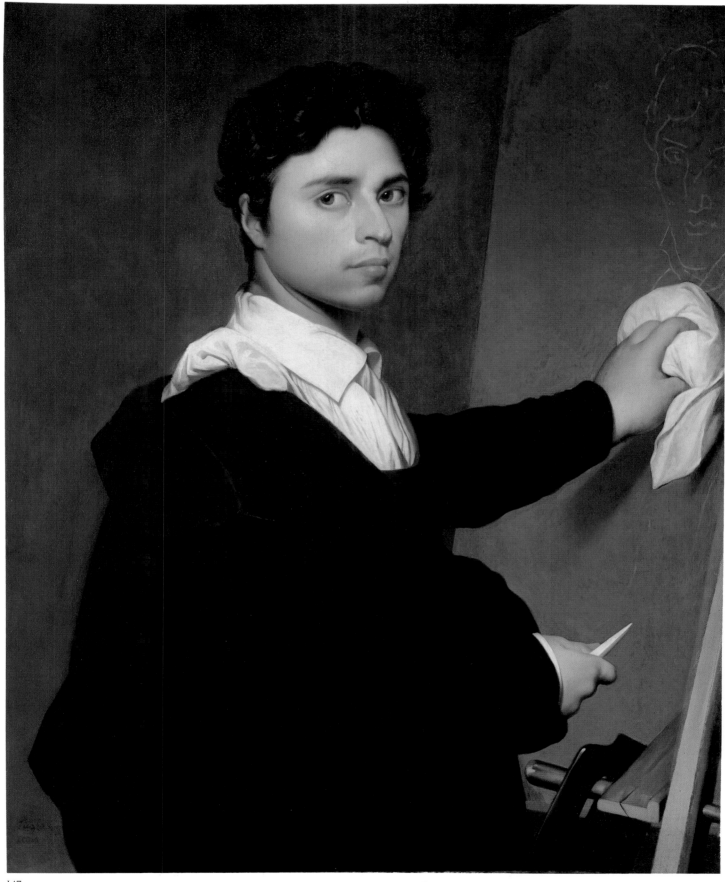

147

Fig. 283. *Self-Portrait*, 1804, revised ca. 1850 (W 17). Oil on canvas, 30¾ × 24 in. (78.1 × 61 cm). Musée Condé, Chantilly

a canvas that is still blank but that is no doubt destined to represent the most terrifying subjects, to judge by the dark and wild expression on his face."[3] While this remark has long been known to scholars, another citation recently found confirms that the canvas was indeed blank: "A painter, with a head of stiff, black hair, is silhouetted against a large white canvas; the artist, dressed in black with a white redingote, wipes with a very white handkerchief; this makes an effect of white on white.[4] Sometime between 1824 and 1851 Ingres responded to his critics by drawing on the bare canvas an outline sketch of his portrait of his close friend Jean-François Gilibert (cat. no. 5), a work that had probably been conceived as a pendant to the self-portrait. One occasion for this may have been Ingres's return to Paris in 1824.[5] Alternately, since Ingres had Gilibert's portrait in his studio in 1850, following his friend's death, some scholars believe that he may have made the modification then, as a memorial.[6]

The sketch of Gilibert is visible in a photograph of the early self-portrait taken by Charles Marville (fig. 282). While the date of the photograph is not known, it could not have been taken before 1849, when paper-negative photographs were first available in Paris,[7] nor later than 1851, by which time Ingres had transformed the

painting into an altogether different work, which was engraved that year by Achille Réveil. Indeed, Ingres probably commissioned the photograph to record the appearance of a picture that he was about to alter. Apart from the absence of the outline sketch, every other detail of Forestier's copy conforms to Ingres's painting as photographed by Marville, down to the red border of the handkerchief and its monogram "I"; Forestier's copy is so close, in fact, that some scholars have thought that Marville's photograph depicts her painting.[8] The etching, known only in a single proof (fig. 281), was made after Ingres had added the sketch of Gilibert to his painting. Although its author is not certain, he may be Jean-Louis Potrelle, a young friend of the artist who had executed a companion print of Ingres's 1805 portrait of Bartolini (fig. 55).[9] Ingres corrected the impression himself with pencil and white gouache, defining the profile of his left cheek, adding a highlight to the same cheek and the tip of his nose, and flattening the hair at the top of his head. He then sketched his face on the canvas, next to Gilibert's head, and wrote instructions to the etcher "to modify the movement of the eye" and to note that "the contour of the nose is very fine."[10]

About 1850, Ingres undertook a drastic reworking of the self-portrait. The revisions were so extensive—the original self-portrait seems to have been cut down on three sides if not four[11]—that one wonders why Ingres did not simply begin anew on a fresh canvas. He eliminated the one with Gilibert, painting instead the edge of a new one barely visible at the right; he repositioned the extended left arm, bringing the hand to his chest as if to point to a medal or chain conferred on him by a patron; he straightened his neck and flattened the planes of his face, making the features rounder and more regular and the lips fuller and more sensual. Most important, he changed his attire. He brought his collar higher up on his neck to frame his face, and he enveloped himself in a splendid brown, velvet-collared carrick, pulled open across his sleeve and draped in a manner that suggests a Renaissance cape. The carrick particularly concerned Ingres:

in a set of drawings now at Montauban, he studied the movement of its folds and proposed a new position for the right hand, a change that in the end in he did not adopt.[12] It was this magnificent portrait, a rival to Raphael's *Baldassare Castiglione* at the Louvre (fig. 181), that Ingres had engraved by Réveil in 1851 and displayed in a position of honor at his great retrospective at the 1855 Exposition Universelle.

Five years later, as a result of a complicated chain of events, Ingres agreed to exchange the reworked self-portrait for *The Turkish Bath* (fig. 220), which Prince Napoleon had acquired but could not display because of the degree of nudity depicted. To reward Ingres for his participation in the exposition, the prince had arranged for him to be promoted to a grand officer in the Legion of Honor, the only distinction of that rank awarded that year to an artist. Although Ingres felt indebted to the prince, he was very sorry nonetheless to see the self-portrait leave. On April 7, 1860, he wrote Frédéric Reiset, a curator at the Louvre and a good friend, who had acted as intermediary in the transaction:

> If I had not been bound by my promise to you to give my portrait to the prince, I would not have been able to endure the moment when I parted from that precious portrait, which is no longer a part of its family. The sacrifice is huge, I admit, given the painful feelings that still afflict me. Only for the prince, who honored me with such high esteem, could I furnish such a proof of devotion, and for you, dear Sir, who have been kind enough to involve yourself, as a true friend, in a matter whose object has caused us both so much trouble.[13]

Feeling such a tremendous sense of loss at the thought of giving up his self-portrait, he may have wanted a copy of the departing canvas. It could thus well be that, under these circumstances, Ingres encouraged Madame Héquet to make the copy now at the Metropolitan.

This version of the self-portrait was described in an article by Émile Galichon that appeared in 1861 in the *Gazette des beaux-arts:*

> The features of M. Ingres are already known to us from a portrait that he made

of himself in 1804 and that is reproduced in Réveil's collection. Of this portrait, now owned by Prince Napoleon, there is an exact repetition made by a distinguished pupil, in which M. Ingres represented himself wiping with a cloth the sketch drawn by him on a canvas. The copy conforms to the first idea of the master, modified by a later one, as can be seen in the engraving by Réveil.[14]

Galichon correctly identified the Metropolitan's painting as a copy more closely linked to the 1804 self-portrait than to the revised painting of 1850. What he did not know, however, was that it was first painted as a copy of the latter work: X-radiographs reveal that originally there was neither a sketch of Gilibert nor a blank canvas in the background, but that instead the artist brought his left hand to his breast.

The original proportions of the Metropolitan canvas were also similar to those of the smaller canvas in Chantilly. Presumably before Ingres's death in 1867, this work was enlarged at the bottom and the canvas with Gilibert painted in, even though the oblique edge of the canvas visible at the extreme right made it redundant. It would appear that another painter made these changes, for the left hand that wipes the canvas is painted in a different, and perceptibly inferior, manner.[15] Clearly the second artist worked either from the Forestier copy[16] or from the Marville photograph, for only those two works contained the sketch of Gilibert and the extended left arm, which had since been obliterated in the reworking of 1850. Other details, such as the position of the shirt collar and the puff of linen at the shoulder, also relate more closely to the 1804 portrait than to the later revision. Nevertheless, the Metropolitan portrait could not have existed before the 1850 reworking, since its underlying composition repeats details that occur for the first time in that painting.

Henri Delaborde catalogued the Metropolitan picture in 1870, citing "two reproductions of this portrait [the one in Chantilly], executed by two students of the master and retouched by himself in the last years of his life, [that] belong to Madame Ingres."[17] The second copy to which he refers may be the one made by

Atala Varcollier (née Stamaty),[18] which was modeled on the Chantilly painting rather than the early self-portrait. Armand Cambon, a student of Ingres who had been charged with setting up the Musée Ingres in Montauban following the death of the painter, made a copy of the Metropolitan's picture, then, as Delaborde noted, in the hands of Madame Ingres. In a letter of 1874,[19] Cambon announced his intention to install his copy over the mantle in one of the principal galleries of the museum; by 1877 the copy was included in the museum's catalogue. G. T.

1. The most significant dissenter is Hans Naef, who considers the painting in Chantilly to be a wholly new work painted about 1850. See Naef 1977–80, vol. 3 (1979), p. 203.
2. Eric Bertin has very kindly suggested to me that the Museum's painting may be the work described as "Portrait de M. Ingres. Belle copie faite sous la direction du maître par Mme Gustave Héquet, son élève. L'original appartient à S.A.I. prince Napoléon" ("Portrait of M. Ingres. Fine copy made under the master's direction by Mme Gustave Héquet, his pupil. The original belongs to H.I.H. Prince Napoleon"), which was sold in Paris, Hôtel Drouot, February 21, 1866, no lot number, "après décès de M. Gustave Héquet, homme de lettres & compositeur" ("after the death of M. Gustave Héquet, man of letters & composer"). This hypothesis would require that the work was neither ordered by Ingres nor given to him as a gift but, rather, that it was bought by him or Madame Ingres sometime after the sale but before 1870, when Delaborde recorded it as in the collection of Madame Ingres (see n. 17, below). Gustave Héquet (1803–1865) wrote light opera before he became a music critic for *L'Illustration*, *Gazette de Paris*, and *La France musicale*, but as of this date, nothing is known of his wife.
3. "Il tient à la main un mouchoir qu'il porte, on ne sait trop pourquoi, sur une toile encore blanche, mais destinée sans doute à représenter les objets les plus effrayans, si l'on en juge par l'expression sombre et farouche de son visage." Anon., October 11, 1806 (C.), p. 77; quoted in Lee 1998, p. 69.
4. "Un peintre, dont la tête à cheveux noirs et durs, se détache en découpure sur une grande toile blanche; l'artiste vêtu en noir et recouvert d'une redingote blanche essuie avec un mouchoir très-blanc; ce qui fait blanc sur blanc." Anon. 1806, p. 22; quoted in ibid., p. 69.
5. Ingres left the 1804 self-portrait in Paris when he departed for Rome in 1806 (see cat.

no. 11). He would not have had access to it until he returned to Paris in 1824 and could not have revised it during his directorate in Rome from 1835 to 1841. It seems most possible that the inclusion of Gilibert would have taken place in 1824, if Jean-Louis Potrelle, who died that year, was indeed the author of the etching, which shows the portrait in its modified form. However, Susan Siegfried (1980a, pp. 95–96) believes that the Potrelle etching was done before Ingres left for his first stay in Rome, and thus that the sketch of Gilibert was already present in the painted self-portrait. But if this is correct, one is at a loss to explain the absence of the sketch in Forestier's 1807 copy.
6. A letter from Ingres to Gilibert's daughter Pauline indicates that the portrait of her father was in his studio for restoration; quoted in Boyer d'Agen 1909, p. 416, and noted in Ternois 1961, p. 21. See the discussion in the entries for cat. nos. 5 and 11.
7. The dating of Marville's photograph poses a problem. The Musée Ingres, Montauban; the Bibliothèque Nationale, Paris; and an album assembled by Degas (private collection) have albumen prints of the image made from the same wet-collodion glass plate. This method, invented in England in 1851, was announced in Paris only in August 1851; Anon., August 24, 1851. Examination of several of these prints suggests, however, that Marville's glass-plate negative reproduced an earlier photograph made with a paper negative, which could have been produced in 1849 or later. I thank Malcolm Daniel for his advice on this matter.
8. Lapauze 1911a, p. 46. Siegfried also believes that the Marville photograph reproduces the Forestier painting; Siegfried 1980a, p. 95, n. 9. However, in comparing an original print of the Marville photograph with the actual canvas by Forestier, I noted a number of small variations: the Forestier has fewer highlights in the hair and a different set of shadows cast by the coat sleeve in the lower left corner; further, the hook on the easel at the far right is not the same as the hook in the photograph.
9. Siegfried attributes the engraving to Potrelle; Siegfried 1980a, pp. 96, 97, n. 11.
10. "Modifier le mouvement de l'oeil—Le contour du nez est très fin.—"
11. Although likely, it is still not absolutely certain that the 1804 self-portrait lies beneath the surface of the painting now at Chantilly. X-radiographs taken in 1960 were inconclusive, owing to a lead-rich canvas preparation that rendered the paint layers indistinct to radiography, according to Madeleine Hours, director of the Laboratoires des Musées de France. See Ternois 1961, p. 21, and a letter of June 22, 1963, Archives, Department of European Paintings, The Metropolitan Museum of Art. To my eyes, however, the

surface of the Chantilly canvas bears all the marks of the extensive revisions.

12. Musée Ingres, Montauban, inv. 867.272, 867.269, 867.270. These studies for the carrick do not show Ingres's left hand in its final position at his chest. This suggests that Ingres had not yet decided to eliminate the gesture of wiping the canvas and may also explain the existence of two related drawings—one for his extended left arm (inv. 867.274), the other for his right hand (inv. 867.273)—that Armand Cambon catalogued as studies for the revised self-portrait. Georges Vigne rejects this identification because these details do not appear in the Chantilly canvas, but it is possible that Ingres considered changes that in the end he did not adopt (Vigne 1995a, nos. 2677, 2678). Nevertheless, Daniel Ternois (in Ternois 1959a) regards these last two drawings as inferior in quality and attributes them to a studio assistant; perhaps they were made by the student who painted the Metropolitan's copy.

13. "Si je n'eusse été lié par mon engagement avec vous de donner au prince mon portrait, je n'aurais pu le tenir au moment où je me suis séparé de ce cher portrait qui ne fait plus partie de sa famille. Le sacrifice est grand, je l'avoue, par la pénible émotion dont je suis encore saisi. Il n'y a que le prince qui m'honore d'une si haute estime pour lequel je puisse donner pareille preuve de dévouement, et pour vous, cher Monsieur, qui voulez bien vous mêler, en [sic] vrai ami, d'une affaire dont le motif si inattendu nous

donne à tous deux tant d'ennui." Quoted in Delaborde 1870, p. 252.

14. "Les traits de M. Ingres sont encore connus par un portrait qu'il fit de lui-même en 1804 et qu'on trouve reproduit dans le recueil de Réveil. De ce tableau, actuellement possédé par le prince Napoléon, il existe une répétition très-exacte faite par un élève distingué, dans laquelle M. Ingres s'est représenté essuyant avec un linge l'ébauche tracée par lui sur une toile. Cette copie est conforme à la première pensée du maître, modifiée par la suite, ainsi qu'on peut le voir dans la gravure de Réveil." Galichon 1861a, pp. 359–60; quoted in Burroughs 1960, p. 4.

15. This observation was made in 1960 by Louise Burroughs in an excellent article, the first to set down properly the complicated relationship between the various versions of the portrait; Burroughs 1960, pp. 4–5. See also the correction (*Bulletin du Musée Ingres* 1961, p. 19) in which the photograph of the Forestier copy was substituted for the Marville photograph.

16. The Forestier copy had been sent to Ingres's father in Montauban in 1807. Presumably he kept it there, but the painter may have subsequently taken possession of it.

17. "deux reproductions de ce portrait, exécutées par deux élèves du maître et retouchées par celui-ci dans les dernières années de sa vie, appartiennent à madame Ingres." Delaborde 1870, p. 251.

18. Oil on canvas, 28 3/4 × 36 1/4 in. (73 × 92 cm), sold Hôtel Drouot, Paris, November 15, 1976 (Maître Paul Renaud), lot 110; present

location unknown. Eric Bertin has kindly brought to my attention that this painting, which is cited in Lapauze 1911a, p. 48, as belonging to the Marchand collection, was probably the work sold at the Hôtel Drouot, Paris, March 4, 1935, no. 62.

19. Quoted in Burroughs 1960, p. 7.

PROVENANCE: Possibly the work by Madame Héquet sold at the Hôtel Drouot, Paris, February 21, 1866; possibly purchased at that sale by Ingres; the artist until his death in 1867; bequeathed to his widow, Mme Delphine Ingres, née Ramel, Paris; bequeathed to her brother Albert Ramel upon her death in 1887; his widow, Mme Albert Ramel; their daughter Mme Emmanuel Riant; Wildenstein & Co., Paris and New York; purchased from them by Mrs. Grace Rainey Rogers (1867–1943, New York, October 1, 1937; her bequest to The Metropolitan Museum of Art, New York, 1943

EXHIBITIONS: Paris 1885, no. 156?; Paris 1921, no. 6; Atlanta, Birmingham 1955, no. 4; Duluth 1956; New York 1988–89

REFERENCES: Delaborde 1870, under no. 129; Lapauze 1911a, p. 48; Pach 1939, p. 13, frontispiece; Wildenstein 1954, no. 18, fig. 9; Burroughs 1960, pp. 1–7, ill.; Ternois 1961, p. 21; Sterling and Salinger 1966, pp. 13–15, ill.; Picon 1967, p. 12; Radius and Camesasca 1968, no. 17b, ill.; Baetjer 1980, vol. 1, p. 90, vol. 3, ill. p. 546; Connolly 1980, pp. 52, 53, 65, n. 2, fig. 1; Picon 1980, p. 8, ill.; Ternois 1980, no. 20, ill.; Baetjer 1995, p. 402, ill.; Fleckner 1995, p. 25

148. Self-Portrait at Seventy-Eight

149. Self-Portrait

148. Self-Portrait at Seventy-Eight
1858
Oil on canvas
24⅜ × 20⅛ in. (62 × 51 cm)
Signed, dated, and inscribed upper right: J.A.D.
INGRES / Pictor Gallicus / SE IPSUM
P^xt / anno Ætatis LXXVIII / M DCCC LVIII
[J. A. D. Ingres / French painter / painted this
himself / at the age of 78 /1858]
Galleria degli Uffizi, Florence
New York only

W 285

149. Self-Portrait
1864–65
Oil on canvas
25¼ × 20⅞ in. (64 × 53 cm)
Signed, dated, and inscribed upper right:
J. Ingres peint par lui / pour la célèbre
Académie d'Anvers. [J. Ingres painted by
himself /for the celebrated Academy of
Antwerp.]
*Koninklijk Museum voor Schone Kunsten,
Antwerp*

W 316

While Ingres was director at the Académie de France in Rome, the director of the Uffizi in Florence, Antonio Ramirez di Montalvo, asked him in a letter of December 24, 1839, to provide the museum with a canvas for their gallery of self-portraits of distinguished artists, both national and foreign. Ingres, who was then about to commit himself in earnest to work on the long-delayed portrait of Cherubini (fig. 221), could not in good faith accept a new responsibility. On January 26, 1840, he declined, expressing his gratitude and regret that his obligations at the Villa Medici precluded compliance with the request. He could not, he wrote, neglect his duties simply to satisfy his artistic vanity.[1] The invitation was renewed on December 15, 1855, by a new director, Marchese Luca Bourbon del Monte, who appealed to the artist's strong sense of competition: "You must act as the champion of the Portraits by Painters of the modern French School, because if you appear in this gallery no other celebrated painters of this illustrious nation will be disdainful of sending their own, and I am even certain that all of them would want to follow your lead."[2] This new appeal was seconded by Marchese Tanay de' Nerli, a representative of the Tuscan duchy to the court of Napoleon III.[3]

Owing to a confluence of factors, this time Ingres was ready to oblige. The death of his wife in 1849 and his own advancing years had instilled in him a sense of mortality that had not been nearly as strong in 1840. Also, as part and parcel of his efforts to assemble the retrospective of his work for the Exposition Universelle of 1855, he felt a newly heightened desire to fix the image he would leave to posterity, rather than to allow posterity to form its own. His reworking, about 1850, of his 1804 self-portrait (see cat. nos. 11, 147) provides ample evidence of this intent. Finally, the unanticipated happiness he experienced as a result of his marriage to Delphine Ramel in 1852—he had been devastated by the death of his beloved Madeleine—enabled him to show himself as the truly contented man that he had become.

On March 20, 1858, Ingres wrote to Bourbon del Monte that he had finished his self-portrait:

Monsieur le Directeur,

Several years ago you kindly reminded me that the directorate of the Royal Gallery of Florence had honored me with a request for my portrait, painted by me, to be placed in that magnificent gallery, where the portraits of so many illustrious artists are kept for posterity.

I am extremely honored that my place was recorded in that honorable assembly, and I beg you, Monsieur le Directeur, to accept all my excuses and regret for not complying sooner to the request that you so kindly addressed to me. But I have just completed my portrait, finally, and I am ready to send it to you. However, I wanted to make this portrait simple and humble so that the great Painters among whom I am about to sit will not accuse me of prideful temerity.

Kindly tell me, Monsieur le Directeur, by which means I should send you my painting, in order to avoid delay or accident.

I repeat, Monsieur le Directeur, all my thanks for the signal honor that I am receiving, and I hope that you will accept the expression of the high consideration

With which I have the honor to be
Your very humble and very devoted servant

J. Ingres[4]

The painting arrived in Florence in April 1858 and was immediately submitted to the grand duke for inspection. Ingres heard nothing but compliments. Tanay de' Nerli, who saw the portrait in Ingres's studio, wrote back to Florence on April 12 that it was "magnificent," the inspector of the Uffizi called it "superb," and Bourbon del Monte arranged to have Ingres decorated.[5] Despite his previously expressed misgivings, Ingres revealed something very like "prideful temerity" in a May 30 letter to Charles Marcotte:

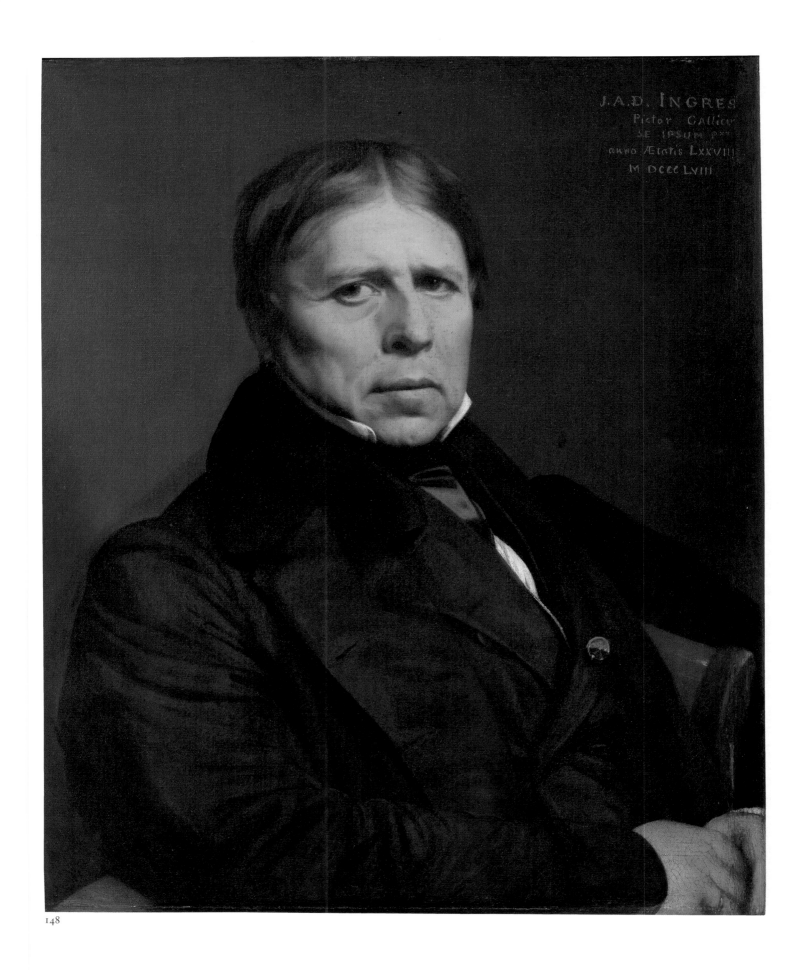

148

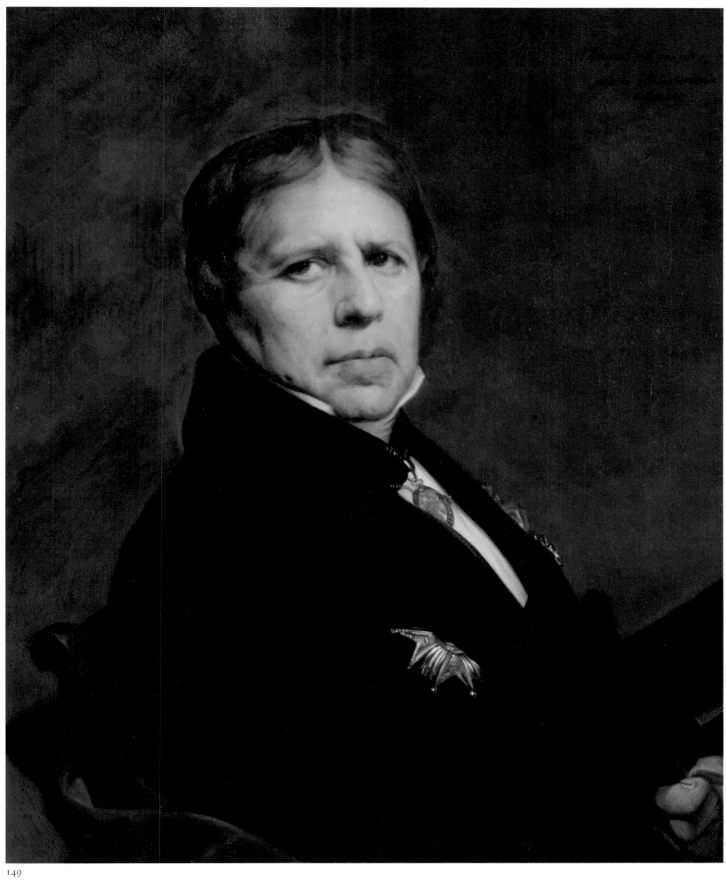

149

Fig. 284. Rembrandt van Rijn (1606–1669). *Self-Portrait at the Age of Sixty-Three*, 1669. Oil on canvas, 33⅞ × 27¾ in. (86 × 70.5 cm). National Gallery, London

Fig. 285. *Self-Portrait at the Age of Seventy-Nine*, 1859 (W 292). Oil on paper, mounted on canvas, 25½ × 20½ in. (64.8 × 52 cm). Fogg Art Museum, Harvard University Art Museums, Cambridge, Massachusetts

Our friend Gatteaux, presently in Florence, is witness to all of the honorable sentiments expressed on the subject of my portrait, modest as it is, and those to which he could admit. . . . The grand duke has kept it for some time in his Pitti Palace apartments. Finally, having judged it worthy to appear alongside the portraits of the great painters in the Uffizi, he will have it placed there, after having gratified the author with the Order of Merit of Saint Joseph of Tuscany.[6]

Considering the society of artists whom he was about to join, it is curious that Ingres portrayed himself not as a painter but as a *grand bourgeois*. The rosette of a grand officer in the Legion of Honor pinned to his vest (in 1855 he had finally achieved the most exalted rank), he wears the stiff and sober costume of a banker or bureaucrat. Lacking even a hint of the dandyism that is often visible in his depictions of other men, this self-portrait calls to mind Ingres's complaint that "for me, it is one of the *labors* of Hercules to *dress myself*."[7] Modern writers have interpreted Ingres's facial expression as demanding and somewhat menacing, "since he [was], particularly at the end of his life, authoritarian and intransigent, often incapable of controlling his bad humor when things [did] not go as he [wished]."[8] Robert Rosenblum sees the

"unmitigated disclosure" of personality characteristic of many of Ingres's portraits of the elderly.[9] Although comparisons with contemporaneous photographs show that Ingres is, in fact, about to smile (see, for instance, fig. 340), that pleasantry is no more than a minor concession to the forbidding intensity that he wishes to convey here. Doubtless he sought to liken this work to his portraits of Bertin and Cherubini (cat. nos. 99, 119), two men

whom he admired tremendously, perhaps because they achieved the dominance in their respective fields that he sought in his own.

At this point in his life, when Ingres wanted nothing more than to make all artists submit to his one true god, Raphael, he had already remade his 1804 self-portrait into a paradigm of Raphaelism (see cat. no. 147). Yet in the portrait destined for the Uffizi he seems instead to hark back to Rembrandt. Ingres, of course, knew Rembrandt's youthful self-portrait of 1633 at the Louvre, but more to the point is the *Self-Portrait at the Age of Sixty-Three* (fig. 284), which exhibits a similar pose seen in half length, as well as a comparable intensity of expression. (Ingres never traveled to London but he must have known the picture through reproduction; Charles Blanc published his book on the Dutch master about the time that the portrait was begun by Ingres.)[10] Rembrandt was more truthful to himself than Ingres, who in this portrait smoothed his skin and darkened his gray hair. The half-length view with an arm brought across the chest had been developed in Italian portraiture during the late fifteenth and early sixteenth centuries, but it was soon adopted extensively by artists in northern Europe. The richly textured surfaces of

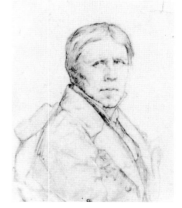

Fig. 287. *Self-Portrait*, 1859. Graphite on paper, 7⅝ × 5⅞ in. (19.5 × 14.8 cm). École des Beaux-Arts, Paris

Fig. 286. Gerothwohl and Tanner. *J.-A.-D. Ingres*. Photograph, ca. 1855. Location unknown

Rembrandt's mature painting are far removed from the porcelain perfection of Ingres's late work, and Ingres himself was disdainful of the earlier master's style. Nevertheless, Rembrandt had studied Raphael intently and had assimilated aspects of Raphael's compositions into his own. A key component of Ingres's portrait for the Uffizi derives from his earlier, Raphael-esque self-portrait: the emphasis on the baleful eyes. Henry Lapauze commented on "the eyes of his twenty-fifth year, which look at you, scrutinize your conscience and would hardly consent to lower themselves. His nostrils quiver, his mouth is going to open for an impetuous imprecation."[11]

Here, for what appears to be the first time in his career, Ingres used a photograph as the primary model for a portrait. By the 1850s photography had become such a ubiquitous studio tool that Henri Delaborde noted this fact without remarking on it as exceptional. Referring to the version of the portrait now at the Fogg Art Museum (fig. 285), Delaborde wrote in 1870, "For the execution of this portrait Ingres used a photograph that M. Masson, in his turn, reproduced as an etched engraving."[12] More than a hundred years later, Hans Naef reproduced the photograph (fig. 286), by the Parisian house of Gerothwohl and Tanner, as well as the subsequent etching by Alphonse Masson.[13] It appears that Ingres first used the photograph to make an oil sketch on paper, carefully reproducing the planes of light and shadow visible in the photograph and slavishly copying the way his hair appeared. Most probably he then had an assistant transfer the outline of the sketch to the canvas destined for the Uffizi and worked with the assistant to paint the costume and chair. The seamlessly smooth final surface is characteristic of his late finished portraits, and since all personality has been eliminated from the brushstrokes, it is impossible to determine the extent of collaboration.[14]

Sometime over the course of the following year, Ingres mounted his preparatory oil sketch on a canvas in order to complete it as a second self-portrait.[15] This portrait, the version now at the Fogg, was intended to serve as a pendant to that of his wife, Delphine (fig. 213), painted in the summer of 1859, and was given to her upon its completion. No longer the stolid bourgeois, Ingres shows himself as a cultivated citizen of the glittering capital of Europe—a man with a permanent seat at the Comédie Française. Slimming his face and figure, he appears in evening dress, wearing his coveted star of a grand officer in the Legion of Honor as well as the decoration he had just received from the grand duke of Tuscany; the new outfit also appears in a drawing now at the École des Beaux-Arts (fig. 287).[16]

Some five years later, in late 1864 or early 1865, Ingres had the second version of the portrait traced and the design transferred to a new canvas destined for the Koninklijke Academie voor Schone Kunsten in Antwerp (cat. no. 149). Ingres had been made an associate member of the Academie on September 6, 1853, the year it was reorganized; he became a full member on August 18, 1857, occupying the seat vacated upon the death of Paul Delaroche. The portrait was obligatory, and, as usual, Ingres's reluctance was evident. On February 12, 1860, he addressed his excuses to the president of the Academie:

Monsieur le Président,
I was unaware, until now, of the obligation of members of the Antwerp Academy of Fine Arts of which your letter of the fourth inst. has the honor of informing me. I would happily submit if my work and my time were not already rigorously accounted for. I still have several engagements to fulfill, and at my age and with my health I am no longer permitted to accept new ones.
To my great regret, Monsieur le Président, I find that I am forced to fail in my duties to an academy of which I am proud to be a member, as well as in my duties to all of you, dear sirs, who have so kindly included me in your midst.
Please accept, Monsieur le Président, the expression of all my feeling and of my high consideration
with which
I have the honor to be
your very grateful servant
J. Ingres
Member of the Institut[17]

More than three years later, Ingres had not yet complied. He wrote from his brother-in-law's house at Meung-sur-Loire on September 21, 1863:

Monsieur le directeur,
I regret that I cannot respond to your request to fix a date at which I will be able to send to the Antwerp Academy the portrait that has been requested several times and that my bad state of health has forced me to defer.
I was very sick for four months this winter; as soon as it was possible, I had to leave Paris to look for rest and a change of atmosphere. In these conditions it was impossible for me to attend to my art, and I fear that to regain my health entirely I will be obliged to leave France for some time as soon as the cold makes itself felt.
I very much regret, Monsieur, that I cannot indicate when I will be able to get back to work. Please believe, however, that I intend to fulfill my promise and that I will attend to the work that interests you as soon as it is possible.
Please, Monsieur, accept the assurance of my very sincere respect
J. Ingres
Senator
Meung[18]

Finally, he announced completion on July 3, 1865:

Monsieur le Président:
I am sorry to be so late in sending my Portrait to the Antwerp Academy, as I promised.
I hope that the Academy, as well as you, Monsieur le Président, will please excuse me, out of consideration for my age and the uncertainty of my health, which prevented me from fulfilling this obligation sooner.
I attach as well a photograph of my new composition of Homer Deified, which I hope the Academy will kindly accept:
Please, Monsieur le Président, accept my sincere respects.
J. Ingres
Senator, member of the Institut
and of the Royal Academy of Fine Arts of Antwerp[19]

This portrait would be the last he would paint. It is remarkably fine. While an assistant may have laid in the figure and costume (some underdrawing in pencil is visible), only Ingres could have painted the face. Pink glazes are freely brushed

over the forehead and lips, while quick, assured strokes delineate the pale brown irises and large pupils of his eyes. Rather than emulating the porcelain finish of the Uffizi portrait, this work has the same sketchy quality as the portrait at the Fogg. No assistant would have taken such liberties. Proud of his abilities at the age of eighty-five, Ingres inscribed the portrait "J. Ingres painted by himself for the celebrated Academy of Antwerp."

The Antwerp portrait retains its original frame, presumably selected by Ingres. It is identical to the frame on Julie Forestier's *Copy after Ingres's 1804 Self-Portrait* (cat. no. 11). G.T.

1. According to Giovanni Poggi, who cites but does not reproduce the two letters in question; Poggi 1949, pp. 58–60. Ingres's letter is transcribed (in Italian) in Florence 1977, p. 64: "I would do anything I can to grant you your honorable and gracious request; however, so much work for people who are waiting has been held up, and so heavy are the obligations of management with which I am charged, that [these responsibilities] absorb the greater part of my time in Rome, and I am at this moment prevented by my conscience from occupying myself with interests that satisfy only my personal vanity as an artist. I feel obliged to confess my embarrassment sincerely, trusting to your understanding, and assure you that I will solicitously seize the first opportunity to respond to your request." ("Farò tutto il possibile per esaudire la vostra onorevole e graziosa richiesta; ma tanto lavoro arretrato per persone che vorrei proprio contentare e le cure della direzione che mi è affidata, che assorbono la parte migliore del mio tempo romano, rendono per me, lo confessso, un problema di coscienza occuparmi in questo momento di interessi che soddisfano solo la mia vanità di artista. Mi sentivo obbligato a far sincera confessione del mio imbarazzo alla vostra benevolenza, pur assicurandovi che afferrerò con sollecitudine il momento adatto per rispondere al vostro appello.")
2. "il devrait représenter le champion des Portraits de Peintres de l'Ecole Française moderne, car s'il figurait dans cette salle aucun autre des célèbres peintres de cette illustre nation ne dédaignerait d'envoyer le sien, et je suis même sûr que tous ambitionneraient de lui faire cortège." Quoted in Rome, Florence 1990, no. 31.
3. Poggi 1949, p. 60.
4. "Monsieur le Directeur,
 Vous avez bien voulu me rappeler il y a déjà plusieurs années, que la direction de la

R[le] Galerie de Florence m'avait font l'honneur de me demander mon portrait, peint par moi-même, pour être placé dans cette magnifique galerie, où les portraits de tant d'illustres artistes sont conservés à la postérité.
 Je suis extrêmement honoré, que ma place ait été marquée dans cette honorable assemblée et je vous prie, Monsieur le Directeur, de recevoir toutes mes excuses et mes regrets, si je n'ai pu me rendre plutôt, à la demande que vous avez bien voulu m'adresser; mais enfin je viens de terminer mon portrait et je suis prêt à vous l'envoyer; ce portrait, cependant, j'ai voulu le faire simple et modeste, afin que les grands Peintres, auprès desquels je viens m'asseoir, ne puissent me taxer d'une orgoueilleuse [sic] témérité.
 Veuillez je vous prie, Monsieur le Directeur, m'indiquer par quelle voie je puis vous expédier mon tableau, afin de prévenir les retards , ou accidents.
 Agréez [sic] encore, Monsieur le Directeur, tous mes remerciements pour l'insigne honneur que je reçois et veuillez recevoir l'expression de la haute considération,
 avec laquelle j'ai l'honneur d'être
 vôtre très humble et très obéissant serviteur,
 J. Ingres."
Quoted in ibid., p. 59.
5. Rome, Florence 1990, no. 31.
6. "Notre ami Gatteaux, présentement à Florence, est témoin de tous les honorables sentiments qu'on exprime à propos de ce portrait, et auxquels, tout modeste qu'il est, il pouvait prétendre. . . . Le grand-duc le tient depuis quelque temps dans les appartements de son palais Pitti. Enfin, l'ayant jugé digne de figurer à côté des portraits des grands peintres dans la galerie des Offices, il va l'y faire placer, après avoir gratifié l'auteur de l'ordre du Mérite de Saint-Joseph de Toscane." Quoted in Delaborde 1870, p. 253; Ternois 1999, letter no. 103.
7. "Faire une *toilette* est pour moi un des *travaux* d'Hercule." Ingres to Gilibert, August 29, 1822, in Boyer d'Agen 1909, p. 86; quoted by Cohn and Siegfried in Cambridge (Mass.) 1980, p. 158.
8. "tel qu'il est, surtout à la fin de sa vie, autoritaire et intransigeant, incapable souvent de maîtriser sa mauvaise humeur quand les choses ne vont pas comme il le désire." Alazard 1950, p. 107.
9. Rosenblum 1967a, p. 92.
10. Blanc 1853.
11. "les yeux de ses vingt-cinq ans, qui vous regardent, scrutent votre conscience et ne consentiraient point à se baisser. Ses narines frémissent, sa bouche va s'ouvrir pour une impétueuse imprécation." Lapauze 1911a, p. 504.
12. "Ingres s'est servi pour l'exécution de ce portrait d'une photographie que M. Masson à

son tour a reproduite dans une gravure à l'eau-forte." Delaborde 1870, p. 253.
13. Naef 1977–80, vol. 3 (1979), p. 206, figs. 9, 10. Eric Bertin has very kindly brought to my attention that the Masson etching was first published in *L'Artiste* on April 5, 1857, as an illustration to an article on Ingres by Théophile Gautier. On May 3, 1857 (p. 92), the magazine noted, "The magnificent portrait of M. Ingres that opens the *Gallery of the 19th Century* was engraved by M. A[.] Masson after a photograph by Messrs. Gerothwohl and Tanner, which the illustrious master has himself identified as the most successful and the best likeness." ("Le magnifique portrait de M. Ingres qui ouvre la *Galerie du XIXe siècle* a été gravé par M. A[.] Masson, d'après une photographie de MM. Gerothwohl et Tanner, que l'illustre maître a lui-même indiqué comme la mieux réussie et la plus ressemblante.")
14. Eric Bertin has informed me that there are at least two copies of the Uffizi painting: one by Étienne-François Haro at the Musée Ingres, Montauban, another by Victor Mottez at the Musée Rolin, Autun.
15. This observation was first made by Marjorie Cohn and Susan Siegfried in Cambridge (Mass.) 1980, p. 158.
16. This drawing stands out as curiously distinct from Ingres's usual graphic style; it may be a copy, not by Ingres, of either the Fogg or the Antwerp portrait.
17. This and the following two letters (see nn. 18 and 19, below) are reproduced thanks to the generosity of Jeff van Gool, archivist of the Koninklijke Academie voor Schone Kunsten:

"à Monsieur le Bourgmestre d'Anvers Président de l'Académie des Beaux-Arts
 Paris 12 février 1860
Monsieur le Président,
 J'ignorais, jusqu'ici, l'obligation des membres de l'Académie des beaux arts d'Anvers, dont votre lettre du 4 c[t] [courant] me fait l'honneur de me donner connaissance. J'y souscrirais volontiers si mes ouvrages et mon tems [sic] n'étaient rigoureusement comptés. Mais j'ai encore plusieurs engagements à remplir et à mon age et à cause de ma santé, il ne m'est plus permis d'en contracter de nouveaux.
 Je me vois donc, à mon grand regret, Monsieur le Président, forcé de manquer à mes devoirs envers une académie, dont je suis fier d'être membre et envers vous tous, Messieurs, qui avez bien voulu m'appeler au milieu de vous.
 Veuillez agréer, Monsieur le Président l'expression de toutes mes sympathies et de la haute considération
 avec laquelle
 j'ai l'honneur d'être

votre très reconnaissant serviteur
J. Ingres
Membre de l'institut"

18. "à Monsieur le directeur de l'Académie des
Beaux-Arts d'Anvers
Meung 21 Septembre 1863
Monsieur le directeur,

Je regrette de ne pouvoir répondre à votre
désir, en vous fixant l'époque à laquelle je
pourrai envoyer à l'Académie d'Anvers, le
portrait qu'elle m'a fait demander plusieurs
fois et dont le mauvais état de ma santé, m'a
forcé de différer l'exécution.

J'ai été très malade pendant quatre mois,
cet hiver et j'ai du quitter Paris, dès que cela
m'a été possible pour chercher le repos et le
changement d'air; dans ces conditions, il m'a
été impossible de m'occuper de mon art et je
crains pour remettre entièrement ma santé,
d'être obligé de quitter la France, pendant
quelque tems [sic], dès que les froids se
feront sentir.

Je regrette beaucoup, Monsieur, de ne
pouvoir vous assigner l'époque à laquelle je
pourrai me remettre au travail; Croyez
cependant, que je tiens à remplir ma
promesse et que je m'occuperai de l'oeuvre
qui vous intéresse aussitôt que cela me sera
possible.

Veuillez, Monsieur, recevoir l'assurance
de ma considération très distinguée.
J. Ingres
Sénateur
Meung"

19. "à Monsieur le Président
de l'Académie R^{le} des beaux arts d'Anvers
Paris 3 juillet 1865

Monsieur le Président:

Je regrette d'avoir tant tardé à envoyer
mon Portrait à l'Académie d'Anvers, comme
je l'avais promis.

J'espère que l'Académie, ainsi que vous,
Monsieur le Président, voudrez bien m'excu-
ser, eu égard à mon âge et à l'irrégularité de
ma santé, qui ne m'ont pas permis de remplir
plus tôt cet engagement.

Je joins à l'envoi une photographie de ma
nouvelle composition d'Homère Deifié, que
je prie l'Académie de vouloir bien accepter:
Veuillez, Monsieur le Président, recevoir
l'assurance de ma haute considération.
J. Ingres
Sénateur, membre de l'Institut
et de l'Académie R^{le} des beaux arts
d'Anvers"

Cat. no. 148. *Self-Portrait at Seventy-Eight*

PROVENANCE: Given by the artist to the
Galleria degli Uffizi, 1858

EXHIBITIONS: Paris 1911, no. 267 (in the
supplement to the exh. cat.) [EB]; Rome, Florence
1955, no. 59 (Rome [EB]), no. 57 (Florence); Rome
1958, no. 3 bis; Rome, Turin 1961, no. 185;
Florence 1963, no. 133; Paris 1967–68, no. 254;
Rome 1968, no. 131; Florence 1968, no. 7 bis;
Florence 1977, no. 30; Rome, Florence 1990, no. 31

REFERENCES: Merson and Bellier de la
Chavignerie 1867, p. 122; Blanc 1870, p. 234;
Delaborde 1870, no. 130; Lapauze 1901, p. 10, n. 1;

Wyzewa 1907, no. XXXIX, ill.; Boyer d'Agen
1909, p. 436; Lapauze 1911a, p. 504, ill. p. 501;
Masterpieces of Ingres 1913, ill. p. 6; *La Renaissance
de l'art français* 1921, ill. p. 270; Fröhlich-Bum 1924,
pl. 70; Hourticq 1928, p. 112, ill.; Malingue 1943,
ill. p. 60; Poggi 1949, pp. 58–60, ill. p. 57;
Alazard 1950, p. 107; Wildenstein 1954, no. 285,
pl. 105; Ternois 1959a, preceding no. 74; Rosen-
blum 1967a, p. 92, fig. 2; Radius and Camesasca
1968, no. 160a, ill.; Florence, Galleria degli Uffizi
1979, no. A468, ill.; Naef 1977–80, vol. 3 (1979),
p. 203, ill. p. 204, fig. 4; Cambridge (Mass.) 1980,
under no. 59; Picon 1980, p. 9, ill., p. 130; Ternois
1980, pp. 7, 103, no. 324, ill., p. 6; Louisville, Fort
Worth 1983–84, ill. overleaf following p. 255;
Zanni 1990, no. 108, ill.; Amaury-Duval 1993,
fig. 275; Vigne 1995b, p. 295; Roux 1996, ill. p. 22

Cat. no. 149. *Self-Portrait*

PROVENANCE: Given by the artist to the Konink-
lijke Academie voor Schone Kunsten, 1865

EXHIBITIONS: Brussels 1866, no. 411; Paris
1911, no. 64; Brussels 1925–26, no. 47; London
1932, no. 342

REFERENCES: Antwerp, Koninklijk Museum
voor Schone Kunsten 1905, no. 1526; Lapauze
1911a, p. 548, ill. p. 529; *Masterpieces of Ingres*
1913, ill. p. 7; Wildenstein 1954, no. 316, fig. 173;
Radius and Camesasca 1968, no. 160c, ill.;
Antwerp, Koninklijk Museum voor Schone Kun-
sten 1977, p. 212, ill.; Picon 1980, p. 9, ill.;
Ternois 1980, pp. 7, 103, no. 326, ill.; Zanni 1990,
no. 108; Bertin 1995, p. 105; Vigne 1995b, p. 295

150. Antoine Thomeguex

April 1841
Graphite
10 ⅛ × 7 ⅜ in. (25.8 × 18.8 cm)
Signed and dated lower left: Ingres / à Madame
Thoneguex / flor 1841 — [Ingres / for
Madame Tho[m]eguex / Flor(ence) 1841]
Private collection

N 384

Some twenty Ingres portraits are devoted to members of three interrelated families the artist came to know in Florence: the Gonins, the Thomeguex, and the Guerbers. Ingres and his wife, Madeleine, became acquainted with the Swiss merchant Jean-Pierre Gonin soon after they moved to the Tuscan capital in 1820, and Gonin offered the artist invaluable support during the often difficult years he spent there. Through Gonin, Ingres came to know some of the prominent families the businessman counted among his friends, notably the Leblancs (see cat. nos. 88, 89, 92–94) and the Lazzerinis (see cat. no. 90).[1]

Born in Geneva in 1783, Gonin had begun his career as a traveling salesman and after marrying in 1809 and starting a family had joined the trading firm of Gerber & Cie., based in Bern. The firm, with branches in a number of European cities and eventually in New York, was chiefly engaged in marketing straw hats and, later, articles of silk as well. In 1815 Gonin was sent to Florence to manage a branch in which he apparently became a shareholder, for it was soon called Gerber, Gonin & Cie. The business obviously prospered, for Gonin maintained a large establishment on the floors above his offices in a palace near the church of Santo Spirito. In the years Ingres knew the family well, the household consisted of the merchant and his hospitable wife, Louise; their six children—Louise (born in 1810), Jean (1812), Étienne (1813), Constantin (1818), Antoine (1819), and Jeanne (1823); the children's titled French governess, Mademoiselle de Bar; Gonin's younger sister Jeanne (born 1787); and the Swiss porcelain painter Abraham Constantin.[2]

Gonin's closest business associate was another Geneva native, Pyrame Thomeguex (born 1789), who owned a straw-hat factory just outside Florence. In 1822 Thomeguex married Gonin's sister Jeanne, who in 1823 bore him a son, Antoine, the subject of this drawing, and a daughter,

Louise, in 1825. Both Gonin and Thomeguex were staunch Protestants, and the two were influential in establishing the first Protestant congregation in their adopted city, L'Église Évangélique Réformée de Florence, as well as the Protestant cemetery just outside the Porta Pinti.

Ingres stayed in frequent contact with the Gonin and Thomeguex families between 1824 and 1834, when he was away from Italy, in France. The chief news from Florence during that period was the death of the Gonins' oldest son, Jean, in 1828 and Louise's marriage in the following year to Auguste Gerber (born 1805), the eldest son of the head of the parent firm in Bern. Having come to work in the Florence branch, Gerber found it necessary to change the spelling of his name to Guerber so that the Florentines would pronounce it correctly.

Ingres first met the new member of the family when he stopped in Florence on his way to Rome in December 1834. During his six years there as director of the Académie de France, he is known to have made at least one brief visit to Florence, in 1836,[3] and surely must have entertained an occasional traveler from Florence. The Gonin children's governess, for example, was a guest at the Villa Medici in August 1838.[4]

Ingres last saw the Gonin clan during a ten-day stopover on his return journey to Paris in April 1841. The timing was fortuitous, for very soon many of them would die or emigrate, owing to a decline in the fortunes of the firm. Jeanne Thomeguex died in 1842, her husband in 1844. Antoine, their only surviving child, moved to Geneva, where he spent the remainder of his long life. Auguste Guerber immigrated to America in 1844 and sent for his wife and children the following year. As for the remaining Gonin children, Étienne was already in America, Constantin soon moved to Geneva, and Jeanne, who married Auguste Guerber's younger brother Édouard in 1845, settled in Bern. Antoine

was the only one to stay in Florence, where he married a Swiss woman in 1850. His mother had returned to Geneva after losing her husband and died there in 1858.

These essential names and dates make the rich series of Gonin-Thomeguex portraits less perplexing. The more important works dating from the years in which Ingres lived in Florence are a drawing that almost surely depicts Louise Gonin at the age of ten (fig. 142); a droll portrait drawing of Pyrame Thomeguex (fig. 141); an oil portrait of Jeanne Gonin done in 1821 (cat. no. 87), before her marriage to Thomeguex; and a drawing of Thomeguex's father, Antoine, a crusty Geneva clockmaker who must have come to Florence on the occasion of his son's wedding (N 260). Other drawings from this period depicting one or another of the Gonin sons have been lost or are known only from photographs.

One of the drawings in the series was executed in Paris in 1825 (N 292; Musée d'Art et d'Histoire, Geneva). Dedicated to Madame Gonin, it depicts an unidentified woman of roughly thirty. It seems plausible that she is again Jeanne Thomeguex, though here the young woman appears less robust than she does in the painting of four years earlier. Among the works that once belonged to her is a delightful pencil portrait of Madeleine Ingres (cat. no. 108) that is dedicated "to her good friend Madame Thomeguex." The existence of these two drawings suggests that Jeanne may have accompanied her friend Madeleine to Paris in the early weeks of that year.

Apparently Ingres made only one portrait during his visit to Florence in 1834, of a handsome, unnamed young man that the artist dedicated to Monsieur and Madame Gonin (N 361; Fogg Art Museum, Cambridge, Massachusetts). The subject may be their second son, Étienne, who had just turned twenty-one and was about to leave for New York;[5] however, there are a number of reasons to suspect that it is actually one of his younger brothers, either Constantin or Antoine, then sixteen and fifteen respectively.

On his return trip to Paris in 1841, during the artist's brief stay in Florence with his old friends, he executed a splendid pair of matching portrait drawings of the Jean-

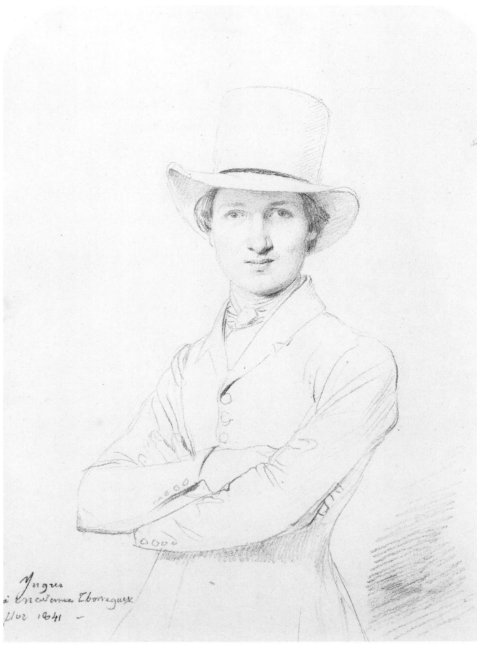

150

Pierre Gonins, both of whom were then approaching sixty; the present drawing of the younger Antoine Thomeguex, just turned eighteen and radiant with confidence; and a rendering of Auguste Guerber at age thirty-five (N 383), already head of the parent firm in Bern and father of five.

H. N.

For the author's complete text, see Naef 1977–80, vol. 2 (1978), chap. 112 (pp. 384–410).
1. For information about the Gonin family home and its importance as a haven for French-speaking visitors to Florence, the author is indebted to Louise Burroughs, née Guerber, Gonin's great-great-granddaughter, who was for many years a curatorial staff member at the Metropolitan Museum in New York. Beginning in the 1950s Mrs. Burroughs supplied the author with much information by letter, and at his invitation she later contributed the essay on the Gonin-Thomeguex-Guerber clan that appears in Naef 1977–80, vol. 2 (1978), pp. 406–10. See also Guerber 1927, p. 215.
2. On Constantin, see Plan 1930.
3. Ingres to Charles Marcotte, November 3, 1836, quoted in Lapauze 1913, p. 96; in Ternois 1999, letter no. 32.
4. Ingres to Alexis Le Go, August 7, 1838, quoted in Henriot 1911, p. 22.
5. Louise Burroughs (see n. 1, above) offered this identification.

PROVENANCE: Mme Pyrame Thomeguex, née Jeanne Gonin (1787–1842), Florence; Pyrame Thomeguex (1789–1844), Florence; their son, Antoine Thomeguex (1823–1899), Bellevue, near Geneva; Théodore de Saussure, mayor of Genthod-Bellevue, until 1903; his nephew Ferdinand de Saussure, Vufflens-sur-Morges, until 1913; his son Jacques de Saussure, Vufflens, until 1969; his widow; private collection

EXHIBITIONS: Lausanne 1953, no. 30, ill.; Zurich 1958a, no. B17; Paris 1959, no. 176; Paris 1967–68, no. 194, ill.

REFERENCES: Daulte 1953, p. XIX, no. 31, pp. 63–64, pl. 31; Naef 1955 ("westschweiz-erischen Freunde"), p. 25, fig. 23; Naef 1966 ("Gonin, Thomeguex et Guerber"), pp. 113–53, no. 15, p. 161, fig. 9, p. 137; Naef 1972 ("Ingres Royiste"), ill. p. 28; Delpierre 1975, p. 23; Naef 1977–80, vol. 5 (1980), pp. 256–57, no. 384, ill.

151. Madame Frédéric Reiset, née Augustine-Modeste-Hortense Reiset, and Her Daughter, Thérèse-Hortense-Marie

1844
Graphite with white highlights
12⅛ × 9⅝ in. (30.8 × 24.5 cm)
Signed, dated, and inscribed lower right: Ingres Del / à / Monsieur / Reiset. / 1844. [Ingres drew (this) / for / Monsieur / Reiset. / 1844.]
Museum Boijmans Van Beuningen, Rotterdam F II 168
London and Washington only

N 400

Ingres's five portraits of members of the Reiset family are visible testimony to a friendship that bound together the nineteenth century's most famous draftsman and its most discriminating connoisseur of drawings. The depth of that friendship was not fully appreciated by early biographers.

Marie-Eugène-Frédéric Reiset was born in Oissel, just outside Rouen, in 1815. His father was a high treasury official, Receveur Général des Finances, like his father before him, and a very wealthy man. Nothing is known about his early education. In November 1835, by which time he owned his own house in Paris, Frédéric married his slightly older cousin Augustine-Modeste-Hortense Reiset, the daughter of his father's brother, a distinguished military man.[1] A few months after the ceremony, the newlyweds set out for Rome, where Ingres had assumed the post of director at the Villa Medici the previous year. An avid student of art, Frédéric called on Ingres, and the two took to each other. Reiset never saw Italy again, but during that brief sojourn he managed to commit to his photographic memory a wealth of art, and he would draw upon those impressions for the rest of his life.

By August 1836 the Reisets were back in France, and in that month their daughter, Thérèse-Hortense-Marie, was born in Passy. Marie, their only child, would marry in 1857 the comte de Ségur, a highly decorated diplomat who later signed himself, by imperial decree, Ségur-Lamoignon. With him she ultimately moved into his family's splendid château at Méry-sur-Oise.

In 1849 Frédéric Reiset gave up his life of moneyed leisure to assume the post of curator of drawings at the Louvre.[2] At that time there were more than thirty-five thousand drawings in the museum's collection, and no one had ever made a proper assessment of it. The new curator thus entered virgin territory, and during the next decade he devoted himself to establishing its perimeters and identifying its major landmarks. In 1861 he was named curator of the paintings collections and finally, in 1874, became director of the national museums, a post he held until his retirement, in 1879.

It would appear that after Ingres returned to Paris in triumph in 1841, at the end of his tenure in Rome, the younger man took the first opportunity to renew their acquaintance. By 1844 their friendship was thriving, for four of the five portraits of the Reiset family date from that year. They were produced in Enghien, where Reiset owned a charming summer house— "your paradise at Enghien," Ingres called it[3]—on the lake. The four drawings are all nearly the same size and may well have been executed one after the other during a single holiday visit in 1844. The artist dedicated two of them to his hostess: one of her father (N 397) and one of her husband (N 398). The other two are portraits of her, one alone (N 399) and this one, with the eight-year-old Marie clutching her skirts; both are dedicated to Reiset. The fifth drawing, executed six years later, is a portrait of Marie at fourteen (N 423).

As their inscriptions indicate, the four drawings of 1844 were intended as tokens of

friendship. In 1846 Ingres provided further evidence of his regard by agreeing—even though he generally shrank from such commissions—to Reiset's request for a painting of his wife, who would shortly be named lady-in-waiting to Princess Mathilde Bonaparte (fig. 207). Reiset, in turn, demonstrated his devotion to the artist by collecting his works. Earlier that year he had managed to acquire the artist's enchanting 1807 portrait of Madame Antonia Duvaucey (fig. 87),[4] and two years later he bought Ingres's recently completed *Venus Anadyomene* (fig. 201).

He also proved to be a good friend in more personal ways. When Ingres lost his beloved wife in 1849, Reiset insisted that he come stay with them. The artist's heartbroken letter informing his friend Charles Marcotte about Madeleine's death the previous day was written at their summer house. "As for me, I wanted to die with her, not let her go, but they brutally pulled me away from her, and my good friend M. Reiset is keeping me here with him in Enghien."[5] In a letter to his brother Paul, Ingres's pupil Hippolyte Flandrin described how he had helped the distraught artist out of Paris: "M. Reiset and I brought the good master, who was in a horrible state, to Enghien, where he is being cared for as if by his own children."[6] As the first anniversary of Madeleine's death approached, Reiset again thought to invite the widower to Enghien, but Ingres gratefully declined.

In 1859 Ingres sold his late masterpiece *The Turkish Bath* (fig. 220) to Prince Napoleon, a great admirer. The painting hung only briefly in the Palais Royal, however, for Princess Clotilde found it shocking. Reiset stepped in, offering to buy from Ingres a youthful self-portrait (fig. 209) and exchange it for the prince's painting.[7] He managed to negotiate the delicate matter with extreme tact, and in a letter dated April 7, 1860, Ingres expressed his gratitude:

Dear Sir:

If I had not been bound by my promise to you to give my portrait to the prince, I would not have been able to endure the moment when I parted from that precious portrait, which is no longer a part of its family. The sacrifice is huge, I admit,

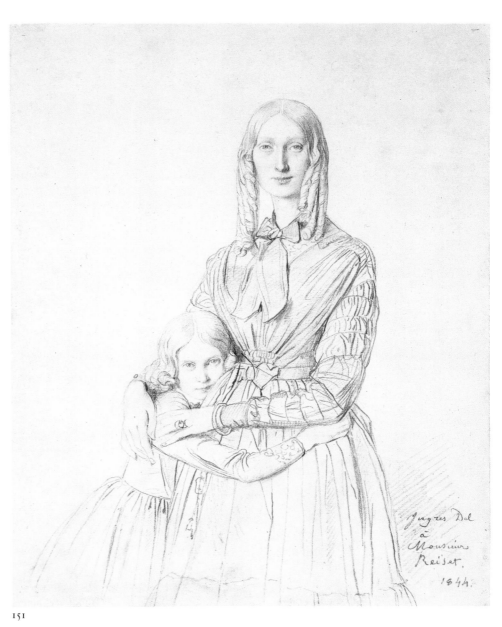

151

given the painful feelings that still afflict me. Only for the prince, who honored me with such high esteem, could I furnish such a proof of devotion, and for you, dear Sir, who have been kind enough to involve yourself, as a true friend, in a matter whose object has unexpectedly caused us both so much trouble.

A thousand thanks, and please believe that I remain your grateful servant,

Ingres[8]

Reiset was later rewarded for his services. The prince had given him an option to buy the self-portrait in the event that he ever wished to sell it. Reiset was able to exercise that option in 1868, the year after Ingres's death. With that self-portrait, the

Venus Anadyomene, and the portrait of Madame Duvaucey, he owned one of the most impressive ensembles of Ingres in private hands. On his retirement, Reiset decided—for unknown reasons—to auction off the most important works from his private collection. These treasures, including the three Ingres paintings, were purchased en bloc by the duc d'Aumale,[9] who in 1886 left them, along with his château at Chantilly and his other collections, to the Institut de France.

Reiset died in 1891, his wife two years later. Still more of Reiset's art holdings, including some thirty-five Ingres drawings, were sold at auction in 1894 and 1895.[10] The painting of Madame Reiset

and the five portrait drawings of the family were left to Marie. 　　　　　　　　H.N.

For the author's complete text, see Naef 1977–80, vol. 3 (1979), chap. 166 (pp. 348–63).

1. Marriage certificate, Archives de Paris.
2. Regarding Reiset's career, see his obituary in Anon., March 7, 1891, p. 78.
3. Ingres to Frédéric Reiset, August 22, 1845, quoted in Delaborde 1870, p. 347; reprinted in Naef 1977–80, vol. 3 (1979), p. 351.
4. See Naef 1968 ("Gioconda").
5. Ingres to Marcotte, July 28, 1849, quoted in Naef 1977–80, vol. 3 (1979), p. 353; in Ternois 1999, letter no. 62.
6. Quoted in Flandrin 1902, p. 147; reprinted in Naef 1977–80, vol. 3 (1979), p. 353.
7. Delaborde 1870, p. 251.
8. Quoted in ibid., p. 252; reprinted in Naef 1977–80, vol. 3 (1979), p. 354.
9. Frédéric Reiset sale, Hôtel Drouot, Paris, April 28, 1879.
10. Hôtel Drouot, Paris, April 16, 1894, and June 25, 1895.

PROVENANCE: Frédéric Reiset (1815–1891), Paris; his daughter, Vicomtesse Adolphe-Louis-Edgar de Ségur-Lamoignon, née Thérèse-Hortense-Marie Reiset, Château de Méry-sur-Oise, until 1899; her daughter Vicomtesse Achille-Jean-Marie Amelot de la Roussille, née Marie-Josèphe-Françoise-Juliette-Madeleine de Ségur-Lamoignon; Baron Pasquier (according to the catalogue of the vicomte d'Hendecourt auction mentioned below); Bernard, vicomte d'Hendecourt; his sale, Sotheby's, London, May 8–10, 1929, no. 211; purchased at that sale for 940 pounds sterling by Galerie Paul Cassirer, Berlin and Amsterdam; sold by them to Franz Koenigs, Haarlem; acquired with the Franz Koenigs Collection by Daniel George van Beuningen in 1940 and given to the Museum Boymans (now Museum Boijmans Van Beuningen), Rotterdam

EXHIBITIONS: Paris 1911, no. 153; Paris 1921, no. 109; Berlin 1929–30, no. 74, ill.; Haarlem 1931, no. 195; Rotterdam 1933–34, no. 81, pl. IV; Basel 1935, no. 12; Rotterdam 1935–36, no. 54, pl. IV; Zurich 1937, no. 249; Amsterdam 1938, no. 73; Amsterdam 1946, no. 119; Brussels, Rotterdam, Paris 1949–50, no. 138; Paris 1952a, no. 96; Washington, Cleveland, Saint Louis, Cambridge (Mass.), New York 1952–53, no. 117; Hamburg, Cologne, Stuttgart 1958, no. 129; Rome, Milan 1959–60, no. 125, pl. 61; Paris, Amsterdam 1964, no. 143, pl. 117; Paris 1967–68, no. 233, ill.; Baltimore, Los Angeles, Fort Worth 1986–87, no. 59, ill.; New York, Fort Worth, Cleveland 1990–91, no. 96, ill.

REFERENCES: Delaborde 1870, no. 406; Lapauze 1903, no. 81, ill.; Lapauze 1911a, ill. p. 387; *Formes et couleurs* 1946, ill. p. [58]; Davenport 1948, p. 862, no. 2462, ill. p. 861; Bouchot-Saupique 1949, p. 437; Ford 1953, p. 356; Haverkamp-Begemann 1957, no. 68, ill.; Ternois 1959a, preceding no. 169; Cambridge (Mass.) 1967, under no. 88; Hoetink 1967, p. 54, ill. p. 53; Hoetink 1968, no. 157, ill.; Paisse 1968, pp. 17, 22–23; Delpierre 1975, p. 23; Naef 1977–80, vol. 5 (1980), pp. 286–87, no. 400, ill.; Pignatti 1981, pp. 296–97, ill.

152. Comtesse Charles d'Agoult, née Marie de Flavigny, and Her Daughter Claire d'Agoult

May 1849
Graphite with white highlights
18 ½ × 15 ½ in. (47 × 39.3 cm), framed
Signed and dated lower right: J. Ingres Del /
1849 [J. Ingres drew (this) / 1849]
Private collection
New York only

N 412

When Madame d'Agoult asked Ingres to create a double portrait of herself and her daughter Claire, she had already been acquainted with the artist for ten years. They had first met in Rome in January 1839, when the countess arrived there in the company of Franz Liszt. At the time, Ingres was director of the Académie de France, and he readily welcomed the notorious lovers to the Villa Medici. The painter and the virtuoso pianist soon established a friendly relationship, one that certainly extended to Madame d'Agoult as well, even though she was by no means as forthcoming as Liszt. Some eight years later, the following account of a concert Liszt gave at the Villa Medici, in the presence of both Madame d'Agoult and Ingres, appeared in *La Mode*:

The symphony was about to end. . . . M. Ingres was in front of me, thrashing about like the devil in holy water. I would never have believed that human flesh could be charged with so much electricity; his every pore seemed to sparkle, all his muscles were rippling, his eyes were dancing in their sockets, his hands flew constantly from his knees to his head, from his head to his knees. He sat down, stood up, swooned to the right, swooned to the left; then he calmed down, raised his finger, and softly, gently tapped out the beat, falling back into his chair and half-shutting his eyes.

When the final note had faded away, he leaped from his chair and rushed into Liszt's arms; the two artists wept with enthusiasm and held each other tightly.

"Do you think the music touched them?" the cashmere dress [Madame d'Agoult] whispered in my ear.

"See for yourself," I said to her.

"They're playacting."

"Ah, madam, you really are a skeptic."

"No, I'm simply experienced. I know great artists. I'm not saying that they're

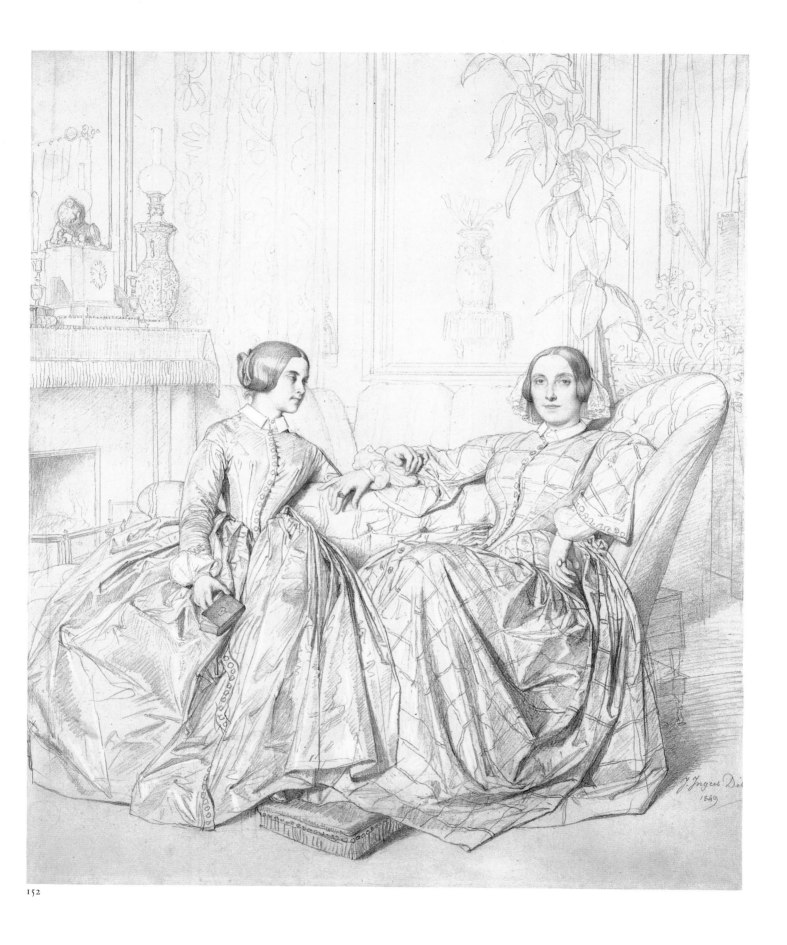

actors; they are always sincere. But they are obliged to have more violent emotions than we do and—my word!—by force of habit, they always put a little artifice into their emotions. They're like brave men, who are always a little bit braver than they'd like to be when they know they're being watched."[1]

The woman who published the piece—anonymously—may well have been motivated by a desire to shock, though there is ample testimony to suggest that her words were not pulled out of thin air. There is no doubt but that Madame d'Agoult was becoming disenchanted with the affair for which she had sacrificed both her marriage and her reputation, and she certainly did not welcome the child of Liszt's—their third and last—that she was carrying at the time.

On her departure from Rome in May 1839, Ingres presented her with a portrait of Liszt (cat. no. 116), even though he doubtless suspected that all was not well between the two. She repaid the kindness in her own way by publishing later that year an open letter to Hector Berlioz, ostensibly written by Liszt, the most impressive passage of which is a veritable paean to Ingres:

> A circumstance that I count among the happiest of my life played no small part in strengthening in me an intimate sense of things and my ardent desire to penetrate further into an understanding and knowledge of art. A man whose genius, aided by exquisite taste and virile enthusiasm, has produced the most beautiful creations in all of modern painting—M. Ingres—welcomed me to Rome with such warmth that the memory of it still fills me with pride. I found him to be everything public opinion had promised, and more. M. Ingres, as you know, spent his youth in constant study and intrepid struggles. He was able to overcome neglect, lack of recognition, and poverty only by dint of persistent work and a heroic stubbornness born of inflexible conviction. Having now reached maturity, he enjoys without vanity a renown won without scheming. That great artist, for whom antiquity has no secrets and whom Apelles would have called his brother, is as much an excellent musician as he is an incomparable painter. Mozart, Haydn, and Beethoven speak the same language to him as Phidias and Raphael.[2]

Here, as in most of her writing, Madame d'Agoult's praise is not so much heartfelt as intellectually contrived.

She broke with Liszt in Florence in October 1839. During the following years, she regularly corresponded with Ingres's German pupil Henri Lehmann, whom she had come to know in Rome. Their letters document her subsequent relations with Ingres, which were not especially close and consisted mainly of exchanges of the common courtesies.[3]

Ingres returned to Paris in triumph in 1841, following the exhibition there the previous year of his *Antiochus and Stratonice* (fig. 194), painted for the duc d'Orléans. Madame d'Agoult is known to have written a piece—now lost[4]—in praise of the work, but in this same period all manner of reservations regarding its creator begin to creep into her letters to Lehmann. These may reflect opinions expressed in her salon by Charles-Augustin Sainte-Beuve, who felt that Ingres had perhaps become too devoted to Raphael while in Rome,[5] or by the brilliant young painter Théodore Chassériau, who confessed to her, without remotely incurring her disfavor, that before leaving Rome he had become disenchanted with both his mentor, Ingres, and his fellow pupil Lehmann.[6]

Reading between the lines in her letters, one senses that Madame d'Agoult's feelings about Ingres were compounded of gratitude, reservations, and a certain degree of self-interest. Largely shut out of aristocratic circles owing to her scandalous affair with Liszt, she had set out to rebuild her reputation by gathering in her salon at 16, rue Plumet the finest writers, thinkers, and artists of the day. Now that Ingres was being lionized, his attendance there was obviously useful. The unsophisticated painter must have felt out of place among such brilliant intellects, but the countess managed to keep him beholden to her with continuing protestations of admiration. Her flattering article on *Cherubini and the Muse of Lyric Poetry* (fig. 221), painted with Lehmann's assistance, documents her opportunism more than it does any particular appreciation for his art.[7]

The artist can only have been pleased to read such nice things about himself, and

when he consented to produce the double portrait of the countess and her daughter, at a time when he was undertaking fewer and fewer such works, he was doubtless influenced by his memory of that article. In his heart, it is unlikely that he had ever really warmed to the somewhat too calculating countess. One senses this in his firm but strangely distanced drawing as well as in his surviving letters to her.[8]

It must have been difficult for the artist to concentrate on his work, for it was at precisely the time of the sittings—in early May 1849—that his beloved wife, Madeleine, exhibited the first symptoms of the ailment that would take her life in only a matter of weeks. Another interesting fact relating to the date of the drawing is that a few days later the countess's daughter Claire would become the wife of the marquis Guy de Charnacé.[9]

Claire was the only surviving child from Marie de Flavigny's marriage to Comte Charles d'Agoult, the union destroyed by the fateful appearance of Liszt. She had been raised in a convent and was reunited with her mother only two years before the double portrait was made. She was endowed with her mother's keen intelligence and was equally independent, determined to be free to do as she wished, and stubborn.

Two years after her marriage, Claire de Charnacé bore a son, Daniel, but by then her relationship with her husband was deteriorating. She consoled herself with writing—her countless articles appeared in newspapers and journals under the pseudonym C. de Sault—and with art. Her gift for drawing is amply displayed in a portrait of her mother that is among the most revealing ever made.[10] Madame d'Agoult died in Paris in 1876, her daughter in Versailles in 1912.

This portrait was engraved by Louis-Adolphe Salmon by 1851, at the latest.

H. N.

For the author's complete text, see Naef 1977–80, vol. 3 (1979), chap. 170 (pp. 391–405).

1. Anon., January 6, 1847, pp. 15–16; reprinted in Naef 1977–80, vol. 3 (1979), p. 391.
2. Anon., October 24, 1839, p. 418; reprinted in Naef 1977–80, vol. 3 (1979), pp. 392–93.
3. See Stern, Liszt, and Lehmann 1947.
4. For the catalogue she made of her writings, see Vier 1955–63, vol. 6 (1963), pp. 139–43.

5. Sainte-Beuve to Charles Labitte, June 23, 1839, quoted in Sainte-Beuve 1938, p. 111; reprinted in Naef 1977–80, vol. 3 (1979), p. 394, n. 1. See also Sainte-Beuve 1938, pp. 115, 116, n. 3, p. 117. For the letter on this topic that Henri Lehmann wrote Madame d'Agoult on June 18, 1839, see Stern, Liszt, and Lehmann 1947, p. 20; reprinted in Naef 1977–80, vol. 3 (1979), p. 394, n. 1.

6. For more on these estrangements, see Stern, Liszt, and Lehmann 1947. See also Madame d'Agoult to Lehmann, March 1 and May 18, 1841, reprinted in Naef 1977–80, vol. 3 (1979), pp. 395–96.

7. Stern, January 7, 1842.

8. Eleven in all, they date from the period when both Ingres and the countess were living in Paris, after returning from Italy (first published in Naef 1967 ["Agoult und Charnacé"], p. 6). This portrait drawing of Madame d'Agoult and her daughter is mentioned in the letters of May 1849 and December 3, 1851.

9. Aragonnès 1938, p. 197.

10. Reproduced after an engraving by Léopold Flameng in Sitwell 1958, p. 53.

PROVENANCE: Comtesse Charles d'Agoult, née Marie de Flavigny (1805–1876), Paris; her daughter Marquise Guy de Charnacé, née Claire d'Agoult (1830–1912), Versailles; her son Marquis Daniel de Charnacé, Croissy-Beaubourg, until 1942; his daughter Comtesse de Saint-Priest d'Urgel, née Claude de Charnacé; her daughter Marquise de la Garde de Saignes, née Anne-Dauphine de Saint-Priest d'Urgel, Paris, until about 1997; the present owner

EXHIBITIONS: Paris 1861 (2nd ser.); Paris 1867, no. 544; Versailles 1881, no. 242; Paris 1913, no. 351; Paris 1921, no. 117; Paris 1934c, no. 40; Paris 1950, no. 128; Washington, Cleveland, Saint Louis, Cambridge (Mass.), New York 1952–53, no. 118, pl. 32; Chicago, Minneapolis, Detroit, San Francisco 1955–56, no. 108, pl. 32; Hamburg, Cologne, Stuttgart 1958, no. 131, ill.; Paris 1967–68, no. 242, ill.

REFERENCES: Galichon 1861b, p. 44; Blanc 1870, p. 235; Delaborde 1870, no. 249; Ronchaud 1880, pp. 24–25, n. 1, p. 25; Both de Tauzia 1888, p. 141; Lapauze 1901, p. 264 (known from the engraving by Louis-Adolphe Salmon); *L'Instantané* 1911, fig. 21960; Lapauze 1911a, p. 405, ill. p. 427; *La Renaissance de l'art français* 1921, ill. p. 261; Fröhlich-Bum 1924, pl. 56; Fischel and Boehn 1925b, vol. 3, ill. p. 27; *Dictionnaire de biographie française*, vol. 1 (1933), col. 794; Bory 1936, ill. on pl. 119; Engel 1936, ill. opp. p. 53; Bertram 1949, pl. 32; Sitwell 1958, ill. p. 125; Ternois 1959a, preceding no. 1 (for the three preparatory pencil sketches, see also nos. 1–3, ill.); Haraszti 1967, p. 32; Naef 1967 ("Agoult und Charnacé"), pp. 6–7, ill.; Sérullaz 1967, p. 213, fig. 4; László and Mátéka 1968, ill. p. 105; Delpierre 1975, p. 23; Naef 1977–80, vol. 5 (1980), pp. 308–10, no. 412, ill.; Vigne 1995b, p. 209, fig. 173

153. Dr. François Mêlier

1849
Graphite with white highlights
9 ½ × 7 ⅛ in. (24.2 × 18.1 cm), within the drawn border
Signed and dated lower right: Ingres Del / 1849. [Ingres drew (this) / 1849.]
Inscribed upper right: Fˢ. Mêlier D. M.
The Metropolitan Museum of Art, New York
Robert Lehman Collection, 1975 1975.1.648
New York only

N 413

Ingres's drawing of Dr. François Mêlier confirms that even in his late years the artist was capable of surrendering himself completely to a sitter's personality in order to capture its uniqueness. In Mêlier he clearly faced an individual of enormous ability, and it comes as no surprise that such a man should be remembered to this day in dictionaries of medical biography. Mêlier's chief professional contributions were the definition and development of the new field of public health or, as he himself first termed it, "médecine politique."

He was born in 1798 in Chasseneuil, in the Charente department, the sole child of modestly affluent parents.[1] At fifteen he was sent to secondary school in Limoges, where he simultaneously began studying medicine in the hope that he could later satisfy his military obligation with service in the army health corps. Before he became eligible for army service, however, the Empire collapsed, freeing him to complete his classical studies. Despite his lively interest in the humanities, Mêlier nevertheless felt a genuine medical vocation, and

in 1815 he became an intern in the hospital at Limoges. Two years later he moved to Paris to continue his training. Mêlier finally received his degree in 1823, and in 1824, while working as an internist at the Hôpital Saint-Louis, he married.

The young doctor first rose to prominence in 1827 with his lecture series on public health, the first ever held, at the Athénée. He was elected to the Académie de Médecine in 1843, and soon thereafter he was asked to prepare a report on the health of workers employed in the state tobacco factories. In subsequent years he submitted numerous recommendations on the management of epidemics. It was at his insistence, for example, that medical stations were established in the major port cities of the Levant, to which most of France's outbreaks of plague, cholera, and yellow fever could be traced. He also made beneficial changes in hospital conditions within his country, especially the institution of quarantine. In 1851—by which time he had become president of the Académie—he initiated and chaired the

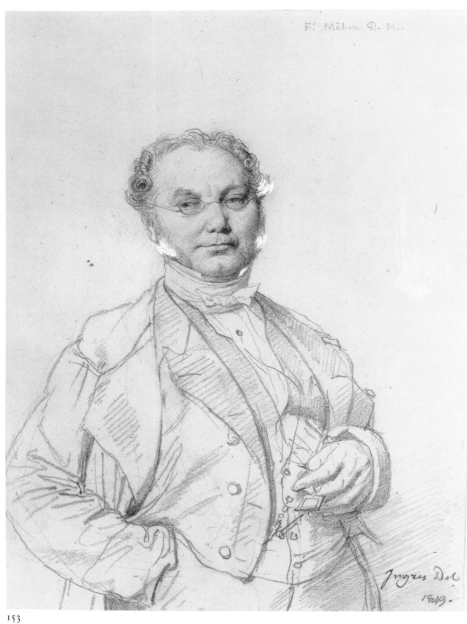

153

first international health conference, to which representatives from all the countries in Europe were invited. In 1854 he was named Inspecteur Général des Services Sanitaires, in which capacity he traveled around the country supervising local responses to threatened epidemics. He continued his work with undiminished energy until 1866. In September of that year, after setting up a Franco-Italian health conference in Turin, dealing with an outbreak of cholera in Amiens, and assisting with the reorganization of quarantine measures in Corsica, he succumbed to a stroke in Marseilles.

How Ingres became acquainted with Dr. Mêlier is unknown. It is probably sig-

nificant that the portrait was executed in the same year that Mêlier's younger daughter married a Dr. Desormeaux. Probably the drawing was commissioned as a wedding gift, for in 1867, the time of the Ingres retrospective exhibition (in which it was included), the portrait belonged to Madame Desormeaux and not her older sister, who would ordinarily have inherited it from their father. H. N.

For the author's complete text, see Naef 1977–80, vol. 3 (1979), chap. 171 (pp. 406–12).
1. Details of Mêlier's career have been drawn from Bergeron 1891.

PROVENANCE: By 1867 at the latest, Mme Antonin Desormeaux, née Blanche Mêlier, Paris,

until 1891; her son Ange-Marie-Gabriel Desormeaux; his son Henri Desormeaux, Le Mans; sold by him to the Walter Feilchenfeldt gallery, Zurich, in 1959; purchased from that gallery by Robert Lehman, New York, 1960; his bequest to The Metropolitan Museum of Art, New York, 1975

EXHIBITIONS: Paris 1867, no. 564; New York 1961, no. 63, ill.; New York 1962, p. 29; New York 1980–81, no. 53, ill.; Copenhagen 1986, no. 3; New York 1988–89

REFERENCES: Blanc 1870, p. 238; Delaborde 1870, no. 373; Bergeron 1891, p. 3 (erroneously as in the collection of the Académie de Médecine, Paris); L'Intermédiare des chercheurs et curieux 1899, col. 12; Naef 1961 ("Zwei unveröffentlichte Ingres-Zeichnungen"), p. 80, ill. p. 81; Naef 1977–80, vol. 5 (1980), pp. 310–11, no. 413, ill.

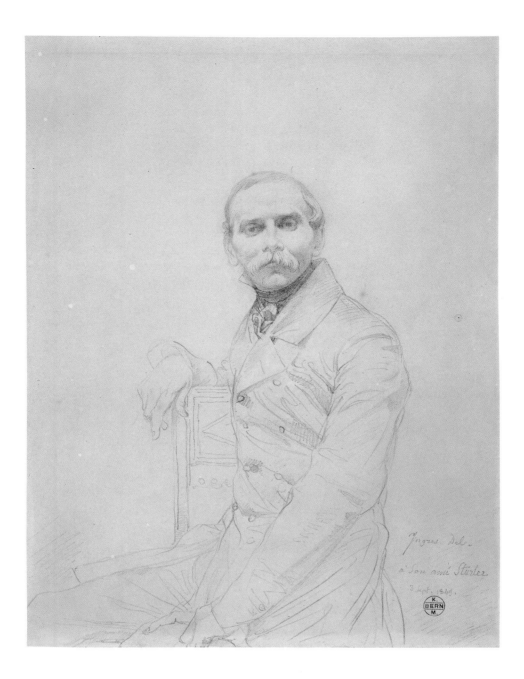

154. Franz Adolf von Stürler

September 3, 1849
Graphite
13 × 9¾ in. (32.9 × 24.8 cm)
Signed, dated, and inscribed lower right:
Ingres Del. / à Son ami Sturler / 3 Sept. 1849.
[Ingres drew (this) / for his friend Stürler /
September 3, 1849.]
At lower right, the Kunstmuseum, Bern,
collection stamp (Lugt 236a)
Kunstmuseum, Bern
Bequest of Adolf von Stürler, Versailles A2207
New York and Washington only

N 415

Franz Adolf von Stürler is now chiefly
remembered as the subject of this portrait
by Ingres and as a benefactor of the art
museum in Bern.[1] His connection with
that city was through his father, who was
born there but left at the age of twenty-
two to take up residence in France.
There, Karl Emanuel Stürler prospered
as an ornamental sculptor and married a
Frenchwoman, who bore him one son,
Franz Adolf, in Paris in 1802.[2] The boy
demonstrated artistic talent at an early
age, and was given instruction in "anat-
omy, perspective, and drawing from

life."[3] He ultimately enrolled in Ingres's
atelier, where he became a close friend
of his fellow pupil Amaury-Duval. In
the latter's reminiscences about Ingres
is the following anecdote:

> Sturler . . . came from the atelier of
> M. Regnault, who at the time was gener-
> ally known by the nickname "Papa
> Kneecap"—supposedly because of the
> care he took in rendering that part of the
> human anatomy, and the superiority he
> had acquired in this respect. . . .
> M. Ingres examined the figure Sturler
> was painting: "Well, Sir," he said, "it's

very good . . . very capable . . . painted with real talent . . . there's nothing I can say to you . . ."

"Sir," Sturler interrupted, "if I thought I could paint as well as all that, I would not have come to ask for your guidance. I came here because I know that it isn't what it should be . . . that it's frankly rather poor."

"Ah, so that's how you want it," said M. Ingres, stepping back and looking him in the eye. "Ah, so you're not happy with what you're doing! Well, then, that's a different matter altogether . . . In that case, you're right, it isn't what it should be . . . It's capable, and nothing more . . . no style, no personality; in that case, yes, it's rather poor . . . Ah, so that's how it is! . . . All right, then, I'll tell you what I think. You have to forget everything you've learned and begin at the beginning. With your talent, you could get along perfectly well without me; you could even make an excellent living that way . . . But since you're aiming higher and farther than that . . . pluck up your courage . . . for everything has to be taken from scratch." [4]

Stürler left for Italy in 1831. Ingres advised him to "head straight for Raphael," [5] obviously convinced that the young painter would find what he most needed in Rome. But on his way south Stürler decided to spend at least a few days in Florence and get to know some of that city's art treasures before proceeding to the capital. The stay of a few days was extended to some twenty-two years. Thanks to his fascination with the tradition of Cimabue and Giotto, the Bern art museum would later acquire an astonishing collection of early Italian paintings. [6]

Although he had little contact with Ingres during his years in Florence, Stürler must always have felt his presence, as he occupied the same atelier that Ingres had used from 1821 to 1824. He also became acquainted there with Ingres's friend from his early years as a pupil of David, the sculptor Lorenzo Bartolini, and at some point he executed a copy of the portrait Ingres made of Bartolini in 1820 (fig. 135). [7] His chief painting inspired by the art of Florence is a large, multifigured work, now in the Musée Ingres, Montauban, depicting the ceremonial installation in Santa Maria Novella of a thirteenth-century painting of the Madonna. [8]

Stürler visited Paris in the summer of 1849, presumably in connection with the death of his mother earlier in the year. [9] It was there, in September, that Ingres produced his portrait drawing of him. [10] Only a very few of the master's pupils were so honored. Ingres had lost his beloved wife Madeleine only weeks before, and their sorrow appears to have brought the two men closer together than ever before.

Stürler left Florence in 1853, married an Englishwoman twenty-four years younger than he, and settled in Versailles. He maintained his friendship with Ingres, and since the parents of Ingres's second wife also lived in Versailles it is likely that they saw each other with some regularity. Ingres's cordial feelings toward the younger man are attested by several letters to Stürler and by the portrait he drew in 1861 of Stürler's wife Matilda (cat. no. 165), one of the last, if not the very last, of his famous pencil likenesses. [11]

Stürler died in 1881. His illustrations for Dante's *Divine Comedy*, which he doubtless considered his greatest achievement, were published posthumously in photogravure. Three years after Stürler's death, this portrait drawing was engraved by Baudran. H.N.

For the author's complete text, see Naef 1977–80, vol. 3 (1979), chap. 173 (pp. 417–25).

1. Huggler 1948 includes a list of Stürler's own works in the Kunstmuseum, Bern.
2. Thieme and Becker 1907–50, vol. 32 (1938), p. 240.
3. "Familienbuch der Stürler" n.d., p. 149.
4. Amaury-Duval 1878, pp. 25–26; reprinted in Naef 1977–80, vol. 3 (1979), p. 418.
5. Delaborde in Stürler 1884, vol. 1, p. V; reprinted in Naef 1977–80, vol. 3 (1979), p. 419.
6. Wagner 1974.
7. Datini 1972, p. 65, no. 173.
8. Today attributed to Duccio, this altarpiece is in the Uffizi, Florence. Stürler's painting is illustrated in Ternois 1965, no. 238.
9. "Familienbuch der Stürler" n.d., p. 149.
10. The drawing is mentioned in Ingres's Notebook X, fol. 26.
11. The drawing is mentioned in ibid., fol. 27.

PROVENANCE: Adolf von Stürler (1802–1881), Versailles; his widow, née Matilda Jarman, until 1900; entered the Kunstmuseum, Bern, as the bequest of Adolf von Stürler, 1902

EXHIBITIONS: Paris 1861 (1st ser.), no. 73; Paris 1867, no. 391; London 1878–79, no. 674 [EB]; Versailles 1881, no. 1449; Basel 1921, no. 112 (?), as *Portrait d'homme*; Zurich 1937, no. 231, pl. XVI; Lausanne 1953, no. 31; Biel 1954, no. 4; Winterthur 1955, no. 248; Zurich 1958a, no. B 18; Paris 1959, no. 177, pl. 8; Bern, Hamburg 1996, no. 10, ill.

REFERENCES: Blanc 1861, p. 191; Galichon 1861a, p. 361; Blanc 1870, p. 239; Delaborde 1870, no. 414; Stürler 1884, frontis. (the engraving by Baudran); Lapauze 1901, p. 249 (known from the list of works in Ingres's Notebook X); Bern, Kunstmuseum n.d., p. 24, pl. 96; Huggler 1948, ill. p. 15; Alazard 1950, p. 153, n. 29; Naef 1963 (*Schweizer Künstler*), pp. 65–73, 81, no. 8, p. 100, fig. 11; Wagner 1974, pp. 9, 13, fig. 11; Naef 1977–80, vol. 5 (1980), pp. 314–15, no. 415, ill.; Amaury-Duval 1993, no. 49

155. Madame Hippolyte Flandrin, née Aimée-Caroline Ancelot

1850
Graphite heightened with white
12¾ × 9⅝ in. (32.4 × 24.4 cm)
Signed, dated, and inscribed lower left: Ingres
Del. / à Son ami et / Son illustre Eleve / h.^te
flandrin. / 1850. [Ingres drew (this) / for his
friend and / his illustrious pupil / Hippolyte
Flandrin. / 1850.]
Inscribed upper right: Madame Aimée hipp^te
flandrin née Ancelot
Musée des Beaux-Arts, Lyons B 1554
London only

N 419

The relationship between Ingres and Hippolyte Flandrin, his favorite pupil, was of tremendous importance to both of them, yet it is no longer clear what it was that they so admired in each other. As is well known, Ingres felt that his true calling was as a narrative painter, and he placed his highest hopes on the very works that art historians now find the most problematic. He was nevertheless a great artist and can therefore be forgiven for failing to recognize his true strengths. Flandrin had none of his master's greatness, and his equally distorted view of the older man's genius seems simply misguided. Distinctly lacking in creative power himself, he placed what talents he had in the service of a meek religiosity. The fact that he was awarded impressive commissions and honors is an indication of the religious temper of the times. But nothing adequately explains why Ingres, an artist of

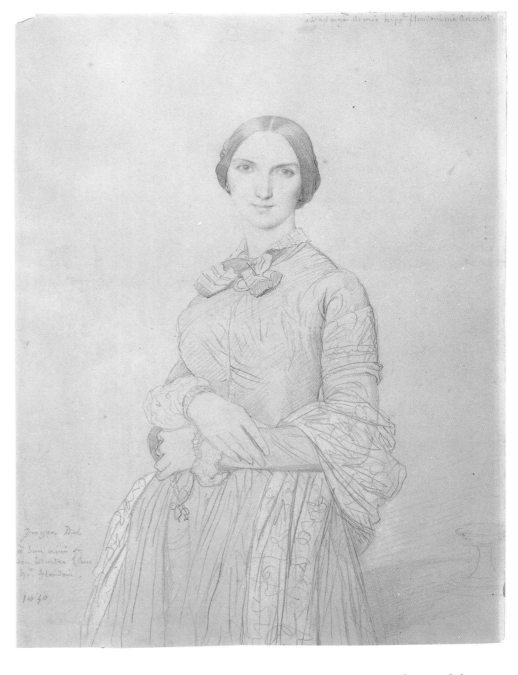

exquisite sensuality and genuine feeling, should have praised his bloodless creations so unreservedly.

Flandrin was born in Lyons in 1809. His family was relatively poor, but his father, having been prevented from developing his own artistic talent, was determined that his offspring should have every opportunity. There were seven children in all, but four died young. The remaining three sons all became painters, and all of them studied with Ingres.

In 1827 Hippolyte and his younger brother Paul entered the École des Beaux-Arts in Lyons, where their teacher in painting, Pierre Révoil, remembered Ingres from the time when they had been fellow pupils in Jacques-Louis David's atelier. Within two years, Hippolyte had won all the prizes available to him at the school, and he was advised to continue his studies in Paris. He arrived there, Paul in tow, in early April 1829. He had hoped to enroll in the atelier of Louis Hersent,[1] but only days after his arrival he wrote his father:

> You know that we'd more or less decided to go to M. Hersent's; I've changed my mind somewhat, and it's not out of whim. Here are my reasons. First, in Paris, M. Ingres is considered to be much more talented than M. Hersent; second, his school is much better run and calmer. He will not tolerate those awful practical jokes that often drive even the best young man to leave a place.[2]

The better Ingres came to know the two Flandrins, the more generous was his treatment of them. Two years later Hippolyte wrote his parents:

> M. Ingres, that good, that excellent man, has just outdone himself in his kindness toward us . . . he asked me to come see him. When I arrived, he said he was pleased with our progress, and that as of today we would no longer have to pay, that he was reimbursing us fully and completely for what we paid for his lessons. . . . I have such love for that great man that I don't know how to express it. I'd like to make everyone share my admiration—just getting to know him would be sufficient.[3]

That same year, Ingres encouraged Hippolyte to compete for the Prix de Rome, and though the young artist was unsuccessful, his failure brought him even closer to his teacher. In 1832, however, he emerged from the competition victorious, the first of Ingres's pupils to be so honored. The winner in musical composition that year was Ambroise Thomas, and the two young men journeyed to Rome together, becoming fast friends.

Hippolyte could not have been more delighted when his adored teacher was elected to become director of the Académie de France in Rome in 1834. Unexpectedly, he was thus given another few years of study under Ingres, and as a result of their daily contact at the Villa Medici the two became increasingly attached to each other. Ingres soon came to think of Hippolyte and his closest friends among the villa's pensioners—the composer Thomas, the sculptor Charles Simart (see cat. no. 162), and the architect Victor Baltard (see cat. nos. 114, 115)—as beloved sons, and all of them would worship him the rest of their lives. Flandrin and Baltard returned to France in 1838, and in a number of letters Ingres confessed how deeply he missed them.

Flandrin would soon be given proof of his teacher's high esteem for him. Ingres's old friend Édouard Gatteaux was one of the most influential members of the Commission des Beaux-Arts in Paris and had vowed to do all he could for artists returning from Rome with Ingres's recommendation.[4] Doubtless, it was largely thanks to him that Flandrin was commissioned to paint an entire chapel at the Paris church of Saint-Séverin, the work that established his reputation as the creator of monumental religious paintings. In 1841, the year Ingres returned from Rome, Flandrin was awarded a second major commission, at the church of Saint-Germain-des-Prés, also in Paris. The original contract called for painting the sanctuary, but again thanks to Gatteaux and also to Baltard, who had been named Inspecteur des Beaux-Arts at Gatteaux's urging, the commission was ultimately extended to include the entire choir and the nave.

It is odd that many of Ingres pupils ended up as church painters, for he himself always shied from such large tasks. In 1846 Ingres was urged by his friends Jacques-Ignace Hittorff and Jean-Baptiste Lepère, architects of the new Saint-Vincent-de-Paul, to undertake the decoration of that church on the place Lafayette, but he declined. Flandrin initially turned them down as well, reluctant to take on a task rejected by his mentor, but ultimately—doubtless at Ingres's urging—he relented. In 1850, while still engaged in the project, he wrote home to Lyons: "Dear Mother, dear Paul, I don't know if I mentioned to you that M. Ingres came by to see my paintings. He was pleased with them, and he made some very flattering remarks. It's a great encouragement, even though I don't take what he's kind enough to say too literally."[5] By that time it was Ingres who felt indebted to Flandrin.

In 1843 the younger painter had married—at a service attended by Ingres and his wife and with organ music provided by Ambroise Thomas—a young relative of his patron Gatteaux. When Ingres lost his beloved wife Madeleine in 1849, Flandrin had been unfailingly attentive, and the couple had taken the widower in for a time when he could not face living in an empty house. Out of gratitude, in 1850 Ingres produced this portrait of Madame Flandrin, dedicating it to "his friend and illustrious pupil." As a companion piece to that drawing, he executed a portrait of Flandrin himself five years later (cat. no. 158).[6] The work vividly captures the sitter's mild, melancholy nature. To appreciate it fully, it is important to note that Flandrin had been cross-eyed since childhood and an unsuccessful operation had left him with almost no sight at all in his right eye.[7]

In the twenty-four years after Flandrin's return from Rome, he accomplished an astonishing amount of work, nearly as much as the giants of Italian fresco painting. Unsurprisingly, it took its toll on him, and in late 1862 his heart nearly gave out. He seemed to recover, and in March 1863 Ingres hosted a small party to celebrate. A description of that event was reported in the *Journal des débats*:

> The day before yesterday, the most celebrated figure in contemporary art gathered around his table several of his friends and a few students who hold the front

rank in the world of painting. Over dessert, the master of the house took the floor. It is his speech, soulfully delivered, listened to with great emotion and warmly applauded, that I'd like to give an idea of here:

"... I have learned much by teaching you, gentlemen, and every day I learn still more. By recommending to you a certain firmness of principle, I have become firmer myself; by showing you the goal toward which you should strive, I have focused on this goal with yet more conviction; by urging you to have faith in yourselves, I have felt more confident and more sure of myself. Let us love art, my friends, let us love it passionately, let us give ourselves over to it entirely. Let us remember the great masters and respect them; let us remember especially the divine Raphael, the very soul of perfection."[8]

In the late autumn, Flandrin took his family to Rome, planning to stay there until he regained his health. His letters to Ingres were filled with memories of their time together at the Académie so many years before. In the last of them he enclosed some pressed flowers, which he labeled "roses from the Villa Medici."[9]

He died in Rome in March 1864. His body was returned to Paris and lay in state at Saint-Germain-des-Prés before burial

in the Père Lachaise cemetery. A few days after his death, Ingres, then eighty-three, summoned his waning strength to create an artistic monument to his beloved pupil. His drawing shows the angel of Death gazing sadly at a female figure weeping at the base of a commemorative monument inscribed with the names of Flandrin's major works. The legend beneath the drawing reads: "Death itself regrets the blow it has just struck!"[10]

H.N.

For the author's complete text, see Naef 1977–80, vol. 3 (1979), chap. 176 (pp. 446–60).

1. A painter and lithographer (1777–1860).
2. Quoted in Delaborde 1865, p. 113; reprinted in Naef 1977–80, vol. 3 (1979), p. 448.
3. Quoted in Delaborde 1865, pp. 149–50; reprinted in Naef 1977–80, vol. 3 (1979), p. 448.
4. Timbal 1881, p. 502.
5. Quoted in Delaborde 1865, p. 389; reprinted in Naef 1977–80, vol. 3 (1979), p. 453.
6. *Madame Hippolyte Flandrin* is entered in Ingres's work list (Notebook X, fol. 26), and *Hippolyte Flandrin* is mentioned in his notes (Notebook X, fol. 9). Both drawings were copied in pencil by Jean Coraboeuf and the copies dated 1895 (Musée Ingres, Montauban).
7. Delaborde 1865, p. 321, n. 1.
8. Quoted in Vinet 1863, p. [2]; reprinted in Naef 1977–80, vol. 3 (1979), p. 455.

9. Flandrin to Ingres, December 26, 1863, quoted in Delaborde 1865, p. 461; reprinted in Naef 1977–80, vol. 3 (1979), p. 456.
10. The drawing, in a private collection, was reproduced in *L'Autographe* 1864, p. 89, together with the letter to the journal editors that Ingres enclosed with the drawing. See also Naef 1977–80, vol. 3 (1979), p. 457, fig. 3.

PROVENANCE: Hippolyte Flandrin (1809–1864); his widow, née Aimée Ancelot, Sèvres, until 1882; their son Paul-Hippolyte Flandrin, until 1921; his widow; her gift to the Musée des Beaux-Arts, Lyons, 1928

EXHIBITIONS: Paris 1861 (1st ser.), no. 53; Lille 1866, no. 842; Paris 1867, no. 334; Paris 1884, no. 408; Paris 1905, no. 40; Paris 1911, no. 163 [EB]; Paris 1923a, no. 248; Lyons, Esslingen 1989, no. 46, ill.; Pittsburgh, Northampton 1992, no. 48, ill.

REFERENCES: Saglio 1857, p. 79; Blanc 1861, p. 191; Delaborde 1861, p. 267; Galichon 1861a, p. 358; Merson and Bellier de la Chavignerie 1867, p. 121 (erroneously dated 1858); Blanc 1870, p. 236; Delaborde 1870, no. 295; Gatteaux 1873 (1st ser.), ill. on pl. 11 (detail); Both de Tauzia 1888, p. 141; Lapauze 1901, p. 249 (known from the list of works in Ingres's Notebook X); Flandrin 1902, p. 148; Lapauze 1903, no. 19, ill.; Doucet 1906, ill. p. 129; Hourticq 1928, ill. on pl. 82 (detail); Naef 1977–80, vol. 5 (1980), pp. 322–23, no. 419, ill.; Paris, Lyons 1984–85, p. 174, under no. 96; Paris, Musée du Louvre 1987, p. 156, ill. p. 157

156. Madame Félix Gallois, née Nathalie-Rose-Joachime Bochet

1852

Graphite and watercolor

13 5/8 × 10 3/8 in. (34.6 × 26.8 cm)

Signed, dated, and inscribed lower left: J. Ingres Del. / à Son cher cousin / et ami Monsieur / Gallois— / 1852. [J. Ingres drew (this) / for his dear cousin and friend Monsieur / Gallois— / 1852.]

Inscribed upper right: nathalie Gallois

The Metropolitan Museum of Art, New York

Robert Lehman Collection, 1975 1975.1.647

New York only

N 430

Beginning about 1810, Ingres executed the portraits of high officials in the Napoleonic administration of Rome, and among these likenesses was one of the tax inspector Edme Bochet (cat. no. 30). Four decades later, the artist would take Bochet's niece Delphine Ramel as his second wife (see cat. no. 159). That marriage brought him a host of new relatives, for Bochet not only had at least five married brothers and sisters but was himself the father of ten children. Ingres promptly set about claiming his new family in his own way, by creating portrait drawings of them.

One of this series is the drawing of Edme's daughter Nathalie, by marriage

Madame Félix Gallois. Less is known about this woman than about any of the other members of Ingres's new family. The only certain information is found in her marriage certificate, excerpted here:

Paris 3rd [arrondissement], June 30, 1840, certificate of marriage between, on the one hand, Louis Félix Gallois, born in Paris in the 9th arrondissement on July 1, 1812, without profession, residing with his father at the Château de Bercy, town of Bercy (Seine), older son of Louis Gallois, landowner, chevalier in the Legion of Honor, present and consenting, and of Anne Louise Angélique Bitter, his wife, who died in Bercy on March 29, 1835—and,

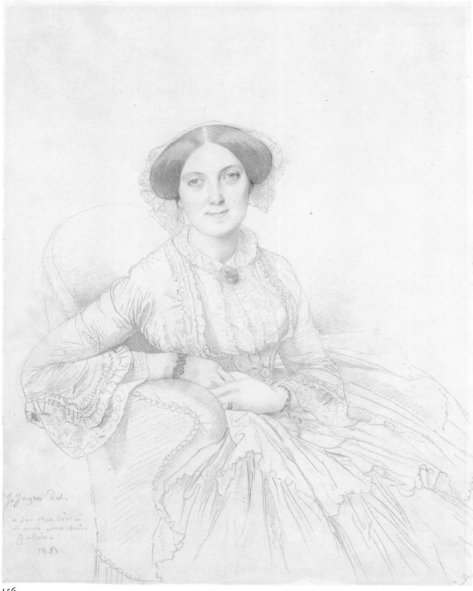

156

Just where the visit to Madame Gallois would take them is indicated in another letter to Marcotte postmarked Versailles in October:

> We're like gypsies wandering through the countryside, from the Touraine to M. Gallois's home in Normandy. I'll wait for some other occasion to tell you about our travels, which were very enjoyable apart from a few moments of fatigue and some enforced idleness—I who am so used to being in my studio.[6]

Whether the Galloises were simply vacationing in Normandy or lived there year-round is unknown. This drawing is a rarity in that the artist has highlighted Nathalie's jewelry in yellow watercolor. The instances of this in Ingres's oeuvre can be counted on the fingers of one hand.

H.N.

For the author's complete text, see Naef 1977–80, vol. 3 (1979), chap. 181 (pp. 500–502).
1. Archives de Paris, quoted in Naef 1977–80, vol. 3 (1979), p. 500.
2. Moreau-Nélaton 1918, vol. [5], pl. IV.
3. Lavigne 1881, p. 80.
4. Ingres's new parents-in-law lived in Versailles.
5. Ingres to Marcotte, June 19, 1852, quoted in Naef 1977–80, vol. 3 (1979), p. 501; in Ternois 1999, letter no. 87.
6. Ingres to Marcotte, [September] 23, 1852, quoted in Naef 1977–80, vol. 3 (1979), p. 501; in Ternois 1999, letter no. 88.

on the other hand, Nathalie Rose Joachime Bochet, born in Paris in the 3rd arrondissement on December 22, 1819, without profession, daughter of Edme François Joseph Bochet, land registrar, chevalier in the Legion of Honor, and of Elisabeth Catherine Joachime Faustine Galli, his wife, both present and consenting.[1]

Nathalie Gallois exudes a patrician air that sets her apart from her distinctly bourgeois relatives. It may reflect the fact that she married a man of leisure, the son of a Parisian who owned a château, and it may also explain why none of the present-day members of the family know anything about her, and why no death date is given for her in the Bochet genealogical charts.[2] Those

documents do tell us that the couple had two daughters and a son, and that Félix Gallois died in 1891. Nathalie was still alive in 1867, for she is listed among the bereaved in the notice of Ingres's death.[3]

This work may not have been executed in Paris, for in the summer of 1852 Ingres and his bride traveled about, calling on various members of Delphine's family. In June he reported to his old friend Charles Marcotte: "On July 15 we are going to Versailles[4] for two weeks, then we're supposed to spend a month at Madame Gallois's, and after that we'll come back to you, in the month of October, I believe, at your charming Poncelet [Marcotte's house in Meaux]."[5]

PROVENANCE: Félix Gallois (1812–1891); the marquis de Biron, Paris, by 1911; his sale, Galerie Georges Petit, Paris, June 9–11, 1914, no. 35, sold for 9,100 francs to Paulme; Maurice Fenaille by 1931; his daughter Mme François de Panafieu, née Antoinette Fenaille, Paris; anonymous sale (M. and Mme François de Panafieu), Hôtel Drouot, Paris, February 9, 1959, postponed to June 23, 1959, no. 7, sold for 6.5 million francs to the Walter Feilchenfeldt gallery, Zurich; purchased from that gallery by Robert Lehman, New York, 1960; his bequest to The Metropolitan Museum of Art, New York, 1975

EXHIBITIONS: Paris 1911, no. 169; Nice 1931, no. 20; Cambridge (Mass.) 1967, no. 100, ill. (sitter identified); New York 1980–81; New York 1988a; New York 1988–89

REFERENCE: Naef 1977–80, vol. 5 (1980), pp. 344–45, no. 430, ill.

157. Pierre-François-Henri Labrouste

May 25, 1852
Graphite
12 ¼ × 9 ¼ in. (30.8 × 23.4 cm)
Signed, dated, and inscribed lower right:
à Messieurs / les Eleves de / Monsieur
Labrouste / architecte / Ingres Del /
1852 [For Messrs. / the students of /
Monsieur Labrouste / architect / Ingres
drew (this) / 1852]
National Gallery of Art, Washington, D.C.
Collection of Mr. and Mrs. Paul Mellon
1995.47.52
New York and Washington only

N 426

Pierre-François-Henri Labrouste is remembered as an architect whose structural solutions were eminently appropriate to his time.[1] His modern approach was most fully realized in two Paris libraries, the Bibliothèque Sainte-Geneviève and the complex that includes the main reading room of the Bibliothèque Nationale. These structures are not especially beautiful, nor are they prominent city landmarks; designed solely with function in mind, they brilliantly exploit the possibilities offered by iron as a building material.

Labrouste was born to well-to-do parents in Paris in 1801. Both he and his next older brother, Théodore—there were four

sons in all—studied architecture at the École des Beaux-Arts. Henri won the Prix de Rome in 1824, three years before his brother did.

Back in Paris, he opened an atelier in 1832. His avant-garde ideas made him extremely popular with his pupils but brought him into conflict with the leading lights of the Académie des Beaux-Arts. Thus, it was not until 1843 that he was awarded his first major commission, the Bibliothèque Sainte-Geneviève. The new structure was opened to the public in 1850 and was immediately seen to have considerable merit. His success allowed Labrouste, now more than fifty years old, to marry

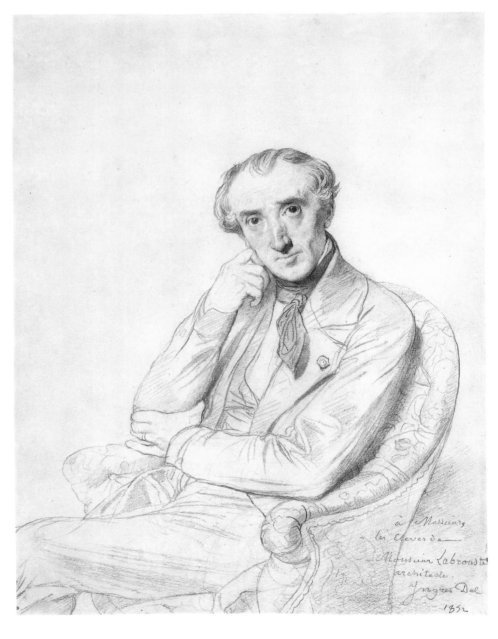

the woman who had already borne him four children.[2] In 1855 he was named architect of the Bibliothèque Nationale, and he spent the rest of his life helping to redesign that complex. He then set his sights on admission into the Académie des Beaux-Arts, although he had previously railed against it, but he would have to wait another twelve years before receiving a seat.

Labrouste died in 1875. The task of summarizing his achievements before the Academicians fell to Ingres's biographer Henri Delaborde, who was secretary of the Académie at that time. In his carefully considered address, Delaborde was perfectly candid about the tensions that had once existed between the deceased and the Académie and about Labrouste's indifference to architectural tradition:

Labrouste's veneration for the monuments of the past was by no means so accommodating that it extended to all of them indiscriminately. On the contrary, he was quite intractable when it came to purely historical considerations, and not particularly susceptible to the kinds of interest inherent in curiosities from another era (apart from their beauty or the harmony of their forms). When it came to relics of other ages, he accepted only what he believed in all good conscience he could draw a lesson from. While in this regard he professed to worship the art of antiquity, he felt for modern art in general, and for the architecture of the seventeenth century in particular, only indifference—indeed, harbored a long-standing aversion—which seemed to predispose him rather poorly to the task he was about to undertake [at the Bibliothèque Nationale].[3]

So very different in temperament and thinking were Labrouste and Ingres that one wonders why the artist consented to draw the architect's portrait, an honor he had long tended to reserve for his closer acquaintances. The commission had come in February 1852, from a group of more than a hundred of Labrouste's former pupils. Ingres initially declined their request, citing among his many other obligations his forthcoming second marriage

in April. He subsequently acquiesced, however, and the sitting took place on May 25.[4] It appears to have gone well, for when Labrouste began to press for admission to the Académie in 1855, he was assured of Ingres's support.[5]

As it happened, the seat finally given to Labrouste in 1867 had been vacated by the death of Ingres's close friend Jacques-Ignace Hittorff. Ingres had also died shortly before—and thus was spared discomfort, for in Labrouste's obligatory oration on his illustrious predecessor, he criticized Hittorff as having been deeply mired in the past.[6]

There may have been a famous witness to the genesis of this drawing. In his book on Pierre-Auguste Renoir, Ambroise Vollard relates that he once asked the painter if he had known Ingres and received the following reply:

I was twelve or thirteen years old [said Renoir] when my employer, the porcelain maker, sent me one day to the Bibliothèque Nationale to copy a portrait of Shakespeare so that he could reproduce it on a plate. Looking for a place to sit, I found myself in a corner where several gentlemen were standing, among them the house architect. I noticed in the group a short, excitable man who was sketching the architect's portrait: this was Ingres. He was holding a pad of paper; he made a sketch, threw it away, began another, and finally, in one stroke, he produced a drawing as perfect as if he'd spent eight days on it.[7]

The dates do not quite match up, for in 1852, at the time the drawing was executed, Renoir was only eleven. This is not enough in itself to discredit his story. It must be noted, however, that Labrouste did not assume the post of architect at the Bibliothèque Nationale until 1855, following the death of the incumbent, Lodovico Visconti, in 1853. Since there is no known Ingres drawing of Visconti, one can only assume that Vollard, ever on the lookout for the colorful anecdote, "improved" on whatever it was Renoir told him.

The drawing was engraved by Claude-Marie-François Dien in 1853.

H. N.

For the author's complete text, see Naef 1977–80, vol. 3 (1979), chap. 178 (pp. 470–78).

1. On the life and work of Labrouste, see especially: Bailly 1876; Delaborde 1878; Millet 1879–80; Bauchal 1887; *Souvenirs d'Henri Labrouste* 1928; Thieme and Becker 1907–50, vol. 22 (1928); Jean Vallery-Radot in Paris 1953b.
2. Marriage certificate dated June 12, 1852, Archives de Paris.
3. Quoted in Delaborde 1878, p. 17; reprinted in Naef 1977–80, vol. 3 (1979), p. 472.
4. See Ingres to Labrouste, May 18, 1852, quoted in Lambert-Lassus 1873, p. 448; reprinted in Naef 1977–80, vol. 3 (1979), p. 475.
5. Salvador Cherubini, Inspecteur des Beaux-Arts, to Labrouste, June 16, 1855, quoted in *Souvenirs d'Henri Labrouste* 1928, p. 88. The newly established relationship possibly also had something to do with the fact that Ingres's beloved pupil Alexandre Desgoffe was later commissioned to paint the reading room of the Bibliothèque Nationale.
6. Labrouste 1868, especially pp. 9, 10, 11–12, 14.
7. Vollard 1920, pp. 239–40; reprinted in Naef 1977–80, vol. 3 (1979), p. 477.

PROVENANCE: Henri Labrouste (1801–1875), Paris and Fontainebleau; his daughter Mme Frédéric Simon, née Anne-Marie-Julie Labrouste, Versailles, until 1926; anonymous sale, Hôtel Drouot, Paris, rooms 9–10, June 14, 1946, no. 8, sold for 181,000 francs; Wildenstein & Co., Inc., New York; sold by them to Dr. T. Edward Hanley, 1950; Dr. and Mrs. T. Edward Hanley, Bradford, Pa., until 1968; E. V. Thaw & Co., New York; purchased from that gallery by Paul Mellon, 1969; Mr. and Mrs. Paul Mellon, Upperville, Va.; their gift to the National Gallery of Art, Washington, D.C., 1995

EXHIBITIONS: Paris 1867, no. 363; Versailles 1881, no. 1441; Paris 1949b, no. 63; Philadelphia 1957, p. 2; Buffalo 1960, no. 83; New York, Cambridge (Mass.) 1961–62, no. 78, ill. p. 35; New York, Philadelphia, Denver 1967–68, p. 63

REFERENCES: Blanc 1870, p. 237; Delaborde 1870, no. 339; Lambert-Lassus 1873, pp. 444–53; Millet 1879–80, p. 13, n. 2; Jouin 1888, p. 103; Lapauze 1901, p. 266 (known from the engraving by Claude-Marie-François Dien, 1853); Lapauze 1911a, p. 463, ill. p. 443 (known from the engraving); Vollard 1920, pp. 239–40; *Souvenirs d'Henri Labrouste* 1928, p. 31; Alaux 1933, vol. 2, p. 118; Vollard 1938, p. 274; Alazard 1950, p. 107; Paris 1951, under no. 409; Paris 1953b, p. 9, under nos. 129, 130, 150, pl. 1 (the engraving); Weigert 1955, pp. 230–31; Anon., February 1962, ill. p. 49; Naef 1977–80, vol. 5 (1980), pp. 336–37, no. 426, ill.; Washington, National Gallery 1996, pp. 67, 86

158. Hippolyte Flandrin

1855
Graphite
12 3/4 × 10 in. (32.2 × 25.3 cm)
Signed, dated, and inscribed lower right: Ingres
à Son ami / et grand artiste hyppolite flandrin
/ 1855. [Ingres for his friend / and great artist
Hippolyte Flandrin / 1855.]
Musée des Beaux-Arts, Lyons B 1553
London only

N 434

This drawing is discussed under cat. no. 155.

PROVENANCE: The same as for cat. no. 155

EXHIBITIONS: Paris 1861 (1st ser.), no. 52;
Lille 1866, no. 841; Paris 1867, no. 333; Paris
1884, no. 407; Paris 1905, no. 39; Paris 1911,
no. 168; Paris 1923a, no. 249; Paris 1967–68,
no. 250, ill.; Philadelphia, Detroit, Paris 1978–79,
no. VII-40; Lyons, Esslingen 1989, no. 47, ill.;
Pittsburgh, Northampton 1992, no. 49, ill.

REFERENCES: Blanc 1861, p. 191; Galichon
1861a, p. 358; Merson and Bellier de la Chavignerie
1867, p. 121 (incorrectly dated 1858); Blanc 1870,
p. 236; Delaborde 1870, no. 294; Gatteaux 1873
(1st ser.), ill. on. pl. 12 (detail); Gatteaux 1875,
no. 60, ill.; Both de Tauzia 1888, p. 141; Jouin
1888, p. 70; Lapauze 1901, p. 243 (known from
the list of works in Ingres's Notebook X); Flan-
drin 1902, p. 148; Lapauze 1903, no. 18, ill.;
Lapauze 1911a, ill. p. 479; Audin and Vial 1918,
p. 345; Hourticq 1928, ill. on pl. 106; Alazard
1950, p. 107; Schlenoff 1956, ill. on pl. XXXII;
Ternois 1962, fig. 2 opp. p. 14; Sérullaz 1967,
p. 213; Naef 1977–80, vol. 5 (1980), pp. 350–51,
no. 434, ill.; Ternois 1980, p. 158, ill.; Vigne
1995b, fig. 190

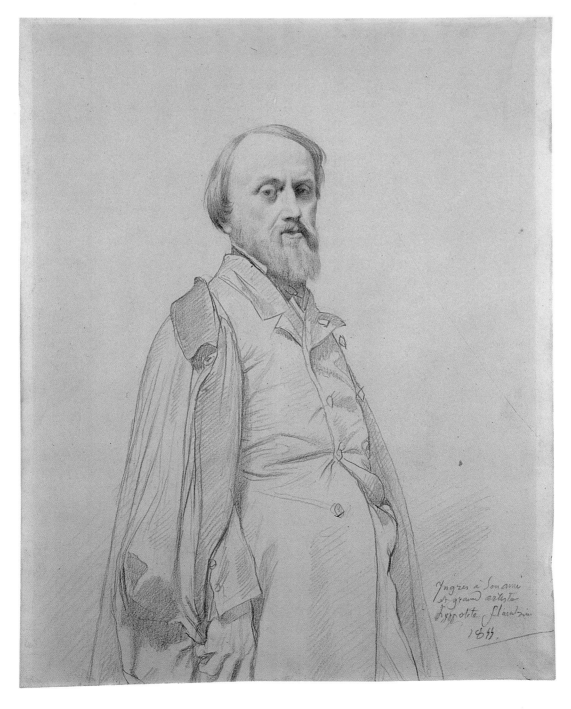

159. Madame Jean-Auguste-Dominique Ingres, née Delphine Ramel

1855
Graphite
13¾ × 10¾ in. (35 × 27.2 cm)
Signed twice upper left (the signature below is
inauthentic): [I]ngres Del. / J. Ingres Del.
[(I)ngres drew (this) / J. Ingres drew (this)]
Inscribed and dated twice upper right (the
inscription below is inauthentic): Madame Delp.
Ingres 1855 / Madame Delp. Ingres 1844
Fogg Art Museum, Harvard University Art
Museums, Cambridge, Massachusetts
Gift of Charles E. Dunlap 1954.0110

N 436

Ingres's beloved wife Madeleine died in July 1849. The first suggestion that he might remarry appears in an unpublished letter from the engraver Luigi Calamatta to Ingres's close friend Charles Marcotte (Marcotte d'Argenteuil) dated August 3, 1851: "You must think me awfully curious, which I can't deny, but after all it's only my sincere interest in our dear friend Ingres (who must have been to see you) that prompts me to ask about his marriage plans."[1] The following April, some two years and eight months after Madeleine's death, the artist joyfully took as his second wife Delphine Ramel, who was almost thirty years younger than he. Public reaction to this unusual alliance was not altogether favorable; the sculptor Antoine Étex, for example, who bore a strong grudge against Ingres, wrote in a review of the 1855 Salon:

> How much veneration can we feel for a man who wails, weeps, and despairs night and day at the loss of his cat, but who remains almost untouched by the death of his wife, the steadfast companion who shared his life of poverty; a man who is so ungrateful toward that cherished memory that he goes and gets remarried so soon after his loss, even though he has reached the respectable age of seventy-five?[2]

For those who did not know the painter well it was easy enough to scoff; however, his closest acquaintances applauded the marriage—witness another unpublished letter to Marcotte from Calamatta: "The news of Ingres's remarriage gives me great pleasure. . . . Their ages strike me as well matched, and with your blessing I'm sure they'll make an excellent couple. I don't generally like second or third marriages, but for him it was necessary. There isn't another Ingres in the world. He and art both will benefit from it."[3]

Indeed, it was Marcotte who first proposed the idea, recognizing that the widower was desperately lonely and simply not himself without a wife at his side. He even selected a woman from his own extended family as a suitable bride. His

brother Marcotte de Quivières had married one of the numerous sisters of Madame Panckoucke and her brother Edme Bochet, who figure so prominently in the early Roman chapter of Ingres's biography (see cat. no. 30). Another of those sisters was a Madame Jean-Baptiste Ramel (see cat. no. 160), living in Versailles, who had an unmarried daughter Delphine, born in 1808. The plan was far advanced before Delphine was apprised of it; however, Ingres had obviously discussed it with one of her friends during sittings for a portrait. In a letter to Madame Henri Gonse dated January 7, 1852, the painter confessed to this sitter (fig. 208): "Lucky for me, her parents are delighted: well, you must think I am too, completely so, but I can say that only to my most discreet friends. And that's how it must be, otherwise I'd stop seeing things with detachment, and goodbye art. And besides, if we were perfect, which is not the human lot, we would get so bored that we'd kill ourselves just as we would from depression."[4] The wedding took place on April 15, 1852. Among the witnesses were Édouard Gatteaux, Marcotte d'Argenteuil, and Edme Bochet.

Madeleine Chapelle had shared the miseries and triumphs of the painter's career for the better part of four decades. Delphine Ramel was his companion for a mere fifteen years. It is only natural that we know so much less about the latter relationship. What the elderly Ingres required was the domestic calm that would permit him to work, and to all appearances Delphine did her best to provide it. He was genuinely devoted to her; in his letters he praises her for her help with his correspondence and for her general solicitude—also, significantly, for her abilities as a pianist. Despite its success, there were those who chose to ridicule the marriage. Many years after Ingres's death, Edmond de Goncourt noted in his diary a scurrilous anecdote he had heard from the painter Alfred Stevens: "In fact, old Ingres was still quite a fornicator even at a well-advanced age. If he was at the opera and some dancer

got him excited, he'd cry out, 'Madame Ingres, to the carriage!' and he went about it on the trip home."[5]

When Ingres died he was buried next to his incomparable Madeleine. In 1887, twenty years later, Delphine was laid to rest by his side.

The artist produced two memorable likenesses of Delphine, a portrait drawing executed in the year they were married (N 427; Musée Bonnat, Bayonne) and a painted portrait of 1859 (fig. 213). There is also the present drawing, in which the sitter is shown in the same pose as in the painting. This third image, though seemingly of impeccable provenance, is suspect in various ways. If it is, in fact, Ingres's work, why was it not included in either the major exhibition of the artist's drawings in 1861 or the retrospective of 1867? It is also curious that the drawing is not mentioned in either Charles Blanc's book on Ingres of 1870[6] or Henri Delaborde's much more carefully researched monograph published the same year. However, this drawing may be mentioned in Ingres's Notebook X (fol. 9) and included in his list of works in the same volume (fol. 26)—unless he is referring to the 1852 drawing instead.[7]

The signature, inscription, and date at the top of the drawing appear to be authentic. These have been copied by another hand just below—presumably because a chosen frame obscured the originals—but with the "1855" misinterpreted as "1844." If the date 1855 is, in fact, correct, this is the only time in his entire career that Ingres based a painting on a drawing made so long before.

All of these considerations would be insignificant if the drawing itself were entirely convincing. The actual likeness—that is, the head and the right hand—seems unexceptional. The use of line in the skirt is indecisive, however: the hatching is lifeless and too tight, so that the shadows seem smudged. And nowhere in the artist's oeuvre is there anything as weak and amateurish as the table with the book lying on top of it. It seems as though someone sought to give greater visual weight to an Ingres bust-length drawing by expanding it and adding accessories.

H.N.

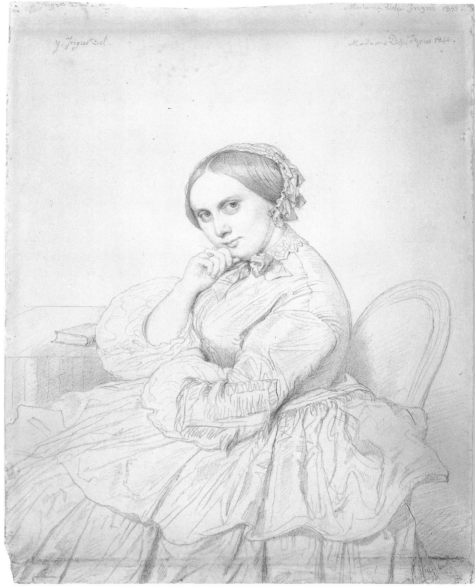

159

For the author's complete text, see Naef 1977–80, vol. 3 (1979), chap. 179 (pp. 479–90).
1. Quoted in ibid., p. 480.
2. Étex 1856, p. 50, note; quoted in Naef 1977–80, vol. 3 (1979), p. 479.
3. Quoted in Naef 1977–80, vol. 3 (1979), p. 480.
4. Quoted in Lapauze 1911a, pp. 457–58; reprinted in Naef 1977–80, vol. 3 (1979), p. 481.
5. Goncourt 1956–58, vol. 18, p. 229, entry for August 11, 1892.
6. See Blanc 1870, pp. 61–62.
7. See Vigne 1995b, p. 329.

PROVENANCE: Probably Mme Emmanuel Riant, née Anne Ramel, niece of the sitter; her husband, Emmanuel Riant, until after 1940; Galerie Wildenstein, Paris, by 1947 at the latest; purchased from Wildenstein & Co., Inc., New York, by Charles E. Dunlap, 1948; his gift to the Fogg Art Museum, Harvard University Art Museums, Cambridge, Mass., 1954

EXHIBITIONS: New York 1947–48, no. 29, as Mme Ramel; Cambridge (Mass.) 1967, no. 104, ill.; Tübingen, Brussels 1986, no. 68, ill.; Cambridge (Mass.) 1980, no. 53

REFERENCES: Lapauze 1901, pp. 243, 250 (cited on the basis of Ingres's Notebook X); Marjorie B. Cohn in Cambridge (Mass.) 1967, pp. 244–45, 246; Durbé and Roger-Marx 1967, ill. p. [7]; Hattis 1967, pp. 7–18, jacket ill., ill. p. 13 (the inscription); Naef 1967 ("Mme Delphine"), pp. 9–13, ill.; Naef 1967 ("Musée Fogg"), p. 6, n. 1; Pincus-Witten 1967, ill. p. 48; Reff 1976, p. 49, fig. 25; Reff 1977, p. [6], fig. 8; Naef 1977–80, vol. 5 (1980), pp. 354–55, no. 436, ill.; Picon 1980, ill. p. 86; Ternois 1980, p. 105; Fleckner 1995, p. 120, fig. 40; Vigne 1995b, p. 295; Mongan 1996, no. 250, ill.; New York 1997–98, [vol. 1], p. 144, fig. 185

160. Edmond Ramel and His Wife, née Irma Donbernard

September 1855
Graphite with white highlights
13 1/4 × 10 1/2 in. (33.5 × 26.5 cm), mounted
Signed, dated, and inscribed bottom center:
à mon cher frere Edmond Ramel / Souvenir
de Cannes. J. Ingres 1855 [for my dear brother
Edmond Ramel / Souvenir of Cannes.
J. Ingres 1855]
Inscribed upper right: Portrait de M^r et M^e
Ed. Ramel.
Private collection

N 435

When he married his second wife, Delphine Ramel, in 1852, Ingres acquired a host of new in-laws, twelve of whom he immortalized in portrait drawings. These Ramel family portraits account for almost half of the pencil portraits the artist produced during the next fifteen years, and it appears that it was his intention from the start to produce an entire Ramel gallery. The first he undertook was more than likely that of his wife, which is dated 1852 (N 427; Musée Bonnat, Bayonne). Those of her parents (N 428, N 429; Fogg Art Museum, Cambridge, Massachusetts) and of her sister Léonie Guille (N 431; Musée Bonnat, Bayonne) were produced in the same year.

Delphine's father, Jean-Baptiste-Joseph-Dominique Ramel, was born in Montolieu (Aude) in 1777. By the time of his marriage, in 1808, he had risen in the tax department to the position of Inspecteur de l'Enregistrement et des Domaines.[1] Her mother, born Marie-Anne-Philippine-Delphine Bochet in Lille in 1785,[2] had a similar background, for her father worked in the same department.

Ingres must have heard of the Ramels long before he thought he might become part of their family. In Rome in 1811 he had painted portraits of Edme Bochet, his future mother-in-law's brother (cat. no. 30), and Madame Panckoucke, their sister (fig. 117). Moreover, his close friend Charles Marcotte, who had been the matchmaker in the artist's betrothal to Delphine, was also related to the family, for his older brother had married one of the Bochet siblings.

The Ramels lived in Versailles, and it was there that the seventy-one-year-old Ingres married their eldest daughter, then forty-three.[3] By the time Marcotte suggested the marriage, there were three other contenders for her hand. One of them was immensely wealthy and might well have won her if he had not withdrawn his suit at the last moment. Marcotte summed up the complex events in a brief note:

> After the family had interviewed Ingres and all but given its consent, another suitor appeared who seemed to offer Mlle. Ramel a very advantageous match. At that point the Ramels withdrew their consent, preferring to await the outcome of negotiations with the latter; but these fell through and they came back to Ingres, who behaved quite generously.[4]

It is not at all surprising that Delphine Ramel's bourgeois parents were swayed by the wealth of their daughter's suitor. Ingres understood the situation, for he was fully aware that at his advanced age and with his more modest resources he could scarcely compete. It did not even occur to him to remind the Ramels that he was famous, and in any case it would have done little good, for as he remarked, the family lived "remote from the realm of the fine arts."[5]

Born in 1808, Delphine was for nearly ten years the couple's only child. Her siblings then appeared in rapid succession, and she dutifully helped to raise them. She also lovingly tended her parents, with whom she lived until her late marriage. When her father retired and gave up the house in Versailles, she did what she could to make a new home for him and her mother. With Ingres and her brother-in-law Jean-François Guille, she bought them a charming house in Meung-sur-Loire,[6] a place that would also become important to Ingres. He reported to Marcotte in June 1853:

> My dear friend, Yes, a great misfortune has befallen the good Ramel family owing to the sudden retirement [of M. Ramel], something we might indeed have predicted a bit sooner—but a bit later! Since Providence never abandons the good, with their courage and their philosophical spirit—which is the case with that respectable head of the family—it turns out that through M. Guille's business dealings there happens to be a beautiful and charming villa for sale in Meung on the banks of the Loire, which we're going to buy and where we can house the Ramel family, who will come live there with their daughter and son-in-law [Guille], and us as well, at least for a few months; and it has a studio.[7]

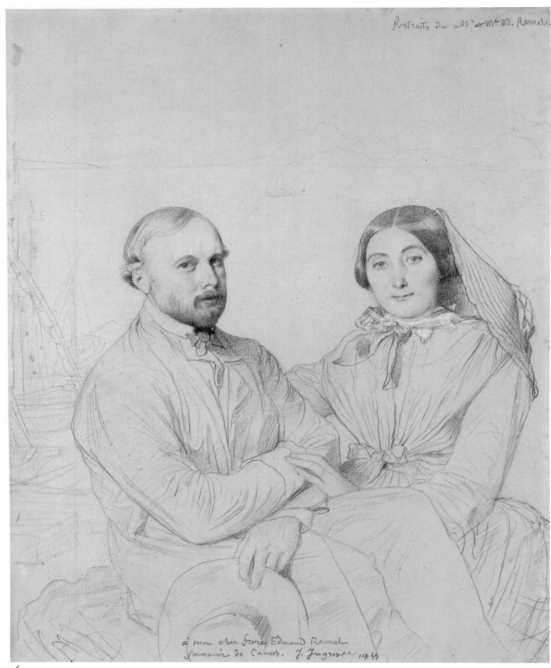

160

Jean-François Guille had married Delphine's sister Léonie in 1850, taking her back to Meung, where he worked as a notary. Ingres's drawing of the couple shows them with their son Fernand, born in 1851.[8] Their second and last child, Isabelle, arrived two years later,[9] and Ingres was named her godfather. At the age of three, she too would become the subject of an Ingres portrait (N 441; Musée Bonnat, Bayonne). Ingres and Delphine spent nearly every summer in Meung, escaping from Paris as soon as it grew too

warm and frequently staying on well into the fall. Since the house had a small studio, the artist was able to work there in peace when he chose not to be caught up in the doings of the extended family, especially those of the Guille children, whom he adored. The only thing he missed was seeing his friends, and as a result he wrote many more letters there than he did in Paris; most of what we know of his late years has been gleaned from his Meung correspondence. In 1858 he described the pleasant life at Meung to Marcotte: "Our

house is charming, honest, comfortable, with beautiful fruits from the garden, peace and quiet, except that we've traded the noise of Paris for the noise of children, but you always need some noise around or it would get too monotonous."[10]

In September 1855 Ingres and his wife spent three weeks in Cannes, where Delphine's brother Edmond held the post in the customs department of Vérificateur des Douanes.[11] The artist repaid Edmond and his wife for their hospitality as only he could, by drawing this double portrait of

them. The setting is indicated by a suggestion of the sea in the background and the rigging of two sailboats on the left.

The trip to Cannes had been hard on Ingres because of the intense heat. Once back in Paris, the couple immediately fled to Meung. During that stay the artist added yet another portrait to the Ramel series, this one of his as yet unmarried sister-in-law Mathilde (N 437; whereabouts unknown). The following year, the young woman would become the wife of a doctor, Norbert-Irénée Hache,[12] of whom Ingres also produced a portrait (N 438; whereabouts unknown).

Adrien Ramel was the only Ramel sibling who never sat for Ingres. Had there been a portrait of him, it would doubtless have been included in the 1867 Ingres retrospective, which was mounted with the assistance of the family. That exhibition did include a drawing of Albert Ramel,[13] the baby of the family, done in 1861 — perhaps the last portrait the artist produced (N 448). The only other portrait drawing from that year is of Madame Adolf von Stürler (cat. no. 165), and in executing it Ingres was forced to use a magnifying glass.[14] The eighty-year-old artist's eye and hand no longer served him as they once had. In the portrait of

Albert Ramel this infirmity is even more evident, and one suspects that Ingres finally decided not to produce any more such drawings, recognizing that they were no longer worthy of him.

H.N.

For the author's complete text, see Naef 1977–80, vol. 3 (1979), chap. 180 (pp. 491–99).

1. Marriage certificate, Archives de Paris.
2. Ibid.
3. The marriage certificate is published in Lapauze 1910, pp. 321–24.
4. Charles Marcotte, unpublished memorandum, quoted in Naef 1977–80, vol. 3 (1979), p. 492.
5. Ingres to Marcotte, early January 1852, quoted in Naef 1977–80, vol. 3 (1979), p. 493; in Ternois 1999, letter no. 79.
6. Wildenstein 1954, p. 32.
7. Ingres to Marcotte, June 20, 1853, quoted in Naef 1977–80, vol. 3 (1979), p. 494; in Ternois 1999, letter no. 89.
8. Birth certificate, town hall, Meung-sur-Loire.
9. Ibid.
10. Ingres to Marcotte, August 20, 1858, quoted in Naef 1977–80, vol. 3 (1979), p. 495; in Ternois 1999, letter no. 105.
11. Death certificate, town hall, Cannes.
12. Marriage certificate, Archives de la Seine.
13. Paris 1867, no. 386.
14. Amaury-Duval 1878, p. 239.

PROVENANCE: Edmond Ramel (1817–1875), Cannes; his widow, née Irma Donbernard

(ca. 1821–1898), Cannes; Henri Haro, Paris, by 1903; his posthumous sale, Hôtel Drouot, Paris, February 3, 1912, no. 141; purchased at that sale for 5,800 francs by Henry Lapauze (1867–1925), Paris; his posthumous sale, Hôtel Drouot, Paris, June 21, 1929, no. 34; purchased at that sale for 125,000 francs by Paul Rosenberg; looted from him during the occupation of France, 1940–45; Paul Rosenberg or his gallery in New York by 1955; sold by Paul Rosenberg & Co., New York, to Benjamin Sonnenberg (1901–1978), New York, 1958; his posthumous sale, Sotheby Parke Bernet, New York, June 5–9, 1979, no. 609; purchased at that sale for $145,000 by the present owners

EXHIBITIONS: Paris 1911, no. 173; Copenhagen 1914, no. 299; Paris 1922b, no. 315; Hartford 1934, no. 173; Brussels 1936, no. 31; London 1936b, no. 16; London 1938b, no. 10 (erroneously dated 1835); Paris 1938b, no. 19 (erroneously dated 1835); New York 1948, no. 2 [EB]; New York 1961, no. 66, ill.; Poughkeepsie, New York 1961, no. 83, ill.; Cambridge (Mass.) 1967, no. 105, ill. (sitter identified); New York 1970, no. 58; New York 1971, no. 4, ill.

REFERENCES: Lapauze 1903, no. 78, ill.; Lapauze 1911a, p. 476; Lapauze 1911b, p. 48 (erroneously described as a portrait of the Guille family); Anon., July 1, 1929, ill. p. 408; *Répertoire des biens spoliés* 1947; Boggs 1962, p. 90, n. 98; Schlenoff 1967, p. 379; Young 1967, p. 181, fig. 10, p. 178; Levey 1968, p. 44; Naef 1977–80, vol. 5 (1980), pp. 352–53, no. 435, ill.

161. Mademoiselle Cécile Panckoucke

Probably September 12, 1856
Graphite
$12\frac{5}{8} \times 9\frac{1}{2}$ in. (32.3 × 24.2 cm)
Signed, dated, and inscribed lower right:
à Mr forgeot. / son très affectionné / Ingres Del. / 12 7bre 1856. [to M. Forgeot. / his very affectionate / Ingres drew (this) / 12 7bre 1856.[1]]
Inscribed upper right, in nearly indecipherable writing: Mademoiselle Cécile Panckoucke.
The Detroit Institute of Arts
Founders Society Purchase, Anne McDonnell Ford Fund and Henry Ford II Fund 64.82
New York only

N 443

Ingres made the following entry in Notebook X, where his late works are listed: "portrait drawing of Mlle Cecile Pankouqu [*sic*]."[2] The artist's biographer Henri Delaborde mentions such a drawing, but since he had not seen it, he guessed that it was executed "in about 1855."[3] Then, in his alphabetical listing of portrait subjects, the work appears again, complete with the date 1856 and the dedication to Monsieur Forgeot, under the name "Madame Cécile Tournouer."[4] Delaborde was apparently unaware that the sitter had married only days after the drawing was completed.

She was the granddaughter of Madame Henri-Philippe-Joseph Panckoucke, née

Cécile Bochet, whose portrait Ingres had both painted (fig. 117) and drawn (fig. 118) in Rome in 1811. The artist's ties to Madame Panckoucke's family were many and complex. It was at the home of her brother, Edme Bochet, an important French official in Rome, that Ingres met Charles Marcotte, who would become his lifelong friend (see cat. nos. 30, 26). A sister of Madame Panckoucke, Félicité Bochet, had married an older brother of Marcotte in 1804.[5] In 1835 their daughter married Madame Panckoucke's son,[6] and the child of this marriage between cousins was the Cécile Panckoucke portrayed in this drawing of 1856. Ingres became a part of this extended

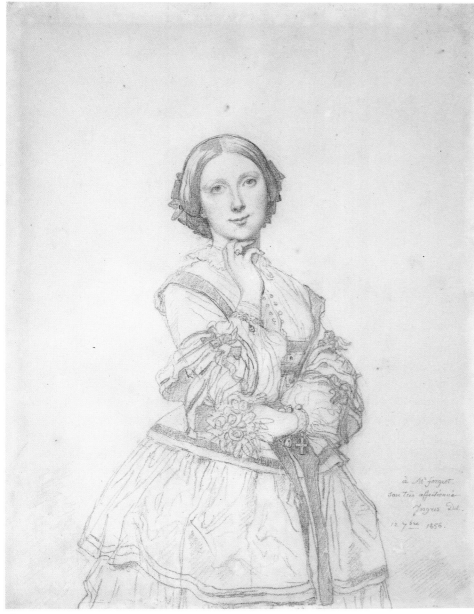

161

Bastide du Lude, who died in Lausanne in 1951.[13] Thanks to the gracious assistance of Hélène Privat-Deschanel, the author was able to find the portrait of Cécile, which had been completely forgotten, in the home of Monsieur Bastide du Lude in Lausanne in 1956, precisely a hundred years after Ingres drew it.[14]

The seventy-five-year-old artist clearly portrayed his young relative with great affection. Her pose brings to mind the ancient figures of Pudicity that he had remembered as he worked on the pose of Stratonice in his *Antiochus and Stratonice* (fig. 194). It was one that especially appealed to him. H.N.

For the author's complete text, see Naef 1977–80, vol. 3 (1979), chap. 182 (pp. 503–5).

1. Probably the inscription, which has been partially erased, originally read: "Portrait de M^lle Cécile Panckoucke / offert à M^r forgeot / par son très affectionné / Ingres Del. / 12 7^bre 1856" ("Portrait of Mlle Cécile Panckoucke / offered to M. Forgeot / by his very affectionate / Ingres [who] drew [this] / 12 7^bre 1856"). The date may be construed as September 12, 1856 ("7" is probably shorthand for "sept," the French word for "seven").
2. Notebook X, fol. 26, quoted in Naef 1977–80, vol. 3 (1979), p. 503. See Vigne 1995b, p. 329.
3. Delaborde 1870, no. 388.
4. Ibid., no. 421.
5. Moreau-Nélaton 1918, vol. [5], pl. III.
6. Marriage contract dated May 31, 1835, drawn up by M^e Dutertre in Boulogne-sur-Mer.
7. Moreau-Nélaton 1918, vol. [5], pl. III.
8. Birth certificate, Archives de Paris.
9. Marriage contract dated May 31, 1835, drawn up by M^e Dutertre in Boulogne-sur-Mer.
10. Moreau-Nélaton 1918, vol. [5], pl. III.
11. Hélène Privat-Deschanel to the author, February 6, 1957.
12. Ibid.
13. Maurice Bastide du Lude to the author, October 4, 1956.
14. Naef 1958 ("Notes III"), pp. 414–17, ill. p. 410.

PROVENANCE: Louis-Philippe Morande Forgeot, Bordeaux, until 1864; Mme Jacques-Raoul Tournouër, née Cécile Panckoucke (1836–1903), Saint-Jean-de-Losne, until 1903; her daughter Mme Maurice Bastide du Lude, née Susanne Tournouër, Lausanne, until 1951; her husband, Maurice Bastide du Lude; sold by him to the Walter Feilchenfeldt gallery, Zurich,

family when he took—at Marcotte's urging—Delphine Ramel as his second wife, for Delphine's mother was yet another of the Bochet siblings (see cat. nos. 159, 160). The Monsieur Forgeot to whom the drawing is dedicated was the elder Cécile Panckoucke's second husband.[7] The portrait presents a young woman of twenty at the height of her beauty. The memories she evoked in the artist reached back more than forty years.

Cécile was born in Paris on May 5, 1836.[8] Her father, a lawyer,[9] held the comfortable post of Payeur des Finances.[10] The man she married in September 1856, only days after this bridal portrait was made, was also

a lawyer, but his true vocation lay outside his profession.[11] A talented painter and draftsman, Jacques-Raoul Tournouër was also a passionate geologist, and he was recognized for his contributions in that field in 1877, when he was elected president of the Société Géologique de France.[12] He died, not yet sixty, in 1882, leaving behind three sons and a daughter.

His widow survived him by more than two decades. She had doubtless become the owner of the Ingres portrait many years before, since Monsieur Forgeot died without children in 1864 and his wife a short time afterward. The drawing was left to the sitter's daughter, Madame Maurice

1956; acquired from them by Jacques Seligman & Co., New York, 1957; purchased from that gallery by the Detroit Institute of Arts, 1964

EXHIBITIONS: Bordeaux 1865, no. 309, as *Mme T.;* Paris 1867, no. 393, as *Madame Cécile Tournouer;* New York 1960a, no. 19; Cambridge (Mass.) 1967, no. 109, ill.; New York 1985–86, no. 109

REFERENCES: Blanc 1870, p. 240, as *Mme Cécile Tournouer* (known from Paris 1867); Delaborde 1870, nos. 388, 421 (erroneously catalogued twice: under no. 388 as "Mademoiselle Cécile Panckoucke," as recorded in the list of works in Notebook X, and under no. 421 as "Madame Cécile Tournouer" from Paris 1867); Lapauze 1901, p. 250, as *Mlle Cécile Panckoucke* (cited from the list of Ingres's works in Notebook X); Naef 1958 ("Notes III"), pp. 414–17, ill. p. 410 (sitter identified); Anon. 1964, p. 374, ill. p. 386; Anon. 1965, ill. p. 43; *La Chronique des arts* 1965, p. 56, fig. 224; Cummings 1965, pp. 73, 76–77, ill. p. 75; Naef 1965 ("Ingrisme"), p. 21; Woods 1966, ill. p. 21; Waldemar George 1967, ill. p. 75; Radius and Camesasca 1968, p. 124, ill.; Mongan 1969, p. 148, fig. 32, p. 160; Ternois and Camesasca 1971, p. 124, ill.; Naef 1977–80, vol. 5 (1980), pp. 366–68, no. 443, ill.

162. Madame Charles Simart, née Amélie Baltard

1857
Graphite on tracing paper (mounted on cardboard)
13 1/8 × 10 in. (33.5 × 25.5 cm), mounted
Signed, dated, and inscribed lower right: à Son ami Simard / Ingres Del. / 1857. [for his friend Simar[t] / Ingres drew (this) / 1857.]
Albright-Knox Art Gallery, Buffalo, New York
Elisabeth H. Gates Fund, 1932 32:130
New York only

N 444

The subject of this drawing was the second wife of the sculptor Pierre-Charles Simart (the spelling "Simard" in the dedication is a slip on Ingres's part). Born in Paris in 1828, Amélie Baltard was a full generation younger than the widower she married in October 1852.[1] The marriage lasted less than five years, for Simart was hurt in a traffic accident on May 18, 1857, and died of complications nine days later.[2] It is conceivable that Ingres hoped a portrait of the patient's wife would comfort and lift his spirits, in which case the drawing was done during the few days before he died. Executed on tracing paper, it may be an amended copy of a rejected original. It is mentioned in Ingres's Notebook X and entered in his work list.[3]

Ingres and Simart were linked through a network of acquaintances. The son of a poor cabinetmaker, Simart was born in Troyes in 1806. In his youth he found a patron in Philippe-Marie-Nicolas Marcotte, the oldest brother of Ingres's close friend Charles Marcotte. In Paris he studied with the sculptors Charles Dupaty and Jean-Pierre Cortot,[4] friends of Ingres, who had drawn their portraits in Rome in 1810 (N 59) and 1818 (cat. no. 80), respectively. Simart was awarded the Prix de Rome in 1833, the year that Victor Baltard, to whom he would later become related by marriage, won the same prize for architecture. Two years later, Ingres assumed the directorship of the Académie de France, and together with the painter Hippolyte Flandrin (see cat. nos. 155, 158) and the composer Ambroise Thomas, the sculptor and architect formed the innermost circle of Ingres's protégés in Rome. Of the four, none was more in need of the director's guidance than Simart, for he was somewhat weak and melancholy by nature and plagued with doubts. Like Flandrin, he tended toward the naive and the mystical, hardly qualities the nineteenth century desired in a sculptor, and Ingres strongly urged him to study Phidias. Simart was forever grateful.

In 1841, back in Paris, Simart married Victor Baltard's niece Laure Jaÿ. During the ten years of his first marriage he executed such distinguished commissions as the figures of Justice and Abundance at the Barrière du Trône (place de la Nation) and the ten large reliefs on Napoleon's tomb at Les Invalides.[5] He also produced major works for the château of the wealthy duc de Luynes in Dampierre—doubtless on the recommendation of Ingres, who painted *The Golden Age* (fig. 204) for the same patron.[6] But despite his successes and his happy marriage he never fully managed to shake his melancholy, and when his wife died, in 1851, he was beside himself:

> If my place is among you, try not to notice that this place is empty. . . . The

day comes when one harvests nothing more than the thorn that pierces one's heart. . . . As for me, my soul is in despair, my soul is lost, and if the sun is shining, its joyful rays insult my sorrow. I would like to go live in a dungeon.[7]

The following year he married Amélie, another niece of Victor Baltard, whom he came to think of as a second guardian angel.

[Simart told us]: "Pain and sorrow have been dispelled, I'm no longer alone: my wife, an angel who is gentle and strong at the same time, because she relies on both charity and faith—my wife supports me and encourages me on my days of doubt and weakness. I'm proud of her as a man and as an artist."[8]

The intense religiousness that Amélie demonstrated during her brief marriage would become her whole life in her widowhood. In the notice of her father's death in 1862, five years after that of her husband, she signed herself "Mme veuve Simart, en religion soeur Marie-de-St-Pierre" ("Madame Simart, widow; in the faith, Sister Marie-de-Saint-Pierre").[9] Yet it would appear that her faith was not sullied by the gloom and yearning so characteristic of Simart and Flandrin. She is remembered in the family as a resolute and highly capable woman,[10] and Ingres's Junoesque portrayal of her certainly suggests as much. Soeur Marie died in 1904, at the age of seventy-five. H.N.

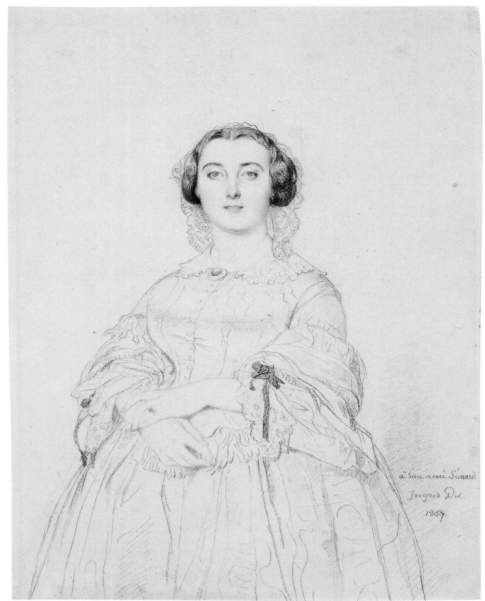

162

For the author's complete text, see Naef 1977–80, vol. 3 (1979), chap. 185 (pp. 545–48).

1. Marriage certificate, Archives de Paris.
2. Eyriès 1860, p. 400.
3. Notebook X, fols. 9, 26; see Vigne 1995b, p. 329.
4. Lami 1914–21, vol. 4 (1921), p. 257.
5. A complete list of his works is given in ibid.
6. Simart executed four friezes for the duc de Luynes depicting the Golden Age and the Iron Age, doubtless in connection with the Ingres program; ibid., p. 260.
7. Quoted in Eyriès 1860, p. 374; reprinted in Naef 1977–80, vol. 3 (1979), p. 546.
8. Quoted in Eyriès 1860, p. 395; reprinted in Naef 1977–80, vol. 3 (1979), p. 547.
9. Lavigne 1881, p. 55.
10. Interview with Madame A. de Sainte-Marie, Sceaux, March 10, 1962.

PROVENANCE: Charles Simart (1806–1857); his father-in-law, Prosper Baltard, Billancourt, until 1862; his brother Victor Baltard (1805–1874), Paris, until 1874; anonymous collector; acquired from that collector by Galerie Wildenstein, Paris, 1931; purchased for $5,500 from Wildenstein & Co., Inc., New York, by the Albright Art Gallery (now the Albright-Knox Art Gallery), Buffalo, N.Y., 1932

EXHIBITIONS: Paris 1861 (2nd ser.); Paris 1867, no. 389; Buffalo 1932, no. 83, pl. II; Buffalo 1935, no. 96, ill.; Springfield, New York 1939–40, no. 27, ill.; Cincinnati 1940; Rochester 1940; San Francisco 1947, no. 16; Detroit 1950a, no. 24; Detroit 1950b, no. 27, ill.; Winnipeg 1954, no. 15; Rotterdam, Paris, New York 1958–59, no. 136, ill.; New York 1961, no. 69, ill.; State College 1963, no. 2; Cambridge (Mass.) 1967, no. 110, ill.; Buffalo 1967–68, no. 39, ill.; Buffalo 1987–88, p. 22, ill.; Buffalo 1992

REFERENCES: Galichon 1861b, p. 44; Blanc 1870, p. 239; Delaborde 1870, no. 412; Lapauze 1901, p. 250 (erroneously cited from the list of Ingres's works in Notebook X); Anon., March 1932, ill. p. 26, as *Mme Semiard; Art News* 1934, ill. p. 4; Slatkin and Slatkin 1942, p. 547, fig. 508; Mongan 1947, no. 24, ill.; Anon., May 1954, p. 20, no. 64, n. 13, fig. 7, p. 13; Mongan 1969, p. 148, fig. 33, p. 161; Naef 1977–80, vol. 5 (1980), pp. 368–70, no. 444, ill.

163. Mademoiselle Mary de Borderieux(?)

1857
Graphite and watercolor with white highlights
13⅞ × 10⅝ in. (35.2 × 27.1 cm), mounted
Signed and dated on the veil, center right: Ingres
Del / 1857. [Ingres drew (this in) / 1857.]
The Woodner Collection, on deposit at the
National Gallery of Art, Washington, D.C.
New York and Washington only

N 445

All attempts to identify with certainty the subject of this drawing have been unsuccessful. The portrait, known ever since the Ingres retrospective in 1867, had not been published when it appeared on the art market in 1977 with the following as yet unverified description: "This drawing is the portrait of Mademoiselle Mary de Borderieux, who later married Monsieur [Émile] de Richemond. She is wearing a first communicant's veil and must be about sixteen or eighteen years old. (She was Protestant.) The drawing has remained in the family since 1857, the date of its creation." [1] It is unique among Ingres's portrait drawings for its dreamy, Raphaelesque religiousness. Its unusual proportions and the placement of the signature suggest that Ingres was picturing an oval frame. H.N.

1. Quoted in Naef 1977–80, vol. 5 (1980), p. 370.

PROVENANCE: Mme R[ichemond?] (unidentified) until 1905; presumably the sitter's family until about 1977; Ian Woodner (1903–1990), New York; The Woodner Collection

EXHIBITIONS: Paris 1867, no. 314, as *Étude de jeune fille,* "graphite drawing, signed: Ingres del. 1857, lent by M***"; Paris 1905, no. 62, as *Portrait de Mlle de Borderieux,* "lent by Mme R."; Cambridge (Mass.) 1985, no. 108; Vienna, Munich 1986, no. 87; Madrid 1986–87, no. 103; London 1987, no. 86, ill.; New York 1990, no. 109, ill.; Washington 1995–96, no. 104, ill.

REFERENCES: Blanc 1870, p. 240 (catalogued from the list in Paris 1867); Delaborde 1870, no. 265, as *"Mademoiselle Borderieux,* lifesize head, drawn in graphite with some light watercolor touches, signed *Ingres del. 1857";* Naef 1977–80, vol. 5 (1980), pp. 370–71, no. 445, ill.

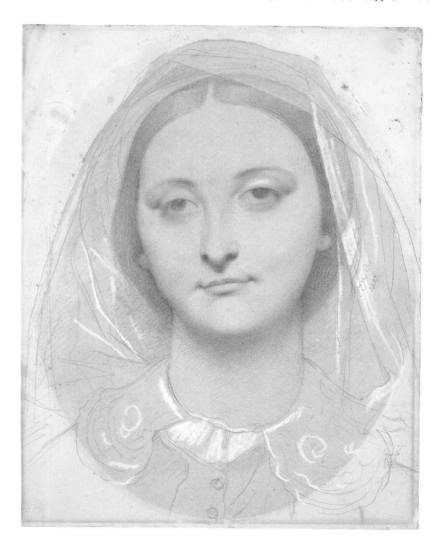

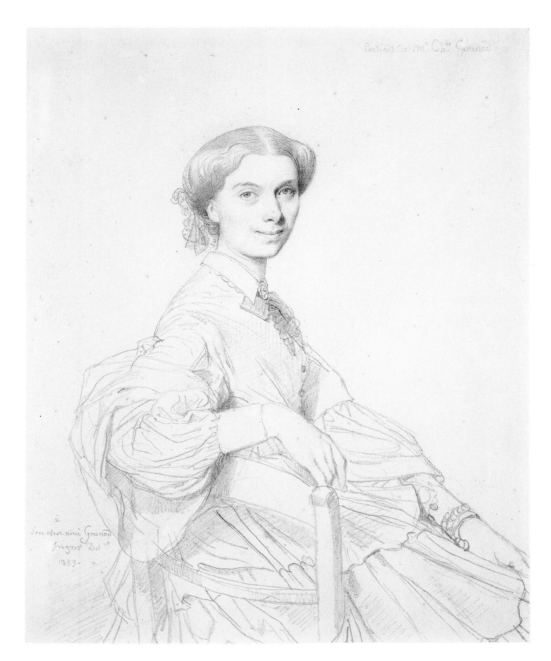

164. Madame Charles Gounod, née Anna Zimmermann

1859

Graphite

10 1/8 × 8 in. (25.7 × 20.2 cm)

Signed, dated, and inscribed lower left: à / Son cher ami Gounod / Ingres Del *vit* / 1859. [for / his dear friend Gounod / Ingres drew (this) / 1859.]

Inscribed upper right: Portrait de M.ᵉ Ch.ˡᵉˢ / Gounod

The Art Institute of Chicago

Gift of Charles Deering McCormick, Brooks McCormick and Roger McCormick 1964.78

New York and Washington only

N 447

This drawing is discussed under cat. no. 117.

PROVENANCE: The same as for cat. no. 117

EXHIBITIONS: Paris 1900a, no. 1090; Paris 1908, no. 106, ill.; Rotterdam, Paris, New York 1958–59, no. 137, pls. 106 (Paris), 98 (New York); Cambridge (Mass.) 1967, no. 112, ill.; Paris 1967–68, no. 256, ill.; Sarasota 1969, p. [3]; Paris 1976–77, no. 32, ill.; Frankfurt 1977, no. 42, ill. p. 91

REFERENCES: Delaborde 1870, no. 310; Lapauze 1903, no. 28, ill.; Mourey 1908, p. 6, ill. p. 7; Prod'homme and Dandelot 1911, vol. 1, ill. opp. p. 192; *La Chronique des arts* 1965, p. 54, fig. 221; Lassus Saint-Geniès and Lassus Saint-Geniès 1965, ill. p. 16; Naef 1966 ("Gounod"), pp. 66–83, fig. 1; Waldemar George 1967, ill. p. 79; Delpierre 1975, p. 24; Naef 1977–80, vol. 5 (1980), pp. 374–75, no. 447, ill.

165. Madame Franz Adolf von Stürler, née Matilda Jarman

October 1861
Graphite
12⅞ × 9¼ in. (32.7 × 23.6 cm), mounted
Signed, dated, and inscribed lower left: à mon
ami / Sturler / J. Ingres / Del. / oct 1861
[for my friend Stürler / J. Ingres / drew (this)
/ October 1861]
Inscribed upper right: MATILDA v STÜRLER
/ NÉE JARMAN
At lower right, the Kunstmuseum, Bern,
collection stamp (Lugt 236b)
Kunstmuseum, Bern
Bequest of Adolf von Stürler, Versailles A2208
New York and Washington only

N 449

This drawing is discussed under cat. no. 154.

PROVENANCE: The same as for cat. no. 154

EXHIBITIONS: Paris 1867, no. 392; London
1878–79, no. 670 [EB]; Versailles 1881, no. 1450;
Basel 1921, no. 111; Zurich 1937, no. 232; Lausanne 1953, no. 32, ill.; Biel 1954, no. 3; Winterthur 1955, no. 247; Zurich 1958a, no. B 19;
Paris 1959, no. 178, pl. 7; Bern, Hamburg 1996,
no. 11, ill.

REFERENCES: Blanc 1870, p. 239; Delaborde
1870, no. 415; Amaury-Duval 1878, pp. 239–40;
Lapauze 1901, p. 250 (known from the list of
works in Ingres's Notebook X); Bern, Kunstmuseum n.d., p. 24, pl. 95; Huggler 1948, ill.
p. 17; Alazard 1950, p. 153, n. 29; Daulte 1953,
no. 30, ill.; Naef 1963 *(Schweizer Künstler)*,
pp. 65–73, 81, no. 9, pp. 100–101, fig. 10; Wagner
1974, p. 9, ill. p. 10; Naef 1977–80, vol. 5 (1980),
pp. 378–79, no. 449, ill.; Amaury-Duval 1993,
no. 272

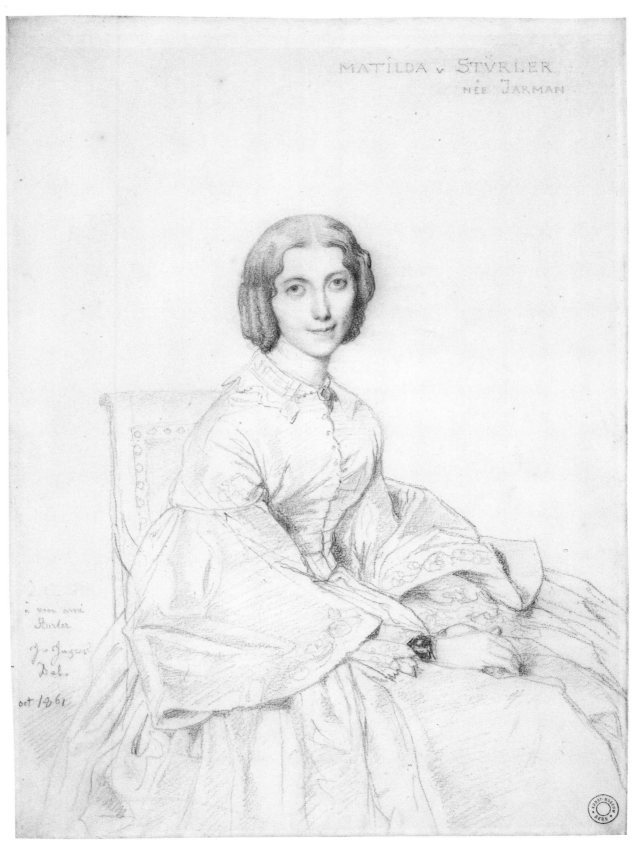

a mon ami
Sturler
J. Ingres
Del.

oct 1861

165

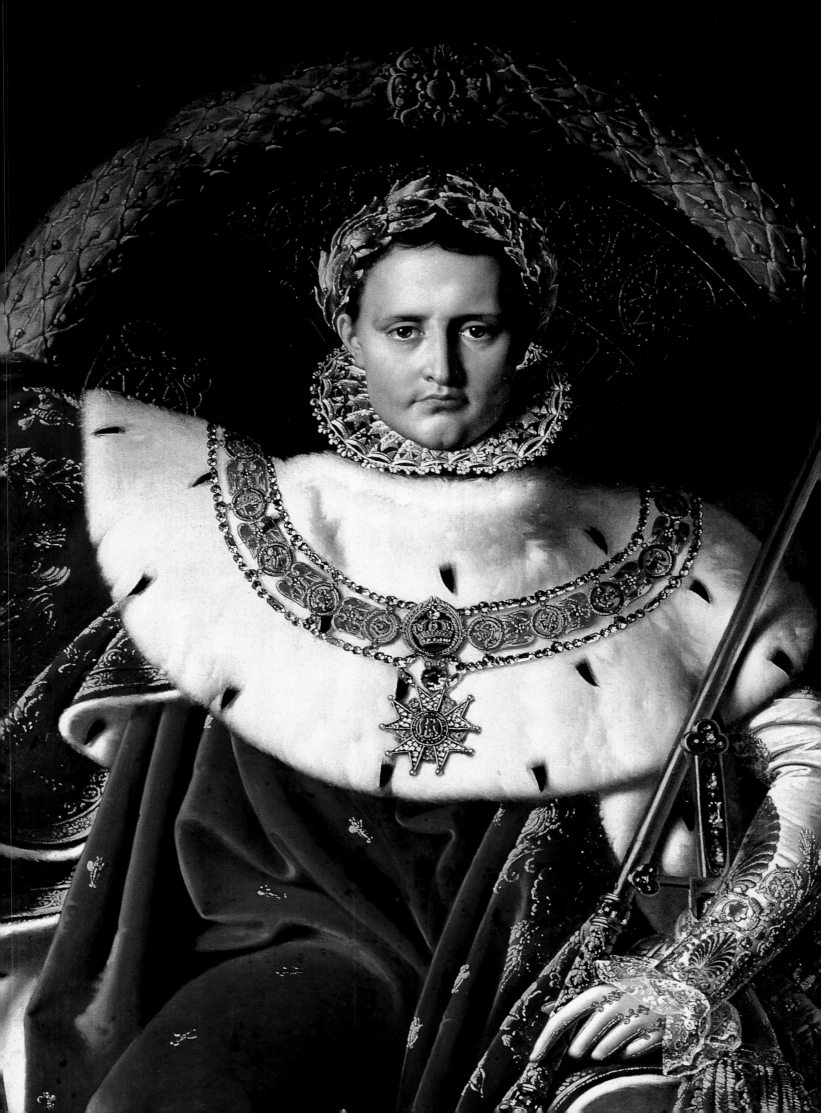

THE CRITICAL RECEPTION OF INGRES'S PORTRAITS (1802–1855)

Andrew Carrington Shelton

Like so much else in the modern world, professional art criticism is essentially a nineteenth-century invention. Although writing on art had been produced in France since the middle of the eighteenth century, it was only after 1800 that the practice became the massively plied and fully professionalized journalistic activity it has remained to this very day.[1] This phenomenon was part of a more general expansion of the press in the nineteenth century: by 1850 hundreds of periodicals of every conceivable stripe were being published in Paris, and a considerable number of these regularly featured articles on art.[2] Most of this writing concerned the Salon (fig. 289), the spectacular exhibition of contemporary art that was held at regular intervals in Paris and consistently attracted visitors from every level of society.[3] As a widespread form of popular entertainment—by the 1840s attendance had reached the million mark[4]—the Salon was reviewed by nearly every periodical in the capital, from the most influential political dailies to obscure and specialized trade journals. The ultimate result of this ever-increasing publicity was a profound transformation in the social profile of the artist. Subjected to the relentless scrutiny of the press in all its guises—from Salon reviews to biographical essays to the most vicious brands of society gossip—the most successful painters and sculptors, once respected but rather obscure members of the cultural elite, emerged as full-fledged media stars.

The growth of professionalized art journalism affected no artist more profoundly than Jean-Auguste-Dominique Ingres, the ultimate, perhaps, of nineteenth-century artistic celebrities. Throughout much of the painter's sixty-year career, the critics acted and he reacted. When the press criticized his early submissions to the Salon, Ingres resolved to live in a state of voluntary exile in Italy; when the critical climate began to change with the spectacular success of his contributions to the 1824 Salon, he immediately resettled in Paris, where he

quickly emerged as one of the leading figures in the contemporary art world. Ten years later, when faced with the hostile reception of *The Martyrdom of Saint Symphorian* (see pages 286–87; fig. 169), the artist announced his retirement from public life and returned to Italy as the director of the Académie de France in Rome.

The vituperative attacks Ingres suffered at the beginning of his career instilled in him a hatred of the press that would last throughout his life. In 1854 Madame Paul Lacroix, a friend of the painter and the wife of the famous art critic known as Le Bibliophile Jacob, reported first-hand on Ingres's unyielding enmity toward the critics: "He used to tell me that criticism drove him mad; that he had been greatly harmed, that his memory was so rancorous that it recalled the slightest hostile word written against him during the past fifty years, that he detested his enemies, and that it did him good if they suffered some misfortune."[5] To Ingres, journalists were at best untalented, irresponsible hacks who whiled away their time on frivolous pursuits (fig. 290); at worst, they were

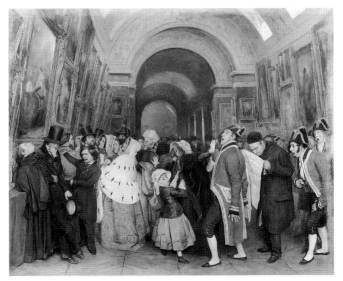

Fig. 289. François-Auguste Biard (1799–1882). *Four o'Clock at the Salon*, 1847. Oil on canvas, 22⅝ × 26⅝ in. (57.5 × 67.5 cm). Musée du Louvre, Paris

Fig. 290. *The Journalist*, 1824–34?. Graphite on paper, 4 × 4⅜ in. (10.2 × 11.2 cm). Musée Ingres, Montauban (867.2733)

libelists and rabble-rousers who represented a threat not only to individual reputations but to the peace and prosperity of the nation as a whole.[6]

At the same time, however, Ingres clearly understood the power of the pen. He was not above sending a journalist a note of thanks for a favorable critique and even, on several occasions, rewarded writers of especially effusive reviews with a work of art.[7] His most celebrated portrait depicts one of the most formidable pressmen of his age, Louis-François Bertin (cat. no. 99), publisher of the immensely influential *Journal des débats*, in whose columns Ingres received some of the most laudatory coverage of his career.[8] Thus, the artist's relationship with the press (and with the public at large, for that matter) was fundamentally opportunistic: when the critics loved him, he was perfectly capable of loving them back; otherwise, he seems to have disdained the entire press corps as a vile pack of scoundrels.

CRITICISM OF PORTRAITURE IN THE NINETEENTH CENTURY

It is beyond the scope of this essay to consider the vast critical corpus devoted to Ingres during his lifetime;[9] such an undertaking would not only require a volume all to itself, it would also be inappropriate in a study of Ingres's portraiture, which usually received short shrift in contemporary writing on the artist. This is largely a function of the academically enforced hierarchy of genres, which ranked portraiture well below monumental history painting, the ostensibly most demanding and thus most venerated picture type during the nineteenth century. Ingres himself was an advocate (one is tempted to say a victim) of this way of thinking: he insisted throughout his career on his status as a history painter and dismissed his portraits as a chore forced upon him by well-meaning but misguided admirers.[10] Of course, posterity has inverted this evaluation; today Ingres is primarily remembered as one of the greatest portraitists of all time, and few are the twentieth-century viewers who do not wish he had expended more energy recording the likenesses of his contemporaries and less time plying the increasingly moribund trade of the history painter—a reevaluation of the artist's achievement that actually began to emerge during his own lifetime.

Nineteenth-century notions of what constituted a great portrait were not so different from those of today. Likeness, both physical and spiritual, was fundamental for most critics, yet success on this count did not in itself make a portrait worthy of public exhibition. In fact, much of the critical commentary on portraiture in the nineteenth century takes the form of attacks on the genre's

Fig. 291. Honoré Daumier (1808–1879). *Le Salon de 1857*. "All the same, it's flattering to have one's portrait in the exhibition." Lithograph. Bibliothèque Nationale, Paris

increasing dominance at the Salon. The reaction of Charles Ballard, critic for *Le Petit Poucet* in 1833, is typical: "It is raining portraits at the Salon; all the rooms are flooded with them; everyone has his portrait, every artist has painted his own. It is an epidemic, an endemic, an infection."[11] The prominence of portraits at the Salon was interpreted as an indication both of the decadence of modern art—the fact that artists either could not or would not apply themselves to the more difficult (and generally less remunerative) categories of art making—and of the vanity of that ever-widening segment of the population which derived undue pleasure from seeing their likenesses displayed at the Salon (fig. 291). The only portraits worthy of public exhibition, most critics agreed, were those that represented famous individuals or demonstrated exceptional aesthetic merit. Simple fidelity to the sitter—just any sitter—was not enough.

Like every other aspect of the critical discourse on art in the nineteenth century, the discussion of portraiture was politically fraught. Undoubtedly one of the reasons critics favored the display of portraits of government officials and other prominent public figures over those of private individuals was that the former afforded them the chance to render their opinions on political as well as aesthetic matters.[12] Many reviewers also extended this prerogative to encompass the assessment of the legions of anonymous portraits on view at each exhibition, ruminating provocatively on such nonaesthetic issues as class, gender, race, and ethnicity.[13] Indeed, the critical attack on the prominence of portraiture was part of a larger sociological discourse aimed at challenging, or at least disparaging, what was perceived to be the mounting political and cultural hegemony of the bourgeoisie. Such attacks were often blatantly politicized. An anonymous critic for the right-wing legitimist journal *La Mode*, for instance, seized upon the profusion of portraits at the 1833 Salon as an opportunity to malign not only the artistic policies of the newly installed Orléanist regime but also the vulgar tastes and pretensions of those who allegedly had brought it to power:

> Here are the arts today as the revolution [of 1830] has made them for us; here they are in all the splendor conferred on them by the munificence of the civil list, the enlightened taste of the citizen-king, and the patronage of M. d'Argout . . . Painting has fallen back this year on the *genre picture* and on the *portrait.* . . . The rue Saint-Denis has invaded the Louvre; private life has taken over the Salon. Here are the landlords in profile, the manufacturers looking you squarely in the face, the candlemakers in full sergeant-major's dress, with their Legion of Honor crosses, rendered at their request very large and very conspicuous.[14]

Ingres's portraits were by no means immune from this sort of banter. For even though the sheer prominence and authority of his creative personality generally ensured that critics remained focused on aesthetic issues, social and political concerns were never very far from their minds.

The present discussion will concentrate on several key moments during Ingres's career in which his engagement with portraiture was particularly crucial to the formation of his critical personae: the Salons of 1806 and 1833, the Bonne-Nouvelle exhibition in 1846, and the Exposition Universelle in 1855. Its primary aim will be to establish the general outlines of how the artist's critical reputation evolved over time, rather than to engage in detailed analyses of individual texts.[15]

THE SALON OF 1806

Although Ingres had established his credentials as a promising history painter by winning the prestigious Prix de Rome in 1801, it was with a single portrait of a woman that he made his public debut at the Salon of 1802.[16] The critics were unimpressed: "Readers, spare us this one," remarked the only reviewer who bothered to comment on this now-unidentified canvas, "we can find nothing to say. . . ."[17]

Determined to make the public take notice, Ingres sent no fewer than four works to the 1806 Salon, all of them portraits: *Madame Rivière* (cat. no. 9), *Mademoiselle Rivière* (fig. 58), a self-portrait (cat. nos. 11, 147),[18] and the monumental *Napoleon I on His Imperial Throne* (cat. no. 10, fig. 288).[19] Not surprisingly, the critics' attention was focused squarely on the last canvas, a painting Ingres may well have undertaken without an official commission as a means of making a name for himself.[20] If so, the gambit was only partially successful: although he managed to capture the critics' attention with this work, they had almost nothing good to say about it. Chief among the problems cited were its strange stylistic archaisms—its unrelieved frontality and forced symmetry; its lack of conventional modeling and its bizarre, "lunar" lighting; its indiscriminate detail and unrelenting surface realism. According to most critics, Ingres had purposely rejected the officially sanctioned art-historical prototypes of the sixteenth and seventeenth centuries in a misguided attempt to "make art regress" by imitating crude Gothic medallions and the uncouth daubings of "Jean de Bruges"

(Jan van Eyck).[21] The outraged response of Comte Frédéric de Clarac, archaeologist and art connoisseur, who reviewed the Salon of 1806 for the *Annales littéraires de l'Europe*, is typical:

> Is it not too bizarre an idea to want to revive the old, stiff, and awkward manner of the Early Renaissance painters? This is what M. Ingres is doing: he affects a great severity of pose and design, and he takes for grandeur what is in fact nothing but *manner*. . . . The portrait of the Emperor by this painter seems to have been done after a Gothic medallion; he is laden with a quantity of draperies that give no hint that there might be a body underneath, and the head seems to have been set on cushions.[22]

No less remarkable than the vehemence of the critical attack on Ingres's painting is its uniformity. Neither aesthetic creed nor political affiliation colored the critics' response to any appreciable degree: they all hated it, thoroughly and unequivocally.[23]

The reviewers' disdain for Ingres's picture was rendered all the more acute by their general enthusiasm for another portrait of the emperor in coronation robes exhibited at the same Salon (fig. 68). This painting by Robert Lefèvre, a fashionable but completely conventional portraitist in the tradition of David, offered all the visual tricks and formal devices that one expected to find in an official, grand-manner portrait: a confident, dynamic, hand-on-hip pose; a carefully coordinated set of sumptuous props and accoutrements that worked to enframe rather than compete with the main figure; and, most important perhaps, an expertly rendered illusion of deep, three-dimensional space. Such conventional merits on the part of Lefèvre only heightened the critics' awareness of Ingres's deviancy and their tendency to regard him as an impudent novelty seeker.[24]

This notion of Ingres as one who was more interested in gaining attention than in making genuinely beautiful works of art informed the critics' reception of his other contributions to the Salon of 1806 as well. The self-portrait (cat. nos. 11, 147), for instance, was maligned for what many reviewers took to be a pretentious display of coloristic asceticism. "A painter, with a head of stiff, black hair, is silhouetted against a large white canvas; the artist, dressed in black with a white redingote, wipes with a very white handkerchief; this makes an effect of white on white."[25] Such was one pamphleteer's satirical assessment of the monochromatic canvas. For other reviewers, it was not so much the painting's formal qualities that were objectionable but rather its trumped-up emotional content. Thus, an anonymous critic for the conservative *Mercure de France* ridiculed the artist's "dark and wild expression" and joked that the voluminous drapery thrown over his shoulder "must inconvenience him mightily in the heat of composition and in the kind of crisis that his genius seems to be undergoing."[26]

Ingres's two female portraits scarcely fared better. Reviewers deemed the portrait of Madame Rivière (cat. no. 9) to be marred by many of the same stylistic peculiarities as the self-portrait. They were particularly disturbed by the painting's attenuated color scheme and lack of conventional chiaroscuro. Clarac, for instance, complained that the figure was "painted without shadows and so enveloped in draperies that one spends a long time in guesswork before recognizing anything there."[27] Another reviewer caricatured the painting as "a lady all in white, white shawl on a white dress, head and arms white mixed with a little pink."[28] Yet here again, it was not only the form of the painting that the critics found disturbing. Pierre Chaussard, one of the most formidable critics in Paris and author of a 533-page review entitled *Le Pausanias français*, objected to Ingres's excessively sensual characterization of the sitter—"a lady," the writer indignantly remarked, "whom we know to be a model of grace and decency."[29]

Surprisingly, critics were more forgiving before the portrait of Madame Riviere's thirteen-year-old daughter. "People are not stopping often enough before the portrait of a young person . . . in which the defects of the manner adopted by the artist are much less obvious than in his other works," the politically and aesthetically conservative Jean-Baptiste Boutard observed in his important review for the *Journal de l'Empire*.[30] Chaussard concurred but seemed to attribute this improvement in quality more to the sitter than to the artist. "The subject should have inspired him," he grumbled, "a lovely young person . . . fresh as a rosebud, who seems to call for the brush of Correggio."[31] Thus, the undeniable charm of Mademoiselle Rivière seems to have blinded the critics to Ingres's stylistic archaisms, which most viewers since 1806 have found to be more pronounced in this portrait than in that of the adolescent's mother. The irony of this situation was not lost on Ingres. "Imbeciles," he later exclaimed of the critics' preferences for *Mademoiselle Rivière*, "you praise that which, of all my works, I believe leaves the most to be desired in terms of achieving the sublime beauties that this age and this sex demand."[32]

Having left for Rome just days before the opening of the 1806 Salon, Ingres was not in Paris when the critical

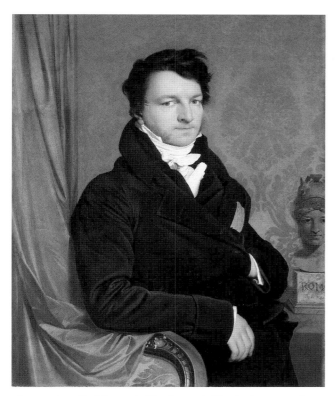

Fig. 292. Detail of *Baron de Montbreton de Norvins* (cat. no. 33)

Fig. 293. Horace Vernet (1789–1863). *Charles X Reviewing the Paris Garrison and the Royal Guard*, 1824. Oil on canvas. Châteaux de Versailles et de Trianon

returns began to come in. When word of the fiasco reached Italy, the artist was stunned. "So the Salon is the scene of my disgrace?" he asked in a plaintive letter to Pierre Forestier, the father of his current (and soon-to-be former) fiancée. "Am I changed overnight from a distinguished painter into a man whose works cannot be looked at?"[33] It did not take long for his shock to turn into defiance: "Yes, art really needs someone to reform it," he later proclaimed in response to the accusation that he was attempting to overturn the reigning aesthetic order, "and I should really like to be that revolutionary."[34] Ingres thus took the critics' bait, fashioning himself into an unjustly persecuted genius whose works could not possibly be understood by the philistine masses. Such an oppositional stance was difficult to maintain, however, for his thirst for conventional success—"I am devoured by ambition"[35]—was almost as strong as his desire to remain true to his artistic ideals.

Ingres ultimately refused to compromise, though. As a result, his paintings met with more than a decade and a half of unrelenting critical animosity. When he next submitted works to the Salon, in 1814 and 1819, the same charges were mechanically repeated by the critics— Ingres was a willfully crude, gauche renegade intent on

pushing art back to some semibarbaric medieval or Early Renaissance phase.[36]

The critical tide finally began to turn in Ingres's favor in 1824, when he exhibited *The Vow of Louis XIII* (fig. 146) at the Salon. Although this work—the first of his monumental history paintings to be publicly shown in Paris— was by no means universally acclaimed, it did prompt the critics to take a fresh look at the artist, and what they found, for once, was far from Gothic. For here it was evident that one of the most venerated masters in art history, Raphael himself, had usurped "Jean de Bruges" and the other "primitive" artists as Ingres's principal source of pictorial inspiration.[37] While the critics generally appreciated this switch, several alleged that Ingres had been overzealous in his wholesale appropriation of his new idol's style.[38] This charge, which would plague Ingres for the rest of his career, failed to bring him down in 1824, however. His new, Raphaelesque manner earned him not only the officer's cross of the Legion of Honor but a seat in the Institut de France as well.

What little critical commentary there was on the only portrait Ingres exhibited in 1824, the *Baron de Montbreton de Norvins* (cat. no. 33, fig. 292), suggested that all the artist's works would benefit from his enhanced stature

Fig. 294. Balthasar Denner (1685–1749). *An Old Woman*, 1724. Oil on copper, 15 × 12¼ in. (38 × 31 cm). Musée du Louvre, Paris

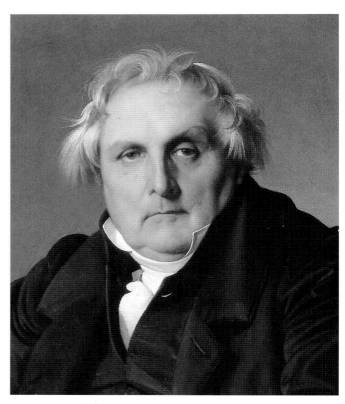

Fig. 295. Detail of *Louis-François Bertin* (cat. no. 99)

as a history painter.[39] "It is nothing but a very simple portrait," Étienne Delécluze, recently appointed art critic to the powerful *Journal des débats*, noted approvingly, "but in the energy of the design and modeling, in the expressive power that the artist has concentrated in the face, in the calm and grandeur that reign in the disposition of the lines and the light, one recognizes the work of a man who can truly be called a history painter."[40] Initiating a rivalry that would continue for the next thirty years, Delécluze went on to oppose Ingres's portrait with Horace Vernet's hastily executed likeness of King Charles X, which was also on display at the 1824 Salon (fig. 293). The resulting contrast encapsulated for Delécluze the essential stylistic rift characterizing the contemporary school: "From this comparison, I conclude that these able painters have given us, each with his talents, an excellent work in what we have called the *Homeric* style, by M. Ingres, and a very fine picture in the *Shakespearean* genre, by M. Horace; that one seeks the *probable*, the other admits nothing but the *real;* that M. Ingres will have as admirers only a small number of connoisseurs, while M. Horace's new creation will have a popular success."[41] Thus, Ingres is depicted—in what will become his familiar art-historical guise—as the champion of an ideal, elitist classicism (Delécluze's "Homeric style") in opposition to the naturalistic, crowd-pleasing Romanticism ("the Shakespearean genre") of Vernet.

Ingres's reputation as a classicist was not so rigid in 1824 as to prevent reviewers of a different aesthetic persuasion from embracing his work. Stendhal, Delécluze's most formidable opponent in the critical debates over the 1824 Salon, was equally enthusiastic about Ingres's portrait but on radically different grounds. For him it was not "the grand, elevated, and simple style"[42] that provided the work's main appeal but rather its expressive force, virtuoso handling of light and shade, and bold color contrasts. "What audacity in this century, when timidity has killed color, to make the figure of the individual stand out against a red background,"[43] he exclaimed. Stendhal went on to proclaim Ingres a superior portraitist to both the school of David and the English Romantics and expressed the desire to see "a multitude of very fine portraits" from the artist's hand at the next exhibition.[44]

THE SALON OF 1833

While Ingres did exhibit two portraits at the Salon of 1827 (see cat. nos. 97, 98),[45] their presence was overshadowed

by the unveiling of what would come to be regarded as his principal achievement in monumental history painting, *The Apotheosis of Homer* (fig. 315). After completing this canvas in record time, Ingres turned to the other and far more troublesome subject painting then on his easel, *The Martyrdom of Saint Symphorian* (fig. 297), which had been commissioned by the government in 1824 but would not be ready for public inspection until the fateful Salon of 1834. In the meantime, it was exclusively as a portraitist that Ingres appeared before the public: in 1833 he sent two works in this genre to the Salon, the recently completed portrait of Louis-François Bertin (cat. no. 99, fig. 295) and that of Madame Duvaucey (fig. 87), which had been executed more than a quarter of a century earlier in Rome.[46]

Given Ingres's pretensions as a history painter, it is ironic that he achieved his first real popular success in 1833 as a portraitist. The primary catalyst behind this outburst of public enthusiasm was the mesmerizing illusionism of *Monsieur Bertin*. The crowd "allows itself to be captivated by the charm of truthfulness," a somewhat bemused and condescending Gustave Planche reported in his review for the highbrow intellectual journal *Revue des deux mondes*. "It studies, as best it can, the details of the head, rendered with such prodigious insight; it examines attentively, with an almost childish glee, the realism of the fabrics, the thrust of the armchair; it goes into ecstasies before the pose, so simple and so forceful at the same time; it never tires of gazing avidly at the eyes and lips so full of the powers of sight and speech."[47] A few critics responded enthusiastically to the portrait's illusionism as well. "It is impossible to take truthfulness any further," an anonymous reviewer for *L'Artiste* marveled. "This is . . . a portrait in flesh and bone, a portrait that walks and talks."[48]

Other reviewers, less enamored with the sheer veracity of the painting, accused Ingres of indulging in a brand of vulgar illusionism that was unworthy of High Art. Writing for the posh literary and artistic journal *L'Europe littéraire*, the liberal critic Louis de Maynard complained that the painting constituted "a minute and microscopic study" that had more to do with the hyperrealistic "curiosities" of the obscure eighteenth-century German painter Balthasar Denner (fig. 294) than with the sublime productions of Ingres's self-proclaimed hero, Raphael.[49] He went on to debunk the painting's vaunted expressive veracity by portraying it as the result of a kind of farcical standoff between the artist and his model over who could endure the most sittings. "On this subject," he reports,

"here is the painter's most fitting comment to his model: '*Sir, I am tiring you*'; and the model's possibly sublime response: '*I defy you to do so.*'"[50]

Surprisingly, it was not so much the eye-popping illusionism of *Monsieur Bertin* that dominated the critical discourse but rather the manner in which the portrait was deemed to express what was quickly emerging as Ingres's alleged "system" of art making. Most reviewers agreed that the work exemplified the painter's justly celebrated draftsmanship; indeed, by 1833 the perception of Ingres as "the god of drawing" had already become something of a critical cliché.[51] There was a downside to this reputation, however, as critics began to contrast Ingres's excellence as a draftsman with his alleged failings as a colorist. They were nearly unanimous in condemning the uniformly dull tonalities of *Monsieur Bertin*, particularly in the flesh, which many characterized as lifeless and leaden.[52] Finally, with regard to the third major element of Ingres's personalized aesthetic "system"—his programmatic imitation of Raphael—reviewers continued to complain that the painter depended more on art-historical precedents than on nature for inspiration. "M. Ingres is copying itself," Maynard proclaimed, succinctly expressing the opinion of many of his anti-*ingriste* colleagues.[53]

The critics' insistence on assessing *Monsieur Bertin* as an exemplar of a unified theory of art making seems to have been motivated less by the qualities of the portrait itself than by growing concerns over Ingres's influence in the contemporary school. By 1833 Ingres had emerged as a formidable *chef d'école*, presiding over one of the largest and most important teaching ateliers in Paris.[54] The aesthetic principles believed to be embodied in his paintings therefore became a matter of potentially national concern—all the more so given the persistent, if ultimately unfounded, rumors that Ingres was seeking the position of First Painter to the King.[55] This prospect scandalized many critics, who shared the fears expressed by the anonymous reviewer for *Le Constitutionnel:* "M. Ingres is exclusive, there is no harm in that, so long as this exclusivity shows itself only when the brush is in his hand. But what will happen if M. Ingres is consulted by those with the power to reward and encourage? Everything that offends M. Ingres's susceptibilities will be banned."[56]

The specter of an *ingriste* dictatorship seems to have kept discussion of *Monsieur Bertin* focused on the aesthetic ambitions of the artist as opposed to the professional or political agenda of his famous sitter. Inevitably, however, references to the journalist's career did impinge upon

the critical assessment of the painting. An unabashedly adulatory review in *L'Artiste*, for instance, hailed Bertin as the father of French journalism, the "distinguished man who has single-handedly created the entire political press."[57] Of course, not everyone was so impressed. An anonymous critic for the *Messager des dames* offered what was clearly meant to be a facetious description of Bertin as the "most skillful defender of the present government" and mockingly congratulated this "advocate of the *juste-milieu*" for having procured "a painter of the *juste-milieu*" to execute his portrait.[58] The antigovernment sentiment intimated here was more fully articulated in the virulently oppositional satirical paper *Le Charivari*. On May 15 the paper published a caricature of Ingres's painting retitled "M. Bêtin-le-Veau" ("M. Bêtin the Clod"; fig. 296);[59] in the accompanying article, Bertin is vilified as the embodiment of "the prostitution of the press," just as the regime to which he catered is demonized as "parliamentary prostitution."[60]

Although the bulk of the critical attention in 1833 was directed toward *Monsieur Bertin*, the portrait of Madame Duvaucey was by no means overlooked. Some critics, in fact, expressed a preference for the earlier portrait,[61] the

Fig. 296. Unidentified artist. *M. Bêtin-le-Veau*. *Le Charivari*, May 15, 1833

most ardent being Théophile Gautier, who flatly proclaimed it the most beautiful thing in the exhibition. In so doing, Gautier seems to have been making a conscious break with accepted critical opinion on Ingres, defiantly celebrating exactly those elements in *Madame Duvaucey* that the majority of his colleagues found most objectionable. Thus, while the old charges of "Gothicism" were leveled against the portrait,[62] Gautier lauded its archaistic simplicity: "There is in this portrait such a sanctity of line, such a religion of form in the smallest details, its execution is so primitive, that one finds it extremely hard to believe that it was painted at the height of David's reign, twenty years ago."[63] Similarly, while many of his colleagues found the figure lacking in vibrant color and in relief,[64] Gautier reveled in its pale tonalities and subtle, attenuated modeling: "The entire head lives and moves, and does so without the benefit of color, with a simple local tone skillfully graduated according to the forms and the movement; for our part, we greatly prefer this to the multicolored knitwear with which the school of Gros clothes its figures, and it seems to us indisputably truer to life and more appealing to the eye."[65]

At the Salon of 1834, Ingres attempted to follow up on his success of the previous year by reappearing in the guise of a history painter. The results were disastrous, as the long-awaited *Martyrdom of Saint Symphorian* (fig. 297) was pilloried in the press, particularly by liberal critics, who seemed more determined than ever to prevent the artist from erecting his colorless, retrogressive system into the new aesthetic order of the day.[66] The only other painting Ingres exhibited at the Salon of 1834, the eleven-year-old portrait of Madame Leblanc (cat. no. 88), was no less viciously attacked. Outcries over the work's anatomical irregularities were added to the usual complaints that its figure was flat and colorless, and, as so often in the nineteenth century, such commentary quickly degenerated into the cruelest parody. "I cannot believe," the virulently antiacademic A.-D. Vergnaud remarked, "that this monster, lacking the upper part of her head, with orbicular eyes and sausagelike fingers, is not the distorted perspective of a doll, seen too close and reflected on the canvas by several curved mirrors, with no sense of the whole in each of its details."[67]

Faced with such hostility, Ingres resolved to abandon his thriving atelier in Paris and return to Italy as the director of the Académie de France in Rome. Before this departure, which was meant to signal the end of his public career, he renounced all pending official commissions and declared that he would never again exhibit at the

Fig. 297. *The Martyrdom of Saint Symphorian*, 1834 (W 212). Oil on canvas, 13 ft. 4 in. × 11 ft. 1½ in. (407 × 339 cm). Cathédrale Saint-Lazare, Autun

Fig. 298. Bertall (1820–1882). *"Fragment du martyr de saint Symphorien, par M. Ingres"* (Fragment of "The Martyrdom of Saint Symphorian," by M. Ingres). *Le Journal pour rire*, December 1, 1855

Salon. His resolve with regard to the latter declaration was tested in the spring of 1835, when he refused to submit his latest production, a portrait of the prominent Orléanist statesman the comte Molé (fig. 158), to the 1835 Salon. The artist had not, however, completely forsaken the public, for in November 1834 he had placed the portrait on display before a limited audience in his studio.[68] This became the first of a series of relatively exclusive but well-publicized studio exhibitions in which Ingres introduced his works to the public.[69] Most of these featured portraits: *Cherubini and the Muse of Lyric Poetry* (fig. 221) and the *Duc d'Orléans* (cat. no. 121) were exhibited in the spring of 1842;[70] the *Baronne de Rothschild* (cat. no. 132) in August 1848;[71] the earlier *Madame Moitessier* (cat. no. 133) and probably *Madame Gonse* (fig. 208) in January 1852;[72] the first *Lorenzo Bartolini* (fig. 53), *Madame Moitessier* (again), and the *Princesse de Broglie* (cat. no. 145) in December 1854;[73] and finally, *Madame Ingres* (fig. 213) in July 1864.[74]

THE BONNE-NOUVELLE EXHIBITION (1846)

Although Ingres persisted in his avoidance of the Salon for the final thirty-three years of his career, the public was afforded several opportunities to view his works in a setting other than his studio. The first such occasion came in January 1846, when the artist reluctantly agreed to participate in a vast historical survey of French painting since the end of the eighteenth century. This exhibition, one of the first of its kind ever organized in France, was staged in a commercial gallery situated within a chic shopping complex at 22, boulevard Bonne-Nouvelle. The potentially compromising air of commercialism imparted by such a locale was mitigated by the exhibition's status as a charitable event for the eminently respectable Société des Artistes Peintres, Sculpteurs, Architectes et Dessinateurs[75] and by the fact that the works on display were not for sale (at least not overtly) but had been borrowed from some of the most prestigious private collections in France. Despite these circumstances, Ingres initially balked at the prospect of displaying his works in such a "bazaar,"[76] relenting only when it was agreed that his canvases would be physically separated from all the other works on display. His submissions to the Bonne-Nouvelle exhibition were thus grouped together in a small alcove separated from the rest of the gallery by a large curtain (fig. 299). Ingres's similar demands on the organizers of the Exposition Universelle nine years later suggest that it was not so much public exposure he objected to after 1834 but rather the potentially incriminating juxtaposition of his works with those of his ostensibly less talented colleagues.

The eleven paintings that Ingres contributed to the Bonne-Nouvelle exhibition constituted something rarely experienced by art lovers in early-nineteenth-century France—a single-artist retrospective.[77] The canvases,

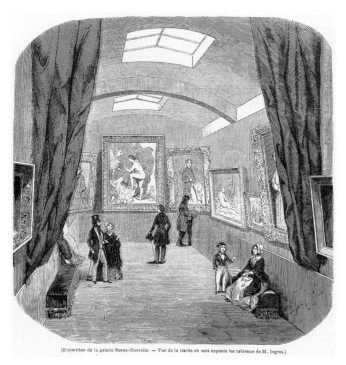

Fig. 299. View of the Ingres installation at the Boulevard Bonne-Nouvelle, Paris, 1846. *L'Illustration*, February 14, 1846

which ranged in date from *Oedipus and the Sphinx* of 1808 (fig. 82)[78] to the celebrated portrait of the comtesse d'Haussonville of 1845 (cat. no. 125),[79] appear to have been carefully chosen to summarize the first four decades of Ingres's career. Although modest by the standards of twentieth-century blockbusters, the resulting display came as a total revelation to contemporary critics. "Never was an exhibition as favorable to M. Ingres as this one," the former Napoleonic soldier turned art critic Auguste Jal exclaimed, "the reason being that there has never been such an opportunity to study and understand him, since never before have such a large number of his finest works been seen together."[80] Even Baudelaire, whose review of the Bonne-Nouvelle exhibition for *Le Corsaire-Satan* was sarcastically entitled "The Classical Museum" ("Le Musée Classique"), seemed impressed with Ingres's novel multiwork display: "In a special room M. Ingres proudly displays eleven pictures, that is to say, his whole life, or at least samples of each period—in short, the entire Genesis of his genius."[81]

Three of the eleven works by Ingres in the Bonne-Nouvelle exhibition were portraits: *Monsieur Bertin* (cat. no. 99), the *Comte Molé* (fig. 158), and the *Comtesse d'Haussonville*. Their simultaneous display prompted new insights on the part of the critics, whose previous preoccupation with the artist's style—and with the implications of the dissemination of that style for the future of

the French school—had tended to override considerations of his involvement in individual genres. In 1846 reviewers began to seriously consider Ingres's talents as a portraitist per se. Leading the discussion was the artist's own pupil and eventual biographer, Amaury-Duval, whose critique centered on the elevation of the imaginative aspects of portraiture over its purely mimetic components. "M. Ingres's portraits, like those of all the great masters, are not materialistic and petty-minded imitations of nature," Amaury-Duval contended:

> Indeed, if the painter's objective were a literal reproduction of what was before his eyes, this would implicitly concede that the daguerreotype was the most perfect expression of art. The portrait, if the masters are to be believed, is nature interpreted. These geniuses of painting are the commentators who elucidate with a personal eloquence the open book before us and who make us contemplate beauties under an aspect that reveals the depth of their intelligence.[82]

While Amaury-Duval may at first seem to be offering a rather conventional apology for a genre that had long been disdained as a mimetic, mechanical art form, he is ultimately interested in establishing more than the imaginative faculties of the portraitist. He believes that a truly great portrait must not only transcend the precise reproduction of the model's physical and even spiritual makeup, but it must also convey something of the unique aesthetic sensibility of the individual who created it:

> Each painter has a different eclecticism, an eye that is his own, with the result that there are as many kinds of portraits as painters and that the same model can be presented under as many guises as there are artists, all dissimilar among themselves, yet all to the same extent true. What is peculiar to the masters is that they impose on us their manner of seeing nature: the aspect that your unpracticed eye was unable to find, they reveal to you in a flash.[83]

Ingres's portraits fulfilled all these requirements so perfectly that whenever Amaury-Duval encountered one of his master's models, he was tempted to declare that, "reversing the order of things," the sitter resembled his or her portrait.[84]

Amaury-Duval's contention that Ingres's portraits were fundamentally more about the portrayer than the portrayed informs other reviews of the Bonne-Nouvelle exhibition as well, particularly those dealing with the outrageous anatomical distortions that had long been recognized as one of the most troubling aspects of the artist's paintings. In 1846 such discussions focused on the

portrait of the comtesse d'Haussonville (cat. no. 125, fig. 300), whose arms were widely perceived as being out of proportion with the rest of her body. While most reviewers regarded this detail as a simple mistake,[85] a few began to perceive that such obvious departures from objective reality manifested a conscious aesthetic choice on the part of the artist. Jal, for instance, contended that the excessive length of the countess's right arm was an "error" that "M. Ingres has probably intended." Explaining this detail as a virtuoso demonstration in foreshortening, he concluded that the resulting fault in proportion—"however shocking it may be"—must ultimately be forgiven.[86] The critic and arts administrator Frédéric Bourgeois de Mercey likewise pointed to the countess's meaty appendages as examples of the "bizarreness in drawing" that characterized Ingres's portraits and concluded that they should be

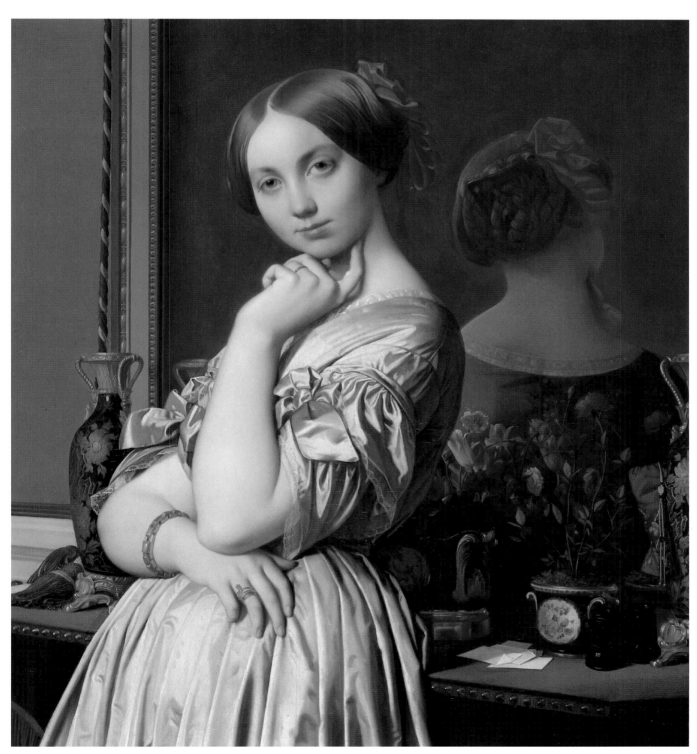

Fig. 300. Detail of *Comtesse d'Haussonville* (cat. no. 125)

regarded as "something wholly other than imperfections."[87] What is beginning to emerge here is an essentially modern (and modernist) appreciation of Ingres's paintings as objects whose ultimate referent was not optical reality but rather the unique aesthetic sensibility of the artist himself. Instead of lamenting the painter's departure from visible truth, such critics as Amaury-Duval, Jal, and Mercey were beginning to appreciate—however tentatively in the case of the last two—the formal quirks and visual disjunctions of Ingres's paintings as essential components of his creative genius.

The tendency in 1846 to read Ingres's portraits primarily as testaments to his aesthetic individuality is in keeping with the general drift of the critical discourse on the artist after 1834. Even though reviewers had always been concerned with Ingres's stylistic peculiarities as the manifestation of a special, even eccentric, artistic sensibility, until 1834 their principal task had been to situate his achievement within the context of the nation's cultural development as a whole. After Ingres's abandonment of the collective, national space of the Salon for the private space of the atelier and the single-artist retrospective, this connection between his works and the larger social, cultural, and economic contexts in which they were generated appeared to grow more and more tenuous.[88] Thus, it was not a collection of diverse, disconnected canvases created at different times and for various purposes that the critics encountered on the boulevard Bonne-Nouvelle but rather a representative sample of a unified whole—an assemblage of intimately related, mutually reinforcing pictures that together provided an accurate representation of a particular artistic life.[89]

In the end, it was the portraits that most consistently interfered with the illusion of Ingres's works as more or less direct emanations of his own particular aesthetic sensibility. For even though critics like Amaury-Duval insisted on the actively creative as opposed to the passively mimetic character of the master's portraits, their emphatic referentiality to the world outside the cloistered, privatized space of the atelier and single-artist exhibition ensured that the social and political implications of Ingres's picture making did not completely disappear as critical issues.

In 1846 this is demonstrated most clearly by the reviewers' insistence on reading Ingres's portraits as emblems of social class. It was they, for example, who popularized the emphatically sociological reading of *Monsieur Bertin* as an icon of the newly empowered middle class. Anticipating Manet's much-quoted description of the journalist as the "Buddha of the bourgeoisie—

affluent, satiated, triumphant,"[90] Charles Ver-Huell, critic for *L'Espérance*, hailed Ingres's portrait as "the apotheosis of the plebeian."[91] It was, however, an anonymous reviewer for the *Journal des artistes* who provided the most considered analysis of the social significance of Ingres's three portraits on the boulevard Bonne-Nouvelle. He too described Bertin as the very personification of the level-headed *bourgeois*—"a thinker, a philosopher, a wise politician, a courageous citizen who always confronted the turmoil of political passions with firmness and integrity."[92] This critic then proceeded to contrast the direct, unembellished portrait of Bertin to that of the elegant, refined Molé, whom he regarded as epitomizing the honorable and conscientious aristocrat, "the heir of some fine name who has a wonderful understanding of all the responsibilities bequeathed by his forefathers and who always knows how to discharge them."[93] Displayed side-by-side, these two portraits constituted "an admirable résumé of the principles of the revolution of 1789: the new man and the gentleman of old, the descendant of Mathieu Molé and the creator of a race that was yesterday unknown, walking in step and placed by their high abilities in that sphere which unites every feeling of respect and gratitude due to those who serve their country with all their mental powers."[94] Thus, Ingres's two male portraits functioned not simply as icons of class difference but also offered poignant evidence of the social harmony and reconciliation that allegedly existed under the rubric of a modern, meritocratic regime.

The *Comtesse d'Haussonville* (cat. no. 125) was not exempt from this sociological discourse. The conservative Catholic critic Charles Lenormant regarded the painting of the beautiful young countess as evidence of the aristocracy's induction into the modern meritocracy alluded to by the critic of the *Journal des artistes*: "At the sight of Mme la comtesse d'Haussonville's portrait, is it not immediately apparent that despite every possible right to figure in the most exclusive society, politics have caused her to be born and to live in a world that respects the empire of ideas more than the tyranny of rank?"[95] For the critic of the *Journal des artistes*, the portrait functioned somewhat differently—as a potent reminder of the inevitable perpetuation of class distinctions in modern, post-revolutionary society. "Do you think she was born in some suburb? Behind some shop counter?" he asked rhetorically. "No doubt as much beauty can be found in every class of society, but not this patrician elegance, this delicacy, this polish, which only birth or education imprints on the natures of the elite."[96]

Many reviewers found Ingres's evocation of the comtesse d'Haussonville's social class less engaging than his characterization of her gender. The painting, most agreed, positively breathed feminine grace and elegance. Several went so far as to term the countess coquettish,[97] while the reviewer for the Fourierist *Démocratie pacifique* interpreted the placement of her right arm as Ingres's delicate way of indicating that she was pregnant![98] Still others focused on the portrait's elaborately wrought interior setting as the most potent signifier of the countess's exquisite femininity. "Nothing is more gracious than this portrait of an elegant, witty woman, represented in the midst of the myriad objets d'art or curios that make up her feminine world and in which the delicacy of her taste is expressed," a seemingly smitten critic for the right-wing *Quotidienne* proclaimed.[99] Such an association of the props and accoutrements in Ingres's portrait with a specifically "feminine world" reflects the emergence in France during this period of a consumerist culture largely dominated by women. As the century progressed, economically empowered middle- and upper-class females increasingly based their identity not so much on who they were or what they did but rather on how they spent their money.[100] And while the portrait of the comtesse d'Haussonville is exceptional in Ingres's oeuvre for the sheer extent of its accessorizing,[101] his subsequent portrayals of socially prominent women evince an ever-increasing fixation on elements of costume and jewelry (see, for instance, cat. nos. 133, 134, 145). Not everyone welcomed this development. "M. Ingres is ill adapted to these trifles," the radical republican critic Théophile Thoré complained with regard to the profusion of feminine accessories in the *Comtesse d'Haussonville*.[102] Somewhat more playfully, the anonymous reviewer for the deluxe illustrated magazine *L'Illustration* characterized the inclusion of the countess's reflection along with that of her "coquettish entourage" in the mirror over the mantelpiece as Ingres's concession to the vanity of his beguiling sitter: "What would a man not do to satisfy the whims of a pretty woman?"[103]

THE EXPOSITION UNIVERSELLE (1855)

Almost a decade passed before the general public was afforded another opportunity to judge Ingres's talents as a portraitist.[104] When the Exposition Universelle opened its doors on May 15, 1855, he was one of four French painters (the others were Vernet, Delacroix, and Decamps) who had been invited to stage a multiwork retrospective

for this massive international exhibition.[105] His sixty-nine works, arranged in a gallery specially set aside for the purpose (figs. 301, 302),[106] constituted a spectacular return to the public sphere and provoked a torrent of opinion in the press. Undoubtedly dreading this critical onslaught, Ingres fled the capital only days after the exhibition opened, taking refuge in his new country house in Meung-sur-Loire.[107] He was probably wise to do so, for despite the praise lavished on his works by the *ingriste* party faithful, the Exposition did not generate the kind of universal adulation it has generally been credited with in the art-historical literature. The artist's detractors (and there were many in 1855; see figs. 298, 303) were pressing at the gate, anxious to render their opinion on what many regarded as the most outrageously inflated artistic reputation of the century.

The general themes of the critical discourse on Ingres in 1855 remained what they had been for the past several decades.[108] Die-hard traditionalists hailed him as the keeper of the classical flame, while liberal and progressive critics continued to chide him for an unimaginative dependence on art-historical precedence and to denounce his work as totally incompatible with modern sensibilities. Ingres's reentry into the emphatically public space of the official exhibition also prompted reviewers to reconsider the political implications of his works. This can be seen most clearly in the frequent use of political metaphors to describe his relationship with other luminaries of the contemporary school. Writing in *L'Illustration*, A.-J. Du Pays compared the legendary antagonism between Ingres and Delacroix to parliamentary factionalism: "It is like the right and the left in the old Chambers of Deputies."[109] Similarly, Arthur Ponroy formulated the ongoing rivalry between Ingres and the wildly popular Horace Vernet as that between "absolutist" and "constitutional" painting. Resurrecting the predominant portrayal of the artist from the 1830s, Ponroy cast Ingres as an intolerant despot, "the god and the priest of an artistic religion that acknowledges nothing but docile beliefs or hostile incredulities."[110] Vernet, in contrast, was "very much a free thinker, an eclectic, a liberal, a Voltairean" who sought (partially out of impotence) to follow popular opinion rather than imperiously impose his own ideas upon it.[111]

The writer who took the tendency to politicize Ingres's achievement the furthest in 1855 was the pro-Catholic, Bonapartist critic Eugène Balleyguier. Writing under the pseudonym Eugène Loudun, Balleyguier declared the modern school to be dominated by three personalities,

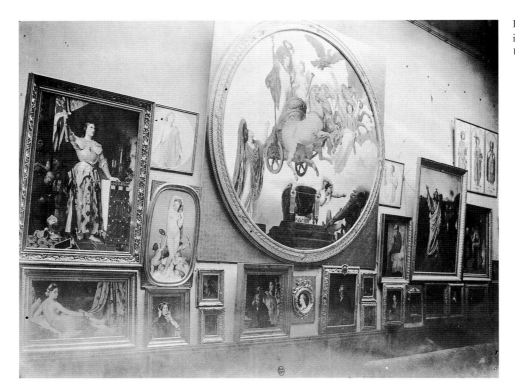

each of whom represented a distinct segment of contemporary French society.[112] Delacroix embodied the Revolutionary impulse; his painting, like revolution itself, was marred by ugliness, brutality, and violence. Vernet, in contrast, was the artist of the peace-and-prosperity-loving bourgeoisie. Targeting his works to the lowest common denominator, he offered optically thrilling but intellectually impoverished replicas of visual reality. Finally,

Ingres was for Balleyguier the perpetuator of a timeless classical ideal, the artist of the social and cultural elite—"that caste which does not seek because it already possesses and which, rare and select, in every nation guards the noble traditions of the beautiful like a sacred trust."[113]

Despite the renewed interest in the political connotations of Ingres's work in 1855, the retrospective format of the Exposition Universelle encouraged many critics to

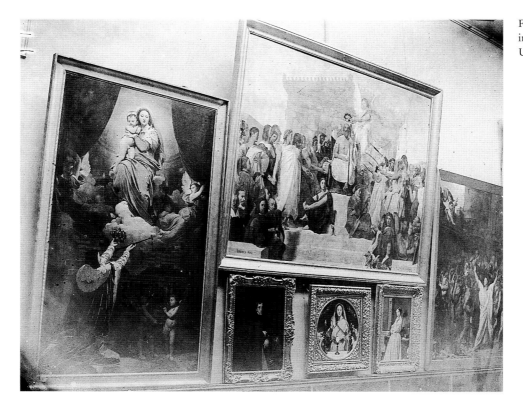

continue to concentrate on the fundamentally ahistorical, apolitical aspects of Ingres's art—to attempt to isolate and explain those personal qualities that "best characterize the master's genius."[114] As in 1846, such discussions tended to focus on the extent to which Ingres's paintings deviated from the exact replication of visual reality. Arguing from the traditional classicist dictum that art must transcend nature, several of the artists's staunchest supporters, such as Gautier and Edmond About, defended his right to interpret what he saw rather than simply imitate it.[115] That something less conventional, more personal, was also being detected in Ingres's work is demonstrated by the remarks of Vicomte Alphonse de Calonne, the conservative but certainly not unimaginative critic for the *Revue contemporaine*. For Calonne, Ingres deviated from the standard classicist routine of selecting and recombining the most beautiful parts of nature; rather, he projected his own particular, internally generated ideal on the world around him: "He willfully takes up again the work of the great creator and reshapes the human body in his image, or, to be more accurate, in the image of the god that he harbors within himself."[116] Thus Calonne, like several of his predecessors in 1846, locates the essence of Ingres's art not in its mimetic truthfulness but in its expression of a highly personalized aesthetic ideal.

Of course, the greatest theoretician of artistic individuality in 1855 was the arch-Romantic champion of the imagination, Charles Baudelaire. *"The beautiful is always bizarre,"* the poet emphatically declared in the introduction to his review of the Exposition Universelle. "I do not mean to say that it should be coldly, deliberately bizarre, for in that case it would be a monster that had jumped the tracks of life. I am saying that it always contains a little bizarreness, a naive, unintentional, and unconscious bizarreness, and that it is this bizarreness that particularly makes it Beautiful."[117] Baudelaire regarded such "bizarreness" not only as a necessary component of beauty but also as the ultimate expression of both historical specificity and artistic individuality—the inevitable by-product "of the milieus, regions, customs, race, religion, and temperament of the artist."[118] It is to art what taste is to food, and without it one painter's works could not be distinguished from those of any other.

Although Baudelaire's assessment of Ingres's contribution to the Exposition Universelle was informed by the standard Romantic denigration of Ingres as an unimaginative pasticheur, the critic could hardly overlook the formal oddities characterizing the painter's canvases. At times, in fact, he verges on overtly celebrating the "freakishness"

—Ah! mon Dieu, qu'est-ce que c'est que ça! — Il paraît que c'est un monsieur qui s'est trouvé gelé dans la salle réservée de M. Ingres....

Fig. 303. Nadar (Félix Tournachon; 1820–1910). "—Ah! mon Dieu, qu'est-ce que c'est que ça?—Il paraît que c'est un monsieur qui s'est trouvé gelé dans la salle réservée de M. Ingres. . . ." (Good God, what's that?—It seems to be a gentleman who froze in the Ingres room.) *Le Journal pour rire*, October 13, 1855

of Ingres's painting, contending that, while the artist's reputation with "high society" was founded upon his supposed perpetuation of the classical ideal, "the eccentric, the blasé, the myriad fastidious minds always in search of novelty . . . were pleased by his bizarreness."[119] In the end, however, Baudelaire's begrudging admiration of Ingres's eccentricities could not overcome his revulsion for what he otherwise regarded as the artist's complete lack of imagination. After cataloguing the anatomical distortions in Ingres's canvases at the Exposition Universelle—"an army of fingers elongated too uniformly into spindles, with narrow tips that crush the nails, . . . arms too sturdy, too full of Raphaelesque succulence, . . . a navel that strays toward the ribs, . . . a breast pointing too far toward the armpit"—Baudelaire concludes that the bizarreness of the artist's work arises from an "immoderate taste for *style*."[120] Thus, Ingres's painting does not display the "naive, unintentional, and unconscious bizarreness" that is an essential ingredient of beauty but rather the cold, calculated strangeness that can result only in monstrosities. Indeed, at one point Baudelaire chillingly compares the

effects of Ingres's canvases to the light-headedness caused by the rarefied air of a chemical laboratory; the artist's contorted, distorted figures constituted for the poet "a population of automatons that disturbs our senses by its all too visible and palpable strangeness."[121]

Fifteen of Ingres's sixty-nine works at the Exposition Universelle were portraits, the largest number ever to be exhibited during his lifetime. They received an unprecedented amount of critical attention and, as with almost everything else pertaining to the artist in 1855, were the subject of intense critical debate. Ingres's supporters hailed his ability to penetrate to the very souls of his sitters, capturing their spiritual as well as physical likenesses.[122] Many admirers celebrated the elevated, generalized quality of the portraits as evidence of Ingres's transcendence of vulgar materialism, while others concentrated on their "speaking" likenesses[123] and meticulous detail as a gauge of his professional conscientiousness.[124] The reactions of Ingres's detractors were more uniform—and infinitely more entertaining. Practically all the anti-ingristes agreed that his portraits were stiff and colorless, his figures so completely devoid of life as to resemble mannequins or waxworks more than living human beings.[125] Indeed, it was almost as if some sort of informal contest had been declared to see who could devise the most imaginatively devastating characterizations of the artist's "dead portraits."[126] Not to be outdone by Baudelaire's comparison of Ingres's figures to an unearthly population of automatons, Paul Mantz claimed that to move from the celebrated portraits of the Venetian and Flemish masters to those of Ingres was like leaving a "never-ending festival that offers sunshine, movement, living nature, to enter, suddenly melancholy and chilled, the cold rooms of a hospital for lymphatic or bilious patients."[127] The palm for writing the most rhetorically virtuoso denunciation must, however, be given to the brothers Goncourt. Where was the animating "moral life," the elevating "intelligent beauty" of Ingres's art-historical heroes, they wondered before his canvases on display in 1855:

> Is it in these mute images of women, these cold busts, these silent countenances, these dead portraits so far surpassed by the portraitist Coignet [sic]? Is it in these pathetic miniatures of the aristocracies and beauties of woman . . . in which the swollen oval of the face is deformed by sickly jowls, in which the cheekbone is painted violet, in which the figure neither turns nor develops in the round, coated from one contour to the other with a flat tint, without tonal modeling—a linear facsimile and not a living mirror of the face and the radiance of the soul.[128]

Whatever disagreement there was over the quality of Ingres's portraits in 1855, the Exposition Universelle inaugurated a widespread tendency among critics to regard them as superior to all his other productions. "The portrait is his triumph," Charles Duval declared, voicing a sentiment that was echoed throughout the press, whether pro- or (somewhat more begrudgingly) anti-ingriste.[129] This elevation of Ingres's portraits over his subject paintings—the former had long been admired, but only in 1855 did they begin to be consistently regarded as his masterpieces[130]—is attributable at least in part to the recent emergence of Realism as the latest manifestation of the artistic avant-garde. Since at least the late 1840s, naturalism and contemporaneity had been the rallying cries of the most advanced artistic and critical factions in Paris, as the Romantics' extravagant colorism and high-keyed emotionalism had come to be regarded as scarcely less relevant to modern life than the bloodless academic work of the Neoclassicists.[131] Of course, no one in 1855 was prepared to portray Ingres as an avant-garde Realist; Baudelaire came the closest, perhaps, in his famous—and purposely outrageous—coupling of Ingres and Courbet as the most prominent "immolators" of the artistic imagination in the contemporary school.[132] Still, it is certainly not coincidental that two of the most outspoken advocates of an emphatically modernist, Realist aesthetic in 1855—the republican critics Maxime Du Camp and Pierre Petroz—were also enthusiastic admirers of Ingres's portraits. The superiority of these works, both critics argued, lay in the way they prevented Ingres from indulging in the retrogressive, historicizing pursuits that normally marred his subject pictures. "There he has reached the summum of art," Du Camp declared, "for the very simple reason that he has reproduced honestly what he has seen, without viewing it and understanding it through his memories of Raphael."[133] Petroz concurred, attributing the excellence of Ingres's portraits to the fact that, "placed in direct communication with nature, he forgets his system, allows himself the spontaneity of his impressions, recovers all his verve and dexterity as a practicing artist."[134] Thus, however dubious Ingres's credentials as a subject painter, as a portraitist he was "the leader in the contemporary school, perhaps the only one."[135]

This heightened appreciation of the visual acuity informing Ingres's portraits was used by several of his more fanatical antagonists to indict his shortcomings in other, ostensibly more demanding artistic spheres. Georges Niel prefaced his assessment of the portraits with a declaration of Ingres's "inadequacy for large-scale compositions."[136] To be a successful history painter, Niel

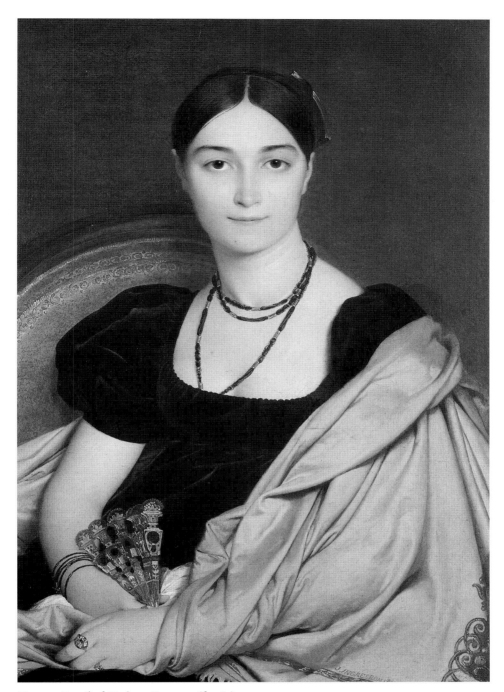

Fig. 304. Detail of *Madame Duvaucey* (fig. 87)

argued, one had to be "an artist of genius, . . . a great poet," but Ingres was simply "a studious spirit."[137] The critic who insisted most forcefully that Ingres's superiority as a portraitist was the by-product of his inferiority as a history painter was the obscure Théodore Labourieu, of *Le Moniteur dramatique:*

> As a painter M. Ingres—and posterity will say this of him—is no more than a very able portraitist, a very faithful reproducer of still lifes. By dint of patience, trial and error, and analyses, he manages to forage, like Balzac, up to the field of truth. By chance he is

surprised to discover in himself the genius of Raphael and Molière; but then the air he breathes in this lofty region becomes too heady, too pure, too plentiful for his ailing lungs and vitiated nature. And so he hastens to return to the restricted atmosphere in which he can live at ease, that is, into his painting as a copyist, before a portrait, a jewel, a cashmere shawl, which this time he renders easily down to the finest traits, the finest lines, the finest thread.[138]

This remarkable passage brings together many criticisms long applied to Ingres: his fundamental lack of genius and

imagination, the all-too-apparent laboriousness of his working method, his obsessively niggling style and fetishization of insignificant details. What sets Labourieu's analysis apart, however, is its molding of these critiques into a sweeping denunciation of what can only be described as Ingres's Realism, which is negatively defined as the inability to cope with anything beyond the most mundane realities of the visual here-and-now. Ingres thus found himself in a no-win situation in 1855: damned if he attempted to perpetuate the classical ideal of Raphael and the ancients, damned if he remained content to record as meticulously as possible the visible world around him.

Ingres's critical fortune over the past century and a half seems to have confirmed Labourieu's contention that it is primarily as a portraitist, as well as something of a Realist manqué, that the artist would be remembered. Another assertion repeatedly made in 1855—that Ingres was a better portrayer of men than of women—has proved far less prophetic. "In his portraits of women, the artist, it seems to us, is less able or less fortunate," Félix Mornand contended in the *Journal des demoiselles*. "His rigid, uncompromising brush either renders grace badly or fails to supply it where it may be wanting."[139] Such opinions help explain the otherwise surprising fact that, of Ingres's seven female portraits at the Exposition Universelle, only one, the early *Madame Duvaucey* (figs. 87, 304), elicited real critical enthusiasm. In this singular instance, however, the reviewers were of the same mind. "This is not a portrait that gives pleasure," About exclaimed, "it is a portrait that gives rise to dreams."[140] Calonne was even more effusive, declaring *Madame Duvaucey* "a masterpiece that time has made the equal of the most beautiful heads by Perugino, Leonardo, or Raphael."[141] Even the most uncompromising of Ingres's detractors fell under the painting's spell. The celebrated photographer and virulently anti-*ingriste* art critic Nadar begrudgingly admitted that *Madame Duvaucey* contained "a charm of real intimacy,"[142] while Paul Mantz declared it the only work by Ingres "that strikes a sympathetic chord in me."[143] As these remarks suggest, it was not so much the style of the portrait that attracted reviewers but what was universally regarded as the almost disconcertingly enigmatic charm of the sitter. Gautier, whose enchantment with the painting dated back more than two decades,[144] offered what was perhaps the most evocative analysis of the picture's beguiling appeal:

M. Ingres has arrived at a terrifying intensity of life: these black, steady eyes beneath the slender arc of the eyebrows enter your soul like two jets of flame. They

follow you, they haunt you, they charm you (in the magical sense of the word). The imperceptible smile that hovers on the thin lips seems to mock your impossible passion, while the hands make a pretense of playing distractedly with the tortoiseshell leaves of a small fan, signifying utter indifference.—This is no woman that M. Ingres has painted, but the likeness of the ancient Chimera, in Empire dress.[145]

As for Ingres's male portraits, reviewers continued to regard *Monsieur Bertin* (cat. no. 99) as his undisputed masterpiece. The always enthusiastic Calonne proclaimed the painting not only Ingres's greatest work but "the most notable piece of art that our century has produced."[146] Almost in spite of themselves, critics continued to be attracted to the painting's mesmerizing trompe-l'oeil illusionism. Planche, who in 1833 had ridiculed the crowd's untutored enthusiasm for the portrait, declared it a "real resurrection" of the sitter, who had died in 1841.[147] About likewise marveled at the astounding illusion of Bertin's girth: "The figure as a whole is surprisingly three-dimensional," he exclaimed, "to walk around it would be quite a trip."[148] Other reviewers found the principal appeal of *Monsieur Bertin* to be the way in which it encapsulated an entire era of modern French history. "This is the clearest, most accurate, and most striking image that could be given of the bourgeoisie in power from 1830 to 1848 . . . ," Calonne declared, perpetuating the sociological reading of the painting inaugurated nine years earlier on the boulevard Bonne-Nouvelle. "This painting is more than a work of art, it is a symbol."[149] Again, it is Gautier who gives the most piquant assessment of this aspect of Ingres's portrait: "Is this not the revelation of an entire epoch, this magnificent pose of M. Bertin de Vaux [sic] resting his fine, strong hands on his powerful knees, like a bourgeois Caesar, with all the authority of intelligence, wealth, and justifiable self-confidence? . . . This is the *honnête homme* under Louis-Philippe, and the six volumes of Dr. Véron can tell us no more about that vanished epoch."[150] Ingres's portraits thus continued to be the one area of his production that consistently forced critics to incorporate social and political considerations into their critiques. It is perhaps the ultimate testament to the artist's prowess as a portraitist that, when confronted with such a powerful effigy as *Monsieur Bertin*, many critics in 1855 all but forgot "Monsieur Ingres."

The Exposition Universelle represents the final chapter in the history of the critical reception of Ingres's paintings during his lifetime. Even though some of his works continued to be shown in his studio and in the private

galleries that had begun sprouting up along the boulevards, these sporadic forays into the public domain failed to garner much critical attention.[151] It would appear that the almost cathartic venting of opinion in 1855 on the venerated but controversial artist had exhausted the critics and finally induced them to move on to other, more topical concerns. Even the innovative exhibition of more than one hundred of Ingres's drawings (many of them portraits) at the exclusive Salon des Arts-Unis in 1861 failed to create much of a stir.[152]

Such semineglect probably suited the aging and increasingly reclusive artist just fine. In the wake of the Exposition Universelle he had been elevated to the rank of grand officer in the Legion of Honor, the first artistic or literary figure to achieve that status.[153] Seven years later, in May 1862, he was appointed to the Senate by Napoleon III. Ingres must have felt that he had nothing else to prove, that his reputation had been secured. Of course, this belief proved to be illusory: with his death and the massive memorial exhibition in 1867,[154] the process of assessing and reassessing his achievement began all over again. It continues to this day, as every succeeding generation of critics—and, now, historians—constructs the Ingres that best suits its needs and desires. Romantic rebel, despotic Classicist, would-be Realist . . . the critical personae continue to accumulate.

1. A comprehensive history of French art criticism has yet to be written. The best introduction is Wrigley 1993; see also Bouillon 1989, Bouillon et al. 1990, and Orwicz 1994. Indispensable to any investigation of nineteenth-century French art criticism are the bibliographies of Salon reviews in Parsons and Ward 1986, McWilliam 1991, and McWilliam, Schuster, and Wrigley 1991.

2. Literature on the nineteenth-century French press is vast. Most helpful to this study have been Hatin 1859–61, Collins 1959, Bellet 1967, and Bellanger et al. 1969.

3. For most of the nineteenth century, the Salon was held either annually or biennially. Until 1848 it was housed in the Louvre; thereafter it was held at various other locations until 1857, when it was permanently transferred to the cavernous Palais de l'Industrie. See Mainardi 1993, table I, pp. 18–19.

4. Wrigley 1993, p. 80.

5. "Il me racontait que la critique le rendait fou; qu'on lui avait fait beaucoup de mal, que sa mémoire était si rancuneuse qu'elle se souvenait des moindres mots hostiles écrits contre lui depuis cinquante ans, qu'il exécrait ses ennemis et que, s'il leur arrivait malheur ça lui faisait du bien." Madame Lacroix to an unnamed correspondent, undated, reprinted in Boyer d'Agen 1909, p. 44. Paul Lacroix was the cousin of Ingres's second wife, Delphine; see Naef 1977–80, vol. 3 (1979), p. 492.

6. In the aftermath of the declaration of the Second Empire in December 1852, Ingres addressed a letter to his friend Charles Marcotte (see cat. no. 26) complaining of the "infernal demagoguery" ("infernale démagogie") that had been perpetuated by the liberal press. See Schlenoff 1956, p. 187.

7. In 1840 Ingres sent a note to the critic Eugène Pelletan, via his favorite pupil, Hippolyte Flandrin, thanking him for a positive review of *Antiochus and Stratonice* (fig. 194); Ingres to Flandrin, dated December 8, 1840, reprinted in Ternois 1962, p. 21. (For the article in question, see Pelletan, August 22, 1840.) On April 13, 1861, Ingres presented Théophile Gautier with a sheet of sketches (private collection, London; Paris 1971, no. 39) relating to *The Turkish Bath* (fig. 220), in appreciation, perhaps, for the critic's adulatory review of *La Source* (fig. 202), which had appeared in the official *Moniteur universel* only two months earlier; see Lapauze 1911a, pp. 519–20, and Gautier, February 18, 1861. Five years later, Ingres gave Gautier an even more extravagant gift—a revamped study (W 324; Musée des Beaux-Arts, Angers) for several figures in *The Apotheosis of Homer* (fig. 315).

8. That Ingres was aware of the professional advantages to be culled from a relationship with Bertin is clear from his advice to Flandrin at a particularly crucial juncture in the young artist's career: "You will see Papa Bertin, won't you? He is an excellent man, and you must *be there*." ("Vous verrez papa Bertin, n'est-ce pas; c'est un excellent homme, et il faut *être là*.") Ingres to Flandrin, dated November 22, 1838, reprinted in Ternois 1962, p. 13. Ingres was also personally acquainted with the principal art critic of the *Journal des débats*, Étienne Delécluze, whose portrait he drew in 1856 (N 440; Fogg Art Museum, Cambridge, Massachusetts, inv. 1943.849).

9. A comprehensive study of Ingres's critical reception has yet to be written. However, three unpublished Ph.D. theses consider the subject during various phases of the artist's career. For the early period, see Siegfried 1980a and Lee 1995; for the middle decades, see Shelton 1997.

10. Ingres's correspondence is full of disparaging references to his obligations as a portraitist, particularly during the middle years of his career; see, for example, the passages from various letters reprinted in Boyer d'Agen 1909, pp. 300–301, 302, 349, 363, 379–80, and 388.

11. "Les portraits pleuvent au Salon; toutes les salles en regorgent; tout le monde a le sien, tous les artistes ont fait de leur. C'est une épidémie, une endémie, une contagion." Ballard 1833, p. 11.

12. For an analysis of the politicization of art criticism in the early nineteenth century, see Siegfried 1994.

13. For a groundbreaking analysis of how assumptions about ethnicity affected the critical reception of one of Ingres's portraits, see Ockman 1995, pp. 67–83.

14. "Aujourd'hui, voici les arts tels que la révolution nous les a faits; les voici dans toutes la splendeur dont les ont dotés les munificences de la liste civile, le goût éclairé du roi-citoyen, et le patronage de M. d'Argout . . . La peinture s'est réfugiée, cette année, dans le *tableau de genre* et dans le *portrait*. . . . La rue Saint-Denis a fait irruption au Louvre; la vie privée s'est emparée du salon. Voici des propriétaires en profil, des manufacturiers qui vous regardent en face, des fabricans de chandelle en grande tenue de sergent-major, avec leur croix d'honneur, qu'ils ont recommandé de faire bien large et bien apparente." Anon., March 16, 1833a, pp. 245–46. Apollinaire-Antoine-Maurice d'Argout, former director of fine arts, was minister of the interior from December 1832 to April 1834.

15. For examples of provocative, "deconstructive" analyses of the critical and art-historical writing on Ingres, see Rifkin 1983 and Ockman 1995.

16. Paris (Salon) 1802, no. 719.

17. "Lecteurs, faites-nous grâce de celui-ci, nous ne savons qu'on dire . . ." Anon. 1802, p. 159. Lapauze (1911a, pp. 37–38) identifies the portrait of the comtesse de La Rue (W 13) as the painting Ingres exhibited at the 1802 Salon. This cannot be the case, however, since, as Wildenstein (1954) points out, the Zurich canvas is dated "An XII" (1803–4).

18. The painting in Chantilly (fig. 209), generally identified as the work shown in 1806, was radically reworked by Ingres sometime before 1851. The approximate appearance of the canvas is preserved in an etching (fig. 281), a photograph by Charles Marville (fig. 282), and two copies, one made by Julie Forestier, the other by Ingres's studio (cat. nos. 11, 147).

19. Paris (Salon) 1806, nos. 272, 273. It has traditionally been assumed that Ingres exhibited *Monsieur Rivière* (fig. 57) at the Salon of 1806 as well. The complete silence of the critics on this work has more recently led scholars to suggest that it was withheld from the exhibition, perhaps for political reasons (Monsieur Rivière was a well-known royalist); see Naef 1972 ("Famille Rivière"), p. 193, n. 1. However, as Hélène Toussaint has noted, the critics' failure to discuss the painting might have been a function of its conventionally Davidian style; see Paris 1985, p. 25. There is no evidence to support Delaborde's contention (1870, p. 24) that Ingres exhibited the portrait of his father (cat. no. 4) at the 1806 Salon.

20. This controversial thesis was put forward by Siegfried (1980a, p. 49, and 1980b, p. 69) and has been accepted by Rosenblum (1985, p. 68). It has also been resisted, particularly by the French, including Foucart (1983, pp. 84–85) and Toussaint (in Paris 1985, p. 35).

21. "rétrograder l'art." Chaussard 1806, p. 178.

22. "N'est-ce pas un idée trop bizarre que de vouloir faire revivre l'ancienne manière roide et gauche des premiers peintres du temps de la renaissance des arts? C'est ce que fait M. Ingres; il affecte une grande sévérité de pose et de dessin, et il prend pour de la grandeur, ce qui, au fait, n'est que de la *manière*. . . . Le portrait de l'Empereur, par ce peintre, paroît avoir été fait d'après une médaille gothique; il est accablé d'une quantité de draperies qui ne laissent pas soupçonner qu'il y ait dessous un corps, et la tête paroît posée sur des coussins." Clarac 1806, pp. 126–27.

23. For a detailed analysis of the possible political motivations behind the attack on Ingres's painting, see Siegfried 1980a, pp. 61–88, and Siegfried 1980b. Lee (1995, p. 94) explicitly denies that politics played any role in the picture's reception.

24. It has been suggested that the exhibition of Lefèvre's portrait, which was already hanging in the Senate, was instigated by Dominique Vivant Denon, director of the imperial museums, specifically to hurt Ingres's chances for success; see Lee 1995, p. 87. Whatever the case, Ingres harbored a lifelong hatred of this official, whose seat in the Académie, ironically enough, he eventually came to occupy.

25. "Un peintre, dont la tête à cheveux noirs et durs, se détache en découpure sur une grande toile blanche; l'artiste vêtu en noire et recouvert d'une redingote blanche essuie avec un mouchoir très-blanc; ce qui fait blanc sur blanc." Anon. 1806, p. 22.

26. "l'expression sombre et farouche"; "doit prodigieusement le gêner dans le feu de la composition, et dans l'espèce de crise que son génie paroît éprouver." Anon., October 11, 1806 (C.), p. 77.

27. "peinte sans ombres et si enveloppée de draperies, qu'on est longtemps à deviner avant d'y reconnoître quelque chose." Clarac 1806, pp. 127–28.

28. "une dame toute en blanc, schall blanc sur une robe blanche, tête et bras blancs mêlés d'un peu de couleur rose." Anon. 1806, pp. 22–23.

29. "une dame que nous savons être un modèle de grace et de décence." Chaussard 1806, p. 181.

30. "On ne s'arrête point assez devant le portrait d'une jeune personne . . . où les défauts de la manière adoptée par l'auteur sont beaucoup moins sensibles que dans ses autres ouvrages." Boutard, October 4, 1806.

31. "Le sujet devait l'inspirer: c'est une jeune et belle personne . . . fraîche comme le bouton de rose, et qui semble appeler les pinceaux de Corrège." Chaussard 1806, p. 182.

32. "Imbéciles, vous louez davantage l'ouvrage que je crois de mes ouvrages, celui où il y a tout à faire pour arriver aux beautés sublimes que demande cet âge et ce sexe." Ingres to Pierre Forestier, reprinted in Lapauze 1910, p. 62.

33. "Le Salon est donc le théâtre de ma honte? . . . D'un jour à l'autre, suis-je changé de peintre distingué en un homme dont on ne peut regarder les ouvrages?" Ingres to Pierre Forestier, October 22, 1806, reprinted in Lapauze 1910, p. 44.

34. "Oui, l'art aurait bien besoin qu'on le réforme, et je voudrais bien être ce révolutionnaire-là." Ingres to Pierre Forestier, November 23, 1806, reprinted in ibid., p. 61.

35. "l'ambition me dévore." Ibid., p. 63.

36. It appears that only one portrait, that of Ingres's friend Charles Marcotte (cat. no. 26), was among the artist's contributions to the Salons of 1814 and 1819. This painting, submitted in 1814, went almost completely unnoticed by reviewers; see Boutard, November 11, 1814, p. 184, and Anon., February 15, 1815 (M.). For a general assessment of the critical reception accorded Ingres's works in 1814 and 1819, see Siegfried 1980a, pp. 264–98, 349–74, and Lee 1995, pp. 103–43.

37. On the influence of Raphael on Ingres's artistic production after 1820 and its impact on his critical reception at the 1824 Salon, see Siegfried 1980a, pp. 374–416.

38. See pp. 274–75 in this catalogue.

39. Paris (Salon) 1824, no. 925. Although the *livret* lists Ingres as having exhibited "portraits," the critics mention only *Norvins*.

40. "Ce n'est qu'un portrait bien simple; mais, à la vigueur du dessin et du modelé, à la puissance d'expression que l'artiste a concentrée sur le visage, à ce calme et à cette grandeur qui règnent dans la disposition des lignes et de la lumière, on reconnoît l'ouvrage de ce qu'on peut vraiment appeler un peintre d'histoire." Delécluze, December 12, 1824.

41. "De ce rapprochement, je tire la conclusion que ces habiles peintres nous ont donné chacun avec son talent, l'un, M. Ingres, un excellent ouvrage dans ce que nous avons nommé le style homérique, l'autre, M. Horace, un fort beau tableau, dans le genre *shakespearien*; que l'un cherche le *vraisemblable*, que l'autre n'admet que le *vrai*; que M. Ingres n'aura pour appréciateurs, qu'un petit nombre de connoisseurs, tandis que la nouvelle production de M. Horace aura un succès de vogue." Ibid.

42. "le style grand, élevé et simple." Ibid.

43. "Quelle hardiesse dans ce siècle, où la timidité a tué le *coloris*, que de faire ressortir la figure du personnage sur un fond rouge." Stendhal 1867, p. 245.

44. "une foule de portraits forts beaux." Ibid., p. 246.

45. See Paris 1827 (Salon), nos. 575, 576. The reviewers were virtually silent on the portrait of Madame Marcotte de Sainte-Marie (cat. no. 97), while that of the comte de Pastoret garnered a bit more critical attention, largely because of the notoriety of its sitter (see cat. no. 98).

46. According to Lenormant (1833, vol. 2, pp. 158, 164), Ingres planned to exhibit "a portrait of 1823" ("un portrait de 1823") at the 1833 Salon as well, but it could not be delivered to Paris in time. This is undoubtedly the portrait of Madame Leblanc (cat. no. 88), which would be exhibited the following year (see p. 504 and n. 67, below).

47. "se laisse prendre au charme de la vérité. Elle étudie, selon ses forces, les détails de la tête, rendus avec une si prodigieuse conscience; elle examine attentivement, avec une joie presque puérile, la réalité des étoffes, la saillie du fauteuil; elle s'extasie devant l'attitude, si simple et si puissante à la fois; elle ne se lasse pas de contempler avidement les yeux et les lèvres si pleins de regard et de parole." Planche 1833, pp. 88–89.

48. "Il est impossible de pousser la vérité plus loin. C'est . . . un portrait en chair et en os, un portrait qui marche et qui parle." Anon. 1833b, p. 130.

49. "une étude minutieuse et microscopique." Maynard 1833, p. 58. Robert Rosenblum (1967a, p. 137) first compared *Monsieur Bertin* to portraits by Denner on the basis of Maynard's remarks.

50. "Voici, à ce sujet, un mot bien vrai du peintre à son modèle: *Monsieur, je vous fatigue;* et la réponse peut-être sublime du modèle: *Je vous en défie.*" Maynard 1833, p. 58.

51. "le dieu du dessin." Anon., April 3, 1833 (E.). Compare Gautier 1833, p. 152: "He has become a legend. He is the personification of drawing, as Decamps is that of color." ("Il est devenu un mythe; c'est la personnification du dessin, comme Decamps est celle de la couleur.")

52. See, for instance, Anon., March 10, 1833 (H. H. H.): "The cold and systematically drab flesh tones bear no sign of belonging to any kind of life." ("Les carnations froides et systématiquement terreuses ne portent l'indication de l'être d'aucune nature."); Anon., March 15, 1833: "But do you not see . . . a certain monotony of color, which robs the flesh of its vigor and the picture of its brilliance?" ("Mais . . . ne voyez-vous pas je ne sais quelle monotonie de couleur, qui ôte à la carnation sa vigueur, au tableau son éclat?"). Even Delécluze (March 22, 1833) noted that Ingres's color lacked transparency but excused this as a fault that plagued many great draftsmen.

53. "M. Ingres, c'est la copie." Maynard 1833, p. 69; see also Planche 1833, pp. 89–91. A few critics did, however, recognize *Bertin* as signaling a stylistic shift in Ingres's art. Laviron and Galbacio (1833, p. 62), for instance, accused the artist of exaggerating Rubens in his pursuit of a modish naturalism!

54. See Angrand 1982.

55. These rumors are referred to in Anon., March 8, 1833; Anon., March 9, 1833; Cazalès 1833, p. 302; and Maynard 1833, p. 58.

56. "M. Ingres est exclusif, il n'y a pas de mal, tant que cette exclusion ne se manifeste que le pinceau à la main; mais si M. Ingres est consulté par le pouvoir qui récompense et encourage, qu'arrivera-t-il? Que tout ce qui blessera les susceptibilités de goût de M. Ingres sera proscrit." Anon., March 9, 1833.

57. "homme distingué qui a créé à lui seul toute la presse politique." Anon. 1833b, p. 130.

58. "défenseur le plus habile du gouvernement actuel"; "l'avocat du *juste-milieu*"; "un peintre de *juste-milieu*." Anon., March 28, 1833, p. 45.

59. The title is a reference to the name not of Ingres's sitter, Bertin *l'aîné*, but rather that of his younger brother and copublisher of the *Journal des débats*, Bertin de Vaux. (There was much confusion over the names of the two men.) The transformation of *Bertin* into *Bêtin* is a play on the French words for stupid or brute *(bête)* and cretin *(crétin)*.

60. "l'improstitution de la presse"; "l'improstitution parlementaire." Anon., May 15, 1833.

61. See, for instance, Anon., March 10, 1833 (H. H. H.), and Hauréau, March 20, 1833.

62. See, for instance, Anon., March 16, 1833b; Mennechet 1833, pp. 127–28; and Pillet, March 19, 1833.

63. "Il y a dans ce portrait une telle sainteté de lignes, une telle religion de la forme dans les moindres détails, le faire en est si primitif, que l'on a toutes les peines du monde à croire que cela ait été peint en plein règne de David, il y a quelque vingt ans." Gautier 1833, p. 153.

64. See, for instance, Anon., March 9, 1833; Anon., March 15, 1833; and Laviron and Galbacio 1833, p. 63.

65. "Toute la tête vit et remue, et cela sans le prestige de la couleur, avec un simple ton local, habilement gradué selon les formes et le mouvement, que nous préférons beaucoup, pour notre part, au tricot prismatique dont l'école de Gros revêt ses personnages, et qui nous semble incontestablement plus vrai et plus agréable à l'oeil." Gautier 1833, p. 153.

66. For a detailed analysis of the critical reception of *Saint Symphorian*, see Shelton 1997, pp. 32–104.

67. "Je ne puis croire, que ce monstre, sans dessus de tête, aux yeux orbiculaires, aux doigts saucissonnés, ne soit pas la déformation perspective d'une poupée, vue de trop près, et réfléchie sur la toile par plusieurs miroirs courbes appliqués, sans ensemble à chacun des détails." Vergnaud 1834, p. 17.

68. See Anon., November 26, 1834 (H.); Farcy 1834; and Thoré, November 16, 1834.

69. For a detailed analysis of Ingres's studio exhibitions from 1841 through 1854, see Shelton 1997, pp. 245–98, 381–404, 444–76.

70. See Anon., March 10, 1842; Anon., April 28, 1842; Lenormant 1842; Stern, January 7, 1842; Thoré 1842; Varnier 1842; and Damay 1843.

71. See Anon., August 7, 1848; Anon., August 13, 1848; Anon., August 15, 1848 (L.); Gautier, August 2, 1848; Geofroy 1848; and Champfleury 1894, pp. 112–15, 141–50.

72. In a letter dated January 31, 1852, to Comte Alfred-Émilien Nieuwerkerke, Directeur Général des Musées Impériaux, Ingres announced that the portrait of Madame Moitessier would be on view at his residence at 17, quai Voltaire for two days. He also mentioned a second portrait, which could be seen for only a day in his studio at the Institut; see Lapauze 1911a, p. 446. This is almost certainly *Madame Gonse*, which was finished around this time. Press notices mention only the Moitessier portrait, however; see Galimard 1852 and Galimard, February 28, 1852.

73. For the works shown in this exhibition, see Naef 1973 ("Exposition oubliée") and Shelton 1997, pp. 474–75. For contemporary reaction, see Anon., December 16, 1854 (A. de G.), and Delécluze, December 8, 1854.

74. See Burty 1864.

75. For the Société des Artistes and the organization of the 1846 exhibition, see *Le Baron Taylor* 1995.

76. See the letter from Ingres to Baron Taylor, December 11, 1845, reprinted in ibid., p. 124.

77. For one-person exhibitions held in France prior to 1846, see Shelton 1997, pp. 350–52. For the development of retrospectives after mid-century, see Jensen 1994, pp. 107–37.

78. This painting was later reworked and exhibited at the Salon of 1827; see Paris 1967–68, no. 35.

79. The other works on display were the *Grande Odalisque* (fig. 101), *The Sistine Chapel* (fig. 100), *Philip V of Spain and the Marshal of Berwick* (W 120), *Paolo and Francesca* (fig. 103), *The Entry into Paris of the Dauphin, the Future Charles V* (fig. 136), *Monsieur Bertin* (cat. no. 99), the *Comte Molé* (fig. 158), *Antiochus and Stratonice* (fig. 194), and the *Odalisque with Slave* (fig. 190). In addition, drawings after three of Ingres's most famous history paintings—*The Martyrdom of Saint Symphorian, The Vow of Louis XIII,* and *The Virgin with the Host* (the latter two by the engraver Luigi Calamatta [see cat. no. 105])—hung in the vestibule of the main gallery; see Paris 1846, nos. 43–53, 93–95 (supplement).

80. "Jamais exposition ne fut aussi favorable à M. Ingres que celle-ci; c'est que jamais on ne peut aussi bien l'étudier et le comprendre, parce que jamais on ne vit réuni un aussi grand nombre de ses plus belles oeuvres." Jal 1846, p. 202.

81. "M. Ingres étale fièrement dans un salon spécial onze tableaux, c'est-à-dire sa vie entière, ou du moins des échantillons de chaque époque,—bref, toute la Genèse de son génie." Baudelaire 1990, p. 92.

82. "Les portraits de M. Ingres, comme ceux de tous les grands maîtres, ne sont pas des imitations matérielles et mesquines de la nature. En effet, si le peintre se posait pour but une reproduction textuelle de ce qu'il a devant les yeux, ce serait concéder implicitement que le daguerréotype est l'expression la plus parfaite de l'art. Le portrait, si j'en crois les maîtres, est la nature interprétée. Ces génies de la peinture sont les commentateurs qui nous expliquent le livre ouvert devant nous avec une éloquence personnelle, et qui nous en font envisager les beautés sous l'aspect que leur découvre la profondeur de leur intelligence." Amaury-Duval 1846, pp. 89–90. Compare Baudelaire (1990, p. 93), who claims that Ingres's portraits are "true portraits, that is to say, the ideal reconstruction of the individuals" ("de vrais portraits, c'est-à-dire la reconstruction idéale des individus").

83. "Chaque peintre a un éclectisme différent, un coup d'oeil qui lui est propre; c'est ce qui fait qu'il est autant de variétés de portraits que de peintres, et que le même modèle peut être présenté sous autant de physionomies qu'il y a d'artistes, toutes dissemblables entre elles, et cependant toutes vraies au même degré. Ce qui est particulier aux maîtres, c'est qu'ils nous imposent leur manière de voir la nature; ce côté que vos yeux inexpérimentés n'avaient point su trouver ils vous le révèlent tout d'un coup." Amaury-Duval 1846, p. 90.

84. "renversant l'ordre des choses." Ibid.

85. See, for instance, Anon., February 11, 1846 (C. A. D.), and Ver-Huell, January 20, 1846.

86. "M. Ingres a probablement recherché"; "toute choquante qu'elle puisse être." Jal 1846, p. 202.

87. "bizarreries de dessin"; "toutes autres choses que des incorrections." Lagenevais 1846, p. 539. Mercey's justification of Ingres's "bizarreries" is challenged in d'Arnaud 1846.

88. This issue is treated more fully in Shelton 1997.

89. See, for instance, Jal 1846, p. 201: "They [Ingres's paintings] lend each other mutual support. They show the author under all his aspects; one completes the other, so to speak." ("Ils se prêtent un mutuel appui; ils montrent l'auteur sous toutes ses faces; l'un complète l'autre, pour ainsi dire.")

90. "bouddhah de la bourgeoisie cossue, repue, triomphante." Proust 1913, p. 88, quoted in Naef 1977–80, vol. 3 (1979), p. 115.

91. "l'apothéose du plébéien." Ver-Huell, January 25, 1846.

92. "un penseur, un philosophe, un sage politique, un citoyen courageux qui opposa toujours à l'effervescence des passions politiques la fermeté et l'intégrité." Anon. 1846, p. 61.

93. "l'héritier de quelque beau nom qui comprend à merveille tous les engagements légués par ses pères et qui saura toujours les remplir." Ibid.

94. "un admirable résumé des principes de la révolution de 1789: l'homme nouveau et le vieux gentilhomme, le descendant de Mathieu Molé et le créateur d'une race hier inconnue,

marchant de pair et placés par leurs hautes capacités dans cette sphère où viennent se confondre tous les sentiments de respect et de reconnaissance qu'on doit à ceux servent leur pays de toute leur intelligence." Ibid.

95. "En voyant le portrait de Mme la comtesse d'Haussonville, ne s'aperçoit-on pas aussitôt qu'avec tous les droits possibles à figurer dans la société la plus exclusive, la politique cependant l'a fait naître et vivre dans un monde qui tient plus de compte de l'empire des idées que de la tyrannie des rangs?" Lenormant 1846, pp. 670–71.

96. "La croyez-vous née dans quelque faubourg? au fond de quelque comptoir? Sans doute, dans toutes les classes de la société on peut trouver autant de beauté, mais non cette élégance patricienne, mais non cette délicatesse, cette suavité que la naissance ou l'éducation impriment seules aux natures d'élite." Anon. 1846, p. 61.

97. See, for instance, Amaury-Duval 1846, p. 92: "full of elegant and graceful coquetry" ("plein de coquetterie élégante et gracieuse").

98. Anon., January 15, 1846: "The right hand that presses her belt is in every way a charming poem, which young mothers will understand better than anyone." ("La main droite qui presse sa ceinture est tout un poème charmant, que les jeunes mères comprendront mieux que personne.") The countess was, in fact, pregnant at one point during Ingres's work on the portrait; she gave birth to her third child on September 21, 1843. It might also be noted that Ingres's adoption of the final pose in February of that year (according to Munhall in New York 1985–86, p. 52) roughly coincided with the date on which his sitter would have become aware of her pregnancy. Whether or not the final portrait is meant to project a maternal theme remains, however, purely conjectural.

99. "Rien de plus gracieux que ce portrait d'une femme élégante et spirituelle, représentée au milieu des mille objets d'art ou de curiosité qui composent son monde féminin et où se reconnaît la délicatesse de son goût." Ronchaud, February 19, 1846.

100. The classic study of this phenomenon is Saisselin 1984; see also Higonnet 1992, pp. 84–122.

101. See Munhall in New York 1985–86, pp. 78–103, for a comprehensive account of the objects in the painting.

102. "M. Ingres ne s'arrange guère de ces coquetteries." Thoré 1846, p. 59.

103. "coquet entourage"; "Que ne ferait-on pas pour satisfaire la fantaisie d'une jolie femme?" Anon., February 14, 1846, p. 379.

104. The studio exhibition of December 1854 featuring three portraits elicited scant reaction in the press; see n. 73, above.

105. The definitive study of the 1855 Exposition Universelle is Mainardi 1987, pp. 33–120.

106. Mainardi's contention (ibid., p. 63) that Ingres exhibited only forty-one works fails to take into consideration the listing of several items under the same number in the livret. Also, two of Ingres's paintings were not included in the original catalogue: the portrait of Madame Reiset (fig. 207), no. 5048 in the supplement, and the cameo portrait of Prince Napoléon (fig. 6), added after the exhibition had opened. For Ingres's demand for a separate exhibition space, see his undated letter to Frédéric Bourgeois de Mercey, Commissaire Général of the Exposition Universelle, reprinted in Leroi 1894–1900a, pp. 904–5, and translated in Mainardi 1987, p. 51.

107. According to Lapauze (1911a, p. 476), Ingres left Paris "the day after the opening" ("au lendemain de l'ouverture") and did not return until June 15.

108. See Shelton 1997, pp. 476–532.

109. "C'est comme la droite et la gauche des anciennes chambres des députés." Du Pays 1855, p. 419. It hardly needed stating that Ingres represented the right and Delacroix the left.

110. "le dieu et le prêtre d'une religion artistique qui n'admet que de dociles croyances ou des incrédulités ennemies." Ponroy 1855, p. 222.

111. "un très libre-penseur, un éclectique, un libéral, un voltairien." Ibid.

112. Loudun 1855, pp. 113–24.

113. "cette caste qui ne cherche pas, parce qu'elle possède, et qui, rare et choisie, chez tous les peuples, garde, comme un dépôt sacré, les nobles traditions du beau." Ibid., p. 123.

114. "charactérisent le mieux le génie du maître." Calonne 1855, pp. 111–12.

115. Gautier 1855, p. 147, and About 1855, pp. 126–27.

116. "Il reprend volontiers l'oeuvre du grand ouvrier et repétrit le corps humain à son image, ou, pour parler plus juste, à l'image du dieu qu'il loge en lui." Calonne 1855, pp. 110–11.

117. "Le beau est toujours bizarre. Je ne veux pas dire qu'il soit volontairement, froidement bizarre, car dans ce cas il serait un monstre sorti des rails de la vie. Je dis qu'il contient toujours un peu de bizarrerie, de bizarrerie naïve, non voulue, inconsciente, et que c'est cette bizarrerie qui le fait être particulièrement le Beau." Baudelaire 1990, p. 215.

118. "des milieux, des climats, des moeurs, de la race, de la religion et du tempérament de l'artiste." Ibid.

119. "gens du monde"; "aux excentriques, aux blasés, à mille esprits délicats toujours en quête de nouveautés . . . il plaisait par la bizarrerie." Ibid., p. 230.

120. "une armée de doigts trop uniformément allongés en fuseaux et dont les extrémités étroites oppriment les ongles, . . . des bras trop robustes, trop pleins d'une succulence raphaélique, . . . un nombril qui s'égare vers les côtes, . . . un sein qui pointe trop vers l'aisselle"; "goût immodéré du style." Ibid., p. 227.

121. "une population automatique et qui troublerait nos sens par sa trop visible et palpable extranéité." Ibid., p. 224.

122. See, for instance, Gautier 1855, p. 164: "To the outer likeness of the model he joins the inner likeness; beneath the physical portrait he paints the moral portrait." ("A la ressemblance extérieure du modèle il joint la ressemblance interne; il fait sous le portrait physique le portrait moral.")

123. See, for instance, Perrier 1855, p. 45: "Intelligence is what first leaps to the eye in the portrait of M. le comte Molé [fig. 158] as in that of Madame L. B. [Madame Leblanc; cat. no. 88]. The effect produced by these two countenances . . . is such that one catches oneself wanting to hear them speak so as to have the pleasure of sharing their thoughts." ("L'esprit est ce qui saute aux yeux tout d'abord dans le portrait de M. le comte Molé comme dans celui de madame L. B. L'effet que produisent ces

deux physionomies . . . est tel qu'on se surprend à désirer qu'elles parlent pour jouir avec elles de ce qu'elles pensent.")

124. See, for instance, Belloy, June 10, 1855: "He spares no effort to arrive at the fullest realization of both the human types and the scenes that he wishes to render: . . . costume, pose, the smallest accessories combine to this end, contrary to the methods of those vulgar *portraitists* who elevate everything they touch and who seat in the same gilded armchair people of very different ranks." ("Rien ne lui coûte pour arriver à l'expression complète des types humains comme des scènes qu'il veut rendre: . . . le costume, la pose, les moindres accessoires concourent à ce résultat, contrairement au procédé de ces *portraitistes* vulgaires qui anoblissent tout ce qu'ils touchent, et assoient dans le même fauteuil doré des gens de conditions tout à fait différentes.")

125. See, for instance, Labourieu, October 25, 1855, which describes Napoleon in Ingres's *Bonaparte as First Consul* (cat. no. 2) as "this waxwork . . . this dummy decked out in a lackey's uniform" ("cette figure de cire . . . ce mannequin affublé d'un habit de laquais").

126. "portraits morts"; Goncourt 1893, p. 191. For a provocative analysis of the tendency in nineteenth-century criticism to stress the morbidity of Ingres's figures, see Ockman 1995, pp. 85–109.

127. "fête éternelle que donnent le soleil, le mouvement, la vivante nature, pour entrer, mélancolique et transi tout à coup, dans les froides salles d'un hôpital habitués par des malades lymphatiques ou bilieux." Mantz 1855, p. 226.

128. "vie morale"; "beauté intelligente"; "Est-ce en ces images muettes de femmes, en ces bustes froids, en ces physionomies silencieuses, en ces portraits morts de si loin dépassés par le portraitiste Coignet [*sic*]? Est-ce en ces miniatures dérisoires des aristocraties et des beautés de la femme . . . où l'ovale fluxionné est déformé par les bajoues morbides, où la pommette est fardée de violet, où la figure ne tourne ni ne rondit, enduite, d'un contour à l'autre, d'une teinte plate, sans modelage de tons, facsimilé de linéature, et non miroirs vivants du visage et des rayonnements de l'âme." Goncourt 1893, p. 191. The comparison to Léon Cogniet, a relatively well known but decidedly mediocre academic artist, is clearly meant as an insult.

129. "Le portrait est son triomphe." Duval 1856, p. 49.

130. For declarations of Ingres's superiority as a portraitist, see Mornand 1855, p. 227; Perrier 1855, p. 44; Thierry 1855, p. 203; and Baudelaire 1990, p. 225. Although Noémie Cadiot (Vignon 1855, pp. 189–90) does not actually proclaim Ingres a better portraitist than history painter, six of the eight pictures she lists as his masterpieces are portraits.

131. The best general account of the emergence of avant-garde Realism in France remains Nochlin 1971.

132. Baudelaire 1990, pp. 225–26.

133. "Il est arrivé là au *summum* de l'art par la raison fort simple qu'il a reproduit sincèrement ce qu'il a vu, sans le regarder et le comprendre à travers ses souvenirs de Raphaël." Du Camp 1855, pp. 45–46.

134. "mis en communication directe avec la nature, il oublie son système, se laisse aller à la spontanéité de son impression,

retrouve toute sa verve et sa dextérité de practicien." Petroz, May 30, 1855.

135. "le premier dans l'école contemporaine, peut-être le seul." Ibid.

136. "insuffisance pour les grandes compositions." Niel, July 15, 1855.

137. "un artiste de génie, . . . un grand poëte"; "un esprit studieux." Ibid.

138. "M. Ingres, comme peintre—et la postérité le lui dira—n'est qu'un très-habile portraitiste, qu'un très-fidèle reproducteur des natures mortes. A force de patience, de tâtonnements, d'analyses, il fourrage même, comme Balzac, jusque sur le terrain de la vérité. Par hasard il se surprend à avoir le génie de Raphaël et de Molière; mais alors l'air qu'il respire sur cette haute région est trop violent, trop pur, trop abondant pour ses poumons malades, pour sa nature viciée; aussi s'empresse-t-il de rentrer bien vite dans l'atmosphère étroite où il peut vivre à l'aise, c'est-à-dire dans sa peinture de copiste, en face d'un portrait, d'un bijou, d'un cachemire, dont il rend cette fois avec aisance jusqu'aux moins traits, jusqu'aux moindres linéaments, jusqu'à moindre trame." Labourieu, October 25, 1855.

139. "Dans les portraits de femmes, l'auteur est, ce nous semble, moins habile ou moins heureux. Son pinceau rigide et antitransacteur, ou rend mal la grâce, ou ne la supplée point là où elle peut être absente." Mornand 1855, p. 227. For other declarations of the inferiority of Ingres's female portraits, see Boiteau d'Ambly 1855, p. 472; Perrier 1855, p. 45; and Goncourt 1893, p. 191.

140. "Ce n'est pas là un portrait qui fait plaisir, c'est un portrait qui fait rêver." About 1855, p. 133.

141. "un chef-d'oeuvre que le temps a fait l'égal des plus belles têtes du Pérugin, de Vinci, de Raphaël." Calonne 1855, p. 109.

142. "un charme d'intimité réel." Nadar, September 16, 1855.

143. "qui fasse vibrer en moi une corde sympathique." Mantz 1855, p. 225.

144. In addition to the comments on the portrait from the critic's review of the 1833 Salon quoted above (p. 504), see Gautier, June 27, 1847.

145. "M. Ingres est arrivé à une intensité de vie effrayante: ces yeux noirs et tranquilles sous l'arc mince de leurs sourcils vous entrent dans l'âme comme deux jets de feu. Ils vous suivent, ils vous obsèdent, ils vous charment, en prenant le mot au sens magique. L'imperceptible sourire qui voltige sur les lèvres fines semble vous railler de votre amour impossible, tandis que les mains affectent de jouer distraitement avec les feuilles d'écaille d'un petit éventail, en signe de parfaite insouciance.—Ce n'est pas une femme qu'a peinte M. Ingres, mais le portrait ressemblant de la Chimère antique, en costume de l'Empire." Gautier 1855, p. 165.

146. "le morceau d'art le plus considérable que notre siècle ait produit." Calonne 1855, p. 112.

147. "véritable résurrection." Planche 1855, p. 1143.

148. "La figure entière est d'un relief surprenant, on en ferait le tour: ce serait un voyage." About 1855, p. 132.

149. "C'est l'image la plus nette, la plus précise, la plus frappante que l'on puisse donner de la bourgeoisie régnante de 1830 à

1848. . . . Ce tableau est plus qu'une oeuvre d'art, c'est une symbole." Calonne 1855, p. 112.

150. "N'est-ce pas la révélation de toute une époque que cette magnifique pose de M. Bertin de Vaux [*sic*] appuyant, comme un César bourgeois, ses belles et fortes mains sur ses genoux puissants, avec l'autorité de l'intelligence, de la richesse et de la juste confiance en soi? . . . C'est l'honnête homme sous Louis-Philippe, et les six tomes du docteur Véron n'en racontent pas davantage sur cette époque disparue." Gautier 1855, p. 164. The "six volumes of Dr. Véron" refers to the celebrated memoirs of the maverick entrepreneur Louis-Désiré Véron, *Mémoires d'un bourgeois de Paris*, which was just then beginning to appear.

151. The most important studio exhibition after 1855 was that of July 1864; see n. 74, above. The displays of *La Source* (fig. 202) and *Jesus among the Doctors* (fig. 219) at the Galerie Martinet in 1861 and 1862, respectively, constitute Ingres's most significant appearances in a gallery during the same period. For these occasions, see, among other notices, Banville 1861; Delécluze, April 3, 1861; Gautier, February 18, 1861; Delaborde 1862; and Delécluze, April 17, 1862.

152. The only extensive press coverage of this exhibition appeared in the *Gazette des beaux-arts;* see Delaborde 1861, Galichon 1861a, and Galichon 1861b.

153. This promotion constituted the government's attempt to assuage Ingres's bitter disappointment at not being the only artist awarded the Grand Medal of Honor at the Exposition Universelle; see Mainardi 1987, pp. 109–13.

154. See Paris 1867.

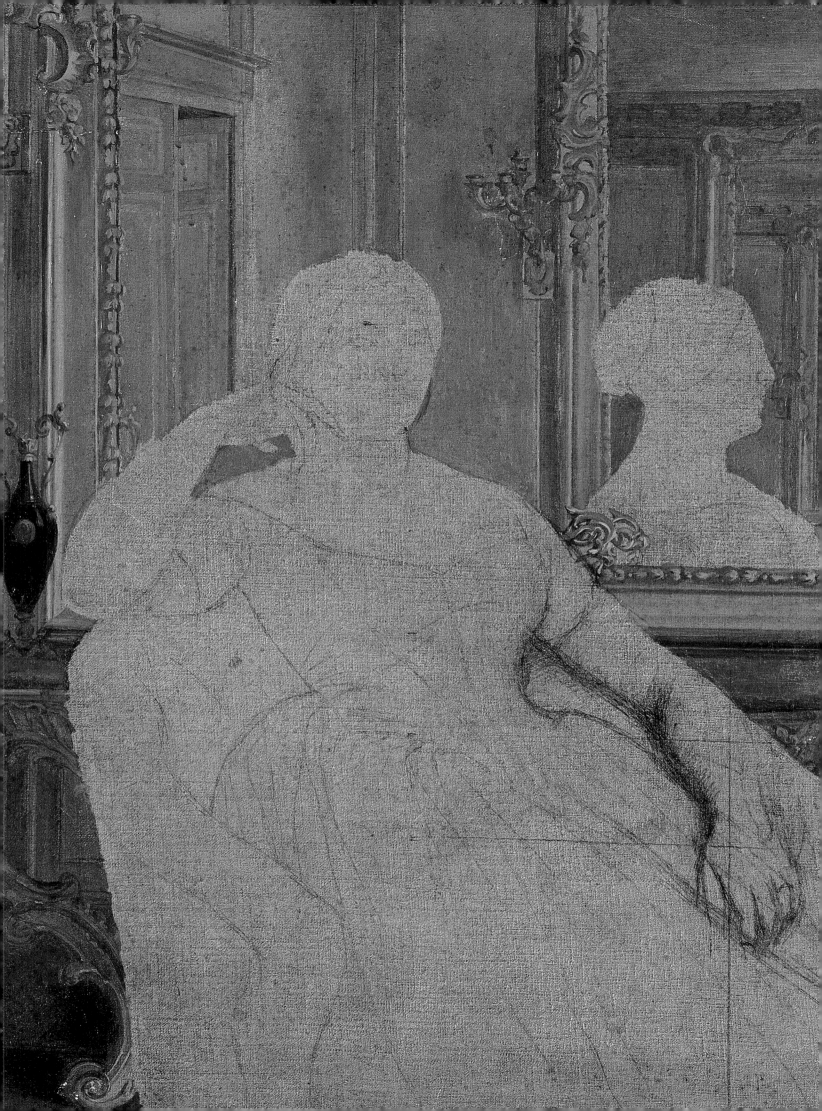

INGRES AND CO.: A MASTER AND HIS COLLABORATORS

Georges Vigne

The reputation of every great painter who was the master of a studio is eventually shadowed by the specter of collaboration, which can cast suspicion over even the most revered works. Thus, the public no longer indignantly demands frequent viewings of the Vatican Loggias, now that less and less of the work is ascribed to Raphael; Rembrandt's *Man with a Golden Helmet,* once seen as an undisputed masterpiece, is regarded today as a devalued canvas by an overly clever student. The quest for absolute authenticity—often pursued with a rigor that leaves too little room for simple visual pleasure—has particularly harmed those great painters who were unfortunate enough to encourage emulators or to be sought out by talented followers. It is worrisome to see confusion between Prud'hon and Constance Mayer, or Delacroix and Pierre Andrieu, or Corot and Paul-Désiré Trouillebert shedding such damning light on the master's weaknesses and limitations while doing little to elevate the follower's reputation. In this regard, Gustave Moreau was no doubt the most sensible of all. He wore white gloves when he looked at his students' works and forbade unauthorized intrusions into the secret lair in which he kept his own precious gems. How astonished and disappointed Georges Rouault was, when he finally entered that closed studio as its new curator, to find that it contained several hundred unfinished canvases and nothing more!

Today, artistic debate no longer centers on the quality or importance of a given work but rather on the degree to which a collaborator helped create it. Pleasure—or its absence—must be put to this test, which reassuringly claims to remove all chance and uncertainty. But what does one gain by being so conditioned by an absurd desire for historical truth that one excessively admires a second-rate autograph work and disdains a first-rate collaborative one? Rubens poses just such a dilemma, as did Raphael before him.

The example of Ingres is particularly enlightening to any discussion of collaborative practices. Over the course of the last hundred years, the issue has gradually taken on greater significance with respect to his work, as information concerning the role of his students becomes more precise and accurate. Analysis of the phenomenon has progressed slowly and gradually, study by study, biography by biography—no doubt for fear of seeing the entire edifice of a remarkable body of work crumble too quickly into suspicion. Nonetheless, collation of the various accounts and documents, as well as examination of unpublished papers in the Musée Ingres, Montauban (a task, I hasten to admit, that is nowhere near complete as of this writing), only confirms what certain purists probably wish would never be revealed: that Ingres often relied on the pencil or brush of a follower, even in genres in which he had attained such a level of perfection that one would not expect a given work to be "soiled" by others' hands. The painted portrait, the absolute bastion of Ingres's genius, is no exception (even if the present commercial value of these works has kept it from being suggested too freely that the master overcharged for paintings he had not created entirely alone).

Ingres's earliest biographers took great pains, out of deference, to allay even the slightest doubt as to the authenticity of his paintings. Allusions to his collaborators are all but nonexistent before the twentieth century, and Amaury-Duval, in his important book *L'Atelier d'Ingres* (1878), was intentionally silent on practices that he had been told about but had not witnessed firsthand. While he apparently never worked for Ingres himself, his anecdote regarding the Muse's hand in the portrait of Cherubini not only omits any mention of Henri Lehmann's work on that figure but even suggests that Ingres was its sole author. Devout falsehood or simple ignorance? What is known about this episode comes from other sources—mainly from Raymond Balze and Paul Flandrin, who were interviewed long after Ingres's death, but also from anonymous collaborators who shared their small, almost insignificant confidences with historians.

In aiming to understand Ingres's collaborative process, I must extend my analysis to his entire oeuvre, for this phenomenon cannot be properly examined on the basis of

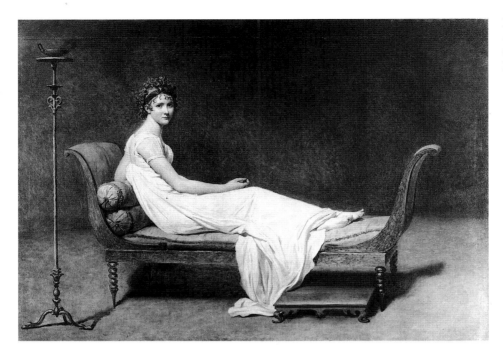

Fig. 306. Jacques-Louis David (1748–1825). *Madame Récamier*, 1800. Oil on canvas, 68 1/2 × 96 1/8 in. (174 × 224 cm). Musée du Louvre, Paris

his portraiture alone. The weight of tradition, customary practice at the beginning of the nineteenth century, and Ingres's character must also be considered. Of preeminent importance, however, is the fact that he was a student of Jacques-Louis David. In fact, research into Ingres's collaborators has coincided with similar examinations of the works of his last and most important teacher, for it is well known that David did not hesitate to ask for assistance from the most talented members of his studio. Artists such as Jean-Germain Drouais, François-Xavier Fabre, and Anne-Louis Girodet had the privilege of helping him with several of his canvases, including the *Belisarius* (Musée du Louvre, Paris) and the famous *Intervention of the Sabine Women* (fig. 42). If David later called on the somewhat less remarkable gifts of Georges Rouget, at the height of his fame he nonetheless had had

the brilliant idea of using the true talents he came across in his teaching.

It is no surprise, therefore, that in 1800 Ingres was given the honor of participating in David's portrait of Madame Récamier (fig. 306), for which he painted the candelabra and the footrest. Tradition is not the only source for this information: three modest yet eloquent drawings from the Musée Ingres archives are visibly related to the painting;[1] two show the same elements of furniture and the third, the young woman's basic pose. It is difficult to say whether these are preparatory studies or sketches of the finished painting drawn by the young artist to commemorate his prestigious assignment. But the third drawing (fig. 307), which differs from the painting in numerous ways, remains puzzling. If it is a proposal made for the overall composition, then it represents

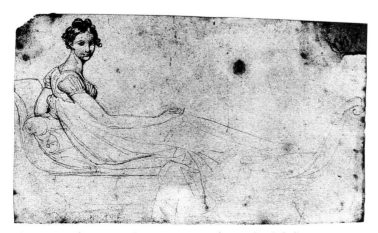

Fig. 307. *Madame Récamier*, ca. 1800. Graphite and red chalk on paper, 2 5/8 × 4 1/2 in. (6.8 × 11.3 cm). Musée Ingres, Montauban (867.3637)

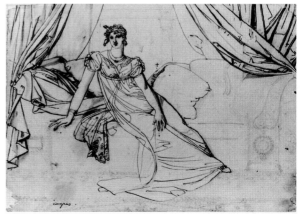

Fig. 308. *Madame Béranger*, before 1806. Graphite and ink on paper. Private collection

Fig. 309. Detail of landscape in
Caroline Rivière (fig. 58)

an early instance of the competitiveness that soon caused a rift between master and student. Ingres's famous portrait of 1806 depicting Napoleon seated on his throne (cat. no. 10) seems to have been the final straw in the deteriorating relationship, since the figure of the emperor was apparently adapted from one that David had unsuccessfully submitted to the Salon the year before, as witnessed by a small sketch in the Musée des Beaux-Arts, Lille. Before the break, which was not made public until Ingres's submission of the painting to the Salon of 1806, the young artist had created a "copy of a portrait for David," mentioned in the list of works in the painter's Notebook IX.[2] Unfortunately, nothing further is known about this work (which, oddly enough, does not figure in the more precise and exhaustive list in Notebook X), not even whether the portrait Ingres copied was by David himself. But the mention does confirm both the significant bond between the two men during the years 1800 to 1805 and the reality of the student's contributions to his master's paintings.

Ingres's participation in the portrait of Madame Récamier greatly influenced his subsequent work. For one thing, he adopted the same general approach almost immediately afterward for his portrait of Madame Béranger (a painting that was either never completed or has since been lost, but whose overall composition has recently become known through a pencil-and-ink sketch [fig. 308]),[3] and then again for his portrait of Madame de Senonnes, as witnessed by the preliminary sketches (figs. 128–30). But more important is the fact that Ingres surely found in his work with David a justification for

the practice of collaboration: he believed himself entitled to use the services of others, and he did so in ways that ultimately proved more of a help than a hindrance to his reputation. In that regard, he seems always to have maintained a certain respect for David—the painter, if not the man. By imitating his master in this way, Ingres remained David's pupil to the end of his life, as well as his most lucid successor. His inclusion of David's profile in the 1865 drawing *Homer Deified* (fig. 316) may thus be seen as a final homage and a moving pardon toward a master he had long ago rejected.

Ingres's collaborative practices were not truly consistent throughout his career. By the time he was an elderly artist, he had trained many talented assistants whom he had come to trust, and he used helpers almost as proxies, to complete his numerous commissions more quickly. However, during the first years of his stay in Italy, beginning in 1806, he sought help for another reason (the constant specter of poverty indicates that he was anything but overworked). It seems that the young master was looking at that time for artists who were especially talented in areas, such as landscapes, that were outside his own abilities and interests. It was, in fact, only after his return to Paris in 1824 that Ingres began to adopt the truly collaborative practices he had learned with David.

Despite Ingres's use of help in the early years in Rome, it is difficult to credit the hypothesis advanced in 1985 by Hélène Toussaint that an outside hand, perhaps that of Pierre-Henri de Valenciennes, executed the charming landscape that appears in the background of the portrait of Caroline Rivière, a work completed in 1805 (fig. 309).[4]

Fig. 310. Ingres, with François-Marius Granet (1775–1849). Detail of landscape in *Charles-Joseph-Laurent Cordier* (fig. 93)

Toussaint argues that the landscape is neither in character with Ingres's work nor particularly well integrated with the figure of the girl—as the rather clumsy arrangement of the foreground would indeed attest. But a professional landscape painter like Valenciennes would probably have done a better job of matching his work to Ingres's, as artists such as François-Marius Granet, Alexandre Desgoffe, and Paul Flandrin later did. It is true that Ingres had had little landscape experience in David's studio beyond the customary classical ruins and ancient citadels, for the master's teaching (like Ingres's own later on) was almost exclusively based on portraying the human body and making copies of assigned works. Yet it is also easily imaginable that Ingres—faced with a patron's difficult request—managed to fulfill it, however awkwardly, by imitating the currently popular landscape style of Valenciennes's followers. (Although it has never been securely established, it seems that the landscape was included because of an imperative request made by Philibert Rivière himself.)

Ingres's first known collaborator was his friend Granet, a landscape artist and genre painter. This is revealed by the last will, dated April 14, 1866, of the comtesse Mortier, née Léonie Cordier, which tells us clearly, but not without an unfortunate spelling error, just who created the background in the 1811 portrait of her father (figs. 93, 310), which she was then bequeathing to the Louvre: "I leave to the Musée du Louvre as an outright gift, and on the express condition that the painting will be exhibited in the Louvre galleries among the works of the great modern painters, with a mention of my father's name in the catalogue, the magnificent portrait that Ingres painted of him, depicting in the background the Temple of Cybele painted by Grasset."[5] Even if Granet still enjoyed in 1866 the public favor he has largely since lost, such an admission of collaboration was hardly conducive to enhancing the value of the portrait. If anything, it demonstrates great honesty on the part of the donor, who was conveying information already widely known in her family: Ingres had obviously not bothered to hide from Cordier a friend's collaboration in the execution of his portrait.

A similar style and a strict chronological correspondence indicate that Granet was also responsible for the backgrounds in a portrait of himself, from about 1809 (cat. no. 25), and in another, from about the same time, of Joseph-Antoine Moltedo (cat. no. 27), in addition to a later one of Count Gouriev (cat. no. 86, fig. 311). In its cartons of unpublished documents, the Musée Ingres has the preparatory sketch for the landscape in the Gouriev portrait (fig. 312).[6] This panoramic view of a property that the Russian minister owned in Italy is stained with a few spots of blue paint that may be of the same hue as the magnificent sky in the finished work. The drawing cannot be conclusively attributed to Granet, but it may very well be his. Again, as in the portrait of Caroline Rivière, the landscapes in these four works must be considered in light of the fact that Ingres was obviously not used to painting such scenes and quite likely even distrusted his aptitude in that area.[7] Having a landscape expert among his friends made it all the more tempting to use someone else's services in order to enhance his own work—and it was a temptation he did not resist.

During his first stay in Rome, Ingres also introduced landscape backgrounds into several of his portrait drawings, which served for a while as his principal means of livelihood. The archives of the Musée Ingres contain a group of some forty landscapes in pencil, all quite similar in style and format;[8] the number in ink that each bears in one corner indicates that they all came from the same sketchbook. Among these landscapes, one can easily recognize most of those Ingres used in his portrait drawings from the years 1811 to 1818, that is, the portraits of Charles

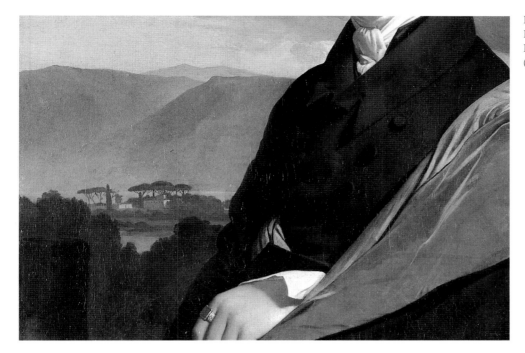

Marcotte and Philippe Petit-Radel (both 1811; fig. 112, N 67); an unknown man (ca. 1811; N 74); Adolphe Colombet de Landos (ca. 1810; N 83); the Montagu sisters (1815; N 158); Mrs. Mackie, Mrs. Badham, and Lord Grantham (1816; cat. nos. 60, 62, 64); Sebastiani (undated; N 218); Louis-Étienne Dulong de Rosnay and Alexandre Bénard (both 1818; N 231, 235). He recopied these in whole or in part (figs. 313, 314) and even used the same sketch for the backgrounds of two different portraits.

Who was the author of this sketchbook, which was attributed to Ingres by all the specialists and by the curators at Montauban? I have cautiously given him the name the "Master of the Little Dots,"[9] because of his singular

habit of covering his compositions with dotted lines (perhaps traced in a camera obscura) that were intended as markers for the placement of various elements. Hélène Toussaint has suggested he may be François Mazois, an architect to the court of Naples and a friend of Ingres, basing the identification on a comparison of the drawings from Montauban with one in the Bibliothèque Nationale in Paris.[10] However, I cannot second this ingenious suggestion, especially since it rests on the study of a single drawing, which may not even be typical of Mazois; furthermore, although the Paris drawing bears an undeniable resemblance to those in the sketchbook, the similarity is far from conclusive. Finally, the fairly mediocre quality

Fig. 312. François-Marius Granet (1775–1849) (?). *View of Palombara Sabina*, before 1821. Ink and wash on paper. Musée Ingres, Montauban

of the drawings in the sketchbook—which violate the most elementary rules of perspective—is hardly worthy of an architect. That said, my curiosity was especially piqued by the recent appearance of two Roman landscapes (private collection, Paris), depicting the Ponte Fabricio and the Porta San Sebastiano, that seem to be much more clearly related to the ones by the "Master of the Little Dots." Whatever differences exist can be explained by the Roman works' later date of 1825, which is written on each of the drawings. Mazois's return to France in 1819 unfortunately rules him out as the source of the two Roman works, which further weakens his tie to the landscapes in the dismembered Montauban sketchbook. Prudence requires that the real author remain anonymous a while longer. But it is nonetheless interesting to see that Ingres, while surely recognizing the limitations of the drawings in the sketchbook, did not hesitate to use them extensively. Something of the originals' limpness is still discernible in Ingres's copies, although it is effectively minimized by his conscious efforts to maintain a light touch.

During his first Italian journey, Ingres did not have to deal with collaborations on his history paintings, which, though potentially difficult, were the most important ones for him. That he was nonetheless at least helped in his research for such works is attested by a group of stumped-charcoal drawings depicting drapery, some of which were clearly preparatory studies for the apostles' cloaks in the contemporaneous *Christ Giving the Keys to Saint Peter* (fig. 106).[11] While the highlights and shadows

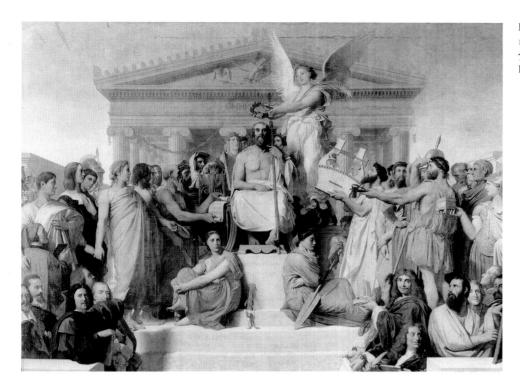

Fig. 315. *The Apotheosis of Homer*, 1827 (W 168). Oil on canvas, 59⅞ × 79⅞ in. (152 × 203 cm). Musée du Louvre, Paris

in these studies are too heavily accented to belong to Ingres's visual vocabulary, he must have considered the works a kind of source book for his new pursuit of painting austere draped figures inspired by Christianity. Still, the rather mundane landscape in the painting, with its ridiculously scrawny palm tree, only confirms how bored the artist must have felt at having to render such elements, which were obligatory in historical scenes—even as it leaves us certain that no outside hand joined in the composition of the work. Similar claims may be made for *The Entry into Paris of the Dauphin, the Future Charles V* (fig. 136), with its banal, papier-mâché decor. Nonetheless, the anecdote of Ingres posing for his friend Abraham Constantin for the figure of the Virgin in *The Vow of Louis XIII* (fig. 146)[12]—the drawings exist at the Musée Ingres[13]—confirms that by the end of his stay in Italy, he had become accustomed to taking help wherever he could find it. When it was not available from models, engravings, antiquities, or paintings, he had no qualms about approaching other artists. However, the temptation to employ an outside hand in his history paintings had not yet crossed his mind in any concrete way.

The opening of Ingres's private teaching studio in Paris at the end of 1825 and his subsequent appointment as a professor at the École des Beaux-Arts in December 1829 had major consequences for the rest of his career: he could now revive, with a whole new generation, the collaborative practices he had witnessed at David's studio more than twenty years earlier. The first person he turned to as an assistant was a fellow artist from Montauban,

Prosper Debia—no doubt because none of his young students was as yet sufficiently trained. Debia, who helped Ingres complete *The Apotheosis of Homer* (fig. 315) on schedule, gave the following account of their work together in his short memoir of Ingres:

> An exhibition of works by living painters was announced for the following year (1827); I had offered to help. The opening of the Salon having been considerably delayed, I arrived in Paris too soon, and I ended up staying there much longer than anticipated. But then, what an invaluable compensation was in store for me!
>
> At the Louvre, they were decorating a gallery to display antiquities collected from the ruins of cities buried

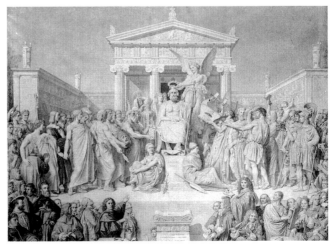

Fig. 316. *Homer Deified*, 1864–65. Graphite, ink wash, and white highlights on paper, 29⅞ × 33⅝ in. (76 × 85.5 cm). Musée du Louvre, Paris

Fig. 317. Hippolyte Flandrin (1809–1864). Head of Ingres from *Study for "The Martyrdom of Saint Symphorian,"* before 1832. Oil on paper, mounted on canvas, 9⅝ × 8⅛ in. (24.5 × 20.5 cm). Musée Ingres, Montauban (867.89)

Fig. 318. Detail of *Louis-François Bertin* (cat. no. 99)

under the ashes of Vesuvius. The artists hired to create important works, mainly for the ceiling of that gallery, called the Galerie Charles X, requested the same delay as for the opening of the Salon. . . .

My illustrious friend had never liked having deadlines hanging over him. This was made all the worse by the fact that he had barely finished sketching out his canvas: he had made only a great many preparatory drawings, most of them done in pencil on paper to serve as guidelines.

In that perilous situation, forced to enter without delay into a supreme struggle upon whose outcome the triumph of a still uncertain reputation rested, Ingres had no choice but to pull himself out of the lengthy hesitations to which his mind had become accustomed under the influence of the outrageous criticisms leveled at his peerless talents, which went unrecognized for far too long.

To surmount this irksome obstacle, the support of friendship was perhaps not entirely useless, and I dare add that it did not fail him. Even if, in the rapid execution of that masterpiece and upon the master's friendly invitation, my feeble brush was occasionally fortunate enough to dab the canvas at his side—this is an honor

that will never fade from my memory—I have no illusions about the title of "collaborator," which, in a moment of indulgent effusiveness, the great artist wished to attribute to me. Nonetheless, this kind of participation served as a basis for the personal closeness, henceforth unshakable, that grew between that great reformer of the school and the devoted friend who remained with him until the finished painting was installed for the grand opening of the Galerie Charles X.[14]

The collaboration was, of course, carefully kept secret. Debia's memoirs reached only a small audience, and many historians attributed to Armand Cambon the honor of having assisted Ingres on the scaffolding—a great privilege indeed for someone who was barely eight years old at the time!

No doubt the habit of collaboration was formed at that exact moment, as Ingres realized that a less talented hand, if well directed and totally controlled, could be of great service to him without any major impact on the final result. It is nonetheless doubtful that this kind of expedient always left him satisfied. He worked assiduously, for example, to perfect the hastily executed composition of *The Apotheosis of Homer,* spending more than forty years

on *Homer Deified* (fig. 316) to remove absolutely every trace of collaboration, not only by poor Debia but also by the archaeologist Désiré Raoul-Rochette, who had helped with the Greek and Latin inscriptions. Yet even in this endeavor, he openly took inspiration from a plate in a work by his friend the architect Jacques-Ignace Hittorff when he changed the position of the temple in his composition.

The Martyrdom of Saint Symphorian (fig. 169), commissioned in the same period as *The Apotheosis of Homer* but not finished until the Salon of 1834, was certainly the first painting that Ingres's students worked on. While no documents survive that would help to measure the extent of their participation, there are two works by Hippolyte Flandrin in the Musée Ingres that make some assumptions possible.[15] The first, a small portrait of Ingres, hooded and in profile (fig. 317), was used as the basis for one of the figures in the background of the painting. The second, a male nude standing with his hands behind his back and his wrists visibly bound (as also shown in a *modello* in a private collection), is clearly similar to the first version of the pose for the main figure. It seems that Flandrin, then a candidate for the Prix de Rome, was already considered talented enough to assist his master and even to make formal suggestions for a painting. Since Flandrin left Paris in 1833 after winning the prize, he cannot have participated in the execution of the painting itself. But these two concrete testimonies to his involvement in its genesis appear to indicate that this was the period in which Ingres began to look to his studio for practical assistance. Out of devotion to their master, the students kept silent, but his own love for them led Ingres to preserve at least two of the studies that one of them made, which have now become invaluable as documentary evidence.

If one is to believe the contents of a letter dated August 30, 1897, from the ceramist Ovide Scribe to Jules Momméja, curator of the Musée Ingres, it was the obscure Duthanofer whom Ingres asked during that same period to paint the chair and the celebrated reflection of light on its arm in the portrait of Louis-François Bertin (fig. 318, cat. no. 99): "When you go to see the portrait of M. Bertin at the Louvre, please be sure to notice the point of light on the arm of the chair. You can see a window with its curtains in it. The chair was painted by Duthanofer, a well-known decorator at the time. The master made him do that point of light over five or six times, never finding it quite detailed enough in its rendering of the curtains. I heard this detail from a fellow disciple, the son of that same Duthanofer."[16] Scribe's statements should often be taken with a grain of salt, but Duthanofer's son

apparently got the anecdote directly from his father. Still, Duthanofer has never been listed among Ingres's close friends, and no artist by that name figures in any of the known lists of his students. Why would the master have asked the decorator to render that point of light—a request that met with so little immediate success—instead of painting it himself? Was he truly incapable of doing it? Beyond the apparent implausibility of the story, what needs to be underscored here is the presence of total strangers in Ingres's circle, as well as the resultant difficulty in quantifying them, or even, in some cases, of naming them.

Ingres's assumption of the directorship of the Académie de France in Rome in 1835 marks the beginning of true, full collaboration on his painted works. Though far from Paris, he managed to gather a fair number of his students in Rome, among them the Flandrins and the Balzes, Desgoffe, and sometimes Lehmann and Théodore Chassériau. The Villa Medici became for a time the seat of a small court that revolved around Ingres and his wife, Madeleine. The directorial couple were accompanied on their travels by the members of this inner circle and were frequently offered drawings that these artists made during their own brief side trips—Paul Flandrin to Naples, Desgoffe to Capri (these works were most often diplomatically dedicated to Madame Ingres, a powerful presence behind her husband). On occasion, the master even recruited the amiable Charles Gounod into this circle (cat. no. 117). A talented amateur draftsman, Gounod compliantly acceded when asked by Ingres to trace engravings under his supervision and then proceeded to entertain him at the piano with melodies by his beloved Mozart; some of Gounod's copies were found among Ingres's bequeathed papers in Montauban.[17]

Too busy with the administrative functions that he had conscientiously undertaken, Ingres had little time to work on the four paintings he had promised to complete during his six-year term as director: *Antiochus and Stratonice* for the duc d'Orléans (fig. 194), *The Virgin with the Host* for the czarevitch, the future Czar Alexander II (fig. 200), the *Odalisque with Slave* for Marcotte (fig. 190), and the portrait of Luigi Cherubini (see cat. no. 119). As for *Antiochus and Stratonice*, we have the famous anecdote related by Charles Blanc:

> How often they consulted nature! Whether one of Ingres's students, one of the Balzes or one of the Flandrins, got down on his knees and Ingres threw a drapery over his back to capture by sheer good luck several handsome folds, or whether the master himself, running wild and half-dressed across the room, imagining

Fig. 319. Ingres and unidenti-
fied assistant. Detail of *Back-
ground for "Antiochus and
Stratonice,"* ca. 1825(?).
Graphite, ink, and wash on
paper, 23⅞ × 36⅞ in. (60.5 ×
93.7 cm). Musée Ingres,
Montauban (867.2194b)

himself in the role of Seleucus, flung himself panting
onto a mattress to show his students the design of that
drapery, which he wanted them to make natural as well
as noble, expressive as well as beautiful. And what naive
goodwill in that small, squat, obese man, who, without
fearing that his actions might be comic, without even
suspecting it, imbued himself with the passions he had
to paint, to the point of mimicking the despair of an
ancient hero and courting ridicule in the hope of
attaining supreme beauty![18]

It must be remembered that, at the time, no one yet
dared admit the importance of the contributions by
Ingres's students; Blanc, for example, reduced their role
to simple graphic assistance. Not until Henry Lapauze's
book appeared in 1911 did this more significant confes-
sion emerge from Raymond Balze: "Ingres was extremely
emotional about it: he actually cried. He related the sub-
ject to my brother and me several times while we worked.
I was the one who did the furniture and the lyre, which
changed position many times. My brother Paul had the
most extraordinary patience, for both this painting and
the Boss. Initially, before the columns that are now there,
the background included the *Battle of Arbela*, after the
mosaic in Pompeii, then the labors of Hercules, of which
almost nothing remains, and finally the columns and all
the architecture."[19] But we also know that the architect
Victor Baltard, then a pensioner at the Villa Medici,
helped the master conceive the antique decor of the
scene (see fig. 319) and that Madeleine Ingres posed for

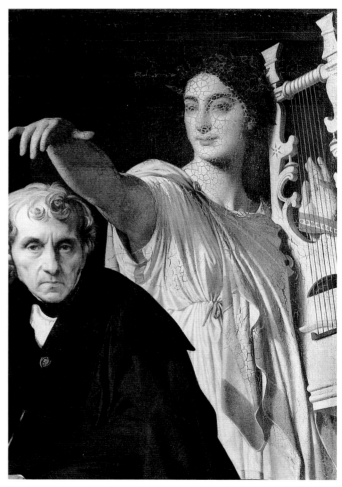

Figure 320. Ingres and Henri Lehmann (1814–1882). Detail of
Cherubini and the Muse of Lyric Poetry (fig. 221)

Fig. 321. *Tracing of a Figure of Satan for a Temptation of Christ*, 1836. Graphite and annotations in ink, 6½ × 8½ in. (16.6 × 21.5 cm). Musée Ingres, Montauban

the doctor, Hippolyte Flandrin for the patient's arms, and Ingres himself for the prostrate father.

Seeing *Antiochus and Stratonice* today, few would suspect that so many people worked so hard to perfect it. It is true that part of Ingres's genius was to harmonize his collaborators' highly diverse talents, to direct them, to even out the results of their work, and always to add the finishing touches that would erase any hesitant passages by a talent that did not accord with the rest. But were there any such talents? The Flandrin brothers were surely worthy successors to their master—so much so that the perspicacious Baudelaire characterized Paul Flandrin with this penetrating question in his *Salon of 1845:* "But who, then, is the extravagant one, the fanatic, who first thought of Ingres-izing the countryside?"[20] As for the Balzes, Ingres monopolized their talents for a dozen years (1835–47), first in reproducing Raphael's Loggias, then the Stanze, and thus guaranteed for himself collaborators who were totally imbued with his own principles, besides being servile executants and brilliant copyists. (The Balzes' own work makes it quite clear that this double enslavement, under Raphael and Ingres, killed most of any individuality they might have had.) While the master loved these four students like his own sons, Hippolyte Flandrin remained in some ways the favorite, thanks to his rapid success as a portraitist and muralist. Flandrin's popularity, which both reflected the excellence of his training and guaranteed the perpetua-

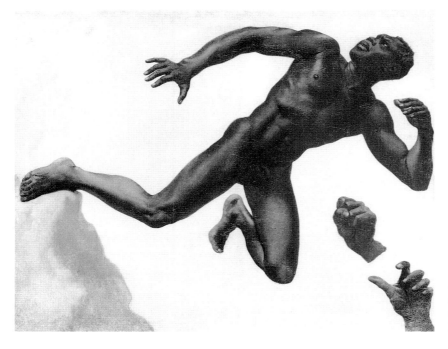

Fig. 322. Théodore Chassériau (1819–1856). *Figure of Satan for a Temptation of Christ*, 1836–38. Oil on canvas, 21⅝ × 28⅞ in. (55 × 73.5 cm). Musée Ingres, Montauban (867.180)

tion of the Ingres studio's rules, also absolved him from the duty of long-term collaboration.

The portrait of Cherubini and his Muse (fig. 221) was the only painting by Ingres that became known as a collaborative work soon after it was made. Lehmann openly acknowledged his participation in letters to Marie d'Agoult: "I am also working for M. Ingres, which you must not repeat since he intends to pass off what I am doing for him as his own work, after touching it up, of course" (October 24, 1840); "M. Ingres begged me to help him. I had to choose. . . . I thus agreed, and I am giving him all the time he wants. . . . I will not tell you what I am doing for him because he demanded the most absolute discretion on the subject. All you need to know is that he even trusts me with the most important things, and that he is very happy" (December 16, 1840).[21] The painting itself is not named—a promise is a promise—but it is rather precisely situated in the chronology. Indeed, over time, the bitumen used by Lehmann to add sheen to the Muse's skin revealed all too well the quality of his participation (fig. 320). The entire figure is eroded, whereas that of the musician still demonstrates the excellence of the materials chosen by Ingres, who always maintained a prudent distrust of the seductive product that destroyed so many Romantic paintings.

The same requirement of secrecy—strictly applied to students who were not in the inner circle of disciples—had previously been imposed on Chassériau. By means of a letter to Édouard Gatteaux dated November 19, 1836, Ingres commissioned Chassériau to do a study for

a figure of Satan that he wanted to add to a Temptation of Christ:

> I must ask you, my dear fellow, to do me the favor of helping me in something that I most urgently need. The enclosed tracing will show you what I want. We must therefore find among my students the one who can render the best portrait of a model, and if you do not come up with anyone better, I believe I can suggest young Chassériau. If you would, then, please go find him and pass on my offer to him. . . . It is especially important that he copy the type of individual as closely as possible. Please impress upon him that this must be kept strictly secret. He should close his studio to visitors while he is working on it. Since I do not wish to hide anything from you, the subject I am treating is *the Lord chasing the Devil from a mountaintop*. The student himself doesn't need to know this: all I need from him is a simple figure of a Negro in that pose.[22]

The Musée Ingres still has the tracing Ingres provided, as well as the magnificent study that Chassériau delivered in 1838 (figs. 321, 322). Although conforming to the sketch, Chassériau's figure stands out against a startling blue sky that seems to have been an invention by the young student, who was then barely nineteen years old. Ingres's composition, apparently never completed, came to a paltry conclusion in a simple drawing from 1860 dedicated to Paul Lacroix.[23]

The final period of Ingres's career, which covers his last stay in Paris (1841–67), seems almost unimaginably prolific for a painter who had a reputation for slowness—even if that supposed slowness should, in fact, be carefully reconsidered. It is obvious that the presence of students at his side—and the bad habits that he had gotten into for at least two of his recent Roman canvases (*Antiochus and Stratonice* and the portrait of Cherubini)—increasingly led him to call upon the talents of the Balzes and Paul Flandrin, and later of Armand Cambon. It might even be said that Ingres's triumphant return to Paris and his official stature as leader of the Neoclassical school encouraged him to follow the course of least resistance. After all, the public success of *Antiochus and Stratonice* and Louis-Philippe's purchase of the portrait of Cherubini had excited almost unanimous admiration (which these works still enjoy), without in any way revealing the existence of assistants. Since the participation of helpers had not caused the paintings to be any less admired, why should Ingres fail to avail himself of them? And so, when he repurchased *The Dream of Ossian* (fig. 95) and *Virgil Reciting from "The Aeneid"* (fig. 94), he entrusted his young followers with the task of preparing the ground for his planned alterations.

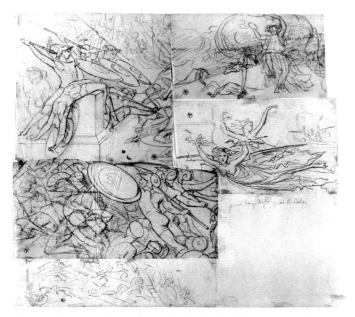

Fig. 323. Raymond Balze (b. 1818). *Studies for "The Iron Age,"* 1843–47. Graphite and red chalk on paper. Musée Ingres, Montauban (MIC.29)

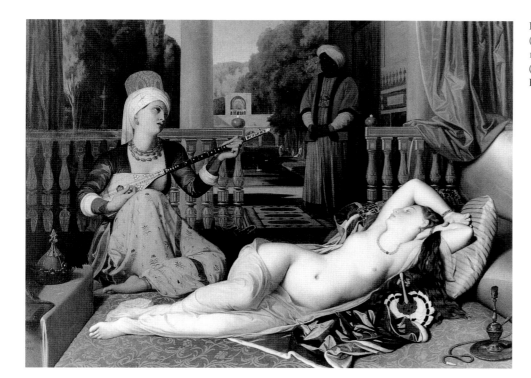

Fig. 324. Ingres and Paul Flandrin (1811–1902) (?). *Odalisque with Slave*, 1841. Oil on canvas, 29⅞ × 41⅜ in. (76 × 105 cm). Walters Art Gallery, Baltimore

Ingres's first great commission of the 1840s—the decoration of the Salon of Minerva in the Château de Dampierre—was a gargantuan undertaking for a man who loved small formats and sober, simple compositions and who still remembered his troubles with *The Apotheosis of Homer* and *The Martyrdom of Saint Symphorian*. There are two artists whom scholars regularly mention as clearly having assisted on the Dampierre project: Alexandre Desgoffe for the landscape of *The Golden Age* (fig. 204) and Auguste Pichon for the sadly empty architecture of *The Iron Age*. Unable to determine the exact nature of his participation, art historians have neglected the contribution of a certain Joseph Tourtin, who is named in two letters to Gatteaux, dated October 9, 1844, and July 21, 1845. They are also unaware of the role played in Dampierre by a certain François Baranton (or Barenton), who is mentioned several times by Scribe in his letters to Momméja. The ceramist claimed to be a close friend of Baranton, an artist from Orléans who later specialized in stained-glass windows. On November 10, 1897, Scribe wrote, "Let me tell you a little about The Golden Age at Dampierre, the duc de Luynes's residence. Since Baranton turned out to be the only assistant, I got several details from him."[24] While Scribe's friend is doubtless guilty of some boastfulness, since he was clearly not the only assistant on *The Golden Age*, his assertion should not be rejected entirely.

Only with *The Iron Age*, however, did Ingres's collaborative practices undergo a true evolution: apart from two miserable sketches by the master, which Gatteaux bequeathed to the Louvre, there are five drawings by another artist, Raymond Balze, which impart most of what is known about the composition. These works (fig. 323), now in the Musée Ingres, are glued onto a single board, and an inscription on the mounting paper clearly indicates the author's name and the reason for the studies: "pour l'age de fer par R. Balze" ("for the iron age by R. Balze").[25] It is not difficult to reconstruct the chain of events: Ingres, suddenly realizing that his deadline for finishing the mural paintings was fast approaching, had no choice but to ask his faithful Raymond to start creating the first groups of figures for *The Iron Age*, to which he had so far given little thought. Just as quickly, he had the no less considerate Pichon execute an ancient acropolis, which was, moreover, derived largely from a design by Félix Duban, the architect hired to restore the château. Because of unforeseen circumstances—the Revolution of 1848, then Madeleine Ingres's death the following year—these initial drawings were not developed into preparatory sketches, nor was the subject ever painted. Again, as Chassériau had done for the Temptation of Christ, Ingres's collaborators had taken the project further than the master himself had.

Several of Ingres's students copied his works during this time. Among these were Hippolyte Flandrin, whose version of the portrait of Cherubini (1843; Musée du Château, Versailles) left out the Muse but had an astonishing variation in the musician's right hand,[26] and Franz Adolf von Stürler, who copied the 1820 portrait of Bartolini (1845; Museo Nacional del Prado, Madrid). The most

Fig. 325. Ingres, Armand Cambon (1819–1885), and Michel Dumas (1812–1885) (?). *Saint Germaine Cousin of Pibrac*, 1856 (W 278). Oil on canvas, 73¼ × 45⅝ in. (186.1 × 115.9 cm). Saint-Étienne de Sapiac, Montauban

important of such works was the second version of the *Odalisque with Slave*, now in the Walters Art Gallery, Baltimore (fig. 324), which was apparently executed in 1841 by Paul Flandrin. In the March 10, 1846, issue of *Le Constitutionnel*, Théophile Thoré had written, "There exists a repetition of that Odalisque with some changes, painted in 1841 by M. Ingres himself, for the court of Württemberg. Collectors had a chance to see it exhibited at M. Léopold's gallery on the boulevard Italien. The background is a landscape, which gives the composition air and space. We believe this was handled by M. Flandrin, the best landscape artist of the Ingres school."[27] Although pointedly stating that Ingres was the author of the painting, Thoré also seems almost obliged to mention the name of a student with regard to the landscape—even as he feigns uncertainty.

However, in an article published on June 16, 1890, in *Le Courrier de Tarn-et-Garonne*, Momméja dared to publish an excerpt from a letter that he had received from Paul Flandrin: "It is quite true that a repetition of the

Odalisque with Slave from the Marcotte collection was made about 1841, since I am the one whom M. Ingres assigned to copy it. I painted the entire canvas, figure and landscape. The background landscape had been chosen by M. Ingres from a sketch I had made of the duc de Luynes's park in Dampierre. As for the figure, it was probably retouched by M. Ingres."[28] Flandrin may perhaps be referring to the same "secret project for Ingres" that Pierre Miquel mentioned, without further details, in his commentary on the artist's work.[29] The content of this letter is extremely important, since the second *Odalisque with Slave* has never been contested as a work painted solely by Ingres. Flandrin's statements may be attributable to a flawed memory—his use of the word "probably" is astounding—or to his desire to appear as great a painter as his master. Or perhaps they constitute a perfectly sincere admission that should prompt a reevaluation of the attribution of the painting. Whatever the case, Flandrin's confession indicates that student contributions of such magnitude were entirely plausible, and must have existed, and that the master's attentive supervision was enough to ensure that he would receive credit for works he may scarcely have touched.

The works of the 1850s are particularly eloquent in this regard. *Saint Germaine Cousin of Pibrac* (fig. 325) is visibly a collective labor by Ingres, Cambon, and Michel Dumas; the Musée Ingres owns two studies for the saint's hands by Dumas,[30] but naturally only Ingres signed the painting. The Balzes clearly participated in *Joan of Arc at the Coronation of Charles VII* (fig. 215), which was copied by Pichon for the city of Orléans in the following years, but with variants that suggest Ingres oversaw its execution. Paul Balze and Desgoffe similarly shared in the making of *La Source* (fig. 202). But we do not know how extensive the work of these collaborators was, nor at what point the master began to intervene. The few extant accounts of these paintings bear equal witness to the students' love for Ingres and respect for his memory and to their legitimate desire to see at least some of their contributions recognized and appreciated.

The project of a ceiling for the Salon de l'Empereur in the Hôtel de Ville, Paris (1853), constituted an important commission for Ingres, one in which he definitely had the assistance of his students. Raymond Balze posed for the emperor and drew Ingres as Nemesis in the central painting, *The Apotheosis of Napoleon I* (fig. 210), but it was his brother Paul who made, and signed, the charming oil sketches for most of the figures and the eagles (fig. 326). Perhaps we should also attribute to Paul the miniatures

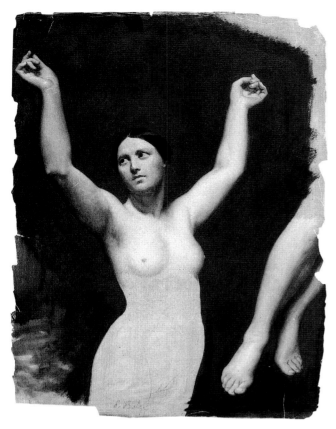

Fig. 326. Paul Balze (1815–1884). *Sketch for "The Apotheosis of Napoleon I,"* 1853. Oil on wood, 17¾ × 13⅜ in. (45 × 34 cm). Musée Ingres, Montauban (MIC.44)

less, studies for several of the figures, now in the Cambon archives at the Musée Ingres,[32] seem to indicate that Cambon was largely instrumental in putting the finishing touches to some of the panels. These documents, while not easily interpreted, constitute important pieces of evidence. Ingres has never been thought responsible for the ceiling panels in the Hôtel de Ville, nor for those that accompanied *The Apotheosis of Homer* in the Galerie Charles X, the latter having been executed by the Charles brothers and Auguste Moench (when the painting was later moved elsewhere, it was replaced by a superb copy made in 1860 by the Balzes and Dumas). To my mind, this is a grave injustice, since the master's participation in these two projects was total, lengthy, patient, and attentive—as witnessed by the numerous extant drawings that are indisputably in his hand.

By this time, certain of Ingres's students had earned respectable reputations because they were truly talented and, as their abilities grew, they were able to blend more and more into the spirit and style of their master. Indeed, who would imagine that students took part in Ingres's last series of portraits, from the *Comtesse d'Haussonville* of 1845 (cat. no. 125) to the celebrated *Venus on Paphos* of

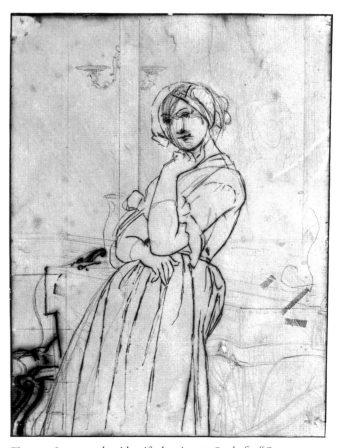

Fig. 327. Ingres and unidentified assistant. *Study for "Comtesse d'Haussonville,"* 1845. Graphite on paper, 9¼ × 6¾ in. (23.4 × 17.2 cm). Musée Ingres, Montauban (867.259)

in the Musée de Châteauroux, which for a long time were attributed to Jules Bastien-Lepage and on which the signature "Balze" was finally identified only a few years ago. There is no doubt that the execution of the immense central tondo required the help of faithful collaborators, but their contributions can no longer be evaluated, since the work was destroyed in a fire in 1871.

But in the allegories of the eight cities conquered by Napoleon—Rome, Milan, Naples, Vienna, Moscow, Cairo, Madrid, and Berlin—which were intended to surround the main painting, the students finally appeared completely as themselves, their works arrayed like constellations around that of the master. Pichon, Desgoffe, the two Balzes, Paul Flandrin, Sébastien Cornu, Albert Magimel, and Cambon executed these in their entirety, although contradictory lists and the destruction of the paintings (of which no photographs exist) make it difficult to determine how the labor was divided. The numerous studies Ingres made for these figures[31] confirm that nothing was painted without his approval. Neverthe-

1852–53 (fig. 14), which depicts the features of the beautiful Madame Balaÿ? The assertion seems incongruous at first, for these paintings appear to represent the final flowering of an artist who was unsurpassed as a portraitist. Yet certain undeniable facts must be recognized, and certain clues deciphered that are offered by several drawings in the Musée Ingres's catalogued archives and cartons of unpublished works, as well as by a small sketch for the second portrait of Madame Moitessier.

The portrait of the comtesse d'Haussonville was preceded by an entire series of magnificent studies (cat. nos. 125–131). Among these is a rather curious one—a virtuoso ink sketch of the figure against a carefully rendered decor in graphite (fig. 327). The styles of the two parts of the drawing are so different that one must admit that a collaborator who specialized in the depiction of bourgeois interiors, furniture, and knickknacks worked with Ingres on those sections of the painting. After all, he had already, for the 1842 portrait of the duc d'Orléans (cat. no. 121), engaged a rather mediocre drudge to draw the wreathed column pattern decorating the wall covering in the sitter's salon at the Tuilleries.[33] Could Ingres, ever eager to be known as a history painter, stand to waste his time painting upholstered white armchairs or porcelain vases and opera glasses on a mantelpiece? Plagued as he considered himself by portrait commissions during the last twenty years of his life, could he really set aside fables and antiquity for such petty occupations? No doubt he preferred to leave them to the faithful Cambon, who many times in his own paintings had demonstrated a real genius for depicting materials, objects, and reflections of light on furniture. It was Cambon who had taken the liberty, for the Salon of 1864, of painting a Galel (Musée Ingres, Montauban) that was simply a barely disguised variation on his master's *Bather of Valpinçon* (fig. 81), yet surrounded by a wealth of multicolored draperies rendered with prodigious virtuosity. Unfortunately, the figure itself was much less successful.

Cambon enjoyed a privileged position with Ingres. A relative and fellow native of Montauban, he was very close to the artist, who later made him executor of his estate and helped him become the director of the Musée de Montauban, as well as author of its first catalogue. A drawing signed by Cambon and preserved in Ingres's files (fig. 328) is captioned "Vierge a l'hostie" ("Virgin with the Host") but obviously depicts part of the wall decorations for the first portrait of Madame Moitessier, dated 1851 (cat. no. 133). Though small, the sheet effectively conveys the quality of Cambon's contributions to the large female likenesses of Ingres's final years—and even to certain other canvases, since the caption is evidently related to the repetition of *The Virgin with the Host* that was executed for Madame Marcotte at the same time as the portrait (private collection, London).

The second portrait of Madame Moitessier, completed in 1856 (cat. no. 134), raises other questions, since the drawn studies and painted sketch for its background, all at the Musée Ingres,[34] hardly resemble Cambon's characteristic work, which is always—and sometimes overly—elegant in style. No doubt Cambon was unavailable for some reason, and Ingres resolved to use another artist, who first drew at his request eight studies of furniture on blue-gray paper (fig. 269). The same artist then made the small painted study (cat. no. 144), on which he summarily brushed in a few suggestions from the drawings around a simple outline of the figure painted by the master. The final painting took another approach, however, and was based mainly on drawings different from those used for the study in Montauban. Was the execution of the magnificent decor in the London portrait left to the assistant who had initially created it? Whether or not he actually painted it, he certainly at least sketched it onto the canvas.

Fig. 328. Armand Cambon (1819–1885). *Study for "Madame Moitessier" (Wall Decorations)*, ca. 1851. Graphite on paper. Musée Ingres, Montauban

Fig. 329. After Agostino Tassi (1565–1644). *The Investiture of Taddeo Barberini*, ca. 1814. Graphite on paper, 10⅝ × 8¾ in. (26.9 × 22.2 cm). Musée Ingres, Montauban (867.1250)

The indisputable presence of collaborators on these marvelous late portraits implies that assistants may also have worked on the likenesses of the baronne de Rothschild, dated 1848 (cat. no. 132), and the princesse de Broglie, dated 1853 (cat. no. 145). These two works, together with the previously mentioned portraits from the same period, form a group marked by a remarkable homogeneity of spirit, equal to that of the marvelous male portraits made with Granet almost forty years earlier. Both portraits contain crests of arms and wallpaper designs of a simplicity that suggests Ingres indeed relegated them to a humble and grateful assistant. It is obvious that the master was the one who conceived of the compositions, and the only one who executed the figures. It is also certain that he himself designed the arrangement of the draperies—even consulting the sitters on the choice of garments; witness, for example, the beautiful drawn studies of the stunning gown worn by Baronne de Rothschild (Musée Ingres, Montauban).[35] But Ingres was probably tempted to entrust to another talented painter, whether Cambon or someone else, the tasks of detailing the folds and painting in the accessories and jewelry, all the while reserving the right to add the final touches, the very ones that confer on

these paintings their artistic value and authentically Ingresque character.

In the highly finished portrait of Madame Gonse (fig. 208), the skin is so fine as to be almost transparent, with the sketch lines underneath barely concealed, yet the fabrics are generally painted with much thicker strokes. More advanced scientific analysis will one day help to clarify the real differences in treatment among the various portions of this work: they should confirm Ingres's ultimate responsibility for the painting, while still acknowledging the subtle gradations of interventions by other hands. It is known that one of the Balzes copied the portrait of the comtesse d'Haussonville and that Paul Flandrin copied the one of the baronne de Rothschild;[36] there are many repetitions of Ingres's three late self-portraits, including those by Étienne-François Haro, Cambon, and Mademoiselle Jacquiot. Perhaps these works provide clues to the identities of Ingres's last assistants: could the same hands that copied them have had the opportunity to participate as well in the execution of the original canvases?

As to the talent of Ingres's student assistants, at least partial credence may be given to Baudelaire's insightful judgment in his review of the Salon of 1846:

> Around M. Ingres, whose teachings must inspire some kind of fanatical austerity, are grouped several men, the best known being Messrs. FLANDRIN, LEHMANN, and AMAURY DUVAL. But what an immense distance from master to students! M. Ingres is still alone in his school. His method is the result of his nature, and however bizarre and obstinate it might be, it is sincere, which is to say, involuntary. Passionate lover of antiquity and its model, respectful servant of nature, he makes portraits that rival the best Roman sculptures. These gentlemen have—coldly, willfully, pedantically— translated the unpleasant and unpopular part of his genius into a system; for what distinguishes them is pedantry, above all. What they saw and studied in the master is curiosity and erudition. Whence their attempts at thinness, pallor, and all those ridiculous conventions, adopted without reflection or good faith. They have gone far, very far, back into the past, to copy with servile childishness some deplorable errors, and have voluntarily denied themselves all the resources of execution and success that the experience of centuries had prepared for them.[37]

Already a bit dated at the time, Baudelaire's judgment must be revised in light of developments during the following decade. First of all, the talent of these students (which was still difficult to appreciate in 1846) grew con-

siderably over the next ten years; a few of them even became masters in their own right. As for the "Boss," his final period was characterized by a greater suppleness of line, by a more youthful style, that might even be attributed to the influence of the younger generation of artists he had helped to form. Ingres's art had always taken inspiration from others, first the ancients, then his contemporaries; so why not from his own students as well? It is no doubt remarkable, but not really surprising, that he may have studied Hippolyte Flandrin's sketched portrait of Madame Balaÿ—whether the original or a tracing of it given to him by Paul Flandrin—in creating his *Venus on Paphos*, or that he copied almost line for line an engraving by Victor Mottez after a composition by Charles Le Brun for the decor in his *Molière at the Table of Louis XIV*. The close community in which these individuals lived, their constant communication and profound aesthetic compatibility, could not fail to encourage all sorts of strange, fertile, and multifarious influences: the master acted as the students' guide, but the students also served as a source of renewal for him. In fact, Ingres's style had always drawn its strength and originality from the continuity of such multidirectional interchanges. When Pichon was assigned to "restore" the *Virgil Reciting from "The Aeneid,"* which Ingres had left virtually as a sketch after trying several times to perfect it, or when the Balzes discovered and restored canvases that Ingres had disowned and given to them covered with a coat of white paint, no one accused them of having betrayed or destroyed these works. Instead, they received as much praise as the master himself would have.

One example seems fairly typical: *The Investiture of Taddeo Barberini* (fig. 329). This work was a copy of a painting by Agostino Tassi, drawn from a tracing made by Ingres about 1814. Raymond Balze, who inherited it, later confided his thoughts to Henry Lapauze: "Ingres bequeathed to me a very large drawing on rice paper, depicting the crowning of a prince by Pope Urban VIII in the chapel of the Quirinale. He left me this important work, composed of almost one hundred figures, and inscribed on it the names of the garments and their colors, thinking that I might finish it—which I have scrupulously kept from doing."[38] But, as Lapauze suspected, it was probably Balze himself who colored the principal group of figures with some cursory touches of paint. No doubt he then hesitated, either because of the fragility of the paper or the difficulty of the task, leaving his attempt unfinished and therefore rather inelegant. Yet Balze's scruples, which sounded very honorable several decades after the master's death, do not seem quite appropriate in light of the fact that he so often wielded Ingres's brush in his stead. Clearly, what Balze found himself lacking more than anything else was an encouraging or a dissuasive word from the master—for although Ingres's students may have painted on his canvases, it was his guidance that made their work convincing and prevented it from falling into pastiche. Ingres's mastery of painting gave him the right to approve, have redone, or completely reject the slightest detail executed by an assistant. Every one of his paintings, therefore, forms a part of his oeuvre, even if he sometimes felt the need to find allies and substitutes for his own hands. More than anything, it was the power of Ingres's will and his intellectual control that brought about the mysterious alchemy that creates masterpieces.

1. Inv. 867.3637–39.
2. Fol. 123; see Vigne 1995b, p. 325.
3. Ibid., ill. p. 340.
4. Toussaint in Paris 1985, pp. 30–31.
5. "Je laisse au musée du Louvre à titre de don, et à la condition expresse que le tableau sera exposé dans les Galeries du Louvre, parmi les oeuvres des grands peintres modernes, le nom de mon père étant inscrit dans le catalogue, le magnifique portrait qu'Ingres a fait de lui, et représentant au fond du tableau le temple de Sybille peint par Grasset." For the complete text, see Naef 1977–80, vol. 1 (1977), p. 262.
6. *Bulletin du Musée Ingres*, nos. 63–64 (1990), cover ill.
7. Hélène Toussaint (1990a) has quite rightly challenged the attribution to Ingres of three landscapes hitherto unquestioningly considered to be his: the two tondi in Montauban and the one at the Musée des Arts Décoratifs in Paris.
8. Inv. 867.4313, 4315, 4316, 4318, 4324–26, 4331, 4337–40, 4342, 4346, 4347, 4350, 4352, 4356–59, 4361, 4362, 4373, 4374, 4377, 4378, 4385, 4386, 4390–92, 4394–97, 4399, 4400, 4404, 4406, 4437, 4459.
9. In Rome, Paris 1993–94, pp. 357–59.
10. Toussaint 1994.
11. For instance, Musée Ingres, inv. 867.1761–65, 1773, 1775, 1776, 1779, 1782.
12. Blanc 1870, p. 80.
13. Inv. 867.2528–30.
14. "Une exposition des ouvrages des peintres vivants était annoncée pour l'année suivante (1827); je m'étais proposé d'y assister. L'ouverture du salon ayant été considérablement retardée, j'arrivai trop tôt à Paris, et mon séjour y fut bien plus prolongé que je ne l'avais prévu. Mais aussi quel précieux dédommagement m'était réservé!

"On décorait, au Louvre, une galerie destinée à recevoir les antiquités recueillies dans les ruines des cités ensevelies sous les cendres du Vésuve. Les artistes chargés d'exécuter des oeuvres importantes, principalement au plafond de cette galerie, dite galerie Charles X, sollicitèrent le retard apporté à l'ouverture du salon. . . .

"Mon illustre ami n'avait jamais aimé d'être ainsi limité par le temps. Il se trouvait d'autant plus embarrassé qu'il avait à peine arrêté le trait sur la toile: seulement il avait fait un grand nombre d'études préparatoires, tracées la plupart au crayon, sur papier, pour lui servir d'indication.

"Dans cette situation périlleuse, forcé d'engager sans délai une lutte suprême d'où dépendait le triomphe d'une réputation encore contestée, Ingres dut se soustraire à ces longues hésitations dont son esprit avait contracté l'habitude sous l'influence des critiques outrageantes adressées à ses talents hors ligne, trop longtemps méconnus.

"Pour surmonter cet obstacle importun, les encouragements de l'amitié ne furent peut-être pas tout à fait inutiles, et j'ose ajouter qu'ils ne lui firent pas défaut. Mais si, dans l'exécution rapide de ce chef-d'oeuvre et sur l'invitation amicale du maître, mon faible pinceau a quelquefois été assez heureux pour se poser sur la toile à côté du sien, c'est là un honneur dont le souvenir ne s'effacera jamais de ma mémoire, sans m'aveugler toutefois, sur le titre de collaborateur que, dans un moment d'indulgente effusion, le grand artiste voulait bien m'attribuer. Néanmoins, cette sorte de participation servit de base à l'intimité, dès lors inaltérable, qui s'établit entre ce grand réformateur de l'école et l'ami dévoué qui était resté à ses côtés jusqu'à ce que le tableau terminé eût été mis en place au grand jour de l'ouverture de la galerie Charles X." Debia 1868, pp. 6–7.

15. Inv. 867.89 and 50.547.

16. "Quand vous reverrez le portrait de M. Bertin au Louvre, remarquez je vous prie le point lumineux sur le bras du fauteuil. On y distingue une fenêtre avec ses rideaux. Ce fauteuil a été peint par Duthanofer, décorateur connu en ce temps là. Le maître lui a fait refaire cinq à six fois ce point lumineux, ne le trouvant jamais assez poussé dans le détail du rideau. J'ai eu ce détail d'un condisciple, le fils de ce Duthanofer." Momméja Papers, Musée Ingres, Montauban, vol. 1, "Ingres. Documents." This had already been reported by Toussaint in Paris 1985, p. 74.

17. Musée Ingres, unpublished drawings.

18. "Que de fois la nature a été consultée! soit qu'un élève d'Ingres, l'un des Balze ou l'un des Flandrin, se mettant à genoux, Ingres lui jetât sur le dos la draperie pour saisir en flagrant bonheur quelques beaux plis, soit que le maître lui-même, courant éperdu et déshabillé à travers la chambre, et jouant en pensée le rôle de Séleucus, vînt se précipiter haletant sur un matelas pour fournir à ses élèves le motif de cette draperie, qu'il voulait naturelle autant que noble, expressive autant que belle. Et quelle bonne foi naïve dans cet homme petit, obèse et ramassé, qui, sans craindre le comique de son action, sans même le soupçonner, se pénétrait des passions qu'il avait à peindre, au point de mimer le désespoir d'un héros antique, et frisait le ridicule pour atteindre, s'il était possible, à la suprême beauté!" Blanc 1870, p. 118; quoted in Montauban 1993–94, p. 12.

19. "L'émotion de Ingres était extrême: il en pleurait. Il nous raconta le sujet plusieurs fois pendant que nous y travaillions, mon frère et moi. C'est moi qui ai fait les meubles et la lyre, nombre de fois changée de place. Mon frère Paul a eu pour ce tableau et le Patron la patience la plus extraordinaire. Primitivement, avant les colonnes actuelles, le fond se composait de la *Bataille d'Arbelles*, d'après la mosaïque de Pompéï, puis des travaux d'Hercule, dont il ne reste presque rien, puis enfin des colonnes et toute l'architecture." Lapauze 1911a, pp. 356–57.

20. "Mais quel est donc l'extravagant et le fanatique qui s'est avisé le premier d'*ingriser* la campagne?" Baudelaire 1956, p. 78.

21. "Je travaille aussi pour M. Ingres, ce qu'il ne faut pas dire puisqu'il a l'intention de faire passer pour de lui ce que je lui fais, bien entendu en y retouchant"; "M. Ingres me pria de l'aider. Il fallut opter. . . . J'ai donc promis, et je lui donne tout le temps qu'il veut. . . . Je ne vous dirai pas ce que je fais pour lui puisqu'il m'a demandé la plus absolue discrétion à ce sujet. Il vous suffira de savoir qu'il me confie jusqu'aux choses les plus importantes et qu'il est très content." Quoted in Stern, Liszt, and Lehmann 1947, pp. 132, 138–39, and by Toussaint in Paris 1985, pp. 81–82.

22. "Il faut, mon cher, que vous me fassiez le plaisir de me seconder dans une chose qui me fait le plus grand besoin. Le calque ci-joint vous indiquera ce que je veux. Il faut donc trouver parmi mes élèves celui qui sait le mieux faire le portrait d'un modèle, et, si vous ne me trouvez mieux, je crois pouvoir vous désigner le jeune Chassériau. Je vous prie donc de me l'envoyer chercher et de lui faire part de ma proposition. . . . Surtout qu'il copie le type de l'individu le plus possible. Je vous prie de lui recommander le plus grand secret. Qu'il ferme son atelier aux désoeuvrés pendant ce temps. Comme je ne dois rien vous cacher, le sujet que je veux traiter est *le Seigneur chassant le démon du haut de la montagne*. Quant à l'élève, il n'a pas besoin de le savoir: je lui demande une simple figure de nègre dans cette attitude." Quoted in Delaborde 1870, pp. 319–20.

23. I subscribe to the commonly held opinion that this Temptation of Christ was never painted, since it has not resurfaced in the last 150 years. Still, it was fleetingly evoked in an article by the architect Maurice Du Seigneur (1888, p. 327): "My friend Zando can sit at the piano and play me a bit of overture, in the low register, to render melodically the musical part of the poem. *First scene:* the Buttes Montmartre at night, the cathedral of Sacré-Coeur is unfinished and, in the scaffolding, working by moonlight, a squad of laborers stand out in black silhouettes like Callot's little devils. The Moulin de la Galette spreads its wings enormously, a cat meows, and a white, white, white Pierrot comes toward me. Showing me Paris, he strikes the pose of Satan in Ingres's painting of *Christ in the desert*. He seems to be saying: Here is my Empire; then, pointing more specifically to the plains of Monceaux, he says: Choose among all these residences, I give you Meissonnier's studio, the Palais Gaillard, the house of Dumas II, or even the mansions of Jules Cousin on the rue de Prony—choose. . . ." ("L'ami Zando peut se mettre au piano et me faire un petit bout d'ouverture, dans les notes graves, pour rendre d'une façon mélodique la partie musicale

du poème. *Premier tableau:* les buttes Montmartre la nuit, l'église du Sacré-Coeur est inachevée et, dans ses échafaudages, travaillant au clair de lune, une escouade d'ouvriers qui se détachent en silhouettes noires, semblables à des diablotins de Callot. Le moulin de la Galette allonge démesurément ses ailes, un chat miaule et Pierrot tout blanc, tout blanc, tout blanc s'approche de moi, et, me montrant Paris, prend la pose de Satan dans le tableau du *Christ au désert*, de M. Ingres. Il semble me dire: Voici mon Empire, puis me désignant plus spécialement la plaine Monceaux, il me dit: choisis parmi toutes ces demeures, je te donne l'atelier de Meissonier, le palais Gaillard, la maison de Dumas II, ou même les hôtels de Jules Cousin, rue de Prony, choisis. . . .")

Was the architect referring only to the study by Chassériau, or perhaps to a painting he had seen in a very private collection? His tone, at once jocular and complicit, suggests a certain pride in knowing of an unpublished work by the great painter, which he very intentionally mentions here. Furthermore, studies of Ingres's work were not yet sufficiently numerous at the time for either the project of the Temptation of Christ or even the relation between the composition and Chassériau's study to be familiar to art lovers.

24. "Je vous parlerai un peu de l'Age d'or à Dampierre chez le duc de Luynes, Barenton ayant été en la circonstance l'unique auxiliaire, j'ai eu par lui quelques détails." Momméja Papers, Musée Ingres, Montauban, vol. 1, "Ingres. Documents." For more details, see Montauban 1997–98.

25. Montauban 1997–98, ill.

26. Paris 1985, ill. p. 88.

27. "Il existe une répétition de cette Odalisque avec des changements, peinte en 1841 par M. Ingres lui-même, pour la cour de Wurtemberg. Les amateurs ont pu la voir exposée chez M. Léopold, au boulevard Italien. Le fond est un paysage, qui donne un peu d'air et d'espace. Nous croyons qu'il a été exécuté par M. Flandrin, le meilleur paysagiste de l'école ingriste." Thoré, March 10, 1846, quoted in Bertin 1996, p. 60.

28. "Il est bien vrai qu'il a été fait, vers 1841, une répétition de *l'Odalisque à l'esclave* de la collection Marcotte, puisque c'est moi qui ai été chargé par M. Ingres de la copier. J'ai peint le tableau tout entier, figure et paysage. Le fond de paysage avait été choisi par M. Ingres sur un motif que j'avais fait du parc de M. le duc de Luynes, à Dampierre. Quant à la figure elle avait été sans doute retouchée par M. Ingres." Momméja, June 16, 1890, quoted in Bertin 1996, p. 61.

29. Miquel 1975, vol. 2, p. 412.

30. Unpublished drawings.

31. Musée Ingres, inv. 867.1129–45.

32. Unpublished drawings.

33. Gastinel-Coural 1990, ill. p. 27.

34. Inv. 867.317–19; Vigne 1990, ill. pp. 30, 31.

35. Inv. 807.372–75.

36. Flandrin's work, which dates to about 1850, was recently acquired by the Israel Museum in Jerusalem and published in Weiss-Blok 1997, pp. 125–30.

37. "Autour de M. Ingres, dont l'enseignement a je ne sais quelle austérité fanatisante, se sont groupés quelques hommes dont les plus connus sont MM. FLANDRIN, LEHMANN et AMAURY DUVAL. Mais quelle distance immense du maître aux élèves! M. Ingres est encore seul de son école. Sa méthode est le résultat de sa nature, et quelque bizarre et obstinée qu'elle soit, elle est franche, et pour ainsi dire involontaire. Amoureux passionné de l'antique et de son modèle, respectueux serviteur de la nature, il fait des portraits qui rivalisent avec les meilleures sculptures romaines. Ces messieurs ont traduit en système, froidement, de parti pris, pédantesquement, la partie déplaisante et impopulaire de son génie; car ce qui les distingue avant tout, c'est la pédanterie. Ce qu'ils ont vu et étudié dans le maître, c'est la curiosité et l'érudition. De là, ces recherches de maigreur, de pâleur et toutes ces conventions ridicules, adoptées sans examen et sans bonne foi. Ils sont allés dans le passé, loin, bien loin, copier avec une puérilité servile de déplorables erreurs, et se sont volontairement privés de tous les moyens d'exécution et de succès que leur avait préparés l'expérience des siècles." Baudelaire 1956, pp. 132, 140, n. 2, 156–59, 162.

38. "Ingres m'a légué un très grand dessin sur papier végétal, représentant le couronnement d'un prince par le pape Urbain VIII, dans la chapelle du Quirinal. Il me légua cet important travail composé de près de cent figures et y inscrivit le nom des vêtements et leurs couleurs, pensant que je pourrais le terminer, ce dont je me suis bien gardé." Lapauze 1911a, pp. 145–46.

CHRONOLOGY, BIBLIOGRAPHY, INDEX, AND PHOTOGRAPH CREDITS

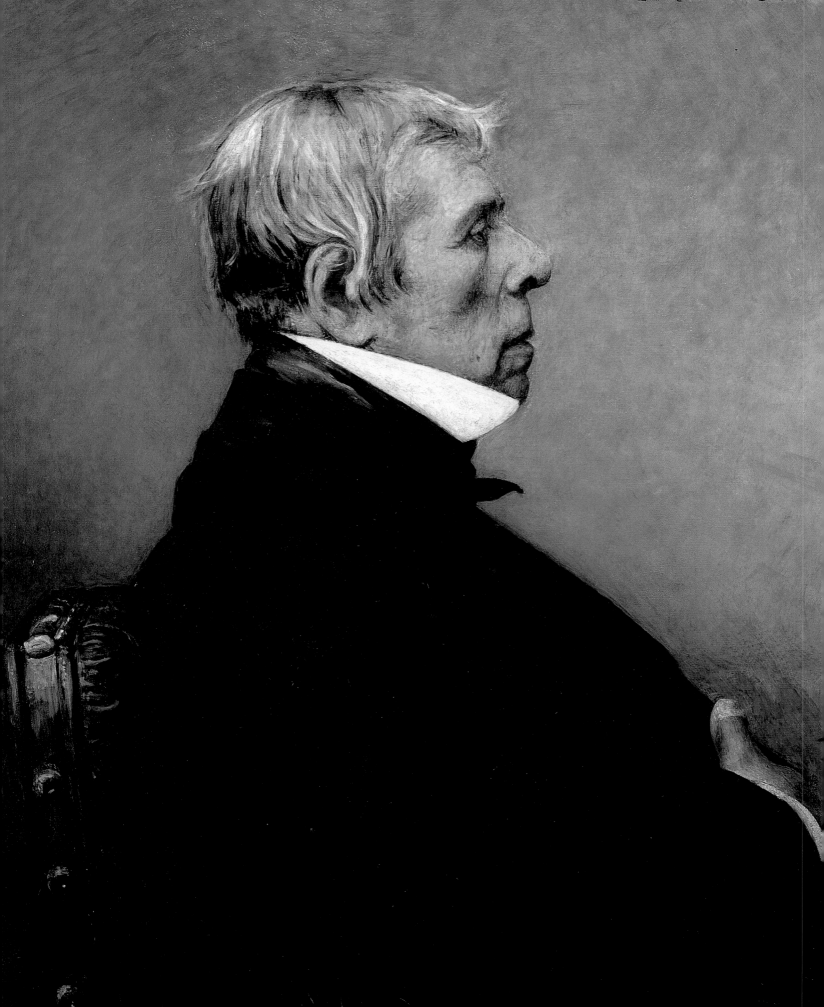

J·A·D·INGRES

1780 – 1867

CHRONOLOGY

Rebecca A. Rabinow

August 29, 1780
Jean-Auguste-Dominique Ingres is born in Montauban, France. He is the eldest child of Jean-Marie-Joseph Ingres (1755–1814), a sculptor, painter, and decorative stonemason, and Anne Moulet (1758–1817), the daughter of a master wigmaker. The couple will have six other children: Anne (1782–1784), Jacques (1785–1786), Augustine (1787–1863), Anne-Marie (1790–1870), and twin boys Pierre-Victor (1799–1803) and Thomas-Alexis (1799–1821).
(Vigne 1997, pp. 13–15)

September 14, 1780
Baptized in the church of Saint-Jacques, Montauban.

Fig. 331. *Joseph Ingres and His Daughters Augustine and Anne-Marie*, ca. 1796. Graphite, ink, and wash on paper, 6¾ × 9⅞ in. (17.1 × 25.2 cm). Musée Ingres, Montauban (867.275)

1786–91
Attends the Collège des Frères des Écoles Chrétiennes, Montauban.

1789
The French Revolution. The Bastille is stormed on July 14, 1789; in late August of the same year the Constituent Assembly issues the Declaration of the Rights of Man.

Ingres's earliest-known signed drawing is made this year.
(Ternois and Camesasca 1971, p. 83)

1790
Ingres's father is appointed a member of the Académie Royale de Peinture, Sculpture et Architecture, Toulouse.

1791–99
On June 21, 1791, King Louis XVI and Queen Marie-Antoinette are arrested in Varennes. The monarchy is abolished on August 10, 1792; Louis XVI is executed on January 21, 1793, Marie-Antoinette on October 16 of the same year. After a period known as the Terror (1793–94), French politics are dominated by a series of coups d'état, which continue until Napoleon Bonaparte (1769–1821) assumes power in 1799.

1791–97
Attends the Académie Royale de Peinture, Sculpture et Architecture, Toulouse (renamed during the Revolution as the École Centrale du Département de Haute-Garonne). His teachers are the painter Joseph Roques (1754–1847), the sculptor Jean-Pierre Vigan (1754–1829), and the landscape painter Jean Briant (1760–1799). Ingres wins various drawing prizes there, including awards for life studies and composition: "the young [student] . . . will one day honor his country through [his] superior talents."
("ce jeune . . . honorera un jour sa patrie par la supériorité de [ses] talents." Ternois and Camesasca 1971, p. 83)

1794–96
Studies violin and performs with the Toulouse orchestra.

August 1797
With his friend Guillaume Roques (1778–1848), son of his first teacher, Ingres goes to Paris to study with Jacques-Louis David (1748–1825).

October 24, 1799
Accepted as a student at the École des Beaux-Arts, Paris.

November 1799
Napoleon dissolves the Directory and declares a new republic. He serves as First Consul during this period (known as the Consulate), which lasts until May 1804.

October 4, 1800
Ingres, along with Joseph-François Ducq (1762–1829), wins second place in the Prix de Rome competition. The subject of the preliminary

concours (judged in late March) is *Cincinnatus Receiving the Deputies of the Senate* (W 1; location unknown). The definitive subject of the competition is *Antiochus and Scipio* (W 2; destroyed). The first prize is won by another of David's students, twenty-one-year-old Jean-Pierre Granger (1799–1840). Because of their artistic prowess, Ingres and several other students at the École des Beaux-Arts are exempted from military conscription.

In a letter of November 1800, Ingres's residence is listed as 29, rue des Jeûneurs.
(Suvée to the minister of war, November 23, 1800, in Brunel and Julia 1984, letter no. 109, p. 211)

1800
Paints the candelabra and footrest in David's portrait of Madame Récamier (fig. 306).

February 2, 1801
Ingres's painting of a male torso (fig. 44) is awarded the Prix du Torse, a prize given by the École des Beaux-Arts for half-length figure painting.

September 29, 1801
Wins the Grand Prix de Rome for *The Ambassadors of Agamemnon* (fig. 45). The subject of the preliminary *concours* is *Hector Bidding Farewell to Andromache* (W 6; location unknown). Owing to the dismal state of French finances, however, prizewinners are not permitted to take the trip to Rome. Instead, the government provides Ingres with a stipend of sixty francs and a studio in the former Couvent des Capucines. Ingres is not awarded his trip to Italy until 1806.

December 17, 1801
Named a corresponding member of the Société des Sciences et Arts de Montauban.
(Ternois and Camesasca 1971, p. 83)

January 26, 1802
Napoleon becomes president of the Italian Republic.

January 29, 1802
Ingres, along with Édouard Thomassin, wins the Prix du Torse at the École des Beaux-Arts (W 9; Muzeum Narodowe, Warsaw).

Opposite: Fig. 330. Léon Bonnat (1833–1922). *J.-A.-D. Ingres* (detail). Oil on canvas, 31⅛ × 25⅝ in. (79 × 65 cm). Musée Bonnat, Bayonne

545

Fig. 332. Paul Flandrin (1811–1902), after Fleury Richard (1777–1852). *Ingres Posing Nude in David's Studio*, ca. 1800. Ink and graphite on paper, 8⅝ × 6¼ in. (22 × 16 cm). Musée Ingres, Montauban

September 2, 1802 (opening date)
Exhibits at the Paris Salon (held at the Muséum Central des Arts) for the first time: no. 719, *Portrait of a Woman* (W 12; location unknown).

Summer 1803
Receives a commission for the portrait *Bonaparte as First Consul* (cat. no. 2). The painting, which depicts Bonaparte pointing to a decree granting the town of Liège 300,000 francs to rebuild areas recently damaged by the Austrians, is unveiled to the citizens of Liège on May 23, 1805.

Mid-May 1804
French Empire established. On December 2, 1804, Napoleon crowns himself emperor and his wife Josephine empress at Notre-Dame Cathedral, Paris. The following March Napoleon is proclaimed king of Italy.

1804–5
Paints portraits of his father (cat. no. 4); the engraver Desmarets (cat. no. 7); his childhood friends Belvèze-Foulon (cat. no. 6) and Jean-Pierre-François Gilibert (cat. no. 5); the soon-to-be mayor of Montauban, Joseph Vialètes de Mortarieu (fig. 52); the sculptor Lorenzo Bartolini (1777–1850), who had resided with Ingres at the Couvent des Capucines in Paris (fig. 53); the Rivières (cat. no. 9; figs. 57, 58); and others, as well as his *Self-Portrait* (see cat. nos. 11, 147). In 1805 Ingres also begins *Napoleon I on His Imperial Throne* (cat. no. 10).

June 1806
Engaged to the artist and musician Marie-Anne-Julie Forestier (b. 1782), daughter of a lawyer to Parliament.

(Lapauze 1910)

September 1806
Receives state funding for his stay in Rome. He travels there via Turin, Milan, Lodi, Piacenza, Parma, Reggio, Modena, Bologna, and Florence, and arrives at the Académie de France on October 11. Studies perspective and anatomy and draws from live models as well as after the antique. Allotted a small room at San Gaetano.

(Ingres to Pierre Forestier, October 5, 1806, in Boyer d'Agen 1909, pp. 45–46; Méras 1967, p. 16)

September 15, 1806 (opening date)
Ingres (listed as a pensioner at the École de France in Rome and as a student of David) exhibits several paintings at the Paris Salon, the first Salon of the Empire, held at the Musée Napoléon: no. 272, *Napoleon I on His Imperial Throne* (cat. no. 10), loaned by the Corps Législatif; and no. 273, several portraits exhibited under the same number, including the artist's *Self-Portrait* (see cat. nos. 11, 147), *Madame Philibert Rivière* (cat. no. 9), *Caroline Rivière* (fig. 58), and possibly *Joseph Ingres, the Artist's Father* (cat. no. 4). These works are not well received by the critics, prompting Ingres to comment, "So the Salon is the scene of my disgrace; . . . The scoundrels, they waited until I was away to assassinate my reputation. . . . I have never been so unhappy."

("Le Salon est donc le théâtre de ma honte; . . . Les scélérats, ils ont attendu que je sois parti pour m'assassiner de réputation. . . . jamais je n'ai été si malheureux." Ingres to Pierre Forestier, October 22, 1806, in Boyer d'Agen 1909, pp. 47–48)

November 23, 1806
Writes to his fiancée's father that he will never again exhibit at the Salon, since it causes too much suffering.

(Ingres to Pierre Forestier, November 23, 1806, in Boyer d'Agen 1909, p. 49)

Fig. 333. Achille Réveil (1800–1851). *Engraving after Ingres's 1804 Self-Portrait, Revised ca. 1850.* From Albert Magimel, *Oeuvres de J. A. Ingres* (Paris, 1851), fig. 1

July 2, 1807
Breaks his engagement to Julie Forestier and blames his self-doubt, the hardening of his heart, and his unwillingness to return to Paris on the negative criticism his works received at the Salon.

(Lapauze 1910, p. 180)

February 1808
France occupies Rome; the following year Napoleon declares the Papal States annexed to France. Pope Pius VII (1742–1823) consequently excommunicates Napoleon and the French army in June 1809 and is imprisoned.

1808
The annual exhibition of the Académie de France in Rome includes Ingres's recent *Bather of Valpinçon* and *Oedipus and the Sphinx* (figs. 81, 82). These paintings by Ingres, as well as those by his fellow-student Joseph-Denis Odevaere (1778–1830), are severely criticized when they are sent to Paris.

(Lapauze 1924, vol. 2, p. 85)

Ca. 1808
Begins painting *Venus Anadyomene* (fig. 201); finishes it forty years later.

1809
An international exhibition on the Campidoglio, Rome, includes two portraits by Ingres (possibly those of François-Marius Granet [cat. no. 25] and Madame Duvaucey [fig. 87]) as well as his *Sleeping Nude* (now known as *The Sleeper of Naples*; see fig. 85). The latter is purchased from the show by Joachim Murat (1767–1815), famous French general, Napoleon's brother-in-law, and the king of Naples from 1808 to 1815.

(See p. 101 in this catalogue)

February 1810
Rome is proclaimed the second capital of the French Empire.

November 1810
Having completed his term at the Villa Medici, Ingres chooses to remain in Rome and rents a room on the Via Gregoriana. Meanwhile, a fellow pensioner at the Villa Medici, the engraver Édouard Gatteaux (1788–1881), introduces Ingres to Charles Marcotte (Marcotte d'Argenteuil; 1773–1864), inspector general of forests and waterways in Rome, whose portrait Ingres paints (cat. no. 26).

(Daniel Ternois in Amaury-Duval 1993, p. 46)

1811
Receives two commissions for Monte Cavallo, a former papal residence in Rome being transformed into an imperial palace for Napoleon: *Romulus, Conqueror of Acron* (fig. 96), for

Josephine's apartments, and *The Dream of Ossian* (fig. 95), for the ceiling of Napoleon's bedroom.

(Siegfried 1980a, pp. 236–37; Ingres to the Académie Royale des Beaux-Arts, June [20], 1825, in Angrand 1982, p. 48, n. 13)

Jupiter and Thetis (fig. 92) is the last student exercise Ingres sends to the Académie des Beaux-Arts from Rome; it is purchased by the state twenty-three years later. He also works on a number of portraits at this time.

1812–13

Allotted a large studio in the tribune of Santissima Trinità dei Monti (a church adjacent to the Villa Medici) in which to work on the paintings for Monte Cavallo as well as others, such as *Virgil Reciting from "The Aeneid"* (fig. 94), commissioned by General Miollis, French governor of Rome, for his residence at the Villa Aldobrandini.

In 1813 Ingres paints his first version of *Raphael and the Fornarina* (W 86; location unknown) and works on *The Sistine Chapel* (fig. 100), which Marcotte commissioned the previous year.

(Vigne 1995a, p. 42; Ingres to the Académie Royale des Beaux-Arts, June [20], 1825, in Angrand 1982, p. 48, n. 13)

December 11, 1812

Asks parents' consent to marry Laura Laureta Zoëga (1784–1825), the eldest daughter of a Danish archaeologist residing in Rome. A short time later Ingres breaks off the engagement, explaining that his parents oppose the match and that his future financial state is bleak.

(Rostrup 1969, pp. 119–23 [EB])

December 4, 1813

Marries Madeleine Chapelle (1782–1849), a milliner from Guéret, in the church of San Martino ai Monti; Ingres proposed to Chapelle in a letter of August 7, 1813, written before the two ever met.

March 14, 1814

Ingres's father dies at Montauban. At the end of August of this year, the artist's mother travels to Rome for a brief visit with her son.

Spring 1814

Travels to Naples, where he executes the portraits of Napoleon's youngest sister, Queen Caroline Murat (1782–1839; cat. no. 34), and other members of the royal family. Ingres will paint three additional works for the Murats: the *Grande Odalisque* (fig. 101), a pendant to *The Sleeper of Naples* (fig. 85); *The Betrothal of Raphael* (fig. 102); and *Paolo and Francesca* (fig. 103).

The Murats lose power the following year and flee Naples, leaving many of their possessions, including Ingres's paintings, in the royal palace. After Joachim Murat is executed in October 1815, his family does not pay the artist for the works they commissioned. This causes Ingres great hardship; four years later he still is paying debts incurred during this period.

(Ingres to Gilibert, July 7, 1818, in Boyer d'Agen 1909, pp. 35–36)

April 6, 1814

After a series of military defeats, Napoleon abdicates at Fontainebleau. French functionaries leave Rome. In May the comte de Provence (1755–1824), the future Louis XVIII, returns to Paris and assumes the throne. The period from 1814 to 1824, excluding a brief interlude in 1815, is known as the Bourbon Restoration.

Fig. 334. Lorenzo Bartolini (1777–1850). *Medallion of J.-A.-D. Ingres*, 1806. Bronze, diam. 10 3/8 in. (26.5 cm). École des Beaux-Arts, Paris

Mid-May 1814

Ingres has returned to Rome from Naples. In a letter to Marcotte, he reports having recently completed a replica of *Raphael and the Fornarina* (fig. 127) for the comte de Pourtalès, whom he charged 40 louis. Ingres also questions whether Marcotte is absolutely positive that he wants him to paint a third version of the work.

(Louisville, Fort Worth 1983, p. 78; Ingres to Marcotte, May 26, 1814, in Ternois 1986b, pp. 182–83)

November 1, 1814 (opening date)

Ingres (from Rome) exhibits at the Salon (held at the Musée Royal des Arts, Paris): no. 533, *Don Pedro of Toledo Kissing the Sword of Henry IV* (W 101; later reworked [W 141], private collection); no. 534, *The Sistine Chapel* (fig. 100); no. 535, several portraits exhibited under the same number (among them *Charles Marcotte* [cat. no. 26]). Also included, although not listed in the Salon catalogue, is the second version of *Raphael and the Fornarina* (fig. 127).

Again Ingres's contributions are poorly received by the critics.

(Siegfried 1980a, pp. 246, 262–63, 328–29, n. 83; Ingres to Marcotte, May 26, 1814, in Ternois 1986b, pp. 183–84)

1815

Ingres's wife endures a difficult childbirth, and their baby does not survive. Paints and draws portraits of diplomats and foreign tourists to earn a living.

March 1815

After nine months of exile on the island of Elba, Napoleon returns to France and resumes power during a three-month period known as the Hundred Days. On June 22, Napoleon is again forced to abdicate and is exiled to the island of Saint Helena in the southern Atlantic. Louis XVIII resumes power. When Pope Pius VII reclaims Monte Cavallo in Rome, Ingres's paintings are among those removed from the palace and placed in storage.

(Siegfried 1980a, p. 304)

March 14, 1817

Ingres's mother dies at Montauban.

1817

With the help of Charles Thévenin (1764–1838), director of the Villa Medici, Ingres receives a commission from the French ambassador to Rome, the duc de Blacas, to paint a decoration for Santissima Trinità dei Monti on the theme of *Christ Giving the Keys to Saint Peter* (fig. 106). The painting, begun in the spring of 1818, is finished in May 1820.

In November, receives a commission to paint *Roger Freeing Angelica* (fig. 104) as an over-door decoration in the Throne Room at Versailles.

(Bertin 1998, LR.119)

July 7, 1818

Writes to his friend Gilibert, "I still admire the same things: in painting, Raphael and his century, the Ancients above all, the divine Greeks; in music Glück [*sic*], Mozart, Haydn. My library is composed of a score of books, masterpieces that you know well. With all this, life has many charms."

("Mes adorations sont toujours: en peinture, Raphaël et son siècle, les Anciens avant tous, les Grecs divins; en musique, Glück [*sic*], Mozart, Haydn. Ma bibliothèque est composée d'une vingtaine de volumes, chefs-d'oeuvre que tu devines bien. Avec cela, la vie a bien des charmes." Ingres to Gilibert, July 7, 1818, in Boyer d'Agen 1909, p. 35)

1818–1819

Between Easter 1818 and Easter 1819, moves from 34, Via Gregoriana to number 40 on the same street.

(Angrand and Naef 1970a, p. 15, n. 20)

June 1819

Travels to Florence at the invitation of his friend Bartolini.

August 25, 1819 (opening date)

Ingres (from Rome) exhibits at the Salon (held at the Musée Royal des Arts, Paris): no. 619, *Grande Odalisque* (fig. 101), commissioned by Caroline Murat but never delivered to her, being instead purchased directly from the Salon by the comte de Pourtalès; no. 620, *Philip V and the Marshal of Berwick* (W 120; private collection), painted for the duque d'Alba; and no. 1648, the state-owned *Roger Freeing Angelica* (fig. 104). Yet again Ingres complains that his contributions have been vilified by the French press.

(Siegfried 1980a, pp. 419–20, n. 3; Ingres to the Académie Royale des Beaux-Arts, June [20], 1825, in Angrand, 1982, p. 48, n. 13)

Mid-December 1819

At the request of Comte Amédée-David de Pastoret (1791–1857), a recently finished version of *Paolo and Francesca* (W 121; Musée des Beaux-Arts, Angers) is included in the exhibition lottery organized by the Parisian Société des Amis des Arts.

(Angrand and Naef 1970a, pp. 15–16 [EB]; see also Siegfried 1980a, pp. 421–26, n. 5.)

Summer 1820

Ingres and his wife move to Florence. They stay first at Bartolini's palazzo, where Ingres paints his host's portrait (fig. 135). In the spring of 1821 Ingres and his wife move to 6550, Via della Colonna and then to Ingres's studio on the Via delle Belle Donne. By mid-April 1821 the artist boasts of two superb studios in the middle of Florence. While in Florence, he copies paintings in the Uffizi Gallery and the Pitti Palace.

(Ingres to Gilibert, April 20, 1821, in Boyer d'Agen 1909, pp. 67–69)

August 29, 1820

The French Ministry of the Interior commissions *The Vow of Louis XIII* (fig. 146) for the cathedral of Notre-Dame, Montauban. Although Ingres considers the sum he will receive—3,000 francs—quite modest, he realizes it is an important opportunity to prove himself as a history painter and works on the commission for the next four years.

(Ingres to Gilibert, October 7, 1820, and April 20, 1821, in Boyer d'Agen 1909, pp. 56, 71)

April 24, 1822 (opening date)

Although Ingres is listed in the Salon catalogue as having exhibited no. 719, *The Entry into Paris of the Dauphin, the Future Charles V* (fig. 136), there is no evidence that this painting, owned by the comte de Pastoret, is included.

(Angrand and Naef 1970a, p. 21, n. 45)

1822–23

The comte de Pastoret commissions *Virgin with the Blue Veil* (W 203; Museu de Arte, São Paulo) and, in 1823, a portrait of himself (cat. no. 98). Meanwhile, Ingres works on other portraits, including those of Madame and Monsieur Leblanc (cat. nos. 88, 89). The artist complains that he would prefer to work exclusively on history paintings and not waste his time on less important works.

(Angrand and Naef 1970b, p. 8, n. 70; Ingres to Gilibert, April 29, 1822, in Boyer d'Agen 1909, p. 86 [letter redated in Ternois 1986b, p. 199])

December 27, 1823

Elected a corresponding member of the Académie des Beaux-Arts, Paris.

September 16, 1824

Upon Louis XVIII's death in 1824, Charles-Philippe, the comte d'Artois (1757–1836), is named king. Ingres is invited to the coronation of Charles X held at Rheims cathedral on May 29 of the following year.

October 13, 1824

Ingres departs for Paris, bringing with him *The Vow of Louis XIII* (fig. 146), which is added to the Salon (no. 922) on November 12. Already hanging at the Salon, which opened on August 25, are: no. 923, *Henry IV Playing with His Children* (W 113; Musée du Petit Palais, Paris), lent by the duc de Blacas; no. 924, *The Death of Leonardo da Vinci* (W 118; Musée du Petit Palais, Paris), lent by the duc de Blacas; and no. 925, several portraits under the same number, including *Jacques Marquet, Baron de*

Fig. 335. Pierre-Jean David d'Angers (1788–1856). *J.-A.-D. Ingres*, ca. 1826. Brown ink on paper, 6 1/8 × 4 3/4 in. (15.6 × 12 cm). Fogg Art Museum, Harvard University Art Museums, Cambridge, Massachusetts

Montbreton de Norvins (cat. no. 33). Also exhibited, although not listed in the Salon catalogue, are: *Aretino and the Envoy from Charles V* (W 103; private collection); *Aretino in the Studio of Tintoretto* (W 104; private collection); *The Entry into Paris of the Dauphin, the Future Charles V* (fig. 136); and *The Sistine Chapel* (W 131; Musée du Louvre, Paris).

For the first time Ingres's paintings are well received. On January 12, 1825, he is named to the rank of chevalier in the Legion of Honor, and two days later, at the Salon award ceremony, Charles X personally presents him with the Cross of the Legion of Honor. In May Ingres describes the award ceremony as the happiest day of his life.

(Angrand and Naef 1970a, p. 23, n. 55; Ingres to Gilibert, November 12, 1824, in Boyer d'Agen 1909, p. 120; Ingres to Gilibert, May 13, 1825, in ibid., p. 125; EB)

December 24, 1824

Having witnessed the triumph of *The Vow of Louis XIII* (fig. 146), the minister of the interior commissions Ingres to paint *The Martyrdom of Saint Symphorian* (fig. 169) for Autun Cathedral. It will be the first of Ingres's paintings on which his students collaborate. Thanks to commissions such as this, he creates considerably fewer portraits during his second stay in the French capital.

(See p. 53 in this catalogue; EB)

Late 1824–1825

After arriving in Paris, Ingres stays with Charles Thévenin on the quai de Bourbon. By the middle of May 1825 Ingres is frustrated that he has been unable to secure an acceptable apartment and studios (one for male students, one for female) in the faubourg Saint-Germain, which he needs because his success at the Salon of 1824 has led to a large number of commissions. While waiting for their July 15 move to

Fig. 336. Pierre-Jean David d'Angers (1788–1856). *Medallion of J.-A.-D. Ingres*, ca. 1826. Bronze, diam. 3 3/4 in. (9.5 cm). The Metropolitan Museum of Art, New York, Gift of Samuel P. Avery, 1898 (98.7.48)

the rue de l'Abbaye, Ingres and his wife reside in a small apartment at 49, quai des Grands Augustins. It seems likely, however, that the couple never reside at rue de l'Abbaye; by late 1825 they are installed in an apartment on the passage Sainte-Marie, off the rue du Bac.

(Ingres to Gilibert, May 13, 1825, in Boyer d'Agen 1909, pp. 123–24, 126; Blanc 1870, p. 90; Angrand 1982, p. 25; Amaury-Duval 1878, p. 14)

June 25, 1825

Elected into the Académie des Beaux-Arts, winning by a single vote over Horace Vernet (1789–1863). Ingres thus replaces the baron Dominique Vivant Denon (1747–1825), the former director general of French museums.

February 1826

Ingres does not wish to make any more portraits as he considers them "a considerable waste of time," given the dryness of the subject matter and the minimal financial rewards.

("une perte de temps considérable." Ingres to Gilibert, February 27, 1826, in Boyer d'Agen 1909, pp. 132–33)

April 1, 1826

Installs himself in a two-room studio on the rue des Marais-Saint-Germain (renamed the rue Visconti in 1864, after the architect). He soon opens a drawing atelier next to his personal studio, and by late February 1826 he has fourteen students. When his students run out of room, he permits them to use his private studio.

(Blanc 1870, p. 90; Ingres to Gilibert, February 27, 1826, in Boyer d'Agen 1909, pp. 131–32; Angrand 1982, p. 44)

1826

Comte Auguste de Forbin (1777–1841), director of the Musées Royaux, commissions a ceiling decoration, *The Apotheosis of Homer* (fig. 164), for the Galerie Charles X, a museum of Egyptian and Etruscan antiquities in the Palais du Louvre. Ingres begins work on the painting in October 1826 and completes it in late 1828. He is paid 20,000 francs.

(August 12, 1826, letter from the Direction des Musées Royaux to the vicomte de La Rochefoucauld, in Angrand 1982, pp. 23–24 [EB])

October 11, 1826

Writes to his friend Gilibert that the minister has just awarded him a "rather nice accommodation," worth about 1,200 francs, at the Institut de France, as well as the authority to take a studio. The two-floor apartment is located in the southwest corner of the Institut's second courtyard, known as the Cour Mazarine. The promised studio, which Ingres has use of by April 1828, is a former storage area for plaster models. It is situated on the ground level of the third courtyard, known as the Cour des Cuisines.

Ingres's atelier functions for at least eight years (the artist leaves for the Académie de France in Rome in 1834); however, Ingres retains the studio throughout his life. A note written after the artist's death refers to the two rooms in the Cour Mazarine as the premises where M. Ingres's entire school was raised.

("assez beau logement." Ingres to Gilibert, October 11, 1826, in Boyer d'Agen 1909, p. 141; Archives Nationales, Paris, F13 1180 and F17 3591; Munhall in New York 1985–86, pp. 82, 85)

November 12, 1826

Arrives in Montauban to be present when *The Vow of Louis XIII* (fig. 146) is placed in the choir of the cathedral. The official ceremony takes place on November 20. Ingres remains in Montauban until November 22 and then spends several days in Autun, where he draws the Porte Saint-André and the Roman walls that will reappear in the already commissioned *Martyrdom of Saint Symphorian* (fig. 169).

(Viguié 1966, p. 19)

November 4, 1827 (opening date)

Exhibits at the Salon: no. 575, *Portrait of a Man* (*Comte de Pastoret*, cat. no. 98), and no. 576, *Portrait of a Woman* (*Madame Marcotte de Sainte-Marie*, cat. no. 97). Although Ingres's *Martyrdom of Saint Symphorian* (fig. 169) is listed as no. 577 in the Salon catalogue, the painting is not finished in time and is not exhibited; however, an older work, *Oedipus and the Sphinx* (fig. 82), is included, as is no. 1302, Charles-Simon Pradier's engraving after Ingres's painting *Raphael and the Fornarina*.

The Galerie Charles X at the Palais du Louvre opens to the public. Ingres's painting—the unfinished ceiling with *The Apotheosis of Homer* and its pendentives (fig. 164)—is located in Room IX.

(Angrand 1982, p. 22)

December 30, 1829

Named professor at the École des Beaux-Arts, replacing Jean-Baptiste Regnault (1754–1829). Ingres boasts to a friend, "The hour of my independence has just sounded and I am free. . . . I receive 1,600 francs from the Institut, which lodges me. My students bring me 300 francs each month. I can thus live quite well . . . and set aside all that I earn with my paintbrush."

Begins teaching at the École des Beaux-Arts on April 1, 1830; serves as vice-president of the school in 1832 and president in 1833. After a six-year hiatus, he returns to teach from 1841 to 1851.

("L'heure de mon indépendance vient de sonner et je suis libre. . . . J'ai 1.600 francs de l'Institut qui me loge. Mes élèves me rapportent 300 francs le mois. Je puis donc vivre très bien . . . et mettre de côté tout ce que je gagnerai avec mon pinceau." Ingres to Gilibert, January 1, 1830, in Boyer d'Agen 1909, p. 221; Bertin 1998, p. 18)

Fig. 337. Federico de Madrazo y Kuntz (1815–1894). *J.-A.-D. Ingres*, 1833. Oil on canvas, 21¼ × 17¾ in. (54 × 45 cm). Hispanic Society of America, New York

Late July 1830

During the three days of street fighting known as the July Revolution, Ingres, along with Eugène Delacroix (1798–1863), Paul Delaroche (1797–1856), Eugène Devéria (1808–1865), and Jean-Baptiste Paulin-Guérin (1783–1855), spends a night guarding paintings in the Louvre.

Charles X is overthrown, and the duc d'Orléans, Louis-Philippe (1773–1850), is proclaimed king of France. The resulting July Monarchy lasts eighteen years.

May 1, 1831 (opening date)

Included in this year's Salon are: no. 758, an illustrated copy of La Fontaine's *Oeuvres complètes*, with Ingres's ink drawing of *Philemon and Baucis*; and under no. 2664, Ingres's lithograph of the *Grande Odalisque*.

(Rome, Paris 1993–94, pp. 265, 267; Bertin 1995, p. 106; Bertin 1996, p. 43)

Mid-February–early October 1832

A cholera epidemic sweeps Paris, and more than 18,500 people die. Among the victims is Ingres's friend Guillaume Guillon Lethière (1760–1832), former director of the Académie de France in Rome.

(Angrand 1982, p. 35; Fierro 1996, p. 617)

September 29, 1832

Ingres's favorite pupil, Hippolyte Flandrin (1809–1864), wins the Grand Prix de Rome for *Theseus Recognized by His Father* (fig. 166).

1832

Paints the portrait of Louis-François Bertin (1766–1841; cat. no. 99), publisher of the *Journal des débats*. The painting is exhibited in Ingres's studio before it is shown in the Salon of 1833.

(Shelton 1997, pp. 56, 96, n. 51)

March 1, 1833 (opening date)
Exhibits at the Salon: no. 1279, several portraits, including the recent portrait of Louis-François Bertin (cat. no. 99) and the much earlier *Madame Duvaucey* (fig. 87). Also included is no. 3304, Pradier's print after Ingres's *Virgil Reciting from "The Aeneid."*

The portrait of Bertin is a critical success, perhaps prompting the heir to the French throne, the duc d'Orléans, to commission in the spring *Antiochus and Stratonice* (fig. 194) as a pendant to Paul Delaroche's *Assassination of the Duc de Guise* (fig. 191).

(Bertin 1997, p. 59)

May 1, 1833
Promoted to the rank of officer in the Legion of Honor.

March 1, 1834 (opening date)
Exhibits at the Salon: no. 998, *The Martyrdom of Saint Symphorian* (fig. 169); and no. 999, *Portrait of a Woman* (*Madame Jacques-Louis Leblanc*, cat. no. 88). Critical response to the much-anticipated *Saint Symphorian* is unfavorable; consequently, Ingres declares that he will never again exhibit at the Salon. Furthermore, on May 17, 1834, he applies for the directorship of the Académie de France in Rome.

(Shelton 1997, p. 129)

Mid-March 1834
Visits Le Havre for a few days.

(Shelton 1997, pp. 105–6)

July 5, 1834
Named director of the Académie de France in Rome (at the Villa Medici), replacing Horace Vernet (1789–1863). Before leaving Paris Ingres relinquishes two official commissions: *The Coronation of the Virgin* for the apse of Notre-Dame-de-Lorette and *The Battle of Fornovo* for Louis-Philippe's Galerie des Batailles at Versailles. Ingres also draws a number of portraits, which he gives as farewell gifts to friends. In homage, his students present him with a silver cup inlaid with gold.

(Shelton 1998, pp. 51, 56, n. 3; Lapauze 1924, vol. 2, p. 227)

October 31, 1834
The French state acquires *Jupiter and Thetis* (fig. 92) for the museum in Aix-en-Provence.

(Angrand 1967, p. 95 [EB])

Late November 1834
Ingres exhibits the portrait of the comte Molé (fig. 158), prime minister under Louis-Philippe, in his studio. A journalist describes the experience: "You enter the small salon that serves as M. Ingres's studio and all of a sudden you find yourself in the presence of eyes that see, a mouth that is about to speak, a head that thinks; it is the new masterpiece by M. Ingres, or, to be more accurate, it is the distinguished descendant of the great judge, the glory of French magistrature, Mathieu Molé. . . . This new masterpiece by our great painter, this 'adieu' that he offers before leaving France to establish his school in that ancient city Rome . . . is destined to produce a grand sensation." The portrait of Molé is soon brought to the Palais des Tuileries for a special viewing by the royal family.

("Vous entrez dans le petit salon qui sert d'atelier à M. Ingres, et tout d'un coup vous vous trouvez en présence d'un regard qui voit, d'une bouche qui va parler, d'une tête qui pense; c'est le nouveau chef-d'oeuvre de M. Ingres, ou, pour parler plus vrai, c'est le digne descendant du grand magistrat, la gloire de la magistrature française, qui avait nom Mathieu Molé. . . . Ce nouveau chef-d'oeuvre de notre grand peintre, cet adieu qu'il nous fait avant de quitter la France, pour établir son école dans cette vieille Rome . . . est destiné à produire une grande sensation." Anon., November 26, 1834 [H.], p. 3; *Journal des artistes*, November 30, 1834 [EB])

November 30, 1834
A decade after Ingres received the commission, *The Martyrdom of Saint Symphorian* (fig. 169) is hung in Autun Cathedral.

Early December 1834
Having postponed their departure to avoid snowstorms, Ingres, his wife, and student Georges Lefrançois (1803–1839) now leave Paris for Italy. They travel via Milan, Bergamo, Brescia, Verona, Padua, Venice, and Florence before arriving in Rome on January 4, 1835. The pensioners of the Villa Medici include a number of Ingres's former students, among them Hippolyte Flandrin and his brother Paul (1811–1902), Paul and Raymond Balze (1815–1884; 1818–1909), Henri Lehmann (1814–1882), and Victor Mottez (1809–1897).

(Lapauze 1924, vol. 2, p. 227)

May–June 1835
With Lefrançois, Ingres visits Orvieto and Sienna.

(Lapauze 1924, vol. 2, p. 230)

November 23, 1835
Minister of the Interior Adolphe Thiers (1797–1877) asks Ingres to paint murals for the church of La Madeleine in Paris. The artist refuses.

(Bertin 1998, LR.129–31 and Bertin n.d.)

1835–41
With the help of his wife and the Académie's new secretary-librarian Alexis-René Le Go (1798–1883), Ingres restores and enlarges the Villa Medici. He establishes an archaeology course, enriches the library, increases the number of life classes, and augments the collection of plaster casts of artworks from antiquity and the Renaissance. He paints little himself but

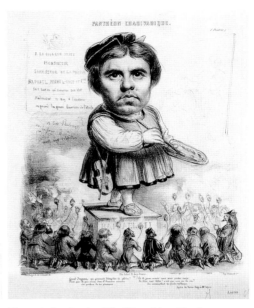

Fig. 338. Benjamin. *The "Panthéon Charivarique": Ingres or Raphaël II. Le Charivari,* May 27, 1842

produces some twenty-three portrait drawings, most as gifts for friends.

(Ternois in Amaury-Duval 1993, pp. 32–33; see p. 327 in this catalogue)

Late August–September 1837
Rome is plagued by cholera, and the inhabitants of the city are quarantined. In late August Xavier Sigalon (1787–1837), one of the pensioners at the Villa Medici, dies of the disease, as do six nuns at the neighboring Sacré Coeur. On September 5, Ingres reports that four to six hundred new cases of cholera are diagnosed each day; he is later commended for the manner in which he handles the difficult situation.

(Ingres to M. Dumont, August 31, 1837, in Boyer d'Agen 1909, p. 262; Ternois 1980a, p. 105, n. 14; Ingres to Gatteaux, September 5, 1837, in Boyer d'Agen 1909, p. 265)

May 1839
Visits Spoleto, Spello, Ravenna, and Urbino.

(Ternois and Camesasca 1971, p. 85)

August 1839
Much to Ingres's delight and thanks to the intervention of Gatteaux, the duc d'Orléans purchases *Oedipus and the Sphinx* (fig. 82). The painting, which bears the date 1808, was completely reworked by Ingres in the late 1820s shortly before it was sold to César-Eugène Gossuin (1787–1832), one of the earliest collectors of the artist's work and a fellow student in David's studio.

Among the many visitors to the Villa Medici this year are the Hungarian composer and pianist Franz Liszt (1811–1886) and Liszt's lover, Comtesse Charles d'Agoult (née Marie de Flavigny, 1805–1876), an author and occasional

critic who publishes under the name Daniel Stern.

(Ingres to Gatteaux, August 29, 1839, in Ternois 1986a, p. 38; Bertin 1995, p. 103)

1839–40
Finishes the two paintings undertaken since his arrival in Rome: *Odalisque with Slave* (fig. 190), ordered in 1834 by Marcotte, and *Antiochus and Stratonice* (fig. 194) for the duc d'Orléans. He also works on *Cherubini and the Muse of Lyric Poetry* (fig. 221) and begins to contemplate his return to Paris.

August 1840
Informs Gatteaux that he has consented to paint a portrait of the duc d'Orléans: "[B]etween us . . . despite all the honor I feel over the prince's desire to be painted by no one other than myself, it is still a matter of doing another portrait! You know how far removed I am at present from this genre of painting."

("Entre nous . . . malgré tout l'honneur que je ressens de la volonté du prince de n'être peint que par moi, il faudra donc encore faire un portrait! Vous savez quel éloignement j'ai à present pour ce genre de peinture." Ingres to Gatteaux, August 6, 1840, in Ternois 1986a, p. 41)

Late August 1840
Ingres's recently completed painting *Antiochus and Stratonice* (fig. 194) is privately exhibited in the apartments of the duc d'Orléans. The *Journal des débats*, reporting on the event, labels the painting "one of the most beautiful productions of the French School."

("l'un des plus belles productions de l'école française." Anon., August 27, 1840, p. 3; Bertin 1997, p. 58)

September 6, 1840
Receives an official commission for a ceiling painting in the Throne Room of the Palais du Luxembourg, Paris.

(Bertin 1998, LR.119)

1841
While in Rome, the future Czar Alexander II of Russia (1818–1881) commissions *The Virgin with the Host* (fig. 200). The resulting painting depicts the Virgin flanked by Saints Alexander and Nicholas, patron saints of the czarevitch and his father.

April 6, 1841
Remains at the Villa Medici until his replacement—Victor Schnetz (1787–1870)—is chosen. Departs Rome on April 6 and stops in Florence and Pisa en route to France.

Back in Paris, Ingres returns to his apartment at the Institut, which had been kept for him during his absence. On June 5, Louis-Philippe invites the artist to visit Versailles, where he personally gives him a tour of his new museum.

That evening Ingres dines with the king at his private residence at Neuilly-sur-Seine. A week and a half later, on June 15, the review *La France littéraire* fetes Ingres with a banquet for 426 people, presided over by the marquis de Pastoret and featuring a concert of extracts from Gluck's *Orfeo ed Euridice* and Weber's *Euryanthe*, conducted by Ambroise Thomas (1811–1896) and Hector Berlioz (1803–1869). In addition, the Comédie Française grants Ingres free admission for life. Nonetheless, the artist continues to refuse to participate in official exhibitions, contending that the Salon has evolved into "an art gallery, a bazaar where the enormous number of objects overwhelm [the viewer] and where industry reigns in place of art."

("un magasin de tableaux à vendre, un bazar où le nombre énorme des objets assome et où l'industrie règne à la place de l'art." Lapauze 1924, vol. 2, pp. 258–59; New York 1985–86, p. 82; Shelton 1997, p. 229; Anon., June 16, 1841 [J. J.], pp. 3–4; Bertin 1998, LR.39; Delaborde 1870, p. 372, in Siegfried 1980a, p. 3)

Early Summer 1841
Acquaintances of the artist see his recently completed painting *Cherubini and the Muse of Lyric Poetry* (fig. 221) at his apartment.

(See pp. 381–82 in this catalogue; Naef 1977, vol. 3, pp. 63–64)

Mid-July 1841
Exhibits *The Virgin with the Host* (fig. 200) in his studio at the Institut.

(Janin 1841, pp. 1–2; Bertin 1995, p. 109)

Late 1841
After the earlier success of the portraits of Louis-François Bertin and the comte Molé, Ingres is deluged with requests for more. He begins one of the baronne de Rothschild (1805–1886; cat. no. 132) in late 1841 and finishes it in 1848.

(Ingres to Gilibert, October 2, 1841, in Boyer d'Agen 1909, p. 302)

1842
Serves as president of the École des Beaux-Arts.

(Bertin 1998, p. 18)

February 19, 1842
Invites the members of the Académie des Beaux-Arts to view *Cherubini and the Muse of Lyric Poetry* (fig. 221) in his studio. Louis-Philippe purchases the painting of the Italian-born composer for 8,000 francs from the artist on June 18 of this year. It is the second painting by Ingres to enter the contemporary art museum in the Palais du Luxembourg; the first was *Roger Freeing Angelica* (fig. 104).

(Archives, Académie des Beaux-Arts, Paris, procès-verbaux, tome 2E9, p. 460; Shelton 1997, p. 313, n. 122; Ingres to the Académie Royale des Beaux-Arts, June [20], 1825, in Angrand 1982, p. 48, n. 13)

April 1842
Exhibits his portrait of the duc d'Orléans (cat. no. 121), along with *Cherubini and the Muse of Lyric Poetry* (fig. 221), *The Virgin with the Host* (fig. 200), and possibly the *Odalisque with Slave* (fig. 190), in his studio.

(Bertin 1995, p. 109; Shelton 1997, p. 303, n. 40, p. 313, n. 124)

May 1842
Delivers his portrait of the duc d'Orléans two months before the sitter dies from a carriage accident on July 13, 1842.

On July 26 Ingres is commissioned to design cartoons for the seventeen stained-glass windows destined for the duc d'Orléan's funerary chapel. The artist receives 15,000 francs for his work; the windows are installed on the first anniversary of the duke's death.

(Shelton 1997, pp. 334, 406, n. 22)

Early Summer 1842
Begins his portrait of the comtesse d'Haussonville, née Louise-Albertine de Broglie (cat. no. 125), which he finishes three years later.

July 1842
Receives the Prussian Cross of Civil Merit, probably awarded at the behest of the duc d'Orléans's Prussian-born widow, Helene, the grand duchess of Mecklenburg-Schwerin (d. 1858).

(Ingres to Gilibert, July 26, 1842, p. 350 [letter redated in Ternois 1986b, p. 194])

January 1843
Exhibits *Christ Giving the Keys to Saint Peter* (fig. 106) in his studio.

(Bertin 1995, p. 109)

Fig. 339. Unidentified artist. *J.-A.-D. Ingres.* Ink and graphite on paper. Cabinet des Estampes et de la Photographie, Bibliothèque Nationale de France, Paris

August 1843
Ingres and his wife stay at the Château de Dampierre, where the artist begins *The Golden Age* (fig. 204) and *The Iron Age*, two murals commissioned in September 1839 by the duc de Luynes for the great hall of his château at Yvelines. After work on the murals is interrupted in 1847, they are never completed.

Late Summer 1843
Becomes a member of the Akademie der Künste und Mechanischen Wissenschaften, Berlin.
(Bertin 1998, LR. 97)

May 13, 1844
The Municipal Council of Montauban decides to name a street after Ingres. This year the city's new museum acquires two paintings by the artist: *Monsieur Belvèze-Foulon* (cat. no. 6), from the Belvèze Family, and *Roger Freeing Angelica* (W 233), at the Scitivaux sale. Although Ingres is honored by the attention he receives both in Montauban and Paris, he feels overworked and overcommitted to his projects.
(Bertin 1995, p. 106; Ingres to Gilibert, June 7, 1844, in Boyer d'Agen 1909, p. 371)

1844
Paints portrait of Edmond Cavé (1794–1852; cat. no. 124), director of fine arts in the Ministry of the Interior, as a pendant to that of his wife (b. 1810; cat. no. 123).

April 24, 1845
Promoted to the rank of commander in the Legion of Honor.
(Bertin 1998, LR. 124)

May 1845
Accepts honorary membership in the Association des Artistes Peintres, Sculpteurs, Graveurs, Architectes et Dessinateurs, Paris, recently formed by the baron Taylor (1789–1879).
(Paris, Fondation Taylor 1995, p. 115)

June 1845
Exhibits portrait of the comtesse d'Haussonville (cat. no. 125) in his studio for four days.
(See pp. 407–8 in this catalogue; Lapauze 1911 p. 382)

Summer 1845
Receives commission to decorate the new Parisian church of Saint-Vincent-de-Paul, designed by Jean-Baptiste Lepère (1761–1844) and his son-in-law Jacques-Ignace Hittorff (1792–1867). Ingres renounces the work two years later when he is asked to submit his plans for approval by the municipal authorities.
(Shelton 1997, pp. 337, 409, nn. 36, 37; Horaist 1980, pp. 31–34; Ewals 1980, pp. 35–43)

July 1845
Becomes a member of the Koninklijke Academie, Amsterdam.
(*Moniteur des arts* 1845, p. 184 [EB]; Ewals 1984, pp. 34–36)

January 11–March 15, 1846
Agrees to participate in a public exhibition in Paris for the first time since the Salon of 1834. The organizers—the Association des Artistes Peintres, Sculpteurs, Graveurs, Architectes et Dessinateurs—plan a solo exhibition of the artist's work, but in early November 1845 Ingres requests that his pictures be shown with those by other members of the group.

The exhibition opens at the Galerie des Beaux-Arts, located at 22, boulevard Bonne-Nouvelle, on January 11, 1846. A general admission fee of one franc is charged to benefit the relief and pension funds of the artists' society. Ingres's paintings, segregated from the other works in a separate room, are: no. 43, *The Sistine Chapel* (fig. 100), lent by Marcotte; no. 44, *Antiochus and Stratonice* (fig. 194), lent by the duchesse d'Orléans; no. 45, *Philip V and the Marshal of Berwick* (W 120), lent by the duc de Fitz-James; no. 46, *Odalisque with Slave* (fig. 190), lent by Marcotte; no. 47, *Louis-François Bertin* (cat. no. 99), lent by the sitter's son; no. 48, *Oedipus and the Sphinx* (fig. 82), lent by the duchesse d'Orléans; no. 49, *Comte Louis-Mathieu Molé* (fig. 158), lent by the sitter's family; no. 50, *Grande Odalisque* (fig. 101), lent by the comte de Pourtalès; no. 51, *The Entry into Paris of the Dauphin, the Future Charles V* (fig. 136), lent by the marquis de Pastoret; no. 52, *Comtesse d'Haussonville* (cat. no. 125), lent by the sitter's family; no. 53, *Paolo and Francesca* (W 121; Musée des Beaux-Arts, Angers), lent by Comte Turpin de Crissé.

Ingres's portraits are favorably reviewed by critics such as A. de Lestelley, who writes in *La Revue indépendante:* "Yes, M. Ingres is our century's master without equal with regard to his portraits. In this exhibition, where one finds a fairly large number of these by David, Gérard, Gros, and Hersent, none surpass his."
("Oui, M. Ingres est le maître sans égal de notre siècle en fait de portraits. Dans cette exposition, où l'on retrouve un assez grand nombre de ceux de David, de Gérard, de Gros et d'Hersent, aucun ne surpasse les siens." Lestelley 1846, p. 258; Paris, Fondation Taylor 1995)

November 1846
Ingres and his wife move to an apartment in the Institut that previously belonged to the architect and engraver Laurent Vaudoyer (1756–1846).
(Bessis 1972, p. 23, n. 5; Archives Nationales, Paris, F17 3592)

December 1846
Becomes a foreign associate member of the fine-arts section of the Royal Academy, Belgium.
(Bertin 1998, LR.116)

February 1848
The Revolution of 1848, in which the constitutional monarchy is overthrown, ushers in the Second Republic. On December 10, 1848, Louis-Napoléon Bonaparte (1808–1873), nephew of Napoleon I, is elected president of France.

August 1848
Exhibits *Venus Anadyomene* (fig. 201) and the portrait of the baronne de Rothschild (cat. no. 132) in his studio.
(Bertin 1995, p. 109; Geofroy 1848, pp. 441–49)

Fig. 340. Victor Laisné (b. 1807). *J.-A.-D. Ingres.* Calotype, ca. 1855. Cabinet des Estampes et de la Photographie, Bibliothèque Nationale de France, Paris

Fig. 341. Barthélémy Menn (1815–1893). *J.-A.-D. Ingres.* Black chalk, 9 × 7½ in. (22.8 × 19.2 cm). Musée d'Art et d'Histoire, Geneva

October 29, 1848

Named a member of the Permanent Commission of Fine Arts. Fights for artists' rights to exhibit at the Salon and for suppression of the Salon jury. Resigns membership in the committee on May 17, 1849.

1849

Serves as vice-president of the École des Beaux-Arts.

July 27, 1849

Madame Ingres, who has suffered from a blood ailment since March, dies at age sixty-seven. A despondent Ingres spends time with his friend Frédéric Reiset (1815–1891), the newly appointed curator of drawings at the Musée du Louvre, and Reiset's family at their summer home in Enghien. In September he travels to Chauconin, near Meaux, to visit the Marcottes at their country home, Le Poncelet.

(EB)

September 1849

No longer able to remain in the apartment where his wife died, Ingres moves out of the Institut to a small apartment nearby at 27, rue Jacob. Later, on December 28, he asks to be relieved of his duties as president of the École des Beaux-Arts for the following year.

(Boyer d'Agen 1909, pp. 406–9; Archives Nationales, Paris, F17 3592; Bessis 1972, pp. 25–28)

Late June 1850

Travels to Jersey, Avranches, Caen, and Bayeux, before returning to Paris on July 18. Ingres reports that in moments of sorrow, his mind fills with music by Haydn.

(Ingres to Gatteaux, July 3 and 9, 1850, in Ternois 1986a, pp. 49–51)

Ca. March 1851

Moves to 49, rue de Lille.

(Ternois 1989, p. 30, letter no. 9, n. 5)

June 15, 1851

Participates in the inauguration of the monument to Nicolas Poussin at Les Andelys in northeastern France.

(Ternois and Camesasca 1971, p. 85)

July 18, 1851

Writes to the Municipal Council of Montauban, announcing his gift of artwork to the city and mentioning his eventual bequest. "I am happy," he states, "to think that I will always be in Montauban, and that there, where, owing to circumstances, I was unable to live, I will remain for eternity."

("Je suis heureux de penser que je serai toujours à Montauban, et que là où, par circonstance, je n'ai pu vivre, je resterai éternellement." Ingres to M. Crosilhes, mayor of Montauban, July 18, 1851, in Boyer d'Agen 1909, p. 418 [originally published in Lapauze 1901, p. 82])

By October 1851

Ingres's private studio is located inside the courtyard at 17 bis, quai Voltaire.

(Ternois 1989, p. 30, letter no. 9, n. 5; Parisian Land Registrar, 1852 [D1P4, carton 1232]; Hillairet 1985, p. 661)

October 25, 1851

Resigns as professor at the École des Beaux-Arts. He is assigned the title of rector and receives an annual allowance of 1,000 francs.

(Ternois and Camesasca 1971, p. 85)

November 1851

Albert Magimel's *Oeuvres de J. A. Ingres*, with 102 reproductions of the artist's work by Achille Réveil, is published by Firmin Didot Frères.

November 8, 1851

Ingres receives a state commission for *Joan of Arc at the Coronation of Charles VII* (fig. 215) and a copy of *The Virgin with the Host* (fig. 11). Both paintings are completed in 1854.

(Schlenoff 1956, p. 276 [EB])

December 2, 1851

Louis-Napoléon Bonaparte proclaims himself emperor and takes the title Napoleon III, thus beginning the Second Empire, which will last until 1870.

Early January 1852

Exhibits *Madame Moitessier Standing* (cat. no. 133) in his studio at 17 bis, quai Voltaire. It is probable that he exhibits *Madame Gonse* (fig. 208) in his studio at the Institut at about the same time.

(Bertin 1995, p. 109; see p. 518, n. 72, in this catalogue)

April 15, 1852

Seventy-one-year-old Ingres marries forty-three-year-old Delphine Ramel (1808–1887), a relative of Marcotte, at her family home in Versailles. The couple had hoped to purchase a *hôtel particulier* at 95, rue de l'Université but instead remain at 49, rue de Lille (renumbered 3, rue de Lille in 1855).

(Blanc 1870, p. 173; Ternois 1989, p. 32, letter no. 17, n. 1; Hattis 1967, p. 13; Ingres to Calamatta, April 13, 1852, in Ternois 1980a, p. 87; Ternois 1986a, p. 54, n. 3)

March 2, 1853

Signs a contract to paint the ceiling and eight decorative panels of the Salon Napoléon in the Hôtel de Ville, Paris, for which he will be paid 60,000 francs. Chooses *The Apotheosis of Napoleon I* (fig. 210) as his subject and, with the assistance of his students, completes it by the end of the year in a studio lent to him by Gatteaux. This ensemble is later destroyed during a fire in May 1871.

(Ternois 1980a, p. 107, n. 59; Shelton 1997, p. 447)

Fig. 342. Nadar (Félix Tournachon; 1820–1910). *Ingres Chasing a Camera*. "And to think that this [the vogue for painting in a photorealist manner] is the fault of the regretted M. Ingres." Published in *Nadar, Jury au Salon de 1857*, p. 38

Late March 1853

The comte de Nieuwerkerke (1811–1892), superintendent of fine arts, provides Ingres with a studio at the Louvre.

(Ingres to Calamatta, undated, in Ternois 1980a, pp. 88, 107, n. 61; Lapauze 1911a, p. 466 [EB]).

August 19, 1853

Ingres, his wife, and her sister and brother-in-law (Madame and Monsieur Jean-François Guille) purchase a house at Meung-sur-Loire, near Orléans, for the women's parents. (Their father, Monsieur Ramel, had recently retired.) Ingres and his wife spend the next thirteen summers at the house, which has a small studio.

Late January 1854

Exhibits *The Apotheosis of Napoleon I* (fig. 210) in Gatteaux's studio at 47, rue de Lille. The emperor and empress pay a visit in late January to see the painting.

(Blanc 1870, pp. 175–76; Bertin 1995, p. 109)

Early May 1854

The Ingres Room at the Hôtel de Ville, Montauban, is inaugurated. It features gifts the artist had presented to his native city since 1851, including some fifty canvases, Greek and Etruscan vases, prints, and books.

(Garric 1993, p. 39 [EB])

December 1854

Again exhibits his work in his permanent studio at 11, quai Voltaire. On view are: the first version of *Lorenzo Bartolini* (fig. 53); *Madame Moitessier Standing* (cat. no. 133); *Princesse de Broglie* (cat. no. 145); *Joan of Arc at the Coronation of Charles VII* (fig. 215); *The Virgin with the Host* (W 276; Musée du Louvre, Paris); and *Venus Anadyomene* (fig. 201).

(Naef 1973 ["Exposition oubliée"], pp. 23–25; Bertin 1995, p. 109)

April 1855

Assumes the Institut lodgings formerly occupied

Fig. 343. Unidentified artist. *Delacroix and Ingres.* "M. Delacroix, named a member of the Institut, finally takes his place near Ingres.—End of dispute.—One last mark of the pencil, one last stroke of the paintbrush, tomorrow nothing more will be said about it." *Journal pour rire,* January 3, 1857

by the painter Jean-Baptiste Isabey (1767–1855).
(Archives Nationales, Paris, F17 3592)

May 15, 1855 (opening date)

Ingres, who has not exhibited in the Paris Salons since 1834, agrees to participate in the fine-arts section of the Exposition Universelle, where he is honored with a retrospective. He shows sixty-nine works, including forty oil paintings, four studies, and twenty-five cartoons for stained glass. The portraits on display include: no. 3344, *Bonaparte as First Consul* (cat. no. 2), lent by the city of Liège; no. 3363, *Cherubini and the Muse of Lyric Poetry* (fig. 221), lent by the emperor; no. 3364, *Madame Duvaucey* (fig. 87), lent by Reiset; no. 3365, *Comtesse d'Haussonville* (cat. no. 125); no. 3366, *Madame Moitessier Standing* (cat. no. 133); no. 3367, *Princesse de Broglie* (cat. no. 145); no. 3368, *Madame Leblanc* (cat. no. 88); no. 3369, *Madame Gonse* (fig. 208); no. 3370, *Comte Louis-Mathieu Molé* (fig. 158); no. 3371, *Comte de Pastoret* (cat. no. 98); no. 3372, *Louis-François Bertin* (cat. no. 99); no. 3373, *Self-Portrait* (fig. 209); no. 3374, *The Artist's Father* (cat. no. 4); no. 5048, *Madame Reiset* (fig. 207); as well as a cameo portrait of Prince Napoleon (fig. 6).
(See p. 509 in this catalogue)

September 1855

Ingres and his wife spend three weeks visiting her brother Edmond Ramel at Cannes.

November 15, 1855

Ingres is offended that he must share the grand

medal of honor of the Exposition Universelle with nine others: the French artists Alexandre-Gabriel Decamps (1803–1860), Eugène Delacroix (1798–1863), François-Joseph Heim (1787–1865), Louis-Pierre Henriquel-Dupont (1797–1892), Jean-Louis-Ernest Meissonier (1815–1891), and Horace Vernet (1789–1863); the Belgian Henri Leys (1815–1869); the Englishman Sir Edwin Landseer (1802–1873); and the German Peter von Cornelius (1783–1867). After he threatens to boycott the exhibition's closing ceremonies, Ingres is promoted to the rank of grand officer in the Legion of Honor on November 14. The emperor personally presents him with the medal at the ceremonies the following day.
(EB)

April 1856

While repairs are conducted on his Paris apartment, Ingres takes refuge at Meung-sur-Loire, where he completes several paintings, including *Madame Moitessier Seated* (cat. no. 134).
(Ternois and Camesasca 1971, p. 85)

Early January 1857

Exhibits *La Source* (fig. 202) as well as *Madame Moitessier Seated* (cat. no. 134) in his studio. So many people wish to attend this private viewing that Ingres fears his floor cannot support the weight. During the course of the exhibition several offers are made for *La Source;* the highest bid comes from Louis-Philippe's minister of the interior, Comte Charles-Marie Tanneguy Duchâtel (1803–1867), who pays 25,000 francs for it.
(Ingres to Calamatta, January 10, 1857, in Boyer d'Agen 1909, p. 433; see p. 441 in this catalogue)

January 10, 1857

Much to Ingres's disgust, Delacroix is elected to the Institut. The artists have long been seen as the leaders of two different camps—Ingres, a champion of a linear, somewhat Neoclassical style, and Delacroix, a proponent of a brushier, Romantic style—and caricaturists seize the opportunity to depict the rivals (see figs. 217, 343).
(Ingres to Calamatta, January 10, 1857, in Boyer d'Agen 1909, p. 434)

August 18, 1857

Named a full member of the Koninklijke Academie voor Schone Kunsten, Antwerp.
(See also July 1865, below)

March 20, 1858

Promises to send his self-portrait to the Royal Academy of Florence (cat. no. 148), which had requested it several years earlier to add to their renowned collection of artist's self-portraits. Ingres consequently is named a knight of the Order of San Giuseppe di Toscana.

(Ingres to Luca Bourbon del Monte, March 20, 1858, in Boyer d'Agen 1909, p. 436 [originally published in Lapauze 1901, p. 10, n. 1])

April 15, 1859 (opening date)

A work by Ingres appears in the Salon: no. 3808, a small watercolor of his *Birth of the Muses* integrated into Hittorff's miniature *The Temple of the Muses* (Musée du Louvre, Paris).
(Bertin 1995, p. 106; Shelton 1998, p. 56, n. 5)

1859

Sells his painting *The Turkish Bath* (fig. 220) to Prince Napoleon. His wife, Princess Clotilde, is shocked by the image, so the diplomatic Reiset arranges to purchase a self-portrait from Ingres, which he then exchanges for Prince Napoleon's *Turkish Bath*.
(Boyer d'Agen 1909, pp. 438–39; Naef 1977–80, vol. 3 [1979], p. 354)

October 1859

Ingres and his wife move to a "bien, superbe" apartment with a stunning view of the Seine River at 11, quai Voltaire.
(Ingres to Calamatta, October 4, 1859, in Ternois 1985, p. 58; Ingres to Calamatta, December 30, 1859, in Ternois 1980a, p. 99)

March 1861

An exhibition of more than one hundred drawings by Ingres is organized at the Parisian Société des Arts-Unis in their galleries located at 26, rue de Provence. The show, which includes many portrait drawings, is the subject of two important articles by Émile Galichon in the March 15 and July 1 issues of the *Gazette des beaux-arts.*
(EB)

Fig. 344. Pierre Petit (1832–1909). *J.-A.-D. Ingres.* Photograph, ca. 1865. Cabinet des Estampes et de la Photographie, Bibliothèque Nationale de France, Paris

April 1862

Finishes *Jesus among the Doctors* (fig. 219), which had been commissioned twenty years earlier by Queen Marie-Amélie for the chapel of the Château de Bizy. Exhibits the painting in his studio.

The *Gazette des beaux-arts* makes a public appeal for the government to acquire *Jesus among the Doctors*, and before the month is over, there are published reports that the emperor has purchased the painting for 150,000 francs. This sale does not in fact take place, and the painting is later included in Ingres's bequest to the city of Montauban.

(EB; Galichon 1862, pp. 487–88; Dax 1862, p. 255)

May 1, 1862 (opening date)

Three works by Ingres are included in the fine-arts section of the London International Exhibition: no. 79, *La Source* (fig. 202); no. 236, a portrait drawing of the comte de Nieuwerkerke (fig. 218); and no. 237, a version of the drawing *The Tomb for the Lady Jane Montagu* (Musée du Louvre, on deposit at the Musée Ingres, Montauban).

(EB)

May 4, 1862

Twenty-three paintings and eighteen drawings by Ingres are included in the Exposition des Beaux-Arts, curated by Ingres's former student Armand Cambon (1819–1885), at the Hôtel de Ville in Montauban. Among the works displayed is the portrait of Ingres's childhood friend Gilibert (cat. no. 5), which is lent by the sitter's daughter Pauline. The artist also sends his self-portrait as well as his portraits of his wife and his father.

(Ingres to Armand Cambon, April 7, 27, and June 4, 1862, and Ingres to Pauline Gilibert, April 23, 1862, in Boyer d'Agen 1909, pp. 441–50; EB)

May 1862

Jesus among the Doctors (fig. 219) appears in the first exhibition organized by the Parisian Société Nationale des Beaux-Arts in their galleries at 26, boulevard des Italiens (also known as the Galerie Martinet). The exhibition benefits the Artists' Association Fund.

(EB; Ingres to Ch. Dufour, July 1, 1862, in Foucart-Borville 1972, p. 21)

May 25, 1862

Napoleon III appoints Ingres to the Senate. Art critics such as Pierre Dax praise the government for the honor, which implies that the arts—along with diplomacy, administration, and defense—are considered worthy of national merit.

(Dax 1862, p. 255)

June 1, 1862

Presented with a gold medal by more than two hundred artists.

(Ternois and Camesasca 1971, p. 85)

July 4, 1862

Made a member of the Imperial Council of Public Instruction.

September 1862

Works on a small version of *The Golden Age* (fig. 206), which he considers one of his principal compositions, and on his portrait *Julius Caesar* (W 311). Writes to his friend Gatteaux that his work keeps him happy and that "a Haydn sonata and the miniature score of *The Marriage of Figaro* round out my life [in Meung-sur-Loire]."

("une sonate de Haydn et la petite partition des noces de Figaro complète ici ma vie." Ingres to Gatteaux, September 9, 1862, and Delphine Ingres to Gatteaux, September 15, 1862, in Ternois 1986a, pp. 58–59)

Winter 1862–63

Ill for several months, Ingres leaves Paris in order to rest.

(Ingres to the director of the Koninklijke Academie voor Schone Kunsten, Antwerp, September 21, 1863; see p. 463 in this catalogue)

July 14, 1863

Cambon presents Ingres with a golden crown on behalf of the citizens of Montauban.

(Dax 1863, p. 46)

March 1864

A month after Marcotte's death, a painting in his collection—Ingres's *Odalisque with Slave* (fig. 190)—is exhibited with the dealer Francis Petit. The painting does not sell, and three years later is included as lot 17 in the first posthumous sale of Ingres's work.

(Bertin 1995, p. 108)

July 1864

Exhibits six paintings in his studio on the quai Voltaire: a portrait of his wife (fig. 213); a "Vierge médiatrice" (unidentified); a "répétition réduite" of *Oedipus and the Sphinx*, owned by the comte Duchâtel (W 315; Walters Art Gallery, Baltimore); a "réduction" of *The Golden Age* (fig. 206); *Homer and His Guide* (W 298; Musées Royaux des Beaux-Arts de Belgique, Brussels); and *The Turkish Bath* (fig. 220).

(Blanc 1870, pp. 206–7; Burty 1864, pp. 204–5 [EB])

August 14, 1864

The *Courier artistique* reports that Napoleon III has commissioned a portrait of his eight-year-old son, the Prince Impérial (1856–1879). The portrait, which Ingres supposedly promises to begin in November, is never painted.

(EB)

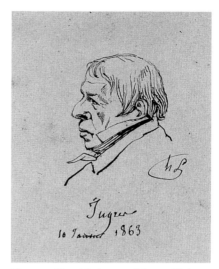

Fig. 345. Henri Lehmann (1814–1882). *J.-A.-D. Ingres*, 1863. Ink on paper, 9 1/8 × 7 in. (23.2 × 17.8 cm). Art Institute of Chicago

August 24, 1864

An avenue in the sixteenth arrondissement of Paris is named after Ingres. The thoroughfare had previously been known as the avenue Boulogne, then the avenue Rossini, before it is renamed for the artist (fig. 347).

(Hittorff to Ingres, September 4, 1864, in Naef 1972 ["Hittorff"], p. 19; Hillairet 1985, p. 655)

October 1, 1864

Georges Rosendal, writing for *L'Artiste*, praises the collection of Ingres's work already in the Musée de Montauban: "All the works of the master are now represented in this museum; large original compositions, painted studies, copies by him, prints made under his observation."

("Toutes les oeuvres du maître sont maintenant représentées dans ce musée; soit grandes compositions originales,

Fig. 346. Adolphe-Jean-François Marin Dallemagne (b. 1811). *J.-A.-D. Ingres*. Photograph, ca. 1861. Cabinet des Estampes et de la Photographie, Bibliothèque Nationale de France, Paris

Fig. 347. Unidentified artist. *New Street Names.* "At the corner of the rue Ingres: 'Why don't we have, on the corner of each street, a statue of its patron . . .'") *La vie parisienne,* September 24, 1864

soit esquisses peintes, soit copies par lui-même, soit gravures faites et tirées sous ses yeux." Rosendal 1864, p. 146)

May 1865

Homer Deified (fig. 316) is exhibited with the dealer Haro, where it is priced at 40,000 francs. The elaborate drawing does not sell and eventually returns to Ingres's widow.

(Siegfried 1980a, p. 4; *Gazette des beaux-arts,* bulletin mensuel, June 1, 1865, p. 566 [EB])

July 1865

Ingres, who had been appointed associate member of the Koninklijke Academie voor Schone Kunsten, Antwerp, in September 1853 and made a full member in August 1857, finally complies with the Academie's regulations and sends them his recent *Self-Portrait* (cat. no. 149).

(Archives, Koninklijke Academie voor Schone Kunsten, Antwerp)

August 1865

Receives the grand cross of the Imperial Order of Guadalupe.

(*Moniteur des arts* 1865 [EB])

March 1866

King Leopold II of Belgium (1835–1909)—nephew of Ingres's former patron, the duc d'Orléans—acquires Ingres's recent painting, *Homer and His Guide* (W 298; Musées Royaux des Beaux-Arts de Belgique, Brussels).

This painting along with Ingres's *Self-Portrait* (cat. no. 149) and *Lorenzo Bartolini* (fig. 135) are included in the Exposition Générale des Beaux-Arts held in Brussels in August. Ingres is consequently named commander of the Order of Leopold.

(*La Chronique des arts,* 1866, pp. 102–3 [EB]; Bertin 1995, p. 105)

August 28, 1866

While in Meung-sur-Loire, Ingres drafts a will in which he bequeaths many of his own paintings and thousands of his drawings, as well as works by other artists, to the city of Montauban. Among his other bequests he leaves *Virgil Reciting from "The Aeneid"* (fig. 94) to the Académie of Toulouse. His wife is named as his residuary legatee.

(Lapauze 1901, pp. 296–99)

January 8, 1867

Makes a tracing of Giotto's *Entombment of Christ.* That evening, he catches cold and contracts double pneumonia.

January 14, 1867

The eighty-six-year-old Ingres dies at 1:00 A.M. in his apartment at 11, quai Voltaire, Paris.

January 17, 1867

Ingres's funeral is held at the church of Saint-Thomas-d'Aquin. A large crowd gathers in the snow to watch the funeral procession from the church, through the place Vendôme, to the Père Lachaise cemetery.

(Blanc 1867–68 [pt. 9], pp. 240–41)

February 8, 1867

The city of Montauban accepts Ingres's bequest, which in addition to his artwork consists of paintings and drawings by other artists, antique sculpture, assorted prints, cameos,

medals, portraits of the Popes, plaster casts (including one of Ingres's right hand), books, musical scores, furniture, and a violin. As the artist specifies in his will, Cambon is entrusted with the organization of the bequest, which is installed on the first floor of the Hôtel de Ville (now the Musée Ingres).

(Boyer d'Agen 1909, pp. 456–60)

April 10, 1867 (opening date)

A posthumous retrospective of Ingres's work opens at the École des Beaux-Arts during the Exposition Universelle. The exhibition of about 150 paintings and 430 drawings attracts large crowds. The critics are universally impressed by Ingres's skill as a draftsman. Many mention Ingres's portraits; the critic Amédée Cantaloube calls the portraits "true history paintings; they are simultaneously individuals and types. The physiognomy of each of our social classes is found here, rendered by characteristic accents and therefore generalized."

("de vrais tableaux d'histoire: ce sont à la fois des individus et des types. La physionomie de chacune de nos classes sociales s'y trouve rendue par des accents caractéristiques et, partant, généralisés." Anon., April 24, 1867; Cantaloube 1867, p. 53; EB)

April 27—May 6–7, 1867

Selections of Ingres's works are included in posthumous sales on April 27 ("Tableaux, dessins et oeuvres en cours d'exécution dépendant de la succession de M. Ingres") and May 6–7 ("Tableaux, dessins, aquarelles et études peints par M. J. D. A. [*sic*] Ingres et désignés par lui pour être mis en vente publique"). Both sales are held at the Hôtel Drouot, Paris, room number 8. The April sale includes sixteen works belonging to Ingres's widow, as well as the *Odalisque with Slave* (fig. 190), owned by Marcotte's heirs. The second sale consists of ninety lots, works that the artist sold to the dealer Haro on October 13, 1866.

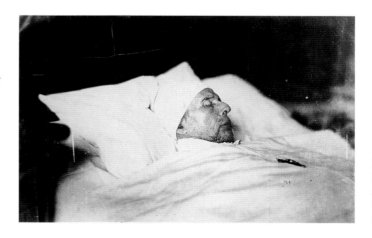

Fig. 348. Charles Marville (1816–1878?). *Ingres on His Deathbed.* Gelatin silver print, 1867. Private collection

BIBLIOGRAPHY

Compiled by Jean Wagner

Abbott 1938. J[ere] A[bbott]. "A Drawing by J.-A.-D. Ingres." *Smith College Museum of Art Bulletin*, no. 18–19 (June 1938), pp. 7–9.

About 1855. Edmond About. *Voyage à travers l'exposition des beaux-arts*. Paris, 1855.

Ackerman 1986. Gerald M. Ackerman. *The Life and Work of Jean-Léon Gérôme, with a Catalogue Raisonné*. London and New York, 1986.

Adam 1859. Adolphe Adam. *Derniers Souvenirs d'un musicien*. Collection Michel Levy. Paris, 1859.

Adhémar 1949. Jean Adhémar, comp. *Inventaire du fonds français après 1800*. Vol. 5. Paris: Bibliothèque Nationale, Cabinet des Estampes, 1949.

L'Ain 1977. Gabriel Girod de L'Ain. *Le Lieutenant-Général Comte Dulong de Rosnay (1780–1828) et sa famille*. [Paris], 1977.

Alain 1949. Alain [Émile Chartier]. *Ingres*. Paris, 1949.

Alaux 1933. Jean-Paul Alaux. *Académie de France à Rome: Ses Directeurs, ses pensionnaires*. 2 vols. Paris, 1933.

Alazard 1936. Jean Alazard. "Ce que J.-D. Ingres doit aux primitifs italiens." *Gazette des beaux-arts*, 6th ser., 16 (November 1936), pp. 167–75.

Alazard 1942. Jean Alazard. *Musée du Louvre. J.-D. Ingres 1780–1867: Quatorze Dessins*. Paris, 1942.

Alazard 1950. Jean Alazard. *Ingres et l'ingrisme*. Paris, 1950.

Alexandre 1905. Arsène Alexandre. *Jean-Dominique Ingres: Master of Pure Draughtsmanship*. London, 1905.

Alexandre 1920a. Arsène Alexandre. *Collection Kélékian: Tableaux de l'École française*. Paris, 1920.

Alexandre 1920b. Arsène Alexandre. "Invocation aux maîtres de France." *La Renaissance de l'art français et des industries de luxe* 3 (October 1920).

Alexandre 1921. Arsène Alexandre. "Comprendre Ingres, c'est comprendre la Grèce et la France." *La Renaissance de l'art français et des industries de luxe* 4 (May 1921), pp. 194–205.

Allentown 1977. *French Masterpieces of the 19th Century from the Henry P. McIlhenny Collection*. Allentown Art Museum, May 1–September 18, 1977. Exh. cat. Allentown, 1977.

Alvin 1882. Louis Alvin. "Notice sur Louis Calamatta." *Annuaire de l'Académie royale des sciences, des lettres, et des beaux-arts de Belgique* 48 (1882), p. 233.

L'Amateur sans prétention 1825. L'Amateur sans prétention. "Salon de 1824." *Le Mercure du dix-neuvième siècle* 8 (1825), pp. 101–10.

Amaury-Duval 1846. Amaury-Duval. "De M. Ingres, à propos de l'exposition Bonne-Nouvelle." *La Revue nouvelle* 7 (February 1, 1846), pp. 77–94.

Amaury-Duval 1856. Amaury-Duval. "Monsieur Ingres. II." *L'Artiste*, 6th ser., 1 (May 18, 1856), pp. 175–77.

Amaury-Duval 1878. Amaury-Duval. *L'Atelier d'Ingres: Souvenirs*. Paris, 1878.

Amaury-Duval 1921. Amaury-Duval. "M. Ingres." *La Renaissance de l'art français et des industries de luxe* 4 (May 1921), pp. 241–52.

Amaury-Duval 1924. Amaury-Duval. *L'Atelier d'Ingres*. Reprint of 1878 ed. Edited by Élie Faure. Paris, 1924.

Amaury-Duval 1978. Amaury-Duval. *L'Atelier d'Ingres*. Paris, 1978.

Amaury-Duval 1993. Amaury-Duval. *L'Atelier d'Ingres*. Edited by Daniel Ternois. Paris, 1993.

Amherst 1958. *The 1913 Armory Show in Retrospect*. Amherst College, February 17–March 17, 1958. Exh. cat. Amherst, Mass., 1958.

Amsterdam 1938. *Honderd jaar Fransche kunst*. Amsterdam, Stedelijk Museum, July 2–September 25, 1938. Exh. cat. Amsterdam, 1938.

Amsterdam 1946. *Teekeningen van Fransche meesters, 1800–1900*. Amsterdam, Stedelijk Museum, February–March 1946. Exh. cat. Amsterdam, 1946.

Andover 1958. Exhibition. Andover, Mass., Abbot Academy, February 1958.

Angrand 1966. Pierre Angrand. *Marie-Élizabeth Cavé: Disciple de Delacroix*. Lausanne and Paris, 1966.

Angrand 1967. Pierre Angrand. *Monsieur Ingres et son époque*. Lausanne and Paris, 1967.

Angrand 1972. Pierre Angrand. *Le Comte de Forbin et le Louvre en 1819*. Lausanne and Paris, 1972.

Angrand 1982. Pierre Angrand. "Le Premier Atelier de M. Ingres." *Bulletin du Musée Ingres*, no. 49 (December 1982), pp. 19–58.

Angrand and Naef 1970a. Pierre Angrand and Hans Naef. "Ingres et la famille de Pastoret: Correspondance inédite." *Bulletin du Musée Ingres*, no. 27 (July 1970), pp. 7–24.

Angrand and Naef 1970b. Pierre Angrand and Hans Naef. "Ingres et la famille de Pastoret: Correspondance inédite." *Bulletin du Musée Ingres*, no. 28 (December 1970), pp. 7–22.

Annet and Trianon 1833. A. Annet and H. Trianon. *Examen critique du Salon de 1833*. Paris, 1833.

Anon. 1800. Anonymous. "Dernières Observations sur cette exposition." 1800.

Anon. 1802. Anonymous. *Revue du Salon de l'an X, ou Examen critique de tous les tableaux qui ont été exposés au Muséum*. Paris, 1802.

Anon. 1806. Anonymous. *L'Observateur au Musée Napoléon, ou La Critique des tableaux en vaudeville*. Paris, 1806.

Anon., September 1806. Anonymous. "Nouvelles concernant les arts, les sciences et les belles lettres: Salon de 1806." *Gazette de l'amateur des arts*, no. 9 (September 1806), pp. 2–7.

Anon., September 27, 1806 (C.). C. "Salon de l'art, 1806." *Mercure de France* 25 (September 27, 1806), pp. 596–602.

Anon., October 4, 1806 (C.). C. "Salon de l'art, 1806." *Mercure de France* 26 (October 4, 1806), pp. 26–31.

Anon., October 11, 1806 (A. D.). A. D. [Achille-Étienne Gigault de Lasalle?]. "Salon de 1806." *La Gazette de France*, October 11, 1806.

Anon., October 11, 1806 (C.). C. "Salon de 1806." *Mercure de France* 26 (October 11, 1806), pp. 74–80.

Anon., October 17, 1806. Anonymous. "Salon de 1806." *Le Publiciste*, October 17, 1806.

Anon., February 15, 1815 (M.). M. "Salon de 1814." *Journal général de France*, February 15, 1815.

Anon. 1824 (N.). N. "Salon de 1824." *Lettres champenoises* 19 (1824), pp. 224–37.

Anon., December 11, 1824 (F.). F. "Exposition de Mil huit cent vingt-quatre." *Le Drapeau blanc*, December 11, 1824.

Anon. 1825 (M.). M. *Revue critique des productions de peinture, sculpture, et gravure exposées au Salon de 1824*. Paris, 1825.

Anon., December 15, 1827. Anonymous. "Beaux-Arts." *La Gazette de France*, December 15, 1827.

Anon., December 18, 1827a. Anonymous. "Figaro au Salon de 1827." *Le Figaro*, December 18, 1827, pp. 926–27.

Anon., December 18, 1827b. Anonymous. "Salon de 1827." *La Pandore*, December 18, 1827.

Anon. 1828. Anonymous. "Exposition de 1827 et 1828." *Annales de la littérature et des arts* 31 (1828), pp. 119–25.

Anon., January 13, 1828. Anonymous. "Musée Royal. Exposition de 1827." *Journal des artistes*, January 13, 1828, pp. 17–20.

Anon., April 13, 1828. Anonymous. "Musée Charles X." *L'Incorruptible*, April 13, 1828.

Anon. 1831. Anonymous. "Ouverture du Salon de 1832." *L'Artiste* 2 (1831), pp. 265–66.

Anon. 1833 (C.). C. "Salon de 1833." *Le Siècle* 1 (1833), pp. 394–403.

Anon. 1833a. Anonymous. *L'Observateur aux Salons de 1833*. Paris, 1833.

Anon. 1833b. Anonymous. "Salon de 1833." *L'Artiste* 5 (1833), pp. 57–58, 129–31, 153–62.

Anon., March 1833. Anonymous. "Salon de 1833." *Causeries du monde* 1 (March 1833), pp. 92–96.

Anon., March 8, 1833. Anonymous. "Musée." *Le Corsaire*, March 8, 1833.

Anon., March 9, 1833. Anonymous. "Salon de 1833." *Le Constitutionnel*, March 9, 1833.

Anon., March 10, 1833 (D.). D. [Louis Desnoyers?] "Ouverture du Salon de 1833." *Le Voleur*, March 10, 1833.

Anon., March 10, 1833 (H. H. H.). H. H. H. "Exposition de 1833." *La Quotidienne*, March 10, 1833.

Anon., March 15, 1833. Anonymous. "Salon de 1833." *La France nouvelle*, March 15, 1833.

Anon., March 16, 1833a. Anonymous. "La Mode au Salon." *La Mode* 14 (March 16, 1833), pp. 245–49.

Anon., March 16, 1833b. Anonymous. "Salon de 1833." *La Propriété*, March 16, 1833.

Anon., March 17, 1833. Anonymous. "Salon de 1833." *Le Charivari*, March 17, 1833.

Anon., March 24, 1833. Anonymous. "Salon de 1833." *Le Figaro*, March 24, 1833.

Anon., March 28, 1833. Anonymous. "Salon de 1833." *Messager des dames* 2 (March 28, 1833), pp. 45–47.

Anon., March 31, 1833 (D.). D. [Louis Desnoyers?] "Ouverture du Salon de 1833." *Le Voleur*, March 31, 1833.

Anon., April 3, 1833 (E.). E. "Exposition de 1833." *Journal du commerce*, April 3, 1833.

Anon., April 5, 1833. Anonymous. "Salon de 1833." *Petit Courrier des dames* 24 (April 5, 1833), pp. 151–52.

Anon., April 7, 1833 (H. H. H.). H. H. H. "Exposition de 1833." *La Quotidienne*, April 7, 1833.

Anon., April 14, 1833. Anonymous. "Salon de 1833." *Courrier des théâtres*, April 14, 1833.

Anon., April 20, 1833 (J. H.). M^me J. H. "Salon de 1833." *Journal des femmes*, April 20, 1833, pp. 210–12.

Anon., May 1, 1833. Anonymous. "Exposition de 1833." *La Gazette de France*, May 1, 1833.

Anon., May 15, 1833. Anonymous. "M. Bêtin-le-Veau." *Le Charivari*, May 15, 1833.

Anon. 1834. Anonymous. "Salon de 1834." *Annuaire des artistes* 1 (1834), pp. 5–18.

Anon. 1834a. Anonymous. *Lettres sur le Salon de 1834*. Paris, 1834.

Anon., March 6, 1834. Anonymous. "Salon de 1834." *L'Indépendant*, March 6, 1834.

Anon., March 9, 1834. Anonymous. "Salon de 1834." *Journal des artistes*, March 9, 1834, pp. 147–54.

Anon., March 10, 1834. Anonymous. "Le Salon de 1834." *La Gazette de France*, March 10, 1834.

Anon., March 13, 1834. Anonymous. "Salon de 1834." *Le Figaro*, March 13, 1834.

Anon., March 25, 1834. Anonymous. "Le Salon de 1834." *La Gazette de France*, March 25, 1834.

Anon., November 26, 1834 (H.). H. "Portrait de M. le comte Molé, Pair de France, par M. Ingres." *Journal des débats*, November 26, 1834.

Anon. 1837. Anonymous. "Salon de 1837. (X^e Article.) Aquarelles.—Dessins." *L'Artiste* 13 (1837), pp. 196–98.

Anon., October 24, 1839. Anonymous. "Lettre d'un bachelier ès-musique, San Rossore, 2 octobre 1839, à M. Hector Berlioz." *Revue et gazette musicale*, October 24, 1839, p. 418.

Anon., August 27, 1840. Anonymous. "Le Nouveau Tableau de M. Ingres." *Journal des débats*, August 27, 1840.

Anon. 1841. Anonymous. "Banquet offert à M. Ingres." *L'Artiste*, 2nd ser., 7 (1841), pp. 413–14.

Anon., June 16, 1841 (J. J.). J. J. "Banquet offert à M. Ingres." *Journal des débats*, June 16, 1841.

Anon. 1842. Anonymous. "Un Peut de tout." *L'Artiste*, 3rd ser., 1 (1842), pp. 199–201.

Anon., March 10, 1842. Anonymous. "Portrait de M. Chérubini par M. Ingres." *Bulletin des beaux-arts*, March 10, 1842.

Anon., April 28, 1842. Anonymous. "Portraits de S. A. R. Mgr le duc d'Orléans, par M. Ingres." *Bulletin des beaux-arts*, April 28, 1842.

Anon. 1843a. Anonymous. "Actualités.—Souvenirs." *L'Artiste*, 3rd ser., 3 (1843), pp. 141–44.

Anon. 1843b. Anonymous. "Salon de 1843. Acquisitions faites par la direction des beaux-arts." *L'Artiste*, 3rd ser., 4 (1843), pp. 97–98.

Anon., March 3, 1843. Anonymous. *La Presse*, March 3, 1843.

Anon., March 5, 1843. Anonymous. *Journal des artistes*, March 5, 1843.

Anon. 1846. Anonymous. "Exhibition de l'Association des artistes peintres, sculpteurs, architectes et graveurs." *Journal des artistes*, January 11, 1846, pp. 9–10; February 1, 1846, p. 33; February 8, 1846, pp. 41–42; February 15, 1846, pp. 49–51; February 22, 1846, pp. 61–62.

Anon., January 12, 1846. Anonymous. "Feuilleton du 12 janvier 1846." *L'Écho français*, January 12, 1846.

Anon., January 15, 1846. Anonymous. "Exposition de tableaux au profit de la caisse de secours et pensions de la Société des artistes, boulevart Bonne-Nouvelle, 22." *La Démocratie pacifique* 6, no. 15 (January 15, 1846).

Anon., January 18, 1846. Anonymous. "Exposition de la Société des artistes." *Le Constitutionnel*, January 18, 1846.

Anon., January 30, 1846 (H. M.). H. M. "Exposition de la galerie Bonne-Nouvelle." *Moniteur de la mode* 5, no. 10 (January 30, 1846), pp. 236–37.

Anon., February 1846. Anonymous. "Exposition de Peintures au profit de l'Association des artistes au boulevard Bonne-Nouvelle." *Les Abeilles de la littérature, des sciences, des beaux-arts et de l'industrie* 2, no. 6 (February 1846), pp. 182–85.

Anon., February 1, 1846 (G. G.). G. G. "Peinture: Exposition de tableaux anciens et modernes de l'école française au profit de l'Association des artistes peintres, sculpteurs, graveurs et architectes." *Panthéon des artistes* 1, no. 1 (February 1, 1846), pp. 3–6.

Anon., February 1, 1846. Anonymous. "Exposition des galeries Bonne-Nouvelle." *Moniteur des arts* 3, no. 1 (February 1, 1846), pp. 1–3.

Anon., February 11, 1846 (C. A. D.). C. A. D. "Exposition dans les galeries du boulevard Bonne-Nouvelle, n° 22, en faveur des artistes malheureux." *La France*, February 11, 1846.

Anon., February 14, 1846. Anonymous. "Exposition des ouvrages de peinture dans la galerie des beaux-arts, boulevard Bonne-Nouvelle, 22." *L'Illustration* 6 (February 14, 1846), pp. 376–79.

Anon., March 8, 1846 (F. C. A.). F. C. A. "Exposition des galeries Bonne-Nouvelle—M. Ingres." *Moniteur des arts* 3, no. 6 (March 8, 1846), pp. 41–42.

Anon., March 15, 1846. Anonymous. "Revue de la semaine." *L'Artiste*, 4th ser., 6 (March 15, 1846), pp. 33–36.

Anon., January 6, 1847. Anonymous. "Les Mémoires d'une veuve, M. Ingres." *La Mode*, January 6, 1847, pp. 15–16.

Anon., January 9, 1847. Anonymous. "Modes parisiennes." *Journal des dames et des modes* 98, no. 2 (January 9, 1847).

Anon., March 13, 1847. Anonymous. "Modes parisiennes." *Journal des dames et des modes* 98, no. 11 (March 13, 1847).

Anon., August 28, 1847. Anonymous. "Modes parisiennes." *Journal des dames et des modes* 98, no. 35 (August 28, 1847).

Anon., December 4, 1847. Anonymous. "Modes parisiennes." *Journal des dames et des modes* 99, no. 49 (December 11, 1847).

Anon., December 11, 1847. Anonymous. "Modes parisiennes." *Journal des dames et des modes* 99, no. 50 (December 11, 1847).

Anon., February 19, 1848. Anonymous. "Modes parisiennes." *Journal des dames et des modes* 100, no. 8 (February 19, 1848).

Anon., August 7, 1848. Anonymous. "Revue de Paris." *Le Siècle*, August 7, 1848.

Anon., August 13, 1848. Anonymous. "Portrait de Madame la baronne de Rothschild et la *Vénus Anadyomène*, tableaux de M. Ingres." *Journal des beaux-arts*, August 13, 1848.

Anon., August 15, 1848 (L.). L. "M. Ingres. Portrait de M^me la baronne de Rothschild. Vénus sortant de la mer." *Le Constitutionnel*, August 15, 1848.

Anon., August 24, 1851. Anonymous. "Héliographie sur verre." *La Lumière*, August 24, 1851, pp. 14–15.

Anon., December 16, 1854 (A. de G.). A. de G. "L'Atelier de M. Ingres." *L'Athénaeum français* 3, no. 50 (December 16, 1854), pp. 1188–89.

Anon., July 6, 1855. Anonymous. *Travaux des lettres, des sciences et des arts*, no. 6 (July 6, 1855), p. 68.

Anon., September 8, 1855. Anonymous. "Exposition universelle de 1855." *Le Coiffeur parisien* 5 (September 8, 1855).

Anon., April 7, 1867. Anonymous. "Exposition des oeuvres d'Ingres." *La Chronique des arts et de la curiosité*, April 7, 1867, p. 109.

Anon., April 15, 1867. Anonymous. "Nouvelles des arts." *La Presse*, April 15, 1867.

Anon., April 24, 1867. Anonymous. [Review of Paris 1867.] *L'Univers illustré*, April 24, 1867.

Anon. 1876. Anonymous. "Chronique de l'Hôtel Drouot." *L'Art* 4 (1876), pp. 294–95.

Anon., December 15, 1877. Anonymous. "Tribunal civil: M. Ingres et le portrait de M^me Moitessier." *La Chronique des arts et de la curiosité*, December 15, 1877, pp. 368–69.

Anon., August 6, 1881. Anonymous. "Dons et acquisitions des Musées Nationaux." *La Chronique des arts et de la curiosité*, August 6, 1881, p. 218.

Anon., June 22, 1889 (T. W.). T. W. "Une Exposition de portraits d'architectes à l'École de Beaux-Arts." *La Chronique des arts et de la curiosité*, June 22, 1889, p. 189.

Anon., March 7, 1891. Anonymous. Obituary for Frédéric Reiset. *La Chronique des arts et de la curiosité*, March 7, 1891, p. 78.

Anon., February 1, 1896. Anonymous. "Nouvelles." *La Chronique des arts et de la curiosité*, February 1, 1896, pp. 37–38.

Anon., September 1, 1896 (A. R.). A. R. "Deux Dessins d'Ingres à l'École des Beaux-Arts." *Gazette des beaux-arts*, 3rd ser., 16 (September 1, 1896), pp. 250–51.

Anon., April 1, 1897. Anonymous. "Le Portrait de Bertin l'Aîné par Ingres." *Gazette des beaux-arts*, 3rd ser., 17 (April 1, 1897), pp. 331–32.

Anon., August 1918. Anonymous. "Two Portrait Drawings by Ingres." *Burlington Magazine* 33 (August 1918), pp. 72–74.

Anon., November 1919. Anonymous. "Portaits by Ingres." *American Magazine of Art* 11 (November 1919), pp. 15–17.

Anon., February 15, 1923. Anonymous. "Musée du Louvre: Les Collections Léon Bonnat." *Beaux-Arts*, February 15, 1923, p. 39.

Anon., June 1926. Anonymous. "A Drawing by Ingres." *Bulletin of the Museum of Fine Arts* (Boston), June 1926, pp. 37–38.

Anon., July–August 1926. Anonymous. "Les Ventes." *Le Bulletin de l'art ancien et moderne*, no. 730 (July–August 1926), pp. 231–36.

Anon., July 15, 1926. Anonymous. "Revue des ventes de mai et juin." *Le Figaro artistique*, July 15, 1926, pp. 633–38.

Anon., July 1, 1929. Anonymous. "Auktionsnachrichten." *Kunst und Künstler* 27 (July 1, 1929), p. 408.

Anon., October 1929. Anonymous. "Notes of the Month." *International Studio* 94 (October 1929), pp. 61–65.

Anon., January 1930. Anonymous (Le Vieux Collectionneur). "La Curiosité." *Le Bulletin de l'art ancien et moderne*, no. 764 (January 1930), pp. 35–40.

Anon., March 1932. "On View in the New York Galleries." *Parnassus* 4, no. 3 (March 1932), p. 26.

Anon., May 1933. Anonymous. "Ingres in a Little-Known Portrait." *Connoisseur* 91 (May 1933), p. 347.

Anon., September–October 1933. Anonymous. "The Significance of the Century of Progress Art Exhibition." *Bulletin of the Art Institute of Chicago* 27 (September–October 1933), pp. 82–88.

Anon., August 1934. Anonymous [Mary Morsell]. "Chicago Exhibit Richly Rewards Summer Visitors." *Art News* 32 (August 18, 1934), pp. 3, 6, 14.

Anon., December 11, 1937. Anonymous. "Northampton: A New Ingres Drawing and a Bonnard Landscape." *Art News* 36, no. 11 (December 11, 1937), p. 17.

Anon., October 1, 1938. Anonymous. "Ingres Considered This Drawing a Potboiler." *Art Digest* 13 (October 1, 1938), p. 13.

Anon., March 1946. Anonymous. "Focus on Drawing." *Art News* 45, no. 1 (March 1946), p. 17.

Anon., June 1948 (j.w.). Anonymous (j.w.). "Cronache–Basilea: Disegni del Louvre–collezioni private di Vienna." *Emporium* 107 (June 1948), pp. 275, 276–78.

Anon., June 1950. Anonymous. "The Metropolitan Museum of Art, 1940–1950: A Report to the Trustees on the Buildings and the Growth of the Collections." *The Metropolitan Museum of Art Bulletin*, n.s., 8 (June 1950), pp. 281–324.

Anon., February 2, 1952. Anonymous. "French Drawings: From the 'Fouquet to Gauguin' London Show." *Illustrated London News* 220, no. 5885 (February 2, 1952), p. 178.

Anon., March 1952. Anonymous. "Out of the Fogg." *Virginia Museum of Fine Arts Members' Bulletin*, March 1952, p. 1.

Anon., February 1953. Anonymous. "A Notable Accession." *Poster of Events for February 1953*, City Art Museum, Saint Louis, 1953.

Anon., August 1953. Anonymous. "New York: Cinque secoli di disegni francesi." *Emporium* 59 (August 1953), pp. 69, 75.

Anon. 1954. Anonymous. "Art News of the Year." *Art News Annual* 23 (1954), p. 189.

Anon., May 1954. Anonymous. "Checklist of Drawings in the Collection of the [Albright Art] Gallery." *Gallery Notes* 18, no. 3 (May 1954).

Anon., Easter 1956 (V.). V[. . .]. "Zwei Ingres-Zeichnungen." *Rheinischer Merkur* (Cologne) 13 (Easter 1956), p. 8.

Anon., December 1, 1956. "At the Royal Academy: Fine Portrait Drawings." *Illustrated London News* 229 (December 1, 1956), p. 950.

Anon., January 27, 1958. Anonymous. "The Last Ingres." *Time*, January 27, 1958, pp. 68, 71.

Anon., June 1, 1958. Anonymous. "Bildnis Barbara Bansi." *Die Weltkunst* 28, no. 11 (June 1, 1958), p. 10.

Anon., February 1959. Anonymous. "French Drawings." *The Metropolitan Museum of Art Bulletin*, n.s., 17 (February 1959), pp. 164–71.

Anon., summer 1960. Anonymous. "Inaugural Show at Berkeley." *College Art Journal* 19 (summer 1960), pp. 378–79.

Anon., April 7, 1961. Anonymous. "The Road of Raphael." *Time*, April 7, 1961, pp. 68–71.

Anon., February 1962. Anonymous. "The Hanley Collection." *Art International* 6, no. 1 (February 1962), p. 49.

Anon., October 1963. Anonymous [Ruth Davidson]. "Chicago's Drawings in New York." *Antiques*, October 1963, pp. 464–65.

Anon. 1964. Anonymous. "Accessions of American and Canadian Museums, April–June 1964." *Art Quarterly* 27, no. 3 (1964), pp. 370–92.

Anon., July–August 1964. Anonymous. "Coup d'oeil sur les grandes ventes de la saison." *L'Oeil*, nos. 115–16 (July–August 1964), pp. 40–41.

Anon. 1965. Anonymous. "Accessions, January 1 to December 31, 1964." *Bulletin of the Detroit Institute of Arts* 44, no. 2 (1965).

Anon., January 12, 1966. Anonymous. "Liszt-Porträt auf sonderbarem Umweg in das Haus Wahnfried zurückgekehrt." *Bayreuther Tagblatt*, January 12, 1966.

Anon., February 1967. Anonymous. "International Salesroom." *Connoisseur* 164 (February 1967), p. 122.

Anon., March 11, 1967. Anonymous. "Ingres: A Gala Opening at the Fogg." *Harvard Alumni Bulletin*, March 11, 1967, pp. 22, 26.

Anon., April 1, 1968. Anonymous. "Aus der Auktion H. A. Rittershofer, Berlin, 22 April 1968." *Die Weltkunst*, April 1, 1968, p. 296.

Anon. 1969 [Director]. Director. "Report of the President and Director, Permanent Collection, Annual Report 1967–1968." *Los Angeles County Museum of Art Bulletin* 18, no. 3–4 (1969), pp. 13, 14.

Anon., summer 1969. Anonymous. "Accessions of American and Canadian Museums, October–December 1968." *Art Quarterly*, summer 1969.

Anon., April 1971. Anonymous. "Ingres in Rome." *Apollo* 93 (April 1971), p. 335.

Anon., July–December 1979. Anonymous. "Chronologie des expositions réalisées de 1951 à 1976." *Bulletin du Musée Ingres*, nos. 43–44 (July–December 1979), pp. 59–60.

Antiques **1969.** *Antiques* 96 (November 1969).

Antwerp, Koninklijk Museum voor Schone Kunsten 1905. Koninklijk Museum voor Schone Kunsten. *Descriptive Catalogue*. Vol. 2, *Modern Masters*. Antwerp, 1905.

Antwerp, Koninklijk Museum voor Schone Kunsten 1977. Koninklijk Museum voor Schone Kunsten. *Catalogus schilderijen 19de en 20ste eeuw*. Brussels and Antwerp, 1977.

Apollo **1970.** Parke-Bernet Galleries Advertisement. *Apollo* 92 (October 1970), p. 128.

Apollo **1975.** Advertisement for London 1975. *Apollo* 101 (February 1975), pp. 48–49.

Apponyi 1913–26. Rodolphe Apponyi. *Vingt-cinq Ans à Paris (1826–1850): Journal du comte Rodolphe Apponyi, attaché de l'ambassade d'Autriche-Hongrie à Paris*. 4 vols. Paris, 1913–26.

Aragon 1833. Madame Alex[andre] Aragon. "Salon de 1833." *Journal des femmes* 4 (March 30, 1833), pp. 146–49.

Aragonnès 1938. Claude Aragonnès. *Marie d'Agoult: Une Destinée romantique*. Paris, 1938.

Arbuthnot 1885. A[lexander] J[ohn] A[rthuthnot]. "Bentinck, Lord William Cavendish (1774–1839)." In *Dictionary of National Biography*, vol. 4, pp. 292–97. London, 1885.

Arnould 1939. Louis Arnould. *Victor Baltard, 1805–1874: Causerie faite le 20 juin 1937 sur la demande de la Société "Les Amis de Sceaux" dans le salon de la Villa Baltard*. Le Puy-en-Velay, 1939.

Art at Auction **1971.** *Art at Auction: The Year at Sotheby's and Parke-Bernet*. London, 1971.

Artaud, March 2, 1833. [Nicolas-Louis-Marie Artaud]. "Ouverture du Salon de 1833." *Le Courrier français*, March 2, 1833.

Art Digest **1946.** *Art Digest*, March 15, 1946.

Art International **1971.** *Art International*, May 1971.

Art News, **April 1930.** *Art News* 28 (April 26, 1930).

Art News, **May 1930.** *Art News* 28 (May 3, 1930).

Art News **1934.** *Art News* 32 (June 16, 1934).

Art News **1967.** *Art News* 66 (September 1967).

Arts in Virginia **1989.** *Arts in Virginia* 29, nos. 2–3 (1989), pp. 4–5.

Athanassoglou-Kallmyer 1990. Nina Athanassoglou-Kallmyer. "An Artistic and Political Manifesto for Cézanne." *Art Bulletin* 72 (September 1990), pp. 482–92.

Atlanta 1959. "Collectors' Firsts." Atlanta Art Museum, 1959.

Atlanta 1984. *The Henry P. McIlhenny Collection: Nineteenth Century French and English Masterpieces*. Atlanta, High Museum of Art, May 25–September 30, 1984. Exh. cat. Atlanta, 1984.

Atlanta 1996. *Rings: Five Passions in World Art*. Atlanta, High Museum of Art, commemorating the Summer Olympics, 1996. Exh. cat. introduction by J. Carter Brown. New York, 1996.

Atlanta, Birmingham 1955. *Painting: School of France*. Atlanta Art Association Galleries, September 20–October 4, 1955; Birmingham Museum of Art, October 16–November 5. Exh. cat. Atlanta, 1955.

Aude 1921. Édouard Aude. *Le Musée d'Aix-en-Provence*. Paris, 1921.

Audin and Vial 1918. Marius Audin and Eugène Vial. *Dictionnaire des artistes et ouvriers d'art du Lyonnais*. Vol. 1. Paris, 1918.

Aulanier 1961. Christiane Aulanier. *Histoire du Palais et du Musée du Louvre*. Vol. 8, *Le Musée Charles X et le Département des antiquités égyptiennes*. Paris, 1961.

Austin 1977. "Old Master Drawings." Austin, University of Texas Art Museum, February 6–April 3, 1977.

L'Autographe **1864.** *L'Autographe*, April 27, 1864.

Auvray and Chatelain 1833. F[élix-Henri] Auvray] and Jean-Baptiste-François-Ernest, chevalier de Chatelain. *Prométhéides: Revue du Salon de 1833*. Paris, 1833.

Auzas 1958. [Jacqueline Pruvost-Auzas]. "Les Portraits français au Musée d'Orléans." *La Revue française*, supp. to no. 97 (January 1958).

Ayrton 1971. Michael Ayrton. *The Rudiments of Paradise: Various Essays on Various Arts*. London, 1971.

Babin 1898. Gustave Babin. "Madame de Senonnes par Ingres." *Gazette des beaux-arts*, 3rd ser., 19 (January 1, 1898), pp. 21–26.

Baetjer 1980. Katharine Baetjer. *European Paintings in The Metropolitan Museum of Art by Artists Born in or before 1865: A Summary Catalogue*. 3 vols. New York, 1980.

Baetjer 1995. Katharine Baetjer. *European Paintings in The Metropolitan Museum of Art by Artists Born before 1865: A Summary Catalogue*. New York, 1995.

Bailey 1995. Colin B. Bailey. "Renoir's Portrait of His Sister-in-Law." *Burlington Magazine* 137 (October 1995), pp. 684–87.

Baillio 1989. Joseph Baillio. "De Voltaire à Bonaparte: Révolution et réaction." *L'Oeil*, no. 412 (November 1989), pp. 28–37.

Baillot 1864. R[ené] Baillot. "Baillot à Vienne." *Le Ménestrel* (Paris), October 2, 1864, pp. 349–50.

Baillot **n.d.** *Baillot (Pierre-Marie-François de Sales), 1771–1842*. N.p., n.d. [after 1886].

Bailly 1876. Antoine-Nicolas-Louis Bailly. *Notice sur M. Henri Labrouste*. Paris, 1876.

Baker 1913. C[harles] H[enry] Collins Baker. "An Unpublished Drawing by Ingres." *Burlington Magazine* 23 (July 1913), pp. 192–93.

Baker and Henry 1995. Christopher Baker and Tom Henry, comps. *The National Gallery: Complete Illustrated Catalogue*. London, 1995.

Ballard 1833. C[harles] B[allard]. "Exposition du Musée." *Le Petit Poucet* 3, no. 1 (April 7, 1833), pp. 5–15.

Baltimore 1934–35. *A Survey of French Painting: Exhibition*. Baltimore Museum of Art, November 23, 1934–January 1, 1935. Exh. cat. Baltimore, 1934.

Baltimore 1989. "Master Drawings by French Artists in the Museum's Collection." Baltimore Museum of Art, May 9–July 23, 1989.

Baltimore 1991. "As Artists See Us: Drawings from the Museum Collection." Baltimore Museum of Art, May 14–August 14, 1991.

Baltimore, Los Angeles, Fort Worth 1986–87. *Nineteenth-Century French Drawings from the Museum Boymans-van Beuningen*. Baltimore Museum of Art, December 16, 1986–January 25, 1987; Los Angeles County Museum of Art, February 26–April 12; Fort Worth, Kimbell Art Museum, April 25–June 14. Exh. cat. by A. F. W. M. Meij and Jurriaan A. Poot. Washington, D.C., 1986.

Balze 1880. Raymond Balze. *Ingres: Son École, son enseignement du dessin, par un de ses élèves*. Paris, 1880.

Balze 1921. Raymond Balze. "Notes inédites d'un élève de Ingres." *La Renaissance de l'art français et des industries de luxe* 4 (May 1921), pp. 216–18.

Banks 1979. Ada Shadmi Banks. "Two Letters from Girodet to Flaxman." *Art Bulletin* 61 (March 1979), pp. 100–101.

Bann 1997. Stephen Bann. *Paul Delaroche: History Painted*. London, 1997.

Banville 1861. Théodore de Banville. "La Source, tableau de M. Ingres." *Revue fantaisiste* 1, no. 6 (May 1, 1861), pp. 359–61.

Barbier 1883. Auguste Barbier. *Souvenirs personnels et silhouettes contemporaines*. Paris, 1883.

Barcelona 1993–94. *Versalles: Retratos de una sociedad, siglos XVII–XIX*. Barcelona, Centro Cultural de la Fundación "La Caixa," December 10, 1993–January 30, 1994. Exh. cat. Barcelona, 1993.

Barker 1890. G. F. R[ussell] B[arker]. "Grattan, Henry (1746–1820)." In *Dictionary of National Biography*, vol. 22, pp. 418–25. London, 1890.

Le Baron Taylor **1995.** *Le Baron Taylor, L'Association des artistes et l'exposition du Bazar Bonne-Nouvelle en 1846*. Paris, 1995.

Barousse 1973. Pierre Barousse. *Catalogue du Musée Ingres*. Montauban, 1973.

Barousse 1977. Pierre Barousse. "L''Idée' chez Monsieur Ingres." In *Actes du colloque international: Ingres et le Néo-Classicisme, Montauban, octobre 1975*, pp. 157–67. [Montauban, 1977.]

Barzun 1949. Jacques Barzun. "Romanticism: Definition of a Period." *Magazine of Art* 42 (November 1949), pp. 242–48.

Basel 1921. *Exposition de peinture française*. Basel, Kunsthalle, May 8–June 30, 1921. Exh. cat. Basel, 1921.

Basel 1935. *Meisterzeichnungen französischer Künstler von Ingres bis Cézanne*. Basel, Kunsthalle, June 29–August 18, 1935. Exh. cat. Basel, 1935.

Bassan 1969. Fernande Bassan, comp. *Politique et haute société à l'époque romantique: La Famille Pastoret d'après sa correspondance (1788 à 1856)*. Paris, 1969.

Bauchal 1887. Ch[arles] Bauchal. *Nouveau Dictionnaire biographique et critique des architectes français*. Paris, 1887.

Baudelaire 1956. Charles Baudelaire. *Curiosités esthétiques*. Edited by Jean Adhémar. Lausanne, 1956.

Baudelaire 1961. Charles Baudelaire. *Oeuvres complètes*. Edited by Yves-Gerard Le Dantec and Claude Pichois. Rev. ed. Paris, 1961.

Baudelaire 1975–76. Charles Baudelaire. *Oeuvres complètes*. Edited by Claude Pichois. 2 vols. New ed. Paris, 1975–76.

Baudelaire 1990. Charles Baudelaire. *Curiosités esthétiques*. Edited by Henri Lemaître. Paris, 1990.

Bean 1964. Jacob Bean. *100 European Drawings in The Metropolitan Museum of Art*. New York, 1964.

Beaunier 1909. André Beaunier. "Ingres und Delacroix." *Kunst und Künstler* 7, no. 10 (1909), pp. 447–55.

Bedford 1959. John Robert Russell, duke of Bedford. *A Silver-Plated Spoon*. London, 1959.

Béguin 1967. Sylvie Béguin. "Le Portrait de Madame Gaudry née Hittorf par Ingres." *La Revue du Louvre et des Musées de France* 17 (1967), pp. 228–32.

Belgrade 1939. *La Peinture française au XIXᵉ siècle / Francusko slikarstvo u XIX stoleću*. Belgrade, Muzej Princa Pavla, 1939. Exh. cat. Belgrade, 1939.

Bell 1926. Clive Bell. "Ingres." *Burlington Magazine* 49 (September 1926), pp. 124–35.

Bellaigue 1910. Camille Bellaigue. *Gounod*. Paris, 1910.

Bellanger et al. 1969. Claude Bellanger et al. *Histoire générale de la presse française*. 5 vols. Paris, [1969–76].

Bellet 1967. Roger Bellet. *Presse et journalisme sous le Second Empire*. Paris, 1967.

Bellier de la Chavignerie 1867. Émile Bellier de la Chavignerie. "Notes sur l'oeuvre de M. Ingres." *La Chronique des arts et de la curiosité*, February 24, 1867, pp. 59–60.

Belloy, June 10, 1855. A. de Belloy. "Exposition universelle." *L'Assemblée nationale*, June 10, 1855.

Bénédite 1908. Léonce Bénédite. "Les Collections d'art aux États Unis." *La Revue de l'art ancien et moderne* 23 (March 1908), pp. 161–76.

Bénédite 1921. Léonce Bénédite. "Une Exposition d'Ingres." *Gazette des beaux-arts*, 5th ser., 3 (June 1921), pp. 325–37.

Beneke 1889. Beneke. "Reinhold, Johann Gotthard R." In *Allgemeine deutsche Biographie*, vol. 28, pp. 80–82. Leipzig, 1889.

Benois 1903. A. Benois. "Ingres Portraits" (in Russian). *Mir Iskusstva* 10 (1903), pp. 57–60.

Benoist 1953. Luc Benoist. *Ville de Nantes, Musée des Beaux-Arts: Catalogue et guide*. Nantes, 1953.

Benson 1937. E. M. Benson. "Problems of Portraiture." *Magazine of Art* 30 (November 1937), special supp., pp. i–xxviii.

Béraldi 1885–92. Henri Béraldi. *Les Graveurs du XIXᵉ siècle: Guide de l'amateur d'estampes modernes*. 13 vols. Paris, 1885–92.

Bérard 1921. Léon Bérard. "Devant les nouvelles salles du Musée Ingres." *La Renaissance de l'art français et des industries de luxe* 4 (May 1921), pp. 220–25.

Béraud 1827. Anthony Béraud. *Annale de l'école française des beaux-arts*. Paris, 1827.

Berezina 1960. Valentina N. Berezina. *Ingres: Portrait of N. D. Gouriev* (in Russian). Saint Petersburg (then Leningrad), 1960.

Berezina 1964. Valentina N. Berezina. *The Hermitage* (in Russian). Saint Petersburg (then Leningrad), 1964.

Berezina 1967. Valentina N. Berezina. *Jean Auguste Dominique Ingres* (in Russian). Saint Petersburg (then Leningrad), 1967.

Berezina 1972. Valentina N. Berezina. *French Painting of the Nineteenth Century: From David to Fantin-Latour* (in Russian). State Hermitage Museum. Saint Petersburg (then Leningrad), 1972.

Berezina 1977. Valentina N. Berezina. *Jean Auguste Dominique Ingres* (in Russian). Moscow, 1977.

Berezina 1980. Valentina N. Berezina. *French Painting of the Nineteenth Century in the Collection of the State Hermitage* (in Russian). Moscow, 1980.

Berezina 1983. Valentina N. Berezina. *French Painting: Early and Mid-Nineteenth Century*. The Hermitage Catalogue of Western European Painting. New York, 1983.

Berezina 1987. Valentina N. Berezina. *French Painting of the Nineteenth Century in the Collection of the State Hermitage* (in Russian). 2nd ed. Moscow, 1987.

Berger 1949. Klaus Berger. *Französische Meisterzeichnungen des 19. Jahrhunderts*. Basel, 1949.

Bergeret 1848. Pierre Nolasque Bergeret. *Lettres d'un artiste sur l'état des arts en France: Considéré sous les rapports politiques, artistiques, commerciaux et industrielles*. Paris, 1848.

Bergeron 1891. J[ules] Bergeron. Éloge de M. Mêlier lu dans la séance du 11 décembre 1888." *Mémoires de l'Académie de médecine* 36 (1891).

Bergman-Carton 1995. Janis Bergman-Carton. *The Woman of Ideas in French Art, 1830–1848*. New Haven and London, 1995.

Berkeley 1960. *Art from Ingres to Pollock*. Berkeley, University of California, 1960. Exh. cat. Berkeley, 1960.

Berlin 1929–30. *Ein Jahrhundert französischer Zeichnung*. Berlin, Galerie Paul Cassirer, December 1929–January 1930. Exh. cat. Berlin, 1930.

Bern 1948. *Dessins français du Musée du Louvre*. Bern, Kunstmuseum, March 11–April 30, 1948. Exh. cat. Bern, 1948.

Bern 1995. Stéphane Bern. *Madame Figaro*, June 30, 1995.

Bern, Hamburg 1996. *"Zeichnen ist sehen": Meisterwerke von Ingres bis Cézanne aus dem Museum der Bildenden Künste, Budapest, und aus Schweizer Sammlungen*. Bern, Kunstmuseum, March 29–June 2, 1996; Hamburg, Kunsthalle, July 5–September 8. Exh. cat. edited by Judit Gesko and Josef Helfenstein. Ostfildern-Ruit bei Stuttgart, 1996.

Bern, Kunstmuseum n.d. *Berner Kunstmuseum: Aus der Sammlung, wiedergaben von Gemälden, Zeichnungen und Plastiken*. Bern, n.d.

Bernheim-Jeune and Bernheim-Jeune 1919. Josse Bernheim-Jeune and Gaston Bernheim-Jeune. *L'Art moderne et quelques aspects de l'art d'autrefois*. 2 vols. Paris, 1919.

Bertin 1995. Eric Bertin. "Les Peintures d'Ingres. II: Expositions et ventes publiques du vivant de l'artiste." *Bulletin du Musée Ingres*, nos. 67–68 (1995), pp. 103–11.

Bertin 1996. Eric Bertin. "Les Peintures d'Ingres III: Estampes et photographies de reproduction parues du vivant de l'artiste." *Bulletin du Musée Ingres*, no. 69 (1996), pp. 39–62.

Bertin 1997. Eric Bertin. "Les Peintures d'Ingres. IV: Un Prétendu Modèle pour la Stratonice." *Bulletin du Musée Ingres*, no. 70 (April 1997), pp. 53–60.

Bertin 1998. Eric Bertin. "Ingres: D'après les lettres reçues de contemporains illustres." *Bulletin du Musée Ingres*, no. 71 (April 1998), pp. 17–50.

Bertin n.d. Eric Bertin. "Quatre Lettres de Thiers conservées par Ingres." In *Actes du colloque "Thiers, collectionneur et amateur d'art" tenu à la Fondation Dosne-Thiers (Paris), le 28 mai 1997*. Paris, forthcoming.

Bertram 1949. Anthony Bertram. *Jean-Auguste-Dominique Ingres*. London and New York, 1949.

Bessis 1969. Henriette Bessis. "Ingres et le portrait de l'Empereur." *Archives de l'art français*, n.s., 24 (1969), pp. 89–90.

Bessis 1972. Henriette Bessis. "Une Correspondance inédite de M. Ingres." *Bulletin du Musée Ingres*, no. 31 (July 1972), pp. 23–30.

Biel 1954. "Peinture moderne: Chefs-d'oeuvre des XIXᵉ et XXᵉ siècles." Biel, Städtische Galerie, 1954.

Biographie des hommes vivants **1818.** *Biographie des hommes vivants*. Vol. 4. Paris, 1818.

Birnbaum 1960. Martin Birnbaum. *The Last Romantic: The Story of More than a Half-Century in the World of Art*. New York, 1960.

Bissière 1921. Roger Bissière. "Notes sur Ingres." *L'Esprit nouveau*, no. 4 (January 1921), pp. 388–401.

Blakiston 1972. Georgiana Blakiston. *Lord William Russell and His Wife, 1815–1846*. London, 1972.

Blanc 1846. Charles Blanc. "La Stratonice.— M. Ingres." *La Réforme*, March 17, 1846.

Blanc 1853. Charles Blanc. *L'Oeuvre de Rembrandt*. Paris, 1853.

Blanc 1861. Ch[arles] B[lanc]. "Le Salon des Arts-Unis." *Gazette des beaux-arts* 9 (February 1, 1861), pp. 189–92.

Blanc 1866. Charles Blanc. "Grammaire des arts du dessin, architecture, sculpture, peinture." *Gazette des beaux-arts* 21 (September 1, 1866), pp. 226–49.

Blanc 1867–68. Charles Blanc. "Ingres: Sa Vie et ses ouvrages," parts 1–9. *Gazette des beaux-arts* 22 (May 1, 1867), pp. 415–30; 23 (July 1, 1867), pp. 54–71; (September 1, 1867), pp. 193–208; (November 1, 1867), pp. 442–58; 24 (January 1, 1868), pp. 5–25; (April 1, 1868), pp. 340–67; (June 1, 1868), pp. 525–45; 25 (August 1, 1868), pp. 89–107; (September 1, 1868), pp. 228–48.

Blanc 1869. Charles Blanc. "Calamatta." *Gazette des beaux-arts*, 2nd ser., 2 (August 1, 1869), pp. 97–116.

Blanc 1870. Charles Blanc. *Ingres: Sa vie et ses ouvrages*. Paris, 1870.

Bloomington 1957. *Baudelaire and the Graphic Arts.* Bloomington, Indiana University, October 25–November 19, 1957. Exh. cat. Bloomington, 1957.

Blume 1949–79. Friedrich Blume, ed. *Die Musik in Geschichte und Gegenwart.* 16 vols. Kassel, 1949–79.

Blunt and Whinney 1950. Anthony Blunt and Margaret Whinney. *The Nation's Pictures.* London, 1950.

Boggs 1962. Jean Sutherland Boggs. *Portraits by Degas.* Berkeley and Los Angeles, 1962.

Boime 1971. Albert Boime. *The Academy and French Painting in the Nineteenth Century.* New Haven and London, 1971.

Boime 1973. Albert Boime. "Ingress et Egress chez Ingres." *Gazette des beaux-arts,* 6th ser., 81 (April 1973), pp. 193–214.

Boime 1985. Albert Boime. "Declassicizing the Academic: A Realist View of Ingres." *Art History* 8 (March 1985), pp. 50–65.

Boiteau d'Ambly 1855. Paul Boiteau d'Ambly. "Salon de 1855." *La Propriété littéraire et artistique* 1, no. 14 (August 1, 1855), pp. 468–73.

Bonnaire 1937–43. Marcel Bonnaire. *Procès-verbaux de l'Académie des beaux-arts.* 3 vols. Paris, 1937–43.

Bordeaux 1865. "Société des amis des arts de Bordeaux, 14e exposition." Bordeaux, Galerie de la Société des amis des arts, 1865.

Bordeaux, Paris 1965–66. *Chefs-d'Oeuvre de la peinture française dans les musées de l'Ermitage et de Moscou.* Bordeaux, May 14–September 6, 1965; Paris, September 24, 1965–January 1966. Exh. cat. Bordeaux, 1965. Paris ed., *Chefs-d'Oeuvre de la peinture française dans les musées de Leningrad et de Moscou.* Paris, 1965.

Bordes 1974. Philippe Bordes. "Girodet et Fabre: Camarades d'atelier." *Revue du Louvre* 24 (1974), pp. 393–99.

Bordes 1979. Philippe Bordes. "Les Peintres Fabre et Benvenuti et la cour d'Élisa Bonaparte." In *Florence et la France: "Rapports sous la Révolution et l'Empire." Actes du colloque, Florence, 2–3–4 juin 1977,* pp. 187–207. Florence and Paris, 1979.

Bordes and Pougetoux 1983. Philippe Bordes and Alain Pougetoux. "Les Portraits de *Napoléon en habits impériaux* par Jacques-Louis David." *Gazette des beaux-arts,* 6th ser., 102 (July–August 1983), pp. 21–34.

Borowitz 1979. Helen O. Borowitz. "Two Nineteenth-Century Muse Portraits." *Bulletin of the Cleveland Museum of Art* 66 (September 1979), pp. 246–67.

Bory 1934. Robert Bory. *Liszt et ses enfants Blandine, Cosima et Daniel.* Paris, 1934.

Bory 1936. Robert Bory. *La Vie de Franz Liszt par l'image.* Geneva, 1936.

Bosson et al. 1992. J. Bosson, J. Delord, M. Favarel, J.-P. Laurens, D. Marti, and M. Massip. *Jean-Marie-Joseph Ingres (1755–1814).* Montauban, 1992.

Boston 1970. *Masterpieces of Painting in The Metropolitan Museum of Art.* Boston, Museum of Fine Arts, September 16–November 1, 1970. Exh. cat. by Edith A. Standen and Thomas M. Folds. New York, 1970.

Boston 1986. "Masterpieces from the Henry P. McIlhenny Collection." Boston, Museum of Fine Arts, June 27–August 31, 1986.

Boston 1988. "Nineteenth-Century European Drawings and Watercolors." Boston, Museum of Fine Arts, April–October 1988.

Boston 1992. "The Art of Drawing." Boston, Museum of Fine Arts, January 8–March 29, 1992.

***Boston Museum Bulletin* 1967.** Special issue for Henry Preston Rossiter. *Boston Museum Bulletin* 65 (1967).

Both de Tauzia 1879. Both de Tauzia. *Notice supplémentaire des dessins, cartons, pastels et miniatures des diverses écoles, exposés depuis 1869, dans les salles du Ier étage au Musée National du Louvre.* Paris, 1879.

Both de Tauzia 1888. Both de Tauzia. *Musée National du Louvre, dessins, cartons, pastels et miniatures des diverses écoles, exposés, depuis 1879, dans les Salles du Ier étage, deuxième notice supplémentaire.* Paris, 1888.

Boucher 1965. François Boucher. *Histoire du costume en Occident de l'antiquité à nos jours.* 2 vols. Paris, 1965.

Bouchot-Saupique 1949. J[acqueline] Bouchot-Saupique. "Le Portrait dessiné français (à propos de l'exposition du dessin français)." *Les Arts plastiques* 11–12 (November–December 1949), pp. 427–40.

Bouchot-Saupique 1950. Jacqueline Bouchot-Saupique. "Le Portrait dessiné français de Fouquet à Cézanne." *Musées de France* 1950, supp., pp. 11–18.

Bouchot-Saupique 1958. J[acqueline] Bouchot-Saupique. "Dessins français des collections américaines." *Art et style* 47 [1958], pp. [7]–[11].

Boudaille 1961. Georges Boudaille. *Le Musée de l'Ermitage: Peintures, dessins.* Paris, 1961.

Bouillon 1989. Jean-Paul Bouillon, ed. *La Critique d'art en France, 1850–1900: Actes du colloque de Clermont-Ferrand, 25, 26 et 27 mai 1987.* Saint-Étienne, 1989.

Bouillon et al. 1990. Jean-Paul Bouillon, Nicole Dubreuil-Blondin, Antoinette Ehrard, and Constance Naubert-Riser. *La Promenade du critique influent: Anthologie de la critique d'art en France, 1850–1900.* Paris, 1990.

Bouisset 1926. Félix Bouisset. *Le Musée Ingres: Historique—une visite au musée—la salle du Prince Noir.* Montauban, 1926.

Boutard, October 4, 1806. M. B. [Baron Jean-Baptiste Boutard]. "Salon de l'Art, 1806." *Journal de l'Empire,* October 4, 1806.

Boutard, November 7, 1806. M. B. [Baron Jean-Baptiste Boutard]. "Salon de l'an 1806." *Journal de l'Empire,* November 7, 1806.

Boutard, November 11, 1814. M. B. [Baron Jean-Baptiste Boutard]. "Salon de 1814." *Journal de l'Empire,* November 11, 1814.

Bouyer 1909. Raymond Bouyer. "Legs Émile Perrin." *Le Bulletin de l'art ancien et moderne,* March 27, 1909, p. 103.

Bouyer 1912. Raymond Bouyer. "Portrait de M. de Vèze, d'après Ingres, graveur de M. D.-A. Maillart d'après le dessin d'Ingres." *La Revue de l'art ancien et moderne* 32 (October 1912), p. 272.

Bouyer 1921. Raymond Bouyer. "L'Exposition d'art hollandais et l'exposition Ingres." *La Revue de l'art ancien et moderne* 40 (June 1921), pp. 51–54.

Boyer 1936. Ferdinand Boyer. "Le Palais-Bourbon sous le Premier Empire." *Bulletin de la Société de l'histoire de l'art français,* 1936, pp. 91–123.

Boyer d'Agen 1909. [J. A. B.] Boyer d'Agen, ed. *Ingres d'après une correspondance inédite.* Paris, 1909. Reprinted, Paris, 1926.

Boyer d'Agen 1926. [J. A. B.] Boyer d'Agen. *Ingres dessinateur des antiques, d'après un album inédit.* Paris, 1926.

Breeskin 1951. Adelyn D. Breeskin. "From Maryland Collections: Brilliant Facets of French 19th-Century Art." *Art Digest* 26, no. 4 (November 15, 1951), p. 11.

Brière 1924. Gaston Brière. *Musée National du Louvre. Catalogue des peintures, I.: École française.* Paris, 1924.

Bro 1978. Lu Bro. *Drawing: A Studio Guide.* New York, 1978.

Brooklyn 1921. *Paintings by Modern French Masters Representing the Post-Impressionists and Their Predecessors.* Brooklyn Museum, 1921. Exh. cat. Brooklyn, 1921.

Brooklyn 1939. Exhibition. Brooklyn Museum, 1939.

Brown 1982. Hilton Brown. "Looking at Paintings." *American Artist* 46 (December 1982), pp. 68–69, 86–88.

Brown and Orth 1997. Elizabeth A. R. Brown and Myra Dickman Orth. "Jean du Tillet et les illustrations du grand *Recueil des roys.*" *Revue de l'art,* no. 115 (1997), pp. 7–24.

Brownell 1928. W[illiam] C. Brownell. *French Art: Classical and Contemporary, Painting and Sculpture.* New York, 1928.

Brugerolles 1984. Emmanuelle Brugerolles. *Les Dessins de la collection Armand-Valton: La Donation d'un grand collectionneur du XIXe siècle à l'École des Beaux-Arts.* Paris, 1984.

Bruges 1962. *La Toison d'Or: Cinq Siècles d'art et d'histoire.* Bruges, Musée Communal des Beaux-Arts, Groeningemuseum, July 14–September 30, 1962. Bruges, Exh. cat. 1962.

Brunel and Julia 1984. Georges Brunel and Isabelle Julia, eds. *Correspondance des Directeurs de l'Académie de France à Rome.* New series. Vol. 2. Rome, 1984.

Brussels 1866. *Exposition générale des beaux-arts.* Brussels, August 1866. Exh. cat. Brussels, 1866.

Brussels 1890. "Portraits du siècle: Troisième Exposition." Brussels, 1890.

Brussels 1925–26. *Exposition David et son temps.* Brussels, Musée Royal des Beaux-Arts de Belgique, December 1925–January 1926. Exh. cat. Brussels, 1925.

Brussels 1935. *Cinq Siècles d'art: Peintures.* Brussels, Exposition universelle et internationale, May 24–October 13, 1935. Exh. cat. Brussels, 1935.

Brussels 1936. *Ingres—Delacroix: Dessins, pastels, et aquarelles.* Brussels, Palais des Beaux-Arts, January–February 1936. Exh. cat. Brussels, 1936.

Brussels 1936–37. *Les Plus Beaux Dessins français du Musée du Louvre (1350–1900).* Brussels, Palais des Beaux-Arts, December 1936–February 1937. Exh. cat. Brussels, 1937.

Brussels 1947–48. *De David à Cézanne.* Brussels, Palais des Beaux-Arts, November 1947–January 1948. Exh. cat. Brussels, 1947.

Brussels 1960. "La Gloire des Communes belges." Brussels, 1960.

Brussels, Rotterdam, Paris 1949–50. *Le Dessin français de Fouquet à Cézanne.* Brussels, Palais des Beaux-Arts, November–December 1949; Rotterdam, Museum Boymans-van Beuningen, January 1950; Paris, Musée de l'Orangerie, February–March. Exh. cat. Brussels, 1949.

Bruun-Neergaard 1811. Tønnes Christian Bruun-Neergaard. *Notice sur Thomas-Charles Naudet, peintre de paysage.* Paris, 1811.

Bruyas 1876. Alfred Bruyas. *La Galerie Bruyas.* Paris, 1876.

Bryson 1984. Norman Bryson. *Tradition and Desire: From David to Delacroix.* Cambridge, 1984.

Bucharest 1931. *Desenul francez in secolele al XIX-lea si al XX-lea.* Bucharest, Muzeul Toma Stelian, November 8–December 15, 1931. Exh. cat. [Bucharest, 1931.]

Bücken 1928. Ernst Bücken. *Die Musik des 19. Jahrhunderts bis zur Moderne.* Vol. 4 of *Handbuch der Musikwissenschaft.* Wildpark-Potsdam, 1928.

Buenos Aires 1939. *Siete siglos de pintura francesa.* Buenos Aires, Museo Nacional de Bellas Artes, 1939. Exh. cat. Buenos Aires, 1939.

Buenos Aires 1939a. *La pintura francesa de David a nuestros días: Óleos, dibujos y acuarelas.* Buenos Aires, Museo Nacional de Bellas Artes, July–August 1939. Exh. cat. Buenos Aires, 1939.

Buffalo 1932. "Nineteenth Century French Art." Buffalo, Albright Art Gallery, November 1–30, 1932. Exh. cat., *Catalogue of the Exhibition of Nineteenth Century French Art: Paintings, Water Colors, Drawings, Prints, Sculpture.* Introduction signed G[ordon] B[ailey] W[ashburn]. Lockport, N.Y., 1932.

Buffalo 1935. *Master Drawings Selected from the Museums and Private Collections of America.* Buffalo, Buffalo Fine Arts Academy, Albright Art Gallery, January 1935. Exh. cat. foreword by Gordon Washburn; introduction by Agnes Mongan. Buffalo, 1935.

Buffalo 1960. *The T. Edward Hanley Collection, Drawings, Watercolors, Prints.* Buffalo, Albright Art Gallery, January 6–February 14, 1960. Exh. cat. Buffalo, 1960.

Buffalo 1967–68. *Drawings and Watercolors from the Albright-Knox Art Gallery.* Buffalo, Albright-Knox Art Gallery, December 18, 1967–January 31, 1968. Exh. cat. Buffalo, 1967.

Buffalo 1987–88. "Intimate Gestures, Realized Visions: Masterworks on Paper from the Collection of the Albright-Knox Art Gallery." Buffalo, Albright-Knox Art Gallery, December 12, 1987–January 31, 1988. Exh. cat., *Masterworks on Paper from the Albright-Knox Art Gallery,* by Cheryl A. Brutvan. New York, 1987.

Buffalo 1992. "Women Observed." Buffalo, Albright-Knox Art Gallery, February 28–April 12, 1992.

Buffalo, Albright Art Gallery 1954. "Check List of Drawings in the Collection of the [Albright Art] Gallery." *Gallery Notes* 18, no. 3 (May 1954).

Bührle Collection 1986. *Fondation Emil G. Bührle Collection.* Text in German, French, and English by Leopold Reidemeister et al. 2nd ed. Zurich, 1986.

Bulit 1993. L. Bulit. "Nouvelles Découvertes de documents sur Ingres et Murat." *Cavalier et Roi, bulletin des Amis du Musée Murat,* no. 24 (January 1993), pp. 8–10.

Bulletin du Musée Ingres 1961. *Bulletin du Musée Ingres,* no. 9 (July 1961).

Burke's Peerage, Baronetage and Knightage. *Burke's Genealogical and Heraldic History of the Peerage, Baronetage and Knightage.* [1st]–105th ed. London, 1833–1970.

Burn 1984. Barbara Burn. *Metropolitan Children.* New York, 1984.

Burroughs 1918. B[ryson] B[urroughs]. "Two Ingres Portraits." *Bulletin of The Metropolitan Museum of Art* 13 (May 1918), p. 119.

Burroughs 1919. B[ryson] B[urroughs]. "Recent Accessions: Drawings by Ingres." *Bulletin of The Metropolitan Museum of Art* 14 (November 1919), pp. 246–47.

Burroughs 1919a. B[ryson] B[urroughs]. "Portraits of M. and Mme. Leblanc by Ingres." *Bulletin of The Metropolitan Museum of Art* 14 (June 1919), pp. 133–34.

Burroughs 1932. Louise Burroughs. "Ingres in Florence." *Creative Art* 10 (May 1932), pp. 365–68.

Burroughs 1946. Louise Burroughs. "Drawings by Ingres." *The Metropolitan Museum of Art Bulletin,* n.s., 4 (February 1946), pp. 156–61.

Burroughs 1960. Louise Burroughs. "A Portrait of Ingres as a Young Man." *The Metropolitan Museum of Art Bulletin* 19, no. 1 (summer 1960), pp. 1–7.

Burroughs 1966. Louise Burroughs. "Ingres et la famille Gonin." *Genava,* n.s., 14 (1966), pp. 162–72.

Burrows 1931. Carlyle Burrows. "Letter from New York." *Apollo* 13 (April 1931), pp. 237–39.

Burty 1864. Ph[ilippe] Burty. "Six Tableaux nouveaux de M. Ingres." *La Chronique des arts et de la curiosité,* July 10, 1864, pp. 204–5.

Burty 1865. Philippe Burty. "L'Exposition de Bordeaux." *Gazette des beaux-arts* 18 (May 1, 1865), pp. 465–76.

Butler 1968. [Joseph T. Butler.] "The American Way with Art: Henry Preston Rossiter Honoured by Boston Museum." *Connoisseur* 167 (April 1968), pp. 270–71.

Byron 1901. George Gordon, Lord Byron. *The Works of Lord Byron: Letters and Journals.* Vol. 5. New ed. Edited by R. E. Prothero. London, 1901.

Byron 1974. George Gordon, Lord Byron. *Byron's Letters and Journals: The Complete and Unexpurgated Text of All the Letters Available in Manuscript and the Full Printed Version of All Others.* Edited by Leslie A. Marchand. Vol. 3. London, 1974.

Caffe 1875. [Paul-Louis-Barthélemy] Caffe. [Obituary for Louis Martinet]. *Journal des connaissances médicales,* May 30, 1875, pp. 159–60.

Cairns and Walker 1952. Huntington Cairns and John Walker. *Great Paintings from the National Gallery of Art.* New York and Washington, D.C., 1952.

Cairns and Walker 1966. Huntington Cairns and John Walker. *A Pageant of Painting from the National Gallery of Art.* Vol. 2. New York and Washington, D.C., 1966.

Calonne 1855. Alphonse de Calonne. "Exposition universelle des beaux-arts." *Revue contemporaine,* 21 (August 15, 1855), pp. 107–37.

Cambon 1885. Armand Cambon. *Catalogue du Musée de Montauban.* Montauban, 1885.

Cambridge (Mass.) 1929. *Exhibition of French Painting of the Nineteenth and Twentieth Centuries.* Cambridge, Mass., Harvard University, Fogg Art Museum, March 6–April 6, 1929. Exh. cat. Cambridge, Mass., 1929.

Cambridge (Mass.) 1934. "Loan Exhibition: French Drawings and Prints of the Nineteenth Century." Cambridge, Mass., Harvard University, Fogg Art Museum, March 21–April 28, 1934.

Cambridge (Mass.) 1948–49. "Seventy Master Drawings." Cambridge, Mass., Harvard University, Fogg Art Museum, November 1948–January 1949. Exh. cat., *One Hundred Master Drawings,* edited by Agnes Mongan. Includes thirty additional drawings. Cambridge, Mass., 1949.

Cambridge (Mass.) 1958. "Watercolors, Drawings and Sculpture from Collections of Members of the Class of 1933." Cambridge, Mass., Harvard University, Fogg Art Museum, 1958.

Cambridge (Mass.) 1961. *Ingres and Degas: Two Classical Draughtsmen.* Cambridge, Mass., Harvard University, Fogg Art Museum, April 24–May 20, 1961. Exh. cat. Cambridge, Mass., 1961.

Cambridge (Mass.) 1962. *Forty Master Drawings from the Collection of John Nicholas Brown.* Cambridge, Mass., Harvard University, Fogg Art Museum, summer 1962. Exh. cat. Cambridge, Mass., 1962.

Cambridge (Mass.) 1964. *Studies and Study Sheets: Master Drawings from Five Centuries.* Cambridge, Mass., Harvard University, Fogg Art Museum, 1964. Exh. cat. Cambridge, Mass., 1964.

Cambridge (Mass.) 1967. *Ingres Centennial Exhibition, 1867–1967: Drawings, Watercolors and Oil Sketches from American Collections.* Cambridge, Mass., Harvard University, Fogg Art Museum, February 12–April 9, 1967. Exh. cat. by Agnes Mongan and Hans Naef. "Technical Appendix," by Marjorie B. Cohn, pp. 241–49. Cambridge, Mass., 1967.

Cambridge (Mass.) 1973. *Ingres' Sculptural Style: A Group of Unknown Drawings.* Cambridge, Mass., Harvard University, Fogg Art Museum, February 9–March 11, 1973. Exh. cat. by Phyllis Hattis. Cambridge, Mass., 1973.

Cambridge (Mass.) 1980. *Works by J.-A.-D. Ingres in the Collection of the Fogg Art Museum.* Cambridge, Mass., Harvard University, Fogg Art Museum, October 19–December 7, 1980. Exh. cat. by Marjorie B. Cohn and Susan L[ocke] Siegfried. Fogg Art Museum Handbooks, vol. 3. Cambridge, Mass., 1980.

Cambridge (Mass.) 1985. "Woodner Collection." Cambridge, Mass., Harvard University, Fogg Art Museum, 1985.

Cambridge (Mass.), Fogg Art Museum 1966. *Fogg Art Museum: Acquisitions 1965.* Cambridge, Mass., 1966.

Cambridge (Mass.), New York 1965–67. *Memorial Exhibition: Works of Art from the Collection of Paul J. Sachs [1878–1965], Given and Bequeathed to the Fogg Art Museum, Harvard University.* Cambridge, Mass., Harvard University, Fogg Art Museum, November 15, 1965–January 15, 1966; New York, Museum of Modern Art, December 19, 1966–February 26, 1967. Exh. cat. compiled by Agnes Mongan. Cambridge, Mass., 1965.

Canaday 1957. John Canaday. "Four Women." *Philadelphia Museum of Art Bulletin* 52 (1957), pp. 43–49.

Cantaloube 1867. Amédée Cantaloube. [Review of Paris 1867.] *Revue libérale* 1, no. 4 (May 25, 1867), pp. 531–32.

Capers and Maddox 1965. Roberta M. Capers and Jerrold Maddox. *Images and Imagination: An Introduction to Art.* New York, 1965.

Carlier 1864. J.-J. Carlier. "Victor Dourlen." *Mémoires de la Société dunkerquoise pour l'encouragement des sciences, des lettres, et des arts* 9, 1862–64 (1864), pp. 512–27.

Cassirer 1919. Else Cassirer, ed. *Künstlerbriefe aus dem neunzehnten Jahrhundert.* 2nd ed. Berlin, 1919.

Cassou 1934. Jean Cassou. "Ingres et ses contradictions." *Gazette des beaux-arts,* 6th ser., 11 (March 1934), pp. 146–64.

Cassou 1936. Jean Cassou. "Ingres." *L'Art et les artistes* 31, no. 164 (February 1936), pp. 145–75.

Cassou 1947. Jean Cassou. *Ingres.* Brussels, 1947.

Castagnary, May 15, 1867. Castagnary. "Exposition des oeuvres de M. Ingres." *Liberté,* May 15, 1867.

Castagnary, May 18, 1867. Castagnary. "Exposition des oeuvres de M. Ingres." *Liberté,* May 18, 1867.

Cavé 1850. Marie-Élisabeth Cavé. *Le Dessin sans maître.* Paris, 1850.

Cavé 1851. Marie-Élisabeth Cavé. *L'Aquarelle sans maître.* Paris, 1851. [2nd ed., 1856.]

Cavé 1863. Marie-Élisabeth Cavé. *La Couleur . . . ouvrage approuvé par M. Eugène Delacroix pour apprendre la peinture à l'huile et à l'aquarelle.* Paris, 1863.

Caylus 1752–67. [Anne-Claude-Philippe] Caylus, comte de. *Recueil d'antiquités égyptiennes, étrusques, grecques et romaines.* 7 vols. Paris, 1752–67.

Cazalès 1833. E. de C[azalès]. "Quelques Réflexions sur l'art en France et sur le Salon de 1833." *Revue européenne* 6, no. 21 (May 1833), pp. 292–309.

Cazelles and Lefebure 1979. Raymond Cazelles and Amélie Lefebure. *Peintures célèbres du Musée Condé.* Chantilly, 1979.

Champa 1968. Kermit Champa. "Ingres Centennial in Paris." *Artforum* 6, no. 6 (February 1968), pp. 40–45.

Champfleury 1894. Champfleury [Jules-François-Félix Husson]. *Oeuvres posthumes de Champfleury: Salons, 1846–1851.* Paris, 1894.

Chantilly, Musée Condé 1979. *See* **Cazelles and Lefebure 1979.**

Chapel Hill 1978. *French Nineteenth Century Oil Sketches: David to Degas.* Chapel Hill, University of North Carolina, William Hayes Ackland Memorial Art Center, March 5–April 16, 1978. Exh. cat. by John Minor Wisdom et al. Chapel Hill, N.C., 1978.

Charlemont 1867. Lady Églé Charlemont. "Un Nouveau Chapitre des Mémoires de Lady Églé." *Revue de Paris,* November 1, 1867, pp. 82–113.

Chartres 1858. *Exposition archéologique et d'objets d'art organisée par la Société archéologique d'Eure-et-Loir.* Chartres, La Société archéologique d'Eure-et-Loir, 1858. Exh. cat. Chartres, 1858.

Chartres 1869. *Exposition départementale organisée par la Société archéologique d'Eure-et-Loir.* Chartres, La Société archéologique d'Eure-et-Loir, Partie Archéologique & Artistique, 1869. Exh. cat. Chartres, 1869.

Chaudonneret 1980. Marie-Claude Chaudonneret. *Fleury Richard et Pierre Révoil: La Peinture troubadour.* Paris, 1980.

Chaussard 1800. Pierre-Jean-Baptiste Chaussard. "Beaux-Arts. Exposition des ouvrages de peinture, sculpture, gravure, architecture composés par les artistes vivans." *Bulletin universel des sciences, des lettres et des arts,* no. 4, an IX [1800], pp. 27–29.

Chaussard 1806. Pierre-Jean-Baptiste Chaussard. *Le Pausanias français: État des arts du dessin en France, à l'ouverture du XIX^e siècle. Salon de 1806.* Paris, 1806.

Chennevières 1853. Ph[ilippe] de Chennevières. *Portraits inédits d'artistes français.* 2nd ed. Paris, [1853].

Chennevières 1882–83. Henry de Chennevières. *Les Dessins du Louvre.* [Vol. 2], *École française.* Paris, [1882–83].

Chennevières 1883. Henry de Chennevières. "Les Donations et acquisitions du Louvre depuis 1880, peintures et dessins." *Gazette des beaux-arts,* 2nd ser., 28 (October 1, 1883), pp. 346–60.

Chennevières 1884. Henry de Chennevières. "Les Donations et acquisitions du Louvre depuis 1880." *Gazette des beaux-arts,* 2nd ser., 29 (January 1, 1884), pp. 55–65.

Chennevières 1885. Philippe de Chennevières. "Souvenirs d'un directeur des Beaux-Arts: Le Comte de Nieuwerkerke." *L'Artiste* 55 (April 1885), pp. 250–60.

Chennevières 1886. Ph[ilippe] de Chennevières. *Souvenirs d'un directeur des Beaux-Arts.* Part 3. Offprint from *L'Artiste.* Paris, 1886. Reprinted, Paris, 1979.

Chennevières 1889. Ph[ilippe] de Chennevières. *Souvenirs d'un directeur des Beaux-Arts.* Part 5. Offprint from *L'Artiste.* Paris, 1889. Reprinted, Paris, 1979.

Chennevières 1903. Henry de Chennevières. "La Nouvelle Salle des portraits-crayons d'Ingres au Musée du Louvre." *La Revue de l'art ancien et moderne* 14 (August 1903), pp. 125–40.

Cheron, August 25, 1855. Paul Cheron. "Exposition universelle." *Le Théâtre,* August 25, 1855.

Chicago 1933. *Catalogue of a Century of Progress Exhibition of Paintings and Sculpture Lent from American Collections.* Art Institute of Chicago, June 1–November 1, 1933. Exh. cat. Chicago, 1933.

Chicago 1934. *Catalogue of a Century of Progress Exhibition of Paintings and Sculpture.* Art Institute of Chicago, June 1–November 1, 1934. Exh. cat. Chicago, 1934.

Chicago 1941. *Masterpieces of French Art Lent by the Museums and Collectors of France.* Art Institute of Chicago, April 10–May 20, 1941. Exh. cat. Chicago, 1941.

Chicago 1946. *Drawings Old and New.* Art Institute of Chicago, 1946. Exh. cat. Chicago, 1946.

Chicago 1955. *Great French Paintings: An Exhibition in Memory of Chauncey McCormick.* Art Institute of Chicago, January 20–February 20, 1955. Exh. cat. Chicago, 1955.

Chicago 1961. "Fiftieth Anniversary Exhibition: Drawings from the Collection of the Art Institute of Chicago." Art Institute of Chicago, 1961.

Chicago 1978. *European Portraits, 1600–1900, in the Art Institute of Chicago.* Art Institute of Chicago, July 8–September 11, 1978. Exh. cat. by Richard Born et al. Chicago, 1978.

Chicago, Minneapolis, Detroit, San Francisco 1955–56. *French Drawings: Masterpieces from Seven Centuries.* Art Institute of Chicago; Minneapolis Institute of Arts; Detroit Institute of Arts; San Francisco, California Palace of the Legion of Honor, 1955–56. Exh. cat. compiled under the direction of Jacqueline Bouchot-Saupique by Roseline Bacou and Maurice Sérullaz. Chicago, 1955.

Chicago, Saint Louis 1985–86. *Great Drawings from the Art Institute of Chicago: The Harold Joachim Years, 1958–1983.* Art Institute of Chicago, July 24–September 30, 1985; Saint Louis Art Museum, March 10–May 16, 1986. Exh. cat. by Martha Tedeschi. New York and Chicago, 1985.

Chicago, Toledo, Los Angeles, San Francisco 1962–63. *Treasures of Versailles.* Art Institute of Chicago, October 6–December 2, 1962; Toledo Museum of Art, January 12–February 17, 1963; Los Angeles County Museum of Art, March 12–April 28; San Francisco, California Palace of the Legion of Honor. Exh. cat. Chicago, 1962.

Chopin 1904. Frédéric Chopin. *Souvenirs inédits de Chopin: Lettres de Chopin à sa famille et de sa famille à lui. Lettres des Wodzinski. Lettres des élèves et des connaissances de Chopin. Correspondance de M^lle Stirling. Mélanges.* Edited by Mieczyslaw Karlowicz. Paris and Leipzig, 1904.

Christoffel 1940. Ulrich Christoffel. *Klassizismus in Frankreich um 1800.* Munich, 1940.

La Chronique des arts 1866. *La Chronique des arts et de la curiosité,* April 1, 1866.

La Chronique des arts 1867. *La Chronique des arts et de la curiosité,* April 28, 1867.

La Chronique des arts 1875. *La Chronique des arts et de la curiosité,* August 14, 1875.

La Chronique des arts, January 1878. *La Chronique des arts et de la curiosité,* January 1878.

La Chronique des arts, February 1878. *La Chronique des arts et de la curiosité,* February 1878.

La Chronique des arts 1894. *La Chronique des arts et de la curiosité,* November 10, 1894.

La Chronique des arts 1901. *La Chronique des arts et de la curiosité,* February 2, 1901.

La Chronique des arts 1912. *La Chronique des arts et de la curiosité,* February 10, 1912.

La Chronique des arts 1964. *La Chronique des arts et de la curiosité,* May–June 1964.

La Chronique des arts 1965. *La Chronique des arts et de la curiosité,* February 1965.

La Chronique des arts 1990. *La Chronique des arts et de la curiosité,* October 1990.

Chudant 1929. A. Chudant. *Catalogue du Musée de Besançon.* Paris, 1929.

Cincinnati 1940. "The Place of David and Ingres in a Century of French Painting." Cincinnati Art Museum, February 4–March 3, 1940.

Cincinnati 1941. *Masterpieces of Art: European Paintings from the New York and San Francisco World's Fairs; to Which Have Been Added a Number of Outstanding Paintings from Public and Private Collections of Cincinnati.* Cincinnati Art Museum, January 15–February 9, 1941. Exh. cat. Cincinnati, 1941.

Cincinnati 1947. "Fashion for the Greco-Roman Taste of the Continent and the New Republic." Cincinnati, Taft Museum, 1947.

Cincinnati 1959. *The Lehman Collection, New York.* Cincinnati Art Museum, May 8–July 5, 1959. Exh. cat. edited by Gustave von Groschwitz. Cincinnati, 1959.

Cincinnati Art Museum 1956. Cincinnati Art Museum. *Guide to the Collections of the Cincinnati Art Museum.* Cincinnati, 1956.

Cincinnati Art Museum 1984. Cincinnati Art Museum. *Masterpieces from the Cincinnati Art Museum.* Cincinnati, 1984.

Cincinnati, Taft Museum 1939. Taft Museum. *Catalogue of the Taft Museum.* Cincinnati, 1939.

Cincinnati, Taft Museum 1958. Taft Museum. *Catalogue of the Taft Museum.* Cincinnati, 1958.

Clarac 1806. F[rédéric] de C[larac]. "Lettre sur le Salon de 1806." *Annales littéraires de l'Europe* 12 (1806), pp. 94–130.

Claretie 1873. Jules Claretie. *Peintres et sculpteurs contemporains.* Paris, 1873.

Clark 1971. Kenneth Clark. "Ingres: Peintre de la vie moderne." *Apollo* 93 (May 1971), pp. 357–65.

Clark 1973. Kenneth Clark. *The Romantic Rebellion.* London, 1973.

Clarke 1939. John Lee Clarke Jr. "David and Ingres: The Classical Ideal. Springfield Shows Two Great French Neo-Classicists." *Art News* 38, no. 8 (November 25, 1939), pp. 9, 16.

Cleveland 1927. "Special Exhibition of Drawings by Old and Modern Masters." Cleveland Museum of Art, 1927.

Cleveland 1929. "French Art since Eighteen Hundred." Cleveland Museum of Art, November 7–December 9, 1929. Exh. cat. published in *Bulletin of the Cleveland Museum of Art* 16 (November 1929), pp. 155–72.

Cleveland 1932–33. "Drawings from 1630 to 1830." Cleveland Museum of Art, 1932–33.

Cleveland 1963. *Style, Truth and the Portrait.* Cleveland Museum of Art, October 1–November 10, 1963. Exh. cat. by Rémy G. Saisselin. Cleveland, 1963.

Cohn 1968. Marjorie B. Cohn. "Profile Portrait of Guillaume Guillon Lethière by J. A. D. Ingres." In *Fogg Art Museum Acquisitions, 1966–1967,* pp. 54–59. Cambridge, Mass., 1968.

Cohn 1969. Marjorie B. Cohn. "The Original Format of Ingres Portrait Drawings." In *Colloque Ingres [1967],* pp. 15–26. [Montauban, 1969.]

Collins 1959. Irene Collins. *The Government and the Newspaper Press in France, 1814–1881.* London, 1959.

Columbus 1956. *International Masterpieces Exhibit.* Columbus Gallery of Fine Arts, November 8–December 16, 1956. Exh. cat. Columbus, 1956.

Combs 1939. Lilian Combs. "Reports of the Department for 1938: Prints and Drawings." *Annual Report for the Year 1939,* pp. 20–22. [*Bulletin of the Art Institute of Chicago* 33, part 3 (March 1940).]

Compin and Roquebert 1986. Isabelle Compin and Anne Roquebert. *Catalogue sommaire illustré des peintures du Musée du Louvre et du Musée d'Orsay.* Vol. 3. Paris, 1986.

Comstock 1953. Helen Comstock. "An English Portrait by Ingres." *Connoisseur* 132 (August 1953), p. 69.

Condon 1996. Patricia Condon. "Ingres, Jean-Auguste-Dominique." In *The Dictionary of Art,* vol. 15, pp. 835–46. New York, 1996.

Connoisseur 1962. *Connoisseur* 149 (March 1962).

Connolly 1972. John L. Connolly Jr. "Ingres and the Erotic Intellect." In *Woman as Sex Object: Studies in Erotic Art, 1730–1970,* edited by Thomas B. Hess and Linda Nochlin, pp. 16–31. *Art News Annual* 38. New York, 1972.

Connolly 1980. John L. Connolly Jr. "Napoleon and the Age of Gold: A Bicentennial Celebration of the Birth of J. A. D. Ingres." In *The Consortium on Revolutionary Europe, 1750–1850: Proceedings,* vol. 2, edited by Donald D. Horward, John L. Connolly Jr., and Harold T. Parker, pp. 52–68. Athens, Ga., 1980.

Constans 1995. Claire Constans. *Les Peintures.* 2 vols. Musée National du Château de Versailles. Paris, 1995.

Copenhagen 1914. *Exposition d'art français du XIX^e siècle.* Copenhagen, Statens Museum for Kunst, May 15–June 30, 1914. Exh. cat. Copenhagen, 1914.

Copenhagen 1960. *Exposition des portraits français de Largillierre à Manet.* Copenhagen, Ny Carlsberg Glyptotek, October 15–November 15, 1960. Exh. cat. Copenhagen, 1960.

Copenhagen 1967. *Ingres i Rom: Tegninger fra Musée Ingres i Montauban.* Copenhagen, Thorvaldsens Museum, March 2–April 2, 1967. Exh. cat. Copenhagen, 1967.

Copenhagen 1986. *Franske mestervaerker: Malerier og tegninger fra det 19. og 20. Arhundrede fra Robert Lehman collection, Metropolitan Museum of Art, New York / French Masterpieces: XIX & XX Century Paintings and Drawings from the Robert Lehman Collection, The Metropolitan Museum of Art, New York.* Copenhagen, Ordrupgaard Museum, April 17–June 22, 1986. Exh. cat. by George Szabo. Copenhagen, 1986.

Copenhagen, Stockholm, Oslo 1928. *Udstillingen af fransk malerkunst fra den første halvdel af det 19. aarhundrede.* Copenhagen, Ny Carlsberg Glyptotek, March 31–April 21, 1928; Stockholm, Nationalmuseum, May 12–June 16; Oslo, Nasjonalgalleriet, July–August. Exh. cat. Copenhagen, 1928. Swedish ed., *Franskt måleri från David till Courbet.* Stockholm, 1928. Norwegian ed., *Fransk malerkunst fra David til Courbet.* Oslo, 1928.

Corbucci 1886. Vittorio Corbucci. *Luigi Calamatta incisore.* Civitavecchia, 1886.

Cornillot 1957. Marie-Lucie Cornillot. *Collection Pierre-Adrien Pâris, Besançon.* Inventaire général des dessins des musées de province, 1. Paris, 1957.

Cortissoz 1930. Royal Cortissoz. *The Painter's Craft.* New York, 1930.

Coupin 1824. P[ierre] A[lexandre] [Coupin]. "Notice sur l'exposition des tableaux en 1824." *Revue encyclopédique* 24 (December 1824), pp. 589–605.

Coupin 1828. P[ierre] A[lexandre] [Coupin]. "Exposition des tableaux en 1827 et 1828." *Revue encyclopédique* 37 (March 1828), pp. 857–69.

Coural 1980. Jean Coural, with Chantal Gastinel-Coural and Muriel Müntz de Raïssac. *Paris: Mobilier national soieries empire.* Paris, 1980.

Coural and Gastinel-Coural 1983. Jean Coural and Chantal Gastinel-Coural. "La Fabrique lyonnaise au XVIIIᵉ siècle. La Commande royale de 1730." *Revue de l'art,* no. 62 (1983), pp. 49–64.

Courboin 1895. F[rançois] Courboin, ed. *Inventaire des dessins, photographies et gravures relatifs à l'histoire générale de l'art, légués au Département des Estampes de la Bibliothèque Nationale par A. Armand.* 2 vols. Lille, 1895.

Courboin 1923–28. François Courboin. *Histoire illustrée de la gravure en France. . . .* 4 vols. Paris, 1923–28.

Courcy 1957. G[eraldine] I. C. de Courcy. *Paganini, the Genoese.* 2 vols. Norman, Okla., 1957.

Courcy 1961. G[eraldine] I. C. de Courcy. *Chronology of Nicolo [sic] Paganini's Life /Chronologie von Nicolo Paganinis Leben.* German translation by Hans Dunnebeil. Wiesbaden, 1961.

Courthion 1947–48. Pierre Courthion. *Ingres raconté par lui-même et par ses amis: Pensées et écrits du peintre.* 2 vols. Vésenaz-Genève, 1947–48.

Courthion 1968. Pierre Courthion. "Ingres au Petit Palais." *XXᵉ siècle* 30, no. 30 (June 1968), pp. 5–13.

Cousseau 1991. Henry-Claude Cousseau, with Béatrice Sarrazin, Claude Allemand-Cosneau, and Vincent Rousseau. *Le Musée des Beaux-Arts de Nantes.* Paris and Nantes, 1991.

Critica d'arte 1966. *Critica d'arte* 13, n.s., no. 81 (1966), appendix ["Cultura selezione informazione artistica internazionale," edited by Licia Ragghianti Collobi], pp. 1–20.

Crow 1995. Thomas E. Crow. *Emulation: Making Artists for Revolutionary France.* New Haven and London, 1995.

Cummings 1965. Frederick Cummings. "Romantic Portraitist: Three Drawings by Ingres." *Bulletin of the Detroit Institute of Arts* 44 (1965), pp. 70–77.

Cunningham 1972. Charles C. Cunningham. "Ingres—Portrait of the Marquis de Pastoret." *Calendar of the Art Institute of Chicago* 66, no. 3 (May–August 1972), pp. 2–4.

***Daily Independant* 1938.** *Daily Independant* (Sheffield), August 20, 1938.

Dallas 1951. *Four Centuries of European Painting: An Exhibition of Sixty British and European Paintings from the Fifteenth to the Nineteenth Centuries on Loan to the Museum from the Collections of the Marquess and Marchioness of Amodio, M. Knoedler and Company, Inc. . . .* Dallas Museum of Fine Arts, 1951. Exh. cat. Dallas, 1951.

Dallas 1962. *The Arts of Man: A Selection from Ancient to Modern Times.* Dallas Museum of Fine Arts, October 6–December 31, 1962. Exh. cat. by John Lunsford. Dallas, 1962.

Damay 1843. Damay. "Une Visite à l'atelier d'Ingres." *Mémoires de l'Académie des sciences, agriculture, commerce, belles-lettres et arts du département de la Somme* 5 (1843), pp. 449–54.

Darmstadt 1972. "Von Ingres bis Renoir." Darmstadt, Hessisches Landesmuseum, 1972.

D'Arnaud 1846. Camille D'Arnaud. "Beaux-Arts." *L'Artiste,* 4th ser., 7 (August 9, 1846), p. 96.

Dascalakis 1937. Ap. Dascalakis. *Rhigas Velestinlis: La Révolution française et les préludes de l'indépendance hellénique.* Paris, 1937.

Datini 1972. Giulio Datini. *Musei di Prato, Galleria di Palazzo Pretorio, Opera del Duomo: Quadreria comunale.* Bologna, 1972.

Daulte 1953. François Daulte. *Le Dessin français de David à Courbet.* Lausanne, 1953.

Davenport 1948. Millia Davenport. *The Book of Costume.* 2 vols. in 1. New York, 1948.

David d'Angers 1891. Pierre-Jean David d'Angers. *Lettres de P.-J. David d'Angers à son ami, le peintre Louis Dupré.* Edited by Robert David d'Angers. Paris, 1891.

Davies 1934. Martin Davies. "An Exhibition of Portraits by Ingres and His Pupils." *Burlington Magazine* 64 (May 1934), pp. 241–42.

Davies 1936. Martin Davies. "A Portrait by the Aged Ingres." *Burlington Magazine* 68 (June 1936), pp. 257–68.

Davies 1946. Martin Davies. *French School.* National Gallery Catalogues. London, 1946.

Davies 1946a. Martin Davies. *The British School.* National Gallery Catalogues. London, 1946.

Davies 1957. Martin Davies. *French School.* 2nd ed. National Gallery Catalogues. London, 1957.

Davies 1970. Martin Davies. *French School: Early 19th Century, Impressionists, Post-Impressionists Etc.* Additions and some revisions by Cecil Gould. National Gallery Catalogues. London, 1970.

Dax 1862. Pierre Dax. "Chronique." *L'Artiste* 32, n.s., 1 (June 1, 1862), pp. 253–55.

Dax 1863. Pierre Dax. "Chronique." *L'Artiste* 33, n.s., 2 (July 15, 1863), pp. 45–47.

Dayton 1971. *French Artists in Italy, 1600–1900.* Dayton Art Institute, October 15–November 28, 1971. Exh. cat. Dayton, 1971.

Deane 1965. Basil Deane. *Cherubini.* Oxford Studies of Composers, 3. London, 1965.

Debia 1868. Prosper Debia. *Souvenirs intimes sur Ingres.* [Written February 1867.] Montauban, 1868.

Decamps 1834. Alexandre D[ecamps]. *Le Musée: Revue du Salon de 1834.* Paris, 1834.

Deconchy 1875. F[erdinand] Deconchy. "Victor Baltard, notice biographique." *Société Centrale des Architectes, Annales* 1, 1874 (1875), ill. opp. p. 233.

Degas 1931. *Lettres de Degas.* Edited by Marcel Guérin; preface by Daniel Halévy. Paris, 1931.

Degas 1947. Edgar Germain Hilaire Degas. *Letters.* Edited by Marcel Guérin; translated by Marguerite Kay. Oxford, 1947.

Degenhart 1943. Bernhard Degenhart. *Europäische Handzeichnungen aus fünf Jahrhunderten.* Berlin, 1943.

Delaborde 1861. Henri Delaborde. "Les Dessins de M. Ingres au Salon des Arts Unis." *Gazette des beaux-arts* 9 (March 1, 1861), pp. 257–69.

Delaborde 1862. Henri Delaborde. "De quelques traditions de l'art français à propos du tableau de M. Ingres: Jésus au milieu des docteurs." *Gazette des beaux-arts* 13 (November 1, 1862), pp. 385–400.

Delaborde 1865. Henri Delaborde, ed. *Lettres et pensées d'Hippolyte Flandrin.* Paris, 1865.

Delaborde 1870. Henri Delaborde. *Ingres: Sa Vie, ses travaux, sa doctrine, d'après les notes manuscrites et les lettres du maître.* Paris, 1870.

Delaborde 1874. Henri Delaborde. "Victor Baltard." *Revue des deux mondes,* April 15, 1874, pp. 793–94.

Delaborde 1878. Henri Delaborde. *Notice sur la vie et les ouvrages de M. Henri Labrouste.* Paris, 1878.

Delaborde 1884. Henri Delaborde. Foreword to *La Divine Comédie de Dante Alighieri, l'Enfer, Le Purgatoire et le Paradis. Recueil de cent onze compositions par A. v. Stürler.* Vol. 1. Paris, 1884.

Delaborde 1984. Henri Delaborde. *Ingres: Sa Vie, ses travaux, sa doctrine, notes et pensées de J. A. D. Ingres.* Brionne, 1984. Reprint of Delaborde 1870 without the catalogue and letters.

Delacroix 1850. Eugène Delacroix. "Le Dessin sans maître, par Mᵐᵉ Élisabeth Cavé." *Revue des deux mondes,* n.s., 7 (September 15, 1850), pp. 1139–46.

Delacroix 1923. Eugène Delacroix. *Oeuvres littéraires d'Eugène Delacroix.* Edited by Élie Faure. 2 vols. Paris, 1923.

Delacroix 1932. Eugène Delacroix. *Journal de Eugène Delacroix.* Edited by André Joubin. New ed. 3 vols. Paris, 1932.

Delacroix 1935–38. Eugène Delacroix. *Correspondance générale de Eugène Delacroix.* Edited by André Joubin. 5 vols. Paris, 1935–38.

Delacroix 1948. Eugène Delacroix. *The Journal of Eugène Delacroix.* Translated by Walter Pach. New York, 1948.

Delacroix 1960. Eugène Delacroix. *Journal de Eugène Delacroix.* Edited by André Joubin. 3 vols. Paris, 1960.

Delaire 1907. E[dmond Augustin] Delaire. *Les Architectes élèves de l'École des Beaux-Arts.* 2nd ed. Paris, 1907.

Delécluze, January 2, 1824. [Étienne-Jean] D[elécluze]. "Dix-neuvième Lettre à un Parisien sur l'Italie." *Journal des débats,* January 2, 1824. [The letter is datelined Florence, July 18, 1823.]

Delécluze, November 23, 1824. [Étienne-Jean] D[elécluze]. "Exposition du Louvre 1824." *Journal des débats,* November 23, 1824.

Delécluze, December 12, 1824. [Étienne-Jean] D[elécluze]. "Exposition du Louvre 1824." *Journal des débats,* December 12, 1824.

Delécluze, December 16, 1827. [Étienne-Jean] D[elécluze]. "Musée Charles X." *Journal des débats,* December 16, 1827.

Delécluze, December 23, 1827. [Étienne-Jean] D[elécluze]. "Salon de 1827." *Journal des débats,* December 23, 1827.

Delécluze, January 2, 1828. [Étienne-Jean] D[elécluze]. "Salon de 1827." *Journal des débats,* January 2, 1828.

Delécluze, March 3, 1833. [Étienne-Jean] D[elécluze]. "Salon de 1833." *Journal des débats,* March 3, 1833.

Delécluze, March 22, 1833. [Étienne-Jean] D[elécluze]. "Salon de 1833." *Journal des débats,* March 22, 1833.

Delécluze, January 28, 1846. [Étienne-Jean] Delécluze. "Exposition des ouvrages de peinture dans la galerie des beaux-arts, boulevard Bonne-Nouvelle, 22." *Journal des débats,* January 28, 1846.

Delécluze, January 15, 1852. Étienne-Jean Delécluze. *Journal des débats*, January 15, 1852.

Delécluze, December 8, 1854. É[tie]nne-J[ea]n Delécluze. *Journal des débats*, December 8, 1854.

Delécluze 1855. É[tienne]-J[ean] Delécluze. *Louis David, son école et son temps: Souvenirs*. Paris, 1855.

Delécluze, October 27, 1855. É[tie]nne-J[ea]n Delécluze. "Exposition universelle. Beaux-Arts." *Journal des débats*, October 27, 1855.

Delécluze, April 3, 1861. É[tie]nne-J[ea]n Delécluze. "Exposition de peinture d'artistes contemporains et loterie au profit de la Société des amis de l'enfance." *Journal des débats*, April 3, 1861.

Delécluze 1862. Étienne-Jean Delécluze. *Souvenirs de soixante années*. Paris, 1862.

Delécluze, April 17, 1862. É[tie]nne-J[ea]n Delécluze. "Jésus au milieu des docteurs, tableau de M. Ingres." *Journal des débats*, April 17, 1862.

Delécluze 1983. É[tienne] J[ean] Delécluze. *Louis David, son école et son temps: Souvenirs*. Reprint ed. with a new introduction, notes, and illustrations, by Jean-Pierre Mouilleseaux. Paris, 1983.

Delignières 1890. Emmanuel Delignières. "Notice sur des tableaux de Louis David et d'Ingres au Château de Moreuil en Picardie." *Réunion des Sociétés des beaux-arts des départements* 14 (1890), pp. 489–96.

Dell 1912. R[obert] E. D[ell]. "Art in France." *Burlington Magazine* 22 (March 1912), pp. 373–74.

Delpierre 1954. Madeleine Delpierre. "Les Amis de George Sand." *Bulletin du Musée Carnavalet* 7, no. 2 (December 1954), pp. 28–33.

Delpierre 1958. Madeleine Delpierre. "Les Costumes de cour et les uniformes civils du Premier Empire." *Bulletin du Musée Carnavalet* 11, no. 2 (November 1958), pp. 2–19.

Delpierre 1975. Madeleine Delpierre. "Ingres et la mode de son temps (d'après ses portraits dessinés)." *Bulletin du Musée Ingres*, no. 37 (July 1975), pp. 21–26.

Delpierre 1986. Madeleine Delpierre. "Ingres et la mode du châle cachemire d'après ses portraits féminins dessinés et peints." In *Actes du colloque: Ingres et Rome, Montauban, septembre 1986*, pp. 75–83. [Montauban, 1986.]

Delteil 1908. Loys Delteil. *Le Peintre-graveur illustré (XIXᵉ et XXᵉ siècles)*. Vol. 3, *Ingres et Delacroix*. Paris, 1908.

Delteil 1925. Loys Delteil. *Manuel de l'amateur d'estampes des XIXᵉ et XXᵉ siècles (1801–1924)*. 2 vols. Paris, 1925.

Denison and Mules 1981. Cara D. Denison and Helen B. Mules, comps., with Jane V. Shoaf. *European Drawings, 1375–1825*. New York, 1981.

Desains 1833. [Charles Desains]. *Annales du Musée et de l'école moderne des beaux-arts . . . Salon de 1833*. Paris, 1833.

Desazars de Montgailhard 1924. [Marie Louis] Desazars de Montgailhard. *Les Artistes toulousains et l'art à Toulouse au XIXᵉ siècle*. Part 1. Toulouse, 1924.

Deslandres 1967. Yvonne Deslandres. "Ingres." *Jardin des arts*, no. 155 (October 1967), pp. 20–35.

Dessins de Jean-Dominique Ingres 1926. Un *Choix de dessins de Jean-Dominique Ingres*. Dessins et peintures des maîtres du XIXᵉ siècle à nos jours, 2nd ser., vol. 1. Paris, 1926.

Dessins de Jean-Dominique Ingres 1930. Un *Choix de dessins de Jean-Dominique Ingres*. 2nd ed. Dessins et peintures des maîtres du XIXᵉ siècle à nos jours, vol. 1. Paris, 1930.

Dessins du Musée du Louvre n.d. *Dessins du Musée du Louvre, sixième série, école française*. Florence, n.d.

Detroit 1950a. *French Painting from David to Courbet*. Detroit Institute of Arts, February 1–March 5, 1950. Exh. cat. Detroit, 1950.

Detroit 1950b. *Loan Exhibition of Old Master Drawings from Midwestern Museums*. Detroit Institute of Arts, June 1–September 15, 1950. Exh. cat. Detroit, 1950.

Detroit 1951. *French Drawings of Five Centuries from the Collection of the Fogg Museum of Art, Harvard University*. Detroit Institute of Arts, May 15–September 30, 1951. Exh. cat. Detroit, 1951.

Dictionary of National Biography. *Dictionary of National Biography*. Vols. 1–22, edited by Leslie Stephen [and Sidney Lee]. London, 1885–1901. Reprinted 1921–22; 1937–38. Vol. 23 (*The Dictionary of National Biography . . . Supplement, January 1901 –December 1911*), edited by Sidney Lee, London, 1912; reprinted 1920, 1927, 1939. Vol. 24 (*The Dictionary of National Biography . . . 1912–1921*), edited by H. W. C. Davis and J. R. H. Weaver, London, 1927; reprinted 1938.

Dictionnaire de biographie française. *Dictionnaire de biographie française*. Vols. 1– . Edited by J. Balteau, M. Barroux, and M. Prevost. Paris, 1933–.

Diehl 1950. Gaston Diehl. *Le Dessin en France au XIXᵉ siècle*. Paris, 1950.

Dodgson 1935. Campbell Dodgson. "Quarterly Notes." *Print Collector's Quarterly* 22, no. 4 (October 1935), pp. 280–81.

Dollfus 1909. Max Dollfus. *Histoire et généalogie de la famille Dollfus de Mulhouse, 1450–1908*. Mulhouse, 1909.

Doucet 1906. Jérôme Doucet. *Les Peintres français*. Paris, [1906].

Doudan 1876–77. Ximénès Doudan. *Mélanges et lettres*. 4 vols. Paris, 1876–77.

Dresden 1904. *Offizieller Katalog der grossen Kunstaustellung*. Dresden, May 1–October 1904. Exh. cat. Dresden, 1904.

Dreyfus 1912. Albert Dreyfus. "Jean Auguste Dominique Ingres." *Die Kunst* 25 (1912), pp. 125–47

Druilhe 1949. Paul Druilhe. *Histoire de la musique*. Paris, 1949.

Du Camp 1855. Maxime Du Camp. *Les Beaux-Arts à l'Exposition universelle de 1855*. Paris, 1855.

Ducis 1879. J[ean]-F[rançois] Ducis. *Lettres de Jean-François Ducis*. Edited by Paul Albert. Paris, 1879.

Duleep Singh 1928. Frederick Duleep Singh. *Portraits in Norfolk Houses*. 2 vols. Norwich, 1928.

Dulong n.d. Louis-Étienne Dulong, comte de Rosnay. *Précis de la vie militaire de Mʳ Louis-Étienne Dulong, comte de Rosnay*. Bastia, n.d.

Duluth 1956. Exhibition. Duluth, University of Minnesota, Tweed Gallery, January 1–31, 1956.

Dumas 1852. Alexandre Dumas. *Mes Mémoires*. Vol. 12. Brussels and Paris, 1852.

Dumas 1908. F[rançois] G[uillaume] Dumas. *The Franco-British Exhibition, Illustrated Review, 1908*. London, [1908].

Duncan 1978. Carol Duncan. "Ingres's *Vow of Louis XIII* and the Politics of the Restoration." In *Art and Architecture in the Service of Politics*, pp. 80–91. Cambridge, Mass., and London, 1978.

Du Pays 1855. A.-J. Du Pays. "Exposition universelle des beaux-arts. M. Ingres." *L'Illustration* 25 (June 30, 1855), pp. 419–22.

Duplessis 1870. Georges Duplessis. "Le Cabinet du M. Gatteaux." *Gazette des beaux-arts*, 2nd ser., 4 (October 1, 1870), pp. 338–54.

Duplessis 1876. Georges Duplessis. "La Collection de M. Camille Marcille." *Gazette des beaux-arts*, 2nd ser., 13 (March 1876), pp. 419–39.

Duplessis 1881. Georges Duplessis. "Une Lithographie inconnue de J.-A.-D. Ingres." *Gazette des beaux-arts*, 2nd ser., 24 (September 1, 1881), pp. 273–75.

Duplessis 1896. Georges Duplessis. *Les Portraits dessinés [par J.-A.-D. Ingres]*. Paris, 1896.

Dupouy 1969. Pierre Dupouy. "Ingres et Baudelaire." In *Colloque Ingres [1967]*, pp. 41–46. [Montauban, 1969.]

Durbé and Roger-Marx 1967. Dario Durbé and Claude Roger-Marx. *Ingres*. Paris, 1967.

Duret 1867. Théodore Duret. *Les Peintres français en 1867*. Paris, 1867.

Du Seigneur 1888. Maurice Du Seigneur. "L'Art d'être artiste chez soi. IV.—Rêves d'artistes." *La Construction moderne*, April 21, 1888, pp. 326–28.

Duval 1855. Ch[arles]-L. Duval. "Beaux-Arts. École française." *Le Globe industriel et artistique*, October 28, 1855, pp. 414–15.

Duval 1856. Ch[arles]-L. Duval. *Exposition universelle de 1855: L'École française au Palais Montaigne*. Paris, 1856.

Edinburgh 1995. *The Three Graces: Antonio Canova*. Edinburgh, National Gallery of Scotland, August 9–October 8, 1995. Exh. cat. by Timothy Clifford et al. Edinburgh, 1995.

Edinburgh, London 1961. *Masterpieces of French Painting from the Bührle Collection*. Edinburgh, International Festival, August 19–September 17, 1961; London, National Gallery, September 29–November 5. Exh. cat. London, 1961.

Eisendrath 1953. William M. Eisendrath. "A Drawing by Ingres." *Bulletin of the City Art Museum of St. Louis* 38, no. 2 (1953), pp. 14–16.

Eisler 1977. Colin Eisler. *Paintings from the Samuel H. Kress Collection*. Vol. 4, *European Schools, Excluding Italian*. London, 1977.

Eisler 1990. Colin Eisler. *Paintings in the Hermitage*. New York, 1990.

Eitner 1987–88. Lorenz Eitner. *An Outline of Nineteenth Century European Painting: From David through Cézanne*. 2 vols. New York, 1987–88.

Eitner 1996. Lorenz Eitner. "French Paintings, 1800–1860." Typescript, 1996, Department of Curatorial Records and Files, Washington, D.C., National Gallery of Art.

Eitner forthcoming. Lorenz Eitner. *French Paintings, 1800–1860*. Forthcoming volume of the Systematic Catalogue of the Collections of the National Gallery of Art. Washington, D.C., n.d.

Elgar 1951. Frank Elgar. *Ingres*. Paris, 1951.

Énault, May 25, 1855. Louis Énault. "Palais des beaux-arts." *La Presse littéraire*, 2nd ser., 3 (May 25, 1855), p. 418.

Encyclopaedia universalis 1970. *Encyclopaedia universalis*. Vol. 8. Paris, 1970.

Encyclopédie de la musique 1958–61. *Encyclopédie de la musique*. Edited by François Michel, François Lesure, and Vladimir Fedorov. 3 vols. Paris, 1958–61.

Engel 1936. Hans Engel. *Franz Liszt*. Potsdam, 1936.

Escholier 1929. Raymond Escholier. *Delacroix: Peintre, graveur, écrivain*. Vol. 3. Paris, 1929.

Escholier 1943. Raymond Escholier. *La Peinture française au XIXᵉ siècle*. Vol. 2, *Ingres, Delacroix, Daumier, Corot*. Paris, 1943.

Étex 1856. Antoine Étex. *Essai d'une revue synthétique sur l'Exposition universelle de 1855*. Paris, 1856.

Étex 1878. Antoine Étex. *Les Souvenirs d'un artiste*. Paris, 1878.

Ewals 1980. Léo Ewals. "Les Peintures murales de l'église de Saint-Vincent-de-Paul: L'Histoire d'une commande." *Bulletin du Musée Ingres*, no. 45 (July 1980), pp. 35–43.

Ewals 1984. Léo Ewals. "Ingres et la réception de l'art français en Hollande." *Bulletin du Musée Ingres*, nos. 53–54 (December 1984), pp. 34–36.

Eyriès 1860. Gustave Eyriès. *Simart statuaire, membre de l'Institut: Étude sur sa vie et sur son oeuvre*. Mémoires de la Société d'agriculture, des sciences, arts, et belles-lettres du Département de l'Aube, 2nd ser., 11, nos. 53–56. Troyes, [1860].

Fabre 1806. [Victorin] Fab[re]. "Salon de l'an 1806." *La Revue philosophique, littéraire et politique* 51 (1806), pp. 217–28.

Faison 1958. S[amson] Lane Faison Jr. *A Guide to the Art Museums of New England.* New York, 1958.

"Familienbuch der Stürler" n.d. "Familienbuch der Stürler." Manuscript, n.d., Stadtbibliothek Bern. Mss. Hist. Helv., XXXII, A 17.

Farcy 1828. [Charles] F[arcy]. "Examen du Salon de 1827." *Journal des artistes,* February 3, 1828, pp. 65–68.

Farcy 1833. [Charles-François] F[arcy]. "Exposition au Louvre." *Journal des artistes,* March 17, 1833, pp. 169–76.

Farcy 1834. Charles F[arcy]. "Françoise de Rimini et M. Molé, par M. Ingres." *Journal des artistes,* November 9, 1834, pp. 297–99.

Feilchenfeldt 1972. Marianne Feilchenfeldt. *25 Jahre Feilchenfeldt in Zürich, 1948–1973.* [Zurich, 1972.]

Feinblatt 1969. Ebria Feinblatt. "An Ingres Drawing for Los Angeles." *Connoisseur* 170 (April 1969), pp. 262–65.

Feydeau 1858. Ernest Feydeau. "Voyage à travers les collections particulières de Paris. Collection de M. Adolphe Moreau." *L'Artiste,* 7th ser., 3 (May 2, 1858), pp. 293–98.

Fierro 1996. Alfred Fierro. *Histoire et dictionnaire de Paris.* Paris, 1996.

Finberg 1910. Alexander Joseph Finberg. *Ingres.* London and New York, 1910.

Fischel and Boehn 1925a. Oskar Fischel and Max von Boehn. *Die Mode: Menschen und Moden im neunzehnten Jahrhundert.* Vol. 1, *1790–1817.* 4th ed. Munich, 1925.

Fischel and Boehn 1925b. Oskar Fischel and Max von Boehn. *Die Mode: Menschen und Moden im neunzehnten Jahrhundert.* Vols. 2, *1818–1842,* 3, *1843–1878.* 5th ed. Munich, 1925.

Fitzsimmons 1953. James Fitzsimmons. "Benefit for Private Education." *Art Digest* 27, no. 13 (April 1, 1953), p. 14.

Flameng sale 1919. *Collection François Flameng.* Sale cat., Paris, Galerie Georges Petit, May 26–27, 1919.

Flandrin 1902. Louis Flandrin. *Hippolyte Flandrin: Sa Vie et son oeuvre.* Paris, 1902.

Flandrin 1911. Louis Flandrin. "Deux Disciples d'Ingres: Paul et Raymond Balze." *Gazette des beaux-arts,* 4th ser., 6 (August 1911), pp. 139–55; (October 1911), pp. 317–32.

Flâneur 1806. *Le Flâneur au Salon, ou Mᵣ Bonhomme: Examen joyeux des tableaux mêlé des vaudevilles.* Paris, [1806].

Fleckner 1995. Uwe Fleckner. *Abbild und Abstraktion: Die Kunst des Porträts im Werk von Jean-Auguste-Dominique Ingres.* Mainz, 1995.

Fleming 1973. John Fleming. "Art Dealing and the Risorgimento, I." *Burlington Magazine* 115 (January 1973), pp. 4–16.

Flint 1992. *The Art of Drawing: Old Masters from the Crocker Art Museum, Sacramento, California.* Flint Institute of Arts, June 2–August 2, 1992. Exh. cat. by Jeffrey Ruda. Flint, Mich., 1992.

Florence 1963. *Mostra documentaria e iconografica dell'Accademia delle Arti del Disegno. Catalogo.* Florence, Archivio di Stato, February 3–March 13, 1963. Exh. cat. Florence, 1963.

Florence 1968. *Ingres e Firenze, con una sezione dedicata agli artisti toscani contemporanei di Ingres.* Florence, Orsanmichele, July 13–August 20, 1968. Exh. cat. by Anna Maria Ciaranfi; introduction by Mathieu Méras. Florence, 1968.

Florence 1977. *Pittura francese nelle collezioni pubbliche fiorentine.* Florence, Palazzo Pitti, April 24–June 30, 1977. Exh. cat. Florence, 1977.

Florence, Galleria degli Uffizi 1979. Galleria degli Uffizi. *Gli Uffizi: Catalogo generale.* Florence, 1979.

Florisoone 1969. Michel Florisoone. "Ingres introducteur de l'art moderne." In *Colloque Ingres [1967],* pp. 53–55. [Montauban, 1969.]

Fontainas and Vauxcelles 1922. André Fontainas and Louis Vauxcelles. *Histoire générale de l'art français de la Révolution à nos jours.* 3 vols. Paris, 1922.

Fontana 1812. Fontana. *Choix de gravures à l'eauforte, d'après les peintures originales et les marbres de la galerie de Lucien Bonaparte.* London, n.d. [1812].

Ford 1939. Brinsley Ford. "Ingres' Portrait Drawings of English People at Rome, 1806–1820." *Burlington Magazine* 75 (July 1939), pp. 3–13.

Ford 1953. Brinsley Ford. "Ingres' Portraits of the Reiset Family." *Burlington Magazine* 95 (November 1953), pp. 356–59.

Ford 1957. Brinsley Ford. "British Portraits." *Antiques* 71 (May 1957), pp. 443–47.

Forestié 1886. [Louis Édouard] Forestié. *Jean Marie Joseph Ingres père, peintre et sculpteur.* Montauban, 1886.

Formes et couleurs 1946. *Formes et couleurs* 8, no. 4–5 (1946).

Forrer 1902–30. L[eonard] Forrer, comp. *Biographical Dictionary of Medallists; Coin, Gem, and Seal-Engravers, Mint-Masters, &c. . . .* 8 vols. London, 1902–30.

Fort Worth 1953. "An Exhibition of Old Masters." Fort Worth Art Center, January 20–February 6, 1953. Exh. cat. Fort Worth, 1953.

Foucart 1971. Bruno Foucart. "Victor Mottez et les fresques du Salon Bertin." *Bulletin de la Société de l'histoire de l'art français,* 1969 (1971), pp. 153–73.

Foucart 1982. Jacques Foucart. "L'Ingrisme en France et dans le monde en 1981 et 1982." *Bulletin du Musée Ingres,* nos. 49–50 (December 1982), pp. 71–98.

Foucart 1983. Jacques Foucart. "Ingres et l'ingrisme dans le monde en 1980 et 1981." *Bulletin du Musée Ingres,* nos. 51–52 (December 1983), pp. 77–98.

Foucart 1987. Bruno Foucart. *Le Renouveau de la peinture religieuse en France, 1800–1860.* Paris, 1987.

Foucart-Borville 1972. Jacques Foucart-Borville. "Deux Lettres inédites d'Ingres." *Bulletin du Musée Ingres,* no. 32 (December 1972), pp. 21–26.

Fouché 1908. Jean-Louis Fouché. "L'Opinion d'Ingres sur le Salon. Procès-Verbaux de la Commission permanente des beaux-arts (1818–1849)." *La Chronique des arts et de la curiosité,* March 14, 1908, pp. 98–99, and April 4, 1908, pp. 129–30.

Fouquet 1930. Jacques Fouquet. *La Vie d'Ingres.* Paris, 1930.

Fourcaud 1884. L. de Fourcaud. "Salon de 1884." *Gazette des beaux-arts,* 2nd ser., 29 (May 1884), pp. 377–90.

Francis 1932. H[enry] S. F[rancis]. "Drawings in the Classic and Romantic Tradition before 1830." *Bulletin of the Cleveland Museum of Art* 19 (December 1932), pp. 166–69.

Francis 1948. Henry S. Francis. "Two Graphic Portraits by Ingres." *Bulletin of the Cleveland Museum of Art* 35 (March 1948), pp. 34, 36–37.

Frankfurt 1967. *Erwerbungen des Kupferstichkabinetts, 1946–1966: Auswahl.* Frankfurt am Main, Städelsches Kunstinstitut, 1967. Exh. cat. Frankfurt am Main, 1967.

Frankfurt 1977. *Französische Zeichnungen aus dem Art Institute of Chicago.* Frankfurt am Main, Städelsches Kunstinstitut, February 10–April 10, 1977. Exh. cat. Frankfurt am Main, 1977.

Frankfurter 1931. Alfred M. Frankfurter. "Thirty-five Portraits from American Collections." *Art News* 29, no. 33 (May 16, 1931), pp. 3–4.

Frankfurter 1940. Alfred M. Frankfurter. "Master Paintings and Drawings of Six Centuries at the Golden Gate." *Art News* 38, no. 38 (July 13, 1940), pp. 7–14, 25.

Frankfurter 1946. Alfred M. Frankfurter. *Supplement to the Kress Collection in the National Gallery.* New York, 1946.

Frankfurter 1951. Alfred M. Frankfurter. "Washington: Celebration, Evaluation." *Art News* 50, no. 2 (April 1951), pp. 26–35, 62–63.

Frémy, October 23, 1855. Arnould Frémy. "M. Prodhomme à l'Exposition. La Peinture française." *Le Charivari,* October 23, 1855.

French Art 1932. *French Art: An Illustrated Souvenir of the Exhibition of French Art at the Royal Academy of Arts.* London, 1932.

French Art 1933. *Commemorative Catalogue of the Exhibition of French Art, 1200–1900, London, January–March 1932.* London, 1933.

French Painting 1990. *Five Hundred Years of French Painting: The Hermitage, Leningrad, the Pushkin Museum of Fine Arts, Moscow.* [Vol. 2], *19th and 20th Centuries.* Translated by Yuri Pamfilov. Saint Petersburg (then Leningrad), 1990.

Frerichs 1963. L. C. J. Frerichs. *Keuze van tekeningen bewaard in het Rijksprentenkabinet, Rijksmuseum, Amsterdam.* Amsterdam, 1963.

Friedlaender 1952. Walter Friedlaender. *David to Delacroix.* Translated by Robert Goldwater. Cambridge, Mass., 1952.

Friedländer 1922. Max J. Friedländer. *Die Lithographie.* Berlin, 1922.

Fröhlich-Bum 1924. L[ili] Fröhlich-Bum. *Ingres: Sein Leben und sein Stil.* Vienna and Leipzig, 1924.

Fröhlich-Bum 1926. L[ili] Fröhlich-Bum. *Ingres: His Life and Art.* Translated by Maude Valerie White. London, 1926.

Froidevaux-Flandrin 1984. Madeleine Froidevaux-Flandrin. *Les Frères Flandrin, trois jeunes peintres au XIXᵉ siècle: Leur Correspondance, le journal inédit d'Hippolyte Flandrin en Italie.* [France], 1984.

Fuchs 1944. Max Fuchs. *Lexique des troupes de comédiens au XVIIIᵉ siècle.* Paris, 1944.

Gabet 1831. Charles Gabet. *Dictionnaire des artistes de l'école française au XIXᵉ siècle.* Paris, 1831.

Gaborit-Chopin 1973. Danielle Gaborit-Chopin. "Faux Ivoires des collections publiques." *Revue de l'art* 21 (1973), pp. 94–101.

Gaier 1980. Claude Gaier. "Le 'Napoléon' d'Ingres au Musée d'Armes." *Le Musée d'Armes* 27 (1980), pp. 1–5.

Gaigneron 1981. Axelle de Gaigneron. "Les Nouveaux Choix de Mᵣ Woodner." *Connaissance des arts,* no. 348 (February 1981), pp. 74–79.

Galbacio, March 11, 1833. Bruno Galbacio. "Exposition de beaux-arts dans les galeries du Louvre." *L'Estafette,* March 11, 1833.

Galichon 1861a. Émile Galichon. "Description des dessins de M. Ingres exposé au Salon des Arts-Unis." *Gazette des beaux-arts* 9 (March 15, 1861), pp. 343–62.

Galichon 1861b. Émile Galichon. "[Description des] Dessins de M. Ingres [exposés au Salon des Arts-Unis], deuxième série." *Gazette des beaux-arts* 11 (July 1, 1861), pp. 38–48.

Galichon 1862. Émile Galichon. "Le Nouveau Tableau de M. Ingres." *Gazette des beaux-arts* 12 (May 1, 1862), pp. 487–88.

Galimard 1852. Auguste Galimard. "Un Portrait par M. Ingres." *Revue des beaux-arts* 3, no. 4 (February 15, 1852), pp. 49–50.

Galimard, February 28, 1852. [Auguste Galimard]. "Promenade à travers les monuments de Paris." *Le Théâtre,* February 28, 1852.

Gallery Events 1969. *Gallery Events,* October 1969. Kansas City: Nelson Gallery and Atkins Museum.

Garric 1993. Jean-Michel Garric. *Le Musée Ingres de Montauban.* [Montauban], 1993.

Garrisson 1965. Robert Garrisson. "Ingres vu par X. Doudan (1842–1850)." *Bulletin du Musée Ingres,* no. 17 (July 1965), pp. 9–11.

Garrisson 1966. Robert Garrisson. "Notes de lecture, A. Barbier, M. Ingres, et Louis-César-Joseph Ducornet." *Bulletin du Musée Ingres,* no. 19 (July 1966), pp. 17–22.

Gasser 1943. M[anuel] G[asser]. "J. A. D. Ingres als Zeichner." *Annabelle* (Zurich), December 1943, p. 30.

Gastinel-Coural 1990. Chantal Gastinel-Coural. "Les Fonds de portraits d'Ingres: À propos du portrait du duc d'Orléans par Ingres." *Bulletin du Musée Ingres,* nos. 63–64 (1990), pp. 25–27.

Gatteaux 1873 (1st ser.). Édouard Gatteaux. *Collection de 120 dessins, croquis et peintures de M. Ingres classés et mis en ordre par son ami Édouard Gateaux [sic].* 1st ser. Paris, n.d. [1873?]

Gatteaux 1873 (2nd ser.). Édouard Gatteaux. *Dessins, croquis et peintures de M. Ingres de la collection de Édouard Gatteaux, du Musée National du Louvre et l'École des Beaux-Arts à Paris.* 2nd ser. Paris, n.d. [1873?].

Gatteaux 1875. Édouard Gatteaux. *Collection de 120 dessins, croquis et peintures de M. Ingres, classés et mis en ordre par son ami Édouard Gatteaux, reproduits en photographie par Ch. Marville, photographe des Musées Nationaux,* I. Paris, 1875.

Gatti 1946. Lelio Gatti. *Ingres: L'idealista della forma.* Milan, 1946.

Gault de Saint-Germain 1819. Pierre-Marie Gault de Saint-Germain. *Choix des productions de l'art les plus remarquables exposées dans le Salon de 1819.* Paris, 1819.

Gautier 1833. Théophile Gautier. "Salon de 1833." *La France littéraire* 6 (1833), pp. 139–66.

Gautier, June 27, 1847. Théophile Gautier. "Une Visite à M. Ingres." *La Presse,* June 27, 1847.

Gautier, August 2, 1848. Théophile Gautier. "L'Atelier de M. Ingres en 1848." *L'Événement,* August 2, 1848. Reprinted in Gautier 1880, pp. 241–50.

Gautier 1855. Théophile Gautier. *Les Beaux-Arts en Europe.* Vol. 1. Paris, 1855. Includes a reprint of his "L'Exposition universelle de 1855," *Le Moniteur universel,* July 12, 14, 1855.

Gautier 1857. Théophile Gautier. "Ingres." *L'Artiste,* April 5, 1857, pp. 5–6.

Gautier, February 18, 1861. Théophile Gautier. "Exposition du Boulevard Italien: La Source, tableau de M. Ingres." *Le Moniteur universel,* February 18, 1861.

Gautier 1880. Théophile Gautier. *Fusains et eaux-fortes.* Paris, 1880.

Gazette des beaux-arts **1885.** *Gazette des beaux-arts,* 2nd ser., 32 (September 1, 1885).

La Gazette de l'Hôtel Drouot **1984.** *La Gazette de l'Hôtel Drouot,* September 28, 1984.

Gebauër 1855. Ernest Gebauër. *Les Beaux-Arts à l'Exposition universelle de 1855.* Paris, 1855.

Geelhaar 1975a. Christian Geelhaar. "Un Petit Portrait de Liszt." *Neue Zürcher Zeitung,* April 5–6, 1975, p. 37.

Geelhaar 1975b. Christian Geelhaar. "Un Petit Portrait de Liszt." *Berner kunstmitteilungen,* March–April, 1975.

H. E. van Gelder 1950. H. E. van Gelder. "Ingres en de familie Taurel." *Maandblad voor beeldende Kunsten* 26 (January 1950), pp. 2–10.

J. G. van Gelder 1950. J. G. van Gelder. "Van Fouquet tot Cézanne in het Museum Boymans." *Maandblad voor beeldende kunsten* 26 (February 1950), pp. 27–35.

Geller 1952. Hans Geller. *Die Bildnisse der deutschen Künstler in Rom, 1800–1830.* Berlin, 1952.

Geneva 1951. *De Watteau à Cézanne.* Geneva, Musée d'Art et d'Histoire, July 7–September 30, 1951. Exh. cat. Geneva, 1951.

Geneva 1954. *Trésors des collections romandes (écoles étrangères).* Geneva, Musée Rath, June 26–October 3, 1954. Exh. cat. by Marcel Grandjean. Geneva, 1954.

Geneva 1963. "Centenaire du Palais de l'Athénée." Geneva, 1963.

Gentleman's Magazine **1858.** *The Gentleman's Magazine,* July–December 1858.

Geofroy 1848. L[ouis] G[eofroy]. "Beaux-Arts. Vénus Anadyomène.—Portrait de M^me de Rothschild, par M. Ingres." *Revue des deux mondes,* n.s., 23 (August 1, 1848), pp. 441–49.

Gérard 1867. François-Pascal-Simon Gérard. *Correspondance de François Gérard, peintre d'histoire, avec les artistes et les personnages célèbres de son temps.* . . . Edited by Henri Alexandre Gérard. Paris, 1867.

Gere 1972. Charlotte Gere. *Victorian Jewelry Design.* Chicago, 1972.

Gernoux 1931. Alfred Gernoux. *M^me de Senonnes.* Châteaubriant, 1931.

Getty Museum Journal **1990.** *The J. Paul Getty Museum Journal* 18 (1990), *Acquisitions/1989.*

Getty Museum Journal **1992.** *The J. Paul Getty Museum Journal* 20 (1992), *Acquisitions/1991.*

Giard 1934. René Giard. *Le Peintre Victor Mottez d'après sa correspondance.* Lille, 1934.

Gibert 1862. Honoré Gibert. *Catalogue du Musée d'Aix.* Aix, 1862.

Gide 1905. André Gide. "Promenade au Salon d'automne." *Gazette des beaux-arts,* 3rd ser., 34 (December 1, 1905), pp. 475–85.

Gigoux 1885. Jean[-François] Gigoux. *Causeries sur les artistes de mon temps.* Paris, 1885.

Gilles 1969. Linda Boyer Gilles. "European Drawings in the Havemeyer Collection." *Connoisseur* 172 (November 1969), pp. 148–55.

Gillet 1932. Louis Gillet. "Trésors des Musées de province." *Revue des deux mondes,* September 15, 1932.

Gimpel 1963. René Gimpel. *Journal d'un collectionneur, marchand de tableaux.* Paris, 1963.

Glenbervie 1910. Sylvester Douglas Glenbervie. *The Glenbervie Journals.* Edited by Walter Sichel. London, 1910.

Goessler 1930. Peter Goessler. "Jakob Linckh, ein württembergischer Italienfahrer, Philhellene, Kunstsammler, und Maler." *Besondere Beilage des Staats-Anzeigers für Württemberg* 3 (March 31, 1930).

Golden 1986. Catherine Golden. "Composition: Writing and the Visual Arts." *Journal of Aesthetic Education* 20, no. 3 (fall 1986), pp. 59–68.

Goldner 1988. George R. Goldner, with Lee Hendrix and Gloria Williams. *European Drawings, I. Catalogue of the Collections: The J. Paul Getty Museum.* Malibu, 1988.

Goldwater 1940. Robert J. Goldwater. "David and Ingres." *Art in America* 28 (April 1940), pp. 83–84.

Goncourt 1893. Edmond and Jules de Goncourt. *Études d'art: Le Salon de 1852. La Peinture à l'Exposition de 1855.* Paris, 1893.

Goncourt 1956. Edmond and Jules de Goncourt. *Journal: Mémoires de la vie littéraire.* 4 vols. Paris, 1956.

Goncourt 1956–58. Edmond and Jules de Goncourt. *Journal: Mémoires de la vie littéraire.* 22 vols. Monaco, 1956–58.

Gonse 1900. Louis Gonse. *Les Chefs-d'Oeuvre des Musées de France: La Peinture.* Paris, 1900.

Gonse 1904. Louis Gonse. *Chefs-d'Oeuvre des Musées de France: Sculpture, dessins, objets d'art.* Paris, 1904.

Göpel 1965. Erhard Göpel. "Auktionen." *Die Weltkunst,* November 1, 1965, p. 1038.

Gori 1759. Antonio Francesco Gori. *Thesaurus Veterum Diptychorum Consularium et Ecclesias Ticorum.* . . . 3 vols. Florence, 1759.

Gould 1965. Cecil Gould. *Trophy of Conquest: The Musée Napoléon and the Creation of the Louvre.* London, 1965.

Goulinat 1928. J[ean]-G[abriel] Goulinat. "Ingres et la couleur." *L'Art et les artistes,* n.s., 15, no. 83 (January 1928), pp. 109–13.

Gounod 1896. Charles Gounod. *Mémoires d'un artiste.* 5th ed. Paris, 1896.

Goya bis Beckmann **n.d.** *Goya bis Beckmann.* New York, n.d.

Gräff 1913. Walter Gräff. "Die Einführung der Lithographie in Italien." *Zeitschrift für Bücherfreunde* 4 (February 1913), pp. 324–34.

Granville 1894. Harriet Elizabeth Cavendish Leveson-Gower, Countess Granville. *Letters of Harriet, Countess Granville, 1810–1845.* Edited by the Hon. F. Leveson-Gower. 2 vols. London, 1894.

Granville 1916. Lord Granville Leveson-Gower (first Earl Granville). *Private Correspondence, 1781 to 1821.* Edited by Castalia, Countess Granville. 2 vols. London, 1916.

Greville 1903. Charles C. F. Greville. *The Greville Memoires: A Journal of the Reigns of King George IV., King William IV. and Queen Victoria.* Edited by Henry Reeve. New ed. London, 1903.

Grosse Point Farms 1941. "Masterpieces of the 19th and 20th Century French Drawing from the Fogg Museum of Art at Harvard University and the Museum of Modern Art of New York City." Grosse Point Farms, Mich., Alger House Museum, 1941.

Grunchec 1983. Philippe Grunchec. *Les Concours des Prix de Rome de 1797 à 1863.* Paris, 1983.

Gruyer 1900. François-Anatole Gruyer. *Chantilly: Notice des peintures. École française.* Paris, 1900.

Gruyer 1902. Gustave Gruyer. *Musée de Bayonne: Collection Bonnat.* Bayonne, 1902.

Guerber 1927. Louise Guerber. "Three Portraits by Ingres." *Bulletin of The Metropolitan Museum of Art* 22 (August 1927), p. 215.

Guiffrey 1880–81. Jules Guiffrey. "Lettre sur la Vierge à l'Hostie et le portrait de Cherubini par Ingres 1840." *Nouvelles Archives de l'art français,* 2nd ser., 2 (1880–81), pp. 353–58.

Guiffrey 1923. Jean Guiffrey. "Le Musée Bonnat à Bayonne." *Beaux-Arts,* August 1, 1923, pp. 209–24.

Guiffrey 1923a. Jean Guiffrey. "Un Nouveau Portrait d'Ingres au Musée du Louvre." *Beaux-Arts,* March 15, 1923, p. 71.

Guiffrey and Marcel 1911. Jean Guiffrey and Pierre Marcel. *Inventaire général des dessins du Musée du Louvre et du Musée de Versailles.* Vol. 6. Paris, 1911.

Guillaume 1937. Germaine Guillaume. "Merry-Joseph Blondel et son ami Ingres." *Bulletin de la Société de l'histoire de l'art français,* 1936 (1937), pp. 74–91.

Guyot de Fère 1836. [François-Fortuné] Guyot de Fère. *Annuaire statistique des artistes français.* Paris, 1836.

Guyot de Fère 1855. [François-Fortuné] Guyot de Fère. "Beaux-Arts." *Journal des arts, des sciences et des lettres et de l'Exposition universelle,* no. 6 (July 6, 1855), pp. 67–69.

Haarlem 1931. *Kind en kunst.* Haarlem, Frans Halsmuseum, November 3–30, 1931. Exh. cat. Haarlem, 1931.

Haberling, Hübotter, and Vierordt 1932. W[ilhelm] Haberling, F. Hübotter, and H[ermann] Vierordt. *Biographisches Lexikon der hervorragenden Ärzte aller Zeiten und Völker.* Vol. 4. Berlin and Vienna, 1932.

Hale 1964. Robert Beverly Hale. *Drawing Lessons from the Great Masters.* New York, 1964.

Halévy 1841. Fromental Halévy. "Ingres chez Cherubini." *Revue et gazette musicale de Paris,* July 25, 1841.

Halévy 1960. Daniel Halévy. *Degas parle. . . .* Paris, 1960.

Hamburg, Bremen 1961. *Ingres-Zeichnungen aus dem Ingres-Museum in Montauban.* Hamburg, Kunsthalle, July–August 1961; Bremen, Kunsthalle. Exh. cat. Hamburg, 1961.

Hamburg, Cologne, Stuttgart 1958. *Französische Zeichnungen von den Anfängen bis zum Ende des 19. Jahrhunderts.* Hamburg, Kunsthalle, February 1–March 16, 1958; Cologne, Wallraf-Richartz-Museum, March 22–May 5; Stuttgart, Württembergischer Kunstverein, May 10–June 7. Exh. cat. [Hamburg], 1958.

Hammer 1968. Karl Hammer. *Jakob Ignaz Hittorff, ein Pariser Baumeister, 1792–1867.* Stuttgart, 1968.

Haraszti 1967. Emil Haraszti. *Franz Liszt.* Paris, 1967.

Hardouin-Fugier 1985. Elisabeth Hardouin-Fugier. "Monsieur Ingres vu par Louis Lacuria, 1832–1838." *Bulletin du Musée Ingres,* nos. 55–56 (December 1985), pp. 39–55.

Hartford 1934. "Loans in Honor of the Opening of the Avery Memorial, Nineteenth Century French Painting." Hartford, Conn., Wadsworth Atheneum, 1934. Exh. cat., *The Collections in the Avery Memorial.* Hartford, 1934.

Hatin 1859–61. Louis Eugène Hatin. *Histoire politique et littéraire de la presse en France.* 8 vols. Paris, 1859–61.

Hattis 1967. Phyllis Hattis. "Le Portrait de M^me Delphine Ingres 1855." *Bulletin du Musée Ingres,* no. 20 (December 1966; [pub. February 1967]), pp. 7–18.

Hattis 1971. Phyllis Hattis. "Ingres in Rome." *Art News* 70, no. 3 (May 1971), pp. 26–29, 75–77.

Hauptman 1977. William Hauptman. "Ingres and Photographic Vision." *History of Photography* 1 (April 1977), pp. 117–28.

Hauréau, March 20, 1833. [Jean-Barthélemy Hauréau]. "Revue des arts—Salon." *La Tribune politique et littéraire,* March 20, 1833.

Hauréau, March 15, 1834. [Jean-B[arthélemy] H[auréau]. "Salon de 1834." *La Tribune politique et littéraire,* March 15, 1834.

Haussonville 1874. Louise-Albertine de Broglie, vicomtesse d'Haussonville. *Les Dernières Années de Lord Byron.* Paris, 1874.

Hautecoeur 1913. Louis Hautecoeur. "Ingres et les artistes français à la Trinité des Monts." *Revue des études napoléoniennes* 2, no. 1 (January–June 1913), p. 273.

Havemeyer Collection 1931. *H. O. Havemeyer Collection: Catalogue of Paintings, Prints, Sculpture, and Objects of Art.* New York: The Metropolitan Museum of Art, 1931.

Havemeyer Collection 1958. *The H. O. Havemeyer Collection.* 2nd ed. New York: The Metropolitan Museum of Art, 1958.

Haverkamp-Begemann 1957. E[gbert] Haverkamp-Begemann. *Vijf eeuwen tekenkunst: Tekeningen van Europese meesters in het Museum Boymans te Rotterdam.* Rotterdam, 1957.

Hébert 1901. Ernest Hébert. "La Villa Médicis en 1840: Souvenirs d'un pensionnaire." *Gazette des beaux-arts,* 3rd ser., 25 (April 1, 1901), pp. 265–76.

Heil 1941. Walter Heil. "Exhibition of French Drawings and Water Colors in the M. H. de Young Memorial Museum." *Pacific Art Review* 1, no. 2 (summer 1941), pp. 46–47.

Heine 1868. Heinrich Heine. *Allemands et Français.* Oeuvres complètes de Henri Heine. Paris, 1868.

Heise 1959. Carl Georg Heise. *Grosse Zeichner des XIX. Jahrhunderts.* Berlin, 1959.

Henriot 1911. Émile Henriot. "Lettres inédites de M. Ingres." *Mercure de France,* May 1, 1911.

Henriot 1926–28. Gabriel Henriot. *Collection David Weill.* 3 vols. Paris, 1926–28.

Hervé 1993. Robert Hervé, ed. *Le Mécénat du duc d'Orléans, 1840–1842.* Paris, 1993.

Hess 1884. David Hess. *Joh. Caspar Schweizer, ein Charakterbild aus dem Zeitalter der französischen Revolution.* Edited by Jakob Baechtold. Berlin, 1884. Originally published as *Johann Caspar Schweizer und seine Gattin Magdalena Hess: Eine biographische Skizze in 50 freien Umrissen,* 1822.

Hess 1953. Thomas B. Hess. "Ingres." *Art News Annual* 22 (1953), pp. 149–72, 176–82.

Higonnet 1992. Anne Higonnet. *Berthe Morisot's Images of Women.* Cambridge, Mass., 1992.

Hillairet 1985. Jacques Hillairet. *Dictionnaire historique des rues de Paris.* Paris, 1985.

Hitchcock 1938. H[enry]-R[ussell] H[itchcock] Jr. "A Note on A. Leclère." *Smith College Museum of Art Bulletin,* June 1938, pp. 9–11.

Hníková-Malá 1963. Dagmar Hníková-Malá. *Jean-Dominique Ingres* (in Czechoslovakian). Prague, 1963.

Hoetink 1967. H. R. Hoetink. "Three Centuries of French Art." *Apollo* 86 (July 1967), pp. 50–55.

Hoetink 1968. H. R. Hoetink. *Franse tekeningen uit de 19e eeuw: Catalogus van de verzameling in het Museum Boymans-van Beuningen.* Rotterdam, 1968.

Holme 1944. Bryan Holme. *Master Drawings.* New ed. New York and London, 1944.

Honour 1955. Hugh Honour. "Newby Hall, Yorkshire." *Connoisseur* 134 (January 1955), pp. 247–49.

Horaist 1980. Bruno Horaist. "Une Lettre d'Ingres à propos de la décoration de l'église Saint-Vincent-de Paul à Paris." *Bulletin du Musée d'Ingres,* no. 45 (July 1980), pp. 31–34.

Houghton 1873. Richard Monckton Milnes, Lord Houghton. *Monographs: Personal and Social.* 2nd ed. London, 1873.

Hourticq 1928. Louis Hourticq. *Ingres: L'Oeuvre du maître.* Paris, 1928.

Houssaye 1846. Arsène Houssaye. "Le Salon de 1846." *L'Artiste,* 4th ser., 6 (1846), pp. 37–43.

Houston 1986–87. *A Magic Mirror: The Portrait in France, 1700–1900.* Houston, Museum of Fine Arts, October 12, 1986–January 25, 1987. Exh. cat. by George T. M. Shackelford and Mary Tavener Holmes. Houston, 1986.

Houston 1997–98. *Picasso and Photography: The Dark Mirror.* Houston, Museum of Fine Arts, November 16, 1997–February 1, 1998. Exh. cat. by Anne Baldassari. Translated by Deke Dusinberre. Paris and New York, 1997.

Houston, New York 1986. *J. A. D. Ingres: Fifty Life Drawings from the Musée Ingres at Montauban.* Houston, Museum of Fine Arts, February 1–March 16, 1986; New York, Frick Collection, May 6–June 15. Exh. cat. by Avigdor Arikha. Houston, 1986.

Howe 1947. T[homas] C[arr] H[owe] Jr. "Drawings from the Louvre Museum." *Bulletin of the California Palace of the Legion of Honor* 4, no. 11 (March 1947), p. 91.

Hubert 1986. Nicole Hubert. "À propos des portraits consulaires de Napoléon Bonaparte: Remarques complémentaires." *Gazette des beaux-arts,* 6th ser., 108 (July–August 1986), pp. 23–30.

Huggler 1948. Max Huggler. *Adolf von Stürler und das Stürler-Legat im Berner Kunstmuseum.* [Bern], 1948. Expanded offprint from *Du,* February 1948.

Hugo 1970. Victor Hugo. *Oeuvres complètes.* Edited by Jean Massin. Vol. 16. Paris, 1970.

Hugo n.d. [Adèle Hugo, M^me Victor Hugo]. *Victor Hugo raconté par un témoin de sa vie.* 3 vols. Paris, n.d.

Hugon 1942. Henri Hugon. "La Famille de Madeleine Ingres." *Mémoires de la Société des sciences naturelles et archéologique de la Creuse* (Guéret) 28 (1942).

Hulton 1968. P[aul] H[ope] Hulton. *The César Mange de Hauke Bequest.* London: British Museum, 1968.

Huyghe 1929. René Huyghe. "Complexité d'Ingres." *Beaux-Arts,* August 15, 1929, pp. 5–7.

Huyghe 1961. René Huyghe, ed. *L'Art et l'homme.* Vol. 3. Paris, 1961.

Huyghe 1976. René Huyghe. *La Relève de l'imaginaire: La Peinture française au XIX^e siècle—réalisme, romantisme.* Paris, 1976.

Huyghe and Jaccottet 1948. René Huyghe and Philippe Jaccottet. *Le Dessin français au XIX^e siècle.* Lausanne, 1948.

Huyghe and Jaccottet 1956. René Huyghe and Philippe Jaccottet. *French Drawing of the 19th Century.* London, 1956.

Huysmans 1908. Joris-Karl Huysmans. "La Salle des États au Louvre." In *Certains,* pp. 213–14. Paris, 1908.

***Illustrated London News* 1938.** *Illustrated London News* 193 (August 27, 1938).

Indianapolis 1965. *The Romantic Era: Birth and Flowering, 1750–1850.* Indianapolis, Herron Museum of Art, February 21–April 11, 1965. Exh. cat. Indianapolis, 1965.

Ingres 1863. Jean-Auguste-Dominique Ingres. *Réponse au rapport sur l'École Impériale des Beaux-Arts adressé au Maréchal Vaillant, ministre de la Maison de l'Empereur et des Beaux-Arts par M. Ingres, sénateur, membre de l'Institut.* Paris, 1863.

Ingres 1947. *Écrits sur l'art: Textes recueillis dans les carnets et dans la correspondance de Ingres.* Preface by Raymond Cogniat. Paris, 1947.

Ingres 1994. Jean-Auguste-Dominique Ingres. *Écrits sur l'art / Ingres; Dessins d'Ingres.* Paris, 1994.

***Ingres Portrait Drawings* 1993.** *Ingres Portrait Drawings: 44 Works.* Dover Art Library. New York, 1993.

Innsbruck, Vienna 1991. *J. A. D. Ingres 1780–1867: Zeichnungen und Ölstudien aus dem Musée Ingres, Montauban.* Innsbruck, Tiroler Landesmuseum Ferdinandeum, January 23–February 24, 1991; Vienna, Graphische Sammlung Albertina, March 15–April 28. Exh. cat. by Christine Ekelhart-Reinwetter. Innsbruck and Vienna, 1991.

***L'Instantané* 1911.** *L'Instantané, supplément illustré de la Revue hebdomadaire,* April 29, 1911.

***L'Intermédiaire des chercheurs et curieux* 1899.** *L'Intermédiaire des chercheurs et curieux,* July 7, 1899.

***L'Intermédiaire des chercheurs et curieux* 1902.** *L'Intermédiaire des chercheurs et curieux,* July 30, 1902.

***International Studio* 1928.** *International Studio* 89 (April 1928).

Izergina 1969. Antonina Nikolaevna Izergina. *French Painting in the Hermitage: First Half and Middle of the Nineteenth Century. Guide* (in Russian). Saint Petersburg (then Leningrad), 1969.

***J. A. D. Ingres* 1927.** *J. A. D. Ingres, Gedanken über Kunst.* Edited by Hans Graber. Landschlacht and Constance, 1927.

Jal 1819. Auguste Jal. *L'Ombre de Diderot et le bossu du Marais: Dialogue critique sur le Salon de 1819.* Paris, 1819.

Jal 1828. Auguste Jal. *Esquisses, croquis, pochades, ou Tout ce qu'on voudra sur le Salon de 1827.* Paris, 1828.

Jal 1833. Auguste Jal. *Salon de 1833. Les Causeries du Louvre.* Paris, 1833.

Jal 1846. Auguste Jal. "Exposition d'ouvrages de l'école française au profit de l'Association des artistes peintres, sculpteurs, architectes et dessinateurs." *Moniteur des arts* 2, no. 52 (January 25, 1846), pp. 201–2.

Janin 1840. Jules Janin. "Une Matinée aux portes du Louvre: Le Salon de 1840." *L'Artiste,* 2nd ser., 5 (1840), pp. 289–302.

Janin 1841. Jules Janin. "La Vierge à l'Hostie." *Journal des débats,* July 12, 1841, pp. 1–2.

Jensen 1994. Robert Jensen. *Marketing Modernism in Fin-de-Siècle Europe*. Princeton, 1994.

Jerusalem, Dijon 1981. *Jean-Auguste-Dominique Ingres: 53 Dessins sur le vif du Musée Ingres et du Musée du Louvre*. Jerusalem, Israel Museum, June 23–August 24, 1981; Dijon, Musée des Beaux-Arts, October 3–November 28. Exh. cat. by Avigdor Arikha. Jerusalem, 1981. Dijon ed., *Ingres, dessins sur le vif: Cinquante-deux Dessins du Musée Ingres de Montauban*. Dijon, 1981.

Joachim 1978–79. Harold Joachim. *French Drawings and Sketchbooks of the Nineteenth Century: The Art Institute of Chicago*. Compiled by Sandra Haller Olsen. 2 vols. Chicago, 1978–79.

Johnson 1986. Lee Johnson. *The Paintings of Eugène Delacroix: A Critical Catalogue*. Vol. 3, *1832–1863 (Movable Pictures and Private Decorations)*. Oxford, 1986.

Johnston 1982. William R. Johnston. *The Nineteenth Century Paintings in the Walters Art Gallery*. Baltimore, 1982.

Jones 1995. Jennifer Jones. "The Woodner Collections at the National Gallery of Art." *Drawing* 17 (September–October 1995), pp. 49–53.

Joubin 1930. André Joubin. "Deux Amies de Delacroix: Mᵐᵉ Élisabeth Boulanger-Cavé et Mᵐᵉ Rang-Babut." *La Revue de l'art ancien et moderne* 57 (January 1930), pp. 57–94.

Jouffroy and Bordes 1977. Alain Jouffroy and Philippe Bordes. *Guillotine et peinture: Topino-Lebrun et ses amis*. Paris, 1977.

Jouin 1886. H[enry] J[ouin]. "Épitaphes de peintres." *Nouvelles Archives de l'art français*, 3rd ser., 2 (1886), pp. 108–11.

Jouin 1888. Henry Jouin. *Musée de portraits d'artistes, peintres, sculpteurs, architectes, graveurs, musiciens, artistes dramatiques, amateurs, etc., nés en France ou y ayant vécu*. Paris, 1888.

Jourdain 1949. Francis Jourdain. *Ingres, 1780–1867*. Paris, 1949.

Jourdain 1954. Francis Jourdain. *Ingres (1780–1867)*. Paris, 1954.

Jouvenet 1988. Olivier Jouvenet. "Ingres d'après les carnets inédits de Paul Flandrin." *Bulletin du Musée Ingres*, nos. 57–58 (1988), pp. 39–45.

Jubinal 1846. Achille Jubinal. "Chronique des lettres et des arts: À M. le directeur du *Voleur* et du *Cabinet de lecture*." *Le Cabinet de lecture*, January 20, 1846, pp. 61–62.

Jullian 1969. René Jullian. "Ingres et le paysage." In *Colloque Ingres [1967]*, pp. 85–92. [Montauban, 1969.]

Jullian 1986. René Jullian. "La Première Rencontre d'Ingres avec Rome: La Naissance de l'ingrisme." In *Actes du colloque: Ingres et Rome, Montauban, septembre 1986*, pp. 9–15. [Montauban, 1986.]

Kamakura, Tochigi, Ibaraki, Tokyo 1990. "Dessins français du 16ème au 20ème siècle: Collections du Musée des Beaux-Arts d'Orléans." Kamakura, Museum of Modern Art; Tochigi, Museum of Fine Arts; Ibraki, Museum of Modern Art; Tokyo, Funibashi Art Forum, 1990.

Kamenskaya 1959. Tatiana Kamenskaya. "Les Oeuvres d'Ingres au musée de l'Ermitage." *Bulletin du Musée Ingres*, no. 6 (December 1959), pp. 3–5.

Kansas City 1930. Exhibition. Kansas City, Nelson-Atkins Museum of Art, 1930.

Kansas City 1958. "Twenty-fifth Anniversary Exhibition." Nelson Gallery and Atkins Museum, Kansas City, 1958. Exh. cat. published in *Nelson Gallery and Atkins Museum Bulletin* 1, no. 2 (December 1958), pp. 3–8.

Kansas City 1969. "The Taste of Napoleon." Kansas City, Nelson Gallery and Atkins Museum, 1969. Exh. cat. published in *Nelson Gallery and Atkins Museum Bulletin* 4, no. 10 (1969).

Kapp 1916. Julius Kapp. *Liszt: Ein Biografie*. Berlin, 1916.

Karr 1846. Alphonse Karr. *Les Guêpes*, February 1846.

Keller 1830. Enrico de Keller. *Elenco di tutti i pittori, scultori, architetti, miniatori, incisori in gemme e in rame, scultori in metallo e mosaicisti; aggiunti gli scalpellini, pietrari, perlari ed altri artefici*. Rome, 1830.

Kemp 1970. Martin Kemp. "Ingres, Delacroix, and Paganini: Exposition and Improvisation in the Creative Process." *L'Arte* 9 (March 1970), pp. 49–65.

Kergall 1955. Atala Kergall. "Atala Stamaty filleule de Chateaubriand." Offprint of *Revue d'histoire diplomatique*, July–September 1955.

Kimmelman 1996. Michael Kimmelman. "At the Met with Wayne Thiebaud: A Little Weirdness Can Help an Artist." *New York Times*, August 23, 1996, pp. C1, C25.

King 1942. Edward S. King. "Ingres as Classicist." *Journal of the Walters Art Gallery* 5 (1942), pp. 69–113.

Koenig 1963. Léon Koenig. *Ville de Liège: Musée des Beaux-Arts, Catalogue des peintures françaises*. Liège, 1963.

Kostenevich 1977. A. Kostenevich. *Peinture d'Europe occidentale des XIXᵉ et XXᵉ siècles: Musée de l'Ermitage*. Saint Petersburg (then Leningrad), 1977.

Kostenevich 1987. A. Kostenevich. *Peinture d'Europe occidentale des 19ᵉ–20ᵉ siècles à l'Ermitage*. Saint Petersburg (then Leningrad), 1987.

Krauss 1993. Rosalind Krauss. *Cindy Sherman, 1975–1993*. New York, 1993.

Kübler 1951. Arnold Kübler. "10 Jahre *Du*." *Du* (March 1951), p. 10.

Kunst und Künstler 1911. *Kunst und Künstler* 9 (1911).

Kunst und Künstler 1930. *Kunst und Künstler* 28 (1930).

Kurz 1950. Otto Kurz. "Recent Research." *Burlington Magazine* 92 (August 1950), pp. 239–40.

Laborde 1816–36. Alexandre-Louis-Joseph, comte de Laborde. *Les Monumens de la France classés chronologiquement et considérés sous le rapport des faits historiques et de l'étude des arts*. 2 vols. Paris, 1816–36.

Labourieu, October 25, 1855. Th[éodore] Labourieu. "Les Peintures des beaux-arts." *Le Moniteur dramatique*, October 25, 1855.

Labrouche 1950. Pierre Labrouche. *Les Dessins de Ingres*. Paris, 1950.

Labrouste 1868. [Pierre-François-Henri] Labrouste. *Notice sur M. Hittorff*. Paris, 1868.

Lacambre 1977. Geneviève Lacambre. "Le Voeu de Louis XIII d'Ingres au Musée du Luxembourg." In *Actes du colloque international: Ingres et le Néo-Classicisme, Montauban, octobre 1975*, pp. 49–51. [Montauban, 1977.]

Laclotte 1967. Michel Laclotte. "L'Année Ingres." *La Revue du Louvre et des Musées de France* 17 (1967), pp. 189–94.

Lacrocq 1919–21. Louis Lacrocq. "Les Portraits de Madeleine Ingres, née Chapelle." *Mémoires de la Société des sciences naturelles et archéologiques de la Creuse* (Guéret) 21 (1919–21).

Lacroix 1855. Paul Lacroix. "M. Ingres à l'Exposition universelle." *Revue universelle des arts* 2 (1855), pp. 202–14.

La Fizelière, February 1, 1846. Albert de La Fizelière. "Exposition de l'Association des artistes." *Journal du commerce*, February 1, 1846.

Lafond 1905. Paul Lafond. *Le Musée de Rouen*. Paris, 1905.

Lafond 1906. Paul Lafond. "Les Portraits au crayon de Ingres dans les musées de province." *Musées et monuments de France* 1, no. 7 (1906), pp. 104–5.

Lagenevais 1846. F. de Lagenevais [Frédéric Bourgeois de Mercey]. "Peintres et sculpteurs modernes. I. M. Ingres." *Revue des deux mondes*, n.s., 15 (August 1, 1846), pp. 514–41.

Lagrange 1861. Léon Lagrange. "Exposition régionale des beaux-arts à Marseille." *Gazette des beaux-arts* 11 (December 1, 1861), pp. 542–51.

Lagrange 1867. Léon Lagrange. "Ingres." *Le Correspondant*, May 1867, pp. 34–76.

Lagrange 1867a. Léon Lagrange. "La Mort de M. Ingres.—Le Pavillon Denon." *Gazette des beaux-arts* 22 (February 1, 1867), pp. 206–8.

Lalande 1804. Jérome de Lalande. "Notice sur l'astronome Bernier." *Magasin encyclopédique* 5 (1804), pp. 256–70.

La Mara 1911. La Mara [Marie Lipsius]. *Liszt und die Frauen*. Leipzig, 1911.

Lamathière 1875–1911. Théophile Lamathière. *Panthéon de la Légion d'honneur: Dictionnaire biographique des hommes du XIXᵉ siècle*. 22 vols. Paris, 1875–1911.

Lambert-Lassus 1873. Lambert-Lassus. "Correspondance de M. Lassus avec M. Ingres au sujet du portrait de M. Labrouste." *Nouvelles Archives de l'art français*, 1873, pp. 444–56.

Lami 1914–21. Stanislas Lami. *Dictionnaire des sculpteurs de l'école française au dix-neuvième siècle*. 4 vols. Paris, 1914–21.

Lance 1854. Adolphe Lance. *Notice sur la vie et les travaux de M. Achille Leclère*. Paris, 1854.

Landormy 1942. Paul Landormy. *Gounod*. Paris, 1942.

Lane 1940. James W. Lane. "David and Ingres View in New York." *Art News* 38, no. 14 (January 6, 1940), p. 7.

Langle 1939. Fleuriot de Langle. "Monsieur Ingres et la princesse de Canino." *La Revue de France*, July 1, 1939, pp. 40–42.

Lanzac de Laborie 1896–97. L[éon] de Lanzac de Laborie, ed. *Souvenirs d'un historien de Napoléon: Mémorial de J. de Norvins*. 3 vols. Paris, 1896–97.

Lapauze 1901. Henry Lapauze. *Les Dessins de J.-A.-D. Ingres du Musée de Montauban*. Paris, 1901.

Lapauze 1903. Henry Lapauze. *Les Portraits dessinés de J.-A.-D. Ingres*. 2 vols. Paris, 1903.

Lapauze 1905a. Henry Lapauze. *Mélanges sur l'art français*. Paris, 1905.

Lapauze 1905b. Henry Lapauze. "Le Bain turc d'Ingres d'après des documents inédits." *La Revue de l'art ancien et moderne* 18 (July–December 1905), pp. 385–96.

Lapauze 1910. Henry Lapauze. *Le Roman d'amour de M. Ingres*. Paris, 1910.

Lapauze 1911a. Henry Lapauze. *Ingres: Sa Vie & son oeuvre (1780–1867), d'après des documents inédits*. Paris, 1911.

Lapauze 1911b. Henry Lapauze. *Jean Briant, paysagiste (1760–1799): Maître de Ingres, et le paysage dans l'oeuvre de Ingres*. Paris, 1911. An extract from *La Revue de l'art ancien et moderne* 29 (February–April 1911).

Lapauze 1913. Henry Lapauze. "Lettres inédites de Ingres à son ami M. Marcotte." *Le Correspondant* 252, no. 6 (September 25, 1913), pp. 1069–90; 253, no. 1 (October 10, 1913), pp. 88–107.

Lapauze 1918. Henry Lapauze. "Les Faux Ingres." *La Renaissance de l'art français et des industries de luxe* 1 (November 1918), pp. 341–50.

Lapauze 1918a. Henry Lapauze. "Ingres chez Degas." *La Renaissance de l'art français et des industries de luxe* 1 (March 1918), pp. 9–15.

Lapauze 1919. Henry Lapauze. "Un Portrait inconnu de Ingres: Lady Cavendish Bentinck." *La Renaissance de l'art français et des industries de luxe* 2 (January 1919), pp. 8–10.

Lapauze 1921. Henry Lapauze. In *La Renaissance de l'art français et des industries de luxe* 4 (May 1921).

Lapauze 1922. Henry Lapauze. "Sur quelques oeuvres inédites de Ingres." *La Renaissance de l'art français et des industries de luxe* 5 (December 1922), pp. 649–53.

Lapauze 1923. Henry Lapauze. "Sur un portrait inédit de Ingres: M^me Gonin-Thomeguex." *La Renaissance de l'art français et des industries de luxe* 6 (August 1923), p. 446.

Lapauze 1924. Henry Lapauze. *Histoire de l'Académie de France à Rome.* 2 vols. Paris, 1924.

Lassus Saint-Geniès and Lassus Saint-Geniès 1965. Jacques de Lassus Saint-Geniès and Jean de Lassus Saint-Geniès. *Gounod et son temps.* Paris, [1965].

László and Mátéka 1968. Zsigmond László and Béla Mátéka. *Franz Liszt: A Biography in Pictures.* London, 1968.

Latour 1894–1900. Alexandre de Latour. "Lettres inédites de David d'Angers." *L'Art* 59 (1894–1900), pp. 95–106.

Laurent, June 18, 1841. [Alphonse-Jean Laurent]. "La Cène de M. Ingres pour faire pendant à celle de Leonard de Vinci." *Le Charivari*, June 18, 1841.

Laurent 1983. Jeanne Laurent. *Arts & pouvoirs en France de 1793 à 1981: Histoire d'une démission artistique.* 2nd ed. Saint-Étienne, 1983.

Lausanne 1953. *De David à Cézanne: Dessins français du XIX siècle.* Lausanne, La Vieille Fontaine, 1953. Exh. cat. Lausanne, n.d.

Lausanne, Aarau 1963. "150 Dessins des musées de France." Lausanne, Musée Cantonal des Beaux-Arts; Aarau, Aargauer Kunsthaus, 1963.

Lavallée 1917. Pierre Lavallée. "La Collection des dessins de l'École des Beaux-Arts." *Gazette des beaux-arts*, 4th ser., 13 (October–December 1917), pp. 417–32.

Laver 1937. James Laver. *French Painting and the Nineteenth Century.* New York and London, 1937.

Lavergne, October 25, 1855. Claudius Lavergne. "Exposition universelle de 1855." *L'Univers*, October 25, 1855.

Lavigne 1881. Hubert Lavigne. *État civil d'artistes français: Billets d'enterrement ou de décès depuis 1823 jusqu'à nos jours.* Paris, 1881.

Laviron 1834. Gabriel Laviron. *Le Salon de 1834.* Paris, 1834.

Laviron and Galbacio 1833. Gabriel Laviron and Bruno Galbacio. *Le Salon de 1833.* Paris, 1833.

Lawrenceville 1937. Exhibition. Lawrenceville School, Lawrenceville, N.J., 1937.

Lecomte 1913. Georges Lecomte. "David et ses élèves." *Les Arts*, no. 142 (October 1913), pp. 2–18.

Lee 1995. Yoo-Kyong Lee. "La Fortune critique de Jean-Auguste-Dominique Ingres (étude des critiques à l'occasion des Salons de 1814 à 1834)." Ph.D. dissertation, Université de Paris, 1995.

Lee 1998. Yoo-Kyong Lee. "Une Entrée en scène peu applaudie: Ingres aux Salons de 1802 et 1806." *Bulletin du Musée Ingres*, no. 71 (April 1998), pp. 61–72.

Le Go 1833. A[lexis] Le Go. "Salon de 1833." *La Revue de Paris* 50 (1833), pp. 211–17.

Lemoisne 1946. P.-A. Lemoisne. *Degas et son oeuvre.* Vol. 1. Paris, 1946.

Le Normand 1977. Antoinette Le Normand. "Paul Lemoyne, un sculpteur français à Rome au XIX^e siècle." *Revue de l'art* 36 (1977), pp. 27–41.

Lenormant 1833. Charles Lenormant. *Les Artistes contemporains: Salons de 1831 et 1833.* 2 vols. Paris, 1833.

Lenormant 1842. Ch[arles] Lenormant. "M. Ingres. Portraits de Cherubini et de monseigneur le duc d'Orléans." *L'Artiste*, 3rd ser., 1 (1842) pp. 312–15.

Lenormant 1846. Ch[arles] Lenormant. "Exposition au profit des artistes malheureux." *Le Correspondant* 13 (January–March 1846), pp. 664–74.

Lenormant 1861. Charles Lenormant. *Beaux-Arts et voyages.* 2 vols. Paris, 1861.

Leprieur 1912. Paul Leprieur. "Trois Dessins de maîtres donnés par M. Léon Bonnat au Musée du Louvre." *Les Musées de France* 1 (1912), pp. 24–26.

Lequeux 1842. [Paul] Lequeux. *Notice sur M. Guenepin.* Paris, 1842.

Leroi 1881. Paul Leroi. "Silhouettes d'artistes contemporains." *L'Art* 24 (1881), pp. 335–46.

Leroi 1894–1900a. Paul Leroi. "Le Musée de la Bibliothèque Royale de Belgique." *L'Art* 59 (1894–1900), pp. 892–905.

Leroi 1894–1900b. Paul Leroi. "Vingt Dessins de M. Ingres." *L'Art* 59 (1894–1900), pp. 785–842.

Leroy, April 17, 1867. Louis Leroy. "Exposition des oeuvres de Ingres." *Le Charivari*, April 17, 1867.

Lestelley 1846. A. de Lestelley. "L'Exposition du bazar Bonne-Nouvelle." *La Revue indépendante*, 2nd ser., 1, no. 2 (January 25, 1846), pp. 256–60.

Levey 1968. Michael Levey. "Ingres at Cambridge and Paris." *Master Drawings* 6 (1968), pp. 44–47.

Levitine 1978. George Levitine. *The Dawn of Bohemianism: The Barbu Rebellion and Primitivism in Neoclassical France.* University Park, Pa., 1978.

Leymarie, Monnier, and Rose 1979. Jean Leymarie, Geneviève Monnier, and Bernice Rose. *History of an Art: Drawing.* Geneva and London, 1979.

Lièvre 1934. Pierre Lièvre. "Les Artistes français en Italie: De Poussin à Renoir." *La Revue de l'art ancien et moderne* 66 (June–December 1934), pp. 3–16.

Ligou 1984. Daniel Ligou, ed. *Histoire de Montauban.* Toulouse, 1984.

Lille 1866. "Exposition des beaux-arts." Lille, 1866.

Lilley 1985. Edward Lilley. "Consular Portraits of Napoleon Bonaparte." *Gazette des beaux-arts*, 6th ser., 106 (1985), pp. 143–56.

Lisbon 1948. "Exposition d'oeuvres d'art et de souvenirs historiques appartenant à monseigneur le comte de Paris." Lisbon, Museu Nacional de Arte Antiga, 1948.

Lissingen 1905. Edmond de Lissingen. *Passages de Napoléon Bonaparte au pays de Liège, 1803–1811.* Liège, 1905.

Liszt 1893–1902. Franz Liszt. *Briefe.* Compiled and edited by La Mara [Marie Lipsius]. 7 vols. Leipzig, 1893–1902.

Liszt and Stern 1933–34. Franz Liszt and Daniel Stern [Marie-Catherine-Sophie d'Agoult]. *Correspondance de Liszt et de la comtesse d'Agoult.* Edited by Daniel Ollivier. 2 vols. Paris, 1933–34.

Liverpool 1968. *Gift to the Galleries: An Exhibition of Works of Art Acquired with the Aid of the National Art-Collections Fund for Galleries Outside London.* Liverpool, Walker Art Gallery, 1968. Exh. cat. Liverpool, 1968.

Liverpool, Kingston-upon-Hull, London 1979–80. *Ingres: Drawings from the Musée Ingres at Montauban and Other Collections.* Liverpool, Walker Art Gallery, August 18–September 23, 1979; Kingston-upon-Hull, Ferens Art Gallery, October 13–November 25; London, Victoria & Albert Museum, December 12, 1979–February 24, 1980. Exh. cat. by Pierre Barousse and Michael Kauffmann. London, 1979.

Lockspeiser 1937. Edward Lockspeiser. "Painters and Musicians." *Apollo* 25 (June 1937), pp. 336–38.

London 1878–79. *Winter Exhibition.* London, Grosvenor Gallery, winter 1878–79. Exh. cat. London, 1878.

London 1908. "Franco-British Exhibition." London, Palace of Fine Arts, 1908.

London 1914. *Art français; art décoratif contemporain, 1800–1885.* London, Grosvenor House. Organized by Madame, la comtesse Greffulhe; the exhibition never took place. Exh. cat. London, 1914.

London 1917. *Catalogue of a Collection of Drawings by Deceased Masters, with Some Decorative Furniture and Other Objects of Art.* London, Burlington Fine Arts Club, 1917. Exh. cat. London, 1917.

London 1923. *Exhibition of Nineteenth Century French Painters.* London, M. Knoedler and Co., June 26–July 21, 1923. Exh. cat. London, 1923.

London 1932. *Exhibition of French Art, 1200–1900.* London, Royal Academy of Arts, January 4–March 5, 1932. Exh. cat. London, 1932.

London 1934. *Exhibition of French Drawings from Clouet to Ingres.* London, Wildenstein and Co., 1934. Exh. cat. London, 1934.

London 1936a. *Exhibition of Masters of French 19th Century Painting.* London, New Burlington Galleries, October 1–31, 1936. Exh. cat. London, 1936.

London 1936b. *"La Flèche d'or": Important Pictures from French Collections.* London, Arthur Tooth & Sons, 1936. Exh. cat. London, 1936.

London 1938a. *A Century of French Drawings, from Prud'hon to Picasso.* London, Matthiesen Gallery, May 3–31, 1938. Exh. cat. London, 1938.

London 1938b. "Ten French Painters of the Nineteenth Century." London, Rosenberg and Helft, Ltd., 1938.

London 1947–48. *An Exhibition of Cleaned Pictures (1936–1947).* London, National Gallery, 1947–48. Exh. cat. foreword by Philip Hendy. London, 1947.

London 1952. *French Drawings from Fouquet to Gauguin.* London, Arts Council Gallery, February 2–March 16, 1952. Exh. cat. London, 1952.

London 1956–57. *British Portraits.* London, Royal Academy of Arts, winter 1956–57. Exh. cat. preface by A. E. Richardson. London, 1956.

London 1957. *Ingres: Drawings from the Musée Ingres Montauban.* London, Arts Council of Great Britain, 1957. Exh. cat. London, 1957.

London 1959. *Treasures of Cambridge.* London, Goldsmiths' Hall, March–April 1959. Exh. cat. London, 1959.

London 1961. *Important 18th Century and Early 19th Century Miniatures and Enamels.* London, Garrard and Co., 1961. Exh. cat. London, 1961.

London 1965a. *French and English Drawings.* London, Thos. Agnew & Sons, 1965. Exh. cat. London, 1965.

London 1965b. *Sixty Years of Patronage: Drawings, Gold, Silver, and Ivories from Museums in Great Britain and Northern Ireland Bought with the Aid of the National Art-Collections Fund.* London, Arts Council Gallery, September 17–October 16, 1965. Exh. cat. London, 1965.

London 1968. *The César Mange de Hauke Bequest.* British Museum, London, 1968. Exh. cat. by P. H. Hulton. London, 1968.

London 1969. *Berlioz and the Romantic Imagination.* London, Victoria & Albert Museum, October 17–December 14, 1969. Exh. cat. edited by Elizabeth Davison. London, 1969.

London 1970. *The Antique Dealers' Fair and Exhibition.* London, Grosvenor House, June 10–25, 1970. Exh. cat. issued in *Connoisseur* 175 (June 1970), pp. 136–49.

London 1972. *The Age of Neo-Classicism.* London, Royal Academy of Arts and Victoria & Albert Museum, September 9–November 19, 1972. Exh. cat. London, 1972.

London 1974. *Portrait Drawings, XV–XX Centuries.* London, British Museum, Department of Prints and Drawings, August 2–December 31, 1974. Exh. cat. London, 1974.

London 1975. *Exhibition of French Drawings: Post Neo-Classicism.* London, Colnaghi, February 20–March 27, 1975. Exh. cat. London, 1975.

London 1979. "French Drawings, XVI–XIX Century." London, Wildenstein and Co., June 20–July 14, 1979.

London 1984. *Master Prints and Drawings: 16th to 19th Century*. London, Artemis Fine Arts Ltd., 1984. Exh. cat. London, 1984.

London 1987. *Master Drawings: The Woodner Collection*. London, Royal Academy of Arts, July 8–October 18, 1987. Exh. cat. compiled by Christopher Lloyd, Mary Anne Stevens, Nicholas Turner; edited by Jane Shoaf Turner. London, 1987.

London 1988. *European Drawings: Recent Acquisitions*. London, Hazlitt, Gooden and Fox, Ltd., November 23–December 9, 1988. Exh. cat. London, 1988.

London 1988a. *French Paintings from the USSR: Watteau to Matisse*. London, National Gallery, June 15–September 18, 1988. Exh. cat. London, 1988.

London 1990. *Nineteenth Century French Drawings*. London, Hazlitt, Gooden and Fox, Ltd., 1990. Exh. cat. London, 1990.

London 1996. *Degas as a Collector*. London, National Gallery, May 22–August 26, 1996. Exh. cat. by Ann Dumas. London, 1996.

London, British Museum 1984. *Master Drawings and Watercolours in the British Museum*. Edited by John Rowlands. London, 1984.

London, National Art-Collections Fund 1937. London, National Art-Collections Fund. *Thirty-third Annual Report, 1936*. London, 1937.

London, National Art-Collections Fund 1947. London, National Art-Collections Fund. *Forty-third Annual Report, 1946*. London, 1947.

London, National Art-Collections Fund 1948. London, National Art-Collections Fund. *Forty-fourth Annual Report, 1947*. London, 1948.

London, National Gallery 1986. National Gallery. *National Gallery: Illustrated General Catalogue*. 2nd ed. London, 1986.

London Studio **1932.** *London Studio* (New York) 3 (May 1932).

London, Victoria & Albert Museum 1948. Victoria & Albert Museum. *Portrait Drawings*. Its Small Picture Book, 12. London, 1948.

London, Victoria & Albert Museum 1949. Victoria & Albert Museum, Department of Engraving, Illustration, and Design and Departments of Paintings. *Accessions 1946*. London 1949.

Longa 1942. René Longa. *Ingres inconnu: 129 Reproductions de croquis à la plume du Musée de Montauban*. Paris, 1942.

Long Beach 1978–79. *French Drawings from the E. B. Crocker Collection*. Long Beach Museum of Art, December 10, 1978–January 21, 1979. Exh. cat. by Roger D. Clisby. Long Beach, Calif., 1978.

Lord 1938. Douglas Lord. "Nineteenth-Century French Portraiture." *Burlington Magazine* 72 (June 1938), pp. 253–63.

Los Angeles 1934. *Paintings from the Louvre: An Exhibition of Eleven Canvases Lent by the French Government to the Los Angeles Art Association*. Los Angeles Museum, October 5–November 5, 1934. Exh. cat. Los Angeles, 1934.

Los Angeles 1941. *The Painting of France since the French Revolution*. Los Angeles County Museum, June–July 1941. Exh. cat. Los Angeles, 1941.

Los Angeles 1961. *French Masters, Rococo to Romanticism: An Exhibition of Paintings, Drawings and Prints*. The U[niversity of] C[alifornia at] L[os] A[ngeles] Art Galleries, March 5–April 18, 1961. Exh. cat. Los Angeles, 1961.

Los Angeles 1975. *X: A Decade of Collecting, 1965–1975*. Los Angeles County Museum of Art, April 8–June 29, 1975. Exh. cat. Los Angeles, 1975.

Los Angeles 1978–79. "French Prints and Drawings from the Permanent Collection." Los Angeles County Museum of Art, November 8, 1978–January 8, 1979.

Los Angeles 1983. Exhibition. Los Angeles County Museum of Art, Salvatori Gallery, March 23–May 15, 1983.

Los Angeles 1984. *In Honor of Ebria Feinblatt, Curator of Prints and Drawings, 1947–1985: Essay and Catalogue*. Los Angeles County Museum of Art, October 25–December 30, 1984. Exh. cat. by Bruce Davis. Los Angeles, 1984.

Los Angeles 1987. "European Drawings from the Permanent Collection." Los Angeles County Museum of Art, March 5–May 10, 1987.

Los Angeles 1997–98. *Master Drawings in the Los Angeles County Museum of Art*. Los Angeles County Museum of Art, October 23, 1997–January 12, 1998. Exh. cat. by Bruce Davis. Los Angeles, 1997.

Los Angeles, London, Dublin 1971–72. *The Armand Hammer Collection*. Los Angeles County Museum of Art, December 21, 1971–February 27, 1972; London, Royal Academy of Arts, June 24–July 24; Dublin, National Gallery of Ireland, August 9–October 1. Exh. cat. Los Angeles, 1971.

Louchheim 1944. Aline B. Louchheim. "The Great Tradition of French Drawing from Ingres to Picasso in American Collections." *Art News Annual*, Christmas ed. (December 14, 1944), pp. 127–30, 151–52, 154, 156, 158.

Loudun 1855. Eugène Balleyguier [Eugène Loudun]. *Exposition universelle des beaux-arts: Le Salon de 1855*. Paris, 1855.

Louisville, Fort Worth 1983–84. *In Pursuit of Perfection: The Art of J.-A.-D. Ingres*. Louisville, J. B. Speed Art Museum, December 6, 1983–January 29, 1984; Fort Worth, Kimbell Art Museum, March 3–May 6. Exh. cat. by Patricia Condon, with Marjorie B. Cohn and Agnes Mongan. Louisville, 1983.

Lowry and Lowry 1998. Bates Lowry and Isabel Lowry. *The Silver Canvas: Daguerreotype Masterpieces from the J. Paul Getty Museum*. Los Angeles, 1998.

Lugt 1956. Frits Lugt. *Les Marques de collections, supplément*. The Hague, 1956.

Lyons 1921. "Dessins anciens." Lyons, Bibliothèque municipale, 1921.

Lyons, Esslingen 1989. *De Géricault à Leger: Dessins français des XIXe et XXe siècles dans les collections du Musée des Beaux-Arts de Lyon*. Lyons, Musée des Beaux-Arts, May 18–September 3, 1989; Esslingen, Galerie der Stadt Esslingen, Villa Merkel, November 10–December. Exh. cat. by Dominique Brachlianoff. Lyons, 1989.

Lyttelton 1912. Sarah Spencer, Baroness Lyttelton. *Correspondence of Sarah Spencer, Lady Lyttelton, 1787–1870*. Edited by her great-granddaughter the Hon. Mrs. Hugh Wyndham. London, 1912.

Mabilleau 1894. Léopold Mabilleau. "Les Dessins d'Ingres au Musée de Montauban." *Gazette des beaux-arts*, 3rd ser., 12 (September 1, 1894), pp. 177–201.

MacGregor 1979. Neil MacGregor. "Roman Fashions, London." *Burlington Magazine* 121 (November 1979), pp. 738–41.

Madelène, April 16, 1867. Henry de la Madelène. "Chronique des beaux-arts et de la curiosité." *Gazette des étrangers*, April 16, 1867.

Madelin 1927. Louis Madelin. *La Rome de Napoléon*. Paris, 1927.

Madoff 1989. Steven Henry Madoff. "Face to Face." *Art News* 88, no. 2 (February 1989), pp. 104–7.

Madrid 1986–87. *Dibujos de los siglos XIV al XX: Colección Woodner*. Madrid, Museo del Prado, December 4, 1986–January 31, 1987. Exh. cat. Madrid, 1986.

Madrid 1997–98. *El Triunfo de Venus*. Madrid, Museo Thyssen-Bornemisza, November 19, 1997–February 22, 1998. Exh. cat. Madrid, 1997.

Magimel 1851. [Albert] Magimel, ed. *Oeuvres de J. A. Ingres, membre de l'Institut, gravées au trait sur acier par A[te] Réveil 1800–1851*. Paris, 1851.

Magnin 1919. Jeanne Magnin. *La Peinture et le dessin au Musée de Besançon*. Dijon, 1919.

Mainardi 1987. Patricia Mainardi. *Art and Politics of the Second Empire: The Universal Expositions of 1855 and 1867*. New Haven and London, 1987.

Mainardi 1993. Patricia Mainardi. *The End of the Salon: Art and the State in the Early Third Republic*. Cambridge and New York, 1993.

Mainz 1983. *Ingres: Handzeichnungen*. Mainz, Mittelrheinisches Landesmuseum, March 24–May 1, 1983. Exh. cat. by Wilhelm Weber and Norbert Suhr. Mainz, 1983.

Les Maîtres du dessin **1901.** *Les Maîtres du dessin*. Vol. 2, *Les Dessins français du siècle à l'Exposition universelle de 1900–1901*. Edited by [Claude] Roger-Marx. Paris, 1901.

Malibu, Fort Worth, Washington, Cambridge (Mass.) 1983–85. *Master Drawings from the Woodner Collection*. Malibu, J. Paul Getty Museum, May 28–August 12, 1983; Fort Worth, Kimbell Art Museum, September 10–November 15; Washington, D.C., National Gallery of Art, December 18, 1983–February 20, 1984; Cambridge, Mass., Fogg Art Museum, February 1–March 31, 1985. Exh. cat. by George Goldner. Malibu, 1983.

Malingue 1943. Maurice Malingue. *Ingres*. Monaco, 1943.

Mallet frères et Cie 1923. *Deux Siècles de banque: Mallet frères et Cie, 1723–1923*. N.p. [1923].

Malmö, Göteborg, Stockholm 1965. *Ingres, en utställning från Musée Ingres*. Malmö Museum; Göteborgs Konstmuseum; Stockholm, National-museum; January–April 1965. Exh. cat. by Gunnar Jungmarker. Göteborg, 1965.

Man 1953. Felix H. Man. *150 Years of Artists' Lithographs, 1803–1953*. London, 1953.

Man 1970. Felix H. Man. *Artists' Lithographs: A World History from Senefelder to the Present Day*. New York, 1970.

Manchester 1932. "French Art Exhibition." Manchester, City Art Gallery, 1932.

Mantz 1846. Paul Mantz. "Une Exposition hors du Louvre." *L'Artiste*, 4th ser., 5 (January 18, 1846), pp. 186–89; (January 25, 1846), pp. 198–201.

Mantz 1855. Paul Mantz. "Salon de 1855." *Revue française* 2 (1855), pp. 219–29.

Maraini 1924. Antonio Maraini. "Un disegno sconosciuto di Ingres." *Dedalo* 5 (June 1924), pp. 62–65.

Marangoni 1922. Matteo Marangoni. "Quattro 'Caravaggio' smarriti." *Dedalo* 2 (May 1922), pp. 783–94.

Marmottan 1922. Paul Marmottan. "Sur Achille Leclère." *Bulletin de la Société de l'histoire de l'art français*, 1921 (1922), pp. 125–26.

Marrinan 1988. Michael Marrinan. *Painting Politics for Louis-Philippe: Art and Ideology in Orléanist France, 1830–1848*. New Haven and London, 1988.

Marseilles 1861. "Exposition des beaux-arts." Marseilles, Galerie de l'Exposition, 1861.

Marshall 1823–35. John Marshall. *Royal Naval Biography. . . .* 8 vols. London, 1823–35.

Martine 1926. Charles Martine. *Ingres: Soixante-cinq reproductions de Léon Marotte avec un catalogue par Charles Martine*. Paris, 1926.

Masterpieces of Ingres **1913.** *The Masterpieces of Ingres (1780–1867)*. Gowans' Art Books, no. 47. London, 1913.

Masterpieces of Ingres **1914.** *The Masterpieces of Ingres (1780–1867)*. Reprint ed. Gowans' Art Books, no. 47. London, 1914.

Masters in Art **1906.** *Masters in Art: Ingres* (Boston) 7, no. 79 (July 1906).

Mather 1930. Frank Jewett Mather Jr. "The Havemeyer Pictures." *Arts* 16 (March 1930), pp. 445–83.

Mathey 1932. Jacques Mathey. "Sur quelques portraits dessinés: Par Ingres ou ses graveurs?" *Bulletin de la Société de l'histoire de l'art français*, 1932, pp. 196–99.

Mathey 1933. Jacques Mathey. "Ingres portraitiste des Gatteaux et de M. de Norvins." *Gazette des beaux-arts*, 6th ser., 10 (August 1933), pp. 117–22.

Mathey 1945. Jacques Mathey. *Ingres*. Paris, 1945.

Mathey 1955. Jacques Mathey. *Ingres: Dessins*. Paris, [1955].

Maurois 1948. André Maurois. *J.-L. David*. Paris, 1948.

Maynard 1833. L[ouis] de M[aynard]. "État actuel de la peinture en France. Salon de 1833." *L'Europe littéraire*, March 20, 1833, pp. 37–38; April 1, 1833, pp. 57–58; April 8, 1833, pp. 69–70; April 17, 1833, p. 85.

McCarthy 1978. Michael J. McCarthy. *Introducing Art History: A Guide for Teachers*. Toronto, 1978.

McCorquodale 1977. Charles McCorquodale. "Painting in Focus: Madame Moitessier (The National Gallery)." *Art International* 21, no. 3 (May–June 1977), pp. 54–55.

McDonald 1939. Robert McDonald. "The Print Collection of James H. Lockhart Jr." *Carnegie Magazine* 13 (May 1939), pp. 35–39.

McKee 1927. W[illiam] McK[ee]. "Some Portraits by Ingres." *Bulletin of the Art Institute of Chicago* 21, no. 7 (October 1927), pp. 92–93.

McKee 1928. W[illiam] McK[ee]. "A Complete Collection of Ingres's Graphic Work." *Bulletin of the Art Institute of Chicago* 22, no. 6 (September 1928), p. 77.

McWilliam 1991. Neil McWilliam. *A Bibliography of Salon Criticism in Paris from the July Monarchy to the Second Republic, 1831–1851*. Cambridge, 1991.

McWilliam, Schuster, and Wrigley 1991. Neil McWilliam, ed., Vera Schuster, and Richard Wrigley. *A Bibliography of Salon Criticism in Paris from the 'Ancien Régime' to the Restoration, 1699–1827*. Cambridge, 1991.

Méjanès 1980. Jean-François Méjanès. "Ingres." *Le Petit Journal des grandes expositions*, n.s., no. 98 (1980), pp. 1–4.

Mély-Janin, December 1, 1824. Jean-Marie Mély-Janin. "Salon de 1824." *La Quotidienne*, December 1, 1824.

Members' Calendar 1968. *Members' Calendar, Los Angeles County Museum of Art*, April 1968.

Mémoires de l'Académie des Sciences et Belles-Lettres de Dijon 1937. *Mémoires de l'Académie des Sciences et Belles-Lettres de Dijon, 1936*. Dijon, 1937.

Mendelowitz 1967. Daniel M. Mendelowitz. *Drawing: A Study Guide*. New York, 1967.

Mennechet 1833. Éd[ouard] Mennechet. "Première Visite au Salon." *La Chronique de France* (1833), pp. 123–68.

Méras 1967. Mathieu Méras. "Ingres et l'Italie." *Bulletin du Musée Ingres*, no. 21 (July 1967), pp. 15–20.

Méras 1969. Mathieu Méras. "Ingres et le baron Vialètes de Mortarieu." In *Colloque Ingres [1967]*, pp. 115–22. [Montauban, 1969.]

Méras 1973. Mathieu Méras. "Ingres, Bartolini et Gilibert (trois lettres et un dessin inédits de Lorenzo Bartolini)." *Bulletin du Musée Ingres*, no. 33 (July 1973), pp. 11–17.

Méras 1980. Mathieu Méras. "Théophile Gautier: Critique officiel d'Ingres au *Moniteur*." In *Actes du colloque international: Ingres et son influence, Montauban, septembre 1980*, pp. 205–19. [Montauban, 1980.]

Mérimée 1830. J[ean]-F[rançois]-L[éonor] Mérimée. *De la peinture à l'huile*. Paris, 1830.

Mérimée 1958. Prosper Mérimée. *Correspondance générale*. Edited by Maurice Parturier. 2nd ser. Vol. 6. Toulouse, 1958.

Merson and Bellier de la Chavignerie 1867. Olivier Merson and Émile Bellier de la Chavignerie. *Ingres: Sa Vie et ses oeuvres*. Paris, [1867].

Mesplé 1969. Paul Mesplé. "David et ses élèves toulousains." *Archives de l'art français*, n.s., 24 (1969), pp. 91–102.

Metken 1967. Günter Metken. "Neuer Blick auf Ingres." *Die Weltkunst* 37 (December 15, 1967), pp. 1282–83.

Metternich 1909. Clemens Wenzel Lothar, Fürst von Metternich. *Lettres du prince de Metternich à la comtesse de Lieven, 1818–1819*. Edited by Jean Hanoteau. Paris, 1909.

Mexico City 1994. *De David a Matisse: 100 dibujos franceses. Escuela Nacional Superior de Bellas Artes de Paris*. Mexico City, Centro Cultural / Arte Contemporaneo, July 14–September 25, 1994. Exh. cat. Mexico City, 1994.

Miami 1984. *In Quest of Excellence: Civic Pride, Patronage, Connoisseurship*. Miami, Center for the Fine Arts, January 14–April 22, 1984. Exh. cat. by Jan Van der Marck. Miami, 1984.

Michel 1884. André Michel. "Exposition des dessins du siècle." *Gazette des beaux-arts*, 2nd ser., 29 (April 1, 1884), pp. 314–26.

Michel 1925. André Michel. *Histoire de l'art*. Vol. 7, pt. 1. Paris, 1925.

Michel, Prince of Greece 1992. Michel, Prince of Greece. *Portrait et séduction*. Paris, 1992.

Mikhailovich 1905–9. Nikolai Mikhailovich. *Portraits of Russians Who Lived in the Eighteenth and Nineteenth Centuries* (in Russian). 5 vols. Saint Petersburg, 1905–9.

Miles 1994. Ellen G. Miles. *Saint-Mémin and the Neoclassical Profile Portrait in America*. Edited by Dru Dowdy. Washington, D.C., 1994.

Milhau 1980. Denis Milhau. "Ingres: La Ligne et la couleur." In *Actes du colloque international: Ingres et son influence, Montauban, septembre 1980*, pp. 111–30. [Montauban, 1980.]

Miller 1938. Alexandrine Miller. "Ingres' Three Methods of Drawing as Revealed in His Crayon Portraits." *Art in America* 26 (January 1938), pp. 3–15.

Millet 1879–80. Eugène Millet. *Notice sur la vie et les oeuvres de Pierre-François-Henry Labrouste (lue par M. Charles Lucas à l'Assemblée générale de la Société centrale des architectes, le 26 octobre 1876)*. Offprint of *Bulletin de la Société centrale des architectes*, 1879–80. Paris, n.d.

Millier 1955. Arthur Millier. *The Drawings of Ingres*. Master Draughtsman Series. London, 1955.

Minneapolis 1952. *Great Portraits by Famous Painters*. Minneapolis Institute of Arts, November 13–December 21, 1952. Exh. cat. Minneapolis, 1952.

Minneapolis 1969. *The Past Rediscovered: French Painting, 1800–1900*. Minneapolis Institute of Arts, July 3–September 7, 1969. Exh. cat. Minneapolis, 1969.

Minneapolis, New York 1962. *The Nineteenth Century: One Hundred Twenty-five Master Drawings*. Minneapolis, University of Minnesota, University Gallery, March 26–April 23, 1962; New York, Solomon R. Guggenheim Museum, May 15–July 1. Exh. cat. by Lorenz Eitner. Minneapolis, 1962.

Miotti 1962. Tito Miotti. *Il collezionista di disegni*. Venice, 1962.

Miquel 1975. Pierre Miquel. *Le Paysage français au XIXe siècle*. Vols. 1–3, *1824–1874*. Maurs-la-Jolie, 1975.

Mirecourt 1855. Eugène de Mirecourt. *Ingres*. Les Contemporains. Paris, 1855.

Mitchell and Roberts 1996. Paul Mitchell and Lynn Roberts. *Frameworks: Form, Function & Ornament in European Portrait Frames*. London, 1996.

Molinier 1885. Émile Molinier. "La Collection Albert Goupil." *Gazette des beaux-arts*, 2nd ser., 31 (May 1, 1885), pp. 377–94.

Möller 1914. Tyge Möller. "L'Exposition de l'art français du XIXe siècle à Copenhague." *Gazette des beaux-arts*, 4th ser., 12 (August 1914), pp. 158–63.

Momméja 1888. Jules Momméja. "La Correspondance d'Ingres." *Réunion des Sociétés des beaux-arts des départements*, 1888, pp. 729–41.

Momméja, June 16, 1890. Jules Momméja. "Oeuvres d'Ingres dans les musées d'Europe." *Le Courrier de Tarn-et-Garonne*, June 16, 1890.

Momméja 1891. Jules Momméja. "Les Dessins d'Ingres au Musée de Montauban." *Réunion des Sociétés des beaux-arts des départements* 15 (1891).

Momméja 1893. Jules Momméja. "Ingres à Montauban: Le Musée Ingres." *L'Art* 54 (1893), pp. 92–94.

Momméja 1898. Jules Momméja. "La Jeunesse d'Ingres." *Gazette des beaux-arts*, 3rd ser., 20 (September 1, 1898), pp. 188–208.

Momméja 1904. J[ules] Momméja. *Ingres*. Paris, [1904].

Momméja 1905a. Jules Momméja. *Collection Ingres au Musée de Montauban*. Inventaire général des richesses d'art de la France, province, monuments civils, VII. Paris, 1905.

Momméja 1905b. Jules Momméja. "Le Portrait de Madame Destouches par Ingres." *Gazette des beaux-arts*, 3rd ser., 33 (May 1, 1905), pp. 411–13.

Mongan 1944. Agnes Mongan. "Drawings by Ingres in the Winthrop Collection." *Gazette des beaux-arts*, 6th ser., 26 (July–December 1944), pp. 387–412.

Mongan 1947. Agnes Mongan. *Ingres: 24 Drawings*. [New York, 1947.]

Mongan 1949. Agnes Mongan. *One Hundred Master Drawings*. Cambridge, Mass., 1949.

Mongan 1957. Agnes Mongan. "Ingres et Madame Moitessier." *Bulletin du Musée Ingres*, no. 2 (July 1957), pp. 3–8.

Mongan 1958. Agnes Mongan. "Un Dessin inédit pour le portrait de la princesse de Broglie." *Bulletin du Musée Ingres*, no. 5 (December 1958), pp. 6–7.

Mongan 1965. Agnes Mongan. "Un Portrait dessiné d'Ingres." *Bulletin du Musée Ingres*, no. 17 (July 1965), pp. 3–8.

Mongan 1967. Agnes Mongan. "Hommage à Ingres." *L'Oeil*, nos. 151–53 (September 1967), pp. 22–29, 81.

Mongan 1969. Agnes Mongan. "Ingres as a Great Portrait Draughtsman." In *Colloque Ingres [1967]*, pp. 134–50. [Montauban, 1969.]

Mongan 1996. Agnes Mongan. *David to Corot: French Drawings in the Fogg Art Museum*. Edited by Miriam Stewart. Cambridge, Mass., 1996.

Mongan and Sachs 1940. Agnes Mongan and Paul J. Sachs. *Drawings in the Fogg Museum of Art*. 2 vols. Cambridge, Mass., 1940.

Mongan and Sachs 1946. Agnes Mongan and Paul J. Sachs. *Drawings in the Fogg Museum of Art*. 2nd ed. 2 vols. Cambridge, Mass., 1946.

Moniteur des arts 1845. *Moniteur des arts*, July 6, 1845.

Moniteur des arts 1865. *Moniteur des arts*, August 18, 1865.

Monod 1912. François Monod. "L'Exposition centennale de l'art français à Saint-Pétersbourg." *Gazette des beaux-arts*, 4th ser., 7 (April 1912), pp. 301–26.

Montauban 1862. *Exposition des Beaux-Arts, ouverte à Montauban dans les salles de l'Hôtel de Ville*. Montauban, Hôtel de Ville, 1862. Exh. cat. Montauban, 1862.

Montauban 1951. *Dessins d'Ingres du Musée de Montauban*. Montauban, Musée Ingres, July–October 1951. Exh. cat. Montauban, [1951].

Montauban 1954. "Ingres aquarelliste." Montauban, Musée Ingres, 1954.

Montauban 1967. *Ingres et son temps: Exposition organisée pour le Centenaire de la mort d'Ingres (Montauban 1780–Paris 1867).* Montauban, Musée Ingres, June 24–September 15, 1967. Exh. cat. by Daniel Ternois and Jean Lacambre. Montauban, 1967.

Montauban 1970. *Ingres et la femme.* Montauban, Musée Ingres, June 2–September 30, 1970. Exh. cat. by Pierre Barousse. Montauban, 1970.

Montauban 1980. *Ingres et sa postérité: Jusqu'à Matisse et à Picasso.* Montauban, Musée Ingres, June 28–September 7, 1980. Exh. cat. Montauban, 1980.

Montauban 1985. "Images de la femme chez Ingres." Montauban, Musée Ingres, 1985.

Montauban 1991. *L'Étude pour la tête de Boileau de J. A. D. Ingres et les esquisses peintes pour l'Apothéose d'Homère.* Montauban, Musée Ingres, February 22–May 12, 1991. Exh. cat. by Georges Vigne. Montauban, 1991.

Montauban 1993–94. *Ingres et la musique.* Montauban, Musée Ingres, November 10, 1993–February 27, 1994. Exh. cat. by Georges Vigne, Florence Vignier, and Jean-Marc Andrieu. Papiers d'Ingres, no. 10. Montauban, 1993.

Montauban 1996–97. *Le Regard dessiné.* Montauban, Musée Ingres, November 28, 1996–March 16, 1997. Exh. cat. by Georges Vigne. Papiers d'Ingres, no. 16. Montauban, 1996.

Montauban 1997–98. *Un Bal au château de Dampierre.* Montauban, Musée Ingres, October 3, 1997–February 16, 1998. Exh. cat. by Georges Vigne. Papiers d'Ingres, no. 18. Montauban, 1997.

Montauban 1998. *Bon Voyage, Monsieur Ingres!* Montauban, Musée Ingres, April 4–July 26, 1998. Exh. cat. by Georges Vigne. Papiers d'Ingres, no. 19. Montauban, 1998.

Montesquiou 1897. Robert Montesquiou-Fézensac. *Roseaux pensants.* Paris, 1897.

Montesquiou 1905. Robert Montesquiou-Fézensac. *Professionnelles Beautés.* Paris, 1905.

Montevideo 1939. *La pintura francesa de David a nuestros días: Exposiciones de arte francés.* Montevideo, Salón Nacional de Bellas Artes, 1939. Exh. cat. Montevideo, 1940.

Montfaucon 1729–33. Bernard de Montfaucon. *Les Monumens de la monarchie françoise, qui comprenant l'histoire de France, avec les figures de chaque règne que l'injure des tems a épargnées.* 5 vols. Paris, 1729–33.

Montreal 1953. *Five Centuries of Drawings.* Montreal Museum of Fine Arts, October–November 1953. Exh. cat. [Montreal], 1953.

Montrosier, May 9, 1867. Eugène Montrosier. "Ingres." *Messager des théâtres et des arts,* May 9, 1867.

Montrosier 1882. Eugène Montrosier. *Peintres modernes: Ingres, H. Flandrin, Robert-Fleury.* Paris, 1882.

Montrouge 1974. *Amaury-Duval 1808–1885.* Montrouge, May 2–June 3, 1974. Exh. cat. by Véronique Noel-Bouton. Montrouge, 1974.

Moreau-Nélaton 1918. Étienne Moreau-Nélaton. *Mémorial de famille.* 5 vols. Paris, 1918.

Mornand 1855. Félix Mornand. "L'Exposition universelle de 1855." *Journal des demoiselles* 8, no. 8 (August 1855), pp. 225–31.

Moscow 1955. *Exhibition of French Art of the Fifteenth to Twentieth Centuries. Catalogue.* Moscow, State Pushkin Museum, 1955. Exh. cat. Moscow, 1955.

Mourey 1908. Gabriel Mourey. "Exposition de portraits d'hommes et de femmes célèbres dans le Palais du Domaine de Bagatelle." *Les Arts,* no. 78 (June 1908), pp. 2–7.

Mráz 1983. Bohumír Mráz. *Ingres: Zeichnungen.* Prague, 1983.

Munich 1958–59. *Hauptwerke der Sammlung Emil Georg Bührle, Zürich.* Munich, Haus der Kunst, December 5, 1958–February 15, 1959. Exh. cat. Munich, 1959.

Munich 1964–65. *Französische Malerei des 19. Jahrhunderts von David bis Cézanne.* Munich, Haus der Kunst, October 7, 1964–January 6, 1965. Exh. cat. Munich, 1964.

Musgrave 1974. E. I. Musgrave. *Newby Hall: In the Yorkshire Home of the Compton Family.* Derby, 1974.

Muther 1893–94. Richard Muther. *Geschichte der Malerei im XIX. Jahrhundert.* 3 vols. Munich, 1893–94.

Nadar, September 16, 1855. Nadar [Gaspard-Félix Tournachon]. "Salon de 1855." *Le Figaro,* September 16, 1855.

Nadar 1857. Nadar [Gaspard-Félix Tournachon]. *Nadar jury au Salon de 1857.* Paris, 1857.

Naef 1950. Hans Naef. "Spät und mit wenigen, Bemerkungen zum Thema Ingres." *Weltwoche* September 22, 1950.

Naef 1952. Hans Naef. "A Recently Discovered Drawing by Ingres" [John Robert Russell, duke of Bedford]. *Graphis* 8, no. 43 (1952), pp. 438–40.

Naef 1954 (*Antwortende Bilder*). Hans Naef. *Antwortende Bilder.* Zurich, 1954.

Naef 1955 ("westschweizerischen Freunde"). Hans Naef. "Ingres als Porträtist seiner westschweizerischen Freunde." *Du* 15 (August 1955), pp. 16–26.

Naef 1956 ("English Sitters"). Hans Naef. "Ingres' Portrait Drawings of English Sitters in Rome." *Burlington Magazine* 98 (December 1956), pp. 427–35.

Naef 1956 (Reinhold). Hans Naef. "Zwei unveröffentlichte Ingres-Zeichnungen" [Frau Reinhold mit ihren Kindern, Schwester von Frau Reinhold]. *Schweizer Monatshefte,* March 1956, pp. 649–54.

Naef 1956 ("Vier Meisterwerke"). Hans Naef. "Vier Meisterwerke von Ingres in ihrem Zusammenhang." *Atlantis* 28 (February 1956), pp. 62–69.

Naef 1957 ("Deux Dessins"). Hans Naef. "Deux Dessins d'Ingres: Monseigneur Cortois de Pressigny et le chevalier de Fontenay." *La Revue des arts* 56 (November–December 1957), pp. 243–48.

Naef 1957 ("muses"). Hans Naef. "Monsieur Ingres et ses muses." *L'Oeil,* no. 25 (January 1957), pp. 48–51.

Naef 1957 ("Notes I"). Hans Naef. "Notes on Ingres Drawings, I" [portraits of Victor Dourlen, Jean-Joseph Fournier, M. and M^me Defresne]. *Art Quarterly* 20 (summer 1957), pp. 180–90.

Naef 1957 ("Notes II"). Hans Naef. "Notes on Ingres Drawings, II" [portraits of Louise Vernet, M^me Gabriac, Paul Lemoyne]. *Art Quarterly* 20 (autumn 1957), pp. 289–301.

Naef 1958 ("Marcotte Family"). Hans Naef. "Ingres' Portraits of the Marcotte Family." *Art Bulletin* 40 (December 1958), pp. 336–45.

Naef 1958 ("Meisterwerk"). Hans Naef. "Ein unveröffentlichtes Meisterwerk von Ingres im Staedelschen Kunstinstitut." *Die Weltkunst* 28 (February 15, 1958), p. 9.

Naef 1958 ("Notes III"). Hans Naef. "Notes on Ingres Drawings, III" [portraits of Dr. Espinaud and M^me Tournouër]. *Art Quarterly* 21 (winter 1958), pp. 407–17.

Naef 1958 ("Unpublished English Sitters"). Hans Naef. "Two Unpublished Portrait Drawings of English Sitters by Ingres." *Burlington Magazine* 100 (February 1958), pp. 61–63.

Naef 1960 ("Ingres-Zeichnungen"). Hans Naef. "Vier Ingres-Zeichnungen" (Portrait of an Unknown Girl [State Hermitage Museum, Saint Petersburg], Lucien Bonaparte, Mlle. Lorimier, F. Pouqueville). *Pantheon* 18 (1960), pp. 35–43.

Naef 1960 (Rome). Hans Naef. *Rome vue par Ingres.* Lausanne, 1960.

Naef 1961 ("Schweizer Künstler, II"). Hans Naef. "Schweizer Künstler in Bildnissen von Ingres, II: Die Malerin Barbara Bansi." *Neue Zürcher Zeitung,* Sunday edition, December 10, 1961, pp. 5, 7.

Naef 1961 ("Zwei unveröffentlichte Ingres-Zeichnungen"). Hans Naef. "Zwei unveröffentlichte Ingres-Zeichnungen." *Pantheon* 19 (March–April 1961), pp. 78–81.

Naef 1963 ("Familie Lethière"). Hans Naef. "Ingres und die Familie Guillon Lethière." *Du* 23 (December 1963), pp. 65–78.

Naef 1963 (Schweizer Künstler). Hans Naef. *Schweizer Künstler in Bildnissen von Ingres.* Zurich, 1963.

Naef 1964 ("Familie Hittorff"). Hans Naef. "Ingres und die Familie Hittorff." *Pantheon* 22 (July–August 1964), pp. 249–63.

Naef 1965 ("Gravures"). Hans Naef. "Parmi les gravures de la collection Ingres." *Bulletin du Musée Ingres,* no. 18 (December 1965), pp. 5–10.

Naef 1965 ("Ingrisme"). Hans Naef. "L'Ingrisme dans le monde." *Bulletin du Musée Ingres,* no. 17 (July 1965), p. 21.

Naef 1965 ("Sebastiani"). Hans Naef. "Two Unknown Ingres Portraits: M. and M^me Sebastiani." *Master Drawings* 3 (1965), pp. 276–80.

Naef 1965 ("Thévenin und Taurel"). Hans Naef. "Ingres und die Familien Thévenin und Taurel." *Nederlands kunsthistorisch jaarboek* 16 (1965), pp. 119–57.

Naef 1966 ("Familie Leblanc"). Hans Naef. "Ingres und die Familie Leblanc." *Du* 26 (February 1966), pp. 121–34.

Naef 1966 ("Gonin, Thomeguex et Guerber"). Hans Naef. "Ingres et les familles Gonin, Thomeguex et Guerber." *Genava,* n.s., 14 (1966), pp. 113–53, 161.

Naef 1966 ("Gounod"). Hans Naef. "Portrait Drawings by Ingres in the Art Institute of Chicago, I: Charles Gounod and Madame Gounod." *Museum Studies* 1 (1966), pp. 66–84.

Naef 1966 ("Hayard"). Hans Naef. "Ingres et la famille Hayard." *Gazette des beaux-arts,* 6th ser., 67 (January 1966), pp. 37–50.

Naef 1966 ("Ingres as Lithographer"). Hans Naef. "Ingres as Lithographer." *Burlington Magazine* 108 (September 1966), pp. 476–79.

Naef 1966 ("Lazzerini"). Hans Naef. "La famiglia Lazzerini e il ritratto di Ingres." *Paragone,* n.s., 17 (September 1966), pp. 77–84.

Naef 1966 ("Portrait Drawings"). Hans Naef. "Eighteen Portrait Drawings by Ingres." *Master Drawings* 4 (1966), pp. 255–83.

Naef 1967 ("Agoult and Charnacé"). Hans Naef. "Ingres, Madame d'Agoult und die Marquise Claire de Charnacé." *Neue Zürcher Zeitung,* Sunday edition, October 8, 1967, pp. 6–7, ill.

Naef 1967 ("Demoiselles Harvey"). Hans Naef. "Ingres et les demoiselles Harvey." *Bulletin du Musée Ingres,* no. 22 (December 1967), pp. 7–9.

Naef 1967 ("Familie Stamaty"). Hans Naef. "Ingres und die Familie Stamaty." Special enclosure with *Schweizer Monatshefte,* December 1967.

Naef 1967 ("Ingres und Liszt"). Hans Naef. "Ingres und Franz Liszt." *Neue Zürcher Zeitung,* Sunday edition, September 24, 1967, p. 4.

Naef 1967 ("L'Ingrisme"). Hans Naef. "L'Ingrisme dans le monde." *Bulletin du Musée Ingres,* no. 22 (December 1967), pp. 29–31.

Naef 1967 ("Mme Delphine"). Hans Naef. "Au sujet du portrait de M^me Delphine Ingres de 1856." *Bulletin du Musée Ingres,* no. 21 (July 1967), pp. 9–13.

Naef 1967 ("Musée Fogg"). Hans Naef. "L'Exposition Ingres du Musée Fogg, 12 février–9 avril 1967." *Bulletin du Musée Ingres*, no. 21 (July 1967), pp. 5–7.

Naef 1968 ("Demoiselles Harvey"). Hans Naef. "Encore les demoiselles Harvey." *Bulletin du Musée Ingres*, no. 23 (July 1968), pp. 39–43.

Naef 1968 ("Gioconda"). Hans Naef. "Die Gioconda von Ingres." *Schweizer Monatshefte*, December 1968, supplement, pp. [1–12].

Naef 1969 ("Ingres duelliste"). Hans Naef. "Ingres duelliste." *Bulletin du Musée Ingres*, no. 25 (July 1969), pp. 17–20.

Naef 1969 ("Louise Lafont"). Hans Naef. "Louise Lafont, an Unknown Sitter of a Missing Ingres Portrait." *Master Drawings* 7 (1969), pp. 35–38.

Naef 1969 ("Moitessier"). Hans Naef. "New Material on Ingres's Portraits of M^me Moitessier." *Burlington Magazine* 111 (March 1969), pp. 149–50, 151.

Naef 1969 ("Odalisque à l'esclave"). Hans Naef. "*Odalisque à l'esclave* by J. A. D. Ingres." In *Fogg Art Museum Acquisitions, 1968*, pp. 80–99. Cambridge, Mass., 1969.

Naef 1970 ("Griechenlandfahrer"). Hans Naef. "Griechenlandfahrer im Atelier von Ingres." *Archäologischer Anzeiger* 3 (1970), pp. 433–40.

Naef 1970 ("Ingres et Cordier"). Hans Naef. "Ingres et M. Cordier." *La Revue du Louvre et des Musées de France* 20 (1970), pp. 83–86.

Naef 1970 ("Profilbildnisse"). Hans Naef. "Ingres' frühe Profilbildnisse in Medaillonform." *Pantheon* 28 (May–June 1970), pp. 221–36.

Naef 1970 ("Unpublished Letter"). Hans Naef. "Ingres to M. Leblanc, an Unpublished Letter." *The Metropolitan Museum of Art Bulletin* 29 (December 1970), pp. 178–84.

Naef 1971 ("Doktor Martinet"). Hans Naef. "Die Geschichte des Doktors Martinet und sein Bildnis von Ingres." *Image* (Basel) 42 (1971), pp. 17–21.

Naef 1971 ("Harvey and Norton"). Hans Naef. "Henrietta Harvey and Elizabeth Norton: Two English Artists." *Burlington Magazine* 113 (February 1971), pp. 79–89.

Naef 1972 ("famille Rivière"). Hans Naef. "En marge de trois chefs-d'oeuvre d'Ingres: Précisions sur la famille Rivière." *Bulletin de la Société de l'histoire de l'art français*, 1971 (1972), pp. 193–203.

Naef 1972 ("Hittorff"). Hans Naef. "Une Lettre inédite de Jacques-Ignace Hittorff à Ingres." *Bulletin du Musée Ingres*, no. 32 (December 1972), pp. 17–19.

Naef 1972 ("Ingres Royiste"). Hans Naef. "Ingres Royiste." *Image* (Basel) 46 [1972], pp. 25–28.

Naef 1972 ("Révoil"). Hans Naef. "Révoil dessiné par Ingres." *Bulletin du Musée Ingres*, no. 32 (December 1972), pp. 5–10.

Naef 1972 ("Villa Medici"). Hans Naef. "Ingres und die Villa Medici." *Du* 32 (September 1972), pp. 658–64.

Naef 1973 ("Exposition oubliée"). Hans Naef. "Une Exposition oubliée chez Ingres." *Bulletin du Musée Ingres*, no. 34 (December 1973), pp. 23–25.

Naef 1974 ("Fanny Hensel"). Hans Naef. "Ingres, Fanny Hensel et un dessin inédit." *Bulletin du Musée Ingres*, no. 36 (December 1974), pp. 19–22.

Naef 1974 ("Ingres-Modelle"). Hans Naef. "Vier unbekannte Ingres-Modelle." In *Gotthard Jedlicka, eine Gedenkschrift*, edited by Eduard Hüttinger and Hans A. Lüthy, pp. 66–70. Zurich, 1974.

Naef 1974 ("Ingrisme"). Hans Naef. "L'Ingrisme dans le monde." *Bulletin du Musée Ingres*, no. 36 (December 1974), pp. 37–38.

Naef 1974 ("Navez"). Hans Naef. "Navez, ami oublié d'Ingres." *Bulletin du Musée Ingres*, no. 36 (December 1974), pp. 13–18.

Naef 1975 ("Dupaty and Dejuinne"). Hans Naef. "The Sculptor Dupaty and the Painter Dejuinne: Two Unpublished Portraits by Ingres." *Master Drawings* 13 (1975), pp. 261–74.

Naef 1975 ("Ingres et Bergeret"). Hans Naef. "Ingres et son collègue Pierre-Nolasque Bergeret." *Bulletin du Musée Ingres*, no. 37 (July 1975), pp. 3–18.

Naef 1976 ("Degas et Leblanc"). "Degas, acheteur des portraits de M. et M^me Leblanc." *Bulletin du Musée Ingres*, no. 39 (July 1976), pp. 11–14.

Naef 1977–80. Hans Naef. *Die Bildniszeichnungen von J.-A.-D. Ingres.* 5 vols. Bern, 1977–80.

Naef 1990 ("Caroline Murat"). Hans Naef. "Un Chef d'oeuvre retrouvé: *Le Portrait de la reine Caroline Murat* par Ingres." *Revue de l'art*, no. 88 (1990), pp. 11–20.

Naef and Lerch 1964. Hans Naef and Ch.-H. Lerch. "Ingres et M. Devillers." *Bulletin du Musée Ingres*, no. 15 (September 1964), pp. 5–14.

Nantes, Paris, Piacenza 1995–96. *Les Années romantiques: La Peinture française de 1815 à 1850.* Nantes, Musée des Beaux-Arts, December 4, 1995–March 17, 1996; Paris, Grand Palais, April 16–July 15; Piacenza, Palazzo Gotico, September 6–November 17. Exh. cat. Paris, 1995. Italian ed., *Les Années romantiques: La pittura francese dal 1815 al 1850.* Milan, 1996.

Near 1990. Pinkney Near. "European Drawings and Paintings to 1900." *Antiques* 138 (August 1990), pp. 262–69.

Néto 1990. Isabelle Néto-Daguerre de Hureaux. "Granet et Ingres." *Bulletin du Musée Ingres*, nos. 63–64 (1990), pp. 2–17.

Néto 1995. Isabelle Néto. *Granet et son entourage: Correspondance.* Archives de l'art français, n.s., 31. Nogent-le-Roi, 1995.

Néto-Daguerre and Coutagne 1992. Isabelle Néto-Daguerre and Denis Coutagne. *Granet: Peintre de Rome.* Aix-en-Provence, 1992.

Newark 1954. *From the Collection of Mrs. C. Suydam Cutting.* Newark Museum, February 8–April 25, 1954. Exh. cat. Newark, 1954.

Newark 1960. *Old Master Drawings.* Newark Museum, March 17–May 22, 1960. Exh. cat. Newark, 1960.

New Brunswick, Cleveland 1982–83. *Dürer to Cézanne: Northern European Drawings from the Ashmolean Museum.* New Brunswick, Rutgers University, Jane Voorhees Zimmerli Art Museum, September 12–October 24, 1982; Cleveland Museum of Art, November 16, 1982–January 2, 1983. Exh. cat. by Christopher Lloyd. New Brunswick, 1982.

New Haven, Houston, Indianapolis, Amsterdam, Lausanne 1991–93. *Félix Vallotton.* New Haven, Yale University Art Gallery, October 24, 1991–January 5, 1992; Houston, Museum of Fine Arts, January 31–March 29; Indianapolis Museum of Art, April 25–June 21; Amsterdam, Van Gogh Museum, August 27–November 1; Lausanne, Musée Cantonale des Beaux-Arts, November 21, 1992–January 31, 1993. Exh. cat. by Sasha M. Newman, with essays by Marina Ducrey et al. New Haven and New York, 1991.

New Haven, Paris 1991–92. *Richard Parkes Bonington: "On the Pleasure of Painting."* New Haven, Yale Center for British Art, November 13, 1991–January 19, 1992; Paris, Petit Palais, March 5–May 17. Exh. cat. by Patrick Noon. New Haven, 1991.

Newman 1980. Richard Newman. "The Microtopography of Pencil Lead in Drawings: A Preliminary Report." In *Papers Presented at the Art Conservation Training Programs Conference.* Winterthur, Del.: University of Delaware Program in Conservation of Artistic and Historic Objects, 1980.

New Orleans 1953–54. *A Loan Exhibition of Masterpieces of French Paintings through Five Centuries, 1400–1900, in Honor of the 150th Anniversary of the Louisiana Purchase.* New Orleans, Isaac Delgado Museum of Art, October 17, 1953–January 10, 1954. Exh. cat. New Orleans, 1953.

New York 1925. *Original Drawings by the Old Masters.* New York, Jacques Seligmann Galleries, December 1–19, 1925. Exh. cat. New York, 1925.

New York 1926. "Special Dedication Exhibition of French Art." New York, Museum of French Art, January 1926. Exh. cat. published in *Dedication of the French Institute.* New York, 1926.

New York 1928. "Water Colors and Drawings." New York, [César] de Hauke & Co., 1928.

New York 1930. *The H. O. Havemeyer Collection: A Catalogue of the Temporary Exhibition.* New York, The Metropolitan Museum of Art, March 10–November 2, 1930. Exh. cat. New York, 1930.

New York 1931. "Modern French Paintings, Water Colors, and Drawings." New York, C. W. Kraushaar Art Galleries, October 5–31, 1931.

New York 1933. "Drawings of the Past and Present Time." New York, New School for Social Research, November 14–December 9, 1933.

New York 1934. *Exhibition of Important Paintings by Great French Masters of the Nineteenth Century.* New York, Durand-Ruel Galleries, February 12–March 10, 1934. Exh. cat. New York, 1934.

New York 1935. *An Exhibition of Eleven Paintings from the Louvre Lent by the French Government.* New York, Museum of French Art, January 10–26, 1935. Exh. cat. New York, 1935.

New York 1939. *Five Centuries of History Mirrored in Five Centuries of French Art.* New York World's Fair, 1939. Exh. cat. New York, 1939.

New York 1940. See **Springfield, New York 1939–40.**

New York 1940a. "Masterpieces of Art." New York World's Fair, May–October 1940. Exh. cat.: Walter Pach. *Catalogue of European & American Paintings, 1500–1900.* New York, 1940.

New York 1941a. *French Painting from David to Toulouse-Lautrec: Loans from French and American Museums and Collections.* New York, The Metropolitan Museum of Art, February 6–March 26, 1941. Exh. cat. New York, 1941.

New York 1941b. *Loan Exhibition in Honour of Royal Cortissoz.* New York, M. Knoedler and Co., December 1–20, 1941. Exh. cat. New York, 1941.

New York 1946. *A Catalogue of an Exhibition of Paintings and Prints of Every Description on the Occasion of Knoedler, One Hundred Years, 1846–1946.* New York, M. Knoedler and Co., April 1–27, 1946. Exh. cat. New York, 1946.

New York 1946–47. *American Aid to France.* New York, M. Knoedler and Co., December 1946–January 11, 1947. Exh. cat. New York, 1947.

New York 1947. "Master Drawings from the Fogg Museum Collected by Paul J. Sachs." New York, Century Club, 1947.

New York 1947–48. *An Exhibition of French XIX Century Drawings.* New York, Wildenstein and Co., December 10, 1947–January 10, 1948. Exh. cat. New York, 1947.

New York 1948. *19th and 20th Century American and French Drawings.* New York, Paul Rosenberg Galleries, 1948. Exh. cat. New York, 1948.

New York 1951. *Wildenstein Jubilee Loan Exhibition, 1901–1951.* New York, Wildenstein and Co., November 8–December 15, 1951. Exh. cat. New York, 1951.

New York 1952–53. *Art Treasures of the Metropolitan: A Selection from the European and Asiatic Collections of The Metropolitan Museum of Art.* New York, The Metropolitan Museum of Art, November 7, 1952–September 7, 1953. Exh. cat. New York, 1952.

New York 1960a. "Master Drawings." New York, Jacques Seligmann Galleries, 1960.

New York 1960b. "The Walter C. Baker Collection of Master Drawings." New York, The Metropolitan Museum of Art. June 1–September 5, 1960. Exh. cat. published in Virch 1960.

New York 1961. *Ingres in American Collections.* New York, Paul Rosenberg and Co., April 7–May 6, 1961. Exh. cat. New York, 1961.

New York 1962. *The Lehman Collection, 7 West 54th Street.* Exh. cat. New York, 1962.

New York 1963. *Master Drawings from the Art Institute of Chicago.* New York, Wildenstein and Co., October 17–November 30, 1963. Exh. cat. [Chicago], 1963.

New York 1965. "19th–20th Century Master Drawings." New York, Gallery of Modern Art, 1965.

New York 1970. *Classicism and Romanticism: French Drawings and Prints, 1800–1860.* New York, The Metropolitan Museum of Art, September 15–November 1, 1970. Exh. cat. New York, 1970.

New York 1971. *Artists and Writers: Nineteenth and Twentieth Century Portrait Drawings from the Collection of Benjamin Sonnenberg.* New York, Pierpont Morgan Library, 1971. Exh. cat. by Felice Stampfle. New York, 1971.

New York 1972. *Harry D. M. Grier Memorial Loan Exhibition: Paintings and Drawings Related to Works in the Frick Collection.* New York, Frick Collection, November 14–26, 1972. Exh. cat. New York, 1972.

New York 1973. *Drawings from the Collection of Lore and Rudolf Heinemann.* New York, Pierpont Morgan Library, 1973. Exh. cat. by Felice Stampfle. New York, 1973.

New York 1976. "French Neoclassicism." New York, Wildenstein and Co., April 16–May 15, 1976.

New York 1977. *Treasures from Rochester.* New York, Wildenstein and Co., April 14–May 28, 1977. Exh. cat. by Denys Sutton. New York, 1977.

New York 1978. *The Arts under Napoleon.* New York, The Metropolitan Museum of Art, April 6–July 30. Exh. cat. New York, 1978.

New York 1980–81. *Nineteenth Century French Drawings from the Robert Lehman Collection.* New York, The Metropolitan Museum of Art, November 26, 1980–March 31, 1981. Exh. cat. by George Szabo. New York, 1980.

New York 1981. "19th Century French Drawings and Prints." New York, The Metropolitan Museum of Art, June 23–August 23, 1981.

New York 1984. *French Drawings, 1550–1825.* New York, Pierpont Morgan Library, May 9–July 31, 1984. Exh. cat. New York, 1984.

New York 1984–85. "French Drawings Recently Acquired, 1975–1984." New York, The Metropolitan Museum of Art, November 27, 1984–February 10, 1985.

New York 1985–86. *Ingres and the Comtesse d'Haussonville.* New York, Frick Collection, November 19, 1985–February 16, 1986. Exh. cat. by Edgar Munhall. New York, 1985. Revised ed., New York, 1998.

New York 1986. "Two Portraits by Ingres: *Princesse de Broglie* and *Comtesse d'Haussonville.*" New York, Frick Collection, April 29–June 15, 1986. Exhibition brochure by Edgar Munhall. New York, 1986.

New York 1988a. "Images of Women: Drawings from Five Centuries in the Robert Lehman Collection." New York, The Metropolitan Museum of Art, May 3–July 10, 1988.

New York 1988b. *The Presence of Ingres: Important Works by Ingres, Chassériau, Degas, Picasso, Matisse, and Balthus.* New York, Jan Krugier Gallery, November 5–December 23, 1988. Exh. cat. New York, 1988.

New York 1988c. *Creative Copies: Interpretative Drawings from Michelangelo to Picasso.* New York, Drawing Center, April 9–July 23, 1988. Exh. cat. by Egbert Haverkamp-Begemann. New York, 1988.

New York 1988–89. "Ingres at the Metropolitan." New York, The Metropolitan Museum of Art, December 14, 1988–March 19, 1989.

New York 1989–90. *The Winds of Revolution.* New York, Wildenstein and Co., November 14, 1989–January 19, 1990. Exh. cat. by Joseph Baillio. New York, 1989.

New York 1989–90a. *The Age of Napoleon: Costume from Revolution to Empire, 1789–1815.* New York, The Metropolitan Museum of Art, December 13, 1989–April 15, 1990. Exh. cat. edited by Katell le Bourhis; essays by Charles Otto Zieseniss et al. New York, 1989.

New York 1990. "Master Drawings from the Woodner Collection." New York, The Metropolitan Museum of Art, March 10–May 13, 1990. Exh. cat., *Woodner Collection: Master Drawings,* compiled by Ann Dumas et al.; based on the 1987 Royal Academy of Arts catalogue edited by Jane Shoaf Turner. New York, 1990.

New York 1993. *Splendid Legacy: The Havemeyer Collection.* New York, The Metropolitan Museum of Art, March 27–June 20, 1993. Exh. cat. by Alice Cooney Frelinghuysen et al. New York, 1993.

New York 1995–96. *Fantasy and Reality: Drawings from the Sunny Crawford von Bülow Collection.* New York, Pierpont Morgan Library, September 14, 1995–January 7, 1996. Exh. cat. by Cara Dufour Denison, with Stephanie Wiles and Ruth S. Kraemer. New York, 1995.

New York 1996. *The French Portrait, 1550–1850.* New York, Colnaghi, January 10–February 10, 1996. Exh. cat. by Alan Wintermute and Donald Garstang. New York, 1996.

New York 1997–98. *The Private Collection of Edgar Degas.* New York, The Metropolitan Museum of Art, October 1, 1997–January 11, 1998. Exh. cat. [Vol. 1] by Ann Dumas, Colta Ives, Susan Alyson Stein, and Gary Tinterow. [Vol. 2], *The Private Collection of Edgar Degas: A Summary Catalogue,* compiled by Colta Ives, Susan Alyson Stein, and Julie A. Steiner, with Ann Dumas, Rebecca A. Rabinow, and Gary Tinterow. New York, 1997.

New York, Cambridge (Mass.) 1961–62. *A Loan Exhibition of Paintings and Drawings from the Hanley Collection.* New York, Wildenstein and Co., November 22–December 30, 1961; Cambridge, Mass., Fogg Art Museum, January 24–April 15, 1962. Exh. cat. New York, 1961.

New York, Chicago 1990. *From Poussin to Matisse: The Russian Taste for French Painting.* New York, The Metropolitan Museum of Art, May 20–July 29, 1990; Art Institute of Chicago, September 8–November 25. Exh. cat. Chicago and New York, 1990.

New York, Cleveland, San Francisco 1988–89. *François-Marius Granet: Watercolors from the Musée Granet at Aix-en-Provence.* New York, Frick Collection, November 21, 1988–January 15, 1989; Cleveland Museum of Art, February 7–March 19; Fine Arts Museum of San Francisco, California Palace of the Legion of Honor, April 1–May 28. Exh. cat. by Edgar Munhall; "Memoirs of the Painter Granet," translated and annotated by Joseph Focarino. New York, 1988.

New York, Des Moines, Corpus Christi, Houston, Denver 1979–80. *Master Drawings and Watercolors of the Nineteenth and Twentieth Centuries.* Organized by Baltimore Museum of Art and American Federation of Arts; circulated August 1979–August 1980 to New York, Solomon R. Guggenheim Museum; Des Moines Art Center; Corpus Christi, Art Museum of South Texas; Houston, Museum of Fine Arts; Denver Art Museum. Exh. cat. with introduction by Victor Carlson and entries by Carol Hynning Smith. New York, 1979.

New York, Fort Worth, Baltimore, Minneapolis, Philadelphia 1976–77. *European Drawings from the Fitzwilliam: Lent by the Syndics of the Fitzwilliam Museum, University of Cambridge.* Organized and circulated by the International Exhibitions Foundation to New York, Pierpont Morgan Library; Fort Worth, Kimbell Art Museum; Baltimore Museum of Art; Minneapolis Institute of Arts; Philadelphia Museum of Art. Exh. cat. edited and introduced by Michael Jaffé. Washington, D.C., 1976.

New York, Fort Worth, Cleveland 1990–91. *From Pisanello to Cézanne: Master Drawings from the Museum Boymans-van Beuningen, Rotterdam.* New York, Pierpont Morgan Library, May 15–August 4, 1990; Fort Worth, Kimbell Art Museum, August 18–October 21; Cleveland Museum of Art, November 13, 1990–January 13, 1991. Exh. cat. by Ger Luijten and A. W. F. M. Meij. Cambridge, 1990.

New York, Frick Collection 1949. Frick Collection. *The Frick Collection: An Illustrated Catalogue of the Works of Art in the Collection of Henry Clay Frick.* Vol. 1, *Paintings.* Pittsburgh, 1949.

New York, Frick Collection 1968. Frick Collection. *The Frick Collection: An Illustrated Catalogue.* Vol. 2, *Paintings: French, Italian and Spanish.* New York, 1968.

New York, London 1993–94. *Drawings from the J. Paul Getty Museum.* New York, The Metropolitan Museum of Art, May 24–August 8, 1993; London, Royal Academy of Arts, October 30, 1993–January 23, 1994. Exh. cat. introduction by George R. Goldner. New York, 1993.

New York, Manchester, Detroit, Cincinnati, Cleveland, San Francisco 1952–53. *A Loan Exhibition of Paintings and Drawings by Ingres from the Ingres Museum at Montauban Organized by the Knoedler Galleries for the Benefit of the Museum of Montauban.* New York, M. Knoedler and Co., November 2–29, 1952; Manchester, Currier Gallery of Art; Detroit Institute of Arts; Cincinnati Art Museum; Cleveland Museum of Art; San Francisco, California Palace of the Legion of Honor, 1952–53. Exh. cat. essays by Agnes Mongan and Daniel Ternois. [Paris], 1952.

New York, Morgan Library 1978. Pierpont Morgan Library. *Eighteenth Report to the Fellows, 1975–1977.* New York, 1978.

New York, Paris 1996–97. *Picasso and Portraiture: Representation and Transformation.* New York, Museum of Modern Art, April 28–September 17, 1996; Paris, Grand Palais, October 1996–January 1997. Exh. cat. with essays by Anne Baldassari et al. Edited by William Rubin. New York, 1996.

New York, Philadelphia, Denver 1967–68. *Selections from the Collection of Dr. and Mrs. T. Edward Hanley.* New York, Gallery of Modern Art, January 3–March 12, 1967; Philadelphia Museum of Art, April 6–May 28; Denver Art Museum, February 22–April 30, 1968. Exh. cat. New York, 1967.

Nibelle 1855. Paul Nibelle. "Exposition universelle." *La Lumière,* September 15, 1855, pp. 147–48.

Nice 1931. *Exposition Ingres.* Nice, Palais des Arts, Musée Jules Chéret, March 1–28, 1931. Exh. cat. Nice, 1931.

Nicolle 1920. Marcel Nicolle. *Le Musée de Rouen: Peintures.* Paris, 1920.

Niel, June 17, 1855. Georges Niel. "Exposition universelle des beaux-arts." *La Presse théâtrale,* June 17, 1855.

Niel, July 15, 1855. Georges Niel. "Exposition universelle des beaux-arts." *La Presse théâtrale*, July 15, 1855.

Nisard, March 9, 1833. [Jean-Marie-Napoléon-Désiré] N[isard]. "Salon de 1833." *Le National*, March 9, 1833.

Nisard, April 7, 1833. [Jean-Marie-Napoléon-Désiré] N[isard]. "Salon de 1833." *Le National*, April 7, 1833.

Nochlin 1971. Linda Nochlin. *Realism.* Harmondsworth, 1971.

Norfolk Chronicle **1830.** *Norfolk Chronicle*, July 17, 1830, p. [3].

Northampton, Smith College Museum of Art 1937. Smith College Museum of Art. *Catalogue.* Northampton, Mass., 1937.

Northampton, Smith College Museum of Art 1953. Smith College Museum of Art. *Forty French Pictures in the Smith College Museum of Art.* Northampton, Mass., 1953.

Northampton, Smith College Museum of Art 1958. Smith College Museum of Art. *Check List, European Drawings, Smith College Museum of Art.* Northampton, Mass., 1958.

Norvins 1827–28. Jacques Marquet, baron de Montbreton de Norvins. *Histoire de Napoléon.* 4 vols. Paris, 1827–28.

Norvins 1896. Jacques Marquet, baron de Montbreton de Norvins. *J. de Norvins, Mémorial.* Edited by L[éon] de Lanzac de Laborie. Vol. 2. Paris, 1896.

Norwich Mercury **1821.** *Norwich Mercury*, November 24, 1821.

Nouvelle Biographie générale **1853–66.** *Nouvelle Biographie générale depuis les temps les plus reculés jusqu'à nos jours. . . .* 46 vols. Paris, 1853–66.

Novotny 1960. Fritz Novotny. *Painting and Sculpture in Europe, 1780 to 1880.* Baltimore, 1960.

Oberlin 1967. "Ingres and His Circle: An Exhibition of Drawings." Oberlin, Ohio, Allen Memorial Art Museum, March 3–24, 1967. Exh. cat., with an essay by Agnes Mongan, published in *Allen Memorial Art Museum Bulletin* 24 (spring 1967), pp. 143–83.

Oberti 1954. G[eorges] Oberti. "Ingres et Moltedo." *Le Petit Écho de la Corse*, May 1954, pp. 6f.

Ockman 1991. Carol Ockman. "'Two Large Eyebrows à l'Orientale': Ethnic Stereotyping in Ingres's *Baronne de Rothschild.*" *Art History* 14 (December 1991), pp. 521–39.

Ockman 1995. Carol Ockman. *Ingres's Eroticized Bodies: Retracing the Serpentine Line.* New Haven and London, 1995.

O'Donoghue 1908–25. Freeman M. O'Donoghue. *Catalogue of Engraved British Portraits Preserved in the Department of Prints and Drawings in the British Museum.* 6 vols. London, 1908–25.

Omaha 1951. *Twentieth Century Exhibition. The Beginnings of Modern Painting: France, 1800–1910.* Omaha, Joslyn Memorial Art Museum, October 4–November 4, 1951. Exh. cat. Omaha, 1951.

Omaha 1956–57. *Three Exhibitions: Notable Paintings from Midwestern Collections / Notable Collections at Joslyn Art Museum / [Twenty-fifth] Anniversary Purchase Exhibition.* Omaha, Joslyn Art Museum, November 30, 1956–January 2, 1957. Exh. cat. Omaha, 1956.

Opresco 1928. G. Opresco. "Dessins français du XIXème siècle au Musée Britannique." *La Revue de l'art ancien et moderne* 54 (1928), pp. 325–54.

Orwicz 1994. Michael R. Orwicz, ed. *Art Criticism and Its Institutions in Nineteenth-Century France.* Manchester and New York, 1994.

Ottawa, Chicago, Fort Worth 1997–98. *Renoir's Portraits: Impressions of an Age.* Ottawa, National Gallery of Canada, June 27–September 14, 1997; Art Institute of Chicago, October 17, 1997–January 4, 1998; Fort Worth, Kimbell Art Museum, February 8–April 26. Exh. cat. by Colin B. Bailey et al. New Haven and London, 1997.

Ottawa, Toronto 1934. *French Painting of the Nineteenth Century.* Ottawa, National Gallery of Canada, January 1934; Art Gallery of Toronto, February 1934. Exh. cat. Ottawa, 1934.

Oxford, Ashmolean Museum 1979. Ashmolean Museum. *Nineteenth Century European Drawings in the Ashmolean Museum.* Oxford, 1979.

Oxford, Ashmolean Museum n.d. Ashmolean Museum. *University of Oxford: Drawings Selected from the Collections in the Ashmolean Museum.* Oxford, n.d.

Pach 1939. Walter Pach. *Ingres.* New York and London, 1939. Reprinted, New York, 1973.

Pach 1952. Walter Pach. "A 'New' Portrait by Ingres." *Art Quarterly* 15 (spring 1952), pp. 3–8.

Pach 1955. Walter Pach. "The Heritage of J.-L. David." *Gazette des beaux-arts*, 6th ser., 45 (February 1955), pp. 103–12.

Pagnerre 1890. Louis Pagnerre. *Charles Gounod: Sa Vie et ses oeuvres.* Paris, 1890.

Paisse 1968. Jean-Marie Paisse. "Ingres et le portrait d'enfant." *Bulletin du Musée Ingres*, no. 24 (December 1968), pp. 17–23.

Paisse 1971. Jean-Marie Paisse. "Esquisse d'une analyse psychologique du portrait de la famille Alexandre Lethière." *Bulletin du Musée Ingres*, no. 30 (December 1971), pp. 13–19.

Palm Beach 1951. *Portraits, Figures, and Landscapes.* Palm Beach, Society of the Four Arts, January 12–February 4, 1951. Exh. cat. Palm Beach, 1951.

Pange 1962. Pauline-Laure-Marie de Broglie, comtesse de Pange. *Comment j'ai vu 1900.* Paris, 1962.

Pansu 1977. Evelyne Pansu. *Ingres dessins.* Paris, 1977.

Paris 1846. *Explication des ouvrages de peinture exposés dans la galerie des beaux arts, boulevard Bonne Nouvelle 22.* Paris, January 11, 1846. Exh. cat. Paris, 1846.

Paris 1855. "Exposition universelle de 1855." Paris, Palais des Beaux-Arts, opened May 15, 1855. Exh. cat., *Explication des ouvrages de peinture, sculpture, gravure, lithographie et architecture des artistes vivants étrangers et français.* Paris, 1855.

Paris 1861. *Dessins [d'Ingres] tirés de collections d'amateurs.* [1st ser. and 2nd ser.] Paris, Salon des Arts-Unis, 1861. Exh. cat. [1st ser.]. Paris 1861. Exh. cat. [1st ser.] Paris, 1861. To date, no brochure or catalogue has been identified for the 2nd series.

Paris 1862. Exhibition. Paris, Galerie Martinet, 1862.

Paris 1867. *Catalogue des tableaux, études peintes, dessins et croquis de J.-A.-D. Ingres, peintre d'histoire, sénateur, membre de l'Institut.* Paris, École Impériale des Beaux-Arts, 1867. Exh. cat. Paris, 1867.

Paris 1874. *Explication des ouvrages de peinture exposés au profit de la colonisation de l'Algérie par les Alsaciens-Lorrains.* Paris, Palais de la Présidence du Corps Législatif, April 23, 1874. Exh. cat. Paris, 1874.

Paris 1878. *Exposition universelle de 1878: Notice historique et analytique des peintures, sculptures, tapisseries, exposées dans les Galeries des Portraits nationaux.* Paris, Palais du Trocadéro, 1878. Exh. cat. Paris, 1878.

Paris 1883. *Exposition de portraits du siècle (1783–1883).* Paris, École des Beaux-Arts, April 25, 1883. Exh. cat. Paris, 1883.

Paris 1884. *Dessins de l'école moderne.* Paris, École des Beaux-Arts, February 1884. Exh. cat. Paris, 1884.

Paris 1885. *Catalogue de la deuxième exposition de portraits du siècle.* Paris, École des Beaux-Arts, April 20, 1885. Exh. cat. Paris, 1885.

Paris 1885a. *Exposition Eugène Delacroix, au profit de la souscription destinée à élever à Paris un monument à sa mémoire.* Paris, École des Beaux-Arts, March 6–April 15, 1885. Exh. cat. Paris, 1885.

Paris 1889a. *Exposition centennale de l'art français, 1789–1889.* Paris, Exposition universelle internationale, Palais des Beaux-Arts, 1889. Exh. cat. Paris, 1889.

Paris 1889b. *Portraits d'architectes.* Paris, École des Beaux-Arts, 1889. Exh. cat. Paris, 1889.

Paris 1891. *Exposition des arts au début du siècle.* Paris, Palais du Champ de Mars, May 9, 1891. Exh. cat. Paris, 1891.

Paris 1900a. "Exposition universelle de 1900." Paris, Grand Palais, 1900. Exh. cat., *Catalogue officiel illustré de l'Exposition centennale de l'art français, 1800–1889.* Paris, 1900.

Paris 1900b. "Exposition rétrospective de la guerre." Paris, 1900.

Paris 1905. "Oeuvres d'Ingres." Paris, Grand Palais, Salon d'Automne, 1905.

Paris 1908. *Portraits d'hommes et de femmes célèbres (1830 à 1900).* Paris, Palais du Domaine de Bagatelle, May 15–July 14, 1908. Exh. cat. Evreux, 1908.

Paris 1910. *Exposition de chefs-d'oeuvre de l'école française: Vingt Peintres du XIX^e siècle.* Paris, Galerie Georges Petit, May 2–31, 1910. Exh. cat. Paris, 1910.

Paris 1911. *Exposition Ingres . . . organisée au profit du Musée Ingres.* Paris, Galerie Georges Petit, April 26–May 14, 1911. Exh. cat. Paris, 1911.

Paris 1913. *Exposition David et ses élèves.* Paris, Palais des Beaux-Arts de la Ville de Paris, April 7–June 9, 1913. Exh. cat. Paris, 1913.

Paris 1914. "L'Art français au dix-neuvième siècle." Paris, 1914.

Paris 1919. *Catalogue des collections nouvelles formées par les Musées Nationaux de 1914 à 1919 et qui sont exposées temporairement dans la salle Lacaze depuis le 10 février 1919.* Paris, Musée du Louvre, 1919. Exh. cat. Paris, 1919.

Paris 1921. *Exposition Ingres.* Paris, Hôtel de la Chambre Syndicale de la Curiosité et des Beaux-Arts, May 8–June 5, 1921. Exh. cat. introduction by Henry Lapauze. Paris, 1921.

Paris 1922a. *Cent Ans de peinture française.* Paris, rue de la Ville-l'Évêque, March 15–April 20, 1922. Exh. cat. Paris, 1922.

Paris 1922b. *Le Décor de la vie sous le Second Empire.* Paris, Musée des Arts Décoratifs, May 27–July 10, 1922. Exh. cat. Paris, 1922.

Paris 1922c. *Oeuvres de grands maîtres du dix-neuvième siècle.* Paris, Galerie Paul Rosenberg, 1922.

Paris 1923. "Enrichissements provenant de dons, legs ou achats récents." Paris, Musée du Louvre, 1923.

Paris 1923a. *L'Art et la vie romantique.* Paris, Hôtel Charpentier, February 25–March 25, 1923. Exh. cat. Paris, 1923.

Paris 1923b. *L'Art français au service de la science française.* Paris, Hôtel de la Chambre Syndicale de la Curiosité et des Beaux-Arts, 1923. Exh. cat. Paris, 1923.

Paris 1924. Exhibition. Paris, rue de la Ville-l'Évêque, 1924.

Paris 1928. *Portraits et figures de femmes: Ingres à Picasso.* Paris, Galerie de la Renaissance, 1928. Exh. cat. Paris, 1928.

Paris 1930. *Le Décor de la vie à l'époque romantique (1820–1848).* Organized by the Musée des Arts Décoratifs, Paris. Paris, Musée du Louvre, Pavillon de Marsan, April–May 1930. Exh. cat. Paris, 1930.

Paris 1930a. *Exposition du centenaire de la conquête de l'Algérie, 1830–1930.* Paris, Petit Palais, May–June 1930. Exh. cat. Paris, 1930.

Paris 1931. *Exposition d'oeuvres importantes de grands maîtres du dix-neuvième siècle: Prêtées au profit de la Cité Universitaire de l'Université de Paris.* Paris, Galerie Paul Rosenberg, May 18–June 27, 1931. Exh. cat. Paris, 1931.

Paris 1933a. *Les Achats du Musée du Louvre et les dons de la Société des Amis du Louvre, 1922–1932.* Paris, Musée de l'Orangerie, April–May 1933. Exh. cat. Paris, 1933.

Paris 1933b. *Les Chefs-d'Oeuvre des musées de province, II^e exposition: Portraits et scènes de guerre. École française, 1650–1830. . . .* Paris, Musée Carnavalet, 1933. Exh. cat. Paris, 1933.

Paris 1934a. *Les Artistes français en Italie de Poussin à Renoir.* Paris, Musée des Arts Décoratifs, May–July 1934. Exh. cat. Paris, 1934.

Paris 1934b. *David—Ingres—Géricault et leur temps: Exposition de peintures, dessins, lithographies et sculptures faisant partie des collections de l'École.* Paris, École des Beaux-Arts, 1934. Exh. cat. Paris, 1934.

Paris 1934c. *Exposition de portraits par Ingres et ses élèves.* Paris, MM. Jacques Seligmann & fils, March 23–April 21, 1934. Exh. cat. by Charles Sterling. Paris, 1934.

Paris 1934d. "Cent Ans de portrait français." Paris, Galerie Bernheim-Jeune, 1934.

Paris 1935a. *Portraits et figures de femmes: Pastels et dessins.* Paris, Musée de l'Orangerie, 1935. Exh. cat. compiled by Jean Vergnet-Ruiz. Paris, 1935.

Paris 1935b. *Troisième Centenaire de l'Académie française.* Paris, Bibliothèque Nationale, June 1935. Exh. cat. Paris, 1935.

Paris 1935c. "Quelques Tableaux d'Ingres à Gauguin." Paris, Galerie Bernheim-Jeune, 1935.

Paris 1935d. "Exposition napoléonienne." Paris, Galerie Mazarine, 1935.

Paris 1936. *Exposition "Le Grand Siècle."* Paris, Galerie Paul Rosenberg, June 15–July 11, 1936. Exh. cat. Paris, 1936.

Paris 1936a. *Exposition de portraits français de 1400 à 1900.* Paris, André J. Seligman, 1936. Exh. cat. preface by Claude Roger-Marx. Paris, 1936.

Paris 1937. *Chefs-d'Oeuvre de l'art français.* Paris, Palais National des Arts, 1937. Exh. cat. Paris, 1937.

Paris 1938a. *Exposition de tableaux et dessins: Quelques Maîtres du 18^e et du 19^e siècle.* Paris, Durand-Ruel & Cie., 1938. Exh. cat. Paris, 1938.

Paris 1938b. "Les Influences (Ingres à de Segonzac)." Paris, Galerie Paul Rosenberg, 1938.

Paris 1945. *Musées Nationaux, nouvelles acquisitions réalisées depuis le 2 septembre 1939.* Paris, Musée du Louvre, 1945.

Paris 1946a. *Les Chefs-d'Oeuvres des collections françaises retrouvés en Allemagne par la commission de la récupération artistique et les Services alliés.* Paris, Musée de l'Orangerie, June–August 1946. Exh. cat. Paris, 1946.

Paris 1946b. *Trois Siècles de dessin parisien.* Paris, Musée Carnavalet, May –June 1946. Exh. cat. Paris, 1946.

Paris 1946c. *Chefs-d'Oeuvre de la peinture française du Louvre: Des Primitifs à Manet.* Paris, Petit Palais, 1946. Exh. cat. Paris, 1946.

Paris 1946d. "Dessins, estampes et ouvrages pour la grande Masse." Paris, École des Beaux-Arts, 1946.

Paris 1947a. *Beautés de la Provence.* Paris, Galerie Charpentier, 1947. Exh. cat. Paris, 1947.

Paris 1947b. *Paysages d'Italie.* Paris, Galerie Charpentier, 1947. Exh. cat. Paris, 1947.

Paris 1949a. *L'Enfance.* Paris, Galerie Charpentier, 1949. Exh. cat. Paris, 1949.

Paris 1949b. *Exposition Ingres: Maître du dessin français.* Paris, Galerie André Weil, June 2–25, 1949. Exh. cat. Paris, 1949.

Paris 1949c. *Ingres: Maître du dessin français.* Paris, Galerie Charpentier, 1949. Exh. cat. introduction by Waldemar George. Paris, 1949.

Paris 1950. *Cent Portraits de femmes: Du XV^e siècle à nos jours.* Paris, Galerie Charpentier, 1950. Exh. cat. Paris, 1950.

Paris 1951. *Les Grands Créateurs de Paris et leurs oeuvres.* Paris, Musée Carnavalet, July–October 1951. Exh. cat. Paris, 1951.

Paris 1952a. *Musée Boymans de Rotterdam: Dessins du XV^e au XIX^e siècle.* Paris, Bibliothèque Nationale, February 20–April 20, 1952. Exh. cat. Paris, 1952.

Paris 1952b. *Peintres de portraits.* Paris, Galerie Bernheim-Jeune, 1952. Exh. cat. Paris, 1952.

Paris 1952c. *Cent Portraits d'hommes du XIV^e siècle à nos jours.* Paris, Galerie Charpentier. Exh. cat. Paris, 1952.

Paris 1952–53. *Chefs-d'Oeuvre des collections parisiennes: Peintures et dessins de l'École française du XIX^e siècle.* Paris, Musée Carnavalet, December 1952–February 1953. Exh. cat. Paris, 1952.

Paris 1953a. *Donations de D. David-Weill aux musées français.* Paris, Musée de l'Orangerie, May 6–June 7, 1953. Exh. cat. Paris, 1953.

Paris 1953b. *Labrouste: Architecte de la Bibliothèque Nationale de 1854 à 1875.* Paris, Bibliothèque Nationale, March 10–April 11, 1953. Exh. cat. by R[oger]-A[rmand] Weigert. Paris, 1953.

Paris 1954. *Quelques Aspects de la vie à Paris au XIX^e siècle.* Paris, Musée du Louvre, July 24–October 24, 1954. Exh. cat. Paris, 1954.

Paris 1955. *De David à Toulouse-Lautrec: Chefs-d'Oeuvre des collections américaines.* Paris, Musée de l'Orangerie, 1955. Exh. cat. Paris, 1955.

Paris 1956. *Le Cabinet de l'amateur, organisé par la Société des Amis du Louvre en souvenir de Monsieur A.-S. Henraux, son président, 1932.–1953.* Paris, Musée de l'Orangerie, February–April 1956. Exh. cat. Paris, 1956.

Paris 1956–57. *Donation de D. David Weill au Musée du Louvre: Miniatures, émaux.* Paris, Musée du Louvre, Cabinet des Dessins, October 1956–January 1957. Exh. cat. by Maurice Sérullaz. Paris, 1957.

Paris 1957a. *Charles Baudelaire: Exposition organisée pour le centenaire des Fleurs du mal.* Paris, Bibliothèque Nationale, 1957. Exh. cat. Paris, 1957.

Paris 1957b. *Exposition de la collection Lehman de New York.* Paris, Musée de l'Orangerie. Exh. cat. by Charles Sterling et al. Paris, 1957.

Paris 1957c. *Besançon, le plus ancien musée de France.* Paris, Musée des Arts Décoratifs, February–April 1957. Exh. cat. Paris, 1957.

Paris 1957d. *Théodore Chassériau 1819–1856: Dessins.* Paris, Musée du Louvre, 1957. Exh. cat. by Roseline Bacou and Maurice Sérullaz. Paris, 1957.

Paris 1957e. *L'Enfant dans le dessin du XV^e au XIX^e siècle.* Paris, Musée du Louvre, Cabinet des Dessins, summer 1957. Exh. cat. Paris, 1957.

Paris 1959. *De Géricault à Matisse: Chefs-d'Oeuvre français des collections suisses.* Paris, Petit Palais, March–May 1959. Exh. cat. Paris, [1959].

Paris 1962. *Première Exposition des plus beaux dessins du Louvre et de quelques pièces célèbres des collections de Paris.* Paris, Musée du Louvre, March–May 1962. Exh. cat. [Paris, 1962.]

Paris 1964. "Colmar." Paris, Paul Prouté & ses fils, 1964.

Paris 1967a. "Dessins et aquarelles du XIX^e siècle." Paris, Galerie Christine Aubry, 1967.

Paris 1967b. *Troisième Centenaire de l'Académie de France.* Paris, Académie des beaux-arts, June–July 1967. Exh. cat. Paris, 1967.

Paris 1967–68. *Ingres.* Paris, Petit Palais, October 27, 1967–January 29, 1968. Exh. cat. by Lise Duclaux, Jacques Foucart, Hans Naef, Maurice Sérullaz, and Daniel Ternois. Paris, 1967.

Paris 1968. *Les Maîtres du dessin (1820–1920).* Paris, Galerie Lorenceau, May 21–June 21, 1968. Exh. cat. preface by Claude Roger-Marx. Paris, 1968.

Paris 1969. *Chateaubriand, le voyageur et l'homme politique.* Paris, Bibliothèque Nationale, 1969. Exh. cat. by Alix Chevallier, Madeleine Cottin, and Roger Pierrot. Paris, 1969.

Paris 1969a. *Hector Berlioz.* Paris, Bibliothèque Nationale, 1969. Exh. cat. Paris, 1969.

Paris 1969b. *Napoléon.* Paris, Grand Palais, June–December 1969. Exh. cat. by Claude Ducourtial-Rey et al. Paris, 1969.

Paris 1971. *Le Bain turc d'Ingres.* Paris, Musée du Louvre, 1971. Exh. cat. by Hélène Toussaint. Paris, 1971.

Paris 1973–74. *Dessins français du Metropolitan Museum of Art, New York, de David à Picasso.* Paris, Musée du Louvre, October 25, 1973–January 7, 1974. Exh. cat. Paris, 1973.

Paris 1974. *Portraits français, XIX^e et XX^e siècles.* Paris, Galerie Schmit, May 15–June 19, 1974. Exh. cat. Paris, 1974.

Paris 1974–75. *Louis-Philippe: L'Homme et le roi, 1773–1850.* Paris, Archives Nationales, October 1974–February 1975. Exh. cat. Paris, 1974.

Paris 1976–77. *Dessins français de l'Art Institute de Chicago, de Watteau à Picasso.* Paris, Musée du Louvre, Cabinet des Dessins, October 15, 1976–January 17, 1977. Exh. cat. by Harold Joachim and Suzanne Folds McCullagh. Paris, 1976.

Paris 1977. *La Collection Armand Hammer.* Paris, Musée du Louvre, Cabinet des Dessins, and Musée Jacquemart-André, March 28–May 29, 1977. Exh. cat. Paris, 1977.

Paris 1979. *L'Art en France sous le Second Empire.* Paris, Grand Palais, May 11–August 13, 1979. Exh. cat. Paris, 1979.

Paris 1980. "Revoir Ingres: 86^e Exposition du Cabinet des Dessins." Paris, Musée du Louvre, September 28–November 17, 1980.

Paris 1982–83. *Uniformes civils français, cérémonial, circonstances, 1750–1980.* Paris, Musée de la Mode et du Costume, December 16, 1982–April 17, 1983. Exh. cat. Paris, 1982.

Paris 1983. *Henri Lehmann 1814–1882: Portraits et décors parisiens.* Paris, Musée Carnavalet, June 7–September 4, 1983. Exh. cat. Paris, 1983.

Paris 1983–84. *Raphaël et l'art français.* Paris, Grand Palais, November 15, 1983–February 13, 1984. Exh. cat. Paris, 1983.

Paris 1984. *Dessins originaux, anciens et modernes; estampes anciennes du XV^e au XVIII^e siècle; estampes originales de Maîtres des XIX^e et XX^e siècles.* Paris, Paul Prouté, 1984. Exh. cat. ("Watteau"). Paris, 1984.

Paris 1985. *Les Portraits d'Ingres: Peintures des Musées Nationaux.* Paris, Musée du Louvre, May 30–September 30, 1985. Exh. cat. by Hélène Toussaint. Paris, 1985.

Paris 1989. *Dessins d'Ingres du Musée du Montauban.* Paris, Pavillion des Arts, June 7–September 3, 1989. Exh. cat. Paris, 1989.

Paris 1988. *Instrumentistes et luthiers parisiens, XVII^e–XIX^e siècles.* Paris, la mairie du V^e arrondissement, February 4–March 28, 1988. Exh. cat. edited by Florence Getreau. Paris, 1988.

Paris 1989–90. *Jacques-Louis David 1748–1825.* Paris, Musée du Louvre, October 26, 1989–February 12, 1990. Exh. cat. by Antoine Schnapper and Arlette Sérullaz. Paris, 1989.

Paris 1990. *Acquisitions 1984–1989.* Paris, Musée du Louvre, Cabinet des Dessins, May 31–August 27, 1990. Exh. cat. Paris, 1990.

Paris 1992. *Accrochage d'été des collections permanentes de l'École Nationale Supérieure des Beaux-Arts.* Paris, École Nationale Supérieure des Beaux-Arts, June 17–September 6, 1992. Exh. cat. Paris, 1992.

Paris 1994–95. *Les Oubliés du Caire, Ingres, Courbet, Monet, Rodin, Gauguin . . . : Chefs-d'Oeuvre des musées du Caire.* Paris, Musée d'Orsay, October 5, 1994–January 8, 1995. Exh. cat. Paris, 1994.

Paris 1998. *Picasso papiers collés*. Paris, Musée Picasso, April 1–June 29, 1998. Exh. cat. by Brigitte Léal. Paris, 1998.

Paris, Amsterdam 1964. *Le Dessin français de Claude à Cézanne dans les collections hollandaises*. Paris, Institut Néerlandais, May 4–June 14, 1964; Amsterdam, Rijksmuseum, June 25–August 16. Exh. cat. by C[arlos] van Hasselt. [Paris], 1964.

Paris, Detroit, New York 1974–75. *French Painting, 1774–1830: The Age of Revolution*. Paris, Grand Palais, November 16, 1974–February 3, 1975; Detroit Institute of Arts, March 5–May 4; New York, The Metropolitan Museum of Art, June 12–September 7. Exh. cat. Detroit, 1975. French ed., *De David à Delacroix: La Peinture française de 1774 à 1830*. Paris, 1974.

Paris, Fondation Taylor 1995. *See* Le Baron Taylor 1995.

Paris, Lille, Strasbourg 1976. *Cent Dessins français du Fitzwilliam Museum, Cambridge*. Paris, Galerie Heim, March 18–April 30, 1976; Lille, Palais des Beaux-Arts, May 14–June 21; Strasbourg, Musée des Beaux-Arts, July 3–August 15. Exh. cat. Paris, 1976.

Paris, London 1994–95. *Nicolas Poussin (1594–1665)*. Paris, Grand Palais, September 27, 1994–January 2, 1995; London, Royal Academy of Arts, January 19–April 9. Exh. cat. by Richard Verdi. London, 1995. French ed., *Nicolas Poussin (1594–1665)*. Paris, 1994.

Paris, Lyons 1984–85. *Hippolyte, Auguste et Paul Flandrin*. Paris, Musée du Luxembourg, November 16, 1984–February 10, 1985; Lyons, Musée des Beaux-Arts, March 5–May 19. Exh. cat. Paris, 1984.

Paris, Malibu, Hamburg 1981–82. *De Michel-Ange à Géricault: Dessins de la Donation Armand-Valton*. Paris, École Nationale Supérieure des Beaux-Arts, May 19–July 12, 1981; Malibu, J. Paul Getty Museum, October 20–December 19; Hamburg, Kunsthalle, March 12–May 2, 1982. Exh. cat. by Emmanuelle Brugerolles. Paris, 1981.

Paris, Musée Carnavalet 1928. Musée Carnavalet. *Guide du Musée Carnavalet*. Paris, [1928].

Paris, Musée des Arts Décoratifs 1934. Musée des Arts Décoratifs. *Guide illustré du Musée des Arts Décoratifs*. Rev. ed. Paris, 1934.

Paris, Musée du Louvre 1900. Musée du Louvre. *Catalogue sommaire des dessins, cartons, pastels, miniatures et émaux exposé dans les salles du 1er et 2e étage*. Paris, [1900].

Paris, Musée du Louvre 1919–20. Musée du Louvre. *Le Musée du Louvre depuis 1914, dons, legs et acquisitions*. 2 vols. Paris and New York, 1919–20.

Paris, Musée du Louvre 1966. *Cabinet des Dessins du Musée du Louvre, I: Dessins de l'école française*. Paris, 1966.

Paris, Musée du Louvre 1987. *Nouvelles Acquisitions du Département des Peintures (1983–1986)*. Edited by Jacques Foucart. Paris, 1987.

Paris, New York 1993–94. *Le Dessin français: Chefs-d'Oeuvre de la Pierpont Morgan Library*. Paris, Musée du Louvre, June 1–August 30, 1993; New York, Pierpont Morgan Library, September 15, 1993–January 2, 1994. Exh. cat. by Cara Dufour Denison. Paris and New York, 1993.

Paris, New York 1994–95. *Nadar*. Paris, Musée d'Orsay, June 7–September 11, 1994; New York, The Metropolitan Museum of Art, April 14–July 9, 1995. Exh. cat. by Maria Morris Hambourg et al. New York, 1995.

Paris, Ottawa, New York 1988–89. *Degas*. Paris, Grand Palais, February 9–May 16, 1988; Ottawa, National Gallery of Canada, June 16–August 28; New York, The Metropolitan Museum of Art, September 27, 1988–January 8, 1989. Exh. cat. by Jean Sutherland Boggs et al. New York and Ottawa, 1988. French ed., *Degas*. Paris, 1988.

Paris (Salon) 1802. *Explication des ouvrages de peinture et dessins, sculpture, architecture et gravure, des artistes vivans*. Paris, Muséum Central des Arts, 15 fructidor (September 2), an X (1802). Exh. cat. Paris, 1802.

Paris (Salon) 1806. *Explication des ouvrages de peinture, sculpture, architecture et gravure, des artistes vivans*. Paris, Musée Napoléon, September 15, 1806. Exh. cat. Paris, 1806.

Paris (Salon) 1814. *Explication des ouvrages de peinture, sculpture, architecture et gravure, des artistes vivans*. Paris, Musée Royal des Arts, November 1, 1814. Exh. cat. Paris, 1815.

Paris (Salon) 1824. *Explication des ouvrages de peinture, sculpture, gravure, lithographie et architecture des artistes vivans*. Paris, Musée Royal des Arts, August 25, 1824. Exh. cat. Paris, 1824.

Paris (Salon) 1827. *Explication des ouvrages de peinture, sculpture, gravure, lithographie et architecture des artistes vivans*. Paris, Musée Royal des Arts, November 4, 1827. Exh. cat. Paris, 1827.

Paris (Salon) 1833. *Explication des ouvrages de peinture, sculpture, architecture, gravure et lithographie des artistes vivans*. Paris, Musée Royal, March 1, 1833. Exh. cat. Paris, 1833.

Paris (Salon) 1834. *Explication des ouvrages de peinture, sculpture, architecture, gravure et lithographie des artistes vivans*. Paris, Musée Royal, March 1, 1834. Exh. cat. Paris, 1834.

Paris, Société de reproduction de dessins 1909–14. Société de reproduction de dessins de maîtres. [Publications]. 6 vols. Paris, 1909–14.

Parker 1926. Robert Allerton Parker. "Ingres: Apostle of Draughtsmanship." *International Studio* 83 (March 1926), pp. 24–32.

Parker 1937. K. T. Parker. "Report of the Keeper of the Department of Fine Art for the Year 1936." In *University of Oxford, Ashmolean Museum: Report of the Visitors*, 1936 ([1937]).

Parker 1938. K. T. Parker. *Catalogue of the Collection of Drawings in the Ashmolean Museum*. Vol. 1, *Netherlandish, German, French, and Spanish Schools*. Oxford, 1938.

Parker 1955. James Parker. *Jean Auguste Dominique Ingres, 1780–1867*. New York, 1955.

Parsons and Ward 1986. Christopher Parsons and Martha Ward. *A Bibliography of Salon Criticism in Second Empire Paris*. Cambridge, 1986.

Pasadena, Norton Simon Museum of Art 1989. Norton Simon Museum of Art. *Masterpieces from the Norton Simon Museum*. Pasadena, 1989.

Payne 1965. Blanche Payne. *History of Costume from the Ancient Egyptians to the Twentieth Century*. New York, 1965.

Peinture française au XVIIe et au XVIIIe siècle n.d. *La Peinture française au XVIIe et au XVIIIe siècle*. Paris, n.d. [ca. 1900].

Peisse, May 3, 1834. Louis Peisse. "Beaux-Arts. Salon de 1834." *Le National*, May 3, 1834.

Pélissier 1896. Léon-G. Pélissier, ed. "Les Correspondants du peintre François Xavier Fabre (1808–1834). Lettres de N. D. Boguet." *Nouvelle Revue rétrospective*, 1896, pp. 313–36.

Pelletan, August 22, 1840. Eugène Pelletan. "La Stratonice par M. Ingres." *La Presse*, August 22, 1840.

Pellicer 1979. Laure Pellicer. "François-Xavier Fabre et la peinture italienne." In *Florence et la France: "Rapports sous la Révolution et l'Empire." Actes du colloque, Florence, 2–3–4 juin 1977*, pp. 159–86. Florence and Paris, 1979.

Pereire 1914. Alfred Pereire. *Le Journal des débats politiques et littéraires, 1814–1914*. Paris, 1914.

Péricaud 1834. [Antoine] P[éricaud]. *Le Cimetière de Loyasse*. Lyons, 1834.

Péron and Freycinet 1807–16. François Péron and Louis Freycinet. *Voyage de découvertes aux terres australes*. 2 vols. Paris, 1807–16.

Perrier 1855. Charles Perrier. "Exposition universelle des beaux-arts. II. La Peinture française.—M. Ingres." *L'Artiste*, 5th ser., 15 (May 27, 1855), pp. 43–46.

Pesquidoux, September 2, 1855. Cl. Pesquidoux. "Beaux-Arts." *L'Appel*, September 2, 1855.

Peters 1988. Susan Dodge Peters, ed. *Memorial Art Gallery*. Rochester, 1988.

Petroz, May 30, 1855. Pierre Petroz. "Exposition universelle des beaux-arts." *La Presse*, May 30, 1855.

Pfister 1935. Arnold Pfister. "Französische Meisterzeichnungen von Ingres bis Cézanne in der Basler Kunsthalle." *Pantheon* 16 (October 1935), pp. 329–32.

Philadelphia 1947. "Masterpieces of Philadelphia Private Collections." Philadelphia Museum of Art, May 30–September 14, 1947. Exh. cat. published in *Philadelphia Museum Bulletin* 42 (May 1947), pp. 72–82.

Philadelphia 1949. "The Henry P. McIlhenny Collection." Philadelphia Museum of Art, 1949.

Philadelphia 1950–51. *Masterpieces of Drawing: Diamond Jubilee Exhibition*. Philadelphia Museum of Art, November 4, 1950–February 11, 1951. Exh. cat. Philadelphia, 1950.

Philadelphia 1957. *The T. Edward Hanley Collection*. Philadelphia Museum of Art, 1957. Exh. cat. Philadelphia, 1957.

Philadelphia 1987–88. *The Henry P. McIlhenny Collection: An Illustrated History*. Philadelphia Museum of Art, November 22, 1987–January 17, 1988. Exh. cat. by Joseph J. Rishel. Philadelphia, 1987.

Philadelphia 1994. "A New Look at Old Masters." Philadelphia Museum of Art, 1994.

Philadelphia, Detroit, Paris 1978–79. *The Second Empire, 1852–1870: Art in France under Napoleon III*. Philadelphia Museum of Art, October 1–November 26, 1978; Detroit Institute of Arts, January 15–March 18, 1979; Paris, Grand Palais, April 24–July 2. Exh. cat. Philadelphia and Detroit, 1978.

Philadelphia, Washington 1937–38. *Problems of Portraiture*. Philadelphia Museum of Art, October 16–November 28, 1937; Washington, D.C., Phillips Memorial Gallery, December 6, 1937–January 3, 1938. Exh. cat. Washington, D.C., 1937.

Philipon, April 11, 1833. Ch[arles] Philipon. "Salon de 1833." *La Caricature*, April 11, 1833.

Picon 1967. Gaëtan Picon. *Ingres: Biographical and Critical Study*. Translated by Stuart Gilbert. Geneva, 1967.

Picon 1980. Gaëtan Picon. *Jean-Auguste-Dominique Ingres*. New ed. Translated by Stuart Gilbert. New York, 1980.

Piétri 1939. François Piétri. *Lucien Bonaparte*. Paris, 1939.

Pignatti 1981. Terisio Pignatti. *Il disegno: Da Altamira a Picasso*. Milan, 1981. Also published in English as *Master Drawings: From Cave Art to Picasso*. Translated by Sylvia Mulcahy. New York, 1982.

Pillet, March 4, 1833. F[abien] P[illet]. "Salon de 1833." *Le Moniteur universel*, March 4, 1833.

Pillet, March 19, 1833. F[abien] P[illet]. "Salon de 1833." *Le Moniteur universel*, March 19, 1833.

Pillet, January 16, 1846. Fab[ien] P[illet]. "Ouvrages de peinture exposés dans la galerie des beaux-arts, boulevard Bonne-Nouvelle, no. 22." *Le Moniteur universel*, January 16, 1846.

Pincherle 1922. Marc Pincherle. *Les Violonistes compositeurs et virtuoses*. Paris, 1922.

Pincus-Witten 1967. Robert Pincus-Witten. "Ingres: Harvard's Fogg Museum Mounts a Splendid Centennial Exhibition." *Artforum* 5, no. 9 (May 1967), pp. 46–48.

Pineau 1901. Maurice Pineau. "Origine guérétoise de Madame Ingres." *Mémoires de la Société des sciences naturelles et archéologiques de la Creuse* (Guéret) 13 (1901).

Pinset and Auriac 1884. Raphaël Pinset and Jules d'Auriac. *Histoire du portrait en France*. Paris, 1884.

Pittsburgh 1930. *Exhibition of Paintings by Old Masters*. Pittsburgh, Carnegie Institute, April 10–30, 1930. Exh. cat. Pittsburgh, 1930.

Pittsburgh 1939. *An Exhibition of 100 Prints and Drawings from the Collection of James H. Lockhart, Jr.* Pittsburgh, Carnegie Institute, May 4–June 30, 1939. Exh. cat. by Robert McDonald. Pittsburgh, 1939.

Pittsburgh 1951. *French Painting, 1100–1900.* Pittsburgh, Carnegie Institute, October 18–December 2, 1951. Exh. cat. Pittsburgh, 1951.

Pittsburgh 1958. "Rare Drawings and Prints from the Collection of Dr. and Mrs. James Lockhart, Jr." Pittsburgh, Carnegie Institute, 1958.

Pittsburgh 1979. Exhibition. Pittsburgh, Carnegie Institute, 1979.

Pittsburgh, Memphis, Saint Petersburg, Salt Lake City 1986–87. *Seventeenth, Eighteenth, and Nineteenth Century French Drawings from the Musée des Beaux-Arts, Orléans.* Pittsburgh, Frick Art Museum; Memphis, Dixon Gallery and Gardens; Saint Petersburg, Florida, Museum of Art; Salt Lake City, Utah Museum of Arts; 1986–87. Exh. cat. by David Ojalvo. Washington, D.C., 1986.

Pittsburgh, Northampton 1992. *The Real and the Spiritual: Nineteenth-Century French Drawings from the Musée des Beaux-Arts de Lyon.* Pittsburgh, Frick Art Museum, June 13–August 16, 1992; Northampton, Mass., Smith College Museum of Art, September 15–November 15, 1992. Exh. cat. by Dominique Brachlianoff. Pittsburgh, 1992.

Plan 1930. Danielle Plan. *A. Constantin: Peintre sur émail et sur porcelaine.* Geneva, 1930.

Planche 1833. Gustave Planche. "Salon de 1833. Troisième Article. II. MM. Ingres et Champmartin.—M^me L. de Mirbel." *Revue des deux mondes*, 2nd ser., 2 (1833), pp. 88–97.

Planche 1854. Gustave Planche. "L'Apothéose de Napoléon et le Salon de la Paix. Les Deux Écoles de peinture à l'Hôtel-de-Ville." *Revue des deux mondes*, n.s., 2nd ser., 6 (April 1854), pp. 305–21.

Planche 1855. Gustave Planche. "Exposition des beaux-arts. L'École française." *Revue des deux mondes*, n.s., 2nd ser., 11 (September 15, 1855), pp. 1137–65.

Poggi 1949. Giovanni Poggi. "La collezione degli autoritratti nella Galleria degli Uffizi. I. Reynolds, Ingres, Corot." *Arte Mediterranea*, 3rd ser., January–February 1949, pp. 53–61.

Ponroy 1855. Arthur Ponroy. "Beaux-Arts. École française." *Le Globe industriel et artistique*, July 1, 1855, pp. 143–44; August 5, 1855, p. 222.

Pontier 1900. Henri Pontier. *Le Musée d'Aix.* 2 vols. Aix, 1900.

Pontmartin 1867. A. de Pontmartin. "Chronique." *L'Univers illustré*, 10, no. 365 (April 24, 1867), p. 258.

Pope-Hennessy 1970. John Pope-Hennessy. *Raphael*. New York, 1970.

Popeson 1846. Dick Popeson. "Chronique littéraire de la Revue britannique." *La Revue britannique*, 6th ser., 1 (January 1846), pp. 243–47.

Portland 1941. *Masterpieces of French Painting.* Portland Art Museum, September 3–October 5, 1941. Exh. cat. Portland, Oreg., 1941.

Potter 1984. Margaret Potter. *The David and Peggy Rockefeller Collection.* Vol. 1, *European Works of Art.* New York, 1984.

Poughkeepsie, New York 1961. *Vassar College Centennial Loan Exhibition: Drawings and Watercolors from Alumnae and Their Families.* Poughkeepsie, Vassar College, May 19–June 11, 1961; New York, Wildenstein and Co., June 14–September 9. Exh. cat. Poughkeepsie, 1961.

Pougin 1877. Arthur Pougin. "Charles Gounod." *L'Art* 9 (1877), pp. 11–15.

Prague 1923. *Výstava francouzského umění XIX. a XX. století.* Prague, Spolku Výtvarných Umělců Mánes, 1923. Exh. cat. Prague, 1923.

Prague 1956. "L'Art français de Delacroix à nos jours: Dessins, aquarelles, estampes." Prague, Palais Kinsky, 1956.

Praz 1958. Mario Praz. *La casa della vita.* [Milan], 1958.

Praz 1964. Mario Praz. *An Illustrated History of Interior Decoration.* London, 1964.

Preston 1953. Stuart Preston. "Ingres." *House and Garden* 104 (October 1953), pp. 168–69, 194, 204.

Prevost-Marcilhacy 1995. Pauline Prevost-Marcilhacy. *Les Rothschild: Bâtisseurs et mécènes.* Paris, 1995.

Princeton 1981. "Alumni Exhibition." Princeton University Art Museum, April 25–June 21, 1981.

Prod'homme 1910a. Jacques-Gabriel Prod'homme. "Une Famille d'artistes: Les Gounod." *La Revue musicale*, September 1–15, 1910, pp. 402–19; October 1, 1910, pp. 443–55.

Prod'homme 1910b. J[acques]-G[abriel] Prod'homme. "Lettres de jeunesse de Ch. Gounod (Rome et Vienne, 1840–1843)." *Revue bleue*, December 31, 1910, pp. 833–37.

Prod'homme 1911. J[acques]-G[abriel] Prod'homme. "Lettres de jeunesse de Ch. Gounod (Rome et Vienne, 1840–1843)." *Revue bleue*, January 7, 1911, pp. 8–10.

Prod'homme and Dandelot 1911. J[acques]-G[abriel] Prod'homme and Arthur Dandelot. *Gounod (1818–1893): Sa Vie et ses oeuvres, d'après des documents inédits.* 2 vols. Paris, 1911.

Proust 1913. Antonin Proust. *Édouard Manet: Souvenirs.* Paris, 1913.

Providence 1933. Exhibition. Providence, R.I. Brown University, 1933.

Providence 1954. *French Master Drawings from Claude to Corot.* Providence, Museum of Art, Rhode Island School of Design, May 1–30, 1954. Exh. cat. Providence, 1954.

Providence 1968. *An Exhibition of Early Lithography, 1800–1840.* Providence, Annmary Brown Memorial Library, March 26–April 19, 1968. Exh. cat. Providence, R.I., 1968.

Providence 1975. "Selection V: French Watercolors and Drawings from the Museum's Collection, ca. 1800–1910." Providence, Museum of Art, Rhode Island School of Design, May 1–25, 1975. Exh. cat. published in *Bulletin of Rhode Island School of Design, Museum Notes* 61, no. 5 (April 1975).

Providence 1989. "Treasures on Paper." Providence, Museum of Art, Rhode Island School of Design, June 13–August 19, 1989.

Radius and Camesasca 1968. Emilio Radius and Ettore Camesasca. *L'opera completa di Ingres.* Milan, 1968.

Raffaelli 1913. J[ean]-F[rançois] Raffaelli. *Mes Promenades au Musée du Louvre.* 2nd ed. Paris, 1913.

Raoul, April 24, 1833. Maximilien Raoul [Charles Letellier]. "Salon de 1833." *Le Cabinet de lecture*, April 24, 1833.

Raoul 1962. Rosine Raoul. "The Taste for Drawings." *Apollo* 77 (July 1962), pp. 411–14.

Ratouis de Limay 1920. Paul Ratouis de Limay. "Le Musée d'Orléans." *L'Art et les artistes*, December 1920, p. 107.

Raum 1966. Hans Raum. "Der Weg des Liszt-Bildes aus Haus Wahnfried." *Stuttgarter Zeitung*, January 12, 1966, p. 18.

Réau 1924. Louis Réau. *Histoire de l'expansion de l'art français moderne: Le Monde slave et l'Orient.* Paris, 1924.

Réau 1929. Louis Réau. *Catalogue de l'art français dans les musées russes.* Paris, 1929.

Recklinghausen, Amsterdam 1961. *Polariteit: Het appolinische en het dionysische in de kunst.* Recklinghausen, Städtische Kunsthalle, June 2–July 16, 1961; Amsterdam, Stedelijk Museum, July 22–September 18. Exh. cat. by Thomas Grochowiak et al. Amsterdam, 1961. German ed., *Ausstellung Polarität: Das Apollinische und das Dionysische.* Recklinghausen, 1961.

Reff 1976. Theodore Reff. *Degas: The Artist's Mind.* New York, 1976.

Reff 1977. Theodore Reff. "Degas: A Master among Masters." *The Metropolitan Museum of Art Bulletin* 34, no. 4 (spring 1977), pp. 2–49.

Reinach 1918. S[alomon] R[einach]. "Trois Portraits d'explorateurs par Ingres." *Revue archéologique*, July–October 1918, pp. 214–15.

Reinhold 1853. Johann Gotthard Reinhold. *Dichterischer Nachlass.* Edited by Karl A. Varnhagen von Ense. 2 vols. in 1. Leipzig, 1853.

Rémusat 1958–67. Charles de Rémusat. *Mémoires de ma vie.* 5 vols. Paris, 1958–67.

La Renaissance de l'art français 1921. *La Renaissance de l'art français et des industries de luxe* 4 (May 1921). Special issue: "L'Exposition Ingres."

Reno 1978. *Master Drawings from the E. B. Crocker Gallery.* Reno, University of Nevada, Church Fine Arts Gallery, February 1978. Exh. cat. Reno, 1978.

Renouvier 1863. J[ules] Renouvier. *Histoire de l'art pendant la Révolution, considéré principalement dans les estampes. . . .* 2 vols. Paris, 1863.

Répertoire des biens spoliés 1947. *Répertoire des biens spoliés en France durant la guerre, 1939–1945.* Vol. 2. [Berlin, 1947.]

Retaux 1884. A. Retaux. *Château de Moreuil.* Abbeville, 1884.

Rewald 1943. John Rewald. "Ingres and the Camera." *Art News* 42 (May 1–14, 1943), pp. 8–10.

Rewald 1947. John Rewald. "French Drawing: The Climax; Its West Coast Premiere in San Francisco." *Art News* 46 (April 1947), pp. 29–30, 57.

Ribeiro 1995. Aileen Ribeiro. *The Art of Dress: Fashion in England and France, 1750 to 1820.* New Haven and London, 1995.

Ricci n.d. Seymour de Ricci. *Les Dessins français, les chefs-d'oeuvre de l'art français à l'Exposition internationale de 1937.* Paris, n.d. [1938].

Rich 1938. Daniel Catton Rich. "Monsieur Mallet by Ingres." *Bulletin of the Art Institute of Chicago* 32 (September–October 1938), pp. 66–69.

Richardson 1979. John Richardson, ed. *The Collection of Germain Seligman.* New York, 1979.

Richardson 1996. John Richardson. *A Life of Picasso.* Vol. 2. New York, 1996.

Richmond 1933. E. J. Richmond. "A Study for the Portrait of M^me d'Haussonville by Ingres." *Bulletin of the Rhode Island School of Design* 21 (January 1933), pp. 3–7.

Richmond 1947. *Portrait Panorama.* Richmond, Virginia Museum of Fine Arts, September 10–October 12, 1947. Exh. cat. Richmond, 1947.

Richmond 1952. "French Drawings of the Fogg Art Museum." Richmond, Virginia Museum of Fine Arts, 1952.

Richmond 1961. *A Brief Chronicle of the 25th Birthday Celebration and Catalogue of the Anniversary Loan Exhibition: Treasures in America.* Richmond, Virginia Museum of Fine Arts, January 13–March 5, 1961. Exh. cat. Richmond, Va., 1961.

Rifkin 1969. Adrian D. Rifkin. "Ingres and the Method of Art Criticism in France: The Interaction of Art Theory and Painting in France, circa 1800–1830." Ph.D. dissertation, University of Leeds, 1969.

Rifkin 1983. Adrian D. Rifkin. "Ingres and the Academic Dictionary: An Essay on Ideology and Stupefaction in the Social Formation of the 'Artist.'" *Art History* 6 (June 1983), pp. 153–70.

Riley 1955. M[aud] K[emper] R[iley]. "An Exhibition for Paris." *Art Institute of Chicago Quarterly* 49, no. 2 (April 1, 1955), pp. 27–30.

Rio de Janeiro 1940. *Exposição de pintura francesa, seculos XIX e XX.* Rio de Janeiro, Museu Nacional de Belas Artes, June–July 1940. Exh. cat. Rio de Janeiro, 1940.

Ripert 1937. Émile Ripert. *François-Marius Granet, peintre d'Aix et d'Assise.* Paris, 1937.

Rist 1884–88. Johann Georg Rist. *Lebenserinnerungen.* 3 vols. Gotha, 1884–88.

Ritchie 1940. Andrew Carnduff Ritchie. "The Evolution of Ingres' Portrait of the Comtesse d'Haussonville." *Art Bulletin* 22 (September 1940), pp. 119–26.

Rivau 1947. Hélène du Rivau. "François-Marius Granet." 2 vols. Dissertation, École du Louvre, 1947.

Rizzoni and Minervino 1976. Gianni Rizzoni and Fiorella Minervino. *Ingres.* Milan, 1976.

Robert 1991. Hervé Robert. "Le Destin d'une grande collection princière au XIXᵉ siècle: L'Exemple de la galerie de tableaux du duc d'Orléans, prince royal." *Gazette des beaux-arts,* 6th ser., 118 (July–August 1991), pp. 37–60.

Robert 1993. Hervé Robert, ed. *Le Mécénat du duc d'Orléans, 1830–1842.* Paris, 1993.

Roberts 1968. Keith Roberts. "Current and Forthcoming Exhibitions." *Burlington Magazine* 110 (August 1968), pp. 475–79.

Rochester 1940. "David and Ingres." Rochester Memorial Art Gallery, March 1940.

Rochester 1959. "The James H. Lockhart Collection of Prints and Drawings." Rochester Memorial Art Gallery, 1959.

Rochester 1995–96. *For the Enjoyment of Art: Gifts of Dr. and Mrs. James H. Lockhart, Jr.* Memorial Art Gallery of the University of Rochester, December 9, 1995–February 18, 1996. Exh. cat. Rochester, 1995.

Rodenwaldt 1930. Gerhart Rodenwaldt. "Bildnisse Stackelbergs." *Archäologischer Anzeiger* 3–4 (1930).

Rodenwaldt 1957. Gerhart Rodenwaldt. *Otto Magnus von Stackelberg, der Entdecker der griechischen Landschaft.* Munich and Berlin [1957].

Roger-Marx 1949. Claude Roger-Marx. *Ingres.* Lausanne, 1949.

Rogers 1980. Millard F. Rogers Jr. *Favorite Paintings from the Cincinnati Art Museum.* New York, 1980.

Rome 1809. *Spiegazione delle opere di pittura, scultura, architettura, ed incisione esposte nelle stanze del Campidoglio il dì 19 novembre 1809.* Rome, Campidoglio, 1809. Exh. cat. Rome, 1809.

Rome 1958. *Vedute di Roma di Ingres.* Rome, Palazzo Braschi, June 6–July 6, 1958. Exh. cat. Rome, 1958.

Rome 1968. *Ingres in Italia: 1806–1824, 1835–1841.* Rome, Accademia di Francia, February 26–April 28, 1968. Exh. cat. Rome, 1968.

Rome 1989–90. *Bertel Thorvaldsen 1770–1844: Scultore danese a Roma.* Rome, Galleria Nazionale d'Arte Moderna, October 31, 1989–January 28, 1990. Exh. cat. edited by Elena di Majo, Bjarnes Jørnaes, and Stefano Susinno. Rome, 1989.

Rome 1996–97. *Paesaggi perduti: Granet a Roma, 1802–1824.* Rome, American Academy in Rome, October 30, 1996–January 12, 1997. Exh. cat. edited by Caroline Astrid Bruzelius. Milan, 1996.

Rome, Florence 1955. *Mostra di capolavori della pittura francese dell'Ottocento.* Rome, Palazzo delle Esposizioni, February–March 1955; Florence, Palazzo Strozzi, April–May. Exh. cat. edited by Albert Châtelet. Rome, 1955.

Rome, Florence 1990. *Autoritratti dagli Uffizi: Da Andrea del Sarto a Chagall.* Rome, Accademia di Francia, March 1–April 15, 1990; Florence, Galleria degli Uffizi, September 12–October 28. Exh. cat. Rome, 1990.

Rome, Milan 1959–60. *Il disegno francese da Fouquet a Toulouse-Lautrec.* Rome, Palazzo Venezia, December 18, 1959–February 14, 1960; Milan, Palazzo Reale, March–April. Exh. cat. Rome, 1959.

Rome, Milan 1962. *Il ritratto francese da Clouet a Degas.* Rome, Palazzo Venezia, April 1962; Milan, Palazzo Reale, June–July. Exh. cat. Rome, 1962.

Rome, Oxford 1991–92. *Old Master Drawings from the Ashmolean Museum.* Rome, Palazzo Ruspoli, May 13–July 13, 1991; Oxford, Ashmolean, August 18–October 11, 1992. Exh. cat. by Christopher White, Catherine Whistler, and Colin Harrison. Oxford, 1992. Italian ed., *Il segno del genio: Cento disegni di grandi maestri del passato dall'Ashmolean Museum di Oxford.* Rome, 1991.

Rome, Paris 1993–94. *Le Retour à Rome de Monsieur Ingres: Dessins et peintures.* Rome, Accademia di Francia, December 14, 1993–January 30, 1994; Paris, Espace Electra, March 1–April 3. Exh. cat. by Georges Vigne. Rome, 1993.

Rome, Turin 1961. *L'Italia vista dai pittori francesi del XVIII e XIX secolo.* Rome, Palazzo delle Esposizioni, February 8–March 26, 1961; Turin, Galleria Civica d'Arte Moderna, April 20–May 25. Exh. cat. Rome, 1961.

Ronchaud, February 19, 1846. L[ouis] de Ronchaud. "Exposition du bazar Bonne-Nouvelle." *La Quotidienne,* February 19, 1846.

Ronchaud 1867. L[ouis] de Ronchaud. "L'Oeuvre d'Ingres: Exposition du Palais des beaux-arts." *Revue moderne* 11, no. 2 (May 1, 1867), pp. 430–47.

Ronchaud 1880. L[ouis] de Ronchaud. "Étude sur Daniel Stern." In *Oeuvres de Daniel Stern: Esquisses morales, pensées, réflexions et maximes.* Paris, 1880.

Roos 1937. Frank John Roos Jr. *An Illustrated Handbook of Art History.* New York, 1937.

Rosenberg 1959. Jakob Rosenberg. *Great Draughtsmen from Pisanello to Picasso.* Cambridge, Mass., 1959.

Rosenberg 1970. Pierre Rosenberg. "Twenty French Drawings in Sacramento." *Master Drawings* 8 (1970), pp. 31–39.

Rosenblum 1956. Robert Rosenblum. "The International Style of 1800: A Study in Linear Abstraction." Ph.D. dissertation, New York University, 1956. Reprinted, New York, 1976.

Rosenblum 1967a. Robert Rosenblum. *Jean-Auguste-Dominique Ingres.* New York, 1967.

Rosenblum 1967b. Robert Rosenblum. "Ingres, Inc." In *The Academy: Five Centuries of Grandeur and Misery, from the Carracci to Mao Tse-tung,* edited by Thomas B. Hess and John Ashbery, pp. 67–79. *Art News Annual* 33. New York, 1967.

Rosenblum 1969. Robert Rosenblum. Review of Paris 1967–68. *Revue de l'art,* no. 3 (1969), pp. 101–3.

Rosenblum 1977. Robert Rosenblum. "Picasso's 'Woman with a Book.'" *Arts Magazine* 51, no. 5 (January 1977), pp. 100–105.

Rosenblum 1985. Robert Rosenblum. *Jean-Auguste-Dominique Ingres.* Reprint ed. New York, 1985.

Rosenblum 1989. Robert Rosenblum. *Paintings in the Musée d'Orsay.* New York, 1989.

Rosendal 1864. Georges Rosendal. "M. Ingres et le Musée de Montauban." *L'Artiste,* 8th ser., 6 (October 1, 1864), pp. 145–47.

Rosenthal 1984. Donald A. Rosenthal. "The Portrait of Pierre-François Bernier by Ingres." *Porticus: The Journal of the Memorial Art Gallery of the University of Rochester* 7 (1984), pp. 23–29.

Rosenthal 1987. Léon Rosenthal. *Du Romantisme au Réalisme: Essai sur l'évolution de la peinture en France de 1830 à 1848.* Edited by Michael Marrinan. Paris, 1987.

Roskill 1961. Mark Roskill. "Ingres: Master of the Modern Crisis." *Art News* 60, no. 2 (April 1961), pp. 26–28, 58–59.

Rostrup 1969. Haavard Rostrup. "Ingres et la fille de Zoëga." *Gazette des beaux-arts,* 6th ser., 73 (February 1969), pp. 119–23.

Rotterdam 1933–34. "Tekeningen van Ingres tot Seurat." Rotterdam, Museums Boymans, 1933–34.

Rotterdam 1935–36. *Tentoonstelling van teekeningen van Ingres, Delacroix, Géricault, Daumier uit de verzameling Koenigs.* Rotterdam, Museum Boymans, December 1935–January 1936. Exh. cat. Rotterdam, 1935.

Rotterdam 1951. *19ᵉ eeuwse en moderne schilderkunst uit het Museum van Schone Kunsten te Luik.* Rotterdam, Museum Boymans, 1951. Exh. cat. Rotterdam, 1951.

Rotterdam, Paris, New York 1958–59. *French Drawings from American Collections: Clouet to Matisse.* Rotterdam, Museum Boymans, July 31–September 28, 1958; Paris, Musée de l'Orangerie; New York, The Metropolitan Museum of Art, February 3–March 15, 1959. Exh. cat. New York, 1959. French ed., *De Clouet à Matisse: Dessins français des collections américaines.* Paris, 1958. Dutch ed., *Van Clouet tot Matisse: Tentoonstelling van Franse tekeningen uit Amerikaanse collecties.* Rotterdam, 1958.

Roujon n.d. Henri Roujon, ed. *Ingres.* Les Peintres illustres, no. 21. Paris, n.d.

Rousseau 1954. Theodore Rousseau Jr. "A Guide to the Picture Galleries." *The Metropolitan Museum of Art Bulletin* 12, no. 5 (January 1954, part 2).

Roux 1996. Paul de Roux. *Ingres.* Paris, 1996.

Rowlands 1968. John Rowlands. "Treasures of a Connoisseur: The César de Hauke Bequest." *Apollo* 88 (July 1968), pp. 42–50.

Russoli and Minervino 1970. Franco Russoli and Fiorella Minervino. *L'opera completa di Degas.* Milan, 1970.

Ruvigny 1914. Marquis de Ruvigny. *The Titled Nobility of Europe.* London, 1914.

Sachs 1951. Paul J. Sachs. *The Pocket Book of Great Drawings.* New York, 1951.

Sacramento 1971. *Master Drawings from Sacramento.* Sacramento, E. B. Crocker Art Gallery, 1971. Exh. cat. by John A. Mahey. Sacramento, 1971.

Sacramento 1989. "Old Regime and Revolution: French Drawings in the Crocker Art Museum Collection." Sacramento, Crocker Art Museum, September 12–November 5, 1989.

Saglio 1857. E[dmond] Saglio. "Un Nouveau Tableau de M. Ingres, liste complète de ses oeuvres." *La Correspondance littéraire,* February 5, 1857.

Sainte-Beuve 1884. [Charles Augustin] Sainte-Beuve. "Camille Jourdan et Madame de Staël." *Nouveaux-Lundis* 12 (1884), p. 326.

Sainte-Beuve 1938. Charles Augustin Sainte-Beuve. *Correspondance générale.* Edited by Jean Bonnerot. Vol. 3. Paris, 1938.

Sainte-Beuve 1950. M. Sainte-Beuve. "Ingres modiste." *Arts,* June 30, 1950, p. 1.

Sainte-Foy-la-Grande 1970. "Expo d'art." Sainte-Foy-la-Grande, Château Richelieu, 1970.

Saint-Louis 1846. R. de Saint-Louis. "Exposition de tableaux français en faveur de l'Association des artistes peintres." *La Sylphide,* 2nd ser., 3 (1846).

Saint Louis 1933. "Drawings by Nineteenth Century Masters from the Paul J. Sachs Collection Lent by the Fogg Art Museum." Saint Louis, City Art Museum, January 1933.

Saint Louis 1973. "The Nineteenth Century: Changing Styles/Changing Attitudes." Saint Louis Art Museum, August 16–October 21, 1973.

Saint Louis 1992. "Masterpieces on Paper." Saint Louis Art Museum, April 10–June 14, 1992.

Saint Petersburg 1912. *Exposition centennale de l'art français à Saint-Pétersbourg.* Saint Petersburg, Institut Français, 1912. Exh. cat. Saint Petersburg, 1912.

Saint Petersburg 1923. *Exhibition of Nineteenth-Century Painting. Catalogue cum Guide.* Saint Petersburg (then Petrograd), State Hermitage Museum, 1923. Exh. cat (in Russian) compiled by F. F. Notgaft. Saint Petersburg (Petrograd), 1923.

Saint Petersburg 1938. *Exhibition of Portraits.* Vol. 4, *Eighteenth to the Twentieth Centuries. Catalogue.* Saint Petersburg (then Leningrad), State Hermitage Museum, 1938. Exh. cat. (in Russian). Saint Petersburg (Leningrad), 1938.

Saint Petersburg 1956. *Exhibition of French Art of the Twelfth to Twentieth Centuries. Catalogue.* Saint Petersburg (then Leningrad), State Hermitage Museum, 1956. Exh. cat. (in Russian). Moscow, 1956.

Saint Petersburg 1972. *The Art of Portraiture: Ancient Egypt, Classical, Orient, Western Europe. Catalogue of the Exhibition.* Saint Petersburg (then Leningrad), State Hermitage Museum, 1972. Exh. cat. (in Russian). Saint Petersburg (Leningrad), 1972.

Saint Petersburg, Hermitage 1958. State Hermitage Museum, Department of Western European Art. *Catalogue of Paintings* (in Russian). 2 vols. Saint Petersburg (then Leningrad) and Moscow, 1958.

Saint Petersburg, Hermitage 1966. State Hermitage Museum. *Meisterwerke aus der Ermitage: Französische Malerei des 19. und 20. Jahrhunderts.* Notes by Valentina N. Berezina. Prague and Saint Petersburg (then Leningrad), 1966.

Saint Petersburg, Hermitage 1972. State Hermitage Museum. *Masterpieces of Painting in the Hermitage Museum* (in Russian). Saint Petersburg (then Leningrad), 1972.

Saint Petersburg, Hermitage 1976. State Hermitage Museum. *Western European Painting. Catalogue.* Vol. 1, *Italy, Spain, France, Switzerland.* Saint Petersburg (then Leningrad), 1976.

Saint Petersburg, Moscow 1975. *One Hundred Paintings from The Metropolitan Museum of Art.* Saint Petersburg (then Leningrad), State Hermitage Museum, May 22–July 27, 1975; Moscow, State Pushkin Museum, August 28–November 2. Exh. cat. (in Russian). Moscow, 1975.

Saint Petersburg, Moscow 1988. *From Delacroix to Matisse: Masterpieces of French Painting from the Nineteenth Century to the Early Twentieth Century from The Metropolitan Museum of New York and the Art Institute of Chicago.* Saint Petersburg (then Leningrad), State Hermitage Museum, March 15–May 10, 1988; Moscow, State Pushkin Museum, June 10–July 30. Exh. cat. (in Russian). Saint Petersburg (Leningrad), 1988.

Saisselin 1984. Rémy G. Saisselin. *The Bourgeois and the Bibelot.* New Brunswick, N.J., 1984.

San Diego 1941. "Loan Exhibition of French Painting Presenting a Survey of the Development of Modern Art." San Diego, Fine Arts Gallery, 1941.

San Francisco 1934. *Exhibition of French Painting from the Fifteenth Century to the Present Day.* San Francisco, California Palace of the Legion of Honor, in association with the M. H. de Young Memorial Museum, June 8–July 8, 1934. Exh. cat. San Francisco, 1934.

San Francisco 1939–40. *Seven Centuries of Painting.* San Francisco, California Palace of the Legion of Honor and M. H. de Young Memorial Museum, December 29, 1939–January 28, 1940. Exh. cat. San Francisco, 1939.

San Francisco 1940. *Master Drawings: An Exhibition of Drawings from American Museums and Private Collections.* San Francisco, Palace of Fine Arts, Golden Gate International Exposition, 1940. Exh. cat. San Francisco, 1940.

San Francisco 1940–41. *The Painting of France since the French Revolution.* San Francisco, M. H. de Young Memorial Museum, December 1940–January 1941. Exh. cat. San Francisco, 1940.

San Francisco 1941. *French Drawings and Water Colors.* San Francisco, M. H. de Young Memorial Museum, summer 1941. Exh. cat. San Francisco, 1941.

San Francisco 1941–42. *The Painting of France since the French Revolution.* San Francisco, M. H. de Young Memorial Museum, November 1941–January 1942. Exh. cat. San Francisco, 1941. [Same exh. cat. as San Francisco 1940–41.]

San Francisco 1947. *19th Century French Drawings.* San Francisco, California Palace of the Legion of Honor, March 8–April 6, 1947. Exh. cat. San Francisco, 1947.

San Francisco 1962. *The Henry P. McIlhenny Collection.* San Francisco, California Palace of the Legion of Honor, June 15–July 32, 1962. Exh. cat. San Francisco, 1962.

Santa Barbara 1959. *Drawings of Five Centuries.* Santa Barbara Museum of Art, April 21–May 17, 1959. Exh. cat. Santa Barbara, 1959.

Santa Barbara 1964. *European Drawings, 1450–1900.* Santa Barbara Museum of Art, February 25–March 28, 1964. Exh. cat. Santa Barbara, 1964.

Sarasota 1969. "Au Théâtre." Sarasota, Fla., Ringling Museum of Art, 1969.

Sass 1963–65. Else Kai Sass. *Thorvaldsens Portraetbuster.* 3 vols. Copenhagen, 1963–65.

Saunier 1911. Charles Saunier. "Exposition Ingres." *Les Arts,* no. 115 (July 1911), pp. 2–32.

Saunier 1918. Charles Saunier. "Collection François Flameng." *Les Arts,* no. 167 (1918), pp. 16–24.

Say 1889. Léon Say. "Bertin l'Aîné et Bertin de Veaux." In *Le Livre du Centenaire du Journal des débats, 1789–1889,* pp. 14–47. Paris, 1889.

Scharf 1968. Aaron Scharf. *Art and Photography.* London, 1968.

Scheffer 1828. [Arnold Scheffer]. "Salon de 1827." *Revue française* 1 (1828), pp. 188–212.

Scheffler 1949. Karl Scheffler. *Ingres.* Translated by Ervino Pocar. Bern, 1949.

Schenectady 1960. Exhibition. Schenectady, Union College, 1960.

Schlenoff 1956. Norman Schlenoff. *Ingres: Ses Sources littéraires.* Paris, 1956.

Schlenoff 1967. Norman Schlenoff. "Ingres Centennial at the Fogg Museum." *Burlington Magazine* 109 (June 1967), pp. 376–79.

Schlumberger 1991. Eveline Schlumberger. *Ingres pour ses vitraux.* Paris, 1991.

Schonberg 1963. Harold C. Schonberg. *The Great Pianists from Mozart to the Present.* New York, 1963.

Schramm 1958. H. Schramm. "Men's Dress from the French Revolution to 1850." *Ciba Review,* January 1958.

Schuler, Häusler, and Seifert 1963. J. E. Schuler, Rolf Häusler, and Traudl Seifert. *Erziehung zur Kunst Graphik.* Munich, 1963.

Schumann 1854. Robert Schumann. *Gesammelte Schriften über Musik und Musiker.* 4 vols. in 2. Leipzig, 1854.

Schurr 1968. Gérald Schurr. "International Art Market Trends in New York, London, and Paris." *Réalités* (English ed.), February 1968, p. 13.

Schurr 1976. Gérald Schurr. "Europe. Paris to Strasburg via Lille: The Fitzwilliam Museum." *Connoisseur* 192 (June 1976), pp. 162–63.

Schwarz 1926. Heinrich Schwarz. "Die Lithographien J. A. D. Ingres'." *Mitteilungen der Gesellschaft für vervielfältigende Kunst* (supplement to *Die Graphischen Künste*) 49, no. 4 (1926), pp. 74–78.

Schwarz 1959. Heinrich Schwarz. "Ingres graveur." *Gazette des beaux-arts,* 6th ser., 54 (December 1959), pp. 329–42.

Seattle 1951. "Masters of Nineteenth Century Painting and Sculpture." Seattle Art Museum, March 7–May 6, 1951.

Sédille 1874. Paul Sédille. "Victor Baltard architecte." *Gazette des beaux-arts,* 2nd ser., 9 (May 1, 1874), pp. 485–96.

Seligman 1952. Kurt Seligman. "A Letter about Drawing." *Art Institute of Chicago Quarterly* 46, no. 3 (September 15, 1952), pp. 42–48.

Selz 1968. Jean Selz. *Aquarelle und Zeichnungen, XIX. Jahrhundert.* Munich, [1968].

Senior 1938. E[lizabeth] S[enior]. "A Century of French Drawings from Prud'hon to Picasso." *Burlington Magazine* 72 (June 1938), p. 308.

Senior 1939a. Elizabeth Senior. "Drawing by Jean-Auguste-Dominique Ingres." *National Art-Collections Fund, 35th Annual Report,* 1938 (1939), pp. 32–33.

Senior 1939b. Elizabeth Senior. "Letters—Ingres' Portrait Drawings of English People at Rome, 1806–1820." *Burlington Magazine* 75 (September 1939), p. 128.

Senior 1939c. Elizabeth Senior. "A Portrait Drawing by J. A. D. Ingres." *British Museum Quarterly* 13, 1938–39 (1939), pp. 1–2.

Sérullaz 1967. Maurice Sérullaz. "Ingres dessinateur." *La Revue du Louvre et des Musées de France* 17 (1967), pp. 209–18.

Sérullaz, Duclaux, and Monnier 1968. Maurice Sérullaz, Lise Duclaux, and Geneviève Monnier. *Dessins du Louvre, école française.* Paris, 1968.

Sérullaz et al. 1966. Maurice Sérullaz, Arlette Calvet, Lise Dunoyer, Geneviève Monnier, and André Vantoura. *Dessins français de Prud'hon à Daumier.* Fribourg, 1966.

Seymour 1961. Charles Seymour Jr. *Art Treasures for America: An Anthology of Paintings and Sculpture in the Samuel H. Kress Collection.* London, 1961.

Sèze 1824. [Étienne-Romain] Sèze, Comte de. *Discours prononcé par M. le comte de Sèze à l'occasion de la mort de M. le comte Cortois de Pressigny, Archevêque de Besançon, Chambre des Pairs, séance du samedi 17 avril 1824.* Paris, 1824.

Shapley 1957. Fern Rusk Shapley. *Comparisons in Art: A Companion to the National Gallery of Art, Washington, D.C.* New York, 1957.

Shelton 1997. Andrew Carrington Shelton. "From Making History to Living Legend: The Mystification of M. Ingres (1834–1855)." Ph.D. dissertation, New York University, 1997.

Shelton 1998. Andrew Carrington Shelton. "Un Séjour ignoré d'Ingres sur la côte normande en mars 1834." *Bulletin du Musée Ingres,* no. 71 (April 1998), pp. 51–59.

Sibertin-Blanc 1960. C[laude] Sibertin-Blanc. "Le Portrait de madame d'Haussonville par Ingres." *Rencontres* 2, no. 16 (April 1960), p. 9.

Siegfried 1980a. Susan Locke Siegfried. "Ingres and His Critics, 1806 to 1824." Ph.D. dissertation, Harvard University, 1980.

Siegfried 1980b. Susan L[ocke] Siegfried. "The Politics of Criticism at the Salon of 1806: Ingres' 'Napoleon Enthroned.'" In *The Consortium on Revolutionary Europe, 1750–1850: Proceedings,* vol. 2, edited by Donald D. Horward, John L. Connolly Jr., and Harold T. Parker, pp. 69–81. Athens, Ga., 1980.

Siegfried 1994. Susan L[ocke] Siegfried. "The Politicisation of Art Criticism in the Post-Revolutionary Press." In *Art Criticism and Its Institutions in Nineteenth-Century France,* edited by Michael R. Orwicz, pp. 9–28. Manchester and New York, 1994.

Silbert 1862. Paulin Silbert. *Notice historique sur la vie et l'oeuvre de Granet*. Aix, 1862.

Silvestre 1856. Théophile Silvestre. *Histoire des artistes vivants, français et étrangers: Études d'après nature*. Paris, 1856. [Reprinted as *Les Artistes français*, vol. 2, Paris, 1926.]

Silvestre 1862. Théophile Silvestre. *L'Apothéose de M. Ingres*. Paris, 1862.

Siple 1927. Ella S. Siple. "The Fogg Museum of Art at Harvard." *Burlington Magazine* 50 (June 1927), pp. 307, 309–15.

Siple 1930. Walter H. Siple. "Two Portraits by Ingres." *Bulletin of the Cincinnati Art Museum* 1 (January 1930), pp. 33–41.

Siple 1939. Ella S. Siple. "Art in America: Exhibitions of French Art in New York and Springfield." *Burlington Magazine* 75 (December 1939), pp. 247, 249–50.

Sitwell 1957. Sacheverell Sitwell. "Letters—Lithographs after Ingres Drawings." *Burlington Magazine* 99 (February 1957), p. 61.

Sitwell 1958. Sacheverell Sitwell. *Franz Liszt*. Translated by Willi Reich. Zurich, 1958.

Sitwell 1973. Sacheverell Sitwell. "Saved for the Nation." *Apollo* 98 (October 1973), pp. 258–62.

Slatkin and Slatkin 1942. Regina Shoolman [Slatkin] and Charles E. Slatkin. *The Enjoyment of Art in America*. Philadelphia, 1942.

Slatkin and Slatkin 1950. Regina Shoolman [Slatkin] and Charles E. Slatkin. *Six Centuries of French Master Drawings in America*. New York, 1950.

Smith 1973. Robert Smith. "Was Ingres a Portrait Lithographer? Some Re-Attributions to Géricault." *Nouvelles de l'estampe* 10 (1973), pp. 8–14.

Smith Alumnae Quarterly **1937.** *Smith Alumnae Quarterly*, November 1937.

Soby 1952. James Thrall Soby. "Two Ingres Paintings at the National Gallery." *Magazine of Art* 44 (May 1952), p. 162.

Soccanne 1938a. Pierre Soccanne. "Un Maître du quatuor: Pierre Baillot." *Guide du concert*, April 8, 15, 22, 1938, p. 744.

Soccanne 1938b. Pierre Soccanne. "Quelques Documents inédits sur Pierre Baillot." *Guide du concert*, October 21, 1938, p. 41.

Southampton, Manchester, Hull, London 1995. *Drawing the Line: Reappraising Drawing Past and Present*. Southampton City Art Gallery, January 13–March 5, 1995; Manchester City Art Galleries, March 18–April 30; Hull, Ferens Art Gallery, May 13–June 25; London, Whitechapel Art Gallery, July 7–September 10. A National Touring Exhibition from the South Bank Centre, selected by Michael Craig-Martin. Exh. cat. London, 1995.

Souvenirs d'Henri Labrouste **1928.** *Souvenirs d'Henri Labrouste: Notes recueillies et classées par ses enfants*. N.p., 1928.

Spaletti 1929. Jean-Baptiste Spaletti, ed. *Souvenirs d'enfance d'une fille de Joachim Murat, la princesse Louise Murat, comtesse Rasponi, 1805–1815, publiés par son arrière petit-fils, le comte Jean-Baptiste Spalletti, avec préface, notes et appendice du sénateur M. Mazziotti*. Paris, 1929.

Spalletti 1990. Ettore Spalletti. "La pittura dell'Ottocento in Toscana." In *La pittura in Italia: L'Ottocento*, edited by Enrico Castelnuova, vol. 1, pp. 258–333. Milan, 1990.

Spellanzon 1934. Cesare Spellanzon. *Storia del Risorgimento e dell'unità d'Italia*. Vol. 2. Milan, 1934.

Spoleto 1988. *François-Xavier Fabre*. Spoleto, Palazzo Racani-Arroni, June 27–August 28, 1988. Exh. cat. edited by Laure Pellicer. Rome, 1988.

Springfield, New York 1939–40. *David and Ingres: Paintings and Drawings*. Springfield Museum of Fine Arts, November 20–December 17, 1939; M. Knoedler and Co., New York, January 8–27, 1940. Exh. cat. New York, 1940.

State College 1963. *Aspects of the Apollonian Ideal*. State College, Pennsylvania State University, Mineral Industries Building Gallery, October 6–November 16, 1963. Exh. cat. State College, 1963.

Steiner 1931. Eva Steiner. "An Unknown Drawing by J. A. D. Ingres." *Old Master Drawings* 6 (June 1931), pp. 4–5.

Steiner 1991. Mary Ann Steiner, ed. *The Saint Louis Art Museum Handbook of the Collections*. Saint Louis, 1991.

Stendhal 1867. Stendhal. *Mélanges d'art et de littérature*. Paris, 1867.

Stendhal 1955. Stendhal. *Oeuvres intimes*. Edited and annotated by Henri Martineau. Paris, 1955.

Sterling 1934. Charles Sterling. "Portraits d'Ingres et de ses élèves." *Formes*, April 1934, pp. 3–4.

Sterling 1957. Charles Sterling. *Musée de l'Ermitage: La Peinture française de Poussin à nos jours*. Paris, 1957.

Sterling and Adhémar 1960. Charles Sterling and Hélène Adhémar. *Musée du Louvre. Peintures: École française, XIXe siècle*. Vol. 3. Paris, 1960.

Sterling and Salinger 1966. Charles Sterling and Margaretta M. Salinger. *French Paintings: A Catalogue of the Collection of The Metropolitan Museum of Art*. Vol. 2. New York, 1966.

Stern, January 7, 1842. Daniel Stern [Marie-Catherine-Sophie d'Agoult]. "Le Portrait de Chérubini par M. Ingres." *La Presse*, January 7, 1842.

Stern, Liszt, and Lehmann 1947. Daniel Stern [Marie-Catherine-Sophie d'Agoult], Franz Liszt, and Henri Lehmann. *Une Correspondance romantique: Madame d'Agoult, Liszt, Henri Lehmann*. Edited by Solange Joubert. Paris, 1947.

St.-Georges 1858. Henri de St.-Georges. *Notice historique sur le Musée de Peinture de Nantes d'après des documents officiels et inédits*. Nantes and Paris, 1858.

Stockholm 1958. *Fem sekler fransk konst*. Stockholm, Nationalmuseum, August 15–November 9, 1958. Exh. cat. 2 vols. Stockholm, 1958.

Stürler 1884. A[dolf] Stürler. *La Divine Comédie de Dante Alighieri*. Preface by Henri Delaborde. 3 vols. Paris, 1884.

Swenson 1966. G. R. Swenson. "Heroic Immolation." *Art and Artists* 1, no. 5 (August 1966), pp. 68–71.

Sydney, Melbourne 1980–81. *French Painting: The Revolutionary Decades, 1760–1830*. Sydney, Art Gallery of New South Wales, October 17–November 23, 1980; Melbourne, National Gallery of Victoria, December 17, 1980–February 15, 1981. Exh. cat. compiled by Arlette Sérullaz et al.; translated by Christopher Sells. Sydney, 1980.

Taft Museum **1995.** *The Taft Museum: Its History and Collections*. 2 vols. New York, 1995.

Taggart and McKenna 1973. Ross Taggart and George McKenna, eds. *Handbook of the Collections in the William Rockhill Nelson Gallery of Art and Mary Atkins Museum of Fine Arts*. Vol. 1, *Art of the Occident*. 5th ed. Kansas City, 1973.

Taurel 1885. C[harles]-Éd[ouard] Taurel. *L'Album T*. Amsterdam and The Hague, 1885.

Taylor 1885. Henry Taylor. *Autobiography of Henry Taylor 1800–1875*. 2 vols. London, 1885.

Terlay 1992. Bernard Terlay. "Les Portraits de Granet." *Impressions du Musée Granet* 7 (June 1992), p. 11.

Ternois 1955. Daniel Ternois. "Ingres aquarelliste." *La Revue des arts* 5 (June 1955), pp. 101–4.

Ternois 1956. Daniel Ternois. "Les Livres de comptes de madame Ingres (Ingres à Rome et à Paris, 1835–1843)." *Gazette des beaux-arts*, 6th ser., 48 (December 1956), pp. 163–76.

Ternois 1959a. Daniel Ternois. *Les Dessins d'Ingres au Musée de Montauban: Les Portraits*. Inventaire général des dessins des musées de province, 3. Paris, 1959.

Ternois 1959b. Daniel Ternois. *Guide du Musée Ingres*. Montauban, 1959.

Ternois 1961. Daniel Ternois. "L'Ingrisme dans le monde. Chronique du Musée." *Bulletin du Musée Ingres*, no. 8 (January 1961), pp. 20–21.

Ternois 1962. Daniel Ternois. "Lettres inédites d'Ingres à Hippolyte Flandrin." *Bulletin du Musée Ingres*, no. 11 (July 1962), pp. 5–26.

Ternois 1965. Daniel Ternois. *Montauban—Musée Ingres. Peintures: Ingres et son temps (artistes nés entre 1740 et 1830)*. Paris, 1965.

Ternois 1967. Daniel Ternois. "Ingres et sa méthode." *La Revue du Louvre et des Musées de France* 17 (1967), pp. 195–208.

Ternois 1969. Daniel Ternois. "Ossian et les peintres." In *Colloque Ingres [1967]*, pp. 165–213. [Montauban, 1969.]

Ternois 1980. Daniel Ternois. *Ingres*. Paris, 1980.

Ternois 1980a. Daniel Ternois. "Lettres d'Ingres à Calamatta." In *Actes du Colloque international: Ingres et son influence*, Montauban, septembre 1980, pp. 61–110. [Montauban, 1980.]

Ternois 1985. Daniel Ternois. "Une Nouvelle Lettre inédite d'Ingres à Calamatta." *Bulletin du Musée Ingres*, nos. 55–56 (December 1985), pp. 57–58.

Ternois 1986a. Daniel Ternois. "Une Amitié romaine: Les Lettres d'Ingres à Édouard Gatteaux." In *Actes du colloque: Ingres et Rome*, Montauban, septembre 1986, pp. 17–61. [Montauban, 1986.]

Ternois 1986b. Daniel Ternois. "La Correspondance d'Ingres: État des travaux et problèmes de méthode." *Archives de l'art français*, n.s., 28 (1986), pp. 161–200.

Ternois 1988. Daniel Ternois. "Une Lettre inédite d'Ingres aux peintres de Notre-Dame-de-Lorette." *Revue de l'art*, no. 80 (1988), pp. 88–91.

Ternois 1989. Daniel Ternois. "Ingres et Albert Magimel: Lettres et documents." *Bulletin du Musée Ingres*, nos. 59–60 (n.d. [1989?]), pp. 3–52.

Ternois 1993. Daniel Ternois. "Ingres: Portrait de Monsieur Bertin." Unpublished manuscript. January 1993. Service de la Documentation, Département des Peintures, Musée du Louvre, Paris.

Ternois 1998. Daniel Ternois. *Monsieur Bertin*. Collection "Solo." Paris, 1998.

Ternois 1999. Daniel Ternois, ed. *Lettres d'Ingres à M. Marcotte d'Argenteuil. Archives de l'art français*, n.s., 35. Paris, 1999. Forthcoming.

Ternois 2000. Daniel Ternois. *Dictionnaire Ingres—Marcotte. Archives de l'art français*, n.s., 36. Paris, 2000. Forthcoming.

Ternois and Camesasca 1971. Daniel Ternois and Ettore Camesasca. *Tout l'oeuvre peint d'Ingres*. Paris, 1971.

Ternois and Camesasca 1984. Daniel Ternois and Ettore Camesasca. *Tout l'oeuvre peint de Ingres*. New ed. Paris, 1984.

M.-J. Ternois 1956. Marie-Jeanne Ternois. "Ingres et Montauban." Dissertation, École du Louvre, 1956.

M.-J. Ternois 1959. Marie-Jeanne Ternois. "Les Oeuvres d'Ingres dans la collection Gilibert." *La Revue des arts*, no. 3 (1959), pp. 120–30.

Thévoz 1980. Michel Thévoz. *L'Académisme et ses fantasmes: Le Réalisme imaginaire de Charles Gleyre*. Paris, 1980.

Thiébault 1893–95. Paul-Dieudonné, Baron Thiébault. *Mémoires du général B^on Thiébault*. Edited by Fernand Calmettes. 5 vols. Paris, 1893–95.

Thieme and Becker 1907–50. Ulrich Thieme and Felix Becker. *Allgemeines Lexikon der bildenden Künstler*. 37 vols. Leipzig, 1907–50.

Thierry 1855. Édouard Thierry. "Exposition universelle de 1855." *Revue des beaux-arts* 6, no. 11 (June 1, 1855), pp. 202–5.

Thoré, November 16, 1834. [Théophile] T[horé]. "Portrait de M. Molé, par M. Ingres." *Le Réformateur*, November 16, 1834.

Thoré 1842. T[héophile] Thoré. "M. Ingres." *La Revue indépendante* 3 (June 1842), pp. 794–803.

Thoré, August 19, 1845. Théophile Thoré. "Feuilleton." *Le Constitutionnel*, August 19, 1845.

Thoré 1846. Théophile Thoré. *Le Salon de 1846*. Paris, 1846.

Thoré, March 10, 1846. Théophile Thoré. "Feuilleton." *Le Constitutionnel*, March 10, 1846.

Tietze 1939. Hans Tietze. *Masterpieces of European Painting in America*. New York, 1939.

Tietze 1947. Hans Tietze. *European Master Drawings in the United States*. New York, 1947.

Timbal 1881. Charles Timbal. *Notes et causeries sur l'art et les artistes*. Paris, 1881.

Titeux 1901. Eugène Titeux. "Le Général Dulong de Rosnay." *Carnet de la Sabretache* (Paris), January 31, 1901.

Tokyo 1979. *European Master Drawings of Six Centuries from the Collection of the Fogg Art Museum*. Tokyo, National Museum of Western Art, 1979. Exh. cat. in English and Japanese. Tokyo, 1979.

Tokyo 1992. *Line and Colour: Nineteenth Century French Drawings from the Collection of the Ashmolean Museum, Oxford*. Tokyo Station Gallery, 1992. Exh. cat. by Colin Harrison. Tokyo, 1992.

Tokyo, Kyoto 1961. *Exposition d'art français au Japon, 1840–1940*. Tokyo, National Museum of Western Art; Kyoto, Municipal Museum; 1961. Exh. cat. Tokyo and Kyoto, 1961.

Tokyo, Osaka 1981. *Ingres*. Tokyo, National Museum of Western Art, April 28–June 14, 1981; Osaka, National Museum of Art, June 23–July 19. Exh. cat. Tokyo, 1981.

Toledo 1941. *French Drawings and Water Colors*. Toledo Museum of Art, November 2–December 14, 1941. Exh. cat. [Toledo, Ohio], 1941.

Toledo 1954. *Composer Portraits and Autograph Scores*. Toledo Museum of Art, October 3–November 7, 1954. Exh. cat. Toledo, Ohio, 1954.

Toronto 1935. *Loan Exhibition of Paintings Celebrating the Opening of the Margaret Eaton Gallery and the East Gallery*. Art Gallery of Toronto, November 1–30, 1935. Exh. cat. Toronto, 1935.

Toronto 1944. *Loan Exhibition of Great Paintings in Aid of Allied Merchant Seamen*. Art Gallery of Toronto, February 4–March 5, 1944. Exh. cat. Toronto, 1944.

Toulouse 1939. "Cent Cinquantième Anniversaire de la Révolution française, *1789–1939*." Toulouse, Palais des Arts, 1939.

Toulouse 1950. *Bi-centenaire de l'Académie des arts et de l'École des Beaux-Arts, 1750–1950*. Toulouse, Palais des Arts, May 26–June 11, 1950. Exh. cat. Toulouse, 1950.

Toulouse 1989. *Patrimoine public et révolution française*. Toulouse, Réfectoire des Jacobins, 1989. Exh. cat. Toulouse, 1989.

Toulouse 1989–90. *Toulouse et le Néo-Classicisme: Les Artistes toulousains de 1775 à 1830*. Toulouse, Musée des Augustins, October 11, 1989–January 7, 1990. Exh. cat. by Jean Penent. Toulouse, 1989.

Toulouse, Montauban 1955. *Ingres et ses maîtres: De Roques à David*. Toulouse, Musée des Augustins, May 14–June 26, 1955; Montauban, Musée Ingres, July 6–August 21, 1955. Exh. cat. Toulouse, 1955.

Tourneux 1900. Maurice Tourneux. "L'Exposition centennale: Les Dessins et les aquarelles." *Gazette des beaux-arts*, 3rd ser., 23 (June 1, 1900), pp. 465–78.

Toussaint 1927. Gabriel Toussaint. *Granet: Peintre provençal et franciscain*. Aix-en-Provence, 1927.

Toussaint 1990a. Hélène Toussaint. "Découvertes et attributions: Trois Paysages romains." *Bulletin du Musée Ingres*, nos. 63–64 (1990), pp. 58–65.

Toussaint 1990b. Hélène Toussaint. "Les Fonds de portraits d'Ingres: Peintures à fond de paysage." *Bulletin du Musée Ingres*, nos. 63–64 (1990), pp. 18–24.

Toussaint 1994. Hélène Toussaint. "Ingres et les architectes: Rendons à Mazois . . ." In *Hommage à Michel Laclotte*, pp. 573–78. Milan and Paris, 1994.

Toussaint and Couëssin 1985. Hélène Toussaint and Charles de Couëssin. "À propos de l'exposition Ingres." *La Revue du Louvre et des Musées de France* 35 (1985), pp. 193–206.

Trapp 1967. Frank Anderson Trapp. "A Mistress and a Master: Madame Cavé and Delacroix." *Art Journal* 27 (fall 1967), pp. 40–47, 59–60.

Trapp 1970. Frank Anderson Trapp. *The Attainment of Delacroix*. Baltimore, 1970.

Trésors des musées de province 1958. *Trésors des musées de province*. Vol. 2. Paris, 1958.

Tübingen, Brussels 1986. *Ingres und Delacroix: Aquarelle und Zeichnungen*. Tübingen, Kunsthalle, September 12–October 28, 1986; Brussels, Palais des Beaux-Arts, November 7–December 21. Exh. cat. by Ernst Goldschmidt and Götz Adriani. Cologne, 1986. French ed., *Ingres et Delacroix: Dessins et aquarelles*. Ghent, 1986.

Tulard 1995. Jean Tulard, ed. *Dictionnaire du Second Empire*. Paris, 1995.

Turin 1987. *Lo specchio e il doppio*. Turin, Mole Antonelliana, June 24–October 11, 1987. Exh. cat. Milan, 1987.

Turpin de Crissé 1834. Lancelot-Théodore Turpin de Crissé. "Le Comte Turpin de Crissé." *Le Biographe*, 1834, pp. 210–13.

Utica 1967. "European Paintings from the Rochester Memorial Art Gallery." Utica, Munson-Williams-Proctor Institute, January 15–September 1967.

Uzanne 1906. Octave Uzanne. *Jean-Auguste-Dominique Ingres: Painter*. Translated by Helen Chisholm. London, [1906].

Van Witsen 1981. Leo Van Witsen. *Costuming for the Opera*. [Vol. 1.] Bloomington, Ind., 1981.

Vapereau 1880. G[ustave] Vapereau. *Dictionnaire universel des contemporains*. 5th ed. Paris, 1880.

Varnhagen von Ense 1861–1905. Karl A. Varnhagen von Ense. *Tagebücher*. 15 vols. Zurich, 1861–1905.

Varnier 1840. [Jules] Varnier. "J. A. Ingres. La Stratonice." *L'Artiste*, 2nd ser., 6 (1840), pp. 151–53.

Varnier 1841. Jules Varnier. "M. Ingres." *L'Artiste*, 2nd ser., 8 (1841), pp. 303–8.

Varnier 1842. J[ules] V[arnier]. "Portrait de Chérubini, par M. Ingres." *L'Artiste*, 3rd ser., 1 (1842), pp. 134–35.

Vasari Society 1920–35. *Vasari Society for the Reproduction of Drawings by Old and Modern Masters*. 2nd ser. 10 vols. in 9. Oxford, 1920–35.

Venice 1934. *XIXᵃ esposizione biennale internazionale d'arte*. Venice, 1934. Exh. cat. Venice, 1934.

Venn 1944. A. Venn. *Alumni Cantabrigenses*. Part 2, vol. 2. Cambridge, 1944.

Venturi 1941. Lionello Venturi. *Peintres modernes*. Paris, 1941.

Venturi 1947. Lionello Venturi. *Modern Painters*. 2 vols. New York and London, 1947.

Vergnaud 1828. [Armand-Denis Vergnaud]. *Examen du Salon de 1827*. Paris, 1828.

Vergnaud 1834. A[rmand]-D[enis] Vergnaud. *Examen du Salon de 1834*. Paris, 1834.

Ver-Huell, January 20, 1846. Charles Ver-Huell. "Exposition d'ouvrages de peintures dans la galerie des beaux-arts, boulevard Bonne-Nouvelle no. 22." *L'Espérance*, January 20, 1846.

Ver-Huell, January 25, 1846. Charles Ver-Huell. "Exposition d'ouvrages de peintures dans la galerie des beaux-arts, boulevard Bonne-Nouvelle no. 22." *L'Espérance*, January 25, 1846.

Vermeule 1964. Cornelius Vermeule. *European Art and the Classical Past*. Cambridge, Mass., 1964.

Vernis 1952. Vernis. "International Studio: French Drawings." *Connoisseur* 129 (May 1952), p. 119.

Versailles 1881. *Exposition de l'art rétrospectif*. Palais de Versailles, June 1–July 15, 1881. Exh. cat. Versailles, 1881.

Versailles 1931. *Enfants d'autrefois*. Versailles, Bibliothèque municipale, May–June, 1931. Exh. cat. Paris, 1931.

Verslagen der Rijksverzamelingen 1953. *Verslagen der Rijksverzamelingen van Geschiedenis en Kunst* 75 (1953).

Vevey 1997–98. *Cinq Siècles de dessins: Collections du Musée Jenisch*. Vevey, Musée Jenisch, September 28, 1997–February 1, 1998. Exh. cat. by Giulio Bora. Vevey, 1997.

Vicaire 1864. M. Vicaire. "Obsèques de M. Marcotte, ancien directeur-général des Eaux et Forêts." *La Revue des Eaux et Forêts*, 1864, pp. 100–105.

Vienna 1950a. "Les Dessins français à l'Albertina." Vienna, Graphische Sammlung Albertina, September 1950.

Vienna 1950b. *Meisterwerke aus Frankreichs Museen*. Vienna, Graphische Sammlung Albertina, 1950. Exh. cat. Vienna, 1950.

Vienna 1976–77. *Von Ingres bis Cézanne: Aquarelle und Zeichnungen aus dem Louvre*. Vienna, Graphische Sammlung Albertina, November 19, 1976–January 25, 1977. Exh. cat. Vienna, 1976.

Vienna, Munich 1986. *Meisterzeichnungen aus sechs Jahrhunderten: Die Sammlung Ian Woodner*. Vienna, Graphische Sammlung Albertina, January 26–March 2, 1986; Munich, Haus der Kunst, March 25–May 25. Exh. cat. edited by Veronika Birke and Friedrich Piel. Vienna, 1986.

Vier 1955–63. Jacques Vier. *La Comtesse d'Agoult et son temps; avec des documents inédits*. 6 vols. Paris, 1955–63.

Vigne 1990. Georges Vigne. "Les Fonds de portraits d'Ingres: Le Décor du 'Portrait de madame Moitessier assise' d'Ingres." *Bulletin du Musée Ingres*, nos. 63–64 (1990), pp. 28–31.

Vigne 1995a. Georges Vigne. *Dessins d'Ingres: Catalogue raisonné des dessins du musée de Montauban*. Paris, 1995.

Vigne 1995b. Georges Vigne. *Ingres*. Paris, 1995. English ed. translated by John Goodman. New York, 1995.

Vigne 1997. Georges Vigne. "Le Portrait de Clémence Dechy, ou Ingres et ses soeurs." *Bulletin du Musée Ingres*, no. 70 (April 1997), pp. 13–39.

Vignon 1855. Claude Vignon [Noémie Cadiot]. *Exposition universelle de 1855. Beaux-Arts*. Paris, 1855.

Viguié 1958. Pierre Viguié. "L'Amitié d'Ingres et de Granet." In *Actes du 83ᵉ Congrès national des Sociétés savantes. Aix-Marseille, 1958*. Paris, 1959.

Viguié 1965. Pierre Viguié. "Les Quatre Amours de M. Ingres." *La Revue de Paris*, September 1965, pp. 105–6.

Viguié 1966. Pierre Viguié. "Ingres et Montauban." *Bulletin du Musée Ingres*, no. 20 (December 1966), pp. 19–24.

Vinet 1863. Ernest Vinet. [Celebration of Hippolyte Flandrin's Recuperation.] *Journal des débats*, March 11, 1863.

Virch 1960. Claus Virch. "The Walter C. Baker Collection of Master Drawings." *The Metropolitan Museum of Art Bulletin* 18 (June 1960), pp. 308–17.

Virch 1962. Claus Virch. *Master Drawings in the Collection of Walter C. Baker*. New York, 1962.

Visconti 1809. F[rancesco] A[urelio] V[isconti]. "Lettere nelle quali si dà conto delle Opere di pittura, scultura, architettura, ed incisione esposte nelle stanze de Campidoglio li 19 novembre 1809." *Giornale del Campidoglio*, no. 71 (December 11, 1809), pp. 289–90.

Visites et études 1856. *Visites et études de S. A. I. le Prince Napoléon au Palais des Beaux-Arts.* Paris, 1856.

Vitry 1922. Paul Vitry. *Le Musée d'Orléans*. Paris, 1922.

Voïart 1806. Un Amateur [Jacques-Philippe Voïart]. *Lettres impartiales sur les expositions de l'an 1806. Lettres 1–8.* Paris, 1806.

Vollard 1920. Ambroise Vollard. *Auguste Renoir.* Paris, 1920.

Vollard 1938. Ambroise Vollard. *En écoutant Cézanne, Degas, Renoir.* Paris, 1938.

Wagner 1974. Hugo Wagner. *Italienische Malerei, 13. bis 16. Jahrhundert.* Sammlungskataloge des Berner Kunstmuseums, 1. Bern, 1974.

Waldemar George 1929. Waldemar George. *Le Dessin français de David à Cézanne et l'esprit de la tradition baroque.* Paris, 1929.

Waldemar George 1934. Waldemar George. "Portraits par Ingres et ses élèves." *La Renaissance* 17 (October–November 1934), pp. 193–200.

Waldemar George 1967. Waldemar George. *Dessins d'Ingres.* Paris, 1967.

Waldemar George 1969. Waldemar George. "Faut-il supprimer le prix de Rome?" *L'Amateur d'art*, April 10, 1969, p. 9.

Walker 1963. John Walker. *National Gallery of Art, Washington, D.C.* New York, 1963.

Walker 1984. John Walker. *National Gallery of Art, Washington, D.C.* New York, 1984.

Ward and Fidler 1993. Robert Ward and Patricia Fidler, eds. *The Nelson-Atkins Museum of Art: A Handbook of the Collection.* New York, 1993.

Waroquier 1959. Henry de Waroquier. "À propos d'Ingres." *Bulletin du Musée Ingres*, no. 6 (December 1959), pp. 6–15.

Warrick 1996. Paula J. Warrick. "Portraits of a Caste: Ingres, the Circle of Charles Marcotte d'Argenteuil, and the Bureaucratic Image, 1810–1864." 2 vols. Ph.D. dissertation, University of Delaware, Newark, 1996.

Warsaw 1956. *Malarstwo francuskie od Davida do Cézanne'a.* Warsaw, Muzeum Narodowe, June 15–July 31, 1956. Exh. cat. Warsaw, 1956.

Warsaw 1962. *Francuskie rysunki XVII–XX w. i tkaniny.* Warsaw, Muzeum Narodowe, 1962.

Washington 1940. *Great Modern Drawings.* Washington, D.C., Phillips Memorial Gallery, April 7–May 1, 1940. Exh. cat. Washington, D.C., 1940.

Washington 1951. *Paintings and Sculpture from the Kress Collection Acquired by the Samuel H. Kress Foundation, 1945–1951.* Washington, D.C., National Gallery of Art. Exh. cat. by William E. Suida. Washington, D.C., 1951.

Washington 1966. "Master Drawings from the National Gallery's Collection." Washington, D.C., National Gallery of Art, 1966.

Washington 1974. *Recent Acquisitions and Promised Gifts.* Washington, D.C., National Gallery of Art, June 2–September 1, 1974. Exh. cat. Washington D.C., 1974.

Washington 1978. *Master Drawings from the Collection of the National Gallery of Art and Promised Gifts.* Washington, D.C., National Gallery of Art, June 1–October 1, 1978. Exh. cat. Washington, D.C., 1978.

Washington 1983–84. *Masterpieces from Versailles: Three Centuries of French Portraiture.* Washington, D.C., National Portrait Gallery, November 11, 1983–January 8, 1984. Exh. cat. by Alden R. Gordon. Washington, D.C., 1983.

Washington 1995–96. *The Touch of the Artist: Master Drawings from the Woodner Collections.* Washington, D.C., National Gallery of Art, October 1, 1995–January 28, 1996. Exh. cat. edited by Margaret Morgan Grasselli. Washington, D.C., 1995.

Washington and other cities 1970–72. *Nineteenth and Twentieth Century Paintings from the Collection of the Smith College Museum of Art.* Washington, D.C., National Gallery of Art, May 16–June 14, 1970; and other cities through 1972. Exh. cat. by Mira Matherny Fabian, Michael Wentworth, and Charles Chetham. Northampton, Mass., 1970.

Washington, Cleveland, Saint Louis, Cambridge (Mass.), New York 1952–53. *French Drawings: Masterpieces from Five Centuries.* Washington, D.C., National Gallery of Art; Cleveland Museum of Art; Saint Louis, City Art Museum; Cambridge, Mass., Harvard University, Fogg Art Museum; New York, The Metropolitan Museum of Art, 1952–53. Exh. cat. [New York], 1952.

Washington, Montreal, Yokohama, London 1990–91. *The Passionate Eye: Impressionist and Other Master Paintings from the Collection of Emil G. Bührle, Zurich.* Washington, D.C., National Gallery of Art, May 6–July 15, 1990; Montreal; Yokohama; London; through April 9, 1991. Exh. cat. Zurich, 1990.

Washington, National Gallery 1959. National Gallery of Art. *Paintings and Sculpture from the Samuel H. Kress Collection.* Washington, D.C., 1959.

Washington, National Gallery 1975. National Gallery of Art. *European Paintings.* Washington, D.C., 1975.

Washington, National Gallery 1985. National Gallery of Art. *European Paintings: An Illustrated Catalogue.* New York and Washington, D.C., 1985.

Washington, National Gallery 1992. National Gallery of Art. *National Gallery of Art, Washington.* New York and Washington, D.C., 1992.

Washington, National Gallery 1996. National Gallery of Art. *National Gallery of Art, 1995 Annual Report.* Washington, D.C., 1996.

Washington, New York, Philadelphia, Kansas City 1971. *Ingres in Rome: A Loan Exhibition from the Musée Ingres, Montauban, and American Collections.* Washington, D.C., National Gallery of Art, January 24–February 21, 1971; New York, Wildenstein and Co., April 22–May 22; Philadelphia Museum of Art, March 11–April 11; Kansas City, William Rockhill Nelson Gallery of Art, June 19–July 18. Exh. cat. Meriden, Conn., 1971.

Waterhouse 1946. Ellis K. Waterhouse. "The Knoedler Centenary Exhibition, New York." *Burlington Magazine* 88 (June 1946), pp. 152, 155.

Watrous 1957. James Watrous. *The Craft of Old-Master Drawings.* Madison, Wisc., 1957.

Weigert 1955. R[oger]-A[rmand] W[eigert]. "M. Ingres: Une Lettre inédite (1852)." *Bulletin de la Société de l'histoire de l'art français*, 1954 (1955), pp. 230–31.

Weilguny and Handrick 1958. Hedwig Weilguny and Willi Handrick. *Franz Liszt: Biographie in Bildern.* Weimar, 1958.

Weiss-Blok 1997. Rivka Weiss-Blok. "D'après Ingres: Paul Flandrin." *Israel Museum Journal* 15 (summer 1997), pp. 125–30.

Weitzenhoffer 1986. Frances Weitzenhoffer. *The Havemeyers: Impressionism Comes to America.* New York, 1986.

Wellesley 1958. Exhibition. Wellesley, Mass., Dana Hall, April 1958.

Werner 1973. Alfred Werner. "Jean-Auguste-Dominique Ingres: Wizard of Montauban." *American Artist* 37 (September 1973), pp. 26–31.

West Palm Beach, Coral Gables 1953. *An Exhibition of French Painting: David to Cézanne.* West Palm Beach, Norton Gallery, February 4–March 1, 1953; Coral Gables, University of Miami, Lowe Gallery, March 15–April 5, 1953. Exh. cat. West Palm Beach, 1953.

White 1965. H. Wade White. "Recent Accessions: Five Testimonials in the Bequest of Paul J. Sachs." *Fogg Art Museum Newsletter* 3, no. 2 (October 1965).

White 1972. Christopher White. "The Armand Hammer Collection: Drawings." *Apollo* 95 (June 1972), pp. 456–63.

Whiteley 1977. Jon Whiteley. *Ingres.* London, 1977.

Wichmann 1968. Siegfried Wichmann. "Die Ingres-Ausstellung im Petit Palais in Paris." *Kunstchronik* 21 (May 1968), pp. 115–30.

Wiekenberg 1958. Adolf Wiekenberg. "Andrea Appiani." *Die Weltkunst* 28, no. 10 (May 15, 1958), p. 18.

Wijsenbeek 1956. L. J. F. Wijsenbeek. "Mademoiselle Thévenin door J. A. D. Ingres." *Mededelingen van het Gemeente Museum van Den Haag* 11, no. 1 (1956), pp. 32–35.

Wildenstein 1954. Georges Wildenstein. *Ingres.* London, 1954. 2nd ed., London, 1956.

Wildenstein 1956. Georges Wildenstein. "Les Portraits du duc d'Orléans par Ingres." *Gazette des beaux-arts*, 6th ser., 48 (November 1956), pp. 75–80.

Wildenstein and Wildenstein 1973. Daniel Wildenstein and Guy Wildenstein. *Documents complémentaires au catalogue de l'oeuvre de Louis David.* Paris, 1973.

Wilenski 1931. R. H. Wilenski. *French Painting.* Boston, 1931.

Williamstown 1946. Exhibition. Williamstown, Mass., Williams College, Lawrence Art Museum, 1946.

Wilson 1977. Michael Wilson. *Madame Moitessier.* Painting in Focus, no. 7. London, 1977.

Wilson 1983. Michael Wilson. *French Paintings after 1800.* National Gallery Schools of Painting. London, 1983.

Winnipeg 1954. *French Pre-Impressionist Painters of the Nineteenth Century: Paintings, Watercolors, Drawings, Graphics.* Winnipeg Art Gallery, April 10–May 9, 1954. Exh. cat. Winnipeg, 1954.

Winter 1958. Carl Winter. *The Fitzwilliam Museum: An Illustrated Survey.* Cambridge, 1958.

Winterthur 1955. *Europäische Meister, 1790–1910.* Kunstmuseum Winterthur, June 12–July 24, 1955. Exh. cat. Winterthur, 1955.

Wittkop 1968. Justus Franz Wittkop. *Die Welt des Empire.* Munich, 1968.

Wolf 1925. Georg Jacob Wolf. "Das Gruppenbildnis." *Die Kunst* 51 (1925), pp. 135–50.

Wolf 1942. Alice Wolf. *The Edward B. Greene Collection of Engraved Portraits and Portrait Drawings at Yale University.* New Haven, 1942.

Wolff 1867. Albert Wolff. "Gazette de Paris." *Le Figaro*, April 16, 1867.

Wollheim 1987. Richard Wollheim. *Painting as an Art.* Princeton, 1987.

Woods 1966. Willis F. Woods. "A Survey of Recent Acquisitions." *Art Gallery*, July–August–September 1966.

Worcester 1951–52. *The Practice of Drawing.* Worcester Art Museum, November 17, 1951–January 6, 1952. Exh. cat. published in *Worcester Art Museum News Bulletin and Calendar* 17, no. 3 (December 1951).

Wrigley 1993. Richard Wrigley. *The Origins of French Art Criticism from the Ancien Régime to the Restoration.* Oxford and New York, 1993.

Wrigley 1998. Richard Wrigley. "The Class of 89? Cultural Aspects of Bourgeois Identity in France in the Aftermath of the French Revolution."

In *Art in Bourgeois Society, 1790–1850*, edited by Andrew Hemingway and William Vaughan, pp. 130–53. Cambridge, 1998.

Würtenberger 1925. Ernst Würtenberger. *I. A. D. Ingres*. Basel, 1925.

Wyzewa 1907. T[éodor] de Wyzewa. *L'Oeuvre peint de Jean-Dominique Ingres*. Paris, 1907.

Yard 1981. Sally Yard. "Willem de Kooning's Men." *Arts* 56, no. 4 (December 1981), pp. 134–43.

Yard 1986. Sally Yard. *Willem de Kooning: The First Twenty-six Years in New York*. Outstanding Dissertations in the Fine Arts. New York, 1986.

Young 1967. Mahonri Sharp Young. "Treasures in Gramercy Park." *Apollo* 85 (March 1967), pp. 171–81.

Young 1971. Mahonri Sharp Young. "French Painting of the Nineteenth and Twentieth Centuries." *Apollo* 93 (April 1971), pp. 300–305.

Young 1975. Mahonri Sharp Young. "A Decade of Collecting, Los Angeles County Museum of Art." *Apollo* 101 (March 1975), pp. 215–25.

Yriarte 1867. Charles Yriarte. "Courrier de Paris." *Le Monde illustré*, April 20, 1867, p. 235.

Zabel 1929. Morton Dauwen Zabel. "The Portrait Methods of Ingres." *Art and Archaeology* 28 (October 1929), pp. 103–16.

Zabel 1930. Morton Dauwen Zabel. "Ingres in America." *Arts* 16 (February 1930), pp. 369–84.

Zanni 1990. Annalisa Zanni. *Ingres: Catalogo completo dei dipinti*. Florence, 1990.

Zieseniss 1969. Charles Otto Zieseniss. "Les Portraits des ministres et des grands officiers de la couronne." *Archives de l'art français*, n.s., 24 (1969), pp. 133–58.

Ziff 1977. Norman D. Ziff. *Paul Delaroche: A Study in Nineteenth-Century French History Painting*. Outstanding Dissertations in the Fine Arts. New York, 1977.

Zurich 1917. *Französische Kunst des XIX. u. XX. Jahrhunderts*. Zurich, Kunsthaus, October 5–November 14, 1917. Exh. cat. Zurich, 1917.

Zurich 1937. *Zeichnungen französischer Meister von David zu Millet*. Zurich, Kunsthaus, June 18–September 12, 1937. Exh. cat. [Zurich, 1937.]

Zurich 1953. *Richard-Wagner-Ausstellung*. Zurich, Helmhaus, May 22–July 5, 1953. Exh. cat. Zurich 1953.

Zurich 1958a. *Rome vue par Ingres: Die italienischen Landschaften und Ansichten aus dem Musée Ingres aus in Montauban; Portraitzeichnungen von Ingres aus schweizerischem Privatbesitz*, Zurich. Kunsthaus, March 5–April 13, 1958. Exh. cat. introduction by Hans Naef. Zurich, 1958.

Zurich 1958b. *Sammlung Emil G. Bührle*. Zurich, Kunsthaus, June–end of September, 1958. Exh. cat. Zurich, 1958.

Zurich 1973. *50 Jahre Kunsthandelsverband der Schweiz*. Zürich, Kunsthaus, September 15–November 11, 1973. Exh. cat. Zurich, 1973.

Zurich, Tübingen 1994–95. *Degas Portraits*. Zurich, Kunsthaus, December 2, 1994–March 5, 1995; Tübingen, Kunsthalle, March 18–June 18. Exh. cat. by Jean Sutherland Boggs et al. London, 1994.

INDEX

PHOTOGRAPH CREDITS

Baltimore: fig. 27: The Baltimore Museum of Art, The
Cone Collection, formed by Dr. Claribel Cone and
Miss Etta Cone of Baltimore, Maryland.

Basel: fig. 47: Öffentlich Kunstsammlung, Basel,
Photograph by Martin Bühler.

Boston: cat. no. 55: Museum of Fine Arts, Boston ©
1998, All Rights Reserved; fig. 176: Susan Cornelia
Warren Fund and the Picture Fund.

Cambridge, Massachusetts: All photographs courtesy of
the Fogg Art Museum, Harvard University Art
Museums, © President and Fellows, Harvard College,
Harvard University Art Museums: cat. nos. 47, 126,
127, 137, 159, 190: photographs by David Matthews;
figs. 7, 9, 76, 127, 167, 168, 179, 205, 206, 212, 218,
285: Bequest of Grenville L. Winthrop; fig. 79: Gift
of John S. Newberry in Memory of Meta P. Sachs;
fig. 139: Bequest of Meta and Paul J. Sachs; fig. 335:
Gift of Mrs. Jacob M. Kaplan; Photographic
Services.

Chicago: Photograph ©1998, The Art Institute of Chicago,
All Rights Reserved: cat. nos. 15, 42, 44, 98, 117, 164;
fig. 175: Clyde M. Carr Fund and Major Acquisitions
Endowment, 1967.228; fig. 345: Gift of Walter S.
Brewster, 1954.1073.

Cologne: fig. 12: Rheinisches Bildarchiv Köln.

Detroit: cat. no. 161: Photography © 1998 The Detroit
Institute of Arts.

Geneva: fig. 341: Musée Athénée, © Musée d'art et
d'histoire, Genève; cat. no. 128: Photograph by
S. Waeber.

The Hague: cat. no. 73: © Collection Gemeentemuseum,
Den Haag 19, c/o Beeldrecht Amstelveen.

Kansas City: cat. no. 29: Nelson Atkins Museum of

Fine Arts, © The Nelson Gallery Foundation/
All Reproduction Rights Reserved.

London: fig. 314: © The Board of Trustees of the
Victoria and Albert Museum.

Los Angeles: cat. no. 69: © 1998 Museum Associates,
Los Angeles County Museum of Art, All Rights
Reserved; fig. 109: William Randolph Hearst
Collection.

Lyons: cat. nos. 155, 158: Musée des Beaux-Arts de Lyon,
Studio Basset—69300 Caluire.

Montauban: Photographs from the Musée Ingres, ©
Roumagnac Photographe.

Montpellier: fig. 59: Musée Fabre Montpellier Cliché /
Frédéric Jaulmes.

Nantes: cat. no. 35: Photograph A.G. Ville de Nantes,
Musée des Beaux-Arts.

New Orleans: fig. 267: New Orleans Museum of Art;
The Muriel Bultman Francis Collection.

New York: fig. 85: © Christie's Images. Fig. 35: Courtesy
Cindy Sherman and Metro Pictures. Cat. no. 125:
© The Frick Collection. Fig. 337: Courtesy of the
Hispanic Society of America. Photographs from The
Metropolitan Museum of Art courtesy of the Photo
Studio. Cat. no. 52: The Pierpoint Morgan Library,
Photography by Joseph Sehari. Figs. 17, 60, 264:
© Archivi Alinari / Art Resource NY, 1990, All
Rights Reserved. Fig. 92, 94, 103, 169, 177, 191,
283: Giraudon / Art Resource NY.

Oberlin: fig. 170: Allen Memorial Art Museum, Oberlin
College, Ohio; R.T. Miller, Jr. Fund, 1948 © Allen
Memorial Art Museum.

Oxford: cat. nos. 18, 75, 95: © Copyright in this Photo-
graph Reserved to the Ashmolean Museum, Oxford.

Paris: figs. 32, 33: Cliché Musée National d'Art Moderne,
Paris. Fig. 25: © Arch.Phot.Paris./CNMHS. Cat.
no. 120: © Conservatoire National Supérieur de
Musique. Fig. 248: © Photo Flammarion. Cat. no. 105:
© Photothèque des Musées de la ville de Paris, cliché
Rémi Briant. © Réunion des Musées Nationaux: cat.

no. 23, figs. 9, 11, 13, 14, 21, 24, 28, 49, 51, 61, 66, 69,
81, 82, 104, 117, 156, 160, 202, 203, 215, 221, 223, 228,
244, 289, 293, 294, 306, 316, 318; Photograph by
Michèle Bellot: cat. nos. 17, 20, 22, 92, 93, 102, 136,
118, fig. 87; Photograph by H. Lewondowski: cat.
no. 30, fig. 93; Photograph by J. G. Berizzi: cat. no. 72;
Photograph by Jean: cat. no. 99; Photograph by R.G.
Ojeda: figs. 29, 42, 90, 96, 97, 105, 135, 138, 159, 164,
187, 188, 222, 224, 240, 252, 254, 277, 330; Photo-
graph by Gérard Blot: figs. 58, 220; Photograph by
Popovitch: fig. 68; Photograph by Arnaudet: fig. 70.
Cat. no. 10: © Photo Musée de l'Armée, Paris. Figs. 62,
194, 234: Lauros-Giraudon. Cat. no. 81: Musée des
Arts Décoratifs, Photo Laurent-Sully Jaulmes, All
Rights Reserved.

Philadelphia: cat. no. 32: Philadelphia Museum of Art,
Photograph by Joe Mikuliak, 1995.

Providence: fig. 89: Museum of Art, Rhode Island School
of Design, Museum Appropriation. Photograph by
Erik Gould.

Richmond: cat. nos. 46, 68: © Virginia Museum of Fine
Arts, Photograph by Katherine Wetzel.

Rouen: cat. no. 8: © Musée des Beaux-Arts de Rouen,
Photographie.

Washington, D.C.: © National Gallery of Art: cat. nos.
14, 40, 49, 91, 141, 157: Photographs by Lee Ewing;
cat. no. 26: Photograph by Richard Carafelli; cat. no.
62: Photograph by Dean Beasom; fig. 100: Samuel H.
Kress Collection.

Worcester: fig. 263: Worcester Art Museum, Worcester,
Massachusetts, In Memory of Mary Alexander Riley
with Funds given by her Friends, Photograph ©
Worcester Art Museum.

Other: cat. nos. 108, 140, 323: Photograph by Jean-Loup
Charmet; cat. no. 112, fig. 40: Photograph by Jim
Strong; cat. no. 135: Photograph by Ph. Sebert; figs. 8,
144, 185: Photograph by Erich Lessing; fig. 67: Photo-
graph by P. Bernard; fig. 86: Copy Photo: Anderson
1929A, Rome; fig. 110: Photograph by Michel Dupuis,
Ville de Saint-Malo; fig. 124: Photograph by Allan
Finkelman © 1989; fig. 204: Photograph by Bulloz.